EARLY NETHERLANDISH PAINTING

ITS ORIGINS AND CHARACTER

The Charles Eliot Norton Lectures
1947–1948

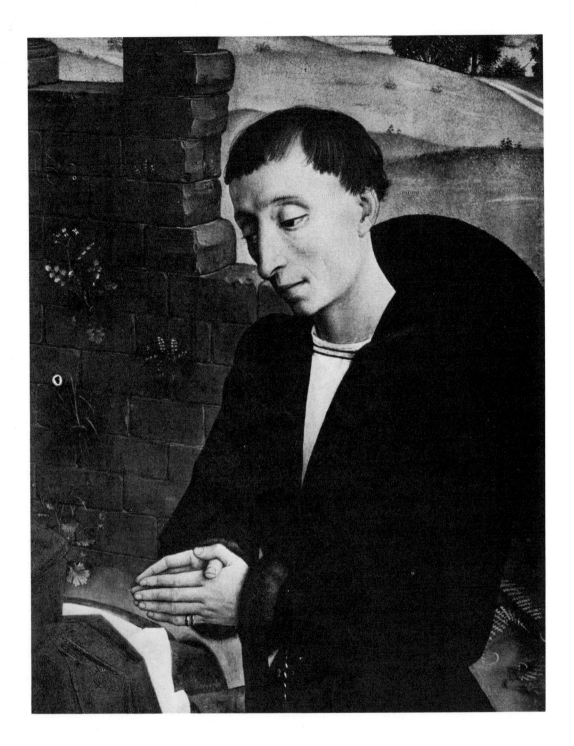

EARLY

NETHERLANDISH

PAINTING

ITS ORIGINS AND CHARACTER

BY

Erwin Panofsky

VOLUME ONE

Icon Editions
Harper & Row, Publishers
New York, Evanston, San Francisco, London

This book was originally published by Harvard University Press. First Icon
edition published 1971.

EARLY NETHERLANDISH PAINTING, Volume 1. Copyright 1953 by The Pres-
ident and Fellows of Harvard College. All rights reserved. Printed in the
United States of America. No part of this book may be used or reproduced
in any manner whatsoever without written permission except in the case of
brief quotations embodied in critical articles and reviews. For information
address Harper & Row, Publishers, Inc., 49 East 33rd Street, New York, N.Y.
10016. Published simultaneously in Canada by Fitzhenry & Whiteside
Limited, Toronto.

STANDARD BOOK NUMBER: 06—436682-0

LIBRARY OF CONGRESS CATALOG CARD NUMBER: 52-5402

76 77 78 79 80 12 11 10 9 8 7 6 5 4

PREFACE

THE title of the present publication is, like most titles, inaccurate. I have not attempted a presentation of Early Netherlandish Painting in its entirety — a task which will have to wait, I believe, for another Max J. Friedländer or Hulin de Loo — but concentrated my efforts on Hubert and Jan van Eyck, the Master of Flémalle and Roger van der Weyden. I have tried to clarify, as far as possible, the historical premises of their achievement; to assess what we know, or think we know, about their style; and to chart, however roughly, the course of those ensuing developments which may be said to constitute the main stream of the Early Netherlandish tradition. Thus limited, the discussion must dwell at some length on the antecedents of the subject and, on the other hand, omit important aspects of the subject itself.

Like my previous book on Albrecht Dürer, this study has grown out of a series of public lectures — in this case, the Charles Eliot Norton Lectures delivered at Harvard University in 1947–1948. It steers, therefore, a similarly precarious course between the requirements of the "general reader" and those of the special student (who may derive some benefit from the notes and bibliography), and this under much less favorable conditions. He who speaks of the life and works of an individual artist places his listeners in armchairs, so to speak, and invites them to admire the varying aspects of a sculptured figure displayed before them on a revolving base. He who attempts to describe a phenomenon as vast and intricate as Early Netherlandish Painting routs them out of their houses and asks them to accompany him on a strenuous tour through the remains of an ancient city partly preserved, partly in ruins, and partly buried in the ground.

Faced with this task, I could not proceed like an archeologist who leads a group of colleagues straight to the most recent excavations. Rather I have contented myself with the role of a cicerone who, while not entirely avoiding excavations and occasionally venturing into tangly thickets where the digging has barely started,* must try to give a general idea of the old city's location and topography and concentrate upon the major sights, familiar though they may be to many members of his party; who often reverts to the same spots to reconsider them in the light of intervening impressions; and now and then points out an unexpected vista that opens up between two walls.

I am very much indebted to the Bollingen Foundation for a most generous grant in aid of the publication of this book, and to the Institute for Advanced Study for a special appropriation which made it possible to print the notes in what I hope will prove to be a fairly convenient

* This applies especially to Chapter IV.

PREFACE

manner. As far as content is concerned, I have enjoyed the help of so many friends, colleagues and students that it is impossible to mention them all; where I am conscious of having made use of specific observations or suggestions, acknowledgement has been made in the proper places. Messrs. G. H. Forsyth, Jr., L. Grodecki, E. Holzinger, W. Koehler, C. L. Kuhn, M. Meiss, C. Nordenfalk, A. Pope, J. Rosenberg, W. Stechow, and H. Swarzenski I wish to thank for many a fruitful discussion and the last-named as well as Mr. H. Bober for having called my attention to a number of pertinent manuscripts. For information on particular problems I am very much obliged to Messrs. M. Davies, J. Dupont, A. L. Gabriel, W. S. Heckscher, J. S. Held, L. H. Heydenreich, R. A. Koch, M. de Maeyer, M. Pease, R. G. Salomon, G. Schönberger, J. Byam Shaw, G. von der Osten, and E. K. Waterhouse as well as to Mmes. A. M. Brizio, I. J. Churchill and M. Salinger. And I shall always be grateful to the late Miss Belle da Costa Greene and Miss Meta Harrsen, both of the Pierpont Morgan Library, Miss Dorothy Miner of the Walters Art Gallery, Mlle. Jeanne Dupic of the Bibliothèque Municipale at Rouen, Mr. Francis Wormald, formerly of the British Museum, M. Jean Porcher of the Bibliothèque Nationale, and M. Frédéric Lyna of the Bibliothèque Royale de Belgique; all of these have shown unfailing patience and friendliness in giving me access to and information about the manuscripts entrusted to their care, and M. Lyna was good enough to let me have several books and articles which were published in Belgium and not available here at the time.

Great difficulty was encountered in obtaining photographs suitable for reproduction. In this respect, too, I am much indebted to many of the friends and colleagues already mentioned, some of whom were even so kind as to give or lend me photographs from their private collections. I am particularly grateful to Miss E. Louise Lucas and Miss Helen B. Harris for much kind help and for permission to reproduce material belonging to the Fogg Museum of Art at Cambridge and the Department of Art and Archaeology at Princeton. And I wish to express my profound appreciation for the unselfish generosity with which Dr. P. Coremans, Director of the "Archives Centrales Iconographiques d'Art National" and the "Laboratoire Central des Musées de Belgique," as well as his helpful associates, Monsieur R. Sneyers and Mademoiselle N. Verhaegen, have placed at my disposal, not only a great number of excellent photographs (designated by "Copyright ACL Bruxelles" in the List of Illustrations) but also all the evidence concerning the technical investigation of the Ghent altarpiece. Other photographs were supplied by or obtained through the good offices of the following: Messrs. P. d'Ancona, J. Pita d'Andrade, A. H. Barr, Jr., V. Bloch, H. Broadley, A. Chastel, W. G. Constable, W. W. S. Cook, J. C. Ebbinge-Wubben, H. Gerson, J.-A. Goris, J. Gudiol Ricart, E. Hanfstaengl, P. Hofer, H. Kauffmann, E. S. King, H. Marceau, K. Martin, E. Meyer, G. I. Olifirenko, H. W. Parsons, A. E. Popham, G. Ronci, H. K. Röthel, P. J. Sachs, Count A. Seilern, Messrs. K. M. Swoboda, John Walker, M. Weinberger, K. Weitzmann, and G. Wildenstein; and Mmes. S. Fosdick, H. Franc, L. Guerry-Brion, M. E. Houtzager, R. McGurn and E. Naramore.

In conclusion, I wish to express my warmest gratitude to Miss Ellen Bailly for her untiring, perceptive and intelligent assistance in converting lecture notes into a book.

E. P.

Princeton, N. J.

CONTENTS

LIST OF ILLUSTRATIONS IN VOLUME ONE

Frontispiece Roger van der Weyden: Peter Bladelin.

PLATES AT END OF VOLUME

ILLUSTRATIONS

ILLUSTRATIONS

DIAGRAMS AND GROUND PLANS

EARLY NETHERLANDISH PAINTING

INTRODUCTION

THE POLARIZATION OF EUROPEAN

FIFTEENTH-CENTURY PAINTING IN ITALY

AND THE LOWLANDS

When two men of the sixteenth century as widely disparate as Luther and Michelangelo turned their conversation to painting, they thought only two schools worth mentioning, the Italian and the Flemish. Luther approved of the Flemings, while Michelangelo did not; but neither considered what was produced outside these two great centers.[1] Giorgio Vasari, the sixteenth-century historiographer of art, quite correctly refers to Dürer as a German when deploring his influence upon a great Florentine;[2] but as soon as the discussion takes a more general turn, the same Vasari automatically classifies not only Dürer but also Dürer's forerunner, Martin Schongauer, as "Flemings" operating in Antwerp.[3]

One-sided though it is, such a reduction of the whole diversity of European painting to one antithesis is not without justification when considered in the light of the preceding developments. From about 1430 down to the end of the fifteenth century, Italy and Flanders (or, to be more precise, the Netherlands) had indeed enjoyed a position of undisputed predominance, with all the other schools, their individual differences and merits notwithstanding, depending either on Italy and Flanders in conjunction or on Flanders alone. In England, Germany and Austria, the direct or indirect influence of the "great Netherlandish artists," as Dürer calls them, ruled supreme for two or three successive generations; in France, in the Iberian peninsula, and in such borderline districts as the southern Tyrol, this influence was rivaled but never eclipsed by that of the Italian Quattrocento; and the Italian Quattrocento itself was deeply impressed with the distinctive qualities of Early Flemish painting.

Italian princes, merchants and cardinals commissioned and collected Flemish pictures, invited Flemish painters to Italy, and occasionally sent their Italian protégés to the Netherlands for instruction. Italian writers lavished praise upon the Flemings and some Italian painters were eager to fuse their *buona maniera antica* with what was most admired in the *maniera Fiamminga*. In Colantonio of Naples and Antonello da Messina the Flemish influence is so strong that the latter was long believed to have been a personal pupil of Jan van Eyck. That Ghirlandaio's "St. Jerome" and Botticelli's "St. Augustine," both in the Church of

Ognissanti, are patterned after an Eyckian "St. Jerome" then owned by the Medici [1] is common knowledge; and so is the fact that the adoring shepherds in Ghirlandaio's "Nativity" of 1485 were inspired by Hugo van der Goes' Portinari altarpiece, which had reached Florence just three or four years before.[2] When we take into account, in addition to such direct "borrowings," the less palpable but even more important diffusion of a Flemish spirit in psychological approach and pictorial treatment (Piero di Cosimo's landscapes, for example, would be inexplicable without the wings of the Portinari altarpiece just mentioned), the influence of Flanders upon the Italian Quattrocento becomes almost incalculable.

What the Italians of the Renaissance — enthusiasts and skeptics alike — considered as characteristic of this Flemish spirit can be inferred from their own words.

First, there was the splendor of a new technique, the invention of which was ascribed, first by implication and later expressly, to Jan van Eyck himself.[3] Second, and in a measure predicated upon this new technique, there was that adventurous and all-embracing, yet selective, "naturalism" which distilled for the beholder an untold wealth of visual enchantment from everything created by God or contrived by man. "Multicolored soldier's cloaks," writes Cyriacus of Ancona, the greatest antiquarian of his time, in 1449, "garments prodigiously enhanced by purple and gold, blooming meadows, flowers, trees, leafy and shady hills, ornate halls and porticoes, gold really resembling gold, pearls, precious stones, and everything else you would think to have been produced, not by the artifice of human hands but by all-bearing nature herself." [4] Third, there was a peculiar piety which seemed to distinguish the intent of Flemish painting from the more humanistic — and, in a sense, more formalistic — spirit of Italian art. A great lady of fifteenth-century Florence wrote to her son that, whichever picture she might be forced to dispose of, she would not part with a Flemish "Holy Face" because it was "una divota figura e bella"; [5] and Michelangelo is said to have remarked, to the dismay of the saintly Vittoria Colonna, that Flemish paintings would bring tears to the eyes of the devout, though these were mostly "women, young girls, clerics, nuns and gentlefolk without much understanding for the true harmony of art." [6]

The most circumstantial and outstanding tribute is paid to Flemish painting in a collection of biographies, composed in 1455 or 1456 by Bartolommeo Fazio, a humanist from Genoa who lived at the court of Alphonso of Aragon at Naples. Of the four painters included in this *Book of Famous Men* no less than two are Flemings: Jan van Eyck and Roger van der Weyden, the latter still alive at the time of Fazio's writing.[7] Jan van Eyck is referred to as "*the* foremost painter of our age" (*nostri saeculi pictorum princeps*). He is praised for his scholarly and scientific accomplishments and credited with the rediscovery of what Pliny and other classics had known about "the property of pigments" — an obvious allusion to those technical innovations which a good humanist felt bound to derive, by hook or by crook, from classical antiquity. In his descriptions of such individual works as he had seen — unfortunately all of them lost — Fazio, too, untiringly stresses pious sentiment on the one hand, and verisimilitude on the other. He is moved by the grief of Roger van der Weyden's Josephs of Arimathea and Marys, witnessing the Descent from the Cross, and by the Virgin's

"dismay, with dignity preserved amidst a flow of tears" when she received the news of Christ's arrest. But no less keen is his enthusiasm for Jan van Eyck's "Map of the World" in which all the places and regions of the earth were represented in recognizable form and at measurable distances; his delight in Jan's "St. Jerome in His Study," where a bookcase, "if you step back a little, seems to recede in space and to display the books in their entirety while he who comes near sees only their upper edges"; and his admiration for a donor's portrait with "a sunbeam stealing through a chink in the wall so that you would think it was the real sun." And Fazio's highest praise is reserved for Jan's picture of a Women's Bath — perhaps a rendering of magic practices — which must have been a *summa* of optical refinements.[1] It included a mirror showing, in addition to the back of a bather represented in front view, whatever else was in the room; an aged woman attendant who "seemed to perspire"; a little dog that lapped up the spilled water; a lamp "looking like one that really burns"; and, furthermore, a landscape — apparently seen through a window — where "horses, people of diminutive size, mountains, woods and castles were elaborated with such artistry that one thing seemed to be separated from the other by fifty miles."

In thus describing the direct juxtaposition of the minutiae of an interior with a vast, almost cosmic panorama, of the microscopic with the telescopic, so to speak, Fazio comes very close to the great secret of Eyckian painting: the simultaneous realization, and, in a sense, reconciliation, of the "two infinites," the infinitesimally small and the infinitely large. It is this secret that intrigued the Italians, and that always eluded them.

II

When we confront Jan van Eyck's famous double portrait of Giovanni Arnolfini and His Wife of 1434 (fig. 247) with a nearly contemporary and relatively comparable Italian work, such as the "Death of St. Ambrose" in San Clemente at Rome executed about 1430 by Masolino da Panicale (text ill. 1) we observe basic similarities as well as basic differences. In both cases the scene is laid in an interior drawn to scale with the figures and furnished according to upper class standards in fifteenth-century Flanders and Italy, respectively; and in both cases advantage has been taken of that representational method which more than any other single factor distinguishes a "modern" from a medieval work of art (and without which the rendering of such interiors would not have been possible), namely, perspective.[2] The purposes, however, to which this method has been turned are altogether different.

"*Perspectiva*," says Dürer, "is a Latin word and means a '*Durchsehung*'" (a view through something). As coined by Boethius and used by all writers prior to the fifteenth century, the word *perspectiva* refers to *perspicere* in the sense of "seeing clearly," and not in the sense of "seeing through"; a direct translation of the Greek ὀπτική, it designates a mathematical theory of vision and not a mathematical method of graphic representation. Dürer's definition, on the other hand, gives an excellent and brief description of "perspective" as understood in postmedieval usage, including our own. By a "perspective" picture we mean indeed a picture

wherein the wall, panel or canvas ceases to be a solid working surface on which images are drawn and painted, and is interpreted — to quote another theorist of the Renaissance, Leone Battista Alberti — as a "kind of window" through which we look out into a section of space. Exact mathematical perspective as developed in the fifteenth century is nothing but a method of making this "view through a window" constructible, and it is well known that the Italians, significantly under the guidance of an architect, Filippo Brunelleschi, had achieved this end about 1420 by drawing the mathematical consequences from the window simile. They conceived of the visual rays as of straight lines that form a pyramid or cone having its apex in the eye and its base in the object seen; of the pictorial surface as of a plane intersecting this pyramid or cone; and of the picture itself as of a central projection onto this plane — perfectly

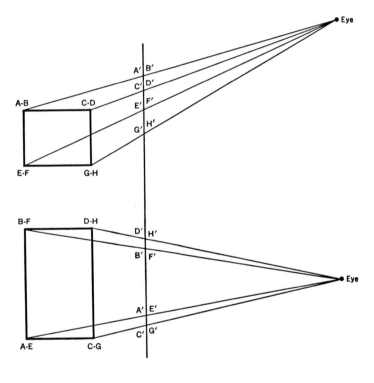

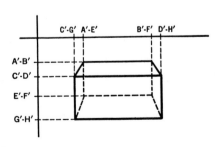

4

analogous to that produced in a photographic camera — which can be constructed by elementary geometrical methods. It should be noted, however, that the Flemings, about thirty years later, arrived at a no less "correct" solution on a purely empirical basis, that is to say, not by deriving a workable construction from optical theory, but by subjecting shop traditions and direct visual experience to draftsmanlike schematization until consistency was reached.

However arrived at, the "correct" construction implies the following rules: in the perspective picture all parallel lines, regardless of location and direction, converge in one of an infinite number of "vanishing points"; all parallels intersecting the picture plane at right angles ("orthogonals," often loosely referred to as "vanishing lines" pure and simple) converge in a *central* vanishing point (often loosely called the "point of sight") which can be defined as the foot of the perpendicular dropped from the eye onto the picture plane and which determines the "horizon" of the picture. This horizon is the locus of the vanishing points of all parallels located in horizontal planes, and all equal magnitudes diminish in direct proportion to their distance from the eye:

> "Les quantités et les distances
> Ont concordables différences,"

to quote from a French treatise on perspective of 1509.

This construction (exemplified by the diagram on the following page) formalizes a conception of space which, in spite of all changes, underlies all postmedieval art up to, say, the *"Demoiselles d'Avignon"* by Picasso (1907), just as it underlies all postmedieval physics up to Einstein's theory of relativity (1905):[1] the conception later to be designated by the Cartesian term *substance étendue* — or, to borrow the expression preferred by Descartes' Netherlandish pupil, Arnold Geulincx, *corpus generaliter sumptum* — which is thought of as being three-dimensional, continuous and infinite. It is thought of as being three-dimensional because every point therein is uniquely and sufficiently determined by three coördinates; it is thought of as being continuous because extension is supposed to be nothing but an attribute of matter and matter is supposed to be everywhere whether or not it assumes the shape of visible and tangible "things" (so that no difference in principle exists between what everyday experience — and, therefore, artistic experience as opposed to scientific analysis — identifies as "solid bodies" in contrast to the "void" or "empty space" that seems to separate and environ them); and it is thought of as being infinite because the three coördinates which determine a given point are parallel to those which determine any other point. In fact a "vanishing point" can be defined only as the projection of a point in which parallels meet; and Alberti explicitly states that the converging orthogonals in a perspective picture indicate the succession and alteration of transverse quantities "quasi persino *in infinito.*"

Two things, however, must be borne in mind. One is that a "correct" perspective construction presupposes, and does not engender, the conception of space which it manifests. The Greeks and Romans, not to mention non-European peoples, never arrived at a "correct" construction because they had never arrived at the modern conception of a three-dimensional,

continuous and infinite space. Postmedieval Europe, on the other hand, had gradually evolved this very conception of space long before the "correct" construction had been worked out, and adhered to it for centuries long after the "correct" construction had ceased to be practiced.

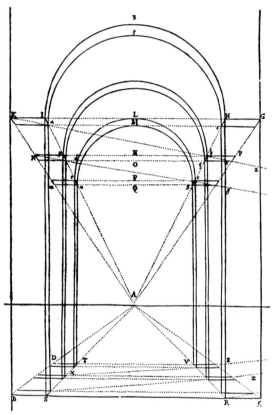

Correct Perspective Rendering of a Loggia (Iacomo Barozzi da Vignola, *Le Due regole della prospettiva*, Bologna, 1682, p. 125.)

The second thing to remember is that modern perspective — whether developed on a theoretical or an empirical basis, whether handled with mathematical precision or intuitive freedom — is a two-edged sword. Since it makes solids and voids equally real and measurable, it can be used for plastic and, if I may say so, topographical purposes on the one hand, and for purely pictorial ones on the other. Perspective permits the artist to clarify the shape and relative location of corporeal things but also to shift the interest to phenomena contingent upon the presence of an extracorporeal medium: the way light behaves when reflected by surfaces of different color and texture or passing through media of different volume and density. Since it makes the appearance of the world dependent upon the freely determined position of the eye, perspective can produce symmetry as well as asymmetry and can keep the beholder at a respectful distance from the scene as well as admit him to the closest intimacy.

6

INTRODUCTION

Since it presupposes the concept of an infinite space, but operates within a limited frame, perspective can emphasize either the one or the other, either the relative completeness of what is actually presented or the absolute transcendence of what is merely implied.

It is these dual possibilities that are exemplified by Jan van Eyck's Arnolfini portrait and the "Death of St. Ambrose" in San Clemente. It matters little — and is in fact hardly perceptible without the application of ruler and compass — that the "Death of St. Ambrose," executed by an artist already familiar with Brunelleschian methods, is fairly "correctly" constructed whereas the Arnolfini portrait is not and has four central vanishing points instead of one. What matters is that the Italian master conceives of light as a quantitative and isolating rather than a qualitative and connective principle, and that he places us before rather than within the picture space. He studies and uses light mainly in terms of rectilinear propagation, employing modeling shadows to characterize the plastic shape of material objects, and cast-shadows to clarify their relative position. Jan van Eyck, however, studies and uses light, in addition, in terms of diffraction, reflection and diffused reflection. He stresses its action upon surfaces as well as its modification by solids and thereby works that magic so ardently admired throughout the centuries: those reflexes on brass and crystal, that sheen on velvet or fur, that subdued luster of wool or seasoned wood, those flames that look "as though they were really burning," those mirrored images, that colored chiaroscuro pervading the whole room. And where the death chamber of St. Ambrose is a complete and closed unit, entirely contained within the limits of the frame and not communicating with the outside world, the nuptial chamber of the Arnolfinis is, in spite of its cozy narrowness, a slice of infinity. Its walls, floor and ceiling are artfully cut on all sides so as to transcend not only the frame but also the picture plane so that the beholder feels included in the very room; yet the half-open window, disclosing the thin brick wall of the house and the tiniest strip of garden and sky, creates a kind of osmosis between indoors and outdoors, secluded cell and universal space.

Millard Meiss has recently pointed out the close connection that exists between Jan van Eyck's "Madonna van der Paele" of 1436 (fig. 248) and Piero della Francesca's Brera altarpiece produced for Federico of Urbino in the early 'seventies, the "earliest example in Italian painting of the Madonna and saints represented in a church" together with the full-scale figure of a donor (text ill. 2).[1] The great Italian appears to be indebted to the great Fleming, not only for the "analysis of color and light, especially in the armor of the Duke" (which may well be compared to that of Jan's St. George) but also for the idea of an architecture which "by implication extends forward beyond the frame, around and over the spectator who stands within it." Yet no two pictures so closely related in iconography and composition could be more different in spirit. Piero's soaring basilica with its unbroken, windowless surfaces is majestic and self-contained, where Jan's small, low, circular church, seen as a "close-up" and communicating with the outdoors by a fenestrated ambulatory, is, like the Arnolfini portrait, both intimate and suggestive of infinity. Where the Duke of Urbino, turned to full profile, is set apart from the community of the saints, the Canon van der Paele, depicted in three-quarter view and kneeling between the Virgin Mary and his patron saint, is included in this

7

community; and the same privilege is accorded, in a lesser degree, even to the beholder. True, the longitudinal arches of Piero's structure, with their anterior impost blocks overlapped by the frame, do suggest incompleteness; but they also keep us at a distance from the event, for they place us in the nave of the edifice, with the triumphal arch (not to mention the lance and gauntlet of the Duke) interposed between us and the apse and transept where the Virgin holds her court. Jan includes us within the boundaries staked out by the columns and thereby draws us, quite literally, into the circle of the *sacra conversazione*; and the carpet spread over the steps of the Virgin's throne, cut off as it is by the lower frame, seems to extend to the very tips of our shoes.

This sense of intimacy is deepened by that worshipful respect for the particular which makes the picture a little world inexhaustibly rich, complete in itself and irreplaceably unique. It is a truism that northern Late Gothic tends to individualize where the Italian Renaissance strives for that which is exemplary or, as the phrase goes, for "the ideal," that it accepts the things created by God or produced by man as they present themselves to the eye instead of searching for a universal law or principle to which they more or less successfully endeavor to conform. But it is perhaps more than an accident that the *via moderna* of the North — that nominalistic philosophy which claimed that the quality of reality belongs exclusively to the particular things directly perceived by the senses and to the particular psychological states directly known through inner experience — does not seem to have borne fruit in Italy outside a limited circle of natural scientists; whereas it is in Italy and, more specifically, in Florence that we can witness the resurgence and enthusiastic acceptance of a Neoplatonism according to which, to quote from its greatest spokesman, Marsilio Ficino, "the truth of a created thing consists primarily in the fact that it corresponds entirely to its Idea."

Thus we can understand the peculiarly one-sided relation between Flemish and Italian painting in the fifteenth century. Flanders and Italy shared the basic principles of "modern" art; but they represented the positive and negative poles of one electric circuit and we can easily conceive that during the fifteenth century the current could flow only from north to south. Exploiting the plastic rather than the pictorial possibilities of perspective, the Italians could gracefully accept some of the Flemish achievements and yet go on with the pursuit of that "beauty" which they found embodied in the art of the Greeks and their own ancestors, the Romans: "I solemnly surrender these beautiful statues to the Roman people whence they had once arisen," wrote Sixtus IV when restoring a part of the papal collection to the Capitol. The Flemings, conceiving of perspective as a means of optical enrichment rather than stereographical clarification and unchallenged by the visible remains of classical antiquity, were long unable to understand an idiom so strongly flavored with Hellenism and Latinism. It was, with but a few and well-motivated exceptions, not until the very end of the fifteenth century that Flemish painting came to be drawn into the orbit of the Italian Renaissance, the classicizing influence first sneaking in, as it were, in the shape of such decorative accessories as garlands of fruits and leaves, playful *putti* or ornamental medallions fashioned after classical cameos;[1] and it took the spirit of a new century, the rise of new artistic centers, and even

the help of a German, Albrecht Dürer, to open Netherlandish eyes to the more basic values of the Italian *rinascimento*.[1]

During the greater part of the fifteenth century, then, painting in Flanders, while making a strong impression on Italy, was virtually impervious to influences from Italy. During the greater part of the fourteenth century, however, the situation had been the reverse; it may be said that the very weapons with which Jan van Eyck and Roger van der Weyden were to achieve their victories had been forged in Siena and Florence; and that the ore that went into the making of these weapons had been mined in Rome and Alexandria.

<div align="center">III</div>

I have remarked that the Greeks and Romans never arrived at a "correct" perspective *construction*. This, however, does not mean that they never arrived at a method of perspective *representation*. Plato thunders against the "deception" or "trickery" of painters who depicted as different in size what was in truth equal, as crooked what was straight, and as either concave or convex what was flat. We hear of genre scenes staged in interiors, and, as early as the end of the fourth century B.C., of such extraordinary specimens of luminarism as Antiphilos' "Boy Blowing a Fire," with the boy's face and the whole setting illumined by reflected light. In the Hellenistic and Roman mosaics and paintings that have come down to us we find not only ground planes, walls and ceilings receding into depth but also an almost impressionistic treatment of forms and the use of cast-shadows and reflections; and, in the famous "Odyssey Landscapes" of the first century, Alberti's definition of a perspective picture as a "view through a kind of window" is so literally realized that we look upon a continuous scenery as though through the openings of a pergola (text ill. 3).

No doubt, then, that Hellenistic and Roman art achieved a perspective interpretation of space; but this space was in itself quite different from that infinite continuum which is visually symbolized in postmedieval art. Unlike nineteenth-century Impressionism, with which the style of the "Odyssey Landscapes" and their kind has often been compared, they do not convey the impression of a stable and coherent world, made to flicker and vibrate by the way it is "seen," but of a world unstable and incoherent in itself. Rocks, trees, ships and tiny figures are freely distributed over vast areas of land and sea; but space and things do not seem to coalesce into a unified whole, nor to extend beyond our range of vision. The volume and color of all the objects are strongly affected by the action of light and atmosphere; but neither their diminution in size nor their optical attenuation is expressed in terms of a constant relation to distance. There are reflections and cast-shadows, but nothing like unified lighting. As a result, the whole has an unreal, almost spectral quality, as though extracorporeal space could assert itself only at the expense of the solid bodies and, vampirelike, preyed upon their very substance.

In fact, classical antiquity never outgrew the feeling that extracorporeal space was something foreign, even inimical, to the world of plastic shapes. In pre-Hellenistic periods, this

<div align="center">9</div>

extracorporeal space had been expressed, in paintings and reliefs alike, as an opaque, esthetically negative surface; and even after Empedocles and Anaxagoras had discovered that air was a material substance, the artists continued to interpret space as a compound of solids and "voids" rather than as a modification of one continuum comprising the corporeal and noncorporeal alike. In Hellenistic and Roman painting — and this can be verified by the few paintings that have come down to us from the period preceding the "Second Pompeian Style" [1] — space was suggested by placing interstices between such solids as rocks, trees, walls and figures, rather than by allotting to solids and intervals an equal share in that *corpus generaliter sumptum* which is reflected in the Brunelleschian construction. In short, space remained a composite of two competing elements, the finite sum total of that which is solid and the equally finite sum total of that which is not.

The very concept of the *infinite* (ἄπειρον) was somehow repugnant to the classical mind ("For evil is a form of the unlimited and good of the limited," to quote a Pythagorean dictum endorsed by Aristotle); [2] and where it was accepted it seemed to contradict the concept of continuity. After Anaxagoras' attempt at overcoming this contradiction by his theory of "homoiomeria" had been reduced to the absurd by Zeno, the classical thinkers had to choose, so to speak, between the "two infinites": if they believed in the infinitesimally small, resulting from continuous and unlimited division, they had to renounce the infinitely large resulting from continuous and unlimited augmentation, and vice versa. The universe of the atomists, Leucippus and Democritus, was infinite but discontinuous in that it consisted of indivisibles whirling around in a void (κενόν) which could be defined only as the "non-being" (μὴ ὄν), and it seems that Democritus applied this atomistic view even to pure mathematics. [3] The opponents of atomism, on the other hand, believing as they did in an unlimitedly divisible continuum, were forced to postulate a limited universe. In mathematics, the antinomy between infinity and continuity was implicitly though not explicitly resolved by the genius of Archimedes and Apollonius of Perge; and Democritus' "atomization" of mathematical figures — exemplified by his analysis of the cone as a summation of disks or laminae of unequal radius and imperceptibly though not infinitesimally small height, [4] and by his famous definition of the sphere as a polyhedron which is "all corner" [5] — went a long way to make this achievement possible. Nonatomistic cosmologists and physicists, however, found it impossible to reconcile a continuous structure of the physical world with what Aristotle terms the "actually" as opposed to the "potentially" infinite (ἐνεργείᾳ ἄπειρον as opposed to δυνάμει ἄπειρον). Precisely because he denied the possibility of the void and insisted on the unlimited and continuous divisibility of all spatial and temporal magnitudes, [6] his universe had to be finite. It is encompassed by the outermost sphere of the firmament beyond which there is "neither place nor void nor time"; [7] and "a magnitude in excess of every finite magnitude is an impossibility since it would have to transcend the heavens." To the mathematicians he leaves the right to stipulate the infinity of numbers and geometrical quantities; but he will not admit infinity to the world of physics. [8] Thus even the "universal space" (τόπος κοινός) is finite; and it differs, moreover, from the space occupied by individual bodies (τόπος ἴδιος) in that the latter has only three dimensions

(διαστάσεις) whereas the former has six: "above" and "below," "before" and "behind," "to right" and "to left." [1]

Formally, the Cartesian *substance étendue* — graphically anticipated by Brunelleschi and Alberti and geometrically reproduced by Desargues — was identical with the space of Euclid. Materially, however, it differed therefrom in that it was acknowledged as a reality, in that it was accepted as the *modus essendi* of the physical universe where Aristotle had relegated it to the realm of mathematical speculation. The classical world view, therefore, did not call for, or even admit, the "modern" perspective construction which, as we could infer from Alberti's own words, lends visual expression to the concept of the "actual" infinite. And a further obstacle, insurmountable to artists and theoreticians alike, to the development of this "modern" construction was the fact that it conflicts with one of the basic tenets of classical optics. "Modern" perspective, we remember, represents a central projection onto a plane surface, which means that magnitudes objectively equal appear inversely proportional to their distances from the eye; if, for instance, two equal vertical lines, *a* and *b*, are seen at the

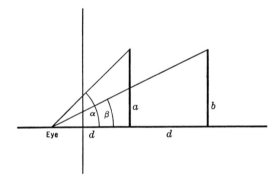

distances *d* and *2d*, respectively, *b* will appear, in the perspective image, precisely half as long as *a*. According to classical optics, however, the apparent magnitudes are not inversely proportional to the distances but directly proportional to the visual angles, *α* and *β*, so that the apparent magnitude of *b* will more or less considerably exceed one half of that of *a*; the Eighth Theorem of Euclid's *Optica*, explicitly stating that "the apparent difference between equal magnitudes seen from unequal distances is by no means proportional to these distances," is so patently at variance with the rules of Brunelleschian perspective that the Renaissance translators of the Euclid text decided to amend it in order to eliminate this flagrant contradiction between two equally revered authorities.[2] What this amounts to is, of course, that classical optics considered our sphere of vision quite literally as a sphere, and it is interesting to note that this assumption more nearly agrees with physiological and psychological reality than that which underlies the Brunelleschian construction. As early as 1624, a friend of Kepler's, named Wilhelm Schickardt, proposed that in our optical experience straight lines and plane surfaces are always curved; this thesis was experimentally confirmed in the nineteenth and twentieth centuries; and according to the latest mathematical analysis, binocular

visual space is a finite piece of a "hyperbolic Riemannian space." [1] Now, since even a simple, spherical surface cannot be developed on a plane, no exact perspective construction could be evolved or even envisaged as long as the urge for such a construction was not strong enough to break down the fundamental assumption of the classical theory of vision. In fact not a single correctly constructed picture is known to have existed in classical antiquity where, as a rule, the vanishing lines tend to converge, herringbone fashion, towards an axis instead of being focused in a unified "point of sight"; which, incidentally, amounts to a rough approximation of a spherical image developed on a plane.

IV

We can easily see that the "modern" conception of space, as ultimately realized in fifteenth century painting, could not develop directly from the "Odyssey Landscapes." In order to convert composite and finite space into continuous and infinite space, the elements of the compound had first to be unified, and this could be achieved only by what looks like regression. The deceptively "modern" view *through* something had to be abandoned in favor of a design *upon* something; and this is what happened in the Middle Ages, beginning with Late Antique and Early Christian art.

Of course, extracorporeal space could never be reduced again to that "flat, opaque, esthetically negative surface" which had formed the background of Periclean paintings and reliefs. Rather it was compressed into a kind of luminous film which still suggests a certain amount of depth and still denotes — though no longer reproduces — a spatial environment; and this quasi-spatial environment could be fused with the forms of figures and objects as soon as these two were similarly attenuated. Solids and voids, pattern and ground, merged as it were into a homogeneous fabric of light and dark within which both play an equally positive role; and it is this impression which Early Christian art tries to convey. In mosaics the design is set out against cloud-dotted blue or many-colored striations, both suggestive of the natural sky, or against mat gold suggestive of the "everlasting light." The vellum of illuminated books is often stained with a purple suggestive of something like space in general; and a similar effect is produced by the deep interstitial shade that foils the forms in reliefs and decorative carvings. The prospect through a "window" begins to close again; but it is closed with a light, porous curtain rather than with a solid, impermeable wall.

The "Abraham Mosaic" in San Vitale at Ravenna (text ill. 4) may be said to epitomize this ambivalent tendency. That it is no longer a *Durchsehung* is evident from the fact that the trees, and even the rocks on the left, follow the curvature of the border, thus demonstrating that the artist thought of his picture as of something filling a frame and not as of something viewed through a frame. Yet there is still a feeling for depth; the ground is treated as sky rather than as a hard, flat surface; and all the forms are interpreted in terms of light and shade. The entire spectacle is thus unified at the expense of linear distinctness and plastic energy; it may be said to symbolize the Neoplatonic cosmology of Proclus and Dionysius the

pseudo-Areopagite, where space itself is conceived of as "the most subtle light," and where the "nothingness" surrounding the Aristotelian universe (beyond which there is "neither place nor void nor time") is filled with the luminous infinity and eternity of God and His angels.[1]

Byzantine art never quite outgrew this ambivalent fluidity, and this is one of the reasons why it experienced a number of successive renascences but never a real Renaissance. Unable or unwilling to cut themselves off from the Hellenistic tradition — "sie waren Greise, aber sie waren Griechen," to quote Wilhelm Vöge's unforgettable and untranslatable phrase[2] — the Byzantine masters always preserved, and often deliberately revived, some of the basic features of Greco-Roman illusionism. They frequently retained a kind of receding ground plane; they rendered terrain and vegetation in pictorial rather than draftsmanlike fashion; they tended to harden into strips the streaks of light and grooves of shade that served for the depiction of drapery, but never went so far as to transform these strips into purely graphic lines. Most important, they continued to use foreshortening and overlapping — the former mostly for the rendering of architecture, the latter mostly in landscapes — to indicate recession in depth.

It was in Western Europe, and in the period known as Romanesque, that art made a clean break with Hellenism. We can observe this transformation under laboratory conditions, so to speak, when we compare a specimen of High Romanesque book illumination, dating from the end of the twelfth century, with its archetype, the famous "Utrecht Psalter" of *ca.* 816–835. A product of the Carolingian *Renovatio*, the "Utrecht Psalter" (text ill. 5) revives — with very different means and intentions — an Early Christian model which must have retained much of the spatial illusionism exemplified by the Odyssey landscapes.[3] Excited little figures, fierce dogs and lions, bucolic flocks of sheep, feathery trees, classicizing but curiously unsubstantial buildings, rivers and clouds; all this is vivaciously rendered with a nervous, intermittent pen (occasionally accentuated by bold washes) and scattered about a scenery organized in depth by hillocks and mountain ranges. Without much explicit indication of three-dimensionality, even without the expedient of a frame through which the scene might be viewed, the very looseness of arrangement and the very sketchiness of treatment give so persuasive an effect of airy expanse that we accept the working surface itself as a symbol of open space, much as we do in modern drawings of which the "Utrecht Psalter" is a cousin many times removed.

By the end of the twelfth century, and after two intermediary transformations, these spirited impromptus emerged as something totally different (text ill. 6).[4] Instead of breezy, frameless pen drawings we have opaquely pigmented miniatures surrounded by a strong, flat border whose function it is to delimit the working area, and not to frame a "view." The figures are reduced in number but enlarged in scale, more substantial in appearance and more composed in behavior; the feathery foliage of the trees is condensed into well-defined shapes not unlike flowers or mushrooms. The buildings offer a sturdier and unmistakably nonclassical aspect; and the loose, impetuous pen strokes and washes have given way to firm, continuous

contours. All this amounts to what may be described as "surface consolidation." As the ground is consolidated into a massive wall of color (the earlier gold grounds, purple grounds and flickering over-all patterns tend to disappear in Romanesque), so is the design consolidated into a schema of two-dimensional areas organized by a network of one-dimensional lines. In our twelfth-century Psalter this "cartographic" tendency is further proclaimed by the elimination of oblique foreshortenings and by the gratuitous introduction of numerous scrolls which, being without inscriptions, can serve no other purpose than to enrich the planimetric pattern; and all the indications of terrain are transformed into a system of brightly colored, sharply delineated ribbons which have lost all reference to three-dimensional reality and operate as mere partitions.

In Romanesque painting, then, line is nothing but line and planes are nothing but planes. Small wonder that this period disrelished and ultimately discarded the shimmering indistinctness of the mosaic (described as "out of fashion," *novum contra usum*, by the Abbot Suger as early as about 1140) [1] and, conversely, produced and cherished two new art forms, both of which amount to a triumph of line and plane over spatial depth: heraldry and storied glass, the latter first mentioned in the second half of the tenth century. [2]

So radical a break with the Hellenistic tradition would seem to mean a final renunciation of every attempt at representing extracorporeal space. And yet this very renunciation was to clear the ground for the development of "modern" as opposed to Greco-Roman space. Romanesque painting eradicated the vestiges of illusionism in favor of flat, clean-cut areas bounded and organized by firm, clean-cut lines; but just for this reason the "pattern" and the interstices could merge into one plane. Similarly, Romanesque sculpture eradicated the vestiges of illusionism in favor of mass forms whose surfaces demanded and received an analogous treatment; but just for this reason the "pattern" and the interstices could merge into one block. This made possible that integration of the representational arts with architecture which is characteristic of the High Middle Ages. Murals and stained-glass windows affirm the impenetrability of architectural boundaries instead of defying or concealing it, and architectural sculpture, unlike the classical metope relief or caryatid, is part and parcel of the edifice instead of being an adjunct or an insertion: the very substance of the wall, the embrasure, the arch, the capital takes shape in the relief, the jamb statue, the archevault figure, the *chapiteau historié*.

Thus it was just the simultaneous reduction of the corporeal and the extracorporeal which, for the first time in European art, established a genuine consubstantiality of these two. From now on, the solids were wedded for better or for worse to their environment; and when the solids began to free themselves from the bondage of the plane, they could not do so without carrying with them, as their indispensable complement, a corresponding spatial envelope. This process culminated in the Gothic style of the thirteenth century.

INTRODUCTION

What distinguishes Gothic shafts and ribs from their Romanesque predecessors is — besides and beyond all technical differences — the simple fact that they are no longer conceived as relief forms integrated with and esthetically predicated upon the walls, piers, or webs to which they are attached; they have crystalized, instead, into what the French graphically call *colonnettes* and *nervures*, independent tubular forms which contrast with the walls, piers and webs as plastic entities having an axis within themselves. A small but very significant symptom of this feeling is the appearance of the so-called corbel ring at a time when Gothic architecture had not as yet completely devaluated the wall. The corbel rings fasten the shafts to the wall much in the same way that gas or water pipes are attached by brackets; and thus explicitly acknowledge the fact that shafts are basically independent of their background. The thirteenth-century architect Villard de Honnecourt stressed this principle of axiality by marking, in his cross sections of piers and mullions, the center of every shaft with a little dot.[1]

Similarly, the figures in Gothic statuary and painting differ from Romanesque ones in that they, too, give the impression of being crystallized around a central axis of their own. In Romanesque sculpture the figure is conceived in relation, not to an axis within it but to a surface behind it, a surface from which it protrudes much as a convex garnet or moonstone does from its setting; esthetically, even a free-standing cult image does not constitute a real "statue" but remains a relief — a relief, however, which, in contradistinction to all other styles, may well be designated as a relief *en cabochon* (text ill. 7).[2]

The Gothic figure, on the other hand, is a real "statue" (text ill. 8): a basically cylindrical body either paralleled by a full-cylindrical colonnette as is the case of the orthodox Early and High Gothic jamb figure, or encased in a half-cylindrical channel as is the case of all Gothic archevault sculptures (and, from the middle of the thirteenth century, of many jamb figures as well). Just so did the figures in the Gothic relief develop into self-dependent statuettes virtually detached from their background and capable of pivoting around their axes as upon a little platform which soon made room for two or more rows of performers, the ones in back no less completely rounded than those in front (text ill. 9). And an analogous change can be observed in paintings and miniatures. In an attempt to duplicate the effect of sculpture — to project a relief onto a plane, so to speak — the figures, however linear in design, are endowed with similar voluminousness, mobility and independence. Moving and turning, they seem to have emancipated themselves from the pictorial surface, and plastic values are no longer suggested by flat strips and patches of color but simulated by a continuous modeling which — a remarkable innovation — gives the impression of a strong light coming from one direction. A climax of this development is reached in the "Breviary of Philip the Fair," produced at Paris about 1295 and commonly ascribed to a renowned illuminator known as "Master Honoré,"[3] the miniatures of which may be said to rival any High Gothic relief in plastic power and vitality (fig. 2).

Now, as I said before, this liberation of the solid bodies was accompanied by the liberation

of a corresponding volume of enveloping space. The Gothic statue, wherever placed, cannot exist without a canopy or tabernacle — both three-dimensionalized descendants of the Byzantine and Romanesque aedicula — which, together with a plinth or console, creates a kind of spatial shell around the figure. In the reliefs, the scene of action is normally overhung by a series of arches (or conventionalized clouds) which, like a valance, determines the front plane of a shallow but undeniably three-dimensional podium. An even more elaborate framing system was often adopted in glass paintings and book illuminations, where the figures are shown as though seen through a complicated Gothic portal, the best known and most glorious example being the "Psalter of St. Louis" of *ca.* 1255 (text ill. 10): and even without such a framing system a spatial effect was assured to miniatures by a new treatment of the ground. It tends to be differentiated from the figures and objects "in front" of it, first, by the use of burnished gold to which the Romanesque style had a marked aversion (not without reason has the style of book illumination of the thirteenth century been called the *style à fonds d'or*); and, later, by the introduction of *rinceaux*, tessellation, diaper patterns and the like, which give the impression of a tapestry spread behind the figures rather than of a solid surface containing them.

Thus the High Gothic style freed from the fetters of two-dimensionality both plastic form and extracorporeal space and, at the same time, preserved that consubstantiality of the one with the other which was the precious heritage of the Romanesque. This was a tremendous advance in the direction of the postmedieval or "modern" conception of space as a continuous and infinite substance; and yet there exists a fundamental, in fact insurmountable, gap between the High Gothic style and the "modern." High Gothic design remains inexorably linear; and High Gothic space, though already continuous, remains inexorably finite. As the interior of a High Gothic cathedral is a sum of distinct parts (even as far as the individual bays are concerned) and does not communicate with the outdoors, so is the space presented in a High Gothic relief or miniature confined to the interval between the front plane and the background which, while shifted back so as to make room for plastic deployment and active intercommunication among the figures, continues to be impenetrable. In contrast with the wide, transfixed gaze so characteristic of the Romanesque style, the narrow, mobile eyes of Gothic figures possess the ability of looking rather than staring; they can focus on a definite object, scan over wide horizons and establish contact with the glances of others. But nowhere do the figures look or act "out of the picture" in order to invite the participation of the beholder, whereas Leone Battista Alberti admires and recommends precisely this.[1] The action, too, unfolds in a direction parallel to the representational plane, passing across our field of vision rather than advancing or receding within it. We see a world of forms communing with each other within their space but not, as yet, a world of forms communing with the spectator within a space in which he shares. In paintings and miniatures these forms remain arrayed upon a transverse standing *line* — or upon a series of transverse standing lines placed above each other — instead of being distributed over a standing *plane* apparently receding in depth; and there is no difference in size between figures and objects "in front" and "in back." In

short, High Gothic art, its world constructed without reference to the visual processes of the beholder and even without reference to his very existence, is still unalterably nonperspective. And now we can almost predict that "modern" space was to come into being when the High Gothic sense of volume and coherence, nurtured by sculpture and architecture, began to act upon the illusionistic tradition that had lingered on in Byzantine and Byzantinizing painting; in other words, in the Italian Trecento.

Touched by but not really rooted in the Carolingian revival and long committed to Late Antique and Early Christian traditions, the art of Italy, particularly south of the Apennines, had not been very progressive up to, and largely including, the thirteenth century. Sculpture and architecture had culminated in a precocious classicism which, after an encounter with the kindred Romanesque of southern France, had ultimately succumbed to Gothic, though with so many reservations that the results, with wall and mass never completely absorbed in structural form, remained essentially different from the High Gothic style of the North. And in Italian painting the influence of Byzantine art had come to prevail to such an extent that Vasari seems justified in referring to its pre-Trecento phase as "*maniera Greca.*" But it was, paradoxically, the very retrospectiveness of Italian painting that qualified it for a leading role after the turn of the thirteenth century. Owing to this retrospectiveness, Italy had upheld the traditions of mosaic, fresco, and panel painting. In Italy walls continued to be adorned with mosaics and murals where the Gothic North, if not entirely eliminating the wall in favor of windows, tended to conceal it with blind tracery, paneling or tapestries; altars were embellished with painted *ancone* instead of with statuary and goldsmiths' work; and painting even invaded the field of the carpenter in such objects — quite foreign to the northern taste — as *cassoni, spallieri* and *deschi da parto.*[1] In all these media there had survived, and were occasionally revived from Byzantine sources, the technical devices of Hellenistic and Roman perspective so thoroughly abandoned in northern Romanesque and Gothic.

The "Dream of Pharaoh" in the Baptistry at Florence, for instance (text ill. 11), displays a simulated cornice and a coffered ceiling both of which are foreshortened according to that "herringbone" construction which, we remember, had its origin in classical antiquity. In one of the mosaics at Monreale (text ill. 12) the Last Supper is staged in a kind of courtyard framed by receding side walls; and another mosaic in the same cycle, presenting the Healing of the Palsied Man (text ill. 13), shows an equally vigorously receding tiled floor treated in surprisingly advanced fashion: instead of forming a "herringbone pattern" the vanishing lines converge, fairly accurately, towards one single point. However, what is preserved in specimens like these is the letter rather than the spirit of a perspective interpretation of space. It is not only that two sets of vanishing lines have been assumed in the "Healing of the Palsied Man," and that the throne and the bed do not conform to the foreshortening of the pavement; nowhere in all our instances do we encounter a setting conceived as a coherent unity, least of all as a rationally constructed interior with its floor, walls and ceiling "fitly framed together" as the Apostle would say. The "Dream of Pharaoh" has a foreshortened cornice and ceiling but no side walls and no floor; the "Last Supper" at Monreale has receding side walls but no

floor and no ceiling; in the "Healing of the Palsied Man," finally, the beautifully receding floor comes to a dead stop at the unforeshortened front of the building from whose roof the bed of the patient is being lowered by two attendants.

In the thirteenth century, then, Italian and Gothic art were comparable to the two brothers in the fairy tale, one of whom had a magic spyglass, whereas the other had a magic rifle: the former could locate the dragon but had nothing to shoot him with; the latter could kill him but did not know where he was. In a High Gothic picture — and even more so in a High Gothic relief — there was much plastic volume and perfect coherence but no perspective; in a product of the *maniera Greca* there was perspective, or at least its rudimentary technical apparatus, but not much plastic volume and no coherence at all. In the Italy of around 1300, dominated in architecture and sculpture by a Romanesque-inclined Gothic and in painting by a more or less thoroughgoing Byzantinism, the two brothers could pool their resources. And this is precisely what happened, engendering a basically new approach to Late Antique and Early Christian spatiality,[1] in Pietro Cavallini, Duccio and Giotto. In the works of these great masters, Gothic modeling asserted itself against the luminous linearity of the Byzantine tradition (so that the filigree of gold lines by which the Byzantines had indicated drapery folds in purely conventional manner assumed in Duccio's paintings the special significance of designating the transfigured or resurrected Christ). It was not only in the marbles of the Pisani who, as is known to all, were thoroughly familiar with Gothic sculpture but also in Gothic sculpture itself that Giotto found the archetypes of his statuesque, space-displacing figures and un-Byzantine, slant-eyed physiognomies;[2] and those who place more confidence in iconography than in "style" may point with gratification to the fact that Duccio's Crucified Christ — like Niccolo Pisano's — is fastened to the Cross with three nails instead of four so that one knee is placed in front of the other, an innovation introduced by the French sculptors of the early thirteenth century in an effort to endow even the most rigid of figures with a maximum of plastic variety and mobility.[3]

Extended from individual features to the composition as a whole, this fusion of the Gothic with the Byzantine resulted in a space which may be defined as Greco-Roman space "vue à travers le tempérament Gothique." Take the "Last Supper" in Monreale with its unsubstantial, loosely interrelated figures and its inconsistent and fragmentary yet, after a fashion, perspective space; add to this other Byzantinizing works which, like the "Dream of Pharaoh" in Florence, show a foreshortened coffered ceiling to supplement the foreshortened walls; reorganize this material according to the standards of a nonperspective but solidly voluminous, dramatically concentrated and, within its limits, perfectly coherent Gothic redaction of the theme such as, for instance, the relief in the Naumburg jube of *ca.* 1260 (text ill. 14): and you will obtain something closely akin to Giotto's "Last Supper" in the Cappella dell' Arena (*ca.* 1305) or to Duccio's "Last Supper" in the "*Maestà*" of Siena Cathedral (1301–1308, text ill. 15).

This was, of course, a mere beginning. By the standards established in the fifteenth century, the space presented in Duccio's "Last Supper" is sorely limited, and its construction

lamentably incorrect. While the orthogonals of the central section of the ceiling converge, if not in a definite vanishing point, at least in a fairly concentrated "vanishing area," those of the lateral sections run considerably lower and the stripes of the tablecloth behave quite erratically. Where there is an undivided ceiling, as in Duccio's "Annunciation of the Virgin's Death" (fig. 6) or in Giotto's "Confirmation of the Franciscan Rule," all the beams of the ceiling converge with reasonable accuracy; but other vanishing lines converge toward different centers, and the Virgin's bench is — like the tablecloth in Duccio's "Last Supper" — a law unto itself. Even the most progressive masters of the next generation, the Lorenzetti brothers who narrowed the "vanishing area" to a geometric point (while many of their less advanced contemporaries relapsed into the antiquated "herringbone" construction), could not bring themselves to treat an entire plane, regardless of divisions or obstructions, as a unified whole, much less to bring into a single focus the vanishing points of all orthogonal planes. In Ambrogio Lorenzetti's "Presentation" of 1342 (text ill. 16) [1] and even in his "Annunciation" of 1344, exact convergence is still limited to the central section of the floor whereas the lateral vanishing lines, separated from the former by the figures, go astray; [2] and in the Siena "Madonna with Four Saints and Angels," the tiles of the pavement and the orthogonal stripes of the carpet converge towards two different vanishing points. [3] It took the painters some time to think in such abstract mathematical terms as "plane" instead of in such concrete visual terms as "central section" or "carpet"; and it took them still longer to proclaim — by expanding the pictorial space in all directions and by focusing all planes in one single "point of sight" — the physical reality of the infinite, an idea which even the philosophers of their period accepted only gradually and with reluctance until Nicole Oresme could envisage a heliocentric system and anticipate Descartes' analytic geometry. But even so, the fact remains that the Italian Trecento laid the foundations for the "modern" conception of space. In contrast to medieval representations, Duccio's "Last Supper" and "Annunciation of the Virgin's Death" are staged in genuine interiors "seen through a window frame" instead of being delineated on a material surface; and in contrast to Hellenistic and Roman representations, the space of which these interiors are a part is thought of as continuous and (potentially at least) infinite rather than composite and finite. Thus several spectacular advances were made long before Brunelleschi's discovery. The same Ambrogio Lorenzetti who found it difficult to discipline his orthogonals has given us the earliest landscape both morphologically accurate and panoramic (text ill. 18) and introduced, in the "Annunciation" just mentioned, a fundamentally important scheme of space construction which I propose to call, for want of a better term, the "interior by implication": without any indication of architecture the fact that the scene is laid indoors is made clear by the simple device of placing the figures upon a tiled pavement instead of rock or grass, whereby the very absence of lateral and supernal boundaries gives the impression of illimitedness. And his brother Pietro's "Birth of the Virgin" (text ill. 17) revived, for the first time since the "Odyssey Landscapes," the idea of *Durchsehung* in explicit fashion: we look into one room through different openings, a bold

anticipation of what we shall encounter, immeasurably perfected, in the Ghent altarpiece (fig. 276).

This is what I had in mind when I said that "the very weapons with which Jan van Eyck and Roger van der Weyden were to achieve their victories had been forged in Siena and Florence." The invention of perspective alone would have sufficed to change the course of history for nearly a hundred years and to assure to Italian art an international predominance which it had lost after the downfall of the Roman Empire — a predominance, however, which, as we readily understand, was limited to the domain of painting. In the three-dimensional media — architecture, sculpture and metal work — the North, the home of the Gothic style, was to remain almost impervious to Italian influences up to the sixteenth century;[1] it even continued to influence the Italian masters. In painting, however, the current was reversed with the advent of Duccio and Giotto, and the erstwhile masters were forced into a position of disciples. From about 1325 the Northern painters and book illuminators felt compelled to absorb the Italian innovations until, towards the end of the fourteenth century, a state of equilibrium was reached. This state of equilibrium marks the phase known as "The International Style of around 1400," when the influences flowed back and forth almost to the point of promiscuity. And it was from this fluid phase that, after a new parting of the ways, the Italy of Masaccio and Fra Angelico and the Flanders of the Master of Flémalle and Jan van Eyck emerged as the only Great Powers in European painting.

I

FRENCH AND FRANCO-FLEMISH

BOOK ILLUMINATION IN

THE FOURTEENTH CENTURY

It was not only through its achievements in the representation of space that Italian Trecento painting gained ascendancy over the Gothic North. Another factor was its success in establishing a new form of psychological expression.

Classical art had developed a vocabulary of postures, gestures, drapery motifs and facial expressions — "pathos formulae," as Aby Warburg used to call them — which manifested an enormous variety of states and emotions; but the character of this vocabulary was determined by a vitalistic or organicistic interpretation of human nature. The ancients conceived of man, not as an immortal soul forced into a precarious, even "miraculous," alliance with the "dust of the ground," but as a harmonious union. The spirit is immanent and not transcendent in relation to the flesh. Conversely, the soul seems capable only of such experiences as are commensurate with the functional capacities and limitations of the body, and every human being constitutes a self-sufficient and self-contained "microcosm," as Democritus first put it.[1]

In many-figured compositions, therefore, the style of writing is polyphonic rather than harmonic. The emotions neither tend to break down the barriers between individuals nor do they force the body into positions incompatible with its natural articulation. The drapery always remains clearly separated from the organic form, and the expression is so evenly distributed over the entire figure that, in case of damage, the loss of the head is not much more serious than that of any other major part.

Christian spiritualism demanded another kind of language: a language that would do justice to the independence of the soul from the body as in martyrdom or ecstasy, and to the extinction or near-extinction of individuality in the presence of the supernatural. As the Middle Ages abolished individualized portraiture, so did they abolish that integral unity between soul and body which we call organic. The Romanesque froze the figures into immobility or twisted them into contortions incompatible with the laws of nature. The Gothic preferred to melt them into lyrical self-abandonment; and in neither case would we speak of a "dramatic" mode of expression.

When young Achilles, spurning the entreaties of the princesses among whom he had been brought up, tears himself away to follow the call of his destiny, he turns from them with a violent *contrapposto* movement expressive of his conflicting emotions, and this movement forms a truly dramatic contrast with the suppliant pose of the maiden kneeling before him.[1] When we compare this Departure of Achilles (text ill. 19) with any Gothic *Noli me tangere*[2] (text ill. 20) — not an entirely unfair comparison in that in both cases a hero repudiates the endearments of a kneeling woman in the fulfilment of his mission — we perceive that in the Gothic composition all forms are dominated by a force beyond and above individual existence. The dramatic contrast between the two figures has disappeared. Instead of being torn between the will to yield and the will to resist, Christ gently sways away from the Magdalen. His hand is raised in blessing instead of expressing either rebuke or farewell, and her love turns into prayer. All the elements of the composition, including the very plants, are subordinated to the sweep of a unifying, curvilinear movement which obliterates even the distinction between body and drapery. Yet the attention of the beholder is forcibly directed toward the foci of spiritual expression, the faces and the hands. In medieval art gesticulating hands frequently seem to lead a life of their own, and a Gothic statue deprived of its head strikes us as much more vitally mutilated than a classical "torso."

Ultimately, most Gothic postures, gestures and drapery motifs can be traced back to classical sources; but they had undergone a metamorphosis which all but obscures their derivation. It was, again, in the Byzantine sphere that the classical vocabulary had been preserved in its more original form — attenuated, stiffened and often diluted by influences from the Asiatic East yet always retaining some of the vitalistic and organicistic feeling that had animated the human figure in Greek and Roman art. Byzantium, to quote Adolph Goldschmidt's immortal simile, passed on the heritage of classical Antiquity "in the form of dehydrated foodstuffs that are inherited from household to household and can be made digestible by the application of moisture and heat."[3] The recurrent waves of Byzantine influence that swayed the western world from the tenth century to the thirteenth bear witness to the success of this food program for undernourished countries.[4] In the North, however, the last of these waves was submerged in the overpowering stream of Gothic. In Italy it froze into the *maniera Greca*; and from this the Trecento masters could evolve a "modern" form of psychological expression by infusing new life into the ghosts of classical "pathos formulae" just as they had evolved a "modern" form of space by restoring the remains of classical perspective.

In his *"Noli me tangere"* in the Arena Chapel (text ill. 22), Giotto restored to the figure of Christ a classical *contrapposto* attitude and reinstated its emphatic contrast with the supplication of the Magdalen. But in retaining some of the Gothic rhythm he avoided disrupting the intrinsic unity of the two figures and achieved a personalization of sentiment beyond the range of all earlier art.[5] Instead of a gesture of either stern rejection or formal blessing, we have, for the first time, one of mild, understanding refusal. And the tension between entreaty and recoil became what it had not been in Gothic art — namely, a drama — and what it had not been in classical antiquity — namely, a drama of purely spiritual significance. The figures regained

some of their pagan vitality without renouncing the Christian privilege of possessing a soul whose experiences transcend the realm of natural existence. We are confronted with a "dialogue of souls" [1] charged with a latent passion that was to be set free by Titian and Correggio.

It is this new, more affective attitude that accounts for the introduction, or at least for the accentuation and elaboration, of many iconographical motifs of an intensely emotional or intimately human nature, now taken for granted but in reality attributable to the Italian Trecento: the Annunciation staged in a domestic interior; the Mary Annunciate on her knees or humbly sitting on the ground; the Angel Gabriel genuflecting or approaching in flight instead of standing; the Nativity with midwives taking care of the new-born Saviour or, conversely, with the Virgin Mother adoring the Christ Child instead of being represented in bed; the Adoration of the Magi with the oldest of the Kings kissing the Infant's foot; the Man of Sorrows in half length; the Madonna of Humility. [2]

One of the most telling instances is the Lamentation of Christ. This scene — as distinguished from the Entombment — is not described in the Bible and was originally foreign to Western art which knew only the Entombment. The Western representations of this subject are, quite literally, "de-positions": the body of Christ is lowered into the sarcophagus by two figures, Nicodemus and Joseph of Arimathea, who support His shoulders and feet much as Hypnos and Thanatos had done with the body of Sarpedon in classical renderings. [3] As a rule, but not always, the grieving Virgin and some Disciples appear behind the sarcophagus; and in many Gothic representations one of the mourners, placed in the center, pours ointment onto the body. The whole composition tends to be fairly symmetrical and gives the impression of quiet, dignified restraint (text ill. 23).

Owing to the Eastern custom of burying the dead in caves, Byzantine art conceived of the Entombment as an act of propulsion rather than of lowering (text ill. 24). The body is pushed into the grave much as — if I may use such a simile — a loaf of bread is pushed into the oven; and it is, therefore, as a procession moving forward rather than as a "de-position" that the Entombment was represented in the "Rabula Gospels" as early as 586. Originally, the group approaching the cave was led by Joseph of Arimathea; but when, in the Middle Byzantine period, an increasingly important role was assigned to the Virgin Mary, it was she who took the lead in the procession; and it was this rearrangement that produced the Byzantine Lamentation or "Threnos." As though the tragic cortège had come to a halt for a last farewell, the Virgin is shown bending forward or even sitting on the ground, throwing herself over the dead Christ, holding His body with her arms, and kissing His mouth (text ill. 25). [4] Despite the fact that the Synod of Aniane had condemned the pagan custom of kissing the dead, this dramatic composition had been adopted in the West in the late twelfth and early thirteenth centuries in the course of the most powerful wave of Byzantine influence. But it had tended to merge with the traditional Entombment in that the body was placed upon a sarcophagus instead of resting on the Virgin's bosom, and in the northern countries this synthetic type was soon superseded by the quiet Gothic Entombment pure and simple. In Italy, on the contrary, the Byzantine "Threnos" persisted, both in its occidentalized form (with the body reposing on

a sarcophagus and the symmetry of the whole group preserved in spite of the motif of the kiss) as is the case with Duccio (fig. 8), and in the original version which was to be glorified in Giotto's fresco in the Arena Chapel (text ill. 26). And in both cases the scene was further emotionalized by the inclusion of motifs not as yet current, so far as I know, in Byzantine art. Huddled mourners were added in the foreground and the grief of the others grows to such proportions that they throw up both arms, tear their hair or frantically bend forward with arms outstretched behind them. It would seem probable that these additional and so expressive features, apparently peculiar to Italian art, were borrowed from Roman and Etruscan funeral monuments; [1] specifically, I should venture the hypothesis that the unforgettable gesture of Giotto's St. John, poignantly contrasting with the quiet attitudes of the figures behind him, was directly inspired by a Meleager sarcophagus which influenced Tuscan artists throughout the centuries. [2]

II

In view of all this, it was, historically speaking, inevitable that Italy should gain ascendancy over the northern countries in the field of painting. Not too much stress should be laid on the fact that the Curia had been moved to Avignon in 1309, not to return to Rome until 1377. Needless to say, the Babylonian Exile of the Church did cause a tremendous conflux not only of Italian clergy but also of Italian scholars, merchants, bankers, lawyers, and artists; also needless to say, it opened many channels of transmission, some of which can be traced with some precision even today. [3] However, the impact of Trecento painting was felt in many places other than Avignon, and long before the Popes had embarked upon major artistic enterprises. While Simone Martini and his relatives (soon to be succeeded by Matteo da Viterbo) did not reach Avignon until *ca.* 1340, [4] a crew of Roman artists was at work at Béziers in Languedoc as early as *ca.* 1302 and was subsequently employed by the King of France, [5] and by 1325 the wave of Italianism had struck regions as widely removed from Avignon as Paris, Spain, South Germany (especially Austria), and even England. We are faced with an infiltration too simultaneous and ubiquitous to be accounted for by an historical accident. As in a system of connecting tubes a liquid, once its level is raised at one point, flows to all others until all levels are equalized, so did Italian painting, once having attained superiority, automatically communicate its achievement to all other countries. It is safe to assume that the history of fourteenth-century painting would not have been much changed had the Popes continued to reside in the Lateran.

This general diffusion of Italianism proceeded, of course, in various ways and with varying results according to the difference of regional conditions. The deepest and most continuous penetration took place in Catalonia and on the Balearic Isles, where ethnic affinity, the relatively late arrival and weak development of the Gothic style, and a well-established tradition of panel painting favored so unrestrained and indiscriminate an appropriation of all available Italian styles that, from *ca.* 1330, Catalan painting and book illumination give the impression of an eclectic Trecento school *in partibus*. [6] The opposite was true of England and South Germany.

The three conditions just mentioned being reversed, Italian influences appeared as sporadic inroads rather than as a continuous permeation and were at first unable to shake the foundations of an essentially Gothic mode of expression.

The Austrian master who from 1324 to 1329 decorated the back of Nicholas of Verdun's Klosterneuburg altarpiece with four great panels indubitably knew, directly or indirectly, the frescos in the Arena Chapel;[1] and his dependence on Giotto is especially evident in his "*Noli me tangere*" (text ill. 21). The general disposition of the scene, with Christ and the Magdalen placed on the right, her arms groping forward and her face uplifted, reveal a passion more human than in earlier Northern representations; and in both pictures the hand of Christ is placed perpendicularly above the hands of the Magdalen. Yet the Austrian painter's composition remains essentially High Gothic. Although he shows an exaggerative interest in the perspective of the sarcophagus (which he developed into a "table-tomb" supported by arcades, provided with heavily projecting consoles and supplemented by the lid which Giotto simply omits), he had no understanding for that which was fundamentally new. Aiming at the abstract rather than the concrete — and therefore perhaps more strongly appealing to the taste of the twentieth century than does Giotto himself — he retained, as it were, only the planar pattern of the composition and disregarded its development in depth. The figures are outlined against a neutral background instead of being embedded in space. The landscape, which Giotto had used as a sounding board amplifying and diversifying the voices of the human figures, is eliminated; and the ground plane no longer recedes, so that the resurrected Christ, placed on a little hillock, appears above rather than behind the Magdalen. The relationship is no longer one of depth, but of height. The figures, formerly massive and fully developed beneath their garments, are elongated and unsubstantial, as though exempt from the law of gravity; the *contrapposto* attitude of Christ is Gothicized into a swaying, floating motion, and where Giotto limits himself to the events described by St. John, the northern master adds the visit of the Three Marys according to Mark XVI so that the *Noli me tangere* is rivaled by another dialogistic scene instead of being set off against the unconsciousness of sleeping soldiers and the quiet presence of immobile angels.

Important though it was in several ways, especially in arousing an interest in perspective foreshortenings,[2] this first encounter with the Trecento remained an interlude. The Klosterneuburg panels and their relatives[3] did not start a general reaction against the earlier South German tradition. The Berlin "Nativity" of *ca.* 1350, though much more literally Giottesque in composition than the four panels of 1324–1329, is more, rather than less, linear and vertical in style;[4] and this whole school of painting petered out in the second half of the century. From *ca.* 1350 "all artistic forces in Austria came to be diverted to another" — and, we may add, distinctly un-Italian — "form of two-dimensional representation, to wit, glass painting."[5]

In England, too, the direct influence of Trecento painting was episodic — so episodic that this influence was not noticed until fairly recently.[6] At precisely the time that the Klosterneuburg panels were painted there appeared in a number of East Anglian manuscripts a style distinguished from its purely Gothic antecedents by an attempt to emulate both the Italian treat-

ment of space and the Italian formulae of expression. In the Crucifixion miniature in the famous "Gorleston Psalter," for instance, the figures are placed on a strip of terrain whose rocky structure, pictorial treatment and perspective recession clearly derive from a Trecento model.[1] And the illuminator adopted from Sienese sources not only the posture and gesture of St. John but also the characteristic motif of the Magdalen embracing the Cross.[2] By 1340, however, this Italianistic episode was over, having no more effect upon the further development of English painting than had the still more ephemeral efforts of that lonely Italianist who, some twenty or thirty years later, illustrated the so-called "Egerton Genesis."[3]

Setting aside the exceptional and fairly complex situation in Hungary,[4] there were only two countries where the Trecento influence on painting was neither so ephemeral as in Austria and England nor so overwhelming and, in a sense, oppressive as in Spain; where it operated as a pervasive force stimulating and guiding rather than interrupting or impeding the growth of an indigenous style. These two countries — which thus developed into secondary centers of dispersion transmitting a kind of predigested Italianism to wherever the Trecento style could not take root by direct assimilation, including the British Isles — were Bohemia and France.

In spite of their geographical separation these two centers were closely joined, not only by dynastic and political but also by cultural ties. Charles IV of Bohemia (born 1316 and German Emperor from 1356 up to his death in 1378) and his father, John the Blind, were thoroughly "Frenchified." John's daughter, Bonne of Luxembourg, was the wife of King Jean le Bon of France, and John himself was killed at Crécy as an ally of Philip VI. Charles IV was educated in Paris and married Blanche of Valois. Both Bohemian rulers maintained the closest relations with Avignon and invited to their court French artists as well as Italian. Their capital, Prague, was pervaded by an international atmosphere not unlike that of Paris where, in 1336, a manuscript commissioned by a Neopolitan ecclesiastic was written by an English scribe and illustrated by a Parisian illuminator, and where, in 1338, a Flemish painter sold to the Countess of Flanders a picture of Roman workmanship.[5] Yet the development took a very different course in France and in Bohemia.

In the peripheral milieu of Bohemia, a number of nationally homogeneous but personally very individual artists, mostly hailing from the Germanic parts of the country, yielded to a great variety of Italian influences, partly direct and partly indirect, partly Tuscan and partly North Italian. As a result we find a succession of at least three comparatively unrelated styles, the continuity of which is largely based upon the persistence of certain national traits.[6] In France — at least in that region north of the *Massif Central* where, *pace* the champions of Avignon,[7] the really momentous events took place — we are in the very center of Gothic civilization. Artists of different origin, yet unified and supported by the solid tradition of their adopted country, engaged in a methodical and — to borrow a happy phrase from Millard Meiss — "selective" assimilation of the various Trecento currents. At the beginning they concentrated on the style of Duccio and his direct followers, a style most readily acceptable to the Gothic taste; then they gained access to Simone Martini, Barna da Siena and the Lorenzetti;

finally, they graduated to the other Italian schools, especially the Florentines and Giotto himself. As a result, we can observe a progressive synthesis, the continuity of which was guaranteed by the very strength of the indigenous tradition and by the very gradualness of Italianization.

<div align="center">III</div>

If any major event in the history of art can be credited to one individual, the initiation of this process must be ascribed to an artist to whom I shall continue to refer by the traditional appellation of Jean Pucelle, active at Paris from *ca.* 1320.[1] He was no less important in the development of painting in the North than were Giotto and Duccio in the development of painting in Italy. But unlike Giotto and Duccio, he did not express himself in large frescoes and panels. He was a book illuminator, or rather, the head of a big workshop engaged in book illumination; and so were most of his distinguished followers. It is, in fact, in libraries rather than in picture galleries, churches and palaces that we must study the antecedents of the great Flemings.

To a great extent, this is due to the accidents of preservation. Most of the castles and mansions which, in spite of the penchant for tapestries, were not infrequently adorned with murals, have been destroyed or rebuilt. The altarpieces and *ex votos* in Northern churches invited the fury of iconoclasts, religious and antireligious alike, or fell prey to no less destructive changes in taste that called for replacement. Books, on the other hand, have a way of surviving in the comparative obscurity, and therefore security, of libraries and private studies, quite apart from the fact that their pages are automatically protected from injuries by exposure. Yet the numerical preponderance and — other things being equal — more progressive character of book illumination cannot be explained by the rate of survival alone.

In the first place, no region or period in Europe produced a greater number and a richer variety of illustrated books than did France and the Netherlands during the fourteenth and fifteenth centuries. With the disintegration of high medieval feudalism and ecclesiasticism the demand for sumptuously illustrated books had been immeasurably increased by the emergence of a wealthy and cultured lay society with its concomitants of passionate collecting and "pride of ownership."

Up to the latter half of the thirteenth century the only liturgical book in private hands had been the Psalter. Now, no person of good standing could show his face without possessing, if not a Breviary, at least a Book of Hours, one of the most characteristic innovations of the fourteenth century. A private and highly individualized service and prayer book (no two are exactly alike), the *Livre d'Heures* had developed from an appendix to the Psalter into an independent book[2] that had become an accepted symbol of wealth and position; a page in the "Hours of Mary of Burgundy" exhibits a charming collection of what was considered *de rigueur* for a lady: a rosary, a bottle of scent, a well-stocked jewel box, and a Book of Hours.[3]

Up to the latter half of the thirteenth century the illustration of secular texts had been virtually restricted to legal, medical, botanical or otherwise professional treatises and a few

<div align="center">27</div>

epics. This circle was now widened by the illustration of countless texts newly composed or translated for the benefit of mundane society: chronicles, didactic poems, fanciful descriptions of foreign lands, popularized philosophy such as the *Somme-le-Roy* or the *Livre des Propriétés des Choses* by Bartholomeus Anglicus, translations or paraphrases of Petrarch and Boccaccio, Livy and Terence, Valerius Maximus and Flavius Josephus; there are even illustrated Aristotles in French. St. Augustine's City of God was available in the translation by Raoul de Presles, and the Bible itself, previously not often read or owned by the layman, was made accessible to him in copiously illustrated translations and paraphrases ("*Bibles Historiales*").

In the second place, we must not forget that, as already mentioned, the tradition of fresco painting was somewhat weakened and a tradition of panel painting practically nonexistent in France at the beginning of the fourteenth century; the three lost retables ordered from Pierre Massonnier in 1327 are about the earliest panels known to have been executed by a French painter.[1] The art of book illumination, however, had been at home in France for many centuries and flourished there so much more vigorously than in any other European country that Dante could refer to it as "quell'arte che alluminare è chiamata in Parisi." In fourteenth-century France, therefore, it was as natural to incorporate the innovations of the Tuscan painters in miniatures rather than in panels as it was natural in eighteenth-century New England to execute Palladian cornices and pediments gleaned from the *Vitruvius Britannicus* in wood rather than in stone.[2]

Thus book illumination had a head start over panel painting, which by comparison tended to remain somewhat *retardataire*. Book illumination, on the other hand, developed so rapidly in the direction of perspective naturalism that it finally ceased to be book illumination. Within the system of a High Gothic page the narrative miniatures had been no less subservient to the purpose of surface decoration than the initials, the frames, the marginal ornament and even the script. During the fourteenth century, however, the miniatures assumed more and more the character of independent paintings and about 1400 many a book illustration, entirely defying the restrictions of a decorative principle, more closely approximated the modern ideal of a "prospect through a window" than did the most progressive panels. Developed into full-fledged landscapes or realistic interiors, the miniatures produced at the beginning of the fifteenth century seem ready to step out of the vellum page and to become *in esse* what they already were *in posse*: "pictures" in the Albertian or "modern" sense of the term.

This is precisely what was to happen in the works of the great Flemings. Their accomplishment amounted to a liberation of the forces that had accumulated in book illumination, and we can easily see that, drained of these forces, book illumination itself was doomed to decay. From the middle of the fifteenth century it became, with only a few glorious exceptions, a derivative and finally a residual art, dependent either on earlier workshop patterns or on the imitation of "real" — meaning panel — pictures. It has been said that book illumination was killed by the invention of printing; but it had already begun to commit suicide by converting itself into painting. Even without Gutenberg it would have died of an overdose of perspective.

IV

This whole development, then, set in with Jean Pucelle. He appeared at a moment when the Paris tradition had reached a point of comparative stagnation. Paris, like Rome, was — and in a measure still is — a reservoir rather than a well: a place where many artists learn and live but few are born, which has the power to attract, to synthesize, and to refine but not to originate. The Paris tradition collected "artists from all parts of the kingdom," disciplined them and often sent them out again; but, when left to itself, it tended to settle down to an elegant routine. This — with such well-known and probably English-inspired exceptions as the rough and vigorous *Somme-le-Roy* of 1311 or the talkatively circumstantial *Légende de St.-Denis* of 1317 — was the case in the first quarter of the fourteenth century.[1] Most of the Paris manuscripts produced in this period, for instance the "Book of Kalila and Dimna" (otherwise known as "The Fables of Bidpai") of 1313 or 1314 (fig. 3), the "Bible of Jean de Papeleu" of 1317 (fig. 4), and even the two "Lives of St. Louis" by Guillaume de St.-Pathus and the Sieur de Joinville, though not executed until 1330–1335 and fairly advanced in ornament, exemplify a late, attenuated phase of the thirteenth-century High Gothic as culminating in the work of Master Honoré (fig. 2).[2] In all these miniatures the emphasis is on contours and flat areas of light and dark rather than on plastic modeling and organic articulation. Instead of being organized around an axis, the flattened, jointless figures give an impression not unlike that of the colored silhouettes in a Javanese shadow play, and whatever depth there is, is suggested by the overlapping of planes rather than by the displacement of volume. Even where the strong modeling of the thirteenth century is in a measure retained, the schematization of form and movement and the hardening of the linear skeleton give a distinctly calligraphic effect.

To juxtapose a specimen of this style with the "Annunciation" in a little Book of Hours, which I still hold to be identical with a Prayer Book executed by Jean Pucelle for Jeanne d'Evreux, Queen of France, between her marriage to Charles IV in 1325 and the latter's death in 1328,[3] produces something like a shock. Reverting to the style of Master Honoré, with whom he may or may not have been in personal contact during his youth, Pucelle concentrated on the effect of plastic forms; but these he modeled by light and shade alone, suppressing all linear contours except for such details as facial features, hands and hair. It was no accident that he favored a semi-grisaille technique reserving color for backgrounds, architectural scenery and human flesh. But even more remarkable is the fact that the figures are placed, for the first time in Northern art, in a coherent perspective setting. A complete little building with its front wall removed, this setting is not, as yet, an "interior" in the strict sense of the term; but its two rooms, especially the main chamber with its receding floor, converging ceiling beams and foreshortened side walls, do constitute a rationally conceived perspective ensemble. Its three-dimensional effect is strengthened by the contrast between the darkness of the little porch or anteroom and the brightness of the main chamber, and even such details as the two consoles of the ceiling or the paneling of the right-hand side wall are pointed up by luminary accents.

Needless to say, this bold departure from the Northern tradition would not have been possible without the aid of Italy; to be more specific, without the aid of Duccio. But what distinguishes Jean Pucelle from his contemporaries in other lands is the way in which this aid was sought and utilized. Unlike the Spaniards, Pucelle did not try to achieve a literal imitation of the Trecento style; not for a moment could any of his works be mistaken for an Italian product as is so often the case with Spanish pictures and miniatures. Unlike the Austrians and Englishmen, he was not satisfied with the appropriation of single motifs or the general compositional pattern. He approached the Trecento style as an intelligent man learns a foreign language: neither in order to transcribe its literature nor to pick out quotations, but to express his own ideas in a new medium.

Pucelle's "Annunciation" (fig. 5) is based, characteristically, not on Duccio's rendering of the Annunciation proper, but on his interpretation of a much rarer subject, the Annunciation of the Virgin's Death (fig. 6). It was from this still more emotional yet wonderfully harmonious composition that he appropriated the architectural setting (disclosing, however, the interior of the anteroom which is blacked out in Duccio's panel) as well as the beautiful posture of the kneeling Angel; from Duccio's "Annunciation" proper he retained, if anything, only the ideas of showing the Virgin standing rather than seated and of placing the Angel within rather than in front of the anteroom. Pucelle, then, takes two pictures, transforms and fuses them, and even his quaint little "doll's house," lacking its front wall but provided with a roof and an attic from which the Dove comes down through a trap door, bears witness to his independent and, upon its premises, perfectly logical thinking. This "doll's house" represents a reinterpretation of the fanciful architectural frames so common in earlier book illumination into real, three-dimensional structures opened up in front, and this reinterpretation enabled Pucelle to display a coherent interior without endangering the graphic unity of the page; he could permit us to look into a "room" by removing the front wall of a house instead of cutting a hole in the vellum. His structures hover before the picture plane instead of extending behind it, and this effect is especially emphasized by the fact that they are held aloft by little caryatids. In the case of the "Annunciation," and in this case only, the caryatid has assumed the shape of a sturdy little angel, and this, I think, is the earliest allusion to a nascent legend which was to attain considerable popularity: after the conquest of the Holy Land by the infidels, the house in which the Angelic Salutation had taken place was said to have been transported by angels from Nazareth to Dalmatia and thence to Italy where it is still venerated, encased by Bramante, as the "Santa Casa di Loreto." [1]

Modeling and perspective were not the only novelties which Jean Pucelle admired in the Italians. He also strove to assimilate that new form of psychological expression of which, he thought, the Angel in the "Annunciation of the Virgin's Death" was a more distinguished example than that in the "Annunciation" proper. He was the first northern artist who replaced the Gothic Entombment by the Italo-Byzantine Lamentation with mourners wringing their hands or covering their faces in unutterable grief and the Virgin Mary throwing herself over the body of Christ in a final embrace (fig. 7). Pucelle's composition is, again, generally

patterned after Duccio's (fig. 8) [1] which, however, exhibits neither the huddled figures in front of the sarcophagus nor the veiled mourner on the right. Since both these motifs occur in the work of Duccio's followers,[2] we may suppose that they were known in Siena as early as about 1320. But Pucelle partly restrained and partly intensified the psychological expression and coördinated all the motifs by a more fluent rhythm. He recreated rather than copied his models.

<div align="center">v</div>

If the narrative miniatures of the "Hours of Jeanne d'Evreux" bear witness to the first impact of Italian art upon Parisian painting, its marginal decoration reveals an influence, no less important for the future, which originates in the North rather than the South of Europe. In the Annunciation page, for example, a succulent ornament blossoms forth from the initial "D," the loop of which is developed into a curious monster while the interior space of the letter shelters the diminutive figure of the King, his majordomo standing — or rather sitting — guard on the other side of the *hasta*. Little figures — in this case angels — are perched upon or interwoven with the marginal decoration; and the *bas-de-page* (the miniature in the oblong space between the last line of the text and the lower border) represents a charming genre scene: a lazy young man, squatting upon a cushion (time-honored symbol of idleness or indolence), spurns the advances of two pretty girls while one of these rejects the overtures of a more energetic but apparently less desirable partner.

Devices such as these, especially the figurated *bas-de-page*, originated in English Psalters and Horae of the late thirteenth and early fourteenth centuries [3] and had reached the Continent by the customary routes via the Channel districts and the Netherlands, and up the valleys of the Rhine and Meuse; we find them first in manuscripts from Cologne, Cambrai and Tournai, Dijon and Verdun (fig. 9).[4] In general appearance, too, Pucelle's little figures — looking as though they were molded out of a pliable and ductile substance — bring to mind the paintings and sculptures produced in these regions; some of the closest parallels both in treatment and in subject are found in the decoration of the choir screen and choir stalls in Cologne Cathedral.[5]

We are ignorant of Pucelle's birthplace. We know only that he was well established in Paris between 1319 and 1324, when he designed the seal of the Confraternity of St.-Jacques-aux-Pèlerins, and for stylistic reasons may assume that he was well acquainted with the work of Master Honoré. It is, perhaps, no more than accident that two of his major authenticated manuscripts were written by English scribes; but he may well have come from the northern or northeastern provinces, the art of which had already exerted some influence on Master Honoré himself.

Be that as it may, it was Pucelle, the great Italianist, who also introduced new Anglo-Rhenish and Anglo-Mosan elements into the Royal Domain and perfected them according to the standards of the Paris tradition. He disciplined the fanciful freedom of Anglo-Rhenish and Anglo-Mosan decoration into a graceful, crystal-clear system; he elevated the *bas-de-page*

—which had shown a tendency either to dangle or to remain too closely involved with the marginal ornament — to the dignity of a real little picture; he refined the "drolleries" into a fairy tale alive with birds and flowers, snails and insects; and among these a place of honor was reserved for the elegant dragonfly, *demoiselle* or *pucelle* in popular French, which became the punning trademark of his shop.

These delightful decorative features are absent from a Bible completed by Jean Pucelle and the English scribe Robert of Billyng on Thursday, April 30, 1327 which, adhering to a more austere tradition, contains only marginal *rinceaux* and historiated initials.[1] They are, however, abundantly present in the third authenticated manuscript by Jean Pucelle and his assistants, the famous two-volume Breviary, called the "*Bréviaire de Belleville*" after the family that owned it before it came into the possession of Charles V;[2] it was written between 1323 and 1326, and its illumination would therefore seem to be roughly contemporaneous with that of the "Billyng Bible."

In these two works the Italianate element is on the whole less conspicuous than in the "Hours of Jeanne d'Evreux" which seems to antedate both. In the "Billyng Bible" it can be detected in the figures but not in the treatment of space. In the "Belleville Breviary" non-Italianate miniatures alternate with others that show Trecento connections both in the style of the figures and in the character of the architectures, but do not keep so closely to determinable prototypes as is the case with the "Annunciation" and "Lamentation" in the "Hours of Jeanne d'Evreux." While partly based on Sienese models and evincing a familiarity with Trecento perspective, the architectures seem to come about by a free manipulation of "props" rather than by the imitation of a given setting, and Northern elements are often intermixed with Italian ones as in the little churches seen in the *bas-de-pages* of the Psalter section; even such more thoroughly Italian structures as the Palace of Saul in the initial in vol. I, fol. 24 v. (fig. 10), skillfully foreshortened and sporting coffered ceilings, are hard to track down to individual models.[3] In a still later manuscript that has been associated with Pucelle's atelier on the strength of a dragonfly appearing in the margin of the dedication page — a *Liber sententiarum* by Durandus of St.-Pourçain completed by another English scribe, William of Kirby, in 1336 — no trace of Italianism is visible.[4] It would seem, then, that in the Pucelle manuscripts the strength of the Italian influence diminished by degrees, from which we may conclude that its evaporation was due, not only to the collaboration of less Trecento-minded assistants (none in the case of the "Hours of Jeanne d'Evreux," two in the case of the "Billyng Bible," three in the case of the "Belleville Breviary") but also to the development of the master himself. As in so many analogous cases, Dürer's for example, an initial phase of avid acquisition may have been followed by one of calm assimilation.

Throughout the "Belleville Breviary" the *bas-de-pages* no longer display mere drolleries or genre scenes as do the "Hours of Jeanne d'Evreux." They contain instead — again by appropriation of an English idea[5] — the elements of a serious and continuous narrative. In fact the whole marginal decoration is fraught with a symbolism so elaborate that its inventor,

doubtless a Dominican theologian, found it necessary to preface the whole work by a circumstantial Commentary the like of which does not occur in any other liturgical manuscript.[1]

The *bas-de-pages* of the Psalter section show — so as to illustrate the parallels drawn by St. Thomas Aquinas in his *De sacramentis*[2] — the Seven Sacraments flanked by Old Testament examples of the Deadly Sins on the left, and by object lessons in the corresponding Christian virtues on the right: on the Saul and David page, for instance, the Holy Eucharist is depicted between the Slaying of Abel (the prime example of Hardness of Heart) and the Giving of Alms as an example of Charity.

The Calendar of the first volume — five of its six leaves unfortunately cut out but reconstructible from the Commentary just mentioned and a great number of replicas[3] — displays, at the top of each page, not only the month and its zodiacal sign, but also one of the Twelve Gates of the Heavenly Jerusalem surmounted by the Virgin Mary (embodiment of the Church) who carries a banner inscribed with one of the Articles of Faith (fig. 11). Before the Gate is seen St. Paul, receiving his vocation in January and reading his eleven letters to their respective addressees during the rest of the year. The *bas-de-pages*, on the other hand, illustrate the concordance between the Old Testament and the New by showing how the Twelve Apostles convert the sayings of the Prophets into the Articles of Faith. When, for instance, the scroll of the Prophet Malachi says (II, 16): "Cum odio habueris, dimitte," that of the Apostle Thaddeus reveals this dictum as signifying the "remissionem peccatorum"; and this "revelation" is visualized, first, literally, by the Apostle's "unveiling" the Prophet; and, second, allegorically, by the Prophet's tearing a stone out of the fabric of the Synagogue and passing it on to the Apostle so that it might serve as building material for the Church, a process which naturally results in the gradual ruination of the Synagogue. A handsome edifice in January and February, it begins to show traces of wear and tear by the middle of the year and is completely reduced to rubble in November and December.

Perhaps even more important is Pucelle's novel way of depicting the months themselves. From time immemorial they had been characterized by the labors and pastimes peculiar to each. January, for instance, was represented as a gentleman feasting (often two-headed in recollection of the Roman Janus), February by a man warming himself at a fire, March by a farmer plowing the fields, and so on.[4] This tradition, one of the most unvarying in the history of art, holds sway in the second volume of the "Belleville Breviary" itself (fig. 12).[5] In the first volume and its derivatives, however, it was abandoned in favor of a totally different principle: the character of each month must be inferred, not from human activity but from the changing aspect of nature (figs. 13–16). With the well-motivated exception of the December picture, where a peasant is shown cutting wood for a huge fire, no human figure is present. We have before us nothing but landscapes showing bare trees in January, a heavy rain in February, budding branches in March, flowers in May, a ripe cornfield in July, falling leaves in the fall months; in the November picture, which usually shows a swineherd beating acorns from a tree for his hogs, the hogs find their acorns without the benefit of human assistance. Diagrammatic though they are, these rudimentary little landscapes — all sur-

mounted by arches on which the sun travels from left to right in the course of the year — announce a truly revolutionary shift of interest from the life of man to the life of nature. They are the humble ancestors of the famous Calendar pictures in the *"Très Riches Heures du Duc de Berry"* at Chantilly, and ultimately, of the "Seasons" by Pieter Bruegel.[1]

Small wonder that Pucelle's inventions and discoveries enjoyed prestige for several generations; he more than any other man is responsible for that continuity which distinguishes the French and Franco-Flemish development from all parallel movements. That the Calendar in the first volume of the "Belleville Breviary" was copied many times has already been mentioned (its known replicas and variations have recently been augmented from six to seven and range from *ca.* 1335 to *ca.* 1415);[2] and to trace the progeny of the "Lamentation" and "Annunciation" in the "Hours of Jeanne d'Evreux" would require a separate monograph. In England the "Annunciation" gave rise to a single, terribly garbled imitation;[3] in France it produced a series of at least eight variants which show a consistent development.[4] In all of these the Virgin is shown seated instead of standing and the Dove no longer enters the room through so unconventional an opening as a trap door.[5] Beginning with the second variant the roof and attic of the little building are omitted so that the "doll's *house*" is changed to what may be called a "doll's *parlor*" effect;[6] and in the most developed one — about 1385 — the impression of an actual interior is cunningly strengthened by the fact that the main chamber is hung with draperies and united with the anteroom, both units being enclosed within one fenestrated wall and provided with a continuous tiled pavement.[7]

<div align="center">VI</div>

Jean Pucelle's workshop was active, presumably well beyond the master's death, up to the middle of the fourteenth century, producing, among other manuscripts, a series of small, closely interrelated service books for the ladies of the Royal Family: the "Psalter and Prayer Book of Bonne of Luxembourg" (died 1349) which has but recently emerged from obscurity;[8] the "Hours of Jeanne II de Navarre" (figs. 13, 14), daughter of Louis X (who also died in 1349);[9] the "Hours of Blanche of Burgundy," aunt of Jeanne de Navarre (died 1348), known as the *"Heures de Savoie"*;[10] and the "Hours of Yolande de Flandre," daughter-in-law of Jeanne de Navarre (died 1353).[11]

The earliest and best of these small manuscripts would seem to be the "Psalter and Prayer Book of Bonne of Luxembourg." In it the style of the atelier retains so much of its freshness that some of the miniatures may well be ascribed to Jean Pucelle himself, and the two Calendars of the "Belleville Breviary" are fused in entertaining fashion: occupation pictures developed from those seen in the second volume of the Breviary are juxtaposed with little landscapes developed from those in the first, and this in such a way that the Signs of the Zodiac are incorporated, as it were, into the scenery; in the February picture, for example, the zodiacal Fishes are caught by a fisherman amid the rain and the bare trees (fig. 15).

The other manuscripts of the group are less imaginative in iconography and their Calen-

dars are — fortunately, in view of the almost complete destruction of the original — mere copies of that in the first volume of the "Belleville Breviary." Their style, too, shows an increasing tendency to become static or even retrogressive. The marginal ornament became either denser or sparser, and in both cases drier. The wealth of flowers, insects and birds tended to shrink and ultimately to disappear, and no advances were made in the conquest of space beyond the imitation and elaboration of such perspective settings as had been introduced by Pucelle himself, especially that of the inevitable "Annunciation." All the other compositions, often enclosed in those tricolor quatrefoils which were to become a standard feature in the manuscripts produced for Charles V, remained non-perspective. And the design became progressively flatter and harder, a process already far advanced in the *Liber sententiarum* of 1336 and culminating in the "*Heures de Savoie*" (fig. 18). In short, as the Pucelle workshop degenerated, its individuality became submerged in the conservative Paris tradition which, as we must not forget, had always persisted as a powerful undercurrent and was to reach another climax in the elegantly calligraphic style characteristic of so many manuscripts produced for Charles V in the 'seventies: the *Information des Princes* (fig. 17), the *Echecs Moralisés*, the *Rational des Offices Divins* or, at least for the most part, the *Grandes Chroniques de France*.[1]

At about the same time, however, a progressive countermovement arose in opposition to this sophisticated, if somewhat barren formality; a countermovement prompted by a craving for volume and space as opposed to two-dimensional patterns, for light and color as opposed to line, for concrete, particularized reality as opposed to abstract, generalized formulae. This modernistic rebellion — comparable indeed to the *philosophia moderna* of those nominalists who found the quality of real existence only in things "individual by virtue of themselves and by nothing else" — was led by artists who can be proved to have been what may be conjectured but cannot be demonstrated of Jean Pucelle: immigrants from the North.

The first, and one of the most important, of these demonstrably "Franco-Flemish" masters — a term which I shall use exclusively with reference to artists born in the Netherlands but working in France — was Jean Bondol, born in Bruges at an unknown date and active in Paris from 1368 to at least 1381.[2] He may be said to have played, on an even larger scale, the rejuvenator's role in the Paris of the 'seventies that Jean Pucelle had played in the Paris of the 'twenties and 'thirties. And as Pucelle had reverted to Master Honoré, so did Jean Bondol revert to Jean Pucelle. It is almost symbolic that the "*Heures de Savoie*," begun for Blanche of Burgundy in the atelier of Jean Pucelle but left unfinished after her death in 1348, was completed after an interval of more than twenty years under the supervision of Jean Bondol.[3]

That this was the case is evident from a comparison between any of the later minatures — for example the St. Leonard freeing two unattractive but rather appealing prisoners (fig. 19) — in the "*Heures de Savoie*" with any of the less accomplished illustrations — for example the "Healing of the Palsied Man" on fol. 513 v. — in Jean Bondol's only authenticated manuscript (fig. 20). This is the famous Bible — or, rather, *Bible historiale* — in the Museum Meer-

manno-Westreenianum in The Hague, presented to Charles V by one of his courtiers, Jean de Vaudetar, which was completed and signed by Jean Bondol in 1371 and forms the nucleus of a voluminous *oeuvre* attributable to him on stylistic grounds.[1]

The miniatures of Jean Bondol and his assistants form a no less striking contrast to the more conservative Paris production of the 'seventies than did the work of Jean Pucelle to, say, the "Bible of Jean de Papeleu" or the "Book of Kalila and Dimna." The vigorously modeled figures are sturdy and stocky with the linear element eliminated even where Jean Pucelle had still retained it, as in the facial features, the hands, and the hair. Figures and objects are rendered with a broad, fluid brush, a technique pictorial rather than sculptural, let alone graphic; and this pictorial tendency is evident throughout. Strong local colors that would tend to separate one area from the other are suppressed in favor of subdued tonality, and the interest is focused not only on the plastic form, but also on the surface texture of things: on the specific tactile qualities of wool or fleecy animals' coats as opposed to flesh, of wood or stone as opposed to metal. Space is suggested in foreshortened buildings or pieces of furniture and by the indication of a receding ground plane, and the general emphasis is on reality and character — at times verging upon caricature — rather than convention and "beauty." With honest, straightforward veracity Biblical events, legends of the saints — or, for that matter, scenes from Roman history — are staged in a bourgeois or rustic environment portrayed with a keen, observant eye for landscape features and such homely details as casually draped curtains, seats and couches with wooden overhangs shaped like diminutive barrel vaults, and crumpled bed clothes.

That these peculiarities of Bondol's style are Flemish rather than French can be demonstrated by a Missal in the Museum Meermanno-Westreenianum which was produced at Ghent, no more than thirty miles from Bondol's native Bruges, in 1366 — two years before he is first mentioned in Paris. In this manuscript,[2] commissioned by Arnold, Lord of Rummen and Quaebeke, we sense a kindred spirit of homespun truthfulness and a similar inclination for soft, contourless modeling and a subdued color scheme; in the charming "Nativity" on fol. 22 (fig. 22) the position and drapery of the foreshortened bed clearly anticipate the "Healing of the Palsied Man" in the Hague Bible. And when we compare the profile portraits on the dedication page of this Bible — Charles V accepting the book from Jean de Vaudetar who kneels before him — with two slightly earlier portraits, one executed by a pureblooded Frenchman, the other by a Netherlandish master, the regional connotations of Jean Bondol's style are no less evident. The famous portrait of Jean le Bon in the Louvre, produced between 1360 and 1364 by a Parisian court painter (possibly Girard d'Orléans), is firm and linear in treatment and sharp and alert in expression (fig. 28). The portrait of the Provost and Archdeacon Hendrik van Rijn in the "Calvary" in Antwerp, given by him to St. John's at Utrecht in 1363, is delightfully vague and dreamy, with the face and hair treated as a harmony of modulated tones instead of being graphically delineated (fig. 103).[3]

No doubt, then, that the portraits of Charles V and Jean de Vaudetar have, on the face of it, more in common with the portrait of Hendrik van Rijn than with that of Jean le Bon.

But where the anonymous artist employed by the Utrecht Canon is plainly provincial, Jean Bondol is cosmopolitan. Like all perceptive immigrants he was no less deeply affected by his new environment than he affected it. Without forfeiting his heritage of optical sensibility and joyful respect for nature, he absorbed the broadening and refining influence of the Parisian milieu, assimilating its tradition of elegant draftsmanship and benefiting by the opportunity of making fresh contacts with Italian art. The dedication miniature of the Hague Bible, for instance (fig. 23), could not have been produced in the Netherlands at this time. Executed on the right-hand leaf of a "tipped-in" double sheet, this miniature — unfortunately somewhat damaged — faces a page entirely filled with a magnificent, gold-lettered inscription (normally found only in manuscripts of considerably earlier periods) which reads, in translation, as follows: "In the year of the Lord 1371, this work [*scil.*, the manuscript itself] was illuminated (*pictum*) by order and in honor of the illustrious prince Charles, King of France, in the thirty-fifth year of his life and the eighth of his reign; and John of Bruges, painter of said King, has made this picture [*scil.*, the dedication miniature] with his own hand."

This unusual testimonial is well deserved. The delicate semigrisaille — the hands and faces rendered in natural colors, and the blue fabric of the background, canopy and cushions enlivened with golden fleurs-de-lys — is a masterpiece of coloristic taste, unfaltering design and intimate individualization; it is significant that "Charles le Sage," quite contrary to the conventions of the period (see fig. 17), wears the cap and gown of a Paris Master of Arts rather than his crown. Moreover the miniature marks the first major step beyond Jean Pucelle in the mastery of space. Jean Pucelle and his immediate followers had limited themselves to what I have called the "doll's house" scheme; they had represented space as a definite volume limited on all sides by a closed receptacle. Bondol began to interpret space as an expanse unlimited, or at least not visibly limited, in height as well as width. He applied perspective to open landscapes as well as to architectures, and in the dedication miniature of the Hague Bible he appropriated, doubtless from Italian sources,[1] the "interior by implication" mentioned in connection with Ambrogio Lorenzetti, its tiled pavement extending to considerable depth and impeccably focused on one vanishing point.

In stressing that he had executed the dedication page *propria manu*, Jean Bondol implies that some of the other illustrations (such, for instance, as the "Healing of the Palsied Man" which we have compared with the later miniatures in the "*Heures de Savoie*") were done by assistants. Yet his own hand may also be recognized in many of the narrative miniatures, for instance in the stories of Samson and David (fols. 123 and 134 v., fig. 21) and the quadrupartite frontispiece of the New Testament (fol. 467) which shows the Nativity, the Adoration of the Magi, the Massacre of the Innocents and the Flight into Egypt. All these pictures are of superior quality and bear witness to a combination of delicacy with sharp-eyed, even humorous, observation and to a delightful sense of sympathy with God's creation. David is shown both as the conqueror of Goliath and as the shepherd's boy so that he seems to protect his flock rather than his people, his sheep dog furiously barking at the dumb, helpless giant.

In the "Nativity" one of the midwives is shown testing the temperature of the Infant's bath, as she does in Giovanni Pisano's relief on the Pisa pulpit. And the ass in the "Flight into Egypt" emerges in half-length from the tall corn that has miraculously sprouted up from the seeds scattered by the Christ Child as the Holy Family passes by.

Two characteristic features must be pointed out in the landscapes. One is the scalariform stylization of the terrain; Samson, carrying the city gates of Gaza, climbs a hill as though he were ascending a flight of stairs. The other is a preference for little clumps of trees so closely bunched together that the whole cluster looks like an overgrown and somewhat complicated mushroom. These clumps of trees (*boquetaux*) constitute, as the geologists would say, an index fossil which helps to identify further manuscripts produced in the workshop or under the influence of Jean Bondol.

It is, in fact, Bondol himself who has first claim to be called the "*Maître aux Boquetaux*" [1] if we insist on retaining this somewhat misleading appellation. This, of course, neither means that every miniature containing a *boquetau* must be by Jean Bondol nor that Jean Bondol's arboreal vocabulary was limited to *boquetaux*. Apart from the two manuscripts thus far discussed, Jean Bondol and his atelier produced or contributed to the illustration of numerous others, the texts ranging from the Bible to the *Grandes Chroniques de France*, from the Golden Legend to Livy, from St. Augustine's City of God to Aristotle's Politics. I shall confine myself to his contributions to the enormous "Bible of Jean de Sy" in the Bibliothèque Nationale (begun as early as 1356 and never completed) because it enables us to appreciate the master not only as an illuminator but also as a draftsman.[2] Besides such finished or nearly finished miniatures as the admirable "Parting of Abraham and Lot," it contains illustrations in all possible states of completion, especially a series of *bas-de-pages*, either lightly contoured and partially touched up with color, or more circumstantially carried out in ink and entirely untouched by the brush.

It is from these exquisite little pen sketches, which give us a clear idea of Jean Bondol's design *qua* design, that we can most easily approach that great work for which he furnished only the cartoons while its execution was left to craftsmen over whom he had no control: the series of tapestries known as the "Angers Apocalypse."

This series, woven by Nicholas Bataille in Paris, was ordered by Louis I, Duke of Anjou (died 1384). His elder brother, King Charles V, had lent him his painter together with an illuminated manuscript of the thirteenth century which was to serve as a model for Bondol's cartoons and has been identified with ms. lat. 403 in the Bibliothèque Nationale ("le roi l'a baillée à Mons. d'Anjou pour faire son beau tappis"). It must be noted, however, that this manuscript is only one member of a large and fairly homogenous group and was apparently not the only one accessible to and utilized by Jean Bondol. In addition to the "royal copy" he must have used such early fourteenth-century Flemish manuscripts as the ones now in Brussels and Cambrai which would appeal to him by their native roughness of style and directness of characterization. A somewhat later Flemish member of the group, preserved in the Rylands Library at Manchester, comes fairly close to Bondol's own style.[3]

Why a particularly cruel and avaricious prince of the fourteenth century should have wished to decorate the halls of his castle — it was only subsequently that the tapestries were given to Angers Cathedral — with 160 yards of Apocalypse instead of with such more customary and suitable subjects as the Arthurian cycle, the Story of the Golden Fleece or the *Chanson de Troie*, it is difficult to say; perhaps this unusual commission announces those pangs of conscience which are pathetically evident in Louis of Anjou's last will and testament.[1] Be that as it may, it is significant that what is perhaps the most monumental decorative enterprise of Northern fourteenth-century art was entrusted to a book illuminator. A hundred years later these cartoons would probably have been designed by a panel painter or would at least have heavily leaned upon panel paintings already in existence; we learn from certain documents that the painters at times resented the pirating of their compositions by mirror makers and textile workers.[2] Another thirty years later, there would have been a good chance of the cartoons' being influenced by engravings or woodcuts; and after that tapestries of this importance would have been designed by such renowned representatives of the *grand goût* as Raphael, Bronzino, Rosso Fiorentino, Charles le Brun, Jean Baptiste Oudry or Jean François Boucher. But in the fourteenth century, we remember, pictorial genius tended to gravitate to what was then the most progressive medium.

No less significant is the fact that Jean Bondol decided, or was asked, to work from much earlier or at least distinctly archaic models. The second half of the fourteenth century was, by and large, a period of observation and not of phantasmagoria. The time of pure preternaturalism had passed and the time for a renewed affirmation of the visionary in contrast with reality was still to come. Bondol, one of the most matter-of-fact artists of his time, would have been unable to do justice to the wildness and weirdness of what Luther called "ein unangenehm zu lesend Buch" ("a book most disagreeable to read") had he not received inspiration from manuscripts which, variations in style and motifs notwithstanding, do not essentially depart from an archetype established about the middle of the thirteenth century.

From these manuscripts, in which every page is horizontally divided into two oblong fields, Bondol appropriated the general idea of arranging his ninety-odd scenes (only seventy-two of which have survived) in two zones or tiers. Moreover the composition of nearly every individual scene is closely dependent upon his manuscript models. Yet it would be unjust to call Bondol's "Apocalypse," as has been done, a series of mere copies. He changed everything exactly as we might expect him to have changed it. He modernized the coloristic effect, shading, for instance, yellow draperies with crimson and greenish ones with deep blue. He gave vent to his enthusiasm for perspective architecture in the foreshortened tabernacles that shelter the Bishops of the Seven Churches in Asia whose figures are inserted between the sections of the narrative, and in such Italianate structures as the Temple of God pointed out to the Visionary in Revelation XI, 1. He lent perspective depth to all the landscapes and elaborated on such details as terrain and vegetation whereas even the latest of his models were entirely two-dimensional. He equipped the Horsemen of Revelation IX, 17–19, with the most wonderful plumed helmets, halberds and scimitars, vitalized the movement of

humans and animals, and sharpened the expression of suffering; and his little personal mannerisms, surviving the somewhat distorting intervention of the weavers, are clearly recognizable. The steplike ledges of terrain, for instance, recur, to give only two examples, in the "Whore Sitting Upon Many Waters" as described in Revelation XVII, 1–2 and the "Reaping of the Harvest of the Earth" as described in Revelation XIV, 15. The most telling instance is perhaps the interpretation of Revelation XIV, 13 where the Dead Which Die in the Lord are shown in groups of three in two enormous beds set slantwise into space (fig. 25). They are enveloped, like multiple cocoons, in the now-familiar crumpled blankets, and the effect is strikingly similar to that of a *bas-de-page* in the "Bible of Jean de Sy" which engagingly depicts the well-known episode of Lot and his daughters (fig. 24).

For all his originality Jean Bondol was not an isolated phenomenon. Analogous proclivities can be observed in the representational arts all over Northern Europe. In the second half of the fourteenth century, when the Black Death had come to an end and, to quote from a contemporary German chronicle, "the world began to live again and to be merry," there arose in these parts a reaction against the senescent High Gothic style. Whether we look at France or England, at Theodoric of Prague in Bohemia or Master Bertram at Hamburg, at decorative sculptures in Flanders or funeral monuments in the Rhineland, we can observe a rising propensity for sturdiness as opposed to frailty, for the convex as opposed to the planar or concave, for large, comparatively undifferentiated spherical surfaces as opposed to linear calligraphy. Even in the matter of dress, the period after 1350 marks a radical break with the High Medieval and, in a sense, the beginning of modern fashion. The gentlemen of the time sported short, tight-fitting doublets (as worn by Jean de Vaudetar in the title page of the Hague Bible), often padded around the chest in order to emphasize simplified plastic shape in contrast to the diversified drapery of the preceding period. The equally tight hose, formerly only thigh-length and attached to what may be called "shorts," now reached up to the waist and had to be fastened to a primitive equivalent of modern suspenders, and ladies wore what may perhaps be described as exterior corsets. In short, even in fashion the emphasis changed from a linear to a plastic stylization.

In France the plastic though not the pictorial tendencies of Jean Bondol were shared by another Franco-Flemish artist, André Beauneveu. A native of Valenciennes, he served Charles V from *ca.* 1360 to 1374, later Louis de Mâle of Flanders, and finally, up to his death before 1402, the King's youngest brother Jean, Duc de Berry. Less ruthless and less politically ambitious, though not much more ethical than Louis of Anjou, this great collector and patron of the arts was a "tycoon" rather than a tyrant. He could be harsh to the point of cruelty and, on occasion, rise to real bravery. But normally he preferred intrigue and negotiation to drastic action and maintained, as far as he could, a neutral and conciliatory attitude in all the major conflicts of his chaotic period. His main concern was to amass riches by all imaginable methods, probably including being bribed by the enemy. For his overweening passion was to call into being or to acquire buildings, tapestries, sculptures, paintings, jewelry, medals, carvings in crystal or ivory, enamels and, above all, illuminated manuscripts. Cautious, cultured

and personally affable, he managed to survive his two wives, all his brothers, all his sons, several of his nephews and died in 1416 at the age of seventy-six, leaving behind him an equally enormous amount of possessions and debts.[1]

This fabulous prince used Beauneveu in many capacities both practical and, as it were, managerial. Principally, however, Beauneveu was a sculptor; and this is what he remained even as a book illuminator. The only miniatures attributable to him with certainty are the twenty-four Prophets and Apostles on the initial pages of the Duc de Berry's Psalter, executed *ca.* 1380–1385 (figs. 26, 27).[2] Dignified figures in semigrisaille enthroned in lone splendor before a background of *rinceaux* or tessellation, they are so closely akin to the statuary of Beauneveu and his collaborators that his authorship might have been surmised even without documentary evidence. To invent twenty-four variations on the monotonous theme of an isolated seated figure is a task which only a sculptor would have imposed upon himself, and the variety of poses and drapery motifs is as impressive as the force of the modeling. The brushwork, however, lacks finesse, plainly betraying the nonprofessional; the hands and faces show little refinement, and the author's interest in space is limited by a sculptural point of view. The emphatic perspective of the thrones serves only to permit the plastic development of the figures. Though Beauneveu was acquainted with the foreshortened floor as seen in the dedication miniature of Bondol's Hague Bible, he never extended it behind the thrones and did not scruple, on several occasions, to show the tiles as pure squares instead of making them obey the rule of convergence. Where Bondol tried to enrich painting by plastic values, Beauneveu translated statuary into the medium of painting.

Beauneveu's miniatures are independent of the Pucelle tradition and untouched by Italian influences. Bondol, we remember, was familiar with Pucelle's style and appears to have made at least some fresh contacts with Italian art. But he was essentially self-reliant; no direct copies after Jean Pucelle are discernible in his work, and he resorted to Italian models for perspective devices rather than for composition and iconography. In other quarters, however, we can observe a deliberate reversion to Jean Pucelle concomitant, understandably, with a deliberate revival of Italianism. The "Breviary of Charles V," produced about 1370 in a workshop as yet unidentified, copies pages and pages from the "Belleville Breviary" (excepting, curiously enough, the Calendar) and other works by Jean Pucelle;[3] and shortly afterwards there emerged two artists, later to enter a kind of partnership, who exploited Jean Pucelle's inventions in a spirit of free re-creation while, at the same time, seeking contact with more recent Italian developments.

One of these two artists is the anonymous Master of the *"Parement de Narbonne,"* a chapel hanging painted in grisaille on silk, perhaps in preparation for embroidery (fig. 29). It was discovered at Narbonne by a nineteenth-century painter (which may have something to do with its questionable condition); but it was indubitably executed in Paris. For, on the two narrow strips that separate the central Calvary from other Passion scenes — on the left, the Betrayal, the Flagellation, and the Bearing of the Cross, on the right, the Lamentation, the Harrowing of Hell, and the *Noli me tangere* — are seen, beneath representations of the

Church and Synagogue, donor's portraits of Charles V and his Queen, Jeanne de Bourbon.[1] In many ways the style of this work, probably produced in the middle 'seventies, adhered to the standards of contemporary Parisian court art. The figures, slender in proportion and calligraphic in design, move with consummate grace. The tone of the narrative is elegantly restrained, and some of the compositions may strike us as almost archaic; the "*Noli me tangere*," for example, is more closely akin to the thirteenth-century formula referred to at the beginning of this chapter than to the new Trecento type inaugurated by Giotto. Within these limitations, however, the Master of the "*Parement de Narbonne*" endeavored to match Pucelle in the realization of plastic volume (though not of perspective space) and not only revived the latter's Ducciesque "Lamentation" but also appropriated motifs from a generation of Sienese painters not as yet known to his great predecessor. Such details as the henchman seen from the back in the "Bearing of the Cross" and the Mongolian-looking, pigtailed Jew in the "Crucifixion" testify to the influence of such masters as Simone Martini and Barna.

The other, even greater, artist is Jacquemart de Hesdin,[2] first mentioned as illuminator to the Duc de Berry in 1384 (which date establishes, of course, only a *terminus ante quem* for his appearance at court). Coming from the Artois, which then belonged to Flanders, he continued the glorious sequence of Franco-Flemish masters initiated by Jean Bondol. But while we know his name and origin it is not easy to isolate his individual style from that of his collaborators.

His atelier produced four sumptuous manuscripts, all Books of Hours and all commissioned by the Duc de Berry. They are, in chronological order, the "*Petites Heures du Duc de Berry*" in the Bibliothèque Nationale at Paris;[3] the "*Très-Belles Heures de Notre Dame*," the strange, eventful history of which will be told very shortly; the "*Très-Belles Heures de Jehan de France, Duc de Berry*," commonly known as the "Brussels Hours," in the Bibliothèque Royale at Brussels;[4] and the "*Grandes Heures du Duc de Berry*" in the Bibliothèque Nationale, completed as late as 1409.[5] Of these, the "Brussels Hours" and the "*Grandes Heures*" are authenticated by documentary evidence, the former by the Duke's inventory of 1402 which lists it as being "enluminées et ystoriées de la main de Jaquemart de Odin," the latter by his inventory of 1412 which ascribes it to "Jaquemart de Hodin et autres ouvriers de Monseigneur." The two other manuscripts must be assigned to the same workshop, not only on stylistic grounds but also because their illustrations served as a basis for those in the documented "*Grandes Heures*."

The difficulty of forming an idea of Jacquemart's artistic personality is caused by the fact that the "*Grandes Heures*" has lost all its full-page miniatures while the remaining ones, derivative in invention and indifferent in quality, are mere shopwork; and that the "Brussels Hours" — apart from the special problem posed by the intrusion of an extraneous dedication page — exhibits a style not easily reconcilable at first glance with that of the "*Très-Belles Heures de Notre Dame*" and the "*Petites Heures*." Pending the publication of a study by Millard Meiss which, it is to be hoped, will give a final answer to these intricate questions, I shall proceed on the somewhat unfashionable assumption that the "Brussels Hours," as

stated in the inventory of 1402, was in fact produced "by the hand of Jacquemart de Hesdin"; and that the same "hand"—though at an earlier stage of its development—may also be recognized in those miniatures of the *"Petites Heures"* which are likely to have been produced by the *chef d'atelier.*

The *"Petites Heures"* is, in fact, the earliest member of the great tetralogy, though never surpassed in imaginativeness and delicacy. Executed about 1380–1385, it opens, as though in recognition of a debt to Jean Pucelle, with a "Belleville Calendar" (fig. 16) copied, after a lapse of more than forty years, from a manuscript such as the "Hours of Jeanne de Navarre." It also follows the Pucelle tradition in the marginal decoration; and one of its "Annunciations" (fol. 141 v., fig. 32) is, almost inevitably, a variation on the type established in Pucelle's "Hours of Jeanne d'Evreux." But what a variation it is! The point of vision is shifted to the side, so that the right-hand wall of the building is seen from without. The architecture is embellished by faintly Italianizing friezes and paneling. The supporting column of the anteroom has been omitted so as not to separate the two figures who seem to be swayed in unison by one emotion. The Virgin, enveloped in the subtlest of draperies, shrinks back from the Angel who presses forward in a diagonal movement parallel to hers, pointing heavenward with an ecstatic gesture that was not to be forgotten for many generations. Transmitted through a long chain of intermediaries, this very gesture recurs, for instance, in Dürer's last version of the Annunciation theme and, transferred from the Angelic Messenger to his pagan equivalent, in the famous "Mercury" by Giovanni da Bologna.[1]

Whether this little masterpiece was manually carried out by Jacquemart or by an assistant so close to him that he deserves to be regarded as his *alter ego*, I dare not decide. There can be little doubt, however, that the admirable though unfortunately slightly damaged page which opens the Horae proper (fol. 22, fig. 30) was decorated by the master himself. Its very prominence—a prominence which, as in so many other cases, accounts for its worn condition—creates a strong presumption of authenticity; it is the Matins page, which, setting as it does the style for the whole manuscript, is almost invariably reserved to the chief illuminator. And this presumption is confirmed, not only by the extraordinary finesse of workmanship but also by that pronounced Italianism—more marked than even in such other *propria manu* miniatures as the "Baptism of Christ" on fol. 209 v. (fig. 31)—which was to culminate in the "Brussels Hours." The very organization of the page as a whole is patterned after the fashion of an Italian cult image. The principal scene—needless to say, another and more sumptuous Annunciation—is surrounded by a frame composed of individual little pictures. On the left and right are seen ten standing Apostles; at the bottom, three seated figures, viz., the two remaining Apostles on either side of the Prophet Jeremiah; on top, three figures in half length, viz., the Man of Sorrows between the Madonna and St. John the Baptist. And this "Man of Sorrows," however Gothic in treatment and sentiment, is purely Sienese in inspiration. The "Annunciation" itself adheres, to some extent, to the tradition established by the "Hours of Jeanne d'Evreux"; in recollection of this archetype, and in contrast to the intervening variants, the Virgin Mary is even shown standing. But

Pucelle's dispassionate statue has been transformed, as by a second Pygmalion, into a living being animated by gentle emotion. The Angel Gabriel approaches the Annunciate in an attitude no less impassioned than in the smaller "Annunciation" on fol. 241 v. But he no longer salutes her in a small doll's house consisting of a narrow little chamber and an even narrower anteroom but in a deep and roomy interior, artfully contrived from three magnified aediculas, which with its tall piers and vaults, deeply receding floor, tracery windows and altar gives the impression of a Gothic hall church. It was not until the following century that the consequences of this transformation from a domestic into an ecclesiastical setting were fully realized.

Among the illuminators who contributed to the "Petites Heures" one personality, already singled out by Chanoine Leroquais, stands apart by reason of a strength and fervor which enabled him not only to hold his own but even to leave the imprint of his style on that of Jacquemart de Hesdin himself. Appropriately entrusted with the Passion scenes (fols. 76–94), he produced compositions intensely dramatic and, small though they are, genuinely monumental. There are few renderings of the Derision of Christ so forcibly expressive of the contrast between depraved cruelty and supreme patience (fol. 82, fig. 36). The hands of the tormentors threshing about like so many flails yet form a beautifully rhythmicized ornament; and the scarlet hood that hides the entire face of the suffering Christ — a very rare interpretation of Luke XXII, 64 — makes His agony doubly mute and doubly eloquent.

In the "Lamentation" on fol. 94 v. (fig. 34), trenchantly set out against a background teeming with Pucellian drolleries, this Passion Master elaborated, like the Master of the "Parement de Narbonne," the Italianate composition exemplified in the "Hours of Jeanne d'Evreux" and its derivatives.[1] But where the Master of the "Parement" had softened the pathos of the scene, the Passion Master intensified it. The sarcophagus is placed diagonally; the woman behind it throws up her arms in wild despair; and there are two mourning figures in the foreground instead of one. This miniature reflects and transfigures the shrill excitement that pervades the Berlin "Lamentation" by Simone Martini.

The spirit of a second "Lamentation" (fol. 286, fig. 35), apparently the work of a capable assistant, is as lyrical as that of the first is dramatic. Some of the Italo-Byzantine motifs inherited from Pucelle and his followers, among them the huddled figure kissing the hand of the Lord, are grouped around a Germanic Pietà, the Mater Dolorosa holding the dead Christ on her lap as though He were a child.[2] This tragic group thus appears surrounded by compassion without being relieved of its loneliness. And the pathos of the head of Christ, helplessly falling back with the hair streaming down, is as unprecedented in earlier art as is the tenderness of the St. John, who with averted face supports the Virgin's arm and shyly embraces her shoulder. This tiny miniature is the germ from which were to flower the Passion scenes of Roger van der Weyden.

While this second "Lamentation" may be said to represent a fusion between Jacquemart de Hesdin and the Passion Master, the former's personal style may be recognized in an enchanting idyll, the "St. John in the Wilderness" on fol. 208 (fig. 33). As though trans-

planting Jean Pucelle's fauna from the marginal decoration to the picture itself and distributing it over an Italianate scenery, he interpreted the Baptist as a boyish Orpheus, surrounded by animals.[1] Armed with his book, the little saint sits in the mouth of a cave, embracing a sentimental lion and resting his left foot against the haunch of a contented panther. There are all kinds of birds, monkeys, rodents and snails. A bear lies in the right foreground; a boar, a goat and a stag look in from the margins; and rabbits shoot in and out of their burrows, one of them showing his tiny white tail. That the setting of this Peaceable Kingdom is Italianate is evident from a Pisan "Nativity" — perhaps a trifle later, but reflecting a well-established tradition — which shows a very similar arrangement (fig. 38). In it, too, a cave is hollowed out of a gigantic, conical agglomeration of Byzantinizing rocks, and in the upper corners are two plateaus where buildings can stand and trees can grow. But at the hands of Jacquemart de Hesdin this agglomeration has assumed the character of delicately contoured stalactites or eighteenth-century *rocaille*.

The rocky scenery of this composition, testifying to the widening range of Italian models employed in the workshop of Jacquemart de Hesdin, is somewhat similar to that in the "Nativity" of the second Book of Hours produced in this workshop, the "*Très-Belles Heures de Notre Dame*" (*ca.* 1385-1390). For reasons unknown, this manuscript was delivered to the Duc de Berry in an unfinished state. The borders, often enlivened by unsubstantial little angels who flutter about like the eidola on white-grounded lekythoi (fig. 39), had been completed; but many of the miniatures and *bas-de-pages* were still missing. Between 1412 and 1413 the Duke gave the manuscript by way of barter to one of his favorites, Robinet d'Etampes, who committed the vandalism of dividing it into two parts. What was approximately finished, he kept for himself; and this portion, formerly in the Maurice de Rothschild Collection at Paris and published in 1922,[2] has disappeared after having been removed by the Nazis. Heraldic evidence suggests that the remainder came into the possession of Duke William VI of Holland and Bavaria, or, possibly, another member of his family, and it is this second portion of the "*Très-Belles Heures de Notre Dame*" which was subsequently illuminated by several masters of the fifteenth century among whom there may or may not have been Hubert and Jan — or Hubert or Jan — van Eyck. Later on, this second portion of the manuscript was divided once more. One part found its way into the Royal Library at Turin where it was destroyed by fire in 1904 (fortunately after having been reproduced *in extenso* two years before);[3] the other was in the collection of the Principe Trivulzio in Milan until it passed, confusingly, into the Museo Civico at Turin, the same town that had been the scene of the catastrophe of 1904.[4]

We are concerned at this moment only with the miniatures completed before the manuscript left the possession of the Duke. These, much larger in scale than those in the "*Petites Heures*" and often sacrificing refinement to impressiveness, were executed by several artists headed by the Master of the "*Parement de Narbonne*" who seems to have joined forces with Jacquemart after the death of his patron, Charles V, in 1380. How much of his individuality he retained even while trying to adapt himself to his new surroundings is

evident, for instance, in the "Flagellation" of the "*Très-Belles Heures de Notre Dame*"[1] which may be called a revised edition of that in the "*Parement de Narbonne*." The "Nativity" in the "*Très-Belles Heures*" (fig. 37),[2] too, was probably designed (though not executed) by the Master of the "*Parement*." But in this case he breaks away, not only from his own past, but also from the entire tradition of Gothic iconography.

In Northern Nativities of the fourteenth century, including that in the "*Petites Heures*" (fol. 143), the Virgin Mary is normally shown recumbent in bed, while the Infant Jesus is either in the manger or being taken care of by His holy mother, St. Joseph or a midwife, and the locale is either indicated by a conventionalized architecture or, more frequently, depicted as a rustic shed. Here, however, the Virgin Mary is on her knees, adoring the Christ Child. The Christ Child, entirely nude, lies on the ground, and the whole scene is staged in the interior of a rocky cave. This Cave of the Nativity, like the Cave of the Entombment, is an Eastern motif which had become standard in Byzantine art. In the northern countries it had been temporarily accepted at the height of Byzantine influence but was discarded in the High Gothic period. In Italy, on the other hand, it continued to be in favor at all times, even after Giotto had revived the rustic shed from Early Christian sarcophagi. But it was in St. Bridget of Sweden's *Revelationes* (composed about 1360–1370, and very probably inspired by pictures which the saint had seen during her sojourn in Italy) that the cave motif was explicitly sanctioned in Western writing (*Revelationes*, VII, 21: "Qui cum intrassent *speluncam*"). Her description places the "nude and most resplendent" Christ Child on the ground ("iacentem in terra nudum et nitidissimum"), and combines this new *mise-en-scène* with the idea that the Virgin Mary, clad in white after having doffed her blue mantle, "adored the Infant as soon as she felt that she had given birth to Him." Needless to say, our Pisan picture is a "Nativity according to St. Bridget" (in fact, the saint is represented in person in a separate cave on the left); and, needless to say, the miniature in the "*Très-Belles Heures de Notre Dame*" — so far as I know, the earliest example of its kind in Northern art and the only one in France — depends upon a model very much like it.[3]

The "*Très-Belles Heures de Notre Dame*," then, is a collective effort in which Jacquemart de Hesdin did not participate in person. The "Brussels Hours," however, presumably executed *ca.* 1390–1395, is, we remember, explicitly described as being both adorned and illustrated "by his hand," and its miniatures are in fact as homogeneous as can be, except for the initials and the first dedication picture (fig. 40).[4]

The expression "first dedication picture" is peculiar but hard to avoid; the manuscript is, in fact, unique in that it possesses two iconographically identical dedication pictures, both showing the Duc de Berry commended to the Virgin Mary by his patron saints, St. John the Baptist and St. Andrew. The first is a double page in semigrisaille wherein the donor and the patron saints are seen on one side, and the Madonna on the other. The second, evidently dependent upon the first, compresses these elements into a single composition and abandons hieratic frontality in favor of a boldly diagonal arrangement (fig. 41). In addition, the second dedication picture conforms to the comparatively loose and fluid style of the remaining

eighteen miniatures whereas the first shows the firmer and more plastic treatment of *ca.* 1380, which also agrees with the appearance of the donor; and, most important, the first, or double, title page appears to have been cut down at the margins. The inference is that it did not originally belong to the manuscript. If it had been intended as a book page, it must have come from another, somewhat larger volume; but it may just as well have been designed as an independent devotional diptych.[1] Thus the question of its authorship arises, and at first glance the double dedication page seems so dissimilar to the rest of the miniatures that it appears to be the work of another illuminator. This writer himself is coresponsible for its tentative attribution to André Beauneveu, with whose Apostles and Prophets it has an obvious similarity;[2] but he has become doubtful of this hypothesis for several reasons.

In the first place, the border decoration includes birds and insects, and the ground consists, not of the customary diaper pattern, tessellae or *rinceaux,* but of a dark blue floral pattern on the donor's page and a dense tapestry of little red angels on the Madonna page. Both these features originated in the atelier of Pucelle,[3] with whom Beauneveu appears to have had no connection, but were accepted by Jacquemart de Hesdin and his associates; the "angels' tapestry" ground appears, for instance, in the "Nativity" just discussed as well as in the "Man of Sorrows" on the Matins page of the *"Petites Heures"* (fig. 30). Secondly, the facial types of the two saints, especially the St. John, are unmistakably Sienese, and it was Jacquemart de Hesdin and not Beauneveu who was susceptible to Italian influence. Thirdly, the figures of the donor and his patron saints are placed upon an emphatically receding and correctly foreshortened checkerboard floor such as we encountered in the "Hague Bible" by Jean Bondol, and we remember that an interest in perspective was wholly foreign to Beauneveu. Fourthly, the double page in the "Brussels Hours" is simply too good for an artist whose miniatures, however grandly conceived, lack the finish of the professional illuminator. I am therefore inclined to believe that the double page is either the work of a master otherwise unknown but holding an intermediary position between Bondol and Beauneveu on the one hand, and Jacquemart de Hesdin on the other; or, possibly, a very early work of Jacquemart de Hesdin himself. The "Trinity" on fol. 137 v. of the *"Petites Heures"* is quite compatible with the Virgin Mary and the St. John in the Brussels double page. And since the latter seems to have been executed as early as about 1380, it may have been produced by the young master as a kind of *pièce de réception* and with the deliberate intent of emulating the style of his seniors: the style of Jean Bondol, illuminator to the King of France, and that of André Beauneveu, artist-in-chief to Jacquemart's new patron.[4]

Whoever its author, the first dedication page of the "Brussels Hours" is a remarkable achievement. Apparently for the first time, no difference is made in scale and prominence between the sacred personages and the donor, whose status approaches that which he was to enjoy in the works of Claus Sluter and Jan van Eyck. The Madonna is the earliest known instance of an iconography that was to spread, in all conceivable media, as far as Hildesheim in Germany and Perugia in Italy. Boldly humanizing the ancient concept of the Mother of Christ as the "Seat of Wisdom" (*sedes sapientiae*), the miniature shows the Infant Jesus,

while still being nursed by the Virgin Mary, engaged in writing.[1] The decoration of the border, finally, marks a resolute break with the earlier French and Franco-Flemish traditions. Previously, fancy-free *rinceaux*, starting from the initial (or, in full-page miniatures, from the corners and/or centers of the margins), would creep all over the borders and play about rather than enframe the miniature. Here these *rinceaux*, enriched by little flowers in addition to the customary ivy leaves, are distinctly axialized and articulated by large quatrefoils (*quarrefors*) which consolidate the corners and divide the border into nearly equal sections, two at the top and bottom, three on either side. What had been a decorative fringe became a quasifunctional "picture frame"; and this novel idea — possibly due to a combined influence from Italy and England, where similar quatrefoils, filled with heads or heraldic devices, had been in favor for a long time [2] — was adopted for all the other miniatures in the "Brussels Hours."

These other miniatures, it will be remembered, are assigned to Jacquemart de Hesdin's own hand in the inventory of 1402; but it is difficult at first glance to accept this statement at face value. Compared with the authentic miniatures in the "*Petites Heures*," those in the "Brussels Hours" strike us not only as more advanced in their free, fluid treatment and soft, cool coloration, but also as so much more radically Italianate that they seem to belong to a different artist. Yet this diversity may well be due, not to a difference of hands but to a change of mind; the two groups of miniatures may be to one another, not as, say, Raphael's "School of Athens" to Perugino's "Tradition of the Keys" but as Raphael's "School of Athens" to his own "*Sposalizio*." Even in the "*Petites Heures*" Jacquemart de Hesdin had been an Italianist by intention, but then his horizon had largely been restricted to prototypes made available to him by French or Franco-Flemish predecessors. The "Brussels Hours" reveals a fresh, direct and more diversified impact. We do not know whether he went to Italy in person, but certain it is that he had become acquainted with Italian artists working in France and had gained access to models as yet unused. In one so responsive to Trecento art these new experiences may well have sufficed to produce an apparently inexplicable change.

The Passion scenes in the "Brussels Hours" abound in those exotic characters which the post-Ducciesque Sienese masters had compounded from classical and oriental sources. In the "Adoration of the Magi" the oldest King kisses the foot of the Christ Child.[3] In the "Nativity," the Virgin Mary is shown on her knees as in the "*Très-Belles Heures de Notre Dame*" although by way of a concession to the Northern tradition the scene is laid in a shed and the Virgin kneels upon her bed instead of on the ground.[4] The "Annunciation," in which the Angel approaches the kneeling Virgin in flight while she turns round to him with a startled *contrapposto* movement expressive of bashful perplexity, introduced to Northern art a lost composition by Ambrogio Lorenzetti that can be reconstructed from several replicas (fig. 42).[5] And the "Bearing of the Cross" — as also, somewhat less literally, the "Deposition" — is directly copied from Simone Martini (figs. 45, 46).[6]

It is, however, not only the wider variety and greater immediacy of influences that distinguish the Italianism of the Brussels miniatures from that of their predecessors. They

approach their models with an entirely new purpose, or rather, on an entirely new level. Hitherto — and this also applies to the earlier works of Jacquemart de Hesdin himself — the imitative intent had been partial, not total. The illuminators had been content to appropriate techniques of modeling, figure types, architectural settings, landscape elements, iconographical novelties, and, above all, methods of space construction, but they had not attempted to duplicate the aesthetic structure of Italian panel painting as such. Their miniatures had remained, in essence, an adornment of the page *qua* page. The Brussels miniatures, filling the whole page and framed rather than bordered, claim the status of pictures as independent of script and marginal decoration as though they were painted on panels. And this reinterpretation of their function led to so bold a departure from established tradition that the workshops of the next generation, however progressive, often continued to conform to the old practice even while experimenting with the new:[1] the ground is no longer elaborated into a decorative pattern but painted blue so as to suggest the natural sky. However flat and opaque this sky may appear to an eye accustomed to the luminary refinements of the subsequent decades,[2] it is in the narrative miniatures of the "Brussels Hours"[3] that we witness the very beginning of naturalism in Northern landscape painting. The Italianate rocks are developed from mere props into a scenery of sweeping slopes and mountain ranges which by their bareness and edgy peaks, often in shape not unlike a Phrygian cap, clearly recall their Mediterranean origin. Winding roads, wattle fences, fields, meadows, and bodies of water lead the eye into depth. The illusion of three-dimensionality is strengthened by the *repoussoir* effect of low, sagging ridges in the foreground. Little buildings, from chapels and fortified castles to rustic dwellings and windmills, emerge in the distance. Even the seasonal changes are indicated — notably in the "Annunciation to the Shepherds" and the "Flight into Egypt" (fig. 44) as opposed to the "Visitation" (fig. 43) — by that contrast between bare and leafy trees which had been made in the Calendars of the "Belleville Breviary" and its derivatives[4] but had not as yet been applied to the regular narrative.

With the "Brussels Hours," then, we have reached a new phase in the assimilation of the Trecento style, and, in a sense, a turning point in the history of Northern European painting. But we have also reached the end of Jacquemart de Hesdin's career as far as it is known to us. For the "*Grandes Heures*," apparently completed after his death, deprived of its full-page illustrations and explicitly assigned to "Jacquemart de Hesdin and others," is no longer representative of his personal style, and its ambitious size and excessively rich decoration make the decay of his workshop all the more evident. The Calendar pages intend to surpass those of the "*Petites Heures*" in richness and circumstantiality, but for this very reason give an impression of excess and ostentation. The "picture frame" borders of the "Brussels Hours" run to seed, so to speak, with rankly luxuriant foliage and illogically multiplied quatrefoils. And such narrative miniatures as have been preserved are all too often mere copies or *pasticcios* of earlier workshop patterns. The "Wedding of Cana" on fol. 41, for instance, is nothing but a replica of that in the Rothschild portion of the "*Très-Belles Heures de Notre Dame*," except for the fact that the wide sleeves of the kneeling servant have kept up with a characteristic

change in gentlemen's fashion;[1] and the "Lamentation" on fol. 77 (fig. 47) incongruously combines the two versions of this theme in the *"Petites Heures,"* the excited woman, her hands thrown up, stridently interrupting the mournful silence of the *Pietà*.

However, in the three latest contributions to this ill-fated manuscript — especially the charming "St. Gregory" on fol. 100 (fig. 48) and the "Reception of the Duc de Berry at the Gates of Paradise" on fol. 96 (fig. 49) — we recognize the hand and spirit of a generation belonging to the future and not to the past.

II

THE EARLY FIFTEENTH CENTURY

AND THE

"INTERNATIONAL STYLE"

T̲ʜᴇ new phase of book illumination that marks the beginning of the fifteenth century was ushered in by artists not officially attached to the somewhat peripatetic court of the Duc de Berry. They operated as independent masters in Paris and were followers of Jacquemart de Hesdin, not in the sense of lineal descent but only insofar as his influence had reached them by diffusion. Their style was rooted in that refined but conservative Paris tradition which, we remember, had persisted throughout the fourteenth century.

In mediocre artists this conservatism prevailed to such an extent that, for instance, the title page of a *Livre des Propriétés des Choses* by Jean de Nizière — otherwise unknown — could easily be antedated by half a century.[1] But even the first-rate productions of purely Parisian workshops tended to be a trifle *retardataire*. The miniatures in one of the most exquisite manuscripts of the first decade of the fifteenth century, the *Livre de Chasse* by Gaston Phébus (fig. 50), charmingly conceived and executed as they are, almost give the impression of diminutive tapestries, the elements of the composition arrayed above rather than behind one another, the animals — mostly shown in full profile — scattered over the surface either singly or in groups, and the overdistinctly foliated trees a little reminiscent of specimens in a herbarium.[2]

Other Parisian masters harked back, not to the elegant calligraphy of the local tradition but to the vigorously sculptural but just as spaceless style of André Beauneveu. In certain cases an additional Germanic influence is felt as in a magnificent Missal, now in Brussels, which, although dependent on Beauneveu in style, is decidedly Germanic in the grim expressiveness of the faces, the convulsive contraction of fingers and toes and in some aspects of the iconography.[3] From the wound in the side of the Crucified Christ (fig. 52) spurts forth a jet of blood aimed at the heart of the Virgin Mary; and it was Heinrich Suso, the upper Rhenish mystic of the fourteenth century, who had conceived this gruesome image and impressed it upon the minds of Southwest German artists: "May ye be moved in your hearts by that rose-colored flawless blood which thus pours forth over the flawless Mother." If it were permissible to make

51

attributions on the strength of a mere name it would be with this Missal — demonstrably executed for the Saint Chapelle in Paris — rather than with the *Livre de Chasse* and its relatives that we might associate the personality of an Upper Rhenish illuminator mentioned in the service of the Royal Family from 1403 to 1415: Haincelin de Haguenot,[1] a native of Hagenau in Alsace, within the very heart of Suso's sphere of influence.

Needless to say, even the most traditional-minded masters of Paris were not wholly impervious to progress; even Jean de Nizière makes more concessions to a modern, perspective treatment of space in the rest of his miniatures than he does in his title page. The "Baptism of Christ" in a Book of Hours for Troyes use, otherwise fairly linear in manner and by no means progressive in the treatment of space, may surprise us by a splendidly lifelike nude set out against an astonishingly "open" landscape;[2] and the workshop that produced the tapestrylike animal pictures in the *Livre de Chasse* achieved at the same time (prior to March 22, 1403) the far less "stylized" miniatures of the *Fleur des Histoires de la Terre d'Orient*.[3] Here the Pope is seen accepting the book in an hexagonal palace standing on a lawn which is surrounded by a rusticated wall, the whole not very clear in architectural construction but convincingly foreshortened and shaded.[4] The "Land of the Tartars" (fig. 51), peopled with gorgeous exotic characters, elephants and dromedaries, gives the impression of a real landscape, still rising rather than receding but considerably less conventionalized than is the case in the *Livre de Chasse*. The foliage of the trees is rendered as a fuzzy mass, not elaborated into isolated leaves; the hillocks and ledges are modeled more softly; and generous use is made of overlapping as a means of suggesting depth.[5]

Decisive progress, however, depended once more upon a transfusion of Flemish blood; and the beginning of this process can be observed in a group of Parisian manuscripts centered around two closely interrelated copies of a French translation of Boccaccio's *Liber de claris mulieribus*, both executed in the same workshop and in the same year, 1402.[6]

What chiefly distinguishes this "Master of 1402," as he has been called, from those thus far considered is a new lightness and airiness which creates a sense of fairly-tale-like poetry. The slim, mannered, extravagantly costumed figures are rendered in a loose, informal, almost impressionistic technique. Penthesilea, rather than "full of great aims and bent on bold emprise," seems to perform for an audience, managing her horse with easy grace and not a little coquetry (fig. 53).[7] Antiope and Oreithyia ("Oretre"), two other queens of the Amazons, battle the Greeks as though they were engaged in a tournament at court (fig. 54). And all this takes place on a distinctly receding stage with relatively ample space before, behind, and between the individual figures. The battle scene, especially, appears to be pushed back into a kind of middle distance, and the phalanx of riders is convincingly arrayed *en échelon*.[8]

In principle such an arrangement *en échelon* is not new. The "Psalter of St. Louis" (text ill. 10), produced about a century and a half before, shows many a phalanx of horsemen quite comparable to that in the Antiope and Oreithyia miniature. But in such earlier renderings the intervals between the individual horsemen are, for want of perspective, implied rather than realized. The transformation of the standing line into a receding ground plan enabled the

Master of 1402 to make these intervals visible. Injecting space between the various planes, he expanded the High Gothic composition as though opening an accordion.

This procedure, it seems, largely sufficed to satisfy the master's spatial needs; it is one of his characteristics that he shows little interest in architecture. Interiors — such as the room in which Sappho, "grante poetresse et grante clergesse," lectures to two young students and a gray-haired colleague [1] — are indicated merely "by implication," that is to say, by a fore-shortened checkerboard which, however, creates an effective spatial illusion by virtue of its considerable depth (fig. 55). Only where the architectural setting has a definite iconographic significance does the Master of 1402 trouble himself to depict it, and then he does not venture beyond what I have called the "doll's house" arrangement, with the interior and exterior of the little buildings visible at the same time. Such is the case, for example, in the prison scene known as *Caritas Romana* (fig. 56) where a young lady, Pero by name, saves the life of her aged father by offering him her breast, a demonstration of loving-kindness praised by Pliny, depicted in Roman wall paintings, much favored by the Baroque, gracefully metamorphosed by Guy de Maupassant,[2] and last observed (or so he says) by Mr. Steinbeck near Route 66 in California.

It was, we remember, Jean Bondol, who had introduced the "interior by implication" into Northern art. This alone would seem to indicate that the Master of 1402 was indebted to the Franco-Flemish tradition; and a Franco-Flemish spirit can also be sensed in the broader, looser, more pictorial technique which distinguishes his style from that of the *Livre de Chasse* or the *Fleur des Histoires de la Terre d'Orient*. It is, indeed, to Jean Bondol's that we may compare, on a different historical level, the role of the Master of 1402. Though there is no way of telling whether or not he, too, was an immigrant from Flanders, like Bondol he vitalized the Paris tradition without forsaking its elegance. Certain it is, moreover, that some of his collaborators were Dutch or Flemish by birth. In two *Bibles Historiales*, unquestionably produced in his atelier, some miniatures are very close to those in the two Boccaccio manuscripts, and certain miniatures such as the superb Solomon pages may well be the master's own work (fig. 58).[3] Others, however, must have been executed by unreconstructed Netherlanders whose style was scarcely affected by Parisian refinement (fig. 57).[4] Their rustic, thickset characters, painted in a powerful, roughhewn technique, their broad, racy faces modeled with brownish washes and at times framed by shaggy woodman's beards, would not surprise us in the contemporary Dutch and Flemish manuscripts which will be discussed in the Fourth Chapter.

II

While all these currents developed and interpenetrated in various ways and with varying results, there arose in Paris the most brilliant genius of pre-Eyckian painting, the man whom I had in mind when I alluded to the new spirit of the three latest miniatures in the "*Grandes Heures du Duc de Berry*." [5] But when he made these additions, he was already at the height of a career the beginnings of which are still obscure, except for the fact that what appears to be

his early style shows some affinity with that of the Master of 1402. Neither are we acquainted with his birthplace and name. One is instinctively inclined to consider him a Franco-Flemish artist rather than a Frenchman *pur sang*; but the hypothesis that he is identical with one Jacques Coene, a native of Bruges who occupied an honorable position in Paris at the beginning of the fifteenth century, is not supported by evidence. We have still to call the great man, after his best-known and most sumptuous work, the "Master of the Hours of the Maréchal de Boucicaut," or, for short, the "Boucicaut Master." [1]

The owner of this eponymous manuscript, Jean II le Meingre *dit* Boucicaut, was a belated specimen of the "verray parfit gentil knight": a dreaded duelist, insuperable horseman and tennis player, adventurous, proud, chivalrous (he founded, for example, a special order for the protection of noble ladies in distress, bestowing upon it his own tournament colors, *vert and argent*), kindly, just and — by the standards of his time — unselfish. Born in 1365, a soldier at twelve, a knight at sixteen, the terror of the Slavs in Prussia and of the British in France and England, a faithful servant of Charles VI at home and abroad, he became "Maréchal de France" at twenty-six. In 1393, having endeared himself to her not only by his prowess but also by his poetry, he obtained the hand of the beautiful Antoinette de Turenne, winning out against a Prince of the Blood, and breaking down the resistance of her father only through the personal intervention of the King and the Pope. The couple "s'entreaimaient de grand amour"; but their "belle et bonne vie ensemble" was often interrupted and was to end in tragedy. In 1396 the "bon Maréchal" was captured by the Turks at the battle of Nicopolis and narrowly escaped execution. He did not return until 1398 to take his revenge, in the following year, by saving Constantinople from his captors. In 1401, the City of Genoa, having subjected itself to the Crown of France, requested and obtained him as Governor. He ruled it wisely and held it against all enemies up to 1410 when he returned and became Governor of Guyenne and Languedoc. In the Battle of Agincourt he was taken prisoner at the head of his troops and died in English captivity in 1421, outliving his wife by six years and their only son by nine.

His Book of Hours — now in the Musée Jacquemart-André in Paris — thus came into the possession of his younger brother and, through the latter's childless son, Jean III le Meingre (died 1490), into that of Jean's first cousin, Aymar de Poitiers (from whom it was to pass into the hands of his famous granddaughter, Diane). These changes of ownership have left their marks on the manuscript. Jean III le Meingre, who caused the last two pages, originally blank, to be illustrated in not too tasteful fashion, may be forgiven. But Aymar de Poitiers tampered with the original miniatures. Wherever he found the Boucicaut arms (*argent an eagle displayed gules beaked and membered azure*) and the Boucicaut device "Ce que vous voudrez" — and he found them in a good many places — he substituted or interpolated his own *azure a chief or six torteaux argent* and "Sans nombre," not even respecting the garments of the Marshal and his wife on the dedication page (fol. 26 v.). Two pages which escaped his attentions (fols. 42 v. and 53 v.) make the damage done to the others still more evident.

Apart from this disfigurement, the forty-one miniatures are well preserved, and all seem to be executed by the master himself. But what is their date?

Thus far the discussion has been centered around dating the manuscript as an entirety. It seems, however, that its execution extended over a number of years, which would not be surprising in view of the hectic life of the noble couple who had little time and presumably small inclination to press the busy painter for delivery. None of the miniatures, of course, can antedate 1393, the year of the Marshal's marriage, and none can postdate 1415, the year of his capture at Agincourt. But to assign to them their place within these twenty-two years is all the more difficult as only a few productions of the atelier are datable with comparative precision: the three pages in the "Grandes Heures" which, we remember, antedate 1409 (figs. 48, 49); [1] the beautiful title page of the Dialogues de Pierre Salmon in Geneva (fig. 69) which must have been executed in 1411 or 1412; [2] a number of miniatures in the Paris copy of the same Dialogues, which precedes the one in Geneva and may be dated 1409–1410 (fig. 68); [3] and the Merveilles du Monde in the Bibliothèque Nationale (fig. 77) which was in existence on January 1, 1413, but can be considered only as shopwork. [4] Using these manuscripts as points of comparison, we may say that the miniatures in the "Boucicaut Hours" fall, roughly speaking, into three classes. The largest group seems to be approximately contemporary with the three pages in the "Grandes Heures," which would date them around 1405–1408; another, smaller group, broader in execution, more schematic in the treatment of drapery, less solidly voluminous in modeling and less assured in the construction of space — in sum, still reminiscent of the style of the Master of 1402 except for a certain monumentality — appears to be earlier; and the last, smallest group, close in effortless perfection to the title page of the Geneva Dialogues, I hold to be later. The inference is that the manuscript was ordered and commenced about or shortly before 1400 (the comparatively quiet interval between the Marshal's glorious return from Constantinople in 1399 and his departure for Genoa in 1401 being a very plausible moment); that the work was continued, without too much energy, during his absence; and that it was completed after his final homecoming in 1409, say in 1410 or 1411. [5]

External corroboration of this assumption may be found in a comparison of the dedication page (fol. 26 v., fig. 64) with the St. Catherine page (fol. 38 v., fig. 65). Both miniatures — the figure of St. Catherine on fol. 38 v. forming a striking contrast with the evidently earlier rendering of this saint on fol. 40 v. — contain a portrait of the Marshal. [6] But in the dedication page he appears as a man in his early thirties whereas in the St. Catherine page he looks a good ten years older. And the earlier likeness conforms to an ideal of youthful knighthood, bearing a marked similarity to the St. George on fol. 23 v., whereas the later one is a notable example of individual characterization. Where he pays homage to the Madonna, he is portrayed as a commander armed and spurred; where he kneels before St. Catherine, he wears the long, brocaded, fur-lined mantle, and the chain and pendant befitting the Governor of Guyenne and Languedoc. The dedication page, a natural point of departure for the illuminator, represents an initial invocation; the St. Catherine page may be interpreted as the thanksgiving of the warrior returned. These two leaves, then, may be taken to represent the beginning and the end of an evolution within the "Boucicaut Hours," even such details as the prie-dieus and their covers reflecting a development from primitive schematization to masterly command of

volume and space; and it is around them that further specimens of the "earlier" and "later" phases can be grouped.[1]

The magnitude of the Boucicaut Master's achievement appears as in a sudden burst of light when we juxtapose his "Visitation" on fol. 65 v. (fig. 59), one of the "late" pages, with the "Visitation" in the "Brussels Hours" by Jacquemart de Hesdin (fig. 43). That the Boucicaut Master was familiar with Jacquemart's style in general and with the "Brussels Hours" in particular, can hardly be questioned. The marginal decoration of the "Boucicaut Hours" fuses, as it were, the playful freedom of the earlier *rinceaux* borders with the structural logic of the "Brussels frames," the corners and the centers of the outer margins being emphasized by what may be called "pseudoacanthus" which here seems to appear for the first time in French and Franco-Flemish book illumination.[2] As in the "Brussels Hours," the miniatures are all full-page pictures (though painted on the versos), and the two "Visitations" in particular are so analogous in general composition as well as in such details as the *repoussoir* devices in the foreground that a direct connection must be assumed. Four or five years ago, the Boston Museum of Fine Arts acquired the fragments of a little Book of Hours which, though hardly later than *ca.* 1405, are in style practically half-way between Jacquemart de Hesdin and the Boucicaut Master.[3]

There was a time when an outstanding scholar was inclined to ascribe the "Brussels Hours" to the Boucicaut Master himself[4] — a pardonable error, for the Boucicaut Master's unique position in the history of art is, in a large measure, due to the very fact that he had the power of synthesizing the delicate, joyful variety of his Parisian predecessors, who had excelled in the minute and the secular rather than in the grand and the sacred, with the sombre, Italianate monumentality which had characterized the later period of Jacquemart de Hesdin. Yet the two masters belong to different types and different generations; and the Boucicaut Master's "Visitation" proclaims this difference all the more eloquently as it so closely depends on that in the "Brussels Hours."

We see at first glance that the figures in the Boucicaut Master's "Visitation," especially the gentle yet reserved Virgin Mary, are endowed with a noble poise and easy grace still foreign to the earlier miniature; even on earth, the Virgin is the Queen of Heaven who now requires two little angels to carry her prayer book and the train of her mantle. But these are comparatively insignificant details. The salient fact is that we are faced with a novel interpretation of the visible world. True, with respect to linear perspective the miniature is still "primitive." The tiny trees at the bottom are out of scale with the larger ones at the side and even more so with the people. The sharp-edged hills defining the foreground and the middle distance do not recede but rather form a series of screens which partly foil and partly enframe the personages. But in the background — treated, as it were, as a separate entity — a miracle has happened. The heads of the Virgin Mary and St. Elizabeth are silhouetted against a landscape which, if isolated from the rest of the picture, might easily be misdated in the middle of the century. A blue lake extends into depth, its surface stirred by tiny ripples which, in the center, reflect the light of the rising sun. On its far bank, a fisherman spreads his net, and on the water,

where it is darkest, floats a swan — that regal bird for which our master had such a passion (there are no less than eight in the "Boucicaut Hours" alone) that he used to be referred to as "Le Maître aux Cygnes." The lake is bordered by hilly country, charmingly enlivened by traces of human activity. A few hovels cluster near the water, a flock of sheep is grazing on a meadow, two hamlets appear in the distance and on a sunlit hill about to be ascended by a peasant and his donkey is perched a windmill. While some of these motifs, *qua* motifs, were not unknown to earlier masters,[1] there is no precedent for their treatment.

By the end of the fourteenth century it had been observed that a certain amount of translucency could be achieved in book illumination by mixing or replacing the normal binding medium (beaten egg-white, technically known as "glare") with other agglutinants. Red pigments, for instance, could be made more transparent by adding egg-yolk to the "glare," and blue ones by tempering them with a recently imported substance, gum arabic. But it was the Boucicaut Master who exploited these new technical possibilities — analogous to "glazes" and "scumbles" in oil painting — for the realization of new optical experiences. It was he who discovered that the sky is not so uniformly and opaquely blue as it appears in the "Brussels Hours" but gradually lightens and fades into a whitish tone towards the horizon; and it was he who learned, and taught his pupils, to enliven these graded skies by genuine, meteorological clouds that overhang the scenery, white, feathery cirri and massive gray cumuli shaded with yellow and crimson (fig. 68).[2] And as he observed that the color and substance of the sky seem to thin out as it approaches the earth, so did he observe that the color and substance of the objects on earth seem to thin out as they recede into depth; the most distant trees, hills and buildings turn into disembodied phantoms, their contours dissolving in the air and local color drowned out in a bluish or grayish haze. In short, the Boucicaut Master discovered aerial perspective; and what this meant at the beginning of the fifteenth century can be gathered from the fact that Leonardo da Vinci had still to fight the belief that an open landscape darkens rather than lightens in proportion to distance.[3]

Since the outdoors and the indoors are complementary aspects of one substance, namely, space, important advances in landscape painting are always accompanied by analogous advances in the interpretation of the interior. Before the Boucicaut Master, we remember, Northern painting had solved this problem in one of two ways: the interior was either exposed by showing a more or less complete structure with the front wall removed, or merely implied by the substitution of a tiled pavement for natural rock or grass.

The Boucicaut Master, too, knew and occasionally used these two traditional methods. In the "Boucicaut Hours" the "Annunciation" (fol. 53 v., fig. 60), the "Presentation" (fol. 87 v.) and the "Pentecost" (fol. 112 v.) are staged in opened-up exteriors detaching themselves from neutral or tessellated grounds. The scene of the "Annunciation" is laid, in obvious recollection of Jacquemart de Hesdin, in an ecclesiastical building seen both from within and from without, the Virgin Mary turning round to the Angel as in the "Brussels Hours" (fig. 42), but kneeling on a cushion instead of on the ground and raising both hands in an expressive gesture of bashful surprise as in the *Très-Belles Heures de Notre Dame.*" In all these instances the buildings are

of larger scale than ever before and are developed into complex structures with dormers, towers, turrets, and deep perspective cavities, giving an impression not unlike that of the elaborate half-models often prepared by architects; but the interior is still an exterior opened up in front.

The "interior by implication," on the other hand, is exemplified by the "St. Jerome in his Study" (fol. 171 v., fig. 61). Yet, when comparing it with such but slightly earlier instances as the Sappho miniature by the Master of 1402 (fig. 55) we notice a striking difference. Apart from being more richly appointed, the Saint's study is organized into a clearly defined section of space. The chair, no longer a movable piece of furniture but a permanent fixture built into the wall, establishes an orthogonal plane while a backdrop is provided behind the figure in the shape of a screen, a little higher than the Saint's head, which parallels the picture plane and clearly detaches itself from the tessellated ground. As a result, the impression of indeterminacy prevailing in all the earlier interiors of this type is changed to a definite corner effect, a corner effect even more explicitly realized in the "Martyrdom of St. Pancras" on fol. 29 v. In the case of the "St. Jerome" the "screen" which does so much to bring about this change is in reality nothing but a piece of ordinary diaper ground as used in hundreds of other illuminations, for instance in the Sappho miniature itself. However, cut down to an appropriate height, provided with an upper border and set off against the tesselation of the ground proper, this piece of diaper ground is here metamorphosed, as it were, into a tangible object, assuming the character of something detached from the pictorial surface rather than forming part of it; in many other instances this bold transformation is carried much further so that the "metamorphosed" piece of ground converts itself into a real curtain suspended from a rod or spread out by angels. No doubt the Boucicaut Master made use of Italian models, not only representations of St. Jerome himself but also such humanistic authors' portraits as the famous "Petrarch" in the "Sala virorum illustrium" (now "Sala dei Giganti") at Padua freely repeated in numerous manuscripts.[1] But in adapting a prototype of this kind to the traditions of Northern book illumination, his "St. Jerome in his Study" more nearly anticipates the general effect of Jan van Eyck's "Medici St. Jerome" (fig. 258) than any other rendering of the subject.

In addition to developing the opened-up exterior and the "interior by implication," the Boucicaut Master either invented or at least immeasurably perfected an entirely new solution which, in a sense, combined the advantages of both. He isolated, as it were, the frontal aperture of the "opened-up" exterior and thereby transformed it into what can perhaps best be described as a "diaphragm": an archway or doorway, apparently overlapped by the frame of the picture, which seems to interpose itself between this frame and the picture space, thus cutting out a "field of vision" from the context of reality and concealing the points in which the orthogonals would touch the margins.[2] What this device is meant to accomplish may be illustrated by a comparatively early example, the "Vigils of the Dead" in the "Boucicaut Hours," fol. 142 v. (fig. 62), the first attempt to capture the full effect of the new, impressive and expensive custom of placing the coffin beneath a so-called *chapelle ardente*, a catafalque bedizened with hundreds of candles. Facing the front end of this *chapelle ardente* which thus presents to us a dense

forest of candles, we find ourselves in a large choir that draws the eye into its dimly lighted depths.[1] But this interior would strike us as narrow and crowded were it confined to what we actually see of it. With a diaphragm inserted and cutting down our field of vision on all sides, the pictorial space apparently transcends the limitations of the picture. What is in view seems to be removed from the painting surface; and what is kept from view seems to extend in all directions.

In this miniature the perfect symmetry of the main vanishing lines and the very rapidity of their convergence are somewhat detrimental to the spatial illusion, and we have some difficulty detaching the "chiel" or *castrum doloris*, as the structure surmounting the coffin was called, from the altar in back of it. But soon the master learned to use linear perspective with more discretion while handling the diaphragm device with greater audacity and infinitely greater effectiveness. In the "St. Catherine" miniature — one of the most mature illuminations in the "Boucicaut Hours" — the diaphragm curtails the field of vision so drastically that the crown of the vaults can no longer be seen; and, even more important, the center of vision is shifted far to the right so that we see much of the left-hand wall but nothing whatever of the right-hand wall (see fig. 65).

It took the genius of the great Flemings to interpret the frame itself as that which cuts down our field of vision, and thus to dispense with a diaphragm altogether. But it is for the Boucicaut Master that we must claim the honor of having anticipated those long "eccentric" perspectives which we admire in the church prospects of Jan van Eyck. The "St. Catherine" miniature in the "Boucicaut Hours" — and, perhaps even more so, the "Vigils of the Dead" in a slightly later Horae in the Bibliothèque Nationale in which the space-limiting curtain is omitted and the extension in depth increased by a multiplication of the bays (fig. 70) [2] — announce, *si parva licet componere magnis*, Jan's "Madonna in a Church" in Berlin (fig. 236) and his "Annunciation" in Washington (fig. 238). It is worth noting also that the very idea of staging the "Annunciation" scene in an ecclesiastical interior, foreshadowed by Jacquemart de Hesdin, was fully realized only by the Boucicaut Master. In the Annunciation miniature of the "Corsini Hours" at Florence he disengages, as it were, the ecclesiastical interior from its architectural shell and thereby anticipates Jan van Eyck's Washington picture with respect to setting as well as perspective.[3]

No less decisive progress was made by the Boucicaut Master in the rendering of domestic, as opposed to ecclesiastical, interiors. In such manuscripts as the two copies of the *Dialogues de Pierre Salmon* in Paris and Geneva (fig. 69) or an approximately contemporary Lectionary donated by the Duc de Berry to Bourges Cathedral (fig. 71),[4] the diaphragm opens up a view of private rooms, or even little suites of private rooms, almost as comfortably, though of course not quite so sumptuously, furnished when they belong to Zacharias, the father of the Baptist, as when they belong to the King of France. Completely self-contained, they still communicate with exterior space through open windows (occasionally with a flower pot on the sill) through which we can see the sky whose brilliance reflects itself on the window panes. And a soft, diffused light makes us feel the contrast between sheltered intimacy and the great outdoors.

59

Boucicaut Master → one of great pioneers of naturalism

As the Boucicaut Master discovered aerial perspective in the open landscape, so did he discover the chiaroscuro of the closed interior.

The Boucicaut Master, then, was one of the great pioneers of naturalism. But he was not — and could not be — a naturalist in principle. To his way of thinking the reality of nature and ordinary human life was but one aspect of a world another sphere of which was dominated by the social and aesthetic habits of an aristocracy demanding the utmost in artificial stylization. We have already noticed that the Virgin Mary, when meeting with her cousin Elizabeth, is waited upon by two celestial page boys. The more ambitious architectures in the "Boucicaut Hours" give the impression of fairy palaces, their pavements composed of gold or silver tiles with green or crimson glazes, the glass of the windows — in contrast to those in the domestic interiors just mentioned — rendered in silver, the walls painted violet or white with milky, violet shadows, the vaults and ceilings bright red or blue-and-gold. The naturalistic skies deepening and darkening toward the zenith are often decked out with golden stars arranged in regular patterns; and while the Holy Family on the journey to Egypt (fol. 90 v.) is greeted by a fantastically gorgeous but not deliberately stylized sunrise, the golden glory that illumines the landscape in the somewhat earlier St. Michael miniature (fol. 11 v.) not only transfigures but transcends reality. Conforming to the conventions of much earlier art, it combines concentric discs with curvilinear rays, the center burnished and the rays glazed with crimson. A still less realistic glory is seen in the dedication picture which, we remember, may be considered as the earliest miniature in the volume and, incidentally, exhibits the first known example of a half-length Madonna on the Crescent in French and Franco-Flemish art (fig. 64).

This dedication picture also exemplifies the antinaturalistic component of the Boucicaut Master's style in what amounts to a real obsession with heraldry. A preoccupation with heraldry was neither new nor unusual in the late Middle Ages, but it runs wild in this particular manuscript in which it swamps the very narrative. No less than thirty of the forty-one miniatures exhibit or exhibited the Boucicaut arms, the Boucicaut motto and the Boucicaut tournament colors. And there are cases in which this heraldic infatuation tends to defy all rules of probability and even ecclesiastical decorum. In the dedication page, an angel is delegated to carry the Marshal's plumed helmet and pennoned lance. The Trinity (fol. 118 v.) rules the universe amidst Boucicaut tapestries (fig. 63). The Virgin Mary (fol. 95 v.) is crowned in a Boucicaut tent. St. Francis receives the stigmata before a galaxy of Boucicaut insignia (fol. 37 v.). St. George fights the Dragon wearing the Boucicaut colors (fol. 23 v.). The very vestments of Angels (fol. 118 v.) and sainted Bishops (fol. 36 v.) are transformed into Boucicaut liveries.

An amazing and, seen in retrospect, most consequential contrast between courtly ceremonial and realistic rusticity — verisimilitude here being defied in order to glorify the Virgin Mary as well as the Marshal — is seen in the "Nativity" (fol. 73 v.) and the "Adoration of the Magi" (fol. 83 v.). The Nativity (fig. 66) is staged in a dilapidated shed set out against a starry sky, the rays of the Light Divine penetrating the interior — if interior it can be called in view of the presence of only one side wall — through holes in the thatched roof. The Virgin kneels before the bed (instead of upon it as she does in the "Brussels Hours"); but she kneels on a

tasseled cushion in which brocaded red alternates with the *argent* and *vert* of the Maréchal de Boucicaut. The same material recurs in the trappings of the majestic bed which forms an even more striking contrast to the humble environment; in apparently deliberate assimilation to the *Lit de Justice* of the French kings, it is surmounted by a cloth of honor and canopy incongruously hung from the rafters of the shed.

The scene of the Adoration (fig. 67) is laid with cleverly veiled consistency in this identical building, changed only by having been turned at an angle of ninety degrees. The solid wall behind the bed, the same adoring angel looking in through the same window, is in the rear instead of on the right. The manger of the animals, accessible to them from a little shelter with lean-to roof and wattle fence, is on the left instead of in the rear. Accordingly the canopied bed now faces the beholder; and in its direct foreshortening, with the Virgin sitting erect on its edge, it gives — and is meant to give — the impression of a royal throne. The younger Magi keeping in the background, and the kneeling figure of the old king symmetrically corresponding to that of St. Joseph, the principal group forms an equilateral triangle that produces the effect of a reception at court. With the harsh contrast between splendor and poverty resolved in the warmth of patrician comfort, this bold combination of regal throne and nonregal environment [1] was to be revived in Jan van Eyck's Madonnas in Melbourne and Frankfort (figs. 243, 252).

The influence of the Boucicaut Master was instantaneous and ubiquitous. Even so conservative a workshop as that which in 1407–1408 produced the *"Térence des Ducs"* [2] was not so completely impervious to this influence as has been assumed, and the Boucicaut Master's only major competitor, the *"Maître du Missel de l'Oratoire de St. Magloire"* whose hand can also be recognized in the *"Boccace de Jean sans Peur"* of 1409–1411 (and who may be identical with the so-called Bedford Master),[3] certainly owes nearly everything to the Boucicaut Master. The latter's style dominated the Paris school up to its inglorious end, and there is no corner in northwest Europe, including England, to which it did not penetrate. For, of all the "predecessors" of the Eycks, he was the most progressive. Though he was indebted to Jacquemart de Hesdin in many ways and may well have made some fresh contacts with Italy, his inmost urge drove him beyond the limitations of the Italian Trecento and made him the prophet of a specifically Northern mode of expression.

III

A very different position is held by the most famous of all medieval book illuminators, the brothers Paul, Herman and John Malouel (*recte* Pol or Polequin, Herman and Jehanequin Maelweel, which is probably a nickname meaning "Paint-well"), commonly referred to as "the Limbourg brothers" although they probably originated from Limbricht (formerly called Lymborch) in Guelders rather than from the district known as the Limbourg.[4] They, too, were innovators; but where the Boucicaut Master was an explorer, they were settlers. On the one hand, they represent a glorious end rather than a beginning. On the other, they surprisingly

anticipated ideas and motifs that could not become fruitful until the dawn of a new era. And this may explain the fact that their immediate influence in France and the Lowlands was over-shadowed by that of the Boucicaut Master, whereas their compositions enjoyed an unexpected posthumous revival almost exactly a century later.[1]

The Limbourg brothers started their career, prior to 1399, as apprentices of a goldsmith in Paris and the effects of this early training may still be felt in that filigreelike ornateness and precision which we admire in so many of their miniatures. From 1402 two of the brothers, Paul and John, were in the service of Philip the Bold of Burgundy, residing in the "hôtel" of his physician, Jean Durant. They may have served Philip's son John the Fearless for a time; but in 1411 at the latest we find the whole triad firmly established at the court of the Duc de Berry who showered favors upon them and liked them so much that he did not resent little practical jokes at his expense.[2] They evidently succeeded Jacquemart de Hesdin in office, and in a sense they were his successors also in art.

Born in the Netherlands, educated in Paris, and serving the Duke of Burgundy before attaching themselves to the court of the Duc de Berry, the Limbourgs were intimately ac-quainted with all the major currents in contemporary art, and it is one of their chief merits that they were able to synthesize them without forsaking their originality. The "Flight into Egypt" in the comparatively early "*Heures d'Ailly*" in the Maurice de Rothschild Collection,[3] with the Virgin Mary quaintly turning away from the beholder instead of facing him, reveals the influence of a composition originating in the circle of the great Melchior Broederlam of Ypres who will be discussed in the following chapter.[4] Other miniatures in the same manu-script, especially the "Vigils of the Dead" with its asymmetrical perspective and impressive *chapelle ardente*,[5] evince the brothers' thorough familiarity with the Boucicaut Master, and even more important was the influence of their predecessor in office, Jacquemart de Hesdin. A Book of Hours recently acquired by Count Seilern in London[6] contains a "Flight into Egypt" which is a straight copy after that in the "Brussels Hours," landscape and all. And even though this manuscript appears to be a workshop production postdating rather than preceding the "*Heures d'Ailly*," this fact would seem to indicate the close relationship between the two ateliers.

The strongest bond between the Limbourg brothers and Jacquemart de Hesdin was an enthusiasm for Italian art which they not only matched but even surpassed. The "*Heures d'Ailly*" and the "Seilern Hours" bear witness to this enthusiasm throughout; and the "An-nunciation" in the latter manuscript shows an Italian scheme of composition — exemplified, for instance, by a panel in the Accademia at Florence formerly ascribed to Agnolo Gaddi and by Giovanni di Benedetto da Como's miniature in a well-known Prayer Book of *ca.* 1375 — which had not been employed thus far in France (except, rather vaguely, in the "*Très-Belles Heures de Notre Dame*"). The Virgin Mary is represented in a richly decorated oratorio or portico set slantwise into space and approached by the Angel Gabriel from the outside, the contrast between exterior and interior space sharpened by the fact that the two figures appear in different planes.[7]

A more elaborate but fundamentally identical version of this miniature is found in the Limbourg brothers *opus maius*, the famous *"Très Riches Heures du Duc de Berry"* in the Musée Condé at Chantilly. Through the cumulative efforts of art historians, magazine editors and film directors this manuscript — begun in 1413, left partially unfinished at the Duke's death in 1416 and posthumously completed by Jean Colombe — is so well known that I shall limit myself to a minimum of comment. Attempts have been made to separate the individualities of the three brothers.[1] It seems, however, more promising to concentrate on stylistic tendencies rather than persons, and of such tendencies we can indeed distinguish three, clearly discernible though interpenetrating and often mutually reinforcing one another as though by electric induction.

Throughout the manuscript, Jacquemart de Hesdin's Italianism, surviving in almost undiluted form in the unique "Zodiacal Man" on fol. 14 v.[2] which may be compared to the figure of Christ in the "Baptism" in the *"Petites Heures"* (fol. 209 v., fig. 31), gains momentum and is carried far beyond its previous scope; even in the normally conservative decoration of the margins the Gothic ivy *rinceaux*, still employed in the *"Heures d'Ailly,"* have given way to genuine Italianate acanthus.

In one group of miniatures this tendency grows to such proportions that we may speak of a third and last phase of *Trecentismo* in France. The models selected for copying were followed even more closely than they had been in Jacquemart de Hesdin's "Brussels Hours," and the circle of these models widened so as to include not only panel paintings but also frescos and an occasional piece of sculpture. Still more important, the Limbourg brothers not only imitated the Sienese, the Pisans and the North Italians, but also Giotto and his followers. When the Master of Klosterneuburg copied the frescos in the Arena Chapel it mattered little whether his model was Sienese or Florentine because he intended to appropriate impressive schemes of composition and not to emulate a style. But when, beginning with Jean Pucelle, the Northern artists tried to do just this, they had to concentrate upon that school with which their native Gothic had the highest degree of affinity, to wit, the Sienese. As time went on, they were able to absorb the spirit of other Italian schools, but it took them nearly a century to gain access to the stereographic monumentality of the Florentines.

The star example in this connection is, of course, the Limbourg brothers' adaptation of Taddeo Gaddi's "Presentation of the Virgin" in the Cappella Baroncelli in Santa Croce which — with changes far less radical than in analogous cases of the past and with exact retention of the complicated architectural setting — was transformed into a "Presentation of Christ." But to this star example may be added a motif apparently borrowed from Giotto himself, the *contrapposto* attitude of the St. John on Patmos (fig. 83), almost a mirror-image of the memorable figure in Giotto's "Stigmatization of St. Francis" (fig. 86), also in Santa Croce.

It would be futile to accumulate further instances of Italian influence in the *"Très Riches Heures."* Apart from iconographic peculiarities such as the inclusion of a group of pious shepherds in the "Nativity" (fig. 81),[3] and from the pervasive Italianism in buildings, landscape elements, figure types and draperies, we may refer to the use of an architectural ornament

from Florence Cathedral for a similarly decorative purpose.[1] A "Boar Hunt" found in the sketchbook of a North Italian painter, Giovanni dei Grassi (but ultimately derived from some Roman hunting sarcophagus), was repeated in the December picture;[2] and the twisted posture of an Early Renaissance figure — such as, for instance, the Isaac in Brunelleschi's well-known "competition relief" of 1401 — was somewhat artificially appropriated for an Adam accepting, not without difficulty, the apple from Eve (fig. 82).[3] One of the brothers, at least, would seem to have studied the sights of Florence in person.

One case is worthy of attention just because it is a little problematic. In the "Meeting of the Three Magi at the Crossroads near Mount Golgotha" (fig. 84) — a scene unknown before the very end of the fourteenth century, apparently inspired by the delightful description in the *Liber Trium Regum* by the Carmelite Johannes Hildesheimensis of *ca.* 1370,[4] and here staged before the gates of Paris — the King in the upper left is literally copied from one of the four gold medals which the Duc de Berry had acquired from two Italian merchants in 1402 (fig. 85).[5] These medals represented the four Roman emperors who played a decisive role in the rise of Christianity: Augustus, under whom Christ was born; Tiberius, under whom He died; Constantine, who adopted Christianity as the official creed of the Empire; and Heraclius, who saved it from the Persians by his victory over Khosroe. All the original pieces are lost. But two of them, the Constantine and the Heraclius, were copied by the Duke's own artisans, which made it possible to make an unlimited number of casts in gold and baser metal. A number of these have survived, and this is how we know that the King in the upper left of our page repeats the equestrian portrait of Constantine. I believe, however, that the horseman in the lower right is also derived from one of the medals. He, too, is represented in pure profile and fits most beautifully into a circle drawn around the very point in which the folds of his long-sleeved tunic converge; he transmits to us, it would seem, either the lost "Augustus" or the lost "Tiberius."

In spite of its Italian connotations and its conscientious topography, a second major tendency characteristic of the Limbourg brothers is evident in the "Meeting of the Three Magi," a tendency which they shared with most of their contemporaries, especially the Boucicaut Master. It reached it climax, however, in the "*Très Riches Heures*," and here it prevails over all others in a second group of miniatures.

If we are careful not to read a derogatory meaning into the word, this tendency may be described as "manneristic." It manifests itself in an emphasis on calligraphic lines, variegated colors, gold and silver at the expense of spatial illusion; in excessive refinement of proportions, behavior and dress of the figures; in richly ornamented armor, brocaded textiles and jewelry: in a preoccupation with patterns within patterns, so to speak. In purest form this taste can be observed in the "Coronation of the Virgin"; the train of her mantle, carried by the now inevitable angels, flows in rhythmical curves instead of being draped in plastic folds as in the more Italianate pictures; and the host of cherubim forms a lovely spiky wreath reminiscent of goldsmith's work.

"Mannerism" also dominates those of the famous Calendar pictures which describe the

pastimes of the higher classes in the months of January, April, May and August (four minia-
tures painted on two double leaves and safely attributable to one hand). The April miniature
(fig. 91) is an excellent case in point, its two protagonists, thin and small-headed like overbred
animals, displaying their gorgeous dress in a pure, bodyless profile view, whereas the minor
personages enjoy a somewhat greater amount of substantiality and freedom. Yet the scenery
that foils these fashion-plate-like figures culminates in a building not only surprisingly real in
appearance but identifiable; it is the castle of Dourdan, one of the Duc de Berry's numerous
residences. There are no less than nine such "architectural portraits" in the Calendar pictures
alone; and they bear witness to the fact that the Limbourg brothers, just as they shared and
intensified the Boucicaut Master's penchant for artificial stylization, also shared and intensified
his sharp-eyed observant naturalism.

This third, naturalistic impulse is no less powerful and pervasive in the "*Très Riches
Heures*" than are the Italianate and the "manneristic" tendencies. As it intruded upon an
exhibition of stilted ceremonial, so did it combine with the sense of dramatic monumentality
imparted to the brothers by their new experiences with the Giottesque. From this resulted the
"Crucifixion" and the still more admirable Gethsemane scene (fig. 87) according to John
XVIII, 5 ("as soon as He had said unto them I am He, they went backward and fell to the
ground"). Here — as already in a "Crucifixion" in the "*Heures d'Ailly*," folio 145 — the death
of Christ and His encounter with His thunderstruck captors are interpreted as genuine noc-
turnes, contrived by the miraculously simple device of imposing a new, naturalistic construction
upon the time-honored grisaille technique. The fact that these two miniatures are painted in
gray — with little flecks of gold to indicate the stars and the flames of torches — suffices to
convey the impression of darkness. Naturalism also dictated the inclusion of countless new
details beyond the topographical. There is the "Annunciation to the Shepherds," expanded into
a complete pastoral with two different groups of shepherds, some of them in tattered garments,
and a great number of sheep scattered beneath a darkening sky. There is the priceless drawing
of an iris on fol. 26 v., accidentally untouched by the brush and thus surviving as the excep-
tionally vivid reflex of a study from nature. There are, above all, the remaining illustrations
of the Calendar.

The series starts with the January picture (fig. 88) in which the customary representation
of King Janus at table is elaborated into a banquet in the tapestried hall of the Duc de Berry,
who sits before a monumental fireplace, protected from its heat by a circular screen of wicker
work, while the High Steward orders the next course with the words "*Approche, approche*."
In poignant contrast to this opulence, the February picture (fig. 89) shows a group of peasants
huddled in a pitifully inadequate cottage and warming themselves at the fire (the smoke of
which is clearly visible against the cold, gray sky) with so little regard for nice manners that
both *Verve* and *Life* Magazines thought it necessary to purify the picture before presenting it to
a twentieth-century public; and it is in this miniature that we encounter the first snow land-
scape in all painting. The picture of June shows haymaking outside the walls of Paris which
encircle the Palais de la Cité and the Sainte Chapelle, the men cutting the grass and the women

65

raking it into a row of stacks whose neat perspective arrangement has always aroused admiration. While the construction of space is far from being correct and consistent according to Eyckian, let alone Italian Renaissance, standards, the sharp break between foreground, middle distance and background which even the Boucicaut Master had not been able to cope with, has been smoothed out so that a modicum of continuity is achieved. And in the even more naturalistic plowing scene in the March picture — painted on the other side of the same double sheet — we meet, for the first time since Hellenistic antiquity, with genuine cast-shadows projected by the figures onto the ground (fig. 90). Even in Italy this epochal innovation does not seem to appear until Masaccio, and in the "Très Riches Heures" itself it recurs only in what seem to be the two latest miniatures entirely executed by the Limbourg brothers, the pictures of December and October.[1]

Genetically, these justly admired Calendar illustrations can be explained, as hinted in the preceding chapter, as a fusion of the Early and High Medieval occupation pictures with the new scheme of Jean Pucelle who had expressed the character of each month by the changing aspect of nature rather than by the changing form of human activity. The very disposition of the Calendar pages in the "Très Riches Heures," with the position of the sun indicated in a half-circle surmounting the scene is modestly anticipated in the "Belleville Breviary" and its descendants, among them the "Petites Heures" and the "Grandes Heures" which were certainly known to the Limbourg brothers.[2] However, the fact that now a sharp distinction is made between the nobles and the poor, that the farmers and shepherds now suffer all the cold and do all the work whereas the Court of the Duc de Berry does all the feasting, hunting and lovemaking, casts an entirely different complexion on the whole cycle.[3] A purely descriptive presentation of labor and leisure, both within the framework of a stratified but basically homogeneous society, is transformed into an antithetical characterization of divergent milieus. The actual processes of work and pastime are of secondary interest as compared to the social sphere in which they unfold. What had been "Janus feasting" or "a youth holding a flower," is now developed into a scene exemplifying the life of the noble; what had been the act of plowing, now represents the life of the plowman seen through the eyes of those who do not plow. And here we touch upon the very roots of the fascinating and contradictory style the development of which we have been following from the last decades of the fourteenth century to the climax of the "Très Riches Heures."

IV

This style, a scintillating interlude between the sober sturdiness of the Bondol generation and the shining perfection of the great Flemings,[4] is often referred to as the "International Style," and not without justification. While all the great historical styles were international in that they were practiced in different countries, most of them did not, in themselves, result from a blend of different national tendencies. The Gothic, the Renaissance, the Baroque and the Rococo owed their existence to the genius of one particular nation or even region and

conquered others by way of unilateral expansion. The style of around 1400, however, though formulated on French soil, had come into being by the interpenetration and ultimate fusion of the Gallic as represented by the French, the Latin as represented by the Italians, and the Anglo-Germanic as chiefly represented by the Flemings; and when it spread to Germany, to Austria, to Spain, to England, to Flanders and even back to Italy — the reflux from north to south beginning and steadily growing from *ca.* 1370–1380 — it did so, as it were, by way of multilateral repatriation.

This process was facilitated by a peculiar fluidity in the relationship between art production and art consumption. The High Medieval system of ecclesiastical or at least semiecclesiastical patronage, conducive to regionalism, was disintegrating everywhere; the system of strict guild organization, conducive to the development of purely local schools, was not as yet firmly established in the Northern countries and began to be undermined by the prestige of individual artists in Italy. Some major painters and book illuminators were attached, as *varlets de chambre*, to the courts of princes, some were engaged in free enterprise, and many of the best were both. Thus there was an unprecedented amount of itinerancy on the one hand and of production for export on the other; and the rise of a collector's mentality, alluded to in the preceding chapter, produced a lively exchange of works of art both from owner to owner and through middlemen. As a result, we sense — all differences notwithstanding — a greater stylistic affinity between Master Francke of Hamburg and the Boucicaut Master, between the Upper Rhenish painter of the Frankfort "Garden of Paradise" and Stefano da Zevio, between Gentile da Fabriano, the Zavattari or Pisanello and the Limbourg brothers, than we can some fifty years later between Dirck Bouts and Piero della Francesca, or between Schongauer and Botticelli. Small wonder that art historians tend to shift important works of the "International" period back and forth between Paris and either Vienna or Prague, between Bourges and Venice, between France and England, and often finally agree they are Catalan.[1]

All this explains, perhaps, that the style of around 1400 was international. It does not account for its amazing sophistication and extravagance in manner, dress, and appurtenances: for those thin, nervous hands and wasplike waists; those choking collars, those turbanlike "*chaperons*"; that jagging of all edges which combined a maximum of waste with a minimum of comfort; that childlike delight in everything that glitters and tinkles. People took to wearing little golden bells on their belts and collars[2] and the very horses wore hundreds of medals, engraved or enameled with images or emblems, every one of which is now a museum piece.[3]

Phenomena like these cannot be explained on a purely rational basis. We may point out, however, that unusual extravagances in manner and fashion tend to occur whenever the ruling class of an aging society begins to feel the competition of younger forces rising against it. We may remember the period of the Counter Reformation, the times of Charles I and Charles II in England, and the half century before the French Revolution which was to abolish (at least for the males) all major opportunities for "conspicuous waste." Towards 1400, when Florence, Siena, and Pisa had long achieved a bourgeois organization, a fierce rivalry for power and prestige approached a climax in precisely those regions in which the International Style arose,

and, in a lesser degree in those in which it was most eagerly accepted. Here the old feudal aristocracies had to assert themselves, not so much against the rise, as against the actual intrusion of a new, protocapitalistic class of merchants and financiers, and this resulted in what may be called an inflationary spiral of social overstatement. At the height of the Middle Ages those entitled to bear coats of arms had borne them without much thinking about it, and people not so entitled had not cared or dared to usurp them. In 1417, Henry V of England had to issue a special decree to the effect that arms were allowed only "to those possessing them by ancestral heritage or by special grant of a person having sufficient authority thereunto."[1] The High Medieval orders had been founded for the conquest of the Holy Land or the colonization of the Slavic East. The orders founded from about 1350 — the Orders of the Garter, the Porcupine, the Jar, the Broomcod or the Golden Fleece — were of purely social significance, uniting a group selected from the elite under the banner of ideals intended to maintain this very elite. Their *raison d'être* was, not unlike that of many modern clubs, to be "exclusive." In short, an aristocracy made self-conscious by a permanent threat of intrusion developed a kind of defense mechanism which led to an overstylization equally foreign to the unchallenged feudalism of the past and to the secure bourgeoisie of the future. But it was only natural that the new mannerisms and luxuries of the old nobility were imitated precisely by those whom they were meant to exclude. The *nouveau riche* — a type comparatively rare in the High Middle Ages — tried to get even with the noble and often outdid him in courtly extravagance. It is significant that from the latter half of the fourteenth century murals depicting the chivalrous romances of the Arthurian cycle invaded the city halls of Cologne and Lübeck and the castles and town houses of such wealthy financiers as Nicolaus Vintler (Runkelstein Castle) and Jacques Coeur.[2] And not only the princess or countess but also the wife of a rich banker or wool merchant would say, to quote from Eustache Deschamps, the sarcastic court poet of Charles V:

> A Book of Hours, too, must be mine
> Where subtle workmanship will shine,
> Of gold and azure, rich and smart,
> Arranged and painted with great art,
> Covered with fine brocade of gold;
> And there must be, so as to hold
> The pages closed, two golden clasps.[3]

It was indeed in small objects of enormous costliness that this feverish passion for luxury was fulfilled: in jewels, medals, ivory carvings, cut crystal and mother-of-pearl; and, most particularly, in those fantastic crossbreeds between sculpture and goldsmithery, unknown before about 1400, which the contemporary inventories describe as *joyaulx d'or esmailliés garnis de pierrerie*. Made of chased gold but covered with enamel in such a manner that the metal shows only in such details as hair and ornaments, and lavishly adorned with pearls and precious stones, these little objects may be said to epitomize the taste of the International Style. While most of them are lost, for obvious reasons, we may still admire the famous "Widener Morse"[4] in comparison with which Abbot Suger's sardonyx chalice, on view in the same room

of the National Gallery at Washington, appears almost simple. Other examples are a little triptych formerly in the Gutmann and Mannheimer Collections, the "Reliquary of the *Ordre du Saint Esprit*" in the Louvre, a "Calvary" in the Cathedral of Gran in Hungary, two smaller pieces in the Treasury of Toledo Cathedral, and the "Reliquary of the Holy Thorn" in the British Museum, where one of the Resurrected emerges from a coffin with a lid of pure gold.[1] But all of them are surpassed by the "*Goldenes Rössel*" in Altötting, a pilgrimage church not far from Munich where the "Little Golden Horse," probably executed at Paris in 1403, has strayed after having been left in pawn by Charles VI of France with his brother-in-law, the Duke of Bavaria (text ills. 27, 28).[2] It is an image of the Madonna and Child surmounted by a golden glory and crowned by two angels, with three small children — in fact, St. Catherine and the two St. Johns — sitting at her feet. This group is ensconced in a bower of gold adorned with finely wrought leaves, enameled roses and a profusion of pearls and gems. In front of a dais engraved with fleurs-de-lys, the King is shown on his knees before a *prie-dieu* (on which reposes his open prayer book), facing a page who carries his helmet, and accompanied by his irascible little dog. A colonnaded substructure shelters his mount and his groom; and we can easily see by the name of the showpiece that this "Little Horse," made of pure gold but enameled a brilliant white, wearing a beautifully ornamented saddle and sparkling with the golden medals we mentioned, impressed itself upon the popular imagination more forcibly than anything else.

To the modern taste, a work like this may seem flamboyant and incoherent, and we may even prefer the rear view, more delicate and closed in composition, to the somewhat confusing front. But to the period of around 1400, this mixture of artificial glitter and pseudoreality (note the naturalistic coat of the dog or the touchingly detailed feet of the King) meant the perfection of art. Charles d'Orléans, the greatest poet of the International Style, describes the favorite subject of nature-minded poetry, Spring, in terms of jewelry and *haute couture*:

Le temps a laissié son manteau	The season has put off its shroud
De vent, de froidure et de pluye,	Of wind, of rain, and of cold,
Et s'est vestu de brouderie,	And is dressed up in a bright and bold
De soleil luyant, cler et beau.	Brocade of sunlight, clear and proud.
Il n'y a beste, ne oyseau,	Not a beast nor bird but sings loud
Qu'en son jargon ne chant ou crie:	In its tongue that the tale may be told:
Le temps a laissié son manteau!	The season has put off its shroud.
Riviere, fontaine et ruisseau	River and rill are endowed
Portent, en livree jolie,	With robes whose embroideries hold
Gouttes d'argent et d'orfaverie;	Drops of silver and filigree gold.
Chascun s'abille de nouveau.	All to new fashion have bowed;
Le temps a laissié son manteau.[3]	The season has put off its shroud.

In historical justice, it must be said that much of what enchants the eye in the works of Jan van Eyck is due to his attempt to recapture in a different medium some of that splendor and meticulous workmanship which must have delighted him in the treasuries of his patrons

and in the workshops of their patient artisans. In a sense, he duplicated with the brush the work of goldsmiths in metal and gems. His painting is "jewellike" in a quite literal sense, meant to recapture that glow of pearls and precious stones which for him, as for Suger, still symbolized "celestial virtues" and seemed to reflect the radiance of the Light Divine.[1]

There is, however, this difference: in the style of Jan van Eyck and of all the great Flemings, a reconciliation has been effected between the elements which in the International Style had remained dichotomous. In an "Adoration of the Magi" by Roger van der Weyden or Hugo van der Goes (figs. 353, 459), the modest but thoroughly self-respecting St. Joseph is the resplendent Kings' inferior in wealth and social standing but neither in scale nor — more important — in human dignity. In the Middle Rhenish "Ortenberg altarpiece" of *ca.* 1420 (which, incidentally, in color and treatment simulates a huge enamel triptych) a patronizing contrast is made between the slim and gorgeously elegant Magi and the pudgy St. Joseph who is presented as a "small man," not only in the literal but also in the figurative sense of the term (text ill. 30).[2] Utterly impervious to the significance of the event, he is entirely absorbed in the menial duty of cooking the soup, a motif which makes its appearance in art precisely at the beginning of the International Style, that is to say, about 1375-1380. In another, nearly contemporary instance, Master Francke's Hamburg altarpiece of 1424, St. Joseph is even made the target of humorous criticism (text ill. 29). While the Virgin Mary, proudly erect on her humble couch, remains a queen in disguise, her husband is an amiable caricature of the Philistine's thrift and caution and confiscates the precious gifts for which, he thinks, the Infant Jesus would have little use and which would be safer in the family's traveling chest.[3]

These and many other cases in which St. Joseph is made an object lesson in the sociology of the poor and humble reveal the same spirit that manifests itself in the Calendar pictures of the "*Très Riches Heures,*" a spirit of slightly artificial fondness bred of overcompensation. It is a truism that a group or class, once made conscious of its own possibilities and limitations, derives vicarious pleasure from the artistic presentation of its opposite. It was in Alexandria and Rome rather than in Arcady that pastoral poetry was born; it was the marquises and cardinals of the seventeenth century who most thoroughly enjoyed Caravaggio's fortune-tellers and cardsharpers; and it was the period of the International Style which, having formalized the life of the noble and wealthy into an orgy of ceremonial and ostentation, discovered the charms of the simple life, the quaintness of the lower classes, in short the genre and particularly the *genre rustique.*[4] We have touched upon the "Annunciation to the Shepherds," appearing as a separate miniature in the "*Très Riches Heures.*" But it is only near the very end of the fourteenth century that this scene was given an independent place within the Books of Hours; it occupies this independent place in the "Brussels Hours" of *ca.* 1390-1395 but not as yet in the "*Petites Heures*" of *ca.* 1380-1385. Later on, it was to be elaborated into an almost entirely secular pastoral, the shepherds and shepherdesses dancing ring-around-the-rosy or even playing hockey.

A distinction had always been made between the various "estates of man"; but in earlier art this distinction had been taken for granted and was expressed in a purely descriptive, en-

tirely unsentimental manner. Now, the peculiarities of the lower classes were studied and interpreted with an interest — half sympathetic and half amused, half supercilious and half nostalgic — not unlike that which "summer people" take in native "characters." There is, for instance, a charming incident in the legend of St. Barbara, where she attempts to flee from the wrath of her highborn pagan father and vanishes behind a stone wall that opens up for her in miraculous fashion. When questioned by the pursuers, one of two shepherds who have observed the miracle refuses to give her hiding place away, whereas the other betrays it, with the result that the flock of the brave shepherd remains intact while that of the wicked one is transformed into grasshoppers. In Master Francke's Helsingfors altarpiece — preceding that in Hamburg by about ten years — the shepherds figuring in this scene are not only "small" in the sociological sense as is the St. Joseph in the Ortenberg altarpiece (whereas the small scale of the St. Barbara may be accounted for by the master's superficial acquaintance with perspective) but also conspicuously poor and picturesque (text ill. 31). In addition to being described as "shepherds" they are, like some of their colleagues in the *"Très Riches Heures,"* affectively interpreted as genre figures with disreputable boots and garments not merely coarse but tattered and frayed at the edges.[1]

So strong was this preoccupation with social contrasts that it affected the mode of presentation as well as the choice of subject. In the *"Très Riches Heures,"* we recall, the figures of the nobles tended to be more linear in design and more severely restricted to the profile and front view — in other words more stylized than the more broadly and freely treated people in less exalted position. But this is not an isolated case. In the "Calvary" by the Westphalian painter, Conrad of Soest (probably 1414 rather than 1404), the Roman dignitaries, accompanied by a pair of those slim, smooth-coated greyhounds whose almost ubiquitous presence is another characteristic of the International Style, are shown in profile and front view and they are rendered in flat, linear fashion, the better to display their pointed shoes and fanciful costumes, the patterns of their brocaded coats and mantles, their jewelry and bell-garnished collars (text ill. 33).[2] The Thieves, however, are so vigorously foreshortened, so sharply characterized and powerfully modeled that Conrad, on the strength of these and similar figures, has often been hailed as a naturalist. He is — in a sense and in part. For him and most of his contemporaries, including the Limbourg brothers, a naturalistic mode of presentation was not as yet a general principle of art; as far as human beings are concerned, it almost amounted to a class distinction.

v

However, the art of around 1400 was not all courtly glamour and precocious naturalism. The deep insecurity of the period, with a breakdown of social and economic standards threatening and a breakdown of religious and philosophical standards nearly completed, expressed itself in what may be called the nocturnal aspect of the International Style. The same lower classes that were cherished in paintings and book illuminations revolted, and their

revolts were suppressed with a violence unparalleled before; and the literature of the time resounds with bitter accusations, outcries of fear and despair, and sighs of sadness and disillusionment. It was in this literature that the word "melancholy" came to be invested with its modern significance. Previously, a man could be a melancholic in the same sense as another man was a "sanguine" or a "choleric," that is to say, his character and physique were supposed to be conditioned by one of the "four humors"; or, he could be a "melancholic" in the sense that he was stricken with a certain form of insanity held to be caused by a disorder of the "black gall" or bile. At the end of the fourteenth century, the word assumed its modern meaning of a purely psychological dejection — a state of mind instead of a disease. In a book "begun out of grief" ("Dont par douleur ay commencé ce livre") Alain Chartier describes, in 1428, how he is kept awake by his sad thoughts about the state of his country and how "Dame Melancholy," approaching his couch, throws over him "her huge, dark mantle" of suffocating grief, a symbol of melancholy far beyond the reach of earlier naturalists and medical men, or, for that matter, that of contemporary illuminators.[1] The ballades of Eustache Deschamps are one prolonged wail:

> Time of unending grief and of temptation,
> Age of lament, of envy and of pain . . .
> Oh lying age, so full of pride and envy,
> Time without honor, lacking judgment true,
> Age full of sadness that frustrates our life.[2]

And the same Charles d'Orléans whose graceful eulogy on spring has just been quoted is the author of the unforgettable line: "Je suy cellui au cueur vestu de noir." He may be likened in more than one sense, to the great melancholics in Shakespeare. His father, like Hamlet's, had been murdered by a close relative when Charles was very young. After a half-hearted participation in the attempts to revenge the deed, he fought at Agincourt, was made prisoner, and spent twenty-five years in English captivity (which, however, did not involve much hardship). And upon his return to France he resigned himself, like Jaques, to a life of pastoral seclusion, with poetry and music as his palliatives, with *nonchaloir*, indifference, as his refuge, and with "Dame Merancolie" as his mistress:[3]

Je suis a cela	It's so with me
Que Merancolie	That Melancholy
Me gouvernera.	Will govern me.
Qui m'en gardera?	No help I see:
Je suis a cela	It's so with me
Que Merancolie	That Melancholy
Me gouvernera.	Will govern me.
Puis qu'ainsi me va,	Till from life's folly
Je croy qu'a ma vie	Death sets me free
Autre ne sera.	No change can be.
Je suis a cela.[4]	It's so with me.

THE "INTERNATIONAL STYLE"

It is often forgotten that the first line of François Villon's immortal "Ballade du Concours de Blois," "Je meurs de soif auprès de la fontaine," is not Villon's own. It belongs to Charles d'Orléans who proposed it to a gathering of poets much as themes of fugues were proposed to musicians in the eighteenth century.[1] In the ballades and rondeaux which he wrote in English captivity, made doubly charming by the slight discrepancy that can be felt between the English tongue and the Frenchman's sense of rhythm and intonation, we find such lines as:

> In the forest of noyous heavyness . . .
> The man forlost that wot not where he goth,[2]

or:

> Alone am y and wille to be alone . . .
> Alone y liue, an ofcast creature.[3]

And one of his rondeaux almost anticipates the mood, the rhythm and, in part, the very words of Verlaine, who very possibly was familiar with him:

Puis ça, puis la,	Hither and yon
Et sus et jus,	And to and fro,
De plus en plus,	Now fast now slow,
Tout vient et va.	All things pass on.
Tous on verra	Every one,
Grans et menus,	Both high and low,
Puis ça, puis la,	Hither and yon
Et sus et jus.	And to and fro.
Vieuls temps desja	Old times anon
S'en sont courus,	Have had their show
Et neufs venus,	And new ones grow.
Que dea! que dea!	What fun, what fun . . .
Puis ça, puis la.[4]	Hither and yon.

In art these moods of sadness, disillusionment and fear are no less clearly reflected than in poetry. In representations of the Trinity, as in many other contexts, the hieratic symbol of the crucified Christ came to be replaced by the heart-rending image of the Broken Body, now ineffably mild and sad, now grim to the point of gruesomeness (fig. 101). The *Piété Nostre Seigneur*—the image of the dead Christ supported by one or two angels—pierced the soul of the beholder with a mingled feeling of hope and unbearable guilt (fig. 75);[5] and a poignant emphasis was placed upon the contrast between the serene, idyllic Infancy of Christ and His Passion. In a German picture of *ca.* 1410, where the Infant Jesus plays and reads at the feet of His mother, implacable angels appear with the Cross, the Lance and the Crown of Thorns, and the Virgin Mary knits the coat upon which lots were to be cast at Golgotha (text ill. 32).[6] In a manuscript of *ca.* 1420–1425 we find the Virgin embracing a sleeping Christ Child twisted into the posture of the dead Christ in a Pietà (fig. 96);[7] even amidst the glitter of the "*Goldenes Rössel*" the palm proffered by the little St. Catherine, the roses and chalice of the little Evangelist, and the lamb of the little Baptist foreshadow the Passion (text ill. 27).

73

EARLY NETHERLANDISH PAINTING

The fears and hopes of Christians had always been focused on the hereafter. But it was only from the fourteenth century that Death, assuming the horrid shape of a skeleton or the still more horrid shape of a decaying corpse, began to accompany the polyphony of existence with a *basso ostinato*. The hectic enjoyment of life found its counterpart in a morbid preoccupation with death and decay. The idea of "everyone, both high and low," sharpened by growing social tensions, was made the central theme of such challenging epics as *Piers Plowman* or *Der Ackermann aus Böhmen*, and it was precisely about 1400 that it took final shape in the "Dance of Death." In the illustration of the Vigils of the Dead, the gruesomeness of the cemetery came to be substituted for the solemnity of a church service (fig. 76);[1] and in an apotheosis of the macabre the stately effigies on the tombs of the great were replaced by — or, still more chillingly, contrasted with — their images as nude corpses in a state of advanced decomposition as in the tomb of Cardinal Lagrange who died in 1402.[2] This custom is first documented for the year 1393, and the idea of contrasting the portrait of the living in the fullness of life with their hideous image in death and decay remained, significantly enough, especially in favor with such sophisticated court artists as Conrad Meit, Ligier Richier, and Germain Pilon.

The most impressive document of this mood is, perhaps, a miniature by the last uncompromising representative of the International Style (for the Bedford Master, briefly mentioned as the Boucicaut Master's only major competitor in Paris, was to yield to the influence of Flemish panel painting towards the end of his career):[3] the Master of the *"Grandes Heures de Rohan."* Not overly refined in taste and technique, utterly disinterested in the modern problem of space, but unsurpassed in power of imagination and feeling, this magnificent barbarian galvanized the combined traditions of Jacquemart de Hesdin, the Boucicaut Master, and the Limbourg brothers into a kind of expressionism receiving additional stimuli from both Italian and Germanic sources.

In the great manuscript after which he is named,[4] the "Annunciation to the Shepherds" is a pagan, bucolic bacchanal, a huge, coarse shepherd wildly dancing to the tune of his own pipe, his wife milking a goat, and only the dog paying attention to the *gloria in excelsis* of the angels (fig. 97).[5] In the illustration of the Vigils of the Dead, however, a dying man is shown giving up his soul to God as he received it, poor, naked, and alone (fig. 98): "As he came forth of his mother's womb, naked shall he return to go as he came."[6] Within the sphere of Northern art, the work of the Rohan Master marks the climax and the end of the International Style.

SCULPTURE AND PANEL PAINTING

ABOUT 1400;

THE PROBLEM OF BURGUNDY

Up to this point I have conscientiously avoided a term familiar to all from many books and museum labels, the term "Burgundian." I believe this term, when applied to works of art produced between *ca.* 1380 and *ca.* 1440, is always ambiguous and often downright misleading.

Geographically, Burgundy is the old Duchy of Bourgogne, a part of Eastern France about twice the size of Long Island, with Dijon and Beaune in the center; in the middle of the fourteenth century it was bounded by the Franche-Comté and Savoy in the east, by the Berry and Bourbonnais in the west, by the Champagne in the north, and by the Dauphiné and the Lyonnais in the south. In 1363, this territory, having reverted to the Crown after the death of the last Capetian duke, Philippe de Rouvres, was given as an appanage to Philip the Bold, the youngest son of Jean le Bon, who had earned his nickname at the battle of Poitiers when a boy of fourteen; and after Philip's marriage to Margaret, daughter of Louis de Mâle and heiress of Flanders, the old Duchy began to develop into something like an empire.

Upon the death of his father-in-law in 1384, Philip the Bold found himself in possession, not only of Burgundy, but also of what roughly corresponds to the northwestern third of modern Belgium with its three "leading cities," Ghent, Ypres, and Bruges, plus certain sections of Northern France. While the reign of his son, John the Fearless, who succeeded him in 1404 and was murdered in 1419, was too short and turbulent for further expansion, his grandson, Philip the Good (1419–1467), became one of the richest and most powerful princes in the Western World. He acquired Brabant and the Limbourg; Holland, Zeeland and the Hainaut with Tournai and Valenciennes; and finally, Luxembourg. Philip's son, Charles the Bold (more correctly: Charles the Rash), added major parts of Alsace and Guelders, including the County of Zutphen, before he was killed in battle in 1477 and left his realm to his daughter Mary through whose marriage to Maximilian I the whole tremendous territory became a part of the Hapsburg monarchy.

In short, what had been a satellite of the French Crown grew into an empire which ethnically and linguistically was half French and half Germanic, whose political interest gravitated towards Germany and England rather than Royal France, and whose economic focus was steadily shifting to the north. To mention an apparently trifling but significant fact: one of the chief industries of Flanders, the manufacture of fine cloth, depended upon the importation of English wool, while one of the chief resources of the English economy, sheep breeding, depended upon the exportation of the wool to Flanders.[1] In every way France and the new Burgundy were drifting apart, and the two reciprocal murders of 1407 and 1419 — first the murder of Louis of Orléans, Regent of France, by John the Fearless, then the murder of John the Fearless by the adherents of his victim, the "Armagnacs" — were not only dynastic family affairs but bloody symbols of historical destiny. It was logical that Philip the Good, although he hated to do so, should conclude a formal alliance with the English almost immediately after the murder of his father (1420), and transfer his court from Burgundy to Flanders.

When we speak of the period after 1384, then, the term "Burgundian" has two different meanings. Either we refer to the new Burgundian empire, a composite political entity comprising diverse countries and nationalities, and in this case the term "Burgundian" has no art-historical significance whatever; or, we refer to the geographical germ of this entity, the original Duchy of Bourgogne, and then the art historian must ask himself whether he may speak of a "Burgundian style" or a "Burgundian school" in the same sense and with the same justification as he does with reference to the periods of Cluny and Autun, Clairvaux and Fontenay, the porch of Beaune and Notre-Dame-de-Dijon.

In the field of book illumination, to which we have devoted so much attention thus far, no major activity seems to have existed in Burgundy even before Dijon was abandoned by Philip the Good. Whatever Philip the Bold and John the Fearless acquired or ordered in the way of illustrated manuscripts was either produced in Paris (as were the great Brussels Bibles, the *Boccace de Philippe le Hardi*, the *Fleur des Histoires de la Terre d'Orient*, the *Livre des Merveilles du Monde*, the *Boccace de Jean Sans Peur* or the *Térence des Ducs*);[2] or by the Limbourg brothers[3] and their associates;[4] or, finally, in Flanders itself, as was the case with a charming Book of Hours, written and illuminated for John the Fearless in Ghent, to which we shall again turn in the following chapter.[5]

The reigns of Philip the Bold and John the Fearless saw, however, a magnificent efflorescence of sculpture and panel painting; but the question remains as to whether these works, produced in Burgundy, can rightfully be called "Burgundian."

II

As has been mentioned, Northern sculpture was virtually untouched by Italian influence up to the sixteenth century. Nevertheless, its general development pursued a course surprisingly similar to that of painting and book illumination in which the Italian element had played such

76

a vital role. In sculpture, as well as in the two-dimensional media, the plastic vigor of the thirteenth century suffered a certain attenuation in the first decades of the fourteenth. Where the Madonna in the north transept of Notre-Dame in Paris (*ca.* 1255, text ill. 34) and the "*Vierge Dorée*" of Amiens (*ca.* 1260) turn on their axes with a gyratory, three-dimensional movement which to the eye presents a curve shaped like a capital "S," the graceful "Notre-Dame la Blanche" of *ca.* 1330 (text ill. 35) seems to bend and sway in two dimensions rather than three so that its curve resembles, not an "S" but a "C"; and the same is true of such more or less contemporary German statues as those adorning the choir of Cologne Cathedral, the St. Catherine's chapel in Strasbourg, or the Holy Sepulchre in Freiburg.[1] Where thirteenth-century figures show a marked differentiation between body and garment, and also between the various parts of the body and the various parts of the garment (with thigh and knees distinctly modeled and the voluminous folds of the mantle treated as units independent from those of the dress), the forms of "Notre-Dame la Blanche" are hidden beneath a drapery of which the thin, tubular folds press through the mantle so that the difference between outer and inner garments is nearly lost in a common pattern of almost linear curves.

From *ca.* 1360, in the work of Beauneveu, Jean de Liége and Jean de Cambrai in France,[2] the Parler family in South Germany and Bohemia,[3] and Master Bertram at Hamburg,[4] we can observe in the domain of sculpture what corresponds to the style of Jean Bondol — or, for that matter, Theodoric of Prague — in the domain of painting. The proportions tend to become stouter. The interest in linear calligraphy abates, not in favor of articulation, but of volume pure and simple (text ill. 36). The next step in the development of sculpture was to parallel the accomplishments of Jacquemart de Hesdin and the Boucicaut Master in integrating plastic shapes and spatial surroundings into one optical — or, as we often say, "pictorial" — percept.

The Italians occasionally tried to achieve this end by simply inflating, as it were, a full-fledged Trecento painting and thereby produced a primitive form of the perspective relief that was to be perfected by Ghiberti and Donatello. Such is the case, for example, in the silver altar of St. John the Baptist in Florence (between 1367 and 1387) where huge, heavily projecting figures of Giottesque character are set out against fenestrated walls or mountainous landscapes enlivened by diminutive hill towns and little figures.[5]

The Northern sculptors tried to create the illusion of space by different means. They either resorted to a very flat relief in which figures and ground seem to be unified as in a delicate drawing or grisaille (as in the Scepter of Charles V in the Louvre or the "Reliquary of the Holy Thorn" in the British Museum);[6] or they wrested from the Gothic high relief what may be called a "theatrical" effect. Instead of presenting to the beholder a perspective image which they, the sculptors, had managed to transpose into a plastic medium, they supplied him with plastic materials which he, the beholder, had to coordinate into a perspective image. Instead of inflating a picture, they expanded a high relief into a theater stage, as seen in the magnificent "Coronation of the Virgin" (*ca.* 1410) in La Ferté-Milon (text. ill. 37).[7] As time went on, this stage was furnished not only with vaulted ceilings but also with curtains, side

walls and even windows through which subsidiary characters might look in on the scene; with the actors offstage, such an elaborate setting can be studied *in vitro*, as it were, in Hans Multscher's "Karg-Altar" in Ulm Cathedral (1433) which deplorably — though, from the point of view of the art historian, not unluckily — has lost all its figures (text ill. 39).[1] Still later, this kind of relief was to blossom out into those elaborate retables where the stage is enlarged into a panoramic scenery, or may be closed by windows of real bull's-eye panes. And it ended up in such sculptured peep shows as seen in Adam Krafft's famous Tabernacle in St. Lawrence's at Nuremberg, not to mention those Southwest German "Oelberge" or Calvaries in which the Passion scenes are re-enacted much in the manner of wax works *à la* Mme. Tussaud's.

In all these instances the spectator is asked and enabled to construct a quasi-pictorial image from the plastic forms provided by the sculptor. And what applies to the figures that move in the imaginary space of a relief also applies, at times with even greater force, to the sculptures in the round that confront us in real space as actual objects. Here, too, the data supplied by the sculptor demand to be coordinated into a picture that constitutes itself in our subjective optical experience. A playfully exaggerated but all the more significant application of this principle is the incorporation of life-sized statues with architecture in such a way that they appear as living persons whose presence contributes to the "scenery" much as the incidental figures — *staffage* in French — do in a painting. Every tourist remembers the stone-carved ladies and gentlemen superciliously looking down upon the visitor from the windows of the mid-fifteenth-century mansion of Jacques Coeur in Bourges. But the idea is much earlier than that. In the little town of Mühlhausen in Thuringia the effigies of Emperor Charles IV and his family graciously greet the populace on the market square from the balcony of the church as though reliving their enthusiastic reception in 1375 (text ill. 38).[2] Conversely, in Strasbourg Cathedral eight squatting figures, carved about 1400, seem to look up to the immense height of the spire as though admiring it with the same stupefaction that we experience (text ill. 40).[3]

It was in the Chartreuse de Champmol — constructed and lavishly endowed by Philip the Bold as, so to speak, the St.-Denis of the Burgundian dynasty — that the new, "pictorial" style of sculpture made a spectacular appearance in France; but it was not by Burgundians that the decisive steps were taken. The great native tradition of sculpture had, of course, persisted throughout the thirteenth and fourteenth centuries. But just because it was a great tradition it tended to be conservative rather than revolutionary, and when Philip the Bold embarked upon his enterprise, he commissioned "foreigners" who hailed from the northern parts of his realm. Of the first sculptor-in-chief, Jean de Marville, we know that he came from Flanders, but too little of his work can be singled out from that of his followers to evaluate fully his importance. What we can fully evaluate is the importance of two slightly younger masters, the great Flemish wood carver, Jacques de Baerze, and the still greater stone sculptor, Claus Sluter from Haarlem in Holland.

Jacques de Baerze was active in Termonde (about nineteen miles from Ghent) and had attracted the attention of Philip the Bold by two carved altarpieces, now lost, in the principal

church of his home town and in the nearby Abbey Church of Byloke (Biloque). He was commissioned to duplicate them for the Chartreuse de Champmol, and both these duplicates — completed in 1391 and the exterior of one of them embellished by the famous paintings of Melchior Broederlam — can still be seen in the Dijon Museum (text ill. 41).[1]

This type of "Schnitzaltar," displaying gilded carvings when open and paintings when closed, appears to be of German origin, one of the earliest known instances being the altarpieces from Marienstatt and Oberwesel of *ca.* 1330. But it originally embodied an architectonic rather than a narrative concept. As a rule, the major "Schnitzältare" of the fourteenth century consist of isolated statuettes neatly arranged in two stories, each sheltered by a private little niche. At times the statuettes of the lower storey are replaced by busts containing relics, and it is only in the Crucifixion, normally placed in the center, that the figures of the crucified Christ, the Virgin Mary, and St. John are necessarily grouped together, yet retain their statuesque self-sufficiency.[2] Jacques de Baerze's "Broederlam" altarpiece, however, consists of many-figured high reliefs representing the Adoration of the Magi, the Entombment, and, in the center, the Crucifixion, which is expanded into a complex Calvary and includes more than twenty figures, several horses, and even such rudiments of scenery as little hillocks and architectures. The most important figures, carved in the round, are so easily detachable that the stupendously naturalistic Crucifix was purloined in the middle of the nineteenth century and may now be admired in the Art Institute at Chicago.[3]

Even in Germany, then, an altarpiece like Jacques de Baerze's would have been exceptional in 1391. In Burgundy it was unprecedented. And as Jacques de Baerze achieved in it the transformation of volumetric relief space into pictorial stage space, so did Claus Sluter (assisted by his nephew, Claus de Werve) achieve a transformation of statues incorporated with the architectural substance into personages acting before an architectural background.[4]

It sounds almost sacrilegious to compare the small and lively reliefs in Jacques de Baerze's altarpieces, or such naïve attempts at a *trompe l'oeil* effect as the figures in the tower of Strasbourg Cathedral, with the majestic portal of the Chartreuse de Champmol (text ill. 42). And yet the light of Sluter's genius should not blind our eyes to the fact that he applied, on however different a scale and in however different a spirit, a fundamentally analogous principle. Most of the portals executed in the latter half of the fourteenth century lack the monumental jamb figures and *trumeau* statues customary in the preceding phase of Gothic, and if jamb figures were retained, they tended to be reduced to the minor scale of the archevault sculptures, so that the profiles of the embrasure and the archevaults merged into continuous channels filled with small-sized statuary, as in the "Frauenkirche" and St. Lawrence's in Nuremberg. In the portal of Champmol, Sluter restored the *trumeau* Madonna and the jamb figures surmounted by gigantic canopies to their ancestral scale and dignity; in fact the *trumeau* Madonna reverts in posture and drapery arrangement to the "Vierge Dorée" of Amiens Cathedral. But he eliminated the archevault sculptures altogether and showed the donors, Philip the Bold and Margaret of Flanders, on their knees, no longer enframed by profiles, but detached from flat surfaces as from a backdrop. Donors' portraits in the round and on a monumental scale are

of the greatest rarity in themselves; only one earlier instance, of *ca.* 1370, is known while the famous statues of the Duc de Berry by Jean de Cambrai, immortalized by Holbein, already seem to presuppose the portal of Champmol.[1] And never before had full-sized kneeling statues been seen in the embrasure of a portal. In permitting two of the jamb figures to kneel and thus creating an empty space between their heads and their canopies, Sluter emancipated the donors — and, by implication, the patron saints and the Madonna — from the architectural context. Instead of being integral parts of a portal, the statues became free agents enacting a scene; instead of being a self-sufficient structure, the portal itself became a stage. In fact, the whole composition is manifestly patterned upon non-architectural models. Showing illustrious personages commended to the Virgin by their patrons, and with no difference in scale being made between the donors, the sponsors and the Madonna herself, it repeats in the round a scheme that is at home in dedication miniatures (such as the title pages of the "Brussels Hours," fig. 40) and funeral reliefs.[2]

In its original coat of naturalistic colors, the portal of the Chartreuse of Champmol was thus intended to reduce the gap that separates the spheres of art and reality. Like Jacques de Baerze's carvings, it provides the elements from which the beholder may derive the experience of a "tableau" — not, of course, in the sense that his eye is deceived, but in that sense that the artist appeals to our ability to transmute tangible things into pictorial images. And the same is true, perhaps to an even greater extent, of Sluter's other major work, the *"Puits de Moïse."* We are, quite understandably and justifiably, enthralled with the purely plastic quality of its statuary. But this magnificent statuary appeared within the context of a gigantic showpiece, originally all gilded and painted, which must have struck the contemporary public much as a *"Goldenes Rössel"* in enormous enlargement, or, to repeat Huizinga's less respectful simile, as a gigantic work of pastry cooking; one of the prophets — those marvels of truly "lithic" sculpture — was originally equipped with spectacles of copper supplied and paid for in 1402.[3]

In contrast to the International Style, where even stone sculptures such as the "Coronation of the Virgin" in La Ferté-Milon or the tympanum of Our Lady's Church at Frankfort[4] and woodcarvings such as the so-called Schöne Madonnen[5] or a remarkable head of Christ in the Museum of Buffalo[6] reflect the precious delicacy of goldsmith's work and book illumination, Claus Sluter's style is monumental. But it is monumental — and this makes it doubly great — without being controlled and sustained by a purely sculptural, let alone architectural, intention. The peculiarities of his very technique — the emphasis on surface texture, the avoidance of gyratory movement in favor of motionless existence, the multiplication of bulging, deeply undercut drapery folds — serve a pictorial as well as plastic purpose. All earlier medieval sculpture, even at the height of Gothic in the middle of the thirteenth century, had permitted the eye of the beholder to cling, as it were, to the lines and surfaces presented to it. Sluter's works force us to explore the forms as with a surgical probe; we feel as though our eye were sending out rays of vision which penetrate into deep, dark hollows or are stopped short by light-reflecting protuberances. Instead of gliding along the plastic shapes, our eye seems to draw them into itself, then project them onto an imaginary picture plane, so that the question

of whether a figure is conceived after the pattern of an "S" or a "C" becomes irrelevant as compared to its optical appearance in space. Sluter, we may say, contains potentially both Michelangelo and Bernini.

A personality such as his could not but exert an enormous influence. But the intensity of this influence naturally depended upon proximity in time and place, and it is nothing but the concentrated emanation of Claus Sluter's style which we mean when we speak of a "Burgundian school of sculpture in the fifteenth century." Sluter himself owes little or nothing to Burgundy. A native of Holland, he had spent his youth in the southern parts of the Netherlands, where sculpture, like painting, had always shown a tendency toward broad, vigorous treatment, emphasis on surface texture and physiognomical individualization. Throughout the fourteenth century the Royal Family of France had favored Flemish sculptors (Jean de Liége, Beauneveu and Jean de Cambrai) as portraitists, and even such modest portraits as those on the epitaph of Jacques Isaak, a Tournai goldsmith, and his wife (1401) are little masterpieces of verisimilitude and penetrating analysis.[1] There are, furthermore, distinct presages of Sluter's individual style in the carved corbels of the "Schepenhuys" in Malines (*ca.* 1380);[2] and it is in Brussels, quite near Malines, that the first traces of his own activity can be discovered. He contributed, it seems, a set of seated Prophets to the decoration of the Brussels Town Hall, and the magnificent consoles of these statues, revealing their earlier date only by a lesser degree of boldness in undercutting the stone and a less drastic subordination of details to a general pattern, are almost identical in style with those which support the jamb figures in the portal of Champmol.[3] Wherever he may have served his apprenticeship, it was as an accomplished master that Sluter appeared in Dijon.

III

As for the state of affairs in panel painting, it has been said that the style of the works associated with Philip the Bold and John the Fearless was "on the whole a little *retardataire* as compared to those produced at the court of the Duc de Berry."[4] However, of panel paintings demonstrably produced in the circle of the Duc de Berry nothing has come down to us save a small Crucifixion formerly in the Renders Collection at Bruges, datable about 1380, which at first glance looks like Sienese work of about 1330.[5] The rest is book illumination; and it is hardly permissible to measure panels by the standards of miniatures. True, the pictures that can be connected with the Burgundian court are all "painted on gold ground"; but so is every other religious picture prior to 1420 (unless the gold be replaced by some other, less expensive kind of abstract foil). And if the paintings produced for Dijon and Champmol, as compared to the "Brussels Hours," the "Boucicaut Hours" or the "*Très Riches Heures,*" appear "a little *retardataire*" in other respects as well, they do so, not as representatives of a specific school but as specimens of a less indigenous and less advanced medium.

It is, therefore, not with book illuminations but with panel paintings produced in other centers of France that the pictures executed under the auspices of Philip the Bold and John

the Fearless should be compared in order to estimate their relative "progressiveness." However, owing to the scantiness of a material which tends to shrink rather than to increase as scholarship advances, it is extremely difficult to ascribe French panel paintings to regional or local "schools"; [1] it is, in fact, somewhat doubtful to what extent we are at all justified in applying this method to the works of artists whose activities were not as yet organized on a geographical basis.

At times it may be easier to connect a given panel with the style of a given book illuminator than to assign it to a given "school" of panel painting. We may refer to the "Portrait of a Lady" in the National Gallery at Washington (officially ascribed to Pisanello) which must have been produced in the closest proximity to the Limbourg brothers (fig. 92); [2] and, most particularly, to the amazingly progressive profile portrait of John the Fearless in the Louvre (fig. 94), an excellent replica of an original which I do not hesitate to ascribe to one of the Limbourg brothers themselves — to be specific, to the author of the April picture in the "Très Riches Heures." [3]

Of the "Ecole d'Avignon," formerly a byword in art-historical writing, it is now admitted that "it is not possible to speak, with reference to our period, of an Avignonese or Provençal school of painting in the proper sense of the term." [4] Of the Worcester "Madonna with St. Peter of Luxembourg," the patron saint of Provence, we still do not know whether it was produced by a native artist or by an immigrant from North Italy. [5] The two Louvre panels with the Legend of St. Andrew, which come from Thouzon in the Comtat Venaissin, are so Italianate that the question of whether they were executed by a Frenchman or by a painter from Siena is still in doubt. [6] A "Calvary and *Noli me tangere*," formerly in the Aynard Collection in Lyons, is certainly Bolognese. [7] A "Bearing of the Cross" in the Louvre, painted on vellum, has justly been associated with Jacquemart de Hesdin. [8] And the delightful "Annunciation" in the collection of Mr. Arthur Sachs in Santa Barbara, California, originally published as a product of Avignon and later on ascribed to a Dijon atelier, is now more or less generally accepted as Parisian. However, this revised attribution is hardly final either. In my opinion and that of other scholars the painting is an unusually fine product of the Bohemian school. [9]

In fact, the "Paris School of about 1400" is even more problematic than the "School of Avignon." Strange though it seems, we have literally not a single painting between the "Parement de Narbonne" and such panels as can be connected with the great Parisian illuminators of the early fifteenth century that can be ascribed to the "School of Paris" with any amount of certainty, and most of the paintings commonly assigned to it are probably not even French. The origin of a much-debated diptych in Berlin, which shows the Crucifixion and a crucified Christ appearing to a Premonstratensian Canon much as He had once appeared to St. Bernard, is difficult to determine, but may perhaps turn out to be Bavarian. [10] Germanic — probably Austrian or South Bohemian — provenance may also be conjectured of the better-known diptych in the Bargello which shows the Crucifixion on the right, and, on the left, the Adoration of the Magi, the latter staged in a distinctly un-French architectural

setting and exhibiting, like the Crucifixion, an equally un-French overcrowding in composition and overanimation in linear movement.[1] And the still more famous "Carrand diptych" (fig. 99) — likewise preserved in the Bargello and likewise testifying to the characteristic inclination to contrast the supreme joy of the Virgin Mary with her supreme sorrow in that it juxtaposes the Crucifixion with a Madonna adored by angels and saints in the "garden inclosed" — seems to originate in a region remote from Paris in the opposite direction. The flat, niellolike treatment of the brocaded garments worn by the angels, female saints and Roman dignitaries, the odd arrangement of the crosses, the amazing device of making the flowery lawn of the garden and the corpse-infested soil of Golgotha spill over upon the lower ledges of the frame, and, last but not least, the wondrous elaboration of the frames themselves, all this is heresy from a French, let alone Parisian, point of view. The "Carrand diptych," the cornerstone of the "Paris School of about 1400," is in reality a product of Valencia, datable in the first third of the fifteenth century.[2]

From the little we know of panel painting produced in France around 1400 we can, however, infer two things: beginning with the earliest known example, the Louvre portrait of Jean le Bon, it shows, true to its ultramontane origin, a consistent tendency towards Italianism, and it is, exception being made for the few works produced within the direct orbit of the great illuminators, considerably less progressive than contemporary book illustration. Problems of space are rarely tackled, and it is significant that the interest in them grows at an inverse ratio to the size of the panels. The smaller they are, and the more they thus approximate the format and technique of book illumination, the more "progressive" do they appear.

It is against this background that the paintings commissioned by Philip the Bold and John the Fearless must be projected. They, too, are fairly Italianate and, comparatively speaking, less "modern" than the illuminations produced for the Duc de Berry. Within the limits of their craft, however, the painters of Dijon can hardly be called *retardataire*. But neither can they be called Burgundian. Like the sculptors, they were all Flemings or even Rhinelanders, with only a few exceptions such as that of Jean d'Arbois who — a native of Franche-Comté and a much older man than the others — was recalled from Milan in 1373 and to whom not a single work can be ascribed with certainty.[3]

Of the many names supplied by documents who are connected with each other and can be associated with an obviously contemporary panel still extant, the "Martyrdom of St. Denis and His Companions" in the Louvre. One of these records refers to the painter Jean Malouel (Maelweel) from Guelders (uncle and early benefactor of the Limbourg brothers), who had been active in Paris up to 1397 when he was enticed from the services of Queen Isabeau into those of Philip the Bold (it was he, by the way, who between 1401 and 1403 was to embellish the *Puits de Moïse* with its resplendent coat of gold and colors).[4] In 1398 he was commissioned with five large pictures for the chapel of the Chartreuse de Champmol. The subjects are not mentioned in the document; but the dimensions are stipulated and are given, in one case, as 4½ by 6½ feet. The other record informs us that in 1416 the painter Henri Bellechose of Brabant (who on May 23, 1415, had been appointed as Malouel's successor after the latter's

death on March 12th of that year)[1] received the colors with which to "finish" (*parfaire*) a "picture of the life of St. Denis." Though one of these documents is silent as to the subject, and the other as to the dimensions and the name of the artist who started the painting, there is a strong presumption that they refer to the same work — provided that this work have the dimensions indicated and evince the participation of two different masters. Recent assertions to the contrary notwithstanding, I hold that these conditions are fulfilled by the picture in the Louvre (fig. 100) which does depict the Legend of St. Denis and measures 1.61 m. by 2.10 m.[2]

A curious combination of cult image and historical narrative, it shows in the center the crucified Christ and God the Father in a glory of angels. On the left, Christ, clad in the same blue, gold-embroidered pluvial as are the three martyrs, visits St. Denis in the Prison de Glaucin — which, in order to emphasize its pagan character, is rendered in a faintly Romanizing or orientalizing style — to administer the Last Sacrament in person; and on the right is shown the Martyrdom itself: St. Denis, his head half severed by the "blunted axe," on the block, St. Rusticus lying beheaded on the ground, and St. Eleutherius awaiting execution. The general scheme of this somewhat archaic composition, still faithful to the Byzantine and Italo-Byzantine habit of making the central motif emerge from two symmetrically descending diagonals, is well in keeping with the date of 1398 and with the presumable style of a mature master who had spent most of his adult life in Paris. There is a decorative, almost heraldic spirit in the emphasis on embroidered and brocaded designs, flat areas of bright, clear color, and undulating borders some of which bear ornamental "Kufic" inscriptions — an orientalizing fad of the Sienese which began to make headway in the North about 1400 and affected the workshop of the Boucicaut Master as well as many other schools of European panel painting.[3] The movements and expression of the Martyrs and the Saviour are gently restrained and the body of the crucified Christ, remarkable though it is for anatomical insight and for skill in handling the Italian technique of shading flesh with green, is modeled with delicacy rather than vigor. All this, however, is at variance with the savage power and naturalistic directness that can be felt in the upper portions of the picture, especially in the somber figure of God the Father, in the magnificent brute of an executioner, and in the fantastic yet amazingly real group of pagans behind him. Here, I think, we can indeed discern the hand of another artist — a younger man and one who had not undergone the mellowing influence of the Paris tradition and had instead been plunged from his native Brabant into the orbit of Claus Sluter.

It might be objected that the stylistic contrast within the "Martyrdom of St. Denis" can be accounted for by the familiar custom, discussed in the preceding chapter, of indicating social or moral inferiority by more naturalistic treatment. The executioner and the onlookers behind him may be thought to differ from the other figures, not because they were painted by a different hand but because they are evildoers and pagans. There would be, however, no justification in making a stylistic difference between the First and Second Persons of the Trinity; and no such difference exists in another picture commonly ascribed to Malouel but executed without the participation of a second artist. This picture is the beautiful *tondo*, one

of the earliest panel paintings of circular form, which is also preserved in the Louvre (fig. 101).[1] It represents the Trinity according to the new, *Pietà*-like form in which God the Father holds the broken Body instead of the Crucifix, and it has been attributed to Malouel, first, because its back bears the arms of France and Burgundy, and second, because it agrees with the "Martyrdom of St. Denis" in several stylistic peculiarities. The childlike, soft-chinned angels' heads are very similar in both pictures, and the dead Saviour in the *tondo*, though even more delicate, is much akin to the crucified Christ in the "Martyrdom of St. Denis." However, the more convincing these parallels between the two paintings, the more striking is their difference with regard to the depiction of God the Father. In the "Martyrdom of St. Denis," He looks like a Sluterian prophet with a mighty round skull, ample hair, low forehead and a thick beard depicted as a woolly mass. In the *tondo*, He is a gentle, sad aristocrat with a long, narrow-browed face, sparse undulating locks, and much less abundant beard in which the strands of hair are treated in linear fashion. Both documentary and stylistic evidence thus seem to support the attribution of both pictures to Malouel, provided that we date the *tondo* a little earlier than the "Martyrdom of St. Denis" and that we accept the hypothesis that the latter was finished by Henri Bellechose.

Around these two large paintings a number of smaller ones have been grouped, some slightly earlier and at least one slightly later. These are a "Lamentation" and an "Entombment" in the Louvre;[2] another "Lamentation" in the Museum at Troyes[3] and a third formerly in the Berstl Collection,[4] a "Crucifixion" in the Chalandon Collection in Paris;[5] and, finally, a "Coronation of the Virgin" in Berlin (fig. 102) which is apparently the latest member of the group.[6] These pictures have indeed many features in common with the "Malouel" *tondo* in Paris. The "Lamentation" in the Louvre and the "Coronation of the Virgin" in Berlin are also roundels. In the two Louvre panels and in the "Lamentation" in Troyes we find, as in the "Martyrdom of St. Denis," hems and trimmings adorned with pseudo-oriental inscriptions.[7] And all but one of the six compositions are centered around the figure of the dead Christ which is depicted in a way somewhat reminiscent of "Malouel."

Yet all these similarities do not sufficiently demonstrate the hypothesis that the six little pictures were executed in a workshop located at Dijon. Since most of them precede rather than follow the "Malouel" *tondo* and are less advanced in the rendering of the nude, they may well testify, not so much to the existence of an "atelier Dijonnais" that would have formed itself under Malouel's influence as to the character of the Parisian milieu to which he belonged before going to Burgundy. For the time being, we have to admit that their origin cannot be established; the sad fact is that the little golden and bejeweled crosses on the diadems of the angels in the "Martyrdom of St. Denis," the Troyes and Berstl "Lamentations" and the Berlin "Coronation of the Virgin," alternately adduced as peculiar to either Paris or Flanders[8] (they do, in fact, recur in Jan van Eyck and Roger van der Weyden) cannot be considered as evidence one way or the other; they are found, as early as about 1350, in the Bohemian Madonna of the Archbishop Ernest of Prague, commonly known as the "Glatz Madonna," at

Berlin [1] and may well originate in the school of Ambrogio Lorenzetti. Conceivably, however, the pictures grouped around the "Malouel" *tondo* have a better claim to representing the elusive Paris school of about 1400 than do the other works thus far ascribed to it.

IV

The "Martyrdom of St. Denis" — and, with a lesser degree of certainty, the large *tondo* in the Louvre — are thus the only panel paintings left which can be accepted as having been executed in Dijon during the reigns of Philip the Bold and John the Fearless; and after the departure of the Court in 1420, when things in Dijon came to such a pass that the wife of Henri Bellechose had to eke out the family income by selling salt and other groceries (*du sel et autres petites denrées*),[2] not much is heard of painting in Burgundy until the second half of the fifteenth century when it revived as an offshoot of the schools of Flanders.[3] Needless to say, Jean Malouel of Guelders and Paris and Henri Bellechose from Brabant must be classified as Franco-Flemish rather than Burgundian artists, with the accent on "Franco" in the case of the former and on "Flemish" in that of the latter. And the most important work of painting that has come down to us from the Chartreuse de Champmol was demonstrably not produced in Dijon at all, but imported from the workshop of a Fleming who, though acquainted with the style of Jacquemart de Hesdin, had come to Paris and Burgundy only as a casual visitor.

This artist — the greatest of all pre-Eyckian panel painters insofar as their work has been preserved — is Melchior Broederlam of Ypres, mentioned in the accounts of Philip the Bold as "peintre monseigneur" from 1391 and as "varlet de chambre" from 1387.[4] His patron employed him, especially in connection with his castle at Hesdin, for the varied tasks which fell within the province of the late medieval master painter, from the painting of banners (in oils!), chairs and wooden galleries to the decoration of a glittering *gloriette* (an ornate "chambrette" or pavilion) all covered with gold leaf, and the preparation of layouts and drawings for tiled floors (*ordonnance de carrelages*). And when Jacques de Baerze, the wood carver, had completed his two altarpieces, the quaintly shaped wings of the more sumptuous one were instantly dispatched to Broederlam to be adorned with paintings on the exterior; the work was paid for in 1394, but the wings were not installed until five years later. Nothing could speak more loudly for the esteem in which Broederlam was held by his master than the very fact that Philip the Bold had these wings shipped from Termonde to Ypres rather than either entrusting them to another painter or keeping Broederlam away from his duties at home.

Completing the Infancy Cycle, merely adumbrated in Jacques de Baerze's carved "Adoration of the Magi," Broederlam depicted the Annunciation and Visitation on the exterior of the left-hand shutter, and the Presentation and Flight into Egypt on its counterpart. And these two double pictures (figs. 104, 105) represent — so far as the material has survived — about the only attempt of a professional Northern panel painter of *ca.* 1400 to face the basic problems that agitated the minds of such book illuminators as Jacquemart de Hesdin and the Boucicaut

Master. Like these two, Broederlam strove for the integration of figures with architectural and natural space, and the fact that he was hampered by the conventions of his medium — which still required the use of gold ground and demanded that every square inch of the area, however queerly shaped, be filled with form — makes this struggle doubly dramatic.

Two of the incidents needed an architectural setting; two had to be staged outdoors. But the chronology of the narrative prevented the painter from placing the buildings on the extreme left and the extreme right where they might have served as coulisses for a landscape prospect in the center. Instead, they had to be shifted to the left in both panels, one of them surmounted by a triangular, the other by a rectangular, space. Nevertheless a reasonably equilibrated surface pattern was achieved by balancing the apparition of God the Father in the triangle on the left with a mountain peak, topped off by a fortified castle, in the triangle on the right; and by filling the two rectangles in the center with approximately analogous motifs, viz., another mountain peak and a steep tower with angels spreading their aquiline pinions above them.

In an effort to break the spell of two-dimensionality, Broederlam devised architectures projecting and receding with equal energy. While pushing back the landscape, they also push forward the frontal plane; and in contrast to the "Martyrdom of St. Denis" — and, for that matter, all contemporary panel paintings in Northern Europe — the standing plane of the figures is well above the lower margin. Thus the pictorial space, though much less unified and much more sharply rising than in the contemporary miniatures in the "Brussels Hours," no longer seems to start behind the backs of the figures but at a comfortable distance in front of them. It should also be noted — a small, but most significant detail — that in the "Visitation" a hawk is seen swooping down from its eyrie; in Broederlam's mind the conventional gold ground had already begun to assume the significance, if not the appearance, of the natural sky in which not only angels and devils but ordinary birds can aviate.

The Temple in the "Presentation" is one of those spindleshanked hexagonal structures which may be considered as magnified Gothic baldachins or tabernacles and were particularly in favor with the Sienese Trecento painters (a slightly later specimen is found in the title page of the *Fleur des Histoires de la Terre d'Orient* and an earlier but even more similar one in the "Angers Apocalypse" by Jean Bondol).[1] Apart from its unusually developed interior and its impeccably constructed tiled floor (both features reminiscent of Ambrogio Lorenzetti's "Presentation" of 1342), this structure is not overly original. The setting of the "Annunciation," however, is truly remarkable. Several years before, the Limbourg brothers — who, we remember, were familiar with Broederlam's compositions[2] — he employed the Italian "exterior type" with a foreshortened portico or oratorio approached by the angel from without; and not only was Broederlam the first Northern panel painter to adopt this scheme, he also elaborated it in a manner not seen before and hardly ever after. He encased the Virgin Mary in a fanciful, airy pavilion turned against the frontal plane at an angle of approximately forty-five degrees so that the figures appear arrayed on a diagonal; after the fashion of the great Trecento masters he adorned this little shrine — one cannot help thinking of the *gloriette* in the castle of Hesdin — with statues of Moses and Isaiah placed on its corners much as Ambrogio Lorenzetti's

"Presentation" is surmounted by the statues of Moses and Joshua; and he enmeshed it in a complex of other buildings.

The intricate symbolism of this rambling and, from a practical point of view, not too convincing architecture will be discussed in one of the following chapters.[1] For the time being we must limit ourselves to admiring Broederlam's performance as a craftsman. Not as yet familiar, of course, with the technique of the van Eycks, he envisaged their aims without possessing their methods. He used glazes only on exceptional occasions, and his color is reminiscent of the clear, flowery brilliance of contemporary book illuminations and enamels. But within the limits of his medium, he worked wonders. All essential forms are modeled with a precision and a richness of nuance unmatched in the fourteenth century, and an equally unrivaled breadth and freedom — what the Italians call *sprezzatura* — enchants us in his plants, his trees, his terrain and such architectural accessories as the Prophet statues on the corners of Our Lady's pavilion. But the most important thing of all is a sensibility for the diffusion of light which fully justifies the use of the term *chiaroscuro*. Broederlam's interiors, in contrast to those of the mature Boucicaut Master, are represented from without; we peep into the rooms instead of entering them. Yet he succeeded in capturing the gradually deepening half light in the open hall behind the Virgin's *tempietto* with its nail-studded shutters and wonderful tiling (which, like that of the tower room, reveals his proficiency in the *ordonnance de carrelages*); and the prospect through the grille of this tower room, with the white-covered altar emerging from the gloom of the dimly lighted chamber, is without parallel in pre-Eyckian painting.

No less remarkable than the deservedly famous "Annunciation," copied or paraphrased in many miniatures and occasionally enlarged into monumental tapestries (text ill. 51),[2] is its counterpart, the "Flight into Egypt." In it Broederlam achieved the most beautiful landscape prior to the "Boucicaut Hours," perhaps less rich in "motifs" than those of Jacquemart de Hesdin, but more than their equal in coloristic and luminary variety and, if I may say so, in luxuriance. He intensified the illusion of depth and at the same time induced a feeling for the immersion of man in nature by the device of making the group emerge from behind a diagonal ledge of terrain which conceals the greater part of the ass, and he reinterpreted the whole scene in a spirit of delightful warmth and intimacy. The Virgin Mary grasps her right elbow with her left hand, and her mantle, realistically hiding part of His halo, envelops the Infant Jesus so tightly that he appears, like a chrysalis, small and immobile. The rustic, gloriously bearded St. Joseph, burdened with blankets and a kettle, drinks water from a little canteen, the duplicates of which can still be seen in France and Belgium when lower-middle-class families venture upon the Puy-de-Dôme or to the seashore.[3]

Yet this amusing and much-imitated detail is more than an example of that milieu realism that has been touched upon in the preceding chapter; it is meant to remind us of the many wonderful events which, according to the Apocrypha, accompanied the journey into Egypt. In the background is seen a pagan idol tumbling from its pedestal at the approach of the Holy Family as described in Pseudo-Matthew XXI and announced in Isaiah XIX, 1: "Behold, the Lord rideth upon a swift cloud, and shall come to Egypt; and the idols of Egypt shall be moved

at His presence"; and this allusion to one miracle justifies the assumption that the motif of St. Joseph quenching his thirst refers to another. The beautifully painted well in the foreground from which his canteen has been filled is not an ordinary well; it must be the miraculous fountain that appeared when the Holy Family was in need of water in the wilderness (Pseudo-Matthew XXIII). In support of this interpretation we can adduce a somewhat later miniature in which the Miracle of the Fountain is combined with two others (the Miracles of the Cornfield and the Bending Tree), and in which St. Joseph is shown in the very act of filling his flask from the miraculous spring (fig. 191).

Depicting as it does the Rest on the Flight into Egypt rather than the Flight itself, this miniature — found in a Book of Hours in the Walters Art Gallery at Baltimore [1] — is an early and, at this time, fairly isolated instance of what was to become a favorite subject of Gerard David and Joachim Patinir. Moreover, it is an indigenous product of Flanders and thus arouses our curiosity about those Netherlandish artists who, like Broederlam but in contrast to all the other masters thus far discussed, remained in their native Lowlands instead of emigrating to France.

IV

THE REGIONAL SCHOOLS OF THE
NETHERLANDS AND THEIR IMPORTANCE
FOR THE FORMATION OF
THE GREAT MASTERS

Pᴿᴵᴼᴿ to the transmigration of the Burgundian court to Flanders, the conditions of art production in the Netherlands differed from those in France by the more dominant role of patrons belonging to the bourgeoisie and the clergy rather than to the high nobility. But within the Netherlands themselves a marked divergence can be felt between the South and West, on the one hand, and the North and East, on the other. Flanders and the Artois were attached to the Burgundian empire; but the seat of this empire was still Dijon. The Hainaut belonged to the Bavarian dynasty (represented by Albrecht I up to 1404, by his son William VI, a son-in-law of Philip the Bold of Burgundy, up to 1417, and by the latter's luckless daughter, Jacqueline, up to 1433); but the interests of this dynasty were centered in Holland. Artistic and intellectual life in the South and West was thus largely dominated by the big cities, Ypres, Bruges, Ghent and Tournai, whereas the North and East abounded in princely courts whose rulers, linked to France and Burgundy by dynastic and cultural ties, were, so to speak, on the spot. Holland had its Bavarian court in The Hague. The Limbourg (the region around Maastricht, Maastricht itself belonging to the Bishopric of Liége) was part of the Duchy of Brabant up to 1406 when it went to Antoine of Burgundy, the second son of Philip the Bold. Guelders (comprising the districts of Arnheim, Nijmegen, Zutphen and Roermond, the last-named known as "Upper Guelders") was ruled by Renaud IV (died 1423), who was married to a highly cultured French noble-woman, Marie de Harcourt et d'Aumale. Cleves, finally, belonged to Count — later on, Duke — Adolph II, who in 1406 had married Mary of Burgundy, the second daughter of John the Fearless, and whose daughter, Catherine, became Duchess of Guelders by her marriage to Renaud IV's successor, Arnold of Egmond, in 1427.

Consequently, though somewhat paradoxically, a more courtly and, if one may say so,

more Parisian atmosphere prevailed in certain sections of the Germanic north and east than in the bilingual regions of Flanders, the Hainaut and the Artois.

Of panel painting in Holland nothing is known to us between the Antwerp "Calvary of Hendrik van Rijn" of 1363 (fig. 103) and the engaging but distinctly provincial Hague Portrait of Lisbeth van Duivenvoorde of 1430 (not strictly speaking a panel, but a painting on vellum mounted and framed),[1] except for the rather problematic memorial tablet of the Lords of Montfoort in the Rijksmuseum at Amsterdam which may be dated about 1390.[2] We possess, however, a number of "pre-Eyckian" panels executed in the Netherlandish-German borderline zone on the lower Meuse and lower Rhine; and these few panels form a striking contrast to those produced in Flanders and the Hainaut which, by comparison, give the impression of *imagerie populaire*. With the exception of such court painters *in partibus* as Melchior Broederlam, it was in Guelders and the Limbourg, the former apparently pervaded by an especially rarified cultural atmosphere, rather than in the future centers of the Flemish efflorescence, that panel painting came closest to the aristocratic ideals of the French and Franco-Flemish production.

One of the most accomplished and sophisticated works of panel painting in the pre-Eyckian Netherlands is a small folding altarpiece of *ca.* 1415, now treasured in the van Beuningen Collection at Vierhouten near Amersfoort (figs. 106, 107).[3] Opened, it catches the eye by the graceful elaboration of its very frames, whose outer strips are decorated with a painted ornament of foliated stems and pine cones, while their inner grooves or chamfers are set with carved rosettes, originally an architectural motif that was adopted by *ivoiriers*, sculptors and painters alike.[4] The central panel is organized by a simulated Gothic architecture adorned with statues of Prophets, Apostles and angels after the fashion of Broederlam but in the workmanlike naturalism of its mighty piers, its moldings, capitals, pinnacles and crockets anticipating the church interiors of Jan van Eyck. Divided into three vertical sections each of which comprises two storeys, the central panel shows in the lower storey of the middle section the Man of Sorrows supported by two angels and, in the upper storey, the Saviour and the Virgin Mary enthroned beneath a gorgeous twin canopy of stone. In the lateral sections are seen, in the upper left, St. James the Less and St. Peter; in the upper right, St. Paul and St. Andrew; in the lower left, SS. Servatius and Lambert; and in the lower right, SS. Martin of Tongres and Remaclus. The wings, divided only horizontally, show, in the lower zone, the four Fathers of the Church and, above, two groups of saints while single saints in half length look down from a kind of balcony in the top piece. On the left we have SS. Magdalen, Dorothy, Agnes, Barbara and Catherine surmounted by St. Lawrence; on the right, SS. Anthony, Benedict, Leonard and Giles surmounted by St. Stephen. The exterior of the wings is less elaborate, the panels being framed by flat, unadorned ledges. The lower tier exhibits a series of ten standing figures; the four Evangelists, led by St. John the Baptist, on the left; SS. James the Great, Denis, Hubert and Vincent, led by St. Michael, on the right. The upper tier is occupied by an elegant and dignified Adoration of the Magi; and the top piece by the Annunciation.

The style of this altarpiece has been characterized as "mi-Parisien et mi-Rhénan,"[5] and

not without reason. While the naturalistic attitude of Netherlandish art asserts itself in the treatment of the architecture and in a careful attention to surface texture, the elegance and poise of the figures recall the Master of 1402 and even the Boucicaut Master. The wide-spaced alignment of the figures in the Adoration of the Magi and the decorative, linear treatment of woven patterns, ecclesiastical accouterments and hair are, however, German rather than either French or Flemish; and the facial types — such, for instance, as the curly-haired, pertly innocent angels with their small mouths and pointed little noses — may remind us of the contemporary Cologne masters, of Master Francke (active at Hamburg, but probably a native of Guelders) and most particularly of Conrad of Soest.

The environment in which this remarkable synthesis of the Flemish, the Parisian and the Germanic was achieved can fortunately be established on hagiological grounds. While the inclusion of St. Denis may be interpreted as a tribute to Royal France, all the other special saints conspicuously honored are especially connected with the Meuse valley: St. Hubert is the patron of Liége; St. Martin was the seventh bishop of Tongres, only about twelve miles to the southwest of Maastricht; and SS. Lambert, Servatius and Remaclus (the first-named, in addition, sharing the patronage of Liége with St. Hubert) are titulary saints of Maastricht itself. It is, therefore, in or near Maastricht that the origin of the van Beuningen altarpiece must be sought.

The phrase "mi-Parisien, mi-Rhénan" may also be applied, with some qualifications, to four delightful panels now divided between the Mayer van den Bergh Collection in Antwerp and the Walters Art Gallery in Baltimore (figs. 108, 109).[1] Correctly reconstructed, these four panels — two of them painted on both sides — constitute a quadriptych. On the exterior are seen the Baptism of Christ and St. Christopher, each in an elaborate landscape; the interior, reading from left to right, exhibits the Annunciation, the Nativity, the Crucifixion and the Resurrection. The two pictures in the center, more symmetrical in composition than the two others, are held together by the segmented glory that occurs in both; a cross reference from the extreme right to the extreme left, on the other hand, is given in that both the "Annunciation" and the "Resurrection" contain the figure of God the Father displaying a book inscribed with the phrase "Alpha et ω," the First and the Last. Needless to say, the recurrence of this inscription expresses what has often been cited as a favorite concept of the period, the contrastive correlation of the Infancy with the Passion, the beginning with the end.

Iconographically, the Baltimore-Antwerp quadriptych is full of unusual, in part apparently original ideas. Sanctioned by Giotto's fresco in the Arena Chapel, the submissive gesture of the Annunciate — hands crossed before her breast — was very popular in the Italian Trecento and widely accepted in Spain and Bohemia. In Northwest European painting, however, it was unusual thus far, and the idea of inscribing the Virgin's answer to the Angelic Salutation ("*Ecce* ancilla domini") on the pages of a book seems to be derived from one of the numerous Trecento pictures in which she reads the prophecy of Isaiah ("*Ecce* virgo concipiet"). The interpretation of the "Nativity" appears to be unique in that St. Joseph has taken off one of his stockings and seems to be cutting it up with a knife, perhaps in order to convert it into a covering for the nude Infant Jesus, and the haloed midwife protects her wonderful brocaded

dress by an apron. St. Christopher, knee-deep in fish, beckons to the Christ Child (Who is gathering fruit on the far bank of the river) instead of carrying Him across as was the usual thing.[1] The "Crucifixion," finally, differs from all comparable interpretations of the scene in that the dying Christ, normally represented as the patient sufferer, pathetically lifts His head while from His mouth proceeds a scroll inscribed: "Eloy, Eloy, lama sabatani." I have no doubt that the selection of this moment of despair was inspired, not by the Gospels themselves but by their hauntingly graphic paraphrase in the *Revelationes* of St. Bridget (IV, 70): "Vocem ex ymo pectoris, erecto capite, oculis in celum directis et lacrymantibus, emisit dicens 'Deus, Deus, lamma sabachthani' " ("Deeply from His breast, raising His head, His weeping eyes turned heavenward, He gave a cry, saying 'My God, my God, why hast thou forsaken me?' ").

Stylistically, the six little pictures appear to be somewhat earlier than the van Beuningen altarpiece (say, about 1400–1410); but they are no less exquisite in execution and no less complex in derivation. The direct or indirect influence of Broederlam can be sensed in the posture and expression of the Annunciate, in the facial type of the St. Joseph in the "Nativity" (which may be compared to that of the St. Simeon in Broederlam's "Presentation"), and in the treatment of foliage and brocaded fabrics — not to mention the Hermit in the Christopher scene, drinking from a jug as Broederlam's St. Joseph drinks from his canteen. The drapery motifs, the architecture of the Virgin's throne, and the general aura of sophisticated refinement bespeak the master's familiarity with the miniature tradition established by Bondol and Beauneveu and culminating in the earlier works of Jacquemart de Hesdin. Other features, however, such as the elongated proportions, the wiry hair of the angels and the Infant Jesus in the Christopher scene and the unbalanced movement of the Resurrected Christ are again reminiscent of German art; and the segmented glories in the "Nativity" and "Crucifixion" are closely paralleled in paintings by Conrad of Soest and his school. There is, unfortunately, no iconographic evidence as to the provenance of the Baltimore-Antwerp quadriptych. But its style would seem to indicate a place of origin a little north of that of the van Beuningen altarpiece, more likely than not in Guelders.

Even where the technical execution of a picture assignable to this general neighborhood is somewhat less refined, we sense the spirit of the International Style. What I have in mind is the charming Nativity of *ca.* 1410–1415 which not so very long ago passed from the Figdor Collection to the Deutsches Museum at Berlin (fig. 110). In it, the Germanic quality discernible both in the van Beuningen altarpiece and the Baltimore-Antwerp quadriptych is so much more marked that its origin has been thought to be Upper rather than Lower Rhenish.[2] While I cannot subscribe to this hypothesis for both stylistic and iconographic reasons (apart from the fact that the picture is painted on oak), I would agree that a certain roughness of style, especially evident in the stringy hair, the graphic treatment of ornamental patterns, and the profusion of gold, suggest a region closer to Germany in the narrower sense of the word than was the Meuse valley, such as, for instance, Northern Guelders or the Duchy of Cleves. Yet there is about the picture a feeling for aristocratic elegance contrasted with quaint and homely detail

which permits us to describe the style of the little masterpiece as court art seen through the temperament of *art populaire*. The Virgin Mary, holding a bowl of soup in her left hand, is somewhat insufficiently protected by a rustic shed, the thatched roof of which is being repaired by three angels. Pious shepherds look in over the wattle fence, a very modern Italianism, thus far known to us only from the nearly contemporary Nativity in the *"Très Riches Heures"* (fig. 81).[1] The Infant Jesus has escaped from eating His soup and flees to St. Joseph who, seated at his workbench, holds out a flower to Him. In the foreground, a midwife prepares His bath, and a kettle of water is heated by two angels fanning the fire on a hearth backed by stepped brick masonry, a curious contrivance anticipating our open-air grills. The Virgin, however, rests upon a beautifully brocaded mattress (placed directly on the ground as in the Baltimore-Antwerp quadriptych and a Guelders book illumination of *ca.* 1420–1425).[2] An angel places a linen-covered pillow behind her; the Christ Child's bathtub is enclosed by one of the earliest and most elegant shower curtains in history, and the water is carried by angels from an ornate golden fountain.

As in Broederlam's "Flight into Egypt" this wealth of amusing detail is not devoid of symbolic significance. The patching of the roof, so natural in view of the Holy Family's predicament, may yet allude to the notion that the structure of the visible Church can never be completed and is in constant need of repair; and that the bath water is brought from what is obviously meant to represent the Fountain of Paradise is certainly a reference to the age-old belief that the first bath of the Christ Child is a symbol of baptism. But the form in which the symbolism has taken shape, this combination of *genre rustique* and fairy-tale-like splendor, is the very signature of the International Style.

II

The few surviving panel paintings and murals produced in the South and West of the Netherlands about or shortly after 1400 are very different in character. In them, the courtly tradition of French and Franco-Flemish art is almost entirely disregarded in favor of a resolute naturalism which at times verges upon caricature, and this tendency toward down-to-earth directness at the expense of refinement can be observed even in the immediate following of Broederlam. The fine Madonna in half-length from the Beistegui Collection, now in the Louvre, manifestly influenced by his Dijon altarpiece, retains some of its qualities and even enhances them by an admixture of Sienese prettiness in the rendering of the "Bambino."[3] This Madonna, however, was probably executed in Burgundy rather than in Flanders. The style of Broederlam's local following is exemplified by a series of Infancy scenes (Nativity, Presentation, Adoration of the Magi, Massacre of the Innocents, and Flight into Egypt) in the Mayer van den Bergh Collection in Antwerp (fig. 111).[4] Painted on the exterior of four shutters which enclosed a small statue, these little pictures are evidently based upon Broederlam in general composition as well as details, but show his polished idiom translated into the language of unassuming simplicity. Landscape and architecture are reduced to

a minimum. The modeling, energetic and somewhat coarse, would strike us as a throwback to Jean Bondol and Beauneveu were it not for the fact that this very broadness has new pictorial implications. The figure style pretends to robust characterization rather than elegance; Herod and his sinister cronies are wicked rather than picturesque. In the "Flight into Egypt," the idyllic is suppressed in favor of the grim and lonely by the elimination of scenery, and the Virgin Mary, huddled upon the donkey, her face entirely veiled, turns away from the beholder. The "Nativity" is in some ways similar to the little Lower Rhenish picture in the Deutsches Museum whose author may have borrowed from a similar composition the mattress-and-shed combination, the pious shepherds (here placed behind the Virgin's couch and possibly the earliest representatives of their kind in Northern art), and the motif of fanning the fire (this action here being performed by St. Joseph). But in the Mayer van den Bergh "Nativity" there are no angels, no midwife, no glamorous accessories, and no golden fountain. Two decades later, in 1420, the school of Ypres had degenerated into plain provincialism as evidenced by the Madonna of Yolande Belle.[1]

What is believed to be Brabantine painting of about 1400 is represented by a panel in the Musée Royal at Brussels, in which three scenes from the Life of the Virgin (the Meeting of Joachim and Anne at the Golden Gate, the Birth of the Virgin, her Coronation and the Presentation of Christ) are arrayed in friezelike sequence (fig. 112).[2] Like an "Entry into Jerusalem" recently discovered on the walls of St.-Quentin in Tournai and now transferred to the Musée d'Histoire et d'Archéologie,[3] the compositions lean heavily upon Italian models. But these are interpreted in a spirit of sturdy bourgeois naturalism. The figures are stockily built and energetically modeled; design and color are rather heavy; and the still-life features of the birth chamber are elaborated with an obvious attempt at workmanlike verisimilitude. It is significant that the brass pitcher seen in such Italian representations of the Birth of the Virgin as that by Paolo di Giovanni Fei in the Accademia at Siena[4] is conscientiously replaced by a handsome piece of indigenous *dinanderie* which, incidentally, will assume some importance in a later context.[5]

The local style of Bruges, finally, is represented by the well-known "Calvary of the Tanners" in St.-Sauveur (fig. 113) which shows the Crucifixion between the fluffy-haired SS. Catherine and Barbara, both these flanking figures emerging from simplified little buildings as did the actors from their *Stände* ("stalls") in the late-medieval mystery plays.[6] The guilds being largely responsible for the *mise-en-scène* of these sacred performances, the "Calvary of the Tanners" may well have borrowed its arrangement from the stage. Fluid and rough in technique, compressing the figures beneath the Cross into two crowded groups, this panel lacks sophistication and dignity, especially when compared to the statuesqueness and poise of a "Calvary" such as the mural in Amsterdam, originating from St. Walburg's at Zutphen in Guelders,[7] where even wall painting — normally given to a rather rough-and-ready style — attained a high degree of perfection. But it is noteworthy that in the "Calvary of the Tanners" Flemish naturalism takes a psychological turn. The painter aims not so much at "beauty" as at emotional intensity. The motif of the *svenimento* (the Virgin swooning in the arms of St.

John) is made real and human by his gesture of holding her hand, and the mild and thoughtful Centurion is sharply contrasted with a deeply moved but slightly brigandlike Longinus.

Expressive though it is, the "Calvary of the Tanners" is tame as compared to a nearly contemporary triptych, recently acquired by the Art Institute at Chicago, which shows a Crucifixion flanked by two horizontally divided wings, the left one depicting, above, St. Anthony tempted by two she-devils and, below, St. Christopher; the right one, St. James the Great and, below, St. George.[1] In this triptych the propensity for crowded composition and drastic characterization has grown to truly horrifying proportions. The "Crucifixion" is packed to the point of breathlessness. The St. Christopher with his distorted posture, wide mouth, long beard and bulbous nose looks like "Rübezahl" in the fairy tale rather than a saint; and the Centurion, instead of conversing with the faithful Longinus, is addressed by a weirdly caricatured soldier made still more sinister by his shieldlike ear-guards, while two only slightly less repulsive characters, one with rings in his ears, lurk in the background. Of the various attributions proposed (Flanders, North Brabant and Westphalia) the first seems preferable to me because of the triptych's affinity to book illuminations demonstrably produced in Bruges;[2] but the attribution to North Brabant is not ununderstandable. Wherever its place of origin, the triptych anticipates the horrors of Jerome Bosch.

The basic difference which thus can be shown to exist between the style of the northern and eastern Netherlands and that of the South and the West does not exclude the existence of equally basic affinities. True, the genteel refinement of such Mosan works as the van Beuningen altarpiece and the Baltimore-Antwerp quadriptych has no equivalent in Flanders, the Hainaut or the Artois; but the homely naturalism of the Brussels "Scenes from the Life of the Virgin" is not entirely foreign to the North and the East. And the psychological expressionism of the "Calvary of the Tanners" or the Chicago triptych has, as will shortly appear, its parallel in a graphic expressionism, relying on a dramatization of linear movement rather than of human character, which we are wont to consider as specifically Germanic.[3] Moreover, throughout the Netherlands the subsoil of civilization remained bourgeois and provincial; and, in contrast to France, a considerable amount of artistic activity was still centered in monastic communities rather than secular workshops.[4] Thus, even in the North and East such highlights as the van Beuningen altarpiece and the Baltimore-Antwerp quadriptych stand out against the shadow of an average or even sub-average production (especially in the field of mural painting which always tended to fall behind the more brilliant and flexible media in fourteenth- and fifteenth-century art north of the Alps). On this average or sub-average level of taste and proficiency, pre-Eyckian art was more or less alike throughout the Lowlands; but the fact remains that the Northeast alone was capable of transcending this level, if only in the exceptional milieu of the Meuse valley which was the homeland of Jean Malouel, the Limbourg brothers, and the van Eycks.

More sculpture and panel painting has been lost in the Netherlands than even in France; that anything is left of Jacques de Baerze's and Broederlam's work is solely due to the fact that some of it escaped from the traditional military and religious battleground of Europe to the comparative safety of Dijon. Thus all our theories as to the regional characteristics of pre-Eyckian painting would rest on shaky ground could they not be corroborated and supplemented by drawing on the richer and clearer source of book illumination. Netherlandish manuscripts have fortunately survived in fairly large numbers and their provenance — ranging from as far north as Holland to as far west as the Artois — can often be determined, if not by inscriptions, at least on linguistic, heraldic or liturgical grounds. Not many of these manuscripts are great, inspiring works of art, and none of them can rival the "Boucicaut Hours" or the "*Très Riches Heures*" in sheer perfection of craftsmanship. The supply of first-rate illuminators, it seems, was even more thoroughly drained by the demands of the French courts than that of first-rate panel painters. Yet these *exceptis excipiendis* unspectacular manuscripts, apart from reflecting many an archetype forever lost in the original, bear witness to an artistic activity that had its virtues as well as its faults and fulfilled a definite historical function.

In the last decades of the fourteenth and at the beginning of the fifteenth century, the style of Flemish book illumination was largely rooted in a tradition exemplified by the "Ghent Missal" of 1366 (fig. 22)[1] and, on a higher level, by Jean Bondol and André Beauneveu. How this "tradition of the 'sixties," superficially modernized and, at the same time, somewhat coarsened by the indigenous proclivity for broad, pictorial treatment, was transmitted to the Northeast is illustrated by a *Sermones Dominicales* most probably produced at Maastricht in 1370, preserved in the Royal Library at Copenhagen.[2] In Holland it is first represented by a copy of Jacob van Maerlant's *Bible in Rhymes* (now in the Royal Academy of Amsterdam) which I should like to date towards 1400 rather than in the penultimate decade of the fourteenth century.[3] This is followed by a group of four manuscripts that can be assigned to the first lustrum of the fifteenth century. First, a gigantic Bible (completed in 1403 by a scribe named Hendrik of Arnheim, perhaps illuminated in the Carthusian monastery of Bloemendaal or "Nieuwlicht" near Utrecht and now preserved in the Bibliothèque Royale at Brussels) which contains only one miniature at the beginning of Maccabees, quaintly depicting a septuagenarian Alexander the Great on his deathbed as he divides his realm among his five successors (fig. 114).[4] Second, three profusely illustrated copies of the *Tafel van den Kersten Ghelove* ("The Table of Christian Faith"), an edifying encyclopedia composed by Dirc van Delft, the Dominican court chaplain of Albrecht of Holland, and completed prior to the latter's death on December 12, 1404. The best and earliest copy, showing the portrait and coat-of-arms of the Duke on fol. 1 v., is preserved in the Walters Art Gallery at Baltimore (fig. 115); two very slightly later and no less richly illustrated ones are in the Morgan Library (fig. 116) and in the British Museum (fig. 117).[5]

The miniatures in these four manuscripts — all historiated initials, not independent

rinceaux — Netherlandish simplification of French ivy leaf

peintures — have much in common. The modeling is broad and energetic and occasionally, especially at the hands of one of the two masters who shared in the illumination of the Dirc van Delft manuscript at Baltimore, attains a high degree of pictorial freedom. Linear perspective is treated with sovereign neglect, but there is often a strong sense of the outdoors. The narrative, though not too smooth, has an engaging naïveté and liveliness and at times attains to genuine pathos. One miniature in the London "Dirc van Delft," normally referred to as "The Man of Sorrows," is one of the most poignant presentations of Christ in the Winepress, the transverse beam of the Cross being interpreted as the head of a press the vat of which is formed by the sarcophagus. But nothing could be more delightful than the guileless way in which the more accomplished illuminator of the Baltimore "Dirc van Delft" condenses the whole work of Creation into the space of one initial, assigning special little islands to the archetypal images of fruit tree, winged fowl, beast of the earth and man. The grounds consist of plain burnished gold, a feature long obsolete in more progressive French and Franco-Flemish practice. The marginal ornament is composed of thick, lazy *rinceaux*, a typically Netherlandish simplification of the French ivy leaf which already occurs in the "Ghent Missal" of 1366 as well as in the Copenhagen *Sermones Dominicales* of 1370,[1] and these heavy *rinceaux* are playfully supplemented by unsubstantial flowers and feathery pen lines which tend to disintegrate into comma-shaped strokes.

Setting aside the anomalous case of the self-taught Cistercian Nicholas of Delft[2] (active in the Monastery of Marienberg at Ysselstein up to his death in 1415), whose exuberant calligraphy has the peculiar charm of such "modern primitives" as John Kane or Louis Vivie, the further evolution of Dutch book illumination was determined by the gradual assimilation of post-Bondol developments in France, the speed and effectiveness of this process varying with the gifts and inclinations of the individual artists. A *Commentary on the Psalms* of 1416 (Paris, Bibliothèque Nationale) does not differ too much from the Dirc van Delft manuscripts, except for the fact that its marginal decoration and its miniatures, still historiated initials on gold ground, show a slight increase in precision and articulation.[3] A real change, however, can be observed in a small group of Utrecht Books of Hours to which may be added, as an exceptionally fine example, a little-known Horae in the Walters Art Gallery at Baltimore (fig. 118).[4] In these a French and Franco-Flemish taste is felt in a more fluent narrative, more flexible figures and draperies, and subtler colors. The borders are lighter, now decorated with hair-thin, skimming *rinceaux*, now punctuated by scattered ornaments, and the entire treatment is soft and loose, at times attaining to real delicacy, at times degenerating into plain negligence.

Chief among the influences that brought about this change was that of Jacquemart de Hesdin. The London *Spieghel der Maeghden* ("Mirror of Maidens") of *ca.* 1415 — a manuscript which once belonged to the Convent of Our Lady in the Vineyard at Utrecht and may well have been illuminated by an art-loving nun rather than a professional — contains a "Madonna Teaching the Infant Jesus" (fig. 119)[5] which in composition and iconography palpably presupposes the "Madonna with the Writing Christ Child" on the first dedication

page of the "Brussels Hours." In style, on the other hand, this miniature is reminiscent of the school of Guelders as well as of Jacquemart de Hesdin, especially of the "Calvary" from St. Walburg at Zutphen. It was, in fact, through Guelders that the French and Franco-Flemish style was most effectively transmitted to Utrecht and its environments.

<div style="text-align:center">IV</div>

This assumption, apparently at variance with Guelders' situation to the east rather than to the west of Holland, but not surprising in view of what was said at the beginning of this chapter, is positively confirmed by two sumptuous and closely interrelated manuscripts which were produced for Renaud IV and his wife, Marie, née d'Harcourt et d'Aumale. Both were written and illuminated — one wholly, the other in part — in Guelders; but three of the four principal artists responsible for their decoration were to become the leading figures in the subsequent development of book illumination in Utrecht.

The Prayer Book — not, as often stated, a Breviary — of Mary, Duchess of Guelders, now preserved in the Staatsbibliothek at Berlin, was executed in the monastery of Marienborn near Arnheim (a house of the Windesheim Congregation of the Brethren of Common Life) and was completed in 1415.[1] The Breviary of the Duke, now in the Morgan Library, is arranged according to Carthusian use and was commenced before 1417. Probably written and in part illuminated in Monnikhuizen, a Charterhouse near Arnheim especially favored by Renaud and destined to be his final resting place, it was, however, unfinished at the time of his death in 1423 and was completed — apparently in Utrecht — not until about 1440–1445.[2]

When opening one of these volumes after having looked at the Dirc van Delft manuscripts or the "Mirror of Maidens" we feel as though entering the ballroom of the Ritz after a simple, wholesome dinner in the house of good friends. Historiated or — in the case of the Berlin Prayer Book — foliated initials vie with *peintures* in rectangular frames. The colors vary, according to the time and quality of execution, from subdued gaiety to dazzling brilliance. In the grounds plain gold gives way to tessellation, to diaper patterns or *rinceaux* and ultimately to naturalistic interiors and landscapes. The margins are embellished with three types of border not found in the Dirc van Delft manuscripts and their relatives. First, we find dense, crisp, sturdy *rinceaux* in which the customary ivy leaves are stylized into little Neptune's tridents, either golden or parti-colored; second, loose, airy arrangements of flowers, trefoils and droplet-shaped leaves lightly held together by pen lines, in part not unlike the ornaments of the Utrecht Books of Hours of 1415 to 1425; third, an intricate line-and-leaf pattern interwoven with "pseudoacanthus palmettes," large cyclamenlike blossoms often sheltering diminutive elves, and little human figures, sacred and profane.

The first two types of border[3] are found in the Prayer Book of the Duchess (fig. 120), and their divergence in style reflects an analogous difference in the style of the miniatures which they enframe. The crisp *rinceaux* with the "Neptune's tridents," the most archaic of the three systems, occur in the Calendar pages as well as in conjunction with no less than

eighty-eight miniatures. Of these, the eight Passion scenes on fols. 20–43 v. are executed by a superior artist whose style is distinctly Germanic. His figures, in all but two cases set out against flat decorated backgrounds, are large in relation to the frames and tend to be crowded into a kind of high relief entirely filling the space between the ground and the frontal plane. There is a certain preference for the pure profile view, and the drapery folds show a linear animation which produces a calligraphic and expressive rather than descriptive or pictorial effect.

The sixty-five miniatures on fols. 146–284 v. (most of them representing saints in groups of three) were supplied by assistants. Their style, however, evinces the influence of a second "illuminator-in-chief," easily recognizable by the fact that he employed the type of borders described as "loose and airy." He contributed the pictures of the months in the Calendar (which was originally not intended to be illustrated) and six large miniatures sharply distinguished from those of the "Passion Master," not only by their marginal decoration but also in style and by the very fact that they occupy the entire page: the tall Angel displaying the Sudarium on fol. 15 v.; the remarkable Last Judgment on fol. 18 v. whose circumstantiality anticipates the well-known panel from Diest in the Brussels Museum [1] and Stephan Lochner's monumental picture at Cologne; [2] the portrait of the Duchess on fol. 19 v.; and the last three miniatures in the volume (fols. 467 v., 475, 476 v.).

This second master, whose taste in ornament is so similar to that of the contemporary Utrecht Books of Hours, may well have been a Dutchman by birth. His approach, however, is as distinctly French and Franco-Flemish as that of the "Passion Master" is Germanic. In at least two cases his borders, however different in execution, presuppose the decorative system of the "Brussels Hours," and his fragile figures with tiny hands, almost diaphanous faces, small pouting mouths and beady eyes almost exaggerate the French and Franco-Flemish taste for svelte, attenuated elegance. It was, I believe, the Limbourg brothers' as well as the Boucicaut Master's ideal which he attempted to emulate; and as the Duchess is known to have exchanged presents with the Duc de Berry, [3] she may easily have been in possession of some manuscript illuminated by the latter's famous painters.

A *ne plus ultra* of aristocratic elegance — but also, it must be admitted, of aristocratic presumptuousness — is reached in the portrayal of the donatrix. The modish headgear and costume, with long, jagged sleeves and a train defying the limitations of the picture space, leave no doubt that the figure is indeed intended as a likeness of Mary, Duchess of Guelders. But she receives her Prayer Book from an angel instead of a terrestrial servant; the scene is laid in what is unmistakably the "garden inclosed" of the "Song of Songs"; a second angel carries a scroll inscribed with the intentionally ambiguous salutation "O mild Marie" ("O gracious Mary") which may refer to Marie de Harcourt et d'Aumale as well as to Mary, Mother of Christ; and God the Father, *personaliter*, dispatches the Dove to the scene. In short, the Duchess of Guelders is pictorially identified with the Queen of Heaven, and, more specifically, with the Annunciate. Perhaps this extraordinary picture was meant as a symbolical or allegorical prayer for offspring (which, however, failed to be granted).

The second master of the Berlin Prayer Book appears to have emigrated (or, if he was a Dutchman, re-emigrated) to Holland where he formed a considerable number of not overly talented pupils. His hand can be recognized in many manuscripts demonstrably executed at Utrecht, and it is from one of these manuscripts that he has received the name under which he is known to art historians. He has been christened the "Master of Otto van Moerdrecht" after a *Postilla in Prophetas* by Nicolaus de Lyra (still preserved in the Utrecht Library) which he illuminated for this cleric, a Canon of Utrecht Cathedral from 1412 and a monk in the Monastery of "Nieuwlicht" from 1423.[1] This "Moerdrecht Master" participated, not only in the illumination of the "Prayer Book of Mary of Guelders" but also, and much more extensively, in that of the "Breviary of Renaud IV," thus constituting a connecting link between the two manuscripts. His contributions are, however, distinctly inferior to such attractive miniatures as the "Last Judgment" or the portrait of the Duchess. In spite of his productivity — his hand can be recognized in seven manuscripts [2] — he was not a first-rate artist and his development was largely retrogressive. After the promising beginning in the "Prayer Book of the Duchess" his style consistently hardened and coarsened, his colors became garish rather than brilliant, his figures puppetlike, his faces downright dumb.

The inception of this process can be observed in the "Breviary of Renaud IV." Within this manuscript (figs. 121–126) the contributions of the Moerdrecht Master are sharply distinguished from those of another illuminator who, on account of his refinement and apparent progressiveness, is generally considered as the Moerdrecht Master's successor. It seems to me, however, that his pages look less "primitive" not because they are later, but because they are the work of a greater and more cosmopolitan artist. And I believe that he, and not the Moerdrecht Master, was the leading spirit in their joint enterprise.

This third illuminator, who had shown his mettle in a remarkable Missal executed for the Teutonic Order as early as 1415 (now in the Archaeological Museum at Zwolle),[3] is known as the "Master of Zweder van Culemborg" after the Bishop of Utrecht (1425 to 1433) for whom he illuminated a sumptuous Missal, now preserved in the Episcopal Seminary at Bressanone in the Tyrol,[4] and under whose reign he was to develop into the leading book illuminator of the episcopal metropolis. That he took part in the "Breviary of Renaud IV" from the very beginning is demonstrated by the fact that he is responsible for the initial page of the "Hours of the Virgin" which bears the Duke's coat-of-arms (fol. 427), as well as for the charming donor's portrait on fol. 324, showing Renaud before St. Nicholas. And that he, not the "Moerdrecht Master," established the layout of the whole manuscript is shown by an examination of the borders. These belong to that third type which I have described as an intricate line-and-leaf pattern interwoven with "pseudoacanthus palmettes," large cyclamen-like blossoms and little human figures — a type of ornament still absent from the "Prayer Book of Mary of Guelders" and an absolute novelty in North Netherlandish book illumination. It is impossible that the Moerdrecht Master, who in all his other works, including the Berlin Prayer Book, employs an altogether different, less sophisticated and much less modern kind of decoration, would have been the inventor of this elaborate system that makes its first

appearance in the Morgan Breviary; and a comparison between a border executed by the "Zweder Master" (such, for example, as fols. 427 v. or 428) and an analogous one produced by the Moerdrecht Master (such, for example, as fol. 260 v.) shows the latter as an unskillful imitator. What is vibrant and graceful on fol. 428 (fig. 121) becomes hesitant, even clumsy, on fol. 260 v. (fig. 122); and the same is true throughout the manuscript.

These very borders make it clear that the Zweder Master, prior to his activity for Renaud IV and Zweder van Culemborg, must have had firsthand experience with what was most modern in France, especially with the innovations of the Boucicaut and Bedford Masters. This is also evident from his narrative miniatures whose style is as advanced as that of the Moerdrecht Master is archaic; it is instructive to examine the little picture on fol. 387 v. in which the Zweder Master partly repainted a "Crucifixion" by the Moerdrecht Master, changing the Crucifix into the Brazen Serpent, replacing the figures of St. John and the Virgin by those of Moses and the Jews (a magnificent group freely repeated in one of the Zweder Master's later works), but merely retouching the cluster of Roman soldiers (fig. 123).[1] His taste in color is light and clear, almost subdued in comparison with the Moerdrecht Master's flamboyancy, his design accurate, his modeling unobtrusive yet carefully detailed, and his command of space remarkable. He makes skillful use of the "diaphragm arch" and handles perspective foreshortening with ease (see e.g. the "Judgment of Solomon" on fol. 265); and such landscapes as that in the "Sermon of St. John the Baptist" on fol. 81 v. (fig. 124) might almost be compared to those of the Boucicaut Master in depth, luminosity and poetry.[2]

In his later career — that is to say, from ca. 1430 — the Zweder Master even shows traces of Eyckian influence as in the "Adoration of the Magi" in a little Book of Hours formerly preserved in the Bum Collection at Kottbus (cf. fig. 127),[3] in the "Betrayal of Christ" in a Horae in the Walters Art Gallery[4] and, even more obviously, in a miniature added about 1430–1435, to the Paris Commentary on the Psalms of 1416[5] which shows the characteristically Eyckian motif of a circular, convex mirror. However, these influences did not basically change the nature of a style well formed as early as the beginning of the 'twenties.

In this respect the Zweder Master differs essentially from his chief disciple and follower who finally completed the "Breviary of Renaud IV" (just as he completed a beautiful Carthusian Missal in the Walters Art Gallery likewise commenced by his teacher).[6] This follower is known either as the "Master of Catherine of Cleves" (Duchess of Guelders from 1427) or as the "Arenberg Master," both these appellations being derived from a Book of Hours produced for this princess and forming part of the Duke of Arenberg's collection at Nordkirchen.[7] He was a member of the new generation for which the influence of the great Flemish panel painters had become central instead of peripheral. In his miniatures he emulates the unified lighting and perspective achieved in the panels of the great masters and their new drapery style, the fabric breaking into sharply lighted and deeply shaded angular forms instead of flowing in softly modeled curves. The seated Jonah in the Morgan Breviary (fol. 291 v., fig. 125) is a free variation on the St. John in the upper tier of the Ghent altarpiece. The kneeling Apostles in the "Ascension" (fol. 231) and the "Coronation of the Virgin"

(fol. 404 v., fig. 126) are almost literally copied after the two foremost Apostles in the "Adoration of the Lamb." A Book of Hours preserved in the Meermanno-Westreenianum Museum at The Hague and datable in 1438 [1] is similarly pervaded by Eyckian influence (fig. 128); and the "Arenberg Hours" itself abounds in literal copies after the Master of Flémalle and others (figs. 129, 130). Impatient in technique and *novarum rerum cupidus* in outlook, the evolution of the Arenberg Master is indicative of a period in which book illumination ceased to be creative. North Netherlandish art was overtaken by the development of panel painting in Flanders, and the short-lived supremacy of Guelders had come to an end. The negligently painted, multipartite altarpiece from Roermond, produced at the time of the "Arenberg Hours" but in general arrangement still reminiscent of early fifteenth-century "Passionstafeln," [2] is almost a sample card of quotations from the great masters of Tournai and Bruges.

It appears, then, that the Utrecht school of book illumination owed much of its outstanding position in the first half of the fifteenth century to an exchange of artistic ideas — and artistic personalities — with that of Guelders. And further evidence of this interrelation is found in a Book of Hours in the collection of Sir Sidney Cockerell at Cambridge, probably illuminated between 1415 and 1420, which, though written in Dutch and provided with a Utrecht Calendar, must have received its decoration and illustration in a Guelders workshop. [3] Some of its border *rinceaux* are nearly identical with those of the Berlin "Prayer Book of Mary of Guelders," "Neptune's tridents" and all; [4] and it contains a series of miniatures — scenes from the Passion and images of saints — so close in style and color to the work of the Berlin Passion Master (fols. 20–132 v.) that they have been ascribed to the same illuminator.

These miniatures are, however, preceded by a series of Infancy scenes in grisaille which show a very different though even more "Germanic" style and the author of which constitutes as strong a link between the school of Utrecht and the school of Guelders as does the Zweder Master. A few years after participating in the illustration of the "Cockerell Hours," he contributed, under the Zweder Master's leadership, a number of miniatures to the big Latin Bible in the Fitzwilliam Museum at Cambridge, illuminated at Utrecht from *ca.* 1425. [5] But a few years before, in about 1415, he had produced a charming Book of Hours, quite recently acquired by the Morgan Library from the collection of the Dukes of Arenberg, [6] which is so intimately related to one of the outstanding specimens of "Lower Rhenish" as opposed to "Dutch" book illumination that the affinity between the two manuscripts can be accounted for only by direct workshop tradition.

This specimen is a well-known Book of Hours, presumably of Guelders origin, which is preserved in the University Library at Liége and should be dated, I think, about 1405–1410 rather than, as is commonly assumed, about 1420. [7] In it, the linearistic expressionism which links the Berlin Passion Master to the Master of the Cockerell Infancy scenes — but in the latter's work seems to abate, by degrees, as his development proceeded from the "Arenberg-Morgan Hours" to the Cockerell manuscript and hence to the Cambridge Bible — reveals, as it were, its primordial force. A strangely violent spirit is felt in its very ornamentation. The

borders of the miniature pages are entirely dominated by a particularly aggressive-looking version, not unlike an Indian arrowhead, of that schematized, triangular leaf which other illuminators used only as spices should be used in cookery. And the telltale "Neptune's tridents" prevailing in the margins of the text pages are noticeably spikier than in the other manuscripts in which they occur and are connected by lines which look like barbed wire.

The same impassioned spirit sways the miniatures. The folds of the drapery curve and billow as if animated by a force within themselves. The movement of Christ bearing the Cross can be described only as violent. The Angel Gabriel in the "Annunciation" (fig. 131), resplendently arrayed in dalmatic, stole and cross-embellished diadem, seems suddenly frozen in a pose retaining the impetus of his flight, and the dais on which the figures are placed seems to tip over. In the "Last Judgment," almost invariably controlled by the principle of symmetry, the Judge is placed off axis, the Resurrected are represented in vehement action, made the more conspicuous by the fact that their number is limited to three, and the very *rinceaux* that decorate the ground contribute by their turbulence to the agitation of the scene. In the "Nativity," of course, a quieter spirit prevails (fig. 132). But even here excitement is provided by the emphatic stylization of hair and drapery folds, by the gesticulation of the midwife, and by the impulsive eagerness of the nursing Infant. Two small iconographic features deserve our attention. St. Joseph fans the fire on an open-air grill so similar to that on which an angel performs the same operation in the "Nativity" in Berlin that it corroborates this little panel's Lower rather than Upper Rhenish origin; and the ends of the front rafters of the shed are carved into the likeness of animals' heads. So far as I know this peculiarity occurs only in one other case, the "Adoration of the Magi" in Master Francke's altarpiece of 1424 (text. ill. 29). It has been hailed as proof of Master Francke's "Heimatssinn" under the assumption that he was born in or near Hamburg; it now turns out to be another argument for his provenance from Guelders.

Even the Liége Hours — somewhat *outré* and slightly unkempt in style though vastly superior to a somewhat similar but later and less exciting series of miniatures inserted into a Breviary in the Teyler Museum at Haarlem [1] — is by no means out of touch with the International Style the influence of which reached Guelders and vicinity not only through direct contact with France but also through South Netherlandish intermediaries — to speak exactly, through the intermediary of the only Flemish school tradition which had developed within the orbit of Melchior Broederlam and had thereby transcended the level of provincialism. The Liége Hours reveals this twofold influence in such iconographic details as the splendid vestments of the Angel Gabriel or the fabulous headgear of one of the soldiers in the Pilate scene, on the one hand, and, on the other, in the treatment and disposition of the frames and marginal *rinceaux* which would seem to derive from what we shall shortly encounter in manuscripts produced at Ypres.[2] And while the border decoration of the "Breviary of Renaud IV" was largely evolved from Parisian models, that of the "Arenberg-Morgan Hours," extremely varied and in part extravagant rather than delicate, presupposes the artist's familiarity with certain contemporary developments at Ghent.[3]

After the lapse of ten or fifteen years — say, about 1420–1425 — the linearism of the Liége Hours could fuse with the pictorialism of the Boucicaut school and produce a Prayer Book in the British Museum possibly made for Mary, Duchess of Cleves, the daughter of John the Fearless of Burgundy.[1] The style of this almost unnoticed manuscript can be described only as effervescent. The borders are literally peppered with leaves, little stars, pellets and prickled roundels connected with each other by the thinnest of pen lines; and the miniatures, though hastily and sketchily done, are full of life and wistful humanity. Several hands may be distinguished, and even the technical treatment of perspective varies between the antiquated herringbone scheme and the more modern type of convergence. Some miniatures, especially the All Saints picture on fol. 30 (fig. 133), retain the linear, by now old-fashioned, style of the "Liége Hours"; others show isolated Saints and Apostles closely akin to those in the "Boucicaut Hours" and the "*Grandes Heures de Rohan*" but animated by a spirit of good-natured neighborliness; still others, such as the pages with St. Christopher, St. John on Patmos, the Flight into Egypt, and the perfectly charming "Saint Susanna in Her Bath" on fol. 31 (fig. 134), exhibit broadly simplified, ultraimpressionistic landscapes, with trees like brushes and fields like blankets spread out on a lawn. Nevertheless these landscapes are evidently derived from those of the Boucicaut Master, and two of them are even embellished by his beloved swan. It is almost symbolic that in this Prayer Book such Lower Rhenish and North-Netherlandish worthies as St. Bavo, St. Hubert, St. Gereon and "St. Oncommer" appear side by side with such eminently Parisian saints as St. Geneviève and St. Fiacrius, the latter so foreign to the Low German scribe that he is addressed by "O sancte Fratre."

v

Pre-Eyckian book illumination in the South and West of the Netherlands differs from that in the North and East in a way similar to pre-Eyckian panel painting. Measured by French and Franco-Flemish standards, the "Flemish" production — for so it may be called for short in disregard of the finer distinction between Brabant, the Hainaut, the Artois, and Flanders in the proper sense of the term — represents a nadir where that of Guelders represents a zenith. But it makes up for lack of refinement by sincerity of feeling and power of imagination. Unpretentious to the point of rusticity, these miniatures — often nothing but pen, brush or pen-and-brush drawings rather than real "illuminations" — have qualities which may be likened to those of good hearty peasants' bread. They are pervaded and illumined by a sense of reality which spurns prettification and looks upon the lowly, the ugly and even the grotesque, not as a special stigma of inferiority or wickedness, but as a necessary element in God's creation.

A good way of getting the feel of this "*réalisme pré-Eyckien*"[2] is to examine a manuscript acquired by the Morgan Library in 1935 whose date and place of origin are firmly established. It was commissioned by Lubrecht Hauscilt (or Auschilt), Abbot of St. Bartholomew's at Bruges, and presented to him by the Duc de Berry on June 7th, 1403.[3] An astrological treatise

whose authorship is fraudulently claimed by one Georgius Zothori Zapari Fenduli, it is in reality a translation from the Arabic of the famous Albumasar (Abû Mâ'šar) whom the Middle Ages revered as a Prophet of Christ, considering him the Islamic counterpart of Virgil.[1]

The earliest illustrated copy of this illegitimate fabrication, a manuscript in the Bibliothèque Nationale, was produced in South Italy in the first half of the thirteenth century.[2] About a hundred years later, this manuscript was copied, in an altogether different style, not very far to the southwest of Bruges; and this High Gothic redaction of the South Italian original, now in the British Museum,[3] was the basis of the Morgan manuscript from which derive in turn three later, utterly unremarkable copies. We can thus observe a fascinating double transformation. The distant planetary divinities (we shall omit the images of the Zodiacal Signs and the so-called "Paranatellonta," viz., the constellations and parts of constellations that "rise together" with the Zodiacal Signs in the course of the year),[4] originally highly conventionalized, stately and faintly classicistic, emerge in the end as familiar, thoroughly human characters, now stolid, now pathetic, now very comical.

Mercury, the intellectual of the Greek and Roman pantheon, had already been changed from his classical aspect to a dignified scholar and musician in the Paris and London versions. But in the Morgan manuscript he appears as a decrepit, bald-headed professor, hooded and cloaked, busily reading with glasses on his nose; or, in his "exaltation," as an elderly composer, his bald head fringed by curly locks, listening to the inner voice with an absorption bordering on mild insanity (fig. 136). The Moon, depicted as the goddess Luna or Diana in the Paris manuscript, was changed in the London version to a vigorous man (which corresponds to ancient oriental, as opposed to classical, beliefs and also agrees with Germanic folklore as still reflected in the fact that the Moon is masculine in German), roaming the woods by way of allusion to her age-old connection with vegetation. In the Morgan manuscript, however, this relatively youthful and dignified figure has assumed the guise of a slouching old peasant, swathed in a rustic hood and carrying a trowel in the pocket of his shabby coat, his upturned, hook-nosed, hatchet face slyly evoking the idea of a crescent (fig. 137). If the spear, the last vestige of his glorious classical ancestry, were replaced by a "lanthorn," this strange pathetic creature might well serve to "disfigure or present the person of Moonshine" in *A Midsummer Night's Dream.*

Saturn, on the other hand, has real, melancholy dignity (fig. 135). The most unlucky and most puissant of the planets, at once a symbol of wisdom and sorrow, wealth and unrewarding toil, regal power and enslavement, he is depicted as a king deposed, his tragic face inclined with grief, his dual nature expressed by the contradictory attributes of sceptre and spade. But the taste for the grotesque again prevails in his "Mansions," especially in the Aquarius whose pug-nosed face somewhat resembles that of the musical Mercury.

The style and spirit of this manuscript are so distinctive that it permits us to locate two further groups of works in Bruges: the colored pen drawings inserted in a collection of religious treatises written in 1410 and now preserved in the Archive at Wiesbaden (fig. 139);[5] and

the charming miniatures, also executed in pen and water color, in a *Somme-le-Roy* now in the Royal Library at Brussels.[1] In the latter manuscript, dated 1415, the edge of the bitter humor pervading the Morgan "Treatise on Astrology" and the Wiesbaden drawings appears somewhat blunted by the civilizing influence of the International Style. But beneath a veneer of good manners we sense the rugged candor of the Morgan manuscript. The illustrations are still vigorous pen-and-brush drawings rather than meticulous miniatures. The Virtues and Vices, while vying with the Duchess of Guelders and the little ladies in the borders of the "Breviary of Renaud IV" in elegance of dress and deportment, have preserved a healthy Flemish chubbiness. The pudgy little children who listen to the prescripts of Prudence are characterized with the same straightforwardness, half sympathetic, half satirical, as are the peasants laboring (or not laboring) in the fields, or the two fierce fighters separated by a still fiercer Moses (fig. 140). The community that has congregated at the feet of the Saviour, the attitudes of its members ranging from quiet thoughtfulness to rapt attention and bitter re-morse, contains a number of figures no less trenchantly caricatured and no less intensely human than the Mercury, the Moon and the Aquarius in the Morgan manuscript; the Apostles, and even Our Lady herself, are no more idealized than are the "common people" at the foot of the hill (fig. 141). As late as 1430–1435, when Jan van Eyck had been established at Bruges five or ten years, the local school of book illumination produced such manuscripts as the London "Chess Book" whose hard-bitten burghers and weatherbeaten, thick-lipped peasants announce Pieter Bruegel.[2]

The spirit prevailing in other centers of the Southern and Western Netherlands was less consciously satirical but no less honest and direct than in Bruges. In a manuscript containing the works of the great mystic Johannes Ruusbroeck, the illuminators of Groenendael near Brussels, where he had lived, show us the master and an assistant in the idyllic setting of a garden shaded by a perfectly enormous tree, the former writing on a wax tablet, and the latter copying on vellum another tablet already inscribed.[3] A little later, about 1410, they represented his beloved follower, the good cook Jan van Leeuw, dividing his labors between efficient work in the kitchen and literary composition in his cell.[4]

The Artois produced, about 1400, the amazing *Pèlerinage de Vie Humaine*, preserved in the Bibliothèque Royale at Brussels, in which the events of the Passion and the imagery of the allegorical descriptions are visualized with an emphasis on the grotesque and the morbid even more trenchant than in the astrological treatise in the Morgan Library (fig. 138);[5] con-ceivably the spirit of the *"réalisme pré-Eyckien"* was here exacerbated by an influence from England. In a slightly later Artesian manuscript, an edifying tract called *Les Examples Moraux* or (from the stereotyped beginning of each gloss) the *"Ci nous dist,"* this pungency has given way to homely simplicity: its thirty-three little miniatures show the style of Jean Bondol adapted, if one may say so, to the requirements of the "poor in spirit."[6] The dumpy figures, their facial type somewhat akin to those in the Flemish contributions to the *Bibles Historiales* in the Bibliothèque de l'Arsenal,[7] move shyly or abruptly within a narrow frame, their haloes materialized into heavy spikes. The narrative is simplified to the extreme; even in

the "Last Supper" the number of disciples is reduced to eight (fig. 147), and in the parable of the man who had divided a tree among his four sons the tree itself is absent. But this very thriftiness permits — or, rather, forces — the beholder to concentrate on what the artist thought essential, the strength and warmth of human relationships. Nothing could be more touching than the humility of Our Lord as He enters Jerusalem on a pathetic, low-slung donkey, welcomed by a lone citizen awkwardly casting his palm (fig. 144). Nothing could be more moving than the spirit of the Nativity where all the customary incidentals are suppressed and nothing remains but the love of the Holy Mother and the embarrassed tenderness of St. Joseph (fig. 143). It is perhaps not by chance that the manuscript contains what seems to be, at this time and in this environment, a fairly isolated representation of the Appearance of Christ to His Mother (fig. 148).[1]

A similar spirit of humble piety and unvarnished simplicity permeates the title miniature of the *Riegle et Ordenance des Soers del Hostelerie Nostre Dame de Tournay*, saved from the ruins of the Tournai Library in May, 1940, where the three leading ladies of this charitable society are seen in adoration of the Madonna (fig. 149);[2] and in the chief example of the Tournai style towards the end of the fourteenth century, a delightful Book of Hours in black and white now in the Bibliothèque Nationale (figs. 145, 146).[3] Its small grisailles present sacred events with the same naïveté and sincerity as do the miniatures in the "*Ci nous dist.*" The Saviour approaches the Gates of Hell in almost casual fashion while the devil attempts to get hold of His cross-staff which is much too large in relation to the architecture; and in the interior of the infernal city a careful distinction is made between the believers about to be released and those who will forever steam in a gigantic cauldron hung from an adjustable pothook. St. John administers the Baptism with the aid of an earthenware jug even more solid than that which has excited comment in the Dirc van Delft manuscripts,[4] and the smiling Christ almost appears to play in the waves of the Jordan. In the borders, finally, the conventional ivy *rinceaux*, reduced to fragile pen lines, are supplemented not only by palmettelike motifs but also by sturdily naturalistic oak leaves and acorns.

The lightness of this marginal ornament curiously contrasts with the solidity of the frames surrounding the miniatures, and this is a phenomenon which deserves some attention. In all but one or two cases the Flemish miniatures produced between *ca.* 1390 and *ca.* 1420 are enframed by profiles meant to create the illusion of real wooden picture frames. In the "*Ci nous dist,*" the Brussels *Somme-le-Roy*, the "Rule of the Sisters of Tournai," and the Ruusbroeck manuscript, these simulated frames consist of plain, beveled strips, carefully shaded so as to give a plastic impression. In the Jan de Leeuw manuscript in Brussels, however, and much more conspicuously in our little Book of Hours from Tournai, they duplicate the elaborately carved "rosette frames" which we remember from the van Beuningen altarpiece. This little piece of make-believe playfully but eloquently typifies the Flemish respect for the materiality of things; and wherever we encounter a similar "rosette frame" in book illumination, we shall be safe in assuming either Flemish origin or Flemish influence.

It must be admitted that the Flemish book illuminations thus far considered can hardly

claim what connoisseurs call "quality"; but where, by a happy conjecture, their homespun immediacy allied itself to that "linearist expressionism" which flourished near the eastern border of the Lowlands, it could bring forth one of the great manuscripts of all times, the "Paris Apocalypse." [1]

As has been pointed out on a previous occasion,[2] this manuscript is the only genuine anticipation of Dürer's "Apocalypse." Never before had the entire content of Revelation been condensed into so small a number of pictures undefiled by script (the text being relegated to the versos); and never before had the multifarious elements of these pictures been organized into so unified an optical space, invested nevertheless with the phantasmagoric quality of a vision.

Of course, the Dürer of 1498 and the Netherlandish illuminators — it matters little whether or not the individual miniatures were executed by the leading master's own hand — of about 1400 are worlds apart, and there are differences in purpose as well as in style and technique. The miniatures, appropriately framed by gold and crimson bands of stylized clouds, are smaller (though similar in format) than Dürer's giant woodcuts. The number of illustrations is twenty-two as against Dürer's fourteen; and while Dürer printed the text without interruption, the "Paris Apocalypse" is carefully arranged in such a way that every chapter of the text — its length adapted to the size of the page by deletions or additions — faces the corresponding miniature. Where Dürer expected the beholder to absorb the sequence of pictures and the text as independent, continuous narratives, the illuminator still thought in terms of individual text-and-picture units.

Yet the internal analogy between the "Paris Apocalypse" and Dürer's woodcut series remains. In both cases the visionary effect is produced by a deliberate contrast between reality and unreality, the rational and the irrational. Figures and objects, taken separately, are invested with the semblance of real existence; but since their interrelation defies all laws of probability, the ensemble has both the sharpness and the madness of a dream. The space is simultaneously dominated by the rules of perspective (as far as they were known and understood at the time) and by the antiperspective principles of axiality and *horror vacui*. The plastic solidity of all forms is contradicted by an impassioned linearism; and owing to a profusion of white, applied not only for the purpose of modeling but also for the delineation of contours, the pictures seem steeped in an unearthly, pallidly glaring light.

An analogous contrast between wild fantasy and a kind of sober posivitism — to some extent inherent in the text but here exaggerated by artist's inventiveness — prevails in the construction of the narrative. The apparition of the Lord in Revelation IV becomes even more overwhelming by the fact that His "rainbow in sight like unto an emerald" is physically supported, as by a caryatid, by a gigantic, peacock-winged angel seen from the back. The dark predictions and imprecations of Revelation II and III turn into realities by the presence of amazing corpses and skeletons rising from their graves, and of sinners listening to the devil or fornicating in bed (fig. 151). In the illustration of Revelation VI, with its phantomlike horsemen and ghostly Hell Mouth, the door and turrets of a castle tumble down in realistic

fashion, and men and women are very literally "hiding themselves in the dens." The "smiting of the third part of the sun and the third part of the moon" (Revelation VIII) is drastically indicated by angular holes cut into the surface of these celestial bodies, and the verse "and the third part of the ships were destroyed" has given rise to one of the most convincing shipwrecks in art (fig. 152). The merits of the "servants of our God" in Revelation VII are exemplified by little genre scenes representing the Works of Mercy (*werken der gratien*), and their effect is illustrated by the figure of a man ascending to Heaven by means of a ladder. And when depicting St. John on "the isle that is called Patmos" the illuminator asks himself the very pertinent question of how the Saint ever got there, and answers it by adding the lifelike figure of a ferryman pushing his boat away from the bank on which he has deposited the visionary (fig. 150).

"To realize a vision in a work of art," if I may be allowed a self-quotation, "the artist has to fulfill two seemingly contradictory requirements. On the one hand, he must be an accomplished master of 'naturalism,' for only where we behold a world evidently controlled by what is known as the laws of Nature can we become aware of that temporary suspension of these laws which is the essence of a 'miracle'; on the other hand, he must be capable of transplacing the miraculous event from the level of factuality to that of an imaginary experience." [1]

Dürer accomplished this by subjecting both the particularizing pictorial naturalism of his master, Michael Wolgemut, and the generalizing, plastic naturalism of Mantegna and Pollaiuolo to the strict discipline of a severely graphic woodcut style developed under the influence of Martin Schongauer. The master of the "Paris Apocalypse" — and this makes his historical position in the Netherlands of *ca.* 1400 analogous to that of Dürer a century later — achieved a similar result by dematerializing, as it were, the earthy solidity of the *"réalisme pré-Eyckien"* in the heat of that expressionism which swayed the art of Northern Guelders. In his "Apocalypse," as in Dürer's, the visionary quality resulted from the fusion of two essentially divergent traditions.

Who this master was and where he worked is not known. On the horizon of his field of vision looms the great shadow of Jacquemart de Hesdin like the Brocken specter; the substitution of a naturalistic sky for gold ground, tessellation or the like, and the representation of angels and Elders as monochromes in blue or red clearly presuppose the "Brussels Hours." The substance of his style, however, is partly Flemish and partly Germanic. The illusionistic treatment of landscape features, the workmanlike description of architectural details and the forthright approach to human nature evoke the memory of Broederlam, the colored drawings in Wiesbaden and the Astrological Treatise in the Morgan Library; whereas the agitated violence of the design, from heads thrown back at a breakneck angle to corkscrew hair and "self-propelling" drapery folds, recall the style of the "Liége Hours." The figures of the Lord and the Evangelist on fol. 5 might be interpolated into this manuscript without creating a stylistic dissonance.

In view of this mixed ancestry the origin of the great master must be sought in a borderline district between the Southwest and the Northeast of the Netherlands, as likely as not in or

near Liége.[1] But he remains an isolated phenomenon. No other manuscript can be ascribed to him or to his workshop, and even his color scheme, with the ubiquitous white high lights, the gray or smoky-red skies and such rare tints as mauve and violet, has no analogy in contemporary book illumination. One would like to think of him, not as a professional *enlumineur* but as an artist normally expressing himself in the more monumental media of tapestry or panel painting. In fact the closest parallel to the style of the "Paris Apocalypse" is found in the much-debated "Weber Triptych," now in the Deutsches Museum at Berlin (fig. 153), which has been shifted from Paris to "Burgundy," and from "Burgundy" to the Diocese of Utrecht,[2] but might well be, if not an earlier work of the Master of the "Paris Apocalypse" himself, at least of an artist very close to him.[3]

VI

One family of manuscripts stands out, in style and workmanship, from the rank and file of Flemish book illumination in the same way that Melchior Broederlam stands out from the rank and file of Flemish panel painters; and, logically enough, this little-known but very important family is intimately associated with Broederlam's workshop. A typical representative of the group, a delightful Horae in the Library of Rouen,[4] shows in its decorative system an unmistakable similarity with the little Book of Hours from Tournai in the Bibliothèque Nationale. In the "Rouen Hours," the miniatures are also bordered by illusionistic "rosette frames" and the marginal *rinceaux* reduced to thin pen lines. But in an attempt to fuse these provincial motifs with the conventions of more stylish book illumination, the corners of the "rosette frames" are accentuated by large quatrefoils such as normally occur in conjunction with flat, ornamental bands, and the *rinceaux* are subtilized into feathery sprays, terminating in golden droplets and serrated lozenges, which issue, not only from the corners but also from the sides.

The pictures themselves are also much finer in quality and emphatically differ from the *cuisine bourgeoise* of the little Horae from Tournai; and when we examine the "Flight into Egypt" on fol. 53 v. (fig. 155) we perceive that it is directly derived from the famous "Flight into Egypt" in Broederlam's Dijon altarpiece. The setting is simplified and the miracles are omitted, in return for which the spirit of the wilderness is stressed by the addition of two Hesdinian animals, a bear and a monkey. But the general character of the scenery, with a steep mountain that even transcends the upper frame, is very much the same as in Broederlam's picture. The Infant Jesus is muffled in the Virgin's cloak in similar fashion; and the recurrence of such striking motifs as the overlapping of the main group by a sloping ledge of terrain and the St. Joseph drinking water from a canteen speaks for itself.[5]

Here, then, we have an atelier working in the direct tradition of Broederlam and, at the same time, familiar with that of Jacquemart de Hesdin. The "Annunciation" (fol. 13, fig. 156) combines an Angel Gabriel not unlike Broederlam's in posture, and holding a scroll of the same curling exuberance, with an Hesdinian Annunciate closely akin to that in the

"Brussels Hours" in every respect, only that the prayer book on which she places her left hand is inscribed with the beginning of the Magnificat. Even the tiny, almost disembodied angels that flutter about the borders of the dedication page (fol. 12 v., fig. 154) derive from Broederlam as well as from Jacquemart de Hesdin. The general idea of these angel-inhabited *rinceaux* comes from the *"Très-Belles Heures,"* but the little creatures themselves are patterned after Broederlam's. Sharp-pinioned, with the ends of their garments wiggling behind them like the tail of a tadpole, they are shorthand abbreviations of the angels in the top part of the Dijon altarpiece reduced to silhouettes.

One page of the "Rouen Hours" (fol. 94 v., fig. 158) shows a gigantic Holy Face hovering above a pretty garden containing an arbor on the left, a fenced-in tree in the center, and a polygonal stone enclosure on the right. It is hard to see the iconographic connection between this garden and the Holy Face; and the garden itself, peopled only by two diaphanous, almost invisible angels, gives a curiously lifeless and deserted impression. But these incongruities can be explained by a miniature (fol. 55 v.) in a related Book of Hours preserved at Carpentras.[1] Here we encounter an almost identical garden which, however, serves as a setting for a Madonna (with the writing Christ Child on her lap as in the "Brussels Hours"), enthroned between St. Agnes and St. Catherine (fig. 159); and here the garden, extending well behind the throne, is densely populated by haloed little figures engaged in making music, pruning trees and making wreaths. This composition thus represents a well-known and consistent program, the *Virgo inter virgines* in the Garden of Paradise, the beatified souls behaving exactly as they should according to such edifying poems as the *Pèlerinage de l'Ame* by Guillaume de Deguileville.[2] The inference is that the Carpentras manuscript, though somewhat inferior in quality, reflects a common workshop prototype more faithfully than does the "Rouen Hours." Therefore some confidence may be placed in the plastic details of its elaborate architectural frames; and since the statues that adorn the frame of the St. Christopher miniature in the "Carpentras Hours" (fol. 65 v.) show an unmistakable affinity to the Prophets in Broederlam's "Annunciation," a further link is established between the Rouen and the Carpentras manuscripts and Broederlam (figs. 163, 164).

The finest and earliest manuscript connected with the "Rouen Hours" has come down to us as a mere fragment consisting of three miniatures inserted into an unrelated Prayer Book in the Kunstgewerbemuseum at Frankfort-on-the-Main.[3] These three miniatures — representing St. Bernard with a kneeling donor (fig. 160), the Crucifixion and the Annunciation (fig. 161) — have the same "rosette frames" and the same feathery foliage interspersed with the same unsubstantial little angels. As the donor in the Rouen dedication page kneels upon a little plot of terrain protruding from the lower left-hand corner of the picture, so does the donor in the St. Bernard miniature — a Cistercian offering a scroll inscribed with a Flemish prayer — on a salient of the tiled pavement. The "Annunciations" are nearly identical in both cases, including the decorative elaboration of the angels' scrolls. The Frankfort pages, then, evidently belong to the same school as does the "Rouen Hours" but represent this school at a somewhat earlier and fresher phase of its development. Their illuminator follows more

closely in the footsteps of Jacquemart de Hesdin in figure and drapery style, and preserves a significant architectural detail which in the "Rouen Hours" had degenerated into a meaningless ornament. Here several scenes, among them the Annunciation and the Commendation of the Donor, are surmounted by a dark blue cloud composed of sketchy angels' heads. The flat design and simplified, archlike contour of this cloud suggest an architectural derivation, and the three Frankfort pages show indeed a real arch, elaborated into beautiful Late Gothic tracery, of which the clouds in the "Rouen Hours" are, so to speak, the shadow.

In spite of their general dependence on the Hesdin tradition, the Frankfort pages are no less intimately connected with Melchior Broederlam than are the "Rouen Hours"; and this is evidenced by a detail no less significant than the canteen of St. Joseph; the pavements are not laid out in simple alternation of light and dark tiles but in definite patterns, large squares in the St. Bernard picture, a swastika or meander pattern in the Annunciation. It is only in the Dijon altarpiece by Broederlam — the *ordonneur de carrelages* — that these patterns occur previous to the Frankfort miniatures, the large squares in the "Presentation of Christ," the swastika or meander pattern not only once but twice in the "Annunciation"; and it is only in schools directly or indirectly connected with the Broederlam tradition that the latter can be shown to persist.[1]

In addition to the manuscripts in Rouen and Carpentras and to the three pages in Frankfort, the group here under discussion comprises a considerable number of other Flemish manuscripts, for instance: a Book of Hours in the Bodleian Library at Oxford very similar to that in Rouen, though not as polished in execution (fig. 162);[2] three very small and somewhat negligent miniatures, inserted into a later Book of Hours in a private collection in Amsterdam,[3] which hold an intermediary position between the manuscripts at Rouen and Frankfort; a small and rather inferior Book of Hours preserved at Urbana, Illinois,[4] which is, however, derived from a model very close to the "Rouen Hours"; and — these two a little farther removed from the original source by an excessive elongation of the figures and a peculiar taste in color partial to cinnabar, orange and chrome yellow — a Missal at Tournai[5] and a Book of Hours in the Collection of Dr. Clowes in Indianapolis (fig. 165).[6]

In view of the pervasive influence of Broederlam this school may be presumed to have been located at Ypres. But it would seem that its relation with the Guelders tradition, already mentioned, was not entirely one-sided. When, for example, the "Last Judgments" in the Rouen, Oxford and Carpentras Hours resemble that in the "Liége Hours" not only in general composition but also in that the figure of Christ is placed slightly off axis, this deviation from the norm may strike us as more easily compatible with the Germanic expressionism pervading the Guelders manuscript than with the quieter spirit prevailing in the Flemish productions. And when the Rouen "Nativity" (fig. 157) shows our old friend, the open-air grill (figs. 110 and 132), transplanted to what is manifestly meant to be an interior, the floor elaborately paved and the Virgin's couch surmounted by sumptuous curtains instead of being sheltered by a rustic shed, the curious utensil looks a little out of place. In cases like these the Guelders

school — indebted, as we have seen, to Broederlam and the Broederlam tradition in several other respects — may well have exerted a retroactive influence on what we may tentatively call the "School of Ypres."

As to the dates of this Ypres group, a *terminus a quo* is established by the Broederlam altarpiece (1391–1392 ff.) while a *terminus ad quem* can be determined only on stylistic grounds and with the aid of datable derivatives. Taking these two factors into consideration, I am inclined to accept the general assumption that the Frankfort pages were executed about 1400, and to date the Rouen, Carpentras and Oxford Hours between 1400 and 1410. At about the same time the "Ypres School" can be seen putting forth new shoots in various other centers.

Perhaps the earliest and certainly the most interesting of these offshoots is found, curiously enough, in England. Here the Ypres tradition took root in two different ways. On the one hand, imported manuscripts were copied by English illuminators; a Sarum Horae in Cambridge,[1] for example, most faithfully reproduces what must have been a sister manuscript of the "Rouen" and "Oxford" Hours. On the other hand, Ypres-trained artists came over to England in person, engaged in many-sided activities and exerted a revolutionizing influence on the insular production.

The style introduced by these Continental artists sharply detaches itself from that of their native confreres in the fragments of a remarkable Carmelite Missal in the British Museum, written in London between 1387 and 1391.[2] What remains of it is a great number (about 1500) of large and small initials barbarically cut out by a misguided collector. The large, historiated initials fall into two sharply divergent groups, a third one holding an intermediary position between them. The first of these groups exhibits the style prevailing in England at the end of the fourteenth century, a style not unlike that of Meister Bertram and his school in its plastic rather than pictorial intent and its small interest in space (fig. 166). The initials of the second group enframe miniatures distinguished by a delicate pictorial modeling and by a command of perspective unparalleled in English book illumination at the time. They are as Continental as the others are insular, and an analogous difference can be observed in the decoration of the letters themselves, as well as in the marginal ornament (figs. 167, 169).

I quite agree with Miss M. Rickert — to whom the history of art owes a great debt for her brilliant reconstruction of the Carmelite Missal — in identifying the greatest champion of the new style, an illuminator formerly held to be an Englishman named Richard Herman, as a Continental artist whose real name was Herman Scheerre. I agree, however, with Mr. Charles L. Kuhn[3] in dating the appearance of this new style considerably later than does Miss Rickert. As in so many other instances, e.g., the "Breviary of Renaud IV," the execution of the Carmelite Missal must have extended over a number of years; its "Hermanesque" initials would be incomprehensible anachronisms not only in England but also on the Continent had they been produced before the first decade of the fifteenth century. I also agree with Mr.

Kuhn in considering Herman Scheerre as a Fleming rather than a Dutchman or a German; but I should venture to say that "the objects which have a more direct connection with Herman Scheerre's style" are no longer "of unknown provenance." As will be seen, they can all be associated with the school of Ypres.

While the "Continental" initials in the Carmelite Missal were produced by artists trained by Herman Scheerre rather than by himself, his own hand can be recognized in the following manuscripts enumerated in a tentative chronological order but slightly different from Mr. Kuhn's:

1. A Book of Hours, executed for an unidentified client, in the British Museum;[1] *ca.* 1405.
2. A Book of Hours in the Collection of Mr. Eric G. Millar in London;[2] *ca.* 1405–1406.
3. A Book of Hours in the Bodleian Library at Oxford (discovered by Mr. Kuhn) which was produced, not before 1405, for a gentleman residing in York and may be called, to avoid confusion with the above mentioned "Oxford Hours," the "York Hours";[3] *ca.* 1406–1407.
4. The well-known "Chichele Breviary" in Lambeth Palace;[4] *ca.* 1408.
5. The "Beaufort Hours" in the British Museum;[5] datable between 1401 and 1411 and, in my opinion, not executed until *ca.* 1408–1409.
6. The so-called "Neville Hours" formerly in the A. Chester Beatty Collection at London;[6] *ca.* 1410.
7. A Bible in the British Museum, sometimes erroneously referred to as the "Bible of Richard II";[7] *ca.* 1410–1412,
8. A Psalter and Horae in the British Museum, executed for John of Lancaster, Duke of Bedford;[8] after 1414.

Among Herman Scheerre's collaborators a distinct, dynamic personality is recognizable in several pages of the "York Hours" as well as in the series of Saints in the "Beaufort Hours" to which Herman himself contributed only the beautiful dedication page (fol. 23 v.);[9] later, it seems, this "Master of the Beaufort Saints" returned to his native Flanders to play his part in the Continental development.[10] As for Herman himself, he signed his full name in what I believe to be his earliest known manuscript (No. 1); in three others he made such charmingly personal entries as "I am Herman, your owne seruant" and "Herman, your meke seruant"; and in no less than seven of his works one or more miniatures are inscribed with a Latin motto that may be regarded as a kind of trademark: "Omnia levia sunt amanti; qui amat non laborat" ("All is easy for one who loves; he who loves toils not"). Once, in the dedication page of the "Beaufort Hours" (fig. 174) this motto is followed by the words "de daer" which have given rise to some discussion and to a futile search for a family named "de Daer" while other scholars have proposed to interpret the "de" as an abbreviation of *Deus*. In my opinion the solution is much simpler. Since "d" between two vowels tends to be elided in Dutch and Flemish (as in "moer" for *moder*, "vaer" for *vader*, etc.), the phrase "de daer" is nothing but

a phonetically spelled *de dader*, which means "the doer" or "the author" — a perfectly reasonable addition to the artist's favorite sentiment.

To illustrate Herman Scheerre's connection with the Ypres school, we may begin with the very miniature that bears the inscription "Hermannus Scheerre me fecit," the picture of St. John the Evangelist in the anonymous Book of Hours in the British Museum (fig. 168).[1] In treatment, type and silhouette the gentle saint is a twin brother of the little Madonna in the initial of the Annunciation page in the "Rouen Hours" and the tiled pavement on which he stands repeats that of the Rouen "Annunciation" itself. The composition of this "Annunciation," moreover, recurs in nearly identical fashion in the same London manuscript (fig. 170);[2] in the "Chichele Breviary" (fig. 175);[3] and, with but minor variations, in the dedication page of the "Beaufort Hours."[4] Here the Angel Gabriel, for all his un-Flemish elegance, more faithfully retains the facial type, the pose and even the hairdo of Broederlam's than in any other known derivative of the Dijon altarpiece. Continental affiliations are also evident in other respects. While the Virgin's prayer book is inscribed with the "Ecce ancilla" as in the Baltimore-Antwerp quadriptych, the architectural framework — though generally conforming to a long-standing English tradition — is reminiscent of Tournai in its square-headed triforium, and of Ypres in its Broederlamesque Prophets' statues. In the marginal ornament English bluebells, rhombic leaves and fern sprouts vie with "Ypres sprays" terminating in serrated lozenges, and the character and placement of the donors' portraits recall the dedication page of the "Rouen Hours" as well as that of the "Clowes Hours" in Indianapolis.

Mr. Kuhn has observed that the St. Christopher miniature in the "York Hours"[5] is almost literally identical with that in the "Beaufort Hours" (fig. 173),[6] except that the latter includes the hermit and his little house. But it must be added that the common prototype of both — the ancestor of a long line of Continental St. Christophers — is reflected in the "Oxford Hours" (fol. 19 v., fig. 162) and, here with the hermit and his cottage, in the "Cambridge Hours."[7] "Rosette frames" occur in the "York Hours,"[8] the Horae in the Millar Collection,[9] and even in miniatures more remotely associated with Herman Scheerre such as the author's portrait in Thomas Occleve's *De regimine principum* in the British Museum.[10] The influence of the Ypres tradition is also apparent in the "Carmelite Missal." Figures such as the St. Louis (fig. 167) (formerly mistaken for King Richard II of England)[11] or the St. Martin[12] bear as outspoken a family likeness to the chivalrous St. George in the Rouen dedication page as does the St. John in Herman's London Book of Hours to the little Rouen Madonna. And the Missal contains no less than three examples[13] of those swastika or meander pavements which, as has been pointed out, derive from Broederlam's *carrelages* and at this early date cannot be found outside the Ypres group at all. As these patterns occur in the company of marginal ornament composed of "Ypres sprays" (fig. 169), the origin of the "new style" in English illumination is all the more evident.

This, of course, is not to say that Herman Scheerre was nothing but an Ypres artist in exile. As we have seen, the dedication page of the "Beaufort Hours" exhibits insular features together with Continental ones. But it reveals the additional influence of the Parisian school

— quite naturally in view of the then close relationship between the London and Paris courts — in the delicately diapered background, the beautifully embroidered cover of the Virgin's *prie-dieu* and the brocaded cloth of honor with its shade-filled canopy. Parisian influence is evident in many other ways and places, for instance in such enchanting interiors as the birth chamber of the Virgin in the "Carmelite Missal";[1] and Herman Scheerre's last known work, the "Psalter and Horae of the Duke of Bedford" (which must postdate 1414 because the owner is already addressed by his ducal title) shows the illuminator succumbing to the spell of the Boucicaut Master. He depicts the Annunciate praying before the altar of a vaulted chapel with a cushion to kneel on (fig. 176),[2] and in such landscapes as the one in the "Anointing of David" he even adopts the Boucicaut Master's hilly backgrounds and starry skies (fig. 177).[3] However, the varied threads that went into the fabric of Herman Scheerre's style produced a result unparalleled not only in the British Isles but also on the Continent. Like Holbein and van Dyck he belongs among those Continental artists whose native style attained a smooth, cool, brilliant perfection under the velvet-gloved discipline of the English court.

It was from this Anglicization of both the Flemish and the French traditions[4] that also resulted the much debated Wilton diptych in the National Gallery which may be said to transplant the style of Herman Scheerre and his associates to the exacting medium of panel painting (fig. 181). Showing as it does King Richard II commended to Our Lady by St. John, St. Edward and St. Edmund, it was and is commonly held to antedate the King's deposition and death in 1399; some scholars even maintain the impossible date of 1377.[5] It seems, however, that Mr. William A. Shaw and Professor Galbraith are absolutely right in thinking that we are faced, not with a portrait of the living Richard, but with a posthumous memorial glorifying his entry into Paradise (hence the eleven angels, wearing the King's badge and collar of the Broomcod, and the sweet, welcoming gesture of the Christ Child). In all probability the diptych was commissioned by Henry V who professed for Richard II a veneration equal to that for his own father, and, in addition, had a strong political motive to stress the fact that a King believed by many to be among the living was in reality dead. It was for this twofold reason that Henry V, some time after his accession in 1413, caused the body of Richard II to be translated from King's Langley to Westminster Abbey, and it was probably in commemoration of this solemn event that the Wilton diptych was ordered.[6] Its special connection with Westminster will, it is to be hoped, be expounded by Mr. Francis Wormald.[7]

VIII

On the Continent the mantle of the Ypres tradition descended upon the School of Ghent. Little is known of it between the year 1366, when the Missal of Arnold, Lord of Rummen and Quaebeke was executed, and the second decade of the fifteenth century.[8] But we reach firm ground with a charming Book of Hours in the Bibliothèque Nationale which was written and illuminated for John the Fearless of Burgundy and must thus antedate his violent death

in 1419.[1] That it was owned by this prince is demonstrated by the miniature on fol. 172 v. which shows the patron saint of Burgundy, St. Andrew, accompanied not only by the ducal coat-of-arms but also by the defiant personal device of John the Fearless, the "plane" with which he proposed to shave the "knotted stick" of his great foe, Louis of Orléans. That it was produced in Ghent is implied by the inclusion of St. Bavo, St. Amelberga and St. Pharahildis in the litanies, and positively proven by its stylistic kinship with two slightly later and closely interrelated Books of Hours, preserved in the Walters Art Gallery at Baltimore, both of which can be assigned to Ghent on direct evidence. One was produced for a prominent Ghent patrician named Daniel Rym, who died in 1431;[2] the other still has its ancient binding fashioned by Joris de Gavere in Ghent.[3]

These three manuscripts, ranging from 1410–1415 to *ca.* 1425, are tied into a close-knit group not only by a general affinity in temperament — a "sweetly sad," soft-spoken gentleness which manifests itself in the interpretation of the narrative as well as in the choice of color — but also by definite details and idiosyncrasies. The content of the pictures tends to spill over into the borders[4] which, if decorated with floral ornament, employ a similar botanical vocabulary, and in the "Hours of John the Fearless" and the "Daniel Rym Hours" include amusing drolleries not unlike those in the "Breviary of Renaud IV." In the few cases in which a naturalistic sky is attempted, the "Hours of John the Fearless" as well as the Horae bound by Joris de Gavere exhibit a very unusual stippling technique whereas the "Daniel Rym Hours" boasts an occasional sky in the Boucicaut manner. In the Nativity page of the "Hours of John the Fearless" (fig. 182)[5] and in the SS. Anthony and Christopher page of the "Daniel Rym Hours" (fig. 187)[6] we find a perfectly identical degeneration of the conventional corner quatrefoils into enormous bulges surrounded by a "border engrailed" and filled with foliate ornament. And the fantastic border of dragons, lions' heads and ivy *rinceaux* which surrounds the St. Bartholomew in the "Hours of John the Fearless"[7] recurs in very similar form in the Flagellation miniature in the "Daniel Rym Hours."[8]

As evidenced by the appearance of naturalistic skies and line-and-leaf borders enriched by flowers and drolleries, even the "Hours of John the Fearless," the earliest member of the group, presupposes a familiarity with fairly recent French and Franco-Flemish art. And the concise but most impressive "Derision of Christ" (fig. 184) showing the face of Our Lord entirely veiled, is unquestionably derived from the *"Petites Heures"* by Jacquemart de Hesdin.[9]

Fundamentally, however, the style of our Ghent manuscripts is Flemish and chief among its sources is, again, the Ypres tradition. "Rosette frames" — the centers of their corner quatrefoils often adorned with tiny heads or shields — abound both in the "Daniel Rym Hours" and in the "Hours of John the Fearless," occasionally even with two rosette-filled chamfers instead of one; and a meander pavement occurs in the latter manuscript in the "Office of the Dead."[10] The "Presentation of Christ" in the "Hours of John the Fearless"[11] is a quaint but clearly recognizable variation on two different themes by Broederlam whose "Presentation" provided the model for the scene itself whereas his "Annunciation" supplied the architectural setting — a picturesque *tempietto* containing an altar and adorned with statues of the Annunciate and

the Angel Gabriel in lieu of Broederlam's Prophets. The queer saw-tooth contour of the floor in the Pentecost scene [1] repeats in somewhat simplified fashion that of the dais in the Madonna page of the "Carpentras Hours." The St. Christopher (fig. 183) [2] is derived from the archetype reflected in the "Oxford" and "Cambridge" Hours although the landscape not only transcends but actually obliterates the right half of the frame and the scene is fancifully enriched by such charming new details as a second ferryman anxiously observing the miracle from his berthed boat, an owl perched on a tree, and an inquisitive bear emerging, Jacquemart de Hesdin fashion, from his cave. The Nativity (fig. 182), [3] finally, is manifestly developed from that in the "Rouen Hours," although the tiles of the pavement are set diagonally instead of frontally. But owing to the omission of manger, animals and angels, the presence of a beturbaned midwife bathing the Christ Child on a three-legged stool, and the elaboration of the couch into a real bedstead whose curtain a servant girl draws back, the scene has been transformed into an interior both more spacious and more sheltered. The figure of the Virgin, however, her halo irradiating the white pillow, is practically unchanged, and her features are of similar cast though blunted into a sweet vacant disk, with eyes, mouth and nose indicated by tiny strokes and dots. And in the foreground is seen, still more incongruous in these well-furnished surroundings, the telltale open-air grill with its stepped back. [4]

Since the "Hours of John the Fearless" has lost its Annunciation page, which may or may not have included an owner's portrait, the type of dedication page favored by our Ghent atelier can be studied only in the "Hours of Daniel Rym" (fig. 186) where we see Daniel Rym venerating his patron saint with the prayer "Sanctus Daniel, ora pro nobis." [5] Daniel himself is snugly ensconced in the lions' den, unaware of the compulsory approach of the food-bearing Habakkuk and fondling the harmless, lamblike creatures. But in spite of all differences in subject, ornamentation, expression and costume, the composition of this page adheres to the Ypres tradition. As in the "Rouen Hours" the main scene is set in a "rosette frame," and Daniel Rym kneels on a piece of turf, only that this is developed into a real little plot of ground with diminutive trees.

Derivative though it is, the style of this Ghent workshop is by no means devoid of originality. We have already noted the engaging details by which the Master of the "Hours of John the Fearless" enriched the St. Christopher scene and the Nativity; but he shows inventiveness, even audacity, in many other places. In the *bas-de-page* of the Pentecost page [6] he illustrated — perhaps by way of allusion to the marriage of his client's daughter, Mary, to Adolph of Cleves in 1406 — the legend of the "Chevalier au Cygne"; [7] in the "Presentation" he added a little bell ringer eagerly at work in the *tempietto*. And in the All Saints miniature he boldly transformed the Trinity into an apparently unique Quaternity, enthroning the Virgin Mary between God the Father and Christ and placing the Dove in a golden ring encircling this unorthodox triad. [8]

The Master of the "Hours of Daniel Rym," for all his wistful innocence, shows himself capable of droll humor and then, again, of a surprisingly subtle interpretation of serious subjects. In the border of the "Bearing of the Cross" (fig. 188) a young woman, emerging from

a big flower, brandishes a distaff and threatens all men with a defiant "ic dou" ("I thrust").[1]
The "Kiss of Judas" (fig. 189),[2] on the other hand, is permeated by a spirit of tragic ambiguity,
the traitor gently embracing Our Lord from behind almost as though he were supporting
Him as does the Virgin Mary in the "Lamentation" by Giovanni da Milano.[3]

Both the "Hours of John the Fearless" and the "Hours of Daniel Rym" are distinguished
by an unusual variety in the decoration of the borders. In addition to the types mentioned —
the modern French line-and-leaf design interspersed with flowers and drolleries and the
archaic but fantastically elaborated ivy *rinceaux* with lions' heads and dragons — we have,
now singly, now in combination (so that a number of pages show what may be described as
double or triple borders), simple, undulating *rinceaux*, English-inspired arrays of shields held
together by a rod like pieces of meat by a skewer,[4] and heavy leaves not unlike those of Amer-
ican oak entwined before a wide, dark band.[5] It is the recurrence of these unusual border
designs that enables us to attach to our Ghent school five or six slightly later manuscripts.
Three Books of Hours, two in the Morgan Library and one in the collection of the Duke of
Arenberg, show the extravagant dragon-and-lion *rinceaux*, and one of the Morgan manuscripts
also contains examples of the overdeveloped corner quatrefoils and of the heavy "oak leaf"
borders, the latter so literally copied that even the indentations of the contour are repeated
(fig. 192).[6] In a Horae in the John Carter Brown Library in Providence,[7] on the other hand,
these heavy "oak leaf" borders blossom forth into fantastic tropical flowers and fruits and
intertwine themselves with drolleries while in the miniatures the native tradition yields to
the influence of the Boucicaut Master. The wonderfully decked out St. George (fig. 193), for
example, clearly descends from that in the "Boucicaut Hours," and the "Vigils of the Dead,"
the church interior viewed through a tripartite diaphragm arch, is based upon the same
miniature which has been mentioned in connection with Jan van Eyck's "Madonna in a
Church" — a miniature found in a Boucicaut manuscript that was demonstrably completed
in Flanders,[8] and this in a style distinctly related to that of the Providence Hours.

The Providence Hours marks the end of the local development that set in with the "Hours
of John the Fearless." At the time of its production — about 1430–1435 — two other schools
of book illumination had appeared on the scene.

One of these was headed by a master known as the "Master of Gilbert of Metz," who has
received his name from a copy of Gilbert's *Description de la Ville de Paris* (preserved in a
miscellaneous codex at Brussels) and seems to have been active, from about 1420, either in
Ghent or in Grammont (twenty miles south of Ghent) where Gilbert lived. His fairly pro-
ductive workshop did not significantly contribute to the general development; its idiom is
nothing but the language of the Boucicaut and Bedford Masters translated into a provincial
patois.[9]

The other school is commonly referred to as the "Gold Scroll" group after its favorite
background pattern of thin, filigreelike gold *rinceaux* on neutral foil — a name not too well
chosen because this pattern was by no means unusual, though less ubiquitous, less dense, and
therefore less conspicuous in earlier schools. This "Gold Scroll" group apparently comprised a

number of different workshops which are all the more difficult to locate as they extensively produced for foreign consumption, furnishing manuscripts not only for England, but for places as distant as Portugal (fig. 194) and Italy.[1] Certain it is, however, that the "Gold Scroll" style was centered in the westernmost regions of Flanders, possibly including the city of Tournai, and that it was rooted in the Ypres tradition. Like the manuscripts assignable to the Ypres School and what we now may call the "Early School of Ghent," the "Gold Scroll" productions are full of "rosette frames" and those blue angel-head arches which, we remember, had made their first appearance in the "Rouen" and "Oxford" Hours. They also contain, almost invariably, a peculiar illustration of the *Commendatio animarum* or *Commendatio defunctorum* in which two angels transport to Heaven a little group of souls in a cloth spread out like a hammock, a motif which appears both in the Cambridge Hours[2] (which, we recall, was copied from an Ypres manuscript) and in the London Book of Hours by Herman Scheerre, the great representative of the Ypres tradition in England.[3] It is, in fact, in Herman Scheerre — or, rather, in his distinctive collaborator, the Master of the Beaufort Saints — that we may touch upon the origin of the "Gold Scroll" style. The Master of the Beaufort Hours, we saw, returned to the Continent after his stay with Herman and here produced his finest works, notably a Horae (also preserved in the British Museum) which by its use, its Calendar and several inscriptions can be located on the western borderline of Flanders.[4] This Horae (figs. 179, 180) not only includes the hammock motif (and, incidentally, a great number of other features characteristic of Herman Scheerre and the Ypres tradition) but also shows the filigree *rinceaux* densened and hardened in precisely that fashion which is characteristic of the "Gold Scroll" group. A Book of Hours in the Grand Séminaire at Bruges (fig. 195) has so much in common with both the Beaufort Saints and the accepted members of the "Gold Scroll" family that it may be regarded as a classic case of "transition."[5] I am, therefore, inclined to consider the Master of the Beaufort Saints as the *fons et origo* of the elusive "Gold Scroll" style; and since his activity in England did not extend, so far as we know, beyond the first decade of the century, no chronological objection can be raised to this assumption. For it was not until 1415-1420 that the "Gold Scroll" style made its appearance on the Continent.

The "Gold Scroll" family is thus consanguineous, as it were, to the "Early School of Ghent" while it is not a blood relation of the Gilbert of Metz family. This, however, facilitated rather than impeded intermarriage between the two contemporaneous clans. Both flourished until about 1440; they frequently interpenetrated; and as time went on, the "Gold Scroll" workshops gradually absorbed the same Parisian elements which had been inherent in the Gilbert of Metz style from the outset; the "Duarte Hours" of 1428–1433 in Lisbon, the only "Gold Scroll" manuscript that can be dated by external evidence, is strongly and directly influenced by the Boucicaut Master.

In the fourth decade of the fifteenth century, therefore, the aspect of South Netherlandish book illumination is very complex — and increasingly discouraging. Like the Arenberg Master, but with considerably less success, the aging ateliers tried to rejuvenate their style by timid,

partly indirect borrowings from the Master of Flémalle.[1] But by 1440 the "Gold Scroll" family died of sheer exhaustion, and the practitioners of the Gilbert of Metz style left the field to younger masters who, even if not of the first rank, were at least capable of assimilating the innovations of modern Flemish panel painting in principle.

<p style="text-align:center">IX</p>

To repeat, the pre-Eyckian schools of painting in the Netherlands, and Netherlandish book illumination from *ca.* 1390 to *ca.* 1430–1440, did not produce many masterpieces. But they are nevertheless indispensable for the understanding of the period in general, and the great masters of Early Flemish painting in particular.

Owing to their innate propensities, these regional schools offered a healthy resistance to the "manneristic" trends in the International Style and thus paved the way for the great synthesis of naturalism and sophistication that was to be achieved by Jan van Eyck. With the curious combination of impressionability and retentiveness characteristic of all provincial art, they accepted, preserved, developed and disseminated artistic ideas — most of them of Italian origin — which had been overlooked or even rejected in the leading French and Franco-Flemish ateliers, and they contributed to this diffusion of motifs the more effectively as they were the principal source for the new art of print making which came into being at the same time and, generally speaking, in the same environment. That graphic art, intended as a cheap substitute for hand-painted miniatures, extensively drew upon what it purported to emulate is not surprising.

To take up the last point first: the oak leaf borders of certain Netherlandish metal cuts are almost literally copied from those in the "Hours of John the Fearless" and its relatives,[2] and it is only by resorting to Flemish book illumination that we can solve a problem that is still troubling the students of the graphic arts. They have marveled at or even questioned the early date — 1423 — of the famous St. Christopher woodcut from Buxheim which is distinguished from the rank and file of contemporary graphic production by its surprising "modernity."[3] Yet all its apparently anachronistic features — the presence of a hermit with his lantern, the enrichment of the scenery by little buildings, the emphasis on spatial depth and the comparatively naturalistic treatment of water and terrain — can be accounted for by Flemish miniatures such as the St. Christopher in the "Beaufort Hours" or, in even greater detail, that in the "Hours of John the Fearless" where even the little animal peeking out of its hole (in this case a rabbit rather than a bear) is prefigured. The woodcut almost literally transcribes an illumination of this kind; and since the "Hours of John the Fearless" certainly antedates 1419 (while the "Beaufort Hours" is even earlier), the date 1423 is no longer a mystery.

To illustrate the importance of the Netherlandish schools as an international stock exchange and, at the same time, as a storehouse of foreign motifs unacceptable to the great centers of France, we may begin with a beautiful "Man of Sorrows" in the Kunsthalle at Hamburg (text. ill. 45), the last known work of Master Francke who, for all his familiarity with the

<p style="text-align:center">123</p>

developments in Paris, owes more to the tradition of his native Lowlands than is generally admitted.[1]

Where all earlier Northern representations show the hands of the Man of Sorrows either crossed before the breast, or lifelessly dangling, or carrying a scourge and a whip, or symmetrically upraised,[2] the balanced gestures of Francke's Christ are expressively dynamic. With His right hand, He shows the wound in His side — a motif apparently adopted from such Italian sources as the "Intercession" by Giovanni Pietro Gerini[3] — while the elevated left exposes the wound in its palm. Even more unusual is the fact that the image of His suffering humanity is invested with the dignity of His divine office in the Last Judgment. Three angels hold up His white, red-lined robe and spread a cloth of honor behind Him, and this identification of the Man of Sorrows with the Judge — entirely justified on doctrinal grounds because at Doomsday Christ will "show His bitter wounds to all mankind saying: 'Behold what I have suffered for you; what have you suffered for me?'" — is further stressed by the addition of two other angels carrying the sword and the lily.

It has been observed that Francke's painting, produced at Hamburg about 1430, is closely akin to a woodcut produced in Flanders about 1460 (text ill. 44).[4] Posture and gestures are so nearly identical in both cases — only that the author of the woodcut has misinterpreted the Saviour's gesture as one of benediction — that the two compositions must be supposed to derive from a common archetype. The woodcut, however, does not include the eschatological symbols, and it has been assumed that they were absent from this archetype; they are thought to have been added by Francke "as a result of a very personal inspiration."[5] If this assumption were correct another composition (text ill. 46), transmitted through no less than five prints of the third quarter of the fifteenth century and duplicating Master Francke's in nearly every respect except that the robe is fastened by a morse instead of a ribbon and is held up by the same angels who carry the lily and the sword,[6] would also depend on Francke's Hamburg picture. However, when we open some of our Flemish manuscripts (text ill. 43) and their English derivatives we find a number of closely interrelated miniatures which agree with the five prints precisely in those features in which the latter disagree with Francke's painting; the eschatological significance of the image is even more explicit in that the angels are expressly identified as "Justitia" and "Misericordia" and that the half-length figure of Christ, supported by a flaming cloud, is floating above a globe and a strip of terrain from which the heads of the Resurrected emerge.[7] The inference is that there existed, prior to 1430–1435, a Netherlandish archetype which showed the Man of Sorrows placing His right hand upon the wound in His side, upraising His left, clad in the robe of the Judge, and attended by the Angels of Justice and Mercy — an archetype which probably preceded, possibly influenced and certainly did not depend upon the admirable composition by Master Francke.

Now, since the gesture of showing the side wound is foreign to the iconography of the Man of Sorrows in earlier Northern art, the same archetype would seem to have influenced the Master of Flémalle in whose representations of the Trinity this gesture appears effectively, if not quite logically, transferred to the dead Christ supported by God the Father (figs. 207,

210). And if this hypothesis were admitted, we should be confronted with a tradition, transmitted by and inferable from our modest miniatures, which left its mark on major panel painting both in Germany and Flanders.

What remains somewhat conjectural in the case of the "Man of Sorrows as the Judge" is demonstrable — or at least as demonstrable as anything can be in the history of art — in the case of the Nativity. The "Nativity" in Master Francke's altarpiece of 1424 (text ill. 47) is the only Northern panel painting of the fifteenth century to stage the scene in a cave entirely free from man-made additions, and it is not only in this respect that it agrees with the *Revelationes* of St. Bridget of Sweden.[1] It is according to her description that Master Francke depicted the kneeling Virgin clad in a plain, white dress (while her blue mantle is spread out by three little angels so as to form an improvised sanctuary) and that he placed the nude, radiant Infant on the ground instead of in the manger. He even went so far as to omit the St. Joseph, who, according to the *Revelationes*, had removed himself from the scene "ne partui personaliter interesset" and only later joined in the Virgin's prayer.[2]

No doubt Master Francke had carefully read St. Bridget's description, but his composition can hardly be explained by this description alone. A literary source may modify but hardly ever breaks an established representational tradition unless the impact of the written word is reinforced by that of a visual experience. As, according to Spinoza, an emotion cannot be suppressed or eradicated save by another emotion, so can an image be supplanted only by another image. In fact, the influence of St. Bridget's text was never strong enough to suppress entirely the iconographic traditions prevailing in the various countries. The Italian Trecento painters, who first translated her vision into a pictorial formula, were loth to discard the cherished figure of St. Joseph whom they occasionally tucked away in a separate little cave but hardly ever omitted (fig. 38). Conversely, Northern panel painters could never bring themselves to abandon the familiar shed in favor of the unaccustomed cave;[3] even the Hanseatic painters directly influenced by Master Francke's "Nativity" (such as the Master of the Nikolai-Kirche at Rostock and the Master of St. Jürgen at Wismar) replaced his cave by structures in which natural rocks are fantastically combined with roofing and timber work.[4]

Master Francke, therefore, would scarcely have so radically departed from the native tradition had he not come in contact with pictures showing the cave in addition to a text merely describing it; and that such pictures existed in the North is known to us from the "Nativity according to St. Bridget," discussed in the Second Chapter, in the *"Très-Belles Heures de Notre Dame"* of 1385–1390 (fig. 37).[5] But this miniature — produced at a time when the Italian influence on Northern art was approaching its climax, and by a master who was a prime exponent of this influence — had found no following in French and Franco-Flemish art; in the only known French example patterned upon it, found in a *Bible Moralisée* in the Bibliothèque Nationale, the cave has been absorbed in general scenery.[6] It was in the provincial Netherlandish schools that the "Nativity According to St. Bridget" was not only accepted but developed in all its scenic and iconographic implications. Beginning with a miniature in one of the earliest "Gold Scroll" manuscripts, commonly dated about 1415–1420,[7] a solid tradition

established itself and spread to the Gilbert of Metz group as well as to the Master of Zweder van Culemborg (fig. 127).[1] The "Nativity" in a little Horae in the Walters Art Gallery (text ill. 48),[2] where the rock is expanded into a saddle-shaped hillside on which the Annunciation to the Shepherds takes place, and where two kneeling angels participate in the Adoration of the Christ Child, might be considered a variation on Meister Francke's panel were it not much more probable that Francke — a native of Guelders, and in a sense a stranger in Germany — had been inspired by common Netherlandish sources.

However, while Master Francke, in deference to the text, eliminated the figure of St. Joseph he chose to abandon a significant motif especially stressed in St. Bridget's description, the motif of the candle. Perhaps in unconscious recollection of texts describing the Birth of Bacchus (the iconography of which has also contributed much to that of the Nativity in other respects), St. Bridget had introduced a new symbol for the old idea of the ascendancy of the Light Divine over the light of nature. She tells us how St. Joseph, prior to his withdrawal, had brought a lighted candle and placed it in the cave; and how, after the birth of the Saviour, the "divine radiance" (*splendor divinus*) that emanated from the Christ Child "totally annihilated" (*totaliter adnihilaverat*) the "material light" (*splendor materialis*) of the flame.[3] Accordingly, the Italian panels based on the *Revelationes* either exhibit a candle placed on a shelf of rock in the interior of the cave, or, more frequently, held in St. Joseph's hand;[4] and this second choice was invariably adopted by the Netherlandish illuminators.

Master Francke, then, omitted the St. Joseph and his candle, while accepting the cave. The great Flemings rejected the cave, which they replaced by the usual shed, while retaining St. Joseph and his candle. Chief among these were the Master of Flémalle and his disciple, Roger van der Weyden. From the former's Dijon "Nativity" (fig. 201) the candle motif found its way into the latter's Bladelin, or Middelburg, altarpiece; and from the Bladelin altarpiece into a host of later pictures and prints all over the Continent. The Brigittine origin of the candle was often forgotten; in an attempt to surpass the panel painters in verisimilitude some later illuminators even replaced it by a lantern. But it had not been introduced as a naïve indication of the fact that the Nativity took place at night. It was — though it did not always remain so — the symbol of a light that is obscured rather than the source of a light that illumines.[5]

Why French and Franco-Flemish art objected not only to the cave but also to the candle (significantly, even the one and only Franco-Flemish "cave Nativity," that in the "*Très-Belles Heures de Notre Dame*," shows a candleless St. Joseph with hands raised in prayer) it is difficult to say. St. Bridget's *Revelationes* itself enjoyed far greater popularity both in the Germanic countries and in Italy than in France; and that this was so is perhaps based upon the same French conservatism and formalism which objected to an Eastern setting at variance with a tradition of many centuries and to a motif that interfered with St. Joseph's devotion. "Encombré par sa tradition," French and Franco-Flemish art was averse to motifs too Italianate, as it were — to motifs either too exotic or too emotional or too undignified. But it was precisely such motifs which appealed to the taste of the provincial schools, especially those of the

Netherlands. Here they were eagerly adopted and held in store, so to speak, for the great masters, and it was only after the lapse of several decades that, sanctioned by the authority of these great masters, they were at last admitted even to France.

Thus, the faintly exotic gesture of the Annunciate in the Baltimore-Antwerp quadriptych (fig. 108b), which is exceedingly rare in French and Franco-Flemish Annunciations, had achieved a certain degree of popularity in the Northwestern provinces, and it is by the persistence of a Guelders and Lower Rhenish tradition — exemplified by the Zweder Master[1] and the Cologne painter of the Brenken altarpiece in Berlin[2] — that we can account for its appearance in the Ghent altarpiece (fig. 276).

In another context, that of the Nativity, this gesture of devotion — hands crossed before the breast — was taken up by Jacques Daret, a pupil of the Master of Flémalle. In every other respect, however, his "Nativity," now in the Thyssen Collection at Lugano (fig. 233), is thoroughly dependent upon the Master of Flémalle, particularly in the depiction of a miracle first mentioned in the Apocryphal Gospels of Pseudo-James and Pseudo-Matthew. According to them the birth of Christ was attended by two midwives, one of whom — originally called Zelomi but later going under the name of Zebel or even Rachel — believed in the Virgin's purity whereas the other, originally called Salome, insisted on tangible proof — with the result that her guilty hand withered and was cured only by touching the new-born Saviour.[3] This incident, not often represented even after the Dijon "Nativity,"[4] had been frequent in Early Christian, Byzantine and Italo-Byzantine renderings; but it hardly ever occurs in French and Franco-Flemish art where the midwives, if present, normally limit themselves to their professional activities. They busy themselves with the Infant or are engaged in preparing His bath, with no reference made to their convictions.[5] It was, again, in a peripheral, Germanic milieu that the old Eastern legend continued to be cherished by artists. The most circumstantial pictorial account of it is found in a series of German miniatures illustrating Wernher of Tegernsee's *Lied von der Maget* ("Song of the Virgin").[6] In a queer miniature, dated 1406, by a Polish-Silesian artist the two midwives are antithetically placed on either side of the Virgin's couch.[7] In one of those Spanish Nativities in which the Virgin adores the Christ Child with her hands crossed over her breast, the cured and converted Salome joins her in prayer.[8] And in the Baltimore-Antwerp quadriptych (fig. 108c) she is even distinguished by a halo, perhaps because she was generally confused with St. Mary Salome, the "Mother of Zebedee's children." Here, then, we have another case in which a great Flemish painter drew from indigenous regional sources rather than from the cosmopolitan French and Franco-Flemish tradition.

Apart from such specific iconographical motifs, we can observe in the schools of Germany and the Lowlands a general iconographical tendency shared and brought to fruition by the great Flemings but foreign, even repugnant to the French and Franco-Flemish taste. They cultivated what may be called the humility theme, as paradigmatically formulated in the *Madonna dell' Humiltà*.

As Millard Meiss has brilliantly shown, it was Simone Martini who had lent visual expression to Dante's:

> Vergine Madre, figlia del tuo figlio,
> *Umile ed alta* più che creatura

in the image of the Madonna dignified by the attributes of the Apocalyptic Woman — "clothed with the sun, and the moon under her feet and upon her head a crown of twelve stars" — yet humbly sitting upon the ground.[1] The very word *humilis*, it should be remembered, derives from *humus*, and to "sit upon the ground" can mean humility as well as "humiliation":

> For God's sake, let us sit upon the ground
> And tell sad stories of the death of kings.

French and Franco-Flemish art was therefore reluctant to subject Our Lady to the indignity of this posture, except for the extremity of the Crucifixion and the Lamentation.[2] The "Madonna of Humility" was never very popular in France, and it is perhaps not without significance that the earliest known example (of *ca.* 1360–1365) occurs in a manuscript produced at the very outskirts of the area commonly designated as French.[3] The theme was, however, much in favor in England[4] and Flanders.[5] And when the Master of Flémalle, who took it up no less than four times, mostly omitted the Apocalyptic attributes and always placed the Virgin in a naturalistic environment such as the "garden inclosed" (figs. 198, 226) or even a domestic interior (figs. 203, 211) it was, I think, through Flemish rather than French intermediaries that he became familiar with the corresponding Italian prototypes.[6] Where his Madonnas of Humility appear in the *hortus conclusus*, sitting in front of a grass-topped enclosure of masonry, his connection with the regional type (fig. 154) is very evident.

What applies to Our Lady applies even more to ordinary female saints. Both in the Lowlands and the Germanic countries artists became almost inordinately fond of placing them upon the ground, whether they were assembled in lovely groups (as in the van Beuningen altarpiece, the woodcut known as the "*Vierge de Bruxelles*" allegedly of 1418,[7] or the charming Upper Rhenish "Garden of Paradise" in Frankfort)[8] or represented singly.[9] St. Geneviève, bravely holding up her candle which the devil tries to extinguish while an angel untiringly relights it, is depicted standing in French manuscripts[10] but sitting on the ground in what we tentatively called the "Prayer Book of Mary of Cleves";[11] and in the "Ghent Horae" bound by Joris de Gavere we meet a modest ancestress of Jan van Eyck's "St. Barbara" of 1437 (fig. 254), squatting instead of standing, and with her tower, small though it still is, already built upon the ground instead of being carried by her as an attribute (fig. 190).[12]

So popular was the humility posture in Netherlandish and Northwest German art that it was employed even within the context of the Annunciation, that great mystery which by its very nature does not readily lend itself to an idyllic or informal mode of depiction. Annunciates posed like a *Madonna dell' Humiltà* are seen, for example, in Taddeo Gaddi's fresco in Santa Croce, where the Virgin Mary is placed directly on the ground;[13] in a panel, ascribed to Simone

Martini, now in the Stocklet Collection at Brussels, where she is huddled upon a pillow;[1] and in a picture by Niccolò di Buonaccorso where she sits on the footrest of her throne instead of on the throne itself.[2] But this arrangement, not too frequent even in Italy, was, it seems, positively offensive to the French sense of decorum. So far as I know not a single instance occurs in French or Franco-Flemish art.[3] It was accepted, however, in two much-imitated compositions by Conrad of Soest,[4] in the van Beuningen altarpiece, and in the little Book of Hours from Tournai (fig. 145).[5] In the central panel of his Mérode altarpiece (fig. 204) the Master of Flémalle elaborated the nondescript setting of the Tournai Hours into a comfortably furnished apartment. But in spite of these new appointments the Virgin, ignoring the comfort of an ornate bench, is curled up in front rather than seated upon it, which makes the picture's dependence upon the regional — here even local — tradition all the more obvious.

Moreover, the very idea of staging the scene in a fullfledged bourgeois interior resulted from a development which — like the "domestic" interpretation of the Madonna of Humility pure and simple — had originated in Italy and had been carried on in the borderline districts between France and Germany rather than in France itself. It is from such richly furnished "doll's house" settings as those in the well-known mural in S. Maria Novella[6] and, on the other hand, from such genuine, if somewhat bare, interiors as those in the panels by Giovanni da Milano[7] and Bernabò da Modena[8] that the "realistic interiors" of the Flemish painters were to develop; but it is the Brenken altarpiece just mentioned (text ill. 49) and an Upper Rhenish picture in the Reinhart Collection at Winterthur (text ill. 50), both probably based on Italian models,[9] which give us some idea of the intermediaries between the Trecento — or early Quattrocento — and the Master of Flémalle. His Annunciation may be said to have resulted from a fusion of two Italian themes, the Annunciate in the guise of the Madonna of Humility and the Angelic Salutation in a domestic interior; and this fusion would not have been possible had not the concepts of Taddeo Gaddi, Niccolò di Buonaccorso and Giovanni da Milano, rejected by the French and Franco-Flemish masters, been able to survive in the less rarefied atmosphere of the provincial schools.

The same, incidentally, is true of another motif which distinguishes the Mérode altarpiece from all other renderings of the Annunciation scene thus far considered: the Christ Child bodily descends from Heaven as a *parvulus puer formatus*. Opposed by theologians from the outset and formally condemned by Pope Benedict XIV, this motif, too, was "popular rather than dignified"; it, too, was of Italian origin; and it, too, was as much in favor in Germany (numerous instances from as early as 1379, one of them being the Brenken altarpiece) and in the Lowlands (where it occurs, e.g., in the "Haarlem Breviary" of *ca.* 1420[10] and twice in the work of the Arenberg Master)[11] as it was avoided in France. Here, setting aside one very dubious example,[12] it did not make headway until after 1430 when French and Franco-Flemish art had lost the initiative and tended to succumb to influences from the Northeast.[13]

Due to the unfortunate depletion of the material, pre-Eyckian painting in the Netherlands is visible to us only in scattered fragments and dim reflections. Its importance should not be overestimated, but neither should it be minimized. If the indigenous tradition did not provide the seeds for the great Flemings' garden it did provide its soil.

V

REALITY AND SYMBOL IN

EARLY FLEMISH PAINTING: "SPIRITUALIA

SUB METAPHORIS CORPORALIUM"

WHEN discussing the architecture in Melchior Broederlam's "Annunciation" (fig. 104) I hinted at but did not enlarge upon the fact that it is invested with a symbolical significance which justifies its intricate complexity.

As in most contemporary renderings of the scene, the main attribute of the Annunciate is a prayer book, here placed on the lectern before her. But, in contrast to all these representations, she holds in her left hand a skein of purple wool. This is an unmistakable reference to the Apocrypha which tell us of the life of Our Lady prior to the Angelic Salutation. Like many "daughters of kings, prophets and high priests," Mary, "a virgin from the tribe of David," had been brought up in the temple of Jerusalem until she had reached the marriageable age. But since she wished to preserve her virginity she was betrothed — or, as Pseudo-Matthew phrases it, "given in custody" — to the aged Joseph. She and a number of other maidens, variously described as living in Joseph's house or summoned from diverse parts of the land, were asked by the priests to make a new veil for the Temple. The work of each was determined by lot, and to the humblest of the maidens there was given the most precious of materials, the "true purple."[1] It was while the Virgin "was working the purple wool with her fingers" (either in the house of St. Joseph or in that of her parents) that she was approached by "a youth of indescribable beauty saying: 'Be not afraid, Mary, thou hast found grace before God.' "

In Early Christian, Byzantine and High Medieval art, the Annunciate is, therefore, often represented with a spindle.[2] In the fourteenth and fifteenth centuries, however, allusions to her manual occupation had normally disappeared from renderings of the Annunciation proper[3] and were restricted to those of a preliminary scene more often than not shown in a marginal picture, the "Virgin at the Loom" attended by angels.[4] In reintroducing the motif of the purple wool, then, Broederlam reverted to the Apocrypha and we may thus assume that the other unusual features of his composition are also intended to revive the implications

of the Apocryphal version: the circular structure behind the Virgin's shrine, its gloomy in-
terior disclosing the "Table before the Lord," must be meant to represent the Temple.

This assumption is confirmed by the sharp and doubtless intentional distinction made
between this massive, domed, oriental-looking structure and the transparent Gothic gable
of the adjacent loggia, the windows of which are illumined by the gold ground that shines
through their tracery and emphatically contrast with the black slitlike openings of the
circular edifice. The window being the accepted symbol of illuminating grace and, therefore,
of the "new light" (lux nova) of Christian faith as opposed to the "darkness" or "blindness"
of Judaism, a triad of windows [1] so prominently, even incongruously, placed upon a cornice
and so pointedly opposed to the dark apertures in a building of different style, can mean only
one thing: the Trinity, which assumes the form of physical reality in the very act of Christ's
Incarnation. It was on this account that the Virgin Mary could be acclaimed as the "temple
and sanctuary of the Trinity," or more simply, the Templum Trinitatis.[2] Whether or not the
three lamps — as yet unlit — in the chandelier suspended from the ceiling of her little shrine
are a further allusion to the Trinity, I dare not decide. But certain it is that the placement of
this shrine between the orientalistic temple and the Gothic hall with its three windows
stresses the doctrine that the Virgin's impregnation with the Holy Spirit marks the transition
from the Old Dispensation to the New.

The same idea is expressed by the two prophets' statues, Moses on the Virgin's left,
Isaiah, whose "Behold a virgin shall conceive" is the locus classicus for the Annunciation, on
her right. And her unique qualifications are signified by two further characteristic features
of the setting, the towerlike appearance of the Temple and the presence of a walled garden
which even the Angel Gabriel is not allowed to enter. The tower — in recollection of the
myth of Danaë who was imprisoned in a turris aënea in order to protect her from any inter-
course with men — was a recognized symbol of chastity,[3] not only in representations of this
virtue in general (as in the famous fresco in the Lower Church at Assisi) but also with
reference to the Annunciation in particular (as in the Princeton panel by Guido da Siena
and its derivatives).[4] The walled garden, on the other hand, is obviously the "garden inclosed"
of the Song of Songs.

In spite of all this evidence it might seem hazardous to attach so specific a significance
to the architectural features of Broederlam's painting were it an isolated case. It marks, how-
ever, the beginning of a consistent tradition. A miniature from the Boucicaut workshop [5]
shows practically all the elements discussed except that they are somewhat modernized and
rearranged into a more rational pattern. We have the circular tower, here surmounted by a
weather vane; the "garden inclosed"; and, on the other side of the Annunciation chamber,
a Christian chapel designated as such by its more definitely Gothic style, by a cross on the roof,
and by an altar decked out with candlesticks and a tripartite retable. In another miniature
from the same workshop (fig. 74) [6] the Angel enters through the door of a Gothic twin-
tower façade while on the other side is seen a sanctuary characterized as Jewish and oriental
by its cupola, the bulbous domes of its towers, and an altar that bears no candlesticks and ex-

hibits the Tablets of the Law instead of a triptych. In residual form the contrast between Gothic *tempietto* and fancifully non-Gothic tower even survives in an "Annunciation" in the Prado in which the figures are copied from those in the Mérode altarpiece by the Master of Flémalle.[1] And when Conrad Witz placed the Annunciation scene between two actual personifications of the Church and the Synagogue he merely made explicit what the antithetic *mise-en-scène* of his forerunners had implied.[2]

The development of this antithetic *mise-en-scène* culminates in the last Flemish painting to stage the Annunciation in or before an architecture seen from the outside instead of in an ecclesiastical or domestic interior. This is the much-debated "Friedsam Annunciation" in the Metropolitan Museum (fig. 284) which, whether considered as an original by either Hubert or Jan van Eyck, as a product of Hubert's "circle" or as a trustworthy replica of later date,[3] is now nearly unanimously accepted as an "Early Eyckian" composition and can thus safely be exploited for iconographic purposes. In it, the contrast between Gothic and vague orientalism has given way to a dichotomy between Gothic and archeologically correct Romanesque; and instead of a fantastic conglomeration of separate units we have what seems a workmanlike and perfectly unified little church, apparently portrayed from life. Yet this little church, vertically bisected into two stylistically different halves, is just as imaginary as the complex structures of Broederlam and the Boucicaut Master; and the new contrast between two chronological "periods" — Gothic and Romanesque — is no less clearly indicative of the antithesis between Judaism and Christianity than is the earlier contrast between two geographical spheres, Western and Oriental.

On the Virgin's right — and we should remember that the right side is still considered as the "right" side whereas the left is held to bear evil or "sinister" implications — are seen two orthodox Gothic buttresses; on her left, however, there is only one buttress, and this is just as orthodoxically Romanesque, consisting as it does of a simple square pier with a cylindrical shaft and a correctly profiled impost block. On the "Gothic" side both the front and side walls are pierced by windows, again symbols of divine illumination. Out of the corner buttress there grow white flowers, symbols of purity, and the buttress of the portal culminates in that kind of finial the German and Flemish names of which (*Kreuzblume, Kruisbloeme*) mean "cross-flower." On the "Romanesque" side we have, instead, two columns of jasper or porphyry which clearly allude to the two famous columns "in the porch of the temple," Jachin and Boaz (I Kings VII, 21); and their clean-cut Romanesque bases are supported by a correctly rendered twelfth-century console carved into the likeness of a monkey (text ill. 53). The monkey symbolized all the undesirable qualities thanks to which Eve brought about the Fall of Man and was thus used as a contrastive attribute of Mary, the "new Eve," whose perfection blotted out the sin of the "old": "Eva occidendo obfuit, Maria vivificando profuit." Even Dürer saw fit to associate the Madonna with the monkey,[4] and that it was especially, and fittingly, connected with the Annunciation scene — the very act in which the curse pronounced upon the "old Eve," "in dolore paries filios," is converted into the blessing "et paries filium, vocabis nomen eius Jesum" — is attested by the well-known panel at Aix-en-Provence, pro-

duced about 1443 by a Flemish-trained French master, where the monkey appears as a carved ornament surmounting the Virgin's reading desk.[1]

Even the empty niche above the door is not without significance. It waits, so to speak, for a statue of the unborn Saviour, the *lapis in caput anguli* of Psalm CXVIII, 22, and Matthew XXI, 42, which was interpreted as "keystone" as well as "headstone of the corner." In manuscripts of the *Speculum humanae salvationis* we see two workmen actually putting this keystone in place in order to prefigure the advent of Christ,[2] and it was very logical to allude to this concept within the context of the Annunciation. With the two workmen replaced by angels, the placing of the keystone appears in the Austrian "Annunciation" from Heiligenkreuz of *ca.* 1400;[3] and, somewhat later (though not fully understood by the illiterate weaver), in a beautiful tapestry in the Metropolitan Museum based upon Broederlam's "Annunciation" in composition and reminiscent, I think, of the "Paris Apocalypse" in style (text ill. 51).[4]

In only one respect does the "Friedsam Annunciation" depart from the symbolism encountered in the Broederlam painting and the Boucicaut miniature, but even here a new interpretation is superimposed upon an old and familiar motif. The *hortus conclusus* has run to seed; its wall has crumbled and is overgrown with vegetation; the very steppingstone before the entrance of the little Church is so corroded that its apparently pagan inscription can no longer be read. The "garden inclosed" is thus transformed into a realm of unregenerate nature surrounding the structure which symbolizes the eras "under Law" and "under Grace." And compared to a world controlled by the blind forces of growth and decay, the shrine of Judaeo-Christian religion, divided though it is into the Old and the New Dispensation (or, as the schoolmen put it, the spheres of "imperfect" and "perfect" revelation), appears as one indestructible edifice.

II

The "Friedsam Annunciation" teaches us the important fact that the apparently sudden interest in Romanesque form which can be observed at the time of the van Eycks and which was to sweep all over Northern painting is not exclusively a matter of esthetic preference or "taste." Owing to the increasing influence of Italian painting which often shows non-Gothic architecture, and to the familiarity with the East through travelers' reports and sketches, the Northern artists of the fourteenth century had become more conscious of differences between architectural styles than their predecessors had been. Previously the Gothic style, having attained a kind of monopoly from the middle of the thirteenth century, had been taken for granted. Now it came to be thought of as something native and Christian as opposed to something foreign and oriental, whether Saracenic or Jewish. And with the gradual emergence of a naturalism which made a direct appeal to optical experience this stylistic contrast had begun, as we have seen, to be exploited as a new symbol of the old antithesis between the Church and the Synagogue. However, when this naturalism had reached the proportion of a basic postulate, when everything presented to the eye was put to the test of verifiability, so to speak, the

vague orientalism of Broederlam's or the Boucicaut Master's circular towers, cupolas and bulbous domes no longer satisfied the hunger for reality. And it was by looking around in their actual environment that the fathers of Flemish fifteenth-century painting made the surprising discovery that the required contrast to the Gothic style could be found right at hand in the accurately observable monuments of the indigenous past instead of in dubious records of distant Asia. They came to feel that the style of the eleventh and twelfth centuries, surviving in hundreds of buildings still in use but entirely ignored by the Northern painters of the thirteenth and fourteenth, had much in common with what was known of the architecture in the Holy Land, and they were quite right. Massively vaulted or domed according to "Roman, Byzantine and Saracen methods,"[1] solid and gloomy, yet richer and more varied in the use of materials and ornament, these ancient structures — always called "Byzantine" until Messrs. Gunn and de Gerville proposed the terms "Romanesque" and *"l'art Roman"* in 1819 and 1823, respectively — have more affinity, and actually a more intimate connection, with those of the Near East than do the Gothic ones. It was quite justifiable to substitute "Romanesque" for "Oriental" buildings wherever the contrast between Christianity and Judaism was intended;[2] even today synagogues tend to be "Romanesque" and churches tend to be "Gothic."

Thus the Romanesque style, *qua* style, came to carry the same iconographic significance which had previously been attached to orientalistic forms. In many cases this significance was and remained limited to a purely descriptive or historical level, as when the city of Jerusalem, seen from Mount Golgotha, is represented as a surging sea of Romanesque houses and towers, or when Roger van der Weyden's Presentation of Christ — a Jewish ritual performed in the Jewish Temple — takes place in a Romanesque semi-central-plan church. More frequently, however, the Romanesque forms were employed on a symbolical plane as in the "Friedsam Annunciation" and this is especially evident in their application to the familiar theme of the "symbolic ruin."

To express the antithesis of Christianity and Judaism (or paganism) by a contrast between intactness and ruination was, we remember, not new in the fifteenth century. As early as about 1325 Jean Pucelle had demonstrated the birth of the new order by showing how the structure of the synagogue is gradually wrecked so as to furnish building material for the fabric of the Church (fig. 11). Similarly, a *Cité de Dieu* manuscript of the early fourteenth century portrays St. Augustine holding a model of the undamaged and undamageable City of God in his right hand, and a model of the crumbling and ruined City of the Earth in his left (text ill. 55).[3] But in these cases no difference in architectural style had been made between the intact and the ruined structure. In the fifteenth century the symbolic ruin — and the above instances leave little doubt that it is symbolic — came to be introduced into representations of the Infancy of Christ, viz., the Nativity (quite literally the birth of a new era) and the Adoration of the Magi which was commonly interpreted as signifying the acceptance of Christianity all over the world, each of the Magi representing one of the continents then known. It is hard to tell whether the ruin in Gentile da Fabriano's "Adoration of the Magi" of 1423[4] is supposed to be Romanesque or Roman. But in Northern pictures from *ca.* 1440 the style of these ruined struc-

tures is almost invariably distinctly Romanesque, and this (among other things) is what distinguishes the central panel of Roger van der Weyden's Bladelin altarpiece (fig. 337) from its direct prototype, the "Dijon Nativity" by the Master of Flémalle (fig. 201), or the "Berlin Adoration of the Magi" by the Middle Rhenish Master of the Darmstadt Passion [1] — strongly influenced by Jan van Eyck — from that of his regional forerunner, the Master of the Ortenberg Altarpiece (text ill. 30). This kind of setting remained typical of Flemish as well as German renderings of these two scenes until, under the influence of the Italian Renaissance, the ruins of Romanesque buildings were replaced by those of classical temples and triumphal arches.

It appears, then, that the use of Romanesque features for symbolical purposes was fairly general in the formative phase of early Flemish painting. But it was in the van Eyck brothers, and most particularly in Jan, that it assumed the character of a systematic revival. In the Master of Flémalle's early "Betrothal of the Virgin" in the Prado (fig. 199), the contrast between the Old Dispensation and the New is expressed by two structures — or rather, two portions of one and the same structure — which are not, if one may say so, on the same level of morphological accuracy. The Miracle of the Rod — with the High Priest Abiathar sacrificing in the Holy of Holies and the reluctant Joseph feebly struggling against those who try to force him to enter [2] — is staged in a building which by its dome, its circular plan and its richly decorated columns proclaims itself to be the Temple of Jerusalem. The reception of the holy couple, on the other hand, takes place at the entrance of a Gothic narthex of which, as yet, no more than the doorway exists (a visual indication of the fact that the Betrothal of the Virgin is, as it were, a mere preamble to the story of Redemption). Here, as in Broederlam's "Annunciation," a deliberate contrast has been made between an "old" and a "new" type of architecture. And if it has been said that, since the Miracle of the Rod takes place in the same Temple as does the Betrothal, "there was no obvious reason why, on symbolical grounds, the painter should have tried to differentiate the style of the two buildings" [3] we must remember that it is the first appearance of the Virgin and not of St. Joseph which announced the approach of the new era; and that, according to medieval interpretation, it is the western and not (as in a Christian church) the eastern part of the Jewish Temple which was supposed to "signify the spiritual state of the New Law." [4] However, while the Gothic of the new narthex is so naturalistic that the model of the structure can be recognized in a transept façade then in course of erection,[5] the style of the old sanctuary is still a fantastic mixture of heterogeneous elements; round arches alternate with pointed ones and the reliefs in the spandrels and on the capitals smack of the early fifteenth rather than the twelfth century. Moreover, the Master of Flémalle does not seem to have developed this kind of architectural symbolism *à la* Broederlam in his later works. It is significant that the "Annunciation" in his Mérode altarpiece (fig. 204) is free from Romanesque features while these were introduced into the "Annunciation" in the Ghent altarpiece (fig. 276) which, as pointed out by M. de Tolnay, seems to be based upon the former.[6]

Jan van Eyck, however, almost became an archeologist. He learned to recreate Romanesque churches, chapels and palaces; he studied and used the forms of Romanesque inscriptions (from

which he revived the "square C," not very frequent after the middle of the twelfth century and virtually absent from Gothic epigraphy); and he imagined Romanesque reliefs and frescoes which, were they real, we could assign to definite schools and date within the limits of a few decades.[1] I say, "to recreate" and "to imagine" because it is only in very exceptional cases that we can identify one of his architectural details with an actual monument. Even then his rendering is a free transformation rather than a literal record,[2] and never can a whole scenery or setting be shown to portray a particular place. The landscape of the "Rolin Madonna" (fig. 244), though doubtless inspired by the Meuse valley, is so imaginative that scholars have identified the city, with equal assurance, as Lyons, Maastricht, Liége and Prague.[3] Minor artists of the time would occasionally attempt to portray an actual edifice but often grotesquely distorted its essential proportions while faithfully reproducing its non-essential details.[4] Jan van Eyck, however, had so thoroughly "replenished his mind by dint of much portraying," as Dürer would say, that he was able to design buildings, sculptures, paintings and ornaments in whichever style he desired without resorting to individual models. Drawing from the "secret treasure of the heart," he could endow with the semblance of utter verisimilitude what was in fact utterly imaginary. And this imaginary reality was controlled to the smallest detail by a preconceived symbolical program.

Throughout the Middle Ages the relation between Judaism and Christianity had been an ambivalent one. The Synagogue was both the enemy and the ancestress of the Church; the Jews were considered as blind and wicked in that they did not recognize the Saviour when he appeared, yet as clear-sighted and saintly in that the Old Testament announced His coming on every page. At Bamberg Cathedral we see, in one and the same portal, the Apostles standing on the shoulders of the Prophets, and a personification of the victorious Church contrasted with an image of the blindfolded, vanquished Synagogue beneath which the eyes of a Jew are being put out by a devil.[5]

It was Jan van Eyck who resolved this ambivalent feeling into a sense of continuity and ultimate harmony. In the "Annunciation" of the Ghent altarpiece, he not only changed the Master of Flémalle's bourgeois living room into a more resplendent and complex apartment elevated high above the ground (as though the Virgin were actually in the "tower of chastity") but also introduced, as I have mentioned, the now familiar contrast between Gothic and Romanesque forms. But he did not align these forms one against the other. He rather established a complementary relationship in that he reserved the Gothic treatment for such features as seem to have been added to an essentially Romanesque interior as bearers of a special significance. The Gothic style appears only in the tracery of the two outside windows, the one on the right admitting the rays of the sun which paint two pools of light directly behind the Annunciate; and in the little niche with laver and water basin, which is an indoors substitute for the most typical symbols of the Virgin's purity, the "fountain of gardens" and "well of living waters" of the Song of Songs.[6]

In Jan van Eyck's "Annunciation" in the National Gallery at Washington (fig. 238) the scene is laid, for the first time in panel painting, in the interior of a church. By its twin columns

this church suggests the nave of Sens or the choir of Canterbury (which Jan van Eyck may have visited during his stay in England in 1428) while its square-headed triforium is reminiscent of Tournai Cathedral. Yet we are faced with an imaginary structure. And this structure seems to have been built from top to bottom instead of from bottom to top. It is Romanesque — even Early Romanesque — in the clerestory with its flat ceiling and simple, round-arched windows, a little more advanced in the triforium, and early Gothic in the lower zone where windows and arcades alike show pointed arches. Empirically, this is odd. Symbolically, however, it is not only consistent but profound. The picture illustrates, in architectural terms, the self-revelation and self-explication of the Trinity which marks the transition from the Jewish to the Christian era, the Trinity being, again, signified by the three Gothic windows in the lower zone. The round-arched window in the clerestory, however, shows the image of the Lord Sabaoth of the Old Testament, nimbed with a simple, not cruciform, halo, resting His feet upon the earth according to Isaiah LXVI, 1, and surmounted by cherubim, four-winged and standing on wheels according to Ezekiel X. This Godhead, triune in essence but not as yet in existence, unfolds Itself as the explicit Trinity in the act of the Incarnation, and this act is conceived as an emanation proceeding from above to below (both in the Washington picture and the Ghent altarpiece the Annunciate's answer to the angelic salutation is written upside down so that God in His Heaven can read it). And the downward path of the ray divine on which the Dove of the Holy Spirit descends, the downward path from Triune God to Trinity, is mirrored in a downward transition from one window to three and, at the same time, from Romanesque to Gothic.

This basic concept is commented upon, as it were, in the murals on either side of the Lord Sabaoth — murals apparently of about 1200 and very similar in style to specimens recently uncovered in Tournai — and in the nielli of the pavement which, did they exist in reality, would have to be dated somewhat later (fig. 239). Instead of emphasizing the contrast between the Old Dispensation and the New, this decoration stresses their continuity. The murals represent the finding of Moses, prefiguring the reception of Christ by the community of the faithful, and the Giving of the Ten Commandments prefiguring the giving of the New Covenant. The nielli represent, in chronological order, Samson Slaying the Philistines (prefiguring the triumph of Christ over sin), Samson and Delilah (prefiguring the Entombment), the Death of Samson (prefiguring the Crucifixion), and the Victory of David over Goliath (prefiguring Christ's victory over the Devil). The roundels that mark the intersections of the bands enframing these scenes exhibit the Signs of the Zodiac, which proclaim, as they do in the façades of so many cathedrals and abbey churches, that the King of kings rules the physical as well as the spiritual universe. But the arrangement of these roundels is so unusual that they seem to convey a more special message. As can be inferred from those that are exposed to view, the Signs are not arrayed in their customary sequence but in parallel rows running from back to front as also do the Samson and David scenes. As a result, the position of the Annunciate coincides with the Sign of the Virgin with whom Our Lady had been identified ever since Hellenistic and Arabic astrology had come to interpenetrate with Christian beliefs. Assuming that the first two Signs occupied a separate row, the Angel would kneel upon the Ram, the sign of March when the

Annunciation took place (March 25), and near the right-hand margin of the picture there appears, next to the lilies and the footstool (which may or may not be an allusion to Isaiah LXI, 1, and many other passages in Scripture), the Capricorn, the sign of December and Christmas.[1]

Where Romanesque forms are thus employed to visualize the antithesis between the Old and the New Dispensation, the eras "under law" and "under grace," their symbolism is, so to speak, retrospective; it expresses a reconciliation of the present with the past. In other works of Jan van Eyck, however, this symbolism is projected into the future. To his way of thinking, the Romanesque was appropriate not only to the old, terrestrial Jerusalem — and thus, by implication, to Judaism as opposed to Christianity — but also to the New, or "Heavenly," Jerusalem and thus, by implication, to the life in Heaven as opposed to the life on earth.

In the dedication page of the "Brussels Hours," the "Wilton Diptych," Claus Sluter's portal of the Chartreuse de Champmol, and many funerary monuments, the donor, we recall, had been granted an artistic status equal to that of the Madonna and the Saints. He had been admitted, by way of anticipation, to the state of ultimate bliss. But this had been possible only because the scene was laid in a superterrestrial environment, the figures being set out against an ideal background often explicitly characterised as "Heaven" by an abundance of angels. Jan van Eyck's naturalism demanded an apparently real architectural setting, and it was for this reason that this setting had to be an architecture manifestly different from normal experience — an architecture visibly anticipating the "Heavenly Jerusalem." Therefore, wherever a picture by Jan van Eyck represents a donor admitted to the presence of the Deity and thus proleptically attaining the state of "them which are saved," the setting is not only exceedingly sumptuous, with marble floors, columns of jasper and porphyry, rich furnishings and the profusion of ornaments as described in Revelation XXI, XXII, but also invariably Romanesque. And in order further to distinguish this quasi-celestial architecture, Jan van Eyck was careful to intersperse the Romanesque ensemble with Gothic elements and even liked to include some features suggestive of pagan antiquity. He wished to express the ultimate absorption of the whole present and the whole past in the fulfillment of the Last Days.

The most conspicuous example of this kind is the "Madonna of Nicholas Rolin" (fig. 244) presented to Autun Cathedral by the mighty and unscrupulous Chancellor of Philip the Good. Here, where a human being has gained admission to the elevated throne room of the Madonna without the benefit of a canonized sponsor, it was doubly imperative to designate this throne room as part of a palace not of this earth. The beautiful garden seen through a triad of openings, with a cluster of lilies in the center and abounding in roses and irises, brings to mind both the *hortus conclusus* and the Garden of Paradise. The glittering Meuse suggests the "pure river of water, clear as crystal" that runs through the New Jerusalem. And the style of the architecture is generally Romanesque. The bases of the columns, as well as the spandrels of the tripartite arcade, show Gothic tracery, and the scenes on the historiated capitals are, on the left, examples of sin taken from the Old Testament (the Expulsion from Paradise, the story of Cain and Abel, and the Drunkeness of Noah) and, on the right, an example of virtue taken from Roman history, viz., the Justice of Trajan.[2]

In the Dresden triptych, too, the architecture and the stained glass in the clerestory windows — again three in number — are Romanesque (figs. 240–242). But the bases of the columns, the blind arcades beneath the windows of the lower storey and the Apostle statues with their consoles and crocketed canopies are Gothic. And here the Expulsion from Paradise and the Sacrifice of Isaac, displayed on the capitals of the right-hand pier, are contrasted with Roman soldiers on the opposite side and, even more surprisingly, with an almost classicistic lion hunt which, on the capital in the left shutter, surmounts the figures of St. Michael and the donor.

In the "Madonna of the Canon van der Paele," finally, we have a setting patterned, in a general way, upon such Romanesque models as St. Bénigne-de-Dijon or Neuvy-St.-Sépulcre (fig. 248). But again we find Gothic quatrefoils on the steps of the Virgin's throne and Gothic statuettes and little niches in its principals. And once more the capitals of the piers exhibit a Biblical incident(Abraham and Melchizedek), on the one side, and a classical hunting scene on the other.[1]

III

The use of such apparently naturalistic artifacts as Gothic windows, Romanesque columns, classical hunting reliefs and monkey-shaped consoles for purposes of allegorical signification bears witness to a type of symbolism virtually unknown to the High Middle Ages. A non-perspective and non-naturalistic art, not recognizing either unity of space or unity of time, can employ symbols without regard for empirical probability or even possibility. In High Medieval representations, personages of the remote past or the distant future could share the stage of time — or, rather, timelessness — with characters of the present. Objects accepted and plainly recognizable as symbols could mingle with real buildings, plants or implements on the same level of reality — or, rather, non-reality.

In the "Crucifixion" of the beautiful Psalter of Yolande de Soissons of *ca.* 1275, (fig. 1), for instance,[2] there are assembled beneath the Cross, not only the Virgin Mary, St. John and the Centurion, but also such witnesses to the divinity of Christ as could not have been present on Mount Golgotha: Moses, the prophet Balaam and Caiaphas, who owes his inclusion in this illustrious company to his "unconscious prophecy" in John XI, 50, where he says, "one man should die for the people and the whole nation perish not." In literal illustration of Simeon's words according to Luke II, 35, ("Yea, a sword shall pierce through thy soul also") a huge sword protrudes from the bosom of Our Lady. In order to bring out the identity of the Cross with the tree of Life, the Cross is depicted as a hybrid of artifact and twelve-branched, richly foliated tree, and on its top is seen the familiar symbol of Christ's sacrifice, the pelican nursing her young with her own blood. We can easily see that such a blend of present, past and future, of things real and things symbolic, proved to be less and less compatible with a style which, with the introduction of perspective, had begun to commit itself to naturalism. The application of perspective, we remember, implies that the painting surface is understood as a "window"

through which we look out into a section of space. If taken seriously, this means no more nor less than that pictorial space is subject to the rules that govern empirical space, that there must be no obvious contradiction between what we do see in a picture and what we might see in reality — excepting, of course, the symbolic representation of spiritual events as in Roger van der Weyden's "Seven Sacraments" and those supernatural phenomena which defy the laws of nature by definition as is the case with angels, devils, visions, and miracles.

On the other hand, the world of art could not at once become a world of things devoid of meaning. There could be no direct transition from St. Bonaventure's definition of a picture as that which "instructs, arouses pious emotions and awakens memories"[1] to Zola's definition of a picture as "un coin de la nature vu à travers un tempérament." A way had to be found to reconcile the new naturalism with a thousand years of Christian tradition; and this attempt resulted in what may be termed concealed or disguised symbolism as opposed to open or obvious symbolism.

When the illuminator of *ca.* 1275 wished to represent the Prophets of the Old Testament as witnesses to the Crucifixion, he simply placed them beneath the Cross and identified them by suitable attributes and scrolls; when Broederlam wished to represent them as witnesses to the Annunciation he had to introduce them under the guise of statues attached to an apparently real *tempietto*. When the illuminator of *ca.* 1275 wished to evoke the ideas associated with the Pelican in Her Piety he could simply draw a Pelican in Her Piety on top of what is both a Cross and a tree; when Jan van Eyck wished to do likewise he had to introduce her under the guise of a little brass group surmounting the armrest of an apparently real throne (text. ill. 56).[2] When the illuminator of *ca.* 1275 wished to allude to Simeon's prophecy he could represent its fulfillment by showing the Mater Dolorosa, her heart transfixed by a sword; when Dürer, reverent heir to the Flemish tradition, wished to allude to the same prophecy, he showed the Madonna in the happiness of her motherhood, overshadowed by a big iris the ancient name of which was *gladiolus*, or "sword-lily."[3]

The principle of disguising symbols under the cloak of real things is, however, not a new invention of the great Flemings, nor does its application begin with Melchior Broederlam. It emerged, as a concomitant of the perspective interpretation of space, in the Italian Trecento. In Giotto's "Dance of Salome" in Santa Croce the roof of Herod's palace is topped with statues of pagan divinities interconnected by classicistic garlands.[4] Similarly the evil, anti-Christian implications of the locale in Duccio's "Christ among the Doctors" are indicated by four armed and winged idols.[5] The temple in Ambrogio Lorenzetti's "Presentation" of 1342 (text. ill 16), on the other hand, is adorned with statues of Moses, Joshua and angels, and his "Martyrdom of the Franciscan Missionaries to Morocco" is staged in a kind of loggia the crowning statuary of which opposes Minerva, Mars and Venus to their Christian counterparts, Justice, Fortitude, and Temperance.[6]

This, however, was a mere beginning, and the further development did take place in Northern art to reach its climax in the great Flemings. In the Trecento, the disguise of symbols is not too difficult to penetrate; they are all statues or reliefs having a definite and easily recog-

nizable iconographic significance. In Early Flemish painting, on the other hand, the method of disguised symbolism was applied to each and every object, man-made or natural. It was employed as a general principle instead of only occasionally just as was the case with the method of naturalism. In fact, these two methods were genuine correlates. The more the painters rejoiced in the discovery and reproduction of the visible world, the more intensely did they feel the need to saturate all of its elements with meaning. Conversely, the harder they strove to express new subtleties and complexities of thought and imagination, the more eagerly did they explore new areas of reality.

In the end, the whole universe "shone" as Suger would say, "with the radiance of delightful allegories"; and it has justly been said of the "Annunciation" in the Mérode altarpiece that God, no longer present as a visible figure, seems to be diffused in all the visible objects.[1] The naturalism of the Master of Flémalle and his fellow painters was not as yet wholly secular. It was still rooted in the conviction that physical objects are, to quote St. Thomas Aquinas (*Summa Theologiae*, I, qu. I, art. 9, c), "corporeal metaphors of things spiritual" (*spiritualia sub metaphoris corporalium*); and it was not until much, much later that this conviction was rejected or forgotten.

Needless to say, so total a sanctification of the visible world confronts the modern beholder — including the art historian — with a serious problem. If every ordinary plant, architectural detail, implement, or piece of furniture could be conceived as a metaphor, so that all forms meant to convey a symbolical idea could appear as ordinary plants, architectural details, implements, or pieces of furniture: how are we to decide where the general, "metaphorical" transfiguration of nature ends and actual, specific symbolism begins? Where a Prophet remains a Prophet even though converted into a statue, and where the Pelican in Her Piety remains the Pelican in Her Piety even though converted into the knob of an armrest, there can be no doubt as to the artist's intention. And where the principle of disguised symbolism was not as yet developed to perfection, the very awkwardness of the result may help to give us some assurance. There is so little practical or "esthetic" justification for those three tracery windows perched upon a cornice in Broederlam's "Annunciation" that we are simply forced to accept them as a Trinitarian symbol. There is so obvious an improbability in the combination of temple and narthex in the Master of Flémalle's "Betrothal of the Virgin" that we cannot help interpreting this contrast as indicative of a deliberate antithesis.

In the same artist's Mérode altarpiece, however, the pot of lilies is perfectly at ease upon its table, and if we did not know its symbolical implications from hundreds of other Annunciations we could not possibly infer from this one picture that it is more than a nice still-life feature. In view of these many parallels, we are safe in assuming that the pot of lilies has retained its significance as a symbol of chastity; but we have no way of knowing to what extent the other objects in the picture, also looking like nice still-life features, may be symbols as well. There is, I am afraid, no other answer to this problem than the use of historical methods tempered, if possible, by common sense. We have to ask ourselves whether or not the symbolical significance of a given motif is a matter of established representational tradition (as is the case

with the lilies); whether or not a symbolical interpretation can be justified by definite texts or agrees with ideas demonstrably alive in the period and presumably familiar to its artists (as is the case with all those symbols revolving around the relationship between the Old and the New Testament); and to what extent such a symbolical interpretation is in keeping with the historical position and personal tendencies of the individual master.

In the case of the Mérode altarpiece, for example, it is not easy to determine just which of the objects other than the pot of lilies — and, of course, the pious books on the Virgin's table — carry a determinable meaning. Several of them recur in an analogous context in other works, both by the Master himself and by others, and can thus be shown to conform to an established tradition. The laver and basin have already been mentioned as an indoors substitute for the "fountain of gardens" and "well of living waters," one of the most frequent symbols of the Virgin's purity. The lions on the armrests of her bench bring to mind the Throne of Solomon described in I Kings X, 18 ff., with its two lions "beside the stays" and twelve "on the one side and on the other upon the six steps," time-honored simile of the Madonna as *Sedes Sapientiae*.[1] And the candlestick, supporting the candle which signifies Christ much as a mother does her child, was also a familiar symbol of Our Lady:

> Ipsa enim est candelabrum et ipsa est lucerna . . .
> Christus, Mariae filius, est candela accensa.[2]

Other features, however, such as the fireplace with its screen and the two wall brackets (one holding another candle and the other empty), do not so readily lend themselves to a symbolical interpretation, and the Marian symbolism of the candle itself seems to be superseded by another idea akin to St. Bridget's notion of physical illumination "reduced to nothingness" by the radiance of the Light Divine:[3] the candle on the table has gone out, emitting a wisp of smoke, at the approach of the angel.

With the Master of Flémalle, then, the principle of disguised symbolism has not as yet crystallized into a perfectly consistent system. And, as he was apt to intermix disguised symbols with objects apparently devoid of meaning, so would he at times relapse into the open or obvious symbolism of an earlier period. In the "Madonna of Humility" in the G. Muller Collection at Brussels (fig. 226)[4] — which, though not an original, can be accepted as a faithful copy — the Virgin Mary is placed in a naturalistically rendered garden. But on the grassy bench is seen a bunch of lilies in an elaborate vase entirely out of tune with the campestral environment; and at her feet there is a crescent — a tangible, man-made object rather than a celestial body, a planted symbol rather than a disguised one. The Master of Flémalle's reality, not as yet completely stabilized and coherent, with tables threatening to tip over, benches extended to incredible length, interiors still combined with exterior views, could not absorb symbolical content so completely that there remained no residue of either objectivity without significance or significance without disguise.

It was in the art of Jan van Eyck that this residue was eliminated. In his compositions the significant objects neither compete with non-significant ones nor do they ever step before

the footlights. In the "Ince Hall Madonna" in Melbourne (fig. 243), for instance, we have a candlestick, a ewer, and a basin. Besides these, there are only two other objects that look like "still-life features," and these are more rather than less significant: three pieces of fruit on the window sill, and a carafe of clear glass illumined by the sun. The fruit, beautifully fresh and intact, suggests by this very intactness the *gaudia Paradisi* [1] lost through the Fall of Man but regained, as it were, through Mary, the "new Eve." And the transparent carafe was one of the most frequent Marian symbols; specifically, it brings to mind a stanza from a Nativity hymn demonstrably known to Jan van Eyck, because he quoted its beginning in another picture:

> As the sunbeam through the glass
> Passeth but not breaketh,
> So the Virgin, as she was,
> Virgin still remaineth. [2]

Precisely the same motifs — candlestick, basin, fruit and glass carafe — recur in the later "Lucca Madonna" in Frankfort (fig. 252), augmented only by the now familiar four lions on the armrests of the Virgin's throne. And a still later panel in Antwerp (fig. 255), Jan's only Madonna in an outdoor setting, throws, as it were, a retrospective light upon the meaning of the ewer and basin. These shining objects are here replaced by an exquisite little fountain, also of polished brass, which represents, quite literally, the "fountain of gardens."

IV

In Jan van Eyck, then, all meaning has assumed the shape of reality; or, to put it the other way, all reality is saturated with meaning, and I shall devote the rest of this chapter to a more detailed analysis of one of his loveliest and best known pictures, the "Madonna in a Church" in the Kaiser Friedrich Museum at Berlin (figs. 236, 237).

No donor or other mortal being present, the scene is laid in a basilica of purely Gothic cast — though even here a subtle difference suggestive of growth and internal development has been made between the arcades and triforium of the nave, which show the sturdy, plastic style of the thirteenth century, and the more fibrous forms of the vaulting system and the whole chevet, which would be about a hundred years later; that the chevet dates from a more recent period is explicitly expressed by the fact that its triforium and clerestory are raised above those of the nave so that the vault of the crossing is hidden from view by the much lower nave vaults and we receive the impression of a *sanctum sanctorum*, miraculously opening up at the end of the nave in which we find ourselves. All observers praise the painter's stupendous power in suggesting, in a picture "ain't twice the size of a postal card," as Mr. Rumbin would say, the vastness of a light-pervaded cathedral; the profusion and precision of glittering detail; the telling characterization of all sorts of materials; and the superb harmony of the composition. The soaring chevet enhances the Virgin's head with an architectural crown surmounting the real one; the luminary accents concentrated on the left are balanced by two spots of sunlight

cast upon the floor on the right; and a near identical pattern of majestic verticals and graceful curves appears, in reversed symmetry, both in the Virgin's drapery and in the shafts and vault-ribs of the architecture.

However, some critics have taken exception to one thing, the "disproportion" that exists between the dimensions of the Madonna and those of the architectural environment.[1] They feel that the figure of the Virgin is much too large in relation to the edifice and are inclined to account for this flaw by the artist's immaturity. It is true that the "Madonna in a Church" is probably the earliest of Jan van Eyck's uncontested panel paintings. But even so, it is the work of an accomplished master — a man in his thirties who had already served great princes for several years — and it would be surprising to encounter such an obvious miscalculation in a picture so astonishingly progressive in perspective and so meticulously accurate in the proportioning of all the other features. A master capable of establishing perfectly correct dimensional relations between bases, shafts, capitals, colonnettes, arcades, windows, furnishings, and incidental figures would hardly have increased the size of the Madonna so unreasonably had he intended to draw her to scale. In reality, his picture represents, not so much "a Virgin Mary in a church" as "the Virgin Mary as The Church"; not so much a human being, scaled to a real structure, as an embodiment in human form of the same spiritual force or entity that is expressed, in architectural terms, in the basilica enshrining her. And in doing so, it follows, in spite of its apparent naturalism, an age-old tradition both in idea and in form.

Ever since the Song of Songs had been interpreted as an allegory by the Fathers, the Bridegroom was identified with Christ, and the Bride with the Church, who in turn was mystically equated with Our Lady. "Everything that is said of the Church," writes Honorius of Autun whose commentary upon the Song of Songs enjoyed unparalleled authority, "can also be understood as being said of the Virgin herself, the bride and mother of the Bridegroom." And the composition which we know as the Coronation of the Virgin is rooted in miniatures showing the *Sponsus* in loving union with the *Sponsa*.[2]

In order to lend artistic expression to this mysterious and many-leveled identity of Virgin and Mother, Mother and Daughter,[3] Daughter and Bride, Queen of Heaven and Church on Earth, an image had been devised which may be described as "the Virgin Mary in a church and as The Church." The figure of the Mother of God, who at the same time personifies the Church as a spiritual entity, was framed by an aedicula or tabernacle which, however much diminished in scale, conventionalized in form and abbreviated in structural detail, was meant to suggest a complete ecclesiastical building.

In Herrad of Landsberg's *Hortus deliciarum* of 1181 we find an image of this kind which, to dispel any doubt as to its meaning, is explained by the following text: "The queen seated within the sacred edifice (*in templo*) signifies the Church that is called the Virgin Mother."[4] And in some other High Medieval miniatures this identification assumed such a degree of concreteness that the figure of the Virgin Mary — with or without the Infant Jesus — could be inscribed with the name of an individual church or ecclesiastical community. Between SS. Ludger and Benedict, there appears a Madonna and Child inscribed with the word "Werthina,"

and thereby identified with the Westphalian Abbey of Werden where this manuscript was produced in the eleventh century (text ill. 54).[1] Receiving gifts from Emperor Henry III and his wife Agnes, the Virgin Mary — here, as also in the *Hortus deliciarum*, without the Infant Jesus — is designated as "Spira," the Cathedral of Speyer.[2] And how unquestioningly the schematized aedicula enclosing the principal figure in such representations was accepted as the abbreviated image of an actual church can be inferred, not only from the inscription in the *Hortus deliciarum*, which explicitly identifies the framing device as a *templum* but also from the fact that the aedicula enframing the well-known early thirteenth-century Madonna in the northern transept of Reims (text ill. 52) was fashioned into the diminutive likeness of a contemporary cathedral, repeating as it does the architectural system of Chartres.[3]

With the change from open to disguised symbolism these conventionalized aediculae — thus far accepted, so to speak, as hieroglyphs and perpetuated through countless late medieval paintings, sculptures, book illuminations and liturgical objects [4] — were naturally converted into apparently real ecclesiastical structures. But these apparently real structures continued to signify "The Church," and the more naturalistic they looked the more clearly had they to reveal, by ancient devices, deliberately retained and new devices skillfully invented, that they still meant more than real structures.

In a painting nearly contemporaneous with Jan van Eyck's "Madonna in a Church" his great competitor for immortality, Roger van der Weyden, elaborated the conventional aedicula into an exquisite little outside chapel or oratory, projecting from a brick wall and opening onto a lawn (fig. 306). Realistically interpreted, this little chapel or oratory would be ridiculously small (clearing as it does less than six feet) were it supposed to be in scale with the Madonna. However, the painter intended to retain, within the framework of a naturalistic style, the traditional preponderance of the figure over her shrine — and yet to designate this shrine, whether we call it an outside chapel, an oratory or a plain niche, as a symbolic representation of the Church.[5] Small though it is by empirical standards, this little structure sums up in its imagery the entire doctrine of redemption. It is adorned with statues and reliefs showing the ancestors of Christ and the Prophets of the Old Testament; the Infancy from the Annunciation to the Adoration of the Magi; the Resurrection and Pentecost; and, surmounting a "cross-flower," the Coronation of the Virgin. On the side, moreover, grows an iris, the passional significance of which has just been mentioned; and on the other a columbine (called *ancolie* in French and by its name and purple color held to be the flower of melancholy and sorrow), accepted symbol of the Sorrows of the Virgin.[6]

Jan van Eyck, more deeply absorbed than Roger in problems of space and light, and more deeply in love with infinite variety, decided upon an entirely different solution. Instead of accepting the traditional scheme of a Madonna ensconced in a small aedicula and transforming this aedicula into a symbol of the Church by naturalistic elaboration and rich typological imagery, he expanded it into a whole cathedral. But just for this reason he found it necessary to stress its more than natural significance by retaining the old proportion — or disproportion — between the figure and its architectural surroundings. His cathedral, too, is not

a church but typifies the Church. He gives us, like Roger, the whole doctrinal system in the guise of an individual building. In the jubé are seen, besides a statue of the Madonna herself, the prophets of the Old Testament, the Annunciation, the Coronation of the Virgin and, towering over everything, the Crucifixion. The *Missa Beatae Mariae Virginis* with candles lighted on her altar, is celebrated not by human beings but by angels, and the idea of intercession is expressed by the statue of a saint significantly placed above the transept door that connects the Church with the outside world. But all this would not have made Jan's meaning clear had he not preserved the dominant scale of the principal figure. The very genius of the Church, the Virgin Mary — both mistress and personification of the edifice — seems to sweep towards us like a gigantic vision.

The "disproportion" between the figure and the architecture, then, is not a sign of immaturity. It is, on the contrary, a symbol: a deviation from nature which, deliberately retained within the framework of a naturalistic style, makes us aware of the fact that this wealth of physical detail, so carefully observed and reconstructed, is dominated by a metaphysical idea. Positive proof of this is found in the remarkable treatment of the light. The symbolical import of sunlight — especially of sunlight streaming through Gothic windows — has so often been stressed in this chapter that no further discussion is necessary. Moreover, Millard Meiss has recently analyzed Jan's picture and pointed out that its original frame was inscribed with the second stanza of the very hymn which, at the beginning of the fifth, contains the lines:

> As the sunbeam through the glass,
> Passeth but not breaketh . . .[1]

It seems to have escaped notice, however, that in this painting by a master so renowned for his naturalism — as also, though less conspicuously, in his two other renderings of the Madonna in an ecclesiastical setting, the "Madonna van der Paele" and the Dresden triptych — the sun shines from the North.

There is in all Christendom no Gothic church having a fullfledged cathedral choir with radiating chapels that would face the West and not the East. And if it is hazardous to accuse the most observant of painters — and also one of the most erudite — of a mistake in scale, it would be almost sacrilege to accuse him of a mistake as to the simplest law of nature and the most familiar of ecclesiastical customs. If he decided to reverse the laws of nature, he must have had a reason for doing so. And this reason is, simply, that the light he depicted was not intended by him to be the light of nature but the supernatural or "superessential" light which illumines the City of God, the Light Divine disguised as the light of day. With Jan van Eyck this light, though independent of the laws of astronomy, was subject to the laws of symbolism. And the strongest of these symbolical laws — so strong that, in case of conflict, it would take precedence over all other symbolical implications, especially that of North and South — was the positive nature of the right and the negative nature of the left.[2] The ray of divine illumination must strike the person blessed with this illumination from his or her right; and such is the case, for example, in Jan van Eyck's "Annunciation" in Washington, where a distinction is made between

the ray divine that comes from the Virgin's right and the natural light that comes from her left.

In the "Madonna in a Church" there is no such distinction. There is only what looks, and is meant to look, like the natural light of the sun. But Jan van Eyck wanted this apparently natural light to operate, as it were, as a supernatural radiance emanating from God. Therefore, it had to come from the Virgin's right. And lest anybody believe this to be an accident, it also comes conspicuously from the North — conspicuously because he chose to represent it, a rare occurrence even with him, as a sharply-defined beam that paints the pavement with patches of brightness so that the position of the sun — standing as high in the firmament as it would at the fifty-first degree of latitude at full noon — cannot be doubted for a moment. By this very defiance of the laws of astronomy the apparently natural light reveals its truly supernatural character.

This interpretation may seem farfetched to the modern beholder, but the painter himself has given us an unmistakable hint. On the border of the Virgin's magnificent red robe there is embroidered and partly visible the favorite Mariological text of the van Eyck brothers, a text which recurs in the Ghent altarpiece [1] and also in two other Madonnas in which the light seems to come from the North: [2] "Haec est speciosior sole, super omnem stellarum dispositionem. Luci comparata invenitur prior. Candor est enim lucis aeternae, speculum sine macula Dei majestatis." This text is the Little Chapter for Lauds on the Feast of the Assumption according to the use of several Flemish, North French and Lower Rhenish dioceses. [3] Taken from the Book of Wisdom VII, 29 and 26, it reads in translation as follows: "It [meaning: Divine Wisdom as diffused in the Universal Church and embodied in the Virgin Mary] is more beautiful than the sun and above the whole order (*dispositio*) of the stars. Being compared with the [natural] light, she is found before it. She is the brightness of eternal light, and the flawless mirror of God's majesty." Here it is said in so many words that the radiance of the light to which Divine Wisdom is likened is not only more brilliant than the sun but also independent of the natural order of the universe (*super omnem stellarum dispositionem*); and that it is superior as compared to the light of day. For, as the text continues (VII, 30 and VIII, 1): "After this cometh night, but against Wisdom evil doth not prevail; she reacheth mightily from one end [of the world] to the other." What more convincing pictorial image could there be of a light that is above the order of the physical universe, that illumines a day not followed by night, and that "reacheth from one end of the world to the other," than a sun which shines from the North and thereby proclaims that it can never go down?

VI

"ARS NOVA"; THE MASTER OF FLÉMALLE

With the disaster of Agincourt in 1415, the death of the Duc de Berry in 1416 and the withdrawal of Philip the Good to Flanders, the stage was set for Early Flemish painting to come into its own.

Except for such apparently infrequent cases as that of Melchior Broederlam, the most progressive and talented artists of Netherlandish birth had hitherto been lured into the orbit of the great illuminators in Paris or into the service of the French princes. Now the prophets no longer went to the mountain; the mountain had come to the prophets. Instead of seeking employment abroad, the men of genius had every reason to stay in their homeland and settle in one of the Flemish emporia where they could enjoy, along with the favors of the Burgundian Court and its smaller rivals or satellites, the patronage of the wealthiest and most cosmopolitan society in Europe.

Both Jan van Eyck and Roger van der Weyden served bankers, merchants, ecclesiastics and wealthy craftsmen as well as the Duke of Burgundy and his nobles. And while these two great artists were not as yet enrolled with local guilds, such was the case with nearly all the others who lived and died as master painters in the various towns and mostly worked for an upper middle class clientele.

This shift of artistic activity from feudal Bourges and Dijon to the bourgeois centers of the Netherlands was conducive to local diversity, on the one hand, and to national consolidation, on the other. The very fact that even the greatest of painters were identified with established communities and subjected themselves to the rules of a strict guild system facilitated the formation of local "schools" which we are still accustomed to connect with places rather than with persons, as when we speak of the schools of Tournai, Bruges, or Ghent, of Brussels, Antwerp, or Haarlem. But at the same time the end of large-scale emigration to France caused, or made possible, the reunion and self-assertion of those indigenous forces which had been alienated and scattered for more than a century. Jean Bondol and André Beauneveu, Jacquemart de Hesdin and the Boucicaut Master, Jean Malouel and the Limbourg brothers — all these illustrious Franco-Flemings had been expatriates. Their efforts had been swallowed up by the International Style, and those who had stayed in the Lowlands had rarely risen above the level of provincialism. Now, with what may be called the repatriation of the Flemish genius, the

149

volatile elegance of the International Style refined and cosmopolitanized the domestic tradition while the naïve strength of the domestic tradition lent stability and substantiality to the International Style. It was from this fusion of sophistication and candor, worldliness and piety, brilliance and truthfulness that the *ars nova* or *nouvelle pratique* of Early Flemish painting arose.

The expression *ars nova* — originally coined as early as about 1320 but deliberately transferred to a development that took place exactly a century later — is borrowed from Johannes Tinctoris, and the expression *nouvelle pratique* from Martin le Franc. These authors, the former a theorist writing about 1475, the latter a poet writing about 1440, do not deal with the art of painting; the masters whom they hail as standard-bearers of a "novel style" are two composers, Guillaume Dufay and Gilles Binchois.[1] But the historical position of these "fathers of modern music" — both born in the Hainaut about 1400 and both connected with the court of Philip the Good — is so surprisingly analogous to that of the "fathers of modern painting" that the appropriation of the terms *ars nova* and *nouvelle pratique* by art historians may seem permissible. Dufay and Binchois, of whom Tinctoris says that nothing worth listening to had been composed before their time, are to the followers of Guillaume Machaut (died 1377) as the van Eyck brothers and the Master of Flémalle are to the Limbourgs and the Boucicaut Master. In fact, the music of such late-fourteenth-century masters as Solages, Trebor, Senleches and Galiot — some of them serving the same familiar devotees of the International Style as did the great French and Franco-Flemish illuminators — can be described in terms nearly identical with those which have been applied to the *Fleur des Histoires de la Terre d'Orient*, the *Boccace de Philippe le Hardi* or the *"Très Riches Heures."* Planning to publish a collection of these little-known compositions and inviting comment upon their possible relation to contemporary paintings and book illuminations, the eminent musicologist, Dr. W. Apel, was kind enough to give me a succinct characterization of their stylistic criteria; and I cannot resist the temptation of freely quoting him:

"Seen as a whole, these works give the impression of an overrefined, courtly civilization, precious and mannered, varied and full of ideas. Their most conspicuous peculiarity is an extraordinarily complicated system of notation which I have described as 'mannered' in my book on the notation of polyphonic music.[2] It represents a unique phenomenon in the history of musical notation sharply distinguished from the comparatively simple systems employed by Machot as well as Dufay.

"Since early notation is mainly intended to represent rhythm, it is only natural that the rhythmical organization is also marked by a complexity and intricacy the like of which is not found in the whole history of music. The most sophisticated syncopations of Stravinsky and other moderns are child's play by comparison. Both from a rhythmical and a harmonic point of view one is inclined to speak of 'filamentization' (*Zerfaserungsstil*). Yet there are certain pieces — intended to give a special, "realistic" effect — which are simpler in structure and attractively exploit natural sounds such as the call of birds: 'occi, occi, occi, tu-tu-tu.'"

THE MASTER OF FLÉMALLE

That the distinctive qualities of this music — manneristic refinement and overcomplexity coupled with an unconsummated, fractional longing for nature — exactly parallel those of the International Style is too evident to require amplification. And no less evident is the analogy which exists between the *ars nova* of Dufay and Binchois and that of the van Eyck brothers and the Master of Flémalle. In both cases we have a "repatriation"of Flemish art to Flemish soil — a repatriation due not to one single genius but to the efforts of several great men endowed with equal gifts and striving for a common goal, however divergent their taste and character. And in both cases the consequences of this repatriation meant a fulfillment of the nostalgia for a more "natural" mode of expression.

In painting as well as in music, precious or tortured sentiment gave way to simple, strong and uninhibited veracity, and in painting as well as music this change in feeling demanded and produced a change in technical procedures. As Dufay and Binchois extended the Guidonian scale by two full notes at each end and restrained rhythmical and polyphonic complexity in favor of clear-cut contrapuntal contrast and harmony ("with the recognition of thirds and sixths as consonances music was conceived as a functional progress of chords"),[1] so did the van Eyck brothers and the Master of Flémalle increase the range of their palette from deepest blues and reds to yellows brilliant enough to take the place of actual gold, and began to think of coloristic and luminary values as primary rather than secondary factors of pictorial composition. Where the illuminators of the International Style, however advanced, belong to the Middle Ages, the Early Flemish painters, however much indebted to the past, belong to the modern times.

These new artistic aims were predicated upon what is commonly referred to as the "new oil technique." The old belief that this new method was invented by Jan van Eyck has long been discredited, but we do not know who, if anybody, was really the first to employ it. Nor is there unanimity as to the extent to which it deserves its traditional name.[2]

The use of oil as a binding medium was not unknown to earlier periods. From Heraclius and Theophilus, both writing in the tenth century, down to Cennino Cennini and the "Strassburg Manuscript" of *ca.* 1400, linseed and other oils were recommended along with such media as fig juice, egg yolk, egg white, whole egg, or that mixture of egg yolk and water which is called "tempera" in the narrower sense of the term; and methods were taught by which the oils might be thickened, purified, bleached and "dried" (boiling with pumice stone or bone ash and baking in the sun for thickening and purification, an admixture of chalk, ceruse, white copperas, litharge, or, ultimately, sulphate of zinc for dessication). Cennini even stresses the fact that oils were favored by the "Germans" — by which he probably refers to all Northerners — rather than the Italians.[3]

It would seem, however, that the application of these oil techniques was the exception rather than the rule. They were recommended and practised, either for reasons of durability rather than for artistic effect (as is the case with the coating of walls,[4] columns,[5] statues,[6] doors,[7] armorial shields, and, we recall, processional banners[8]); or for specific and unusual purposes: for what was called *pictura lucida* (small paintings thinly painted upon metal foil so as to

simulate translucent enamel),[1] and for those glazes — either over metal foil or tempera — which achieved such special effects as the luster of gold cloth and velvet.[2] It is significant that what seems to be the most explicit fourteenth-century source — a passage in the *Reductorium morale* by the Benedictine Pierre Bersuire (Petrus Berchorius), a friend of Petrarch — refers to the oil process solely as a means of lending permanence to wall paintings and therefore bases its moral interpretation upon the concepts of *firmitas* and *tenacitas*: "In general, a picture or image is outlined by contours and finally painted in colors; the colors, however, are tempered with oil so that they may more firmly adhere and endure. By such images things actually absent or past are brought to life, and with them the temple of the saints is decorated on its surfaces. In like manner the righteous man may properly be called an 'image.' For, he is first outlined by the painters (that is, the prelates and preachers) by means of good teaching; then he is colored with virtues; and in composing him there is applied the oil of mercy so that he may be able to persist in the state of virtue more easily and steadfastly. Proverbs 21: [There is] *oil in the dwelling of the righteous.*"[3]

It was thus not the use of oils as such which distinguished the method of the great Flemings from that of their forerunners; it has even been denied that oils played a significant role in their procedure at all.[4] This theory, according to which the Flemish technique of the fifteenth century — which did not differ essentially from that of the early sixteenth — was nothing but an improved tempera process, goes certainly too far and is at variance, not only with what is obvious to the eye but also with all the literary evidence. It cannot be by chance that even firsthand sources such as Dürer's *Diary of His Journey to the Netherlands* and ancient inventories or contracts explicitly speak of "oil paintings" and, by contrast, of pictures executed "*sans huelle*,"[5] and Dürer himself has left us the following recipe for the treatment of "good ultramarine" for which he had to give from ten to twelve ducats an ounce: "It should be mixed with nut oil that has been purified as much as possible by passing it through a little wooden box with the bottom a hand thick, and painted as thinly as possible; the ground, too, should be soaked with oil and the underpainting should be done in lower grade (*schlecht*) ultramarine."[6] This passage throws some light on what was probably the real novelty in the procedure of the old masters. Rather than inventing entirely new processes, they appear to have perfected the traditional ones and thus to have developed a system of stratification, not unlike that employed in later Limousine enamel work, which permitted them to combine the minuteness of book illumination with the substantiality of tempera painting and the luminosity of *pictura lucida*.[7]

The whole picture was built up from bottom to top by superimposing "rich" and therefore translucent paint (viz., pigments tempered with a fat medium, mostly, though not exclusively, oil)[8] upon "lean" and therefore more or less opaque paint (viz., pigments tempered with other, aqueous media or, possibly, an emulsion). Lighter and darker tones were produced by applying the translucent colors over an opaque underpainting — significantly called *doodverw*, "dead color," in Dutch and Flemish — which pre-established the light values and, to

some extent, the general color; and finer gradation — in certain cases even an optical mixture of two colors — was achieved by applying further films of pigment.

As a result, the light is not entirely reflected from the top surface of the picture, where opaque pigments appear only in the shape of highlights. Part of the light penetrates the coat or coats of translucent paint to be reflected from the nearest layer of opaque pigment, and this is what endows the pictures of the old masters with their peculiar "depth." Even the darkest tones could never turn opaque, and ultimately the whole multiple coat of paint would coalesce into a hard, enamellike, slightly uneven but uniformly luminous substance, irradiated from below as well as from above, excepting only those sporadic whites or light yellows which, by their very contrast to the transparent depth of the surrounding pigments, assume the character of "high lights."

This new technique enabled the painters not only to improve the gradation of light but also to revolutionize the distribution of color values. As long as all the pigments had been opaque the light intensity of a given color could be increased only by adding lead white, which naturally reduced its color intensity. It was therefore just in the relatively dark tones, undiluted with white, that the color intensity was at its highest; the shaded portions of a figure or drapery — whether the shadows were expressed by the same kind of pigment or by a different one as when yellow is shaded with orange or crimson — were coloristically more intense than both the strongly and the moderately lighted portions. With translucent pigments at his command the painter was able to strengthen the light intensity of a given color without an admixture of lead white, simply by using a thinner film of paint, and thus to avoid a reduction of color intensity. As a result, it was in the moderately lighted portions or "middle tones" — less thickly painted than were the shadows yet not loaded with lead white as were the high lights — that the maximum of color intensity was reached.[1]

This not only enhanced the unity and brilliance of the picture but also its verisimilitude. By a fundamental law of optics, the intensity of any given color is lowered both by an excess and a deficiency of light, both in the deeply shaded portions, where color turns black, and in the strongly lighted ones, where it turns white. It was only by the introduction of the "new oil technique" that painting could do justice to this law of optics, and we can easily see why the Italian humanists and *cognoscenti* were so greatly impressed with what appeared to them "to have been produced, not by the artifice of human hands, but by all-bearing nature herself."

II

When the Italian writers of the Renaissance drew the first outline of a history of art, the genealogy of Early Flemish painting appeared very simple. Its father was Jan van Eyck of Bruges, and Jan van Eyck was the master of Roger van der Weyden:

> A Brugia fu tra glialtri piu lodati
> El gran Iannes: el discepul Rugiero
> Cum altri di excellentia chiar dotati.[2]

Today the situation has become more complex. We know that Bruges was not the only center of the initial development. We know that Jan van Eyck had an elder brother named Hubert. We know that Roger van der Weyden, though not uninfluenced by Jan van Eyck, represents a very different tradition, and that this different tradition was established by the Master of Flémalle, who seems to have been Jan's senior by ten or fifteen years. On the other hand we do not know — at least there are as many opinions about these problems as there are art historians — what difference in age there was between Jan and Hubert van Eyck; what either of them contributed to the Ghent altarpiece which had been left unfinished by Hubert and was completed by Jan; and what either of them had accomplished before.

Under these circumstances it does not seem rewarding to look once more for one "true founder" of the Flemish school.[1] When Dr. de Tolnay places the combined crowns of Hubert and Jan van Eyck upon the head of the Master of Flémalle, leaving only a modicum of independence to the "gran Iannes," he assumes all the unknown quantities to be zero and, in some cases, transfers the known ones to the wrong side of the equation.[2] Yet he was right in pointing out — and this remains a major contribution to our knowledge — that several known paintings by the Master of Flémalle would seem to antedate all the authenticated or, at least, unanimously accepted works of Jan van Eyck (which are, however, compressed into the last three lustra of his life); that the Master of Flémalle appears to have exerted a certain influence upon Jan (the extent and importance of which remain, however, to be determined); and that the personality of Hubert is still too controversial to serve as a basis for discussion. It is, therefore, with the Master of Flémalle that our survey of the great Flemings should start.

Ever since this master, named after three panels in Frankfort which are supposed to come from Flémalle (or Flemael) near Liége, was recognized as an artistic individuality, a close affinity was observed between his style and that of Roger van der Weyden; but this affinity was interpreted in various ways. At first he was thought of as an ingenious follower of Roger.[3] Then he was promoted from Roger's disciple to Roger's master and — on the basis of documents already known before his "discovery" — identified with one Robert Campin, painter of Tournai.[4] Finally his works were ascribed, as products of a youthful phase, to Roger van der Weyden himself.[5]

That the third of these hypotheses is untenable will become apparent, I hope, as soon as we shall have acquainted ourselves with Roger van der Weyden's style itself. For the time being, I shall limit myself to showing that much can be said for the second, that is to say for the assumption that the Master of Flémalle is identical with Robert Campin.

Robert Campin is mentioned as a master painter in Tournai as early as 1406 and would thus seem to have been born some time about 1375. A home owner from 1408, he became a citizen in 1410 (from which we may conclude that he was not born in Tournai itself) and, as "peintre ordinaire de la ville," headed an apparently considerable workshop which never lacked commissions and apprentices. In 1423 he was swept into political prominence by a revolt of the organized craftsmen against the patriciate. He became Dean of the painters' guild in this year and was a member of one of the three City Councils established by the new regime until it was

overthrown in 1428. He then retired from public life and was even mildly prosecuted for un-Tournaisian activities. This, however, did not diminish his popularity as an artist and *chef d'atelier*; and when he had another, quite different conflict with the authorities in 1432, living as he did with a mistress engagingly named Leurence Polette, the sentence imposed upon him — a pilgrimage to St.-Gilles and banishment from the city for one year — was commuted to a moderate fine upon the personal intervention of the reigning princess, Jacqueline of Holland, Bavaria and the Hainaut.[1] He continued to prosper until he died on April 26, 1444, outliving Hubert van Eyck by nearly eighteen years and Jan van Eyck by nearly three.

In 1427, two young men, both described as natives of Tournai, began their apprenticeship (*apresure*) with Robert Campin: Rogelet de le Pasture ("Roggie" van der Weyden) on March 5, and Jaquelotte ("Jimmie") Daret on April 12. Five years later, in 1432, both were admitted to the painters' guild as masters: Rogelet — now "Maistre Rogier" — de le Pasture on August 1, Jaquelotte — now "Maistre Jaques" — on October 18, the feast day of St. Luke. Daret, curiously enough, was elected Dean of the guild on the very same day.[2] Since we know that the great Roger van der Weyden was in fact a native of Tournai,[3] that his death in 1464 was commemorated there by a special Mass in which the painters' guild participated,[4] and that he invested money in Tournai securities as late as in the 'forties,[5] it seemed very clear that he was identical with that "Rogelet de le Pasture" who served his apprenticeship with Robert Campin from 1427 to 1432; and that, therefore, Robert Campin was identical with the Master of Flémalle whose style has so much in common with Roger's.

However, those who hold that the Master of Flémalle is identical with Roger van der Weyden himself believe that we are faced with a case of fortuitous homonymy. According to them, the "Rogelet de le Pasture" who apprenticed himself to Robert Campin in 1427 would have been a person entirely different from the great Roger van der Weyden: he was, they think, identical with one "Maistre Rogier le paintre" who received modest remunerations for painting shields and regilding the lettering on an epitaph in 1436 and 1437[6] (when the great Roger was firmly established as City Painter of Brussels), and he as well as his master, Robert Campin, are supposed to have spent all their lives as insignificant craftsmen obscurely engaged in similar menial tasks.

Some of the arguments adduced in favor of this view can easily be dismissed. Assertions to the contrary notwithstanding, the "Maistre Rogier le paintre" who painted shields and gilded letters in 1436 and 1437 may easily be identical with one Rogier de Wanebac who had become *franc maistre* at Tournai on May 15, 1427.[7] And the artistic importance of Robert Campin cannot be contested on the grounds that he accepted commissions which a modern painter would consider beneath him. The professional standards of the later Middle Ages were very different from ours. Jean Malouel had coated the *Puits de Moïse*;[8] Broederlam had painted chairs and galleries;[9] and even Jan van Eyck and Roger van der Weyden were to polychrome sculptures both in stone and brass.[10]

There remains, however, one serious difficulty for those who believe in the identity of "Rogelet de le Pasture" with Roger van der Weyden and, consequently, of Robert Campin

with the Master of Flémalle. On November 17, 1426 — three and a half months before "Rogelet de le Pasture" began his apprenticeship with Robert Campin — a "Maistre Rogier de le Pasture" was presented by the municipality of Tournai with the so-called *vin d'honneur*, a gift of wine customarily offered to distinguished visitors or, though less frequently, to meritorious citizens on special occasions; he even received eight measures (*lots*) instead of the usual four.[1] How could a "master" so honored in one year become an "apprentice" in the next? And how could this apprentice be identical with the great Roger van der Weyden of whom we know that, born about 1400, he was a married man and a prospective father when "Rogelet" began his apprenticeship?[2]

To resolve this difficulty we have to bear in mind that a difference must be made between an apprenticeship *de facto* and an apprenticeship *de jure*. In Tournai as well as elsewhere an apprentice was not necessarily an indentured boy of fourteen or fifteen; he could be a comparatively mature artist who wished to work in an established workshop while not being eligible for membership in the guild, much as a modern scholar, while holding a full professorship in one university, may teach as a mere "lecturer" in another. When Jacques Daret began his *apresure* with Robert Campin in 1427, he had been in the latter's service for nearly nine years,[3] and was, we remember, elected Dean of the guild on the very day on which he became a free master. In spite of being referred to as "Jaquelotte," he must have been a full-grown man and a fairly accomplished painter when he began his "apprenticeship," and a rather dignified personage when he concluded it. Similarly the great Roger van der Weyden may have decided to enter the workshop of Robert Campin under the label of "apprentice" although he was about twenty-seven years of age and a potential *pater familias*.

Yet it appears surprising that this young painter, however famous he was to be in later years, should have been designated as "Maistre" and honored with the *vin d'honneur* even before he entered Campin's atelier. It has been thought that he might have become a free master in some guild outside Tournai, perhaps even a sculptors' guild, before 1426. This conjecture, however, cannot be demonstrated and even if true would not settle the problem. In the entire discussion, it seems to me, too little attention has been paid to the fact that the two crucial entries, that concerning "Rogelet's" apprenticeship and that concerning the distinction bestowed upon "Maistre Rogier," occur in two entirely different sets of records, the former in those of the Tournai painters' guild, the latter in those of the Tournai municipality. In the records of a painters' guild the designation "maistre" would automatically apply to an artist; in those of a municipality, it was more likely to apply to a man of learning or official position. In fact, when on October 18 of the following year, 1427, the great Jan van Eyck — bearing the master's title from 1422 at the latest, court painter to the Duke of Burgundy, and passing through Tournai as a special envoy of his illustrious master — was offered the *vin d'honneur* by the city (and only four measures at that), the very same municipal records refer to him, not as "*Maistre* Jehan d'Eyck" or "*Maistre* Johannes," but, almost discourteously, as "Johannes, *pointre*."[4] From this pointed distinction between "*Maistre* Rogier de le Pasture"

and "Johannes, *pointre*" we may infer that the former, whoever he may have been, was not designated as "maistre" in his capacity of artist.

We are thus faced with two possibilities. Either young Roger van der Weyden had acquired a master's degree in some university and was honored by his home town on the occasion of his triumphant return, the double allotment of wine conceivably due to a coincidence of this event with his marriage.[1] Or, we are confronted with a case of "fortuitous homonymy" after all; there is no reason why those who believe in the identity of "Rogelet de le Pasture," the apprentice of 1427, with Roger van der Weyden, the famous painter, should not accept the major premise of their opponents: the non-identity of this "Rogelet" with the "Maistre Rogier" of 1426. If "Maistre Rogier" is identified with the great master of Brussels while "Rogelet" is demoted to an inferior artisan of Tournai, why not identify "Rogelet" with the great master of Brussels while raising "Maistre Rogier" to the status of a visiting cleric or jurisconsult?

I am inclined to accept the second of these alternatives. The first would explain Roger's advanced age when beginning his "apprenticeship" with Robert Campin and harmonize with his markedly intellectual turn of mind but would be at variance with the customs of the period; no other painter of the fifteenth century has, so far as we know, enjoyed an academic education in his youth.[2] The second would make Roger's development perfectly normal if we are ready to assume that he, like Jacques Daret, entered Campin's workshop as a fairly accomplished painter rather than an "apprentice" in the ordinary sense of the term but, unlike Daret, had received his early training outside Tournai. And it is precisely this assumption which would account for the fact that even his earliest works appear to presuppose some familiarity with the style of Jan van Eyck and be entirely in harmony with the documents. Of "Rogelet de le Pasture," the apprentice, we know at least that he was, like the great Roger van der Weyden, a native of Tournai and a painter by profession. Of "Maistre Rogier de le Pasture," the gentleman thus styled in the same context in which Jan van Eyck is called "Johannes *pointre*," we know nothing but the name. And that this name could very well have been borne by two different persons is demonstrated by the fact that Roger's own father — Henry van der Weyden, a master cutler of Tournai — possessed a namesake, long confused with him, in Henry van der Weyden, master sculptor of Louvain.[3]

Be that as it may, on no account can the identity of Robert Campin with the Master of Flémalle be disproved on documentary grounds. And positive proof of this identity is furnished by the works of Jacques Daret. Of him we know that he had spent almost fifteen years with Robert Campin before becoming an independent master, and that he stayed in Tournai, with very few interruptions, for the rest of his life. He was an unadulterated product of Campin's workshop. We must expect his work to reflect the style of his one and only teacher; and what it reflects is the style of the Master of Flémalle.

Our knowledge of Daret is based upon four paintings — a "Visitation," a "Nativity," an "Adoration of the Magi" and a "Presentation of Christ" — the date and authorship of which are indisputable. Now scattered over three different collections, they originally adorned the exterior of a "Schnitzaltar" (its interior showing the Twelve Apostles and the Coronation of

the Virgin in the center, and nothing but an ornament of fleurs-de-lys on azure on the inner surfaces of the wings), which was commissioned, in 1434, by Jean du Clercq, Abbot of St. Vaast at Arras, and was completed in July, 1435, at the latest.[1]

Like many artists who had the misfortune of being too closely associated with stars of the first magnitude — Verrocchio with Leonardo, Wolgemut with Dürer, Lievens with Rembrandt, Holbein the Elder with Holbein the Younger — Daret is often referred to in somewhat disparaging terms. But while he was no genius he was a sound, by no means unattractive painter; and for the early date of 1434 — only two years after his "graduation" — his panels are distinctly progressive, being no less advanced in craftsmanship than the works of even his greatest contemporaries. This alone precludes the idea that, instead of being a disciple of the Master of Flémalle and a fellow-student of Roger van der Weyden, he should have been, as Mr. Davies aptly puts it, "the pupil and companion of two duds in a backwater." [2]

In addition, however, there are most definite ties that link three of Daret's panels with works by the Master of Flémalle, and one — the "Visitation" (fig. 232) — with an early composition by Roger van der Weyden which was developed from the same workshop pattern (fig. 311).[3] Daret's "Presentation" (fig. 235) shows a circular building, adorned with reliefs, which reflects the influence of the Master of Flémalle's "Betrothal" in the Prado (fig. 199).[4] His "Adoration of the Magi" (fig. 234) repeats, with literal reminiscences in certain figures, a composition by the Master of Flémalle transmitted to us by an apparently reliable copy in Berlin (fig. 223).[5] His "Nativity," finally (fig. 233), is nothing but a slightly pedestrian version of the famous "Nativity" in Dijon (fig. 201). It agrees with it in the general setting, the facial types and the outlandish costumes. It shows the candle in the hand of St. Joseph, a motif found only in book illuminations before it was adopted by the Master of Flémalle (and, later on, by Roger van der Weyden). And it is the only panel painting outside the Dijon "Nativity" not only to allude to the story of the two midwives but to unfold it as a complete little drama.[6] Had Robert Campin not been identical with the Master of Flémalle, and had Roger van der Weyden's association with Tournai been limited to one day of glory in 1426, how could we account for this triangular interrelationship?

III

That the Dijon "Nativity" [7] includes the two midwives as well as the St. Bridget's candle must warn us not to overlook the Master of Flémalle's connection with the regional schools of the Netherlands. He was a Fleming and, in a more exclusive sense than Jan van Eyck, a panel painter. He must have been steeped in the traditions of his native country and of his special craft, all the more so as he was a "city painter" rather than a cosmopolitan court artist. It would be against nature had he based himself so predominantly or even exclusively upon Franco-Flemish book illumination as has been supposed.

The influence of Franco-Flemish miniatures, especially of the Italianizing kind, cannot be denied and is extremely important. The general composition of the Dijon panel with its

obliquely placed shed, the triad of angels on the left and the single angel on the right has justly been derived from the "Nativity" in the "*Très Riches Heures*" (fig. 81) [1] and here we also find the adoring shepherds — a motif newly assimilated from Italian sources (though, we remember, not foreign to the provincial tradition either). Furthermore, a close similarity has been observed between the Dijon "Nativity" and the miniatures in the "Brussels Hours" by Jacquemart de Hesdin.[2] With them it shares a taste for cool, pearly colors (purplish brown, white shaded with blue or mauve, and a neutral gray) which merge into an admirable, silvery tone by virtue of the Master's command of the *nouvelle pratique*. The landscape, with its winding roads, luminous bodies of water, bald hills surmounted by fortified castles, and mountains shaped, Italian fashion, like Phrygian caps, harks back to that in the "Flight into Egypt" in the "Brussels Hours" (fig. 44) and further presupposes, I believe, the refining influence of the Boucicaut Master who more than all the other illuminators had anticipated the Flemings in exploring aerial perspective. It is as though the Italianate topography of Jacquemart de Hesdin and the Limbourg brothers were viewed through the softening haze that casts itself over the vistas of the Boucicaut Master; even the contrast that still exists between this naturalistic scenery and the metallic gold of the rising sun — here, as in other cases, a symbol of Christ — is prefigured in the "Boucicaut Hours."

Nevertheless the style of the Master of Flémalle was firmly rooted in the tradition of panel painting, both Franco-Flemish and Flemish. The illusionistic rendering of grained, weather-beaten wood which we admire in the Dijon "Nativity" has rightly been compared to that in the "Martyrdom of St. Denis" by Jean Malouel and Henri Bellechose (fig. 100),[3] and it is interesting to note that the crucified Christ in this panel wears a loincloth of that striped material for which the Master of Flémalle had such marked predilection. But a similar treatment of wood may be found, nearer home, in the little "Nativity" in Berlin (fig. 110) which also foreshadows the Master of Flémalle's broad, viscous technique. And his chiaroscuro effects have their antecedents in a development which had reached an advanced stage in Melchior Broederlam: the dimly illumined stable seen through bright lattice work has no closer parallel in earlier art than in Broederlam's "Annunciation" where the gloomy interior of the Temple is seen through a strongly lighted grille (fig. 104).

The Dijon "Nativity," probably executed about 1420–1425, is an early but not the earliest work attributable to the Master of Flémalle. A wall painting, recently discovered in the Church of St.-Brice at Tournai, has been connected with a record of payments made to a "mestre Robiert le pointre," and he in turn has been identified with Robert Campin. But even if both these assumptions were correct (as they well may be), this early mural, an "Annunciation" surmounted by angels, would not appreciably contribute to our knowledge of the Master of Flémalle. Murals are difficult to compare with panel paintings at best, and this particular one, though not without grandeur in concept, is so hastily and roughly done that it can be rated only as a decorator's job; in fact the church was pressed for time as well as money after an extensive remodeling of the chevet. Worse still, the painting is so badly damaged that what remains of it has justly been described as "ces vestiges de peinture." [4]

Shortly after this "Annunciation" was discovered, however, there came to light a magnificent triptych of later but still comparatively early date which bears all the earmarks of authenticity (figs. 196, 197). Sold at Christie's in 1942 and now preserved in the Collection of Count Seilern in London,[1] it shows in the center the Entombment — or, rather, a bold combination of the orthodox Entombment with a Lamentation *à la "Parement de Narbonne"* and Jacquemart de Hesdin — the Virgin Mary bending deeply over the body of Christ and gently restrained by St. John the Evangelist. The right wing shows the Resurrection, the left, the crucified Thieves, the empty Cross of Christ and the unfortunately repainted donor with his little dog. Only two sections of the triptych, the "Entombment" and the "Resurrection," are materially (not spatially) connected by a curving wattle fence, and there is a certain discrepancy in scale and treatment between the relieflike concentration in the central panel and the perspective depth and scattered looseness of the wings.

Produced as early as, say, 1415–1420 and painted on heavily tooled gold ground, the Seilern triptych is evidently more primitive than the Dijon "Nativity." We sense the master's tremendous power of observation and expression (he was the first to see the weeping people dry their eyes with the back of their hands), his struggle for tangible plasticity (especially evident in the employment of figures turning their backs upon the beholder), his color taste (though he does not as yet attain the silvery harmony of the Dijon "Nativity"), and his predilection for exotic apparel and striped fabrics. The influence of the Boucicaut Master is still absent; but that of Jacquemart de Hesdin is already felt — quite apart from the iconography of the Entombment scene — in the organization of the landscapes, the curved receding wattle fences being especially reminiscent of the "Annunciation to the Shepherds" in the "Brussels Hours." Such details as the clump of trees silhouetted against the gold ground, on the other hand, bring to mind the little "Guelders" Nativity just mentioned, and a connection with indigenous Netherlandish panel paintings is also evident in the facial types. Suffice it to compare the Joseph of Arimathea and Nicodemus with the St. Simeon and St. Joseph in Melchior Broederlam's "Presentation" (fig. 105).

Between the Seilern triptych and the Dijon "Nativity" there may be placed the "Madonna of Humility Before a Grassy Bench" in Berlin (fig. 198) which I am inclined to accept at least as shopwork,[2] and the original of the "Adoration of the Magi," already discussed (fig. 223). The latter composition is authenticated by its exploitation in Daret's altarpiece,[3] and the Berlin Madonna is closely linked to it by such significant details as the lettered borders of the Virgin's mantle and the plump, baldish Infant revealed rather than concealed by a transparent drapery. The head of the Berlin Madonna, on the other hand, closely resembles the angels' heads in the Seilern "Entombment."

The "Betrothal of the Virgin" in the Prado (fig. 199), the iconography of which has been discussed in the preceding chapter,[4] also appears to be earlier than the Dijon "Nativity." Though more advanced than the Seilern triptych, it seems more primitive, especially in the handling of perspective, than the Dijon picture and shares the triptych's tendency toward violent contrasts in scale and composition. The Betrothal scene is enacted by large-sized figures

crowded into a solid mass whereas the Miracle of the Rod shows smaller figures freely scattered over space, and the wan-faced woman emerging from behind the figure of the Virgin Mary is almost a sister of the St. Veronica in the Seilern "Entombment." In the Prado panel, too, we can observe the persistence of regional traditions. The architectural setting — a circular structure contrasted with a square narthex viewed at an angle — is pre-figured in Broederlam's "Annunciation" and bears, we recall, a similar symbolical connotation; and if the weird ugliness of many physiognomies, particularly that of the High Priest and the St. Joseph, has been acclaimed as an anticipation of Jerome Bosch [1] it should be remembered that this anticipation had been anticipated, as it were, in the "réalisme pré-Eyckien" of ca. 1400, notably in the book illumination of Bruges. [2]

A special problem posed by the Prado "Betrothal" is its purpose. Its size and oblong format (ca. 36" by 30") suggest an independent devotional picture or small retable; but this assumption is at variance with two facts. First, there exists in the church of Hoogstraaten near Antwerp a friezelike painting of the later fifteenth century wherein the Miracle of the Rod and the Betrothal of the Virgin, freely but unimaginatively copied from the Prado panel, are followed by other incidents from the life of St. Joseph, viz., his Dream, the Repentance of his Doubt, and the Nativity of Christ. [3] Second, and more important, the back of the Prado panel exhibits two statues painted in grisaille, one representing St. James the Great, the other St. Clare of Assisi (fig. 200). [4]

Unless we wish to credit the author of the Hoogstraaten picture with an unusual blend of parrotism and originality, we are led to suspect that all the scenes, not only the Miracle of the Rod and the Betrothal, were copied from the Master of Flémalle — in other words, that the latter's picture in the Prado was but one panel within a cycle. And this suspicion is strengthened by the existence of the grisailles on its back. From Jan van Eyck to Rubens sculptures "in stone color," as Dürer put it, [5] were the usual thing on the exterior of folding altarpieces, forming a striking contrast with the resplendent interior which was not visible except on special occasions. It is, so far as we know, on the reverse of the Prado "Betrothal" that simulated statues of this kind occur for the first time; [6] and it would be surprising had they made their appearance in a place other than that which was to be theirs for more than two centuries. The inference is that the Prado panel (its oblong format comparable to that of the even larger fragments of Conrad Witz' Geneva altarpiece) [7] may have belonged to a folding triptych the interior shutters of which, presumably flanking a "Coronation of the Virgin" or an "Adoration of the Magi," would have shown the scenes from the life of Our Lady and St. Joseph in a two-storey arrangement while the Saints on the outside were surmounted, as was customary, by the Annunciation.

The illusionistic imitation of sculpture by "stone-colored" paintings may be regarded as complementary to that illusionistic imitation of living human beings by sculpture which we encountered on the spire of Strasbourg Cathedral and in the house of Jacques Coeur. [8] In both cases the artist indulges in a tour de force; and in both cases this tour de force seals, with a playful flourish, a serious alliance between sculpture and painting which had been in the making for a long time and was of fundamental importance for the genesis of the ars nova.

EARLY NETHERLANDISH PAINTING

As Jacques de Baerze and Claus Sluter conceived of their sculptured figures as existing in a quasi-pictorial space, so did the Master of Flémalle and Jan van Eyck conceive of their pictorial space as a locus of quasi-sculptured figures. And in employing the time-honored grisaille technique for directly "creating" statues instead of merely representing them as integral parts of an architectural setting (as Broederlam had done), they not only challenged the sculptor in his own field but also acknowledged their indebtedness to him. For their grisailles presented to the eye of the beholder not so much what the general public could see in churches and on the market square as what painters could see in the workshops of sculptors.

Until the very end of the fifteenth century the "color of the stone" was rarely revealed to the ordinary spectator; major statuary was, as a rule, coated with paint and often gilded, and it was by the painters that the coating and gilding was done. As has been mentioned, even Jan van Eyck and Roger van der Weyden did not disdain this kind of work, and of the Master of Flémalle we know that it was a major part of his activities. In Ste.-Marie Madeleine at Tournai there can still be seen a beautiful Annunciation group — unfortunately disfigured by modern whitewash and incongruous heads — which was completed in 1428 by Jean Delemer and "pointe de plusieurs couleurs" by Robert Campin — a group, incidentally, which left its mark on the imagination of Roger van der Weyden.[1] Such a continued intimacy between painter and sculptor [2] was bound to change the outlook of both. Seeing the statues in the nude, as it were, the painters could observe the operation of light on form as under laboratory conditions, and the grisailles, in which they recorded this experience "in black and white," may well have been instrumental in gradually educating the public — and the sculptors — to appreciate the beauty of the monochrome. Conversely, they learned to conceive of their ordinary figures — the men and women portrayed as real men and women and not as simulated artifacts — in terms of sculptural weight and volume. And this is precisely what distinguishes the figure style of the Master of Flémalle from that of Broederlam, Jacquemart de Hesdin and even the Limbourg brothers.

The kneeling woman in the Seilern "Entombment," the "Madonna of Humility" in Berlin, the Virgin in the Dijon "Nativity," the officiating High Priest in the Prado "Betrothal" — all these and other figures seem to belong to a new race. Displacing space like blocks of granite immersed in water, their draperies now simplified into quasi-stereometric prisms and rhomboids, now billowing in large curvilinear folds, now crumpled into complicated mazes, now angularly bent and spread where they are intercepted by the ground, they give the impression of Sluterian sculptures come to life. And this is, in a sense, what they are: as the painter's simulated statues may be described as human beings turned into stone, so may his human beings be described as statues turned into flesh.

THE MASTER OF FLÉMALLE

IV

The cool, silvery tone characteristic of the Dijon "Nativity" also distinguishes a picture which for this reason alone may be ascribed to a comparatively early phase of the Master of Flémalle's activity, the "Somzée" or "Salting Madonna" in the National Gallery at London (fig. 203).[1] c. 1428

Clad in a white robe shaded with mauve, offering her breast to the Christ Child with her right hand and resting her left elbow on a richly carved cupboard, the enormous, moon-faced figure sits before rather than upon a bench (apparently on a low footrest as does the Annunciate of Niccolò de Buonaccorsi[2] or, for that matter, the Virgin Painted by St. Luke of Roger van der Weyden). The bench, a pillow and an open Bible placed in its corner, stands before a fireplace, the Virgin being protected from its heat by a circular screen of wicker work not unlike the one seen in the January picture of the *Très Riches Heures.*" The fireplace projects from the rear wall of the room, and this wall is pierced by a window, with a low triangular stool beneath it, which looks out over a magnificent city prospect.

The idea of representing the Madonna of Humility in a domestic setting originated, we recall, in Italy and was, as may be concluded by analogy, transmitted to the Master of Flémalle through similar provincial intermediaries as was the Annunciation in a bourgeois interior, and in elaborating this domestic setting the master also moved in the path of established tradition. The spatial environment, suggested only by a violently receding tiled floor, is still what I have called an "interior by implication." The wooden bench, adorned with lions of brass, is a bourgeois version of the Throne of Solomon mentioned in the preceding chapter. An open window — though disclosing only the sky, and not as yet a landscape or city prospect — occurs in several miniatures by the Boucicaut Master (figs. 69, 71) and nail-studded shutters rendered in bold foreshortening already figure in the "Annunciation" by Melchior Broederlam (fig. 104).

Yet all these elements, from the nails of the shutters and the jewels on the border of the Virgin's robe to the distant hills and buildings seen through the window, are reinterpreted in a new, uncompromising spirit which may be defined as a spirit of materialism rather than of mere naturalism. Every detail seems to be not only real but tangible, and it is obvious that the circular firescreen is nothing but a material substitute for a halo[3] which the master, at this stage of his development, could neither bring himself to retain in its conventional, nonrealistic form nor to discard altogether; two generations later, Mantegna — a kindred spirit on the other side of the Alps — was to devise noble marble thrones in such a way that the headpieces of their backs fulfilled a similar function.[4]

The only discordant note is struck by the liturgical chalice on the Virgin's left, singularly out of place in a domestic environment. True, the authenticity of this chalice is questionable: the right-hand section of the picture, about one sixth of its width, is entirely modern, and in a mediocre fifteenth-century copy which shows the composition in its entirety we see, instead of

the sumptuous cupboard, a simple little cabinet; and, instead of the chalice, a kind of bowl.[1] Conceivably it is from this copy that we must reconstruct the original appearance of the "Salting Madonna," in which case the restorer would have indulged in an irresponsible flight of fancy. But it is equally conceivable (and I am inclined to prefer this second alternative) that the fifteenth-century copyist simplified the composition (as he demonstrably did in other respects),[2] whereas the modern restorer did his poor best to repeat a damaged portion of the original. A chalice — symbol of the future Passion of Christ — occurs so rarely in the context of a Madonna composition (the only parallel that comes to mind is the "*Goldenes Rössel*," text ill. 27) that it is harder to credit its invention to a restorer of the nineteenth century than to believe in its retention by the Master of Flémalle. With him, we remember, relapses into "open" instead of "disguised" symbolism were by no means unusual. For all his innovatory spirit he represents an early, even preliminary phase in the development of the *ars nova*. While looking forward to the future he remained, like many revolutionaries, deeply committed to the past.

v

This Januslike nature of the master's style is particularly evident in his next major work, the so-called "Mérode altarpiece" (fig. 204).[3] A triptych owned by the Mérode family as long as it has been known, it was originally commissioned by a couple named Inghelbrechts residing at Malines. It shows, in the center, the famous "Annunciation" the iconography of which has been discussed in the preceding chapter. On the left wing we see the donors kneeling outside a door that leads into the Annunciation chamber. The right-hand wing, on the other hand, gives us a glimpse into the workshop of St. Joseph overlooking the market square, and the iconography of this apparent genre scene is no less remarkable than that of the principal event.

St. Joseph has manufactured two mousetraps, one on his work table, the other displayed on a window shelf for customers to see, and this has been brilliantly explained by Meyer Schapiro as an allusion to the then well-known Augustinian doctrine of the *muscipula diaboli* according to which the marriage of the Virgin and the Incarnation of Christ were devised by Providence in order to fool the devil as mice are fooled by bait. For the time being, though, he is engaged in producing what I believe to be (on the strength of Vermeer's "Milkmaid") the perforated cover of a footstool intended to hold a warming pan. But be that as it may, the very fact that he is shown as a carpenter, obvious though it seems, proclaims a fundamental change in social outlook. The International Style, we recall, had treated St. Joseph as an object of condescension or mild fun, pathetically immersed in his worries or trying to make himself useful as a substitute cook or nursemaid; it was not until about 1600 that he was to be glorified as the *Gemma mundi* and that great gentlemen and even monarchs would be named after him. From the beginning of the fifteenth century, however, he began to be extolled as the exponent of all the homely virtues, invested with the modest dignity of a good craftsman and bread winner, usefully and contentedly busy in his own workshop; Meyer Schapiro has shown that

this revaluation was championed by such contemporary theologians as Johannes Gerson. But if we look for visual antecedents of the worktable scene in the Mérode altarpiece, we may refer to the little Guelders "Nativity" in Berlin (fig. 110).

As pointed out by Dr. de Tolnay, the Mérode altarpiece made a lasting impression on Jan van Eyck who may have seen it when he spent the feast day of St. Luke with the painters' guild of Tournai in 1427 or when he revisited this city on March 23 of the following year.[1] There is little doubt that the "Annunciation" in the Ghent altarpiece (fig. 276) exploits and revises the central panel of the Mérode triptych, and a comparison between these variations on the same theme makes the contrast between a perfected and a preliminary phase of Early Flemish naturalism all the more striking.

It is not only that the casual arrangement of the objects, especially noticeable in the disorderly conduct of the towel, has given way to rectilinear discipline, that the bourgeois living room has been converted into an elevated hall combining Romanesque and Gothic forms in symbolic contrast, and that the Virgin Mary kneels before a *prie-dieu* instead of being curled up on the floor: Jan van Eyck's "Annunciation" is to the Mérode altarpiece as the Cathedral of Chartres is to the Cathedral of Laon.

Where the Mérode altarpiece shows three distinct units only two of which — the "Annunciation" and the donors' wing — are connected by the half-open door with its little steps (much as the central panel and the right-hand wing of the Seilern triptych were by the wattle fence), the four sections that constitute the upper tier of the Ghent altarpiece form one coherent interior which we perceive as through a quadrupartite glass door; an illusion strengthened by the cast-shadows which the dividing frames paint on the pavement of the room. And where the Mérode "Annunciation" strikes us as being primarily conceived in terms of surface relations and only secondarily in terms of space relations,[2] the opposite is true of its revised edition in the Ghent altarpiece. The Master of Flémalle embroiders the pictorial surface into a decorative pattern so densely woven that we may speak of *horror vacui*. Every inch is covered with form. The folds of the draperies, however naturalistically arranged and modeled, luxuriate into a complicated linear ornament that spreads itself over the picture plane, and there is hardly any space between the figures and the lower frame. Jan van Eyck, like Henry James' Linda Pallant, "knew the value of intervals"; he separated the forms by superbly calculated hiatuses which suggest the presence of a continuous and homogeneous expanse, no matter whether it is taken up by solids or interstices. The draperies, though no less abundant, are not allowed to forget that their primary allegiance belongs to the plastic figure. And an empty strip of foreground is left in front of the figures so as to detach them from the picture plane and integrate them with three-dimensional space.

However, preoccupied though the Flémalle Master was with surface patterns, he was no less vitally interested in the conquest of space, and it was by the conflict between these two tendencies that he was compelled to stretch to the utmost the traditional methods of suggesting depth. In the Seilern triptych, the Dijon "Nativity" and the Prado "Betrothal," he revived the Giottesque device of turning important figures, especially those placed in the foreground,

away from the beholder so that they face in the same direction as we do, thus serving as spear-heads for our imaginary advance into depth. And in two cases he resorted to a perspective method which — contrary to a widespread assumption — is archaic rather than progressive: "oblique" or "two point" as opposed to "normal" or "one point" perspective.

When a cubiform body, seen from within or without, is placed in such a way that one of its surfaces is parallel to the picture plane, the vanishing lines will converge — no matter whether exactly or approximately — toward one point directly opposite the eye of the beholder ("point of sight"). When a cubiform body is placed in such a way that only one of its *edges* is parallel to the picture plane, the vanishing lines will converge — again no matter whether exactly or approximately — towards two points on either side of the "point of sight," thus forming a bicuspid figure (hence *perspectiva cornuta*, "horned perspective," to quote the picturesque expression of Johannes Viator). The shed in the Dijon "Nativity" — not to mention the distant house on the highroad — and the Gothic narthex in the Prado "Betrothal" are both examples of oblique or "two point" perspective.

Already known in classical antiquity, the "oblique" view had been reintroduced by Giotto and reached the Northern countries toward the end of the fourteenth century. We have seen that it was vigorously exploited by such artists as Broederlam and the Limbourg brothers; and, for psychological reasons explained elsewhere, it attained a respectable degree of accuracy long before the "normal" view was similarly perfected.[1] But it practically disappeared again from both Italian and Flemish painting when post-Gothic perspective had outgrown the stage of experimentation, that is to say, about 1430. After this time, it survived only in more or less provincial spheres or in such media as had become *retardataire* and was not to be resumed in major painting until the century had run its course and a third generation had grown tired of the normal view. There is no instance of "oblique" perspective in Jan van Eyck;[2] none in such masters as Petrus Christus, Hugo van der Goes or Dirc Bouts; none in the great Italian painters from Masaccio to Raphael; none in Dürer; and only one — and this in a most special case — in Roger van der Weyden.[3]

Beginning with the "Salting Madonna" and the Mérode altarpiece, the Master of Flémalle himself used only "normal" or "one point" perspective, but this he handled with a particular violence which, in a sense, defeats its own ends. Walls, ceilings and floors recede at breakneck speed. Tables or stools are presented in a kind of bird's-eye view. Benches seem to extend to the length of a footbridge. The general effect resembles that of a photograph taken with a wide-angle lens. If the construction were mathematically exact, and if we were able to observe the Master's pictures from a point commensurate to the short distance assumed by him, these distortions would disappear and the spatial illusion would be intensified. Since this is evidently impossible, all those too vehemently foreshortened forms seem to be flattened into the picture plane the more they strain away from it, and thus contribute to the surface pattern rather than strengthen the illusion of depth. From a diametrically opposite point of view, and with a diametrically opposite intention, the Master of Flémalle achieved an effect not unlike that aspired to by Cézanne and van Gogh. Cézanne and van Gogh wished to affirm the plane sur-

face while still committed to a perspective interpretation of space; the Master of Flémalle strove to affirm perspective space while still committed to a decorative interpretation of the plane surface.

These tensions between the parts and the whole, planar and spatial values, are apparent everywhere in his work. The smooth, large surfaces of softly modeled flesh (in which the lavish use of lead white tends to produce a certain shininess) are often inscribed with sharp, linear details. Conversely, the wrinkles and veins of a hand may form so dense an accumulation that we almost lose the sense of unity. And the lighting, handled as violently as is perspective, separates the objects rather than fuses them. The cast-shadows of the Master of Flémalle are produced by a hard, concentrated light which duplicates the objects in a clearly recognizable silhouette (or even two where he assumes a double source of illumination); the emphasis is upon the delineation of forms on a shadow-receiving surface. Jan van Eyck's cast-shadows are produced by a soft, diffused light which creates vague patches of darkness fading into penumbra; the emphasis is on the unification of forms by an enveloping medium. In short, the style of the Master of Flémalle retained, to use Paul Frankl's indispensable terms, an "additive" as opposed to a "divisive" — or, as I should prefer to call it, "synoptic" — character.

VI

If the Mérode altarpiece was personally inspected by Jan van Eyck on one of his visits to Tournai, it must have been completed, or nearly completed, in 1427–1428, and this is precisely the date which we should assign to it for general stylistic reasons. A little later — say in 1429 or 1430 — the Master of Flémalle produced a work much larger and, to judge from its tremendous influence, still more renowned. It is, or rather was, a huge triptych with a "Descent from the Cross" in the center. On the left wing was seen the Good Thief, a mourning woman and the donor; on the right wing, the Bad Thief and two Roman soldiers, one of them the Centurion who believed that Christ was the Son of God. The ensemble is transmitted through a small and clumsy but obviously reliable copy in Liverpool (fig. 230); of the original only a fragment of the right wing, showing the Bad Thief and the busts of the two Romans, is preserved in the Städelsches Kunstinstitut at Frankfort-on-the-Main (fig. 205).[1]

As we learn from this fragment, the original was painted on finely tooled gold ground, here evidently employed, not as a matter of course but with a definite and conscious intention. The Dijon "Nativity" shows the Master of Flémalle perfectly capable of staging his narratives in open landscapes. It was in deference to the monumentality of the task (open, the altarpiece must have measured about 12 by 7½ feet) and to the solemnity of the content that he, the naturalist, bowed to an age-old tradition of ecclesiastical art. Like the best of his followers, for instance, Roger van der Weyden and Geertgen tot Sint Jans, he used gold ground in order to achieve a special hieratic effect as a modern composer such as Verdi might use the Gregorian modes when writing sacred music.[2]

Were it not for the fact that the Frankfort fragment was placed on the left of the Cross and that the donor appeared in the opposite wing, one would feel tempted to interpret the Frankfort Thief as the Good rather than the Bad.[1] For, while the figure of the Bad Thief is normally distinguished by violence of movement and coarseness of type, it here appears so perfect in structure and modeling and so tragically beautiful in movement and expression that it almost seems to defy the limitations of the Gothic style. There is in the chiseled features of this heroic sinner a strange affinity to the Apostles' heads in the approximately contemporary "Last Supper" by Castagno, and the pathos of his pose seems to foreshadow the "Dying Slave" by Michelangelo. A direct contact with Italy would seem improbable; but certain it is that the master, if out of touch with the Italian present, was acting under the spell of the Italianate past. I quite agree with Winkler's unjustly neglected suggestion that the style of this particular work harks back, not only to earlier panel painting in general, but quite specifically to that most monumental and most Italianizing school of panel painting which had been represented, some fifteen years before, by Jean Malouel and Henri Bellechose.[2] The Master of Flémalle's Bad Thief is prefigured by the Dead Body in the Louvre *tondo* (fig. 101) and the crucified Christ in the "Martyrdom of St. Denis" (fig. 100); and of all his forerunners Henri Bellechose appears to have been most closely akin to him in personality and temperament. Even in the landscape there can be felt a kind of Tuscan severity, and the Sienese tradition of characterizing Romans and other pagans by fantastic accoutrements, half oriental and half classical — the fillet as an attribute of such exotic types being a favorite motif of the Lorenzetti brothers — had been especially cherished in the circle of the two masters of Dijon. But the gesture of the believing Centurion, hand over his heart, and the awe-stricken attitude of his almost believing companion are without precedent or parallel.

The "Descent from the Cross," unfortunately, cannot be admired in the original, but its replicas[3] give us an idea of its general aspect and make us realize the importance of its individual features. The Virgin swooning in the arms of St. John (a concept originating in Italy and acclimated in Germany and the Germanic Lowlands rather than in France), the woman wringing her hands before her breast, the two groups of weeping angels hovering around the Cross, and the impassioned Magdalen turning her back upon the beholder, her right foot blindly groping upwards and her arms outstretched as though reaching for the body of Christ — all these motifs were not to be forgotten for a long time. And the pattens discarded by the man in the striped cloak climbing the ladder, though possibly introduced only in order to lend verisimilitude to his barefooted ascent, yet bring to mind the verse: "Put off thy shoes from off thy feet, for the place whereon thou standest is holy ground," an idea exploited in this sense by generations of Early Flemish painters. As a whole, however, the composition is somewhat crowded — "gepfropft," to quote Willem Vogelsang's felicitous term[4] — and dissonant with unresolved discords of movement and rigidity, trenchant diagonals and stiff verticals. Only a few years later there appeared what may be called a painted critique of this "Descent from the Cross." Its author was Roger van der Weyden who, we recall, was associated with the Master of Flémalle from 1427 to 1432, and this one picture, the famous "Descent from the Cross" lately

transferred from the Escorial to the Prado (fig. 314), should suffice to prove the non-identity of the two painters.

In criticizing the Master of Flémalle, Roger did homage to him. In many ways the "Descent from the Cross" is more Flémallesque than any other work of his, and there is little doubt that he was serving his "apprenticeship" in Tournai while the great triptych was being executed. However, entering the workshop of Robert Campin as a comparatively mature artist and rising to world fame almost immediately after leaving it, Roger van der Weyden, like many very gifted students, not only learned from but also taught his instructor. And the first traces of this retroactive influence can be discovered, I think, in the very work from which the Master of Flémalle received his art-historical name.[1]

Of this altarpiece, originally a triptych which I should like to date about 1430–1432, only the wings have come down to us. Like the "Bad Thief," they are preserved at Frankfort and show a standing Madonna nursing the Infant, a St. Veronica displaying a transparent Sudarium, and a Trinity depicted as a sculpture in grisaille (figs. 206–208). Compared with the works thus far considered, these three panels — the "Trinity" originally forming the back of the "St. Veronica" — are as relatively Rogerian as Roger's "Descent from the Cross," formerly in the Escorial, is relatively Flémallesque. Instead of being placed before an open landscape, the Madonna and the St. Veronica, standing on a narrow strip of beflowered turf, detach themselves from flat hangings of Lucchese silk brocade, and this deliberate limitation of space recalls to mind, not only Roger's "Descent from the Cross" but also his early Madonna in the Gemälde-galerie at Vienna, the latter similarly foiled by a brocaded backdrop (fig. 307). The colors, though still subdued, are warmer and deeper. The proportions are pronouncedly slender, and the draperies show a new taste for thin, tubular folds flowing in rhythmical curves. Expression and movement are deliberately restrained, and all the compositions are pervaded by an un-expectedly tender, an almost lyrical sentiment.

This is particularly true of the "Trinity" which — except for the fact that the left hand of the dead Christ is placed upon the wound in His side -— reminds us at once of Roger's later "Depositions in Half-Length" (transmitted in copies, figs. 394, 395)[2] and of the *tondo* ascribed to Jean Malouel. And yet it is precisely in this "Trinity" that the master's materialism — repressed, as it were, by a spirit extraneous to his innate propensities — asserts itself with redoubled force. The picture is as harsh in treatment as it is tender in sentiment. Surpassing even the simulated statutes on the back of the Prado "Betrothal" in plastic aggressiveness, the group protrudes from its niche, and is illumined by a hard light. The head of God the Father and the legs of the dead Christ cast sharply delineated double shadows upon the adjacent sur-faces, and the Dove sits plumb on a cervical muscle as though upon a perch.

This latent tension between reality and fantasy, the softer emotions and "tough-minded-ness," is sharpened into open conflict in the remarkable Madonna in the Musée Granet at Aix-en-Provence (fig. 209).[3] Probably somewhat later than the panels from Flémalle, this picture is even more "Rogerian" in its fluent, curvilinear drapery style and its tendency to com-press the figures into a shallow, frontalized relief space; had all the other paintings by the

Master of Flémalle been lost it would be pardonable to ascribe this work to a close follower of Roger, if not to Roger himself. But behind these surprisingly Rogerian figures — St. Peter, St. Augustine and an Augustinian Abbot — the enthroned Madonna, surrounded by a gigantic wreath of clouds, appears in the sky as the Apocalyptic Woman, "clothed with the sun, and the moon under her feet." A visionary theme like this presented no problem to the prenaturalistic style of the "Boucicaut Hours"; and it presented a problem susceptible of solution to the trans-naturalistic style of the Renaissance and the Baroque. The Master of Flémalle's materialism, however, could convey the idea of a miracle only by resorting — if I may abuse a philosophical term — to a "misplaced concretion." The massive, heavily modeled and emphatically fore-shortened throne of the Virgin is so palpably real, and the moon under her feet so obviously a piece of hardware rather than a celestial body, that it is difficult to see how the whole arrange-ment can levitate in mid-air; and the very realism of the draperies, made to hang freely as they would in the absence of solid ground, makes us doubly conscious of a contradiction. The laws of nature are miraculously suspended and conscientiously respected at the same time.

VII

The Master of Flémalle imposed the principles of his style on portraiture as well as nar-rative.[1]

During the High Middle Ages there was, as a rule, no such thing as an independent or autonomous portrait, meant to immortalize the appearance of an individual for its own sake. Portraits served as a means of authentication on coins or seals, as instruments of salvation in donor's portraits or funerary effigies, as records of specific events or statements of political theory in the case of monuments or ceremonial representations in ivory plaques and minia-tures. The independent or autonomous portrait came into being, and could come into being, only in the second half of the fourteenth century when new religious trends and an even newer philosophy, nominalism, asserted the right of the particular against the claims of the universal, the right of the senses — which are necessarily limited to the particular — against the claims of the intellect.

From the beginning an interesting contrast between two rival types may be observed. The earliest known examples in painting are, on the one hand, the Louvre portrait of Jean le Bon of ca. 1360, already adduced in other connections (fig. 28); and, on the other, the portrait of Archduke Rudolf IV of Austria in the Diocesan Museum at Vienna, produced about five years later.[2] Both paintings are bust portraits without hands, the figure tightly confined within the frame. But the foxy countenance of Jean le Bon, delineated in graphic rather than either plastic or "painterly" fashion, appears in full profile; whereas the bluff face of the Archduke, painted in a plastic yet broadly pictorial manner reminiscent of Theodoric of Prague, is rendered in three-quarter view. The latter has its ancestors in Northern donor's portraits where the three-quarter view had predominated throughout the High Middle Ages; the former, Italianate in concept as it is in style, is a medal all'antica transposed into painting.

170

THE MASTER OF FLÉMALLE

This difference determined the history of the independent portrait for nearly two centuries. In Italy the profile portrait persisted throughout the Quattrocento and even farther.[1] In the North it had a tremendous vogue for about sixty years (though the interesting self-portrait of the paintress Marcia in the *Boccace de Philippe le Hardi* of 1402[2] still follows the example set by the portrait of Archduke Rudolf); but this vogue, a facet of fourteenth-century Italianism, did not outlast the first three lustra of the fifteenth. The famous portrait of Louis II of Anjou (died 1417) in the Bibliothèque Nationale,[3] the Limbourgesque Portrait of a Lady in the National Gallery at Washington (fig. 92) and the Louvre Portrait of John the Fearless which, we remember, would seem to reflect a work by one of the Limbourg brothers themselves (fig. 94), are the last representatives of their kind.[4]

Between, say, 1420 and 1500 not a single independent portrait in pure profile can be found in Flanders, France and Germany. Here the profile view was not revived until the beginning of the sixteenth century when the leaders of the Northern *rinascimento*, Dürer, Massys, Burgkmair and Holbein the Younger, resumed it as a classicizing Renaissance device.[5] Throughout the fifteenth century, the Northern painters employed exclusively the three-quarter view, preferably in the form of the so-called "kit-cat" portrait which shows the sitter *en buste* or in half-length and includes, however uncomfortably at times, the hands. The individual is thought of, not as a quasi-Platonic idea but as a familiar reality (it is, after all, not very often that we observe our fellow beings in pure profile view), subject to change, integrated with a spatial environment, and able to make contact with the beholder.

The beginning of this development may be seen in the circle of John the Fearless of Burgundy. His portrait in the Louvre still shows the face in full profile though the body is already turned at an angle, and the hands, with a piece of table for them to rest upon, are included.[6] But in a second portrait of the same prince, transmitted to us through the excellent copy in Antwerp which seems to originate in the workshop of Roger van der Weyden (fig. 378),[7] we have the first example of the real "kit-cat" portrait. Not only are the hands included but the face is turned at the same angle as the body though its aspect still falls a little short of the three-quarter view. It is as though the artist had attempted to get away from the still-fashionable pure profile, yet was unable to evade its spell entirely; the head is turned, not at an angle of approximately forty-five degrees, but at an angle only about half that wide, the tip of the nose almost tangent to the contour of the cheek. The face is averted from the light so that the side fully exposed to the beholder is illuminated whereas the side partially concealed is shaded.

Compared to this portrait of John the Fearless, the portraits of the Master of Flémalle — some two or three of which have come down to us in the original while five or six others are either somewhat doubtful or are transmitted only through copies[8] — are immeasurably advanced in plasticity, optical verisimilitude and psychological individualization. In two respects, however, they are conservative or even archaic. They are archaic in that the master, with his characteristic *horror vacui*, again reduced the space between the figure and the margin (whereas the contemporary and otherwise provincial Dutchman who produced the portrait of Lisbeth van Duivenvoorde was bold enough to represent her in almost full-length);[9] they are con-

servative in that he did not change the system of illumination. The heads are still averted from the light, and so consistently did the master adhere to this principle that he applied it even to companion pieces where man and wife are turned toward each other and yet appear to be illumined from opposite directions (figs. 217–219).

In both these respects a difference in principle exists between the Master of Flémalle and Jan van Eyck. The latter not only re-enlarged the frame in relation to the figure — which in itself creates a sense of free existence in space — but also reversed the system of illumination. Instead of being turned away from the light, the face of the sitter is directed towards it, so that the side exposed to the beholder is differentiated by innumerable shades and half-shades. The earlier method, still followed by the Master of Flémalle, results, of course, in a more forceful contrast between the two sides of the face, but this increase in local volume is more than offset by a comparative flattening of the configuration as a whole. The largest surfaces are uniformly lighted instead of being diversified, and the whole head, plus the headgear, is hit by the light broadside-on, so that it seems to be pressed back against the ground. According to the Eyckian system it cleaves the light waves head-on, as it were, so that it seems to project itself out of the depths of space. Jan departed from it only where portraits are integrated with an ensemble as is the case in the Ghent altarpiece and the Dresden triptych, and here the apparent relapse into the earlier tradition is motivated by the postulate of uniform illumination. In the Ghent altarpiece the light, coming from the right, must strike the face of the donatrix "Flémalle-fashion" because she is turned to the left; in the Dresden triptych the same applies to the donor because the light comes from the left while he is turned to the right. Where the Master of Flémalle did not hesitate to sacrifice optical unity at the altar of a principle, Jan had no scruples about abandoning the principle in favor of optical unity.

VIII

In the last phase of the Master of Flémalle's career another "retroactive" influence, possibly at work from as early as *ca.* 1427–1428, began to gain momentum and served to resolve, to some extent, the tensions that had come to a head in the Madonna at Aix-en-Provence: the influence of Eyckian art. This process can be observed, I think, in two pictures, both preserved in the Hermitage at Leningrad. One of them — perhaps only an excellent replica — is another "Trinity of the Broken Body" (fig. 210) [1] wherein the rigidly frontalized and axialized figure of God the Father, the *infulae* of His tiaralike crown hanging in motionless symmetry and embroidered with pearls and precious stones, seems to reveal the master's acquaintance with the majestic image of the Lord in the Ghent altarpiece. The other is a new, much-copied redaction of his favorite theme, the Madonna of Humility in a domestic setting (fig. 211).[2] The Virgin Mary, her robes bulkier and more crumpled than in the panels from Flémalle and the Madonna at Aix-en-Provence but more elaborately "arranged" and stylized than in the paint-

ings preceding these two, sits on the floor before a fireplace, warming her hand in order not to give a chill to the nude Infant Whom she is about to swaddle.[1]

The room and its appointments recall the Mérode altarpiece and the "Salting Madonna" — except that the three-legged stool which figures in the latter now bears a basin and pitcher of brass — and the perspective distance is still extremely short, with the usual result of horizontal surfaces threatening to tip over. Yet the general impression is very different from that of these two earlier interiors. The light is milder so that a soft duskiness, pleasantly contrasting with the sheen of polished brass, develops in the background; and for once we have a feeling of comparative spaciousness, enhanced by such "intervals" as the uncovered portions of the floor and the rear wall of the fireplace. In my opinion it is only by the influence of Eyckian art that these new features — including the basin-and-pitcher motif which seems to be peculiar to Jan van Eyck — can be accounted for. The Leningrad Madonna is generally dated about 1435, and even if we set aside the controversial works ascribed to Jan van Eyck's youth it would postdate his "Ince Hall Madonna" of 1433.

While in the case of the two pictures at Leningrad the Eyckian influence remains debatable, it is an incontestable and uncontested fact in the last extant work of the Master of Flémalle, the wings of a triptych executed in 1438 for Heinrich von Werl, Professor at the University of Cologne and, for a time, Provincial of the Minorite Order.[2] The central panel, probably representing a Madonna enthroned, is lost; only an approximate idea of its appearance may be derived from a drawing in the Louvre which reproduces a *Sacra Conversazione* of about the same time though of entirely different format (fig. 231).[3] The wings are preserved in the Prado. The right one shows, within a well-appointed interior, St. Barbara engaged in reading in front of a fireplace (fig. 213); the left one, the donor and his patron saint, St. John the Baptist, in a barrel-vaulted anteroom (fig. 212).

The St. Barbara panel, achieving a maximum of spaciousness within the still prevailing limitations of a short-distance or wide-angle perspective, exhibits all the symbols of purity familiar to us from the Mérode altarpiece, the "Salting Madonna" and the Madonna at Leningrad: the vase containing flowers, the towel, and the basin and pitcher of brass (the latter, I think, appropriated through the intermediary of Roger van der Weyden).[4] The painter took the liberty of transferring the attributes of the Virgin Mary to a virginal saint, and were not the figure identified as St. Barbara by the tower that dominates the landscape seen through the window, she might easily be mistaken for Our Lady herself — as has, in fact, occasionally happened.[5] Yet closer inspection reveals a number of significant changes. The Annunciation lilies seen in the Mérode altarpiece have been replaced by irises, and the lions transforming ordinary benches into "Thrones of Solomon" have disappeared. Added, however (and again, I believe, transmitted through Roger), is the specifically Eyckian symbol of the glass carafe illumined by the sun.[6] And it should be noticed that the tower is still under construction, just as in Jan van Eyck's "St. Barbara" of 1437 (fig. 254).

In the left wing of the Werl altarpiece the master's indebtedness to both Jan van Eyck and Roger van der Weyden is even more evident. From the wooden partition which divides the

depth of the room into two nearly equal parts (and through an opening at the bottom discloses, far in the background, a covered bench with crumpled cushions all painted in very dark blue), there hangs a circular, convex mirror reflecting the left-hand wall with its window, the back of the Baptist, a man and a boy — presumably the painter and his small assistant — as they enter the room, and the half-open door that conceals the donor. A mirror image of this sort, depicting in a charmingly distorted miniature the space beyond the limits of the picture plane, was almost a sign manual of Jan van Eyck. One mirror of this kind was admired by Fazio in the lost "Women's Bath" then owned by Cardinal Ottaviani;[1] another can still be seen in the London Arnolfini portrait of 1434 (fig. 247). In any other painter's work (such as Petrus Christus' "St. Eloy" of 1449, fig. 407) the presence of this motif amounts to an explicit, respectful quotation. The Baptist, on the other hand, repeats, as will be seen in one of the following chapters, a beautiful gesture invented by Roger for an altogether different purpose — a gesture of gentle recoil rather than formal presentation.[2]

The room depicted in the donor's wing extends to about the same depth as does its counterpart. But it is seen, surprisingly, through a "diaphragm arch," and even more surprising than this resumption of so obsolete a device is the fact that the general disposition of the latest triptych by the Master of Flémalle reverts, almost verbatim, to that of one of his earliest, the Mérode altarpiece. Even in 1438 the spatial content of the three pictures is not completely unified. A solid wall cuts off the anteroom from the central chamber, however this may have been fashioned. The donor, like the Inghelbrechts couple, kneels before a couple of little steps and is permitted to look into but not to enter what may be called the Holy of Holies. And the apartment of St. Barbara must have been as thoroughly separated from the central chamber as is the workroom of St. Joseph in the Mérode altarpiece. The perspective construction, with the beams of the ceiling approximately converging toward a point far to the left yet nowhere near the visual focus of the central panel, is nearly identical in both cases, and the St. Barbara is as completely absorbed in her reading — and thus as completely out of contact with the central scene — as is the St. Joseph in his carpenter's work.

In a sense the Master of Flémalle's development has run full cycle. He could not step out of the circle which his own genius had drawn, and we can easily conceive that in the end he came to depend on those whom he had helped to form. Like many great innovators — and he was a great innovator — his latest years were overshadowed by the very light which he had lit.

IX

With the exception of a beautiful though unfortunately truncated and partly overpainted picture in the Pennsylvania Museum of Art (fig. 216) — an "Intercession of Our Lady with Christ" in half-length the iconography of which harks back to the fourteenth century and was to exert a strong and varied influence on Roger van der Weyden and, through him, a host of later artists[3] — I have mentioned all the works by the Master of Flémalle which I know and can accept as authentic.[4] These, however, are a mere fraction of his oeuvre. Numerous works,

in part of the first order, are known to us only through copies, and some such copies have already been touched upon in the preceding paragraphs: the Liverpool replica of the Descent from the Cross triptych, the Berlin "Adoration of the Magi," the Louvre drawing after a lost "*Sacra Conversazione*," and the "Madonna of Humility" in the G. Müller Collection at Brussels.[1] Of other compositions thus preserved we may list: the early "Virgin in an Apse" (best replica in the Metropolitan Museum, fig. 222);[2] the "Trinity of the Broken Body with Four Angels," not unlike that in Leningrad but much more violent in every respect and possibly a workshop redaction rather than an original invention (best replica in the Museum at Louvain);[3] a "Mass of St. Gregory" (best replica now in the Dr. E. Schwarz Collection at New York, fig. 227);[4] a series of subjects from the *Speculum humanae salvationis* (the "Vengeance of Tomyris" and the "Slaying of Sisera by Jael," both prefigurations of Our Lady's victory over the Devil, transmitted by a picture in Berlin, fig. 224,[5] and a drawing in Braunschweig, fig. 225, respectively);[6] and, possibly, a "St. Luke Painting the Virgin" reflected in a picture by that great parasite of the past, Colin de Coter (fig. 228).[7] In addition, we have a number of portraits: the Berlin portrait of Robert de Masmines, the brave, fat counselor and general of John the Fearless and Philip the Good who gave his life before Bouvines in 1430 (fig. 220);[8] the "Man in a Turban," also in Berlin;[9] the portraits of Bartholomew d'Alatruye and his wife at Brussels;[10] and the Portrait of a Princess (supposedly Mary of Savoy, wife of Filippo Maria Sforza) at Dumbarton Oaks (fig. 221).[11]

Whether such copies or replicas are in fact based upon originals by the Master of Flémalle and to what extent they are "faithful" is, of course, not always easy to decide. In certain instances, as in the portrait of Robert de Masmines and the "Madonna of Humility" in the Müller Collection, they come so close to the master's personal style that they are widely — and understandably — accepted as genuine.[12] In others, as in the "Adoration of the Magi" at Berlin, they are authenticated by their reflection in the work of Jacques Daret. In still others, as in the "Madonna in an Apse," they have come down to us in so many replicas, in part by famous masters of the sixteenth century known to have drawn on compositions by the Master of Flémalle, that we can accept the common features of these replicas as constants. And in a uniquely fortunate case, that of the "Descent from the Cross," we can compare a number of replicas with a fragment of the original.

Often, however, we have to trust the intuitive impression that a given composition shows the "spirit" of the master, and in cases of this kind we must be very careful. The Master of Flémalle kept a big workshop, and his authority was such that he was arbitrarily exploited as well as faithfully copied. Not only the presence of unconformable or uncongenial elements but also an excess of similarity — especially if the analogues are found in different originals — must warn us against accepting as *bona fide* copies or authorized workshop redactions what, in reality, are nothing but pastiches.

It is in this category that fall, in my opinion, the "Annunciation" in the Prado which combines figures derived from the Mérode altarpiece with an ecclesiastical setting entirely foreign to the atmosphere in which those figures lived;[13] the "Death of the Virgin" in the National

Gallery at London where Flémallesque elements are intermixed with Goesian ones;[1] a "Madonna Nursing the Infant" by an anonymous Westphalian master which constitutes a little *Summa artis Flemallianae*;[2] and two extremely famous works — the "Crucifixion" in Berlin (fig. 398) and the Calvary triptych in the Abegg Collection in Switzerland (fig. 399) — which have been adduced as cogent evidence for the identity of the Master of Flémalle with Roger van der Weyden and will therefore come up for discussion later.[3]

To make amends for these eliminations, however, I should like to be a little more positive as to a lost, indubitably authentic "Crucifixion" which can be reconstructed from convergent sources.

The large triptych with the "Descent from the Cross" in the center was copied, not only in its entirety (as in the copy at Liverpool) but also piecemeal, so to speak. The Thieves were separately used by early engravers, and the central panel, the "Descent from the Cross" itself, was a favorite of book illuminators. One of these miniatures is found in the "Arenberg Hours" of *ca.* 1435 whose author, we recall, specialized in copying Flemish panel paintings renowned at his time.[4] Constrained by the format of the book and not overly meticulous as a craftsman, the Dutch illuminator narrowed the proportions of the composition and omitted several details, especially the patterns of the garments; but in a general way his rendering sufficiently agrees with the other replicas to be called faithful (fig. 130).[5] Now, on another page of the "Arenberg Hours," we have a many-figured "Crucifixion" that strikes us as Flémallesque at first glance (fig. 129). The Thieves are obviously derived from those in the Descent from the Cross triptych. The group of St. John and the Holy Women is not unlike the analogous group in the same altarpiece, and the group of soldiers on the other side of the Cross not only evinces the Master of Flémalle's predilection for fantastic, orientalizing apparel but also includes one of his favorite and most characteristic motifs, a richly draped figure seen from the back.[6]

Given the illuminator's notorious dependence on well-known Flemish panel paintings, we can at least infer that a famous "Crucifixion," agreeing more or less with the miniature in the "Arenberg Hours," was in existence prior to *ca.* 1435; the only rub is in the "more or less." Fortunately the degree of accuracy with which the Arenberg Master rendered his model — and, therefore, the presumable character of this model itself — can be determined by an entirely independent document, an early picture by Gerard David who in his youth was no less prone to draw upon the great Founders than was the Arenberg Master two generations before.

This picture (fig. 229), formerly in the monastery of St. Florian in Upper Austria and now preserved in the Thyssen Collection at Lugano, is manifestly derived from the same archetype as is the miniature in the "Arenberg Hours," and the reconstruction of this archetype is, so to speak, a matter of extrapolation: we may accept as authentic all that in which the two versions agree and have to assay probabilities wherever they differ.[7]

They agree, down to the minutest details, in the group of soldiers, except for the fact that in Gerard David's painting the cloak of the figure seen from the back is gaudily striped while it is plain in the miniatures. Since we have seen that the Arenberg Master always neglected the patterns of textiles (witness his copy after the "Descent from the Cross"), we may accept

these stripes as authentic and note them as significant in view of the Master of Flémalle's well-known partiality for fabrics of this sort. The head looking out of the picture behind the soldier with the beribboned headgear — perhaps a youthful self-portrait of Gerard David — would seem to have been added by the latter, and the same may be true of the two dogs in the foreground as well as the landscape, which is inspired by Eyckian rather than Flémallesque models.[1] The group of St. John and the Holy Women, on the other hand, differs considerably in the two versions, and here the miniature deserves more credence than the painting. Including motifs manifestly derived from Roger van der Weyden and pyramidally arranged upon receding diagonals, the group in the painting reflects the influence of Gerard David's teacher, Geertgen tot Sint Jans, to whom the picture was attributed before its authorship was established.[2]

On the whole, then, the Arenberg Master's "Crucifixion" would seem to render its model as adequately as does his "Descent from the Cross." Apart, of course, from the difference in quality, the original of the "Crucifixion" must have looked very much like the miniature, the only difference being that the cloak of the figure seen from the back must have been striped and that the Thieves, as is the case in Gerard David's picture, must have been absent. These, we have seen, the illuminator appropriated from the Descent from the Cross triptych. Unable, for reasons of space, to display them in the "Descent from the Cross" itself, yet unwilling to leave them unused, he simply inserted them, instead, into his "Crucifixion." But in doing so, he unwittingly — or, perhaps, wittingly — acknowledged the fact that both these compositions were inspired by one and the same artist, *fortior eo*: the Master of Flémalle.

VII

JAN VAN EYCK

In telling the story of the van Eyck brothers, whose shadows loom so large over our previous discussions, we can unhappily not begin at the beginning. It would seem natural to discuss the elder brother, Hubert, before the younger, Jan, and to take up the latter's works in chronological order. But of Hubert's style we have no authenticated example except his contributions to the Ghent altarpiece and these can be determined, if at all, only by an attempt to disentangle them from Jan's. Of Jan, on the other hand, we have no authenticated work unquestionably antedating the Ghent altarpiece. It is, therefore, from Jan's, the later master's, later style that we must try to find our way back.

Jan van Eyck [1] is first heard of as painter and *varlet de chambre* to John of Bavaria, the unconsecrated Bishop of Liége who, after the death of his brother, William VI of Holland, had usurped the territory of his niece, Jacqueline, and established residence in the Hague. He employed Jan for the decoration of his castle from October 24, 1422 (at the latest) until at least September 11th, 1424. And since Jan is already referred to as "master" at the time of his appointment we may assume that he was born not later than *ca.* 1390.[2] There is also some doubt as to his birthplace. For many centuries it has been taken for granted that both brothers were born at "Eyck," viz., Maaseyck, some eighteen miles north of Maastricht. Recently it has been proposed that they were natives of Maastricht itself where the name "van Eyck" is not uncommon as a family name. But since the evidence for this hypothesis is as yet inconclusive,[3] I am inclined to accept, for the present, the traditional view.

At the end of his employment in Holland, Jan van Eyck repaired to Bruges, but stayed there for only a short time. On May 19, 1425, he was appointed as painter and *varlet de chambre* to Philip the Good of Burgundy and moved to Lille prior to August 2 of this year. Here he resided, with major and minor interruptions, until the end of 1429, having married, at an undetermined date, a lady of whom nothing is known except that her Christian name was Margaret, that she was born in 1406, and that she presented him with a minimum of two children. Soon after, presumably in 1430, he established himself at Bruges for good and spent the rest of his life in a stately house "with a stone front" (acquired in 1431 or 1432), combining the office of a court artist with the normal activities of a bourgeois master painter who would not consider it beneath his dignity to accept such commissions as the coloring and gilding of the statues on the façade of the Town Hall. He died on July 9, 1441.[4]

Throughout the sixteen years of their association the Duke and his painter — the first Early Flemish master to sign his works and, so far as we know, the only one to imitate the nobles in adopting a personal motto, the famous *Als ich chan*, "As best I can," in which becoming pride is so inimitably blended with becoming humility — lived on terms of mutual esteem and confidence. Philip the Good not only admired Jan van Eyck as a great artist but also trusted him as a familiar and a gentleman. As early as 1426 the painter undertook, in the name of his master, certain confidential pilgrimages and "secret voyages," and during the following years he was a member of two embassies to the Iberian peninsula. After two previous marriages, both terminated by death, Philip the Good was still without an heir, and the first of the voyages overseas, lasting from early summer to October, 1427 (when Jan van Eyck received his *vin d'honneur* at Tournai on the eighteenth), was undertaken, it seems, in order to negotiate a marriage with Isabella of Spain, daughter of James II, Count of Urgel. This having failed for reasons unknown, another mission was dispatched to Portugal in order to obtain the hand of the eldest daughter of King John I, also named Isabella. This time the envoys succeeded, though only at the price of two exceedingly rough and dangerous crossings — entailing lengthy stopovers in England on both trips. They started on October 19, 1428, and returned — with the Infanta — as late as December, 1429; the marriage took place on January 10, 1430.[1]

Apart from another "secret mission" in 1436,[2] the Duke of Burgundy honored his painter by at least one personal visit to his workshop, showed him his favor by all kinds of extra payments and an occasional gift of silver cups, exempted him from a general cutback in jobs and salaries decreed in 1426, and acted as godfather by proxy (at the sacrifice of another half dozen silver cups) when a child of Jan's was baptized sometime before June 30, 1434. He even extended his affection beyond the grave. After Jan van Eyck's death his widow received a substantial gratuity "in consideration of her husband's services and in commiseration with her and her children's loss"; and nine years later, in 1450, his daughter Livina (Lyevine) was enabled to enter the Convent of St. Agnes at Maasseyck by a special grant from Philip the Good.

On one occasion, when the bureaucrats in Lille had made some difficulties about Jan's salary, the Duke came down upon them with an order that has the ring of the Italian High Renaissance rather than of the Northern Middle Ages. He enjoined them, under threats of gravest displeasure, to honor the claims of Jan van Eyck without delay or argument; for he, the Duke, "would never find a man equally to his liking nor so outstanding in his art and science": "nous trouverions point le pareil a nostre gré ne si excellent en son art et science."[3]

What may be dismissed as humanistic hyperbole in Bartolommeo Fazio, who praises Jan van Eyck as a man of literary culture (*litterarum nonnihil doctus*), proficient in geometry, and a master of "all arts that may be added to the distinction of painting,"[4] is thus borne out by the testimony of Philip the Good. By the very wording of his reprimand (*art et science*, a phrase not uncommon in the early fifteenth century) he implies that the achievement of an artist, and particularly those of his favorite painter, had to be considered not only as a matter of superior skill but also of superior knowledge and intelligence.

This judgment is confirmed by Jan van Eyck's pictures. Only a keen intellectual curiosity

could have devoted so much interest to theological texts, chronograms, astronomical details, cabalistic invocations and even paleography. Only a logical mind could have so thoroughly refined and systematized the principle of "disguised symbolism" that in his world, as I expressed it, "no residue remained of either objectivity without significance or significance without disguise." Only the instinct of a historian could have rediscovered the indigenous Romanesque and recaptured its spirit in all its phases and manifestations. And only an imagination controlled and disciplined by geometry, the "art of measurement," could have determined the impeccable proportions of Eyckian architecture.

II

That Jan was also an expert in alchemy, as Vasari would have it, is of course an assumption derived from the belief that he was the inventor of oil painting. This belief, we know, can no longer be maintained. Yet the fact remains that he must have devised certain improvements unknown before — improvements which enabled him to surpass both in minuteness and in luminosity whatever was achieved by his predecessors, contemporaries and followers. Whether he distilled new varnishes, driers and diluents — and in this case Vasari's reference to alchemy and his amusing tale of Jan's innovations having started with the development of a quick-drying varnish[1] might, after all, contain a grain of truth — or merely applied the processes of the *nouvelle pratique* with greater sophistication, it is difficult to say. Certain it is, however, that in his pictures the oil technique, though not invented by him, first revealed itself in its full glory, the translucency of the colors — "radiant by themselves without any varnish" — enhanced by an increasingly economical use of lead white which he employed (apart, of course, from the rendering of linen, etc.) for luminary surface accents rather than the construction of plastic form.[2]

From the sheer sensuous beauty of a genuine Jan van Eyck there emanates a strange fascination not unlike that which we experience when permitting ourselves to be hypnotized by precious stones or when looking into deep water. We find it hard to tear ourselves away from it and feel drawn back by what Magister Gregorius, compelled to revisit a statue of Venus again and again although it meant a walk of more than two miles, described as "some kind of magical persuasion." Whoever has tried to give a fair amount of conscientious attention to other paintings hung in the same room will remember that even a Rubens may strike him as "just a painting," a mere semblance as opposed to a reality, when looked at with an eye still carrying the imprint of a Jan van Eyck. In fact, a picture by Jan van Eyck claims to be more than "just a painting." It claims to be both a real object — and a precious object at that — and a reconstruction rather than a mere representation of the visible world.

The first of these claims is stressed by the very treatment of the frames which he invariably provided himself and which have come down to us in at least eight instances. Setting aside the exceptional case of the Ghent altarpiece, these frames are elaborated into complex moldings and painted so as to simulate marble or porphyry. Moreover, this marbleization is carried over

to the back of the panel, and carefully lettered inscriptions are seemingly incised into the artificial stone. By this legerdemain, which may seem reprehensible to the purist, Jan van Eyck not only showed off his virtuosity (as did the Limbourg brothers when they fooled the Duc de Berry with the wooden dummy of a gorgeous Book of Hours) [1] but also emphasized and glorified the materiality of the picture. The modern frame is nothing but a device for isolating the picture space from the space of nature. The Late Medieval frame, exemplified by the van Beuningen altarpiece with its carved rosettes (fig. 107), or, more extravagantly, by the "Carrand diptych" with its elaborate gilt tracery (fig. 99), is an ornamental setting which compasses the picture as chased metal does a precious stone. Jan van Eyck's frames are, in a sense, both. In subduing them coloristically, he stressed the modern idea of the panel as a "picture," that is, as the projection plane of an imaginary space. But in transfiguring them into what looks like marble, he retained the idea of the panel as a tangible piece of luminous matter, united with its frame into a complex *objet d'art* composed of many precious materials.

The impression that paintings by Jan van Eyck confront us with a reconstruction rather than a mere representation of the visible world is more difficult to rationalize. Very tentatively, we may say this: the naturalists of the fifteenth century, avid for observation yet in many ways committed to convention, were plagued by the problem of striking a balance between the general and the particular — between the total aspect of a face or hand and the wrinkles of the skin, between the total aspect of a piece of fur or fabric and its individual hairs or fibers, between the total aspect of a tree and its individual leaves. Before Jan van Eyck, these details, if not entirely suppressed, tended to remain distinct from each other as well as from the whole and give the impression either of a whole incompletely differentiated or of a mass of details incompletely unified. The hand of the St. George in the "Madonna van der Paele," however much detailed, remains a totality so that no contradiction is felt between its complexity and the simplicity of the polished armlet from which it emerges (fig. 249). The face of the Giovanni Arnolfini in the London double portrait, smooth though it is, seems sufficiently rich in detail to harmonize with the intricacies of the plaited Italian straw hat and fur collar (fig. 247).

This Eyckian miracle was brought about by what may be likened to infinitesimal calculus. The High Renaissance and the Baroque were to develop a technique so broad that the details appeared to be submerged, first in wide areas of light and shade and later in the texture of impasto brushwork. Jan van Eyck evolved a technique so ineffably minute that the number of details comprised by the total form approaches infinity. This technique achieves homogeneity in all visible forms as calculus achieves continuity in all numerical quantities. That which is tiny in terms of measurable magnitude yet is large as a product of the infinitesimally small; that which is sizable in terms of measurable magnitude yet is small as a fraction of the infinitely large.

Thus Jan van Eyck's style may be said to symbolize that structure of the universe which had emerged, at his time, from the prolonged discussion of the "two infinites"; he builds his world out of his pigments as nature builds hers out of primary matter. The paint that renders skin, or fur, or even the stubble on an imperfectly shaved face (fig. 262) seems to assume the

very character of what it depicts; and when he paints those landscapes which, to quote Fazio once more, "seem to extend over fifty miles," even the most distant objects, however much diminished in size and subdued in color, retain the same degree of solidity and the same fullness of articulation as do the very nearest. Jan van Eyck's eye operates as a microscope and as a telescope at the same time — and it is amusing to think that both these instruments were to be invented, some 175 years later, in the Netherlands — so that the beholder is compelled to oscillate between a position reasonably far from the picture and many positions very close to it.[1] And while thus being reminded of the limitations of nature, we share some of the experience of Him Who looks down from heaven but can number the hairs of our head.

However, such perfection had to be bought at a price. Neither a microscope nor a telescope is a good instrument with which to observe human emotions. The telescopic view tends to reduce human beings to those "figures of diminutive size" which people distant landscapes; the microscopic view tends to magnify their very hands and faces into panoramas. In either case the individual is apt to be de-emotionalized, whether he be reduced to the status of a mere part of the natural scenery or expanded into a small universe.

By nature, Jan van Eyck was by no means an impassive artist, and where occasion demanded it — as in the animated Genesis scenes on one of the capitals in the "Rolin Madonna" or in the truly terrifying "Slaying of Abel" in the Ghent altarpiece — he could be as dramatic as any other artist of his time. But in the "classic," unanimously accepted works of his maturity (in all those, that is, with which we are concerned in this chapter) [2] these dynamic elements are relegated to the background. The emphasis is on quiet existence rather than action, and with the significant exception of the Annunciate in the comparatively early picture at Washington, who retains, in much attenuated form, the emotional *contrapposto* attitude of her Italianate predecessors, the principal characters are nearly motionless, communicating with each other only by virtue of spiritual consubstantiality. Measured by ordinary standards, the world of the mature Jan van Eyck is static.

III

When we exclude, for the time being, the problematic Ghent altarpiece and the contested "early works," we are left with no more than twelve — or, possibly thirteen — dated or datable pictures by Jan van Eyck. Four of these are portraits in half-length and therefore difficult to compare with the more complex narratives. Three were unfinished at the time of the master's death so that his personal contribution is hard to estimate. One is an elaborate brush drawing on white-grounded wood rather than a painting, and the dates of all these pictures, ranging from 1432 to 1441, cover only the last nine years of his activity.

Yet even within this limited material a definite development can be discerned. It was only by degrees that Jan's compositions attained that immobility which Dr. de Tolnay has happily described as *cristallisation de l'espace* and *insensibilisation des personnages,*[3] and that his technique turned from glittering freedom and effervescence to that stony severity which overawes

us in the "Paele Madonna." And it was only for a brief period that this almost inhuman flaw-lessness persisted. In the end the master's style came to be irradiated, as it were, by some of the warmth and humanity that can be sensed in his "earlier" works.

To begin, then, with Jan van Eyck's religious paintings other than the Ghent altarpiece (his secular compositions being known to us only through literary descriptions or somewhat questionable copies), the earliest dated picture is the "Ince Hall Madonna" of 1433, now in the National Gallery at Melbourne (fig. 243);[1] the face is, unfortunately, partially repainted. Al-though the scene is laid in a bourgeois interior — the symbolical implications of which have already been explained in Chapter Five, as has the iconography of most of the other works now to be considered from a stylistic point of view — the dignity of Our Lady transcends her sur-roundings. In significant contrast to the "Salting Madonna" by the Master of Flémalle, doubly significant should it have exerted some influence on the "Ince Hall Madonna," she does not nestle in a corner, so to speak, but occupies the center of the stage, proudly erect before a cloth of honor surmounted by a canopy. The composition thus resulted from a fusion between the domesticity of the Master of Flémalle and the courtly ceremonial of the "Boucicaut Master" (fig. 67). But it is not, as yet, rigidly formalized. The crimson mantle of the Virgin,[2] revealing little of the plastic form beneath, is casually spread out in folds in which the curvilinear fluency of the International Style still competes with modern angularity, and an impression of airiness is conveyed by the fact that there is plenty of room between her head and the canopy. In spite of her central position, she sits a little sideways, and in spite of the canopy her seat is not a regal throne or even a regular chair, but a mere bench without back and armrests; her pose is thus halfway between that of a Madonna Enthroned and a Madonna of Humility. A touch of human intimacy is felt in the way in which the Virgin Mary holds an illuminated Book of Hours for the Infant Jesus to look at and even allows Him to turn the pages. Moreover, while the main group gives an impression of approximate bilateral symmetry, the composition as a whole is by no means perfectly axialized. The pattern of the brocaded cloth of honor is con-spicuously asymmetrical, and the center of vision is slightly shifted off axis so that more of the left wall is exposed to view than of the right and the vanishing lines converge at unequal angles.

Three years later, in the "Madonna van der Paele" at Bruges (fig. 248),[3] all movement is suppressed. The composition is inexorably symmetrical both in its figural and architectural elements, and the Madonna group has crystallized into a compact conical shape. St. Donatian, the titular saint of the church for which the work was destined, is a magnificent motionless statue, and the patron and namesake of the Canon van der Paele, St. George, while presenting his protégé and courteously tipping his helmet, seems to be frozen in these very acts just as the smile seems to be frozen on his face. The Infant Jesus and His mother, though turning their faces towards the donor, remain immobile and remote. The Virgin now occupies a real throne adorned with symbolic sculptures, and even these, notably the group of Cain Slaying Abel on the Virgin's right,[4] are severely restrained in comparison with the analogous reliefs in the Ghent altarpiece. The drapery of the Madonna accentuates the volume beneath it, but less as an organic form than as a kind of stereometric solid not unlike an inverted and truncated

pyramid. The fabric is angularly corrugated almost as in the simulated statues of the Ghent altarpiece, and all the other surfaces, including human flesh and hair, give an impression of sculptural hardness. The principal group seems very large and statuesque, being so close to the beholder that the carpet is cut off in front by the lower frame, and is as tightly encompassed by the armrest of the throne, the columns and the canopy as a cult image is by its niche. And the two saints appear almost colossal since the surrounding space is cut down to a minimum — though, we remember, this very device "includes" us in the narrow, circular sanctuary and thereby produces a sense of nearness both in a material and spiritual sense.

It may be thought that an informal Madonna in a domestic setting cannot be fairly compared with a Queen of Heaven holding court in what is meant to signify the Heavenly Jerusalem. Yet we can show that the difference between the "Ince Hall Madonna" and the "Madonna van der Paele" cannot be accounted for by the difference in purpose and iconography alone. On the one hand, there is a formal altarpiece iconographically similar to the "Madonna van der Paele" but even freer in style than the "Ince Hall Madonna"; on the other hand, there is a picture nearly identical with the "Ince Hall Madonna" in intention and subject but even more rigid than the "Madonna van der Paele" in form.

The altarpiece referred to is the little triptych in Dresden presumably ordered by an Italian gentleman named Michele Giustiniani (figs. 240–242).[1] Expanding and varying the idea of a deep, carpeted, tripartite throne room as found in the Boucicaut Master's *Tite Live* in the Bibliothèque Nationale (fig. 79),[2] Jan van Eyck confronts us with a Romanesque basilica, quite small but even more resplendent than the somewhat forbidding structure of the "Paele Madonna," the aisles of which constitute one continuous space. In the richly decorated central nave, surmounted by the symbolical triad of windows, we see the Madonna enthroned; in the side aisles, St. Michael with the donor on the left, and St. Catherine alone on the right. What the composition of this triptych does have in common with that of the "Paele Madonna" — the splendor and formality of the setting and the perfect symmetry of the arrangement — is easily explained by the analogous theme. In every other respect, however, the Dresden triptych is even farther removed from the "Madonna van der Paele" than is the "Ince Hall Madonna" (so that a still earlier date, say about 1430–1431, is indicated). The space envelops the figures with comfortable amplitude; the figures of the standing saints occupy less than two thirds of the available area and the Madonna, pushed far back, appears almost tiny. A generous amount of pavement is interposed between the edge of the carpet and the lower frame, and there is much more headroom beneath the canopy than even in the "Ince Hall Madonna." The whole picture scintillates rather than glows, and all the surfaces are alive, now with the sparkle of the slivers of glass in a kaleidoscope, now — as in the fluffy hair of the St. Catherine — with the hazy softness of swansdown. The round-cheeked, curly and bejeweled St. Michael looks almost boyish in comparison with the metallic St. George in the "Paele Madonna" and there is much vivacity and friendliness in the Christ Child's active response to the homage of the donor.

Conversely, the so-called "Lucca Madonna" in Frankfort (fig. 252),[3] though just as domestic and unofficial as is the "Ince Hall Madonna," is more rather than less austere and

hieratic than the "Madonna of the Canon van der Paele" and may be dated at about the same time, perhaps a trifle later. In spite of the informal setting, symmetry rules supreme — to such an extent that the window in the left-hand wall has an identical twin in the niche in the right. The low bench has been replaced by a regal chair *à la* Throne of Solomon so that every reminiscence of the Madonna of Humility is obliterated. As in the "Paele Madonna" the group is compact and statuesque in itself, and it is monumentalized in relation to its surroundings, the headroom beneath the canopy being severely restricted and the carpet emphatically cut in front. In surface treatment there is the same tendency toward crystalline precision and systematization, and the drapery is carved into big prismatic folds. The nursing Infant, rectangularly posed in pure profile, clutches the symbolic apple without a sign of either feeling or consciousness.

Soon after the "Lucca Madonna," however, this rigidity began to soften without a loss in monumentality, and it is this fusion of mellowness and grandeur that characterized Jan van Eyck's *ultima maniera*. The first example of this development is the remarkable St. Barbara in Antwerp dated 1437 (fig. 254).[1] It is not a painting but rather a meticulously detailed and finished drawing executed with the finest of brushes on a white-grounded panel, and may in fact have been commenced as a mere *préparation*. I do not believe, however, that it can be accepted as typical of Eyckian underdrawings;[2] if the paint were removed from Eyckian pictures carried out in color, we could hardly expect to find a similarly detailed drawing underneath. Every Early Flemish painting presupposes, of course, a careful but much more generalized *préparation*; such minutiae as the fine lines of the saint's hair, the details of the incidental figures or the subtleties of the architecture would have been obliterated by even the first and thinnest coat of paint had the "St. Barbara" ever been transformed into a real picture. We have to assume that Jan van Eyck, either of his own accord or at the suggestion of a discriminating client, decided to elaborate this particular "preparation" into a finished product *sui iuris*, and this assumption is corroborated by the very fact that the little monochrome is set, like a real "picture," in an elaborate frame simulating red, black-veined marble and inscribed with a beautifully lettered "IOHĒS DE EYCK ME FECIT. 1437." A subsequent attempt at coloring did not, thank God, proceed beyond some patches of blue in the sky.

That Jan van Eyck resumed the problem of the open landscape contrasting with complicated architecture and teeming with little figures — a problem which he had neglected for several years — reveals a nostalgia for concreteness, multiplicity and freedom as opposed to abstraction, uniformity and systematization. The facial type and fluffy hair of the saint evokes the memory of the St. Catherine in the Dresden altarpiece while the motif of turning the pages of an illuminated Book of Hours reminds us of the "Ince Hall Madonna." The drapery, too, resembles the freely spreading forms seen in the picture of 1433 more than the compact and somewhat schematic arrangement in the "Lucca Madonna" and the "Madonna van der Paele" of 1436. This freedom, however, resulted from a loosening subsequent to systematic organization. Luxuriant though they seem to be, the folds are kept in order by a few forcible guiding lines and clearly divided into three large areas, each functionally significant: the flat, plowshare-like folds that spread on the ground, the big rhombohedron that encloses the lower part of

the figure, and the concentration of crumpled material that marks the zone of transition between the two. And the wealth of microscopic and enchanting detail is but the fanciful counter accompaniment of the dominant theme, the saint and her tower, the central axis of the figure (marked by the face and the left hand) and the central axis of the edifice defining one mighty vertical.

The idea of a St. Barbara sitting on the ground — a Barbara of Humility, as it were — can, we recall, be explained by the regional Flemish tradition.[1] But here her attribute is monumentalized into a structure of gigantic proportions and invested with an entirely new meaning. The symbol of the tower originally referred to the fact that Barbara, like Danaë, had been imprisoned by her pagan father in order to protect her beauty from defilement. But the legend also relates that he discovered her conversion to Christianity after she had caused his workmen to build a chapel with three windows instead of a bathhouse with two as he had authorized her to do.[2] To artists it was natural to transfer these Trinitarian windows from the chapel to the tower of imprisonment. Jan van Eyck, however, transformed the tower of imprisonment into the tower of a cathedral represented in course of erection, depicting the multifarious activities of the workmen and the idle curiosity of visiting townspeople with an amazing sense of reality and not without subtle humor, as when the traditionally elegant architect-in-chief, "carrying a cane and saying *par cy me le taille,*'" attempts to make himself understood by his foreman who, arms akimbo, yells down to him from the top of the tower. The underlying idea, however, is one of real solemnity; according to St. Paul, all Christians are "God's builders," incessantly working on a structure not to be completed until the Day of Judgment.

What remained a promise in the small St. Barbara panel was fulfilled in the later and still smaller "Madonna at the Fountain," also preserved at Antwerp (fig. 255).[3] The unusual wording of the inscription "IOHES DE EYCK ME FECIT + CPLEVIT ANO 1439" ("Jan van Eyck made and completed me," instead of either the one or the other)[4] may have a direct reference to the "St. Barbara" which, though "made" by Jan van Eyck was not a "completed" picture; perhaps both panels were acquired by the same patron.

At first glance the "Madonna at the Fountain" looks almost archaic, so much so that a misguided scholar has been stirred to correct the "1439" into "1429."[5] In contrast to the four Madonna compositions thus far discussed, the Virgin Mary is shown standing instead of enthroned, a theme less rich in plastic possibilities, and she is clad in the traditional blue mantle which in the other paintings had been audaciously replaced by a robe of glowing red. Moreover the figure is not embedded in the space of either an interior or an open landscape. The prospect into depth is blocked by a cloth of honor spread out by two angels and by the rose hedge of the *hortus conclusus*, with the portentous sword-lily conspicuous on the right.

Yet this apparently spaceless and indeed deliberately archaizing picture which brings to mind the schema of the "Virgin of Yolande Belle" of 1420 and bears a possibly more than accidental resemblance to Roger van der Weyden's early Madonna at Vienna (fig. 307),[6] is full of depth and complexity. To look at it is an experience analogous to hearing a performance on the clavichord, where the ear, once adjusted to the small volume of the instrument, perceives

dynamic differences more acutely than when exposed to more powerful sounds. Just because our range of vision is so limited, the successive planes — defined by the blue sky, the hedge, the grassy bench, the cloth of honor, the figure itself and, in the foreground, the boldly asymmetrical accent of the "fountain of gardens" — detach themselves from each other with a vigor in comparison with which all other pictures in the same room appear almost flat. Just because the design is reduced to essentials, our attention is held by the contrapuntal relationship that exists between the large surfaces and long tubular folds in the center and the crumpled and cascading motifs on either side, and by the even more basic interaction of body and drapery; never before in Jan's work had the plastic form so eloquently asserted itself against its covering. Just because the posture of the Virgin, her hands collected in the center, is so rigid, and because the movement of the very young Christ Child — much livelier and more babyish than in all earlier compositions — is so ruthlessly forced into the picture plane, we are doubly touched by the inwardness of the Virgin's expression and by the tenderness of the Infant's embrace.

IV

The words "Johannes de Eyck me fecit et complevit" proved to be ominous. After 1439, the year of both the "Virgin at the Fountain" and the portrait of his wife, Jan van Eyck was not to "complete" a single painting — except, perhaps, a "Holy Face" produced in 1440 which has come down to us in six replicas, the smallest of which (fig. 256) might be the original.[1] Three compositions, however, can claim to have been "made" by him, insofar at least as he was responsible for their design and, in two cases, had begun their execution.

The best documented and, as far as the genealogy of Early Flemish painting is concerned, most important of these three works is the "Madonna with St. Barbara, St. Elizabeth of Thuringia and a Carthusian Donor" in the Robert de Rothschild Collection at Paris (fig. 257).[2]

Grandiosely conceived, the stillness of the figures contrasting with the sweep of wide-spaced arches that set off but do not limit a vast panorama, this picture yet fails to carry conviction; to invert a famous dictum of Vasari's, it seems to have been "constructed, not born." The proportions of the architecture are subtly out of joint. All the surfaces, especially those of the porcelainlike faces, are too smooth. The hands want in articulation. The draperies are wooden. St. Elizabeth's triple crown lacks the subtlety and sparkle of other Eyckian goldsmith's work. The right-hand half of the landscape somewhat mechanically repeats a number of details seen in the "Rolin Madonna" (fig. 244) [3] which also seems to have served as a model for the mixed style of the architecture (Romanesque arches and columns with Gothic tracery on the spandrels and bases); and the clumsy tower — apart from the fact that the familiar symbolism of its three Gothic windows and cross-shaped finial is inconsistent with the presence of a statue of Mars — does not seem to detach itself from either the figures before or the distant landscape behind it.

In view of these weaknesses the "Rothschild Madonna" has occasionally been doubted.

Its style seemed to suggest Petrus Christus rather than Jan van Eyck,[1] and this attribution has subsequently been confirmed — with the important qualification that the basic plan of the composition probably remains Jan van Eyck's — by documents. According to these, the "image of the Most Blessed Mary, Mother of God, St. Barbara and St. Elizabeth" had its original place in the Carthusian monastery of Genadedal, near Bruges. It was a gift of the Prior, Jan Vos (whereby the identity of the previously anonymous Carthusian donor is firmly established), and it was dedicated by a visiting Bishop, Martin of Mayo in Ireland, on September 3, 1443. In 1450, Jan Vos was transferred to Nieuwlicht near Utrecht, which we remember as one of the centers of Dutch book illumination, and took the picture with him. "At present," says the Nieuwlicht chronicler to whom we owe our information, "it belongs to our aforesaid monastery and can be seen on the altar of St. Barbara." By way of compensation, however, the Prior ordered for Genadedal a free and somewhat abridged replica, without St. Elizabeth of Thuringia, the so-called "Exeter Madonna" at Berlin (fig. 408).

The "Rothschild Madonna," then, was completed some time before September 3, 1443; and it cannot have been commenced until after March 30, 1441, this being the day of the death of Jan Vos's predecessor, Guerardus de Hammone. Of these approximately two and one-half years only three months and ten days had elapsed when Jan van Eyck expired on July 9, 1441. Some time, of course, must be deducted from the period after Jan's death for the interval between the picture's completion and its "benediction" by the Bishop of Mayo. But allowance must also be made for the interval between the death of Guerardus de Hammone and Jan Vos's accession, for the interval between his accession and the commissioning of the picture, and for the last illness of Jan van Eyck. In all probability, therefore, Jan van Eyck could do little more than to lay out the composition of the "Rothschild Madonna" in the most general terms. The elaboration of the design, and certainly the actual execution of the picture, must have been left to a man whom he had trained; who was entitled and able to wind up unfinished business, so to speak; and who had access to whatever was left of personal sketches and workshop drawings (needless to say, painters and book illuminators alike kept copies of works delivered for subsequent use and comparison). This man can have been none other than Petrus Christus whom tradition has always regarded as Jan van Eyck's disciple and successor and whose stylistic peculiarities have been recognized in the "Rothschild Madonna" even before it was known to have been commissioned too late for Jan to have carried it out. He was, as no one has ever doubted, the author of the "Exeter Madonna" that was to replace the Rothschild picture in 1450 and closely follows its composition. He was and remained in touch with the Carthusian Order as evidenced by the New York Portrait of a Carthusian of 1446. And though he did not become a citizen of Bruges until July 6, 1444, nothing whatever militates against the assumption that he had joined Jan van Eyck some time in the 'thirties and, after the latter's death, conducted the workshop in the name of the widow until such time as he saw fit to establish himself as a master in his own right.[2]

The documented fact that the "Rothschild Madonna" was executed between March 30, 1441, and September 3, 1443 lends credibility to the inscribed date, "1442," of another picture

that raises the problem of Petrus Christus *vs.* Jan van Eyck: the "St. Jerome in His Study" in the Detroit Institute of Arts (fig. 258).[1]

When this small picture, measuring only 8¼ by 5¼ inches, came to light some twenty-five years ago, it was unanimously attributed to Petrus Christus. But its invention, widely imitated both at home and abroad, was soon recognized as Jan van Eyck's. With the St. Jerome changed to a St. Thomas Aquinas but most of the enchanting paraphernalia retained, the composition recurs, for example, in the "*Très-Belles Heures de Notre Dame*,"[2] and in Florence it served as a model for two monumental frescoes in the Church of Ognissanti, the "St. Jerome" by Ghirlandaio and the "St. Augustine" by Botticelli.[3]

Even as a Petrus Christus, therefore, the Detroit painting would duplicate a "St. Jerome" by Jan van Eyck which, as we happen to know, was owned by the Medici: "A small Flemish picture in oils, in an etui, showing a St. Jerome engaged in study, with a bookcase (*armarietto*) containing several books in perspective and a lion at his feet; a work of Master John of Bruges." However, when the cleaning of the picture revealed the date 1442, diminutively inscribed upon the strip of wall between the back of the chair and the curtain of the bookcase, a more exciting possibility presented itself. Assuming that this date, somewhat irregular in placement and appearance, represents, like the "1662" on Rembrandt's "Syndics" of 1661, a "correction and amplification" (here meant to rectify what was presumably stated on the dark-green marbleized frame whose existence is proved by remnants of paint on the panel's back), the Detroit picture may be more than a mere copy after the "Medici St. Jerome"; it may be the "Medici St. Jerome" itself, begun by Jan van Eyck shortly before his death and finished, unbeknownst to the Medici, by Petrus Christus in 1442.[4] Its hypothetical history would parallel the documented history of the "Rothschild Madonna," except for the fact that, while the latter's execution was left entirely to Petrus Christus, the former would have been partly carried out by Jan's own hand.

The Detroit picture shows indeed a marked difference in style and quality. While the saint's chair, most of his robe (which, in addition, shows traces of over-painting), the lower part of the strongbox that serves him as a writing table and the depressed-looking lion show the conscientious but somewhat pedestrian style of Petrus Christus, the upper right-hand sector of the picture — roughly delimited by the outer contour of the curtain and the lower edge of the tablecloth — is worthy of the greatest of painters. Petrus Christus, notorious for his inexpressive, pudgy hands and general tendency toward simplification, can hardly be credited with a hand so sensitively inserting slender fingers between the leaves of the big Bible as if to hold two passages for comparison; with the unobtrusively effective play of light on shining or translucent objects; and with the "rich-looking gloom" diffused in the recesses of the *armarietto*.

A direct clue not only to the picture's authorship but also to its original destination is furnished, I think, by the microscopic yet perfectly legible superscription of the twice-folded letter on the saint's worktable: "Reuerendissimo in Christo patri et domino, domino Ieronimo, tituli Sancte Crucis in Iherusalem presbytero cardinali" ("To the Most Reverend Father and Lord in Christ, Lord Jerome, Cardinal-Priest of the Holy Cross of Jerusalem"). Addressing St.

Jerome — in contradiction to a well-established tradition which either considered him as a cardinal *sine titulo* or invested him with the Church of Santa Anastasia — as "Cardinal-Priest of the Holy Cross of Jerusalem" (that is, of Santa Croce in Gerusalemme), this very formal salutation assigns to him the titular church of the only cardinal known to have been in personal contact with Jan van Eyck, the excellent Nicholas Albergati.[1] A graceful, half-humorous compliment, it makes St. Jerome the lineal predecessor of Jan's old patron who, therefore, may be presumed to have commissioned the picture.

The Detroit picture thus compensates, to some extent at least, for the loss of that other "St. Jerome" which was admired at Naples by Bartolommeo Fazio [2] and, to judge from his description, must have had much in common with the painting in Detroit. It makes us realize that Jan's interpretation of the great translator represents not only a triumph of genre and still-life painting but also a new evaluation of intellectual activity. He transformed the Boucicaut Master's bare "corner" into what may be called a "scholastic interior," warmed by the presence of cherished objects and pervaded by an atmosphere of contented seclusion — the workplace of one who is both a saint and a humanist. And there is a particular fitness in associating him with the fatherly protector of that Tommaso Parentucelli who, when elected Pope in 1447, assumed the name of Nicholas V in honor of his late benefactor and was to become the founder of the Vatican Library.

While the "Rothschild Madonna" and the Detroit "St. Jerome" constitute a problem because of the intervention of Petrus Christus, the last of Jan van Eyck's posthumous works, the so-called "Ypres altarpiece," does so because of the non-intervention of Petrus Christus. Instead of being immediately finished by Jan van Eyck's legitimate heir, this altarpiece appears to have left his workshop in an unfinished or even rudimentary state and assumed its final shape in a long process of supplementation and overpainting.

The "Ypres altarpiece" (fig. 259) [3] is a round-topped triptych — ordered by Nicholas van Maelbeke, Provost of St. Martin's at Ypres from 1429 to 1445 — as large in scale as the two other posthumous panels are tiny; opened, it measures about 1¾ by 2 meters. The wings were never touched by Jan van Eyck and their interest is chiefly iconographic. On the interior, four Marian symbols are depicted in elaborately naturalistic fashion: the Burning Bush and the story of the Golden Fleece, on the left; the Shut Gate (according to Ezekiel XLIV, 2) and Aaron's Rod, on the right. The exterior, painted in grisaille and executed as late as 1550, shows the Emperor Augustus ("Octauianus") with the Sibyl of Tibur; and, in the upper zone, the Virgin Mary glorified by three musical angels, both groups represented in three-quarter length and surrounded by *mandorlas*.

The composition of the central panel, however, is, *qua* composition, indubitably Eyckian. Depicting Nicholas van Maelbeke on his knees before Our Lady and authenticated by two independent copy drawings of *ca.* 1460, the picture may be called a final synthesis of the "Madonna of the Chancellor Rolin" with the "Rothschild Madonna." The standing posture of the Virgin and the general appearance of the Christ Child are features it holds in common with the Rothschild picture. With the "Rolin Madonna," however, it shares a prevailing atmosphere

of intimacy. The Virgin, again clothed in a red robe, turns toward the sponsorless donor with homely friendliness instead of maintaining a pose of inapproachable frontality. And what applies to the figures also applies to their setting. Like the "Rolin Madonna," the Ypres altarpiece induces a sense of elevation by the lowness of the horizon. But as in the "Rothschild Madonna," the landscape is treated, not as a framed prospect, but as a scenery limitlessly continuing behind the piers and columns of a structure which, though built like a chevet in a polygonal apse, gives the impression of an open portico.

In execution, however, this latest work of Jan van Eyck is far from authentic. We have no right to assume that, after all the accretions of the last three hundred years had been removed (before the recent cleaning the donor had an entirely different face with bald pate and pointed, seventeenth-century beard) a uniformly Eyckian stratum has been reached. What has been uncovered is merely the stratum of the sixteenth century which still employed a technique no less resistant to modern cleaning than that of the fifteenth. The face of the Infant Jesus can have received its sweet, Leonardesque smile and equally Leonardesque *sfumato* treatment only at the hands of a painter familiar with the style of Quentin Massys. The group of St. Martin Sharing his Mantle which crowns the sumptuous crozier betrays its date, about 1530 or so, by an impressionistic sketchiness entirely foreign to the era of Jan van Eyck. The hard, flashy treatment of the Provost's brocaded and embroidered pluvial inspires as little confidence as does his heavy head (which in the copy drawings shows a tonsure), the pudgy hands of all the figures, and the robe of the Madonna which in the drawings lacks its bejeweled borders and reveals the Virgin's left foot.

The inference is that the central panel of the Ypres altarpiece left Jan van Eyck's workshop in a state at which, for the most part, the execution had not proceeded beyond the first or second coat of paint. Apart, perhaps, from certain sections of the landscape, the most convincing portion is the upper part of the architecture, characteristically combining Romanesque capitals with fourteenth- or even fifteenth-century vault-ribs. This portion is more thinly and less glossily painted than most of the rest, but just this peculiarity may indicate that it escaped the attentions of the sixteenth century. Though not really finished at the time of the master's death, it apparently seemed finished enough to be allowed to stand as it was.

In its present state, then, the Ypres altarpiece is a monument to Jan van Eyck the composer rather than to Jan van Eyck the painter; but had his hand not been stayed by fate, it would have been a glorious finale to his career.

v

Plotted against the compositions dated or datable between 1433 and 1441, most of the undated ones fall readily into place.

Of the Dresden triptych (figs. 240–242) we have already seen that it must be somewhat earlier than the "Ince Hall Madonna" of 1433, and of the "Lucca Madonna" that it must be

approximately contemporaneous with, if not a little later than, the "Madonna of the Canon van der Paele" of 1436.

A similar date I should also assign to the "Stigmatization of St. Francis" in Philadelphia (fig. 268) were it not for the fact that — though this is rank heresy — I have considerable doubts as to its authenticity.[1] No such doubts, however, can arise with regard to the authenticity and date of the most recent addition to Jan van Eyck's *oeuvre*, an "Annunciation" in the Thyssen Collection at Lugano (fig. 253).[2] This work consists of two separate panels painted in grisaille, thus offering an aspect analogous to that of the Dresden altarpiece when closed. The versos of the panels, however, do not display paintings in natural colors or remnants thereof, nor do they bear the marks of recent bisection as do, for instance, the Frankfort "Trinity" and "St. Veronica" by the Master of Flémalle. They are, instead, carefully marbleized in the same way as are the chamfered frames, from which we may conclude that Jan van Eyck himself had decided, for reasons unknown, to convert the exterior shutters of a triptych into an independent devotional image.

In fact, the two pictures are so sophisticatedly conceived and, in a sense, so colorful that they transcend the limitations of ordinary grisailles. They well deserved to be promoted to the status of a self-sufficient diptych which may be described as a symphony in marble — marble of different grain, different hue and different polish. The carved moldings of the actual frames, treated so as to look like gray marble, merge, as it were, with the painted moldings of simulated ones; though these are somewhat lighter in color, it takes some time to tell where reality ends and fiction begins. And the simulated frames enclose what purports to be flat marble slabs so dark and so highly polished that they reflect the backs of the snow-white "statues" in front of them.

The statues themselves offer an interesting contrast to the analogous but much earlier ones — in ordinary grisaille — on the exterior of the Dresden altarpiece. Where these show a certain fluency of design and a certain warmth of expression, the Angel smiling and the Virgin Mary raising a demurely welcoming hand, the Thyssen diptych exhibits harder, rockier drapery forms and juxtaposes an unsmiling Gabriel with an Annunciate immobilized by the miracle. Like the "Madonna of the Canon van der Paele" and the "Lucca Madonna" the Thyssen "Annunciation" marks the climax of *insensibilisation des personnages*.

Three other works, on the other hand, would seem to antedate this climax.

The first of these is the famous "Madonna of the Chancellor Rolin" in the Louvre (figs. 244–246), the iconography of which has been discussed at length in Chapter Five.[3] Here we may add that its composition — all differences, especially the donor's independence of celestial patronage, notwithstanding — has much in common with the dedication picture in a Book of Hours from the workshop of the Boucicaut Master (Paris, Bibliothèque Nationale), in which an unknown donatrix is presented to Our Lady by an angel (fig. 78).[4] The room in which the scene is laid — an airy hall opened in the rear by a tripartite colonnade — prefigures, *in nucleo*, the palatial chamber of the "Rolin Madonna."

As to the date of the picture, external evidence is lacking. A recent attempt to show that

Jan van Eyck's "secret mission" of 1436 took him to Prague, and that a number of motifs in the "Rolin Madonna" reflect the impression of this conjectural trip, can be demonstrated to be futile.[1] We have thus to rely on stylistic considerations, and these would seem to indicate a somewhat earlier date. The folds of the Virgin's crimson robe are, as it were, halfway between the fluid freedom of the "Ince Hall Madonna" and the angular systematization of the "Madonna van der Paele." The surfaces are treated with an attention to texture still reminiscent of the Dresden altarpiece. Human hair, for example, is suggested by a diffusion of light and shade rather than by a concentration of high-lights in protracted, wavy lines, and a similar contrast between a pictorial and — within the limitations of Eyckian luminarism — graphic interpretation can be observed when we compare the bulls-eye windows in the "Madonna of the Chancellor Rolin" with those in the left-hand window of the "Lucca Madonna." The glistening landscape, the garden alive with flowers and peacocks, the funny little men looking over the parapet, the downy wings of the angel, the stained glass and the fantastically chased and bejeweled crown (a motif significantly absent from all the later works of Jan van Eyck): all this bespeaks joyful exuberance rather than austerity.

All things considered, the "Rolin Madonna" may be dated about 1433-1434, shortly before the Arnolfini portrait in London (fig. 247) — the *ne plus ultra* in landscape painting apparently coinciding with the *ne plus ultra* in the rendition of the interior — and a date like this is well in harmony with the appearance of the donor. With his still relatively youthful face and full, sensuous lips, he strikes us as a man this side of sixty. Nicholas Rolin was born in 1376, and how he looked at seventy, with sunken eyes, a lean, deeply lined face and bitter mouth, can be seen in his portrait on the exterior of the "Last Judgment" at Beaune (fig. 325). Of course, this later likeness is not by Jan van Eyck but by Roger van der Weyden, which makes a great difference. But even so it would seem that more than nine or ten years were necessary to work such a change in a man who was to reach the age of eighty-six.

If the "Madonna of the Chancellor Rolin," though antedating the "Madonna van der Paele" and the "Lucca Madonna," seems to be later than the "Ince Hall Madonna" and, by an even greater margin, the Dresden altarpiece, both these comparatively early works seem to postdate the two last paintings here to be discussed, the Washington "Annunciation" (figs. 238, 239)[2] and the "Madonna in a Church" at Berlin (figs. 236, 237).[3]

These two pictures are more wonderfully aglitter with ornamental carving, *niello* work, stained glass, jewelry, and brocade than even the Dresden triptych (never before had the Angel Gabriel been shown in a brocaded pluvial, sceptered and with a crown on his head),[4] and in both the architectural space soars to even greater height in relation to the figures. Instead of figures enframed by architecture, we have architectures inhabited by figures. In two respects, moreover, the Washington "Annunciation" and the "Madonna in a Church" evince an allegiance to earlier traditions soon to be shaken off and form, so to speak, a little group by themselves. In both cases, the mantle of Our Lady is blue according to an age-old custom which Jan van Eyck first broke in the "Ince Hall Madonna" of 1433 and consistently defied ever after with the exception of the deliberately archaic "Madonna at the Fountain" of 1439. And in both

cases the center of vision is shifted far to the right, quite near the margin of the picture, whereas the perspective in all the paintings after the "Ince Hall Madonna" is perfectly symmetrical or, in the "Ince Hall Madonna" itself, so very slightly eccentric that the deviation is scarcely perceptible.[1]

In this respect, we recall, the Washington "Annunciation" as well as the "Madonna in a Church," are variations — magnificently original variations, to be sure — on themes first stated by the Boucicaut Master.[2] In the "Annunciation," the Boucicaut Master's influence is further evidenced by the very idea of staging the scene in an ecclesiastical setting, an idea emphatically at variance with the tradition established by the Master of Flémalle, and it is in the "Boucicaut Hours" itself that the unusual attitude of the Virgin — looking up from her book and raising both hands before her breast — has its closest parallel (fig. 60). Quite apart from technique, color taste, facial types and drapery style, so many retrospective features would alone justify dating the two pictures some time before the "Dresden altarpiece." I should like to propose 1428–1429 for the Washington "Annunciation" and 1425–1427 for the "Madonna in a Church" which, more loosely and lushly painted than any other commonly accepted work of Jan van Eyck, is certainly the earliest of all. This work, if any, must constitute the link between his known maturity and his conjectural beginnings.

VI

As a portraitist, Jan van Eyck is both the most exhaustive and the most tantalizing interpreter of human nature; his portraits are at once intensely near and infinitely remote.

A portrait aims by definition at two essential and, in a sense, contradictory qualities: individuality, or uniqueness; and totality, or wholeness. On the one hand, it seeks to bring out whatever it is in which the sitter differs from the rest of humanity and would even differ from himself were he portrayed at a different moment or in a different situation; and this is what distinguishes a portrait from an "ideal" figure or "type." On the other hand, it seeks to bring out whatever the sitter has in common with the rest of humanity and what remains constant in him regardless of place and time; and this is what distinguishes a portrait from a figure forming part of a genre painting or narrative. Rembrandt's "Old Woman Paring Her Nails," though doubtless retaining the distinctive features of the model, is not a portrait but a genre picture because the old lady is completely engrossed in a specific activity. Dürer's "St. Jerome with a Death's Head," though demonstrably "portraying" an individual old gentleman ninety-three years of age, who received three stuivers for the sitting, is not a portrait but a religious image because the saint appears completely absorbed in a specific emotional situation and tries to convey its content to the beholder. In either case we have individuality but not a revelation of a human being in his entirety. Conversely, Rigaud's "*Président Gueidan en Berger Musicien*" and Reynolds' "David Garrick between Tragedy and Comedy" are not, respectively, a genre picture and a narrative but portraits because the characters, though masquerading as an Arcadian shepherd or pretending to be torn between conflicting psychological impulses, in fact

Jan Van Eyck's portraits — descriptive rather than interpretive

parade their total personalities. And it is not only by retaining his characteristics in physiognomy and costume but also by not permitting his autonomous personality to be submerged by emotion (however violent this emotion may become in certain Baroque pictures) that the donor preserves his portrait status in an altarpiece.

If carried to an extreme, these two requirements, individuality and totality, would be mutually exclusive. An absolutely unique personality would be reduced to an infinity of particularities exclusively his — and even then only *hic et nunc* — and thereby cease to be a total human being. An absolutely total personality would be reduced to basic qualities so universally and profoundly human that he would cease to be an individual; it is no accident that Rembrandt's latest portraits, which closely approximate this ultimate totality, were criticized or even rejected as not being "good likenesses."

All portraitists, then, must balance these two postulates, and the manner in which this balance is achieved depends on period, nationality, and personal inclination. Very roughly speaking, it may be said that an emphasis on individuality or uniqueness — characteristic of the fifteenth century as opposed to the High Renaissance and the Baroque and, within this chronological framework, of Northern rather than Italian art — leads to a descriptive and static approach: the sitter tends to be depicted as an isolated *haecceitas*, betraying little of his inner life and having, as it were, no history. Conversely, an emphasis on totality or wholeness — characteristic of the High Renaissance and the Baroque and, within this chronological framework, of Italian rather than Northern art — leads to an approach interpretive and dynamic: the sitter tends to be depicted as a representative example of humanity in general, full of vitality and functionally determined by his relation to others as well as by his own past.

In a general way, Jan van Eyck's portraits fall in the first of these two categories: they are descriptive rather than interpretive. But since with him the process of description amounts to reconstruction rather than reproduction, they transcend the limitations of their category and constitute a class by themselves. It is certainly difficult, if not impossible, to define his personages in terms of psychological characteristics, to imagine their history or to fathom their thoughts and feelings; they may even strike us as only potentially alive, at least in relation to others. But just this absence — or, rather, latency — of definable qualities endows them with a peculiar depth, a depth which we feel both tempted and discouraged to explore. We are face to face, not so much with the mere appearance of an individual as with his very core or essence, unique yet independent of place and time, unqualifiable by any agency extraneous to itself yet utterly human.

There is, to be sure, a marked development in Jan's interpretation of his subjects; it is as though a gradual awakening of consciousness were taking place within them. But even at the end, we never get hold of them as "characters." Mysteriously emerging from an undefined gloom into an oncoming light, these hauntingly real but always enigmatic presences recall a passage of William James wherein he describes his brother Henry's method of constructing personages: "Their orbits come out of space and lay themselves for a short time along of ours, and then off they whirl into the unknown, leaving us with little more than an impression of

their reality and a feeling of baffled curiosity as to the mystery of the beginning and end of their being." [1]

The earliest portrait that bears a date — October 10, 1432 — holds a unique position within the series of Eyckian portraits and, for that matter, in all Northern fifteenth-century art. Preserved in the National Gallery at London, it represents a man of about thirty, his face framed by the perpendicular lappets of a green headdress effectively contrasting with the red of the sable-trimmed coat; he holds a rolled letter in his right hand while his left is covered by the right forearm (fig. 261).[2] It is the only portrait by Jan van Eyck that bears an inscription in French (LEAL SOVVENIR, which means "Loyal Remembrance"), and it is the only Northern portrait of the fifteenth century in which an attempt is made to emulate a scheme of composition derived from classical antiquity. The figure emerges from behind a stone parapet, on which the words LEAL SOVVENIR appear to have been engraved with a chisel, precisely as do the effigies of Roman soldiers or provincial artisans from behind their memorial tablets, and the chips and cracks in the stone of this parapet, indicative of venerable age, make the painter's antiquarian intention even more obvious. Moreover, above the seemingly incised LEAL SOVVENIR we find a seemingly painted inscription in somewhat questionable Greek, reading, in transliteration, "Tymotheos" (the mutilated last letter originally a "square Sigma").

Since this Greek name does not occur in the Netherlands prior to the Reformation — and even then only sporadically — we are obviously faced with a case of humanistic metonomy: the name "Timotheos" would seem to designate the sitter by comparing him to a great figure of the classical past, much as the Duke of Burgundy was likened to Alexander or Scipio, and the poet Chaucer to Socrates, Seneca and Ovid. And the only classical Timotheos who might fittingly be compared to Jan van Eyck's young client would seem to be Timotheos of Miletus, the revolutionary of Greek music at the time of Plato and Euripides, whose name had remained famous throughout the Middle Ages and grown to semi-legendary proportions in the fifteenth century.

From this we may conclude that the London portrait represents a musician, and a musician renowned for his bold, innovatory spirit. And the fact that it bears a motto in French, while all the other portraits by Jan van Eyck are inscribed, if at all, in Latin or Flemish, leads us to suppose that this musician was connected with the court of Philip the Good. In short, "Timotheos" would seem to be identical with one of the two great Flemish composers who, we recall, were jointly credited with having transformed the music of the fourteenth century into an *ars nova*, Guillaume Dufay and Gilles Binchois. Either of these could have been rightfully acclaimed as a "new Timotheos," and both were in their early thirties in 1432. However, Dufay was constantly abroad from 1428 to 1437 whereas Binchois, having abandoned a military career, was firmly entrenched at the Burgundian court in 1430 at the latest; according to tradition he entered the service of Philip the Good as early as 1425, in exactly the same year as Jan van Eyck.

It is therefore with Jan's "opposite number" in music that we are tempted to identify the elusive "Timotheos." This hypothesis, which finds some support both in the texts of Binchois'

chansons and in his portrayal in a miniature of ca. 1441,[1] has recently been confirmed by the observation that the humanists of the fifteenth, sixteenth and seventeenth centuries were accustomed to think of the historical Timotheos as the favorite court musician of Alexander the Great (who in turn was habitually compared to Binchois' princely patron, Philip the Good),[2] and it certainly does not conflict with what the London portrait tells us of the subject's personality. His strong, blunt face with square jaw, short pointed nose and prominent cheekbones might belong to a young Flemish peasant; but there is thoughtfulness in the high, wrinkled forehead, visionary force in the dreamy yet steady eyes, a formidable strength of passion in the wide, firm mouth. It is not an intellectual face, but a pensive and lonely one, and it is not difficult to see in it both the "honest soldier" that Gilles Binchois had been in his youth and the composer of the touching *Je me recommande humblement* and the somber *Deul angouisseux*.

However, this interpretation of the picture is unavoidably tinged by the very assumption which it corroborates. We have to admit that to the unguided — or, if you like, unbiased — eye the picture would not have given away any secrets. Owing to the device of the parapet and to the comparative smallness of the figure in relation to the surrounding area, the image of "Timotheos" does seem to "come out of space"; but his "orbit" does not as yet "lay itself along of ours." Looking into the void, he is not only out of contact with the beholder but also with everything else, his consciousness submerged in an almost trancelike state.

Stylistically, the London "Timotheos" has much in common with the Berlin portrait of a stern-faced nobleman whose identity has been established by the so-called "Recueil d'Arras," a volume of sixteenth-century copies after portrayals of men and women connected with the court of Philip the Good. He is Baudouin de Lannoy, Governor of Lille, Chamberlain to the Duke, and senior member of the embassies to Portugal and Spain (fig. 260).[3]

Sir Baldwin's face shows more detail than that of "Timotheos" (which can, however, be accounted for by the riper age of a man born as early as 1386–1387), and his left hand is partly shown beneath his right which holds the emblem of his courtly office, a white wand. But in posture the two portraits are as similar as they are in the proportional relation between figure and frame[4] and in psychology. In both pictures the figure is cut below the chest, and between the right-hand contour and the frame a strip of ground is left which makes the body look a trifle sparse within the field; there is also a considerable interval between the face and the upper margin, an interval about as high as the face is long. The right hand, carrying an attribute, appears in the lower left-hand corner and is clenched into a fist seen in similar foreshortening. And the vacant, far-off glance gives an impression of suspended consciousness.

In time, the "Baudouin de Lannoy" would seem to precede the London "Timotheos," which seems much freer; the head is not as yet turned to a regular three-quarter view, and the tip of the nose is almost as close to the contour of the cheek as in the portrait of John the Fearless at Antwerp (fig. 378). The only question is whether the difference amounts to a few years or only a few months. Baudouin de Lannoy and Jan van Eyck lived in Lille up to the end of 1429. Both were members of the missions to the Iberian peninsula, and Sir Baldwin wears a cloak made of twelve ells of purple gold brocade (*drap d'or violet-cramoisy*) which he had

received as a present from Philip the Good in 1427. It would seem probable, therefore, that the portrait was done not long after he received this precious gift, especially since he was more closely associated with the painter up to 1429 than later on. On the other hand, Sir Baldwin wears the collar of the Golden Fleece of which he was a charter member. This order, however, was not instituted until the marriage of Philip the Good and Isabella of Portugal on January 10, 1430, and we happen to know that the insignia were not delivered to Sir Baldwin until November 30, 1431. We are thus faced with two alternatives: either the portrait was painted at the end of 1431 or the collar of the Golden Fleece was superimposed, as was quite frequently done in analogous cases, upon a picture executed before the sitter had received his new distinction. I am inclined in favor of the first alternative, in which case the conferment of the Golden Fleece may well have been the *causa occasionalis* for the commission of the portrait.

In 1433, Jan van Eyck made one of the great discoveries in portraiture. In the London portrait of a "Man in a Red Turban," completed on October 21 of that year, the glance of the sitter is turned out of the picture and sharply focused upon the beholder with an air of skepticism intensified by the expression of the thin mouth with its slightly compressed corners (fig. 262).[1] For the first time the sitter seeks to establish direct contact with the spectator, and since the artist showed him *en buste*, omitting the hands, nothing detracts from the magnetism of the face. We feel observed and scrutinized by a wakeful intelligence.

This "look out of the picture" is typical of self-portraits where it is indeed unavoidable, unless the painter puts in the irises and pupils *ex post facto*;[2] small wonder that the earliest reference to the "Man in a Red Turban," an entry in the inventory of the Earl of Arundel of *ca.* 1655, mentions it as a "Ritratto di Gio. van Eyck de manu sua."[3] There are, it is true, some objections to this identification. The sitter appears older than a man may be expected to look at about forty or forty-five, and from the rather striking likeness that exists between him and Jan's wife, Margaret, it has been concluded that he is more probably the artist's father-in-law.[4] Yet I incline to accept the picture as a self-portrait. Jan van Eyck may have chosen his wife for analogy rather than complementarity. The "turban" gives an impression of studied informality often affected by painters. It is more natural to assume that that important innovation, the "look out of the picture," first suggested itself to a painter observing his own face in a mirror than to a painter facing another person. And, above all, the very character of the Man in a Red Turban, impressionable yet imperturbable, disillusioned yet insatiably curious, agrees with the idea which Jan van Eyck's pictures convey of their maker.

Three years later the "look out of the picture" recurs in the Vienna portrait of a wealthy goldsmith named Jan de Leeuw, born on October 21, 1401 (fig. 265).[5] This we learn from the rhymed inscription on the frame, a chronogram in Flemish in which the word "Leeuw" had to be replaced by a little lion because the letters L, V, and VV would have added 65 to the desired result, 1436.

Somberly clad in a dark, fur-trimmed coat and black cap and foiled by a bluish background, he is portrayed *en buste* as is the "Man in a Red Turban"; but the right hand, holding a ring, and part of the left forearm are included as in the "Timotheos" and the "Baudouin de

Lannoy." This attempt at combining the advantages of the bust portrait with those of the "kit-cat" scheme somewhat cramps the composition, but what is lost in amplitude is gained in plastic force and monumentality. Compared to the earlier portraits the face is very large in relation to the field (the ratio of its length to the height of the panel being about 1:2.7 as against 1:3.5 in the "Man in a Red Turban," and 1:4 in both the "Timotheos" and the "Baudouin de Lannoy"), and the hands are shifted nearer to the center. In the domain of portraiture, the "Jan de Leeuw" may be said to correspond exactly to the "Lucca Madonna" and the "Madonna of the Canon van der Paele" which was produced in the same year; it is to the "Baudouin de Lannoy," the "Timotheos" and the "Man in a Red Turban" as the "Lucca Madonna" and the "Madonna van der Paele" are to the Dresden altarpiece and the "Ince Hall Madonna."

Unfortunately the portrait of Jan de Leeuw has suffered by a previous cleaning so that the shades have lost some of their depth and the finer nuances of the modeling are partly gone. But there remains the impression, not only of acumen and formidable energy but also of a certain self-sufficiency. And it is, among other things, the absence of this essential quality which makes it difficult to accept the authenticity of the somewhat analogously composed but, if I may say so, pseudo-intensive portrait of another goldsmith preserved at Sibiu (formerly Hermann-stadt or Nagyszeben) in Romania (fig. 270).[1]

As the portrait of Jan de Leeuw parallels the "Paele Madonna" so does Jan's latest portrait, the portrait of his wife Margaret (fig. 267),[2] the "Madonna at the Fountain." Completed on June 17, 1439, and still preserved at Bruges, it combines, like the "Madonna at the Fountain," an almost archaic emphasis on symmetry and two-dimensionality with plastic energy and spaciousness. Cut well below the waist, but originally not including the right hand which was painted in afterwards,[3] the figure dominates a sphere which yet appears to be less limited than in the earlier portraits. The lady is clad in a scarlet-red gown trimmed with gray fur and girt with a dark green sash, and her forcefully modeled face stands out from the flat, wide wings of the white coif and the calligraphic maze of its pleated ruche much as the statuesque figure of the "Madonna at the Fountain" does against the decorated flatness of the cloth of honor and the flowering hedge. This contrapuntal tendency, as we have called it, also reveals itself in the selection of a view which is half way between the orthodox three-quarter profile and full-face frontality. The face is averted from the beholder by much less than forty-five degrees and this very fact places the relation between the sitter and the beholder on a different basis. The frank scrutiny to which we felt subjected by the Man in a Red Turban, and the almost aggressive will-power which tried to subdue us in the Portrait of Jan de Leeuw, have mellowed into calm attentiveness, reserved and incurious, expectant rather than active, and, just for this reason, not a little disconcerting.

Even more important, however, is the fact that the face is placed much higher in the picture plane, the space above it being reduced to about one third of its length, whereas the corresponding ratio had been about 1:2.5 in the "Jan de Leeuw," and as much as 1:1 in the "Baudouin de Lannoy," the "Timotheos" and the "Man in a Red Turban." It is as though the personality of the sitters, as they become gradually more conscious of themselves, acquired

a kind of ascendancy over that of the beholder. And it is for this reason — though not for this reason alone — that I agree with Millard Meiss in doubting the normally accepted early date of the Vienna portrait of Nicholas Albergati, Cardinal of Santa Croce in Gerusalemme (fig. 263), already mentioned as the probable first owner of the Detroit "St. Jerome." [1]

This admirable prince of the Church — a kindly ascetic "remote from all passion and striving for comfort and peace in his every thought" and now almost a saint himself — was a man of proverbial wisdom and integrity, and the most successful diplomatist of the Curia. While serving, preparatory to the peace of Arras of which he was the chief architect, as a Legate to the Kings of France and England and to the Duke of Burgundy, he visited Bruges from December 8 to 11, 1431. And it was probably on this occasion that Jan van Eyck portrayed him in the drawing preserved in the Kupferstichkabinett at Dresden (fig. 264).[2] This drawing, done in silver point on white-grounded paper, is of abiding interest, not merely as the only authentic drawing by Jan van Eyck [3] but also because it is inscribed with color notes the language of which attempts to capture the nuances observed by the most sensitive of eyes: *geelachtich und witte blauwachtich* ("yellowish and white-bluish"); *rotte purpurachtich* ("purplish red"); *die lippen zeer witachtich* ("the lips very whitish"); *die nase sanguynachtich* ("the nose a little sanguineous").

Though other possibilities are not excluded, it is in fact most probable that the Dresden drawing was executed during the Cardinal's brief stay at Bruges. But it does not necessarily follow that the Vienna painting was executed without delay. It took Dürer more than five years to start the engraving of Erasmus of Rotterdam whom he had twice drawn in 1520,[4] and a similar thing may well have happened in the case of Nicholas Albergati who, like Erasmus, was far away and, for all we know of his character, not likely to grow violently impatient.

In fact the Albergati portrait stands as much by itself within the *oeuvre* of Jan van Eyck as does the Erasmus engraving within the *oeuvre* of Dürer. In both cases we feel the strain of working from a drawing without an opportunity to refer back to the living model, and in both cases, I believe, we sense the artist's attempt mentally to reconstruct, as it were, the sitter's appearance after the lapse of several years. In this, Jan van Eyck was probably more successful than Dürer whose engraving was received by Erasmus with polite dissatisfaction. But he, too, endeavored to make his subject appear, not only more dignified [5] but also somewhat older than he does in the drawing. The Cardinal's expression is sterner, his face is more deeply lined, his hair is thinner, the crown of his head is higher, and his brow has been steepened by a last-minute *pentimento*. The result, meant to recapture a reality no longer accessible to the artist, lacks the complete integration of details to which we are accustomed in the works of Jan van Eyck; but it excels in monumentality. Clad in a *cappa clausa* trimmed with white fur, the figure is seen to the waist rather than *en buste*. The head rises above an enormous, rigorously simplified mass of crimson with a majesty entirely foreign to the earlier portraits, and the psychological interpretation by far transcends the possibilities of the "Baudouin de Lannoy" and the "Timotheos." The Cardinal's eyes are not focused upon the beholder; but neither do they gaze into the void. Pensive rather than dreamy, almost a little smiling, Nicholas Albergati

lives in a world of supreme lucidity, withdrawing from human contact, not for want of aware-
ness but by virtue of, quite literally, "detachment."

As far as masculine portraits are concerned, Jan van Eyck's last word is, I believe, the
Berlin portrait of Giovanni Arnolfini (fig. 266).[1] This shrewd financier from Lucca, who had
established himself at Bruges in 1420 and was to die as a knight and Councillor of Philip the
Good, is portrayed in a posture closely approaching frontality. For the first time both forearms
are fully displayed, forming the horizontal plinth of a symmetrical pyramid, and the problem
of the hands, that eternal worry of all portraitists, is solved to perfection. Instead of being either
omitted or asymmetrically squeezed in at the bottom of the picture, they are collected in the
center and placed at a comfortable distance from the lower margin. And their extraordinary
smallness, combined with the fact that the left hand is partly hidden behind the right sleeve,
prevents them from forming a second focus of light and psychological interest sufficiently
powerful to divert our attention from the face.

The face itself, framed on three sides by a fantastic scarlet headdress, hovers pale and lean
above the dark green mass of the torso, and its expression is deepened to inscrutability. Bau-
douin de Lannoy and "Timotheos" lived in a world exclusively their own and utterly remote
from that of others. The Man in a Red Turban and Jan de Leeuw strive, more or less forcibly,
for human contact yet remain enigmatical; and Nicholas Albergati keeps serenely aloof from
us. Giovanni Arnolfini, his snakelike eyes deliberately avoiding ours, seems literally to "whirl
off into the unknown."

Comparatively uniform though they may appear at first glance, the portraits of Jan van
Eyck thus show a development as definite as that of his more complex compositions. And even
without X-ray examinations, and quite apart from such objections as may be raised on botanical
grounds, it would be obvious that the gesticulating and distinctly non-mysterious "Man with
the Pink" in the Kaiser Friedrich Museum at Berlin (fig. 271)[2] has no place within this
development.

VII

The relatively late date of the Berlin "Arnolfini" is further confirmed by the double por-
trait in London, mentioned at the very beginning of our discussions, which doubtless confronts
us with the same person (fig. 247).[3] Dated 1434, and referred to in the inventories of Margaret
of Austria as representing "Hernoul le Fin" or "Arnoult Fin" and his wife, it not only estab-
lishes Giovanni Arnolfini's identity — and by implication, that of his lady, Jeanne Cenami —
but also shows him three or four years younger.

In a comfortably furnished interior, suffused with warm, dim light, Giovanni Arnolfini
and his wife are represented in full length. He wears black coat and hose, a black straw hat,
and a sleeveless tunic of purple velvet trimmed with sable; she is less austerely attired in a blue
dress, of which only the sleeves and a small part of the skirt are visible, and an ample green
robe, lined and trimmed with ermine, which is fastened around the waist by a pink girdle.

The husband gingerly holds the lady's right hand in his left while raising his right in a gesture of solemn affirmation. Rather stiffly posed and standing as far apart as the action permits, they do not look at each other yet seem to be united by a mysterious bond, and the solemnity of the scene is emphasized by the exact symmetry of the composition, a central vertical connecting the chandelier with the mirror on the wall and the little griffon terrier in the center of the foreground.

This prochronistic masterpiece — not until Holbein's "Ambassadors" do we find a parallel in Northern painting — can neither be classified as a "portrait" nor as a "religious composition" because it is both. While recording the personalities of Giovanni Arnolfini and Jeanne Cenami, it glorifies the sacrament of marriage.

According to canon law, marriage was concluded by taking an oath, and this oath (*fides*) implied two actions: that of joining hands (*fides manualis*) and, on the part of the groom, that of raising his forearm (*fides levata*, a gesture still retained by our own legal procedure). This is what we see in numerous representations of the fourteenth and fifteenth centuries in which a marriage ceremony is depicted, no matter whether they show the marriage of David and Michal [1] or of Perseus and Andromeda,[2] as well as on tombs, mostly English, commemorating noble couples.[3] And this is evidently what takes place in the double portrait by Jan van Eyck. Here the fact that a marital oath is taken is further emphasized by the lone candle burning in the chandelier and obviously not serving for a practical purpose because the scene is staged in broad daylight. A burning candle, symbol of the all-seeing Christ, not only was, and often is, required for the ceremony of taking an oath in general but also had a special reference to matrimony: the "marriage candle" (*Brautkerze*), a Christian substitute for the classical *taeda*, was either carried to church before the bridal procession, or ceremoniously given to the bride by the groom, or — as is here the case — lit in the home of the newlyweds.

What distinguishes the Arnolfini portrait from other representations of marriage ceremonies — apart from the fact that Jan van Eyck, confronted with a problem of compressing two separate moments into one action, preferred to show the groom grasping the hand of the bride with his left and raising his right, whereas most other artists did the opposite — is that the participants are quite alone. This, however, is easily explained. According to Catholic dogma, the sacrament of marriage is the only one which is not dispensed by the priest but is bestowed by the recipients themselves. Two people could conclude a perfectly valid marriage in complete solitude, and it was not until 1563 that the Council of Trent condemned such clandestine weddings which had produced extremely awkward situations in the past if one of the partners subsequently denied the fact that a marriage had taken place. From then on, the Church required the presence of a priest and two witnesses; but even today, the priest acts not as a dispenser of the sacrament, as in a baptism or confirmation, but merely as a *testis qualificatus*.

Giovanni Arnolfini and Jeanne Cenami — he a native of Lucca, she born in Paris of Italian parents — had no close relatives at Bruges. They apparently considered their marriage as a very private affair and chose to have it commemorated in a picture which shows them taking

the marital vow in the hallowed seclusion of their bridal chamber — a picture that is both a double portrait and a marriage certificate. And this explains that curious wording of the signature which has given rise to so much unnecessary discussion: "Johannes de Eyck fuit hic," "Jan van Eyck was here." [1] No other work of art is signed in this peculiar fashion which rather reminds us of the undesirable epigraphs recording the visits of pilgrims or tourists to places of worship or interest. But here the artist has set down his signature — lettered in the flourished script normally used for legal documents — as a witness rather than as a painter. In fact, we see him in the mirror entering the room in the company of another gentleman who may be interpreted as a second witness.

With the subject thus identified, not as an ordinary portrait but as the representation of a sacrament, the atmosphere of mystery and solemnity which seems to pervade the London picture takes tangible form. We begin to see that what looks like nothing but a well-appointed upper-middle-class interior is in reality a nuptial chamber, hallowed by sacramental associations and often sanctified by a special *benedictio thalami*; and that all the objects therein bear a symbolic significance. It is not by chance that the scene takes place in a bedroom instead of a sitting room, for the matrimonial bed was so sacred that a married couple in bed could be shown visited and blessed by the Trinity,[2] and even the scene of the Annunciation had come to be staged in what was officially referred to as the *thalamus Virginis*. The crystal beads and the "spotless mirror" — *speculum sine macula*, here explicitly characterized as a religious object by its frame which is adorned with ten diminutive scenes from the Passion — are well-known symbols of Marian purity. The fruit on the window sill recalls, as in the "Ince Hall" and "Lucca" Madonnas, the state of innocence before the Fall of Man. The little statue of St. Margaret, surmounting the back of the chair near the bed, invokes the patron saint of childbirth. The dog, seen on so many tombs of ladies, was an accepted emblem of marital faith. And there is little doubt that the discarded pattens in the lower left hand corner are here intended, as possibly already in the case of the "Descent from the Cross" by the Master of Flémalle (fig. 230) and certainly in the "Nativities" by Petrus Christus (fig. 402) and Hugo van der Goes (fig. 463), to remind the beholder of what the Lord has said to Moses on Mount Sinai.

In the London Arnolfini portrait, then, Jan van Eyck not only achieved a concord of form, space, light and color which even he was never to surpass, but also demonstrated how the principle of disguised symbolism could abolish the borderline between "portraiture" and "narrative," between "profane" and "sacred" art.[3]

To summarize: Jan van Eyck's uncontested *oeuvre* [4] — to which would have to be added those many works with which we are acquainted only through more or less reliable copies [5] or literary descriptions [6] — developed, much as Dürer's did by his own testimony, "from the novel and the manifold to the restrained and simple," this latter phase being preceded by the classic balance of the "Rolin Madonna" and the London Arnolfini portrait and followed by a final, contrapuntal synthesis.

Heir to the Master of Flémalle and to his brother Hubert, whose possible influence on him remains to be clarified, Jan van Eyck was independent of the Italianism of the fourteenth century. And the earlier regional tradition had been too thoroughly absorbed in the style of his predecessors to play a major role in his development. It was only occasionally, as in the humility pose of his St. Barbara or in the gesture of his Annunciate in the Ghent altarpiece,[1] that he remembered the indigenous past. And if his blond-maned girl angels and girl saints have their ancestresses in the Ghent manuscripts and, still earlier, in the "Calvary of the Tanners" at Bruges (fig. 113), it may have been his brother Hubert who acted as an intermediary.

From the Master of Flémalle, Jan van Eyck seems to have appropriated, specifically, the idea of adorning the exterior wings of his altarpieces with simulated sculpture in grisaille; the idea of landscapes or city prospects viewed through windows[2] (although it was he himself who monumentalized these windows into elaborate colonnades); and the idea of a domestic interior as a setting for representations of the Madonna and the Annunciation. However, he exploited these ideas with sovereign independence and, more important, with the intention of reconciling the modernism of the Master of Flémalle with the refinement which he admired in the works of the Limbourg brothers and the Boucicaut Master.

The latter, whose influence had to be stressed over and over again, to whom Jan owed not only individual motifs and schemes but also such basic concepts as the magic device of eccentric perspective and, as will be seen, much of his method of organizing distant landscapes, was without question the greatest single force that operated on his mind and formed his style. If anyone, the Boucicaut Master must be considered as Jan van Eyck's chief forerunner and, in a sense, chief master. Him he greeted both as the prophet of a new era and as the thaumaturge of glittering refinement — the same glittering refinement which he admired in the works of the embroiderers, the goldsmiths, and the enamelists. In contrast to the Master of Flémalle and in a certain opposition to the traditional attitude of the *réalisme pré-Eyckien*, Jan van Eyck, the courtly aristocrat, was in instinctive sympathy with the International Style. He overcame it, not by avoiding, but by absorbing and thereby transcending it.

HUBERT AND/OR JAN VAN EYCK;

THE PROBLEMS OF THE GHENT ALTARPIECE

AND THE TURIN-MILAN HOURS

OF Jan van Eyck we know more than of any other Northern painter of the fifteenth century. Of his brother Hubert we know very little, so little in fact that he has been called a *personnage de légende*.[1] Apart from a very dubious reference of 1413 (a gentleman named De Visch-van der Capelle bequeathed to his daughter, a nun in the convent of Bourbourg near Gravelines, a "work by Hubert" without revealing the latter's surname or place of residence), we have only four meager records preserved in the City Archives of Ghent. From these we learn that in the fiscal year 1424–25 a "meester Luberecht" received six shillings for two designs which he had made for an altarpiece at the behest of the magistrates; that in the fiscal year 1425–26 the apprentices of a "meester Ubrechts" received, from the same magistrates, a gratuity of six groats (viz., half a shilling) presumably on the occasion of a visit to the master's workshop (which leads us to believe that he had obtained the commission in the meantime and had begun to carry out the final design on panels); that on March 9, 1426, "meester Hubrechte de scildere" had in his shop an image of St. Anthony and "other works" pertaining to an altar which one Robert Poortier and his wife, Avezoet's Hoeghen, planned to set up in Our Lady's Chapel in St.-Sauveur; and that in the same year inheritance tax was paid on the property left by "Lubrecht van Heyke."

While these four records[2] differ as to the spelling of the master's Christian name, and while his surname is mentioned only once, it can hardly be questioned that they refer to the same personality, especially since the fourth and last agrees with a statement in Hubert van Eyck's lost epitaph (destroyed in 1578 but transmitted through two independent copies made shortly before) according to which he died on September 18, 1426.[3] However, that this Hubert, Ubert or Lubert van Eyck was the brother of the famous Jan, and that he was responsible or coresponsible for the Ghent altarpiece — finally restored to its original place in St. Bavo's in

205

1945 — is vouched for only by the partly damaged inscription of the altarpiece itself. Inscribed on the exterior frames of the wings, it reads, to the best of my belief, as follows:

"Pictor Hubertus e Eyck · maior quo nemo repertus
Incepit · pondus · q[ue] Johannes arte secundus
[Frater perfunctus] · Judoci Vijd prece fretus
Versu sexta mai · vos collocat acta tueri."

"The painter Hubert van Eyck, greater than whom no one was found, began [this work]; and Jan, his brother, second in art, having carried through the task at the expense of Judocus Vyd, invites you by this verse, on the sixth of May, to look at [or, possibly, "to protect"] what has been done."[1] No matter whether this or another reconstruction of the text is accepted, we learn from it three things: first, that the work was begun by Hubert and finished by Jan; second, that it was dedicated on May 6, 1432 (the year is given in the last line of the inscription which is a chronogram); third, that the rich and public-spirited Judocus (Jodocus) Vyd or Vyt, who was to be elected Mayor of Ghent in 1433, is credited with having paid Jan van Eyck for completing the work but not with having commissioned Hubert to start it.

The lettering of these momentous hexameters is identical with that of the names of the Prophets and Sibyls inscribed below their images in the crowning lunettes, but it differs from that of the numerous inscriptions within the paintings themselves and from the unquestioned legends on the frames of the Adam and Eve panels. This divergence, coupled with the alleged unseasonableness of the chronogram, has given rise to the suspicion that Hubert had in fact no hand in the Ghent altarpiece at all. It has been claimed that his name was associated with it by the Ghent patriots of the Renaissance who wished to match the glory of Jan van Eyck's Bruges and Roger van der Weyden's Brussels, and that the hexameters were a forgery of the late sixteenth century, committed partly in order to boost Hubert's reputation and partly in order to secure the property rights to the Ghent altarpiece for the collateral descendants of Jodocus Vyd so that it might not be handed over to Queen Elizabeth of England in payment of a debt contracted by the then Protestant municipality of Ghent.[2] However, while there may have been good reason to inform Queen Elizabeth that the Ghent altarpiece was private and not public property, there was not much point in informing her that the Prophet Micah was the Prophet Micah or that the Cumean Sibyl was the Cumean Sibyl. That chronograms were not unusual in the first half of the fifteenth century is evidenced, for example, by that inscribed on Jan van Eyck's portrait of Jan de Leeuw.[3] Even the fact that the frames of the wings — those of the "corpus" are modern — were restored and repainted in the sixteenth century does not of itself invalidate the authenticity of the hexameters; they may be faithful copies of an original inscription, and this assumption is corroborated by the fact that Hubert, and not Jan, van Eyck was locally credited with the Ghent altarpiece, or at least with its inception, a good many decades before its first restoration and three generations before the time of Queen Elizabeth. In 1495, a German doctor named Hieronymus Münzer was shown the grave of the "magister tabellae" right in front of the altarpiece while Jan's remains were resting in the

Church of St. Donatian at Bruges;[1] and on August 1, 1517, a visiting Cardinal, Louis of Aragon, and his party were told by the Canons that the Ghent altarpiece —in the visitors' estimation "the most beautiful work of painting in Christendom" — was painted "about a hundred years ago, by a master from Germany named Robert (*de la Magna Alta decto Roberto*) who had not been able to finish it because he died," and that it was "completed by his brother who was also a great painter."[2] This is a very explicit account which, apart from the curious but easily explicable phrase "de la Magna Alta decto Roberto,"[3] exactly agrees with the content of the hexameters. And if Münzer's testimony has been impugned on the grounds that the chapel in which the Ghent altarpiece is admired today — the first in the ambulatory on the south side — forms part of a superstructure incapable of housing any tomb at all, he has recently been vindicated by an extraordinary discovery. As ascertained by two young Belgian scholars, the chapel of Jodocus Vyd and Isabel Borluut was not located in the upper choir but in the enormous lower church or crypt, in fact directly underneath the present "chapelle de l'Agneau Mystique." And it is in this semi-subterranean chapel, a little narrower and naturally very much lower but built on the same plan and lighted from the same direction, that the Ghent altarpiece had its place from May 6, 1432, to August 19, 1566, when it was removed for fear of the iconoclasts. Not until *ca.* 1587 was it installed in its present location.[4]

We must, therefore, accept the tenor of the hexameters as basically correct and are thus faced with the problem of separating the respective contributions of the two brothers. This problem has been a baffling one for many years and is a baffling one still. A gallant attempt at cutting the Gordian knot by a computation of working hours (with the result that Jan van Eyck would have been unable to execute more than one quarter of the Ghent altarpiece between September 18, 1426 and May 6, 1432) is hardly convincing,[5] and it is characteristic that similar statistical considerations have led another scholar to exactly the opposite conclusion.[6] We can but try to coordinate and to interpret, according to our lights, the available data — prodigiously augmented of late by the brilliant research work of Dr. Paul Coremans and his associates at the Laboratoire Central des Musées Royaux de Belgique — and wait for further developments which may entail new changes in our hypotheses.[7]

II

The exterior of the Ghent altarpiece (figs. 274–277) displays, in the lower storey, the portraits of Jodocus Vyd and his wife, Isabel (or Elizabeth) Borluut, and between them the two St. Johns, the Baptist and the Evangelist, as simulated statues in grisaille. The upper storey is occupied by the "Annunciation" (the *Ecce ancilla*, as in the Washington picture, written upside down), and the lunettes surmounting it are elaborated into little vaulted chambers from which look down the Prophet Zachariah and the Erythrean Sibyl on the left, matched by the Prophet Micah and the Cumean Sibyl on the right.

Iconographically, this arrangement is both consistent and understandable. As the Annunciation almost invariably opened the series of miniatures illustrating the Hours of the Virgin, so its normal place in a folding altarpiece was on the exterior of the wings where it was either

displayed alone or, if combined with other subjects, on top (as in the van Beuningen altarpiece, fig. 106). The presence of the Prophets and Sibyls is justified by the inscriptions on their scrolls which prophesy the glory of the Virgin Mary and the Incarnation of Christ. St. John the Baptist was the original titular saint of the Church of St. Bavo's which was not dedicated to this worthy hermit until 1540 and did not become a cathedral until 1559. The fact that the altarpiece was dedicated on May 6, the Feast of John the Evangelist's martyrdom *ad portam Latinam,* lends some support to the conjecture that he was the titular saint of Jodocus Vyd's family chapel,[1] and the presence of the donors needs no explanation.

Aesthetically, too, the exterior of the Ghent altarpiece is reasonably coherent. The scale of the figures — except for those in the lunettes whose somewhat smaller size is justified by their very location — is uniform. The natural colors of the donors' portraits, the Annunciation and the Prophets and Sibyls are so much subdued that we may speak of these panels as "semigrisailles" which harmonize with the "stone color" of the two statues, the whole thus forming the usual contrast with the brilliant spectacle of the interior where even the frames are gilded instead of being painted in a neutral tone. The illumination is also uniform throughout, the light coming from the right at an angle of about forty-five degrees (so that the face of Isabel Borluut, in contrast to Jan's general custom, is turned away from it), and the only apparent inconsistency, the pools of sunlight appearing on the right-hand wall behind the Annunciate — presupposing that the sun shines from the left, that is to say, in this case, from the north — can be accounted for by the same symbolical considerations which produced, we recall, an analogous anomaly in the "Virgin in a Church."[2] The four niches of the lower storey, finally, housing the heavy statues and seemingly recessed into a massive wall, provide a logical substructure for the airy Annunciation chamber, and the architectural plan and perspective rendering of the latter are, occasional assertions to the contrary notwithstanding, perfectly rational.

There are only three features which somewhat disturb the structural design and one of which constitutes, in addition, a unique iconographic anomaly. First, the upper panels are cut round on top whereas the corresponding central panels of the "corpus," though painted round, are actually square; as a result, these central panels and their frames are only partially covered when the altarpiece is closed — a rather disagreeable effect not evident from even the most recent reproductions and photographs and therefore schematically indicated in our figure 274. Second, the dividing frames of the upper storey are not on axis with those of the lower. Third, the Annunciation (fig. 276) is painted on four separate panels, the pair in the middle showing nothing but architectural environment: a Flémallesque city prospect on the left and an equally Flémallesque still life of laver, basin and towel, on the right.

These discrepancies would seem to confirm the suspicion, first voiced some twenty years ago, that the Ghent altarpiece was not originally planned as it is but came about by a makeshift assemblage of disparate elements,[3] and that some of these elements could be incorporated only after having been subjected to alterations enforced by purely practical conditions. It has justly been pointed out that, were not the upper panels of the shutters cut round at the top, the

heavy ribs of the low chapel (its height from floor to keystone amounting to only 5.35 m.) would prevent the opening and closing of the altarpiece; even as it is, the upper wings could be moved only by folding the Adam and Eve panels against the panels with the Musical Angels, which accounts for the traces of hinges in the authentic frames of the former.[1] Had the altarpiece been designed for its place of destination, these difficulties — and the ensuing discord between shutters and "corpus" — would certainly have been avoided by planning the whole on a slightly less ambitious scale. The lack of coaxiality between the upper and the lower sections of the wings would not have been allowed to disturb the unity of the ensemble had it been possible to fashion each section of one element rather than two. And no artist in his right mind would have insisted on painting the Annunciation, a subject involving two figures only, on four separate panels had he not acted under some compulsion.

<p style="text-align:center">III</p>

Even so, the exterior of the Ghent altarpiece offers a relatively harmonious and homogeneous aspect as compared to the interior (fig. 275). While other folding retables of the time, even when their shutters are composed of two panels, one on top of the other, always have one large panel in the center, the whole of the Ghent altarpiece, shutters and "corpus" alike, is horizontally divided into two storeys or tiers, and these are very different in character.

The central panel of the lower tier (fig. 278) shows the throngs of the Blessed (*chori beatorum*), which constitute the Community of the Saints,[2] converging — from the four corners of the world, as it were — toward the "Fountain of the Water of Life" and the altar of the Lamb; the altar is surrounded by two semicircles of angels — eight praying, four carrying the instruments of the Passion and two censing — and surmounted by the Dove of the Holy Ghost, which floats down in a semicircular halo now restored to rainbowlike brilliance and unclouded precision. To the right of the fountain are seen the Twelve Apostles (seven of them kneeling), St. Paul, St. Barnabas and a group of Martyrs clad in red pluvials or chasubles, among them St. Stephen, the protomartyr, and St. Livin, one of the special patrons of the city of Ghent. To the left of the fountain are "those who believed in Christ even before He came": the Minor Prophets (traditionally juxtaposed with the Twelve Apostles), the Patriarchs and, possibly, the Gentile "Christians by desire," including a conspicuously white-robed figure which, to judge from the classical cast of its features and the laurel bough in its hands, can hardly be identified with anyone but Virgil, the greatest pagan witness to Christ's divinity. His wreath of lilies of the valley, one of the most characteristic Marian flowers, would seem to allude to the famous "Iamque redit virgo" of the Fourth Eclogue, the Roman parallel to Isaiah's "Ecce virgo concipiet"; and it is, in fact, with Isaiah rather than Jeremiah that we may identify the solemn personage on Virgil's right, clad in a dark blue mantle and red turban, and carrying what seems to be a myrtle rather than an almond branch.[3] The altar, placed in the middle distance, is approached from the right by the Holy Virgins and from the left by a group of Confessors, all but one of them clad in blue vestments so as to distinguish them from

<p style="text-align:center">209</p>

the "purpurati Martyres" in the foreground. Among the Confessors no individuals can be identified, but among the Virgins we recognize St. Ursula with her arrow and, at the head of the procession, the traditional tetrad of SS. Agnes, Barbara, Catherine, and Dorothy.

In the shutters (fig. 279), each of them divided into two separate panels corresponding to the donors' portraits and simulated statues on the exterior, the afflux of the *chori beatorum* continues. The inner panel of the right-hand wing shows the Holy Hermits led by St. Paul of Thebes (?), St. Anthony and St. Benedict of Nursia (?), the Magdalen and St. Mary of Egypt bashfully emerging from behind a huge rock; the outer, a group of Holy Pilgrims including St. James the Great and the aged, sharp-nosed St. Cucuphat of Barcelona (?) whose wizened figure, though lifted by heavy walking shoes, forms an almost humorous contrast to the gigantic, red-robed St. Christopher (that the order of these two panels was originally reversed, as suggested by a sixteenth-century copy at Antwerp, is impossible because the portrait of Isabel Borluut is known to have been on the back of the Hermits panel until this panel was split in 1893).[1] In the inner picture of the left-hand wing are seen the "Knights of Christ" headed by St. Martin (?), St. George and St. Sebastian, the latter's silver shield inscribed with sacred names: "D[OMINV]S FORTIS ADONAY SABAOT V.. EM[ANV]EL I.H.S. XR. AGLA." The outer picture — stolen in 1934 and unrecovered thus far — exhibited the "Just Judges." The strongly individualized features of the Judges have always invited attempts at identifying the individual figures with contemporary or nearly contemporary personages, the oldest and least credible hypothesis being to the effect that the first and fourth of the Judges (reading from left to right) are self-portraits of Hubert and Jan van Eyck; the latest though by no means final one, that the four riders in the first rank represent the Counts of Flanders from the inception of the Burgundian dynasty: Philip the Bold, Louis de Mâle, John the Fearless, and Philip the Good.[2]

These countless figures, even the giant St. Christopher not much taller than two feet and all the others considerably shorter, are uniform in scale and move in a semicontinuous landscape. In the central panel the scene is laid in a flowery meadow, uninterruptedly extending into the middle distance, whereas the stony foreground of the lateral pictures is screened off from the middle distance by rocks and clusters of shrubs and trees; but the admirable background with its verdant hills, visionary buildings, finely etched silhouettes of exotic trees, pines, and luminous sky continues throughout the five panels.

With this lower zone of the altarpiece the upper disagrees not only in structure but also in scale and general conception. Its wings exhibit, of course, the same axial discrepancy observed on the exterior; but in the central section or "corpus," too, three separate vertical pictures are superimposed upon a single oblong one, bringing the total number of panels to seven above as against five below. The scale of the figures in these upper pictures is as colossal as that in the lower ones is small, and where we would expect to be transported into an Empyrean realm above the clouds, we find ourselves standing in a most solid world of tiled pavements, stone-carved niches and heavy oaken furniture. Moreover the upper pictures, their size and weight nearly crushing the paradisial scene beneath, are incongruous even among

themselves. The three pictures in the center (fig. 280), depicting the Lord enthroned between the Virgin Mary and St. John the Baptist, constitute a coherent unit (even in that they are painted on panels about twice as thick as those of the shutters but only about two thirds as thick as that of the "Adoration of the Lamb").[1] The figures, all somewhat over-life-sized, are foiled by brocaded hangings and concentric moldings of uniform design, and the vanishing lines of the pavement reasonably agree — and, as ascertained by the recent examination in the Laboratoire Central, always agreed — with the placement of the pictures in relation to each other. This unit is, however, sharply divided from the adjacent panels (figs. 281, 282), commonly but somewhat loosely referred to as "the Musical Angels." Here the figures, those on the left singing, those on the right playing the organ, the harp and the *viola da gamba*, are only about two-thirds as large as those in the center, the background is treated as natural sky, and the perspective of the much more elaborate pavement — its tiles adorned with such symbols as the Lamb, the "M" of the Virgin Mary, the "IHS," "ω," and "YECYC" of Christ, and the caballistic "AΓΛΑ" (or "AGLA") which we also encountered on the shield of St. Sebastian — is based on the assumption that the two panels are separated by a distance only about one-third as wide as it is. The flanking figures of Adam and Eve, finally, are somewhat under life size, thus holding an intermediary position between the central triad and the Musical Angels. They are seen from below(so that their standing plane is not visible and Adam's right foot, slightly protruding beyond the picture plane, is seen from underneath), and are confined to narrow niches surmounted by reliefs which represent the sacrifice of Abel above the figure of Adam and the Slaying of Abel above the figure of Eve.

Attempts have been made to justify these incongruities by pointing out that a similar disproportion in scale exists in many representations of the Last Judgment (especially in Roger van der Weyden's famous altarpiece at Beaune, fig. 326) [2] and in such altarpieces as Enguerrand Quarton's "Coronation of the Virgin" at Villeneuve-lès-Avignon.[3] To this, however, there are three objections. First, while such parallels may account for the discrepancy between the upper and the lower tiers, they would not explain the incongruities within the upper tier itself. Second, there is an essential difference between a dimensional disparity within an otherwise unified ensemble and one within a series of separate panels not tied together by any principle of spatial unity; and, more important, between an ascent from that which is heavy to that which is light, and an oppression of that which is light by that which is heavy. Third, in Last Judgments as well as in the retable at Villeneuve (which, according to the contract does not so much represent the "Coronation of the Virgin" pure and simple as the whole hierarchy of the religious universe, the "Paradise." the "sky," the "world" with the cities of Rome and Jerusalem, "Purgatory" and "Hell") the contrast between large and small figures brings out an antithesis between divinity and humanity, Heaven and earth. In a Last Judgment, it is to Christ, the Virgin Mary, St. John the Baptist and the Apostles, associate justices in the court of courts, that the large scale is reserved as an attribute of supernatural greatness while the small scale is allotted to the Resurrected. In Quarton's cosmography an elaborate gradation in size is made between the "Coronation" group, the saints, the saved souls admitted

to Heaven, and the unfortunate inhabitants of Purgatory and Hell, the last-named being about half as large as the saved souls and these about half as large as the saints. In the Ghent altarpiece, however, we find ourselves in Paradise in the lower zone as well as in the upper. Sanctified by the Fountain of Life and the Lamb, the lower zone is peopled, not by ordinary human beings but by the Community of the Saints, including the very Apostles who, in a Last Judgment, share the heroic scale of the Judge and the Intercessors. Theologically speaking, we are faced, not with a contrast between Heaven and earth but with a duality of Heavens, one on top of the other.[1] And this brings us to the iconography of the Ghent altarpiece which, in its present form, is no less problematical and contradictory than is its compositional structure.

IV

Seen as a whole, the interior of the Ghent altarpiece may be said to depict the ultimate beatitude of all believing souls, Christians, Jews and Gentiles alike, united in the worship of the Lord; it is, to appropriate a brief and telling German term, an *Allerheiligenbild* (All Saints picture).[2]

The basic type of such *Allerheiligenbilder* — the iconography of which deserves closer study than it has received thus far — appears to have been established almost as soon as the Feast of All Saints (November 1) was formally instituted in 835. Transmitted through two Sacramentaries of the tenth century (one in the University Library at Göttingen, the other in the Biblioteca Capitolare at Udine)[3] which seem to reflect a Carolingian prototype, this archetypal All Saints picture (text ill. 65) shows the *chori beatorum* symmetrically arranged in several zones, the women on the left of the Deity, that is to say, on the right-hand side of the picture.

In deference to Early Christian symbolism and in accordance with the liturgy of the Vigils and Feast of All Saints, the basic texts of which are Revelation V, 6–12, and VII, 2–12, the earliest representations depict the Deity in the guise of the Lamb, His blood pouring into a chalice proffered by the Church: "And I beheld, and, lo, in the midst of the throne, and of the four beasts, and in the midst of the elders, stood a Lamb as it had been slain (*Agnum stantem tamquam occisum*)"; and: "After this I beheld, and, lo, a great multitude which no man could number, of all nations and kindreds, and people, and tongues, stood before the throne, and before the Lamb, clothed with white robes, and palms in their hands . . . and all the angels stood round about the throne, and about the elders and the four beasts, and fell before the throne on their faces, and worshipped God." But a significant change set in with the thirteenth century, and by the middle of the fourteenth there crystallized what may be called the "new style" *Allerheiligenbild*. The group of worshipers were more eloquently diversified; the scene was laid either in a great city — the City of God or the Heavenly Jerusalem — or in clouds overhanging a landscape; musical angels made their appearance;[4] the Virgin Mary and St. John the Baptist were represented as the leaders of the Blessed, the

former further distinguished, in many instances, by being awarded a seat on the right of the Deity; and, most important, the Deity Itself — now mostly elevated above the *chori beatorum* rather than forming their center — was no longer depicted in the guise of the Lamb but either as the "King of kings" Whose image expresses the three Persons of the Trinity in one enthroned figure or, ultimately, as the explicit Trinity (two human figures enthroned with the Dove between them or the "Throne of Mercy"), the Adoration of the Lamb surviving only in the direct illustration of the Apocalypse and the Commentaries thereon.

The most important of these developments (which also affected the illustration of Revelation itself) can be accounted for, I think, by that vigorous revival of Augustinianism which can be observed from the middle of the thirteenth century and left its traces in such widely different texts as the penultimate Canto of Dante's *Paradiso* and that well-known chapter of the *Golden Legend* where the liturgy of the Feast of All Saints is concretized, as it were, into a colorful vision vouchsafed to the sacristan of St. Peter's at Rome;[1] and certain it is that the replacement of the Lamb by the *Rex regum* or the Trinity had nothing to do with those time-honored injunctions which condemn the representation of Christ in the guise of the Lamb — injunctions restricted to renderings of the Christ Incarnate, primarily the Crucifixion.[2] It is, in fact, in illustrated manuscripts of the *De Civitate Dei* and its vernacular versions (the very demand for illustrations and translations of the *City of God* being a characteristic symptom of the Augustinian revival just mentioned) that the new type of *Allerheiligenbild* appeared for the first time[3] and continued to appear (now at the beginning of the book, now at the end, now in both places) as a glorification of what St. Augustine calls "the Eternal Beatitude of the City of God and the Perpetual Sabbath" (text ill. 66).

Once formulated, this "new style" All Saints picture — a *"Cour Céleste"* invariably dominated by either the King of kings or the Trinity — enjoyed great popularity in a variety of contexts. With all kinds of modifications, it served to illustrate, apart from the *De Civitate Dei* and the *Golden Legend* themselves, the *Commune Sanctorum* in Breviaries,[4] the prayer *De pace* in Books of Hours,[5] and the Hours of the Trinity in printed *Livres d'Heures*;[6] it appeared as a frontispiece in illuminated Bibles,[7] and as an image of Paradise in such moral treatises as Guillaume de Deguileville's *Pèlerinages*[8] or Denis de Ryckel's *Traité des quatre dernières choses*.[9] It shone from painted retables. In all these instances the whole Community of the Saints, arrayed "from rank to rank" and led by Our Lady and St. John the Baptist, worships either the *Rex regum* or the Trinity, and such widely different altarpieces as an anonymous Spanish triptych of *ca.* 1420, preserved in the Metropolitan Museum,[10] and Dürer's "Landauer-Altar" of 1511 can be labeled with equal justification as *Allerheiligenbild*, "The Paradise according to St. Augustine" and "The Adoration of the Trinity."

In several respects the interior of the Ghent altarpiece agrees with these "new style" or "Augustinian" All Saints pictures: it shares with them the interpretation of the Supreme Being as an enthroned figure in papal garb, a type originating and widely used in the French translations of St. Augustine's *De Civitate Dei*, its first known example being a miniature in a *Cité de Dieu* manuscript of about 1370;[11] the prominence accorded to the Virgin Mary and

the Baptist; and the presence of Musical Angels. If it were true that the Ghent altarpiece once had a predella depicting Hell,[1] even this feature would have had a parallel in the Spanish triptych of *ca.* 1420 where the beatitude of the Elect is contrasted with the fate of Lucifer and the rebellious angels transformed into devils and cast into a gigantic Hell-mouth.

In other respects, however, we observe some striking deviations from the then generally accepted *Allerheiligenbild.* St. John the Baptist not only wears above his "raiment of camel's hair" a sumptuous green mantle, its bejeweled borders no less resplendent than those adorning the blue robe of Our Lady, but is also granted the unprecedented privilege of occupying, like her, a throne on the side of the Lord. All other All Saints pictures — excepting those, of course, which were produced under the influence of the Ghent altarpiece itself — either keep to the text of the *Golden Legend,* and in this case the Virgin Mary is enthroned alone on the right of the Lord while the space on His left remains vacant and the Baptist is relegated to his place at the head of "many elders and venerable fathers";[2] or they depart from this text under the influence of the Last Judgment, and in this case the Virgin Mary and the Baptist are symmetrically placed on either side of the Lord but are depicted kneeling instead of enthroned.[3] The figures of the First Parents are not only magnified to nearly the size of the *Rex regum* and His companions but also raised to their exalted level whereas they should be ranked — and are so ranked in all comparable representations[4] — among the personages of the Old Testament; in Dante's vision (where Adam is not mentioned at all) Eve is even placed at the feet of the Virgin "who closed and healed the wound inflicted and left open by the other." The famous Musical Angels, finally, are unique in two respects: instead of fluttering about the central group or being stationed here and there among the worshipers, they occupy two panels quite by themselves, and they lack the distinctive attributes of their celestial nature, the wings; so far as I know, they are the only wingless angels in Northern fifteenth-century painting.

Puzzling though these anomalies are, they are insignificant as compared to the appearance of two motifs, and central ones at that, which do not fit into the tradition of the "new style" All Saints pictures at all and thus make the iconography of the ensemble, as it is, extremely confusing: the Dove and the Lamb.

Where, as in the Ghent altarpiece, the Supreme Being is represented in the guise of a single figure which, by definition, expresses all the Three Persons of the Trinity, there is, again by definition, no place for the Dove which supplements the images of the First and Second Persons as a symbol of the Third; no Dove appears, therefore, in any of those *Cité de Dieu* manuscripts, where, we remember, the Deity was first represented as a single figure in papal garb and where this figure was perfectly interchangeable with the explicit, threefold image of the Trinity.[5] The presence of the Dove in the Ghent altarpiece thus creates a curious ambiguity; for here, too, the papal figure is conceived, and clearly designated by its attributes, as an image of God in His complete Trinitarian essence. Depicted as a man in the prime of life, the Lord is enthroned before a threefold molding. His cloth of honor shows the Christological symbol of the Pelican in Her Piety, ensconced in grapevines, and the inscription

IHESUS XPS; the pearl embroidery of His stole, however, spells out the Old Testament epithet SABAωT. And the similarly embroidered border of his mantle displays in an alternating pattern the very phrases PEX PEΓV, ΔNC ΔNANXIN ("Rex regum, Dominans dominantium") of which St. Augustine has written: "In these words neither the Father is specially named, nor the Son nor the Holy Ghost, but the blessed and only Potentate, the King of kings and Lord of lords, the Trinity Itself." [1]

Seen in connection with the figures of the Virgin Mary and St. John the Baptist — read horizontally, so to speak — this sublime image retains, as in the normal "Augustinian" *Allerheiligenbild*, its total Trinitarian significance. Seen in connection with the Dove beneath it — read vertically, as it were — it suddenly changes its meaning: since the Third Person is explicitly represented by the Dove, the papal figure can no longer be interpreted as the Trinity in Its entirety but only as either a combination of the First Person with the Second [2] or, if the Lamb is included into the combination of images and thereby recognized as the equivalent of Christ, as God the Father alone. And that the latter, less farfetched alternative was unanimously accepted in the fifteenth and sixteenth centuries is demonstrated by the earliest texts in which the dominant figure of the Ghent altarpiece is mentioned by name: the *Kronyk van Vlaenderen* of 1458 [3] and Dürer's *Diary* of 1521.[4]

In relation to the three upper figures, then, the Dove may be described — from a doctrinal as well as a compositional point of view — as an appendage. In relation to the "Adoration of the Lamb," it represents — again from a doctrinal as well as a compositional point of view — an intrusion. Were it not for the Dove, the pictures in the lower zone of the Ghent altarpiece, even the central panel alone, would constitute an All Saints picture all by themselves. And if the Dove could be shown to have been substituted for something else — which, as we shall shortly see, is more than probable on purely technical grounds — we should have every reason to believe that they were actually intended to constitute an All Saints picture all by themselves — an All Saints picture, however, which diverges from the contemporary or nearly contemporary tradition in that it shows the *chori beatorum* arrayed around rather than beneath the object of their devotion; in that it fails to include the Virgin Mary and St. John the Baptist; and, above all, in that it represents the Deity in the guise of the Lamb instead of as the King of kings or the Trinity. In all these respects the composition differs from the more recent *Allerheiligenbilder* developed under the influence of the *City of God* and the *Golden Legend*; but it agrees all the more palpably with the "old style" *Allerheiligenbilder* (text ill. 65), directly derived from the liturgy of the Feast of All Saints and the passages of Revelation embedded therein.

By the very fact that it *is* an Adoration of the Lamb, the "Adoration of the Lamb" in the Ghent altarpiece thus proclaims its dependence upon a much earlier iconography (best exemplified, we recall, by those old Sacramentaries where even the motif of the chalice receiving the blood of the Lamb is prefigured); and that a representational type which for the last two or three centuries had been restricted to straightforward illustrations of Revelation VII was suddenly resumed for the purpose of a liturgical All Saints picture would seem to constitute a

deliberate revival. Such a revival, however, is not surprising in a family of artists who, we remember, took so keen an interest in the productions of the Romanesque style and were accustomed to associate it with the idea of the Heavenly Jerusalem.

In spite of its faithfulness to tradition, the lower zone of the Ghent altarpiece contains certain elements unparalleled in both the "old style" and "new style" redactions of the All Saints picture. One of these novel features — the inclusion of the Fountain of Life into an *Allerheiligenbild* — is not too difficult to explain. The image of the life-giving fountain, one of the oldest symbols of salvation and fairly ubiquitous in the Old Testament, occurs in Revelation XXI, 6, and VII, 17, the latter versicle immediately following the sections selected for the liturgy of the Feast of All Saints. Here the "fountain" or "fountains" are mentioned only by way of a promise. But they were naturally associated with the "pure *river* of water of life, clear as crystal, proceeding out of the throne of God and the Lamb" in Revelation XXII, 1; and that this passage, belonging to the description of the Heavenly Jerusalem which was in turn identified with Paradise, was the direct inspiration of Hubert van Eyck — or, rather, his theological advisers — is proved by the fact that the discrepancy between *fons* and *fluvius* did not prevent it from being inscribed upon the fountain in the Ghent altarpiece itself.[1] In addition, a purely iconographical development had paved the way to the inclusion of the Fountain of Life, a motif still flourishing or even revived in fourteenth- and early fifteenth-century art, in an All Saints picture. The fountain had come to be interpreted both as a meeting place of all the faithful and as a kind of boundary mark between the Old Law and the New, the state of nature and the state of grace.[2] Renderings of this type could easily fuse with illustrations of Revelation XXII, 1, and such an earlier, perhaps pre-Eyckian, fusion is well exemplified by the archetype of the much debated "Fountain of Life" in the Prado.[3] Here the "river proceeding out of the throne of God and the Lamb" according to Revelation (hence John the Evangelist, and not John the Baptist, is seen enthroned on the left of the Lord) flows into an octagonal, canopied well on either side of which are stationed, not the *chori beatorum* as in the Ghent altarpiece but representatives of the Church Triumphant and the vanquished Synagogue — a naturalistic dramatization, so to speak, of the debate between *Ecclesia* and *Synagoga* that used to take place by the Fountain in high medieval representations.

The other novelty — a most unusual extension of the traditional *chori beatorum* — can be accounted for, I feel, only by the special wishes of the patron or patrons. In the central panel we have only the canonical groups of saints enumerated in the liturgy of the Feast of All Saints: Patriarchs and Prophets, Apostles, Martyrs, Confessors, and Virgins. The inner panels of the shutters show the Holy Hermits, also mentioned in the liturgy, and the Knights of Christ who occur, if not in the liturgy itself, in texts derived from it (such as the *Golden Legend*). The two groups on the extreme left and right, however — and this may be the inner reason for the not unheard-of but most unusual subdivision of the shutters into two separate pictures[4] — constitute an exception. Even the Holy Pilgrims do not, so far as I know, form an accepted category within the Community of the Saints; they would seem to have been singled out as an independent group only in order to balance the Just Judges on the opposite end.

And these Just Judges pose a real problem. They have no hagiological status at all, and in the Ghent altarpiece their group includes, in contrast even to that of the Pilgrims, not a single identifiable saint. They represent, in fact, a class of persons often prayed for or against in Christian churches (a special mass, for instance, was occasionally said *contra injustos judices*) but never to my knowledge prayed to. Considering that they occupy the place on the extreme left traditionally allotted to donors and, further, that the term *judices* — constantly coupled with the term *exercitus* in liturgical acclamations much as the Judges and Knights are visually juxtaposed in the left shutter of the Ghent altarpiece — commonly designated, not so much members of the judiciary in particular, as high-ranking civilian officials (as opposed to the military) in general,[1] we cannot but conclude that our Just Judges do not constitute a *chorus beatorum* in the same sense as do the Martyrs, Confessors, Virgins or Holy Hermits. They are admitted to the hierarchies of the Blessed, not as an accepted category of saints but as the ideal representatives of a specific group of living dignitaries who hoped to be included with the Elect.

When we recall that one of the few documents referring to Hubert van Eyck is the record of a payment for "two designs (*bewerpen*) which he had made for an altarpiece (*taeffele*) at the behest of the magistrates (*scepenen*)" in 1425, we are much tempted to identify these magistrates — who shortly after visited Hubert's workshop and gave a gratuity to his apprentices [2] — with that specific group of dignitaries symbolized by the Just Judges; and, therefore, to identify their *taeffele* with what is now the lower storey of the Ghent altarpiece. If so, its program would announce, within a purely religious context and in a mood of serene confidence, those "Justice Pictures" which, more and more secularized in subject matter and more and more pessimistic in spirit, were to adorn so many town halls both in the Lowlands and in Germany: our *Justi Judices*, hopefully if proleptically admitted to Paradise, would be the ancestors of Roger van der Weyden's Trajan and Herkinbald, administering justice remorselessly but vindicated by God; of Dirc Bouts' Emperor Otto, involuntarily committing a judicial murder but later on atoning for it; and, finally, of Gerard David's corrupt and terribly punished Sisamnes.[3]

<div align="center">v</div>

From what has been said it will be apparent that the Ghent altarpiece, as it is, can hardly be accepted as a work of art executed according to plan. I cannot but side with those who hold that it was composed of originally unrelated elements left behind by Hubert van Eyck in various stages of noncompletion, and subsequently adapted, supplemented and finished by Jan at the expense of Jodocus Vyd who, wealthy and influential as he was, could easily persuade Hubert's original clients to cede their rights to him. The final result — a rich man's dream in size and splendor but not too satisfactory in design — can be accounted for only by a series of hypotheses.

(1) What is now the lower storey was originally intended as an independent All Saints altarpiece, probably ordered by the *Echevins* of Ghent in 1425 and conceivably destined for

their chapel in the Town Hall rather than for the Cathedral, in which the archaic idea of representing the Beatitude of Paradise as an Adoration of the Lamb, and not as an Adoration of the *Rex regum* or the Trinity, was both revived from ancient archetypes and modified according to individual specifications.

(a) Several scholars, including myself, have entertained the theory that this All Saints retable, prior to its incorporation in the present ensemble, possessed projecting top pieces such as can be seen in countless triptychs of the fourteenth and fifteenth centuries, that of the central panel providing the space for an image of the Deity. This theory has been exploded by the recent examination in the Laboratoire Central.[1] However, another result of this very examination, combined with the conclusions that may be drawn from the foregoing iconographic analysis, enables us, I think, to propose a more viable theory. Some twenty years ago, there was observed, beneath the present surface, two rays converging toward a point about 2 cm. higher than the focus of the rays now emanating from the Dove. The recent investigation has demonstrated that these two "subjacent rays" are remnants of a complete system (apparently erased, for the most part, before the present coat of pigments was put on); and, more important, that they were not produced with the brush but raised by the application of *gesso sottile* and gilded (an operation normally performed as soon as the design had been established and before the painting process proper began.[2] This pencil of rays, then, must have been emitted by a glory subsequently superseded by the iconographically incongruous Dove[3] — a glory which we have every reason to imagine as a pendent semicircle having about the same diameter as the Dove's halo but wholly or partly overlaid with gold. Glories of this type, often encircling an image of God in half-length but just as often unadorned with any figural design, are very frequent in late fourteenth- and early fifteenth-century art (the "Boucicaut Hours," for example, contain magnificent specimens of both kinds);[4] and no more fitting motif could have occupied the space now filled by the Dove, whether the golden semicircle displayed the divine image or served as a direct visual symbol of that "God-given" light which illumines the Heavenly Jerusalem so that its citizens "need no candle, neither light of the sun" (Revelation XXII, 5).

From a compositional point of view, the effect of such a glory — the curve of its circumference pleasantly echoed by a skyline not as yet broken by the tower on the left which has turned out to be a later addition — would have been even more satisfactory if the "Adoration of the Lamb" had been a little taller in format than it is now. And while the technical investigation has effectively disposed of the conjectural top piece, it does not, I believe, entirely exclude the possibility that the central panel was indeed trimmed by a few centimeters both at the top and at the bottom — provided that this action was taken at a time when the actual painting had not as yet progressed beyond fairly limited areas.[5]

There is, in fact, some reason for suspecting such a curtailment: the height of the central panel is now considerably less than that of the wings (*ca.* 138 cm. as against *ca.* 149 cm., including the unpainted edges concealed by the frames), which in a Flemish altarpiece of about 1430 is a distinct anomaly;[6] the central panel, as it is now, appears unpleasantly wide (*ca.*

243 cm., again including the unpainted edge) in relation to its own height whereas, had it been 11 cm. higher, its proportions would have been more normal, in fact exactly concordant with the golden section; and the "subjacent rays" converge, as mentioned before, at a point slightly but perceptibly higher than do the rays now visible on the surface. Why it would have seemed advisable to trim the "Adoration of the Lamb" is easy to imagine. The total height of the ensemble resulting from the superimposition of a second row of pictures upon the original All Saints altarpiece was limited, to the last inch, by the exiguous height of the chapel. It would, therefore, have been imperative to make — or keep — the lower tier as short as possible; but it would have been equally imperative, both for artistic and technical reasons, to strengthen — or, at least, not to weaken — the frame of the central panel. Surrounding what had become the nucleus of a much larger structure and subjected to the load and stress of the added upper storey, it could not be permitted to be much narrower than it is now. The only solution, then, would have been to reduce the "Adoration of the Lamb" in height.

Reconstruction of the lower storey of the Ghent altarpiece based on the hypothesis that the central panel was shortened by 11 cm. as indicated by broken lines. If approximately 1.5 cm. are allowed for the unpainted edges, the width of all frames in Alternative A would be uniquely determined at 5⅔ cm. In Alternative B it would vary between 8.5 cm. (the width of the ledge dividing the shutters equaling that of the frames) and 17 cm. (the width of this ledge equaling zero). The letters a, b, c, and d indicate the boards of which the central panel is composed.

(b) While this curtailment of the central panel remains conjectural, we can be sure that each of the shutters was always — and, I believe, mainly for the iconographic reasons set forth above — divided into two separate panels.[1] Even as an independent altarpiece, then, the lower storey must have been a pentaptych which, if its central panel was not cut down, must have looked precisely as it does now; and, if its central panel was cut down, can only have offered one of the two aspects sketched in the subjoined diagram. Assuming that the lateral panels were treated as entirely separate units (Alternative A), the shortening of the central panel by 11 cm. would have made it possible to double the width of its then narrow frame (5⅔ cm.)

without increasing the total height of the pentaptych. Assuming, as seems rather improbable, that each pair of the lateral panels was set into a fairly wide over-all frame subdivided by a narrower ledge (Alternative *B*), the shortening of the central panel would have made it possible to retain a frame about as wide as it is now, yet to reduce the total height of the pentaptych by the amount by which the central panel was trimmed. In neither case, however, would it have been necessary to shorten the shutters; and to preserve their original height would have seemed the more desirable as the tall, large-scaled pictures that were to be superimposed upon them tend, even as it is, to have a somewhat oppressive effect.

(2) Turning now to the upper storey of the Ghent altarpiece, we must begin with the central triad of pictures which, we remember, constitute a coherent unit in treatment as well as in scale.

(a) The subject of this "upper triptych," as we may call it for short, should not be referred to as a "Deësis" (viz. the Intercession of Our Lady and St. John the Baptist with Christ as seen in renderings of the Last Judgment) without reservations. The Lord appears, as has been seen, not in "that form in which He is the Son of Man" [1] but as the triune God; the Virgin Mary, absorbed in reading, is not represented as the *Maria Mediatrix* but as the Queen of Heaven with the "crown of twelve stars upon her head"; [2] and the Baptist, instead of praying or pointing with the incisive gesture associated with the words "Behold the Lamb of God," raises his hand in a manner didactic rather than suppliant or indicatory. As evidenced by the encomium inscribed on the back of his throne — culled from a sermon of Peter Chrysologus but omitting precisely those epithets which stress his precursorship [3] — he does not appear as *praecursor Christi*, let alone as *praeco judicis*, but in his capacity of *Dei testis* or, to use another title which means the same thing, *totius medius Trinitatis*: [4] as the revealer and mediator of the whole Trinity.

The "upper triptych" would thus be entirely appropriate as a crowning feature of that composite *Allerheiligenbild* as which the interior of the Ghent altarpiece presents itself today — were it not for the fact, already mentioned, that the dominant figure is now determined, by the addition of the Dove, as an image of God the Father rather than of the "whole Trinity" and that the Baptist, arrayed in garments more resplendent than is usual even where he appears at the head of the Blessed, is elevated to the rank of "Synthronos." These iconographic singularities as well as the discrepancy in scale suggest that the "upper triptych" was originally designed as an independent retable, probably specifically honoring St. John the Baptist (who, as will be remembered, was the patron saint of Ghent Cathedral up to its dedication to St. Bavo in 1540). An image of the Deity — no matter whether depicted as the *Rex regum* or the explicit Trinity — flanked by two saints, or by the Virgin Mary and one of the two St. Johns, is unexceptionable as the subject of an altarpiece from an iconographic point of view (in fact one of the oldest painted retables, the famous "Soester Altar" at Berlin, shows nothing but the Throne of Mercy between the Virgin and St. John the Evangelist). The only objection that might be raised would refer to form rather than content. It is quite true that retables resembling the "upper triptych" in structure — retables, that is, which have no shutters and display only three

sacred images in nichelike compartments — were not in fashion in the Northern fifteenth century. They do, however, occur in painted renderings of ecclesiastical interiors; and then they tend to carry a special connotation of venerable, at times pre-Christian, antiquity: we find them either in legendary scenes from the remote past in which a miracle occurs before an altar (the Mass of St. Hubert, the Mass of St. Gregory) or, with the Lord Between Two Saints replaced by Moses Between Two Prophets, in the Presentation of Christ.[1] It may well be that the very flavor of oldness and solemnity which seems to have surrounded triptychs of this type in the fifteenth century appealed to that sense of the hieratic and the archaic which is so characteristic of Eyckian art.

(b) That the "Musical Angels" flanking the "upper triptych" differ from it in scale and perspective has already been mentioned. But even in the measurements of the panels on which they are painted there is a slight but jarring discrepancy (the panels of the Angels are just 4 cm. shorter and 3 cm. narrower than the adjacent ones) which leads to the conclusion that they had to be "cut to measure" after the fact and under adverse circumstances — an operation which quite possibly included a rounding off of their tops. The inference is that the "Musical Angels" represent an element originally unrelated to the "upper triptych" as well as the All Saints altarpiece beneath it. And since it is as unusual for altarpieces to have shutters exhibiting nothing but musical angels as it is for angels, musical or otherwise, to have no wings, we may conjecture that the "Musical Angels" had originally been intended for a context less strictly governed by the rules of religious iconography than a retable: they may have been destined for an ambry, or, perhaps more probably, for an organ. Organ shutters, organ cases and the parapets of organ lofts were traditionally and appropriately decorated with music-making figures, or groups of figures, occupying individual panels; and these, though frequently appearing as orthodox angels as in Gonesse and Santa Maria la Real at Nájera, were no less frequently depicted as wingless beings — musical genii, so to speak, or actual musicians — as is the case at Grand Andely, Nonancourt and Augsburg.[2] The musical "angels" in the Ghent altarpiece, it would seem, were originally conceived as the northern cousins of Luca della Robbia's glorified choristers at the *Cantoria* of Florence Cathedral.

(c) There remain the two outermost panels of the upper storey showing the figures of Adam and Eve. If our analysis is correct they, and they alone, would be *ad hoc* additions to elements already extant before the Ghent altarpiece received its present form, and this agrees with the uncontested fact that they stand out from their surroundings by a quality of palpable existence which relates them to the exterior rather than the other interior pictures.

Their proportions were of course determined, on the one hand, by the difference in width between the "Musical Angels" and the lower shutters and, on the other hand, by the height and shape of the panel representing the Lord. But seldom has so great a virtue been made of so dire a necessity. By turning the two nudes at an angle of 45 degrees, thus minimizing width in favor of height, the painter managed to squeeze into the narrow space two figures somewhat smaller in scale than the central triad yet very much larger than the Musical Angels. By encasing these figures in deep, shadowy niches and adding to the effect of drastic foreshortening

that of an unusually strong light, he invested them with a plastic solidity which makes us feel that they are nearer to our eye than are the Musical Angels, and this impression is enormously strengthened by the use, often remarked upon, of an emphatic *di sotto in sù* or "worm's eye" perspective.[1] Since the figures of Adam and Eve are placed above the eye level of the beholder, the surface on which they stand remaining invisible and Adam's right foot seen from below, they seem to approach or even to transcend the picture plane. As a result, the smaller size of the Musical Angels passes unnoticed or, rather, is subconsciously accounted for by the illusion that they are further removed from the eye than both the First Parents and the giant figures of the "upper triptych." By virtue of this optical device, lending an almost aggressive energy to their vigorous modeling, the figures of Adam and Eve thus serve to soften, if not to conceal, the dimensional disparity between the central triad and the Musical Angels. They represent a master stroke of the first order; but this master stroke entailed the promotion of the First Parents to a position of undeserved sublimity and, in the "Annunciation" on the exterior, the interpolation of those two extra panels which, having no *raison d'être* from a narrative point of view, were filled with motifs gratefully accepted from the Master of Flémalle. Jan, it would seem, welcomed the *mise-en-scène* of the Mérode altarpiece with what amounts to a sigh of relief. There is good evidence to show that he originally planned to treat the upper storey of the exterior in precisely the same fashion as the lower, that is to say, to divide it into simulated niches, valanced by trefoil arches, analogous to those which shelter the donor's figures and the statues of the two Saint Johns. These arches are still preserved beneath the present coat of paint;[2] but since there would have been six of them (one in each central panel, two in each of the lateral ones), they would have conflicted with the four units of the lower tier even more sharply than does the Flémallesque interior now.

VI

From the inscription of the Ghent altarpiece we know that it was Hubert van Eyck who "began" and Jan, his brother, who "completed" it. If our hypotheses are correct, this completion would have amounted to much more than the carrying out of a well-defined project: Jan would have taken over no less than three unfinished works quite different in character and destination,[3] and — "Judoci Vyd prece fretus" — not only finished them but also combined them into what may be called a super-retable.

Be that as it may, certain it is that Jan, and Jan alone, was responsible for, first, the exterior of the Ghent altarpiece in its entirety; and, second, for the figures of the First Parents with the simulated reliefs surmounting them. That the exterior is Jan's and not Hubert's is one of the few propositions on which a nearly general agreement has been reached.[4] Its program, entirely coherent from an iconographical point of view, glorifies the person of Jodocus Vyd who had no known connection with Hubert, and its style agrees with Jan's in every way. Suffice it to compare the donors' portraits with the "Timotheos" of 1432 or the drapery of the Annunciate with that of the "Ince Hall Madonna" of the following year —

comparisons which, incidentally, corroborate the natural assumption that the exterior pictures were tackled only after the remodeling of the interior had been completed.

The style of the "First Parents" evidently agrees with that of the exterior. The round-faced, slightly slit-eyed Eve [1] is the robuster ancestress of the Annunciate in style as much as from the point of view of doctrine. The way in which the figures emerge from the darkness of their deep niches resembles the effect of the grisaille statues and the donors' portraits; as Adam's foot is seen in "worm's eye perspective," so are the books of the Prophets above the "Annunciation." And Jan van Eyck's consummate naturalism is evident from the difference, indicating the use of a living model, that exists between the pale complexion of Adam's body and the tan of his hands.

Hubert's contribution to the Ghent altarpiece can thus be looked for only in the interior exclusive of the Adam and Eve panels; and even here it cannot be expected to stand out very clearly. The altarpiece has suffered considerable damage and, prior to its recent treatment in the Laboratoire Central, undergone no less than five restorations, the earliest and most important one performed by Jan van Scorel and Lancelot Blondeel in 1550.[2] Much of Hubert's work must have been limited to underdrawing and underpainting which, even if his design was respected for the sake of economy and out of veneration for the dead master, was bound to be obscured in the course of execution. Where Hubert's work had proceeded to the stage of actual painting Jan would naturally have tried to harmonize it with his own. Where the X-rays — and, in some cases, the naked eye — reveal a definite stratification it is not always possible to decide whether this stratification is due to the restoration of 1550 or antedates it; and, even if the latter, whether it signifies an alteration or a *pentimento* — a change imposed by Jan on Hubert or on himself.

In spite of all these difficulties, and with the reservation that the final report of the Laboratoire Central has not as yet been published, I believe that differences are discernible and that the most noticeable of these has already been recognized by the very first scholar, Max Dvořák, who ever attempted to solve the problem in critical fashion.[3] As pointed out by him, a distinct stylistic dichotomy exists within the "Adoration of the Lamb" (fig. 278). Its foreground is seen in a kind of semi-bird's-eye view which produces an effect halfway between recession in depth and rise, and the fountain itself is rendered in a primitive wide-angle perspective not unlike that in the earlier works of the Flémalle Master; whereas, farther back, the meadow seems to recede more easily and the altar of the Lamb, constructed with a different point of sight, shows a less violent yet more effective foreshortening.

An analogous difference can be observed in the figures. Except for the tonsured St. Barnabas at the apex of the Apostles group and his bald-headed counterpart on the Prophets side, who seem to play an intermediate role in style as well as in placement, the kneeling figures nearest to the fountain strike us as more archaic than the rest. Somewhat reminiscent, again, of the Master of Flémalle in his earlier works, they give an effect which may be described as glyptic rather than plastic. The modeling does not seem to penetrate the substance in its entirety and leaves a core of unorganized mass beneath a network of hard, scooped-out drapery.

And, emphatic though this modeling is, the figures give the strange impression of being compressed between two frontal planes rather than freely developed in three-dimensional space — an impression accentuated by a preponderance of the pure profile view (employed in no less than seven Apostles and as many Prophets) which was all but obsolete in the third decade of the fifteenth century. The costumes of the Prophets show that fairy-tale-like orientalism which marked the productions of the International Style and vigorously survived in the earlier phase of the Flémalle Master, and the somber, long-haired and long-bearded Apostles (fig. 283*b*) are pronouncedly Italianate. Physiognomically, they conform to a type current in all Tuscan trecento painting, especially to the Old Testament characters in Giotto's frescoes in the Arena Chapel, and their postures, soles turned toward the beholder, invite comparison with the Disciples in Taddeo di Bartolo's "Death of the Virgin" in the Palazzo Pubblico at Siena.[1]

The angels encircling the altar of the Lamb and the processions approaching it from the background, on the other hand, are fully elaborated as three-dimensional entities and modeled more emphatically as well as more softly. Their style is as compatible with Jan's as that of the Apostles and Prophets is not. The draperies of the Angels are not too different from that of the "Ince Hall Madonna," and the leaders of the Holy Virgins, St. Catherine and St. Dorothy, are almost sisters to Our Lady as she appears in the "Madonna in a Church" (fig. 236), a picture probably executed while Jan was still at work on the interior of the Ghent altarpiece. Even more noteworthy than the treatment of the single elements of which these two processions are composed is their collective organization. Though the individual figures are perfectly detached from one another, they seem to merge into one compact, space-displacing body; the heads of the Virgins in particular add up to a receding horizontal surface as do, if I may use so homely a simile, the cobblestones of a pavement, or, to be more poetic, the little waves and ripples on a sheet of water.

Dvořák was right, I think, in dissociating the foreground section of the "Adoration of the Lamb" from the rest — only that this dissociation cannot be expressed by a clear-cut dividing line. We have, instead, between the figures in the foreground and the Virgins and Confessors what may be called a transitional zone where even the naked eye is able to detect a rearrangement of the hilly ledges which form the *locus standi* of the various groups; and even within the foreground itself only the fountain and the kneeling figures in its immediate vicinity seem to reveal the style of Hubert in comparatively undiluted form. The processions of Confessors and Virgins are simon-pure Jan, and the same is true of the more distant parts of the scenery where the aerial perspective and the very topography, while anticipating the luminous panoramas in the "Rolin Madonna" and the "St. Barbara," hark back to the landscapes of Jan's hero, the Boucicaut Master; his humble houses, village churches and windmills emerge from behind wooded mountain ranges and rounded hillocks in much the same way as do the fabulous architectures in the background of the "Adoration of the Lamb." Everything else would seem to represent all possible degrees of supersedure. The altar of the Lamb and the surrounding angels, for example, were evidently so far from completion that the work of the older master is almost entirely supplanted by that of the younger; whereas the figures arrayed

Ghent Altarpiece - greatest masterpiece of early Flemish painting

behind the Apostles and the Prophets, less convincingly integrated into unified, three-dimensional groups than are the Virgins and Confessors yet more minutely differentiated and individualized than the Apostles and Prophets themselves, appear to have been left by Hubert in a state advanced enough to require extensive retouching but not complete remodeling.

This somewhat disappointing result agrees, however, with the general habit of painters to begin the final execution of their pictures in an area of maximum interest rather than start at the margins;[1] and if we are right in assuming that the lower storey of the Ghent altarpiece is identical with the *taeffele* commissioned by the city magistrates — and still in the state of project drawings in 1424-1425 — Hubert could have spent on it, at the utmost, one year, a goodly part of which would have been consumed in preliminary work.

In addition to what he was able to carry out in color, however, he must naturally be credited with the general design of the central panel and, in particular, with the application of those raised and gilded rays from which we concluded the existence of a glory now superseded by the Dove. Since these rays underlie the blue of the sky and the green of the turf and shrubbery, they must antedate the final execution of the whole upper half of the picture. And to ascribe them — as remnants of a composition subsequently altered — to Jan is clearly impossible because he would never have resorted to the archaic method of raising decorative details in relief and would never have stooped to use metallic gold. The very existence of these "subjacent rays" suffices, I believe, to prove, on the one hand, that we cannot eliminate the participation of Hubert altogether; and, on the other, that, whatever we may decide to assign to him cannot include the magnificent panorama which constitutes the upper ranges of the scenery. Where the skyline of this panorama was subsequently enlivened by such Mediterranean plants as cypresses, palm trees and umbrella pines — in part so thinly painted that the underlying forms shine through — we may, therefore, assume that Jan improved upon himself, so to speak, after his trips to Spain and Portugal had made him familiar with southern vegetation.[2]

In other places, however, we are unquestionably faced with repaintings, repairs and additions for which neither of the two brothers can be held responsible. The Tower of Utrecht Cathedral ("Domtoren"), proudly soaring near the center of the composition, has been correctly ascribed to Jan Scorel who may have inserted it in order to show that he, the citizen of Utrecht in Holland, had been deemed worthy to restore the greatest masterpiece of Early Flemish painting.[3] The Lamb was repainted at a period unknown and now faces the beholder, in slightly embarrassed fashion, with an extra pair of ears.[4] And most of the grayish, fuzzily painted buildings directly opposite to the Utrecht Tower — partly inspired by the city prospect of Cologne and sharply contrasting in style and color with the imaginary but wonderfully precise and compact structures devised and executed by Jan himself — owe their existence to the repairs necessitated by a conflagration in 1822 which had spilt hot cinders and molten lead upon the altarpiece.[5]

The panels flanking the "Adoration of the Lamb" differ from it in that the space seems to recede by stages rather than continuously, the groups in the foreground being screened off from

the more distant parts of the scenery by coulisses of shrubbery and rocks; and, furthermore, in that the ground consists of earth and rock — though strewn with precious stones — rather than grass. These differences do not, however, warrant the conclusion that Hubert had no part at all in their design and execution, let alone the more radical hypothesis that Jan had appended them, as an *ex post facto* addition, to what Hubert had planned and executed as a two-storeyed but shutterless retable.[1]

That the Hermits, Pilgrims, Knights, and Judges walk on hard ground, and not on a soft meadow, would seem to express the "rough ways" on which mankind must travel on its road to the "green pastures" of salvation. And as far as the difference in the treatment of space is concerned, we happen to know that the landscape background of the lateral panels was even more thoroughly altered than that of the "Adoration of the Lamb": the recent X-ray examination has shown that the scenery was intended to be continuous throughout the pentaptych, not only in the distance (as is now the case) but also in the middle plane. The terrain above the Prophets and Patriarchs originally continued into the panel showing the Knights of Christ; the rocks behind the Hermits and the exotic orange grove behind the Pilgrims supersede a grassy hillside and a domestic tree with short, thick trunk and radiating branches. It is, of course, possible to interpret these changes as self-emendations rather than a remodeling of Hubert's work. But they differ from such obvious afterthoughts as the cypresses, palm trees and umbrella pine in the far distance not only technically but also in that they affect the same "transitional zone" which in the central panel seemed to reveal an encounter between two different personalities; and the original tree now covered by Jan's orange grove belongs to a type apparently foreign to his vocabulary whereas rather similar trees occur in the "Friedsam Annunciation" (fig. 284), a picture now almost generally accepted as a work by — or, at least, after — Hubert and certainly not attributable to Jan.

In regard to the scenery the two shutters have clearly more in common with each other than either has with the central panel. In regard to the figural composition, the situation is reversed: in this respect, the right-hand shutter has more in common with the central panel than with its counterpart on the left. The serried ranks of Hermits and Pilgrims — bolt upright and arrayed on the same base line — can easily be read as continuations of the dense throngs of Martyrs and Apostles in the "Adoration of the Lamb." In facial type and psychological expression, too, they belong to the same, somber race. And as the austerely unkempt Apostles contrast, in style and spirit, with the Holy Virgins, so do the Hermits with their lovely feminine companions, St. Magdalen and St. Mary of Egypt who can be shown to have been added to the original group when the landscape background was changed.[2] In short, the panels of the right-hand shutter exhibit, even more clearly, a stylistic dichotomy analogous to that which can be observed in the "Adoration of the Lamb": the figures in the foreground strike us as "Hubertian"; those farther back — the two female anchorites appearing in the same "transitional zone" as do the angels surrounding the fountain — as "Janesque."

In the groups of Knights and Judges, on the other hand, all traces of Hubert's style have been obliterated. Complex, animated and loosely constructed rather than simple, calm and

compact, they move in different planes (the foremost Knight, St. George, being considerably farther removed from the picture plane than the foremost Judge), and yet the content of the two panels is fused into a unified, interlocking pattern. In spite of the continuous landscape, the Hermits and Pilgrims are, as groups, confined to separate sections of space. The Knights and Judges, however, form one cavalcade not interrupted by, but apparently proceeding behind, the dividing frames which overlap the croup of the horse of St. George in such a manner that its off hind leg extends into the adjacent panel. With regard to the left shutter, then, we may conclude that Jan went further than to repaint the scenery and make additions in the "transitional zone": for reasons which we can only surmise [1] he must have completely redesigned the figural composition.

The upper storey of the interior confronts us with problems in part much simpler and in part even more complex than does the lower. That the "First Parents" are by Jan in concept as well as execution has already been mentioned, and the "Musical Angels," though probably designed by Hubert, would also seem to be Jan's as far as the actual painting is concerned. While the spaceless composition of these two pictures strikes us as distinctly archaic, the treatment of pearls and precious stones, brocaded fabrics and hair, wood and fayence tiles is as characteristic of Jan as is the somewhat strained expression of the faces; it has also rightly been stressed that the selection of colors appears to presuppose the existence of the panels underneath.[2] The vivid reds, blues and greens of the singers correspond to the bright, variegated colors of the Knights and Judges whereas the dark, purplish-brown brocade of the organist and the harpist, overshadowing the crimson of the *viola da gamba* player, echoes the drab browns and olive greens, broken only by St. Christopher's red mantle, of the Hermits and Pilgrims.

The real difficulty is presented by the "upper triptych." Intended, as I believed them to be, for an independent altarpiece, the three majestic figures, each enveloped in a veil of solitude, exist in the absolute, remote from contact with that which is beneath and beside them. As they stand by themselves within the compositional context, so do they stand by themselves with regard to style. When we observe the surface treatment and, quite particularly, the palaeography of the inscriptions with their profusion of "square C's," we cannot doubt that the three panels were thoroughly gone over by Jan. But when we turn from accident to substance, from epidermis to structure, so to speak, we cannot fail to see what even those who believe in Jan's exclusive authorship were forced to admit: that they are hard to reconcile with his authenticated or universally accepted works.[3]

In spite of vigorous modeling and — in the figures of Our Lady and St. John the Baptist — foreshortening, the figures seem to be developed in two dimensions instead of in three. The drapery is "scooped out" to such an extent that the general impression is one of concavity rather than convexity. The contours of the gold-embroidered and jewel-studded borders move in languorous, calligraphical curves (Wölfflin might have spoken of a "cantilena of line") which have no parallel in Jan's stereographic style. The hands are enormous and powerfully compact; in comparison with the fleshy hands of the Baptist and the large-boned right of the

Lord, even the hands of the rustic Adam appear almost elegant. And the physiognomies — excepting that of the Lord, which must have been entirely repainted by Jan — differ decisively from his customary types. The Virgin's face is beautifully statuesque rather than prettily feline, and the almost Giottesque St. John nearly duplicates, as far as the facial type is concerned, the "St. Paul of Thebes" in the Hermits panel. All differences in scale, intent and execution notwithstanding, the giant images of the "upper triptych" are easier to associate with the Apostles and Prophets than with the First Parents, the figures on the exterior or even the Musical Angels. While these, though probably designed by Hubert, became essentially Jan's, the panels representing the Lord, Our Lady and St. John the Baptist, though certainly remodeled by Jan, remained essentially Hubert's. And this conclusion seems to be confirmed by what may be considered as the most spectacular result of the recent examination in the Laboratoire Central.

This examination has revealed, first, that the gold lines now marking the joints of the pavement in these three panels were added in the sixteenth century; second, that the pavement itself, the color of its tiles fluctuating between dark olive green and dull red, supersedes an earlier one which showed a vivid alternation of bright and dark tiles; third, and even more important, that the bottom section of the central panel — the image of the Lord — presents a puzzling stratification (see diagram). The lines of the pavement as well as the contours of a crown placed at the feet of the Lord are scratched into the ground (B); so is the inscription on the footpace of His throne, and it is possible to ascertain that its text (VITA SINE MORTE . . .) is the same as it is now whereas the form of the letters and the distribution of words are different. The first coat of paint (C) contains the original pavement with its alternately bright and dark tiles, some fragments of the original inscription — painted in heavy, black letters of rather unattractive form — but no trace of the crown; and while most of the inscription seems to have been intentionally rubbed off, the crown can never have been executed in color at all because the tiling is carried from left to right without interruption. This stratum, representing what may be called a "first state" of the picture, is covered by a sheet of silver foil (D). And it is this sheet which forms the foundation of the coat of paint now visible (E), containing the present, dark-tinted pavement, the present inscription — lettered in brown and agreeing with the inscriptions on the semicircular moldings not only in color but also in palaeographical character (note the "square C's" in SENECTVTE and SECVRITAS) — and the crown.[1]

This unexpected discovery has led the experts to the conclusion that all the changes represented by stratum E and constituting a "second state" of the picture, were effected in the sixteenth century, presumably by Scorel and Blondeel in 1550, and that the crown was added (ajoutée) at this time. Though this conclusion is supported by the fact that the somewhat lax and pulpy technique of the crown compares unfavorably with the brilliance and precision with which the gold, pearls and precious stones are rendered in other areas of the same picture, it is at variance with two facts. First, while the treatment of the crown is inferior to that of, for example, the morse and the node of the scepter, it is admittedly identical with that of the

scepter's top as well as the tiara;[1] and since these latter details cannot have been "added" but can only have been repainted in the sixteenth century, the same may be assumed of the crown. Second, and this represents what Thomas Aquinas would call a *demonstratio ex necessitate* as opposed to an *argumentum probabile*, we know from an unimpeachable source, the *Kronyk van Vlaenderen* already quoted, that the crown was in evidence in 1458 at the latest, nearly a hundred years before the recorded activities of Scorel and Blondeel and when the Ghent altar-piece was as good as new.[2] We can hardly avoid the conclusion that both the crown and the present inscription, though obviously repainted in the sixteenth century, are Eyckian and not post-Eyckian; and that it was Jan who, after having rubbed off most of the earlier inscription, covered the bottom zone of the picture with silver foil, presumably as a means of insulation that would smooth out the irregularities of the surface and prevent the very substantial paint of the "first state" from growing through.

A. Wood.
B. Gesso ground containing scratched-in outlines of the pavement, the crown and the original inscription on the front of the dais.
C. Coat of paint containing the original pavement and fragments of the original inscription but no traces of the crown.
D. Silver foil.
E. Coat of paint containing the pavement, the inscription and the crown as now apparent.

This leaves us with only two alternatives: Jan either corrected himself or Hubert. And of these alternatives, the first is difficult to accept. Assuming that Jan was responsible for both the "first" and the "second state" of the picture, we should be forced to believe that he, though enjoying full freedom of action, reversed himself not once but twice: he would have discarded the crown (which, we recall, was planned when the design was scratched into the gesso ground) and reinstated it after completing the uninterrupted pavement and the first inscription. Moreover, we should be forced to ascribe to him, that wonderful epigraphist, a type of lettering which, as is evident both from the scratched-in contours in stratum *B* and the black characters preserved in stratum *C*, is plainly incompatible with his sophisticated writing style. Assuming, however, that the "first state" can be credited to Hubert and that it was he who, for some reason, had departed from the original project in carrying through the pavement and omitting the crown, Jan would have had compelling reasons to restore the *status quo*. Once it had been decided to superimpose the "upper triptych" upon the "Adoration of the Lamb," it

would have seemed advisable to reinstate the crown as a connecting link bridging the empty expanse between the feet of the Lord and the Dove underneath. It would then have been necessary to rearrange the words of the inscription so as to appear, again, on either side of the crown, as well as to revise its lettering according to the standards set in the inscriptions of the semicircular moldings. And to eliminate the conspicuous alternation of light and dark tiles in favor of a more subdued and neutral color scheme would have served to lessen the discord, unpalatable even now, between the solid pavement above and the diaphanous landscape below.

Interpreted in this manner (and in accordance with the fact that the crown was demonstrably in evidence throughout the fifteenth century), the most tangible alteration observed in the Ghent altarpiece would seem to corroborate, not only the assumption that the "upper triptych" contains a greater amount of Hubertian substance than any other portion of the work but also the more general hypothesis that the present ensemble resulted from an ingenious combination of heterogeneous elements rather than from a predesigned uniform plan.

<div align="center">VII</div>

From this admittedly conjectural analysis of the Ghent altarpiece, Hubert van Eyck emerges as an artist less modern, cosmopolitan and polished than his brother Jan, yet less bourgeois, provincial and "tough-minded" than the Master of Flémalle who was, for all we know, his senior by several years and, in addition, a native of Flanders rather than the Meuse district. In Hubert, too, we may sense a certain tension between the will to conquer volume and space and an allegiance to the more graphic tendencies of the past. In his draperies the novel, plastic mode of expression is still somewhat at odds with decorative linearism. His treatment of linear perspective, exemplified by the lower section of the "Adoration of the Lamb," and especially by the fountain, tends to be archaically overemphatic. He conceives of space as a foiling background rather than an all-enveloping medium and has not entirely cast off the spell of fourteenth-century Italianism.

These characteristics are present in two pictures which, therefore, may be ascribed to Hubert rather than Jan van Eyck: the "Three Marys at the Tomb," transferred from the Cook Collection at Richmond to the van Beuningen Collection at Vierhouten near Rotterdam; and the "Friedsam Annunciation" in the Metropolitan Museum.

The recent cleaning of the van Beuningen picture (figs. 285, 286) [1] has dispelled all previous doubts as to its quality and early date; but it has also posed a number of new problems. A pencil of rays, coming in from the right at an angle of *ca.* 45 degrees and obviously emanating from a figure of the resurrected Christ, compels us to assume that the scene was originally contiguous to an "Ascension" — which means that the picture is either the left-hand wing of a triptych or, in my opinion more probably, the fragment of a friezelike composition as exemplified by the pre-Eyckian "Life of the Virgin" in the Brussels Museum. [2] The rocks in the upper left-hand corner are completely overpainted. And while the picture as a whole is uniformly conceived and executed, certain details reveal, perhaps even more clearly than in

<div align="center">230</div>

the Ghent altarpiece, the supervening hand of Jan. On the whole, the van Beuningen picture has much in common with the foreground section of the "Adoration of the Lamb"; compare, for example, the face of the kneeling Magdalen, seen in full profile, with that of the foremost Prophet, or the drapery of the huddled soldier on the right with that of the second Apostle in the front row. The perspective of the sarcophagus with its enormously elongated lid is even more archaic than that of the fountain in the Ghent altarpiece. The magnificent landscape agrees with the foreground and middle plane of the scenery in the "Adoration of the Lamb" rather than with the distant panorama, and the architectures are rendered with a topographical accuracy entirely foreign to Jan.[1] But Jan, it would seem, repainted the sky and the skyline, adding such characteristic little touches as a flight of birds, some snow-capped mountains and an umbrella pine; and he must also have remodeled the two impressive figures in the center: the brutish soldier with the halberd and the dragon helmet and, above all, the white-robed, fluffy-haired angel who differs from the other figures in the same way as does, in the Ghent altarpiece, the Angel Gabriel from the Apostles.

Behind the rocks on the left the sun is about to rise, which brings to mind the "Dijon Nativity" by the Master of Flémalle. But here the sun is visible, even concretized into a disc of metallic gold whereas, in the "Three Marys at the Tomb," it merely incandesces the sky and casts a rosy light upon the city of Jerusalem. The motif of the rising sun was evidently suggested by Mark XVI, 2 ("And very early in the morning the first day of the week, they came unto the sepulchre at the rising of the sun"); but there is little doubt that the painter was no less aware of its symbolic implications — here, as in one of Dürer's woodcuts, signifying the rebirth rather than the birth of Christ — than was the Master of Flémalle. He even seems to have accentuated these implications by creating a curious conflict, difficult to explain by sheer inadvertence in so accomplished an artist, between the sunbeams irradiating the distant landscape from the left and the undefined light illumining the foreground from the right. In a manner quite different from that employed by Jan in the "Madonna in a Church," yet in the same spirit, he seems to have defied the laws of nature in order to affirm the supernatural character of a light *super omnem stellarum dispositionem*.

While the validity of this interpretation may be questioned, certain it is that the principle of "disguised symbolism" was deliberately, even spectacularly, applied in the "Friedsam Annunciation" (fig. 284) the iconography of which has been discussed at length in the Fifth Chapter. Here I should like to add that the similarity which I always believed to exist between this panel — unfortunately much damaged and apparently cut down at the top, which would explain the virtual absence of sky — and the "Three Marys" in the van Beuningen Collection has become even more apparent after the latter picture has been cleaned;[2] and that its composition as well as its style place it in the orbit of Hubert rather than Jan. The scene is staged at the door of a little building approached by the Angel from the outside, and not within an interior — an arrangement still reminiscent of Broederlam and the Limbourg brothers and never found in Flemish panel painting after 1430; it demonstrates, not only the early date of the composition but also its allegiance to an Italianism which Jan van Eyck had thoroughly

outgrown. The oblique perspective of the building, too, is both archaic and Italianate; as we remember, even the Master of Flémalle did not employ two-point perspective after the "Dijon Nativity," and Jan van Eyck avoided it throughout. The Angel Gabriel is represented in pure profile, again a feature equally foreign to Jan as to the host of later Flemish painters. The figures, in spite of their voluminous drapery, give the impression of being flattened against the picture plane rather than being crystallized around an interior axis. The rich but purely northern vegetation is closely akin to that in the lower rather than the upper ranges of the "Adoration of the Lamb," and the intriguing tree emerging from behind the decaying wall is reminiscent, as has been mentioned before, of that concealed beneath Jan's orange grove in the "Holy Pilgrims."

VIII

The question of "Hubert and/or Jan" [1] also enters a problem as difficult as that of the Ghent altarpiece and debated, if possible, with even greater heat: the problem of their *juvenilia*.

The early works of great artists are a source of constant trouble to art historians. Rarely authenticated by documentary evidence, they are attributed exclusively on stylistic grounds; and since the productions of a great innovator inevitably exerted a tremendous influence on others, the works ascribed to him as "early" originals are bound to give rise to a controversy as to whether they were in fact produced by him before his style had crystallized into its recognized, canonical form or have the appearance of "earliness" only because an imitator of the great man's mature style involuntarily retranslated it into a less developed idiom.

In the case of the van Eyck's the controversial *juvenilia* are centered around a number of miniatures added to the "*Très-Belles Heures de Notre Dame*" the complicated history of which has been summarized in Chapter One. It will be remembered that its original owner, the Duc de Berry, bartered it in an unfinished state to one of his familiars, Robinet d'Etampes; that Robinet d'Etampes divided it into two sections one of which passed into the ownership of the Holland-Bavaria dynasty; that the first part of this section (which was divided once more at an unknown date) was destroyed in the conflagration of the Royal Library at Turin in 1904; and that the second, then owned by the Principe Trivulzio of Milan, is now preserved in the Museo Civico at Turin.[2]

When it left the possession of Robinet d'Etampes, this "Turin-Milan Hours," as we may call it for the sake of brevity, lacked a considerable number of miniatures which were added at various dates up to the middle of the fifteenth century. The latest of these do not present any particular problems. They are typical productions of Flemish illuminators, probably active at Bruges, who, after the fashion of their period, largely resorted to the imitation of well-known panel paintings and in selecting their models displayed a laudibly catholic taste. A copy after the "Descent from the Cross" by the Master of Flémalle hobnobs with a variation on the Jan van Eyck-Petrus Christus "St. Jerome" at Detroit (here superficially transformed into a St.

Thomas Aquinas), and this again with a "Bearing of the Cross" derived from a prototype to which we shall revert in the course of this Chapter.[1]

There are, however, in the "Turin-Milan Hours" two series of miniatures of obviously "Eyckian" character which appear to antedate these manifestations of a belated eclecticism and so much surpass them in quality that it seemed justifiable to acclaim them as early works of the van Eycks themselves.

The first of these two series — designated as "Hand H" by Hulin de Loo who first pronounced both groups authentic works of the van Eyck brothers — comprises four large miniatures, one initial and two *bas-de-pages*.

1) The Lord Enthroned in a Ceremonial Tent, Worshiped by Angels (fig. 287). In the initial: a donor. In the *bas-de-page*: seven angels praying and making music.[2]

2) The Agony in the Garden (fig. 288). In the initial: the Flagellation of Christ (not by "Hand H"). In the *bas-de-page*: the Bearing of the Cross (not by "Hand H").[3]

3) The *Pietà* with St. John the Evangelist, the Magdalen and Mary Cleophas (fig. 289). No historiated initial. In the *bas-de-page*: the Queen of Sheba Wading through the River Cedron. This little miniature, surprisingly similar in iconography to Persian book illuminations, represents the Christian version of the same oriental legend that gave rise to the curious statues of the *Reine Pédauque* on Early Gothic cathedrals: Solomon, suspecting that the beautiful Queen had misshapen feet, worked magic to the effect that she believed the ground to be a body of water alive with fish and was thus compelled to lift her skirts when setting foot on it. According to this Christian version, she recognized the Tree of Life from which the Cross of Christ was to be fashioned, so that she was considered as the *typus* of St. Helena, and this explains her presence in our *bas-de-page* which, like the main miniature, belongs to an "*Oraison de la Vraie Croix.*"[4]

4) The Calvary (fig. 290). No historiated initial. In the *bas-de-page*: the Sacrifice of Isaac (not by "Hand H").[5]

The other series — "Hand G" according to Hulin de Loo — consists of seven large miniatures, five initials and six *bas-de-pages*.

1) The Betrayal of Christ (fig. 298). In the initial: the Agony in the Garden, according to Matthew XXVI, 39, and Mark XIV, 35. In the *bas-de-page*: the Denial of St. Peter and the Derision of Christ.[6]

2) St. Julian and His Wife Ferrying Christ over the Mouth of a River (fig. 296). In the initial: St. Julian Killing his Parents (not by "Hand G"). In the *bas-de-page*: St. Julian and the Stag (not by "Hand G"). St. Julian and St. Martha, patron saints of the Hospitalers, are invoked in one prayer because both were venerated, as stated in the prayer itself, as *pastores et hospitatores Christi*, St. Martha by reason of Luke X, 38, and John XI, 20, St. Julian by reason of his legend. In order to atone for the unwitting slaying of his parents, he and his wife devoted their lives to ferrying strangers over dangerous waters and befriending them in every way until one of their passengers — according to the best-known version of the legend, a leper whom St. Julian took in his own bed — revealed himself as Christ. The

general assumption that the woman in the ship is St. Martha is based only on the occurrence of her name in the prayer. But the two saints were never held to have been in personal contact, and in all analogous representations, e.g. in the *"Heures de Savoie"* and a later Horae in the Bibliothèque Nationale, it is always St. Julian's wife who, dressed as in our miniature, accompanies him and the Lord on their voyage. The scene in the *bas-de-page* refers to the legend according to which a stag pursued by the youthful St. Julian addressed him with the words: "How darest thou pursue me, thou who art destined to slay thy own father and mother."[1]

3) The *Virgo inter Virgines* (fig. 294). In the initial: St. Ursula (not by "Hand G"). In the *bas-de-page*: a throng of Holy Virgins worshiping the Lamb. This page would seem to be the earliest member of the "Hand G" series, for it is only here that the original border decoration of the fourteenth century was painstakingly erased and replaced by up-to-date acanthus *rinceaux* with drolleries — a risky and time-consuming experiment which was never repeated.[2]

4) The Prayer on the Shore (fig. 297): a prince on a white charger, accompanied by his *cortege* and welcomed by a great lady, her retinue and an old man who may represent the lower classes, offers prayers to God the Father Who appears in a glory. In the initial: Christ Blessing and the Dove of the Holy Spirit, supplementing the figure of God the Father in the main miniature. In the *bas-de-page*: a marshy landscape enlivened by cattle, three ladies (one of them kneeling), and two knights on horseback scanning the horizon as though looking out for the prince and his party. According to the authorities who had occasion to inspect the destroyed original, the banner showed the arms of Holland, Bavaria and the Hainaut, reversed on account of the banner's being turned about.[3]

5) The Birth of St. John the Baptist (fig. 299). In the initial: God the Father enthroned. In the *bas-de-page*: the Baptism of Christ, supplemented by the figure of God the Father in the initial.[4]

6) The Mass of the Dead (fig. 300). In the initial: the Last Judgment. In the *bas-de-page*: the Benediction of the Grave. The *chapelle ardente* displays the arms of Holland and the Hainaut.[5]

7) The Finding of the True Cross (fig. 295). In the initial: the Crucified Christ (assistant of "Hand G"). In the *bas-de-page*: Proof of the True Cross according to Paulinus of Nola (assistant of "Hand G").[6]

The miniatures of the "H" series are admittedly inferior to those of the "G" series in quality, and more important is the fact that they are less homogeneous in style. The brush work, the choice of color and such Morellian criteria as the treatment of faces, hands, hair, and even rocks clearly indicate one and the same hand; but this hand was employed in the service of different modes of expression and imagination. The sharpest distinction exists between the "Lord Enthroned," the *"Pietà"* and the "Agony in the Garden," on the one hand, and the "Calvary," on the other. In the three former miniatures, the foreground is densely filled with massive forms, the figures are stockily robust, and the over-abundant garments break into

angular, crumpled folds the profusion of which exaggerates — and therefore presupposes — the drapery style of the Mérode altarpiece and the "Rolin Madonna." The "Calvary," on the contrary, induces a sense of spaciousness and delicacy. The scene is laid on a wide tableland overlooking the *Häusermeer* of Jerusalem; the figures — the Virgin Mary almost motionless, the St. John, in spite of his contorted face and twisted hands, nobly restrained — are tall and slender; the folds of their robes are as daintily sculptured as those of the Holy Virgins in the Ghent altarpiece.

However, while this "Calvary" is in a class by itself, the style of the three other miniatures is not homogeneous either. The "Agony in the Garden" depends so exclusively on Jan van Eyck that it may well be a copy of a lost original. The style of the "Lord Enthroned" and the "*Pietà*," however, derives from two different sources: here Eyckian features commingle with elements as distinctly Flémallesque as the angels and the tent in the "Lord Enthroned" (compare the "Seilern triptych," the Leningrad "Trinity" and the *Sacra Conversazione* drawing in the Louvre) or the St. John supporting Our Lady in the "*Pietà*," a figure anticipated in the Master of Flémalle's "Descent from the Cross" and paralleled in several compositions from the circle of Roger van der Weyden.

The only possible conclusion is that the "Hand H" miniatures, not datable by external evidence, were produced by an artist who was an imitator rather than an inventor; who, while essentially a follower of Jan van Eyck, was also open to Tournaisian influences; who was not active until *ca.* 1440–1445; and who exploited models of different date. That this artist was Petrus Christus, who answers this description very well and in his Metropolitan Museum "Lamentation" (not to mention a somewhat doubtful "*Pietà*" in the Louvre) comes fairly close to the Turin "*Pietà*," is difficult to prove and not too probable.[1] The only thing we know for sure is that the "Calvary" in the "Turin-Milan Hours" is a close copy of an Eyckian original more famous and considerably earlier than are the models of the three other miniatures, including the "Agony in the Garden" — an original which seems to have been exported to Italy not later than *ca.* 1430 and courted imitation abroad as well as at home. In addition to our miniature, it was literally copied in a Flemish painting in the Cà d'Oro at Venice (fig. 291) and in an Italian panel preserved in the Museo Civico at Padua. It was freely adapted by a Mantegnesque master, allegedly Nicola di Maestro Antonio, in a picture in the Venice Accademia (fig. 292),[2] and its magnificent cityscape seems to have exerted some influence, as early as between 1428 and 1435, upon a fresco by Masolino da Panicale.[3]

In contrast to the somewhat heavy-handed, heterogeneous and derivative style of the "H" series, the "Hand G" miniatures give the impression of sophistication, consistency and, most important, sovereign originality; none of them has thus far been exposed as a copy, and none of them ever will be. The problem which they present lies in their very perfection; they preserve the charm — and remain subject to the limitations — of the International Style while apparently transcending the possibilities of even the van Eycks.

The slim, graceful figures "weigh little on the earth." Their draperies, soft and clinging rather than bulky, retain much of the curvilinear fluency so characteristic of the period about

1400. The perspective, though efficacious and free from exaggerations *à la* Master of Flémalle, is distinctly primitive, as can be seen, for example, in the "Birth of St. John" where the vanishing lines of the ceiling converge while those of the chest and table do not. And the architecture of the otherwise so modern "Mass of the Dead" projects, after the fashion of so many earlier illuminations, beyond the upper margin of the miniature. But in spite of these retrospective features, the "Hand G" miniatures convey an experience of space in all its aspects — expanse and limitation, unity and multiplicity, color and light — the like of which cannot be derived from anything before the seventeenth century.

Except in the "*Virgo inter Virgines*" and the "Finding of the True Cross," the figures, even if occupying the foreground, are small in relation to their surroundings, as if scaled down to their environment instead of the environment being scaled down to them. The plastic volume is minimized in favor of chiaroscuro effects and tonal contrasts as when the horse of the prince in the "Prayer on the Shore" stands out from its surroundings as a flat patch of white; or when, conversely, the figures in the "Baptism of Christ" — so tiny that we are tempted to speak of a "landscape with *staffage*" rather than a scene — are silhouetted against the blinding light on the river. Reflections on quiet waters, the choppy waves of an estuary and the long breakers on the ocean beach, highlights on shining objects and the penumbra beneath a piece of furniture: all this is studied with a contagious *joie de peindre*. And where the "Betrayal" and the "Crucifixion" in the "*Très Riches Heures*" had been "nocturnes negative" (if I may coin this phrase), that is to say, pictures giving the effect of night by virtue of having no color at all,[1] the "Betrayal" in the "Turin-Milan Hours" is a "nocturne positive," giving the effect of night by virtue of having colors different from those of day.

The prospect through three consecutive rooms in the "Birth of St. John" has justly been hailed as an anticipation of Pieter de Hooch, while the "Mass of the Dead" has been compared, with equal right, to the vast church interiors by Emmanuel de Witte,[2] a comparison which may be extended even to the use of figures (accompanied by little dogs) seen from the back. In the works of the Master of Flémalle such figures are dynamic rather than contemplative, "spearheading" as I expressed it, "the beholder's advance into depth"; in the "Mass of the Dead," as in the de Witte paintings, they invite us to share their mood of quiet, overawed absorption in a visual experience. And if the two sea pieces in the "Turin-Milan Hours" seem to foreshadow the marine pictures of Simon de Vlieger or Jan van de Capelle, such *bas-de-pages* as the "Benediction of the Grave" and the "Watch on the Marshes," their figures towering above a low horizon at which, quite literally, "earth and sky appear to meet," may be considered the only true flat landscapes before the times of Philips de Koninck and Hercules Seghers.

The style of the "Hand G" miniatures, then, is at once more deeply committed to the past and more prophetic of the future than any other phenomenon in the history of art. There is nothing like them in fifteenth-century painting except for a number of other compositions commonly ascribed to "Hand G" itself.

Setting aside a "Crucifixion" (fig. 293) in the Kaiser Friedrich Museum (which I still consider as a pastiche based on the archetype that underlies the "Calvary" in the "Turin-Milan

Hours" and its relatives),[1] two of these compositions — all presumably panel paintings like the original "Calvary" — are, I believe, authentic but have not come down to us in the original. One is a many-figured "Bearing of the Cross" precariously reconstructible from one of the later miniatures in the "Turin-Milan Hours," one or two drawings and a number of paintings (figs. 304, 305).[2] Based upon the grand, epic tradition of the Trecento,[3] it was to stimulate the imaginations of Schongauer, Dürer and Raphael.[4] The other is an "Adoration of the Magi" transmitted primarily through a pen drawing on vellum in the Kupferstichkabinett at Berlin (fig. 302) which gives the impression of a careful workshop record rather than either an ordinary copy or a preliminary study;[5] and, secondarily, through no less than five provincial miniatures, the earliest by the Master of Zweder van Culemborg, the second — datable 1438 — by the Arenberg Master (fig. 128), the last by an anonymous Dutch illuminator of *ca.* 1465.[6]

This "Adoration of the Magi" draws from the same French and Franco-Flemish sources which were exploited by the German representatives of the International Style, especially Master Francke. The composition was established, in nuclear form, in the circle of the Limbourg brothers;[7] its elaboration into a dramatic contrast between gorgeousness and rusticity recalls the "*Très Riches Heures*"; and the impressive figure of the young King clad in a fur-trimmed, trailing gown and seen from the back in three-quarter view occurs in France as early as 1402.[8] But to feature the animals as co-stars, as it were, to develop the shed into an enormous *repoussoir* in front of a wide, hilly landscape, and to make the Magi's retinue emerge from a deep gorge is as original as it is "modern." All these enchanting novelties were significantly omitted by the imitators, and so was the key idea of the composition, not to be fully understood until Hugo van der Goes, the idea of moving the entire central group well back into the picture space and thus to build the whole configuration around a void.

It is tempting to assume that the painting reproduced in the Berlin drawing was once united with two tall panels in the Metropolitan Museum, a richly orchestrated "Calvary" and a stupendous "Last Judgment" (figs. 301, 303).[9] Transferred from wood to canvas but retaining their original frames inscribed with long quotations from Isaiah, Revelation and Deuteronomy, they have long been attributed to "Hand G" and this attribution cannot be doubted in view of such striking analogies as exist between the Christ in the "Last Judgment" and the Christ in the Turin "Betrayal," between the interceding Virgin Mary and the saint with a prayer book in the *Virgo inter Virgines* miniature, between the sea that "gives up the dead which were in it" and the waves and surf in the "Prayer on the Shore" and the "Crossing of St. Julian." In 1841, when still belonging to a Russian count named Tatistcheff, the New York pictures were inspected by one of the most distinguished art historians of the time, Johann David Passavant, and Tatistcheff told his guest that they were the wings of a triptych the central panel of which represented the Adoration of the Magi but had unfortunately been stolen by a servant some time before Passavant's visit. Could it be that the Berlin drawing reflects this very "Adoration"? Its proportions (14.7 cm. by 12 cm.) correspond exactly to those of the missing central panel, which must have measured 56.5 cm. by 46 cm., and its skyline would be approximately continuous with that of the New York "Calvary" and "Last Judgment."[10]

Attractive though this theory may appear, it is open to question on esthetic as well as iconographic grounds. The style of the "Adoration of the Magi" seems somewhat earlier than that of the Metropolitan Museum panels and the scale of its figures is considerably larger. But more important is the fact that we know of no other triptych showing the Calvary and the Last Judgment on either side of an Adoration of the Magi, a combination conflicting with the chronology of the scenes and hardly justifiable even by symbolical considerations; whereas we do know that the Calvary and the Last Judgment were often represented in direct juxtaposition, and that a diptych of this description was left by the Duc de Berry in 1416.[1] Even assuming that Tatistcheff's account was correct, the stolen "Adoration of the Magi" may easily have been a later insertion, made at a time less sensitive to iconographic conventions. I am, therefore, inclined to believe that the Metropolitan Museum panels were conceived as a diptych from the outset,[2] a diptych which, like that owned by the Duc de Berry, directly contrasted the Sacrifice of Christ with the consummation of its purpose.

Be that as it may, the juxtaposition of the "Last Judgment" with a "Calvary" which, painted on an equally tall and narrow panel, is sharply divided into two zones — the upper showing the crosses and a dense crowd of callous soldiers and dignitaries, the lower the grieving Virgin comforted by St. John, the two other Marys, the Magdalen wringing her hands and the lone figure of an elderly woman in semi-oriental dress whose enigmatic presence will be accounted for shortly — entailed a number of peculiar deviations from customary iconography. Instead of being based upon a division according to right and left, the composition is here based upon a division according to above and below; so that the words "Venite benedicti patris mei" appear twice on either side of Christ while the "Ite vos maledicti in ignem eternum" is similarly repeated in the lower zone. Instead of being segregated from the Damned on the same level, the great majority of the Elect is already admitted to Heaven and grouped around "the Twelve Apostles on the twelve seats of their glory." With the Community of the Saints, including the First Parents, nearly assembled, and the Virgin Martyrs marching down the aisle between the seats of the Apostles, the upper part of the picture constitutes an *Allerheiligenbild* rather than the top section of a normal Last Judgment: the whole illustrates, so to speak, not only the twenty-first chapter of St. Augustine's *De Civitate Dei*, which deals with the Last Judgment, but also the twenty-second which, we remember, describes the "Eternal Beatitude of the City of God and the Perpetual Sabbath."

This *Tabernaculum Dei cum hominibus*, to quote from the inscription on the frame, is poised like an enchanting vision above a spectacle as horrifying as any canto in Dante or Milton. A barren earth and an angry sea give up their dead. A youthful, brilliantly armored St. Michael, sword drawn and legs astraddle, controls the Specter of Death, a giant skeleton that seems to rush toward the beholder in head-on foreshortening and stares at us with sightless eyes. Its bat wings, inscribed with the words CHAOS MAGNV and VMBRA MORTIS are stretched throughout the width of the picture so as to separate, most literally, the realm of light from the "mist of darkness," and the droves of the Damned plummet headlong into the pit to fall prey to hideous demons who merge with their victims in a seething mass of tortured

confusion. To compare this evocation of the Abyss with the phantasmagorias of Jerome Bosch is saying too much and too little; conceived by a mind profoundly sane and optimistic, its horrors are not dreamt but seen. Bosch's Paradise has fundamentally the same weird, nightmarish quality as his Hell. In the New York "Last Judgment," both Hell and Paradise are, each within its sphere, supremely real.

<div align="center">IX</div>

Given the "Eyckian" character of both the "Hand H" and the "Hand G" group, and given the latter's relation, established by heraldic evidence, to the dynasty of Holland-Bavaria and the Hainaut, three hypotheses have been proposed:

First: "Hand G" is supposed to be identical with Hubert van Eyck and "Hand H" with Jan. And since the "Prayer on the Shore" seems to refer to an important event in the life of William VI — either his perilous journey from England to Holland in 1416, the happy outcome of which was hailed as a miracle or, alternatively, his and his father's, Albrecht's, victory over the Frisians in 1398 — both groups are held to antedate William's death on May 31, 1417.[1]

Second: "Hand G" is supposed to be identical with Jan, not Hubert, van Eyck, and "Hand H" with a disciple or imitator of Jan, possibly but not necessarily Petrus Christus.[2]

Third: "Hand G" is supposed to be identical with a Dutch artist active in the early 'thirties (the *terminus ante quem* being established by the extinction of the dynasty with the death of William VI's daughter, Jacqueline, on October 9, 1436) whereas "Hand H" is thought to be identical with a follower of either Hubert or, preferably, Jan van Eyck.[3]

Of these hypotheses the first has already been disposed of as far as the identification of "Hand H" with Jan van Eyck is concerned. We have seen that the "Hand H" miniatures cannot possibly be dated prior to *ca.* 1440–1445 and cannot possibly be assigned to a master of the first rank. And if Jan is not responsible for the inferior productions of "Hand H" there is no earthly reason why Hubert rather than he should be credited with the superior achievements of "Hand G." As far as is known, Hubert van Eyck had no contact with either William VI or any other member of the Holland-Bavaria family whereas Jan, we remember, served William's wicked brother, John, from at least 1422 to 1424. And all the concrete "motifs," however irrelevant, by which the history of art establishes "connections" between its objects turn out to link "Hand G" to works of Jan and not of Hubert.

All differences in style notwithstanding, the group of maidens in the *bas-de-page* of the *Virgo inter Virgines* is as closely akin to the Virgin Martyrs adoring the Lamb in the Ghent altarpiece as is the charger in the "Prayer on the Shore" to the white horse in the Just Judges panel which hardly anyone attributes to Hubert.[4] The Gothic basilica in the "Mass of the Dead" as unmistakably resembles, again all differences in style notwithstanding, that in the "Madonna in a Church" as does the bedroom in the "Birth of St. John" the nuptial chamber of the Arnolfinis.[5] The St. Michael in the New York "Last Judgment" looks like a younger brother of his namesake in the Dresden triptych, and his buckler is inscribed with similar

<div align="center">239</div>

cabalistic inscriptions, among them ADONAY and AGLA, as is the shield of St. Sebastian in the Ghent altarpiece. The hitherto unexplained woman on the extreme right of the New York "Calvary," finally, observing the grief-stricken group around the Virgin Mary with a compassionate yet mysteriously knowing expression and joining her hands in a gesture of meditation, wears the same soberly exotic costume (a white turban with a long veil in back, completed by a black woolen scarf knotted at the throat) as does, again in the Ghent altarpiece, the Erythrean Sibyl.[1] In fact, she *is* the Erythrean Sibyl, for many centuries the only one to play a solo part in art, on the mystery stage and in liturgy. Recognized by St. Augustine as the author of the *Versus de die judicii* ("Judicii signum tellus sudore madescit . . ."), the "nobilissima Eryctea" not only kept her place in the *Dies irae* which, from the end of the fourteenth century, supplanted this *Versus* in the Requiem, but also remained the heroine of the pseudo-Augustinian sermon "Vos, inquam, convenite, o Judaei" which once formed part of the Christmas service. And she owes her privileged status in this long tradition to the same fact which justifies her appearance in the New York diptych (and, incidentally, confirms the assumption that it was always intended to be a diptych): her prophecy, and hers alone, refers to both the Life and Passion of Christ and the Last Judgment.[2]

There remain, then, the second and the third hypotheses which constitute the case of the youthful Jan van Eyck *vs.* a Dutchman active about 1430–1435. And some aspects of this case — which naturally hinges upon the date of the "Hand G" miniatures and, more specifically, upon their priority or posteriority in relation to the Ghent altarpiece — have been debated in a manner that invites presentation according to the scholastic scheme of proposition, objection and reply: *Videtur quod, Sed contra* and *Respondeo dicendum.*

Videtur quod: the "Prayer at the Shore" commemorates either William VI's youthful exploits in the battle against the Frisians or his miraculous escape from shipwreck and therefore antedates his death in 1417. *Sed contra*: the miniature, illustrating the "prayer of a sovereign prince," does not refer to any historical event but merely interprets and naturalistically elaborates the prayer itself on the basis of Psalm LXVIII (LXIX) which asks for deliverance from various dangers, among them the "waterflood" and "deep waters,"[3] and promises "to magnify God with thanksgiving" if this request be granted. *Respondeo dicendum*: it seems too much of a coincidence that an illuminator confronted with the task of illustrating a prayer in which no specific mention is made of the dangers of the sea should have hit upon the Sixty-eighth Psalm, and have derived therefrom a scene of thanksgiving and welcome on the shore, had he not remembered a definite watery incident from actual history. But this, of course, does not prove that this incident must have been the wonderful preservation of William VI; nor, if so, that the miniature must antedate his death. Even if it does refer to his preservation, it may well have been ordered as a memorial, as it were, by his brother or daughter.

Videtur quod: William's beautiful white horse is a direct ancestor, still showing the gracile elegance of the International Style, of the mighty animal in the Just Judges panel of the Ghent altarpiece. *Sed contra*: the illuminator was already familiar with but misinterpreted the rider in the Ghent altarpiece because he showed the horse beautifully collected although the hands of

the prince are joined in prayer and neither of them is free to hold the bridle.[1] *Respondeo dicendum*: the carriage of a horse can and should be controlled by the legs rather than the reins which, if the rider uses both hands (as in countless representations of St. George fighting the dragon, St. Martin dividing his mantle or Longinus thrusting his lance into the side of the crucified Christ), are either dropped on the withers or fastened to the pommel of the saddle. In the present case, the curb — as taut as, for example, that of St. Martin's horse in Butinone's and Zenale's well-known altarpiece in Treviglio Cathedral — is obviously fastened in this way whereas the snaffle, reduced to a thin line curving behind the curb, is allowed to hang loose.[2] But while this equestrian analysis refutes the objection according to which the "Prayer on the Shore" presupposes the "Just Judges," it does not necessarily prove the proposition.

Videtur quod: the *bas-de-page* of the *Virgo inter Virgines* page precedes and anticipates the Ghent altarpiece because the maidens — not Martyrs but just *Sanctae Virgines* and therefore carrying prayer books instead of palms — still proceed in an isocephalic file instead of forming what I have termed a "compact, space-displacing body" and because its individual members are still ethereal and Limbourgesque. *Sed contra*: the miniature depends upon the Ghent altarpiece because the Lamb illogically turns His back upon the worshippers whereas, in the Ghent altarpiece, He is symmetrically placed between two groups.[3] *Respondeo dicendum*: the *bas-de-page* in the "Turin-Milan Hours" may derive, not from the Ghent altarpiece but from earlier prototypes such as the "old style" All Saints pictures repeatedly referred to above [4] or, as the Lamb is placed on a hill instead of an altar, from the numerous illustrations of Revelation XIV, 1 ("I looked and, lo, a Lamb stood on Mount Sion"). In representations of this kind the women, if present, are always relegated to the "sinister" side, facing the rear part of the Lamb, and the little procession in our *bas-de-page*, illustrating a prayer exclusively addressed to the Holy Virgins, may just as well be a partial copy, thoroughly modernized, of a Gothic or even pre-Gothic miniature as a partial copy, retranslated into a more archaic idiom, of the "Adoration of the Lamb" in the Ghent altarpiece.[5] But would not the illuminator have been guilty, in either case, of thoughtlessness in not reversing the Lamb while eliminating the worshippers in front of Him? This is, it seems to me, by no means as certain as has been assumed. In turning His back upon the Virgins, the Lamb turns His head toward the St. Ursula in the initial which, as in the case of the "Baptism," demands to be read together with the *bas-de-page*. In addition, and this is even more important, in appearing behind rather than in front of the Lamb, the Virgins form a procession that seems to have followed Him. And a procession like this is circumstantially described in a famous late-fourteenth-century poem the spirit of which has justly been compared to that of Eyckian art: "In wondrous manner," we read in *The Pearl*, "I was suddenly aware of a procession. The noble city of glory and splendor was suddenly filled with virgins, all unsummoned . . . Hard was it to find the gladdest face among them. *Before them walked the Lamb in state* . . . and, though great was their number, there was no crowding among them, but mild as gentle maidens at Mass so walked they forth in perfect joy." [6] It is, therefore, not possible to prove or disprove the priority of either the miniature or the Ghent altarpiece on grounds of logical consistency.

This scholastic discussion could be prolonged *ad infinitum* without achieving conclusive results, and the margin between the earliest and the latest possible date is too close to decide the question on the external evidence of costumes and armor. The really fundamental objection to the attribution of the "Hand G" miniatures to the youthful Jan van Eyck, and the basic reason for dating them in the 'thirties, is that there exists nothing remotely comparable to them before 1417, when William VI died, nor even before 1424, when Jan left the employ of William's brother, John. But the trouble is that there is nothing remotely comparable to them after 1424 either, and least of all in Holland.

In the 'thirties, as has become apparent over and over again, book illumination had lost its impetus everywhere. Dutch book illumination in particular — so carefully studied that major surprises can hardly be expected — had either sunk to the level of stereotyped repetition or else resorted to the imitation of Flemish panel painting, as did precisely the most progressive illuminators, the Master of Zweder van Culemborg and the Arenberg Master. Their works, significantly exploiting Flémallesque as well as Eyckian originals, represent the optimum of Dutch illumination in the fourth decade of the fifteenth century, and not for a moment could they be mistaken for anticipations rather than derivatives of their Flemish models. They prove, moreover, the fallacy of what may be called the *argumentum ex effectu*. It has been said that the "Hand G" group must be Dutch because it was extensively imitated in Holland.[1] But since the copying of Flemish models had become a general practice in Holland from *ca.* 1435, the Dutch repercussions of, say, the "Adoration of the Magi" by "Hand G" do not prove any more about its place of origin than do the repercussions of, say, the Ghent altarpiece in the "Breviary of Renaud IV of Guelders" (fig. 126)[2] or those of the Master of Flémalle's "Descent from the Cross" and "Crucifixion" in the "Arenberg Hours" (figs. 129, 130).[3] It should also be noted that, conversely, the "Birth of St. John" in the "Turin-Milan Hours" made a profound impression on the mature Roger van der Weyden,[4] that the New York "Last Judgment" was freely copied by Petrus Christus as late as 1452 (fig. 410),[5] and that the influence of the New York "Calvary" and the lost "Bearing of the Cross" reached as far as Valencia.[6]

The sad fact is that the works of "Hand G" are parachronistic no matter whether we date them as early or as late as possible (their *terminus ante quem*, we repeat, being the death of Jacqueline in 1436). Even when dated in the 'thirties — or, rather, just when dated in the 'thirties — they would be understandable only as works of a great genius. And if this great genius — who, at the same time, supposedly "misunderstood" the Ghent altarpiece — has been identified with Albert van Ouwater, this identification is inadmissible on purely historical grounds.

It is a matter of record that Ouwater was the founder of the School of Haarlem and we have no reason to doubt that he excelled in the domain of landscape painting.[7] But the assumption that this school flourished as early as about 1430–1435 has no basis in fact. In the field of book illumination, production was largely centered in Utrecht, and nothing is known of artistic activities at Haarlem except that, up to 1439, even the polychroming of carved altarpieces had to be taken care of by artisans called in from Brussels.[8] The existence of a progressive

school of painting at Haarlem prior to the second half of the century is vouched for exclusively by Carel van Mander, and his trustworthiness is more than suspect. Writing in 1604, the "Dutch Vasari" frankly admits his intention to prove that modern oil painting was as old in his beloved Haarlem as it was in Bruges or Brussels. With this end in mind, he claims that Ouwater was a contemporary of Jan van Eyck, basing this claim upon the tale of an old gentleman who had heard from a still older gentleman that Ouwater's famous pupil, Geertgen tot Sint Jans, was no longer alive as early as *ca.* 1474.[1] We know, however, by reason of stylistic and historical evidence, that Geertgen's activity must have extended up to at least 1485;[2] and even if the old gentlemen had been correct, van Mander's conclusions as to Ouwater's lifetime would be invalidated by the only authentic document referring to the latter; he is known to have buried a daughter of unrecorded but apparently not too advanced age (if she had been a married woman or a nun her father would not have taken care of the funeral) as late as 1467, twenty-six years after the death of Jan van Eyck.[3]

Ouwater, then, was not Jan's contemporary but belonged to a younger generation, and this is indirectly confirmed by van Mander himself. For, he attributes to Ouwater a "Raising of Lazarus" which he describes at great length and which agrees, down to the minutest detail, with a picture now preserved in the Kaiser Friedrich Museum at Berlin (fig. 435) — a picture which cannot possibly antedate the middle of the century and has nothing whatever in common with the works of "Hand G." Those bent on identifying "Hand G" with Ouwater must either claim that Ouwater was not the author of the "Raising of Lazarus" described by van Mander; or, that the "Raising of Lazarus" described by van Mander is not identical with the picture preserved at Berlin. But both these theories are hardly tenable. There is no reason to adopt van Mander's chronology while rejecting his attribution; needless to say, a patriotic biographer can more safely be trusted with the identification of a local picture which he describes with meticulous accuracy than with the wishful dating of a local artist whom he admittedly attempted to make as early as possible. And the existence of another picture "similar" to that described by van Mander[4] is more than unlikely. As will be demonstrated in the last Chapter, the composition itemized by van Mander represents so bold and unique a departure from the accepted interpretation of the Lazarus theme that no two pictures of the same kind can be presumed to have been produced by different artists.[5]

With Hubert disqualified at the start and Albert van Ouwater eliminated in the running, the contest for the laurels of "Hand G" thus narrows down to a race between an unknown genius — presumably a genius Flemish rather than Dutch — and Jan van Eyck; and no one, I think, can be blamed for backing the latter. Had Dürer's "Apocalypse" and its relatives come down to us undated and unsigned, we should be faced with an analogous dilemma. They, too, would appear to be linked to the accepted *oeuvre* of a great master yet strike us as "different" in many respects; they, too, would seem to be incredibly advanced and yet somehow archaic; they, too, would have no parallel in the entire domain of German woodcut production in the fifteenth century. We should be forced either to postulate a Great Anonym — or to ascribe them to young Dürer.

As has been pointed out by Miss Bella Martens, the celebrated white horse in the "Prayer on the Shore" derives in gait and conformation from an animal like that in the *Livre des merveilles* from the Boucicaut workshop (fig. 77),[1] and similar connections can be observed throughout the works of "Hand G." The Gothic basilica in the "Mass of the Dead," seen in "eccentric" perspective and embellished by a meander pavement, derives from such ecclesiastical interiors (fig. 70) as have been mentioned in connection with Jan van Eyck's "Madonna in a Church" plus the "Ypres tradition."[2] The domestic setting of the "Birth of St. John" stems from those little suites which can be seen in the Boucicaut Master's Bourges Lectionary (fig. 71).[3] The woman at the foot of the bed, seen from the back, might have been inspired by the shepherdess in the July picture of the "*Très Riches Heures*,"[4] and the perspective arrangement of the Elders in the "Vision of St. John on Patmos" in this famous manuscript (fig. 83) would seem to have served as a model for that in the New York "Last Judgment" which, in addition, may have been influenced by the eschatological scenes devised by the Bedford Master and his associates.[5]

It is, however, not only in such individual motifs that the works of "Hand G" hark back to the art of the recent past. Some of the most amazing qualities of the "Turin-Milan Hours," qualities that seem beyond the reach of any artist prior to *ca.* 1430 — or, for that matter, any artist of the fifteenth century — can be interpreted as a climactic and, as it were, one-sided development of tendencies inherent in the International Style but later subdued in favor of that classic equilibrium which is the signature of full-fledged Early Flemish naturalism. The miniatures of the Boucicaut Master often show the same almost impressionistic looseness and luminosity of treatment which strikes us as so "modern" in the works of "Hand G." Some of the figures in the Calendar pictures of the "*Très Riches Heures*" are even smaller in relation to their surroundings than those in the "Birth of St. John." And those amazing *bas-de-pages* which seem to anticipate the flat landscapes of the seventeenth century are not inexplicable if considered, not in the general context of "landscape painting" but in the specific context of "*bas-de-page* decoration."

At the beginning of the fourteenth century, the figures in a *bas-de-page* had been arrayed upon the bottom *rinceaux*, and even after the introduction of perspective their standing plane continued to be conceived as a mere adjunct or extension of these bottom *rinceaux*, that is to say, as a receding but extremely narrow strip of terrain permitting the figures to stand out against the vellum ground. The earlier miniatures in the "*Très Belles Heures de Notre Dame*" itself offer a number of telling examples (fig. 39). It is only by a daring yet perfectly logical extension of this principle — the vellum ground transformed into natural sky and the horizon of the standing plane moved back without being appreciably raised — that miracles such as the "Benediction of the Grave" and the "Watch on the Marshes" came into being.

What applies to the apparent modernity of the *bas-de-pages*, applies *mutatis mutandis* to the large miniatures. Compared with the London Arnolfini portrait, the "Birth of St. John"

gives the impression of modernity only because size and volume are sacrificed at the altar of spaciousness — because the artist was as yet unable to combine pictorialism and plasticity by fully developing the figures while cutting down the space on all sides; and the same is true, to an even greater degree, of the "Mass of the Dead" as compared to the "Madonna in a Church."

While these two ecclesiastical interiors are generally similar, the church in the "Mass of the Dead" is not only simpler in concept (its apse lacking a triforium as well as an ambulatory) but also, significantly, different in style. Where the "Madonna in a Church" exhibits in the arcades and triforium of the nave those sturdy, plastic thirteenth-century forms which go so well with the voluminousness of the huge figure, the church in the "Mass of the Dead" is built throughout in the thin, fibrous style of the late fourteenth or early fifteenth century; so that the capital-less piers give the impression of clustered streaks of light and shade rather than clustered colonnettes. And where the "Madonna in a Church" transports the beholder into an interior which ideally transcends the frame as well as the picture plane, the "Mass of the Dead" arrests us in front of a structure which, though materially projecting beyond the upper margin, is entirely contained within the pictorial space. Under the pretext — perhaps suggested by miniatures in the *"Très Riches Heures"* [1] — that the building is under construction, the illuminator places us in front of a basilica still lacking its transept (note the unfinished vaults of the crossing and the raw brick of the western transept wall). In spite of its deceptively modern appearance, the church in the "Mass of the Dead" is nothing but a most original and, by the apparently incomplete state of the building, well-motivated version of the good old "doll's house" interior, and its tremendous triumphal arch is nothing but a "diaphragm" in naturalistic disguise.

It is thus easier to conceive of the "Birth of St. John" as a prelude to the Arnolfini portrait, and of the "Mass of the Dead" as a prelude to the "Madonna in a Church," than to imagine the "Birth of St. John" as a postscript to the Arnolfini portrait and the "Mass of the Dead" as a postscript to the "Madonna in a Church." And this applies, incidentally, to iconography as well as to style. As the domestic interior was at home, so to speak, in representations of such subjects as the Birth of the Virgin or the Birth of St. John and was subsequently transferred to a portrait, so was the ecclesiastical interior, seen in eccentric perspective, at home in representations of the Funeral Offices and was subsequently transferred to the Madonna.

In fine, the style of the "Hand G" miniatures may well be interpreted as a preliminary phase of that which we know from the authenticated works of Jan van Eyck. Even in these, we could observe a development from intimacy and liveliness to austere solemnity, from sparking variety to geometric simplicity, from spaciousness to plastic concentration. The works of "Hand G" — which, if by Jan, would seem to date from his documented employment by John of Holland, viz., between 1422 or somewhat earlier and 1424, rather than from a hypothetical activity under William VI [2] — carry the tendencies of his youth to greater lengths than do the "Madonna in a Church" and the Dresden altarpiece; but they contradict the style of his maturity no more than does Dürer's "Apocalypse" the "Melencolia I." They may be said to represent the fluid out of which the solid form of Jan's accepted works was to

crystallize. And if the grief of the St. John in the lost "Calvary" and the convulsions of mental anguish and physical suffering that horrify us in the New York "Last Judgment" seem incompatible with the tranquil temper of Jan's later years, we should bear in mind that this tranquillity resulted from the rigorous control, and not from the absence, of passion. Toned down to bitter concentration, the emotional intensity of the St. John still smoulders in the faces of the Martyrs in the "Adoration of the Lamb," and the amazing Abel in the Ghent altarpiece — posed like an antique Endymion or an Early Christian Jonah but almost Mantegnesque in modeling and expression [1] — screams no less horribly than do the Damned in the New York "Last Judgment."

IX

ROGER VAN DER WEYDEN

Roger van der Weyden [1] was born, we recall, at Tournai in 1399 or 1400, the son of a master cutler named Henry. Nothing is known of his boyhood and early youth except that he was not at Tournai on March 18, 1426, when the house of his father, recently deceased, was sold without his participation. In the same year he married (as can be concluded from the fact that his first child, a son named Corneille, was eight years old in 1435), and this marriage, too, would seem to have taken place outside Tournai: his bride, Elizabeth Goffaerts, hailed from Brussels. Her mother, Cathelyne, however, bore the same family name, van Stockem, as did the long-suffering wife of Robert Campin, and this very fact lends further support to the assumption that it was the latter, alias the Master of Flémalle, whose workshop Roger entered on March 5, 1427, and left as "Maistre Rogier" on August 1, 1432.

Where the young master turned immediately upon his "graduation" is unknown. Certain it is, however, that he was most successful from the outset and ultimately settled in the native city of his wife. As early as October 20, 1435, he was able to invest a considerable sum of money in Tournai securities, and on May 20, 1436, the city fathers of Brussels resolved not to fill the position of City Painter ("Portrater der stad van Brussel" or "der stad scildere") after Roger's death [2] — a resolution from which we learn that this position was his at the time and may infer that it had been especially created for him not long before. Whether he was appointed for the express purpose of supplying the courtroom of the Town Hall with the "Examples of Justice" that were to delight eight generations of travelers is not known. Certain it is, however, that these four celebrated panels are not mentioned until 1441, and that the first pair of them was not completed until 1439.[3] It was about this time that he was granted the privilege of wearing the same particolored cloak (*derdendeel*) as did the "geswoerene knapen" of the city of Brussels.[4]

Internationally famed and financially prosperous (further purchases of Tournai securities are recorded for 1436–1437, 1442 and 1445, and in 1449 he gave 400 crowns to Corneille who wished to enter the Charterhouse of Hérinnes), Roger van der Weyden represents, perhaps even more paradigmatically than Jan van Eyck, the novel type of bourgeois genius. Though honored by princes and dignitaries at home and abroad, he lived the dignified and uneventful life of a good citizen charitable to the poor, generous to religious institutions, intent

247

upon the welfare of his community, and solicitously providing for his wife and children.[1] He received splendid commissions from Spain and Italy, yet did not disdain to polychrome and emblazon a stone relief in the Minorites' Church [2] or to attend to the coloring of twenty-four brass statuettes.[3] And except for occasional business trips and a pilgrimage to Italy in the Holy Year of 1450, nothing seems to have interrupted his quiet, laborious life until it ended on June 18, 1464.

Of Roger's personality we know little more than that he was a man of integrity and rare unselfishness. It was to him that people turned as an arbitrator when a dispute arose between a fellow painter and his clients.[4] On May 7, 1463, the Duchess of Milan, Bianca Visconti, effusively thanked her "noble and beloved master Roger of Tournai, painter in Brussels" for the courtesy and kindness which he had shown to her young protégé, Zanetto Bugatto, and the unstinting generosity with which he had instructed him "in everything he knew about his art." [5] And in 1459 the Abbot of St.-Aubert at Cambrai noted with gratification that Roger had improved and considerably enlarged the stipulated dimensions of an altarpiece commissioned in 1455 "pour le bien de l'oeure." [6] These are small things, perhaps, in themselves, but not quite usual at a time when painters were secretive about their methods and even the greatest were paid according to working hours and the cost of materials used.

Happily such scanty records are supplemented, and corroborated, by two portraits which, however inadequately, inform us of Roger's physical appearance. His features are known, first, from an inscribed drawing in the "Recueil d'Arras" (fig. 389); and, second, from his self-portrait in one of the "Examples of Justice" which is transmitted to us through the Berne tapestry to which we shall shortly turn (fig. 388). In spite of the indifferent quality of the Arras drawing and the inevitable distortion of the woven copy, we feel at once that we are in the presence of greatness, and this impression is borne out by no less illustrious a witness than Nicolaus Cusanus. In an attempt to describe the way in which God looks at the world, the Cardinal refers to "that face of the outstanding painter Roger in the most precious picture preserved in the Town Hall at Brussels" (*facies illa . . . Bruxellis rogeri maximi pictoris in preciosissima tabula quae in praetorio habetur*). Though a motionless image, he says, this face seems to pursue the beholder with its glance wherever he goes as does the eye of God which observes the human being "wherever he may be" and is fixed on him "as though on him alone." After an established custom of medieval scholasticism, Cusanus endeavored to carry the mind of his readers to that which is divine by means of a *similitudo* taken from human activity. But he might not have chosen this particular simile had his imagination not been stirred by this thoughtful, deadly-serious face with deep, bitter folds around a wide, generous mouth and enormous, visionary, indeed inescapable eyes.[7]

II

"Jan van Eyck," Max J. Friedländer once aptly remarked, "was an explorer; Roger van der Weyden was an inventor." [8] Not that Roger was unable to do justice to what may be called

the surface blandishments of the visible world. There are enchanting details in many of his pictures, and in sensibility to color he was second to none. No visitor to Beaune or Philadelphia will ever forget the modulations of blue in Roger's "Last Judgment" or the polyphony of warm lilac-rose, pale gray-blue, flaming vermilion, drab gray, and gold in his "Calvary." But it is true that Roger substituted for Jan van Eyck's pantheistic acceptance of the universe in its entirety a principle of selection according to which inanimate nature and man-made objects are less important than animals, animals less than man, and the outward appearance of man less than his inner life. One of his contemporaries admired his paintings for *sensuum atque animorum varietas*, and Carel van Mander praised him for having improved the art of the Lowlands by an increase in movement and, most particularly, by the "characterization of emotions such as sorrow, anger or joy as was required by the subject." [1]

Thus Roger's world is at once physically barer and spiritually richer than Jan van Eyck's. Where Jan observed things that no painter had ever observed, Roger felt and expressed emotions and sensations — mostly of a bitter or bittersweet nature — that no painter had ever recaptured. The smile of his Madonnas is at once evocative of motherly affection and full of sad foreboding. The expression of his donors is not merely collected but deeply pious. Even his design is expressive rather than descriptive; it was he, for instance, who discovered how much the pathos of a Crucifixion might be intensified by contrasting the rigidity of the Body with the undulating movement of a billowing loincloth. His iconographic innovations, too, were often designed to create new emotional situations. He permitted donors directly to participate in sacred events and, conversely, introduced contemporary personages into Biblical narratives as *dramatis personae* who, as Leone Battista Alberti would say, "attract the eyes of the beholder even though the picture may contain other figures more perfect and pleasing from an artistic point of view." [2] He combined half-length portraits with half-length Madonnas into diptychs in which the sitter is represented in prayer. And it seems to be he who if not invented, at least reformulated and popularized the subject of St. Jerome compassionately extracting the thorn from the foot of his faithful lion. [3]

When we compare, for example, Jan van Eyck's "Madonna van der Paele" with the central panel of Roger van der Weyden's "Columba altarpiece" (so called after the Church of St. Columba in Cologne which was its home from 1493) [4] we perceive what seems to be an irreconcilable contrast. The "Madonna van der Paele" is strictly symmetrical, and its weighty, immobilized figures, receding from the central plane as well as from each other, are painted as though they were crystallizations of light itself. Its style is static, spatial and pictorial. In the Columba altarpiece (fig. 353) the central group is shifted to the left and the slender, supple figures of St. Joseph and the Magi, all in action, are pressed against the picture plane so as to form a sharply delineated pattern; its style is dynamic, planar and linear. Roger's composition looks almost like a throwback to the fourteenth, if not the thirteenth century, and he has often been said to represent a kind of Gothic counterrevolution against Jan van Eyck. However, while it is true that Roger's style has fundamental characteristics in common with what we call High Gothic and that he revived a number of motifs and devices nearly forgotten for

half a century or more, he was not, as has occasionally been said, a "reactionary." [1] He arrived at his apparently archaic solutions not only from an entirely "modern" starting point but also for a very "modern" purpose: far from simply opposing to the ideals of Jan van Eyck and the Master of Flémalle those of an earlier period, he attempted to break new ground by the old device of *reculer pour mieux sauter*.

Jan van Eyck had not so much resolved as negated the problems posed by the great painter of Tournai; he had eliminated the tensions and contradictions characteristic of the latter's manner by abolishing their very *raison d'être*. Where, as in Jan's mature style, all physical and emotional action was absorbed into pure existence there could be no conflict between movement and rest. Where all surface relations were transposed into space relations there could be no conflict between two-dimensional design and composition in depth. Where all details were perfectly integrated with total form there could be no conflict between a pictorial and a linear mode of presentation. Roger van der Weyden, however, set out to develop the expressive and calligraphical possibilities inherent in the style of the Master of Flémalle without forfeiting the consistency and purity attained by Jan van Eyck.

While Roger's figures are more dynamic than Jan's their movements are both more fluent and more controlled than the Master of Flémalle's. And while their grouping is denser and more diversified than in an Eyckian composition it is less crowded and more coordinated than in a Flémallesque one. It is as though a living chain of figures were thrown across the picture plane — a chain whose links remain distinct though conjoined by artful repetition and variation. And the component parts of every figure, body and garments alike, are both articulated in form and function and unified by an uninterrupted flow of energy. In short, Roger van der Weyden may be said to have introduced into Flemish fifteenth-century art the principle of *rhythm* in contradistinction to meter — definable as that by which movement is articulated without a loss of continuity.

This rhythm unfolds within a kind of foreground relief neatly divorced from the space behind it. But both foreground relief and background space are what I should like to call "stratified" into a series of planes deliberately frontalized yet interconnected in depth. The entire picture space is thus made to obey a common principle analogous to the "rhythmical" organization of figure movement: articulation is accomplished without destroying continuity. In the central panel of the Columba altarpiece this system of interlocking frontal planes is particularly evident, not only in the general disposition of the figures, the succession of piers, arches and posts in the building, and the stratification of the landscape but even in inconspicuous details. The donor on the extreme left looks on from a plane located between that of the St. Joseph and the pillar behind him. The little greyhound on the extreme right attaches the figure of his master to the very front plane (the hat in front of the oldest king, incidentally, fulfills a similar function) and the rigidly frontalized animals behind the Virgin Mary obligingly bend their heads into the planes in front of them.

As the principle of rhythm overcomes the tension between movement and rest in the behavior of the figures, and between surface and depth in the organization of space, so does it

overcome the tension between the pictorial and the graphic in the presentation of plastic form as such; and this, I believe, is the very essence of Roger van der Weyden's "linearism." As in all Early Flemish painting, his lines are not abstract contours separating two areas of flat color, but represent a condensation or concentration of light or shade caused by the shape and texture of the objects. However, in Roger's paintings these forms assume a linear quality without relinquishing their luminary significance. Eyebrows or eyelids, the bridge of a nose, the edge of the lips, strands of hair, or, for that matter, the borders and folds of a garment are indicated by lines designed with the precision of an engineering drawing yet innervated by a vital force that sharpens their angles and intensifies their curvature. While never disrupting the unity of plastic shapes and color areas, they achieve a purely graphic beauty and expressiveness.

III

That Roger van der Weyden, though essentially a "follower" of the Master of Flémalle, was well acquainted with Eyckian art is undeniable. It is going too far, it seems to me, to revive the old Italian tradition according to which he was an actual "pupil" of the "gran Iannes." [1] But since we know that he was away from Tournai prior to entering the workshop of the Master of Flémalle, nothing prevents us from admitting that he may have been in contact with Jan van Eyck during his absence. In fact a touch of Eyckianism can be observed in even the earliest works attributable to him: the Vienna "Madonna Standing" (fig. 307) briefly referred to on two previous occasions; [2] and the Thyssen "Madonna in an Aedicula" (fig. 306), examined from an iconographic point of view in Chapter Five. [3]

I do not hesitate to date these two small pictures as early as *ca.* 1430–1432. Though executed by Roger, they would seem to have been produced by him while he was still a member — that is to say a kind of junior partner — of the fertile collective enterprise that was the workshop of Robert Campin; and this might also explain the disquieting fact that a "St. Catherine" (fig. 308) of exactly the same dimensions as the Vienna Madonna, now combined with it into a somewhat incongruous diptych, is much inferior to the Madonna itself. Rightly considered as "shopwork" [4] yet apparently preceding the establishment of Roger's own atelier, its shortcomings may be explained by the participation of a fellow "apprentice."

While the wide, ovoid, moonlike faces of the Thyssen and Vienna Madonnas, so different from Roger's later types, are still decidedly Flémallesque, the harmony of their proportions, the elegant design of their draperies, which, I believe, exerted a retroactive influence on the Master of Flémalle, and the flattening of the picture space into a kind of relief (delimited in the Vienna panel by a brocaded cloth of honor in back and a delicate curtain of tracery in front) are already unmistakably Rogerian. But in the pictorial treatment, especially the softly unifying play of light and shade, we sense an Eyckian point of view. The Vienna Madonna also brings to mind Jan's "Madonna in a Church" in that Our Lady wears a crown — a motif foreign to the Master of Flémalle — and the Infant emerges from a swaddling cloth arranged in similar fashion, one corner hanging loose from beneath the Virgin's left hand. [5]

This shadow of Eyckian influence takes tangible shape in three important compositions which mark Roger's emergence as a major artist *sui juris*: the "Madonna on a Porch," also known as the "Madonna Embraced by the Christ Child," which has unfortunately come down to us only through a number of fairly free or incomplete replicas (fig. 386), so that all we can say about it is that it must be approximately contemporaneous with the two others;[1] the "Annunciation" in the Louvre subsequently expanded (though, in my opinion, not by Roger himself) into a triptych with a "Visitation" on the right and a donor's portrait on the left (figs. 309, 310);[2] and a "St. Luke Painting the Virgin Mary" transmitted through several replicas, the best of which, preserved in the Boston Museum of Fine Arts, has so much merit that it has been accepted as an original by several authorities (fig. 313).[3] These three compositions clearly postdate the Vienna and Thyssen Madonnas while no less clearly antedating all other works by Roger van der Weyden — except, perhaps, for the original of the right-hand wing appended to the Louvre "Annunciation," the beautiful "Visitation" in the Speck von Sternburg Collection at Lützschena (fig. 311) which has already been mentioned in connection with Jacques Daret.[4]

In intensity of expression, grace of posture and fluency of line, the Boston "St. Luke" and the Louvre "Annunciation" have outgrown the limitations of the two early Madonnas without as yet decisively subordinating space and volume to relieflike design and rhythmical movement. And the faces, the eyeballs delicately modeled within their sockets and the lips and eyelids tenderly contoured, approach Roger's ideal of structured beauty without as yet attaining that etched precision which characterizes his mature and later works. In many details the continued influence of the Master of Flémalle is evident. The Virgin portrayed by St. Luke sits, like the Salting Madonna, on the footrest of her throne rather than on its seat. The chamber of the Annunciate presupposes the same "Salting Madonna" and, in an even higher degree, the Mérode altarpiece. Such features as the fireplace with its sconce, the long — though not overlong — bench, and the nail-studded window shutters speak for themselves.

On the whole, however, the two pictures are more deeply imbued with an Eyckian spirit than any other known work by Roger van der Weyden (apart, of course, from that lost "Bathing Scene" which Fazio saw at Genoa and which, to judge from his description and the strangely non-Rogerian choice of subject, must have been derived from Jan's "*Feminae e balneo exeuntes*" in the collection of Cardinal Ottaviano).[5] The space, by Roger's standards fairly deep, is pervaded by a mild, diffused light which here and there — as in the charming corner occupied by St. Luke's faithful ox and little library — produces remarkable chiaroscuro effects. The tiling of the pavements exhibits rich and complicated patterns significantly absent from the religious pictures of the Master of Flémalle. The Angel Gabriel wears a shimmering brocaded pluvial as do the Gabriel in the Washington "Annunciation" and the "Musical Angels" in the Ghent altarpiece. The chamber of the Annunciate is embellished with such eminently Eyckian objects as the glass carafe and fruit which made their first appearance in the "Ince Hall Madonna," a bed and chandelier decidedly reminiscent of the London Arnolfini portrait and a brass medallion, gleaming from the penumbra of the deep-red tester, that takes

the place of the Arnolfinis' historical mirror. And the "St. Luke" is Eyckian, not only in that the throne of Our Lady — its armrest carved into a group representing the Fall of Man — is surmounted by a cloth of honor and canopy but also in that the whole setting with its tripartite colonnade, walled garden and river view is derived from the "Rolin Madonna"; even the two little figures looking over the parapet have been retained.

Perhaps this pronounced Eyckianism can be accounted for by the assumption that the "Annunciation" and the "St. Luke" — both executed, I believe, about 1434–1435 — were actually painted at Bruges. According to a great scholar Roger's "St. Luke" was painted for the Brussels painters' guild and is identical with a picture inspected there by Dürer in 1520.[1] But while it is true that Dürer was shown a "Sanct Lucas Tafel" at Brussels (and had to pay two stuivers for having it "opened up," from which we may conclude that it had shutters) he does not attribute this painting to "the great Master Rudiger" whose "four historical pictures" he had just admired in the "Golden Chamber" of the Town Hall.[2] On May 20, 1521, however, Dürer saw several other works by Roger at Bruges, viz., one or more panels in the Church of St. James, and "Rudigers gemalte Kapellen" in the Palace of the Dukes which in 1493 had become "the Emperor's House";[3] and while the pictures in St. James' may well have been produced outside Bruges, the pictorial decoration of a chapel — and in Dürer's German the word *Kapelle* can only mean that — would seem to presuppose the painter's physical presence. Since we are ignorant of Roger's whereabouts between his "graduation" on August 1, 1432, and his appointment as City Painter of Brussels not long before May 20, 1436, it does not seem unreasonable to fit his activity at Bruges into this dark interval.

In spite of their indebtedness to both the Master of Flémalle and Jan van Eyck, the Boston "St. Luke" and the Louvre "Annunciation" are more visibly imprinted with Roger's personality than are the two earlier Madonnas, even where — or, rather, precisely where — he resorted to direct quotation. The regal room in which Our Lady sits for her portrait (somewhat incongruously combined with St. Luke's private quarters) is, we recall, borrowed from the "Rolin Madonna." But everything has been transformed in thoroughly Rogerian fashion. According to Roger's anthropocentric philosophy the little figures in the background no longer merge with the scenery but are raised to the status of relatively independent individuals, greatly enlarged in size, proudly detaching themselves from their surroundings; it should be noted that Jan's two fashionable young men have been replaced by a dignified couple that may be meant to represent St. Joseph and St. Anne. The pleasant roundness of an arcade has given way to the severe rectangularity of trabeated architecture. Such charming details as the bridge, the islets and the boats are omitted. The air is thin and clear. And the horizon, instead of stretching across the entire width of the three openings, is laterally obstructed by buildings which change a direct contrast between the near and the far to a step-by-step and much more limited progression: continuous space has been transformed into "stratified" space.

In representing St. Luke portraying the Virgin, the art of painting renders account of its own aims and methods.[4] Figuratively speaking, representations of this kind were always self-portraits, and as time went on they tended to become self-portraits in a literal sense also;

in fact Roger's St. Luke bears a perhaps more than accidental resemblance to the "Maistre Rogiel" represented in the Arras drawing. And as the painter assumed the character of individualized reality, so did his subject. In High Medieval art, when portraiture from life was the exception rather than the rule, St. Luke produced the image of Our Lady by sheer inspiration; but with the rise of naturalism he needed a model. This model was often furnished him by a vision,[1] a type surviving through the centuries and ultimately glorified by Raphael. The Master of Flémalle, however, could not but bring the vision down to earth. In his "St. Luke," transmitted to us through Colin de Coter's picture at Vieure (fig. 228),[2] the Virgin has deigned to descend to St. Luke's workshop in the flesh. Sitting before his easel, he portrays her *al vif*, as Villard de Honnecourt would say; and this type also survived in numerous variants.

Roger's interpretation is at once more delicate and more sublime. He, too, conceives of Our Lady, not as a vision but as an apparent reality. But instead of visiting St. Luke in his studio she receives him in an ideal throne room. Instead of bringing along his stool, easel, mahlstick, paintbox, and palette, he carefully portrays her in silverpoint. While thus engaged, he maintains a graceful and reverent attitude which can best be described as genuflexion, and thereby the static and secular group of painter and model is transformed into something closely resembling an Annunciation scene, St. Luke taking the place of the Angel Gabriel. It is, in fact, in Roger's own Louvre "Annunciation" that the pose of his St. Luke has its closest parallel.

True, the gliding motion of Roger's Gabriel — one knee more sharply bent than the other but neither knee touching the ground — is adumbrated in that beautiful group in Ste.-Marie Madeleine at Tournai which was completed by Jean Delemer (and polychromed by Robert Campin!) in 1428, the second year of "Rogelet de le Pasture's" apprenticeship.[3] But it was Roger who introduced this motion into painting (where Gabriel had thus far been depicted only standing, kneeling or approaching in flight), perfected it with his inimitable sense of rhythm and, at the end of his career, sublimated it into inexpressible beauty in the "Annunciation" of the Columba altarpiece.

As Roger improved upon — or, rather, synthesized — the traditional interpretations of the Angel, so did he improve upon — or synthesize — the traditional interpretations of the Annunciate whom he represented in a pose halfway between the startled *contrapposto* attitude of a maiden surprised at prayer and the tranquil composure of the Madonna of Humility. And he was also the first to throw full light upon the idea of the *thalamus Virginis*.[4] Where a bed appears in such contemporary or slightly earlier renderings as the Brenken altarpiece or the "Annunciations" by Masolino, Fra Angelico and Bicci di Lorenzo it is removed into an alcove in the rear or nearly hidden in an adjacent room, a modest footnote to the main text.[5] In Roger's Louvre panel the Annunciation chamber itself is conspicuously and unequivocally characterized as a *thalamus*, a nuptial room not unlike the interior in the Arnolfini portrait, and the symbolic significance of the bed is clearly manifested by the fact that the chased medallion suspended from its headboard bears the image of the Lord.

A difficult issue is raised by the relationship between the Louvre "Annunciation" and the

Master of Flémalle's "St. Barbara," the right-hand wing of the Werl altarpiece of 1438. These two pictures have evidently much in common, sharing a number of "Eyckian" details absent from both the Mérode altarpiece and the "Salting Madonna." Whoever painted the one must have known the other, and at first glance the "St. Barbara" with its hard light and primitive wide-angle perspective appears to antedate the softly illumined and astonishingly rationalized "Annunciation," perhaps the most consistently focused interior of the first half of the fifteenth century. The Louvre picture is, therefore, often considered as an elaboration of the "St. Barbara," and its dependence on the latter has been defended on the ground that its author, with the proverbial thoughtlessness of an imitator, had placed the bench too close to the fireplace to permit its practical use [1] (although he was careful to close the damper and thus to intimate that the fireplace had been put out of commission by March 25). In reality the Louvre "Annunciation" precedes rather than follows the Werl altarpiece which seems to antedate it, not because it is earlier but because it is archaic — because its master was too old to change the habits of a lifetime. The Master of Flémalle, then about sixty, could adopt but not assimilate the Eyckian elements which here as in the other wing intrude upon a universe incapable of being transmuted in its entirety, and I firmly believe that it was Roger, not he, who appropriated them at the source.

This assumption is, I believe, confirmed rather than contradicted by the much-discussed basin-and-pitcher set which, most circumstantially rendered and apparently perfectly identical, occurs in both the Louvre "Annunciation" and the "St. Barbara" (figs. 214, 215). Since the two pitchers are shown in a different light and at different angles, this concurrence cannot be explained by a copy relationship between the two paintings nor even by the use of a common workshop drawing. We are faced with two separate and independent portrayals of what seems to be the same object, and this has been adduced as conclusive proof of the identity between the Master of Flémalle and Roger van der Weyden. Only one painter, it has been thought, could have represented this distinctive vessel twice.[2] However, that the object depicted in the two panels is really one and the same is not so certain as it may seem. *Dinanderies* of this kind, however remarkably shaped, were produced *en masse*. A somewhat simpler vessel, lacking the angular protuberances of the body but very similar in every other respect, is seen as early as about 1400 in the Brabantine "Birth of the Virgin" in the Brussels Museum (fig. 112).[3] And on closer inspection some minor differences can be discovered even between the pitchers seen in our two paintings: that in the Louvre "Annunciation" has a Tau-shaped thumb grip and a collar composed of three elements (an angular "torus" between two moldings) while that in the Barbara panel has a collar composed of only two elements and a plain knob for a thumb grip. Thus the two pitchers may be, after all, twins rather than one individual. But even if we were to dismiss their dissimilarity as purely "representational," even if only one vessel were depicted in both pictures, nothing would prevent us from imagining that this vessel belonged to Roger but was sketched by the Master of Flémalle during a visit, or that Roger sent it to his old master as a birthday present, or that both artists had made independent drawings of it while still associated at Tournai.

Be that as it may, one thing is abundantly clear: in artistic interpretation, the two sup-posedly identical pitchers are no less different than are the two certainly nonidentical water carafes (one smooth and carefully tied up at the top, the other strigulated and casually stop-pered). The Master of Flémalle's pitcher, casting a strong, distinct shadow upon a light wall, is squat and potbellied, its visible surface flickering with a multiplicity of luminary accents. Roger's pitcher, set out against a uniformly dark background, has a totally different personality: it is trim and slender, its visible surface clearly organized into a lighted part enlivened by small areas of shade, and a shaded part enlivened by small areas of light. In short, where the Master of Flémalle's vessel is a telling example of an "additive" style, Roger's is rendered in "divisive" or "synoptic" fashion; it is seen, so to speak, à travers le tempérament de van Eyck.

The two pitchers, then, whether or not reflecting the same model, differ rather than harmonize, and the same is true of all the other photographic juxtapositions which are sup-posed to prove the Master of Flémalle's identity with Roger van der Weyden and bring to mind old Friedrich Lippmann's immortal advice to his young men: "For God's sake, children, if you want to prove something, don't illustrate it."

An excellent case in point is the juxtaposition of two right hands, that of the Master of Flémalle's Centurion, and that of a St. John by Roger van der Weyden (figs. 250, 251).[1] No doubt these two hands are very similar in the topography of the skin folds, but here the similarity ends. As in the case of the two pitchers, the short, thick hand of the Centurion is rendered in "additive" fashion; the thumb and little finger are disjoined from the back of the hand as is the little finger from the fourth and the fourth from the third, and there are so many small, sharply illumined veins and wrinkles that it is hard to gain an impression of general form, much less of unified lighting. The long, slender hand of the St. John, however, is animated by a continuous flow of life and feeling (again we may speak of rhythmicization), and the small luminary accents that mark anatomical details are smoothly co-ordinated into large fields of light, shade and penumbra: here, too, a Flémallesque model appears transfigured by the application of Eyckian methods (fig. 249).

IV

The composition to which this St. John belongs is the "Descent from the Cross" which was the pride of the Escorial from 1574 and has now taken its rightful place among the Titians and Velasquez' in the Prado (figs. 314, 315).[2] Originally the central panel of a triptych, this picture proved to be as inevasible as Leonardo's "Last Supper" and Dürer's "Apocalypse." Through copies and variations in all media the composition came to be known far and wide and it was all but impossible for generations of artists to free themselves from its influence when dealing with similar subjects. Individual motifs, especially the Magdalen, were never forgotten and the impression made by the other figures could be eclipsed only by later inven-tions of Roger himself. How this influence filtered down to what may be called the folkloristic level is illustrated by a small woodcut from the Life of St. Lydwina which appeared at

Schiedam in 1498, shortly after her canonization. The touching group of the unhappy girl and her helpful companions — she broke a rib while skating and spent the rest of her life as a suffering invalid, rewarded for her patience by spiritual illumination and wonderful visions — manifestly reflects the monumental triad of figures in the left half of Roger's "Descent from the Cross."

The triptych was commissioned by the local Archers' guild for Notre-Dame-hors-les-Murs at Louvain (perhaps that Louvain sculptor, Henry van der Weyden, though certainly not Roger's father, was a relation after all), and one of its many copies, the Edelheer altarpiece in St. Peter's in the same town, is dated 1443.[1] The original, however, I hold to have been executed soon after the Louvre "Annunciation" and the "St. Luke." In fact, it may have been the remuneration for this gigantic enterprise (the "Descent from the Cross" alone measures 2.00 by 2.65 meters) rather than his fee for the "Examples of Justice" in the Brussels Town Hall that enabled Roger to make his substantial investment of October 20, 1435; municipal authorities do not, as a rule, pay big sums of money four years in advance.

It is in the "Descent from the Cross" that we see Roger "face to face." The influence of Jan van Eyck is restricted to that "synoptic" mode of presentation which constituted an inalienable heritage; and while the outward appearance of the personages with their vigorously modeled bodies, copious draperies and full-fleshed faces is undeniably reminiscent of the Master of Flémalle, their inward essence is as un-Flémallesque as can be. Physiognomically, the Virgin Mary may bring to mind the Frankfort Madonna (fig. 206),[2] and the Nicodemus has often, and rightly, been compared with the Robert de Masmines (fig. 220).[3] As human beings, however, they belong to a different species, and as a whole Roger's "Descent from the Cross" is, as I ventured to call it, a painted critique of the Master of Flémalle's (fig. 230).

No visual emphasis is placed on the mechanics of the scene although they are, in fact, more logically thought out than in most previous renderings. The ladder is kept out of sight as far as possible; the only figure exclusively preoccupied with a technical problem appears behind and not before the Cross; and it takes some little time to discover that the task of support mainly devolves upon the aged Joseph of Arimathea who braces his knee against the weight of his burden while his fine old face, a prefiguration of Rembrandt's Rabbis, shows nothing but quiet sorrow. Instead of being loosened from the Cross or dangling in mid-air, the dead Christ is sufficiently lowered to come to rest, as it were, in the arms of His friends, and His body displays its perfect shape without anatomical distortion or perspective foreshortening; one has only to compare the outline of this neck and this torso with the analogous contours in the Master of Flémalle's "Thief" and "Trinity" to become fully aware of the irreconcilable difference between the two painters. The composition is developed horizontally rather than vertically and, showing a group of mourners centered around the Body and enframed by two "personnages latéraux inclinés formant parenthèse," brings to mind an Entombment or Lamentation rather than a Descent; it has justly been observed that it is, "en principe," an offshoot of such High Gothic Entombments as that in the *Parement de Narbonne*.[4]

Roger's intention was not focused on action nor even "drama" but on the fundamental

problem of compressing a maximum of passion into a form as rigorously disciplined as a Shakespearean sonnet. In the "Descent from the Cross," as in the lost composition described by Fazio, "dignity is preserved amidst a flow of tears." All but three of the participants — the servants behind the Cross and the two oldest of the men — are weeping, and tears still stream over the face of the Mater Dolorosa though she has collapsed in a deathlike faint; it may be said that the painted tear, a shining pearl born of the strongest emotion, epitomizes that which the Italians most admired in Early Flemish painting: pictorial brilliance and sentiment. Yet all the passions are restrained. There is sweet piety in the expression of the young woman supporting the Virgin Mary, mild sadness in the eyes and mouth of Joseph of Arimathea and resolution in the set face of St. John. And all the shapes and movements, however intensely expressive of grief, are governed by the two great principles which I have tried to describe at the beginning of this chapter. They are restricted to a stratified relief space, here palpably delimited by two planes, and unified by a pervasive rhythm of dynamic curves either interflowing (as in the continuous line that runs from the right shoulder of the Joseph of Arimathea through the Body into the left arm of the Nicodemus), or symmetrically corresponding (as in the "parenthèse" formed by the St. John and the Magdalen), or echoing each other as in the figures of the Mater Dolorosa and the dead Christ — their polyphonic movement contrasted with and steadied by a succession of vertical accents whose function may be likened to that of beats as opposed to rhythm in music.

Roger's "Descent from the Cross" is still a youthful work animated by a rich, unrepressed and, in spite of the subject, almost sensuous vitality soon to give way to austere unworldliness. Yet it states Roger's principles with perfect clarity. And that Roger himself was intuitively conscious of the novel yet somehow retrospective nature of these principles may account for the fact that he felt obliged to justify their application by a curious fiction: he confronts us, not with an ordinary painting but with a simulated "Schnitzaltar" wherein the scene is enacted by carved and polychromed figures encompassed by a gilded shrine, its front plane emphasized by open tracery that fills the upper corners (a motif already present in the two early Madonnas and brilliantly developed in two slightly later works).[1] This fiction was not dictated by an illusionistic purpose; not the slightest attempt is made to imitate the technical peculiarities of sculpture as opposed to living characters. On the contrary, what Roger intended was precisely the opposite of what was achieved by the familiar statues in grisaille. In these the painter creates a condition that justifies him in investing artifacts with a semblance of tangible reality. Roger creates a condition which justifies him in subjecting human beings to a principle of abstract stylization.

v

Soon after the completion of the "Descent from the Cross," that is to say, in 1436–1437, Roger would seem to have produced two works in which the youthful feminine types of the Escorial picture, still vaguely Flémallesque, appear refined to greater spirituality: a major

composition, apparently a *"Virgo inter Virgines,"* of which only a fragment, the "Magdalen Reading" in the National Gallery at London,[1] survives (fig. 316); and the beautiful "Madonna Duran" or "Madonna in Red" in the Prado (fig. 317).[2]

As the "Descent from the Cross" defines Roger's position in relation to the Master of Flémalle, so does this "Madonna in Red," much imitated throughout the fifteenth century, define his position in relation to Jan van Eyck. With the Virgin Mary clad in a glowing crimson robe and permitting the Infant Jesus to handle — even rather roughly — the pages of a manuscript, the picture is manifestly derived from Jan van Eyck's "Ince Hall Madonna." But instead of flowing and spreading like a cascade of liquid ruby, the robe of the Prado Madonna, its folds precise and, by comparison, sparse, seems to congeal into a concentrated, plastic shape. And where Jan permits us to approach Our Lady in the familiar atmosphere of a domestic interior, however regally appointed, Roger enjoins us, as it were, to kneel before a statue of the Queen of Heaven.

Roger's two early Madonnas had anticipated, to some extent, this sculptural impression in that the figures are encompassed by a niche or aedicula, its arch "valanced" with lacelike tracery. The Prado picture, however, goes much farther in that the figure, after the fashion of the Frankfort Trinity by the Master of Flémalle, is placed upon a projecting console: we behold, like King Leontes, a woman of flesh and blood presented to us under the guise of a statue. As though to intensify this impression, the niche itself is devoid of sculptural decoration, a frame rather than a shelter. Its ground, instead of being covered by a cloth of honor or receding in softly lighted concavity, is filled with a darkness which, even if originally not quite so opaque as now, must always have conveyed the effect of a neutral foil. The patterns of the tracery are elegantly simple rather than ornate or intricate. And while the two earlier figures wear crowns on their heads, the Prado Virgin wears a simple kerchief. However, an angel — emerging, as it were, out of the keystone of the niche — is about to place upon her head what is not so much a crown of glory as one of purity, perseverance and faith in sorrow.

These three epithets, descriptive of the new, multivalent expression of the Virgin's face, are used advisedly. They are borrowed from the inscriptions of a but slightly later triptych — or, rather, a pair of triptychs almost indistinguishable as to style and quality — which make explicit what the Prado Madonna merely implies (figs. 318–321). In these twin altarpieces — one now divided between the Capilla Real at Granada and the Metropolitan Museum, the other coming from the Convent of Miraflores near Burgos and preserved in the Kaiser Friedrich Museum at Berlin[3] — three Mariological scenes, the Virgin's Adoration of the Infant Jesus, the Lamentation and the Appearance of Christ to His Mother, are enframed by richly sculptured doorways much as the "Virgin in Red" is by the opening of her severely simple niche. As in the Prado picture, the arches are "valanced" by wooden tracery (of basically identical if slightly more elaborate design), and from each of the keystones there descends an angel holding a crown. But here the threefold significance of the *corona vitae* is explicitly defined by scrolls inscribed with Scriptural texts boldly reworded in praise of Our Lady. In the "Adoration of the Infant Jesus": "This woman was found most worthy and free from all blemish, therefore

259

she shall receive the crown of life; from the First Letter of James." In the "Lamentation": "This woman was most faithful in the Passion of Christ, therefore there is given to her the crown of life; from the Second Chapter of Revelation." In the "Appearance of Christ to His Mother": "This woman persevered, conquering everything, therefore there has been given to her a crown; from the Sixth Chapter of Revelation." [1]

To present, after the Dijon "Nativity" and the Ghent altarpiece, the picture space as viewed through a doorway is both an archaism and a great innovation. Roger's doorways are archaic in that they are lineal descendants of the old "diaphragm arch" *à la* Boucicaut Master (figs. 62, 65, 70, etc.) and the still older architectural frames *à la* Jean Pucelle (figs. 5, 7) or Herman Scheerre (fig. 174). They are fundamentally novel in that they combine and reinterpret the functions of these earlier devices. They can be read both as "diaphragms" invested with architectural substantiality and as "architectural frames" drawn into the picture itself. They cut out, as I phrased it, a field of vision from the context of reality. Yet they are three-dimensional structures incorporated with this very context: fully developed Gothic portals, profusely adorned with statuary, and structurally connected with barrel-vaulted porticoes which in turn lead to a landscape or to tripartite, oblong halls. And since the landscape is in the center while the halls are on either side, we receive the impression of a vista flanked by two coulisses much as in the case of the "St. Luke Painting the Virgin."

It is essentially within the prosceniumlike area of these porticoes that the action takes place. Yet the figures and objects strive to advance beyond this narrow stage, in part emphatically overlapping the embrasures of the portals (note, for example, the feet of the Body and the mantle of the Virgin in the Lamentation, Christ's robe and the Virgin's bench in the Appearance). In short, Roger's portals belong and do not belong to the pictorial space. As structures comprised within it, they contribute to restricting the movements of the figures to a "stratified" foreground relief while accentuating their plastic and dynamic potentialities. As doorways placed in front of it, they retain the optical significance of a "diaphragm arch."

In addition to its purely formal importance, the introduction of these elaborate portals had tremendous iconographic advantages. Like the sculptors of Chartres and Reims, the painter could combine epigrammatic concision with epic prolixity; he could concentrate upon a few crucial themes yet supplement them by a circumstantial narrative. In the "Granada-Miraflores" altarpiece, as we may call it for short, these crucial themes are, we remember, the Adoration of the Infant Jesus, the Lamentation, and Christ's Appearance to His Mother. But in the archevaults of the portals — their splayings adorned with statues of the Four Evangelists, St. Peter and St. Paul — the life of the Virgin is unfolded in its entirety. The "Adoration of the Infant Jesus" is surmounted by the six canonical Infancy scenes (on the left, the Annunciation, the Visitation and the Nativity, on the right, the Adoration of the Shepherds, the Adoration of the Magi and the Presentation in the Temple); the "Lamentation," by six scenes from the Passion beginning with the Leave-Taking of Christ and ending with the Entombment; the "Appearance," by scenes from the period of the Virgin's bereavement beginning with the Three Marys' Account of Their Visit to the Sepulchre and ending with the Assumption. [2]

What looks like a triad of stanzas is thus in reality a trilogy of cantos. And so sophisticated is the arrangement of the little scenes in the archevaults that their sequence may strike us, at first, as somewhat bewildering. We wonder why the narrative begins at the apex of each archevault and runs counterclockwise, instead of following the more natural course from lower left to lower right prescribed to it, some fifteen years later, in Roger's own "St. John triptych." But then we realize that only in this way the Assumption could be appropriately placed at the apex of the right-hand archevault, and that only in this way the Adoration of the Infant could be prefaced, as it were, by a movement from Heaven to earth while the Appearance of the resurrected Christ could be epilogized by a movement from earth to Heaven.

With most of the narrative relegated to the *voussures*, the principal themes could be treated with sublime succinctness, as symbols rather than stories. The first panel — occasionally referred to as "Nativity" although this subject is dealt with in one of the archevault sculptures — shows, not so much an event as an emotional situation cast into an image of Roger's own invention. "Umile ed alta più che creatura," the Virgin Mary, humbly sitting on the ground in front of a resplendent cloth of honor, adores the Infant Jesus with hands pointing downward (another Rogerian innovation),[1] and her robe — its border, as in the two other scenes, embroidered with the "Magnificat" — is white to designate the *munda ab omni labe* of the inscription; to Roger's intellect the symbolic significance of colors was no less real than was their beauty to his eye, and it is not by accident that Our Lady wears red, the color of *Christi dolor*, in the "Lamentation," and blue, the color of *perseverantia*, in the "Appearance." With no one present but her sleeping husband, she is no less alone with her Son than she will be when kissing Him farewell. And that Roger did expect us to think of the Passion while contemplating a scene from the Infancy is evident from the reliefs on the capitals where the Sacrifice of Isaac and the Death of Absalom prefigure the work of Redemption and, more specifically, the lance thrust of Longinus.[2] Moreover, the fact that the Virgin holds the Christ Child on her lap in the very act of adoration, brings to mind those texts in which she addresses the dead Saviour with words such as "Now I hold Thee on my lap as a dead body, Thee Whom I held on my lap as a slumbering babe."[3]

The Adoration of the Infant Jesus thus prepares us, in a sense, for the Lamentation under the Cross. Repeatedly re-edited in Roger's own workshop (at least four interrelated variants are known)[4] and no less eagerly exploited by successive generations than the "Descent from the Cross," this composition owes its success, in typical Rogerian fashion, to a creative revival of the past. It reverts to the Italianate tradition of the fourteenth century, and it is its inherent Italianism which made it possible that at the height of the Flemish Renaissance a Michelangelesque Christ could be interpolated into what is essentially the same configuration.[5]

In Trecento painting, that most characteristic feature of the Byzantine "Threnos," the heart-rending motif of the last kiss, not only invaded and dramatized the Gothic Entombment scene but also a number of previously static devotional images as when the Man of Sorrows was supplemented by the Mater Dolorosa. And where the German masters developed their tragic but physically inactive *Pietà* from the Madonna Enthroned (replacing, as it were, the

Infant sitting on His mother's knees by the analogously posed and originally diminutive figure of the dead Christ), the Italian masters created a superficially similar but essentially different image by fusing the "Threnos" with the Madonna of Humility: the Body, never diminished in size, is diagonally outstretched; the Virgin sits upon the ground instead of on a throne or bench; and instead of motionlessly mourning after the fashion of the mothers in a Slaughter of the Innocents, she bends over her Son, kissing His mouth. Cecco di Pietro's panel in the Museo Civico at Pisa, dated 1377, is the best-known but not the earliest example of this type.[1]

Swept into the Northern countries by the wave of Italianism, this "Cecco di Pietro type" was transposed into sculpture without significant iconographic changes as in a beautiful Rhenish group of *ca.* 1430, preserved in the Landesmuseum at Münster,[2] dedramatized so that only the humility posture remained, as in several miniatures of the Rohan workshop,[3] or enriched by the addition of figures normally associated with the Mater Dolorosa, particularly St. John the Evangelist, as in the works of Jacquemart de Hesdin and his circle. And it is in one of the tiny *bas-de-pages* in the *"Très-Belles Heures de Notre Dame"* (fig. 39) that the "Lamentation" in the "Granada-Miraflores" altarpiece has its closest precedent.[4] But it took Roger's uncompromising severity to transmute the Body of Christ into so rigid a corpse, its right arm stiffly cleaving to its side without regard for linear euphony, and to tighten the Virgin's embrace into so desperate a hold, her hands locked in a last effort to keep what cannot be kept. The access to the landscape is barred by the Cross; and the storied capital on the left reveals the root of the tragedy, the Expulsion from Paradise.

That the third panel of the "Granada-Miraflores" altarpiece represents the Appearance of Christ to His Mother is in itself characteristic of Roger's complex psychology. As a rule, a Life of the Virgin ends triumphantly with her Coronation or Assumption. The Appearance, however, is not a Glorious Mystery, nor does it belong to the Joyful or Sorrowful Mysteries; it partakes of the nature of all three, carrying with it the grief of the Passion, the bliss of an unhoped-for encounter and the promise of celestial reunion. Yet it may be that the choice of the rare subject was codetermined by the wishes of the patron; for it is in Spain that it occurs in a number of fourteenth-century altarpieces whereas the Northern countries seem to have known it, prior to Roger, only in miniatures of devotional treatises and popular woodcuts dependent thereon.

From the earliest times it was believed that the resurrected Christ, before appearing to Mary Magdalen and the Disciples, had shown Himself to His mother; but this event is not recorded in the Bible or the Latin *Apocrypha*. Christ's Appearance to the Virgin, therefore, does not occur in Western art up to the early fourteenth century and remains comparatively rare even then. Setting aside a type apparently confined to Spain, where Our Lady, as was assumed by St. Ambrose, witnesses the Resurrection itself,[5] and the very special case of Guillaume de Deguileville's *Pèlerinages*, where Christ appears to her as a pilgrim,[6] all these representations are based, in some way or other, on Pseudo-Bonaventure's *Meditationes*. According to his moving description (almost literally repeated in Ludolf of Saxony's *Vita Jesu Christi*), the Virgin was alone in her house, "prayenge and swete teres schedynge," when

Christ, clad in a white robe, appeared to her and greeted her with the words: "Salve sancta parens." Kneeling down, she asks: "Art thou Jesu my blessed sone?", whereupon Christ goes down to His knees by her side and answers: "Ego sum; resurrexi et adhuc tecum sum." Then both rise and embrace, she clasping Him tightly and "restynge all vppon hym" while He "gladly bare her vppe and sustened hire." After this they sit down side by side and speak to each other until His departure.[1]

Characteristically, the motif of the embrace was most eagerly accepted in Germany;[2] in other countries the moment of the Appearance proper was preferred. The Virgin is depicted either sitting on the floor of her chamber (as in a Cavallinesque fresco in S. Maria di Donnaregina at Naples)[3] or, normally, kneeling in prayer while Christ stands before her in a quiet attitude, raising His hand in a gesture of blessing or, very often, of showing the wound in its palm.[4] And in one instance — a miniature in the Artesian *Ci nous dist* of *ca.* 1390 (fig. 148), which happens to be the earliest known example in the Netherlands[5] — the Lord turns away from His mother with the characteristic movement of the *Noli me tangere*, almost as though the illuminator had been dimly aware of the old Eastern tradition according to which the resurrected Christ addressed Our Lady with the same "Touch me not, for I am not ascended to my Father" as he did the Magdalen.[6]

Roger's interpretation of the scene — so unique that it could only be copied but not developed — exploits all these sources, adheres to none and transcends them all. The addition of the Resurrection scene in the background and the idea of adorning the capitals with prefigurations of Christ's triumph over death and the Devil — on the left, David's victory over Goliath,[7] on the right, Samson rending the Lion[8] and carrying away the gates of Gaza[9] — are Roger's own. But even where he conformed to tradition, textual or representational, he transmuted and personalized it. He knew, of course, the *Meditationes*; in fact, he is the first and only artist to do justice to Pseudo-Bonaventure's "prayenge and swete teres schedynge," depicting as he does Our Lady as surprised in prayer and weeping at the same time. But his Christ wears red instead of white. The *contrapposto* of the Virgin, closely resembling that of the Annunciate in the Louvre picture, differs from both the almost universally accepted kneeling posture and the humility pose of the fresco in S. Maria di Donnaregina. And the gesture of her hands denotes a blend of reverence, amazement and joy not found in any other representation.

A climax of expressiveness and delicacy is reached in the figure of Christ. As in the Appearances to the Disciples He must identify Himself by His wounds: "Behold my hands and my feet, that it is myself." Thus His mantle must expose the wounds in His feet and in His side while His upraised hands must show the "print of the nails."[10] These features are found in many pre-Rogerian renderings. But in holding the robe in place by an almost imperceptible pressure of the right arm, guardedly withdrawing its elbow and gently bending back both hands at the wrist, the figure of the Lord conveys an indescribable feeling of modesty and tender denial;[11] the significance of the *Ostentatio vulnerum* is qualified by the spirit of the *Noli me tangere*. Yet an *Ostentatio vulnerum* it remains, and closer examination reveals the

gesture of Roger's Christ to be almost identical with that of Master Francke's "Man of Sorrows as the Just Judge" (text ill. 45).

If a specific motif was ever developed in conformity both with tradition and the requirements of a specific problem it is the attitude of Christ in Roger's "Appearance," and it is difficult to see how the indisputable similarity that exists between this figure and the Baptist in the left wing of the Werl altarpiece can be explained by the assumption that Roger van der Weyden borrowed it from the Master of Flémalle instead of *vice versa*. M. J. Friedländer should never have disavowed the view which he himself so nicely formulated: "as employed by Roger, the movement is meaningful, born out of the situation; not so in the context of the Master of Flémalle's composition."[1] In the Werl altarpiece St. John the Baptist should either point at the Lamb as he does in innumerable other representations, or present the donor in customary fashion as he does in the Portal of the Chartreuse de Champmol, the Wilton Diptych or the "Brussels Hours." There is no justification for him to raise his hand in a gesture which traditionally implied — and, though charged with a more complex meaning, continues to imply in Roger's "Appearance" — the idea of showing the "print of the nails." The inference is that the "Granada-Miraflores" altarpiece, still linked in many ways to the Prado Madonna, precedes, however slightly, the Werl altarpiece and must be dated in 1437–1438.

The year 1439 saw the unveiling of Roger's "Examples of Justice" — or, to be more exact, of their first installment. Some fifteen years ago, Hulin de Loo conjectured that the original program had been limited to the Justice of Trajan whereas the two panels glorifying the Justice of Herkinbald or Archambault, one of the Counts of Bourbon, were added after October 30, 1454, when Charles the Bold married a lineal descendant of their legendary hero and, to the delight of the citizenry, established residence in Brussels rather than Bruges; and recent investigations seem to bear out this hypothesis.

From as early as 1339 the Palazzo Pubblico at Siena boasted Ambrogio Lorenzetti's Allegories of Good and Bad Government, and even before that Giotto had adorned the Palazzo del Podestà at Florence with murals of a similar character, now lost.[2] The civic pride of the Northern communities demanded representations analogous in purpose but less general and philosophic in subject matter — representations that would exemplify the administration of justice by specific incidents from what was then considered as history. Roger's "Examples of Justice," ushering in a long series of similar cycles both in the Lowlands and Germany, are the earliest of their kind of which more than a literary record remains. Though the originals were destroyed when the Brussels Town Hall burned down in 1695, they are reflected in the Berne tapestries mentioned earlier (fig. 387).[3] However, the evidence of these tapestries (datable about 1460–1470) can be accepted only with substantial reservations. Not only is the style of Roger's compositions obscured by the flattening and schematizing effect of a severely limited and basically *retardataire* medium; we also learn from the newly discovered description of a seventeenth-century eyewitness — and here again Hulin de Loo seems to be right — that they were cut and edited. Motifs were changed, subdivisions suppressed, and whole scenes "telescoped" or entirely omitted.

According to the new document, Dubuisson-Aubenay's *Itinerarium Belgicum* of *ca.* 1630,[1] each of the four panels was subdivided into two "sections," and the whole cycle comprised eight separate scenes. First panel, first section: the Emperor Trajan, setting out on a campaign, is stopped by a poor widow imploring him to punish one of his soldiers who had killed her only son; second section (not separated from the first in the tapestry): execution of the culprit. Second panel, first section: "more than four hundred and fifty years later," Pope Gregory the Great meditates on the pagan Emperor's virtue before the famous Colonna Traiana (this part omitted in the tapestry) and prays to God for his salvation; second section: Trajan's tongue, the instrument of just judgment, is found to have been miraculously preserved in his head. Third panel, first section: Herkinbald slays, during his last illness, his own nephew for rape; second section (combined with the first in the tapestry): a servant deplores the deed[2] while a woman looks on in amazement and — according to Dubuisson-Aubenay who seems to have confused the second section of the third panel with the second section of the second — Roger van der Weyden himself witnesses the scene.[3] Fourth panel, first section: since Herkinbald has failed to include the slaying of his nephew in his confession, his Bishop refuses to administer the Last Sacraments but the Count is absolved by divine intervention, the Host having been conveyed to his mouth in miraculous fashion; second section (apparently absorbed, at least in part, into the first in the tapestry): a "very great number" (*frequens turba*) of bystanders.

VI

No more, then, can be inferred from the Berne tapestry than that the dramatic events were interwoven with, yet clearly detached from, dense crowds and that the figures were organized into a "stratified relief," the scenery — presumably even the church interior — operating as a backdrop rather than an environment. This is to be expected from a work so closely following the "Granada-Miraflores" altarpiece; for, it is in the latter that Roger's early phase comes to a close. It stands at the beginning of a period in which the mobile countenance of youth hardened and sharpened into the firm physiognomy of the "middle years." From now on there was to be explication, diversification and, ultimately, reconciliation, but no fundamental change.

There is, of course, an unmistakable difference between the Virgin Mary in the first panel of the "Granada-Miraflores" altarpiece and, say, the adoring Mother in the Bladelin triptych (fig. 337)[4] which must be dated, on historical grounds, some little time after 1452. But in physiognomical type and psychological interpretation the two figures seem sisters when compared to the Annunciate in the Louvre picture or the Madonna painted by St. Luke; and the same applies to the types of Christ and the Mater Dolorosa when compared with any later work, on the one hand, and the "Descent from the Cross," on the other. With the "Granada-Miraflores" altarpiece Roger's ideals of human beauty and dignity were irrevocably fixed, and it shows him decided on a course of viewing drapery in graphic rather than plastic terms, of slenderizing all proportions, of suppressing mellifluousness in favor of precision. Pursued

with Roger's single-mindedness, this course led, for a time, to a decidedly un-Eyckian, even "anti-Eyckian" style: a style of almost ascetic purity, diagrammatic rather than descriptive, reducing the multifarious wealth of things to an ordered cosmos of symbols. This style, foreshadowed in the "Granada-Miraflores" altarpiece and destined to outlast even the trip to Italy by one or two years, reached its climactic stage in the second half of the 'forties.

The number of works produced by Roger in this decisive decade has been deplorably reduced by time. Nothing is left of the *dipinture* commissioned by Lionello d'Este of Ferrara, one of them inspected by Cyriacus of Ancona on July 8, 1449.[1] The famous "Carmelite Madonna" of 1446 — Our Lady, crowned with stars, between a group of Carmelites and the family of a Knight of the Golden Fleece — was heavily damaged by the iconoclasts and is now lost altogether, except for the fact that the principal figure may be preserved in one of the very few drawings that have a reasonable claim to authenticity (fig. 385) as well as in a number of painted replicas.[2] Several variations on Roger's favorite subject, the Descent from the Cross, two of them condensing the scene into a group of half-length figures (figs. 393–395) and one interpreting it as a Bearing of the Body to the Sepulchre rather than a Deposition (fig. 392), have come down to us only in copies.[3] And one or two compositions which for stylistic reasons may be dated in the late 'forties have survived only as fragments.[4] We have, however, two works of the first magnitude: the Calvary triptych in the Gemäldegalerie at Vienna, and the "Last Judgment" in the Hôtel-Dieu at Beaune.

Of these two works the Vienna triptych (figs. 322–324),[5] showing the Crucifixion in the central panel, the Magdalen on the left, and St. Veronica on the right, is certainly the earlier; still intimately linked to the style of the 'thirties, it has much in common with the great "Descent from the Cross" as well as the "Granada-Miraflores" altarpiece and is commonly — and, I believe, correctly — dated about or shortly after 1440. The flying mantle of the St. John, for example, though more emphatically linearized and animated by a more sweeping movement, is manifestly derived from that in the "Descent from the Cross" whereas his general posture, his face, and, most particularly, his right hand, more closely resemble the corresponding features in the "Granada-Miraflores" altarpiece. The faces of the Virgin Mary and the Magdalen are of the same cast as that of Our Lady in the "Appearance," and the striated landscape, entirely different from both the would-be Eyckian river view in the "St. Luke Painting the Virgin" and the elaborate prospects in the Bladelin and Columba altarpieces, looks almost like the background of the Granada-Miraflores "Lamentation," expanded on either side so as to continue into two lateral panels.

Yet this apparently conservative triptych, apart from marking a further step in the development from discursive description to concentrated stylization, is full of those surprising innovations which have, in part, been mentioned at the beginning of this chapter. Familiar as we are with Dirc Bouts, Hugo van der Goes and Memlinc, we take it for granted that a triptych showing a Biblical event in the center and standing saints in the wings can unify these elements by a continuous scenery. But in 1440 this fusion of dramatic action with sheer existence (as opposed, for instance, to the Dresden altarpiece by Jan van Eyck where all the figures are

practically motionless, or to the "Descent from the Cross" by the Flémalle Master where all the figures are involved in the event) was something of a novelty. And even more audacious is Roger's idea of including the donors within the drama itself.

A middle-aged couple, unfortunately not identified, they kneel directly beneath the Cross and are permitted to take a modest part in the action itself, the woman engrossed in sorrowful contemplation, the man raising his head and lifting his eyes to the crucified Christ as does the St. John. These donors retain, of course, their portrait status in that they are represented in fashionable costumes (which are said to corroborate the dating of the work in *ca.* 1440) and conventional poses. Moreover they are aligned on a diagonal which, instead of converging with the standing line of the two opposite figures, as was the usual thing, runs parallel to it; they are thus separated from the protagonists by a kind of channel which "keeps them at a distance" and, from a purely compositional point of view, creates a situation which, within the framework of a new style, resembles that of the "Descent from the Cross": a central group, flanked by two figures "formant parenthèse," is governed by parallelism rather than symmetry — only that a close interlacement of curves has been transformed into an open pattern of verticals.

These verticals are, however, diversified into a calculated variety of poses, gestures and drapery motifs, and interconnected by such curvilinear links as the mantle of St. John and the trailing robe of the Virgin. And they are counterpointed by the violent movement in the upper zone of the picture, where the ends of Christ's loincloth are lifted and agitated by a supernatural breeze so as to move in unison, as it were, with the mournful flight of the lamenting angels.

While this beautifully expressive motif — which we are apt to take for granted because we know it from so many later representations, including the far-famed though spurious "Dürer Crucifix" at Dresden — is a personal invention of Roger's, the figure of the crucified Christ itself achieved popularity, not because it was new, but because it is, in a sense, archaic. In opposition to the rigid type then favored by the older Flemish masters,[1] the slender figure in the Vienna triptych, knees slightly bent so as to suggest meekness and suffering while not impairing the impression of sublimity, revives and perfects the aristocratic French and Franco-Flemish ideal exemplified by the "*Très Riches Heures*," the "*Missel de l'Oratoire de St. Magloire*" and, most particularly the "Boucicaut Hours" where even the diagonal arrangement of the loincloth is anticipated.[2]

A truly revolutionary motif, however, is the representation of the Virgin Mary in a pose thus far reserved to saints in ecstasy, particularly the Magdalen: in the Vienna triptych it is the Mater Dolorosa, and not the *Magna peccatrix*, who embraces the Cross and reaches for the feet which the great sinner had "washed with tears and wiped with the hair of her head." To imagine Our Lady in this posture was not entirely foreign to mystical writing;[3] but so to represent her in a work of art was so bold an innovation that it was accepted only by slavish copyists[4] and one ingenious pasticheur who tried to out-Roger Roger while out-Flémalling the Master of Flémalle (fig. 398).[5]

The "Last Judgment" of Beaune,[1] unfortunately extensively restored, has never left the place, or at least the building, for which it was destined. On August 4, 1443, the Chancellor Nicholas Rolin — whom a contemporary chronicler describes as "one of the great minds of the realm, to speak temporally, for as regards the spiritual I will keep silent" —[2] sought to relieve his conscience by the foundation of a splendid hospital, and it is in this "Hôtel-Dieu de Beaune," though no longer in its chapel, that Roger's altarpiece can still be admired. Since the chapel was dedicated on December 31, 1451, we possess both a *terminus post* and a *terminus ante quem*; and since the portrait of the Chancellor seen on the exterior of the altarpiece shows him at about the same age as does the famous dedication page of the "*Chroniques du Hainaut*" of 1446 (fig. 330, ascribed by some to Roger himself and, even if not executed, certainly designed by him),[3] we may assume that the "Last Judgment" was well in progress at that time.

From a technical point of view, the altarpiece may be described as a triptych raised to the second power. Not unlike the upper storey of the Ghent altarpiece, it is composed of a tripartite "corpus" and two bipartite, movable wings; their sections are, however, equal in height so that two small separate shutters are required to cover the top of the tall central panel. When open, this super-triptych — measuring about eighteen feet across — thus shows no less than nine panels of four different formats; when closed, no less than six of three different formats.

The program of the exterior (fig. 325) is reminiscent of the Ghent altarpiece in iconography also. The upper zone shows an Annunciation in grisaille, the work of an indifferent assistant; beneath it are seen the donors venerating the patron saints of the place of destination: instead of the two Saint Johns, we have St. Sebastian, invoked against the plague from time immemorial, and St. Anthony, protector from leprosy and skin disease and special patron of the Beaune Hospital up to December 30, 1452; and here as in the Ghent altarpiece the two saints are represented as simulated statues while the donors' portraits are painted in natural colors toned down so as to harmonize with the grisailles. In style, however, the "Last Judgment" marks the climax of Roger's "anti-Eyckian" phase. Where Jodocus Vyd and Isabel Borluut emerge from the gloom of indistinct recesses, the formidable Chancellor — then twelve or thirteen years older than when he sat for his portrait in Jan van Eyck's Rolin Madonna but still "unwilling to let anyone rule in his place, intent upon rising and expanding his power to the very end and dying sword in fist"[4] — and his long-faced second wife, Guigonne de Salins, are depicted in a sharply defined but bare and narrow-looking environment. Attended by angels bearing their escutcheon and kneeling before *prie-dieux* the covers of which are inwrought with their heraldic devices, *three keys in pale or* and *a tower or*, they are encompassed by barrel-vaulted cells the depth of which is cut in half by damasked gold cloths. Projected against this severe background and painted with a minimum of modeling, the thin, pallid figures, both clad in black, give the impression of disincarnate silhouettes rather than solid, space-displacing bodies.

As for the "Last Judgment" itself (figs. 326–329), the excessive width and numerous subdivisions of the open altarpiece necessitated — or, rather, permitted — a thoroughly Rogerian departure from the contemporary tradition. All other Northern painters of the period, when

attempting a fully orchestrated "Last Judgment," aimed at a cumulative and illusionistic effect. Stephan Lochner's early masterpiece in the Wallraf-Richartz Museum at Cologne,[1] Jan van Eyck's diptych in the Metropolitan Museum,[2] the panel in the Musée des Arts Décoratifs elusively connected therewith,[3] and the impressive though provincial panel from Diest near Louvain [4] — all these representations are calculated to impress the beholder with a kind of cosmic catastrophe staged within a space as deep, continuous and crowded as was within the artist's power to achieve, and with a description of Heaven and Hell as graphic and circumstantial as in the famous "Enfer" miniature in the *Très Riches Heures*." [5]

Compared with such exuberance Roger's "Last Judgment" appears — and in a measure is — frankly medieval, from the general disposition down to the old symbols of lily and sword which were repugnant to the modernism of Stephan Lochner, Jan van Eyck and even the Master of Diest. Instead of relying on the psychological impact of depth, he overawes us with a phantasmagoric contrast between space and spacelessness; instead of displaying a profusion of picturesque details partly edifying and partly horrible, he concentrates upon a few portentous essentials; instead of evoking chaos he glorifies a supreme and final order. And in accomplishing this he was effectively assisted by — or, to put it the other way, effectively made use of — the very structure of his altarpiece. The angels bearing the instruments of the Passion are relegated to the upper shutters so as not to interfere with the majestic isolation of the Judge; the "corpus," unified by the enormous span of the rainbow, is mainly occupied by the Deësis group; Heaven and Hell are confined to the narrow panels at either end; and the tall central picture is reserved to the Lord, far above the reach of even the Intercessors, and to the noble embodiment of His office, the Archangel Michael weighing the souls of men.

In so directly superimposing the figure of the Judge upon the Psychostasia — a motif absent from nearly all contemporary Last Judgments in Northern art and, where it occurs, reduced to insignificance — Roger reverted to the High Gothic tradition. We must turn our eyes to the past and look at the main portal of Bourges Cathedral (which Roger may have visited should he have gone to Burgundy in person) to find an adequate precedent; and it is not only in this respect that the Beaune altarpiece carries us back to the thirteenth century. Its long, friezelike format, resembling the lower register of a monumental tympanum, demanded horizontal alignment rather than deployment in depth, and it is precisely the resurgence of a medieval, essentially non-perspective style, the transformation of a panorama into a gigantic diagram, that sets the Beaune altarpiece apart from all comparable representations of the Last Judgment. As in Enguerrand Quarton's "Coronation of the Virgin" the celestial sphere is indicated by gold ground.[6] But here this gold ground, inscribed with the *Venite benedicti* in white and the *Discedite a me maledicti* in black, is bordered by a continuous band of feathery, rose-colored clouds so that it gives the impression of a magic curtain extending from the extreme left to the extreme right and raised in the center in a gigantic arch around the St. Michael and the four angels sounding the last trump. This curling band of clouds provides a base deep enough to permit the tall, ascetic figures to arrange themselves in a "stratified relief" but not to recede into space.

The front plane of this relief is defined by the Intercessors and the two leaders of the Apostles, SS. Peter and Paul. Behind them, the other Apostles and the Community of the Saints — the latter significantly limited to seven representative figures, a pope, a bishop, a prince and a monk on the left, a virgin, a princess and a married woman on the right — are arrayed on two concentric curves. But so flat are these curves that we involuntarily read the four groups in terms of a superbly balanced and rhythmicized surface pattern rather than of a semicircular apse. Beneath this celestial apparition the desolate earth, a narrow strip of wavy, barren land devoid of vegetation and water, stretches between the Castle of Paradise and Hell. The dead rise from cracks and holes rather than graves; and where Stephan Lochner and the Master of Diest depicted Heaven as a big, cheerful palace alive with throngs of Elect and little angels curiously looking down from the battlements or "making a joyful noise" with harps and lutes, Roger succeeded in investing even the golden Castle of Paradise with a spirit of claustral austerity, its empty stairs and halls silently waiting for the Saved.

Yet Roger's outward medievalism does not prevent him from being, inwardly, astonishingly modern. His is the first, and for a long time the only, representation of the Last Judgment to include Hell while omitting the Devil; and his Resurrected, tiny in comparison with the members of the celestial tribunal and made even tinier by the towering figure of the St. Michael which, standing on the ground, supplies a direct standard of measurement, no longer merge into an indistinct mass of humanity. They are all individuals, their animation increasing in almost cinematographic progression, and their emotions ranging from blind astonishment, hopeful incredulity and quiet assurance to furious protest and howling despair — until the Elect are admitted to Heaven and the Damned, gnashing their teeth and clawing each other, are rushed into the flames in a crescendo of terror. There are no angels to rescue the Resurrected nor any demons to drag them down. The fate of each human being, determined by the Judge without assistance or interference, inevitably follows from his own past, and the absence of any outside instigator of evil makes us realize that the chief torture of the Damned is not so much physical pain as a perpetual and intolerably sharpened consciousness of their state.

The Damned — one of the most conspicuous groups significantly repeating the pattern of an Expulsion from Paradise — are many and the Elect are few. And when we look once more at the St. Michael holding the scales (fig. 327), we observe a revealing reinterpretation of accepted iconographic traditions. As is well known, the weighing of souls in representations of the Last Judgment has a prototype in classical art and literature where Hermes — or, occasionally, Zeus — holds the golden scales on which are placed two images representing the "death-lots" (κῆρε, fata) of heroes about to engage in mortal combat, and he whose κῆρ or fatum goes down is doomed.[1] This allegory involves two different and contradictory kinds of symbolism: natural feeling attaches a positive significance to height and a negative one to lowness (we all use words such as "high" and "low," "lofty" and "base," "elated" and "depressed," "superior" and "inferior" in precisely this sense); whereas in the process of weighing the positive significance attaches to that which "outweighs" its counterpart so that it is the winning side which goes down. In a classical Psychostasia, where the scales are fraught with

death, these two kinds of symbolism coincided because the sinking scale announced the victory of death, and, therefore, destruction while the rising scale announced its defeat and, therefore, preservation. They conflicted, however, when the idea of weighing was transplanted to the domain of Christian eschatology, St. Michael, the Christian Psychopompos, taking the place of Hermes and, occasionally, the hand of God taking the place of Zeus. Then the things to be balanced were not one death against another but good against evil, with the result that good must go down in order to outweigh evil; in many representations of the Last Judgment the devil, therefore, does his worst to bring down his side of the balance by tugging at the beam or even putting his foot in one of the scales.[1]

As long as these scales were occupied, after the fashion of the classical Psychostasia, by little human figures conceived as images of individual souls, or of sins and virtues within an individual soul, this contradiction did not become apparent. The poses and gestures of the figures, indicative of good or bad conscience, tended to overshadow the significance of their position; and, more important, the contest was not a contest in principle: whichever way the scales might turn in one particular case the outcome might be reversed in any number of others.[2] But when the content of the scales came to be thought of in general terms, and non-anthropomorphic symbols of redeeming grace — the Lamb, the Chalice or the Gospel book — came to be opposed to equally non-anthropomorphic symbols of evil such as reptiles, millstones or devil's masks, the very doctrine of salvation made it imperative that the balance be turned in favor of good. And this is what happened — perhaps in connection with the rise of scholasticism — by the end of the twelfth century and became a typical feature of the Last Judgments of the great French cathedrals. In the tympanum of Autun, good is still personified by a human figure, praying and placed in its scale by an angel; but the other scale is already occupied by a horrid little monster signifying evil as such.[3] In the tympana of Chartres (south transept), Amiens and Bourges both human figures are replaced by symbols, a devil's mask being contrasted with the Lamb in Amiens and with the Chalice at Bourges. And in all these instances the symbol of good triumphantly "outweighs" the symbol of evil although the devils, manipulating the balance or clinging to the pan containing the emblem of sin, make desperate attempts to turn the scales the other way.[4]

Roger — more naturalistic and, in a sense, more humanistic than the High Medieval sculptors — retransformed the symbols of good and evil into human images; but he went out of his way to make it clear that the two little figures, far from portraying individual souls, continue to express the ideas of virtue and sin in general: they are inscribed *virtutes* and *peccata*. According to the standards of Chartres, Amiens and Bourges, then, the virtues should "outweigh" the sins. Yet the figure inscribed *virtutes*, hands folded in prayer, rises, whereas the other, mouth open in a cry of anguish and hands shaking with despair, sinks. Roger has thus reinstated the natural, expressive significance of "rising" and "sinking" within the framework of an interpretation determined by scholastic rationalization. And in so doing he has created a tragically ambivalent symbol of human nature and destiny. Virtue soars into the light and sin goes down to darkness; but the sum total of evil "outweighs" the sum total of

good. By the very logic of the weighing simile the central motif of his composition places the accent on Daniel's "Thou art weighed in the balance and art found wanting" rather than Christ's "Thy sins be forgiven."

To many such an interpretation of Roger's "Last Judgment" would seem to attribute too pointed a significance to details which the modern mind is apt to consider as a matter of artistic preference. It should be borne in mind, however, that all the features stressed in the foregoing analysis were noted — and, apparently, objected to — by Roger's very contemporaries. In 1473 Memlinc completed a "Last Judgment," second in fame only to Roger's own, which had been commissioned by Angelo Tani, the senior representative of the Medici at Bruges, but by a remarkable concatenation of circumstances found its way into the Marien-kirche at Danzig. As was only natural, he based his composition on that of his master. But he "corrected" it in precisely those respects which I have emphasized. The space is deeper. The Castle of Paradise is even gayer than in Lochner's panel (which Memlinc probably knew), its halls crowded with Elect, its roof and balconies full of music-making cherubs, its stairs lined with angels vesting the souls with new garments, and St. Peter greeting every guest with a handshake. Devils of all description abound. The number of Resurrected is legion. The St. Michael (revealing the additional influence of Petrus Christus' copy after Jan van Eyck) is brilliantly armored beneath his pluvial and brandishes a cross-staff in addition to holding the balance. And, most important, the outcome of the Psychostasia is once more reversed: the personification of virtue — a praying figure perhaps portraying the donor's friend, Tommaso Portinari — again "outweighs" the personification of sin.[1]

VII

"When, in the year of the Jubilee," writes Bartolommeo Fazio in his biography of Gentile Fabriano, "Roger of Gaul, the outstanding painter, visited the Church of St. John Lateran, he was, so they say, seized with admiration for the work [viz., Gentile's frescoes, completed by Pisanello and now unfortunately lost], asked the name of the author, heaped praise upon him, and deemed him superior to all the other Italian painters."[2]

Until fairly recently this statement has never been doubted, and further evidence of Roger's stay in Italy was thought to be furnished by the beautiful portrait of a member of the Este family in the Metropolitan Museum (fig. 366). The sitter was believed to be either Lionello d'Este (whose contacts with Roger are proved by Cyriacus of Ancona's testimony and several records of payment) or Lionello's elder half-brother, Meliaduse, and the portrait was supposed to have been executed at Ferrara in 1450. Some twelve years ago, however, it was proved to represent Francesco d'Este, an illegitimate son of Lionello who had been sent to the Burgundian court in 1444, and therefore to have been painted in the Netherlands rather than Italy.[3] In view of this important correction it has been said that Roger's visit to Italy could no longer be accepted as a fact and that Fazio's statement might be "a typical example of those anecdotes told in the streets and in taverns frequented by artists, the intention of which was to exalt the

name of one renowned master by coupling it with that of another still more famous artist." [1]
However, while it is true that the identification of Francesco d'Este destroys the basis for the
assumption that Roger stayed and worked at Ferrara it does not necessarily disprove his journey
to Italy.

By documentary evidence we know that he was still at home around June 15, 1450, but
this leaves plenty of time for his pilgrimage, especially if we assume that he did not make a
detour to Ferrara but proceeded to Rome on the direct route via Bologna and Florence.[2]
Artists' taverns or no, the testimony of the well-informed and usually reliable Fazio, writing
eight years before Roger's death, cannot lightly be dismissed; and the statement that "Roger's
work shows no signs whatever of the influence either of Gentile, whom he is said to have ad-
mired, or of other Italian painters, as, for instance, Benozzo Gozzoli or Pisanello or Fra An-
gelico" [3] is at variance with the available evidence. It can be shown that Roger knew, and was
impressed by, not only Gentile da Fabriano and Fra Angelico but also several other Florentine
artists.

Convincing proof of this is furnished by a composition which is "sotto la cupola" even
today. Originally gracing the chapel of the Medici villa at Careggi, mentioned by Vasari and
Lodovico Guicciardini and now preserved in the Uffizi, it is customarily referred to as an
"Entombment" but rather shows a Last Farewell before the Entrance to the Sepulchre (fig.
331).[4] In front of a rock-hewn cave containing the sarcophagus, we behold a frontalized and
nearly symmetrical group centered around the dead Christ. His body is upheld by Joseph of
Arimathea and Nicodemus while the Virgin Mary and St. John reverently lift His arms as
though to kiss His hands; the Magdalen, frozen in a posture of mute, helpless despair, kneels
in the foreground.

The very fact that the scene is staged before a cave represents a break with Northern
iconography and it has long been conjectured that the composition is based upon a formula
developed by Fra Angelico and best represented by a panel, probably executed by one of his
assistants, in the Pinakothek at Munich (text ill. 57).[5] This conjecture, I think, can be con-
verted into a certainty. In the first place, Roger appropriated two details apparently peculiar to
Fra Angelico: the framework of masonry by which the mouth of the cave is squared into a
regular doorway, and a peculiar kind of tree the branches of which spread from one point into
a fanlike pattern. This outlandish tree, occurring twice in Roger's Uffizi picture and not identi-
fiable with any known species, is as foreign to his and other Flemings' botanical vocabulary as
it is typical of Fra Angelico's.[6] In the second place, the iconography of Roger's composition
can be shown to have resulted from a specifically Tuscan development.

Both Fra Angelico's Munich panel and Roger's Uffizi picture are variously designated as
"Entombment," "Lamentation" and "Man of Sorrows." This indecision is not surprising; the
composition, defying all of these categories, had gradually evolved from a Romanesque version
of the Descent from the Cross — exemplified, for instance, by the Albani Psalter and a fine
Psalter in the Turin Library — where the arms of Christ, already unfastened, are grasped and
raised by Our Lady and St. John.[7] It was in Tuscany, where this ancient type of Deposition is

monumentally represented by the well-known group in Volterra Cathedral,[1] that it was gradually stripped of all mechanical implications and thus transformed into what I have called a "Last Farewell." In the groups in S. Antonio at Pescia and S. Miniato al Tedesco (also late thirteenth century) the figures engaged in loosening and supporting the Body are either inactive or absent so that the dead Christ, His feet still nailed to the Cross, mysteriously hovers between the Virgin Mary and the St. John;[2] and in a panel by a follower of Bernardo Daddi the Body is entirely detached from the Cross, its lower part concealed by a sarcophagus after the fashion of a Man of Sorrows.[3] Fra Angelico had only to restore it to its full length, to add a supporting figure, and to transfer the scene from Mount Golgotha to the entrance of the Tomb.

It would be incomprehensible — all the more so because the general current of influence had long ceased to flow from South to North — had Roger employed a scheme of composition so deeply rooted in Tuscan tradition without a firsthand contact with Florentine sources. Conversely, his version of the indigenous theme made such an impression in the circles of Andrea del Castagno, Jacopo del Sellaio and even Michelangelo that it belongs in the history of Florentine as well as Flemish painting.[4]

Needless to say, Roger yielded to Fra Angelico's influence only in accidents and not in essence. The Body, angular and skinny by all Italian standards, is placed slightly aslant. The figures — all in tears, the Joseph of Arimathea still vaguely reminiscent of the "Descent from the Cross" and the St. John an attenuated yet even more expressive variation on that in the Vienna triptych — are as Rogerian as possible. While challenging the Florentine perspectivists by the obliquely placed stone slab and the foreshortened figure of the Magdalen, he carefully stabilized his projection plane by her discarded hat and ointment jar. And the figure of the Magdalen herself, showing her naked soles to the spectator (as do the Apostles in the Ghent altarpiece), anticipates the taste of Hugo van der Goes, Schongauer and Dürer rather than conforms to that of Fra Angelico.

The inference is that the Uffizi picture was commissioned by the Medici while Roger was in Florence and was conceived, if not executed, under the direct impact of Florentine models. The same may be assumed, though with a somewhat lesser degree of confidence, of the "Madonna with SS. Peter, John the Baptist, Cosmas and Damian" in the Städelsches Kunstinstitut at Frankfort (fig. 332).[5] Discovered at Pisa in 1833, displaying the Florentine arms (*argent a fleur de lys florencé gules*) in the center of the frontal parapet, and showing the Virgin flanked by the Medici family saints and the name saints of Cosimo's two sons, the picture was, and by many still is, believed to have been ordered by old Cosimo.

This belief is not, in my opinion, invalidated by the fact that a Louvain family, in no wise connectable with Roger van der Weyden, also bore *argent a fleur de lys florencé gules*;[6] that SS. Cosmas and Damian may be interpreted as patrons of a medical faculty as well as the Medici clan;[7] and that they bear the features of two Burgundian courtiers, Jean le Fèvre de St. Remy called "Toison d'Or" (the King of Arms of the Golden Fleece) and Pierre de Beffremont or Beauffremont, Comte de Charny (the same who had acted as godfather by

proxy for Philip the Good when Jan van Eyck's child was baptized in 1434).[1] For, these two haughty courtiers — "Toison d'Or" so much so that he discarded his family name, le Fèvre, as too bourgeois — had even less to do with Flemish physicians than they may have had with the Medici (in fact, we happen to know that Jean le Fèvre had been in Italy on numerous occasions, including a mission to Pope Eugene IV, the great ally of Cosimo).[2] But even if no connection existed between the Frankfort Madonna and the Medici its composition would testify to its connection with Florentine art. At Roger's time, Northern representations of the "Sacra Conversazione" were dominated by the principle of isocephaly rather than triangulation. There is no contemporary parallel in Flemish art to a Madonna with four saints arranged in such a way that her head — as in so many paintings by Roger's followers — forms the apex of an isosceles triangle rather than the center of a straight horizontal; that she is raised upon a series of polygonal steps; and that this polygonal pedestal, unobscured by carpet or drapery, proclaims, as it were, its pure stereometric structure. As the Uffizi picture can be accounted for only by the influence of a work such as Fra Angelico's Munich "Entombment," so can the Frankfort Madonna be accounted for only by the influence of a work such as Domenico Veneziano's "*Sacra Conversazione*" from Santa Lucia dei Magnoli.[3]

In style and what may be called morphology, however, the "Medici Madonna" is no more Italianate than the Uffizi "Entombment." The Virgin Mary appears in a ceremonial tent not unlike that in the lost *Sacra Conversazione* by the Master of Flémalle, and the figures are no less Rogerian than in the "Last Judgment" at Beaune. While trying to compete with Domenico Veneziano's statuesqueness, Roger almost exaggerated his own Gothicism; it is as though his first encounter with the Quattrocento had strengthened rather than weakened his will to affirm his personal style much as, under entirely different historical conditions, the second atelier of Charlieu reacted to the quiet monumentality of the Portail Royal of Chartres with an outburst of Burgundian violence.

A work produced immediately after the "Medici Madonna" and the Uffizi "Entombment" shows even fewer signs of Roger's contact with Italy. It is a triptych in the Louvre (figs. 333, 334) which, as we learn from the arms on the back of its wings, was commissioned by Jean de Braque and his wife, Catherine of Brabant, and is therefore datable with some precision; the donor died in 1452 and can hardly have been married for more than one or two years because his wife was only nineteen at the time of his death.[4]

In iconography this triptych may be described as an ingenious variation on a theme introduced to the North by the Master of Flémalle. By adding the figure of St. John the Evangelist, Roger transformed the Intercession of Our Lady with Christ, as represented in the older master's Philadelphia picture (fig. 216), into a hieratic triad not unlike a Deësis, except for the fact that the Evangelist does not participate in the intercession. These three half-length figures, set out against a matutinal landscape and spaced so as to keep in contact with yet not encroach upon each other, occupy the oblong central panel. The left wing shows St. John the Baptist displaying a book and pointing to Christ; the right wing, the Magdalen tenderly carrying her ointment jar.

The style of this work is still linked to that of the preceding decade. The face of Christ resembles the implacable countenance of the Judge in the Beaune altarpiece, so much so that it is thought to have been painted "d'après le même carton." [1] The right arm of the Baptist repeats, even more literally, that in the "Medici Madonna." The pellucid landscape, its foreground concealed by the figures, is little more than a richly embroidered foil, and Roger did not hesitate to place beautifully lettered inscriptions — all but one taken from the Gospel of St. John [2] — right in the sky. "No one would think of asking," says M. J. Friedländer, "where in Heaven or on earth these presences are really dwelling." [3]

Yet there is something about this archaically symmetrical composition, "perhaps the most perfect realization of the ideal of grave spirituality pursued by the master during his middle period," [4] which seems to foreshadow a final change. Like all "perfect realizations of an ideal," be they the Sistine Madonna or the Apollo Belvedere, the *Nozze di Figaro* or the nave of St.-Denis — the Braque triptych harbors potentialities inimical to the very ideal of which it is the temporary fulfillment. "Gravely spiritual" though it is, its colors, from the vermilion and yellow of Christ's halo and the brocaded sleeve of the Magdalen to the delicate lilac of her dress and the faint blue and rose of the sky, glow with a warmth and brilliance unparalleled in the works of the 'forties. The expression of the Virgin Mary and the Magdalen is tempered, as it were, by lyrical sentiment; nobler and sadder than ever before, their faces are no longer severe. The Magdalen's hair is rendered with almost Eyckian attention to texture. And there is a restrained but — for this very reason — almost voluptuous tenderness in the way in which her breasts are molded and her throat is made to shine through the transparent fabric of her veil. In short, we sense a latent nostalgia for precisely those values which had been more and more emphatically suppressed after the great "Descent from the Cross": for richer color and softer light, for physical beauty and tender emotions. It is this re-humanization of style and sentiment which prepared the way for Roger's latest style.

VIII

Symptomatic of this new feeling is the Bladelin altarpiece in the Kaiser Friedrich Museum at Berlin (figs. 335–340). [5] Its donor was Peter Bladelin, reorganizer of Burgundian finance and "receveur général" of Philip the Good, one of the richest men of the period, yet more sincerely pious and humane than most. Childless and wishing to put their wealth to a use both beneficial and spectacular, he and his wife, Margaret van Vagewiere, decided upon a truly Faustian enterprise. Between Moerkerke and Aardenburg (to the northeast of Bruges) they founded a whole city, complete with castle, church and prebends: the town of Middelburg, so called because part of the land had been acquired from the Cistercian Abbey of Middelburg on Walcheren. The castle was begun in 1448, the church in 1452; and owing to excellent preparation and management the city is said to have been largely completed within six years (although the church was not dedicated until June 12, 1460, and the walls were not raised until 1464). [6]

It was for the church of this new town that the Bladelin triptych was destined, and we may assume that it was commenced not long after 1452. Closed, it shows an "Annunciation" in grisaille which, in spite of its crudeness, is not devoid of interest and sharply differs from other productions normally referred to as "shopwork" or assigned to Vrancke van der Stockt.[1] Opened, it extols the Saviour's advent on earth and the whole world's acceptance of His reign by illustrating, down to the minutest detail, a text well known but not thus far translated into a cycle of images: the chapter *De Nativitate domini nostri Jesu Christi* of the *Golden Legend*. In the left wing the birth of Christ is announced to the Occident by the miracle that was to give rise to the foundation of the Church of Araceli: kneeling before an open window the upper panes of which display the arms of the Holy Roman Empire, holding his crown in his left hand and swinging a censer with his right ("thura ei offerens"), the Emperor Augustus does homage to an apparition pointed out to him by the Sibyl of Tibur: "a golden circle compassing the sun at noon time and, in the midst thereof, a virgin of wonderful beauty, holding an infant on her bosom." The perspective of the room is so constructed that the principal vanishing lines converge toward the very center of this apparition, and the mysterious words heard in conjunction with it ("Haec est ara coeli") are boldly visualized in that the Virgin's throne is placed upon a vested altar. In the right wing the Birth of Christ is announced to the Orient by the appearance of the Star of Bethlehem: the three Wise Men are seen genuflecting, "on a hill," not before a star pure and simple but — in strict accordance with the text — before a "star which had the form of a beautiful infant." [2]

Between the East and the West — in the center of the universe, as it were — we behold the Nativity itself. Here, too, we find a number of iconographic novelties. The donor (Frontispiece), his fine-boned face expressing deepest piety but full of sadness, is permitted to participate in Our Lady's devotion as were the donors of the Vienna triptych in her sorrow. The background, usually a continuous landscape, is clearly divided between a hilly meadow where the Annunciation to the Shepherds takes place and a stately town — supposedly the city of Middelburg, but if so, rendered in a somewhat proleptic and thoroughly idealized interpretation (it is not easy to see how Bladelin's castle could have been built in purely Romanesque style). And the conventional wooden shed is replaced by a ruin, also Romanesque, the most conspicuous feature of which is a huge marble column. Appearing here for the first time, this column was to hold a prominent place in numerous later Nativities, including the Portinari altarpiece by Hugo van der Goes; in Roger's mind it may have been associated both with the column on which the Virgin Mary was said to have supported herself "when the hour of giving birth had come" and with the column to which Christ was to be tied when suffering the Flagellation.[3]

This "Nativity" bears witness to that nostalgic desire for warmth and intimacy which I have tried to describe. The Virgin Mary, resembling, we recall, the white-clad *mulier sine labe* in the "Granada-Miraflores" altarpiece, is less lonely and tragic; she is surrounded by the fellow-feeling of touching little angels and good, soft-nosed animals in which the traditional contrast between the ass and the ox — the former symbolizing the Old Testament or Judaism,

the latter the New Testament or Christianity [1] — is expressed with an empathic understanding entirely foreign to Roger's middle years. The ass, with his lowered head and inattentive ears, is cut off from the admiring circle and his vision is blocked by the head of the ox; he innocently symbolizes the proverbial blindness of the Synagogue whereas the ox looks on with an expression closely akin to piety.

The lineation, while still precise, is softer and more fluid. A warm chiaroscuro, forgotten since the days of the Louvre "Annunciation," pervades the interior of the ruined building. And, most significant, the composition reverts in principle to the Master of Flémalle's Dijon "Nativity." From it Roger not only borrowed the candle motif and the general disposition of the figures (the donor taking the place of the believing midwife) but also the idea of setting the architecture slantwise into space — so far as I know the only prominent "oblique view" in Flemish panel painting between the "Friedsam Annunciation" and Gerard David's "Justice of Cambyses." He emended, of course, the earlier picture's shaky perspective. He perfected the balance between solids and voids. And he equilibrated and rationalized the whole design in the assurance of his mastership; it is characteristic that the front corner of the building, the real pivot of every two-point construction, is placed exactly on the central axis of the panel. But the very fact that he chose to revive a composition about thirty years old reveals, I think, a secret longing for his youth.

This mellowed mood was conducive to the resurgence of Italian memories quite different from those which had come to life in the "Medici Madonna" and the Uffizi "Entombment" — memories, not of abstract iconographic outlines that could be filled with non-Italianate forms but of concrete representational motifs embodying the Renaissance ideal of human beauty and deportment. Two of the three dignitaries witnessing the vision of Emperor Augustus bear the familiar features of Jean le Fèvre de St. Remy and Pierre de Beffremont as also do the attendants of King David in the fragment of a contemporary composition (fig. 341, formerly in the Schloss Collection at Paris) which represented David Receiving the Cistern Water according to II Samuel XXIII, 15–17).[2] The third, however, perhaps the court astrologer, differs from these two stiffly posed dignitaries in that he stands as only Italians stand: hands on hip, one leg bent and stepping back. It is the attitude selected by Donatello for his David and by Castagno for his Farinata degli Uberti, and also familiar to such minor masters as Francesco di Stefano called Pesellino.[3]

That this amiable eclectic, fusing the tradition of Masaccio with the more pleasing manner of Fra Angelico and Filippo Lippi, aroused Roger's interest can be gathered from the St. John triptych in the Kaiser Friedrich Museum at Berlin (figs. 342–346), an almost identical replica of which, though smaller by one third, exists in the Städelsches Kunstinstitut at Frankfort.[4]

Like the "Granada-Miraflores" altarpiece, this triptych is composed of three equal panels, each of them showing the principal scene enframed by a sculptured portal. The first depicts the Birth — or, rather, Naming — of St. John the Baptist according to Luke I, 57–63 (it will be remembered that the little St. John was originally supposed to be called Zacharias "after the name of his father" when the latter, still speechless after his encounter with the Angel Gabriel,

"asked for a writing table, and wrote, saying: his name is John"); the second, the Baptism of Christ; the third, the Martyrdom of St. John according to Matthew XIV, 10 f. and Mark VI, 27 f. The archways are flanked by buttresses so that there is room for twelve statues (Apostles) instead of six. The archevault sculptures, their sequence here running clockwise from lower left to lower right within each portal, complete the narrative into a cycle in which the story of the Baptist is interwoven with appropriately selected scenes from the Life of Christ.

In general disposition, then, the St. John triptych closely resembles the "Granada-Miraflores" altarpiece, all the more so as in both cases the central panel opens onto a landscape while the lateral ones disclose interiors. But nothing could be more mistaken than to consider the two works as more or less contemporaneous — either by dating the St. John triptych too early as was the usual thing until Hulin de Loo called attention to the fact that the costumes preclude a date prior to 1445,[1] or by dating the "Granada-Miraflores" altarpiece too late as threatens to become the fashion now.[2] Setting aside such minor though significant dissimilarities as the treatment of the portals — in the "Granada-Miraflores" altarpiece the arches are round and "valanced," their spandrels filled with flowing tracery, in the St. John triptych they are pointed and unvalanced, their spandrels filled with perpendicular tracery — we are confronted with a totally different interpretation of the visible world.

In the "Granada-Miraflores" altarpiece all movements are as constrained as they are free and fluid in the St. John triptych (we may compare, for example, the St. Joseph in the "Adoration of the Infant Jesus" or the figure of Christ in the "Appearance" with the St. John in the "Baptism"), and this liberation of movement is accompanied by — or, if we prefer, predicated upon — an expansion and liquefaction of space. In the "Granada-Miraflores" altarpiece the figures remain, in spite of protest, behind the portals as behind the doors of a prison; in the St. John triptych they step through these doors and act in front of rather than behind them. Here the portals themselves operate as *repoussoirs* rather than framing devices. In the central panel, where a vaulted portico is attached to the archway, this portico is covered with a ribbed cross-vault instead of a barrel-vault, so that the cubic content of the vaulted space transcends the profile of the arch instead of being defined by it. In the lateral panels the porticoes are omitted altogether so that the arches open immediately onto complicated interiors — that of a comfortable Flemish fifteenth-century dwelling house on the left, that of a Gothic palace boasting a Romanesque banquet hall on the right — extending far into depth and filled with a chiaroscuro the modulated richness of which even surpasses what struck us as new and unusual in the Bladelin altarpiece. The very sculptures of the portals are conceived in terms of light and space rather than solid volume. In the "Granada-Miraflores" altarpiece the jamb statues are placed on colonnettes and separated from the archevault groups by tall, elaborate pinnacles; in the St. John triptych they are placed on consoles and separated from the archevault groups only by shadow-filled interstices. And the archevault groups themselves are almost treated like little paintings translated into sculpture. The figures are suffused with light and embedded in a space which more often than not takes shape in actual scenery. Two of the three Temptations of Christ (central panel, right-hand archevault) and two of the incidents

from the earlier life of the Baptist (central panel, left-hand archevault) are staged in land-scapes; the scene of the Nativity (left portal, lower right) and many other incidents is laid in architectures rendered in perspective; and Zacharias' encounter with the Angel Gabriel (left panel, lower left) takes place in an interior made real by an altar and a door through which three Jews are entering.

It has long been noted that the Peter de Hoochian prospects through a sequence of rooms in the two lateral panels of the St. John triptych, particularly in the "Birth of St. John," would not have been possible had Roger not been struck by Jan van Eyck's interpretation of this very

Ground plan of the apartments represented in the St. John Altarpiece by Roger van der Weyden.

subject in the "Turin-Milan Hours" (fig. 299),[1] to which, we remember, several miniatures — among them the "St. Thomas Aquinas" based upon the "Medici St. Jerome" of 1441–1442 — were added by Flemish illuminators toward the middle of the fifteenth century. This observation is unquestionably true, and if confirmation were needed it might be found in the appearance of a meander pavement, hitherto foreign to Roger's vocabulary, in the "Martyrdom of St. John the Baptist." However, influences do not descend upon a great master as chance visitors. Rather they are invited by him of his own volition and for his own purposes. That the St. John triptych shows the influence of Jan van Eyck's "Birth of St. John" reveals the same "nostalgic" mood which we could sense in the Bladelin altarpiece; and that it was produced at about the same time, that is to say two or three years after Roger's return from Italy,

is all the more probable as in it, too, recollections of his youth are fused with reminiscences of Florence.

In earlier representations of the Martyrdom of St. John, the presentation of his head to Salome, if represented at all, is separated from his decapitation which, according to Scripture, took place in the prison.[1] Roger condensed the two incidents into one scene involving violent activity on the part of the henchman, seen from the back, and a gyratory *contrapposto* movement, expressive of a fastidious reluctance, not experienced by pre-Rogerian Salomes, on the part of the "daughter of Herodias." Both these figures are Italianate. The henchman bears a hardly accidental resemblance to the executioner in Pesellino's "Martyrdom of SS. Cosmas and Damian" (which, incidentally, is based upon a lost composition by Masaccio);[2] the pose of Salome, her face averted from the charger in her hands in such a manner that its axis parallels the diagonal movement of her arms, is developed from a type so common in the Quattrocento that it is difficult to lay one's finger on the individual model remembered by Roger. In Florentine art this *contrapposto* attitude was rampant, so to speak, from Ghiberti to Giovanni del Ponte[3] until its classic formulation was achieved by Leonardo da Vinci. And it is, curiously enough, in Leonardo's "Leda," *fons et origo* of so many evocations of ideal beauty, from Raphael's "Galatea" and "Venus" down to the garden statue in Watteau's *Embarquement pour l'Ile de Cythère*," that Roger's Salome has her closest analogue.

An even more startling reminiscence of Florence is discernible in the Birth — or, rather, Naming — of St. John. Here the infant St. John is brought to his father by a young woman who, being haloed, can be none other than Our Lady herself, and this is so rare a feature that it deserves some attention. Whether the Virgin Mary was present at the birth of St. John — let alone at his naming which, according to Luke I, 59, "came to pass on the eighth day" — is left in doubt by the Evangelist; he merely says that she "abode with her cousin," Elizabeth, "about three months" after the Visitation (which took place in the sixth month of Elizabeth's pregnancy) and then "returned to her own house." Opinion was therefore sharply divided on this point. Some authorities explicitly deny that the Virgin assisted at the event or do not mention her in this connection at all. Others take refuge behind a noncommittal *fortassis* ("and perhaps the glorious Virgin stayed with her cousin up to the day of the birth of St. John so that she might cherish the child on her most blessed bosom"). St. Ambrose and the Venerable Bede, however, accepted her presence as a fact, and the more popular writers such as Jacobus a Varagine and Pseudo-Bonaventure fondly describe how she lifted the infant from the floor, took him in her arms, swaddled, and kissed him.

But only one source, the anonymous *Vitae Patrum*, translated into Italian by a Dominican named Domenico Cavalca (died 1342), seems to assert that Our Lady not only assisted at the birth of St. John but also "brought him to Zacharias" when he was to be named; and only once does this particular incident appear in art prior to Roger's triptych: in one of the reliefs on the south door of the Baptistry at Florence.[4] Here, in the Baptist's church and in the Baptist's city, this extraordinary distinction of the precursor was more justifiable than any-

where else, and it is hard to believe that Roger van der Weyden should have selected so unique an iconography without remembering the masterpiece of Andrea Pisano.

The St. John triptych thus appears to postdate Roger's journey to Italy and even to be somewhat more advanced than the Bladelin altarpiece in comparison with which it is both more Eyckian and more Italianate. And this revision also affects the date of a much-debated work which was originally considered as late but subsequently tended to be dated about 1445: the altarpiece of the Seven Sacraments in the Musée Royal at Antwerp (figs. 347–349).[1] Everyone, however, seems to agree that it is approximately contemporary with the St. John triptych, and since the latter appears to have been produced between 1452 and 1455, the same would seem to be true of the "Seven Sacraments."

Executed for Philip the Good's old friend and adviser, Jean Chevrot, Bishop of Tournai from 1437 to 1460, the work is a non-folding triptych not very much smaller than the "Corpus" of the "Last Judgment" at Beaune[2] and well preserved except for the repainting of several heads in the wings and the addition of an incidental figure in the central panel. It represents the Seven Sacraments as though the rites were simultaneously performed in one great church, the central panel and the right-hand wing showing the nave and the southern side-aisle while the northern side-aisle is seen in the left-hand wing. These three architectural units are viewed through plain Gothic portals (their spandrels emblazoned with the arms of the diocese of Tournai and the personal devices of Jean Chevrot in front of episcopal staffs) which differ, however, from old-fashioned diaphragm arches in that their perspective aspect is carefully differentiated according to the eccentric location of a fairly unified point of sight.

The nave is fittingly reserved for the offering of the Holy Eucharist which takes place on the main altar in the *chevet*. The other sacraments are dispensed in the side-aisles, those of Baptism, Confirmation, and Penance in the north aisle, those of Holy Orders, Matrimony and Extreme Unction in the south, and Confirmation is administered by Bishop Jean Chevrot in person; his amiably skeptical, horse-lipped face is known to us from the dedication page of the "*Chroniques du Hainaut*" (fig. 330).[3]

In view of its somewhat uninspired and not overly precise execution the Chevrot triptych can hardly be accepted as an original in the sense of manual authenticity. Its invention and design, however, cannot be ascribed to any one but Roger. The idea of staging all the ceremonies in one ecclesiastical interior is in itself unprecedented,[4] and the problems created by this novel arrangement are solved in masterly and thoroughly Rogerian fashion. True, the simultaneous representation of seven scenes produces the impression of an even distribution in depth apparently at variance with Roger's customary procedure. But the very organization of the architecture, providentially conforming to his sense of stratification, articulates this seemingly continuous progress from front to back into a sequence of distinct relief compositions; each scene is confined to the area of one chapel and the adjacent bay of the side-aisle, the latter clearly delimited by the pattern of the pavement. The special difficulty entailed by the surprising fact that the second chapel of the northern side-aisle — between the scenes of Baptism and Confirmation — has been turned over to a youngish Canon and his retinue, so

if I may be permitted a self-quotation.

that the sacrament of Penance is pushed back into the corner between the wall and the rood screen, has been overcome with so much ingenuity that the resulting shift in planes and interruption of continuity is hardly noticeable, the little group of children marching home from Confirmation serving as an efficient means of unification. And the angels superintending the individual rites, each of them clad in the appropriate liturgical color,[1] display explanatory verses derived from Scripture, St. Ambrose and Peter Lombard in exactly the same manner as are the analogous texts in the "Granada-Miraflores" altarpiece.[2]

While the Eucharist is offered in awe-inspiring solitude, the other ceremonies are developed into ecclesiastical genre scenes rendered with an understanding for human nature and an attention to individual physiognomies and liturgical detail which may surprise us in an artist whose mind was normally concerned with universals rather than particulars. But we must bear in mind that great artists, however consistent, were seldom one-sided. As Jan van Eyck's epic existentialism resulted, if I may be permitted a self-quotation once more, "not from the absence but from the control of passion," so did Roger's dramatic idealism result, not from the absence but from the control of visual susceptivity. He knew where an unusual subject required an unusual amount of naturalistic characterization, and he subordinated this naturalistic detail to the preternaturalistic purpose of making us aware of that mysterious power that binds and sustains the life of the faithful from the cradle to the grave. The structure in which the rites are performed assumes the significance of a huge symbol expressing the Church as a spiritual institution, and the rites themselves are interpreted as seven aspects of one great mystery, deriving their unity from the gigantic Calvary that dominates the ensemble. It is this all-pervading sense of mystery which justifies the appearance of a bed in a basilica, which penetrates the soul of the dying man and moulds the thoughts of the old priest who, while enveloping the hands of the newlyweds in his stole, permits his eye and mind to stray away from the present and wander into the past and future.[3]

As the marriage scene, including the little griffon, reveals the influence of Jan van Eyck's Arnolfini portrait, so does the architectural setting of the whole picture presuppose Roger's familiarity with the "Madonna in a Church."[4] But of the many artists who were inspired by this admirable interior, Roger may be said to be the one who most completely transformed, yet most completely understood, the original. He transformed it in that he shifted the center of vision from right to left and reversed the direction of the light; in that he replaced Jan's imaginary architecture by a real structure — to wit, the Church of Ste.-Gudule at Brussels,[5] the proportions of which he attenuated, however, to such an extent that the relative thickness of the piers is nearly halved — and in that he filled the room with a thin, cool, even, entirely non-pictorial light. He understood it in that he interpreted the tremendous scale of Jan's Madonna, not as a mistake but as an expression of the supernatural. Retaining the "disproportion," he substituted for the gigantic Madonna a still more gigantic Calvary, the figures by far transcending those of the wings in size and the Cross fantastically towering above the real world in which the rites are performed.

It is not only this recrudescence of Eyckian influences which places the "Seven Sacra-

ments" in the sixth decade and, quite particularly, in the vicinity of the St. John altarpiece. The woman witnessing the death of her husband anticipates Anna, the prophetess, in the "Presentation" of the Columba altarpiece (fig. 354b). The sweet, oval face of the young bride resembles, all differences in expression notwithstanding, that of the Salome in the "Martyrdom of St. John." The lost profile of the woman beneath the Cross, seen from the back and turning her head to the right, has its only parallel in the henchman proffering the Baptist's head. And, like this henchman's, her twisted posture can hardly be explained without an Italian model such as, for example, the servant in the "St. Nicholas Throwing Gold to the Maidens" by Roger's favorite artist, Gentile da Fabriano.[1]

Corroborating evidence for the late date of the "Seven Sacraments" may be found in the personality of that young Canon who, with his retinue, intrudes upon the ceremonies. Occupying the chapel on the right of Bishop Jean Chevrot, he must have been a distinguished visitor rather than an ordinary member of the local Chapter and must have held some office that raised him far beyond the rank and file of other canons. There is good evidence to show that he is none other than Pierre de Ranchicourt, Bishop of Arras from 1463. Before his elevation to the Episcopate, he had held numerous benefices, among them those of Canon of Liége Cathedral, Canon and Archdeacon of Cambrai Cathedral, Canon and Chancellor of Amiens Cathedral, and, first and foremost, Protonothary Apostolic de numero participantium, which office — probably symbolized by the inkwell and pen holder at his belt — implied the right of precedence over bishops and archbishops. Since he did not obtain the protonotharyship until 1451, this date establishes a terminus ante quem non for the triptych; and there is reason to believe that it was ordered in 1453 when Pierre de Ranchicourt, after a lengthy stay at the Curia, officially presented himself in the Netherlands.[2]

One of the factors that enable us to make this identification is the fact that the Canon of the Chevrot triptych, now elevated to the Episcopate and looking, accordingly, ten or eleven years older, recurs as the donor of the well-known "Lamentation" in the Mauritshuis at The Hague (fig. 359) where he enjoys the sponsorship of his patron, St. Peter, and his co-patron, St. Paul.[3] And since he was not consecrated until April 17, 1463 (and this, according to ancient tradition, in Rome), the problem of this retable, still variously assigned to Roger, Memlinc, and an anonymous follower of Roger, may be resolved by a reasonable compromise. Even assuming that the new Bishop lost as little time as possible in ordering the picture, Roger — who died on June 18, 1464 — would not have had time to execute it himself. But he may well have furnished a general sketch and, possibly, a few studies for individual motifs; and this would account for the picture's contradictory qualities. Grand in conception but un-Rogerian in color, somewhat mannered in postures and gestures, and pervaded by almost maudlin sentiment, it may well have been produced by a lesser master who had the opportunity of working from preparatory material left by Roger — perhaps indeed by Memlinc who, as we happen to know, established himself at Bruges in 1465.[4]

Compared to the style of the 'forties even Roger's latest creations, though more austere in spirit than the Bladelin altarpiece, the St. John altarpiece and the Chevrot triptych, bear witness to that *adoucissement* which may be interpreted as an afterglow of his experiences in Italy.[1] Even when faced with tasks of a different nature he was never to revert to the ascetic austerity of the "Last Judgment."

This *ultima maniera* is first exemplified, I believe, by a magnificent "Crucifixion" in the Pennsylvania Museum of Art (figs. 350, 351). Painted on two separate panels (which, however, can hardly be interpreted as either the exterior wings of a folding retable or the central and right-hand panels of a triptych the left-hand panel of which would be missing), this work is generally assigned to the 'forties or even 'thirties.[2] One scholar, however, has proposed to identify it with the altarpiece commissioned for the Abbey of St.-Aubert at Cambrai in 1455 and delivered in June, 1459. And though this identification is not acceptable for various reasons, the date implied by it appears convincing to me.[3]

True, the figure of the crucified Christ, its quiet form contrasting with the agitated curves of the loincloth, may bring to mind the Vienna "Calvary," and the ancestry of the St. John supporting the swooning Virgin can be traced back through many intermediaries to the great "Descent from the Cross." But these analogies are limited to motifs and do not extend to style and interpretation. In spite of the recurrence of one or two figure types, the Philadelphia "Crucifixion" is no less far removed from the Vienna "Calvary" than is Michelangelo's "Last Judgment" from his "Battle of Cascina."

As though to free the event from all limitations of time and space, the scene is laid in an environment entirely imaginary yet conceived under the impact of a concrete religious and optical experience. Instead of being permitted to roam over a landscape with the city of Jerusalem emerging in the distance, our glance is blocked by a grim stone wall surmounted by gold ground and surprisingly hung with two cloths of honor of flaming vermilion, their surfaces broken only by a square pattern of creases. With a boldness of which only Roger was capable this wall, rising behind a barren strip of land with a horribly real skull and a bone at the foot of the Cross, this wall has been bodily transplanted, as it were, from the interior of a fifteenth-century church, where large, carved Crucifixes were displayed before analogous draperies (text ill. 58),[4] to the sacred soil of Mount Golgotha.

Set out against this severe yet tremendously colorful background, the figures may strike us, at first glance, as almost monochromatic. Yet the flesh tones and the soft colors of the garments (the Virgin Mary's a pale gray-blue, St. John's a light, clear lilac-rose) create a harmony no less rich for being subdued. And the treatment of form and movement is far from abstract and ascetic. The figures are svelte rather than attenuated. Their long-limbed, delicately modeled bodies move with a resilient grace which is a perfect blend of Gothic fluency and Italian equilibration; and the lineaments of their draperies, which seem to consist of a thinner, more pliable fabric than in the earlier works, are animated by a new feeling for sustained melody.

It is this sense of supple freedom and flowing curvature which distinguishes the St. John in the Philadelphia "Crucifixion" from his lineal ancestors and links him with the justly famous Angel Gabriel in the Columba altarpiece, now in the Pinakothek at Munich and unfortunately disfigured by much overpainting (figs. 352–356), the date of which can be established with comparative accuracy. It was copied as early as 1462, and the city prospect in its central panel, far from "repeating" that in the Bladelin altarpiece, corrects the "proleptic" view of Middelburg in almost every detail (the castle, for example, is now duly Gothic), from which we may infer a date prior to 1462 but somewhat later than *ca.* 1455: say, about 1458–1459.[1]

The central panel itself has been considered at the beginning of this chapter. Now, more familiar with the preceding developments, we realize that this late "Adoration of the Magi" sums up the experience of a lifetime. Complete harmony is achieved between surface pattern and organization in depth, line and volume, stability and movement, symmetry and asymmetry (note how the dominant figure of the Virgin Mary is slightly shifted to the left while forming the axis of a triadic group the other members of which are the St. Joseph and the second Magus). And in the type and bearing of the personages Northern art has here attained for once that balance of ease and grandeur which can best be described as nobility. The Virgin Mary is one of the gentlest yet queenliest ever painted, and the third Magus,

> A station like the herald Mercury
> New-lighted on a heaven-kissing hill,

would strike us as a prince even if his part were not enacted by the heir of Burgundy. For, there is little doubt that the youthful figure which, as Alberti would say, "attracts the eyes of the beholder" in the Columba altarpiece (fig. 356) is the same person who appears in Roger's portraits of Charles the Bold.[2] One of these portraits, owned by Charles' granddaughter, Margaret of Austria, is known to us only through her inventories and a sixteenth-century drawing;[3] but an excellent replica in the Kaiser Friedrich Museum at Berlin (fig. 379), doubtless produced in Roger's own workshop and differing from Margaret's only in that the young prince holds a sword in his left hand instead of a roll of parchment in his right, has been preserved[4] and agrees, I think, with the third Magus. There is, of course, a difference between a portrait pure and simple and a portrait "in character," and the Berlin picture (which may have been ordered in 1454 when Charles the Bold established residence at Brussels at the age of twenty-one) shows him as a very young man, his features still preserving some of their adolescent undefinedness.[5] In the Columba altarpiece he looks more mature and very much thinner, and his somewhat weak chin has been strengthened in an effort at idealization. But the aggressive, somewhat prognathous mouth with its watchfully pinched corners, the large, impatient eyes, the somber eyebrows and, most important, the long, unruly hair recur in both pictures; to judge from the many other portraits of personages belonging to the entourage of Philip the Good, it would seem that at this most formal of all courts no one but the Crown Prince could afford to wear his hair as though there were no scissors and combs.

Iconographically, the "Adoration of the Magi" is a restatement, more condensed yet richer, of the same idea that underlies the Bladelin altarpiece: Christianity's eternal hope for the ultimate conversion of the whole world, including the Jews. The contrast between the ass and the ox — their movements, as we now see, not only determined by formal considerations but also expressive of the fact that they typify, respectively, the Old and the New Testaments — is softened down to a mild antithesis between bewildered yet thoughtful impassivity and vivid interest. What applies to the animals applies to the humans. In the background, at the head of a long procession of oriental characters including a negro, is seen a group of Jews identified by the fact that their beturbaned and be-earringed leader resembles the David receiving the Cistern Water (fig. 341; a subject regarded as a *typus* of the Adoration of the Magi) and is clad in yellow, a color traditionally associated with Judaism.[1] And while those standing farther back are merely inquisitive, he is absorbed in somber meditation, not wholly convinced but gravely weighing the words of his aged companion who touches his sleeve with one hand while pointing at Our Lady and the Christ Child with the other. The whole scene — the only Adoration of the Magi in Roger's work, not counting one of the little archevault groups in the "Granada-Miraflores" altarpiece[2] — is almost joyous and would be festive had it been in Roger's nature to be festive. But right in the center of the composition, attached to the main pillar of the decaying Romanesque structure, appears a Crucifix.[3]

The left wing of the altarpiece shows a revised version of the Louvre "Annunciation" so perfect that it is difficult to say more about it than that it is perfect. The complex interior with its numerous still-life features has been simplified so that only the most significant objects — the bed, the lily in its vase, and a *prie-dieu*, the carving of which exhibits the Fall of Man — remain. The Dove, absent from the Louvre "Annunciation" as it was from the Mérode altarpiece, has been reintroduced, and the "Ave gracia plena dominus tecum" is inscribed on the pictorial surface in disregard of its non-naturalistic effect. The boyish Angel of the Louvre picture, a little short of stature and weighed down by his heavy, brocaded pluvial, has been replaced by an ineffable being, his slender body enveloped in a quiet flow of curvilinear drapery, who glides into the room like a white cloud. It is, significantly, hard to remember whether or not he has wings; not visibly attached to his body and completely integrated with the silhouette of the pluvial, they are no longer a necessary attribute of his celestial nature. Barely touching the ground with the tips of his toes, he seems to float in space by virtue of his very weightlessness, and the Annunciate has been transfigured into a princess. It seems the most natural thing in the world that the wall of her chamber is pierced by a stained glass window even more sumptuous than that of the regal hall in which she is portrayed by St. Luke as the Madonna Enthroned, and that the tester of her bed, hung with a piece of priceless gold brocade, has been converted into a royal canopy.

However, even to Roger this ultimate grace might have been unattainable had he not gone through the experience of Italian art, and that this experience still lingered in his memory is attested by the other wing of the Columba altarpiece, the "Presentation of Christ in the Temple." It has been noted that the interpretation of this scene — as compared, for example, to

Broederlam's Dijon altarpiece or Stephan Lochner's charming panel at Darmstadt — reverts to earlier traditions and that the architectural setting evinces a certain Italianism. Substituting Simeon for the High Priest rather than the High Priest for Simeon and nearly suppressing the altar, the composition emphasizes the touching moment in which the old man "takes up the child in his arms" and not the formal "Presentation to the Lord"; and the interpretation of the locality as a nave separated from the sanctuary by a "triumphal arch," the southern nave arcade appearing behind the figure of Simeon, vaguely recalls Altichiero's fresco in the Cappella di San Giorgio at Padua.[1] But a more manifest connection with Italian art can be observed in the figure of the maiden carrying the basket with the "pair of turtledoves": gracefully turning her head against the forward movement of her right shoulder, she casts her glance at the beholder instead of at the event. Figures thus looking out of the picture were as foreign to the Gothic taste as they were popular in Italy. Here they occur as early as the fourteenth century,[2] and they were especially in favor at Florence where Leone Battista Alberti explicitly recommended the inclusion of figures establishing psychological contact with the spectator, and where Roger could see the most telling examples in the works of Fra Filippo Lippi. Combining, as it were, the dignity of Fra Filippo's St. Augustine in the Turin "Four Fathers of the Church" with the youthful vivacity of the attending angel in his "Annunciation" in San Lorenzo,[3] the girl with the turtledoves may be said to anticipate the stately ladies in Ghirlandaio's "Birth of the Virgin" in Santa Maria Novella.

The Columba altarpiece is Roger's last word in the domain of the Infancy scenes. His last representation of the Passion is, I believe, the great "Crucifixion" (severely damaged and not improved by a recent restoration) which was originally in the Charterhouse of Scheut and passed to the Escorial in 1574 (figs. 357, 358). It must have formed part of a big donation of "moneys as well as pictures" which Roger bestowed upon that monastery, and since the new foundation — a daughter house of Hérinnes which Roger's son, Corneille, had entered in 1449 — was not ready for occupation until 1456, this date would seem to be a *terminus post quem*. I am inclined to date the work as late as *ca.* 1462.[4]

This "Crucifixion" has much in common with the Philadelphia "Calvary" (which, incidentally, confirms the latter's dating after rather than before the Bladelin altarpiece). The almost colorless figures are comparatively similar in facial type, and they are foiled by a red cloth of honor, hung from a wall, which shows the familiar pattern of creases. But the composition has been simplified as well as monumentalized, and the last vestiges of drama have been suppressed. All indications of natural scenery have disappeared. The cloth of honor, much enlarged and devoid of a fringe, covers nearly the entire background. The loincloth hangs motionless. And, most important, the figures of the Virgin Mary and St. John are separated by the Cross. Instead of swooning in the arms of the beloved disciple, Our Lady stands alone, drying her tears with her robe; on the other side of the Cross, St. John lifts up his hands in a restrained gesture of sorrow. Renouncing the beautiful group of the Virgin supported by St. John which he himself had incessantly perfected from the "Descent from the Cross" to the Philadelphia "Calvary," Roger reverted to the oldest, most hieratic Crucifixion type. The

figures, consumed rather than overwhelmed by grief, are statuesque images rather than characters in a dramatic narrative.

It is no more than a coincidence, yet a remarkable one, that a strange similarity exists between the Escorial "Crucifixion" and one of the last drawings by Michelangelo.[1] Here, too, the St. John, plaintively raising his arms, looks up while the Virgin Mary looks down; here, too, she maintains herself at the brink of collapse, hands to her face and knees sagging. At the end of their careers, and almost a hundred years apart, the greatest sculptor of the Italian Renaissance, turning to the Middle Ages in renunciation of the "fables of the world," and the greatest painter of the Late Gothic North, having experienced the Florentine *rinascimento*, met, as it were, halfway between two worlds.[2]

<div align="center">x</div>

Roger van der Weyden, while often hailed as a "portraitist of the first order,"[3] has been reproached with a certain lack of objectivity:

> The countenances which he presents to us show very different features; but they are all forced into a somewhat confining scheme — a thing which the born portraitist will never do. He has few peers in rendering emotions . . . But with him the grand pathos arises from his powerful dramatic imagination; he transfers it to his figures as a capable stage director is able to transfuse it into his actors. Where no dramatic or tragic situation is present, where he must decipher and synthesize the passive countenances of his models by the most subtle handling of composition and lineament, he is not equally interested. When we compare Jan van Eyck's Rolin, his Arnolfini, his Cardinal of St. Cross, his Timotheus with Roger's Jean de Gros or Laurent Froimont, even with his most daring and spontaneous creation, the aged Rolin on the exterior of the Beaune altarpiece, the first thing that strikes us is not the relief of the physiognomies which tells so much about their individuality but Roger's lineaments and Roger's artistic habits — the way in which he outlines the eyelids with swinging strokes, causes the lips to swell, gives tension to the eyebrows, models an ear. Had he lived in a period in which personal artistry and virtuosity played the predominant role as at the time of Parmeggianino, Rosso, Goltzius or Cornelis van Haarlem, he would have been in danger of becoming one of the most extreme mannerists, almost entirely neglectful of his models as such.[4]

While this judicious criticism is more illuminating than fulsome praise it should be borne in mind that the stylization of Roger's portraits is by no means a matter of wilful self-assertion. Eliminating the antinomies prevailing in the style of the Master of Flémalle (and thereby temporarily suppressing its inherent potentialities), Jan van Eyck had developed the "descriptive" portrait to a point beyond which no further advance was imaginable. Exhaustively particularized, completely unique, and existing within an indefinable space exclusively his own, each personage is, as Leibniz would say, a "monad without windows" or, to borrow a telling phrase from a great nominalist, a *res se ipsa singularis*, "a thing individual of and by itself" — solidly real but incommensurable with any other member of the species and isolated from the rest of the world. Progress was possible only on one of two roads leading in opposite directions but ultimately converging toward the "interpretive" and later on meeting, *via* Memlinc, in the masters of the sixteenth century: the sitter's individuality could be made accessible to the beholder, either by presenting him within a well-defined environment which the beholder can

share; or, by reducing the amorphous complexity of his being to well-defined psychological qualities and attitudes which the beholder can re-experience.

The first of these methods was adopted by Petrus Christus and perfected by Dirc Bouts; the second, perfected by Hugo van der Goes, was initiated by Roger van der Weyden. And both entailed, at the beginning, a certain loss in density and depth of interpretation. In placing a model, rendered in purely descriptive fashion, in the corner of a naturalistic interior, Petrus Christus forced the beholder to divide his attention between the figure and its surroundings. In attempting to convert a forever enigmatical *haecceitas* into a comprehensible personality, Roger van der Weyden had to sharpen and flatten the three-dimensional image in both a literal and a figurative sense.

Instead of emerging from the depths of space, his figures are set off against a tinted surface — now blue, now green, now nearly white — the two-dimensional character of which is occasionally stressed by the fact that it is embroidered with decorative inscriptions and heraldic devices. Instead of integrating an infinite number of details into a plastic whole, Roger concentrated on certain salient features — salient both from a physiognomical and psychological point of view — which he expressed primarily by lines, reducing the modeling to such an extent that the direction of the light is not always easily determinable at first glance (for, being familiar with both the Master of Flémalle and Jan van Eyck, he employed both the Eyckian and the Flémallesque systems of lighting). In short, he divested the individual of his mystery by way of rationalization.

In a sense Roger's portraits are abstractions. But their abstractness results from a tendency to clarify rather than to formalize. Suppressing what he considered unimportant and stressing, even exaggerating, what he deemed significant, his method is less comparable to that of the mannerist than to that of the caricaturist, except, of course, for the fact that the latter overstates the case with the deliberate intent to distort and expects the beholder to notice and enjoy this very distortion. If relief "tells us much about individuality," line may tell us even more about "character." [1]

Roger's portraits, then, should be interpreted as studies in character rather than studies in individuality, the difference being that, while individuality is innate, character — literally translated "that which is engraved upon something" — is formed. It is formed by the action of outside forces upon that unchangeable core with which we feel in direct though unspecifiable contact when contemplating a portrait by Jan van Eyck. A likeness conceived as a study in character will therefore reflect these outside forces together with their substratum; it will present the sitter, not as a *res se ipsa singularis* but as a thing co-determined by its environment.

The men and women in Jan van Eyck's portraits are so exclusively themselves that they do not primarily strike us as "products of society." We take no particular cognizance of their "breeding," rank and deportment and hardly notice the way they carry their heads or arrange their fingers; even distinctive attributes such as Baudouin de Lannoy's Chamberlain's wand or "Tymotheos'" scroll — not to mention Giovanni Arnolfini's letter — do not especially impress themselves upon our memory and give the effect of casual accessories rather than essential

symbols. Not so with the portraits of Roger van der Weyden. His subjects, regardless of age, sex and station in life, appear to us, with very few exceptions, almost as members of one aristocratic family, all distinguished-looking, well-bred and consciously, almost self-consciously, self-possessed. The emphasis is on the general characteristics of good birth: well-marked bone structure, sharply contoured noses, lips and eyelids; long, slender fingers; and a general sense of delicate spareness. The hands are never separated, as in Jan's "Baudouin de Lannoy," nor placed on axis with the face, as in the "Giovanni Arnolfini"; they are collected in one corner and frequently arranged in such a way that the palm of one rests on the back or in the palm of the other, so that interesting contrasts can be created between the sweeping curve of shoulder and arm and the rigid vertical of the head, the calm, quite literally "composed" position of the hands and the complicated pattern of their fingers. The glance of the eyes, often impassive but never vague, bespeaks awareness as well as detachment. And the dignity expressed by an attribute so deeply permeates the consciousness of the bearer that the attribute becomes, as it were, an integral part of his personality. No one would readily call the Baudouin de Lannoy the "Man with the Wand" or the "Tymotheos" the "Man with a Scroll." But if we did not know the identity of Francesco d'Este (fig. 366)[1] or the "Grand Bâtard de Bourgogne" as represented in Roger's admirable portrait at Brussels (fig. 365),[2] the "Man with the Hammer" and the "Man with the Arrow" would be appropriate and telling designations.

All this results not so much from Roger's own "artistical habits" as from the hereditary characteristics, ideals and conventions of a society to which the majority of his clients belonged and the traditions of which the painter studied, respected and, in a measure, shaped; suffice it to compare the hands of Charles the Bold in the Berlin portrait (fig. 379) with those of his grandfather, John the Fearless, in the familiar portrait at Antwerp (fig. 378),[3] or the noble posture of Philip the Good in the dedication miniature of the *Chroniques du Hainaut* with that of Louis I, Duke of Savoy, in one of the much-debated silverpoint drawings which — apparently in preparation for the tombs of Louis de Mâle and Joan of Brabant, completed in 1455 and 1458, respectively — were copied from such family portraits as were available and, like the Antwerp portrait of John the Fearless, must be assigned to Roger van der Weyden's workshop rather than to Jan van Eyck (figs. 380–383).[4]

With Roger's men and women, then, these aristocratic traditions are more than mere conventions, and one great charm of his portraits — as, later on, of Holbein's, Bronzino's, Velasquez', and van Dyck's — is the way in which the sitters' "first nature," if I may say so, asserts itself in interaction with the second, how individual content informs and illumines the preterindividual style. In Roger's portraits ceremonial attributes — even a sword if figuring as such, as in the Berlin portrait of Charles the Bold — are always held between forefinger and thumb.[5] But in the fastidious, slightly feminine hand of Francesco d'Este the tiny hammer, nearly slipping away from his tentacular fingers, becomes a symbol of the same discouraged though haughty indifference that reveals itself in his morosely protruding mouth and moody eyes. In the hand of the "Grand Bâtard" the arrow, lightly but firmly grasped and cutting across the whole picture in a magnificent diagonal, proudly proclaims virile pride and ag-

gressiveness. In the "Portrait of a Young Lady" in the Kaiser Friedrich Museum at Berlin (fig. 360),[1] the well-behaved position of the hands, the palm of the right covering the back of the left, expresses a healthy self-assurance which harmonizes with the quiet challenge of her frank, clear gaze and the affable firmness of her slightly humorous mouth. In the superficially similar but considerably later "Portrait of a Young Lady" in the National Gallery at Washington (fig. 367),[2] the hands are analogously placed but the intertwisted fingers reveal a smouldering excitability which, even more severely repressed, lives in her veiled, downcast eyes and full, sensuous lips.

In short, the formalism and comparative uniformity of Roger's portraits subtly strengthens rather than weakens his power of characterization. While the Berlin portrait of Charles the Bold does justice to his troubled, complex nature — suspicious, friendless, even cruel yet somehow noble and sensitive — the almost diaphanous face of an unknown gentleman in one of his most revelatory portrayals, one of the finest gems in the Thyssen Collection at Lugano, shines with sublimed humanity bordering on sainthood (fig. 364).[3] In the dedication scene of the "*Chroniques du Hainaut*," inexorably dominated by Burgundian etiquette, the patience of the great man of action, the Chancellor Rolin, seems to be sorely tried by the boredom of a ceremony complacently and somewhat superciliously endured by his neighbor, the good Bishop Chevrot of Tournai (fig. 330). And even where the Chancellor and his wife appear as pious donors, on the exterior of the Beaune "Last Judgment," Roger succeeded in exploiting the conventionality of their poses and demeanor as a kind of neutral foil for her bland, icy arrogance and his imperious energy.

To trace an evolution in Roger's portraits is difficult because the chronological distribution of the material is extremely uneven. Of all the independent portraits, including even the slightly doubtful ones, which have come down to us either in the original or in reliable copies, more than seventy-five per cent date from the years between *ca.* 1450 and *ca.* 1460. This may be due to losses which we are unable to detect for lack of copies or documents, though the particular scarcity of independent portraits in the 'forties, agreeing as it does with the spirit of a period that culminated in the "Last Judgment," may well be more than an accident. But what remains assures us that Roger's approach to portraiture developed in accordance with the fluctuations of his general style.

Setting aside two fairly Flémallesque paintings the more impressive of which I do not know in the original — one, often ascribed to the Master of Flémalle himself, the "Man in Prayer" in the Metropolitan Museum (fig. 361),[4] the other a youthful portrait of the famous Guillaume Fillastre, who was to succeed Jean Chevrot both in the Episcopate of Tournai and in the councils of Philip the Good, in the Merton Collection at Maidenhead (fig. 362)[5] — the earliest of Roger's portraits is the Berlin "Young Lady" just mentioned (fig. 360). This charming work — the sitter tentatively identified as either Roger's wife[6] or, on the strength of a drawing in the "Recueil d'Arras," a daughter of Baudouin de Lannoy[7] — is Eyckian rather than Flémallesque, not only in the method of illumination and in the emphasis on volume and surface texture but also in that the glance is directed toward the beholder, a device

never resorted to in any other authentic portrait by Roger. The painting presupposes both the Jeanne Cenami in the London Arnolfini portrait and the "Man in a Red Turban" and would seem to be contemporaneous with the "St. Luke Painting the Virgin" and the Louvre "Annunciation." This date — *ca.* 1435 — also agrees with the costume. The cut of the gown is halfway between Jeanne Cenami's and the Second Mary's in the "Descent from the Cross," and the coif is fashioned from solid linen whereas the ladies in Roger's later portraits prefer materials which permit the shoulders to be seen in alluring transparency.[1]

Such a semi-translucent coif, consisting of what we would call batiste or cambric, appears for the first time in the donor's portrait of Guigonne de Salins on the exterior of the "Last Judgment" at Beaune. And it is in the neighborhood of this masterpiece of abstractive stylization, forming a striking contrast to the similarly immobile but by comparison almost massive donatrix in the Vienna "Calvary," that we must place the much-debated "Portrait of a Lady of High Rank" in the Rockefeller Collection at New York (fig. 363).[2] It shows a middle-aged princess, her sharply delineated face quite as distinguished and nearly as long as that of Guigonne de Salins but more intelligent, and humanized by the kindly expression of the nearsighted eyes and the touch of a whimsical smile about the mouth. Her coif is very similar in design to Guigonne de Salins' but fashioned of jewel-studded gold cloth and sheerest gauze so that its wings and front fold are nothing more than a veil. Instead of severe black she wears a gown of red gold brocade girt with a green sash woven in checkers; but the unpictorial rendering of the precious materials so closely agrees with the "Last Judgment" and the "*Chroniques du Hainaut*" that the date of the picture must be assumed to be about the same, that is to say, *ca.* 1445.[3]

In spite of its excellent quality, the Rockefeller portrait poses a problem of authorship. The sitter has been identified, beyond any reasonable doubt, as Isabella of Portugal, the wife of Philip the Good whom Jan van Eyck helped to escort to Flanders;[4] born in 1397, she was forty-eight in 1445 and her rank would account for the ermine with which the Rockefeller Lady's gown is trimmed; but the trouble is that the panel bears the inscription PERSICA SIBYLLA · I^A · , the numeral referring to the fact that the Persian Sibyl occupies the first place in the traditional list of ten established by Varro and sanctioned by the authority of Lactantius, Isidore of Seville and Bede.[5] This numeral unequivocally characterizes the picture as the first member of a series, whether executed or merely contemplated, and it would have been surprising had the reigning Duchess of Burgundy consented to be portrayed for such a collective enterprise.[6] Furthermore, the figure detaches itself, not from a neutral surface but from a mottled brown background apparently intended to simulate wood, and even more disturbing is the fact that the paleographical character of the inscription, reminiscent of the *literae antiquae* in Renaissance writing books rather than Northern fifteenth-century lettering, does not agree with Roger's practice at all. Since this unusual inscription stands out in fairly high relief, I am inclined to believe that it — and, probably, the illusionistic brown background as well — was added in the sixteenth century when representations of Sibyls in half-length were much in favor — or, rather, returned to favor — in Northern panel painting; the ornate, from

293

the point of view of a later period outlandish, costume of the Duchess, not very different from the attire then customarily associated with the Sibyls, would have invited such a reinterpretation, and we have an exact parallel in the portrait of a Lady by Memlinc, dated 1480, which in the sixteenth century was labelled "Sybilla Sambetha quae et Persica."[1] If this assumption is permissible, the Rockefeller picture would have originally been a portrait pure and simple, depicting Isabella of Portugal in her own ducal personality; and as such it would have made an excellent counterpart to the portrait of Philip the Good *en ung chapperon bourellée* (fig. 376, transmitted only through copies)[2] which, to judge from its concordance with the dedication miniature of the *Chroniques du Hainaut*, must have been executed at about the same time.

None of the other independent portraits, then, are earlier than *ca.* 1450. Their sequence begins, it seems, with the portraits of Jean le Fèvre de St. Remy and Pierre de Beffremont which were exploited, we recall, in compositions datable around 1450 but are not preserved in the original.[3] Then follow, to omit a few pictures which I hesitate to accept:[4] the wonderful portrait in the Thyssen Collection, so closely akin in style and spirit to the equally wonderful donor's figure in the Bladelin altarpiece that it must be assigned to about the same period, not long after 1452;[5] the "Charles the Bold"[6] and the "Grand Bâtard de Bourgogne,"[7] both probably toward 1455; the "Francesco d'Este," probably about 1455 or shortly after;[8] the "Portrait of a Young Lady" in the National Gallery at Washington[9] and a quite similar but noticeably weaker portrait in the National Gallery at London,[10] both probably between 1455 and 1460; and, finally, the "Philip the Good without Headgear" (fig. 377, transmitted only through copies) which, since he looks considerably older than in 1446 and, in accordance with his own edict of 1460, wears his head shaved and covered with a toupée, must be the latest of all.[11]

A special wing in Roger's portrait gallery is occupied by a group of four or five works, all datable towards 1460, which represent a significant and exceedingly influential innovation: the portrait of the sitter, hands joined in prayer, is combined into a diptych with a Madonna in half-length. Three of these diptychs — their component parts now separated by many miles of land and in two cases by the Atlantic — have been reconstructed in an essay by Hulin de Loo which will always be remembered as a masterpiece of detection.[12] The existence of two others he could infer from the praying gesture in the portraits of Duke John of Cleves (transmitted through a copy in the Bibliothèque Nationale)[13] and in the portrait of an unidentified young man in the Viscount Bearsted of Maidstone (formerly W. H. Samuel) Collection at London.[14]

These "devotional portraits," as they may be called, can be explained by a fusion of two traditional types: double portraits of man and wife, and representations of the Madonna interceding with Christ, both portrayed *en buste*.[15] The sitter praying to the Virgin takes, as it were, the place of the Virgin praying to Christ, not only in that he joins his hands in supplication, but also in that he occupies the right-hand ("sinister") panel whereas the rules of heraldry grant him a place on the left-hand ("dexter") panel in matrimonial double portraits.[16] Setting out the figures against a severely neutral background, and not as yet uniting them in the intimacy

of a naturalistic interior as, for example, in Memlinc's well-known portrait of Martin van Nieuwenhove in the Hospital of St. John at Bruges, Roger created a lasting emotional situation — lasting and, therefore, compatible with the basic postulates of portraiture — which permitted him to characterize his subjects in terms of the ultimate, so to speak. He portrayed them in a state where thought, imagination and will are submerged in a transcendent experience which, in however sublimated form, retains the quality of love; it is significant that diptychs of this kind are always composed of a masculine and a feminine element.[1]

As long as the devotional portrait was taken as seriously as it was by its initiator, it put the sitters to a test which not all of them could stand. Even Roger — or, rather, particularly Roger — could not transform the coarseness of a greedy administrator and entrepreneur such as Jean Gros, secretary to Charles the Bold from 1469 and one of the most hated *contrerôleurs des domaines et finances* from 1472, into a convincing semblance of piety. The very fact that his portrait, now in the Art Institute at Chicago,[2] represents him in prayer, makes us doubly aware of his fattish, materialistic face, bulging eyes and ill-shaped hands (fig. 369). Because of these defects — although they are the subject's rather than the interpreter's — the picture has been called a school piece.[3] This is probably going too far since just the veracity of the characterization bears witness to Roger's personal responsibility. But it is not improbable that he, who could not possibly have liked the man, left more than the usual share of work to his assistants; and the same seems to be true of the other half of this diptych, the Madonna formerly in the Renders Collection at Bruges (fig. 368).[4] It is nothing but a specimen — albeit an exceptionally carefully executed one — of a fairly stereotyped composition, repeated over and over again, which had been developed from the "St. Luke Painting the Virgin" by the simple device of isolating and slightly rearranging the upper portion of the Madonna figure and changing the angle at which the Christ Child is held. And no great effort has been made to establish a formal or psychological relation between the Madonna and the unattractive donor.

By contrast, the two other diptychs, that of Philippe de Croy (the portrait in the Antwerp Museum,[5] the Madonna in the Huntington Art Gallery at San Marino)[6] and that of Laurent Froimont (the portrait in the Museum at Brussels,[7] the Madonna in the Mancel Collection of the Museum at Caen),[8] are labors of love. Philippe de Croy, Seigneur de Sempy — later on, de Quiévrain — and Governor of the Hainaut from 1456, was one of the most chivalrous and cultured gentlemen in the entourage of Philip the Good and Charles the Bold. His portrait (fig. 371), its dark ground enlivened with his still enigmatical device "LP," shows him precisely as we imagine him to be: supremely elegant, serious, incapable of any mean thought, sincerely pious, and of refined artistic and intellectual tastes. He was in fact a great lover of fine manuscripts, and it is this love for beautiful books to which Roger seems to allude in establishing an unusual kind of connection between the portrait and the Madonna (fig. 370) that originally formed its counterpart. Painted on gold ground in order to differentiate between the celestial and terrestrial realms, this picture shows the Christ Child, supported by the slender right hand of the Virgin, leaning on a precious Book of Hours firmly held in posi-

tion by her left; while she looks on in motherly love and gentle sadness, He, playing with the golden clasps, seems to incline both toward the book and the donor.

Of Laurent Froimont nothing is known except what we can learn from the portrait itself (fig. 373); it is inscribed with a motto befitting his youthful, candid personality ("Raison l'ensaigne") while its back reveals his family name accompanied and qualified by a representation of the Martyrdom of St. Lawrence. Whoever he was, Roger deemed him worthy of closer communion with Our Lady than any of his other subjects. To some extent the figure of the Madonna (fig. 372), painted on a dark ground ornamentally inscribed with the angelic salutation, conforms to the "St. Luke type"; the Virgin has bared her breast in order to nurse the Infant, and the end of her kerchief curves across her throat like a scarf. In facial type and posture, however, she is closely akin to the central figure of the Columba altarpiece. Instead of caring for the physical well-being of the Child, she joins the donor in his prayer and the Infant Jesus himself, casting His glance on the donor's face, raises His hand in a delightfully imperfect gesture of blessing.

Roger produced Madonnas in half-length not only as component parts of portrait diptychs but also as independent devotional images; and each of these compositions was endlessly repeated, with more or less significant changes, in his own workshop as well as by his followers, including the greatest: Dirc Bouts and Hugo van der Goes.

One archetype is represented, we recall, by the panel from the Renders Collection originally united with the portrait of Jean Gros. A "close-up" of the Madonna portrayed by St. Luke, it shows the Virgin nursing the reclining Christ Child, supporting Him with her right hand and offering Him her breast with her left. As an isolated devotional image this composition occurs, apart from many later copies and variations, in two paintings which may be classified as adequate workshop productions, one in the Art Institute at Chicago,[1] the other — with the Infant sitting instead of reclining — in the "Madonna with the Iris" in the Kaiser Friedrich Museum at Berlin.[2]

A second archetype fuses, as it were, the Virgin of the St. Luke picture with that of the "Medici Madonna" in that the Infant is held by both hands and must find the Virgin's breast for Himself.[3] In later variants the telltale feature of the scarflike kerchief and even the nursing motif as such tend to be abandoned,[4] and Roger himself appears to have reformulated the second archetype in a beautiful picture at Donaueschingen — according to those who have seen it after a recent cleaning, an indisputable original — in which the Christ Child plays with a strand of the Virgin's hair (fig. 374).[5]

This motif recurs in what is probably the last of Roger's Madonnas in half-length, a composition transmitted by an excellent replica in the Straus Collection in the Museum of Fine Arts at Houston, Texas (fig. 375).[6] In every other respect, however, this composition is entirely atypical in that it shows the Infant cradled in His mother's arms, seeking her mouth with His, and looking at us over His averted shoulder. Far from depending on the "Madonna on a Porch" —[7] or, for that matter, on any other recent and indigenous model — it derives from a tradition remote in space as well as time.

Our churches, museums and private collections are so full of Madonnas in half-length that we involuntarily assume this most popular type of devotional image to have been omnipresent in Christian art. It was, however, an innovation of the Byzantine Middle Ages which invaded Western panel painting through the intermediary of the Italian Dugento and Trecento. In the North the type occurs throughout the fourteenth century but seems to have lost its popularity in the first half of the fifteenth, and on the Netherlandish scene the latest known example prior to *ca.* 1450[1] is the Broederlamesque Madonna from the Beistegui Collection, now in the Louvre. Nothing of the kind was produced by either the van Eycks or the Master of Flémalle, and it was chiefly through Roger's personal influence that from the seventh decade of the fifteenth century, half-length Madonnas became as frequent in the Lowlands as they had always been in Italy.[2]

Since none of his Madonnas in half-length seem to antedate 1450, it has long been conjectured that he was prompted by Italian reminiscences when he transformed his own Madonnas in full-length, even though of much earlier date, into compositions *en buste*.[3] The Houston picture, however, is not a Rogerian Madonna reduced to an Italo-Byzantine scheme but an Italo-Byzantine Madonna transfigured by Roger. And thereby hangs a tale.

In 1440 a Cambrai Canon named Fursy du Bruille brought back from Rome an Italo-Byzantine Madonna of the so-called "Glykophilousa" type which he bequeathed to his Chapter in 1450; it is still venerated in Cambrai Cathedral under the name of "*Notre-Dame de Grâces*" (text ill. 59). Like many icons of its kind this panel was reputed to be a work of St. Luke, and in 1454 it was decided, for reasons both religious and political, to popularize it throughout the Netherlands. No less than fifteen copies were ordered for distribution — three from Petrus Christus and twelve from one Hayne de Bruxelles — and one of Hayne's productions has found its way into the Nelson Gallery at Kansas City (text ill. 60).[4]

Roger van der Weyden, being in contact with Cambrai from 1455 and having delivered his altarpiece of 1459 in person, was surely one of those who admired the "*Notre-Dame de Grâces*," and it was from this very picture that he appropriated the basic traits that distinguish the Houston Madonna from its predecessors: the position of the Virgin's hands (the right holding the seated Infant up, the left supporting His back); the motif of the Infant reaching for the Virgin's chin; the *contrapposto* of shoulder and face; the look "out of the picture"; and, above all, the embrace as such. Needless to say, the composition reflected in the Houston picture is a work of independent genius, and it is fascinating to compare it with the copy by Hayne de Bruxelles. The latter shows how far a Flemish painter of the middle of the fifteenth century could — and could not — succeed in literally transcribing a model so unfamiliar in style. He faithfully repeated the outlines of the composition and went out of his way to imitate all such exotic details as the hairdress, the kerchief carefully arranged in broad, parallel folds and the gold-embroidered borders, whereas he could not help transforming the modeling of the nude, the treatment of drapery, the facial types, and the expression according to the native tradition: his sweet, Flemish Madonna dreamily lowers her eyelids and the Infant does not look at the beholder. Tied to his model, Hayne de Bruxelles attempted to keep to its letter; Roger, entirely

free from it, was able to revive its spirit. Thoroughly independent from the *"Notre-Dame de Grâces"* in all externals, his painting is animated by the very passion of "sweet love" that had inspired the original invention of the "Glykophilousa."

<div align="center">XI</div>

Even when deducting from Roger's *oeuvre* all that which does not seem acceptable [1] and making allowance for the division of labor in a well-organized workshop, we are amazed by the sheer volume of his production; setting aside all stylistic considerations, the output of the Master of Flémalle cannot be added to it without creating an artist of heroic rather than human proportions.

Thus far, however, I have not mentioned the very pillars of that "unitarian" theory which fuses the personalities of Roger van der Weyden and the Master of Flémalle into a kind of Superman: a "Calvary" in the Kaiser Friedrich Museum at Berlin [2] and a triptych, discovered as recently as 1931, in the Abegg Collection at Zug in Switzerland.[3] The former, long accepted as a Master of Flémalle, is so Rogerian that its attribution to the older master was thought to be tenable "only under the assumption of an exceptionally late date." [4] And when the latter came to light it was at once acclaimed as a Roger van der Weyden so Flémallesque that the identity of the two painters seemed to be established.[5] It was, in fact, this "découverte sensationelle" which caused the greatest living expert on Early Flemish painting to join the "unitarians." "By the Abegg triptych," says M. J. Friedländer, "the total *oeuvre* is firmly joined together." [6] Supposedly contemporary with, or even antedating, the great "Descent from the Cross," it seemed to be the missing link between what had long been ascribed to two different painters.

However, when a work of art gives the impression of having been produced by either one or the other of two great masters, it often turns out to have been produced by neither; and this, it seems to me, is the case both of the Berlin "Calvary" and the Abegg triptych.

The Berlin "Calvary" (fig. 398) has always been a puzzle. To some extent its strangely contradictory quality can be accounted for by the fact that an almost romantic landscape and a thunderous sky have been painted over the original gold ground (it should be noted, though, that the four angels nearest the Cross are old and fairly well-preserved,[7] and the pseudo-Bernardian inscription issuing from the Virgin's mouth [8] may well repeat an original one). The principal incongruities, however, are inherent in the composition as such and should have aroused suspicion as soon as the Master of Flémalle's historical position was recognized. As long as he was considered a follower and not a forerunner of Roger van der Weyden these incongruities were not too disconcerting. A follower could easily have combined a figure so closely resembling the unbelieving midwife in the Dijon "Nativity" as does the squatting woman in the lower right-hand corner with a Mater Dolorosa that might have stepped out of the Vienna "Calvary" [9] did not her grief "bear such an emphasis"; he could easily have designed a St. John wiping his eye with a gesture similar to that of one of the angels in the Seilern trip-

<div align="center">298</div>

tych while duplicating the averted figure in the "Seven Sacraments" as far as the delineation of the neck is concerned.[1] But once we agree in dating the Dijon "Nativity" about 1420–1425 and the Seilern triptych even earlier — whereas the Vienna "Calvary" was produced about 1440 and the "Seven Sacraments" not before 1451 and even according to the most conservative estimate not before 1445 — the Berlin picture becomes unacceptable as a work of either the Master of Flémalle or Roger van der Weyden. It cannot be ascribed to the Master of Flémalle who never reached the stage represented by the Vienna "Calvary" and the "Seven Sacraments"; it cannot be ascribed to Roger who, even accepting for a moment the "unitarian" thesis, could not possibly have practiced the styles of his twenties, his forties and his fifties at the same time. True, Roger often reverted to a well-established formula, as in the many versions of the St. John supporting the Virgin Mary, and did not even shrink from using the same design for more than one picture, as is the case with the right arm of the Baptist in the "Medici Madonna" and the Braque triptych or with the head, hands and feet of the Christ Child in several Madonnas.[2] But in the former case we have a process of metamorphosis extending over a number of years and reflecting the general change in Roger's stylistic development; and in the latter we have the application of a labor-saving device confined, as a rule, to paintings closely akin in date and character and resulting in mechanical repetition. A true musician, Roger either wrote variations on a given theme or reused it, unchanged, in different compositions; he never mixed styles.

The Berlin "Calvary," then, must be ascribed to an artist distinct from both the Master of Flémalle and Roger van der Weyden and cannot antedate the middle of the fifteenth century. Fusing the Master of Flémalle of 1415–1430 with the Roger of 1440–1455, this artist — whether an independent master or an unusually self-willed collaborator who might have played a similar role in Roger's workshop as did the Master of the Beaufort Saints in Hermann Scheerre's [3] — was not without imagination and progressive spirit. But he was one of those near-geniuses who try to compensate for their lack of creative vigor by an excess of "originality"; and he was not a very good draftsman. The figure of the St. John, effectively conceived, is marred by a mass of shapeless, wooden drapery concealing an awkwardly upraised arm and by an impossible foot. His bold idea of arraying the women to the left of the Cross on one receding diagonal almost anticipates Hugo van der Goes (and is, therefore, beyond the compass of both Roger van der Weyden and the Master of Flémalle) but does not quite "come off" for want of rhythmical coordination. And in attempting to outdo the pathos of Roger's Mater Dolorosa by forcing her to clasp the Cross with both hands, he sharpened her passion into something dangerously close to both hysteria and sentimentality and lost sight of the natural limitations of human anatomy.

The history of the Berlin "Calvary" cannot be traced back beyond 1892 when it was bought at the Hulot sale in Paris. Of the Abegg altarpiece (fig. 399) we know, or can infer, much more. Its central panel also represents the Calvary. Its right-hand wing shows Joseph of Arimathea and Nicodemus accompanied by a servant bearing the ladder required for the Deposition, and in the left-hand wing, kneeling on a narrow porch, is seen the donor splendidly

dressed after the Italian fashion and wearing what has been believed to be the Order of the Porcupine. The stained glass window, emblazoned with *bendy or and gules on a chief azure three estoiles of the first*, proclaims him a member of the house of de Villa, a noble family partly composed of landowners and courtiers in its native Piedmont, and partly of wealthy bankers operating in the Netherlands; Hulin de Loo has proposed to identify him as one Oberto de Villa; but this identification, though not impossible and almost unanimously accepted by recent writers, is by no means a proven fact.[1]

The presence of this donor's portrait not only seems to link the Abegg altarpiece to Roger van der Weyden but also to create a presumption in favor of the comparatively early date (1435–38) usually assigned to it.[2] For, a member of the same de Villa family — according to Hulin de Loo, one of Oberto's three younger sisters, Antonina, Amedea, and Bartolomea — played the role of either donor or donatrix in a triptych originally composed of Roger's Louvre "Annunciation" and two panels now in the Galleria Sabauda at Turin, a triptych commonly dated between 1432 and 1435 or at least before 1440 (fig. 309). While the right wing of this dismembered altarpiece shows a Visitation closely related to that in the Speck von Sternburg Collection at Lützschena its left wing exhibits the portrait of a cleric, apparently a Doctor of Canon Law, who occupies a place not rightfully his. The picture is very much repainted; the cleric's face is painted on an inserted piece of different wood; and the original head, cut out of the panel, is said to be identical with a "Portrait of a Young Lady" that passed from the Heseltine Collection into the Edmond de Rothschild Collection at Paris (fig. 401). Since the Turin wings are exactly as high and somewhat less than half as wide as the Louvre "Annunciation" (86 cm. by 36 cm. as against 86 cm. by 92 cm.), and since an X-ray investigation of the donor's wing disclosed the de Villa arms, it cannot be doubted that the three panels, two of them still preserved near their original place of destination, once constituted a triptych donated by one of the Piedmont de Villas.[3]

This, however, by no means proves that the Louvre "Annunciation" and the Turin wings were executed by the same hand and at the same time. There are countless cases in which a single picture was subsequently provided with shutters so as to form a triptych. Suffice it to recall Hugo van der Goes' Frankfort Madonna with wings by an indifferent follower (fig. 455); the Boutsian "Martyrdom of St. Hippolytus" in St.-Sauveur at Bruges with the donors' wing by Hugo van der Goes; or the two St. Francis panels "by the hand of Jan van Eyck" left by Sir Anselm Adornes with the injunction that his and his wife's portraits should be added on the protecting shutters.[4] That the Turin wings are also later additions is highly probable for several reasons. In the first place, the iconography of the triptych as reconstructed is none too good: where the left wing of a triptych shows a donor unaccompanied by saints and placed in a locale distinct from that of the central panel (as in the Mérode and Abegg altarpieces) the right wing does not normally illustrate a separate scene but a subject that can be read as a mere adjunct to the principal event; a triptych composed of an isolated donor's portrait, an Annunciation in the center, and a "Visitation" on the right-hand shutter gives the impression of a *pis aller*. In the second place, the Heseltine-Rothschild portrait — if it were really identical

with the face of a donatrix cut out of one of the Turin wings, which would be possible only if the eyes could be shown to have been entirely repainted — would in itself disprove their attribution to Roger; before its provenance from the Louvre-Turin triptych was claimed it was considered as the work of a follower, and that is precisely what it is.[1] In the third place, the Turin "Visitation," though often judged as "equal in kind, equal in value and equal in date" to that at Lützschena (figs. 311, 312),[2] is in reality a considerably later version thereof, appreciably harder in style and adapted to the exigencies of a narrower space. The group has been compressed so as to fit into a panel measuring 86 cm. by 36 cm. as against 57 cm. by 36 cm.; the freely flowing movements of the figures have been stiffened; and there is no room for the trailing ends of their robes. Furthermore, St. Elizabeth's costume has been significantly modernized. In the Lützschena picture her gown has long sleeves with tapering cuffs of white fur at the wrists; in the Turin version the sleeves are wider and quite short, ending far above the elbow and exposing the sleeves of an underdress. This detail appears to be foreign to the fashion of the 'thirties whereas perfectly identical gowns are worn by the Sibyl of Tibur in the left wing of the Bladelin altarpiece (fig. 340) and, still somewhat later, by the Magdalen in Dirc Bouts' "Lamentation" in the Louvre (fig. 421). The inference is that the Turin wings did not originally belong to the Louvre "Annunciation." We must assume that an unidentified member of the de Villa family, having acquired the "Annunciation" as a single picture, had it expanded into a donatable altarpiece not earlier than *ca.* 1455.[3] As chance would have it, another member of the same clan, which seems to have had a penchant for bargains, was to act in precisely the same fashion some twenty-five years later; the banker Claudio de Villa bought from the Master of the Legend of St. Catherine (a follower and possibly a son of Roger van der Weyden) two panels showing the Presentation of the Keys to St. Peter and — to make the coincidence doubly remarkable — a Visitation copied after the Turin version;[4] commissioned a follower of this follower, an artist known as the Master of the Legend of St. Barbara, to add two panels showing the story of Job; and had his portrait painted into the "Visitation" while ordering that of his wife to be included in one of the Job scenes.[5]

The Louvre "Annunciation" does not, therefore, warrant any conclusion as to the date and authorship of the Abegg altarpiece; and when we turn to the latter with a mind unprejudiced by the approval of so many authorities we are struck at once with a taste for the bizarre and the turbulent utterly at variance with Roger's sense of balance and "dignity preserved amidst a flow of tears."

The spindly architecture in the donor's wing — a caricature of those in the "Madonna on a Porch" and the "Granada-Miraflores" altarpiece yet, contrary to Roger's custom, meticulously focused in a single vanishing point — is as interminably high and deep as the ladder in the opposite wing is long. The statuette of the Annunciate in the right-hand spandrel of the frontal arch is precariously tilted, a small yet significant detail which in itself precludes the authorship of Roger van der Weyden. Even the donor himself with his sprawling, unshod legs, sacklike body, and flat-crowned porkpie hat bashfully leaning against his knees gives a slightly absurd impression. Allowance must, of course, be made for his unusual Italianate

costume (it should be noted, by the way, that the aforesaid porkpie hat conforms to a much later fashion than the more lampshade-like specimen sported by Giovanni Arnolfini in the London double portrait, having its relatively closest parallel in a North Italian miniature of 1450–1460).[1] But with such masters as Jan van Eyck, Pisanello, the Limbourg brothers, or, for that matter, Roger van der Weyden, even the most preposterous accouterments never impress us as funny.

The *dramatis personae* themselves behave precisely as good actors should not: they are either "too tame" as is the misty-eyed Joseph of Arimathea or "o'erstep the modesty of nature," contorting their bodies and "sawing the air with their hands." And — more important, because it is a matter of actual observation rather than subjective reaction — their style exhibits the same heterogeneous mixture of earlier and later elements which made the Berlin "Calvary" unacceptable; in fact both works seem to have been produced by one artist (conceivably the same who, somewhat earlier and under Roger's personal supervision, had been entrusted with the execution of the "Seven Sacraments"), and the Abegg altarpiece, too, can hardly be dated before *ca.* 1455.[2] Such figures as the St. John, the weeping woman in the lower right-hand corner and the Joseph of Arimathea can be traced back to Roger's great "Descent from the Cross" while the Magdalen is derived from that in the Master of Flémalle's lost "Deposition," and the ladder-bearing servant from the two Roman soldiers in the Frankfort fragment of the "Bad Thief." But the crucified Christ closely resembles that in the Vienna "Calvary," and M. J. Friedländer himself has observed that the most striking similarity exists between the servant and the youngest Magus in Roger's Bladelin altarpiece.[3]

Those who consider the Abegg altarpiece as an early work of Roger van der Weyden may be inclined to interpret these two parallels as presages rather than reminiscences. But in a third instance we have what constitutes, not only an obvious borrowing but also a misapplication. The face of the standing woman throwing up her arms (fig. 400) agrees, line for line, with that of the admirable Magdalen in the "Seven Sacraments" (fig. 348), and here the question of priority cannot be in doubt. In the Magdalen there is a beautiful consonance between the tilt of her head and the movement that sways her body as a whole, and the expression of her face accords with her unobtrusively sorrowful gesture, arms lowered and hands folded in her lap. The figure in the Abegg altarpiece, however, stands stiffly erect and the still face of the Magdalen, one of the stillest in all art, has been incongruously combined with arms wildly flung in the air and abruptly emerging from a bunchy accumulation of lingerie. Far from being so close to both the Master of Flémalle and Roger van der Weyden that it would force us to admit their identity, the Abegg altarpiece is only close enough to them to accentuate their difference. In juxtaposition with Roger's genuine works it exemplifies what he was not — and thereby makes us see, once more, what he was.

EPILOGUE

THE HERITAGE OF THE FOUNDERS

Fʀᴏᴍ, roughly speaking, 1430, the style initiated by the Master of Flémalle and the van Eycks began to spread all over Europe, and for two or three decades their direct influence was more intense abroad than in their homeland. While the rest of the Continent was still engaged in assimilating their achievements, the scene in the Lowlands was already beginning to be dominated by their heirs.

During these twenty or thirty years, the international role of the Master of Flémalle seems more important — and was certainly more conspicuous — than that of Jan van Eyck. To comparatively primitive artists, the former's dramatic power was easier of access than the latter's descriptive sophistication. "Inventions" — schemes of composition, groupings, figure types, postures, and gestures — lend themselves more willingly to emulation than "discoveries"; and Jan van Eyck's technique was by its very nature inimitable. Yet it is going too far to say that the initial influence of Flemish painting "emanated in no wise from the works of Jan van Eyck but solely from those of the Flémalle Master."[1] We are faced, not with a question of "yes" or "no," nor even of "more" or "less," but with a question of "where" and "how." The two impulses, the Eyckian and the Flémallesque, operated in various environments with varying intensity, and their relative effectiveness depended upon — and is therefore indicative of — the character of the recipients.

Setting aside the Iberian peninsula, where the existence of a vigorous Eyckian tradition may be accounted for, in part at least, by Jan's prolonged visits in 1427 and 1428–1429 and by ensuing personal contacts, we can observe a fairly clear and intelligible distribution. In South Germany, Switzerland and Austria, the influence of the Master of Flémalle tended to predominate over that of Jan van Eyck. Of Northwest Germany — that is, Lower Saxony, Cologne and the Middle Rhenish region, the latter always distinguished by "pictorial" leanings — the opposite is true. France, finally, attempted to balance and reconcile the two forces.

In South Germany the earliest exponent of the *ars nova* is Lucas Moser of Wyl (viz., either Rottweil or Weilderstadt, both in Swabia) whose remarkable and still problematical St. Magdalen altarpiece at Tiefenbronn bears the date 1431.[2] This altarpiece represents something so new and unexpected on German soil that the author's famous complaint "Wail, O Art, wail and lament, for no one cares for thee any more" must be interpreted as the outcry of a misunderstood progressive, and not of an outmoded conservative. Probably trained abroad

and cosmopolitan rather than provincial in outlook, Lucas Moser owes much to the tradition exemplified by the Limbourg brothers and, quite particularly, Jacquemart de Hesdin; but at the same time his style was deeply affected by the nascent Flemish naturalism which to him presented itself — in fact, could present itself — only in the person of the Master of Flémalle. The perspective view of the basilica in which St. Magdalen receives her Last Communion is prefigured in the "*Très Riches Heures*,"[1] and the seascape with rocky islets separated by narrow channels, hills shaped like a Phrygian cap and shores enlivened by bare trees is clearly reminiscent of the "Flight into Egypt" in the "Brussels Hours." But it is from the early works of the Flémalle Master such as the Seilern triptych, the Dijon "Nativity," the Prado "Betrothal," and, possibly, the Mérode altarpiece, that Lucas Moser appropriated a modeling that endows figures and objects with a semblance of space-displacing solidity, the "materialistic" interpretation of surface texture, the use of cast-shadows, and even the idea of organizing the ensemble in such a manner that the central and right-hand panels form a coherent unit while the left-hand panel remains comparatively independent.

As Lucas Moser is linked to the Master of Flémalle by common ties with Franco-Flemish book illumination, so is another Swabian painter linked to him by common ties with what is generally referred to as "Burgundian" sculpture. This painter — Hans Multscher of Reichenhofen, residing at Ulm from 1427 — was, as will be remembered, a sculptor himself.[2] But he handled the brush as well as the chisel, and his only authenticated paintings, eight panels from the Niederwurzach altarpiece of 1437 (now in the Deutsches Museum at Berlin), show the same drapery style, and the same temperament, as do such reliefs as the "Karg-Altar" in Ulm Cathedral and the model for the tomb of Louis the Bearded of Bavaria in the Bayrisches Nationalmuseum at Munich. If Lucas Moser may be said to have approached the *ars nova* through the medium of the Limbourg brothers and Jacquemart de Hesdin, Hans Multscher may be said to have approached it through the medium of Claus Sluter. And he is, therefore, both more radically "modern" and more decidedly Flémallesque; for, basically the Master of Flémalle is closer to Sluter than to any Franco-Flemish illuminator. In Multscher's paintings all traces of the International Style have disappeared, and what remains is the language of the Master of Flémalle translated into a Germanic dialect lacking in delicacy and polish but saturated with that powerful expressiveness which Dürer called "gewaltiglich."

What applies to Multscher also applies, *mutatis mutandis*, to his contemporaries in Franconia, Bavaria and Austria: the Master of the Tucher altarpiece of about 1445 which still adorns the Frauenkirche at Nuremberg;[3] the Master of the Polling altarpieces (1440 and 1444) in the Munich Pinakothek, presumably identical with Gabriel Angler;[4] the Master of the Albrecht altarpiece, now divided between the museums of Vienna and Berlin, which was produced in 1438;[5] and Conrad Laib of Salzburg whose most important work, a large "Calvary" in the Vienna Gemäldegalerie, is dated 1449.[6] The style of all these masters is Flémallesque in substance; but it is affected by Eyckian influence in accidents.

Conrad Laib paid tribute to Jan van Eyck, not only in adopting a German version of the motto "*Als ich chan*" ("*Als ich chun*")[7] but also in including in his Vienna "Calvary" two

equestrian figures, one seen in approximate profile view, the other directly from behind, which are of unmistakably Eyckian ancestry; they may be described as lineal though somewhat freakish descendants of the race to which belong the horsemen in the left wing of Jan's New York diptych and the Knights and Judges in the Ghent altarpiece. The Angel Gabriel in the Albrecht Master's "Annunciation" at Berlin, clad in a brocaded pluvial but turned to full profile, has much in common with the Angels in the Washington and Friedsam "Annunciations," and in a niche behind the Virgin Mary is seen a still-life-like arrangement of objects, among them the familiar brass basin and candlestick, which evidently presupposes the painter's acquaintance with either the Ghent "Annunciation" or such pictures as the "Ince Hall" and "Lucca" Madonnas.[1]

The Tucher Master's "St. Augustine" as well as Multscher's "Nativity" exhibit still-life features the Eyckian derivation of which is even more obvious. In these two panels a number of books — their very presence somewhat surprising in the rustic setting of a Nativity and in itself indicative of a quotation out of context — are placed on a shelf in such a way that they project beyond its front edge and are seen from below, and the same is true of the round deal box that figures in the "St. Augustine."[2] This application of *di sotto in sù* or "worm's eye" perspective is so characteristic of Jan van Eyck (compare, especially, the "Annunciation" and the Prophets' lunettes in the Ghent altarpiece) that a connection, direct or indirect, can hardly be questioned.

All this does not, however, touch what may be called the core of the South German style of about 1440, and even the greatest exponent of this style, Conrad Witz,[3] is no exception. Active at Basel from 1434 and at Geneva from 1444 up to his death in 1447 but born and educated in cosmopolitan Constance, the seat of the Council that put an end to the Great Schism in 1418, he understood the Eyckian innovations more thoroughly than did his lesser South German contemporaries. The faces of his young women with tiny mouths, short noses and pointed chins reflect the delicate, feline ideal of Jan's Madonnas and youthful saints rather than the large, long-nosed, lunary types of the Master of Flémalle. He rejoiced in the sheen and glitter of jewelry and gold brocades; he appropriated and even perfected such optical refinements as reflection and refraction in water;[4] he occasionally adopted the diagonal shadows cast upon the floor by objects outside the picture space (as seen in the "Annunciation" of the Ghent altarpiece); and his — or a close follower's — "Holy Family" in the Museum at Naples shows an ecclesiastical interior in eccentric perspective which would not have been possible without the "Madonna in a Church."[5]

In principle, however, Conrad Witz — and the same applies to his contemporary and fellow-countryman, the great engraver known as the Master of the Playing Cards — adhered to the Master of Flémalle.[6] In spite of his readiness to accept Jan van Eyck's optical devices and observations, his forms seem to be carved out of rock or cast in metal, and he intensified what I have termed the tension between space relations and surface relations. In his Strasbourg panel, representing St. Magdalen and St. Catherine, for example, the latter's robe is manifestly patterned after that of the Annunciate in the Mérode altarpiece; but its folds seem to exuberate into a complex, two-dimensional pattern composed of star-shaped explosions. He shared, to

some extent, the Flémalle Master's *horror vacui* and even outdid him in perspective violence; he assumed very short distances — that is, wide visual angles — as in the Strasbourg picture just mentioned and the Naples "Holy Family"; and he resorted to drastic oblique views as in the Basel "Meeting at the Golden Gate" and the Geneva "Adoration of the Magi." Hs used light and shade as a means of stereometric clarification rather than pictorial synthesis so that his cast-shadows, vigorous and precise, are treated as though they adhered to the surfaces on which they appear; the St. Catherine in the Strasbourg panel and the Virgin Mary in the Nuremberg "Anunciation" actually sit upon a cast-shadow instead of being crossed by it. And where Jan van Eyck fused and transformed his memories of buildings and sceneries into imaginary vistas, however "real," Conrad Witz recorded them in topographical portraits, however stylized. In his pictures we can identify a stretch of shore in the vicinity of Geneva or the cloisters and market place of Basel. And when I said that the Naples "Holy Family" derives from the "Madonna in a Church," I must now add that Jan's ideal basilica has been replaced by Basel Cathedral.

In Northwest Germany a contemporary of Conrad Witz, known as the Master of Heiligenthal and probably active at Hamburg, pursued the opposite course; in his "St. Andrew Baptizing the Wife of the Proconsul of Greece" (text ill. 63) [1] he did his poor best to reproduce Jan's Gothic structure instead of substituting for it a building familiar to him. He somewhat distorted the proportions of the edifice, changed several details and clumsily tacked on an ante-room in order to fill the wider space of his panel; but the very fact that he added to Jan's composition rather than changed its format reveals his desire to be as faithful to his model as he could, and this desire is further evidenced by the retention of the north light and the tell-tale break in the triforium. His picture, dated 1438, is the earliest extant copy of the "Madonna in a Church" and for all its imperfections testifies to the fact that Northwest Germany was as forcibly attracted by Jan van Eyck as were South and Southeast Germany by the Master of Flémalle.

The more essential values of the Eyckian style — especially the treatment of color and light — remained beyond the reach of the Master of Heiligenthal. They were, however, perceived by other, greater Northwest German artists such as Stephan Lochner of Cologne; [2] and, even more clearly, by the delightful middle Rhenish painter known as the Master of the Darmstadt Passion (active about 1440), perhaps the most accomplished colorist and luminarist outside the Netherlands. [3] His pictures, though still painted on tooled gold ground, are pervaded by a soft chiaroscuro utterly foreign to his South German contemporaries and evince an extraordinary sensibility for tactile values. His delicate colors are selected with an eye for tonal modulations rather than the intent to display variety and contrast, and he was fond of the rare combination of green with violet which is anticipated, if anywhere, in the London Arnolfini portrait. His figures are Eyckian in type as well as treatment and show an Eyckian calm and dignity of deportment. His "Madonna Enthroned" in the Deutsches Museum at Berlin, foiled by an admirably painted cloth of honor, compares not unfavorably with Jan's "Lucca" and

"van der Paele" Madonnas, and even where the Virgin Mary receives the Magi amidst a picturesque complex of Romanesque ruins she has a gorgeous oriental carpet under her feet.

In contrast to Germany, where we can recognize a clear division between predominantly Flémallesque and predominantly Eyckian territory, France remained faithful to her historic rôle of *mediatrix et pacis vinculum*. The last stronghold of book illumination in Paris, the workshop of the Bedford Master, opened its doors simultaneously to the Master of Flémalle and Jan van Eyck.[1] And the first major panel painter to embrace the Flemish gospels, active in the "Deep South," attempted a genuine reconciliation between the two rival traditions.

This painter whose only known work is a dismembered altarpiece of monumental proportions — its central panel still preserved in Ste.-Marie Madeleine at Aix-en-Provence, its wings divided between the Musée Royal at Brussels, the Rijksmuseum at Amsterdam and the van Beuningen Collection — may be described as a twin brother of Conrad Witz. Flourishing at exactly the same time (the altarpiece of Ste.-Marie Madeleine was commissioned in 1442), the Master of Aix[2] and Conrad Witz are equally indebted to the Flémalle Master and share what has been termed a *sentiment cubiste*[3] — a passion for powerful modeling and stereometric schematization, impetuous perspective, a somewhat rigid drapery style, and hard, triangular cast-shadows. But with the Master of Aix, Conrad Witz's woodcarved manliness, to transfer to him Goethe's epithet for Albrecht Dürer, is tempered by a more reticent taste in color and a less metallic sense of texture. He seems to transport us into an area of intersection between the orbits of the Flémalle Master and Jan van Eyck; in fact he abandoned himself no less wholeheartedly to the latter's influence than to the former's.

In staging the scene in an ecclesiastical, not a domestic, interior, the central panel of this altarpiece, the well-known "Aix Annunciation," adheres to the French rather than the Flemish tradition,[4] and the projecting pavilion, its corners adorned with Prophet statues, even harks back to Melchior Broederlam. The disposition of the figures, however, is manifestly inspired by the "Annunciation" of the Ghent altarpiece, the only earlier rendering of the subject in Northern art to show both figures kneeling and facing each other in such a way that the heads are on the same level. The borders of the Angel's pluvial are embroidered with statuettes of saints, each framed by Flamboyant aediculas — a motif no less specifically Eyckian than are those mirror images with which these diminutive figures have rightly been compared as equally expressive of a delight in sharply focused "pictures within pictures."[5] The influence of the Ghent altarpiece is also felt in the lateral panels. The figures, Isaiah and Jeremiah, are surmounted by lunettes, containing books and other objects seen *di sotto in sù*, with which they are optically related in much the same way as are Jan van Eyck's Annunciate and Gabriel with the Prophets' lunettes.

In attempting to fuse Flémallesque and Eyckian elements, the Master of Aix conforms to the French ideal of "selective assimilation," and this attitude is typical of his countrymen. The Master of 1456, who is responsible for the "Man with the Wine Glass" in the Louvre and the eponymous though slightly later "Portrait of a Gentleman" in the Liechtenstein Gallery at Vienna, vies with the Master of Flémalle in forcefulness and directness of interpretation

but remains faithful to Jan van Eyck's characteristic method of lighting.[1] In the beautiful Jacques Coeur window in Bourges Cathedral, begun in 1447 and showing an Annunciation flanked by St. James the Great and St. Catherine, the Flémallesque motifs (such as the massive, heavily bejeweled haloes and the incidental angels) are balanced by features as strictly Eyckian as the fluffy-maned St. Catherine, who has been correctly derived from that in the Dresden altarpiece,[2] and the Angel Gabriel, whose gold-brocaded pluvial is adorned with the characteristic statuette border. And if Jean Fouquet, taking a further step in the direction of "selective assimilation," succeeded in finding "a new equilibrium between the two extremes of Flemish and Italian art,"[3] this further step presupposed a reconciliation of the Flémallesque style with the Eyckian.

After their first encounter with the *ars nova*, both Germany and France surrendered to the genius of Roger van der Weyden — France from as early as about 1450,[4] Germany some five or six years later but all the more unconditionally.[5] As time went on his influence came to be rivaled by that of younger Netherlandish masters, the Germans being chiefly attracted by Dirc Bouts, the French by Hugo van der Goes. But these younger masters drew, more or less extensively, from Rogerian sources; and Roger's own inventions never lost their magnetism until his very spirit was resurrected on German soil by Martin Schongauer.

<center>II</center>

Germany and France, then, were conquered by two or three successive waves of Flemish invasion. They were infiltrated by shock troops trained in the camps of the Flémalle Master and Jan van Eyck, swamped by a massive army of Rogerians and held by a post-Rogerian occupation force. A somewhat, though not quite, analogous development can be observed in Spain and Portugal.[6] And the Italian Quattrocento, in sovereign self-confidence, accepted the "*maniera fiamminga*" — largely transmitted through imported panels, tapestries and prints — as an additional stimulus instead of either opposing or yielding to it.

In the Lowlands themselves, however, the very indigenousness and continuity of the development tended to diminish the direct influence of its founders. As has been pointed out at the beginning of this chapter, their direct influence was soon superseded by that of their followers — followers, that is, who, unlike Jacques Daret, were not one-sided imitators of either the Master of Flémalle or Jan van Eyck but had the power of constructive synthesis.

Chief among these was, of course, Roger van der Weyden. But his tremendous influence was supplemented by that of Petrus Christus, a lesser yet, from a historical point of view, equally indispensable master.[7] Probably born about 1410 and a citizen of Bruges from 1444 up to his death in 1472 or 1473, he was the heir apparent to Jan van Eyck. Yet he claimed a share in the legacy of the Master of Flémalle much as Roger van der Weyden, the heir apparent to the Master of Flémalle, had claimed a share in the legacy of Jan van Eyck. But, being Roger's junior by some ten years, Petrus Christus had to come to terms with one who had already welded the styles of the founders into a formidable unity. He had to achieve a

<center>308</center>

second synthesis, so to speak, and this was possible only by a partial cancellation of the first. Roger had sacrificed Eyckian space and volume in favor of rhythmicized relief and line. Petrus Christus endeavored to retain Eyckian space and volume while de-emphasizing rhythmical continuity as well as linear precision, which led him to reduce the complexities of Eyckian modeling to simple, unbroken surfaces. Roger had sharpened and deepened the emotional qualities inherent in the style of the Flémalle Master into grand pathos. Petrus Christus toned down this grand pathos to quiet despondency. In short, he transformed the language of his great predecessors into a homely idiom, plain to the point of artlessness and humbly human rather than heroic — a "basic Flemish" readily assimilable by those who, like himself, hailed from the less developed Northern districts of the Netherlands.

In 1452, we recall, Petrus Christus copied the New York "Last Judgment" by Jan van Eyck (fig. 410).[1] But his copy — an altar wing preserved in the Kaiser Friedrich Museum at Berlin together with its counterpart which shows the Annunciation above and the Nativity below — is an abridged paraphrase rather than a complete translation. Like Aelfric the Grammarian in his English Heptateuch, he left out what he considered unsuitable to the layman and "thereby made his version more readable";[2] what he thought difficult to understand, he explained; and what he chose to retain, he rendered in simple, vernacular language. He omitted the numerous inscriptions. He reduced the throngs of Elect, the varied crowds of Resurrected and the tangled mass of Damned to a few isolated, clearly discernible groups and figures while, on the other hand, providing St. Michael with three palpable foes and adding a gigantic Hell-mouth, a motif dear to popular imagination; he replaced, to give only one instance, the Archangel's colorful peacock wings by ordinary ones and simplified his complex, scintillating armor. For the rich, weird scenery of bursting earth and white-capped waves he substituted a somewhat bare but almost idyllic landscape. It is as though the Eyckian forms had been smoothed over with file and pumice, and an air pump applied to the Eyckian space.

The transformation of a Rogerian invention is well exemplified by Petrus Christus' Brussels "Lamentation" (fig. 403)[3] of which that in the Metropolitan Museum (fig. 404)[4] is a plainer, probably considerably later variant. Both pictures are chiefly derived from Roger's great "Descent from the Cross," the Brussels version even retaining the Flémallesque head-dress of the Virgin Mary and — in dulcified form — the unforgettable gesture of the Magdalen. In composition, however, Petrus Christus' Brussels picture is as different from Roger's as it is in emotional content. The design of the draperies is less complex, and angular rather than curvilinear. The rhythmical flow of Roger's double fugue in two dimensions is broken up into an array of separate units in three-dimensional space.[5] The third Mary and the anonymous companion of Joseph of Arimathea form a little group of bystanders looking on from the rear, and the Magdalen, even more emphatically cut off from the event and turning away from it, sits alone in the left foreground. The figures, with listless, unprepossessing faces and small pudgy hands, move either hesitantly or abruptly as though the inertia of their bodies could not be overcome save by an extra effort of the will.

Taken by themselves, comparisons like these show Petrus Christus in a rather negative light. But his is one of the cases, by no means rare in the history of art, in which gains were possible only with the loss of values already acquired, a case of progress through renunciation. In enfeebling the gestures and movements characteristic of Rogerian art while yet attempting to disclose some of the passion of which these gestures and movements are an expression, Petrus Christus endowed his figures with a shy, introspective depth of feeling which seems unable to communicate itself by outward action and, for this very reason, gives the impression of a peculiar inwardness. In disrupting Roger's rhythmical concatenations and, at the same time, stripping the forms of their Eyckian complexity, he reduced the objects to simple, blocklike volumes which, fitting into the surrounding space as molten metal does into its matrix, constitute a relatively static yet clearly structured and more integrated universe. The lights and shadows, freely playing over comparatively undifferentiated surfaces, begin to assume the character of autonomous values rather than serve the purpose of describing form and texture. And since some of the figures are shown in front view and nearly all of them are disengaged from each other, the picture space seems to open itself toward the beholder.

"His historic role," says Dr. de Tolnay in his fine evaluation of Petrus Christus' achievement, "corresponds to that of Piero della Francesca in Italy."[1] In spite of all differences in outlook and stature, this comparison with the "monarch of painting and architecture"[2] is justifiable, and it is of particular significance that both masters took an active interest in geometric perspective. Petrus Christus did not, of course, approach the problem from a scientific point of view nor did he write a theoretical treatise about it. But out of his intuitive feeling for that unity of space which I have tried to describe, he did discover, on a purely empirical basis, the rule—unknown to Jan van Eyck and Roger van der Weyden—that all orthogonals, regardless of the planes in which they run, converge in a single vanishing point and that this vanishing point is the locus of a general horizon.[3]

This tendency to integrate the object with its environment is also evident in Petrus Christus' portraits in which the half-length figure of the sitter, instead of emerging from dark, amorphous space or being silhouetted against a flat, neutral background, is shown within a real interior.[4] In the portrait of a Carthusian in the Metropolitan Museum, dated 1446 (fig. 405), the sitter appears, like Jan van Eyck's "Timotheos," behind a parapet; but the background is elaborated into the corner of a whitewashed cell the rear wall of which is enlivened by a strong light.[5] And in the portrait of Sir Edward Grymestone in the Collection of the Earl of Verulam at Gorhambury (fig. 406), also dated 1446, this "corner space" is developed into an elaborate interior, its side wall pierced by a circular window;[6] enamored of perspective, Petrus Christus here included the beams of the ceiling[7] which by their recession help to define and deepen the picture space while their cast-shadows lend variety to the gray expanse of the rear wall. Needless to say, in admitting the beholder to the intimacy of the sitter's domestic surroundings, this "corner-space portrait" placed their relationship on an entirely new psychological basis.

In earlier art history writing, Petrus Christus was generally regarded as the principal pupil and direct successor of Jan van Eyck. In recent literature, however, this assumption has

been reversed. According to a theory first formulated in 1926 and now accepted by a sizable majority of scholars,[1] he was not a follower of Jan van Eyck who, later on, tried to fuse the style of his master with that of the Master of Flémalle and, more particularly, Roger van der Weyden; rather he was an independent genius chiefly developing under the influence of the two masters of Tournai, and only in his "later works (after 1450), which show a weakening of his creative faculty,"[2] is he supposed to have succumbed to the spell of Jan van Eyck with whom he is held never to have been in personal contact.

Like many revolutionary theories this modernistic reinterpretation of the facts, based on the silent assumption that Petrus Christus did not arrive at Bruges before 1444 when he was admitted to citizenship, tends to throw out the baby with the bath. It is true that Petrus Christus was more than a mere imitator of Jan van Eyck and that the paintings which he produced between about 1445 and about 1450 have more originality and vitality than most of his later works; and it is also true that these later works — their style exemplified by the "Madonna with St. Francis and St. Jerome" of 1457 (fig. 412)[3] and the "Madonna of the Dry Tree" of about 1462 —[4] are more emphatically Eyckian in character. But it is not true that the period between 1445 and 1450 marks the beginning of Petrus Christus' known activity; that he was never personally associated with Jan van Eyck; and that the latter's influence on him was negligible up to the deadline of 1450 while growing in direct proportion to his age thereafter. The "Exeter Madonna" at Berlin (fig. 408), which on account of its Eyckian character has been placed at the very end of Petrus Christus' career, was demonstrably completed as early as 1450.[5] And even during the preceding half decade the influence of Jan van Eyck is no less noticeable than is, conversely, the influence of Roger van der Weyden and the Flémalle Master during the years from 1450 to about 1455.

While one of the two altar wings in the Kaiser Friedrich Museum, dated 1452, is freely copied after Jan van Eyck's New York "Last Judgment" the other (fig. 409) is full of "Tournaisian" reminiscences, the Nativity revealing its dependence on the Master of Flémalle by the inclusion of the faithful midwife, the Annunciation combining a Virgin Mary posed in Rogerian fashion with an almost literal repetition of the Angel Gabriel in the Mérode altarpiece.[6] And a still later "Nativity," acquired from the Henry Goldman Collection by Mr. Georges Wildenstein in New York (fig. 411), is even closer to the Flémalle Master's Dijon panel, not only in general composition but also in that it revives the candle motif in addition to retaining the oddly beturbaned midwife.[7]

Eyckian influence, on the other hand, can be seen rivaling the Rogerian in a third "Nativity," formerly in the Yturbe Collection at Madrid and now in the National Gallery at Washington (fig. 402),[8] which is generally assumed to have been produced about 1445 and thus would seem to antedate even the Brussels "Lamentation" which I incline to put two or three years later. The peculiar layout of this composition — the scene viewed through a richly sculptured portal, Gothic in style but round-arched — is evidently derived from Roger's "Granada-Miraflores" triptych. But it has rightly been pointed out that the statues of the First Parents in the splayings of this portal are derived from the Ghent altarpiece,[9] and this observation can easily be supplemented by others. The "Slaying of Abel" (the fourth

of the archevault reliefs that show six scenes from Genesis beginning with the Expulsion from Paradise and ending with the Leave-Taking of Seth from his Parents) [1] evinces the influence of the Ghent altarpiece even in the specific feature that a jawbone and not a club is used as a weapon.[2] The adoring angel in the left foreground wears a brocaded pluvial of purely Eyckian cast. And the facial type of the Virgin Mary, however much simplified in Petrus Christus' customary fashion, can be traced back to Eyckian and not Rogerian prototypes, especially the "Madonna at the Fountain." The two portraits of 1446 are lighted according to the Eyckian system and employ the Eyckian device of focusing the sitter's glance on the beholder. And in the inscription of the New York "Carthusian" we find in the word *fecit* a square "C"—an inconspicuous detail yet one that reveals the painter's intention to imitate the little mannerisms of Jan van Eyck's epigraphy.

Between *ca.* 1445 and *ca.* 1455, then, the Eyckian and Rogerian impulses were not mutually exclusive but interacted with varying results. And as regards the time before *ca.* 1445, the very basis of the modern theory is undermined by the well-established cases of the Detroit "St. Jerome" (fig. 258) and the "Rothschild Madonna" (fig. 257). Both works, we remember, can be shown to have been begun by Jan van Eyck and to have been finished by Petrus Christus, the former in part, the latter *in toto*. And since the "St. Jerome" bears the date 1442 while the "Rothschild Madonna"—commissioned by Jan Vos, Prior of the Charterhouse of Genadedal near Bruges—was completed before September 3, 1443, the only possible conclusions are that Petrus Christus, far from appearing at Bruges as late as 1444, was in fact active there from 1441 at the latest;[3] that he was Jan van Eyck's successor in business; and that he practiced at this time a style more deceptively Eyckian than that of even his latest works—a style which he could not have acquired save through prolonged apprenticeship and collaboration.

Petrus Christus' development thus appears somewhat more complex than was envisaged by the modernists. He started out, it seems, as a disciple of Jan van Eyck and after his master's death was able to complete unfinished work in fairly orthodox fashion. What he added to the Detroit "St. Jerome" is indifferent in quality but unadulteratedly Eyckian in style and intention. The same is true of the "Rothschild Madonna"; but here, where his responsibility was greater and his freedom less restricted, his personal tendency towards simplification already declares itself in those characteristics which bewildered the experts long before the picture's history was known—the porcelain smoothness of the faces, the pudginess of the hands, the stagnancy of the draperies, and the airlessness of the landscape.

After this purely imitative phase, which may include the Copenhagen "Donor with St. Anthony"[4] (and, conceivably, the twin "Stigmatizations of St. Francis" thus far ascribed to Jan van Eyck),[5] had come to an end with his establishment as an independent master in 1444, Petrus Christus freely abandoned himself to the influence of Roger van der Weyden and, in a lesser degree, the Master of Flémalle. And under the liberating impact of these two—so powerful at the beginning that, were their authorship in doubt, the works produced by him between *ca.* 1445 and *ca.* 1450 might be ascribed to a "Follower of Roger van der

EPILOGUE: THE FOUNDERS' HERITAGE

Weyden" rather than a "Follower of Jan van Eyck" — he became capable of converting his defects into virtues. Confronted with tasks demanding synthetic vigor rather than analytical subtlety, his innate craving for simplification and generalization produced the volumetric yet broadly pictorial style which we admire in the Washington "Nativity," the Brussels "Lamentation," the two portraits of 1446, the "Madonna" of 1449 in the Thyssen Collection at Lugano,[1] the famous "St. Eloy" in the Robert Lehman Collection at New York (fig. 407), also dated 1449,[2] and, possibly, the "Calvary" in the Museum at Dessau.[3]

When this new impulse had spent itself, and possibly in connection with the problem of "repeating" the "Rothschild Madonna" in the "Exeter Madonna" of 1450 (it should not be overlooked, however, that Petrus Christus not only abridged the composition but also revised it according to the same principle which he applied in his "corner-space portraits"), he underwent a kind of reconversion to his old, Eyckian faith. But it is unjust, I think, to regard this third phase — which produced, in addition to the works already named, the "St. Catherine" in the Maurice d'Alta Collection at Brussels,[4] such modestly attractive donor's portraits as those in the London National Gallery[5] and the Kress Collection,[6] and the enchanting, almost French-looking portrait of a pale young girl in the Kaiser Friedrich Museum, unquestionably one of his very last creations (fig. 413)[7] — as wholly unproductive or even "insipid." In these late pictures Petrus Christus shows himself once more a follower of Jan van Eyck. But what he aimed to accomplish, though at the sacrifice of the ambitions that had inspired him during the climactic phase between 1445 and 1450, was no longer literal imitation but free reconstruction.

III

Petrus Christus was born at Baerle, a place located on what is now the Belgian-Dutch border; in fact, one part of the once unified community, Baerle-Hertog or Baerle-Duc, today belongs to Belgium while the other, Baerle-Nassau, belongs to Holland, and the Mayor of Baerle-Duc cannot reach his town hall without crossing Dutch territory. Some art historians have thus proclaimed him a "Dutchman" in distinction to the "Flemings."[8] It should be borne in mind, however, that the fairly recent division between two modern states cannot be safely reprojected into the past. In Petrus Christus' time his birthplace, less than thirty miles from Antwerp, belonged to the Duchy of Brabant which was entirely independent of what was then the County of Holland,[9] and his formative years exactly coincided with that ascendancy of Flemish — or, to be more precise, South Netherlandish — painting which swayed progressive artists all over Europe, including, we recall, the book illuminators of Utrecht.[10] In the fourth decade of the fifteenth century even a Dutchman more authentic than was a native of Baerle must be presumed to have sought instruction in the southern parts of the Netherlands. In point of fact, he would not have known where else to go; for the only North Netherlandish school of panel painting supposed to have existed "as far back as

the time of Jan van Eyck," the celebrated "school of Haarlem," has turned out to be a figment of Carel van Mander's patriotic imagination.[1]

This was precisely the situation which confronted Dirc Bouts.[2] Apparently some five or ten years younger than Petrus Christus, he was, according to van Mander, born in Haarlem where his house was shown as a point of interest during the biographer's lifetime, and in this respect we have no reason for skepticism.[3] There is, however, little evidence to support van Mander's further assertion that Dirc Bouts was active as a painter in his native city — an assertion not easily reconcilable with the recorded biographical data. About 1447–1448 at the latest, Dirc Bouts married into a prominent and wealthy family of Louvain in Brabant, and it is fair to assume that he immediately established himself in the home town of his wife, Catherine van der Bruggen (charmingly nicknamed "Catherine with the Money"). Possibly he had spent some time at Louvain at an even earlier date — a "Dieric Aelbrechts, schildere" is mentioned in the city records of 1442[4] — and from 1457 he is continually mentioned there, as a highly respected citizen, up to his death in 1475.

What is believed to be his earliest extant work is a series of Infancy scenes in the Prado which I am inclined to date between 1445 and 1450 (figs. 414–417).[5] In spite of their greater finesse, these four pictures, an "Annunciation," a "Visitation," a "Nativity," and an "Adoration of the Magi," are so closely akin to Petrus Christus' Washington "Nativity" that they were long ascribed to him. There is a similar predilection for large, unbroken surfaces which serve the double purpose of defining volume and showing off the interplay of light and shade. There is a similar effort to invite the beholder into the picture space. And there are a great number of tangible iconographic and morphological parallels. Both in the Prado and Washington "Nativities" the shed, seen in perfectly symmetrical front view, is erected on the remains of a Romanesque building the coupled window of which permits the shepherds to look in on the scene. Both pictures show, analogously placed, an angel clad in a brocaded pluvial. And the sculptured portal of the Washington "Nativity," its spandrels filled with circular reliefs of pagan warriors, indubitably furnished the model for the archways through which the four Infancy scenes are viewed; with respect to these reliefs the Prado "Annunciation" is even closer to the prototype than is the Prado "Nativity."

We find, needless to say, differences as well as analogies. The facial types employed by Dirc Bouts, especially for the Virgin Mary and the St. Joseph, are appreciably closer to Roger van der Weyden while the analysis of light is as appreciably closer to Jan van Eyck; in the "Annunciation" and the "Nativity," for example, the shade on the Virgin's face is broken by a reflected light precisely as in Jan's Jeanne Cenami. The tendency towards simplification does not impinge, as it does with Petrus Christus, upon the painter's attention to details and tactile values. There is more delicacy in the interpretation of form as well as subject matter (the draperies are subtler throughout and the life of Adam and Eve after the Expulsion is conceived as a family idyll rather than mere labor). A nicer sense of order and cleanliness dictated the transformation of the dilapidated shed into a rustic but well-preserved structure, and there is an even stronger feeling for the positive value of voids: the figures in

the "Nativity" are placed diagonally so as to leave the right foreground unobstructed, and even in the portals the intervals between the archevault groups have been augmented, and the colonnettes beneath the jamb figures as well as the tracery of the spandrels have been omitted. The landscapes, finally, especially that in the "Visitation," are distinguished by a continuity and complexity beyond the scope of Petrus Christus.

Yet the connection between the Washington "Nativity" and Dirc Bouts' Prado series is undeniable and calls for an explanation. It has been thought that "the two artists received a common schooling in Haarlem during their youth."[1] But this hypothesis is vitiated, not only by the non-existence of a Haarlem school prior to *ca.* 1450 but also by the fact that all the more tangible evidences of a "common schooling" can be accounted for by either Rogerian or Eyckian sources. The idea of enframing the scenes by sculptured portals derives, as has never been doubted, from Roger's "Granada-Miraflores" altarpiece while the brocade-coped angel and at least one of the archevault groups (the Slaying of Abel) can be traced back to Jan van Eyck. A similar combination of Eyckian and Rogerian elements may be observed in the three other Prado pictures which cannot be directly compared with Petrus Christus' "Nativity." In general arrangement and numerous details the "Annunciation" is based on Roger's painting in the Louvre while in the Angel the posture of the Gabriel in the Ghent altarpiece is combined with the scepter motif seen in Jan's Washington "Annunciation." The "Adoration of the Magi," as Eyckian in many ways as the "Nativity," depends upon the fifth archevault relief in the left panel of the "Granada-Miraflores" altarpiece in iconography, especially in that the St. Joseph respectfully touches his cap.[2] The "Visitation," finally, is nothing but a spatialized but fairly literal variant of Roger's painting in the Speck von Sternburg Collection (not, we are gratified to see, of the later version at Turin).

The inference is that young Dirc Bouts — traveling straight to the south and then, possibly after a preliminary stay at Louvain, straight to the west — acquired his education in Brussels and Bruges; that, in addition to studying such individual works of Jan van Eyck and Roger van der Weyden as were accessible to him, he attached himself to Petrus Christus who, a "Northerner" himself, had made the style of these two masters palatable to another "Northerner"; and that this personal attachment to Petrus Christus rather than a "common schooling in Haarlem" accounts for the close kinship that exists between the Washington "Nativity" and the Infancy scenes in the Prado.

In the further course of his career Dirc Bouts immersed himself more and more deeply in the world of Roger van der Weyden. A triptych in the Capilla Real at Granada (figs. 418, 419)[3] — produced, I think, about 1455 rather than about 1450 — comprises a "Crucifixion" derived from Roger's Vienna "Calvary" and his great "Descent from the Cross"; a "Deposition" which shows the latter's influence mingled with that of the two other Rogerian interpretations of this theme; and a "Resurrection" developed from the diminutive group in the background of Roger's "Appearance of Christ to His Mother."[4] The approximately contemporary "Entombment" in the London National Gallery (fig. 420), painted on canvas, reflects one of the archevault groups surmounting the Lamentation in the "Granada-Miraflores"

altarpiece[1] while a composition most adequately represented by a well-known picture in the Louvre (fig. 421)[2] is inspired by this "Lamentation" itself. And that his and his pupils' Madonnas in half-length are based upon Rogerian prototypes has already been mentioned.[3]

However, Dirc Bouts' unique achievement consists in his ability to absorb Roger without being deflected by him. The development of Petrus Christus, the personal pupil of Jan van Eyck, was forced by Roger's influence into a kind of rising spiral which ended at a point perpendicular to its point of departure. Dirc Bouts, no longer bound to Jan by the ties of discipleship, could become a Rogerian while steadily advancing beyond the position conquered by Petrus Christus between 1445 and 1450.

That Roger's influence on Dirc Bouts did not weaken the latter's allegiance to Petrus Christus is evidenced by such details as the familiar spandrel medallions which, first appropriated in the Prado Infancy scenes, recur — or, rather, recurred — in the wings of the Granada triptych[4] or the figure of the Magdalen in the central panel of this triptych where the Rogerian archetype is reinterpreted on the basis of Petrus Christus' Brussels "Lamentation." Even in the "Lamentation" in the Louvre the Magdalen is reminiscent of Petrus Christus rather than Roger. But more important is the fact that Dirc Bouts not only accepted but perfected Petrus Christus' basic innovations.

His London "Portrait of a Young Man" (fig. 422), dated 1462, depends on Roger van der Weyden in the arrangement of the figure, especially in the position of the hands, and on Jan van Eyck in the method of illumination, the emphasis on volume rather than line and — all technical differences notwithstanding — the loving attention to surface texture. But it is by Petrus Christus' "Grymestone" of 1446, or by a portrait very much like it, that Dirc Bouts was inspired with the idea of placing the sitter in the corner of a fenestrated room. He took, however, the important step of omitting the ceiling and replacing the glazed *œuil de boeuf* by a window disclosing a prospect into the open while a folded shutter conceals the intersection of the rear and side walls. What had been a static stereometrical system, defined by three planes meeting at angles of ninety degrees, has been transformed into a field of interaction between interior and exterior space.[5] And this remarkable innovation not only changed the portrait's visual appearance but also its psychological content.

In placing the sitter in a well-defined environment which the beholder can share, Petrus Christus' corner-space portrait had, as I phrased it, made the individual accessible to us at the price of forcing us to divide our attention between the figure and its surroundings.[6] In Dirc Bouts' portrait of 1462, in which the borderline between the indoors and the outdoors has become fluid and all particulars are submerged in soft luminosity, the mind is no longer distracted by a multiplicity of equally compelling details but relaxes in a sense of all-enveloping unity. We find ourselves in silent rapport with a human being communing with us by way of osmosis, as it were, much as his private chamber does with universal space. Where Roger van der Weyden produced character portraits, Dirc Bouts created, to use an untranslatable German word, the *Stimmungsporträt*.

This transformation of a portrait type inaugurated by Petrus Christus — to whom Dirc

Bouts also owes, it seems, his familiarity with the rule of the unified vanishing point — is indicative of his artistic intent in general. He consistently sought to fluidify the picture space and to produce that *Stimmung* which, literally, is a musical term denoting the "state of being tuned" or "in tune" and, taken figuratively, suggests something like "temper" or "atmosphere."

Bouts' Madonna in the National Gallery at London (fig. 426) presupposes the "first Rogerian archetype" in composition as well as personal appearance except for the homelier cast of the square-browed face and the less elegant shape and movement of the fingers.[1] But it shows the Virgin emerging from behind a parapet on which there is a cushion for the Infant to sit upon — and in contrast to all earlier Madonnas in half-length the figure is placed in a definite interior, its rear wall partly concealed by a brocaded cloth of honor and, on the left, pierced by a window which, as in the portrait of 1462, discloses a luminous landscape. In the "Madonna" in the Metropolitan Museum (fig. 425),[2] derived from the "*Notre-Dame de Grâces*" at Cambrai through the intermediary of Roger's Houston Madonna, the neutral background has been retained.[3] But the Christ Child, instead of looking at the beholder and playing with His toes, concentrates all His attention and affection upon His mother who, instead of responding, is lost in unseeing and unsmiling sadness. The love of the *Glykophilousa* has been transmuted into a sentiment too deep and vague to be communicable.

The "Lamentation" in the Louvre, we recall, is mainly based upon the central panel of the "Granada-Miraflores" altarpiece. But the symmetry of Roger's composition is broken (even the Cross is shifted from the center to the left), and the principal figures are arrayed on a receding diagonal rather than parallel to the picture plane. Space is allowed to filter in between the solid bodies, and the Magdalen — already added to the archetype in Roger's own workshop and retained in many intervening variants — is even more emphatically isolated than in Petrus Christus' Brussels "Lamentation"; each of the mourners is alone with his grief. Instead of trying, however gently, to separate the Virgin Mary from the dead Christ, St. John spreads a cloth beneath His head much as the Corporal is spread beneath the Host, and shyly touches the Virgin's shoulder as though afraid of intruding upon her solitude; instead of passionately clasping and kissing her Son, the Mater Dolorosa holds Him motionlessly on her lap, her eyes blinded by sorrow. Even where Dirc Bouts adopted Roger's idea of including the donor in the narrative, as in a beautiful picture formerly owned by Prince Rupprecht of Wittelsbach, the donor is the recipient of a message rather than the witness to an event; he takes the place of those who, on the Jordan "saw Jesus coming unto them" and heard the Baptist say: "Behold the Lamb of God."[4]

Small wonder that an artist so averse to drama (both in the physical and psychological sense) went even further in "deorganizing" human movement than Petrus Christus had done. In Dirc Bouts' mature and late works, which in this respect may be said to show Western art at its maximum distance from classical antiquity, the figures seem to move reluctantly and give the impression that the body is too alien and extraneous to the soul to interact with it at all. As though foreshadowing that queer, occasionalistic psychology according to which the body acts and suffers by itself while the soul merely "looks on,"[5] they are incapable of

adequate, let alone "beautiful," postures and gestures but either tend to freeze into perpendicular immobility or, if forced into action by the narrative, move with a disjointed jerkiness reminiscent of marionettes.

At times this lack of eurhythmy and "expressiveness" — using the latter term after the fashion of classicistic art theory — may strike the modern beholder as well-nigh comical. He may be inclined to smile at the amiable indifference of the wicked rulers in the gruesome, though characteristically bloodless, "Martyrdom of St. Erasmus"[1] or the mixture of enthusiasm, genuflecting courtesy and absentmindedness with which the armored Abraham in one of the lateral panels of Bouts' *opus maius*, the altarpiece in St. Peter's at Louvain (fig. 427),[2] receives the bread and wine from Melchizedek. But in the central panel of this altarpiece — a most unusual "Last Supper" where Christ, blessing the Host and chalice, addresses the entire community of the faithful instead of announcing the denial of St. Peter and exposing the traitor — the very absence of dramatic tension converts the historical event into a sacred ritual and fills us with a sense of hushed solemnity. And in Dirc Bouts' last finished work (figs. 431, 432) — one of the four panels, depicting two Examples of Justice, that had been commissioned for the Town Hall of Louvain in 1468[3] — the very inadequacy of the gestures with which the Emperor Otto III and his courtiers react to the terrible truth that an innocent man has been executed and that the guilt devolves upon the Emperor's own wife serves to accentuate man's helplessness in the face of catastrophe.

Always, however, the congenital stiffness of Dirc Bouts' figures — not outgrown by even the Elect in Heaven and the Damned in Hell[4] — serves to divert our attention from the bodies to the carefully individualized faces and makes us aware of the complexities that lurk beneath their taciturn mouths and heavy-lidded eyes. And from a stylistic rather than psychological point of view the subdual of the dramatic enhances the importance of the pictorial. A painter bestowing upon his figures the faculty of free, organic movement stresses the difference between humanity and inanimate nature and tends to give predominance to the former. A painter restricting or suppressing this faculty interprets the contents of pictorial space as a totality to which the figures, their appearance determined by the laws of optics rather than their own will, do not contribute much more than do rocks and rivers, buildings and trees, flowers and clouds. It is not often that an artist was so confined as Michelangelo whose world was virtually limited to human beings or Claude Lorrain who confessed himself incapable of providing adequate *staffage* for his landscapes.[5] And as long as painting was confined to the production of cult images, portraits and narratives we are faced with a question of emphasis rather than with an alternative. But even among the "Netherlandish Primitives" we may distinguish between an anthropocentric and a non-anthropocentric point of view, with Jan van Eyck representing a nearly perfect equilibrium. If Roger van der Weyden may be described as a figure painter as little interested in scenery as was possible for a Netherlander, Dirc Bouts may be described as a landscapist as little interested in figure problems as was possible for a man of the fifteenth century.

"Claruit inventor in depingendo rure" ("He excelled as an innovator in depicting the

countryside"). This statement of a Louvain professor of theology, historiographer and iconologist, Johannus Molanus,[1] is as true today as it was at the time of the Council of Trent. Dirc Bouts, we remember, was the first to introduce a window prospect into the half-length portrait and the half-length Madonna. In one or two of these Madonnas[2] he also seems to have extended the window prospect into a background consisting of nothing but "countryside," thereby transferring the scheme of Roger's Braque triptych in the Louvre, where the landscape continues throughout three panels, to an isolated cult image. And he was certainly the first to advance beyond the van Eycks in the organization and interpretation of the landscape space as such. By lining up staggered rows of coulisses on either side of an undulating road, he connected the traditional three planes — foreground, middle distance and background — into a relatively unified expanse; by varying the local coloration not only according to distance and intervening medium but also according to the chromatic quality of the light, he imbued his landscapes with a *Stimmung* as marked as that which emanates from his figures.

When the Prophet Elijah is wakened from his deathlike sleep by an angel and, refreshed by Heaven-sent food and drink, "arises and goes in the strength of that meat forty days and forty nights" (fig. 429), the country is bathed in the clear, cool light of full morning. When, in another prefiguration of the Lord's Supper, the children of Israel gather Manna in the wilderness (fig. 430), the dusky red and slate gray of the cloudy sky and the dark glow of huge, rocky hills convey the feeling of daybreak.[3] And an even stronger contrast, reinforced by the fact that the two principal figures, though forming counterparts, appear in entirely different planes, can be perceived in the "St. John the Baptist" and the "St. Christopher" which together with an "Adoration of the Magi" constitute a small altarpiece in the Pinakothek at Munich (figs. 433, 434).[4] Whether this charming little work, deservedly called "The Pearl of Brabant," is authentic or was produced by the more ingenious of Dirc Bouts' two *Doppelgängers* who has been tentatively identified with his first-born son, Dirc Bouts the Younger, I dare not decide though I am inclined to accept the second of these alternatives. But whoever its author may be, it is, in a sense, more Boutsian than Bouts himself. Its wings — the Christopher panel effulgent with a genuine sunset — represent the maximum of *Stimmungsmässigkeit* that could be reached by Early Netherlandish painting, and the central panel, where isolated vertical units are deployed like chessmen on the board, is the most radical example of the reciprocity which in the Boutsian style exists between the devitalization of the human figure and the vitalization of space. In reducing living beings almost to the status of sign posts on the road into depth, Dirc Bouts had proved for the first time that space can be brought to life even though nothing lives — or, to speak more exactly, moves — within it, and thereby announced the possibility of landscape painting as a species *sui generis*.

IV

Proficiency in landscape painting is also attributed to that Albert van Ouwater who has been mentioned in connection with the problem of the "Turin-Milan Hours." Like Dirc

Bouts, we recall, he was a native of Haarlem; but unlike him, he did not emigrate to the south but practiced his art in his home town where his name occurs in a record of 1467. And if it is true — and there is little reason to doubt it — that he was the teacher of Geertgen tot Sint Jans, he must have been alive in the late 'seventies of the century.[1]

Of Albert van Ouwater's accomplishments as a landscapist we have, unfortunately, no direct visual record. His "Separation of the Apostles," said by van Mander to be in St. Bavo's at Haarlem and to stage the event "in an attractive landscape," survives only in a free replica, the work of a Franconian master of *ca.* 1500.[2] His only preserved and authenticated picture — intriguingly the exact opposite of a landscape painting — is the "Raising of Lazarus" in the Kaiser Friedrich Museum which van Mander describes, from a copy in grisaille since the original had been forcibly removed to Genoa in 1573, with considerable accuracy. He defines it as a picture "higher than wide" and characterizes it as follows: "The figure of Lazarus was, according to the standards of the period, a very beautiful and remarkable nude and most appropriate. There was a beautiful architectural setting, viz., a temple, though the columns of this building were somewhat small. On one side there were Apostles, on the other Jews. There were also some pretty females, and in the background some people looking on through the pillars of the choir."[3]

That the Berlin Panel (figs. 435, 436),[4] which I should like to date about 1455 rather than 1445–1450, is identical with that recorded by van Mander can hardly be questioned. It is of a quality which precludes the possibility of a copy and shows, as has already been intimated, an iconography unparalleled in the history of the subject. In defiance of a long, unbroken tradition, the scene is laid, not in the open air but in an ecclesiastical interior, a Romanesque central plan building consisting of a dome and an ambulatory the outer capitals of which narrate Old Testament stories from the Flight of Hagar and Ishmael to the Promulgation of the Law by Moses. Instead of unfolding from left to right, the composition is strictly frontalized, the followers of Christ and the disgusted Jews forming two nearly symmetrical groups loosely connected by the figure of St. Peter who addresses the latter. Lazarus himself, centrally placed, faces the beholder instead of the Saviour, and his posture is that of one rising rather than being raised from his grave.[5] So many deviations from precedent must be dictated by a definite intention; and this intention was to portray the event, not only as a miracle of the past but also as a presage, ominous yet reassuring, of the future. In replacing the customary open-air setting by a Romanesque structure (which, we remember, carried the connotations of "Jerusalem," both in a topographical and eschatological sense), in giving an unusually prominent role to St. Peter, in evenly dividing the faithful from the unbelievers, in assimilating the posture of Lazarus to that of a Resurrected (compare, for example, the figure beneath the St. Peter in Roger's Beaune altarpiece), and in subjecting the whole composition to the principle of hieratic symmetry, Albert van Ouwater transformed the scene into a simile of the Last Judgment. He interpreted the raising of Lazarus from the semblance of death to transient physical life as a symbol of the Christian's resurrection from real death to eternal spiritual life. And in so doing he illustrated what is revealed in the dialogue between the Lord and Martha (John XI, 23–25):

"Jesus saith unto her, Thy brother shall rise again. Martha saith unto him, I know that he shall rise again in the resurrection of the last day. Jesus said unto her, I am the resurrection and the life; he that believeth in me, though he were dead, yet shall he live."

"Did we not have van Mander's account," writes Max J. Friedländer, "the Berlin picture would be catalogued as the work of an unknown master active in the proximity of Dirc Bouts"[1] — a hypothetical assumption so well founded that it has actually come true, though, as it were, with an inverted sign: the Infancy scenes in the Prado, thus far unanimously attributed to Dirc Bouts, have recently been assigned, albeit with some reservations, to Albert van Ouwater.[2] Ouwater's "Raising of Lazarus" — and we possess no other work of his except, perhaps, the fragment of a composition of nearly equal size, showing a donor's portrait, in the Metropolitan Museum[3] — is indeed very close, not only to the Prado series but also to the triptychs in Granada and Valencia, the London "Entombment" and the Louvre "Lamentation" (compare, for example, the face of the Magdalen in the "Lamentation" with that of the Lazarus). And Ouwater's sources are, so far as can be judged from only one picture, exactly the same as those of Dirc Bouts: his style, like Bouts', may be described as a blend of Jan van Eyck and Roger van der Weyden seen through the medium of Petrus Christus.

This threefold derivation is particularly evident in the architecture of the Lazarus panel. A circular structure of Romanesque style, its columns fashioned of colored marble and crowned with historiated capitals, Ouwater's "temple" clearly presupposes the sanctuary in Jan van Eyck's "Paele Madonna." Its brightness and spaciousness, on the other hand, suggest the influence of a picture so Rogeresque that it is still considered authentic in some quarters, the "Exhumation of St. Hubert" in the London National Gallery (fig. 397).[4] Since the subject is a historical event of the Christian era, the style of the building is here Gothic; but that the London picture was known to Ouwater is evident, not only from the fact that an intercolumnation rather than a column is placed on the central axis of the composition but also from the peculiar motif of the inquisitive crowd looking in through a choir screen. In pictorial treatment, finally, and also in his figure style (compare, for example, his Magdalen with the Virgin Mary in the Washington "Nativity" or with the St. Barbara in the "Exeter Madonna," and his diffident Martha with the bride in the "St. Eloy" of 1449), Ouwater shows himself a follower of Petrus Christus.

Where Jan van Eyck had built up his architecture, just as he did his figures, from an infinity of lustrous particles and where the Master of the Exhumation of St. Hubert had delineated it in draftsmanlike fashion, Ouwater interpreted it, like Petrus Christus, in terms of broad areas of color enlivened by the play of light and shade. But he went beyond Petrus Christus — and thereby parted company with Dirc Bouts whose deep, pure colors have been likened to "rubies and emeralds which do not scintillate with sharply cut edges but glow with softly rounded surfaces"[5] — in desaturating the pigments by liberal admixture of black and white. Characteristically, he replaced the fencelike openwork of the Exhumation Master's choir screen by plain panels with only a small grille in the center. And the gray of these panels,

EARLY NETHERLANDISH PAINTING

differentiated into many shades, is the keynote of the whole color scheme. It serves as a neutral yet not monotonous background for the figures. It matches the color of the ribless dome, blends with the subdued pigmentation of the columns (one of which, however, brightly stands out from the others and lends relief to the dark presence of Christ), and forms an impressive contrast to the strong light that fills the ambulatory. It even seems to invade the local color of the tiles and textiles. In short, Ouwater changed colorism in the direction of tonality.

It would seem, then, that the relationship between Dirc Bouts and Ouwater is one of parallelism and not — although the possibility of mutual influences is by no means excluded — one of dependence. The evidence points to the conclusion that Ouwater, like his fellow townsman, received his early training in the Southern regions of the Netherlands; that he formed a particularly close association, quite possibly at the same time as did Dirc Bouts, with Petrus Christus; and that it was the latter who acted as the principal intermediary between him and the "sources," Jan van Eyck and Roger van der Weyden. Small wonder that the Infancy scenes in the Prado, originally ascribed to Petrus Christus, now form the object of a borderline dispute between Dirc Bouts and Ouwater.

It is tempting to interpret the common qualities of these three masters — their tendency to think in terms of light-affected surfaces rather than local color and line, their preoccupation with the interior and the landscape and, most particularly, their undramatic introspectiveness — as the expression of a mysterious *Rassengemeinschaft* which may seem to connect Petrus Christus, Dirc Bouts and Albert van Ouwater, not only with each other but also with Jan van Eyck, the native of Maasseyck, as opposed to the Master of Flémalle and Roger van der Weyden, the natives of Tournai.[1] We should, however, beware of concretizing a subtle psychological kinship into the massive historical concept of "Dutchness" *vs.* "Flemishness." We may well sense a kind of continuity that connects Petrus Christus, Bouts and Ouwater, through Gerard David, Lucas van Leyden and Jan Scorel, with the mature and late Rembrandt, Terborch and Willem Claesz Heda as opposed to Rubens, van Dyck and Frans Snyders. We may remember that in the second great century of Netherlandish painting, the seventeenth, the landscape and the interior triumphed in Holland rather than in Belgium. We may even attach some symptomatic significance to the fact that Arnold Geulincx, the father of that occasionalism which denied all functional relations between body and soul (and, characteristically, of the definition of space as *corpus generaliter sumptum*), was born in Antwerp and educated at Louvain but became a Protestant and died as a professor of Leyden University. But we should not forget that Dutch and Flemish painting assumed the character of tangible and relatively homogeneous entities only in the course of a long and complicated process which in the fifteenth century had barely started: "Within the general sphere of Netherlandish painting in the later Middle Ages and the Renaissance," says a distinguished historian whose protest against retroactive nationalism commands all the more respect as it comes from a sincere Dutch patriot, "we must distinguish between local and regional schools. Among these schools there was continuous interaction, and in the main we find within them a close community of vision and technique. There existed great individual differences (otherwise there would not have been such wealth)

322

and here and there particularistic traditions. But what certainly did not exist was a dualism. It is impossible to draw a line from east to west and to find unity and consistency north of this line and south of it."[1]

If Petrus Christus, Bouts and Ouwater appear to us as a closely interrelated group they do so, not so much because they were all "Hollanders" (which, we recall, is not even the case with Petrus Christus) but because they formed a closely interrelated group in a purely factual sense. They did not go south as representatives of a "Dutch tradition" which, for all we know, had not as yet been formulated in its future homeland; they went in quest of an education which, when they were young, could be obtained only at Bruges and Brussels and were thrown into personal contact by that combination of design and accident which always governs human affairs. They did interpret a common heritage in a manner which, seen in retrospect, anticipates important facets of what was later to become "Dutch painting." But that the specific physiognomy of their art cannot be accounted for by their racial antecedents is demonstrated by the fact that other pure-blooded Dutchmen, developing under different circumstances, produced a style — or, rather, a variety of styles — which has little or nothing in common with theirs.

A triptych now in the Centraal Museum at Utrecht, for example (fig. 437), showing the Crucifixion between the Mass of St. Gregory and St. Christopher and datable about 1460, was certainly produced at Utrecht. But it has rightly been said that it would not be surprising if the background of its central panel exhibited some landmark of Münster or Lübeck rather than the tower of Utrecht Cathedral.[2] Between this triptych and Ouwater's nearly contemporaneous "Raising of Lazarus" there is a difference in style quite out of proportion with the geographical distance between Utrecht and Haarlem. The colors are variegated and florid as on a piece of peasant's pottery. Figures and draperies move with almost Germanic vehemence. Problems of space are completely neglected; a multiplicity of forms crowds the painting surface from top to bottom, and what should be perspective vanishing lines refuse to converge. Instead of slowly building up a sturdy, smooth, enamel-like stratification of pigments, the brush applies them thinly, rapidly and somewhat roughly, occasionally adding broad or gritty accents.

We may feel inclined to dismiss the author of this triptych and other minor Dutch artists of the second half of the fifteenth century[3] as representatives of a retarded provincialism. But one of the most powerful, prolific and, in his own way, accomplished Dutch panel painters, presumably active at Delft from about 1470, is equally unrelated to Petrus Christus, Bouts and Ouwater. This Master of the Virgin among Virgins, as he is called after a picture in the Rijksmuseum at Amsterdam,[4] was not entirely out of touch with the South Netherlandish tradition. But he appears to have known it only indirectly and never attempted to penetrate its principles. As an imaginative child might pick out articles in a store, he appropriated what appealed to his very personal and somewhat eccentric taste — certain facial types, certain poses, certain gestures (among them, inevitably, that of Roger's Magdalen) and, above all, the richly brocaded fabrics and fanciful headdresses which he elaborated into even more extravagant bonnets, turbans and toques (fig. 438). In all essentials of style he is as remote from Bouts and Ouwater as Bouts and Ouwater are close to Jan and Roger. His technique is irregular, loose

and impatient rather than even, tight and painstaking. His landscapes, far from proclaiming a "pious exultation over the colorful splendor of the earth's garment,"[1] tend to be lusterless and barren, and his color taste is equally opposed to Bouts' *Schönfarbigkeit* and Ouwater's tonality. His preference runs to drab olive-green, loamy tan, various shades of purple and a weirdly pale, hematitelike red. With sovereign contempt for balance and little concern for perspective, he powders or, conversely, packs the painting surface with form. Often the frame cuts deep into the figures so that a number of his pictures give, at first glance, the impression of fragments. And the figures themselves represent a strange race of human beings, both under-bred and hypersensitive, now meek or solemn, now violently excited or hopelessly dejected, now looking like a bundle of clothes with no body inside, now unexpectedly and inconsistently muscular, but always intensely sincere.

Unafraid of ugliness, brutality and suffering, improvising rather than composing, the Master of the Virgin among Virgins may be called an "expressionist," and his works have some of the primitive impact of popular woodcuts. He was, in fact, a woodcut designer as well as a painter — a thing not easily imaginable of Bouts or Ouwater,[2] not to mention Petrus Christus. Where they anticipate later Dutch painting in optical refinement and emotional reticence, this spiritual kinsman of the great Housebook Master (who, though active in the Rhineland, also appears to have been a Hollander by birth and education)[3] foreshadows the religious fervor of Lievens, the moodiness of Hercules Seghers and the ferocity of Rembrandt's youth. Seen within the context of his own period, he and his fellows-in-arms rather than Petrus Christus, Dirc Bouts and Ouwater may claim to represent that indigenous tradition which, as will be seen, was not to achieve the status of a "school" until the sixteenth century.

v

From all that has been said, it seems less justifiable to say that Petrus Christus and Dirc Bouts, emigrating from Baerle and Haarlem to Bruges and Louvain, imported a "Dutch" style into Flanders and Brabant than that Albert van Ouwater, returning to Haarlem from his *Wanderjahre*, imported a Flemish and Brabantine style into Holland. And it is this essentially South Netherlandish tradition which was perpetuated by the most lovable of all the "Primitives": Geertgen of Haarlem, better known as Geertgen tot Sint Jans; in fact, there is good reason to believe that the "little Gerrit," drawn to the South like all his major "Dutch" predecessors, had served his apprenticeship at Bruges, possibly even before he appeared on the scene of his recorded activities.[4]

Whatever else we know of him is almost exclusively based on information supplied by Carel van Mander who describes Geertgen's principal work with sufficient accuracy to permit its identification and, thereby, the reconstruction of an *oeuvre*. And while the everpatriotic biographer was probably wrong in claiming his hero as a native of Haarlem — his real birth-place appears to have been Leyden — he would seem to be correct in stating that he was a pupil of Albert van Ouwater. This statement is borne out by stylistic evidence and well in keeping

324

with the fact that Geertgen spent the rest of his short life in Ouwater's home town rather than his own; instead of establishing himself as a free master in Leyden, he became a *famulus* (which may be roughly translated as "lay brother") in the Monastery — or, to use the technical term, "Commandery" — of the Order of St. John at Haarlem. Depending on the dates assigned to his latest works on stylistic grounds, the estimated year of his death varies between *ca.* 1485 and *ca.* 1495, the truth apparently lying, as is its habit, in the middle. And if he really died at the early age of twenty-eight, he may be presumed to have been born about 1460.

Geertgen tot Sint Jans reached a goal which Petrus Christus had sighted only from afar and which Dirc Bouts and Ouwater had tried to approach by separate roads. He managed to reconcile purity of color with equality of tone. He completed the unification of space as far as possible within the limitations of his period and so effectively combined the poetry of light with the "legitimate joys in the regularity of geometrical forms" that at least one of his pictures may be said to herald the style of Georges de La Tour. This picture is Geertgen's "Nativity" in the London National Gallery, the earliest nocturne in the optically strict sense of the term (fig. 448).[1]

To create the illusion of night had been attempted, we recall, by the Limbourg brothers and the young Jan van Eyck. But even the "Betrayal" in the "Turin-Milan Hours," though already a "nocturne positive," was not as yet, to coin another phrase, a "nocturne absolute." Its scenery, including the distant hills and the far-off city of Jerusalem, still shimmers in the milky light of a sky vespertinal rather than nocturnal, and the flames of the torches are spots of bright color rather than actual sources of illumination. Geertgen's "Nativity" is — *pace* the Master of the *Livre du Cuer d'Amours Espris* and even Piero della Francesca[2] — the first empirical and systematic account of the optical conditions prevailing in a picture space exclusively illumined by non-solar sources located within it. In contrast to most later artists, Geertgen employed not only natural but also supernatural illuminants, and there is no doubt that he was fully aware of the symbolic connotations attaching to this difference. The fire lit by the shepherds on the wintry field is outshone by the *claritas Dei* (Luke II, 9) diffused by the angel; the light of the candle reverently screened by St. Joseph's hand and faintly reflected on his face, is "reduced to nothingness" by the *splendor divinus* emanating from the new-born Saviour. But in excluding every extraneous source of illumination, in contrasting the reddish warmth of artificial light with the silvery coolness of supernatural radiance (much as so many later painters contrasted the former with moonlight), and in describing how forms are either picked out as by a searchlight, or dimmed, or altogether obscured, he is a true ancestor not only of Correggio and the Bassani but also of Caravaggio and his followers. And what specifically links him to Georges de La Tour is his pervasive tendency, by no means limited to the "Nativity," to reduce all objects to their simplest stereographic essence. Going much farther in this respect than even Petrus Christus, he simplified the figure of the Infant into a compact little doll. The wings of his angels are streamlined, so to speak. And the faces of his women and children with globular foreheads, diminutive mouths and noses, receding chins and flat Mongolian eyes approach as nearly as possible the sphericity of objects turned on a lathe.

The London "Nativity" is one of Geertgen's latest works, immediately preceding what appears to be his *opus ultimum*, the so-called "Man of Sorrows" in the Archiepiscopal Museum at Utrecht (fig. 449).[1] I say "so-called" because we are confronted with a complex and unique conception in which the idea of the Man of Sorrows Showing His Wounds is interfused with those of the Bearing of the Cross, the Lamentation, the Double Intercession (the Virgin Mary interceding with her Son, Christ interceding with God the Father), and the Holy Face or Sudarium the eyes of which are fixed on us "as though on us alone." At first glance, these two pictures — a pious pastoral and a scene of agony and compassion, a grouping of stationary forms softly embedded in space and a violent, discordant pattern sharply silhouetted against gold ground — seem to have nothing in common. They agree, however, in that they are both pseudo-fragments — pictures, that is, in which a calculated truncation of the figures produces an effect of seeming arbitrariness essentially different from that of compositions in half-length.[2] In this respect — and in the case of the Utrecht "Man of Sorrows" also in the "expressionistic" quality of content and composition — Geertgen shows himself an adherent of the "indigenous" tradition best represented by the Master of the Virgin among Virgins. But it is significant that he yielded to it only at the very end of his career. On the whole, he proceeded along the lines laid out by Petrus Christus, Dirc Bouts and Albert van Ouwater.

His earliest known work is, significantly, not a panel painting but a miniature on vellum which has justly been compared to a leaf cut out of a Prayer Book: the diminutive Madonna (no more than 4 by 2¾ inches in size) in the Biblioteca Ambrosiana at Milan (fig. 441).[3] Conceivably produced before Geertgen entered the workshop of Ouwater, it conforms to the pattern set by Dirc Bouts in his London Madonna, except that the chubby Christ Child, seen in front view and emerging from His swaddling clothes like a bud from its calyx, is reminiscent of the Infant Jesus in the "Ince Hall Madonna" by Jan van Eyck and that the room is closed against the outside world while being richer and deeper in itself; the window is glazed, but the rear wall has been pushed back so that the cloth of honor assumes the role of a partition within a dimly lighted interior in the recesses of which we discover the Virgin's bedstead.

There is a world of difference between this miniature and the Madonna in the Kaiser Friedrich Museum at Berlin (fig. 447)[4] which is as large and austere, the Infant gravely showing that well-known symbol of the Virgin's Sorrows, the columbine,[5] as the other is small and delightfully childlike. But even this mature and monumental work — more than twice as large as the London Madonna by Dirc Bouts yet not much earlier, it would seem, than Geertgen's London "Nativity" — retains the basic features of the Boutsian composition, accomplishing, however, a further unification of the picture space by the opposite method: instead of being glazed so as to achieve unity by limiting the prospect to the indoors, the window has neither shutters nor glass so as to achieve unity by eliminating the very means of excluding the outdoors.

Between these two Madonnas there may be placed the works produced by Geertgen in his middle period (for, in the development of such short-lived geniuses as Geertgen, Raphael, Mozart or Watteau, five or six years may well be said to constitute a "period"). And it is, not

surprisingly, in the earlier productions of this middle period that we may detect the personal influence of Albert van Ouwater.

In what I still believe, both for stylistic and iconographic reasons, to be Geertgen's first regular panel painting, the charming "Holy Kinship" in the Rijksmuseum at Amsterdam (figs. 439, 440),[1] not only the disposition of the figures but also, more specifically, the architectural setting is evidently inspired by Ouwater's "Raising of Lazarus." While slightly shifting the point of vision to the right and substituting for the Romanesque central plan building a Gothic basilica with rib-vaulted nave and flat-roofed side-aisles, Geertgen retained Ouwater's Romanesque marble columns and historiated capitals, thereby expressing, in architectural terms, the same idea which had prompted the high-medieval motif of the Apostles supported by the Prophets.

In the two following pictures, the "Adoration of the Magi" in the State Gallery at Prague[2] and the "Raising of Lazarus" in the Louvre (fig. 442),[3] the elaborate landscapes, full of optical refinements, bear witness to Ouwater's tutorship. And as the Virgin Mary in the "Adoration" is reminiscent of Ouwater's Martha, so does Geertgen's "Raising of Lazarus," however different from Ouwater's in every other respect, reflect its impression in the figure of Christ and, even more noticeably, the long-gowned Jew turning his back upon the beholder.

The second group of works attributable to Geertgen's middle period, comprises, I believe, two works especially devoted to the patron saint of his Order. One of them is a little devotional image in the Kaiser Friedrich Museum at Berlin which one would like to imagine in one of the brethren's cells, perhaps the painter's own; it represents St. John the Baptist in the Wilderness (figs. 443, 446).[4] The other is a huge triptych, originally stationed in the Church of St. John, which showed the Passion of Christ when open and the story of St. John the Baptist and his relics when closed. Only the right-hand wing has survived. Sawed apart and cut down at the top at an early date, it now consists of two panels, both in the Gemäldegalerie at Vienna: the "Story of the Baptist's Remains," originally on the exterior (fig. 445), and the "Lamentation of Christ," (fig. 444) originally on the interior (its figures, therefore, considerably larger in scale in order to match those of the lost "Calvary" which occupied the center).[5]

The scene of the Lamentation is laid on an elevated ledge precipitously overhanging a fertile plain and uninterruptedly sloping upward to a prowlike head where the Thieves are being taken down from their crosses and thrust into a pit. In the "Story of the Baptist's Remains" the complexity of the narrative — comprising the concealment of the Precursor's head by Herod's pious first wife, the burial of his body, the burning of his bones by order of Julian the Apostate, and their partial salvation and solemn reception by monks who thus became the founders of the Order of St. John and are accordingly portrayed as members of Geertgen's own religious community[6] — necessitated a subdivision of the scenery into many compartments. But this very cellularity of the picture space, organized by the undulating contour of the ledge that sweeps from the lower left to the upper right, creates the impression of ordered homogeneity. We can easily understand that Dürer, whose alleged pilgrimage to Haarlem no longer seems so unbelievable as used to be assumed, saw fit to appropriate Geertgen's scheme

when dealing with a similar multitude of groups and figures in his "Martyrdom of the Ten Thousand" of 1497–1498.[1] In the Berlin "St. John in the Wilderness," finally, the customary division of the landscape prospect into distinct planes is entirely abolished. The movement of the hilly terrain, the bendings of a little brook and an artful perspective arrangement of trees and shrubs lead the eye, step by step, into a gradually thickening wood almost imperceptibly melting into the distance where the city of Jerusalem diaphanously rises into the rosy sky.

This little picture — in my opinion a trifle later than the big altarpiece — also left its impression on Dürer's imagination. In one of his finest early drawings, a "Holy Family" in the Berlin Kupferstichkabinett,[2] he seems to have remembered its lovely landscape, so much the opposite of a "wilderness"; and almost a quarter of a century later the memory-image of Geertgen's Baptist was to revive in Dürer's *Melencolia*.[3] Although the posture of the thinker in repose, his elbow on his knee and his chin in his hand, is almost as old as Western art itself, no two other examples of this widespread type so closely resemble one another. Geertgen's and Dürer's figures agree, not only in general form and outline but also in that they convey the feeling of an almost physical depression which makes the body sag, allows the knees to draw apart and causes the free hand to lie on the lap like a lifeless thing. The quality of this depression is, needless to say, entirely different. Dürer's Melencolia, an embodiment of frustrated human effort, acutely suffers from her intellectual insufficiency; Geertgen's St. John, a visionary chosen by God, is dreamily immersed in sweetly-sad contemplation. But in both cases the feeling of sorrow, no longer focused upon a single, definable object or cause, has been widened and deepened into an experience far beyond the range of Geertgen's predecessors — a "mood" which differs from a Rogerian "emotion" in that it is lasting, vague and not contingent upon an outward stimulus ("Melancholia est tristitia absque causa," to quote the ancient definition of melancholy), and differs from a Boutsian *Stimmung* in that it is cognizable and, in a measure, articulate. It is, therefore, hardly possible to decide, perhaps even to ask, what Geertgen's St. John is "sorry about" — whether he meditates on the Passion of Christ[4] or, as is suggested by Luke III, 2–3, is filled with "repentance for the remission of sins" although the "word of God" is already near to him, unnoticed, in the guise of the Lamb. Even where Geertgen depicted the grief of the mourners in the "Lamentation" or the misery of the Man of Sorrows, these psychological states seem to transcend the limitations of a mere "emotion." Instead of "having" an experience, his beings seem to be, as the scholastics would say, "informed" by it.

This kind of interpretation requires an attitude which we are wont to associate with the modern era rather than the Middle Ages, and it is not surprising that an artist so inclined was one of the earliest genuine humorists. Like melancholy, humor — as distinguished from wit or satire — thrives on the eternal contrast between the finite and the infinite, with the only difference that this contrast is serenely accepted rather than bitterly or haughtily resented; it is no accident that most great humorists, from Erasmus of Rotterdam and Rabelais to Lawrence Sterne and Jean Paul, were theologians. Geertgen's humor, too, ranges from plain mirth to an understanding tenderness that makes us smile while melting our hearts. There is a touch of

opera buffa in the wicked Julian the Apostate and his obsequiously malevolent advisers, and a touch of farce in the callous henchmen in the "Lamentation" manipulating their ladder with a pitchfork and poking at the dead body of the Bad Thief with a grotesquely elongated lance. But when we look at the "Holy Kinship" we are not only amused but deeply moved by the way in which the children pre-enact their destinies. St. John the Baptist reaches out for the Infant Jesus with rapturous devotion. St. James the Great, with childlike gravity, fills the chalice of his brother, St. John the Evangelist, from his diminutive pilgrim's canteen while James the Less and Simon proudly display a club and a saw, the symbols of their future martyrdom. And there is something both funny and infinitely touching about the enormous feet of the Baptist in the Wilderness, mechanically nuzzling one another while his mind is utterly absorbed in thought.

Unique and independent though he was, Geertgen never forgot what he had experienced when studying South Netherlandish art at the source, not only in remaining faithful to the dense and polished Flemish technique but also in drawing upon his memories of Flemish "inventions." That he was familiar with the Madonna type inaugurated by Dirc Bouts has already been mentioned. The Rogerian Magdalen in his "Lamentation" appears, all differences notwithstanding, more closely linked to the original than any of the translations produced by Petrus Christus, Bouts or the Master of the Virgin among Virgins. And it was probably at Bruges, the center of late fifteenth-century book illumination, that he had a glimpse, if not of the "*Très Riches Heures*" itself, at least of miniatures or drawings derived therefrom. In the "History of the Baptist's Remains" the outlandish accouterments of the Emperor and his courtiers are inspired by the capricious orientalism of the Limbourg brothers rather than the sober reconstructions of Dirc Bouts or Ouwater. And the kneeling henchman in the lower left-hand corner, engaged in scattering the ashes of the saint's bones, is an almost literal "borrowing": his contorted posture nearly duplicates that of the Adam in the Chantilly "Fall of Man" (fig. 82)[1] a tour de force even in the original and a source of bafflement in Geertgen's composition; at first glance it is not easy to see what a shovel so circuitously wielded is meant to accomplish.

These influences, however, are peripheral as compared to the effect of Geertgen's encounter with Hugo van der Goes. He taught Geertgen to construct such boldly three-dimensional groups as the pyramid of mourners — culminating in the wonderful portrait of an old Canon who attends the event "in the form of a servant"[2] — which we admire in the Vienna "Lamentation." He had envisaged that perfectly unified landscape space which Geertgen was to realize in his "St. John in the Wilderness."[3] And one of Hugo's works, the Monforte altarpiece at Berlin (fig. 459), must be considered the greatest single influence on Geertgen's art.[4] In general composition, it served as a model for the "Adoration of the Magi" transmitted through a replica in the Rijksmuseum at Amsterdam.[5] The gesture of the Virgin Mary, gently lifting the little arm of the Christ Child with her left hand, was adopted — in fact, improved upon — in Geertgen's Berlin Madonna. And the figure of the middle-aged Magus resting the weight of his body on one knee while raising his hand to his heart fascinated the

young painter to such an extent that he repeated it over and over again. It reappears not only in its original context but also in the guise of St. Peter in the "Raising of Lazarus" and in that of Nicodemus in the Vienna "Lamentation"; and here it introduces into the scene of sorrow a note of quiet reverence effectively sustained in the humble gesture of the aged Joseph of Arimathea who touches his cap as does St. Joseph, foster father of Christ, when paying homage to the Kings from the East:[1] where other painters foretold the Passion in their Infancy scenes, Geertgen infused his "Lamentation" with the spirit of the Epiphany.

However, Hugo van der Goes did more for Geertgen than enrich his vocabulary and reshape his syntax. Hugo's sombre physiognomies opened his eyes to a new form of human experience not within the reach of even Roger van der Weyden: a wholly subjective pathos which in the warmth of Geertgen's temperament could mellow into sentience.

<div align="center">VI</div>

Hugo van der Goes,[2] "equalled by none this side of the Alps," is perhaps the first artist to live up to a concept unknown to the Middle Ages but cherished by the European mind ever after, the concept of a genius both blessed and cursed with his diversity from ordinary human beings. And it is strange to think that in the same year in which he was buried in a monastery in Brabant, there was begun in Florence the very book in which this concept was formulated for all time: Marsilio Ficino's *De vita triplici*, wherein the formidable apparatus of Neoplatonic cosmology is set in motion to magnify the portrait of the melancholy genius, exalted and oppressed by the influence of Saturn, subject to alternate states of creative exultation and black despair, walking on dizzy heights above the abyss of insanity, and tumbling into it as soon as he loses his precarious balance.[3]

Nothing is known of Hugo's life before May 5, 1467, when he became a free master of the painters' guild at Ghent. We know only that he was a Ghenter by birth, and under the assumption that he became a master at the age of about thirty we may suppose that he was born not long after 1435. Once established, he rose to fame with spectacular speed. Almost immediately after his admission to the guild, he was entrusted with a picture commemorating a great papal indulgence. In 1468 he was made "referee" of the guild and called to Bruges in order to participate in the decoration of the city for Charles the Bold's marriage to Margaret of York on July 3rd;[4] and the *beau monde* of Bruges, where Petrus Christus was aging and Memlinc could not take care of everything, continued to patronize him ever after.

In 1469 and 1472 — to mention only his most important enterprises — he supervised the decorations of two *joyeuses entrées* of Charles the Bold and his Duchess into Ghent. Late in December, 1473, he decorated the church of St. Pharahildis for the services held there over the remains of Philip the Good and Isabella of Portugal prior to their solemn translation to the Chartreuse de Champmol. And in the following year he served as Dean of the painters' guild. But at the very height of his career, some time before November 1, 1475, he decided to leave

<div align="center">330</div>

his native city and the life of the world. He entered the Roode Kloster near Brussels, a priory affiliated with Ruusbroek's Groenendael.

As a *donatus* — a privileged lay brother who had turned over his possessions to a monastic community, obeyed its rules, shared its religious life and work, but otherwise enjoyed considerable liberty — Hugo continued to paint, saw visitors and clients, and in 1479/80 even betook himself to Louvain to evaluate Dirc Bouts' unfinished "Examples of Justice." But he was subject to horrible depressions, feeling incapable of ever completing his work and despairing of the salvation of his soul. A crisis was inevitable, and early in 1481 he suffered an acute attack of suicidal mania which he survived by only one year. A monk named Gaspar Ofhuys, describing this attack in a masterpiece of clinical accuracy and sanctimonious malice,[1] seems very much inclined to side with those who explained the painter's illness as an act of Providence intended to purify him of the sin of pride: Brother Hugo had become a greater celebrity by entering the monastery than if he had stayed out of it; he had enjoyed too many special privileges (the most conspicuous of which, the permission to eat with the regular monks instead of with the lay brothers, he contritely renounced after the crisis); he had too often been permitted to drink wine with the great of the world. Rumor, however, traced the cause of his derangement to his inability to rival the perfection of the Ghent altarpiece.[2] And in this explanation, insufficient though it may be, there may well be a grain of truth.

Of Hugo van der Goes' extant works[3] only one, a triptych of majestic proportions, is authenticated by textual evidence. Commissioned by Tommaso Portinari, the younger and more venturesome — in fact, too venturesome — of the two representatives of the Medici at Bruges, it was admired by generations in San Egidio, the church of the Arcispedale Santa Maria Nuova, at Florence (figs. 461–466).[4] Today it is in the Uffizi, and to see it there, amidst so many Italian pictures, produces a curiously ambiguous feeling. It seems a stranger, yet not so much a stranger as Roger's "Entombment" or Dürer's "Adoration of the Magi" although the former, we recall, is Tuscan in general composition and the latter even vaguely Leonardesque in facial types and attitudes.

Nothing so palpably Italianate is found in the Portinari altarpiece. Yet it seems more at home in these surroundings because in it, as Warburg puts it, Flemish panel painting appears "to have been seized by a violent impulse of growth"[5] which seems to lift it above the plane of Medieval art. This is not a matter of size (the over-all dimensions of the triptych are nearly 8½ ft. by *ca.* 19½ ft.) nor even of stature and emotional intensity; there are figures no less monumental in the works of Hubert and Jan van Eyck, and figures no less impassioned in those of Roger van der Weyden. Rather we face, to borrow an Erasmian term, the emergence of a *totus homo* no longer subject to that medieval dichotomy of body and soul which had forced Jan's and Roger's personages into a kind of dilemma between existing and acting, being themselves and doing justice to the part assigned to them within the narrative. Much as the modern actor, as opposed to the performer in a medieval mystery play — and we should bear in mind that drama, as we know it, did not exist in the Middle Ages — Hugo's characters have acquired what may be called, for want of a better expression and with due caution against

331

derogatory implications, a "stage presence." Like a great actor, each of them seems to define and command an individual sector within the space that he shares with his partners and to enact his role, not by disappearing behind it but by projecting through it the rays of his own personality.

However, while this *totus homo*, "self-determining sculptor and molder of his own self," laid claim to an entirely new dignity he also found himself surrounded by entirely new dangers. Even in Italy, where his birth was preceded by a continuous development extending over nearly two centuries, his baptism was attended by that ominous godmother, Melancholy. And Hugo van der Goes, unsupported by what we call the humanistic movement, had to create him in his own image — the image of a man whose nature may be likened to that of radioactive elements. From "stable" substances no energy can be obtained by any possible rearrangement of atoms or molecules. "Metastable" substances will yield energy when activated by an initial stimulus from without. Only "unstable" substances give off energy in the absence of any exterior stimulus; but in emitting rays they gradually destroy themselves. In this sense Jan van Eyck's human beings may be said to be in a state of stability, Roger van der Weyden's in a state of metastability, and Hugo van der Goes' in a state of instability; which is perhaps the reason for his apparent aversion to portraiture other than in the shape of donors' portraits where the individual appears in an affective context.[1]

In all these cases the nature of the product mirrors the nature of its maker; and as the tension in Hugo's mind reflected itself in his style, so did the tensions in his style have a repercussive effect on his mind. In Italian art, fortified by the revival of classical antiquity, there was no irresolvable conflict between the humanistic glorification and idealization of man and the non-humanistic postulate of total particularization (it is no accident that, as has been mentioned, nominalism never made much headway in Italy), between "great form" and the minutiae of optical appearance. And this is what I had in mind when speaking of the grain of truth in the belief that Hugo's illness was induced by his frustrated ambition to vie with the van Eycks.

In Hugo's development the position of the Portinari altarpiece, executed about 1476,[2] corresponds, in a sense, to that of the Ninth Symphony in Beethoven's. The rules and conventions of a "classic" form are still observed. But they are exploited, not to say strained, to the very limits of their capacity, and the irruption of the famous shepherds, carried away by an experience too powerfully subjective to be expressed without some violation of accepted iconography and "good taste," may well be likened to the startling intrusion of the human voice upon the sound of instruments.

Closed, the triptych displays, as usual, an Annunciation in grisaille (figs. 461, 465). But the two noble figures — the Virgin Mary closing her eyes, pressing her hand to her heart like one about to faint, the Angel Gabriel alighting on earth with his scepter-bearing arm outstretched and pointing heavenward with his right hand — are so intensely animated and enjoy so much freedom of action within their wide, deeply hollowed niches that they defy the very distinction between simulated sculpture and regular painting; they seem to have under-

gone a double metamorphosis as though human beings had first been turned to stone and then brought back to life.

The interior of the wings shows, on the left, Tommaso Portinari and his two older sons, Antonio and Pigello, under the protection of St. Thomas and St. Anthony the Hermit; and, on the right, Tommaso's wife, Maria Baroncelli, and their first-born child, Margherita (not Maria),[1] presented by St. Mary Magdalene and St. Margaret (fig. 464). But in reverting, within the frame of a thoroughly naturalistic style, to the long-outmoded custom of reducing the size of the donors in relation to that of the patron saints, the painter has created a contrast of almost frightening intensity: gigantically looming up behind their protégés and foiled by a scenery of arid hills and leafless trees inhabited by jackdaws, the saints appear austere to the verge of the forbidding.

In the background of the donors' wings are seen, as prelude and epilogue to the Nativity which occupies the center of the altarpiece, the Holy Parents and the three Magi on their way to Bethlehem. And in both cases the iconographical connection with the principal event is fraught with emotional overtones. The Virgin Mary, no longer able to ride, has descended from her donkey and seeks support in the arms of St. Joseph as she will lean on the huge column seen in the central panel (fig. 466). The outrider of the Magi has dismounted and asks directions from a pious shepherd who, in more ways than one, belongs to those who dominate the central panel on the right. Thus streams of energy seem to converge towards the Nativity scene; but in the center of this whirlwind there is calm. Amidst the jubilation of the heavenly host, the quiet reverence of the adoring angels and St. Joseph, the touching, dumb devotion of the ox (the ass, by contrast, remaining impassive), and the wild piety of the shepherds, the Virgin Mary and the Christ Child are alone, encompassed by a circle of solitude. It is in order to accentuate this sense of loneliness that the scale of the figures varies, not according to the laws of perspective — though these are scrupulously observed in the archi-tecture — but so as to create the illusion of distances "measureless to man"; that the piece of ground on which the Infant is placed is so large and so bare; and that the circle of figures surrounding Him is completed in front by what looks like a mere still life, but is in fact the key to an exceptionally intricate system of symbolism.

Placed upon the sacred ground — its sacredness stressed, as in Petrus Christus' Washing-ton "Nativity," by the familiar motif of a discarded patten — are seen two vases containing flowers: an albarello holding a scarlet lily and three irises (the latter Hugo's favorite flower) and a glass with some sprays of columbine. The scarlet lily signifies the blood of the Passion; the iris, we recall, the sword that pierces the heart of the Mater Dolorosa. And the by now familiar symbolism of the columbine[2] is here all the more obvious as the number of big blossoms is exactly seven whereas the number of attending angels, in patent allusion to the *Quinze Joies de la Vierge*, is exactly fifteen.[3] While the flowers announce the Lord's Passion, the sheaf of grain, placed behind the two vessels, refers to the ideas centered around His birth-place. Its name, Bethlehem (which means "House of Bread"), was connected with the "I am the bread which came down from heaven" (John VI, 41) and, therefore, with both the Incar-

nation and the Eucharist. And it was in Bethlehem that Ruth, an ancestress of Christ, had "gleaned ears of corn" in the field of Boaz; it was Bethlehem that became the "City of David," great-grandson of Ruth. This less obvious implication is made explicit by the fact that the ancient building in the background, deserted and bereft of windows though otherwise intact, is clearly designated as David's own palace. Upon the tympanum of its portal is carved his "coat-of-arms," the harp,[1] and I have little doubt that the enigmatical inscription of this portal, the letters "P.N.S.C." — surmounting an "M.V." which can hardly mean anything but *Maria Virgo* — must be read as "Puer Nascetur Salvator Christus," a combination of words familiar to the faithful from the Christmas liturgy and thus inseparably linked in his mind with the idea of Christ's descent from David. The very Introit of the Third Christmas Mass begins with Isaiah's "*Puer* nobis est *natus*"[2] and the Sequence of Midnight Mass includes St. Luke's amplification of this versicle: "Quia natus est vobis hodie *Salvator*, qui est *Christus* dominus, in civitate David" (Luke II, 11).

Contrasts analogous to those which prevail in the scale and disposition of the figures and in the far-flung connotations of the iconographic program are also evident in the treatment of form and color. Hugo's attempt to combine a maximum of spatial depth and plastic energy with a maximum of surface detail resulted in a terrific tension not only between three-dimensional and two-dimensional form but also between surface and line. And it is in the very precision of his design, in those *tretz netz* admired by his contemporaries[3] and noticeably more prominent in the Portinari altarpiece than in his other works, that this tension can be felt. The outer contours seem to be bent and tightened by the same internal pressures which make the surfaces bulge and recede; the wrinkles and creases of the skin, the strands of hair, the weave of a straw hat are etched into these surfaces with an incisiveness which at times all but destroys their continuity. The colors, instead of sounding consonant chords or merging into tonal harmony, shed what Paul Valéry would call "une étrange lueur contradictoire." In the wings, the sombre depth of claret, dark olive-green, warm brown, and velvety black contrasts with pale tan and glaring white. In the central panel, the brilliant gold-and-vermilion of the coped angels clashes with the dark blue of the Madonna and the dusky red of the St. Joseph, and this again with the white, the cool aquamarine and the chatoyant green of the other angels. The color of the soil is a dry, loamy yellow, and the flesh tones, modeled with whitish lights, give an impression approaching lividity.

The Portinari altarpiece marks the beginning of that critical phase in which a middle period draws to a close while an *ultima maniera* has not as yet been formed; a conflict of opposing forces has produced a disturbance of equilibrium but not as yet resulted in their disengagement.

The balance of these forces is represented by a work which, as demonstrated in a memorable article by Adolph Goldschmidt, precedes rather than follows the Portinari triptych and may be dated in 1470–1472: the Monforte altarpiece, so called after a Jesuit College from which it found its way into the Kaiser Friedrich Museum at Berlin (figs. 459, 460).[4] Deprived of its wings, which showed the Nativity and the Circumcision of Christ, it is now reduced to a

monumental "Adoration of the Magi," and even this is slightly impaired by the truncation of its top piece wherein was seen a group of adoring angels. But these regrettable losses have not diminished the euphony and festive splendor of the composition. A picturesquely complex, sunlit space is comfortably filled with quiet figures, all drawn to scale, whose dignified deportment and serene expression are equally removed from gloom and excitement; and their Italianate *rilievo* — cut out of the picture, the portraitlike heads in the background might well deceive us into assigning them to the Florentine or Umbro-Florentine school — for once resolves the conflict between general form and linear detail. The irises and columbines, foreshadowing the Passion, are present but so unobtrusive that they might easily go unnoticed, and the colors form a lustrous, richly modulated harmony of deep reds and crimsons, warm greens and browns. From a purely coloristic point of view, it is understandable that the Jesuits of Monforte attributed their altarpiece to Rubens.

While this "Adoration of the Magi," antedating the Portinari triptych by four or five years, shows Hugo van der Goes in what may be termed his "classic" phase, his latest style is ushered in by two large, narrow panels, painted on both sides, which on stylistic as well as historical grounds must be dated about 1478–1479. Preserved in Holyrood Palace, the ancient seat of the Kings of Scotland, they were originally destined for the Collegiate Church of the Holy Trinity at Edinburgh, founded in 1460 by Mary, the widow of King James II. Their donor can be identified as the first Provost of this church, Sir Edward Boncle or Bonkil, whose brother, Alexander, was a naturalized citizen of Bruges and may have helped to negotiate the commission.[1]

The composition and iconography of these panels suggest that they were organ shutters rather than triptych wings, presumably destined for an instrument that had been ordered from Flanders in 1466/67 and to which James III, the son of the foundress, had made a substantial contribution. The interior pictures (fig. 467) — disclosing the side-aisles of a church whose sturdy, Early Gothic piers must have splendidly harmonized with the pipes of the organ when the shutters were open — show, on the left, King James III himself, crowned by the patron of Scotland, St. Andrew, and accompanied by his young heir, the future James IV; and, on the right, his Queen, Margaret of Denmark, protected by a knightly saint who bears the attributes of St. George but must be meant to represent the patron of her native country, St. Canute.[2] The exterior pictures (figs. 468, 469) display, on the left, the Trinity of the Broken Body, clearly derived from the Flémalle Master's composition at Leningrad[3] but humanized by the transformation of God the Father from a stern, white-bearded, tiaraed ruler into a compassionate, youthful, bare-headed mourner, and made even more tragic by the addition of an orb abandoned like a worthless thing; and, on the right, Sir Edward Bonkil kneeling in front of a magnificent organ. The first stanza of the Ambrosian hymn to the Trinity,

O lux beata Trinitas
Et principalis unitas,
Iam sol recedit igneus,
Infunde lumen cordibus,[4]

can be read on the pages of a hymnal placed upon the music rack of the organ, and a slender angel of transcendent beauty, clad in white and assisted by another angel who works the bellows, acts as an organist.

The effect of this work is somewhat vitiated by the fact that the lifeless faces of the King and the Crown Prince, whom Hugo van der Goes had never seen, were painted in *ex post facto* (conceivably at Edinburgh), and that the panel showing the Queen and St. Canute, the latter a feeble replica of the St. George in Jan van Eyck's "Paele Madonna," was executed by an indifferent imitator, perhaps because the ailing master was unable to complete his task with the promptitude demanded by the donor.[1] With these exceptions, however, the Bonkil panels — including the impressive portrait of Sir Edward himself who seems to have sat for it on the occasion of a visit to the Netherlands — show Hugo's style in perfect purity and, in relation to the Portinari triptych, bear witness to an increase of inward excitability combined with a kind of outward assuagement.

Compared to the expression of St. Anthony and St. Thomas, that of St. Andrew is almost mild;[2] compared to the countenance of Tommaso Portinari, that of Sir Edward Bonkil is pensive rather than tense. The color scheme, tending toward unity rather than clamorous diversity, is largely based on red — pure red in the robe of God the Father and the garb of the Crown Prince, crimson in the cloak of St. Andrew and the brocaded dress of the King, purplish violet in the King's mantle — whereas the donor's wing is nearly a monochrome in tan, gray, and pale blue. In the design of the draperies long, flowing parallels prevail. The linear detail of hands and faces is relatively subdued. The figures, keeping near the frontal plane, are foiled by quiet verticals which tend to dominate the composition. And the discrepancies in scale have disappeared.

However, beneath the apparent calm of the Bonkil pictures — in truth a calm before the storm — there lurks a tendency, as yet kept within bounds, to abolish rationality altogether. The very fact that one color, red, recurs in many modulations without asserting its identity produces a strangely unreal effect; and in the Trinity panel, where the deep red of the robe contrasts with the somber slate-gray of the clouds and, even more surprisingly in a work of the late 'seventies, with real gold (here used not only for the huge glory behind the throne but also in the throne itself), this effect is sharpened to one of phantasmagoria. The very tranquilization of the emotions seems to restrain their outward expression rather than diminish their corrosive intensity. And the pictorial space, though free from inconsistencies in the scale of its contents, seems to have lost its stability. The throne of the Trinity has become extensible and flexible. The back appears unnaturally distant from the front as if it were seen through the wrong end of a telescope. The curves of the arms diverge from that of the base as though the whole structure, soberly regular in the Flémalle Master's Leningrad picture, were warped. And the ecclesiastical architecture, fragmentarily emerging from behind enormous canopies in the pictures of the Royal Family and from behind the big organ in the donor's wing, is as unintelligible as it is grandiose.

EPILOGUE: THE FOUNDERS' HERITAGE

The outbreak of the storm can be witnessed, with that mixture of elation and horror which always accompanies the experience of the sublime, in Hugo's latest style, exemplified by the "Nativity" in the Kaiser Friedrich Museum (figs. 471, 472) [1] and the "Death of the Virgin" in the Museum at Bruges. (fig. 473).[2]

In all externals these two paintings form a diametrical contrast. One, a wide, predellalike oblong, invites us into an open space illumined by the light of early morning, there to share in what the very angels called "a great joy"; the other, its vertical format uncomfortably approaching a square, admits us to a windowless interior there to participate in a scene of heart-rending sorrow. In essence, however, the two compositions are so closely akin that even apparent differences reveal themselves as similarities in disguise. If I have said that the "Nativity" invites us into an open space, I must now add that the center of the prospect is obstructed by masonry which, extending as it does beyond the upper margin, transforms the focal area of the picture into a quasi-interior; and that the scene is framed on either side by the wings of an imaginary proscenium from which two gloomy, hortatory Prophets draw semi-transparent curtains — not so much in direct imitation of the mystery theatre (which lacked illusionistic settings and did not cast the Prophets in the role of stage attendants) as in boldly literal illustration of their function "to reveal," that is, "to unveil," the New Dispensation: "Vetus testamentum velatum, novum testamentum revelatum." If I have said that the "Death of the Virgin" admits us to a windowless interior, I must now add that this interior is opened up by a blinding glory, blotting out two thirds of the space above the figures, wherein Christ appears in a cloud of angels. In all earlier representations He quietly appears at the bed to receive the Virgin's soul in His arms. Here He descends from Heaven, showing His wounds, as in His second coming.[3]

In both pictures, then, the very distinction between interior and exterior is defied in favor of a space which has ceased to be rationalizable, let alone metrical, and it is difficult to form a clear idea as to the exact location of figures and objects. In the "Death of the Virgin," for example, all the hands are of nearly the same size no matter whether their owners are close to us or far away; the apparition, colossal in relation to the little room yet small in view of its nearness, seems to exist in a space of its own; and since the head and foot of the bed are parallel to the picture plane, the Virgin Mary seems to lie diagonally across it.[4] Yet these very inconsistencies intensify rather than weaken the experience of space *qua* space. While producing a surface pattern no less precise and intricate than a Late Gothic ornament, the figures are arrayed on receding diagonals (converging, however, not toward the center but toward a point off axis). The pivotal motifs — the bed in the "Dormition," the manger in the "Nativity" — are represented in head-on foreshortening (which, in the case of the bed, seems to be a bold transference from such scenes as the Birth of the Virgin, the Birth of St. John and the Annunciation staged in the *Thalamus Virginis*).[5] And there is air between the solid forms.

Light, color and expression also convey a sense of irrationality. In the "Nativity" a mysterious radiance, emanating not only from the Infant Jesus but also from the attending angels and the Virgin, produces an almost nocturnal effect while, at the same time, a pale yet penetrating

337

light bursts in from the upper left so that the strongest contrasts of light and darkness are concentrated in the figures of the shepherds rushing in upon the scene at a mad gallop. It paints distinct cast-shadows upon the ground and eats up the local colors to such an extent that the total impression approaches the monochromatic. In the "Death of the Virgin," on the other hand, the indistinct bleakness of the light that comes from the left foreground is shattered by the glare of the miraculous apparition while the desaturated blues, reds, mauves, pinks, and browns, some of them as dissonant as unresolved seconds, weirdly contrast with the chalk-white of the Virgin's kerchief and St. Peter's alb and with the green-fringed yellow of the big glory. And the intensity of simple-hearted devotion, prophetic ecstasy and muted sorrow have reached a point at which emotion blots out consciousness and threatens to break down the barrier that protects reason from both the subhuman and the superhuman.

VII

Hugo's development from the Portinari altarpiece to the end is thus a fairly continuous and, in the light of his nature, comprehensible one. Three questions, however, are as yet unanswered. First, what do we know of his beginnings and which are the sources of his early style? Second, how can we account for the evident Italianism of the Monforte altarpiece? Third, how can we explain the gulf that separates its style from that of the Portinari triptych while no such gulf exists between the latter and the Bonkil panels?

The last of these questions has, so far as I know, not even been raised. The second, inextricably connected with the first, has recently been answered by a revival of the old hypothesis, proposed by the excellent E. de Busscher as far back as 1859, according to which Hugo van der Goes had been in Italy prior to his admission to the painter's guild in 1467.[1] And in order to be palatable to the modern art historian this old hypothesis had to be supplemented by the new assumption that the Monforte altarpiece, though certainly not executed until 1470–1472, is Hugo's earliest known work.

This honor had been commonly assigned to a small but justly famous diptych in the Gemäldegalerie at Vienna one leaf of which depicts the Fall of Man, its back exhibiting a simulated statuette of St. Geneviève, while the other displays the Lamentation already mentioned in connection with Geertgen tot Sint Jans (figs. 456–458).[2] But since these three pictures show no trace of Italian influence, and in view of the fact that Hugo's schedule precludes the possibility of a trip to Italy between 1467 and *ca.* 1470, those who believe in such a trip are forced to date the Vienna diptych and its relatives — notably the beautiful Madonna in half-length in the Städelsches Kunstinstitut at Frankfort (fig. 455)[3] which cannot be separated from the St. Geneviève — in a period in which the impact of Quattrocento painting had spent itself, that is to say, not only after the Monforte altarpiece but also after the Portinari triptych and the Bonkil panels. "In the interpretation of space and in the figure composition," to quote from the chief spokesman for this theory, "in the treatment of color and light, and in the rendering of details, the Portinari altarpiece aims at pregnancy and clarity of characterization, at

materiality (*Stofflichkeit*) and objective-naturalistic (*gegenstands-realistische*) effects. The Berlin 'Nativity' — and also the Frankfort Madonna — already shows a radical suppression of these elements in favor of an intensification of psychological content and an empathic experience of the beholder." [1] Moreover, since the Vienna diptych, while unmistakably Eyckian in the "Fall of Man," is even more unmistakably Rogerian in the "St. Geneviève" and the "Lamentation" (compare, for example, the dead Christ with that in the Hague "Lamentation" and the St. John with that in the great "Descent from the Cross"), the champions of an early trip to Italy must further assume that Hugo, far from growing out of the great tradition of the past, discovered Roger only near the very end of his career: "It is not the early works which show a close connection with Roger van der Weyden but precisely the late ones which become again more 'Gothic.' This connection, therefore, does not evince a derivation in the sense of a school tradition but a conscious reversion to a world of forms characteristic of an earlier generation." [2]

To this reinterpretation of Hugo's development there are, in my opinion, serious objections. While it is true that the Berlin "Nativity" and the Bruges "Death of the Virgin," as compared to the Monforte and Portinari altarpieces, revert to Roger in spirit, the Vienna diptych and the Frankfort Madonna descend from Roger in the flesh; they show, as has been seen, a direct appropriation of Rogerian motifs, which is most definitely not the case with the Berlin "Nativity" and the Bruges "Death of the Virgin." And, similarly, while it is true that these two ultimate works are marked by a shift from *Stofflichkeit* and *Gegenstands-Realismus* to psychological expressiveness and by an increasing tendency to irrationalize the picture space, the Vienna diptych represents, it seems to me, a phase in which the values achieved in the Monforte and Portinari altarpieces are still aspired to rather than already abandoned — a "not as yet" rather than a "no longer."

In the "Fall of Man" the figures of Adam and Eve bear witness to an almost passionate attempt to recapture, within the limitations of a self-imposed linearism, the plastic solidity of Jan van Eyck's First Parents (no other work of Hugo's makes us so keenly aware of his frustrating ambition to "rival the perfection of the Ghent altarpiece"), and the space, far from dissolving or becoming incoherent, is perfectly rational. But it is not as yet completely integrated with its contents. The scenery unfolds with admirable continuity and clarity, but it unfolds behind rather than around the figures; these are arrayed along the frontal plane and foiled by the landscape as by a rich tapestry related to them only by the parallelism between the contour of the hillside and the alignment of the three heads. And if the "Fall of Man" is dominated by archaic frontality, the "Lamentation" represents a no less archaic attempt to break the spell of this frontality by force. This spell still sways the Magdalen and the Nicodemus, tightly confined by the lower corners and glued, as it were, to the picture plane in a manner quite different from the treatment of the seemingly similar figures in the foreground of the "Death of the Virgin." The disposition of the other figures is determined by two receding and intersecting diagonals, one formed by the body of Christ, Joseph of Arimathea and the woman raising her arms in lament; the other, by a double phalanx of mourners extending from the Nicodemus in the lower right-hand corner to the two women whose figures mark the apex of the group. But

neither of these diagonals produce an effect so clearly three-dimensional as in Hugo's latest compositions. The body of Christ seems to levitate rather than rest upon the ground. It is impossible to decide whether the mourners are toppling down a slope or advancing on flat terrain, and no interstices exist between the individual members of the group most of whom are in direct physical contact with each other; an irreverent beholder may feel reminded of the German fairy tale entitled *Schwan kleb' an*. Where the "Death of the Virgin" and the Berlin "Nativity" show independent plastic units irrationally manipulated within a space completely mastered, the "Lamentation" shows a close-knit relief group turned at an angle within a space still to be conquered. It is quite true that Hugo's latest pictures are more Rogerian in many ways than the Portinari triptych, let alone the downright anti-Rogerian Monforte altarpiece. But their Rogerianism does not represent a new departure; it results from the recrudescence — after a period of alienation due to unexpected outside stimuli — of the tendencies of the master's own youth. From the very beginning he was no less acutely aware of Roger than of Jan van Eyck. From the very beginning he was determined — or fated — to vie with both without surrendering to either.

I am, therefore, inclined to abide by the orthodox view according to which the Vienna diptych (and, by implication, the Frankfort Madonna) precedes the Monforte altarpiece and should not hesitate to date it as early as *ca.* 1467-1468 — a date confirmed, it seems to me, not only by its meticulous technique but also by a color scheme which, different from both the "Rubenslike" sonorousness of the Monforte altarpiece and the discordant pallor of the latest works, for once approaches the ideal of Eyckian and Boutsian *Schönfarbigkeit*. But even more important is the fact that the Vienna diptych, and only the Vienna diptych, permits us to perceive the ties that link the style of Hugo van der Goes to the artistic life of his home town.

Little is known of painting at Ghent after the death of Hubert van Eyck. About the only piece of evidence is a large "Nativity," dated 1448, which still exists in the Vieille Boucherie and is ascribed, for no particular reason, to one Nabur Martins, occasionally mentioned in contemporary documents. It would be unfair to generalize from this one picture, and a mural at that. But if a rather important commission went to a master who, at a time when Roger's "Last Judgment" and Petrus Christus' "St. Eloy" were nearing completion, expressed himself in a patois derived from the language of the Master of Flémalle, it seems safe to say that the School of Ghent, as constituted in the middle of the fifteenth century, was *retardataire* in comparison with those of Brussels, Bruges and Louvain and could hardly satisfy the needs of rising talent. A gifted novice would have felt free, even compelled, to look beyond this fairly limited horizon.[1]

Such was the case of the first major painter to enter upon the local scene after Hubert's death: Joos van Wassenhove, more commonly known as Joos (or, owing to a humanistic misinterpretation of his Christian name, Justus) van Ghent.[2] Admitted to the painter's guild of Antwerp in 1460, he became, on October 6, 1464, free master at Ghent where he is recorded up to January 19, 1469. Shortly after, he went to Italy and found favor in the discriminating eyes of Federico Montefeltre, Duke of Urbino, whom he served from the end of 1472 at the

340

latest; he is last mentioned there in a document of October 25, 1475. His pre-Italian style — the problems surrounding his later production do not concern us here [1] — can be observed in at least two works of the first order: an "Adoration of the Magi" in the Metropolitan Museum, painted on canvas, which must be considered as his earliest known picture (fig. 450); [2] and a huge "Calvary," flanked by the prefigurations of the *Coup de Lance* and the Crucifixion ("Moses Striking the Rock" and the "Raising of the Brazen Serpent"), which can still be admired in St. Bavo's at Ghent and may be dated about 1465 (figs. 451–453).[3]

As is, to be expected of a gifted painter neither supported nor oppressed by a powerful local tradition, these two works reflect a variety of influences, diversified in space as well as time. Joos van Ghent shows himself familiar with Roger van der Weyden (compare the *dramatis personae* of his "Calvary" with those in Roger's various renderings of the Descent from the Cross, his "Adoration of the Magi" with Roger's Columba altarpiece and "Madonna on a Porch") [4] as well as with Dirc Bouts whose influence was even more potent and extended to such minutiae as the three-legged coffee table in the New York "Epiphany" which made its first appearance in Dirc Bouts' "Adoration" in the Prado (fig. 417).[5] The Roman Captain in the foreground of the Ghent "Calvary" has long been recognized as a respectful quotation from the Ghent altarpiece; [6] but it should be added that the Good (and to a lesser extent the Bad) Thief is a no less respectful quotation from the great "Deposition" by the Master of Flémalle (fig. 230).

Yet Joos van Ghent was anything but an unimaginative eclectic. He not only remolded and harmonized the heterogeneous elements of his style but also infused his compositions with a new spirit of ordered freedom and unassuming dignity. His figures — his ideal of feminine beauty admirably exemplified by the kneeling woman in the "Striking of the Rock" — move with a slow, gliding grace which makes us see why he of all Flemings won the approval of Federico of Urbino, the patron of Piero della Francesca. An affinity with the Italian point of view may also be felt in his comparative indifference, rare in a Northerner, to picturesque detail, in his instinct for decorum (which Leonardo da Vinci defines as "appropriateness of gesture, dress, and locality"), and, most of all, in his innate feeling for monumentality. Under his hand all forms seem to arrange themselves, as under the gentle compulsion of an Orphean lyre, into grand decorative patterns in the plane and grand architectonic patterns in space, unified by sweeping curves and diagonals in which the Rogerian principle of rhythmical concatenation is reconciled with the Boutsian principle of free deployment in depth.

"The way in which his figures invade the middle distance and background," says Friedrich Winkler of Joos van Ghent's "Calvary," "anticipates the very aims of Hugo van der Goes." [7] One must, I think, not only concur with this remark but even expand its scope. We know that Joos and Hugo were friends. Joos acted as guarantor when Hugo was admitted to the Ghent painter's guild on May 5, 1467. Hugo reciprocated by a loan of money when Joos was preparing for his transmigration to Italy. Both, however different in temperament, were of one mind in attempting to reactivate the indigenous tradition yet to escape from it in the direction of the Italian Renaissance, and we may speculate about what would have happened had Hugo rather

than Joos been given a chance to live out his life at the court of Urbino instead of in the Roode Kloster near Brussels. But such is the fascination of genius that the majority of scholars have been looking for Hugo's influence on Joos van Ghent rather than Joos' on Hugo van der Goes.

However, since Joos, free master at Antwerp as early as 1460, must be presumed to have been Hugo's senior by about seven years, there is every reason to suppose that he, at least at the beginning of their relationship, played the role of mentor and not of disciple.[1] And as a work conceived under the influence of Joos van Ghent, Hugo's Vienna diptych loses much of its inexplicability. Joos van Ghent's "Adoration of the Magi" and "Calvary" anticipate it, not only in what Winkler calls the "invasion of the middle distance and background" but also in individual postures, gestures and physiognomical types. We may compare, for example, the attitude of the weeping woman in the upper left of Hugo's "Lamentation" with that of the figure analogously placed beneath the Cross of the Good Thief in Joos' "Calvary"; the strangely inhibited gesture of the woman in the upper right of Hugo's "Lamentation" with that of Joos' Magdalen;[2] the egg-shaped face, wrinkled eyebrows and pinched mouth of Hugo's Magdalen with that of the woman supporting Joos' Virgin Mary.[3] The darkness of the atmosphere, the intensification of the passions, the sharpening of the design, the crowding of the figures into a dense relief — all this belongs, of course, to Hugo, and to him alone. And like all independent minds, he felt the urge to turn from the translations to the originals. While still associated with Joos van Ghent he restudied Roger van der Weyden and Jan van Eyck[4] much as the young Michelangelo, while still a pupil of Bertoldo di Giovanni, restudied Donatello, Giovanni Pisano and the Antique.[5]

A "pupil" as brilliant as Hugo van der Goes would naturally make a deep impression upon his "master"; and this very fact supplies another argument in favor of the assumption that the Vienna diptych stands at the beginning rather than at the end of his known works. As compared to Joos van Ghent's pre-Italian pictures, the work which established his reputation in Italy, the "Communion of the Apostles" still preserved in the Palazzo Ducale at Urbino (fig. 454),[6] shows manifestly Goesian characteristics. The figures are no longer spaced at easy intervals but form those serried "double phalanxes" peculiar to Hugo's Vienna "Lamentation." The faces, hands and draperies are analyzed with a penetrating incisiveness entirely absent from the New York "Adoration of the Magi" and the Ghent "Calvary." And the physiognomies of the Apostles are clouded by that somber pathos which is the very signature of Hugo's genius. This change must be ascribed to a retaliatory influence of Hugo van der Goes. And since this influence must have taken effect prior to Joos van Ghent's departure for Italy which separated the two friends forever, the Vienna diptych — or, at least, a work very much like it for all stylistic intents and purposes — must have been in existence before 1469–1470.[7] When dated before the Monforte altarpiece, this diptych can be understood as an organic outgrowth, however original, of an indigenous tradition preliminarily summarized by Joos van Ghent.

In view of these specific facts, Hugo's hypothetical journey to Italy, supposedly preceding his admission to the guild in 1467, becomes even less probable than it would have been for general considerations. Before Dürer, Gossart and Scorel, a Northern painter did not venture

across the Alps as a young student in quest of inspiration but, if he did at all, as a mature master either attracted by the prospect of work or impelled by religious motives. As a matter of fact, the Italianate features of the Monforte altarpiece do not necessarily presuppose Hugo's personal presence in Italy. Rather than by a trip before 1467 (the effect of which would have somewhat resembled that of a delayed-action bomb) they can be accounted for by the fresh impact of Hugo's experiences at Bruges where he was intermittently active, we recall, from the summer of 1468.[1] The houses of the Tani and Canigiani, the Cavalcanti and Tornabuoni, the Frescobaldi and Portinari must have been full of Florentine paintings which could not fail to leave their imprint on a mind developed in the unprejudiced atmosphere of Ghent: images for private worship, *deschi da parto, cassoni*, and, above all, family portraits. And when we examine Hugo's Italianism more closely we realize that it is virtually limited to physiognomies, especially the donors' portraits and the incidental, portraitlike faces in what the Italians call the *assistenza*. Even in the Monforte altarpiece, where the Italian influence is more pronounced than ever after and where the Moorish king, his retinue and the four onlookers behind the parapet look more or less like portraits by Paolo Uccello or Benozzo Gozzoli, the general structure of the composition, the poses and the drapery motifs are anything but Italianate, and all the principal characters, especially the Virgin Mary, show honest Flemish countenances conforming, in a general way, to the tradition of Roger van der Weyden and Dirc Bouts.[2]

This leads us to the last remaining question: the basic difference between the Monforte altarpiece and the Portinari triptych. In the latter, we remember, the space gives a curious impression of emptiness, the figures tending to disperse and to defy the unity of scale. The character of the colors has shifted from warm, rich consonance to cool, opalescent diversity. An almost chalky white predominates in the flesh tones, and the ideal of youthful beauty — as represented by the Virgin Mary and the adoring angels in the central panel, the Annunciate and the Angel Gabriel on the exterior, and the female saints in the inner right-hand wing — has undergone a transformation the effects of which can still be felt in the Bonkil panels whereas they were to disappear in the Berlin "Nativity" and the "Death of the Virgin." Instead of the wholesome, Flemish oval with rounded cheeks and soft, budlike mouth, we find a type which may be described as triangular, the contour tapering from a wide, bony forehead to a firm, slightly elongated chin, the cheeks less fleshy, the mouths fairly wide, somewhat protruding and set in an expression of sullen reserve.

In order to account for this sudden and somewhat episodic change I venture to suggest that Hugo van der Goes may have gone to France between the completion of the Monforte altarpiece and the inception of the Portinari triptych. At the end of 1473 he supervised, as has been mentioned, the decoration of the Church of St. Pharahildis for the services held there before the last journey of Philip the Good and Isabella of Portugal. Philip had died in 1467 but had expressed the wish that his remains be kept at Bruges and not be moved to the family vault in the Chartreuse de Champmol until the death of the Duchess. Isabella of Portugal died on December 17, 1472, and at the end of the following year the "very noble bodies" were transferred, "in wonderful and devout triumph," from Bruges through Ghent, the Hainaut,

Champagne and Burgundy to reach their destination on February 10, 1474.[1] Two hundred *hommes de pied*, clad in black and carrying torches all the way, protected an enormous cortege composed of "great and puissant nobles, barons as well as other knights, equerries and also clergy and laymen." Hugo van der Goes was directly involved in the preparations for this event and so well thought of by the ducal family that Maximilian I, the husband of Philip's only legitimate granddaughter, paid him a personal visit in the Roode Kloster. Is it too hazardous to suppose that he was included among the *gens laiz* who were deemed worthy to accompany the *très nobles corps* from Flanders to Dijon? There is no positive proof of such an assumption, and probably never will be. But if admitted as a working hypothesis, it would not only answer our question but also throw some light on certain other obscurities, including the rather surprising fact that one of the few painters so profoundly influenced by Hugo that he may be called a disciple of his, the Master of Moulins, was active in a region not too far from Dijon, and that his style reflects the later phase of Hugo's development, beginning with the Portinari triptych, where Geertgen's is exclusively based upon his earlier works, especially the Monforte altarpiece.[2]

It is in France, especially in the works of Jean Fouquet and his circle, that Hugo van der Goes could have seen that barish space, those cooler colors and those whitish faces which distinguish the Portinari triptych from the Monforte altarpiece. It is in France and in the same circle — we may refer to Fouquet's Antwerp Madonna, allegedly commemorating the features of Agnès Sorel, and, most particularly, the Angel Gabriel in the window of Jacques Coèur in Bourges Cathedral — that he could have encountered those "triangular" and somewhat prognathous physiognomies which are so foreign to the Flemish tradition.[3] It may also be noted that the Angel in the "Annunciation" of the Portinari triptych not only raises his arm with the emphatic gesture first encountered in the *"Petites Heures"* (fig. 30) but also approaches the Virgin Mary from the right, two features unparalleled in the Netherlands, except for works dependent upon the Portinari triptych itself, but fairly frequent in France;[4] and that the curtain motif of the Berlin "Nativity" is anticipated, if anywhere, in Fouquet's portrait of Charles VII in the Louvre.[5] In the Bonkil panels, finally, we may detect what I believe to be a reminiscence of the very shrine for which the funeral procession of 1473–1474 was bound.

In the two panels showing the Royal Family kneeling in front of their patron saints as well as in the panel showing Sir Edward Bonkil kneeling in front of the angelic organist, the figures are set out against a background dominated by verticals, and the resulting compositional pattern is as unique, even in Hugo's own work, as is the style of the draperies which, in comparison with his customary formula, strikes us as at once more modern and more archaic. The folds form long, unbroken ridges, separated from each other by wide, deep channels and contrapuntally contrasting with the angular masses which occur where the fabric spreads on the ground or, in the case of the St. Andrew, is bunched about the body. I cannot help feeling that these singularities reflect the impression of the portal of the Chartreuse de Champmol (text ill. 42) where the draperies are treated in, *mutatis mutandis*, very similar fashion, and where an analogous relationship obtains between the kneeling donors, the patron saints and the majestic

verticals of the embrasures. Although some rather specific points of contact may be detected between Hugo's Bonkil and Sluter's Philip the Bold, Hugo's St. Andrew and Sluter's John the Baptist, and even Hugo's Angel and Sluter's St. Catherine, it would be foolish to speak of imitation. Rather we witness the emergence of a memory-image called to the surface by the challenge of a somewhat analogous problem — the problem of constructing donor's portraits incorporated with a quasi-architectural object rather than flanking a central panel — much as the circumstances of a dream may come back to us when we find ourselves in an analogous situation.

<div align="center">VIII</div>

That Hugo van der Goes paid homage to Claus Sluter (precisely as he had to Jan van Eyck in the Vienna diptych and as he did to the Master of Flémalle in the very counterpart of the Bonkil portrait) had no essential effect upon his general development. This was headed for what we call, with some justification, the "Late Gothic Baroque":[1] a style, to use the terms conventionally applied to the real Baroque, of "becoming" rather than "being," and thus preferring contortion to composure, complexity and involution to simplicity and clearness, oblique recession into space to frontality, the "open form," viz., incompleteness and asymmetry, to the "closed."

In following this course, Hugo van der Goes was as exceptional as in every other respect. Maturing in the last two decades of the fifteenth century, the "Late Gothic Baroque" reached its culmination in Germany where its inherent violence was often intensified rather than attenuated by the intrusion of Renaissance elements; suffice it to mention, as artists active in the fields of painting and the graphic arts, Schongauer, Wolgemut, Michael Pacher, Veit Stoss, young Dürer, Grünewald and the amazing Jerg Ratgeb.[2] And in the Netherlands it flourished, no less significantly, in Holland rather than in the south; Geertgen himself in his last phase (as represented by the Utrecht "Man of Sorrows"), the most original of his followers, known as the Master of the Martyrdom of St. Lucy,[3] the Master of the Virgin among Virgins,[4] and, in the early sixteenth century, Jacob Cornelisz. of Amsterdam[5] and Cornelis Engelbrechtsz. of Leiden are cases in point.[6]

Quite different is the aspect of painting in the South Netherlandish sphere. At the beginning of the fifteenth century, we recall, Flanders, the Hainaut and Brabant had been inferior in progressiveness of outlook, refinement of taste and technical proficiency to Guelders, Cleves and even Holland.[7] Near the end of the century the evolution, its course dramatically changed by the establishment of the Burgundian court in Flanders, had run full cycle. It was in Tournai, Bruges, Brussels, and Louvain that the great tradition of Early Flemish painting had been formed and was perpetuated. But the very weight of this tradition, heavy even on the shoulders of Hugo van der Goes, prevented the late-born Flemings from going "Baroque." Left with that choice between exaggeration and eclecticism which, according to Winckelmann, always confronts the epigones of "perfection," they could not but turn to the latter.

There were, of course, attempts to keep abreast of the times by lending more animation to

<div align="center">345</div>

the lines, more intricacy to the postures, more complexity to the draperies, and even Memlinc can be seen moving in this direction from about the end of the eighth decade. But in most cases these attempts did not go beyond a slightly mannered compromise as in the St. Gregory triptych in the Metropolitan Museum, produced by a Bruges master of *ca.* 1490,[1] or, if they did go further, resulted in a certain crudity, as in the works of the Brussels Master of the View of Ste.-Gudule. On the whole, the South Netherlandish production from *ca.* 1480 to 1500 lived on the patrimony of the recent past without maintaining its standards. Aelbert Bouts, Dirc's elder son, feebly endeavored to infuse the compositions of his father with the spirit of Hugo van der Goes (with whom he seems to have had some personal contact) but thereby troubled the quiet waters rather than caused them to flow.[2] Other followers, such as the engaging Master of the Sibyl of Tibur, were content to manipulate Dirc's vocabulary in various ways and to enrich it by new architectural, botanical and zoological accessories.[3] And in the schools of Brussels and Bruges the legacy of Roger van der Weyden was exploited "like a quarry."[4] Beginning with Vrancke van der Stockt,[5] the members of these two schools untiringly repeated and varied Roger's compositional formulae and indiscriminately appropriated figures, buildings, drapery motifs, and animals. "It is," writes Max J. Friedländer, "as though the species 'dog' had become extinct with Roger's death so that the painters of the next generation could familiarize themselves with dogs only through drawings by and after Roger."[6]

It would be unjust to measure the achievement of these painters by standards to which they did not aspire. But it cannot be denied that these standards were lower than those of the preceding decades. The Master of the Legend of St. Catherine (who may or may not be identical with Roger's son, Peter),[7] the Master of the Legend of St. Barbara,[8] the Master of the Legend of St. Magdalen,[9] the Master of the View of Ste.-Gudule,[10] the Master of the Embroidered Foliage,[11] the Master of the Story of Joseph[12] — or, to turn to Bruges, the Master of the Legend of St. Ursula,[13] the Master of the Baroncelli portraits,[14] the Master of the St. Augustine,[15] the Master of the Legend of St. Lucy[16] (not to be confused with the Dutch Master of the Martyrdom of St. Lucy), the Master of the Legend of St. Godelieve —[17] and, probably, the Master of St. Giles[18]: all these well-meaning, unpretentious artists no longer endeavored to move but to please. And this they did by the very virtues of their faults. Never before had the legends of individual saints, preferably female, and the sagas of such Biblical characters as Joseph of Egypt and Job been told at such length, with so many little figures and with such an abundance of "local color" and entertaining detail; the very names under which most of these masters are known are eloquent proof of their passion for story-telling. And while topographical accuracy was all but never aimed at by Jan van Eyck, and very rarely by Roger van der Weyden, the late fifteenth-century painters of Brussels and Bruges flattered the civic pride of their clients, and showed off their own dexterity, by rendering the local landmarks in a manner that would do honor to graduate students in architecture. The Master of the View of Ste.-Gudule received his name from the fact that several paintings of his are embellished with portrayals of this famous church in various stages of completion (while others include the portal of Notre-Dame-du-Sablon, also at Brussels). The Master of the St. Augustine gratuitously inserted into his

eponymous picture an equally exact portrayal of Notre-Dame at Bruges. A series of paintings by the Master of the Legend of St. Lucy, the earliest dated 1480, records the gradual evolution of the Bruges Belfry (finished in 1490) with such precision that the undated panels can be arranged in chronological order. And the Master of the Legend of St. Giles, working at Paris, provides archeologists with valuable information about the portals of Notre-Dame prior to restoration and the lost altar frontal donated to St.-Denis by Charles the Bald.[1]

In short, where the terminal development of early Netherlandish painting in Holland agrees with that of German Gothic in tending towards the "Baroque," the terminal development of early Netherlandish painting in Flanders and Brabant agrees with that of French Gothic in tending towards a *détente* — a first indication of that parting of the ways which was to become a fact in the sixteenth and seventeenth centuries. Even such direct followers or imitators of Hugo van der Goes as the Master of the Liechtenstein Altarpiece (fig. 474),[2] the Master of "Augustus and the Sibyl"[3] or the author of the "Fall of Man" in the Leopold Hirsch Collection[4] sin in the direction of prettification rather than overemphasis.

The term *"détente"* is also applicable to that very model of a major minor master, Hans Memlinc.[5] Born at Seligenstadt on the Main and thus, in a manner of speaking, indeed "oriundus Magunciaco,"[6] he must have left Germany after his preliminary training (perhaps at Cologne) and entered the workshop of Roger van der Weyden in 1459-1460 at the latest. Immediately after Roger's death he seems to have settled at Bruges where he became a citizen on January 30, 1465 and spent the rest of his extraordinarily successful life. He died on August 11, 1494, the leading master — and, after the death of Petrus Christus, the only professional portraitist — of Bruges, one of its hundred wealthiest citizens, and, according to an enthusiastic compatriot, "reputed to have been, at that time, the most accomplished and excellent painter of the whole Christian world."[7]

Posterity has not endorsed this eulogy. While Memlinc exerted considerable influence within the narrow orbit of his time and place, "the following generations thought his creations weak and pale";[8] and while the Romantics and the Victorians considered his sweetness the very summit of medieval art, we feel inclined to compare him to a composer such as Felix Mendelssohn: he occasionally enchants, never offends and never overwhelms. His works give the impression of derivativeness, not because he depended on his forerunners (as even the greatest did and do) but because he failed to penetrate them. The very fact that he, the most placid, serene and suggestible of pupils, fell and remained under the spell of a master as intense, severe and domineering as Roger van der Weyden, precluded both revolt and constructive assimilation. There could be nothing but a submission the very completeness of which prevented understanding. From Roger he appropriated everything except the spirit. From the great Eyckian tradition, the monuments of which surrounded him on all sides, he appropriated only the *agréments*: brocaded cloths of honor and oriental rugs, vistas set off by marble colonnettes, historiated capitals, and convex mirrors.[9] And when he undertook a variation on a Goesian "Descent from the Cross" related to the Vienna "Lamentation" and even more trenchant by virtue of its studied fragmentariness, he managed to retain its compositional dissonances but

failed — or, rather, did not attempt — to recapture its pathos.[1] Like the apprehensive Resurrected in the "Last Judgment" of Bourges Cathedral, a work as typical of the *détente* after Reims and Amiens as Memlinc's and his contemporaries' production is of the *détente* after Roger — his mourners "seem to say 'Oh, dear!' " "[2]

"Memlinc's narrative," to quote Friedländer's summation with which it would be futile to compete, "flows, in gentle waves, towards the blissful goal of redemption and transfiguration, gliding over that which is fearsome and dwelling on festive events. The slight and shallow stream is not obstructed or dammed by that penetrating observation, that intensive, inward interest in the data of form, that meticulous elaboration of details — in short, by those exertions which invest Netherlandish panels with depth, density, weight and rigidity. Ordered and clean like the people near to us, the country greets from afar, parklike, estival, with undulating roads, white horses, quiet bodies of water, swans, cozy and comfortable houses, and blue hills at the horizon — an idyllic homeland where the weather is perpetually fine. Memlinc is neither an explorer like Jan van Eyck nor an inventor like Roger. He lacks both the passion of seeing and the fanaticism of belief."[3]

For all his aversion to "rough edges" and all his allegiance to the Rogerian norm of beauty (did he not pattern the face of Bathsheba's bathing attendant after the model of Roger's late Madonnas?)[4] Memlinc cannot be classified as a thoroughgoing "idealist." According to Bellori's definition, the idealist assimilates every experience to a general concept — "idea" or, rather, "ideal" — which "originates in nature and, transcending its origin, makes itself the origin of art." Memlinc's general concepts, however, originate from tradition rather than nature and his experiences often refuse, as it were, to be lifted to the realm of general concepts. At times, therefore — or, to be more exact, in places — he is surprisingly close to reality. In a Biblical narrative a hand, a flower or a carved cabinet may strike us with the full force of individual existence.[5] He was a careful and sympathetic observer of animals (fig. 478). And his famous Ursula Shrine of 1489 contains, apart from other architectural portraits, two views of Cologne Cathedral precisely as it looked in that year, the choir with its flèche entirely finished, the nave barely begun, and the west front, with its crane, under construction.[6]

In short, Memlinc does not keep at a fixed distance from reality but approaches and withdraws from it in one and the same composition. Only where the area of observation was limited and no "general concepts" were involved, that is to say, in portraits, did he achieve a genuine synthesis of stylization and verisimilitude, a happy medium between Rogerian character and Eyckian individuality. His kindly responsiveness and sincerity could do justice to the best in all kinds of human beings without stooping to flattery, and it is in the field of portraiture that his style, otherwise so unchanging that it is nearly impossible to date his pictures without external evidence, shows progressive development, variety and even originality. Apart from relatively early pictures, such as the Portinari portraits in the Metropolitan Museum, he seldom contented himself with the plain background invariably employed by Jan van Eyck and Roger van der Weyden. He experimented, instead, with the "corner-space" portrait *à la* Christus and Bouts which he developed, not without imagination, by elaborating the corner into a rich in-

terior (as in the portrait of Martin van Nieuwenhove)[1] or by adding columns as in the "Portrait of a Young Man" in the Robert Lehman Collection,[2] the Moreel portraits at Brussels,[3] the double portrait now divided between the Louvre and the Kaiser Friedrich Museum,[4] and the "Benedetto Portinari" in the Uffizi.[5] And a truly important innovation was his idea, bold in its very simplicity, of setting out the figure against a landscape and nothing else. He may have derived this idea from Roger van der Weyden's Braque triptych in the Louvre, especially the Magdalen panel which has, if one may say so, all the makings of a portrait. But in what seem to be the earliest examples, the "Portrait of a Man" in the Städelsches Kunstinstitut at Frankfort[6] and the charming "Young Fiancée" in the Metropolitan Museum (fig. 477),[7] the landscape is still enframed by a kind of window. And since the treatment and costume of the Frankfort panel clearly reveal the influence of Dirc Bouts, Memlinc may have fused the scheme of Roger's Magdalen — or, for that matter, Bouts' *plein-air* Madonnas — with the idea of a window prospect exemplified by the latter's London portrait of 1462. Later on, at any rate, the framing device disappears, and the face of the sitter, dominating the field and proudly rising above a lowered horizon, gains more and more in importance and dignity. This final development, culminating in the admirable portrait of an Italian medalist — or, more probably, amateur numismatist — in the Museum at Antwerp (fig. 480)[8] and the "Portrait of a Man Praying" in the Mauritshuis at The Hague,[9] may well be due to a direct influence of Quattrocento painting where, after Piero della Francesca's famous double portrait of the Duke and Duchess of Urbino, illimited landscape backgrounds were fairly frequent. And it is perhaps more than an accident that Memlinc seems to have reserved this kind of treatment to members of the Italian colony.[10]

Be that as it may, it is certain that Memlinc, living at Bruges up to 1494, had even greater opportunities of familiarizing himself with Italian paintings than Hugo van der Goes. And positive proof of their influence is furnished by his last religious compositions: a "Resurrection of Christ" in the Louvre[11] and three "Madonnas Enthroned" — discreet variations on one theme — in the National Gallery at Washington (fig. 481), the Gemäldegalerie at Vienna, and the Uffizi.[12] In these four pictures the Gothic archways introduced by Roger van der Weyden in the "Granada-Miraflores" altarpiece, and hence appropriated by Petrus Christus and Dirc Bouts, are replaced by structures displaying such unmistakably Quattrocento features as capitals adorned with a degenerate form of the egg-and-dart pattern, lappeted canopies flapping in an imaginary breeze, nude *putti* and succulent garlands of fruit and leaves. But it is characteristic of Memlinc's adaptable yet essentially inalterable nature that the intrusion of these modern elements, apparently derived from Milanese rather than Florentine sources, had not the slightest effect upon his figure style. The "Resurrection" still follows the pattern set by the diminutive scene in the background of Roger's "Appearance of Christ to His Mother," and the three Madonnas are, strange to say, nothing but elaborations of one of Memlinc's earliest works, the central panel of a triptych ordered by an English nobleman, Sir John Donne of Kidwelly, in 1468 at the latest (fig. 476).[13] The Washington panel, the first of the triad and setting the standard for the two other versions, repeats with only superficial changes the arrangement of

the Virgin's robe as well as the action and pose of the Infant Jesus, and the angel with a violin, recurring three times in nearly identical fashion, offers his apple with the same amiably precious gesture as he had done some twenty years before.

From a purely compositional point of view, Memlinc's style seems to have more in common with what Wölfflin calls the *klassische Kunst*, that is, the art of the sixteenth century, than that of all his Netherlandish contemporaries. He preferred the vertical to the oblique, quiet frontality to an impetuous advance into space, simple correspondence to calculated imbalance. Even such exceptionally complex and, at first glance, somewhat chaotic panoramas as the so-called "Seven Joys of the Virgin" at Munich [1] or the "Passion of Christ" at Turin [2] reveal, upon analysis, a cautious equilibrium. And on the whole his design is governed, not only by verticalism, but also by strict, almost pedantic symmetry; a comparison of Roger's Columba altarpiece with its translations by Memlinc, the early "Adoration of the Magi" in the Prado (fig. 479) [3] and the Floreins triptych, dated 1479, in the Hôpital St.-Jean at Bruges, [4] speaks for itself.

However, this apparent affinity to the Cinquecento is negative rather than positive: it is due to retardation rather than progressiveness, and to the absence of Late Gothic Baroque tendencies rather than to the presence of a High Renaissance spirit. In applying the principles of verticalism, frontality and symmetry, Memlinc followed both the inclination of his own dispassionate temperament and the precepts of his native Rhenish tradition.[5] With him, one might say, these principles operate as a set of prohibitions which prevent movement, volume and spatial depth from being realized, and not as a method of imposing order upon movement, volume and spatial depth after — or, rather, in the process of — realization. There was no direct way from Memlinc to the High Renaissance. In order to gain access to the world of Leonardo and Raphael, a new generation of Flemish painters did precisely what Masaccio had done about a hundred years before, what young Michelangelo did at the same time, and what the Carracci and even Caravaggio were to do a hundred years later: they reverted to the sources.

<div align="center">IX</div>

The memory of the Flémalle Master and the van Eycks had, of course, remained alive throughout the second half of the fifteenth century. But prior to 1490-1500 their direct influence, as opposed to that transmitted by tradition, had generally been confined to duplication in such apparently not very numerous copies as the "Madonna in an Aedicula" in the Metropolitan Museum (copied, about 1460, after Jan's "Madonna at the Fountain"); [6] to unimaginative exploitation in second-rate paintings, book illuminations and prints as in the variations of Jan's lost "Bearing of the Cross" and the countless reflections of the "Depositions" by the Master of Flémalle and Roger van der Weyden; and to "respectful quotation" as in the "Calvary" of Joos van Ghent. Hugo van der Goes' ambivalent attitude toward the founders — that blend of hero worship and self-assertion which a modern psychologist might liken to the father complex — was unique as was his whole personality.

The turn of the century, however, confronts us with a genuine revival.[7] Reaching its

climax about 1510 and lasting up to *ca.* 1515–1520, this revival has a quantitative as well as qualitative aspect. We can observe an enormous increase in the production of copies of and variations on the works of Jan van Eyck and the Flémalle Master, indicative of a popular demand which does not seem to have existed in the preceding half-century, and culminating in archaistic reconstructions — among them, it would seem, the pseudo-Eyckian "Man with the Pink" — at times so successful that they are easily mistaken for *bona fide* replicas or even originals. And this revivification of the past, far from being limited to indifferent artists wanting in spirit and imagination, was fostered by the most productive and progressive painters of the time.

As far as the buying public is concerned, this phenomenon might be explained by the rise of a Northern humanism which, as had happened in Italy, was accompanied by the emergence of a novel sense of history with its concomitants of national and regional self-consciousness. The works of the great masters came to be looked upon "at a distance": no longer as possessions, however cherished, but as monuments of a past worthy of study and admired with a feeling akin to nostalgia. It is not until the sixteenth century that the praise of Jan van Eyck as "le roy des peintres" was heard from a Netherlander rather than an Italian[1] and that the name "Belgium," revived from Roman antiquity by the humanists of the Burgundian court, won general acceptance.[2]

On the part of the painters, however, there was something else. They felt, and just the very best of them, that they had to recapture, not only that freedom which Memlinc and the other later fifteenth-century masters of Bruges and Brussels had surrendered to Roger but also that sense of measurable space and ponderable solidity which Roger himself had sacrificed at the altar of transcendentalism. Looking back to pre-Rogerian art, they discovered in the work of the first generation a means of freeing themselves from the domination of the second and clearing the path for those to come.

One of the earliest, and certainly the most important exponent of this revival — an archaism harboring the seeds of progress, as it were — was Gerard David, a native of Oudewater between Gouda and Utrecht and presumably a pupil of Geertgen tot Sint Jans, established at Bruges in 1484, and active there, with brief interruptions, up to his death in 1523.[3] In spite of his probable training under Geertgen, Hugo van der Goes was psychologically inaccessible to him (an "Adoration of the Magi," apparently reflecting a prototype akin to the Monforte altarpiece, has aptly been called "a frozen waterfall");[4] and to Memlinc, his fellow townsman for ten years, he owes little more than those Italianate *putti*-and-garland motifs which he, otherwise averse to decoration, saw fit to introduce in such somewhat pompous compositions as the two panels illustrating the Justice of Cambyses now in the Museum at Bruges[5] and the triptych of Jan de Sedano in the Louvre (fig. 483).[6] But he found real inspiration in the works of Jan van Eyck and the Master of Flémalle. In the "Crucifixion" in the Thyssen Collection, we remember, he fused a Flémallesque composition with an Eyckian landscape (fig. 229),[7] and his image of the Deity in a lunette-shaped painting in the Louvre, the only remnant of what must have been one of his grandest ensembles, reflects the crowning figure of the Ghent altarpiece

(fig. 482).[1] In the Sedano triptych, just mentioned, the Infant Jesus and the First Parents on the exterior show the influence of the "Madonna van der Paele" and the Ghent altarpiece, respectively, while the two musical angels in the central panel, "stiff and round like candles,"[2] are derived from the Flémalle Master's "Madonna in an Apse"—a picture which exerted an almost obsessive influence on Gerard David's contemporaries and which he himself repeated *in toto*, though with the architectural setting significantly monumentalized, in a Madonna in the Epstein Collection at Chicago.[3]

Such palpable "borrowings"[4] would be of small importance were they not external symptoms of an inward affinity. What we admire in the mature Gerard David—his capacity for extricating the archetypal sphere or cylinder from the complexity of natural shapes, his feeling for the unity of solids and space, a treatment of light and shade which often approximates the Leonardesque *sfumato*, and a tonality which in such works as the Sigmaringen "Annunciation," recently acquired by the Metropolitan Museum,[5] foreshadows the blue period of Picasso—all this may be explained, to some extent, as a last flowering of the tradition which can be traced from Petrus Christus to Ouwater and from Ouwater to Gerard David's probable teacher, Geertgen tot Sint Jans. But he would not have been able to place these pictorial qualities in the service of that spacious grandeur which raises his London "Betrothal of St. Catherine" (figs. 485, 486)[6] and his "Virgin among Virgins" of 1509, now in the Museum of Rouen[7] but originally donated by himself to the Carmelite Monastery at Bruges (fig. 484), to the level of the High Renaissance had he not understood the very essence of Jan van Eyck's "Madonna van der Paele" and the Flémalle Master's "*Sacra Conversazione.*" Nor would his Crucifixions, especially the almost miraculous one in the Palazzo Bianco at Genoa,[8] have attained their classic monumentality had he not restored to the figure of the crucified Christ that hieratic rigidity, observed by both the Master of Flémalle and Jan van Eyck, which Roger van der Weyden had abandoned in favor of graceful resilience;[9] even where Gerard David, quite exceptionally, patterned the other figures of a Calvary on a Rogerian model, the crucified Christ remained inflexible.[10]

For Gerard David, middle-aged at the beginning of the new century and working alone in a declining Bruges, the return to the founders was an inner necessity. Striving for a new language without the benefit of a new vocabulary, he approached Jan van Eyck and the Master of Flémalle as Dürer approached the Italians: both with a sense of dependence and spontaneous understanding. This productive archaism, as it may be called, was opposed to the reproductive archaism of his Brussels contemporary, Colin de Coter, who, equally dependent on the past but thoroughly incapable of transcending it, turned the manufacture of Flémallesque copies and paraphrases into a lucrative profession.[11] But it was also opposed to the somewhat supercilious archaism of a younger generation which no longer needed the old masters but imitated their works while, at the same time, asserting its own independence and modernity.

Bernard van Orley, the Protean court painter of Margaret of Austria, colossalized and modernized the "Madonna in an Apse" by placing the principal figure in front of a crowded group of animated angels and setting the whole in an up-to-date Renaissance frame.[12] Jan

Gossart transformed the St. Donatian of the "Paele Madonna" into a somewhat aggressive portrait in half-length.[1] He elaborated the "upper triptych" of the Ghent altarpiece into a Deësis surrounded by ultra-Flamboyant tracery (fig. 488).[2] And in one of his pictures, preserved in the Galleria Doria at Rome (fig. 487), he even tried to emend the "Madonna in a Church" while ostensibly copying it.[3] In an attempt to "rectify" the relationship between figure and architecture, he widened the proportions of the church and set the figure deeper into space. He sobered the illumination by omitting the sunshine effect and filling the windows with clear glass instead of stained; and, most significantly, added a row of piers on the right, thereby achieving some kind of symmetry while spoiling the impression of infinitude. In short, he modernized — and misunderstood — the "Madonna in a Church" in precisely the same manner as did the contemporary French perspectivist, Jean Pèlerin-Viator, Dürer's "Presentation of Christ."[4]

If Gerard David's archaism may be described as both essential and perceptive, Colin de Coter's as essential but imperceptive, and Jan Gossart's as non-essential and imperceptive, a fourth possibility — that of an archaism peripheral rather than central yet comprehending and very consequential — is represented by Quentin Massys.[5] Born at Louvain in 1465 or 1466 but living at Antwerp from 1491 up to his death in 1530, he was a contemporary of Gerard David. But while David carried a sense of the future into a city of the past, Massys carried a memory of the past into a city of the future. Brought up under the shadow of Roger's great "Descent from the Cross" but plunging into the light of what had become the richest, most modern and most cosmopolitan community of Northern Europe, where palaces, churches, and entire streets sprang up overnight[6] and Italians, Portuguese, Germans and negroes mingled with the indigenous population, Massys needed the style of the old masters as a stabilizing rather than a stimulating influence, and as a preparation rather than a substitute for the assimilation of Italian sources. And it is just because of this more distant and, therefore, freer attitude towards the first generation that he was able to accomplish two things which were beyond the reach of other "archaists": he — and his followers — could proceed from imitation and emulation to actual reconstruction; and he could finally effect a genuine synthesis between the indigenous tradition and the Italian High Renaissance.

Massys' beautiful "Madonna Enthroned" in the Brussels Museum (fig. 489)[7] gives, in a general way, a Flémallesque or early Rogerian impression. But the space-displacing, massive form, the luminous hair and the jewel-studded border of the robe suggest an admixture of Eyckian art, and upon closer inspection the figure reveals itself as an ingenious blend of models such as the central figure in the Flémalle Master's "*Sacra Conversazione*" or Roger's "Madonna in Red" with the Virgin Mary in the "upper triptych" of the Ghent altarpiece. A similar fusion can be observed in his variations, also of relatively early date, on the inevitable theme, the Flémalle Master's "Madonna in an Apse." In a picture owned by Count Seilern at London (of which the better-known Madonna at Lyons is a competent replica)[8] the apse is replaced by a Renaissance frame (fig. 490) while in a picture preserved in a private collection in Switzerland[9] (apparently executed by an assistant) the figure appears in a *Hortus conclusus* cut out

from a rich landscape by a low brick wall. But in both cases the posture and gesture of the Infant Jesus are remodeled after the pattern of Jan's "Madonna in a Church," and in the Seilern picture the fibrous Gothic of Jan's cathedral is echoed in the complex ecclesiastical architecture, a curious mixture of interior and exterior view, which somewhat incongruously unfolds behind the Renaissance frame.

The most conspicuous example of a "reconstruction" is Massys' much imitated "Money Changer and His Wife" in the Louvre (fig. 491), dated 1514.[1] Archaic not only in costume but also in technique, this painting evidently parallels Jan van Eyck's "Picture with half-length figures representing a patron making up his accounts with an agent" which Marcantonio Michiel saw in the Casa Lampagnano at Milan, and may even serve to dispel his uncertainty as to whether this picture was Jan's or Memlinc's.[2] Massys' interior, its shelves displaying a still-life-like arrangement of books and writing implements and its table strewn with coins and other shining objects, compares with that in Jan's "St. Jerome" at Detroit, the money changer's wife is dressed in a coat quite similar to that worn by Margaret van Eyck in the Bruges portrait, and the convex mirror turned toward the window is prefigured in Petrus Christus' "St. Eloy." That Quentin Massys' followers were equally adept at "reconstructions" of this kind is indicated by the fact that the Master of the Death of the Virgin, now customarily though not quite cogently identified with Joos van Cleve,[3] could produce a portrait, recently acquired by the Fogg Museum at Harvard, which so successfully recaptures the spirit of an earlier period that it has been considered a copy after a lost Roger van der Weyden of about 1435.[4]

The Master of the Death of the Virgin also exemplifies the ease with which in Massys' circle old inventions could be adapted to new uses and ultimately merged with Italian elements. By the addition of a St. Joseph and the elaboration of the interior after the fashion of Massys' "Money Changers," he transformed a close-up of Jan van Eyck's "Lucca Madonna" into a charming "Holy Family" emerging in half length from behind a parapet (fig. 494),[5] and he applied an analogous method to the Flémalle Master's Frankfort Madonna from which he retained the picturesque kerchief, the nursing motif and the gesture of the Infant Jesus Who with both hands embraces the Virgin's breast (fig. 495).[6] But in several variants of this second composition (which was incessantly repeated in the master's studio) we can observe the intrusion of Italianisms. The Virgin's left hand is foreshortened in Leonardesque manner; the Christ Child is made to stand upon the parapet; and in the latest version, in which the nursing motif has been abandoned, He assumes a posture reminiscent of Raphael's "Bridgewater Madonna" (fig. 496).[7]

The most instructive examples of this interplay between archaic and Italian elements are found, however, in the work of Massys himself. His portrait of an Old Gentleman in the Musée Jacquemart-André at Paris (fig. 492), dated 1513, has rightly been compared with the "Robert de Masmines" by — or, rather, after — the Master of Flémalle with which it agrees in the vigorous modeling and the emphatic detachment of the head from the light ground. But it is, after an interval of almost exactly one hundred years,[8] the first full-profile portrait in Netherlandish painting, and we must remember that this reappearance of a type imported

from Italy in the fourteenth century but completely abandoned after *ca.* 1420, constitutes in itself a Renaissance phenomenon.[1] Italian influence is further suggested by the fact that the face of the sitter bears a kind of family likeness to one of Leonardo's "caricatures" — more appropriately, studies in physiognomy — which has come down to us in an engraving by Wenzel Hollar;[2] and that his curious cap is a but slightly modernized version of the headgear worn by Cosimo de' Medici and other Italian gentlemen about the middle of the fifteenth century.[3]

Neither of these resemblances, however, is close enough to warrant the assumption that the Paris picture is a fantasy rather than a portrait from life. Far from fusing a Leonardesque caricature and other Quattrocento models into an imaginary composite, Massys would seem to have interpreted an actual personage after the fashion of a Leonardesque "caricature" and other Quattrocento models suggested by the appearance and bearing of this very personage. Confronted with the task of portraying a somewhat unprepossessing but thoroughly imposing old gentleman — presumably an Italian himself — he dealt with his model's flaccid jowls and double chin, protruding underlip and pendulous yet sharply contoured nose precisely as Dürer, ten years later, was to deal with the similar countenance of Archbishop Albrecht of Brandenburg. Both Massys' portrait of 1513 and Dürer's "Great Cardinal" of 1523 ennoble their subjects by showing them in a deliberately stylized profile view which minimizes the effect of mass and volume by maximizing the importance of structure and line. And if Massys achieved this stylization with the aid of Italian prototypes, Dürer may have achieved it with the aid of Massys' Paris portrait which he could easily have seen during his stay at Antwerp in 1520–1521.[4]

Misericord in the church at Ludlow in Shropshire
(after Wright).

Massys' "Old Gentleman" is, therefore, not so much the counterpart as the opposite of his famous "Ugly Duchess," now in the National Gallery at London (fig. 493).[5] Where the former, however *outré*, may be accepted as a *bona fide* portrait, the latter is an anonymous study in the grotesque, in fact, a piece of social satire; for, to identify the grim, yet somehow pathetic old creature, made even more repulsive by the excessive richness of her attire and the "disgusting lowness" of her décolleté, with the long-deceased Margaret Maultasch, Countess of the Tyrol, is as arbitrary as to call her "The Queen of Tunis." And her traditional claim to

a ducal coronet rests only on the fact that Sir John Tenniel had the bright idea of employing her features for the immortal Duchess in *Alice's Adventures in Wonderland*.

In iconography, Massys' picture was inspired, I believe, by his good friend, Erasmus of Rotterdam; it shows a horrifying example, perhaps too horrifying from the humanist's uncensorious point of view, of those foolish old women who, to quote from the *Praise of Folly*, still wish to "play the goat," "industriously smear their faces with paint," "never get away from the mirror," and have no hesitation to "display their foul and withered breasts."[1] In design, however, it is directly based, again, upon a "caricature" by Leonardo da Vinci,[2] and the reader may ask why it is here adduced in connection with the problem of archaism. However, while attention has been called to the fact that the atrocious headdress sported by Leonardo's — and, consequently, Massys' — old lady conforms to the fashion of 1430–1450, it has not, so far as I know, been pointed out that this fashion is Northern rather than Italian. In less extravagant form, this two-horned "wimple" is worn, for instance, by Jeanne Cenami and Margaret van Eyck; and it must have been in Eyckian art, or at least in an Eyckian environment, that its contrast with an extremely unattractive countenance was exploited in a satirical spirit. One of the woodcarved misericords in the church of Ludlow in Shropshire, datable about 1440,[3] represents the perennial object of wistful ridicule, the nagging wife who can be stopped only by gag and bridle, under the guise of a woman whose headgear and facial type proclaim her a great-great-aunt, so to speak, of Massys' "Ugly Duchess." Given the derivative character of the representational arts in fifteenth-century England, we may infer that this misericord reflects, however crudely, an Early Flemish prototype which, some fifty years later, was to appeal to Leonardo's all-embracing interest in the scientific exploration of man. And when Massys elaborated Leonardo's impersonal study in human physiognomy into a bitter satire on human folly he reverted, unwittingly, to the tradition of his own ancestors.

The "Archaism of around 1500," then, is not an ephemeral fashion but a phenomenon of basic importance: a prelude to, in fact a facet of, the Renaissance in Netherlandish painting. But it should not be forgotten that this phenomenon was limited to the southern part of the country. The two great pioneers of modernism in Holland, Lucas van Leyden and Jan Scorel,[4] did not look back to Jan van Eyck and the Master of Flémalle because they did not need to free themselves from Roger van der Weyden. Heirs to that slowly growing separatistic tendency which, in the last decades of the fifteenth century, had manifested itself in a cleavage between "Late Gothic Baroque" and *détente*, they no longer conceived of the great Flemings as "their" ancestors. Beginning to think of themselves as *Batavi* much as the men of Flanders, Brabant and the Hainaut began to think of themselves as *Belgae*, they achieved the transition from the Middle Ages to the Renaissance under the guidance of Dürer (whose influence on Gossart, Bernard van Orley, Massys and Massys' school was no less extensive but not equally essential) and, above all, by direct contact with Italy.[5] And it is this declaration of independence from a common past which formalized — and, in a measure, finalized — a genuine division of Netherlandish painting into "Flemish" and "Dutch."

EPILOGUE: THE FOUNDERS' HERITAGE

No survey of Early Netherlandish Painting can be complete without a discussion of Jerome Bosch.[1] Such a discussion, however, is not only beyond the scope of this volume, but also, I am afraid, beyond the capacity of its author. Lonely and inaccessible, the work of Bosch is an island in the stream of that tradition the origins and character of which I have endeavored to describe. His technical procedure is unique as are the operations of his mind, and such connections as are presumed to exist between his paintings and those of the Master of Flémalle, Jan van Eyck, Roger van der Weyden, and Dirc Bouts are imaginary at worst and insignificant at best.[2] Rather he sank his roots into the subsoil of popular and semipopular art — woodcuts, engravings, carvings in wood or stone, and, most important, book illumination. His archaism (for he, too, was an archaist) by-passed the founders and drew inspiration from the sartorial eccentricities of the International Style; from the fantastic and often Rabelaisian humor of the drolleries in fourteenth- and early fifteenth-century manuscripts, English as well as Continental; and from the physiognomical overstatements — crass by a very excess of veracity — of the "réalisme pré-Eyckien."[3] And he must have been especially attracted by the illustration of such allegorical treatises and poems as the *Pèlerinage de Vie Humaine* in which the literal picturalization of verbal imagery had resulted in such truly Boschian phantasmagorias as a big rock shedding tears from an enormous eye into a bucket,[4] or severed human ears transfixed by a barbed skewer (fig. 138).[5]

Edifying — and horrifying — religious literature (for example, the *Ars moriendi* and such accounts of Hell and Purgatory as the *Visio Tundali* or the Legend of the Pilgrim to Jerusalem from Vincent of Beauvais' *Speculum historiale*) must also have played its part in Bosch's intellectual life, together with popular science,[6] Rabbinical legend, the inexhaustible storehouse of native folklore and proverbial wisdom, and, above all, orthodox Christian theology. But there is no conclusive evidence for his familiarity with gnostic, Orphic, and Neoplatonic mysteries; and I am profoundly convinced that he, a highly regarded citizen of his little home town and for thirty years a member in good standing of the furiously respectable Confraternity of Our Lady (*Lieve-Vrouwe-Broederschap*), could not have belonged to, and worked for, an esoteric club of heretics, believing in a Rasputin-like mixture of sex, mystical illumination and nudism, which was effectively dealt with in a trial in 1411 and of which no one knows whether it ever survived this trial.[7] To judge from his works as well as from his portrait (preserved in the "Recueil d'Arras"),[8] Jerome Bosch was not so much a heretic as one of those extreme moralists who, obsessed with what they fight, are haunted, not unpleasurably, by visions of unheard-of obscenities, perversions and tortures. The favorite painter of Philip II[9] might have derived more satisfaction from seeing an attractive heretic burn than from joining her, as a *sinnlich-übersinnlicher Freier*, in an ascent to paradisiacal bliss. Like Philip II himself, he may have been a case for psychoanalysis, but not for the Inquisition.

In spite of all the ingenious, erudite and in part extremely useful research devoted to the task of "decoding Jerome Bosch," I cannot help feeling that the real secret of his magnificent nightmares and daydreams has still to be disclosed. We have bored a few holes through the door of the locked room; but somehow we do not seem to have discovered the key. When

357

Adelphus Müelich, the honest translator of Marsilio Ficino's *De vita triplici*, had happily finished with the First and Second Books, he was stumped by the Third which deals with the "Life That May Be Obtained from the Celestial Spheres," the very arcanum of the Neoplatonic doctrine. And rather than inflict upon his readers a paraphrase of what had remained obscure to himself, he limited his efforts to a translation of the title line and added the following couplet:

> Das gar hoch zu verston,
> Ist hie vss gelon.[1]

Which is in English:

> This, too high for my wit,
> I prefer to omit.

NOTES

In cross references, notes are referred to by the text passages to which they belong. "Note 31 [5] " would refer, therefore, to the fifth note belonging to text page 31.

NOTES

Page 1

1. Martin Luther, *Tischreden*, February 9, 1539, no. 7035. For Michelangelo, see the well-known statements in Francisco de Hollanda's *Dialagos em Roma*, a document of *Michelangiolismo* which has no more, but also no less, relation to Michelangelo than Marxism has to Marx (cf. E. Steinmann and R. Wittkower, *Michelangelo Bibliographie 1510–1926*, Leipzig, 1927, no. 1009).

2. Vasari, *Le Opere di Giorgio Vasari*, G. Milanesi, ed., Florence, 1878–1906, VI, p. 266.

3. Vasari, *op. cit.*, V, p. 398.

Page 2

1. See also p. 188 ff.

2. Cf. A. Warburg, *Gesammelte Schriften*, Leipzig and Berlin, 1932, I, p. 210. For the date of execution, see p. 332.

3. Explicitly, the invention is ascribed to Jan by Vasari, *op. cit.*, I, p. 184, II, p. 565 ff. (see note 180 [1]). By implication, it had been attributed to him by Fazio's statement quoted in note 2 [7], and by the old tradition according to which Roger van der Weyden was Jan van Eyck's pupil (e.g., Bartolommeo Fazio and Giovanni Santi, quoted p. 153) and both excelled in the use of the new oil technique (see Averlino Filarete's treatise on architecture of 1457–1464: *Antonio Averlino Filaretes Tractat über die Baukunst*, W. von Oettingen, ed., Vienna, 1890, p. 640).

4. Description of a triptych, owned by Lionello d'Este of Ferrara, with an Expulsion from Paradise and a donor's portrait in the wings, and an Entombment or Descent from the Cross in the center (cf. also note 2 [7], second paragraph):

"Cuiusce nobilissimi artificis manu apud Ferrariam VIII Iduum quintilium N.V.P.A. III [*scil.*, July 8, 1449, the third year of the reign of Nicolaus V] Lionellus hestensis princeps illustris eximii operis tabellam nobis ostendit primorum quoque parentum ac e supplicio humanati Jovis depositi pientissimo [rare form of *piissimo*] agalmate circum et plerumque virum [archaic form of *virorum*] imaginibus mulierumque moestissime deploratum [should read deplorantium] imaginibus mirabili quidem et potius divina quam humana arte depictam. Nam vivos aspirare vultus videres, quos viventes voluit ostentare, mortuique simile defunctum, et utique velamina tanta, plurigenumque colorum paludamenta, elaboratas eximie ostro atque auro vestes, virentiaque prata, flores, arbores et frondigeros atque umbrosos colles, necnon exornatas porticus et propylea, auro [should read *aurum*] auri simile, margaritis [should read *margaritas* or *margarita*], gemmas, et coetera

omnia non artificio manu hominis quin ab ipsa omni-parente natura inibi genita diceres"

(quoted, with some slight emendations, after F. Winkler, *Der Meister von Flémalle und Rogier van der Weyden*, Strasbourg, 1913, p. 181 f.).

5. Alessandra Macinghi negli Strozzi, *Lettere*, C. Guasti, ed., Florence, 1877, p. 230 f. (letter of March 6, 1460). Of other Flemish pictures — not *arazzi* — in her possession she mentions an "Adoration of the Magi" and a "Peacock" which she finds "cute" (*gentile*).

6. Francisco de Hollanda, *op. cit.*

7. In view of the basic importance of Fazio's brief biographies of Jan van Eyck and Roger van der Weyden, it may be justifiable to reprint them in full after *Bartholomaei Facii De Viris Illustribus*, L. Mehus, ed., Florence, 1745, pp. 46 and 48 (cf. A. von Wurzbach, *Niederländisches Künstlerlexicon*, Vienna and Leipzig, I, 1906, p. 517 and II, 1910, p. 875):

"*Joannes Gallicus* nostri saeculi Pictorum princeps judicatus est, literarum nonnihil doctus Geometriae praesertim, & earum artium, quae ad picturae ornamentum accederent, putaturque ob eam rem multa de colorum proprietatibus invenisse, quae ab antiquis tradita ex Plinii, & aliorum auctorum lectione didicerat. Ejus est tabula insignis in penetralibus Alphonsi Regis, in qua est Maria Virgo ipsa venustate, ac verecundia notabilis, Gabriel Angelus Dei filium ex ea nasciturum annuntians excellenti pulchritudine capillis veros vincentibus, Joannes Baptistae vitae sanctitatem, & austeritatem admirabilem prae se ferens, Hieronymus viventi persimilis, Bibliotheca mirae artis, quippe quae, si paulum ab ea discedas, videatur introrsus recedere, & totos libros pandere, quorum capita modo appropinquanti appareant. In ejusdem tabulae exteriori parte pictus est Baptista Lomellinus, cuius fuit ipsa tabula, cui solam vocem deesse iudices, & mulier, quam amabat praestanti forma, & ipsa, qualis erat, ad unguem expressa, inter quos Solis radius veluti per rimam illabebatur, quem verum Solem putes. Ejus est Mundi comprehensio orbiculari forma, quam Philippo Belgarum principi pinxit, quo nullum consummatius opus nostra aetate factum putatur, in quo non solum loca, situsque regionum, sed etiam locorum distantiam metiendo dignoscas. Sunt item picturae ejus nobiles apud Octavianum Cardinalem virum illustrem, eximia forma feminae e balneo exeuntes occultiores corporis partes tenui linteo velatae notabili rubore, e quis unius os tantummodo, pectusque demonstrans posteriores corporis partes per speculum pictum lateri oppositum ita expressit, ut & terga, quemadmodum pectus videas. In eadem tabula est in balneo lucerna ardenti simillima & anus, quae sudare videatur, catulus aquam lambens, & item equi, hominesque perbrevi statura, montes, nemora, pagi, castella tanto

artificio elaborata, ut alia ab aliis quinquaginta milibus passuum distare credas. Sed nihil prope admirabilius in eodem opere, quam speculum in eadem tabula depictum, in quo quaecumque inibi descripta sunt, tanquam in vero speculo prospicias. Alia complura opera fecisse dicitur, quorum plenam notitiam habere non potui.

"*Rogerius Gallicus* Joannis discipulus, & conterraneus multa artis suae monumenta singularia edidit. Ejus est tabula praeinsignis Jenuae, in qua mulier in balneo sudans, juxtaque eam catulus, ex adverso duo adolescentes illam clanculum per rimam prospectantes ipso risu notabiles. Ejus est tabula altera in penetralibus Principis Ferrariae, in cuius alteris valvis Adam et Eva nudis corporibus e Terrestri Paradiso per Angelum ejecti, quibus nihil desit ad summam pulchritudinem: in alteris Regulus quidam supplex: in media tabula Christus e cruce demissus, Maria Mater, Maria Magdalena, Josephus ita expresso dolore ac lacrymis, ut a veris discrepare non existimes. [This is the triptych also described by Cyriacus of Ancona.] Ejusdem sunt nobiles in linteis picturae apud Alphonsum Regem eadem Mater Domini renuntiata Filii captivitate consternata, profluentibus lacrymis servata dignitate consummatissimum opus. Item contumeliae, atque supplicia quae Christus Deus noster a Judaeis perpessus est, in quibus pro rerum varietate sensuum atque animorum varietatem facile discernas. Bursellae quae urbs in Gallia est, aedem sacram pinxit absolutissimi operis."

Page 3

1. As reflections of this lost composition are frequently adduced, first, a picture once owned by Cornelius van der Geest in Antwerp whose gallery was immortalized by a painting of 1628 by William van Haecht; second, a panel in the Municipal Museum at Leipzig (*Zeitschrift für Bildende Kunst*, XVII, 1882, p. 379 ff.) which represents a nude woman engaged in magic practices before a mirror. Both paintings, however, have no direct connection with the panel formerly owned by Cardinal Ottaviani. The Leipzig picture has no more in common with it than the presence of a nude woman and a mirror; the other seems to reflect an entirely different prototype (see note 203 [5]).

2. For the problems of perspective repeatedly referred to in the following pages, see, apart from the writer's "Die Perspektive als symbolische Form," *Vorträge der Bibliothek Warburg*, 1924–25, p. 258 ff., the excellent monograph by M. Schild Bunim, *Space in Medieval Painting and the Forerunners of Perspective*, New York, 1940, with exhaustive bibliography on p. 207 ff., to which may be added: G. R. Levy, "The Greek Discovery of Perspective: Its Influence on Renaissance and Modern Art," *Journal of the Royal Institute of British Architects*, L, 1942–43, p. 51 ff.; E. Panofsky, *The Codex Huygens and Leonardo da Vinci's Art Theory* (Studies of the Warburg Institute, XIII, London, 1940), especially p. 90 ff.; ———, *Albrecht Dürer*, Princeton, 1943 (2nd ed., 1945; 3rd ed., 1948), p. 274 ff.; W. M. Ivins, *Art and Geometry*, Cambridge, Mass., 1946; J. White, "Developments in Renaissance Perspective," *Journal of the Warburg and Courtauld Institutes*, XII, 1949, p. 58 ff., XIV, 1951, p. 42 ff.

Page 5

1. In spite of all the changes in accident to which space was subjected from *ca.* 1400 to the end of the nineteenth century, it remained unaltered in substance. Even Mannerism and Baroque, even Matisse, Gauguin and Cézanne do not defy the assumption that space, whatever happens within it, is three-dimensional (cf. Cézanne's famous injunction to "treat nature by the cylinder, the sphere, the cone, *everything in proper perspective* so that every side of an object or a plane is directed towards a central point"), continuous and, therefore, static. It was only with Picasso, and his more or less avowed followers, that an attempt was made to open up the fourth dimension of time so that the objects cease to be determinable by three co-ordinates alone and can present themselves in any number of aspects and in all states of either "becoming" or disintegrating. In the present discussion the use of the term "modern" is naturally limited to a pre-Picassian or non-Picassian interpretation of space.

Page 7

1. M. Meiss (who first pointed out Piero della Francesca's indebtedness to Jan van Eyck), "A Documented Altarpiece by Piero della Francesca," *Art Bulletin*, XXIII, 1941, p. 53 ff., especially p. 64. Cf. also Sir Kenneth Clark, "Piero della Francesca's St. Augustine Altarpiece," *Burlington Magazine*, LXXXIX, 1947, p. 205 ff., and Mr. Meiss' answer, *ibidem*, p. 286.

Page 8

1. See also p. 349. Among the "few and well-motivated exceptions" may be mentioned the fifteen Flemish copies after an Italo-Byzantine Madonna imported into Flanders after the Council of Florence and preserved at Cambrai from 1450 up to our day (see p. 297). For the Italian influences on Roger van der Weyden and Hugo van der Goes, also resulting from special circumstances, see pp. 273 ff., 278, 342 f.

Page 9

1. See also note 356 [5].

Page 10

1. See, e.g., the "Hediste Stele" from Pagasai of *ca.* 200 B.C. (E. Pfuhl, *Malerei und Zeichnung der Griechen*, Munich, 1923, vol. III, fig. 748).

2. Aristotle, *Nicomachian Ethics*, II, 5, 1106 b 29 (quoted as Aristotle's own view in C. R. Morey, *Mediaeval Art*, New York, 1942, p. 11).

3. Cf. S. Luria, "Die Infinitesimaltheorie der antiken Atomisten," *Quellen und Studien zur Geschichte der Mathematik, Astronomie und Physik*, Abteilung B (Studien), II, 1933, p. 106 ff.

4. Cf. Luria, *op. cit.*, p. 138 ff., demonstrating that Democritus' much-quoted "cone paradox" (H. Diels, *Die Fragmente der Vorsokratiker*, Berlin, first edition, 1903, fragm. B 155: if the horizontal cross sections of a cone are unequal it would consist of distinct steps; if they are equal it would be a cylinder) could, from the atomist's point of view, be resolved in favor of the first alternative, provided that the individual laminae are imperceptibly — though not infinitesimally — small.

5. Aristotle, *On the Heavens*, III, 8, 307 a, quoted and interpreted by Luria, *op. cit.*, p. 145. It is, however, perhaps not quite correct to speak, with reference to Democritus, of the circle and the sphere as of a polygon or polyhedron with "*unendlich* vielen Ecken." According to him, the number of corners could never reach infinity because even the smallest element has an irreducible magnitude.

6. Aristotle, *Physics*, VI.

7. Aristotle, *On the Heavens*, I, 9, 279 a.

8. Aristotle, *Physics*, III, 7, 207 b.

Page 11

1. Aristotle, *ibidem*, III, 5, 205 b and IV, *passim*.

2. See Panofsky, "Die Perspektive als symbolische Form," pp. 265, 300 ff. For the whole problem of Hellenistic and Roman perspective, see Schild Bunim, *op. cit.*, pp. 12–37 (with instructive diagrams in figs. 74 and 75).

Page 12

1. R. Luneburg, "Metric Methods in Binocular Visual Perception," *Studies and Essays Presented to R. Courant on His 60th Birthday*, New York, 1948, p. 215 ff. For the opposite view, according to which the classic, Brunelleschian construction is an adequate — in fact, the only adequate — method of reproducing the visual image, see M. Zanetti, "Una Proposta di riforma della prospettiva lineare," *L'Ingegnere*, September, 1951; and M. H. Pirenne, "The Scientific Basis of Leonardo da Vinci's Theory of Perspective," *The British Journal for the Philosophy of Science*, III, 1952, p. 169 ff.

Page 13

1. The High Medieval concept of space as the limited Aristotelian τόπος embedded, as it were, in the infinity of God is nicely formulated in a remarkable miniature of *ca.* 1200 formerly in the Forrer Collection at Strasbourg (illustrated in H. Swarzenski, *The Berthold Missal*, New York, 1943, fig. 38) which represents Space itself (*Locus*) as a figure enthroned, holding a scroll inscribed with the following self-characterization:

"Sum locus inque loco teneor; nihil ergo movetur.
Nec jacet extra me nisi rerum conditor ipse,
Cum sibi sit locus et lux, lex, via, vita vel esse.
Nil petit extra se, magis omnia continet in se."

("I am Space, and am held fast in space so that nothing is moved. Nor is anything outside myself, except the very Creator of the world; for He exists for Himself as space and light, the law, the way, the life or being. He wants nothing outside Himself; rather He contains everything within Himself.")

2. The writer remembers this formula from his student days in 1914.

3. Cf. E. T. DeWald, *The Illustrations of the Utrecht Psalter*, Princeton, n.d. [1932]; also D. Panofsky, "The Textual Basis of the Utrecht Psalter Illustrations," *Art Bulletin*, XXV, 1943, p. 50 ff.

4. Paris, Bibliothèque Nationale, ms. lat. 8846 (H. Omont, ed., Paris, n.d.), preceded by London, British Museum, ms. Harley 603 of the eleventh century and by the "Canterbury Psalter" of *ca.* 1150 (*The Canterbury Psalter, with Introduction by M. R. James*, London, 1935).

Page 14

1. *Abbot Suger on the Abbey Church of St.-Denis and its Art Treasures* (E. Panofsky, ed. and trans.), Princeton, 1946, p. 47.

2. Cf. R. de Lasteyrie, "Note sur un châssis de vitrail . . ." *Revue de l'Art Chrétien*, IV, 1893, p. 443 ff.; H. Oidtmann, *Die Rheinischen Glasmalereien vom 12. bis zum 16. Jahrhundert*, Düsseldorf, I, 1912, pp. 47, 51.

Page 15

1. *Villard de Honnecourt, Kritische Gesamtausgabe des Bauhüttenbuches ms. fr. 19093 der Pariser Nationalbibliothek*, H. R. Hahnloser, ed., Vienna, 1935, pl. 63.

2. The similarity which exists between these remarks and those in H. Beenken, "Die Mittelstellung der mittelalterlichen Kunst zwischen Antike und Renaissance," *Medieval Studies in Memory of A. Kingsley Porter*, Cambridge, Mass., 1939, I, p. 47 ff., especially p. 70 f., can be explained by the similarity which exists between Beenken's remarks and those in the writer's *Die Deutsche Plastik des elften bis dreizehnten Jahrhunderts*, Munich, 1924, p. 35 f.; cf. also Beenken's interpretation of the difference between the circular temple at Ba'albek and apparently similar

Baroque structures (Beenken, p. 50 f.) with that of the writer (*Die Deutsche Plastik*, p. 52 f.).

3. Paris, Bibliothèque Nationale, ms. lat. 1023 (H. Martin, *La Miniature française du XIIIᵉ au XVᵉ siècle*, Paris and Brussels, 1923, pl. 18). Recently R. Blum, "Maître Honoré und das Brevier Philipps des Schönen," *Zentralblatt für Bibliothekswesen*, LXVIII, 1948, p. 225 ff., has shown that Master Honoré's authorship, while still quite probable, is not so certain as used to be assumed; on the other hand, he has confirmed the identity of the manuscript with a "Breviarium factum pro rege" on the responsibility of Dominus Galterus, Canon of the Ste.-Chapelle, and paid for in 1296. A manuscript some miniatures of which announce the style of Master Honoré is the "Psalter of Yolande de Soissons" in the Morgan Library, ms. 729; see *The Pierpont Morgan Library, Exhibition of Illuminated Manuscripts Held at the New York Public Library*, November 1933 to April 1934 (hereafter referred to as "*Morgan Catalogue, 1934*"), no. 57, pl. 52.

Page 16

1. Leone Battista Alberti, *Kleinere kunsttheoretische Schriften*, H. Janitschek, ed. (Wiener Quellenschriften für Kunstgeschichte, XI), Vienna, 1877, p. 123.

Page 17

1. Cf. the excellent remarks in G. Swarzenski, "A Marriage Casket and Its Moral," *Bulletin of the Museum of Fine Arts, Boston*, XLV, 1947, p. 55 ff.: "Almost in contrast to the manifestation of architectonic forms and monumental aims there was developed in Italy a flourishing picturesque combination of wood, painting, and gesso. Nowhere else are the art and the craft of the painter and carpenter or cabinet-maker to be found in so intimate collaboration as here, especially in Tuscan Tre- and Quattrocento furnishings . . . one should remember the fact that the refined appreciation of wood as a beautiful material, the enjoyment of the delicate effects of its surface and graining, are significant of the northern countries but almost unknown in Italy."

Page 18

1. Cf. F. Horb, *Das Innenraumbild des späten Mittelalters; seine Entstehungsgeschichte*, Zürich and Leipzig, n.d. [1938]; ———, "Cavallinis Haus der Madonna," *Göteborgs Kungl. Vetenskaps- och Vitterhets-Samhälles Handlingar*, ser. 7, ser. A, III, no. 1, 1945.

2. Cf. E. Rosenthal, *Giotto in der mittelalterlichen Geistesentwicklung*, Augsburg, 1924, with interesting juxtapositions on pls. 35–57.

3. For the origin of this new scheme, see A. Goldschmidt, "Das Naumburger Lettnerkreuz im Kaiser-Friedrich-Museum in Berlin," *Jahrbuch der Königlich Preussischen Kunstsammlungen*, XXXVI, 1915, p. 137 ff. Cf. also R. Berliner, "The Freedom of Mediaeval Art," *Gazette des Beaux-Arts*, ser. 6, XXVIII, 1945, p. 263 ff., especially p. 278; and the judicious assessment of the problem in A. Anderson, *English Influence in Norwegian and Swedish Figure Sculpture in Wood, 1220–1270*, Stockholm, 1949, p. 287, note 1. Recently H. Wentzel, "Miscellanea," *Neue Beiträge zur Archaeologie und Kunstgeschichte Schwabens; Festschrift Julius Baum*, Stuttgart, 1952, p. 40 ff., has proposed to account for the emergence of the "three-nail-type" by the influence of the notorious "Holy Shroud" (*Sindone*) of Turin which, according to him, was given to Besançon Cathedral in 1206 after having been abstracted from Constantinople in 1204. To this hypothesis there are, I think, some insurmountable objections. In the first place, there is, so far as I know, no evidence to show that *any* Shroud reached France before the middle of the fourteenth century when the specimen now venerated at Turin made its appearance in the Collegiate Church at Lirey (Aube), later to be transferred — via Chambéry, Bourg-en-Bresse, Verceil, Nice and Lucento — to its present habitat; the story of the nobleman who brought the Shroud of Christ from Constantinople in 1204 and gave it to Besançon Cathedral must be discounted as one of those innumerable legends intended to corroborate the authenticity of a cherished relic. In the second place, there is no evidence to show that the Turin Shroud was ever at Besançon. Besançon Cathedral did possess a Shroud up to 1794 when it was destroyed by the Commune; but there is no proof that this specimen, fairly identical with that preserved at Turin (see the illustrations in P. Vignon, *Le Linceul du Christ*, Paris, 1902, figs. 12, 14, 16), existed prior to 1523 and, if so, that it had been sent on its odyssey to Lirey, Chambéry etc. by 1350 after having been replaced by a copy kept at Besançon. In the third place, it is, to say the least, extremely doubtful that the Turin Shroud actually shows, or showed, the Saviour with His feet crossed. Vignon, who in 1902 was convinced of the opposite, has more recently attempted to prove this proposition (*Le Saint Suaire de Turin*, 2nd ed., Paris, 1939, p. 39 ff.), maintaining, however, the non-identity of the Turin and the Besançon specimens; but his analysis is based only on the faint traces in the dorsal image ("par devant . . . on ne voit rien"), and the only indisputable fact is that all the old and independent representations of the Turin as well as the Besançon Shrouds (for the latter, see the illustrations, just adduced, in Vignon's book of 1902, for the former, the

copy still preserved at Chambéry, illustrated *ibidem*, pl. IX, and the well-known miniature by Giulio Clovio, *ibidem*, pl. I) show Christ with His legs parallel and His feet well separated. So far as I know, the only Shroud to show Him with His feet crossed is the late specimen at Enxobregas near Lisbon, manifestly influenced by the then generally accepted type of Crucifix (F. de Mély, *Le Saint-Suaire de Turin est-il authentique?*," Paris, 1902, p. 45, fig. 10; cf. Vignon, *Le Linceul*, p. 155, then accounting for this "infidélité" by the copyist's wish to conform to late medieval and Renaissance traditions). In the fourth place, had the "three-nail-type" been evolved from what was held to be the direct imprint of the Saviour's own body, how would it have been possible for so orthodox and well-informed a prelate as Bishop Luke of Tuy to condemn it as a wanton and irreverent innovation?

Page 19

1. Most interesting *pentimenti*, intended to deepen the perspective of the nave, have been discovered in this picture by G. Rowley ("Ambrogio Lorenzetti il pensatore," *La Balzana*, I, 1928, no. 5).

2. This divergence, conjectured by Panofsky, "Die Perspektive als symbolische Form," p. 280, has been verified by Schild Bunim, *op. cit.*, p. 146.

3. The authenticity of this painting has been doubted by Rowley, *op. cit.*, an opinion apparently not shared by the majority of experts.

Page 20

1. Exceptions to this general rule are mostly limited to the fourteenth century and, more important, resulted from the indirect influence of Italian paintings (transmitted through drawings) rather than from the direct influence of sculpture upon sculpture; see, e.g., the interrelated reliefs in the south portal of Augsburg Cathedral, the southwest portal of Ulm Cathedral, and the main portal of the Münster at Thann in Alsace; or the ivory plaque of a Madonna carved for John Grandisson, Bishop of Exeter (London, British Museum, illustrated in F. Saxl and R. Wittkower, *British Art and the Mediterranean*, Oxford, 1948, pl. 33, no. 11). A special case is constituted by the facsimile copies of Italian medals produced by the artisans of the Duc de Berry (cf. p. 64); and an altogether different problem is posed by the employment of Italian *Cosmati* in England, where "Petrus Civis Romanus" produced, from *ca.* 1270, the shrine of Edward the Confessor and the Tomb of Henry III in Westminster Abbey without, however, being able to provide the effigy of the king which was executed in 1291 by the English sculptor William Torrel and shows a pure French-Gothic style (Saxl and Wittkower, *op. cit.*, pl. 32).

Page 21

1. Diels, *op. cit.*, fragment B 34.

Page 22

1. Detail from a beautiful sarcophagus in Cambridge (England) illustrated in C. Robert, *Die antiken Sarkophag-Reliefs*, Berlin, 1890 ff., II, pl. XVIII, no. 27 (S. Reinach, *Répertoire de reliefs grecs et romains*, Paris, 1909–1912, II, p. 442, 2). Cf. also Robert, *ibidem*, nos. 28, 29; pl. XIX, nos. 33, 34; pl. VI, no. 20; and A. Castellani, "Rilievi del rivestimento in bronzo d'una Thensa," *Bulletino della Commissione Archeologica Communale de Roma*, I, 1877, pls. XII, XIII.

2. New York, Morgan Library, ms. 72, fol. 41 v. (French, between 1262 and 1271; see also *Morgan Catalogue*, 1934, no. 55, pl. 51).

3. A. Goldschmidt, "Das Nachleben der antiken Formen im Mittelalter," *Vorträge der Bibliothek Warburg*, 1921–22, p. 40 ff.; especially, p. 49.

4. For an interesting new sidelight on this well-known phenomenon see K. Weitzmann, "Constantinopolitan Book Illumination in the Period of the Latin Conquest," *Gazette des Beaux-Arts*, ser. 6, XXV, 1944, p. 193 ff. He points out that the Northern school perhaps most deeply imbued with Byzantine influences, viz., the Saxon and Thuringian school of the first half of the thirteenth century, kept abreast of the development in Byzantium itself by selecting the most up-to-date, nearly contemporary models for imitation.

5. An iconography of the *Noli me tangere* scene has still to be written. In general, Byzantine art preferred, for theological reasons, to represent the first Appearance of Christ according to Matthew XXVIII, 9, where Christ appears to "Magdalene and the other Mary," greeting them with the word χαίρετε ("All hail"). Accordingly, Christ is shown quietly addressing two kneeling women who either approach Him from one side or are symmetrically disposed on His right and left (G. Millet, "Recherches sur l'iconographie de l'Evangile," *Bibliothèque des Ecoles Françaises d'Athènes et de Rome*, vol. CIX, 2, 1916, figs. 582–588): even where only the Magdalen is shown (e.g., Paris, Bibliothèque Nationale, ms. grec 74, fol. 209 v. and ms. 510, fol. 30 v.), Christ retains a quiet, frontalized pose, and it is this type to which Duccio adheres. The West, characteristically, preferred to illustrate the real *Noli me tangere* according to John XX, 17 and therefore had to bring out the idea of recoil or withdrawal. Christ was shown moving away from the Magdalen and looking back to her in a *contrapposto* attitude similar to that of Achilles departing from the daughters of Lycomedes; but it would seem that this motif was not appropriated directly. Before being applied to the *Noli me tangere*, it had been utilized for a

scene in which the idea of looking back is suggested by the very text, viz., the scene described in Luke VIII, 44–45, where the woman with the issue of blood "comes behind" Christ, touches the border of His garment and causes Him to exclaim: "Who touched me?" (see several sarcophagi in the Lateran, one of them illustrated in C. R. Morey, *Early Christian Art*, Princeton, 1942, fig. 139, or the ivory in the Louvre, illustrated *ibidem*, fig. 143, and in J. J. Marquet de Vasselot, "Un Ivoire chrétien récemment acquis par le Musée du Louvre," *Monuments Piot*, XXVIII, 1925–1926, pl. XIV). From this time-honored composition, it seems, the *contrapposto* motif passed, not only into another scene of withdrawal, viz., the Ascension (see, e.g., the Weimar ivory illustrated in A. Goldschmidt, *Die Elfenbeinskulpturen aus der Zeit der Karolingischen und Sächsischen Kaiser*, II, Berlin, 1918, fig. 150), but also into the *Noli me tangere* so closely connected with the scene in Luke VIII by Christ's objection to being "touched." In the Hildesheim bronze doors the Ascension and the *Noli me tangere*, with the figure of Christ manifestly patterned upon a model such as the Weimar ivory, were even merged into one scene.

In Gothic art, this "runaway pose," as it might be called, tended to dissolve into the simple curve seen in our text ill. 20; but it was faithfully retained in Italian and Italo-Byzantine instances (see, e.g., Millet, *op. cit.*, fig. 590, or R. van Marle, *The Development of the Italian Schools of Painting*, The Hague, 1923–1938, I, 346). Along with it, however, we find another, almost mannered pose of withdrawal in which the legs are crossed as in a pirouette. And it is this chiastic pose — derived from Hellenic dancers and widely exploited in classical and Byzantine art for the expression of a conflict between progress and retardation (as in captives abducted against their will, actors leaving the stage while still addressing their interlocutors, Moses leading the Jews onward while turning back to the Egyptians submerged in the Red Sea) — which was adopted for the figure of Christ in the *Noli me tangere*, not only by Giotto but also by the thirteenth-century Byzantinists of the North (an early instance in H. Swarzenski, *The Berthold Missal*, pl. XII); so that a feeble Bavarian miniature of *ca.* 1275 (H. Swarzenski, *Die lateinischen illuminierten Handschriften des XIII. Jahrhunderts in den Ländern an Rhein, Main und Donau*, Berlin, 1936, fig. 364) could bear a curious resemblance to Giotto's fresco in the Arena Chapel. In all these instances, the Magdalen is shown on her knees. *Noli me tangere*'s with both figures standing are so extraordinarily rare that the one in a Liége manuscript of about 1050 (Munich, Staatsbibliothek, clm 23261) could be mistaken, in spite of

its unequivocal inscription, for a representation of Christ Appearing to His Mother (M. Rooses, *Art in Flanders*, New York, 1914, p. 11).

Page 23

1. See M. Dvořák, *Geschichte der italienischen Kunst im Zeitalter der Renaissance*, Munich, 1927–1928, I, p. 32.

2. For all these subjects, see below, *passim*, and E. Mâle, *L'Art religieux de la fin du moyen âge en France*, first ed., Paris, 1908. Individually, cf., for the Annunciation: D. M. Robb, "The Iconography of the Annunciation in the Fourteenth and Fifteenth Centuries," *Art Bulletin*, XVIII, 1936, p. 480 ff. For the Nativity: H. Cornell, *The Iconography of the Nativity of Christ*, Uppsala, 1924 (cf., however, below, note 46 [3]). For the Lamentation: Millet, *op. cit.*, p. 498 ff. For the Adoration of the Magi: H. C. Kehrer, *Die heiligen drei Könige in Literatur und Kunst*, Leipzig, 1908–1909, II, p. 192 f. (cf. also M. Meiss, "Italian Style in Catalonia and a Fourteenth-Century Italian Workshop," *The Journal of the Walters Art Gallery*, IV, 1941, p. 45 ff., especially p. 66); it seems, however, to have escaped notice thus far that the kiss applied to the foot of the Infant Jesus is described, not only in Pseudo-Bonaventure's *Meditationes* but also in the real Bonaventure's *Lignum Vitae* (*Sancti Bonaventurae . . . opera*, Venice, 1751–1756, V, p. 396) where the soul is invited to contemplate "divinum illud praesepe, ut *pueri pedibus labia tua figes et oscula gemines*," and that it exceptionally occurs in the "Psalter of Yolande of Soissons" of *ca.* 1270–80, Morgan Library, ms. 729 (*Morgan Catalogue*, 1934, no. 51), fol. 275 v. For the Man of Sorrows: G. von der Osten, *Der Schmerzensmann; Typengeschichte eines deutschen Andachtsbildes von 1300 bis 1600*, Berlin, 1935; E. Panofsky, "Imago Pietatis," *Festschrift für Max J. Friedländer zum 60. Geburtstage*, Leipzig, 1927, p. 261 ff. For the Madonna of Humility: M. Meiss, "The Madonna of Humility," *Art Bulletin*, XVIII, 1936, p. 434 ff.; ———, *Painting in Florence and Siena after the Black Death*, Princeton, 1951, p. 132 ff.

3. For early instances of the Entombment with only Nicodemus and Joseph of Arimathea, see, e.g., the "Codex Egberti" in Treves or the "Gospels of Otto III" in Munich. For the Byzantine types of Entombment and Lamentation, see Millet, *op. cit.*, pp. 498–516; cf. A. Goldschmidt and K. Weitzmann, *Die byzantinischen Elfenbeinskulpturen des X.-XIII. Jahrhunderts*, II, Berlin, 1934, nos. 22, 127, 23, 203, 204, 207 (our text ill. 25); and Panofsky, "Imago Pietatis," p. 262. As the Virgin Mary took the place of Joseph of Arimathea in the Eastern "procession" or "cortege,"

so did she occasionally take his place in the Western Entombment as is the case in S. Angelo in Formis.

4. Apart from Giotto, the original Byzantine Lamentation type (without sarcophagus and with the upper part of Christ's body reposing on the Virgin's lap) also survives in Pacino da Buonaguida, Lorenzetti, and many others (cf., e.g., van Marle, *op. cit.*, I. pp. 291, 301). It also occurs in the "*Bible Moralisée*," Paris, Bibliothèque Nationale, ms. fr. 9561 (a French manuscript illuminated by Italian artists), fol. 181, and for its revival in pre-Gothic German Byzantinism, cf. A. Goldschmidt, "Frühmittelalterliche illustrierte Enzyklopädien," *Vorträge der Bibliothek Warburg*, 1923–24, p. 223 f., figs. 15, 16. For a sporadic survival of the original Byzantine Entombment type (with Christ's body pushed into a cave tomb) in early Tuscan painting, see, e.g., van Marle, *op. cit.*, I, p. 347.

Page 24

1. As far as the expression of grief is concerned, the gesture of throwing up both hands is already found in Byzantine instances (e.g., Millet, *op. cit.*, figs. 493, 533, 535); but it is far less conspicuous here than in the Italian Dugento and Trecento, and the other characteristic features — the wringing of hands, the tearing of hair, and, quite especially, the presence of huddled mourners in the foreground — do not seem to occur in Byzantine art at all. All these motifs, however, are frequent in classical representations of such scenes as the Grief of Hecuba, the Death of Meleager, and many anonymous θρῆνοι or *conclamationes*: cf., e.g., Reinach, *op. cit.*, I, pp. 70, 223; II, pp. 123, 199; D. Levi, *Il Museo Civico di Chiusi*, Rome, 1935, p. 20, fig. 4; C. Daremberg and E. Saglio, *Dictionnaire des antiquités grecques et romaines*, II, 2, Paris, 1896, p. 1382, fig. 3352 and p. 1395, fig. 3363; for a survival of the huddled figure in Coptic art, *Early Christian and Byzantine Art, The Walters Art Gallery, An Exhibition held at the Baltimore Museum of Art April 25–June 22, Baltimore, 1947*, no. 99, pl. XXI. Since classical monuments were accessible to Tuscan painters, a subsidiary influence from this direction might be considered.

2. For this Meleager sarcophagus which (as observed by A. Warburg and F. Schottmüller) inspired the Verrocchiesque monument of Francesca Tornabuoni, see Robert, *op. cit.*, III, 2, fig. 282, and Reinach, *Repertoire de reliefs*, III, p. 34. Professor G. Swarzenski called my attention to the fact that the same figure the posture of which was revived in the St. John in Giotto's "Lamentation" also appears to have influenced, some forty years before, one of the Lamenting Mothers in Nicola Pisano's "Massacre of the Innocents" (Siena Pulpit, figure in upper center). Recently the connection among these three figures has been independently observed and analyzed by Albert Bush-Brown, "Giotto: Two Problems in the Origins of His Style," *Art Bulletin*, XXXIV, 1952, p. 42 ff., who leaves open the question as to whether Giotto's St. John was directly inspired by the sarcophagus (as I believe to be the case) or through the medium of Giovanni Pisano. Unfortunately he reproduces the Paris rather than the Florence replica of the sarcophagus in which the figure in question is much more similar to Giotto's St. John.

3. M. Dvořák, "Die Illuminatoren des Johann von Neumarkt," *Jahrbuch der Kunsthistorischen Sammlungen des Allerhöchsten Kaiserhauses*, XXII, 1901, p. 35 ff.

4. A. Peter, "Quand Simone Martini est-il venu en Avignon?" *Gazette des Beaux-Arts*, ser. 6, XXI, 1939, p. 153 ff.

5. See M. Meiss, "Fresques italiennes, cavallinesques et autres, à Béziers," *Gazette des Beaux-Arts*, ser. 6, XVIII, 1937, p. 275 ff.

6. Meiss, "Italian Style in Catalonia," especially p. 50 ff.

Page 25

1. Cf. O. Pächt, *Oesterreichische Tafelmalerei der Gotik*, Augsburg, 1929, p. 5 ff., figs. 1–3; B. Kurth, "Die Wiener Tafelmalerei in der ersten Hälfte des 14. Jahrhunderts," *Jahrbuch der Kunsthistorischen Sammlungen in Wien*, new ser., III, 1929, p. 25 ff., especially p. 29 ff.; pls. II–V. Strictly speaking, the expression "Nicholas of Verdun's Klosterneuburg altarpiece" is not quite accurate. Nicholas' enamels originally served as a pulpit decoration; it was not until 1324–29, and in deference to the new enthusiasm for big, folding retables, that they were rearranged into a tripartite altarpiece the back of which was adorned with the four large panels referred to in the text (cf. K. Drexler, *Der Verduner Altar*, Vienna, 1903).

2. It should be noted, however, that this interest in perspective tended to remain restricted, for a time, to the foreshortening of individual objects such as thrones, bases, canopies, etc., instead of affecting the organization of the picture space as a whole. Cf., apart from many glass paintings from *ca.* 1330, the Königsfelden antependium or the St. Florian altarpiece (Kurth, "Die Wiener Tafelmalerei," figs. 29–32).

3. Cf., for instance, the triptych in the Stiftsmuseum at Klosterneuburg, illustrated in Kurth, *ibidem*, fig. 26.

4. See Kurth, *ibidem*, p. 54 f., and fig. 54; Pächt, *Oesterreichische Tafelmalerei*, fig. 4.

5. Pächt, *ibidem*, p. 7; cf. also Kurth, "Die Wiener Tafelmalerei," p. 55.

6. See O. Pächt, "A Giottesque Episode in English Mediaeval Art," *Journal of the Warburg and Courtauld*

Institutes, VI, 1943, p. 51 ff.; also F. Saxl and R. Wittkower, *op. cit.*, pl. 33.

Page 26

1. For the sake of historical justice it should be remembered that it was W. Kallab who discovered the tradition which connects the rocky landscapes of Hellenistic and Roman painting with Byzantine art and this with the Italian Trecento: "Die Toscanische Landschaftsmalerei im XIV. and XV. Jahrhundert," *Jahrbuch der Kunsthistorischen Sammlungen des Allerhöchsten Kaiserhauses*, XXI, 1900, p. i ff.

2. Pächt, "A Giottesque Episode," p. 51 f. and pl. 14. It seems, however, somewhat doubtful that the border, too, was inspired by the "massive, wooden frames of Dugento retables such as, for instance, the Rucellai Madonna." Frames imitating those of panels and decorated with portrait medallions are an inheritance of late antiquity (the best-known instances being the productions of the schools of Treves and Echternach such as the "Gospels of the Ste.-Chapelle" in the Bibliothèque Nationale, ms. lat. 8851, the "Codex Aureus" of the Escorial and the "Gospels of Henry III" at Uppsala) and were so popular in England at all times that a direct derivation from Italian *ancone* would seem to be unnecessary. The motif of the Magdalen embracing the Cross, anticipated by such donor's figures as that in the early eleventh-century "Gospels of Judith of Flanders" (Morgan Library, ms. 709, fol. 1, illustrated in H. Swarzenski, *The Berthold Missal*, fig. 1), was apparently formulated in the circles of the mendicant Orders; St. Dominic and St. Francis are often shown in the same position. For textual parallels, cf., e.g., the *Rhythmica oratio ad unum quodlibet membrum Christi patientis et in cruce pendentis* printed in *Patrologia Latina*, CLXXXIV, col. 1319:

> "Clavos pedum, plagas duras
> Et tam graves impressuras
> Circumplector cum affectu,
> Tuo pavens in aspectu,
> Tuorum memor vulnerum . . .
>
> Coram crucem procumbentem,
> *Hosque pedes complectentem,*
> Jesu bone, non me spernas,
> Sed de cruce sancta cernas
> Compassionis gratia."

3. See Pächt, "A Giottesque Episode," p. 57 ff., pls. 16–19. The only other manuscripts ascribed to the Egerton Master are the "Derby Psalter," Bodleian Library, ms. Rawlinson G. 185 (Pächt, p. 69 ff., pls. 20, 21) and a Psalter in the British Museum, ms. Add. 44949 (quoted in Pächt, p. 69, note 1).

4. Hungary, ruled by the Anjou dynasty from 1307 to 1382, was exposed to the influence of Italian painting not only via Bohemia and the Tyrol but also by the presence of Italian painters invited by the kings, especially Louis the Great (1342–1382) who was both the first cousin once removed and, for a time, the brother-in-law of Queen Joan of Naples. Hungarian painting and book illumination of the fourteenth century thus offer a very variegated aspect, and the miniatures in the most important illuminated manuscript, the Hungarian Picture Chronicle (formerly in the Nationalbibliothek at Vienna, now in the National Museum at Budapest, ms. no. 404), had long been considered the work of an Italian artist whereas they are now ascribed to a Hungarian; cf. E. Hoffmann, "Die Bücher Ludwigs des Grossen und die ungarische Bilderchronik," *Zentralblatt für Bibliothekswesen*, LIII, 1936, p. 653 ff., and A. Gabriel, *Les Rapports dynastiques franco-hongrois au moyen âge*, Budapest, 1944 (many illustrations). See also A. Heckler, *Ungarische Kunstgeschichte*, Berlin, 1937, p. 73 ff.; K. Divald, *Old Hungarian Art*, London, 1931, p. 116 ff.; E. Berkovits, "La Miniatura ungherese nel periodo degli Angioini," *Janus Pannonius*, I, 1947, p. 67 ff.; M. Harrsen, *The Nekcsei-Lipócz Bible, A Fourteenth-Century Manuscript from Hungary in the Library of Congress*, Washington, 1949.

5. C. Sterling, *La Peinture française; les primitifs* (hereafter quoted as "Sterling, *Les Primitifs*"), Paris, 1938, p. 22.

6. For the history of painting and book illumination in Bohemia, see — apart from Dvořák, "Die Illuminatoren des Johann von Neumarkt" and R. Ernst, *Beiträge zur Kenntnis der Tafelmalerei Böhmens im 14. und am Anfang des 15. Jahrhunderts*, Prague, 1912 — A. Matějček, *Gotische Malerei in Böhmen*, Prague, 1939; *idem* and J. Pesina, *Czech Gothic Painting 1350–1450*, Prague, 1950; O. Kletzl, "Studien zur böhmischen Buchmalerei," *Marburger Jahrbuch für Kunstwissenschaft*, VII, 1933, p. 1 ff.; K. Oettinger, "Neue Beiträge zur Kenntnis der böhmischen Malerei und Skulptur um die Wende des 14. Jahrhunderts," *Wiener Jahrbuch für Kunstgeschichte*, X, 1935, p. 5 ff.; and *idem*, "Der Meister von Wittingau und die böhmische Malerei des späteren XIV. Jahrhunderts," *Zeitschrift des Deutschen Vereins für Kunstwissenschaft*, I, 1934, p. 293 ff. Cf. also the instructive introduction in E. Trenkler, *Das Evangeliar des Johannes von Troppau, Handschrift 1182 der Oesterreichischen Nationalbibliothek*, Klagenfurt and Vienna, 1948.

7. For painting in Avignon, cf. especially L.-H. Labande, *Le Palais des Papes et les monuments d'Avignon au XIVᵉ siècle*, Marseille, 1925; A. R. Michel, *Avignon, les fresques du Palais des Papes*, 2nd

ed., Paris, 1926; P. Pansier, *Les Peintres d'Avignon aux XIVᵉ–XVᵉ siècles*, Avignon, 1934. The fourteenth-century murals in the "Château des Papes" are mostly purely Italian in character (the famous Bathers of 1343-1344 in the Papal Study, incidentally, may be compared with the nudes in the interesting cod. Vat. lat. 1993, produced in Avignon at about the same time by Opicinus de Canistris of Pavia and published by R. Salomon, *Opicinus de Canistris* [Studies of the Warburg Institute, I], London, 1936), with only the frescoes in the "Sale du Consistoire" of *ca.* 1353 participating in the fusion of French and Italian elements which had been initiated by Jean Pucelle and was to culminate in Jacquemart de Hesdin and the Limbourg brothers. In the field of book illumination (see especially L.-H. Labande, "Les Miniaturistes avignonais et leurs oeuvres," *Gazette des Beaux-Arts*, ser. 3, XXXVII, 1907, pp. 213 ff., 289 ff.), we find, at the beginning, a fairly clear division between works bodily imported from Italy such as the Neapolitan Missal of St.-Didier at Avignon (Avignon, Bibliothèque Municipale, ms. 138, cf. V. Leroquais, *Les Sacramentaires et les Missels manuscrits des bibliothèques publiques de France*, Paris, 1924, II, p. 326, pl. LXIII); works produced by immigrant Italian artists on the spot such as the above-mentioned manuscript by Opicinus de Canistris, the Missal in Avignon, Bibliothèque Municipale, ms. 136 (Leroquais, *ibidem*, II, p. 324, pl. LXII), the Pontifical in Avignon, Bibliothèque Municipale, ms. 203 (V. Leroquais, *Les Pontificaux manuscrits des bibliothèques publiques de France*, Paris, 1937, I, p. 55), etc.; and works produced by French artists, some of them as uninfluenced by the Italian style as the illuminator of the *Commentary on Genesis*, Paris, Bibliothèque Nationale, ms. lat. 365. In the further course of the century a kind of synthesis took place; but even as late and sumptuous a manuscript as the "Missal of Clement VII" of *ca.* 1380 in the Bibliothèque Nationale, ms. lat. 848 (Leroquais, *Les Sacramentaires et les Missels*, pls. LXV, LXVI; C. Couderc, *Les Enluminures des manuscrits du moyen âge*, Paris, 1927, pl. XLIV) is comparatively coarse and *retardataire* in style.

Page 27

1. For Jean Pucelle see, apart from Thieme-Becker, *Allgemeines Lexikon der bildenden Künstler* (hereafter quoted as "Thieme-Becker"), XXVIII, 1933, p. 442: V. Leroquais, *Les Bréviaires manuscrits des bibliothèques publiques de France*, Paris, 1934, III, p. 198 ff. His Italian affiliations were, so far as I know, first observed by G. Vitzthum von Eckstädt, *Die Pariser Miniaturmalerei von der Zeit des hl. Ludwig bis zu Philipp von Valois und ihr Verhältnis zur Ma-*

lerei in Nordwesteuropa, Leipzig, 1907, p. 184. In a recent article by R. Blum, "Jean Pucelle et la miniature parisienne du XIVᵉ siècle," *Scriptorium*, III, 1949, p. 211 ff., an attempt has been made to show that Jean Pucelle, though admittedly the most famous book illuminator of his period, was responsible only for the "Billyng Bible" (see note 32 ¹) but neither for the "Hours of Jeanne d'Evreux" (see note 29 ³) nor the "Belleville Breviary" (note 32 ²). While it is true that the whole question will have to be restudied, the fact remains that Jean Pucelle is mentioned in the "Belleville Breviary" as the person who paid the other illuminators, and that the style of this manuscript is indissolubly connected with that of the "Hours of Jeanne d'Evreux" which, since the "Belleville Breviary" was written between 1323 and 1326, can hardly be assigned to a later decade. Especially the drolleries in the two manuscripts are so intimately related in execution as well as in invention that they cannot be dissociated; compare, for example, the figure using a rake as a violin bow in the "Hours of Jeanne d'Evreux" with that using the same rake as a flute in the *bas-de-page* of the February page in the second volume of the "Belleville Breviary," fol. 2 v. Here as in several other cases (for example, *ibidem*, fol. 2) we are confronted with the same individual artist who decorated the "Hours of Jeanne d'Evreux," in my opinion with Jean Pucelle himself. It should also be noted that, so far as can be judged from an old reproduction, the style thus far associated with Jean Pucelle is well in harmony with that of the seal of the Confraternity of St.-Jacques-aux-Pèlerins, known to have been designed by him between 1319 and 1324. For this seal, formerly owned by a collector and connoisseur named Arthur Forgeais and now apparently undiscoverable, see A. Forgeais, "Notice sur le Sceau de la Confraternité des Pèlerins de Saint Jacques," *Société de Sphragistique de Paris*, II, 1852-53, p. 16 ff.

2. See V. Leroquais, *Les Livres d'Heures manuscrits de la Bibliothèque Nationale*, Paris, 1927, introduction.

3. Vienna, Nationalbibliothek, ms. 1857. Cf. P. Durrieu, *La Miniature flamande aux temps de la cour de Bourgogne*, Brussels, 1921, pls. LVI and LVII; O. Pächt, *The Master of Mary of Burgundy*, London, n.d. [1948], pls. 12 and 13; and F. Lyna, "Une Oeuvre inconnue du Maître de Marie de Bourgogne," *Scriptorium*, I, 1946/47, p. 310 ff., tentatively ascribing to this master the Brussels manuscript, Royal Library, ms. II, 1169. Along with Jean Fouquet, the Master of Mary of Burgundy, the Master of the *Livre du Cuer d'Amours Espris* of *ca.* 1465 (Vienna, Nationalbibliothek, ms. 2597) and Simon Marmion belong to the "glorious exceptions" in fifteenth-century book illumi-

nation alluded to on p. 28 (see also Pächt, p. 20). For the two latter masters see respectively E. Trenkler, *Das Livre du Cuer d'Amours Espris des Herzogs René von Anjou*, Vienna, 1946, in addition to the 1926 edition by O. Smital and E. Winkler, and F. Winkler, "Simon Marmion als Miniaturmaler," *Jahrbuch der Königlich Preussischen Kunstsammlungen*, XXIV, 1913, p. 251 ff.

Page 28

1. L.-H. Labande, *Les Primitifs français*, Marseille, 1932, pp. 7 f., 65.

2. G. Hulin de Loo, "Traces de Hubrecht van Eyck; Empreintes contemporaines en Suisse et Allemagne," *Annuaire des Musées Royaux de Belgique*, IV, 1943-44, p. 3 ff., has recently defended the opposite view according to which painting, had we but more of it, would prove to be more advanced than book illumination. However, where the surviving material permits comparison (as between the little Crucifix of the Duc de Berry, mentioned p. 81, and the *"Petites Heures,"* or between the works of as renowned a master as Jean Malouel and those of the Boucicaut Master) the evidence does not seem to support this view. And it is certainly significant that the task of designing what seems to be the most important series of fourteenth-century tapestries, the "Angers Apocalypse" (see p. 39 f.), was allotted to a book illuminator.

Page 29

1. The *Somme-le-Roy* of 1311 is: Paris, Bibliothèque de l'Arsenal, ms. 6329 (cf. Martin, *La Miniature française*, pl. 23, fig. XXVIII; and H. Martin and P. Lauer, *Les Principaux Manuscrits à peintures de la Bibliothèque de l'Arsenal à Paris*, Paris, 1929, pls. XXII, XXIII). The *Légende de St. Denis* is: Paris, Bibliothèque Nationale, ms. fr. 2090-2092 (see Martin, *La Miniature française*, pls. 28, 29, figs. XXXV-XXXVII; ———, *Les Joyaux de l'enluminure à la Bibliothèque Nationale*, Paris and Brussels, 1928, pls. 32-34, figs. XLII-XLVI; and the official edition of the whole manuscript). Cf. also the *Vie et Miracles de St. Denis* by Guillaume l'Ecossais, Paris, Bibliothèque Nationale, ms. lat. 13836 (Martin, *La Miniature française*, pl. 33, fig. XLII; ———, *Les Joyaux*, pl. 35, fig. XLVII).

2. The "Book of Kalila and Dimna" of 1313 or 1314 is: Paris, Bibliothèque Nationale, ms. lat. 8504 (Couderc, *op. cit.*, pl. XXXV); the "Gratian" of 1314: Paris, Bibliothèque Nationale, ms. lat. 3893 (Martin, *La Miniature française*, pl. 25, figs. XXX and XXXI); the "Papeleu Bible": Paris, Bibliothèque de l'Arsenal, ms. 5059 (Martin, *ibidem*, pls. 26, 27, figs. XXXII-XXXIV and Martin and Lauer, *op. cit.*, pls. XXIV,

XXV). The *Life of St. Louis* by Guillaume de St.-Pathus is: Paris, Bibliothèque Nationale, ms. fr. 5716 (Martin, *ibidem*, pl. 30, figs. XXXVIII and XXXIX); that by the Sieur de Joinville, Paris, Bibliothèque Nationale, ms. fr. 13568 (Martin, *La Miniature française*, pls. 31, 32, figs. XL and XLI).

3. The "Book of Hours of Jeanne d'Evreux" (Coll. Maurice de Rothschild, Paris), arranged for Dominican use, was published by L. Delisle, *Les Heures dites de Jean Pucelle, manuscrit de la collection de M. le Baron Maurice de Rothschild*, Paris, 1910. For Duccio's influence on the "Annunciation" (Delisle, pl. 26), see Panofsky, "Die Perspektive als symbolische Form," p. 315, note 49; B. Martens, *Meister Francke*, Hamburg, 1929, pp. 85, 91, figs. 25-26; and Schild Bunim, *op. cit.*, p. 153 ff. For its derivatives, see Robb, *op. cit.*, p. 493 ff. A second "doll's house" imaginatively developed from the same Sienese type, is used in another miniature in the same Book of Hours, viz., the "Miracle at the Tomb of St. Louis" (Martens, *op. cit.*, fig. 27). See also Blum, "Jean Pucelle et la miniature parisienne."

Page 30

1. It is now generally accepted that the "Santa Casa di Loreto," said to have been deposited on its present site on December 10, 1294, is in reality a little Romanesque country church, mentioned as early as a hundred years before, which seems to owe its reputation to the absence of proper foundations, and that the earliest written accounts of the legend do not antedate the second half of the fifteenth century (cf., e.g., F. Cabrol and H. Leclercq, *Dictionnaire d'archéologie chrétienne et de liturgie*, IX, 2, 1930, col. 2473 ff., and J. Hastings, *Encyclopaedia of Religion and Ethics*, VIII, 1915, p. 139 ff., with the interesting reference to the English account in Willam Wey's *Pilgrimage* of *ca.* 1462 which antedates the so-called *Relatio Teramani* by Giorgio Pietro Tolomei, normally adduced as the earliest source, by several years). However, a late fourteenth-century fresco in San Francesco at Gubbio (illustrated in A. Colasanti, *Gubbio*, Bergamo, 1910, p. 44; ———, *Loreto*, Bergamo, 1910, p. 33) is proof of the fact that a legend involving the miraculous salvation of the "Sacred House" of Nazareth, whether or not already focused on Loreto, was current long before it was recorded in writing — a very common thing where folklore is concerned. This legend seems to have been generated in the atmosphere of despair which settled upon the Christian world after the fall of Acre in 1291, and the miniature in the "Hours of Jeanne d'Evreux" may well be the earliest surviving document of a tradition which, in Italy itself, has left its traces only in con-

siderably later monuments (cf., apart from the fresco at Gubbio just mentioned, two Quattrocento paintings reproduced in Colasanti, *Loreto*, pp. 34, 35). In the other miniatures of the "Hours of Jeanne d'Evreux" some of the caryatids are similarly related to the content of the principal scene (as when one of those beneath the "Bearing of the Cross" brandishes a hammer) while others are not — just as some of the *bas-de-pages* "belong" to the main theme (as do, e.g., the "Falling Idols" beneath the "Flight into Egypt") while others, like that beneath the "Annunciation," vaguely and playfully oppose the futile pleasures and struggles of the life in the flesh to the eternal values of the life in the spirit. The only miniature which has neither caryatids nor a *bas-de-page* is, characteristically, the "Crucifixion." In the face of Christ's supreme sacrifice the artist silenced all discordant or accompanying voices.

Page 31

1. Delisle, *Les Heures dites de Jean Pucelle*, pl. 38. Martens, *op. cit.*, p. 92, fig. 27.

2. Cf., e.g., Simone Martini (see p. 44) or Ambrogio Lorenzetti (Siena, Accademia, no. 77).

3. See, e.g., E. G. Millar, *English Illuminated Manuscripts of the XIVth and XVth Centuries*, Paris and Brussels, 1928, pls. 4, 7, 18, 21, 26, 45, 46, 47, etc. Cf. also D. D. Egbert, *The Tickhill Psalter and Related Manuscripts*, Princeton, 1940.

4. See, e.g., for Cologne: Brussels, Bibliothèque Royale, ms. 329 (P. Clemen, "Von den Wandmalereien auf den Chorschranken des Kölner Domes," *Wallraf-Richartz Jahrbuch*, I, 1924, p. 29 ff., especially p. 51); for Dijon: the Breviary of St.-Bénigne (Leroquais, *Les Bréviaires*, pl. XVIII); for Cambrai: the "Breviary of St.-Sépulcre" (*Ibidem*, pls. XIX, XX); for Verdun: the "Breviary of Marguerite de Bar" (*Ibidem*, pls. XXI, XXV). For Tournai, see, e.g., the Horae in the Morgan Library, ms. 754 (*Morgan Catalogue*, 1934, no. 74, pl. 65); the closely related Horae formerly in the possession of Henry Yates Thompson (*One Hundred Manuscripts in the Library of Henry Yates Thompson*, VII, London, 1918, no. 62, pls. XI, XII); the somewhat similar "Quest of the Holy Grail," Paris, Bibliothèque de l'Arsenal, ms. 5218, illuminated by Piérart dou Tielt; and, above all, the *Roman de la Rose* in the Bibliothèque Communale at Tournai, ms. C I, executed there in 1330 (cf. A. Kuhn, "Die Illustration des Rosenromans," *Jahrbuch der Kunsthistorischen Sammlungen des Allerhöchsten Kaiserhauses*, XXXI, 1913/14, p. 1 ff., especially p. 22 ff., figs. 7, 8; further, L. Fourez, "Le Roman de la Rose de la Bibliothèque de la Ville de Tournai," *Scriptorium*, I, 1946/47, p. 213 ff.). It has already been observed by Kuhn that the style of this and the related "Northern" manuscripts of the *Roman de la Rose* closely resembles that of Jean Pucelle; but it may well be that this similarity is not so much due to an — almost instantaneous — influence of Jean Pucelle upon the Tournai workshop as to a parallel development from common sources.

5. Again it was Vitzthum, *Die Pariser Buchmalerei*, who first called attention to Pucelle's English and Rhenish-Mosan connections. For the similarity that exists between his works and the paintings on the choir screen of Cologne Cathedral, see Clemen, *op. cit.*, p. 29 ff. For sculptural parallels of this style (indicative of its itinerary), see the choir stalls in Cologne Cathedral (B. von Tieschowitz, *Das Chorgestühl des Kölner Domes*, Berlin, 1930) which, as W. Vogelsang has shown, are closely connected with — and, von Tieschowitz, p. 36, notwithstanding, probably influenced by — a group of sculptures executed in Utrecht as early as 1317-1318 (W. Vogelsang, "Veertiend'eeuwsche beeldhouwers in Utrecht en Keulen," *Kunst der Nederlanden*, I, 1930-31, p. 456 ff.). A tiny symptom of English influence may, perhaps, be seen in the fact that the medallions in the *bas-de-pages* of the Calendar in the second volume of the "Belleville Breviary" (our fig. 12) are composed partly of ogee arches, a form appearing in English architecture as early as *ca.* 1315 but not encountered on the continent at so early a date.

Page 32

1. Paris, Bibliothèque Nationale, ms. lat. 11935; see Martin, *La Miniature française*, pls. 34, 35, figs. XLIII–XLV; ———, *Les Joyaux*, pl. 38, fig. L. L. Delisle, "La Bible de Robert Billyng," *Revue de l'Art Chrétien*, LX, 1910, p. 297 ff. includes a number of illustrations from a related manuscript (the "Breviary of Blanche de France," Vatican Library, cod. Urb. 603) and references to several others, specifically the "Breviary of Jeanne d'Evreux" (Chantilly, Musée Condé, ms. lat. 1887, illustrated in J. Meurgey, *Les Principaux Manuscrits à peintures du Musée Condé*, Paris, 1930, pl. XXIX); the "Genealogy of the Virgin" in Cambridge, Fitzwilliam Museum, ms. 20 (M. R. James, *A Descriptive Catalogue of the Manuscripts in the Fitzwilliam Museum*, Cambridge, 1895, p. 31 ff.); the "Hours of Jeanne de Navarre" (see note 34²); and the Franciscan Breviary in the Morgan Library, ms. 75. An important manuscript from Pucelle's school (*Decretals of Gregory IX*) has recently been acquired by the Nationalmuseum at Stockholm, ms. B. 1652; see *Stockholm, Nationalmuseum, Gyllene Böcker, Illuminerade medeltida handskrifter i dansk och svensk ägo, Maj-September 1952*, K. Olsen and C. Nordenfalk, eds.

(hereafter quoted as "*Stockholm Catalogue*"), no. 92. Whether the home town of the scribe Robert Billyng is identical with the present Billinge between Liverpool and Manchester is an open question, but he was certainly an Englishman. Pucelle's collaborators mentioned in the very circumstantial colophon are Jaquet Maci and Anciau de Cens. See also Blum, "Jean Pucelle et la miniature parisienne."

2. Paris, Bibliothèque Nationale, ms. lat. 10483–84. This Breviary — for Dominican use — is unfortunately not published *in extenso*. Good illustrations are found in Leroquais, *Les Bréviaires*, pls. XXVII–XXXVI, and Martin, *Les Joyaux*, pls. 39–42, figs. LI–LIV. In addition to "Mahiet" and "Ancelot," obviously identical with the "Jaquet Maci" and "Anciau de Cens" mentioned in the Billyng Bible, there appears a third assistant, called Jean Chevrier. The "Belleville Breviary" is generally supposed (except by R. Blum) to have been executed considerably later than the "Hours of Jeanne d'Evreux" (the *terminus ante quem* of which is 1328 when the Queen died) and the "Billyng Bible" (dated 1327). But Leroquais, *Les Bréviaires*, III, 204, has shown that, while the Feast of Corpus Christi ("Fête-Dieu"), adopted by the Order in 1323, is honored, the Feast of St. Thomas Aquinas, adopted in 1326 and particularly important from a Dominican point of view, is not; and that the same is true of other Dominican feasts adopted in 1332 and 1336. From this we must conclude that the writing of the "Belleville Breviary" was completed prior to 1326, and there is little reason to assume that the decoration of the two volumes was unduly delayed or extended over an unusually long period. The narrative miniatures are stylistically homogeneous with the borders, and no significant difference exists between these, especially the drolleries, and those of the "Hours of Jeanne d'Evreux" (cf. note 27 [1]; figs. 5, 7, 12). The inference is that the execution of the Breviary proceeded more or less simultaneously with that of the Book of Hours — which was presumably ordered on the occasion of the Queen's marriage in 1325 — and partly overlapped that of the "Billyng Bible" which was completed in 1327. The writer thus agrees with Meiss, "Italian Style in Catalonia," p. 50, in feeling that the Italianism of the Pucelle workshop tended to diminish — or, at least, to become less obvious — as time went on but disagrees with him in not considering the "Billyng Bible" as either earlier or more Italianate than both the "Belleville Breviary" and the "Hours of Jeanne d'Evreux."

3. Frequently illustrated; a color reproduction in Martin, *Les Joyaux*, facing p. 1. It should be noted, however, that a miniature in the "*Miracles de Notre-Dame*" at Soissons, probably illuminated in Pucelle's

workshop and full of architectural motifs reminiscent of the "Belleville Breviary," shows a group of buildings so strikingly Tuscan in character that the main "castle" has been identified with the Palazzo Vecchio in Florence (S. C. Cockerell, *The Book of Hours of Yolande of Flanders*, London, 1905, p. 17 and plates following p. 16, no. 2). Cf. H. Focillon, *Le Peintre des Miracles Notre Dame*, Paris, 1950, especially pl. XVIII (without reference to the connection of its architecture with the Palazzo Vecchio).

4. Princeton, N.J., University Library, ms. 83, written in Paris for the Dominican "Symon Comitis" (Simone del Conte or dei Conti). Cf. A. E. Bye, "Illuminations from the Atelier of Jean Pucelle," *Art in America*, IV, 1916, p. 98 ff.; D. D. Egbert, "The Western European Manuscripts," *The Princeton University Library Chronicle*, III, 1942, p. 123, especially p. 127; *The Walters Art Gallery, Illuminated Books of the Middle Ages and Renaissance, an Exhibition held at the Baltimore Museum of Art January 27–March 13, 1949* (hereafter quoted as "*Walters Catalogue*, 1949"), no. 69.

5. According to Egbert, *The Tickhill Psalter*, p. 15, continuous Bible illustration "does not occur [*scil.*, in *bas-de-pages*] before 1300 and appears to be English"; and the "Tenison Psalter" (*ca.* 1284) would seem to be about the earliest instance of a *bas-de-page* containing a serious, Biblical narrative.

Page 33

1. Ms. lat. 10483, fol. 2, "Exposition des ymages des figures qui sunt ou kalendier et ou sautier." The complete text of this apparently unique document — in which the learned author constantly uses the phrase "je mets," completely anticipating the picture which he suggests and almost identifying himself with the illuminator — is found in M. R. James, *A Descriptive Catalogue of the Second Series of Fifty Manuscripts in the Collection of Henry Yates Thompson*, Cambridge, 1902, p. 365 ff.

2. See F. G. Godwin, "An Illustration to the *De sacrementis* of St. Thomas Aquinas," *Speculum*, XXVI, 1951, p. 609 ff.

3. In the first volume of the original (ms. lat. 10483, fol. 6) only the November-and-December page of the Calendar survives (Leroquais, *Les Bréviaires*, pl. XXVII; for the verso, see R. M. Tovell, *Flemish Artists of the Valois Courts*, Toronto, 1950, fig. 16), and from the November picture the little landscape has been cut out. The December landscape, however, suffices to demonstrate the reliability of the replicas, for which see note 34 [2]. Mrs. Tovell's publication, which contains a number of good reproductions covering Franco-Flemish art from *ca.* 1300 up to the van

Eycks, appeared too late to be considered in my text and to be referred to consistently.

4. See J. C. Webster, *The Labors of the Months in Antique and Mediaeval Art*, Princeton, 1938.

5. Ms. lat. 10484, fol. 2 r. and v. This second volume, too, has unfortunately been deprived of all the other Calendar pictures.

Page 34

1. The exceptional appearance of a human being in the December picture — a woodcutter, transformed into the more usual hog killer in the *"Petites Heures"* and *"Grandes Heures"* (see the following note) — may be explained, not only by the artist's wish to distinguish between December and January (bare trees in both cases) but also as an allusion to the *bûche de Noël* which is and was the *pièce de résistance* of the celebration of Christmas in France. Pächt, *The Master of Mary of Burgundy*, p. 38 ff., goes much too far when he credits his hero with "the courage to free himself from the mediaeval conception" in a series of Calendar pictures in which all human activity is discarded in favor of "the physiognomy of nature itself in its continuous seasonal change." The little Calendar landscapes in the Horae Madrid, National Library, ms. Vit. 25–5 (Pächt, pls. 26 and 27, with the July picture erroneously captioned as "June" and the December picture as "July") are nothing but belated descendants of those in the "Belleville Breviary" and their derivatives, revised according to the standards of full-fledged fifteenth-century naturalism. Recently Pächt has discussed the problem of Calendar pictures more fully in a most interesting article which, however, appeared after the text of the present publication had been completed: "Early Italian Nature Studies and the Early Calendar Landscape," *Journal of the Warburg and Courtauld Institutes*, XIII, 1950, p. 13 ff.; even here no mention is made of the Calendars in the "Belleville Breviary" and its derivatives, apart from a cursory reference to the Psalter and Hours of Bonne of Luxembourg (see below, note 34⁸) on p. 40, note 2. The connection between Bruegel's seasonal pictures and the Calendars in manuscripts derived from the *"Très Riches Heures"* (Grimani Breviary, "Hennessy Hours") has been stressed by C. de Tolnay, *Pierre Bruegel l'Ancien*, Brussels, 1935, pp. 38 ff. and 69, note 85.

2. Of these replicas and variations the following are very exact:

(a) that in the "Hours of Jeanne de Navarre," daughter of Louis X, executed in the Pucelle workshop between 1336 and 1349, now in the Maurice (?) de Rothschild Collection at Paris (our figs. 13, 14); cf. H. Yates Thompson, *Thirty-Two Miniatures from the Book of Hours of Joan II, Queen of Navarra*, London, 1899.

(b) that in the "Hours of Yolande de Flandre," executed in the Pucelle workshop about 1353 (Cockerell, *op. cit.*), now in the British Museum, Yates Thompson ms. 27.

(c) that in the *"Petites Heures du Duc de Berry,"* Paris, Bibliothèque Nationale, ms. lat. 18014, executed by Jacquemart de Hesdin about 1380–1385; cf. Yates Thompson, *Thirty-Two Miniatures*, pl. preceding p. 7, and Leroquais, *Les Livres d'Heures*, pl. XIV.

Still fairly faithful are the copies in the *"Grandes Heures du Duc de Berry"* (Paris, Bibliothèque Nationale, ms. lat. 919), executed in the workshop of Jacquemart de Hesdin before 1409 (cf. Yates Thompson, *Thirty-Two Miniatures*, pl. facing p. 8; Leroquais, *Les Livres d'Heures*, pl. XXVII); whereas the variations in the "Hours of Charles VI" by the "Bedford Master" (Vienna, Nationalbibliothek, ms. 1855; H. J. Hermann, *Beschreibendes Verzeichnis der illuminierten Handschriften in Oesterreich*, VIII, VII, 3, Leipzig, 1938, p. 142 ff., pls. XLI, XLII; cf. E. Trenkler, *Livre d'Heures, Handschrift 1855 der Oesterreichischen Nationalbibliothek*, Vienna, 1948) and in the "Breviary of Martin II of Sicily and Aragon" (now Paris, Bibliothèque Nationale, ms. Rothschild 2529; see J. Porcher, *Le Bréviaire de Martin d'Aragon*, Paris [1953]) are very free. For the seventh variant, that in the "Psalter and Prayer Book of Bonne of Luxembourg," see p. 34, note 34⁸.

3. This "Annunciation" is found in the "Taymouth Hours" (H. Yates Thompson, *A Lecture on Some English Illuminated Manuscripts*, London, 1902, pl. XVI). Its derivation from Pucelle (observed by Robb, *op. cit.*, p. 494, note 56) confirms Pächt's assertion that the "Taymouth Hours" (now British Museum, Yates Thompson ms. no. 57) is the only English manuscript "for the illumination of which Pucelle's style could have been the model" ("A Giottesque Episode," p. 53, note 3).

4. Seven of these are enumerated and in part illustrated in Robb, *op. cit.*, p. 494. The eighth is found in a Book of Hours in the Walters Art Gallery, ms. 96, fol. 30 (*Walters Catalogue*, 1949, no. 80, pl. XXXVI, erroneously captioned as no. 88).

5. This change can already be observed in the "Hours of Jeanne de Navarre" (see note 34²), fol. 39 (Yates Thompson, pl. XIV); here the *bas-de-page*, too, is copied from the Annunciation page in the "Hours of Jeanne d'Evreux."

6. "Hours of Yolande de Flandre" (see note 34²), fol. 13 v. (Cockerell, *op. cit.*, pl. [IV], at the end of the volume).

7. P. Durrieu, *Les Très-Belles Heures de Notre-Dame du Duc Jean de Berry*, Paris, 1922, pl. II.

8. Sotheby & Co., *Catalogue of . . . Illuminated Manuscripts and Printed Books Selected from the Renowned Library Formed by Baron Horace de Landau, Sold July 12–13, 1948*, lot 97, p. 64 ff.; see also *The Illustrated London News*, CCXII, 1948, May 29, p. 595.

9. See also note 34 ².

10. Contrary to Cockerell, *op. cit.*, p. 15, the "*Heures de Savoie*" (thus called because Blanche of Burgundy was married to Edward, Count of Savoy, in 1307) was not entirely destroyed in 1904. The surviving pages, preserved in the Catholic Episcopal Library at Portsmouth, England, were edited by Dom P. Blanchard and printed for H. Yates Thompson under the title of: *Les Heures de Savoie, Facsimiles of Fifty-Two Pages from the Hours Executed for Blanche of Burgundy, being all that is known to survive of a famous Fourteenth-Century Ms., which was burnt at Turin in 1904*, London, 1910. The "*Heures de Savoie*" should not be confused with the somewhat — though not too closely — related Hours of her daughter, Jeanne de Savoie (died 1344), now in the Musée Jacquemart-André in Paris (Cockerell, *op. cit.*, p. 14).

11. See again note 34 ².

Page 35

1. The *Information des Princes* is: Paris, Bibliothèque Nationale, ms. fr. 1950 (A. Michel, *Histoire de l'art*, Paris, 1905–1929, III, 1, p. 125, fig. 66); the *Jeu des echecs moralisés*: Paris, Bibliothèque Nationale, ms. fr. 17281 (Martin, *La Miniature française*, pl. 65, fig. XC); the *Rational des Offices Divins*, (dated 1374): Paris, Bibliothèque Nationale, ms. fr. 437 (Martin, *ibidem*, pls. 62, 63, figs. LXXXVII and LXXXVIII); the *Grandes Chroniques de France*: Paris, Bibliothèque Nationale, ms. fr. 2813 (Martin, *ibidem*, pls. 55–57, figs. LXXX–LXXXII, and in several other publications).

2. Cf. Thieme-Becker, IV, 1910, p. 279.

3. This was, so far as I know, first pointed out by Martens, *op. cit.*, p. 240 ff. The miniature showing Blanche of Burgundy adoring the Trinity (our fig. 18) is fol. 2 (Blanchard, *op. cit.*, pl. 3); the miniature of St. Leonard (our fig. 19) is fol. 4 v. (Blanchard, pl. 8).

Page 36

1. Museum Meermanno-Westreenianum, ms. 10 B 23; see also A. W. Byvanck, *Les Principaux Manuscrits à peintures de la Bibliothèque Royale des Pays-Bas et du Musée Meermanno-Westreenianum à la Haye*, Paris, 1924, p. 104 ff.; pls. XLVIII–LI. For two forerunners of this manuscript, see the Bible Historiale in the British Museum, ms. Royal 17 E VI, dated 1357, and the less well-known *Bible Historiale* in the Royal Library at Copenhagen, ms. Thott 6, 2°, which may be assumed to date some time between the London and the Hague redactions; cf. *Stockholm Catalogue*, no. 96, pl. XV. For the sumptuously lettered full-page inscription which faces the dedication page of the Hague Bible and gives detailed information as to its genesis, see, e.g., the "Conrad Bible" in Würzburg, dated 1246 (H. Swarzenski, *Die lateinischen illuminierten Handschriften des XIII. Jahrhunderts*, figs. 877, 878). The observation that Charles V is represented in the garb of a Master of Arts of Paris University was made by Canon A. L. Gabriel who also kindly called my attention to the fact that in the Aristotle manuscript in the Royal Library at Brussels (ms. 9505/06, likewise a product of the Bondol workshop), fol. 2 v., the King is shown among a group of students attending a lecture, dressed in the same costume but with a crown on his head.

2. The Hague, Museum Meermanno-Westreenianum, ms. 10 A 14 (Byvanck, *Les Principaux Manuscrits . . . à la Haye*, p. 99 f.), fol. 22. The Missal, executed by three different illuminators, was ordered by a gentleman whose name (as I learn from Dr. H. Gerson) was Arnoud van Oreye, Lord of Rummen (not "Ruiuuen," as in Byvanck) and Quaebeke (died 1373).

3. The portraits of Jean le Bon and Hendrik van Rijn are illustrated in juxtaposition in Sterling, *Les Primitifs*, p. 27, figs. 13 and 15. As a whole, the "Calvary of Hendrik van Rijn" is illustrated, e.g., in Fierens-Gevaert and P. Fierens, *Histoire de la peinture flamande des origines à la fin du XVᵉ siècle*, Paris and Brussels, 1927–1929, I, pl. IV.

Page 37

1. As other Italian motifs newly assimilated by Jean Bondol and his circle may be listed: first, the little canopies shaped like small barrel vaults (cf., e.g., a Bolognese miniature of 1343 illustrated in *Mostra della pittura bolognese del Trecento*, Bologna, Pinacoteca Nazionale, May-October, 1950, *Guida*, fig. 4); second, the elaboration of the flat background into a pattern of apparently three-dimensional solids which gives the impression of a rusticated wall (excellent examples of this kind are found, for instance, in the Copenhagen *Bible Historiale* just mentioned, others in the Copenhagen "Vincent of Beauvais," ms. Thott 429, 2°, *Stockholm Catalogue*, no. 97).

Page 38

1. See Martin, *La Miniature française*, p. 44 and *passim*; cf., however, Martens, *op. cit.*, p. 240 ff. To

Miss Martens' list of manuscripts (note 220) may be added the "Livre du bien universel selonc la consideracion des mousches a miel" by Thomas of Cantimpré (Brussels, Bibliothèque Royale, ms. 9507, dated 1372) which contains miniatures equal to the best in the Hague Bible and was also produced for Charles V.

2. Paris, Bibliothèque Nationale, ms. fr. 15397; cf. Martin, *Les Joyaux*, pls. 45–48, figs. LVIII–LXII; ———, *La Miniature française*, pls. 45, 46, figs. LIX–LXIV; Martens, *op. cit.*, p. 240, fig. 47. While the text was written in 1356, the major part of the illustrations, mostly unpublished, must have been executed about 1370.

3. See A. Lejard, *Les Tapisseries de l'Apocalypse de la Cathédrale d'Angers*, Paris, 1942; G. Ring, *A Century of French Painting, 1400–1500* (hereafter quoted as "Ring, *A Century*"), London, 1949, Cat. no. 5, fig. 3. For numerous reproductions in color, see *Du, Schweizerische Monatsschrift*, XI, 1951, May number. That Bondol must have used, in addition to the Paris manuscript ms. lat. 403, a model of the type represented by Cambrai, Bibliothèque Municipale, ms. 422, was demonstrated by J. Maquet-Tombu, "Inspiration et originalité des tapisseries de l'Apocalypse d'Angers," *Mélanges Hulin de Loo*, Brussels and Paris, 1931, p. 260 ff. For the Brussels manuscript (Bibliothèque Royale, ms. II, 282), see C. Gaspar and F. Lyna, *Les Principaux Manuscrits à peintures de la Bibliothèque Royale de Belgique*, Paris, 1937–1945, I, p. 110, pl. XXII; and, for its Flemish origin, H. Bober, "The Apocalypse Manuscript of the Bibliothèque Royale de Belgique," *Revue Belge d'Archéologie et d'Histoire de l'Art*, X, 1940, p. 11 ff. Mr. Bober also called my attention to the particularly close relationship between the Angers tapestries and the Apocalypse in the Rylands Library at Manchester (ms. 19) which, though iconographically closely related to the Paris manuscript, must be dated in the third quarter rather than the first third of the fourteenth century (cf. M. R. James, *A Descriptive Catalogue of the Latin Manuscripts in the John Rylands Library at Manchester*, Manchester and London, etc., 1921, p. 57, pls. 41–45). Another series of monumental tapestries apparently executed in the workshop of Nicholas Bataille, and manifestly influenced by the "Angers Apocalypse," was commissioned by the Duc de Berry and consisted of nine hangings representing the Nine Worthies. They are, however, of slightly later date (say, about 1385–1395) and designed by a Franco-Flemish master inferior to Jean Bondol and somewhat related to the illuminator of the Astrological Treatise in the Morgan Library, ms. 785 (see p. 106 f.). About two thirds of this series are now reassembled at the Metropolitan Museum (The Cloisters). See

J. J. Rorimer, "The Museum's Collection of Mediaeval Tapestries," *The Metropolitan Museum of Art, Bulletin*, new ser., VI, 1947–48, p. 91 ff.; ———, *The Metropolitan Museum of Art; Mediaeval Tapestries, A Picture Book*, New York, 1947, fig. 1; ——— and M. B. Freeman, "The Nine Heroes Tapestries at the Cloisters," *The Metropolitan Museum of Art, Bulletin*, new ser., VIII, 1949, p. 243 ff.

Page 39

1. For this will (dated December 26, 1383), see R. Delachenal, *Histoire de Charles V*, V, Paris, 1931, p. 332 f.

2. See, e.g., E. Verwijs and J. Verdam, *Middelnederlandsch Woordenboek*, VII, 1912, col. 541: the painters of Bruges try to prevent the mirror makers and *clederscrivers* from "te werckene van schilderyen up huere clederen, speghelen ende glasen."

Page 41

1. Curiously enough there does not seem to exist a biography of the Duc de Berry. For his activities as a patron and collector, see A. de Champeaux and P. Gauchery, *Les Travaux d'art exécutés pour Jean de France, Duc de Berry*, Paris, 1894; and J. M. J. Guiffrey, *Inventaires de Jean, Duc de Berry*, Paris, 1894–96. For the manuscripts that can be connected with him, see a recent catalogue with contributions by Jean Favière and Jean Porcher which unfortunately appeared too late to be considered in the text: *Musée de Bourges, Chefs-d'oeuvre des peintres-enlumineurs de Jean de Berry et de l'Ecole de Bourges, Hotel Cujas, 23 Juin–4 Septembre*, 1951.

2. Paris, Bibliothèque Nationale, ms. fr. 13091; cf. (apart from Thieme-Becker, III, 1909, p. 121 f.), V. Leroquais, *Les Psautiers manuscrits latins des bibliothèques publiques de France*, Mâcon, 1940–41, II, p. 145 ff.; pls. CXVIII–CXXVII; further, Fierens-Gevaert, *Les Très-Belles Heures de Jean de France*, Brussels, Leyden and Paris, 1924, p. 31 ff. and "planches documentaires," 4, 5. Cf. also *Musée de Bourges, Chefs d'oeuvre*, no. 1. There is no evidence for Fierens-Gevaert's assertion that Beauneveu entered the service of the Duc de Berry as late as 1386. The payment received in this year is not necessarily the first, and Beauneveu is last mentioned in the service of Louis de Mâle of Flanders in 1380–81, having been appointed in 1374. Neither is there much probability in G. Hulin de Loo's identification of the Master of the "*Parement de Narbonne*" with André Beauneveu ("Rapport," *Academie Royale de Belgique, Bulletins de la Classe des Beaux-Arts*, VII, 1925, p. 123 ff.), tentatively endorsed by E. Michel, *L'Ecole flamande du XVe siècle au Musée du Louvre*, Brussels, 1944,

pp. 6 f., 38, pls. I, II. The stylistic "oscillations" within the "Psalter of the Duc de Berry," which are adduced as evidence of Beauneveu's variability, cannot be detected in the only part of the manuscript which is attributable to him on documentary grounds, viz., the twenty-four "illuminations at the beginning."

3. Paris, Bibliothèque Nationale, ms. lat. 1052. See Leroquais, *Les Bréviaires*, III, p. 49 ff.; pls. XLIII–XLVIII. Another outstanding specimen of this "Pucelle renaissance" of *ca.* 1360–1370 which preceded and, in a sense, prepared for the advent of Jacquemart de Hesdin, is the "Bible of Queen Christina," Stockholm, Royal Library, ms. A 165, reputedly executed in 1362 (J. Roosval, "La Bible de la Reine Christine," *Konsthistorisk Tidskrift*, XVII, 1948, p. 68 ff.; *Stockholm Catalogue*, no. 93, pl. XIV).

Page 42

1. Paris, Louvre, frequently illustrated (see Ring, *A Century*, Cat. no. 2, fig. 26). The "*Parement de Narbonne*" must have been executed between the accession of Charles V (1364) and the death of Jeanne de Bourbon (1378); within these limits, the date can be determined only by estimating the age of Charles (born 1337) who seems to be in his middle thirties. The Church, surmounting the portrait of the King, is accompanied by Isaiah holding a scroll inscribed: "Vere languores nostros ipse tulit" (Isaiah LIII, 4); the Synagogue, surmounting the portrait of the Queen, by David holding a scroll inscribed: "Respice in faciem Christi tui" (Psalm LXXXIII, 10).

2. For Jacquemart de Hesdin, see (apart from Thieme-Becker, XVI, 1923, p. 571 f.), the introduction to P. Durrieu, *Les Très-Belles Heures* and Fierens-Gevaert, *Les Très-Belles Heures de Jean de France*. Since the master's birthplace is variously spelled "Esdin," "Esdun," "Oudain," "Odin," and "Hodin," but never "Hesdin," it has been thought to be identical, not with Hesdin in the Artois (which, as part of Flanders, went to Burgundy in 1384, was ceded to France by the Treaty of the Pyrenees in 1659 and is today roughly coextensive with the Départment Pas-de-Calais) but with Houdeng-Aimeries or Houdeng-Goënies, both in the Hainaut. However, the occurrence of "Esdin" and "Esdun" makes the commonly accepted reading somewhat more probable. That the master worked for the Duc de Berry as early as about 1380 is also confirmed by the *Cité de Dieu* manuscript referred to in note 47[4]. A "Last Judgment," dated 1405, which seems to reflect Jacquemart's style in the medium of wall painting, is found in the church of Ennezat near Riom, one of the Duc de Berry's residences; see M. Thibout, "Les Peintures murales de l'Eglise d'Ennezat," *Revue des Arts*, II, 1952, p. 85 ff.

3. Paris, Bibliothèque Nationale, ms. lat. 18014; cf. Leroquais, *Les Livres d'Heures*, II, p. 175 ff., pls. XIV–XIX, and *Musée de Bourges, Chefs d'oeuvre*, no. 5. The miniature on fol. 288 v., showing the Duc de Berry setting out for a journey from the gates of a castle, was executed in the workshop of the Limbourg brothers.

4. Brussels, Bibliothèque Royale, ms. 11060/61, edited by Fierens-Gevaert, *Les Très-Belles Heures de Jean de France*; cf. Gaspar and Lyna, *op. cit.*, I, p. 399, pls. XCIII, XCIV; *Musée de Bourges, Chefs d'oeuvre*, no. 2. The inventory notice, reprinted in Fierens-Gevaert, p. 16, leaves no doubt as to the identity of the volume: "Item, unes très belles heures très richement enluminées et ystoriées de la main de Jaquemart de Odin, et par les quarrefors des feuillez en plusieurs lieux faictes des armes et devises de Monseigneur."

5. Paris, Bibliothèque Nationale, ms. lat. 919; cf. Leroquais, *Les Livres d'Heures*, I, p. 9 ff., pls. XXVII–XXXII; *Musée de Bourges, Chefs d'oeuvre*, no. 6. The names "*Petites Heures*" and "*Grandes Heures*" have no liturgical significance as has been erroneously supposed, but refer only to the size of the manuscripts.

Page 43

1. Illustrated in Robb, *op. cit.*, fig. 20. For later instances of the Angel's gesture, see *Art Bulletin*, XVII, 1935, pl. facing p. 446, figs. 15, 16; further, the "Egmont Breviary" in the Morgan Library, ms. 87, fol. 345 v., and the famous "*Heures de la famille de Rohan*," Paris, Bibliothèque Nationale, ms. lat. 9471 (see p. 74), fol. 212, an instance all the more interesting as the motif was here interpolated into a composition almost literally copied from the *Bible Moralisée*, Paris, Bibliothèque Nationale, ms. fr. 9561 (see note 23[4]), fol. 79. For the surprising appearance of the gesture in the Portinari altarpiece by Hugo van der Goes, see p. 344. The Dürer drawing of 1526 alluded to in the text is in the Musée Condé at Chantilly (Lippmann, no. 344). Dürer may have become familiar with the motif on his journey to the Netherlands where it survived after its introduction by Hugo; cf., e.g., a miniature close to Gerard David in the Robert Lehman Collection at New York (*Walters Catalogue*, 1949, no. 206, pl. LXXVIII). Curiously enough, the Matins page of the "*Petites Heures*," illustrated in Rorimer and Freeman, "The Nine Heroes Tapestries," p. 255, and Robb, *op. cit.*, fig. 21 (the Annunciation only), has been eliminated from the *oeuvre* of Jacquemart de Hesdin by Leroquais, *Les Livres d'Heures*, II, p. 187. While it is true that the principal figures, especially the Angel Gabriel, are somewhat influenced by the Passion Master (cf. p. 44), there is no reason to ascribe this master page of the whole manuscript to any one

but the *chef d'atelier*, least of all (as has been suggested orally by some scholars) to Beauneveu whose work is far less delicate in execution and shows no trace of Italianism. For the Italian type of the "Man of Sorrows" in the upper border, see, e.g., a Sienese panel illustrated in Meiss, "Italian Style in Catalonia," p. 62, fig. 18. For the further development of the Annunciation in an ecclesiastical setting, see Robb, *op. cit.*, p. 499 ff. and above, pp. 57, 59, 137 f.

Page 44

1. Cf. Martens, *op. cit.*, p. 92, figs. 35, 36. It should be noted, however, that this "Lamentation" — like the "Annunciation" on fol. 141 v. — is based, not so much on Jean Pucelle's original in the "Hours of Jeanne d'Evreux" as on its later variations in the "Hours of Jeanne de Navarre" and the "Hours of Yolande de Flandre." In the "Hours of Jeanne de Navarre" (Cockerell, plates following p. 16, fig. 3) the sarcophagus is already placed diagonally (in this respect the statement in Martens, p. 237, note 193, stands in need of correction) while the general mood is calmer; in the "Hours of Yolande of Flanders" (Cockerell, pl. [V] at end of volume) the woman behind the similarly placed sarcophagus throws up her arms as does her counterpart in the "Petites Heures," fol. 94 v., whereas the huddled figure in the foreground is omitted.

2. For the hypothesis that the Germanic *Pietà* originated from the Madonna with the Infant Jesus, on the one hand, and from the grieving mothers in the Slaughter of the Innocents, on the other, see E. Panofsky, "Reintegration of a Book of Hours Executed in the Workshop of the 'Maître des Grandes Heures de Rohan,'" *Medieval Studies in Memory of A. Kingsley Porter*, Cambridge, Mass., 1939, II, p. 479 ff., particularly p. 491, with further references.

Page 45

1. As to the iconography of the scene — unique, so far as I know — Mrs. Marylin Lavin, who is preparing a study on the youthful Baptist in art, kindly informs me that it is based on Domenico Cavalca's *Vite dei Santi Padri* (see p. 281), translated from an anonymous *Vitae Patrum*: "E incominciò a trovare di quelle bestiuole piccolle, che stano per il bosco, e incontanente corse a loro, e presele, e abbracciolle, e recassele in grembo, e dimesticavasi con loro, e quelle bestiuole venivano a lui, e stavansi con lui, come fanno a noi le dimestiche." Cavalca even specifically mentions that the little St. John "s'abbracciava coi lioni e colle bestie grandi salvatiche, che trovava nel diserto," and that all creatures, large or small, loved to be petted by him. It appears, then, that the delightful idyl in the "Petites Heures" is Italianate, not only in style but also in

iconography, and that its model must have been inspired by Cavalca. In a relief in the archevaults of the west façade of Auxerre Cathedral (M. Aubert, *La Bourgogne*; *La Sculpture*, Paris, 1930, II, pl. 51) St. John the Baptist in the Wilderness is represented by a full-grown man and is accompanied only by a lion with whom he does not seem to have established any personal relations — a symbol of the desert rather than a "bestia dimestica" — and such fifteenth-century interpretations of the subject as the eponymous engraving by the Master of St. John the Baptist (M. Lehrs, *Geschichte und kritischer Katalog des deutschen, niederländischen und französischen Kupferstichs im XV. Jahrhundert*, I, Vienna, 1908, pl. 28, no. 77) and its numerous relatives are still more widely different from the miniature in the "Petites Heures." It is remarkable, however, that a certain similarity exists between this miniature and such representations of the youthful St. John the Evangelist on Patmos as the two well-known engravings by the Master E. S. (M. Geisberg, *Die Kupferstiche des Meisters E. S.*, Berlin, 1924, pls. 108, 109).

2. This part, edited by P. Durrieu, *Les Très-Belles Heures de Notre Dame*, contains, of course, no miniatures executed after 1413. In addition to those produced by the Master of the "Parement de Narbonne" and other artists then associated with him and Jacquemart de Hesdin (for the distinction between the various "hands," see Hulin de Loo, *Heures de Milan*, Brussels and Paris, 1911, p. 11 ff.), there are only two (originally three) pages (Durrieu, pls. XXV–XXVII) supplied by the Limbourg brothers who, we remember, also added a page to the "Petites Heures" (see note 42³). Miss Mirella Levi d'Ancona calls my attention to the fact that the "unsubstantial little angels" fluttering about in the borders are derived from Sienese models (especially Andrea Vanni).

3. Edited by P. Durrieu, *Heures de Turin*, Paris, 1902.

4. Edited by Hulin de Loo, *Heures de Milan*. For the famous question as to whether Jan and/or Hubert van Eyck contributed to the illustration of the Turin and Milan sections of the *"Très-Belles Heures de Notre Dame,"* see p. 232 ff.

Page 46

1. Durrieu, *Les Très-Belles Heures*, pl. XXI and p. 70.

2. Hulin de Loo, *Heures de Milan*, pl. VI.

3. The adoration of the new-born Saviour by His holy mother is first explicitly described in the *Meditationes Vitae Christi* by Pseudo-Bonaventure, now happily identified as Johannes de Caulibus of S. Gimignano (P. L. Oliger, "Le 'Meditationes Vitae

Christi' del Pseudo-Bonaventura," *Studi Francescani*, new ser., VII, 1921, Numero Speciale, p. 143 ff.; new ser., VIII, 1922, p. 18 ff.). Here it is said that the Virgin Mary, to quote from the old English translation, "knelynghe doun worshipped and loued God" (*The Mirrour of the Blessed Lyf of Jesu Christ*, L. F. Powell, ed., London, Edinburgh, New York, and Toronto, 1908, p. 46). The locale, however, is described (in literal agreement with the *Golden Legend*), not as a cave but as a "common place betwixe tweyne houses that was heled aboue men for to stonde ther fore the reyn and was i-cleped a dyuersorie." Pacino da Buonaguida's rendering in his "Tree of Life" of 1310–1320 (R. Offner, *A Critical and Historical Corpus of Florentine Painting*, New York, 1930 ff., sect. III, vol. II, pt. I, pl. II, 6) seems to be directly inspired by this text, which is all the more probable as his composition is based upon the real Bonaventure's *Lignum vitae* and no difference was made at the time between the Saint's genuine and apocryphal writings. The Pacino type sporadically survived in Italy and, even more emphatically, in Spain (cf., e.g., Ferrer Bassa's and Jaume Serra's "Nativities" of 1346 and 1361, respectively; S. Sanpere i Miquel, *Els Trescentistes* [La pintura migeval catalana], Barcelona, n.d., I, pp. 227, fig. 80, and 273, fig. 99).

At the same time, however, if not a little earlier, the motif of the Virgin adoring the Christ Child occurs, apparently quite independently of Pseudo-Bonaventure, in the northern countries. Here the Infant Jesus is placed in a manger deliberately styled as an altar (for this much earlier custom, see the excellent article by Miss V. Wylie, "A Copper-gilt Shrine in the Museo Sacro of the Vatican Library," *Art Bulletin*, XXVII, 1945, p. 65 f., [with quotation from Walafrid Strabo: "Ponitur Christus in praesepio, id est corpus Christi super altare"]), and the Virgin is represented — often alone — in a fairly stiff pose not unlike that of a donor's portrait. Cf., e.g., the well-known "Gradual of Gisela van Kerssenbroeck" in Osnabrück (C. Dolfen, *Codex Gisle*, Berlin, 1926, pl. 6) which was executed in 1300 as stated in the inscription, and not late in the fourteenth century as assumed by the editor and most later scholars (for a cogent refutation of their arguments, see R. Norberg, "Den heliga Birgitta Codex Gisle i Osnabrück," *Forvännen*, XXXIV, 1939, p. 226 ff.); a North Italian Antiphonary in the Stockholm Museum (ms. B 1578, fol. 71 v.) kindly brought to my attention by Dr. Carl Nordenfalk; and cod. Vind. 1774 (dated 1315), fol. 28 v., illustrated in J. Kvet, *Illuminované Rukopisy Královny Rejčky*, Prague, 1931, pl. X, fig. 25. This type, symmetrized by the addition of St. Joseph, survived up to the end of the fourteenth century, e.g., in the "Claren altarpiece" in

Cologne Cathedral (see Glaser, *Die altdeutsche Malerei*, Munich, 1924, p. 54, fig. 36; A. Stange, *Deutsche Malerei der Gotik*, III, Berlin, 1934–1938, fig. 61) and often even influenced the Nativities according to St. Bridget, which in Germany appeared from *ca.* 1400, in that the Christ Child is not placed upon the ground but in a very high, though no longer altarlike crib or manger (characteristic instance: the altarpiece at Frauenberg Castle, F. Burger, *Die deutsche Malerei vom ausgehenden Mittelalter bis zum Ende der Renaissance* [Handbuch der Kunstwissenschaft], Berlin-Neubabelsberg, I, 1913, p. 143, fig. 157). The textual source of this motif can be inferred from the miniature in the "Gradual of Gisela van Kerssenbroeck" just quoted. Illustrating the first of the three Christmas Masses (the second, Dolfen, pl. 7, is illustrated by the Annunciation to the Shepherds, the third, Dolfen, pl. 8, by a normal Nativity with the Virgin reclining in bed), it is nevertheless inscribed with the first antiphon sung at Vespers in the liturgy of the Feast of the Purification (February 2): "Ipsum quem genuit adoravit" — a noteworthy example of the fact that texts familiar to everyone for many centuries yet failed to produce a visual image until the temper of the times demanded it. Professor Millard Meiss calls my attention to a North Italian Quattrocento picture where the Nativity with the kneeling Virgin still bears the inscription "Quem Genuit Adoravit" (*Catalogo della Pinacoteca di Cremona*, 1950, fig. 67).

Thus the ground for the adoption of the St. Bridget type (for this, see Cornell, *The Iconography of the Nativity of Christ*, and above, p. 125 f.) was more thoroughly prepared in Spain and the Germanic countries than in France, where — setting aside the isolated case of the "*Très-Belles Heures de Notre Dame*" — the motif of the kneeling Virgin does not seem to occur in renderings of the Nativity prior to 1400. And that even then a Nativity with the Virgin on her knees struck the French mind as something out of the ordinary is shown by its peculiar use within the context of the *Bible Moralisée*. Here the Birth of Moses is likened to the Birth of Christ, and his Finding and Adoption by the daughter of Pharaoh to Christ's recognition and veneration by the Christian community. Accordingly, in the earlier manuscripts (Oxford, Bodleian Library, ms. 270 A, middle of the thirteenth century; Paris, Bibliothèque Nationale, ms. fr. 9561 [see note 23[4]]; Paris, Bibliothèque Nationale, ms. fr. 167, *ca.* 1370) the Birth of Moses is juxtaposed with the normal, "nursery type" of Nativity, while his Finding and Adoption are matched by representations of Christ received and worshiped by the Church and/or the community, with a most significant verbal change from *Ecclesia* (Bodl. 270 A and Paris, ms. fr.

9561) to *devota anima* or *devota persona, quae compungitur et compatitur dulci et pauperi infantiae Salvatoris* in the fourteenth-century manuscripts (A. de Laborde, *Etude sur la Bible Moralisée illustrée*, Paris, 1911–1927, pls. 37–38, 763, 727–728). However, in an early fifteenth-century redaction based on ms. fr. 167 but executed in the circle of the Limbourg brothers (Paris, Bibliothèque Nationale, ms. fr. 166; de Laborde, pls. 742–743; see note 62⁶), the scene of worshipful reception is replaced by a "modern Nativity" (developed from the one in the *Très-Belles Heures de Notre Dame*"), with the Virgin Mary on her knees; whereas the "Birth of Moses" is still juxtaposed with an old-fashioned "Nativity" showing the Virgin Mary in bed. From the point of view of these artists, the new Nativity type with the Virgin kneeling still bore the implications of "adoration" rather than "nativity." For the motif of the cave, see p. 125 f.

4. See also note 42⁴. For the initials I must refer the reader to the forthcoming study by Professor Millard Meiss.

Page 47

1. That miniatures on vellum were occasionally used as devotional images is shown, for instance, by Petrus Christus' "Portrait of a Gentleman" in the National Gallery at London (see p. 313) and the Madonna, erroneously ascribed to the same master, in the Galleria Sabauda at Turin (see note 203⁵) where miniatures on vellum are tacked to the wall.

2. The heterogeneous character of the double page was simultaneously observed by Fierens-Gevaert, *Les Très-Belles Heures de Jean de France*, p. 47 ff., and by Panofsky, "Die Perspektive als symbolische Form," fig. 27. Both authors concluded that it was the work of a different artist whom they identified — the former positively, the latter tentatively — with Beauneveu. This attribution is accepted, e.g., in de Tolnay, *Le Maître de Flémalle et les Frères van Eyck*, Brussels, 1939, p. 39, while Ring, *A Century*, Cat. no. 46, pls. 21, 22, ascribes the double page to Jacquemart de Hesdin and all the other miniatures to the Boucicaut Master, in this respect perpetuating the original error of Durrieu. For the appearance of the Duc de Berry (born in 1340) in the Brussels double page and in his other portraits, see Hulin de Loo, *Heures de Milan*, p. 5.

3. The fully developed "angels' tapestry" ground occurs in the "Hours of Jeanne de Navarre," fols. 65 v. and 150 (Yates Thompson, pls. XIX, XXX) and was occasionally adopted in the Bondol workshop (Hague Bible, Museum Meermanno-Westreenianum 10 B 23, fol. 6). A preliminary stage may be seen in a charming unfinished miniature in the second volume of the "Belleville Breviary" (Paris, Bibliothèque Nationale, ms. lat. 10484, fol. 321 v.), where the ground consists of alternating human heads and little animals, all blue, within a framework of mat gold quatrefoils. Similar backgrounds are found in the "Hours of Jeanne d'Evreux," for instance in the "Visitation," the "Flight into Egypt," the "Nativity," etc.

4. In this connection mention may be made of the *Cité de Dieu* of the Duc de Berry now owned by Mr. Philip Hofer in Cambridge, Mass. (A. de Laborde, *Les Manuscrits à peintures de la Cité de Dieu de St. Augustin*, Paris, 1909, I, p. 241 ff., pls. VI, VII, VIII, IX; E. G. Millar, *The Library of A. Chester Beatty; II, A Descriptive Catalogue of the Western Manuscripts*, Oxford, 1930, II, no. 73, pls. CLIX–CLXI; Sotheby & Co., *Catalogue of the Renowned Collection of Western Manuscripts, the Property of A. Chester Beatty, Esq., the First Portion, Sold on June 7, 1932*, lot 19, pl. 25; *Walters Catalogue*, 1949, no. 70). Produced shortly after 1380, this manuscript epitomizes, as it were, the various currents prevailing at the court of the Duc de Berry at this comparatively early time. Its marginal decoration, with animals and insects, harks back to Jean Pucelle and his followers. Ten of its twelve miniatures are in the tradition of Jean Bondol. One, however (vol. II, fol. 206 v.), showing a man tortured as an example of human as opposed to divine justice, reveals the influence of Beauneveu in the heavily tessellated background, the larger scale, the greater plasticity and somewhat coarser type of the figures, and the complete absence of an interest in space; and the style of the "Coronation of the Virgin" (vol. III, fol. 288) is closely akin to the early manner of Jacquemart de Hesdin in the choice of clear, flower-like colors, animation of design, the use of a red "angels' tapestry" ground, and the treatment of the clouds which, in sharp contrast to the conventionalized bands in the other miniatures, aim at a naturalistic, almost atmospheric effect.

Page 48

1. For this theme and its international diffusion, cf. C. P. Parkhurst, Jr., "The Madonna of the Writing Christ Child," *Art Bulletin*, XXIII, 1941, p. 292 ff.; J. Squilbeck, "La Vierge à l'Encrier ou à l'Enfant Ecrivant," *Revue Belge d'Archéologie et d'Histoire de l'Art*, XIX, 1950, p. 127 ff. The Brussels miniature seems to be based upon a cult image of still earlier date, which would explain the curious fact that, in sharp contrast to the correct perspective convergence of the pavement in the donor's page, the floor of the Madonna page exhibits the obsolete "herringbone" construction (cf. pp. 12, 17, 19).

2. See note 26². The monograms and devices in

the "Brussels Hours" (the letters "UE," a bear and a swan) are supposed to allude to a paramour of the Duc de Berry's youth named Ursine. The "U" and "E" would represent the first and last letters of her name, and the two animals (*ours* and *cygne*) would spell out the name itself in the form of a rebus. It should be noted, however, that the combination of bear and swan (in this order) already occurs in the famous "Album" of Villard de Honnecourt (Hahnloser, ed., p. 22, pl. 7). This would either be a remarkable coincidence or point to the possibility that another, older symbolism is involved.

3. Fierens-Gevaert, *Les Très-Belles Heures de Jean de France*, pl. VIII.

4. Fierens-Gevaert, *ibidem*, pl. VI. The posture of the Virgin is very similar to that in the "Tree of Life" by Pacino da Buonaguida (see note 46³); in the Rothschild part of the *Très-Belles Heures*" (Durrieu, pl. IV) the Virgin prays while still reclining on a couch. In spite of its somewhat paradoxical nature the idea of the Virgin kneeling upon the bed was occasionally retained by later illuminators (e.g., Walters Art Gallery, ms. 231, fol. 46 and Morgan Library, ms. 743, fol. 58 v.); but much more frequently this curious compromise between the "adoration type" and the "nursery type" was reasonably modified in such a way that the Virgin is shown kneeling by instead of upon the bed. This was sanctioned by the authority of the Boucicaut Master (see p. 60; fig. 66) and occurs, e.g., in Morgan Library, ms. 293, fol. 42; Walters Art Gallery, ms. 254, fol. 63; ms. 265, fol. 69; ms. 288, fol. 52v.; and Bibliothèque de l'Arsenal, ms. 647, fol. 41 (as one of four variations, three of which show the "adoration type" pure and simple).

5. Fierens-Gevaert, *Les Très-Belles Heures de Jean de France*, pl. IV. For the Lorenzettian prototype, see Meiss, "Italian Style in Catalonia," p. 55 ff., figs. 11, 12. In the iconography of the Annunciation, too, the kneeling posture of the Virgin is in itself an Italianism; it first occurs in Giotto who may have been influenced by the *Meditationes* of Pseudo-Bonaventure (see Robb, *op. cit.*, p. 485). It should be noted, also, that the Angel Gabriel in the "Brussels Hours" is, apparently for the first time in Northern art, clad in liturgical vestments (dalmatic and stole), as is the case in Lorenzetti's panel of 1344.

6. Fierens-Gevaert, *Les Très-Belles Heures de Jean de France*, pls. XVI, XVIII; "planches documentaires," 4.

Page 49

1. Even in the "Boucicaut Hours" itself natural skies alternate with tessellated, diapered or otherwise patterned grounds, and the latter can be observed al-most throughout the fifteenth century. In panel painting, too, gold ground was used for special effect by masters as advanced as the Master of Flémalle, Enguerrand Quarton, Roger van der Weyden, Geertgen tot Sint Jans, etc. (cf. especially note 167²). Neither "abstract" ground in miniatures nor gold ground in panels can, therefore, be used as an *ipso facto* index of date or "progressiveness."

2. See also p. 57 and *passim*.

3. The second dedication page, being a free variation on the first, retains therefrom the "angels' tapestry" ground.

4. See also p. 33 f.

Page 50

1. Durrieu, *Les Très-Belles Heures*, pl. XXVIII, as compared to *ibidem*, pl. VIII.

Page 51

1. Paris, Bibliothèque Ste.-Geneviève, ms. 1028. See also Martin, *La Miniature française*, pl. 74, fig. XCIX; A. Boinet, "Les Manuscrits à peintures de la Bibliothèque Sainte-Geneviève de Paris," *Bulletin de la Société Française de Reproductions de Manuscrits à Peintures*, V, 1921, p. 122, pls. XXXVII, XXXVIII). The contrast between "courants novateurs" and "courants traditionalistes" (the latter represented, on a higher artistic level, by such manuscripts as the Missal for Châlons-sur-Marne use in the Morgan Library, ms. 331, *Morgan Catalogue*, 1934, no. 79, pl. 66) has justly been stressed, with special reference to Jean de Nizière, by de Tolnay, *Le Maître de Flémalle*, p. 10 ff., fig. 149. So far as I know, however, no serious scholar has ever maintained the "fiction" that the French style of about 1400 was "un art homogène."

2. Paris, Bibliothèque Nationale, ms. fr. 616, completely reproduced in an official edition of the Département des Manuscrits de la Bibliothèque Nationale.

3. Brussels, Bibliothèque Royale, ms. 9125 (Gaspar and Lyna, *op. cit.*, I, p. 396, pls. XCI, XCII), fol. 177 v. Gaspar and Lyna note both the relation to Beauneveu (and, less convincingly, to Jacquemart de Hesdin), and the "influences germaniques" among which they adduce, however, the purely Italianate motif of the Magdalen Embracing the Cross, long acclimatized in French and Franco-Flemish art. For the motif of the jet of blood drenching the Virgin, and its derivation from Suso, see C. R. Morey, "A Group of Gothic Ivories in the Walters Art Gallery," *Art Bulletin*, XVIII, 1936, p. 199 ff. The conspicuous accentuation of the Crown of Thorns may be connected with its veneration in the Sainte Chapelle.

Page 52

1. See Thieme-Becker, XV, 1922, p. 487; see also note 61 ³.

2. Paris, Bibliothèque Nationale, ms. lat. 924, fol. 262 v. (Leroquais, *Les Livres d'Heures*, I, p. 39, no. 39, pls. XX–XXII). A somewhat related Book of Hours for Roman use, formerly in the collection of Mr. Robert Garrett in Baltimore, is now in the Princeton University Library; see Seymour de Ricci and W. J. Wilson, *Census of Medieval and Renaissance Manuscripts in the United States and Canada* (hereafter referred to as "de Ricci-Wilson, *Census*"), New York 1935–37, I, p. 873, no. 47.

3. Paris, Bibliothèque Nationale, ms. fr. 12201; cf. Martens, *op. cit.*, p. 197 and p. 266, notes 509–511, with further references.

4. Paris, Bibliothèque Nationale, ms. fr. 12201, fol. 1.

5. *Ibidem*, fol. 17 v.

6. One of these manuscripts is the *"Boccace de Philippe le Hardi,"* Paris, Bibliothèque Nationale, ms. fr. 12420; the other, the *"Boccace du Duc de Berry,"* Paris, Bibliothèque Nationale, ms. fr. 598. See Martin, *La Miniature française*, pl. 86, figs. CXI–CXIII; and, more specifically, Martens, *op. cit.*, *passim*, especially p. 192 ff., p. 241 (note 221), figs. 6, 7, 42, 43, 50, 52, 53, 59, 80. To Miss Martens belongs the credit of having established the Master of 1402 as an artistic personality of note; I differ from her only in stressing his Netherlandish affiliations. A third Boccaccio manuscript (Brussels, Bibliothèque Royale, ms. 9508; Gaspar and Lyna, *op. cit.*, I, p. 436, pl. CII a) presupposes the two Paris manuscripts but was executed somewhat later and in a different workshop. Recently there has been discovered a very fine Parisian Book of Hours, privately owned, which, to judge from the reproductions, is fairly close to the Master of 1402 (L. M. J. Delaissé, "Le Livre d'Heures d'Isabeau de Bavière," *Scriptorium*, IV, 1950, p. 252 ff.).

7. Paris, Bibliothèque Nationale, ms. fr. 598, fol. 46.

8. Paris, Bibliothèque Nationale, ms. fr. 12420, fol. 29.

Page 53

1. Paris, Bibliothèque Nationale, ms. fr. 598, fol. 71 v.

2. Paris, ms. fr. 598, fol. 99. Maupassant's version of the old story is called "Idylle" (*Oeuvres complètes*, VII [*Miss Harriet*], Paris, 1908, p. 203 ff.).

3. Paris, Bibliothèque Nationale, ms. fr. 159, fol. 289 v.; Bibliothèque de l'Arsenal, ms. 5058, fol. 1. See Martin, *La Miniature française*, pl. 75, fig. C; H. Martin and P. Lauer, *op. cit.*, p. 31, pl. XXXVIII.

4. Paris, Bibliothéque de l'Arsenal, ms. 5057, fol. 44 (see also, e.g., fols. 3 v., 7).

5. See also p. 50.

Page 54

1. Pending the publication of the "Boucicaut Hours" *in extenso*, see the essays of Paul Durrieu, who was the first to recognize the Boucicaut Master's paramount importance and listed most of the manuscripts attributable to him and his workshop: "Jacques Coene, peintre de Bruges établi a Paris sous le règne de Charles VI," *Les Arts Anciens de Flandre*, II, 1905, p. 5 ff.; "Le Maître des Heures du Maréchal de Boucicaut," *Revue de l'Art Ancien et Moderne*, XIX, 1906, p. 401 ff.; XX, 1906, p. 21 ff.; "Les Heures du Maréchal de Boucicaut du Musée Jacquemart-André," *Revue de l'Art Chrétien*, LXIII, 1913, pp. 73 ff., 145 ff., 300 f.; LXIV, 1914, p. 28 ff. See also Martens, *op. cit.*, *passim* (see Index); G. Paulsson, *Konstens Wärldhistoria*, III, Stockholm, 1952, p. 25 f., where the Boucicaut Master is justly acclaimed as "the great innovator"; and Thieme-Becker, XXXVII, 1950, p. 222 ff. Thus far only three manuscripts produced by the Boucicaut Master and/or his workshop have been published *in extenso*: the *Livre des Merveilles du Monde*, Paris, Bibliothèque Nationale, ms. fr. 2810 (official edition of the Département des Manuscrits), and two Books of Hours in the Bibliothèque Royale at Brussels, mss. 10767 and 11051 (J. van den Gheyn, *Deux Livres d'Heures attribués à l'enlumineur Jacques Coene*, Brussels, n. d.). The latest additions to the enormous *oeuvre* attributable to the Boucicaut workshop are: two Books of Hours sold at Sotheby's on December 18, 1946 (lot 567) and on July 12 and 13, 1948 (lot 59), respectively (for the latter, see Catalogue quoted above, note 34 ⁸), and a Book of Hours in a private collection at Brussels, described and partly illustrated by L. M. J. Delaissé, "Une Production d'un atelier Parisien et le caractère composite de certains Livres d'Heures," *Scriptorium*, II, 1948, p. 78 ff. For the "tripartite diaphragm" arch of its "Annunciation" and "Vigils of the Dead," pls. 8 and 10 d, cf. the mss. Paris, Bibliothèque Mazarine, ms. 469 (Couderc, *op. cit.*, pl. LV), fols. 66, 117, and Bibliothèque Nationale, ms. lat. 10538, fols. 78, 173 v. (our fig. 76). For a panel ("Dives and Lazarus," formerly in the Engel-Gros Collection at the Château de Ripaille) supposedly executed by or in the workshop of the Boucicaut Master, see G. Ring, "Primitifs Français," *Gazette des Beaux-Arts*, ser. 6, XIX, 1938, p. 149 ff.; ———, *A Century*, Cat. no. 37, pl. 7. To judge from the reproductions, the attribution is unconvincing; I am not even sure that the panel is French. For bibliographical, biographical and heraldic data concerning the "Bouci-

caut Hours," see F. G. A. Guyot de Villaneuve, *Notice sur un manuscrit Français du XIVᵉ siècle; les Heures du Maréchal de Boucicaut* (pour la Société des Bibliophiles Français), Paris, 1889. Cf. also P. Pansier, *Les Boucicaut à Avignon*, Avignon, 1933, especially pp. 31 ff. and 205 ff. (reprint of Antoinette de Turenne's will of April 10, 1413).

Page 55

1. See p. 42; note 42 [5].

2. Geneva, Bibliothèque Publique et Universitaire, ms. fr. 165, fol. 4 (Martin, *La Miniature française*, pl. 90, fig. CXVII; H. Aubert de La Rue, "Les Principaux Manuscrits à peintures de la Bibliothèque Publique et Universitaire de Genève," *Bulletin de la Société Française de Reproductions de Manuscrits à Peintures*, II, 1912, p. 74, pl. XXXV). It was, so far as I remember, the late Professor Adolph Goldschmidt who orally called attention to the fact that the marginal decoration with the beautiful peacock was executed by an English hand. In this connection it is of interest that the Horae, Paris, Bibliothèque Mazarine, ms. 469 (referred to in note 54 [1]) contains an English insertion (fols. 123–149) with an English prayer ("Ye blessed sterre of sterrys") on fol. 140 v. and two obviously English miniatures (a "Man of Sorrows" and a "Madonna") on fols. 126 v. and 141 v., respectively.

3. Paris, Bibliothèque Nationale, ms. fr. 23279 (Martin, *La Miniature française*, pls. 88 and 89, figs. CXV and CXVI). The text of this work — which, incidentally, contains not only the "Dialogues" of Pierre le Fruictier, called Salmon (that is to say, the "Demandes" posed by Charles VI to his somewhat questionable secretary and adviser and their answers) but also the latter's memoirs and correspondence — was published, with some omissions, by G.-A. Crapelet, *Les Demandes faites par le Roi Charles VI, touchant son état et le gouvernement de sa personne avec les reponses de Pierre Salmon*, Paris, 1833.

4. See note 54 [1]. For the earlier literature on this manuscript, see G. Doutrepont, *La Littérature française à la cour des Ducs de Bourgogne* (Bibliothèque du XVᵉ siècle, VIII), Paris, 1909, p. 242.

5. Guyot de Villeneuve, *op. cit.*, p. 36 f., holds that the representation of St. Leonard with two prisoners "en ses petits draps" (fol. 9 v.) alludes to the Marshal's and his friend Guy de la Tremoille's captivity; but this would only prove that the manuscript postdates 1396 — quite apart from the fact that similar representations occur in Books of Hours owned by personages who were never taken prisoner, e.g., in the "Hours of Blanche of Burgundy" known as the "Heures de Savoie" (see p. 34 f.), fol. 4 v. (pl. 8 in the edition by Dom Blanchard) and in the "Dunois

Hours," fol. 269 v. (*One Hundred Manuscripts in the Library of Henry Yates Thompson*, London, V, 1915, pl. LII). On the other hand, de Villeneuve believes the necklace worn by the youngest King in the "Adoration of the Magi," fol. 83 v. (our fig. 67) to refer to the "knotted stick" adopted as a badge by Louis of Orléans in 1403 (see p. 119), which would date this miniature between 1403, when the badge was adopted, and 1407, when Louis was murdered. However, as a *terminus post quem non* the necklace would not be cogent even if it did allude to the "knotted stick," for nothing would militate against the assumption of a posthumous memorial; and it may well be a mere circlet treated "en style rustique" as, for example, the Cross of St. Andrew on the banner of Charles the Bold in the Historical Museum at St. Gaul (O. Cartellieri, *Am Hofe der Herzöge von Burgund*, Basel, 1926, pl. 22).

6. Guyot de Villeneuve, *op. cit.*, p. 57, identifies this portrait as the Marshal's brother, Geoffroy le Meingre. This assumption, however, is all the more unfounded as Geoffroy was younger than the Marshal and did not wear the latter's personal device "Ce que vous voudrez."

Page 56

1. Among the earlier miniatures I should count, apart from fol. 26 v., fols. 13 v., 15 v., 17 v., 18 v., 19 v., 23 v., 24 v., 36 v., 37 v., 40 v.; among the late ones, apart from fol. 38 v., fols. 20 v., 65 v., 73 v., 79 v., 83 v., 90 v., 105 v., 118 v., 128 v. The remaining miniatures would seem to fall between these two classes, fols. 11 v., 30 v., 32 v., 35 v. and 43 v. being comparatively close to the earlier group.

2. The earliest dated instance of what I have called the "pseudo-acanthus leaf" seems to occur in a Book of Hours in the Bodleian Library at Oxford (Douce, 144) dated 1407 (cf. Delaissé, "Une Production d'un atelier Parisien," p. 81).

3. G. Swarzenski, "Miniatures from a Lost Manuscript," *Bulletin of the Museum of Fine Arts, Boston*, XLII, 1944, p. 28 ff.

4. P. Durrieu, in *Les Arts Anciens de Flandre* and *Revue de l'Art Chrétien*, quoted above, note 54 [1]. The non-identity of the Boucicaut Master with the Master of the "Brussels Hours" eliminates the chief argument for the former's identity with Jacques Coene. Jacques Coene was in Milan from 1402 to 1404, which would fit in with the conspicuous Italianism of the "Brussels Hours"; but since the "Brussels Hours" is indubitably not by the Boucicaut Master, and as indubitably antedates Jacques Coene's trip to Italy, the Coene theory loses much of its attractiveness.

Page 57

1. For the windmill on the hill, see, for example, the "Betrayal of Christ" in the "Brussels Hours" (Fierens-Gevaert, *Les Très Belles Heures de Jean de France*, pl. XIII).

2. Paris, Bibliothèque Nationale, ms. fr. 23279, fol. 69.

3. Leonardo da Vinci, *Trattato della pittura*, H. Ludwig, ed. (Wiener Quellenschriften zur Kunstgeschichte, XV ff.), Vienna, 1881, I, p. 260, no. 234 ("Of those who in a landscape represent the more distant objects as being darker"). Leonardo's own views are set forth, e.g., *ibidem*, p. 192, no. 150 (on the fading of the "true color" of the sky near the horizon), and p. 226, no. 194 (on the submergence of local color in distant objects).

Page 58

1. For representations of St. Jerome in his Study, see A. Strümpel, "Hieronymus im Gehäuse," *Marburger Jahrbuch für Kunstwissenschaft*, II, 1925/26, p. 173 ff. (see also below, note 249^3). For the Petrarch portrait, see S. Bettini, *Giusto de' Menabuoi e l'arte del Trecento*, Padua, 1944, pl. 62; J. von Schlosser, "Ein Veroneser Bilderbuch und die höfische Kunst des XIV. Jahrhunderts," *Jahrbuch der Kunsthistorichen Sammlungen des Allerhöchsten Kaiserhauses*, XVI, 1895, p. 144 ff., especially 183 ff. and pl. XXIV (excellent reproduction of the title miniature of the Petrarch manuscript, Darmstadt, Staatsbibliothek, ms. 101); and, most recently, T. M. Mommsen, "Petrarch and the Decoration of the Sala Virorum Illustrium in Padua," *Art Bulletin*, XXXIV, 1952, p. 95 ff. For the Boucicaut Master's familiarity with North Italian art and his supposed stay at Milan, see P. Toesca, *La pittura e la miniatura nella Lombardia*, Milan, 1912, p. 413 f., and Pächt, "Early Italian Nature Studies," p. 43, note 2.

2. The origin and development of the "diaphragm arch" would make an interesting subject for a special study. One of the earliest instances known to me is found in the illustration of the Offices of the Dead in a Book of Hours in the Morgan Library, ms. 515, fol. 153 (de Ricci-Wilson, *Census*, II, p. 1464, no. 515), which has the rare advantage of being dated and located by a circumstantial colophon: it was written and illuminated at Nantes in 1402. Surprisingly fine for a provincial work, this little manuscript may well have been executed by a Paris-trained illuminator who may even have been in contact with the youthful Boucicaut Master. As for Paris itself, we can observe that the genuine "diaphragm arch" — an arch, that is, which overlaps rather than connects with the architecture shown in the picture — occurs, at a compara-

tively early date, in the "*Boccace de Jean sans Peur*" (Bibliothèque de l'Arsenal, ms. 3193, between 1409 and January 1, 1411) but only in miniatures attributable to the Master of the "*Missel de l'Oratoire de St. Magloire*" (note 61^3). See H. Martin, *Le Boccace de Jean sans Peur*, Brussels and Paris, 1911, figs. LX, LXI (cf. also Martens, *op. cit.*, p. 62, fig. 4, and Panofsky, "Die Perspektive als symbolische Form," p. 328, fig. 39), XCII, CXLV. Elsewhere in this manuscript we find a transitional solution in which the delimiting opening is, as it were, halfway between a genuine "diaphragm arch" and an abbreviated exterior (e.g., figs. LXXXIII, CX, CXXVII, CXXX), and the same is generally true of the "*Térence des Ducs*" of *ca.* 1408 (Bibliothèque de l'Arsenal, ms. 664); cf. H. Martin, *Le Térence des Ducs*, Paris, 1907, *passim*. It is only in the illustrations of the "Adelphi," contributed by the most advanced illuminator in this still somewhat enigmatic workshop, that we encounter something approximating though not quite achieving the genuine diaphragm arch (Martin, pl. XIX, 69; XXII, 83; XXIII, 88; XXIV, 89).

Page 59

1. In what seems to be the earliest representation of a *chapelle ardente* (Durrieu, *Les Très-Belles Heures*, pl. X) it is seen from the side as was, and long remained, the usual thing in renderings of ordinary catafalques; and it is placed within a conventional "doll's house" setting rather than within a real church interior. For the fashion of *chapelles ardentes*, see W. H. Forsyth, "A Head from a Royal Effigy," *The Metropolitan Museum of Art, Bulletin*, new ser., III, 1945, p. 214 ff.

2. Paris, Bibliothèque Nationale, ms. lat. 10538, fol. 137 v. (Leroquais, *Les Livres d'Heures*, I, p. 338, no. 158, pl. XXXIV). Since this *chapelle ardente* miniature shows the church interior in asymmetrical view, it is much closer to Jan van Eyck's "Madonna in a Church" than the "Mass" (not "Mass for the Dead") in the Horae, London, British Museum, ms. Add. 16997, adduced as a parallel in the otherwise excellent article by M. Meiss, "Light as Form and Symbol in Some Fifteenth-Century Paintings," *Art Bulletin*, XXVII, 1945, p. 175 ff., fig. 6. For two other miniatures from the Boucicaut workshop which show a more than accidental similarity with universally accepted works of Jan van Eyck, cf. pp. 184, 192.

The Book of Hours, ms. lat. 10538, may have come to Jan van Eyck's attention all the more easily as it had passed, in an unfinished state, into the possession of Philip the Good for whom it was finished in a Flemish workshop about 1430. This workshop (probably located at Ghent) supplied the Genesis illustra-

tions from fol. 221 v. to fol. 268 v., as well as a number of illustrations of the Suffrages (fols. 299–304) and conveniently added the coat-of-arms and badge of Philip the Good on several pages (notably fols. 221 v., 234 v., 286 v.). An even finer Book of Hours closely related to Paris ms. lat. 10538 and probably executed by the same member of the Boucicaut workshop is preserved in the Walters Art Gallery at Baltimore, ms. 260 (de Ricci-Wilson, *Census*, I, p. 786, no. 185); the "Nativity" on fol. 63 v. (our fig. 73) is nearly identical (though reversed) with that in the Paris manuscript, fol. 63 (our fig. 72). For the Walters Horae, see the *Walters Catalogue*, 1949, no. 86 (no illustration). The curiously two-dimensional, even diaphanous character of its miniatures, somewhat at variance with the general tendencies of the atelier, may be accounted for by the assumption that they did not receive the customary "going over."

3. This "Annunciation" (Florence, Corsini Library) is illustrated, e.g., in E. Panofsky, "The Friedsam Annunciation and the Problem of the Ghent Altarpiece," *Art Bulletin*, XVII, 1935, p. 433 ff., fig. 17. For another, somewhat less impressive instance, a miniature in the "Hours of the Holy Ghost" formerly owned by Count Paul Durrieu at Paris, see Robb, *op. cit.*, p. 499, fig. 26.

4. Bourges, Bibliothèque Municipale, ms. 34, fol. 46 v. (illustrated in Durrieu's article in *Revue de l'Art Ancien et Moderne*, XIX, 1906, p. 407; de Tolnay, *Le Maître de Flémalle*, fig. 156; *Musée de Bourges, Chefs d'oeuvre*, no. 15). For the Pierre Salmon manuscripts, see notes 55 [2, 3].

Page 61

1. Owing to a dissension of opinion as to where the Adoration of the Magi had taken place, the shed which was its customary setting in the fourteenth and early fifteenth centuries was at times replaced by a more sumptuous building, as in the altarpiece at Schotten (Hesse), illustrated in Stange, *op. cit.*, II, fig. 140, and the Wildungen altarpiece by Conrad of Soest (*ibidem*, III, fig. 15; M. Geisberg, *Meister Konrad von Soest* [Westfälische Kunsthefte, II], Dortmund, 1934, pl. 5; K. Steinbart, *Konrad von Soest*, Vienna, 1946, pl. V). In a recently discovered manuscript produced in the workshop of the Master of the "*Grandes Heures de Rohan*" (see p. 74), fol. 57, the scene is even laid in the interior of a church; see E. Panofsky, "The de Buz Book of Hours; a New Manuscript from the Workshop of the Grandes Heures de Rohan," *Harvard Library Bulletin*, III, 1949, p. 163 ff., pl. V a. It was, however, left to the Boucicaut Master to combine the rustic shed with the regal cloth of honor and canopy, and to arrange the

scene so as to convey the impression of a reception at court.

2. Cf. H. Martin's edition (quoted in note 58 [2]) and Martens, *op. cit.*, *passim* (see Index).

3. For the Master of the "*Missel de l'Oratoire de St. Magloire*" and his supposed identity with the "Bedford Master" — so-called after two manuscripts executed for John of Lancaster, Duke of Bedford from 1414 and Regent of France from 1423 to 1435, viz., the Horae, British Museum, Add. 18850 and the "Salisbury Breviary," Bibliothèque Nationale, ms. lat. 17294 (cf. note 74 [3]) — see Martens, *op. cit.*, *passim*, especially p. 241, note 222 with list of manuscripts, and Thieme-Becker, XXXVII, p. 211 f. (for the "Hours of Charles VI," cod. Vind. 1855, see also note 34 [2]). The identification of the master with Haincelin de Haguenot — presupposing the latter's questionable responsibility for the *Livre de chasse* and its relatives and his even more questionable identity with one "*Jean* Haincelin" mentioned as late as 1448 (possibly a son or pupil of the real "little John") — does not appear convincing to this writer; see K. Perls, "Le Tableau de la famille des Juvénal des Ursins; le 'Maître du Duc de Bedford' et Haincelin de Hagenau," *Revue de l'Art Ancien et Moderne*, LXVIII, 1935, p. 173 ff. The close affinity between the earlier phase of the "Bedford Master" and the style of the Boucicaut Master is illustrated by the beautiful Breviary of Châteauroux (Leroquais, *Les Bréviaires*, I, p. 315, no. 187, pls. LXVI–LXXIV) which has been connected with either workshop by equally serious scholars. For a panel painting representing a Last Judgment (Paris, Musée des Arts Décoratifs) tentatively ascribed to the workshop of the "Bedford Master," see Ring, "Primitifs Français," fig. 1; ———, *A Century*, Cat. no. 76. See also note 242 [8].

In the United States the mature style of the "Bedford Master" is represented by four important manuscripts: two Books of Hours in the Morgan Library (mss. 359 and 453, *Morgan Catalogue*, 1934, nos. 116 and 117, respectively, the former in my opinion the later of the two); a Paris Missal in the Walters Art Gallery at Baltimore, dated 1429 (ms. 302, *Walters Catalogue*, 1949, no. 95, pl. XXXVIII); and a Book of Hours, also in the Walters Art Gallery (ms. 281, *Walters Catalogue*, 1949, no. 99, pl. XL). The last-named manuscript is of special interest in that it bears, on fols. 15 and 19, the impaled coats-of-arms of Thomas Malet de Berlettes and his wife, Jeanne de Lannoy. The identification of these personages makes it possible to date the manuscript in 1430–35; no other gentleman of the house of Malet married a lady of the house of Lannoy in the first half of the fifteenth century, and a younger brother of Thomas Malet, Jean,

must have married about 1435–38, because two of his sons were executed for rape as early as 1458 (see A. L. de la Grange and Comte du Chastel de la Howarderie, "Généalogie de la famille Malet, dite de Coupigny, de Berlettes et du Hocron," *Souvenirs de la Flandre Wallonne*, VII, 1887, pp. 5 ff., 54 ff., 60 ff.). The manuscript, then, was executed for members of two old families residing at Lille, and it is, in fact, closely connected with four Books of Hours of indubitably Netherlandish origin, three of them belonging, more or less, to the "Gilbert of Metz" family, the fourth being a crossbreed between this family and the so-called "Gold Scroll" group (see p. 121 ff.). Two of the compositions in the "Malet-Lannoy Hours," the "Adoration of the Magi," fol. 91, and the "Presentation of Christ," fol. 97, recur, with relatively minor variations in: Walters Art Gallery, ms. 263, de Ricci-Wilson, *Census*, I, p. 792, no. 221 (fols. 58, 62); Walters Art Gallery, ms. 270, *Census*, I, p. 795, no. 242 ("Presentation" on fol. 59 v.); Morgan Library, ms. 82 (destined for Mons), *Census*, II, p. 1381, no. 82 (fols. 62 v., 66 v.); Walters Art Gallery, ms. 211, *Census*, I, p. 789, no. 201 (fols. 147 v., 151 v.). It is, of course, entirely possible that the Malet-Lannoy couple ordered their Horae in Paris or that the patterns which served as models for the Adoration and Presentation compositions in the four Flemish manuscripts had found their way from Paris into the Netherlands. But there remains the alternative hypothesis that a proficient member of the "Bedford" workshop, in view of the hard times in Royal France, had established himself at Lille, main capital of the Burgundian empire from 1420; and this alternative hypothesis may find some support in the fact that a continuance of the "Bedford" influence can be observed in the "Mansel Master," active in or not far from Lille up to *ca.* 1440 (F. Winkler, *Die flämische Buchmalerei des XV. und XVI. Jahrhunderts*, Leipzig, 1925, pp. 8, 36).

4. For the Limbourg brothers, see Thieme-Becker, XXIII, 1929, p. 227 f., with bibliography up to 1929 (especially important P. Durrieu's edition of the "Très-Belles Heures," quoted in note 34⁷, and the same great scholar's edition of "Les Très Riches Heures de Jean de France, Duc de Berry," Paris, 1904). For two panel paintings that can be connected with the Limbourg brothers, see p. 82. For some additions to the bibliography, see the following notes.

Page 62

1. The Grimani Breviary (Venice, Biblioteca di San Marco) was published *in extenso* by Scato de Vries and S. Morpurgo, *Das Breviar Grimani*, Leipzig, n.d. (See also Winkler, *Die flämische Buchmalerei*, p. 200 ff., pls. 84–88; F. de Mély, "Le Bréviaire Grimani

et les inscriptions de ses miniatures," *Revue de l'Art Ancien et Moderne*, XXV, 1909, p. 81 ff.; de Tolnay, *Pierre Bruegel l'Ancien*, pp. 38 ff., 89, figs. 72, 77). For the Hennessy Hours (Brussels, Bibliothèque Royale, ms. II, 158), see de Tolnay, *ibidem*, figs. 66, 67, 73, 78, 83, 87, 88.

2. On New Year's Day, 1411, the brothers surprised the Duke with an illuminated manuscript which was, in reality, a dummy ("livre contrefait"), consisting "d'une pièce de bois blanc paincte en semblance d'un livre, où il n'a nulz feuillets ne riens escript" (Durrieu, *Les Très Riches Heures*, p. 81). Paul, apparently the oldest of the brothers since his name always takes precedence in the documents, was presented by his patron with a house the owner of which had died in 1409.

3. For the *"Heures d'Ailly"* (executed for the Duc de Berry after 1402 but several years before 1413), see P. Durrieu, "Les 'Belles Heures' de Jean de France Duc de Berry," *Gazette des Beaux-Arts*, ser. 3, XXXV, 1906, p. 265 ff.; and, more recently, J. Porcher, "Two Models for the 'Heures de Rohan,'" *Journal of the Warburg and Courtauld Institutes*, VIII, 1945, p. 1 ff. M. Porcher plans to publish the manuscript *in extenso*.

4. *"Heures d'Ailly,"* fol. 63 (Porcher, *ibidem*, pl. 7 c); for the Broederlamesque picture (Antwerp, Musée Meyer van den Bergh), see p. 95, fig. 111.

5. *"Heures d'Ailly,"* fol. 221 (Porcher, *ibidem*, pl. 6 d).

6. R. Schilling, "A Book of Hours from the Limbourg Atelier," *Burlington Magazine*, LXXXI, 1942, p. 194 ff. (for a discussion of its date, cf., however, Pächt, "Early Italian Nature Studies," p. 40, note 2). Good illustrations are found in Sotheby & Co., *Catalogue of the Manuscripts, Printed Books and Autograph Letters Presented to the Duke of Gloucester's Red Cross and St. John Fund, Sold October 13–15*, 1942, Lot 117. It is interesting to note that, while the "Flight into Egypt" almost literally agrees with the corresponding miniature in the "Brussels Hours," the "Vigils of the Dead" no less closely agrees with the corresponding miniature in the *"Heures d'Ailly,"* fol. 94 v. While both the *"Heures d'Ailly"* and the *"Très Riches Heures"* were executed for the Duc de Berry, the *Bible Moralisée*, Bibliothèque Nationale, ms. Fr. 166 (see Hulin de Loo, "La Bible de Philippe le Hardi historiée par les frères de Limbourc: Manuscrit Français no. 166 de la Bibliothèque Nationale à Paris," *Bulletin de la Société d'Histoire et d'Archéologie de Gand*, XVI, 1908, p. 183 ff.) and the "Breviary of John the Fearless," British Museum, mss. Add. 35311 and Harley 2897 (see note 76⁴) seem to date from the time of the Limbourg brothers' early connection with the Burgundian court; whereas the original

of the Louvre portrait of John the Fearless, if I am right in ascribing it to one of them, appears to have been executed after the death of the Duc de Berry (see note 82 [3]).

7. Cf. Robb, *op. cit.*, p. 496; Panofsky, "The Friedsam Annunciation," especially p. 441 ff. and figs. 9–12; ———, "Once More the 'Friedsam Annunciation and the Problem of the Ghent Altarpiece,' " *Art Bulletin*, XX, 1938, p. 419 ff., especially p. 420 and figs. 1, 2. The "Annunciation" formerly ascribed to Agnolo Gaddi is illustrated in van Marle, *op. cit.*, III, p. 546, fig. 303; that in the "*Très-Belles Heures de Notre Dame*," with the Virgin seated (Hulin de Loo, *Heures de Milan*, pl. IX), is in reality a conflation of the exterior type with the good old Pucelle scheme exemplified by another miniature in the same manuscript (Durrieu, *Les Très-Belles Heures de Notre Dame*, pl. II).

Page 63

1. See, e.g., Hulin de Loo, "Les Très Riches Heures de Jean de France, Duc de Berry, par Pol de Limbourc et ses frères," *Bulletin de la Société d'Histoire et d'Archéologie de Gand*, XI, 1903, p. 178 ff.; H. Beenken, "Zur Entstehungsgeschichte des Genter Altars; Hubert und Jan van Eyck," *Wallraf-Richartz Jahrbuch*, new ser., II/III, 1933/34, p. 176 ff., especially p. 217 ff. In addition to Durrieu's monumental edition of the "*Très Riches Heures*," there may be mentioned a less ambitious publication by M. Malo, "*Les Très Riches Heures du Duc de Berry*," Paris, 1933. Color reproductions of the Calendar have appeared in *Verve*, 1940, no. 7, and *Life*, January 5, 1948; of several other pages, in *Verve*, 1940, no. 10.

2. This much-debated picture has finally found a satisfactory explanation in H. Bober, "The Zodiacal Miniature of the 'Très Riches Heures' of the Duke of Berry; Its Sources and Meaning," *Journal of the Warburg and Courtauld Institutes*, XI, 1948, p. 1 ff.

3. In contrast to Emile Mâle's opinion (*L'Art religieux de la fin du moyen âge en France*, 2nd ed., 1922, p. 37), the "Nativity" in the "*Très Riches Heures*" is not the earliest example of the shepherds' admission to the scene. The motif is indubitably Italian, as shown, e.g., by the "Nativity" in the Fogg Museum at Harvard University, formerly ascribed to the mythical "Ugolino Lorenzetti" and now attributed to Bartolommeo Bulgarini or Bolgarini (M. Meiss, "Bartolommeo Bulgarini altrimenti detto 'Ugolino Lorenzetti'?," *Rivista d'Arte*, XVIII, 1946, p. 113 ff.). For further Italian influences on the Limbourg brothers, especially their familiarity with Ambrogio Lorenzetti and Michelino da Besozzo, see Pächt, "Early Italian Nature Studies," p. 41 ff.

Page 64

1. See F. Winkler, "Paul de Limbourg in Florence," *Burlington Magazine*, LVI, 1930, p. 94 ff.

2. Cf. van Marle, *op. cit.*, VII, p. 87, fig. 47. B. Kurth, "Ein Freskenzyklus im Adlerturm zu Trient," *Jahrbuch des kunsthistorischen Institutes der K. K. Zentralkommission für Denkmalpflege*, V, 1911, p. 9 ff., especially p. 98 ff., believes that the sketchbook drawing was copied from the December page in the "*Très Riches Heures*" rather than the other way around and concludes that the sketchbook, in spite of its inscription, is not the work of Giovanni dei Grassi. This theory has, so far as I know, not been accepted by many scholars other than L. von Baldass, *Conrad Laib und die beiden Rueland Frueauf*, Vienna, 1946, p. 61, and is indeed exceedingly improbable (for an explicit refutation, see Pächt, "Early Italian Nature Studies," p. 39 ff.). For classical analogies to Giovanni dei Grassi's hunting group, cf., e.g., the sarcophagi illustrated in Reinach, *Répertoire de reliefs*, II, pp. 212, 213.

3. See p. 329.

4. Cf. Kehrer, *op. cit.*, I, p. 63. John of Hildesheim, mentioned in 1362 as *biblicus* in Paris, traveled extensively in Italy and France, and his *Historia Trium Regum*, translated into several languages, attracted the attention of Goethe. The Latin original and its Old English version were edited by C. Horstmann, *The Three Kings of Cologne* (Early English Text Society, vol. LXXXV), London, 1886; the account of the meeting at Mount Golgotha, pp. 52 ff. (English), 230 ff. (Latin). Cf. also note 83 [1].

5. J. von Schlosser, "Die ältesten Medaillen und die Antike," *Jahrbuch der Kunsthistorischen Sammlungen des Allerhöchsten Kaiserhauses*, XVIII, 1897, p. 64 ff., especially p. 75 ff. (cf. also Michel, *Histoire de l'Art*, III, 2, p. 905 ff., and E. Panofsky, "Conrad Celtes and Kunz von der Rosen: Two Problems in Portrait Identification," *Art Bulletin*, XXIV, 1942, p. 39 ff., p. 54, note 76).

Page 66

1. The September, October, November and December pictures (fols. 9 v.-12 v.) are painted on a separate quire consisting of only two double leaves; the lower half of the September picture and the entire November picture are by Jean Colombe. The next snow landscape occurs in the "Nativity" in the "Bedford Hours" (British Museum, ms. Add. 18850, fol. 65; cf. note 61 [3]).

2. See p. 33 f.

3. It is interesting to note that the Calendar poems by Folgore da San Gimignano (quoted by Pächt, "Early Italian Nature Studies," p. 46 f.), composed at

the beginning of the fourteenth century, do not emphasize this contrast between the nobles and the poor but deal exclusively with the occupations of the better classes.

4. For a more detailed characterization of this interlude, I cannot do better than to refer the reader to Emile Mâle's *L'Art religieux de la fin du moyen âge en France* and Jan Huizinga's *Waning of the Middle Ages*, London, 1924 (especially useful, the second and third German editions, *Herbst des Mittelalters*, Munich, 1928 and 1931).

Page 67

1. To give a few instances: the well-known *"Vierge à l'Ecritoire"* in the Louvre (P. A. Lemoisne, *Gothic Painting in France*, Florence, 1931, pl. 28), formerly "Southwest French," is now firmly established as Viennese (cf. Sterling, *Les Primitifs*, note 30; Parkhurst, *op. cit.*, p. 297, note 28), and the same is true of the fine "Trinity" in the National Gallery at London (W. Hugelshofer, "Eine Malerschule in Wien zu Anfang des 15. Jahrhunderts," *Beiträge zur Geschichte der Deutschen Kunst*, E. Buchner and K. Feuchtmayr, eds., Augsburg, 1924, I, p. 21 ff., fig. 14) though it is still illustrated as French in Joan Evans, *Art in Mediaeval France, 987–1498*, London, New York and Toronto, 1948, fig. 200. Austrian provenance must also be assumed for the large altarpiece from Heiligenkreuz in the Vienna Museum which was originally considered French and, for a time, even ascribed to the Rohan Master (L. Réau, *French Painting in the XIVth, XVth and XVIth Centuries*, London, Paris and New York, 1939, pls. 41, 42; cf., however, Sterling, *Les Primitifs*, note 31, and Ring, *A Century*, Cat. no. 58, withdrawing her original attribution to the Rohan Master). The Lippmann-Morgan Diptych (Lemoisne, *op. cit.*, pl. 22; Labande, *Les Primitifs français*, pls. XVII, XVIII) is, as already suspected by H. Bouchot, not Provençal but Bohemian, and this applies also to the tiny Madonna now in the Boston Museum of Fine Arts (G. H. Edgell, *Bulletin of the Museum of Fine Arts, Boston*, XXXIII, 1935, p. 33; cf. Sterling, *Les Primitifs*, note 31, and Meiss, "Italian Style in Catalonia," p. 48). The fine organ shutters at Kansas City, formerly "French" (*The William Rockhill Nelson Collection*, Kansas City [first edition, n.d.], p. 43), were soon transferred to Siena (*ibidem*, second edition, n.d., p. 39) and are probably Florentine. And one of the main attractions of the epoch-making exhibition of French Primitives in Paris, 1904, the Douglas-Morgan Quadriptych, can be assigned to an individual Catalan painter, the Master of St. Mark (Meiss, "Italian Style in Catalonia," p. 45 ff.). For further readjustments on similar lines, see p. 82 f.

2. Such bells are first mentioned in the 'eighties of the fourteenth century and occur in art from the 'nineties, e.g., in the effigy of Heinrich von Werther in the Museum at Nordhausen, dated 1397 (W. F. Creeny, *A Book of Facsimiles of Monumental Brasses on the Continent of Europe*, London, 1884, pl. facing p. 24). They are seen in the Wildungen Calvary by Conrad of Soest (see text ill. 33), and in the Hague portrait of Lisbeth van Duivenvoorde of 1430. For the latter, see G. J. Hoogewerff, *De Noordnederlandsche Schilderkunst*, The Hague, 1936–1947 (hereafter quoted as "Hoogewerff"), II, p. 50, fig. 52.

3. The late Mr. Joseph Brummer in New York once showed me a complete collection of such "horse medals," many of them extremely beautiful. Of special interest are those which show no figural representation but only a big Gothic "Y." This letter is very frequent in tapestries (e.g. the "Angers Apocalypse"), paintings (e.g. the curtain in Conrad of Soest's Aachen altarpiece, Geisberg, *Meister Konrad von Soest*, pl. 42, and the brocade lining in the portrait of Lisbeth van Duivenvoorde just quoted) and miniatures (e.g., our figs. 160 and 161); and it has often induced historians to connect such works with persons named Yolande or the like. We know, however, that "lettres grecques et turquesques," and quite especially the "Y gregois," were worn at pageants and tournaments without any reference to proper names (O. Cartellieri, "Rittersprüche am Hofe Karls des Kühnen von Burgund," *Tijdschrift voor Geschiedenis*, XXXVI, 1921, p. 25); and much can be said for the assumption that the "Y" was still understood as the "Pythagorean Letter" whose divergent strokes, unequal in width, were held to symbolize the choice between the wide road of pleasure and the narrow path of virtue (R. Graham, "The Apocalypse Tapestries from Angers," *Burlington Magazine*, LXXXIX, 1947, p. 227). It was simply a symbol of chivalrous *virtus* or feminine chastity which could be used singly, doubly or in combination with other letters as the case may be. It may be noted that the Duc de Berry owned "un Y grec d'un saphir assis en un annel d'or," the gift of his chamberlain, Jean Dompme (Guiffrey, *op. cit.*, I, p. 118, no. 385).

Page 68

1. A. R. Wagner, *Historic Heraldry of Britain*, London, New York and Toronto, 1939, p. 21.

2. T. Krautheimer-Hess, Review of R. S. Loomis, Arthurian Legends in Mediaeval Art, *Art Bulletin*, XXIV, 1942, p. 102 ff.

3. Eustache Deschamps, *Oeuvres complètes*, De Queux de Saint Hilaire and G. Raynaud, eds., Paris,

1878–1903, IX, p. 45 (quoted in O. Cartellieri, *The Court of Burgundy*, New York, 1929, p. 211):

"Heures me fault de Nostre Dame . . .
Qui soient de soutil ouvraige,
D'or et d'azur, riches et cointes,
Bien ordonnées et bien pointes,
De fin drap d'or bien couvertes,
Et quant elles seront ouvertes,
Deux fermaulx d'or qui fermeront."

4. H. T. Bossert, ed., *Geschichte des Kunstgewerbes aller Zeiten und Völker*, Berlin, V, 1932, p. 388, pl. XXI; R. Krautheimer, "Ghiberti and Master Gusmin," *Art Bulletin*, XXIX, 1947, p. 25 ff., figs. 4, 5.

Page 69

1. J. Evans, "The Duke of Orleans' Reliquary of the Holy Thorn," *Burlington Magazine*, LXXVIII, 1941, p. 196 ff.; ———, *Art in Mediaeval France*, fig. 197. For the other objects mentioned, see, in addition to the literature quoted in Krautheimer, *loc. cit.*, p. 30 f., and Bossert, *op. cit.*, p. 386 ff.: A. Michel, *Histoire de l'art*, III, 2, p. 867 ff.; G. Lehnert, ed., *Illustrierte Geschichte des Kunstgewerbes*, Berlin, II, n.d., p. 363 ff.; W. Burger, *Abendländische Schmelzarbeiten*, Berlin, 1930, p. 148 ff. For a wax model and a group of small, polychromed ivories apparently related to the style of gold enamel work, cf. E. Panofsky, "A Parisian Goldsmith's Model of the Early Fifteenth Century?," *Essays in Honor of Georg Swarzenski*, Chicago and Berlin, 1951, p. 70 ff.

2. The "*Goldenes Rössel*" was given to Charles VI by his wife, Isabeau of Bavaria, on New Year's Day, 1404, and pawned by him in the following year; the same fate befell its lost companion piece transmitted by an eighteenth century painting. Cf. M. Frankenburger, "Zur Geschichte des Ingolstädter und Landshuter Herzogsschatzes und des Stiftes Altötting," *Repertorium für Kunstwissenschaft*, XLIV, 1924, p. 23 ff., especially p. 32.

3. *Charles d'Orléans, Poésies*, P. Champion, ed., Paris, 1923–1927, II, p. 307, no. XXXI; the translation given in the text is by Mr. Parker T. Lesley. Another of Charles' *rondeaux* (*Charles d'Orléans, Poésies*, P. Champion, ed., I, p. 247, no. LXXIII) might almost be a paraphrase of the May picture in the "*Très Riches Heures*":

"Jennes amoureux nouveaulx,
En la nouvelle saison,
Par les rues, sans raison,
Chevauchent, faisans les saulx,

Et font saillir des carreaulx
Le feu, comme de cherbon,
Jennes amoureux nouveaulx
En la nouvelle saison.

Je ne sçay se leurs travaulx
Ilz emploient bien ou non;
Mais piqués de l'esperon
Sont autant que leurs chevaulx,
Jennes amoureux nouveaulx."

Recently, a parallel has been drawn between the *rondeau* "Le temps a laissié" and the "*Très Riches Heures*" by H. A. Hatzfeld, "Literary Criticism through Art and Art Criticism through Literature," *Journal of Aesthetics and Art Criticism*, VI, 1947, p. 1 ff.; but his intention was not so much to illustrate the spirit of a specific historical period as to demonstrate a "typically French" tendency "never to show nature without cultural or civilized implication."

Page 70

1. *Abbot Suger on the Abbey Church of St.-Denis and its Art Treasures*, pp. 19 ff., 62 ff., 183.

2. Stange, *op. cit.*, III, fig. 177; C. Glaser, *op. cit.*, p. 80, fig. 58.

3. Stange, *op. cit.*, fig. 6; Glaser, *op. cit.*, p. 70, fig. 48; Martens, *op. cit.*, pl. XXV.

4. For the emergence of the *genre rustique*, see especially J. von Schlosser, "Armeleutekunst alter Zeit," reprinted in *Präludien*, Berlin, 1927, p. 324 ff.; and A. Warburg, "Arbeitende Bauern auf Burgundischen Teppichen," *op. cit.*, I, p. 221 ff. Warburg's article deals especially with the interesting fashion of adorning princely chambers with tapestries transforming the room into a forest alive with "grans personnaiges comme gens paysans et bocherons," the earliest recorded instance being a "chambre semée de bocherons et de bergiers" owned by Valentine of Orléans in 1407.

Page 71

1. Stange, *op. cit.*, fig. 3; Glaser, *op. cit.*, p. 74, fig. 52; Martens, *op. cit.*, pls. IV, XIV; F. Winkler, *Altdeutsche Tafelmalerei*, 2nd ed., Munich, 1944, p. 58.

2. Stange, *op. cit.*, fig. 13; Glaser, *op. cit.*, p. 61, fig. 41; Geisberg, *Meister Konrad von Soest*, pls. 12–18; Steinbart, *Konrad von Soest*, pls. VIII, IX, 26–35. Most recent German writers insist that the date in the inscription of the Wildungen altarpiece, now illegible in its crucial part, should be read as 1404 or even 1403 (Winkler, *Altdeutsche Tafelmalerei*, captions his illustration, p. 13, as "1414" while favoring 1403 in his explanatory text, p. 227). I am inclined to agree with the lone dissenter, C. Hölker, *Meister Conrad von Soest* (Beiträge zur Westfälischen Kunstgeschichte, VII), Münster, 1921, who prefers 1414. According to him, p. 5 f., the first transliterator of the inscription, L. Curtze (writing in 1850), has the nonsensical reading MCCCCIIIV, obviously interpolating two "I"s be-

tween the then still legible four "C"s and the final "IV." Thus is seems safer to conjecture an "X" instead of Curtze's two "I"s than to replace the whole "IIIV" by the words "quarto" or "tertio" as do most recent German writers. However, even Geisberg, who declares the date 1404 as "unshakable," expresses himself more cautiously in other places and admits that the Wildungen altarpiece, if really executed in 1404, would be "a little miracle" (*ein kleines Wunder*). Steinbart, pp. 11 and 25, accepts the date 1404 with considerable reluctance and explicitly states that 1414 would "fit in much better with the general stylistic situation" inasmuch as some of the French and Franco-Flemish sources of the Wildungen altarpiece postdate 1400.

Page 72

1. Alain Chartier's *Espérance ou Consolation des trois Vertus* was written in 1428, and its Prologue concludes with the words: "Dont par douleur ay commencé ce livre." Cf. P. Champion, *Histoire poétique du quinzième siècle*, Paris, 1923, I, p. 135 ff., with reproduction of a miniature illustrating Chartier's encounter with "Dame Mélancholie." This scene is also represented in the title woodcut of *Faits Maistre Alain Chartier*, Paris, 1489.

2. See, e.g., Eustache Deschamps, *Oeuvres complètes*, I, p. 113, no. 31:

"Temps de doleur et de temptacion,
Aages de plour, d'envie et de tourment . . .
Aages menteur, plain d'orgueil et d'envie,
Temps sanz honeur et sanz vray jugement,
Aage en tristour qui abrege la vie."

3. See P. Champion, *Vie de Charles d'Orléans*, Paris, 1911. The line "Je suy cellui" is from *Poésies*, I, p. 36, no. XVIII.

4. Charles d'Orléans, *Poésies*, II, p. 508, no. CCCLXXVI.

Page 73

1. Charles d'Orléans, *Poésies*, I, p. 156, no. C. The only difference is that Charles d'Orléans wrote: "Je meurs de soif *en couste* la fontaine."

2. R. Steele, *The English Poems of Charles of Orleans* (Early English Text Society, Original Series, 215), London, 1941, p. 81, Ballad 70 (translated from *Poésies*, I, p. 88, no. XLIII:

"En la forest d'Ennuyeuse Tristesse . . .
L'omme esgaré qui ne scet ou il va").

3. R. Steele, *op. cit.*, p. 70, Ballad 59 (original composition in English).

4. Charles d'Orléans, *Poésies*, II, p. 484, no. CCCXXXVII; the translation given in the text is by Mr.

Parker T. Lesley. The special appeal of Charles d'Orléans to the modern mind is attested by the fact that his poems have recently been transcribed by hand and copiously illustrated by Henri Matisse: *Poèmes de Charles d'Orléans, manuscrits et illustrés*, Paris, 1950.

5. Paris, Bibliothèque Nationale, ms. lat. 1161 (Leroquais, *Les Livres d'Heures*, I, p. 82, no. 26), fol. 27.

6. "Buxtehude Altarpiece" by a follower of Master Bertram, Hamburg, Kunsthalle (W. Worringer, *Die Anfänge der Tafelmalerei*, Leipzig, 1924, p. 193, fig. 59).

7. "De Buz Hours," fol. 155 (Panofsky, "The de Buz Book of Hours," pl. IX). After the death of Mr. William King Richardson this manuscript, first called to the attention of this writer by Mr. Philip Hofer, became the property of the Houghton Library of Harvard University.

Page 74

1. Paris, Bibliothèque Nationale, ms. lat. 1161, fol. 212.

2. Michel, *Histoire de l'art*, III, 1, p. 381, fig. 193; M. Aubert, *La Sculpture française du moyen âge et de la Renaissance*, Paris, 1926, p. 335; cf. C. R. Morey, *Mediaeval Art*, p. 390. For the general preoccupation with the macabre, see the masterly chapters in Mâle's *L'Art religieux de la fin du moyen âge en France* and Huizinga's *Waning of the Middle Ages*. For the much-debated subject of the Dance of Death, see I. Kozáky, *Geschichte der Totentänze*, Budapest, 1936, and W. Stammler, *Der Totentanz, Entstehung und Deutung*, Munich, 1948. Cf. also E. M. Manasse, "The Dance Motive of the Latin Dance of Death," *Medievalia and Humanistica*, IV, 1946, p. 83 ff.; and — for the interesting representations of a real *chorea* (people of all ranks dancing around a coffin which contains a decaying corpse or skeleton) — F. Saxl, "A Spiritual Encyclopaedia of the Later Middle Ages," *Journal of the Warburg and Courtauld Institutes*, V, 1942, p. 82 ff., especially p. 95 ff., pl. 23 e.

3. See note 61³. The influence of the Master of Flémalle is especially noticeable in the Salisbury Breviary, Paris, Bibliothèque Nationale, ms. lat. 17294, which postdates 1424 (Leroquais, *Les Bréviaires*, III, p. 271, pls. LIV–LXV).

4. Paris, Bibliothèque Nationale, ms. lat. 9471 (Leroquais, *Les Livres d'Heures*, I, p. 281, no. 141, pls. XXXVIII–XLII); some fine color reproductions in J. Porcher, *Les Grandes Heures de Rohan* (Les Trésors de la peinture Française, I, 7 [XV]), Geneva, 1943. The contributions which have appeared after the basic article by A. Heimann, "Der Meister der 'Grandes Heures de Rohan' und seine Werkstatt,"

Städel-Jahrbuch, VII–VIII, 1932, p. 1 ff. (especially important is the article by Porcher, quoted in note 62 ³), are listed in Panofsky, "The de Buz Book of Hours" (to which may be added the observation that the representation of the Trinity in the guise of three Persons of different age emerging in half-length from a piece of drapery, discussed there on p. 180 f., derives from the *"Heures d'Ailly,"* fol. 155). Cf. also Ring, *A Century*, Cat. nos. 86–90, fig. 5, pls. 36–42, color pl. p. 17. The inherent monumentality of the Rohan Master's compositions has always tempted scholars to ascribe to him panel paintings in addition to book illuminations. While the first of these attempts has proved unsuccessful (see note 67 ¹), the recent attribution of a diptych wing in the Museum at Laon (Ring, *A Century*, Cat. no. 89, pls. 41, 42) appears to be very acceptable.

5. Paris, Bibliothèque Nationale, ms. lat. 9471, fol. 85 v. (Leroquais, *Les Livres d'Heures*, pl. XXXIX; Porcher, *Les Grandes Heures de Rohan*, pl. III).

6. Paris, Bibliothèque Nationale, ms. lat. 9471, fol. 159 (Leroquais, *op. cit.*, pl. XLII; Porcher, *Les Grandes Heures de Rohan*, pl. IX). In recollection of the passage quoted in the text (Job I, 21; cf. also Ecclesiastes V, 15) suicides have been known to undress before committing the final act. And the most pious district of France, Brittany, still insists on the rule that infants to be christened be brought to church in the nude, even in bitter cold: "Faut qu'il attende l'bon Dieu tout nu" (Maupassant, *Oeuvres complètes*, X [*Monsieur Parent*], Paris, 1910 ["Le Baptême"], p. 139).

Page 76

1. See L. V. D. Owen, *The Connection between England and Burgundy during the First Half of the Fifteenth Century*, London, 1909; ———, "England and the Low Countries, 1405–1413," *English Historical Review*, XXVIII, 1913, p. 13 ff.: "Trade bound them to England, while politically they were dependent on France."

2. For all these manuscripts, most of them mentioned above, see P. Durrieu, "Manuscrits de luxe executés pour des princes et grands seigneurs Français," *Le Manuscrit*, II, 1895, pp. 82 ff., 97 ff., 130 ff., 145 ff., 162 ff., 178 ff.

3. Cf. Durrieu, *ibidem*, p. 114 ff. and *Les Très Riches Heures*, p. 80 ff.

4. See especially the *Bible Moralisée*, Paris, Bibliothèque Nationale, ms. fr. 166 (see note 62 ⁶) and the "Breviary of John the Fearless," London, British Museum, mss. Add. 35311 and Harley 2897 (F. Winkler, "Ein neues Werk aus der Werkstatt Pauls von Limburg," *Repertorium für Kunstwissenschaft*,

XXXIV, 1911, p. 536 ff.; ———, "Studien zur Geschichte der niederländischen Miniaturmalerei des XV. und XVI. *Jahrhunderts*," *Jahrbuch der Kunsthistorischen Sammlungen des Allerhöchsten Kaiserhauses*, XXXII, 1915, p. 281 ff., particularly p. 320 f.). This manuscript, which was completed by two purely Flemish illuminators, will be more thoroughly investigated by Professor Millard Meiss.

5. See p. 118 ff.

Page 77

1. All these sculptures are frequently illustrated. For "Notre-Dame la Blanche," see, e.g., A. Goldschmidt, *Gotische Madonnenstatuen in Deutschland*, Augsburg, 1923, fig. 13; P. Muratoff, *La Sculpture gothique*, Paris, 1931, pl. LXXXVII. For the German instances: W. Pinder, *Die deutsche Plastik des vierzehnten Jahrhunderts*, Munich, 1925, pls. 22, 23 (Cologne), 25–28 (Freiburg); H. Beenken, *Bildhauer des vierzehnten Jahrhunderts am Rhein und in Schwaben*, Leipzig, 1927, pp. 74 ff. (Cologne), 166 ff. (Strasbourg and Freiburg); O. Schmitt, *Gotische Skulpturen des Strassburger Münsters*, Frankfort, 1924, II, pl. 197; ———, *Gotische Skulpturen des Freiburger Münsters*, Frankfort, 1926, pls. 210–226. For works representing a similar kind of attenuation and planimetric rather than stereographic curvature, see also Pinder, *Die deutsche Plastik des vierzehnten Jahrhunderts*, pls. 29, 30, 32, 33–35, 37–39, 44.

2. For Beauneveu, see (apart from the literature adduced in note 41 ²), Michel, *Histoire de l'art*, III, 1, p. 714 f.; M. Aubert, *La Sculpture française*, p. 344 ff.; de Champeaux and Gauchery, *op. cit.*, *passim*. For Jean de Liége, Aubert, p. 338 ff., and M. Devigne, *La Sculpture mosane du XII au XVI siècle*, Paris and Brussels, 1932, p. 77 ff., pls. XXI, XXII. For Jean de Cambrai, M. Weinberger, "A French Model of the Fifteenth Century," *The Journal of the Walters Art Gallery*, IX, 1946, p. 9 ff. For illustrations, see also G. Tröscher, *Die burgundische Plastik des ausgehenden Mittelalters und ihre Wirkungen auf die Europäische Kunst*, Frankfort, 1940.

3. Cf. Thieme-Becker, XXVI, 1932, p. 243. There are some good illustrations in Pinder, *Die deutsche Plastik des vierzehnten Jahrhunderts*, pls. 82–84, 90–100.

4. Cf. G. Pauli, "Die Sammlung alter Meister in der Hamburger Kunsthalle," *Zeitschrift für Bildende Kunst*, LV, 1920, p. 21 ff.

5. R. Krautheimer, *op. cit.*, p. 31, fig. 6.

6. *Ibidem*, figs. 1, 2. For the "Reliquary of the Holy Thorn," see p. 69. The reliefs from the Servatius Reliquary produced at Maastricht in 1403 (Bossert, *op. cit.*, pl. XXI) combine, in interesting fashion, the

style and technique of the Northern flat relief (as in the "Scepter of Charles V" and the "Reliquary of the Holy Thorn") with those of the silver altar of St. John the Baptist in Florence.

7. For the celestial page boys, see pp. 56, 64.

Page 78

1. K. Gerstenberg, *Hans Multscher*, Leipzig, 1928, p. 21, fig. 6.

2. Pinder, *Die deutsche Plastik des vierzehnten Jahrhunderts*, pls. 87, 88.

3. Schmitt, *Gotische Skulpturen des Strassburger Münsters*, II, pls. 221–224.

Page 79

1. The best illustration of Jacques de Baerze's two altarpieces, together with a clear discussion of their history, is found in A. Kleinclausz, "Les Peintres des Ducs de Bourgogne," *Revue de l'Art Ancien et Moderne*, XX, 1906, p. 161 ff. For Broederlam's paintings, see p. 86 ff.

2. Cf. W. Pinder, *Die deutsche Plastik vom ausgehenden Mittelalter bis zum Ende der Renaissance* (Handbuch der Kunstwissenschaft), Wildpark-Potsdam, I, 1924, p. 112 ff.; G. Dehio, *Geschichte der deutschen Kunst*, Berlin and Leipzig, 1919–1926, II, p. 115 ff., figs. 171 ff. An excellent instance of the German fourteenth-century type of "Schnitzaltar" is Master Bertram's Hamburg altarpiece of 1379, illustrated, e.g., in Dehio, *op. cit.*, fig. 173, and in Winkler, *Altdeutsche Tafelmalerei*, p. 11.

3. See O. Goetz, "Der Gekreuzigte des Jacques de Baerze," *Festschrift für Carl Georg Heise zum 28. Juni 1950*, Berlin, 1950, p. 158 ff.

4. For Claus Sluter, Jean de Marville, etc., see Aubert, *La Sculpture française*, p. 359 ff. and, more specifically, G. Tröscher, *Claus Sluter und die Burgundische Plastik um die Wende des XIV. Jahrhunderts*, Freiburg, 1932. J. Duverger, *De Brusselsche Steenbickeleren . . . met een Aanhangsel over Klaas Sluter*, Ghent, 1933. A. Liebreich, *Claus Sluter*, Brussels, 1936. D. Roggen, "Les Origines de Klaas Sluter," *Annales de Bourgogne*, IV, 1932, p. 293 ff. ———, "Klaas Sluter, Nouvelles notes sur ses origines et son caractère," *ibidem*, V, 1933, pp. 263 ff., 385 ff. ———, a series of articles in *Gentsche Bijdragen tot de Kunstgeschiedenis*, I, 1934, pp. 123 ff., 173 ff.; II, 1935, pp. 103 ff., 114 ff., 127 ff.; III, 1936, p. 31 ff.; IV, 1937, pp. 107 ff., 151 ff.; XI, 1945–1948, p. 7 ff. H. David, *De Sluter à Sambin*, Paris, 1933; ———, "Au Pays de Claus Sluter," *Annales de Bourgogne*, XI, 1939, p. 187 ff.; ———, *Claus Sluter*, Paris, 1951 (for earlier lierature, see the references in Thieme-Becker, XXXI, p. 144). For the Chartreuse de Champmol, see the

monumental publication by C. Monget, *La Chartreuse de Dijon d'après les documents des Archives de Bourgogne*, Montreuil-sur-Mer, 1898–1905.

Page 80

1. Weinberger, "A French Model of the Fifteenth Century," p. 9; p. 10, note 3; fig. 2 (head modern).

2. Cf. D. Roggen, "De Portaalsculpturen van Champmol," *Gentsche Bijdragen tot de Kunstgeschiedenis*, IV, 1937, p. 107 ff., especially p. 132 f.

3. J. Huizinga, *The Waning of the Middle Ages*, Chapter XVIII (*Herbst des Mittelalters*, 2nd ed., pp. 381, 385).

4. Illustrated, for example, in G. Dehio and G. von Bezold, *Die Denkmäler der Deutschen Bildhauerkunst*, Berlin, I, 1905, 15. Jahrhundert, pl. 3.

5. Cf. W. Pinder, "Zum Problem der 'Schönen Madonnen' um 1400," *Jahrbuch der Preussischen Kunstsammlungen*, XLIV, 1923, p. 147 ff. It is interesting to note that a miniature in the "Boccace de Philippe le Hardi" of 1402 shows the paintress Cyrene polychroming a statue of this type (Bibliothèque Nationale, ms. fr. 12420, fol. 92 v., illustrated in Martin, *La Miniature française*, pl. 86, fig. CXII).

6. This beautiful though practically unnoticed head is listed but not illustrated in *Buffalo, Albright Art Gallery, Catalogue of the Paintings and Sculptures in the Permanent Collection*, 1949, p. 213, no. 230; an illustration may be found in *Fortune*, January, 1946. It gives the impression of a head of Christ by Jacquemart de Hesdin enlarged and transposed into a three-dimensional medium, and it is interesting to note that it is said to come from Oost Cappel near Hondschoote, that is to say, from the borderline of Belgium and the Pas-de-Calais where Jacquemart was born.

Page 81

1. See J. Warichez, *La Cathédrale de Tournai*, Brussels, 1935, II, pl. XIX, fig. 30 (not 28). Cf. also G. Ring, "Beiträge zur Plastik von Tournai im 15. Jahrhundert," *Belgische Kunstdenkmäler*, P. Clemen, ed., Munich, 1923, I, p. 269 ff.; P. Rolland, "La Double Ecole de Tournai, peinture et sculpture," *Mélanges Hulin de Loo*, Brussels and Paris, 1931, p. 296 ff.; ———, "La Sculpture funéraire tournaisienne et les origines de l'école de Dijon," *Revue de l'Art* (Antwerp), XLVI, 1929, p. 11 ff; ———, *Les Primitifs tournaisiens, peintres et sculpteurs*, Brussels, 1932; ———, "Stèles funéraires tournaisiennes gothiques," *Revue Belge d'Archéologie et d'Histoire de l'Art*, XX, 1951, p. 189 ff.

2. D. Roggen, "Het Beeldhouwwerk van het Mechelsche Schepenhuis," *Gentsche Bijdragen tot de Kunstgeschiedenis*, III, 1936, p. 86 ff.

3. See especially D. Roggen, "De Portaalskulpturen van het Brusselsche Stadhuis," *Gentsche Bijdragen tot de Kunstgeschiedenis*, I, 1934, p. 123 ff.

4. De Tolnay, *Le Maître de Flémalle*, p. 11.

5. *Les Peintures primitives des XIVe, XVe, et XVIe siècles de la Collection Renders à Bruges*, G. Hulin de Loo and E. Michel, eds., London and Bruges, 1927, pl. 11.

Page 82

1. How complex the situation may be is illustrated by a little Madonna in the National Gallery at Washington (*National Gallery of Art, Preliminary Catalogue of Paintings and Sculpture*, Washington, D.C., 1941, p. 109, no. 130; *Book of Illustrations*, 2nd edition, Washington, D.C., 1941, p. 133). As observed by Professor Charles P. Parkhurst, who kindly permitted me to refer to his findings, this picture is in fact not Lombard but Franco-Flemish, the Madonna being freely derived from that in the first dedication page of the "Brussels Hours," and should be dated about 1410. The portrait and coat-of-arms of Matteo de Attendoli-Bolognini, Governor of the *arx Ticinensis* (which probably means the Castle of Pavia) were painted over the original donor's figure and the original coat-of-arms by a North Italian, probably Milanese, master of about 1450, and the (printed!) dedicatory inscription was pasted on at an even later date. The original coat-of-arms, the tinctures of which cannot of course be ascertained, shows a *castle double towered on a chief an eagle displayed* and apparently belongs to another North Italian family such as the Annoni or d'Annone of Milan or the Vicinio Pallavicino of Turin. The original owner must either have ordered the picture in France or employed an itinerant artist of Northern extraction.

2. *National Gallery of Art, Preliminary Catalogue*, p. 156 f., no. 23; *Book of Illustrations*, p. 170. The attribution to the "French" school rather than Pisanello was made by G. M. Richter, "Pisanello Studies," *Burlington Magazine*, LV, 1929, pp. 58 ff., 128 ff., particularly p. 139, and endorsed by Degenhart, *Antonio Pisanello*, Vienna, 1940, p. 38, fig. 4, as well as Ring, *A Century*, Cat. no. 64, pl. 27. For panel paintings which have been connected with the Boucicaut Master, the Bedford Master and the Rohan Master, see notes 54 [1], 61 [3], 74 [4].

3. M. Dvořák, *Das Rätsel der Kunst der Brüder van Eyck*, Munich, 1925, fig. 52; B. Degenhart, *op. cit.*, fig. 6. The Louvre portrait agrees with the April miniature not only in a general way — extreme smallness of the head in relation to the body, treatment of the drapery, full profile view contrasting with a marked interest in space — but also in the form and gesture

of the Duke's right hand which is almost identical with that of the young lady with the ostrich plume. As shown by the "Moralized Bible" in the Bibliothèque Nationale and the Breviary of John the Fearless in the British Museum (see note 62 [6]) the Limbourg brothers had long-standing connections with the court of Burgundy and it is quite probable that they, singly or as a group, maintained these friendly relations while serving the Duc de Berry.

4. Sterling, *Les Primitifs*, p. 49.

5. Sterling, *Les Primitifs*, fig. 45; ———, *La Peinture française; les peintres du moyen âge*, Paris, 1941 (hereafter quoted as "Sterling, *Les Peintres*"), pl. 39; Ring, *A Century*, Cat. no. 35, pl. 10.

6. Sterling, *Les Primitifs*, fig. 47; ———, *Les Peintres*, pl. 40; Ring, *A Century*, Cat. no. 34. Labande, *Les Primitifs français*, pls. XIV–XVI; Reau, *op. cit.*, pl. 13; G. Bazin, *L'Ecole Provençale, XIV et XV siècles* (Les Trésors de la peinture française, I, 3), Geneva, 1944, pls. 2, 3 (color). Cf. also L. Dimier, "Les Primitifs français," *Gazette des Beaux-Arts*, ser. 6, XVI, 1936, pp. 35 ff., 205 ff. (a very useful collection of abstracts from documents concerning the "French Primitives"), p. 56.

7. Sterling, *Les Primitifs*, fig. 46.

8. This excellent piece, unfortunately much damaged by moisture, is illustrated as Avignonese in Sterling, *Les Peintres*, pl. 44; Bazin, *L'Ecole Provençale*, pl. 1 (color); and even Ring, *A Century*, Cat. no. 33, pl. 9. The correct attribution was made by Beenken, "Zur Entstehungsgeschichte des Genter Altars," p. 216, note 41.

9. Sterling, *Les Primitifs*, fig. 32; ———, *Les Peintres*, pl. 10; Lemoisne, *op. cit.*, pl. 26; Labande, *Les Primitifs français*, pl. XIX; J. Dupont, *Les Primitifs français*, Paris, 1937, p. 22; Ring, *A Century*, Cat. no. 16, pl. 17. The Parisian, even French, origin of the painting, which is hardly later than 1400, is all the more doubtful as the motif of the Christ Child bodily descending from Heaven was, at this early time, as foreign to French art as it was popular in Italy and the Germanic countries (cf. Robb, *op. cit.*, p. 524 f., and above, p. 129).

10. Sterling, *Les Primitifs*, fig. 37; ———, *Les Peintres*, pl. 15; Evans, *Art in Mediaeval France*, fig. 121; Ring, *A Century*, Cat. no. 7, pl. 19. Before being assigned to either a "Franco-Flemish workshop possibly active at Paris" or, simply, the "Ecole de Paris," the diptych was ascribed to the "School of Avignon," and before that — in the Catalogues of the Berlin Museum of 1911 — to the "Upper German School." In view of its un-French iconography, color scheme and technique (cf., on the other hand, the Pähl altar-

piece and the altarpiece from the Augustinerkirche, both in the Nationalmuseum at Munich, illustrated in Stange, *op. cit.*, II, figs. 233, 234; Glaser, *op. cit.*, p. 32 ff., figs. 19, 20; Winkler, *Altdeutsche Tafelmalerei*, p. 46), the original attribution may be more nearly correct than the later ones.

Page 83

1. Sterling, *Les Primitifs*, figs. 24, 25; ———, *Les Peintres*, pls. 7, 9; Lemoisne, *op. cit.*, pls. 19, 20; Dupont, *Les Primitifs français*, p. 13; Réau, *op. cit.*, pl. 6; Ring, *A Century*, Cat. no. 15, fig. 27, pl. 16. J. Schaefer, *Les Primitifs français du XIVᵉ et du XVᵉ siècle*, Paris, 1949, p. 19, refers to the equestrian scene in the background as a "bataille de chevaux," and cites Bartolo di Fredi's "Adoration of the Magi" in the Accademia at Siena as a parallel. However, in this picture (van Marle, *op. cit.*, II, p. 491, fig 318) we have, not a battle, but the three cavalcades of the Magi converging at the crossroads near Mt. Golgotha, a motif known to us from the "*Très Riches Heures*" and later retained, for example, in Jerome Bosch's "Adoration of the Magi" in the Prado. In the Bargello diptych this meeting is parodistically enacted by the grooms of the Magi whose behavior tallies very closely with the description of Johannes Hildesheimensis (see note 64 [4]). At the time of the meeting, he tells us, darkness and a thick fog had settled "over the whole earth." Melchior, having come first, "went to rest in the darkness and the fog after the command of the Lord"; Balthasar stopped near the Mount of Olives and "proceeded after the fog had lifted a little"; and Gaspar "with his retinue came suddenly upon the others" (*cum exercitu suo supervenit*). In fact one of the riders rests his head upon the neck of his horse, the second mounts, and the third stops with a jerk, raising his riding crop in great excitement.

2. Michel, *Histoire de l'art*, III, 1, p. 151, fig. 81 (Madonna wing only); Sterling, *Les Primitifs*, figs. 34, 35; ———, *Les Peintres*, pls. 12, 13; Lemoisne, *op. cit.*, pl. 21; Ring, *A Century*, Cat. no. 6, fig. 24, pls. 1–3. Being somewhat frightened at my courage in assigning so famous and uncontested a "Parisian" picture to the Spanish school, I submitted my conjecture to the foremost authority on Spanish painting, Professor Chandler R. Post, who kindly permitted me to state that both he and Professor Saralegui had considered the "Carrand Diptych" as Spanish for many years; Professor Post is "confident that it was painted by an artist of the circle of Pedro Nicoláu and Andres Marzal de Sas." It is, in fact, to the latter master (probably hailing from Northwest Germany) that H. Marceau (*The John G. Johnson Collection, Catalogue of Paintings*, Philadelphia, 1941, p. 50)

ascribes the closely related though somewhat coarser "Nativity" and "Death of the Virgin," formerly called "North French about 1400," in the Pennsylvania Museum of Art. Steinbart, *Konrad von Soest*, p. 23 f., has recently called attention to a certain similarity that exists between the St. Catherine in the "Carrand Diptych" and one of the young women in the St. Nicholas altarpiece by Conrad of Soest (Geisberg, *Meister Konrad von Soest*, pls. 31, 35; Steinbart, pls. 1, 5). But this similarity proves only that in both cases a French or Franco-Flemish model was employed and transformed by provincial artists of Germanic inclinations.

3. For Jean d'Arbois, see Sterling, *Les Primitifs*, p. 50 and note 32; Ring, *A Century*, Cat. no. 4. From 1401 to 1403 one Herman of Cologne assisted Jean Malouel in his work at Dijon (Thieme-Becker, XVI, 1923, p. 493).

4. Kleinclausz, *loc. cit.*; Dimier, "Les Primitifs français," p. 208. The often repeated assumption that Malouel painted a portrait of John the Fearless in 1412 is without documentary foundation.

Page 84

1. Jean Malouel died on March 12, 1415 (1414 old style). The year 1419, given in Thieme-Becker, XXIII, 1929, p. 599, which has since found its way into the *Enciclopedia Italiana*, seems to be based on a typographical or clerical error.

2. Michel, *Histoire de l'art*, III, 1, p. 149, fig. 79; Sterling, *Les Primitifs*, figs. 51, 53; ———, *Les Peintres*, pls. 35, 36; L. Gillet, *La Peinture française, moyen âge et renaissance*, Paris and Brussels, 1928, pl. XXIII; Lemoisne, *op. cit.*, pls. 35–37; Dupont, *Les Primitifs français*, p. 19; Réau, *op. cit.*, pl. IV (color); G. Bazin, *L'Ecole Franco-Flamande, XIV et XV siècles* (Les Trésors de la peinture française, II, 2), Geneva, 1941, pls. 3, 4 (color); Ring, *A Century*, Cat. no. 54, pl. 20. For a discussion of the documents reprinted by Dimier, "Les Primitifs français," p. 209, see Sterling, *Les Primitifs*, p. 59 and note 42.

3. A good detail, juxtaposed with one found in Meister Francke's "Resurrection," is reproduced in Martens, *op. cit.*, fig. 91. Other early instances of "Kufic" inscriptions in Northern art are found, e.g., in Conrad of Soest's Wildungen "Annunciation" (Geisberg, *Meister Konrad von Soest*, pl. 2) and, which seems to have escaped notice, in miniatures produced in the Boucicaut workshop, e.g., Bibliothèque Nationale, ms. lat. 1161, fol. 31, and Morgan Library, ms. 455 (*Morgan Catalogue*, 1934, no. 114), fol. 73 v. For the origins of the motif, see G. Soulier, *Les Influences orientales dans la peinture toscane*, Paris, 1924, p. 185 ff.

Page 85

1. Michel, *Histoire de l'art*, III, 1, p. 152, fig. 82; Sterling, *Les Primitifs*, fig. 54; ———, *Les Peintres*, pl. 34; Lemoisne, *op. cit.*, pl. 34 A; Réau, *op. cit.*, pl. 37. Dupont, *Les Primitifs français*, p. 21, ascribing both the Louvre *tondo* and the "Martyrdom of St. Denis" to Bellechose, dates the former *ca.* 1420, viz., four years later than the latter; Evans, *Art in Mediaeval France*, fig. 136, accepts this dating but ascribes the *tondo* (with the qualification "probably") to Jean Malouel although he had died in 1415. Ring, *A Century*, Cat. no. 53, pl. 18, dates it *ca.* 1400–1410 but leaves the question of attribution undecided.

2. Sterling, *Les Primitifs*, figs. 48, 52; ———, *Les Peintres*, pls. 31, XXXIII; Lemoisne, *op. cit.*, pls. 18, 34 B; Bazin, *L'Ecole Franco-Flamande*, pl. 7 (color); Dupont, *Les Primitifs français*, p. 14; Ring, *A Century*, Cat. nos. 8, 9, pls. 4, 5.

3. Sterling, *Les Primitifs*, fig. 49; Lemoisne, *op. cit.*, pl. 33; Ring, *A Century*, Cat. no. 52, fig. 28.

4. Sterling, *Les Primitifs*, fig. 50; ———, *Les Peintres*, pl. 30; Ring, *A Century*, Cat. no. 10, fig. 25.

5. Sterling, *Les Primitifs*, fig. 55; ———, *Les Peintres*, pl. 37. Cf. L. Demonts, "Une Collection française de primitifs," *Revue de l'Art Ancien et Moderne*, LXX, 1937, p. 247 ff.; Dupont, *op. cit.*, p. 20; Ring, *A Century*, Cat. no. 50.

6. Sterling, *Les primitifs*, fig. 56; ———, *Les Peintres*, pl. 32; Lemoisne, *op. cit.*, pl. 32; Dupont, *Les Primitifs français*, p. 13. Evans, *Art in Mediaeval France*, fig. 202; Ring, *A Century*, Cat. no. 49, pl. 6.

7. See p. 84.

8. Sterling, *Les Primitifs*, note 40.

Page 86

1. Often illustrated, e.g., in Winkler, *Altdeutsche Tafelmalerei*, p. 37; details showing the angels with the cross-embellished diadems, *ibidem*, pp. 38, 39.

2. Dimier, "Les Primitifs français," p. 209.

3. Cf. Sterling, *Les Primitifs*, p. 128 ff.

4. Cf. Dimier, "Les Primitifs français," p. 210 ff. Broederlam's Dijon altarpiece (Ring, *A Century*, Cat. no. 18) is very often illustrated, e.g., Michel, *Histoire de l'art*, III, 1, p. 147, fig. 78; Kleinclausz, *loc. cit.*; Fierens-Gevaert, *Histoire de la peinture flamande*, I, pls. XVI, XVII; Sterling, *Les Primitifs*, fig. 22 (one wing only); ———, *Les Peintres*, pls. 28, 29; Réau, *op. cit.*, pls. 35, 36; Dupont, *Les Primitifs français*, pp. 16, 17.

Page 87

1. Revelation XI, 1 (Lejard, *op. cit.*, pl. 25; also *Art Institute of Chicago, Masterpieces of French Tapestry, March 17 to May 5, 1948*, p. 14, fig. 3).

2. See p. 62.

Page 88

1. See p. 132.

2. J. J. Rorimer, *The Metropolitan Museum of Art; Mediaeval Tapestries*, fig. 2.

3. The motif of St. Joseph drinking from a canteen was widely imitated, for instance in the Buxtehude altarpiece by a follower of Master Bertram (Worringer, *op. cit.*, p. 188, fig. 56). For its survival in book illumination, see p. 112 and note 112 [5].

Page 89

1. Baltimore, Walters Art Gallery, ms. 211 (de Ricci-Wilson, *Census*, I, p. 789, no. 201; *Walters Catalogue*, 1949, p. 48, no. 129), fol. 155 v. Though conforming to the use of Rouen, the little manuscript was executed in Flanders (see note 121 [9]). It should be noted that a curious similarity in posture, probably explicable by a common source, exists between the St. Joseph filling his flask as represented in this miniature and the St. Joseph blowing the fire in the "Nativity" of the Wildungen altarpiece by Conrad of Soest (Geisberg, *Meister Konrad von Soest*, pls. 3, 4; Steinbart, *Konrad von Soest*, pls. III, 11).

Page 92

1. Cf. Hoogewerff, II, p. 50 ff.

2. *Ibid.*, I, p. 92 ff.

3. See *Catalogue of the D. G. van Beuningen Collection* (by D. Hannema, preface by M. J. Friedländer), Rotterdam, 1949, no. 18, pls. 1–9, with further references. The upper half of the exterior wings is illustrated in Sterling, *Les Primitifs*, fig. 62 (here tentatively assigned to a Burgundian workshop). That the delightful little work cannot be earlier than *ca.* 1415 follows from the fact that the skies in the exterior pictures are already modulated from blue to grey after the fashion of the Boucicaut Master.

4. For ivories, see, e.g., R. Koechlin, *Les Ivoires gothiques français*, Paris, 1924, pls. XXXIII, XXXIV, LXI, LXII, LXIII, LXIV, LXVI, LXVIII–LXX, LXXII, LXXXIV, XCI, CCXXVI; for major sculpture, the de Baerze-Broederlam altarpiece at Dijon (our text ill. 41) or the epitaph of Jacques Isaak in Tournai Cathedral (mentioned above, p. 81); for another painting, the "Man of Sorrows" by Master Francke in the Museum der Bildenden Künste at Leipzig (Martens, *op. cit.*, pl. XLVII, or Glaser, *op. cit.*, fig. 53). For the appropriation of rosette frames in Flemish, Anglo-Flemish and English book illumination, see pp. 109, 112, and *passim*.

5. Sterling, *Les Primitifs*, p. 61.

Page 93

1. The panels at Baltimore are: the "Annunciation," with the "Baptism of Christ" on its back, and

the "Crucifixion"; those in Antwerp: the "Resurrection," with St. Christopher on its back, and the "Nativity" (see *Collections du Chevalier Mayer van den Bergh, Catalogue des tableaux exposés dans les galeries de la Maison des Rois Mages*, Antwerp, 1904, p. 19 ff., with the unwarranted assertion that the panels come from the Chartreuse de Champmol and were executed by Broederlam). The entire quadriptych is illustrated (in an incorrect arrangement) and tentatively assigned to a Franco-Flemish atelier active at Paris in Sterling, *Les Primitifs*, figs. 26–31, whereas the same author, *Les Peintres*, p. 24, pls. 24–27, attributes it to an "atelier du Hainaut"; cf. also Ring, *A Century*, Cat. nos. 19, 20. For a correct reconstruction, based upon a lecture of the writer, see E. P. Spencer, "The International Style and Fifteenth-Century Illuminations," *Parnassus*, XII, 1940, March, p. 30 f. Cf. also Lemoisne, *op. cit.*, pl. 27 ("Burgundian under Paris influence"), and Dupont, *Les Primitifs français*, p. 18 ("Burgundian"). Folding quadriptychs are infrequent but not unheard-of in French and Franco-Flemish art about 1400. The inventory of the Duc de Berry lists two specimens (Guiffrey, *op. cit.*, I, p. 23, no. 34, and p. 32, no. 63), and the second of these was remarkably similar to the Baltimore-Antwerp quadriptych in iconography: "uns tableaux de bois de IIII pièces, attachiez à couplez [joined by hinges], où est l'Annunciacion, la Nativité et Passion Nostre Seigneur, et l'Assumpcion Nostre Dame, tout de painçture." Were it not for the fact that the inventory was drawn up with great conscientiousness, one would feel tempted to assume that the author had confused the "Resurrection" with the "Assumption" and thus to identify the Baltimore-Antwerp quadriptych with that once owned by the Duc de Berry.

Page 94

1. For Trecento "Annunciations" in which the Virgin reads the prophecy of Isaiah, see G. Prampolini, *L'Annunciazione nei pittori primitivi italiani*, Milan, 1939, figs. 15, 19, 29, pls. 18, 21, 35, 36, 44. For the recurrence of the Virgin's gesture in later Northern representations, see p. 127; for that of the prayer book inscribed with the *Ecce Ancilla*, p. 117. The idea of representing St. Christopher and the youthful Christ on opposite banks of the river (only that Christ beckons to the former instead of vice versa) recurs in a curious picture ascribed to Jan de Cock in the Detroit Institute of Arts (no. 43.57).

2. Cf. *Die Sammlung Figdor*, M. J. Friedländer pref., Vienna, 1930, First Part, vol. III, no. 34, pl. XXI ("Netherlandish"). For the recent attribution to the Upper Rhenish school, see G. F. Hartlaub, *Das Paradiesesgärtlein von einem oberrheinischen Maler* (Der

Kunstbrief, 1947), fig. 12; and, less confidently, Winkler, *Altdeutsche Tafelmalerei*, pp. 49, 226. It is interesting to note that the most recent discussion of the *"Paradiesesgärtlein"* no longer refers to the Berlin "Nativity" and rightly stresses the Upper Rhenish master's indebtedness to what I should call Franco-Flemish rather than French sources: L. Fischel, "Ueber die künstlerische Herkunft des Frankfurter 'Paradiesesgärtleins,'" *Essays in Honor of Georg Swarzenski*, Chicago and Berlin, 1951, p. 85 ff.

Page 95

1. See note 63³.
2. Haarlem, Teyler Stichting, ms. 76, fol. 33 v. (see above, p. 105).
3. Michel, *Histoire de l'art*, III, 1, p. 154, fig. 84; Sterling, *Les Primitifs*, fig. 60; ——, *Les peintres*, pl. 38; Dupont, *Les Primitifs français*, frontispiece; Ring, *A Century*, Cat. no. 51, pl. 25.
4. *Collections du Chevalier Mayer van den Bergh, Catalogue*, p. 15 ff., with the unwarranted assertion that the work comes from the Chartreuse de Champmol; Ring, *A Century*, Cat. no. 21. The four panels protect a Madonna statuette placed on a square basis.

Page 96

1. Fierens-Gevaert, *Histoire de la peinture flamande*, I, pl. XXX.
2. Cf. E. Michel, "A propos de l'Exposition d'Art Flamand à Londres," *Gazette des Beaux-Arts*, ser. 5, XIV, 1926, p. 345 ff.; Sterling, *Les Peintres*, p. 23.
3. P. Rolland, *La Peinture murale à Tournai*, Brussels, 1946, p. 38 ff., pls. XXXIII, XXXIV.
4. Cf. van Marle, *op. cit.*, II, p. 526, fig. 337.
5. See p. 254 ff.
6. Frequently illustrated, e.g., Sterling, *Les Primitifs*, fig. 23; Fierens-Gevaert, *Histoire de la peinture flamande*, I, pl. VI.
7. Hoogewerff, I, p. 189 ff., figs. 81, 82.

Page 97

1. H. Huth, "A Mediaeval Painting," *The Art Institute of Chicago, Bulletin*, XLII, 1948, p. 18 ff. C. de Tolnay, "An Early Dutch Panel: A Contribution to the Panel Painting before Bosch," *Miscellanea Leo van Puyvelde*, Brussels, 1949, p. 49 ff., locates the triptych in Holland; however, the similarities adduced are of too general a nature to permit definite conclusions. The type of the crucified Christ, for example, occurs in very similar form in the entire school of Conrad of Soest as well as in the Weber triptych in the Deutsches Museum at Berlin (our fig. 153).

2. See p. 106 ff.
3. Cf. pp. 101, 104.
4. For the controversy as to whether the production

of book illuminations at Utrecht was centered in the Carthusian monastery of Nieuwlicht or in secular workshops, see Hoogewerff, I, p. 376 f.

Page 98

1. See p. 36.

2. Copenhagen, Royal Library, ms. Thott, no. 70,2⁰. Cf. A. W. Byvanck, *La Miniature dans les Pays-Bas septentrionaux* (hereafter quoted as "Byvanck, *Min. Sept.*"), Paris, 1937, p. 131, pl. VIII, fig. 14; *Stockholm Catalogue*, no. 128.

3. Amsterdam, Royal Academy of Sciences, ms. XVIII. Cf. Byvanck, *Min. Sept.*, p. 118, pl. VIII, fig. 20; Hoogewerff, I, p. 82 ff., figs. 30, 31.

4. Brussels, Bibliothèque Royale, ms. 205A, fol. 1. Cf. Byvanck, *Min. Sept.*, p. 123, pl. VIII, fig. 15; Gaspar and Lyna, *op. cit.*, I, p. 418, pl. XCVII b.

5. The manuscript in the Walters Collection (ms. 171, *Walters Catalogue*, 1949, p. 45, no. 119, pl. L) is briefly mentioned in Byvanck, *Min. Sept.*, p. 21, and Hoogewerff, I, p. 583, note, and was more circumstantially described in Byvanck, "Kroniek der Noordnederlandsche Miniaturen, III," *Oudheidkundig Jaarboek*, ser. 4, IX, 1940, p. 29 ff. For the London manuscript (British Museum, ms. Add. 22288), see Byvanck, *Min. Sept.*, p. 146, pl. X, figs. 18, 19, and Hoogewerff, p. 106 ff., figs. 38, 39; for the Morgan manuscript (ms. 691, *Morgan Catalogue*, 1934, no. 96, pl. 75), Byvanck, *Min. Sept.*, p. 150, pl. IX, figs. 16 and 17, and Hoogewerff, p. 109 ff., figs. 41, 42. For all three manuscripts, cf. A. W. Byvanck, *De middeleeuwsche Boekillustratie in de noordelijke Nederlanden*, Antwerp, 1943 (henceforth to be referred to as "Byvanck, *Boekillustratie*"), p. 17. Contrary to the statement in *Min. Sept.*, the Walters and Morgan manuscripts are not portions of the same book though the weaker of the two illuminators who illustrated the Walters manuscript is closely akin in style to the one responsible for the miniatures of the Morgan manuscript. Recently L. M. Daniels, *Meester Dirc van Delft, O. P., Tafel van den Kersten Ghelove*, Antwerp and Utrecht, I, 1939, pp. 72 ff., 79 ff., 92 ff., has discussed the interrelation of the various Dirc van Delft manuscripts on philological grounds and comes to the conclusion that the Walters manuscript postdates 1442 because it allegedly presupposes the textual redaction of Brussels, Bibliothèque Royale, ms. 21974 (Gaspar and Lyna, *op. cit.*, II, Paris, 1945, p. 119, pl. CXLI b) which is dated in this year. This conclusion, not very convincing even from a philological point of view, is, however, entirely unacceptable for stylistic reasons and is further invalidated by a comparison with the lone miniature — an initial representing the Trinity — in the manuscript, The Hague, Royal Library, ms. 133 F 8, fol. 6

(briefly mentioned but not illustrated in Daniels, *op. cit.*, p. 66). This manuscript is dated MCCCVII, an obvious and very frequent error for MCCCCVII, and the rather rustic style of its illumination, including the *rinceaux*, is manifestly derived from that represented by the Walters and Morgan manuscripts. The Walters manuscript must, therefore, antedate 1407, and since it shows the portrait of Albrecht of Holland with his coat-of-arms, nothing militates against the assumption that it was executed during his lifetime, viz., before December 12, 1404. I am gratified to note that Miss M. Rickert has arrived at exactly the same result in an article which, though dated 1949, did not appear until 1951, when this note was completed: "The Illuminated Manuscripts of Meester Dirc van Delft's Tafel van den Kersten Ghelove," *Journal of the Walters Art Gallery*, XII, 1949, p. 79 ff.

Page 99

1. See also a Breviary in the Harvard University Library, ms. Norton 2001, which is dated 1382 and seems to have been produced in the Channel regions of the Continent rather than in England (De Ricci-Wilson, *Census*, I, p. 998).

2. Copenhagen, Royal Library, mss. Thott 2 and 3, 2⁰. See Byvanck, *Min. Sept.*, p. 130, pl. XIV, figs. 30, 31; Hoogewerff, I, p. 112 ff., figs. 43–47; *Stockholm Catalogue*, No. 129.

3. Paris, Bibliothèque Nationale, ms. lat. 432. See Byvanck, *Min. Sept.*, p. 153, pl. XI, figs. 22–25.

4. Chief among these early Utrecht Books of Hours are: Oxford, Bodleian Library, ms. Clarke 30 = 18392 (Byvanck, *Min. Sept.*, p. 151, pl. XII, fig. 27; Hoogewerff, I, p. 142 ff., fig. 58). Stockholm, Royal Library, ms. A. 226 (Byvanck, *Min. Sept.*, p. 155, pl. XXVII, figs. 71–74; Hoogewerff, p. 356 ff., figs. 177, 178). Baltimore, Walters Art Gallery, ms. 185 (*Walters Catalogue*, 1949, p. 46, no. 120; Byvanck, "Kroniek der Noordnederlandsche Miniaturen, III"). And a Horae in the collection of Sir Sidney Cockerell at Cambridge (England) which is, somewhat confusingly, referred to as "Cockerell B" in Byvanck (*Min. Sept.*, p. 126, pl. XXXIII, figs. 95–98), and — at least by implication — as "Cockerell A" in Hoogewerff (p. 138 ff., figs. 55–57); for the other Book of Hours in Sir Sidney's collection, see p. 104. Of slightly later date (*ca.* 1425) are the Horae, The Hague, Royal Library, ms. 131 G 3 (Byvanck, *Min. Sept.*, pl. XXVIII, figs. 75, 76, and *Boekillustratie*, p. 44); and the North Netherlandish miniatures, sloppy rather than early, in the Horae, Krakow, Czartoryski Museum, ms. 2943 (Byvanck, *Min. Sept.*, p. 131, pl. XIII, figs. 28, 29; see also note 122 [1]).

5. London, British Museum, ms. Add. 38527, fol.

90 v. See Byvanck, *Min. Sept.*, p. 146, pl. XII, fig. 26; Hoogewerff, I, p. 122 ff., fig. 48; Parkhurst, *op. cit.*, p. 297, fig. 22.

Page 100

1. Berlin, Staatsbibliothek, ms. germ. quart. 42. See Byvanck, *Min. Sept.*, p. 120 ff., pls. XV–XVIII; *idem, Boekillustratie*, p. 18 ff.; Hoogewerff, I, p. 162 ff., figs. 67–72. A good color reproduction of fols. 19 v. and 20 is found in H. Wegener, *Beschreibendes Verzeichnis der Miniaturhandschriften der Preussischen Staatsbibliothek zu Berlin*, V, 1928, p. 136 ff., pl. IV. To be added to the bibliography given in *Min. Sept.*: H. Jerchel, "Die Niederrheinische Buchmalerei der Spätgotik," *Wallraf-Richartz Jahrbuch*, X, 1938, p. 65 ff.; Stange, *op. cit.*, III, p. 114 ff.; E. Panofsky, "Guelders and Utrecht; A Footnote on a Recent Acquisition of the Nationalmuseum at Stockholm," *Konsthistorisk Tidskrift*, XXII, 1953, no. 2–3, p. 90 ff. I believe, like Stange, that the drawing at Uppsala (his fig. 151) is more closely related to the portrait of Mary of Guelders in the Berlin Prayer Book, fol. 19 v. than to the works of the Westphalian Master of the Utrecht Life of the Virgin (as proposed by O. Benesch, "Kritische Anmerkungen zu neueren Zeichnungspublikationen, I," *Die Graphischen Künste*, new ser., II, 1937, p. 14 ff.), thus confirming the Prayer Book's connection with the style of the Limbourg brothers. In ascribing the miniatures on fols. 146–284 v. to assistants rather than to one of the two main illuminators I follow Byvanck.

2. New York, Morgan Library, ms. 87 (*Morgan Catalogue*, 1934, no. 97, pl. 75). Cf. Byvanck, *Min. Sept.*, p. 149, pls. XIX, XX, XLVII, XLVIII; ———, *Boekillustratie*, p. 22 ff.; Hoogewerff, I, p. 444 ff., fig. 231; Panofsky, "Guelders and Utrecht." For the owner — first identified by Miss Meta Harrsen — see R. Jentjens, *Reinald IV, der zweite und letzte Regent in den vereinigten Herzogthümern Geldern und Jülich* (1402–1423), Münster i. W., 1913. To Miss Harrsen I am deeply indebted for generously informing me of this discovery as well as of the manuscript's probable place of origin and *terminus ante quem* (established by the absence of the hymn "Gloria tibi Domine" from the Office of the Feast of Corpus Christi, fols. 250–253 v., which was adopted by the Carthusian Order in 1417); she also called my attention to the donor's portrait on fol. 324. The participation of the Master of Zweder van Culemborg was, so far as I know, first stressed by Hoogewerff, p. 444.

3. A dramatic encounter between the two systems of marginal decoration is seen on fols. 19 v. and 20 (our fig. 120) where the Passion Master's "Betrayal of Christ" faces the second master's Portrait of the Duchess; an amusing compromise, where, as on the Calendar pages, the former's top and bottom *rinceaux* were supplemented with lateral ornament supplied by the latter.

Page 101

1. For this painting (hardly earlier than *ca.* 1430), see note 242 ⁸.

2. Frequently illustrated. See, e.g., Glaser, *op. cit.*, p. 151, fig. 101, or Winkler, *Altdeutsche Tafelmalerei*, pp. 62, 63.

3. Cf. Martens, *op. cit.*, p. 258, note 410.

Page 102

1. Utrecht, University Library, ms. 252. Cf. Byvanck, *Min. Sept.*, p. 156, pl. XVIII; Hoogewerff, I, p. 385 ff., fig. 186.

2. For further works of the Moerdrecht Master (whom Hoogewerff calls the "Master of the Seraph" on account of the principal miniature in Utrecht, ms. 252, fol. 43 v.), see Byvanck, *Min. Sept.*, p. 24 ff.; ———, "Kroniek der Noordnederlandsche Miniaturen, III," and *Boekillustratie*, pp. 19, 40 ff. I believe, however (with Hoogewerff, p. 404 ff.), that he also participated in the illumination of the big Bible in the Royal Library at Brussels (ms. 9018–19, 9020–23, Byvanck, *Min. Sept.*, p. 123, pls. XXIII–XXV; Hoogewerff, p. 401 ff., figs. 198–203; Gaspar and Lyna, *op. cit.*, II, p. 70 ff., pl. CXXXIII) which was completed in 1431.

3. Zwolle, Archaeological Museum, Unnumbered. See Byvanck, *Min. Sept.*, p. 161, pls. XXXVIII, XXXIX, figs. 104–106; ———, *Boekillustratie*, p. 22; Hoogewerff, I, p. 127 ff., figs. 51–53. For the interpretation of the leonine hexameters on fol. 322 (not quite correctly interpreted in Byvanck, "Aanteekeningen over Handschriften met Miniaturen, IV," *Oudheidkundig Jaarboek*, ser. 3, V, 1925, p. 208 ff.), cf. Panofsky, "Guelders and Utrecht."

4. Bressanone (Brixen), Episcopal Seminary, ms. C 20 (no. 62). See Byvanck, *Min. Sept.*, p. 122, pls. XXXIV, XXXV; ———, *Boekillustratie*, p. 27, figs. 17, 18; Hoogewerff, I, p. 430 ff., figs. 220–225. I agree with Hoogewerff in assigning the great "Crucifixion" (*Min. Sept.*, pl. XXXIV) to a different hand.

For further works by the Zweder Master (christened "Meester Pancratius" by Hoogewerff) and his workshop, see Byvanck, *Min. Sept.*, p. 47 ff., and Hoogewerff, pp. 421–468. To be added: (1) a manuscript in the Nationalbibliothek at Vienna, cod. Vind. 1199–1202 (K. Holter, "Eine Wiener Handschrift aus der Werkstatt des Meisters des Zweder van Culemborg," *Oudheidkundig Jaarboek*, ser. 4, VII, 1938, p. 55 ff.); (2) three manuscripts in the Walters Art Gallery at

Baltimore, dealt with by Byvanck in "Kroniek der Noordnederlandschen Miniaturen, III," and *Boek-illustratie*, p. 27 ff., figs. 19–22, to wit (a) ms. 168 (Book of Hours, *Walters Catalogue*, 1949, no. 121, pl. L), (b) ms. 188 (Book of Hours, *Walters Catalogue*, no. 122, shopwork), (c) ms. 174 (Missal, completed by the Arenberg Master, *Walters Catalogue*, no. 128, pl. XLIX). For a small Book of Hours connected with both the Zweder and the Moerdrecht Masters and containing an exceptionally good miniature by a third personality (Stockholm, Nationalmuseum, ms. 1646 B), see K. Boström, "Un Livre d'Heures d'Utrecht au Musée National à Stockholm," *Nordisk Tidskrift för Bok-och Biblioteksväsen*, XXXVIII, 1951, p. 156 ff., and Panofsky, "Guelders and Utrecht."

Page 103

1. Illustrated in Byvanck, *Min. Sept.*, pl. XIX, fig. 41, and *Boekillustratie*, fig. 12 (as a work of the Moerdrecht Master and without reference to the fact that the "Miracle of the Brazen Serpent" had originally been a "Crucifixion"). The later version of the Moses group is found in the famous Latin Bible in the Fitzwilliam Museum at Cambridge (Unnumbered), vol. I, fol. 72 v. (illustrated in *Min. Sept.*, pl. XXXI, fig. 79). For further information about this important manuscript, see Byvanck, *Min. Sept.*, p. 126; ———, *Boekillustratie*, p. 25, figs. 13–16; Hoogewerff, I, p. 421 ff., figs. 215, 216.

2. New York, Morgan Library, ms. 87, fol. 81 v., illustrated in Hoogewerff, fig. 230. The particularly Boucicautlike "Visitation" on fol. 363 is illustrated in Byvanck, *Boekillustratie*, fig. 11.

3. Byvanck, *Min. Sept.*, p. 117, pls. XLII, XLIII; ———, *Boekillustratie*, figs. 23, 24; Hoogewerff, p. 440 ff., figs. 228, 229; Martens, *op. cit.*, p. 203, fig. 56.

4. Baltimore, Walters Art Gallery, ms. 168, illustrated, e.g., in Byvanck, *Boekillustratie*, fig. 21.

5. Paris, Bibliothèque Nationale, ms. lat. 432 (see note 99[3]), fol. 2 v., illustrated in Byvanck, *Min. Sept.*, pl. XXXVII.

6. See note 102[4].

7. For the "Arenberg Hours," see Byvanck, *Min. Sept.*, p. 117, pls. XLV, XLVI; ———, *Boekillustratie*, p. 33 f.; Hoogewerff, I, p. 447 ff., figs. 232–237. To be added to the bibliography given in *Min. Sept.*: E. (S.) Beissel, "Un Livre d'Heures appartenant à S. A. le duc d'Arenberg à Bruxelles; Etude iconographique," *Revue de l'Art Chrétien*, XV, 1904, p. 436 ff.; and K. de Wit, "Das Horarium der Katharina von Kleve als Quelle für die Geschichte der südniederländischen Tafelmalerei und der nordniederländischen Miniaturen," *Jahrbuch der Preussischen Kunstsammlungen*, LVIII, 1937, p. 114 ff. De Wit's dating of the "Arenberg Hours"

(*ca.* 1430) is certainly too early, and his denial of the Arenberg Master's participation in the Morgan Breviary, ms. 87, can be explained only by the fact that he was unaware of the borrowings from the Ghent altarpiece which occur in this manuscript. For further works of the Arenberg Master (christened "Meester Pelagius" by Hoogewerff), see Byvanck, *Min. Sept.*, p. 65 ff.; ———, *Boekillustratie*, p. 33 ff.; Hoogewerff, p. 456 ff.

Page 104

1. The Hague, Museum Meermanno-Westreenianum, ms. 10 E 1 (formerly 12° 12). See Byvanck, *Min. Sept.*, p. 141, pl. XLIX; Hoogewerff, I, p. 458 ff., figs. 240–244; our fig. 128.

2. Cf. Hoogewerff, I, p. 177 ff., figs. 75, 76. Hoogewerff correctly stresses the influence of the Ghent altarpiece upon the Annunciation; it may be added that the Crucifixion also reflects an Eyckian composition transmitted through various replicas and variations (see p. 235; figs. 290, 291). On the other hand, it should be noted that the Nativity is no less reminiscent of Jacques Daret (fig. 233) than of Petrus Christus (fig. 409), and that the woman seen from the back in the Presentation is derived from the analogous figure in the "Descent from the Cross" by the Master of Flémalle (fig. 230).

3. For this Book of Hours — "Cockerell A" according to Byvanck, "Cockerell B" according to Hoogewerff — see Byvanck, "Aanteekeningen over Handschriften, IX," p. 93 ff., particularly p. 115 ff.; ———, *Min. Sept.*, p. 125, pls. XXXI, fig. 87, and XXXII, figs. 89–94; ———, *Boekillustratie*, p. 20 f., figs. 8, 9; Hoogewerff, I, p. 172 ff., fig. 72. The marginal decoration was apparently completed before the second illuminator added his Infancy scenes in grisaille.

4. Other pages of "Cockerell A" show the more common trefoil leaf found, for example, in the Dirc van Delft manuscripts; still others, a leaf resembling what the heralds call a "cross crosslet," its arms occasionally particolored in the same way as are the "Neptune's tridents." And the recurrence of these "cross crosslets," together with the stylistic affinity of the miniatures, permits attaching to the group of Guelders manuscripts a copy of the *Sachsenspiegel* (the well-known thirteenth-century law book) which, curiously enough, was once in the possession of a gentleman named Zweder and referring to himself as "*residing* at Culemborg" (Berlin, Staatsbibliothek, ms. germ. fol. 880); cf. Byvanck, *Min. Sept.*, p. 119, pl. VIII, fig. 21, and Jerchel, *op. cit.*, p. 65. The owner may have been the chronicler Zweder van Culemborg (died 1494) as well as the Bishop of Utrecht. This manuscript, in turn, appears to be related to a re-

markably beautiful *"Biblia Pauperum"* in the British Museum at London, ms. Kings 5 (cf. H. Cornell, *Biblia Pauperum*, Stockholm, 1925, no. 52, pp. 111, 168 f., 229, pl. 70; C. Kuhn, "Herman Scheerre and English Illumination of the Early Fifteenth Century," *Art Bulletin*, XXII, 1940, p. 138 ff., p. 144, fig. 34). An intermediary position between this *"Biblia Pauperum"* and "Cockerell A," finally, is held by a Bible last quoted as being owned by the Reverend E. S. Dewick (*Burlington Fine Arts Club, Exhibition of Illuminated Manuscripts*, London, 1908, no. 146, pl. 101).

5. For the Cambridge Bible, see note 103 [1]. For the participation of another Lower Rhenish Master in another Utrecht Bible (Brussels, Bibliothèque Royale, ms. 9018–19, 9020–23, see note 102 [2]), see A. Goldschmidt, "Holländische Miniaturen aus der ersten Hälfte des 15ten Jahrhunderts," *Oudheidkundig Jaarboek*, III, 1923, p. 22 ff.

6. New York, Morgan Library, ms. 866; see also *Illuminated Manuscripts from the Bibliothèque of Their Highnesses the Dukes d'Arenberg*, Jacques Seligmann & Co., New York, 1952, no. 79 (three illustrations). The connection of this manuscript with the Liége Hours (see following note) is evident, not only from the style — especially the facial types and the nearly identical feeling for drapery curves — but also from the iconography; no less than four scenes (the Annunciation on fol. 13 v., the Nativity on fol. 33 v., Christ before Pilate on fol. 66, and the Last Judgment on fol. 78 v.) agree with the corresponding compositions in the Liége Hours down to such details as the headgear of Pilate's entourage and the setting (including the "open-air grill") of the Nativity. The date of the "Arenberg-Morgan Hours" — *ca.* 1415 but not earlier — follows from the appearance of close-knit line-and-leaf *rinceaux*, unknown even in France before 1400, on fol. 194; and, even more clearly, from certain extravagances in the marginal decoration which can be shown to have been developed, in the second decade of the fifteenth century, in the school of Ghent: outsized corner quatrefoils (fols. 13 v. and 14), interlacements of animals with lions' and dragons' heads (fol. 79), and wide, rectangular borders filled with a heavy "acanthus" foliage which resembles the leaves of the American oak (fols. 14 and 64). For all these motifs, first appearing in the "Hours of John the Fearless" of 1410–1415 (Paris, Bibliothèque Nationale, ms. Nouv. Acqu. lat. 3055), see p. 118 ff.; figs. 182–193.

7. Liége, University Library, ms. 35. Cf. Byvanck, *Min. Sept.*, p. 60; Hoogewerff, I, p. 175, fig. 73. To be added to the bibliography given in *Min. Sept.*: Stange, *op. cit.*, III, p. 82, figs. 155, 156; Jerchel, *op. cit.*, p. 74. I am glad to notice that W. Vogelsang, *Noord-Nederlandse Handschriften, 1300–1500, Catalogus van de Tentoonstelling in het Rijksmuseum Twenthe-Enschede, December 1950* (a publication which came to my attention through the kindness of Miss Harrsen but could not be considered in other contexts), no. 14, also locates the manuscript in Guelders in spite of its Utrecht Calendar. My reasons for dating it about 1405–1410 rather than about 1420 are the following: First, its undeniable stylistic affinity with the well-known "Apocalypse," Paris, Bibliothèque Nationale, ms. néerl. 3, which no one has ever dated later than *ca.* 1400 (cf. p. 110 ff.; figs. 150–152); second, the character of the marginal decoration in which the system of such Ypres manuscripts as the fragment at Frankfort (Museum für Kunsthandwerk, ms. Linel 11, see p. 113 f. and figs. 160, 161, *ca.* 1400) and the Book of Hours at Rouen (Bibliothèque de la Ville, ms. 3024, see p. 112 f. and figs. 154–158, between 1400 and 1410) appears interpreted in the spirit of the fourteenth century (flat, decorated frames instead of illusionistic "rosette frames") rather than further elaborated; third, the fact that, wherever the "Arenberg-Morgan Hours" (see preceding note) differs from the Liége Hours in such small points as can be used to establish priority, the balance is in favor of the latter. In the "Nativity," for example, the Morgan manuscript omits the animals' heads adorning the front rafters of the shed while adding to the "Last Judgment" the figures of the Virgin Mary and St. John in such a manner (standing instead of kneeling) that one suspects the intrusion of a "Crucifixion."

Page 105

1. Haarlem, Teyler Stichting, ms. 76. Cf. Byvanck, *Min. Sept.*, p. 60; Hoogewerff, p. 176, fig. 74. To be added to the bibliography given in *Min. Sept.*; Stange, *op. cit.*, III, p. 82; Jerchel, *op. cit.*, p. 80. I agree with Hoogewerff (and Byvanck in *Bulletin de la Société Française de Reproductions de Manuscrits à Peintures*, XV, 1931, p. 23 ff.) in the belief that the miniatures did not originally belong to the text, which was written in 1433, and antedate it by about a dozen years. They are painted on separate, "tipped-in" pages, and the very fact that they are all full-page pictures without text on either the recto or the verso would be most unusual in a Breviary of that period.

2. See p. 112 ff.; note 104 [7].

3. See p. 118 ff.; note 104 [6].

Page 106

1. London, British Museum, ms. Egerton 859. So far as I know, this manuscript, kindly brought to my attention by Dr. Hanns Swarzenski, is mentioned only briefly in connection with a single leaf without text — apparently intended as a devotional image like

the one in the Petrus Christus portrait in London, referred to in note 47 [1] — which is preserved in the Kupferstichkabinett at Berlin and literally repeats the "St. Bavo" of the Egerton Prayer Book, fol. 1 v.: P. Wescher, *Beschreibendes Verzeichnis der Miniaturen, Handschriften und Einzelblätter des Kupferstichkabinetts der Staatlichen Museen Berlin*, Leipzig, 1931, p. 165, no. 8517. That the Prayer Book is Lower Rhenish rather than "Dutch" is evident, not only from the style of the miniatures but also from the dialect of the text which, holding an intermediary position between Middle Dutch and German, agrees with the Lower Rhine. The conjecture that it may have been executed for Mary of Cleves is based upon the following considerations. As we learn from the owner's portrait on fol. 36 (which shows her kneeling before St. Matthias, patron of Treves and possibly commemorates a pilgrimage to the "Holy Coat"), the Prayer Book was owned by a lady. Now, the two pages fols. 2 v. and 3, facing each other and representing St. Oncommer (also called "Kümmernis," "Liberata" and "Wilgefortis") and St. Hubert, show the coats-of-arms of France and Burgundy, which seems to indicate that the lady in question was one of the two daughters of John the Fearless who were married to German-Netherlandish princes, viz., either Margaret, wife of William VI of Holland, or Mary, wife of Adolph II of Cleves (see p. 91); and since the style and language of the manuscript are Lower Rhenish rather than Dutch, the second of these alternatives is preferable. This assumption is further corroborated by the unusual prominence given to St. Oncommer or Wilgefortis whose image takes precedence over all others, except that of St. Bavo, and is distinguished by the arms of Royal France. As conclusively shown by G. Schnürer and J. M. Ritz, *Sankt Kümmernis und Volto Santo* (Forschungen zur Volkskunde, 13-15), Düsseldorf, 1934, the cult of this spurious saint, who owes her existence to the misinterpretation of Crucifixes derived from the "Volto Santo" at Lucca, originated in the Germanic Netherlands. The earliest known representations, not listed in Schnürer and Ritz, are found in the "Liége Hours," fol. 13 v., and in "Cockerell A" (according to Byvanck), fol. 191 (illustrated in Byvanck, *Min. Sept.*, pl. XXXII, fig. 191); and the earliest altar dedicated to "sunte Wilgifortis der h. jonfrouwen geheiten sunte Unkommer" was founded, on May 20, 1419, by none other than Adolph II of Cleves, the husband of Mary of Burgundy (Schnürer and Ritz, *op. cit.*, p. 19).

2. Cf. F. Lyna, "Les Miniatures d'un ms. du 'Ci Nous Dit' et le réalisme Préeyckien," *Scriptorium*, I, 1946–1947, p. 106 ff., hereafter quoted as "Lyna, 'Le Réalisme.'"

3. Morgan Library, M. 785. Cf. Lyna, "Le Réalisme," p. 113 f., pl. 10; J. J. Rorimer and M. B. Freeman, "The Nine Heroes Tapestries," pp. 258, 259. This manuscript served as a prototype for three later ones: Paris, Bibliothèque Nationale, ms. lat. 7331 (*ca.* 1460); Paris, Bibliothèque Nationale, ms. lat. 7334 (after 1488, since it contains copies after Johannes Angelus' *Astrolabium magnum*, first printed at Augsburg in that year); and a manuscript, bequeathed to the Bibliothèque Nationale by M. Smith-Lesouëf, which may also be dated in the end of the fifteenth century.

As can be learned from two Missals, one preserved in the Bibliothèque Nationale, ms. 860 (Leroquais, *Les Sacrementaires et les Missels*, II, p. 226 ff.), the other in St.-Sauveur in Bruges, the style of the Bruges school was originally rooted in the "tradition of the 'sixties." The Virgin Mary in the Canon page, fol. 67 v., of the Paris Missal — which must be earlier than 1382 and may be dated about 1370–1375 — almost literally repeats that in the "Calvary of Hendrik van Rijn," and in the Missal of St.-Sauveur (toward 1400) the former's style survives in somewhat petrified form. About the same time, however, a more "caricaturing" spirit asserted itself in the "Calvary of the Tanners" (fig. 113).

Page 107

1. The best-known instance is a Westphalian painting of *ca.* 1370 (Berlin, Deutsches Museum) where the Madonna, enthroned upon the "Throne of Solomon," is flanked by Virgil, displaying the "Jamque redit virgo" from the Fourth Eclogue, and "Albumasar," carrying a scroll inscribed with his "prophecy" (he lived, in fact, in the ninth century A.D.): "In prima facie virginis ascendet virgo pulcherrima . . . et . . . nutriet puerum quem quaedam gens vocat Jesum." See K. Rathe, "Ein unbeschriebener Einblattdruk und das Thema der 'Aehrenmadonna,'" *Mitteilungen der Gesellschaft für vervielfältigende Kunst* (supplement of *Die Graphischen Künste*), XLV, 1922, p. 1 ff.; W. Vöge, *Jörg Syrlin der Aeltere und seine Bildwerke*, II (*Stoffkreis und Gestaltung*), Berlin, 1950, pp. 26, 109, 169 f., fig. 44.

2. Bibliothèque Nationale, ms. lat. 7330. See Warburg, *op. cit.*, II, p. 632.

3. London, British Museum, ms. Sloane 3983. See Warburg, *op. cit.*, figs. 168, 170, 171; F. Boll, *Sternglaube und Sterndeutung*, 3rd ed., W. Gundel, ed., Leipzig, 1926, p. 145 f., figs. 8, 21, 33, 34.

4. See Warburg, *op. cit.*, p. 631 ff.; Boll, *op. cit.*, pp. 55 ff., 141 ff., 145 ff.

5. Wiesbaden, Staatsarchiv. See D. Heubach, *Aus einer niederländischen Bilderhandschrift vom Jahre*

1410; *Grisaillen und Federzeichnungen der altfläm-ischen Schule*, Strasbourg, 1925; F. Lyna, *De Vlaamsche Miniatuur van 1200 tot 1530*, Brussels, n.d. [1933], p. 72, fig. 22; ———, "Le Réalisme," p. 114 f., pl. 10. Along with the colored pen drawings ("Hand III" according to Heubach) the Wiesbaden codex contains a number of silver point drawings of somewhat earlier date ("Hand II," *ca.* 1390–1400) and a number of grisailles contemporary with the colored pen drawings but stylistically somewhat related to the "Liége Hours" ("Hand II").

Page 108

1. Brussels, Bibliothèque Royale, ms. 11041. See Lyna, "Le Réalisme," p. 114, pl. 11; E. Panofsky, "Zwei Dürerprobleme," *Münchner Jahrbuch der Bildenden Kunst*, new ser., VIII, 1931, p. 5., fig. 2. This manuscript is somewhat related to the Apocalypse, once owned by the Duc de Berry, in the Morgan Library, ms. 133 (*Morgan Catalogue*, 1934, no. 115, pl. 81). But even closer, and much more important, is its affinity with a colored pen drawing in the Speck von Sternburg Collection at Lützschena (F. Becker, *Handzeichnungen alter Meister in Privatsammlungen*, Leipzig, 1922, pl. 1) which represents a group of Jews defeated by the Church and fragmentarily reflects the archetype that underlies the much-debated and still enigmatical "Fountain of Life" in the Prado (see p. 216; note 203⁴). This pen drawing must therefore be considered as a Flemish (Bruges or Ghent) product of *ca.* 1415–1420, and not as either "Burgundian" (Becker) or South German (Winkler as reported in P. Post, "Pictor Hubertus d Eyck, Major Quo Nemo Repertus," *Zeitschrift für Kunstgeschichte*, XV, 1952, p. 46 ff.).

2. London, British Museum, ms. Add. 10290.

3. Brussels, Bibliothèque Royale, ms. 19295–19297. See Gaspar and Lyna, *op. cit.*, I, p. 389, pl. LXXXIX a.

4. Brussels, Bibliothèque Royale, ms. II, 138. See Gaspar and Lyna, *op. cit.*, I, p. 163, pl. LXXXIX b.

5. Brussels, Bibliothèque Royale, ms. 10176–10178. See Gaspar and Lyna, *op. cit.*, I, p. 379 ff., pl. LXXXVII.

6. Brussels, Bibliothèque Royale, ms. II, 7831 (formerly Brussels, Colbert de Beaulieu Collection). Cf. Lyna, "Le Réalisme," and L. Morin, "Le Manuscrit Colbert de Beaulieu du 'Ci Nous Dit,'" *Scriptorium*, I, 1946–1947, p. 75 ff., pl. 9.

7. See p. 53.

Page 109

1. Brussels, Bibliothèque Royale, ms. II, 7831, fol. 44.

2. Tournai, Bibliothèque de la Ville, ms. 24. The manuscript was kindly brought to my attention by Dr. Harry Bober.

3. Paris, Bibliothèque Nationale, ms. lat. 1364. See Leroquais, *Les Livres d'Heures*, I, p. 177 ff. For the "Annunciation," fol. 25, see p. 129.

4. Hoogewerff, I, p. 109.

Page 110

1. Paris, Bibliothèque Nationale, ms. néerl. 3. This noble manuscript, the importance of which was first recognized by W. Vogelsang, *Holländische Miniaturen des späteren Mittelalters*, Strasbourg, 1899, p. 31 ff., pls. III–VII, has recently been studied, with great care but without spectacular results, by M. Hontoy, "Les Miniatures de l'Apocalypse flamande de Paris," *Scriptorium*, I, 1946–1947, p. 289 ff. (with complete set of illustrations). It is generally accepted that the miniatures fall into two groups, a superior one comprising fols. 1–11, and an inferior one comprising fols. 11–23 (end). Even within the first group, however, considerable differences exist. Fols. 5 and 6 differ from fols. 1–4 by the use of a more translucent red and a more highly burnished gold in the marginal bands of clouds, and by an even more linear stylization of the hair and the drapery folds. Fols. 7–10 show a taste for darker colors (in some of the marginal cloud bands black is used instead of gold) and a distinctly pictorial treatment (the hair is rendered as a coherent mass instead of a pattern of linear curves). While fols. 5 and 6 are well within the range of the principal illuminator, viz., the author of fols. 1–4, I am inclined to ascribe fols. 7–10 to a third artist much superior to the author of fols. 11–23 but not identical with the master of fols. 1–6.

2. Panofsky, *Albrecht Dürer*, I, p. 52 ff.

Page 111

1. *Ibidem*, p. 55 f.

Page 112

1. No valid conclusions as to the provenance of the illuminator can be drawn from either the title of the manuscript (fol. 1 v.: "Apocalipsis in dietsche") or the dialect of the text which is said to be "West Flemish." The word *dietsch* may denote "Netherlandish" in contradistinction to "Latin" as well as "Northeast Netherlandish" ("Dutch") in contradistinction to Flemish or Brabantine (Verwijs and Verdam, *op. cit.*, II, 1889, p. 182 f.; see also below, note 207.³). And the dialect of the text would indicate the origin of the scribe but not that of the illuminator. So far as I know the only scholar thus far to emphasize the partially Germanic quality of the miniatures and to

point out, however briefly, their connection with the "Liége Hours" and the "Passion Master's" contributions to the "Breviary of Mary of Guelders" is Jerchel, *op. cit.*, pp. 74, 78.

2. This triptych — often alleged, without a shred of evidence, to come from the Chartreuse de Champmol — was ascribed to the "Paris School" by H. Bouchot, *L'Exposition des primitifs français; la peinture en France sous les Valois*, Paris, 1905, pl. VII; to a "Flemish atelier active at Dijon" by Fierens-Gevaert. *Histoire de la peinture flamande*, I, pl. XXII; to the "Burgundian school" by F. Winkler, *Die altniederländische Malerei*, Berlin, 1924, p. 29, fig. 6, Dupont, *Les Primitifs français*, p. 15, and Evans, *Art in Mediaeval France*, fig. 143; and to the North Netherlandish school, "perhaps within the borders of the old Diocese of Utrecht," by Hoogewerff, I, p. 102, fig. 37. The truth would seem to lie almost exactly between Bouchot and Hoogewerff.

3. This observation was made by Dr. Harry Bober, who generously permitted me to make use of it.

4. Rouen, Bibliothèque de la Ville, ms. 3024. See *Catalogue général des manuscrits des Bibliothèques Publiques de France*, II, Paris, 1888, p. 73 (here dated in the fourteenth century); *Exposition d'art religieux ancien, Musée de Peinture, Rouen*, May–June, 1931, Rouen, 1932. The use could not be determined by the late Chanoine Leroquais; the Calendar agrees with the western regions of Flanders. The fine old binding is inscribed: "Bi der gracie gods heift my ghebondē Jacob van dē berghe, priester" ("By the grace of God I was bound by Jacob van den Berghe, priest"); cf. P. Verheyden, *De Gulden Passer*, Antwerp, 1937, p. 33; ———, *La Reliure en Brabant*, Antwerp, 1935, p. 143 (erroneously dating the binding in the middle of the fourteenth century).

5. It is interesting that the "Flight into Egypt" in a Franco-Flemish manuscript of *ca.* 1415 (Walters Art Gallery, ms. 265, fol. 90, *Walters Catalogue*, 1949, no. 88, pl. XXXV, erroneously captioned no. 80) shows the motif of the St. Joseph drinking from the canteen in a form more closely akin to the miniature in the "Rouen Hours" than to Broederlam's painting, from which we may conclude that the motif was transmitted through illuminations or illuminators' pattern drawings rather than through drawings after the original painting.

Page 113

1. Carpentras, Bibliothèque de la Ville, ms. 57 (kindly brought to my attention by Dr. Hanns Swarzenski). See *Catalogue général des manuscrits des Bibliothèques Publiques de France*, XXXIV, 1, Paris, 1901, p. 32. The use is Roman; the Calendar agrees with the western regions of France. The dedication page fol. 55 v. is illustrated in Parkhurst, *op. cit.*, fig. 20.

2. Cf. G. Ludwig, "Giovanni Bellinis sogenannte Madonna am See," *Jahrbuch der Königlich Preussischen Kunstsammlungen*, XXIII, 1902, p. 163 ff., and F. Hartt, "Lignum Vitae in Medio Paradisi: The Stanza d'Eliodoro and the Sistine Ceiling," *Art Bulletin*, XXXII, 1950, p. 115 ff., especially p. 138.

3. Frankfort, Museum für Kunsthandwerk, ms. Linel 11. Cf. G. Swarzenski and R. Schilling, *Die illuminierten Handschriften und Einzelminiaturen des Mittelalters und der Renaissance in Frankfurter Besitz*, Frankfort-on-the-Main, 1929, p. 148 ff., pls. LVIII, LIX; C. Kuhn, *op. cit.*, p. 146, fig. 36.

Page 114

1. Apart from the "Carmelite Missal" (p. 115 f.), I have observed meander pavements (1) in the "Clowes Hours" (see below, note 114[6]), fols. 10 v., 18 v., 20 v., 22 v., 28 v., 30 v., 42 v., 59 v.; (2) in the "Hours of John the Fearless" in the Bibliothèque Nationale (see p. 118 f.), fol. 204 v.; (3) in one of the eight miniatures prefixed to the Horae, The Hague, Royal Library, ms. 131 D 14 (Byvanck, *Les Principaux Manuscrits . . . à la Haye*, p. 34), fol. 9 v. Later on, the motif was appropriated in the dedication page of the "Arenberg Hours" (Hoogewerff, I, fig. 232), in the much-debated "Mass of the Dead" in the "Turin-Milan Hours" (our fig. 300), and, through it, in the St. John's altarpiece by Roger van der Weyden (see p. 280; fig. 345).

2. Oxford, Bodleian Library, ms. Canonici Liturg. 118 (19263), kindly brought to my attention by Dr. Hanns Swarzenski. The manuscript is a mere fragment. Its Calendar is as closely related to that of the "Rouen Hours" as is the style of its miniatures.

3. Amsterdam, W. A. van Leer Collection. Cf. A. W. Byvanck and G. J. Hoogewerff, *La Miniature hollandaise*, The Hague, 1922–1926, pl. 3; Kuhn, *op. cit.*, p. 147. While Byvanck has rightly excluded this manuscript from *La Miniature dans les Pays-Bas septentrionaux*, Hoogewerff, I, p. 139, is still inclined to assign it to the Utrecht school and even extends this opinion to the somewhat later Horae, Morgan Library, ms. 76 (Kuhn, *op. cit.*, fig. 37). The Flemish provenance of this latter manuscript and its connection with the so-called Gold Scroll group (see note 122[1]) were already recognized by Byvanck, "Aanteekeningen over Handschriften met Miniaturen, IX," *Oudheidkundig Jaarboek*, ser. 3, X, 1930, p. 93 ff., figs. 13, 14; cf. also ———, "Kroniek der Noord-Nederlandsche Miniaturen, II," *Oudheidkundig Jaarboek*, ser. 4, IV, 1935, p. 10 ff.

4. Urbana, University of Illinois (Museum of European Culture), ms. MEC 423. See de Ricci-Wilson, *Census*, I, p. 702, no. 15 (here dated in the fourteenth century). This very small Horae for Roman use repeats the standard vocabulary of the "Ypres school" in a greatly simplified and very negligent manner.

5. Tournai, Grand Séminaire, no signature.

6. Indianapolis, Ind., Dr. G. H. A. Clowes Collection, apparently undescribed. This manuscript, which contains 21 full-page miniatures with at least two missing, is of particular interest, not only because its language is explicitly designated as Flemish (fol. 98: "Dit es Stabat Mater Dolorosa in vlamsce") but also because its use (Antiphon in Prime: *Sub tuam protectionem*; Little Chapter in Prime: *Haec est virgo*; Antiphon in None: *Alma virgo*; Little Chapter in None: *Per te Dei*) is identical with that of the "Hours of Daniel Rym" (see p. 119) which was demonstrably produced at Ghent. The "Clowes Hours," probably executed *ca.* 1410–1420, holds in fact an intermediary position between the "Ypres" and the "Ghent" schools; it may be conjectured that it was either produced at Ypres for Ghent use, or, perhaps more probably, by a workshop that had transferred itself from Ypres to Ghent.

Page 115

1. Cambridge, Fitzwilliam Museum, ms. 49. See M. R. James, *A Descriptive Catalogue of the Manuscripts in the Fitzwilliam Museum*, p. 121.

2. London, British Museum, ms. Add. 29704–29705. See — apart from Millar, *op. cit.*, p. 70 f., pls. 79–81 — M. Rickert, "Herman the Illuminator," *Burlington Magazine*, LXVI, 1935, p. 39 f.; ———, "The Reconstruction of an English Carmelite Missal," *Burlington Magazine*, LXVII, 1935, p. 99 ff.; ———, "The Reconstruction of an English Carmelite Missal," *Speculum*, XVI, 1941, p. 92 ff.; ———, *The Reconstructed English Carmelite Missal in the British Museum*, Chicago, 1951.

3. Kuhn, *op. cit.*, p. 152 f., figs. 43, 44.

Page 116

1. London, British Museum, ms. Add. 16698. See Kuhn, *op. cit.*, *passim*, figs. 12, 13 (with further references).

2. London, Eric G. Millar Collection. See Kuhn, *op. cit.*, *passim*, fig. 11.

3. Oxford, Bodleian Library, ms. Lat. Liturg. f. 2. See Kuhn, *op. cit.*, p. 141 ff. and *passim*, figs. 1–6. The manuscript was discovered by Professor Kuhn.

4. London, Lambeth Palace Library, cod. 69. See O. E. Saunders, *English Illumination*, Florence and Paris, 1928, pls. 122, 123; Kuhn, *op. cit.*, *passim*, figs. 14–16.

5. London, British Museum, Royal ms. 2 A XVIII. See Millar, *op. cit.*, p. 72, pl. 85; Kuhn, *op. cit.*, *passim*, fig. 8.

6. London, formerly A. Chester Beatty Collection. See Kuhn, *op. cit.*, *passim*, fig. 10.

7. London, British Museum, Royal ms. 1 E IX. See Millar, *op. cit.*, p. 69, pls. 74–78; Saunders, *op. cit.*, pls. 119–121; Kuhn, *op. cit.*, *passim*, figs. 24–26.

8. London, British Museum, ms. Add. 42131. See Kuhn, *op. cit.*, *passim* (especially p. 149), figs. 17–21. The year 1414 is established as a *terminus post quem* by Herman's engaging inscription on fol. 21: "I comminde me vnto you. I pray God saue the Duke of Bedford." This title was not conferred upon the owner — John of Lancaster, brother of Henry V — until that year.

9. To the "York Hours" (Oxford, Bodleian Library, ms. Lat. Liturg. f. 2) the Master of the Beaufort Saints contributed fols. 6 v., 11 v., 12 v. (see Kuhn, *op. cit.*, p. 141 ff., fig. 5); to the "Beaufort Hours" itself (London, British Museum, Royal ms. 2 A XVIII) everything except for fol. 23 v. (Kuhn, figs. 7, 9). In somewhat crude form his style recurs, it seems to me, in a Psalter for Sarum use which, since the battle of Agincourt was subsequently commemorated in the Calendar, must antedate 1415 (Rennes, Bibliothèque Municipale, ms. 22, described and illustrated in Leroquais, *Les Psautiers*, II, p. 176 ff., no. 391, pls. CXXVIII–CXXX).

10. See p. 122; note 122⁴.

Page 117

1. Kuhn, *op. cit.*, fig. 12.

2. London, British Museum, ms. Add. 16998, fol. 17.

3. Lambeth Palace Library, ms. 69, fol. 4 v. (Saunders, *op. cit.*, pl. 122; Kuhn, *op. cit.*, fig. 16). A nearly identical composition is found in the same manuscript, fol. 313.

4. Millar, *op. cit.*, pl. 85; Kuhn, *op. cit.*, fig. 8.

5. Kuhn, *ibidem*, fig. 5.

6. *Ibidem*, fig. 7.

7. Cambridge, Fitzwilliam Museum, ms. 49, no. 1 according to James' numeration.

8. Kuhn, *op. cit.*, fig. 3

9. *Ibidem*, fig. 11.

10. London, British Museum, ms. Arundel 28, fol. 37 (Kuhn, *ibidem*, fig. 41).

11. Millar, *op. cit.*, pl. 81, c.

12. *Ibidem*, pl. 81, a.

13. London, British Museum, ms. Add. 29704, fols.

14, 26, 31; fols. 14 and 31 are illustrated in Millar, *op. cit.*, pl. 81, a and c.

Page 118

1. Millar, *ibidem*, pl. 79.

2. Kuhn, *op. cit.*, fig. 17. This miniature obviously influenced the rather dismal "Annunciation" in the much later "Hours of Henry de Beauchamp," commonly known as "Warwick Hours," in the Dyson Perrins Collection at Malvern (ms. 18, fol. 12, illustrated in Millar, *op. cit.*, pl. 91).

3. Kuhn, *op. cit.*, fig. 18. The penetration of the Boucicaut style into England is highlighted by the fact that a Book of Hours largely executed in the Boucicaut Master's workshop (Paris, Bibliothèque Mazarine, ms. 469, see Kuhn, p. 156, fig. 40 and above, notes 54 [1], 55 [2]) was completed in England by artists working in the Herman Scheerre tradition.

4. For Herman Scheerre's and his associates' influence on the insular production, see the excellent remarks in Kuhn, *op. cit.*, p. 153 ff. I should like to add an observation concerning John Siferwas' "Sherborne Missal" of 1407 in the Library of the Duke of Northumberland at Alnwick Castle (*The Sherborne Missal*, J. A. Herbert ed., Oxford, 1920). Kuhn justly stresses the fact that Siferwas' style is far more insular than Herman Scheerre's and considers him an English-born illuminator who "either was influenced directly by Herman, or by some related Continental source." It may be asked, however, whether the "impression of flatness and profusion" which distinguishes his style from that of Herman and his circle may not be accounted for by the conjecture that he was a thoroughly Anglicized Rhinelander rather than a moderately Continentalized Englishman. His drapery style is somewhat reminiscent of the "Liége Hours," and his name sounds Germanic rather than English; it may, in fact, be composed of the ancient word *siefern* (meaning: "to trickle" or "to leak") and *vas* (the old spelling of *Fass*, the German word for "vat") and thus represent a satirical patronymic denoting something like "leaking vat." Whatever his nationality, Siferwas' Continental affiliations would seem to be Lower Rhenish rather than Flemish. In his famous "Crucifixion" (*The Sherborne Missal*, pl. XXII, also Millar, *op. cit.*, pl. 82) we can observe a curious detail: the arms of the Thieves are fastened, not to the T-beams of their crosses but to an iron rod parallel to these T-beams. This peculiarity — often combined, incidentally, with a *svenimento* group closely akin to that in the "Sherborne Missal" — appears to be of Westphalian origin and survived almost exclusively within the sphere of influence of Conrad of Soest. It occurs for the first time in two very similiar West-

phalian altarpieces of *ca.* 1370, one in Netze near Wildungen, the other now in the Wallraf-Richartz Museum at Cologne (Stange, *op. cit.*, II, figs. 151–161); then in Conrad of Soest's famous Wildungen altarpiece (text ill. 33); and then in a score of pictures directly or indirectly dependent thereon (e.g., Stange, *op. cit.*, III, figs. 41, 45, 64, 82, 84, 165, 192, 228, 251; Glaser, *op. cit.*, fig. 94; Hölker, *op. cit.*, pl. XVII; R. Nissen, "Der Stand der Derick-Baegert-Forschung," *Wallraf-Richartz Jahrbuch*, X, 1938, p. 139 ff., fig. 88). It was obviously from nearby Westphalia that that great imitator, the Arenberg Master, appropriated it for one of the Thieves in the "Arenberg Hours" (Hoogewerff, I, fig. 233, our fig. 129) although the figure itself is derived from the Master of Flémalle (cf. p. 176 f.).

5. This is especially true of those scholars who believe the Wilton diptych to be Parisian: Réau, *op. cit.*, pl. 4 (ascribing it to Beauneveu); Dupont, *Les Primitifs français*, p. 11; Sterling, *Les Peintres*, pl. XVI (in *Les Primitifs*, figs. 20, 21, however, "toward 1395"); G. Bazin, *L'Ecole Parisienne* (Les Trésors de la peinture française, 1, 5), Geneva, 1942, pl. 7; Schaefer, *op. cit.*, pls. 4, 5. L. Gillet, *La Peinture française, Moyen-Age et Renaissance*, Paris and Brussels, 1928, pl. XXI, and Lemoisne, *op. cit.*, pl. 23, likewise believe the Diptych to be French but date it about 1390 and 1395–1400, respectively. T. Borenius, "Das Wilton Diptychon," *Pantheon*, XVIII, 1936, p. 209 ff., dates it between 1396 and 1399 and attempts to connect it with the first dedication page of the "Brussels Hours," while Dimier, "Les Primitifs français," p. 231 f., assigns it to the Netherlandish school, which is not so unreasonable in view of its connection with the style exemplified by Herman Scheerre. For the correct attribution to the English school, see M. V. Clarke, "The Wilton Diptych," *Burlington Magazine*, LVIII, 1931, p. 283 ff.; W. A. Shaw, "The Early English School of Portraiture," *Burlington Magazine*, LXV, 1934, p. 171 ff.; V. H. Galbraith, "A New Life of Richard II," *History*, XXVI, 1942, p. 223 ff., especially p. 237 ff.; T. Bodkin, *The Wilton Diptych in the National Gallery* (The Gallery Books, no. 16), London, n.d. Recently E. W. Tristram ("The Wilton Diptych," *The Month*, new ser., I, 1949, p. 379 ff., and II, 1949, p. 18 ff.) and J. Evans ("The Wilton Diptych Reconsidered," *Archaeological Journal*, CV, 1948 [published 1950], p. 1 ff.), while rightly insisting on English authorship, have tried to defend very early dates on historical grounds, Tristram insisting on 1377, Miss Evans proposing 1389–1390. As stylistic parallels, however, Tristram quotes only the "Beaufort Hours," the "Bedford Psalter," the "Carmelite Missal," the "Chichele Breviary," and the erroneously so-called

"Bible of Richard II" — in short, the works of Herman Scheerre and his circle — without explaining how this imported style, admittedly "of rather later date than seems probable for the Diptych," could have been practiced by an English panel painter of about 1377. And Miss Evans adduces and illustrates the dedication page of a Psalter in the British Museum (ms. Cott. Domitian A XVII, fol. 75) as containing a portrait of Richard II of *ca.* 1377 whereas the manuscript was executed for Henry VI about 1420, probably in France. Mr. Francis Wormald kindly informs me that it contains, on fols. 8–9 v., computistical tables with dates ranging from 1420 to 1462. It should be added that the figure of Richard II and its English parallels have their closest relatives in donors' portraits attributable to the Ypres school; see, in addition to the "Rouen Hours" itself, an approximately contemporary manuscript formerly in the Pouiller-Ketele Collection at Brussels, illustrated in Parkhurst, *op. cit.*, fig. 21.

6. See preceding note.

7. I am much obliged to Mr. Wormald for having communicated his views to me *in litteris*.

8. See p. 36. I am inclined to assume Ghent provenance for the eight miniatures of *ca.* 1400 inserted at the beginning of a somewhat later Book of Hours in the Royal Library at The Hague, ms. 131 D 14 (Byvanck, *Les Principaux Manuscrits . . . à la Haye*, p. 34 f., pl. XV; Kuhn, *op. cit.*, p. 147, fig. 39); but this assumption must remain conjectural. My reasons are twofold. First, three of the eight miniatures are enframed by a peculiar border, a scroll work of oak leaves coiled around a staff or pole, which in more schematized or more luxuriant form, with the pole often omitted, recurs in manuscripts locatable at Ghent, viz., the remarkable "Hours of John the Fearless" in Paris, the "Hours of Daniel Rym" in the Walters Art Gallery, two Books of Hours in the Morgan Library, and a Horae at Providence (cf. below, notes 119 ¹,², 121 ⁶,⁷). Second, the pairing of St. Christopher with St. Anthony on fol. 15 v. seems to be a Ghent penchant since it recurs in the "Hours of Daniel Rym," fol. 160 v. (our fig. 187); in the Horae, Walters Art Gallery, ms. 169 (see note 121 ⁹), fol. 132 v.; and in the Hermits' and Pilgrims' wings of the Ghent altarpiece. A later woodcut showing the two saints in combination (Schreiber 1379 A; see A. Hagelstange, "Zwei unbeschriebene Holzschnitte aus der Bibliothek des Magdeburger Domgymnasiums," *Jahrbuch der Königlich Preussischen Kunstsammlungen*, XXIX, 1908, p. 223 ff., pl. II) is difficult to locate but certainly copied from a Flemish original. Be that as it may, at any rate the eight miniatures in ms. 131 D 14 are Flemish in the strictest possible sense of the

term, and a certain Broederlam influence is recognizable both in the figure types (compare, e.g., the thickset St. Anthony with the High Priest in Broederlam's "Presentation") and in the patterns of the pavements (especially fol. 9 v., for which see note 114 ¹) though these are here depicted with a sovereign disregard for perspective.

Page 119

1. Paris, Bibliothèque Nationale, ms. lat. Nouv. Acqu. 3055. See V. Leroquais, *Un Livre d'Heures de Jean Sans Peur, Duc de Bourgogne*, Paris, 1939; ———, *Supplément aux Livres d'Heures manuscrits de la Bibliothèque Nationale*, Mâcon, 1943, p. 5 ff. (with bibliography).

2. Baltimore, Walters Art Gallery, ms. 166 (erroneously referred to as ms. 170 in Leroquais, *Un Livre d'Heures de Jean Sans Peur*, p. 53, and Byvanck, "Kroniek der Noordnederlandsche Miniaturen, III"). Cf. *Walters Catalogue*, 1949, p. 47, no. 125. The use, here given as "Arras," is identical with that of the "Clowes Hours" (cf. note 114 ⁶).

3. Baltimore, Walters Art Gallery, ms. 170. Cf. *Walters Catalogue*, 1949, p. 47, no. 126. Roman use, Flemish Calendar. The inscription on the binding reads: "Omnes sancti angeli et archangeli dei orate pro nobis. Joris de Gavere me ligavit in Gandavo." Joris was active at Ghent about 1525.

4. Paris, Bibliothèque Nationale, ms. lat. Nouv. Acqu. 3055, fols. 107 v., 130 v., 178 v. (Leroquais ed., pls. VII, IX, XII, our fig. 183). This disregard for the lateral frames appears to be a good old Flemish tradition. Cf. e.g., the "Sermon of St. Francis" in the thirteenth-century Psalter, Bruges, Grand Séminaire, vol. 55/171, fol. 95, a manuscript otherwise most intimately related to the Northeast French Psalter, Morgan Library, ms. 72 (*Morgan Catalogue*, 1934, no. 55, pl. 51).

5. Paris, Bibliothèque Nationale, ms. lat. Nouv. Acqu. 3055, fol. 89 v. (Leroquais ed., pl. VI).

6. Baltimore, Walters Art Gallery, ms. 166, fol. 160 v.

7. Paris, Bibliothèque Nationale, ms. lat. Nouv. Acqu. 3055, fol. 197 v. (Leroquais ed., pl. XV).

8. Baltimore, Walters Art Gallery, ms. 166, fol. 11 v.

9. Paris, Bibliothèque Nationale, ms. lat. Nouv. Acqu. 3055, fol. 40 v. (Leroquais ed., pl. IV). For the corresponding miniature in the "*Petites Heures*," see p. 44 and fig. 36.

10. *Ibidem*, fol. 204 v. (Leroquais ed., pl. XVI).

11. *Ibidem*, fol. 107 v. (Leroquais ed., pl. VII).

Page 120

1. *Ibidem*, fol. 28 v. (Leroquais ed., pl. III).

2. *Ibidem*, fol. 178 v. (Leroquais ed., pl. XII).

3. *Ibidem*, fol. 89 v. (Leroquais ed., pl. VI).

4. See pp. 95, 105.

5. Baltimore, Walters Art Gallery, ms. 166, fol. 168 v.

6. See note 120 [1].

7. Cf. the article by L. Mirot, quoted in Leroquais, *Supplément aux Livres d'Heures*, p. 9.

8. Paris, Bibliothèque Nationale, ms. lat. Nouv. Acqu. 3055, fol. 195 v. (Leroquais, ed., pl. XIV). For the morphological background of the unorthodox "Quaternity" — which must be interpreted in the light of the discussions centering around the concept of "Immaculate Conception" — see E. H. Kantorowicz, "The Quinity of Winchester," *Art Bulletin*, XXIX, 1947, p. 73 ff., where, however, the actual presence of the Dove has been overlooked.

Page 121

1. Baltimore, Walters Art Gallery, ms. 166, fol. 113 v.

2. *Ibidem*, fol. 106 v.

3. Cf. van Marle, *op. cit.*, IV, p. 227, fig. 113.

4. Paris, Bibliothèque Nationale, ms. lat. Nouv. Acqu. 3055, fol. 195 v. (Leroquais ed., pl. XIV). As an English parallel, cf., e.g., the "Psalter of Eleanor of Bohun" in the Advocates' Library of Edinburgh (*Burlington Fine Arts Club, Exhibition of Illuminated Manuscripts*, 1908, pl. 102).

5. Paris, Bibliothèque Nationale, ms. lat. Nouv. Acqu. 3055, Calendar and fols. 28 v., 172 v., 204 v. (Leroquais ed., pls. I, III, XI, XVI).

6. New York, Morgan Library, mss. 46 and 439 (de Ricci-Wilson, *Census*, II, p. 1374, no. 46 and p. 1449, no. 439). Ms. 46 (adduced by Meiss, "The Madonna of Humility," p. 450 and fig. 20, as a member of the "Gold Scroll" family) is a Horae for Sarum use, datable about 1430–1435 and evidently produced for export to England where ten miniatures and a great number of borders were added. The dragon-and-lion *rinceaux* occur only on text pages, *passim*. Some of the Flemish miniatures, e.g., fols. 15 v., 47 v., 85 v., show the rare peculiarity that the border *décor* consists of tessellation instead of vegetal ornament. The only parallels I know are, first, a Horae formerly in the Edouard Kann Collection at Paris, brought to my attention by the late Miss Belle da Costa Greene (A. Boinet, *La Collection de Miniatures de M. Edouard Kann*, Paris, 1926, no. XV, pl. X, here published as "French, end of the fourteenth century"); second, a Horae formerly in the collection of the Duke of Arenberg (*Illuminated Manuscripts from the Bibliothèque of Their Highnesses the Dukes d'Arenberg*, no. 68, the donors' figures and coats-of-arms on fol. 60 v. and the Last Judgment page overpainted in the last quarter

of the fifteenth century). Morgan ms. 439 is an approximately contemporary Book of Hours for Roman use (with West Flemish Calendar) in which dragon-and-lion *rinceaux* are fairly ubiquitous. The heavy "oak leaf" border occurs on fol. 21 v. ("St. John the Baptist"), while the frame of the St. Christopher miniature, fol. 25 v., has overdeveloped corner quatrefoils not unlike those in the "Hours of John the Fearless," fol. 89 v., and in the "Daniel Rym Hours," fol. 160 v., only that they are filled with tessellation instead of foliate ornament. Another manuscript formerly in the Arenberg Collection (no. 78) is akin to Morgan 46 also in that it was produced in Flanders, presumably at Ghent, for English use.

7. Providence, John Carter Brown Library, ms. 3 (not foliated). Cf. de Ricci-Wilson, *Census*, II, p. 2144, no. 3, and *Walters Catalogue*, 1949, under no. 125). Roman use, Flemish Calendar; as in the "Hours of John the Fearless," SS. Bavo, Amelberga and Pharahildis are honored in the Litanies.

8. See p. 59; note 59 [2]. The influence of the Boucicaut Master is also evident in the "St. George" and a Madonna within an ecclesiastical interior.

9. For the Master of Gilbert of Metz and his circle, see Winkler, "Studien zur Geschichte der niederländischen Miniaturmalerei," p. 311 ff.; ———, *Die flämische Buchmalerei*, p. 29 ff.; F. Lyna, *De Vlaamsche Miniatuur*, p. 91 f.; Thieme-Becker, XXXVII, p. 131. Of manuscripts in American collections which belong, more or less closely, to the Gilbert of Metz group the following may be mentioned: New York Public Library, ms. 28 (de Ricci-Wilson, *Census*, II, p. 1319, no. 28); Morgan Library, ms. 82 (*Census*, II, p. 1381, no. 82, closely related to the former but inferior in execution); Walters Art Gallery, mss. 263, 270 and Suppl. 1 (*Census*, I, pp. 792, 795, 788, nos 220, 242, 193, respectively). The little Horae, Walters ms. 211 (see note 89 [1]) is one of the manuscripts in which the Gilbert of Metz style interbreeds with that of the "Gold Scroll" family, while the Horae, Walters ms. 172 (*Census*, I, p. 788, no. 195) with its fanciful corner quatrefoils and possibly the Horae, Walters ms. 169 (*Census*, I, p. 788, no. 194) hold an intermediary position between the "Gold Scroll" family and the Ghent group.

Page 122

1. Cf. Winkler, *Die flämische Buchmalerei*, p. 25, and Lyna, *De Vlaamsche Miniatuur*, p. 90. The most exhaustive study on the "Gold Scroll" group is found in Byvanck, "Aanteekeningen over Handschriften met Miniaturen, IX, and ———, "Kroniek der Noord-nederlandsche Miniaturen, II." The only manuscript datable by external evidence is the "Duarte Hours"

in the National Archives at Lisbon; see *Bulletin de la Société Française de Reproductions de Manuscrits à Peintures*, XIV, 1930, p. 16, pls. XX, XXI. The others have to be dated on stylistic grounds. Among the earliest examples (*ca.* 1415–1420) are: The Hague, Royal Library, ms. 131 D 14 (see note 118 ⁸); Morgan Library, ms. 76 (see note 114 ³); and Morgan Library, ms. 374, a Missal executed, not for Trent but, as ascertained by Miss Meta Harrsen, for Genoa. The latest phase (*ca.* 1435–1440) is represented by such manuscripts as Brussels, Bibliothèque Royale, ms. 9798 or The Hague, Museum Meermanno–Westreenianum, ms. 10 E 2. The Gold Scroll miniatures in the Horae, Krakow, Czartoryski Museum, ms. 2943 (see note 99 ⁴ and *Bulletin de la Société Française de Reproductions de Manuscrits à Peintures*, XVIII, 1934, p. 68, pl. XV) may be contemporary with the "Duarte Hours" whereas such manuscripts as Aschaffenburg, Hofbibliothek, mss. 3 and 7, Walters Art Gallery, mss. 169 and 259, and The Hague, Royal Library, ms. 76 F 25 would seem to hold an intermediary position between the "Duarte Hours" and the early group. The number of manuscripts in the "Gold Scroll" style is legion, and of manuscripts in American collections not mentioned by Byvanck may be added: Morgan Library, ms. 19 (de Ricci-Wilson, *Census*, II, p. 1368, no. 19); Walters Art Gallery, mss. 173 and 246 (*Census*, I, pp. 794 and 792, nos. 237 and 225); Chicago, Newberry Library, part of the miniatures in ms. 324348 (*Census*, I, p. 536, no. 324348).

2. Cambridge, Fitzwilliam Museum, ms. 49, miniature no. 19 according to James' numeration.

3. London, British Museum, ms. Add. 16698, fol. 44. Kuhn, *op. cit.*, p. 143, discusses this type of representation which, however, should not be referred to as the "Resurrection of the Dead" because it refers to the Personal rather than the Universal Judgment; the *Commendatio animarum* is a special service appended to the Vigils of the Dead which consists of Psalms CXVIII and CXXXVIII, Antiphon and Collect. Of specimens in "Gold Scroll" manuscripts may be mentioned: The Hague, Royal Library, ms. 131 D 14, fol. 101; Morgan Library, ms. 19, fol. 140; Brussels, Bibliothèque Royale, ms. 10776, fol. 112 v.; Paris, Bibliothèque Nationale, ms. lat. 13264, fol. 126 v.; Cambridge, Fitzwilliam Museum, ms. 81, miniature no. 11 according to James. After the motif had been introduced into English illumination by Herman Scheerre and his collaborator, the Master of the Beaufort Saints (British Museum, mss. Royal 2 A VIII, fol. 101 v., and Add. 18213, fol. 125 v., both mentioned by Kuhn, p. 143; the latter illustrated in fig. 23), it frequently recurred in English manuscripts, e.g., in the "Hours of Elizabeth ye Queene" (*Illustra-*

tions from One Hundred Manuscripts in the Library of Henry Yates Thompson*, London, 1914, pl. LXVIII); Cambridge, Fitzwilliam Museum, mss. 51, 53, 54 (miniatures nos. 44, 48, 36 according to James, respectively); British Museum, ms. Harley 2784, fol. 84 v., etc.

4. London, British Museum, ms. Add. 18213. Cf. Kuhn, *op. cit.*, p. 143, figs. 22, 23. In addition to this manuscript, Kuhn rightly ascribes to the post-English period of the Master of the Beaufort Saints a fine Missal in the Musée Plantin-Moretus at Antwerp (ms. 192, Kuhn, figs. 27–29) and, with some reservation, two Books of Hours preserved at Paris (Bibliothèque de l'Arsenal, ms. 565) and Arras (Bibliothèque Municipale, ms. 513). The Horae in the British Museum, ms. Royal 2 A VIII (Kuhn, p. 142 f., fig. 30) is, in my opinion, less intimately related to the Master of the Beaufort Saints. Indubitably executed in England, it would seem to be the work of another Continental artist who in most cases kept to the tradition exemplified by the "Rouen Hours" almost as closely as did the illuminator of the "Cambridge Hours."

5. Bruges, Grand Séminaire, vol. 72/175 (kindly brought to my attention by Dr. Harry Bober). The St. George miniature on fol. 52 v. (fig. 195) surrounded by an architectural frame and showing the hindquarters of the horse concealed by a rock, has equally much in common with the corresponding miniatures in the "Beaufort Hours" (Kuhn, *op. cit.*, fig. 9) and in the Krakow manuscript referred to in note 122 ¹ (our fig. 194).

Page 123

1. As direct borrowings from the Master of Flémalle (Dijon "Nativity") may be mentioned the Two Midwives in the Nativity: Walters Art Gallery, ms. Suppl. 1, fol. 41 v., and Brussels, Bibliothèque Royale, ms. 9016 (Winkler, "Studien zur Geschichte der niederländischen Miniaturmalerei," p. 310 and p. 312, fig. 27); as indirect ones (through the Bedford workshop, as represented by Walters, ms. 281, fol. 97) the woman seen from the back in the Presentation of Christ: Walters, ms. 263, fol. 62; ms. 270, fol. 59 v.; and ms. 211, fol. 147 v. (cf. the Master of Flémalle's "Betrothal of the Virgin" in the Prado).

2. Cf., e.g., A. J. J. Delen, *Histoire de la gravure dans les anciens Pays-Bas. . .*, Paris, 1924–1935, I, pl. XI, 2. For some early woodcuts the borders of which imitate those of miniatures, and one of which even boasts a tessellated background, see M. Weinberger, *Die Formschnitte des Katharinenklosters zu Nürnberg*, Munich, 1925, pls. 2, 4, 5, 6.

3. Schreiber 1349; very frequently illustrated, e.g.,

Michel, *Histoire de l'art*, III, 1, fig. 179; Delen, *op. cit.*, pl. VIII.

Page 124

1. Cf. Martens, *op. cit.*, p. 135 ff., pls. XLVIII–L; Stange, *op. cit.*, III, fig. 12.

2. Cf. von der Osten, *op. cit.*, *passim*; Panofsky, "Imago Pietatis," *passim*.

3. Illustrated in *Burlington Magazine*, XLI, 1922, p. 156, and Panofsky, "Imago Pietatis," fig. 38. Gerini's picture, formerly owned by the Earl of Crawford and Balcarres, has recently been acquired by the Metropolitan Museum.

4. London, British Museum, Schreiber 864; Campbell Dodgson, *Woodcuts of the Fifteenth Century in the British Museum*, London, 1934, no. 109, pl. XXX. Cf. M. Weinberger, "An Early Woodcut of the Man of Sorrows at the Art Institute, Chicago," *Gazette des Beaux-Arts*, ser. 6, XXXIX, 1946, p. 347 ff., fig. 5.

5. Weinberger, *ibidem*, pp. 352, note 13, and 358. Weinberger, denying that the type of the Man of Sorrows showing His wounds — whether exposing the palm of one hand and placing the other at the wound in His side, or raising both hands symmetrically with palms turned toward the beholder — is influenced by the Last Judgment, assumes that "the identity of posture is caused by that of action — the showing of wounds." However, this very action, *ostentatio vulnerum*, is originally an exclusive feature of the Last Judgment, documented as early as the fourth century and persisting throughout the Middle Ages (though artists often, but by no means typically, replaced it by the assymmetrical gestures of blessing and condemnation). It is even characteristic of those representations of Christ the Judge in which the Resurrected are either reduced to insignificance (as in the Flemish Psalter, Morgan Library, ms. 106, fol. 10 v., *Morgan Catalogue*, 1934, no. 50, pl. 46) or entirely omitted (as in numerous book illuminations and, above all, in the so-called "Paten of St. Bernward" of the second half of the twelfth century, illustrated in O. von Falke, R. Schmidt, and G. Swarzenski, *Der Welfenschatz*, Frankfort, 1930, pl. 71). It was from these isolated figures of the Judge — that in the "Paten of St. Bernward" unequivocally inscribed: "Huc spectate viri, sic vos moriendo redemi" — that the motif of the *ostentatio vulnerum* could be most easily transferred to representations of the Man of Sorrows where it does not occur until the fourteenth century.

6. Martens, *op. cit.*, fig. 95. Cf. Panofsky, "Imago Pietatis," fig. 32 and p. 305, note 97.

7. New York, Morgan Library, ms. 46 (see note 121 [6]), fol. 99 v. (the scrolls of the trumpeting angels inscribed: "Unicuique juxta opera largitur. Justus dominus, justum judicium"; and: "Surgite mortui, venite ad judicium, manifestabuntur secreta cordium"); a nearly identical representation in Walters, ms. Suppl. 1, fol. 143 v. In the English Horae, British Museum, ms. Harley 2982, fol. 53, the Man of Sorrows in half-length is completed into a standing figure as in the engraving Pass. 243 by Israel van Meckenem (illustrated in Panofsky, "Imago Pietatis," fig. 34).

Page 125

1. See p. 46; note 46 [3].

2. Cf. Martens, *op. cit.*, p. 151, pl. XXIV (illustrated also in many other works, e.g., Glaser, *op. cit.*, fig. 47 and Stange, *op. cit.*, III, fig. 5). Miss Martens, p. 250, note 296, lists a few exceptional Nativities from which the St. Joseph is absent, to which may be added (apart from the miniatures in the "Codex Gisle" and cod. Vind. 1774, mentioned in note 46 [3]): a miniature in the Bohemian Missal, Zittau, Stadtbibliothek, ms. A VII (Kletzl, *loc. cit.*, fig. 27) which is, however, a mere abridgment of the Pacino di Buonaguida type; Michael Pacher's "Nativity" at St. Wolfgang (Glaser, *op. cit.*, fig. 175); and a miniature in the Horae, Walters Art Gallery, ms. 260, fol. 63 v. (our fig. 73) where the St. Joseph seems to have been omitted by sheer inadvertence. In the productions of the Rohan workshop he is present in representations of the Nativity proper but omitted where the idea of adoration rather than the historical event is stressed, e.g., in the marginal miniatures in the Horae, Bibliothèque de l'Arsenal, ms. 647, fol. 41 (Panofsky, "Reintegration of a Book of Hours," fig. 2).

3. As mentioned above, p. 46, the cave motif had been introduced to the North — not through Italian but through Byzantine sources — before the advent of the Gothic style (cf., e.g., the examples in H. Swarzenski, *Die lateinischen illuminierten Handschriften*, figs. 159, 225, 251, 273, 483, 496, 532, 716, 747, 750, 797, 1024, 1043); but this vogue had been entirely eclipsed by the ensuing development.

4. Cf. Stange, *op. cit.*, III, figs. 271 and 262. It should be noted that under similar conditions — viz., under the impact of the Italianate "St. Bridget type" upon the indigenous tradition — the cave-and-shed combination also occurs in Netherlandish painting, though in considerably less fantastic form; see, e.g., the "Nativity" and "Adoration of the Magi" in the altarpiece from Roermond in Amsterdam (see p. 104) or Petrus Christus' Berlin "Nativity" of 1452 at Berlin (p. 311; fig. 409).

5. See p. 46.

6. Paris, Bibliothèque Nationale, ms. fr. 166, fol. 19 (de Laborde, *Etude sur la Bible Moralisée*, fig. 743).

7. The Hague, Royal Library, ms. 131 D 14 (see note 122 ¹), fol. 42.

Page 126

1. The following instances may be mentioned: The Hague, Royal Library, ms. 76 F 25, fol. 53 (for the manuscript itself, see *Oudheidkundig Jaarboek*, ser. 3, X, 1930, p. 104 ff., fig. 6); Baltimore, Walters Art Gallery, ms. 173 (see note 122 ¹), fol. 44, and ms. 172 (see note 121 ⁹), fol. 33; New York, Public Library, ms. 28 (see above, *ibidem*), not foliated; London, British Museum, ms. Harley 2846, fol. 77 (cave very indistinct but definitely recognizable); Private Collection (formerly Dr. Alfred Bum, Kottbus), Horae by the Arenberg Master, fol. 28 v. (Byvanck, *Min. Sept.*, pl. XLII, fig. 120, our fig. 127).

2. Baltimore, Walters Art Gallery, ms. 211 (see note 89 ¹), fol. 139 v.

3. The supernatural radiance which filled the cave of the Nativity is stressed in the Apocrypha (Pseudo-Matthew, XIII; Arabic Infancy Gospels, III). But the specific motif of its obscuring a natural source of illumination seems to be derived, in a manner still to be explained, from Philostratus' description of the Birth of Dionysus (*Imagines*, I, 14; cf. D. Panofsky, "Narcissus and Echo; Notes on Poussin's Birth of Bacchus in the Fogg Museum," *Art Bulletin*, XXXI, 1949, p. 112 ff.). It would seem that there are direct representational connections between the Birth of Bacchus and the Nativity of Christ, especially in Byzantine art; both scenes are staged in or before a cave, and the midwives attending to the Christ Child may well be the descendants of the nymphs ministering to the infant Dionysus.

4. The first alternative — the candle on a shelf of rock in the interior of the cave — is exemplified by Niccolo di Tommaso's triptych in the Pennsylvania Museum of Art (Johnson Collection), the second — candle held by St. Joseph — by the anonymous panel in the Museo Civico at Pisa (our fig. 38).

5. A symbolic interpretation of the candle in the Dijon "Nativity," but without reference to St. Bridget, was given by de Tolnay, *Le Maître de Flémalle*, p. 14; the St. Bridget passage was duly stressed by Meiss, "Light as Form and Symbol," p. 176, note 2.

Page 127

1. Cambridge, Fitzwilliam Museum, ms. 141; Byvanck, *Min. Sept.*, pl. XLIV, fig. 128. As one of the rare French examples may be mentioned the "Annunciation" in the "Hours of Charles VI," Vienna, Nationalbibliothek, ms. 1855, fol. 25 (H. J. Hermann, *Beschreibendes Verzeichnis*, VIII, VII, 3, pl. XLV).

2. Robb, *op. cit.*, fig. 28.

3. *Protevangelium Jacobi*, XIX, XX (only Salome named); Pseudo-Matthew, XIII (Salome and Zelomi); *Golden Legend*, chapter *De Nativitate* (Salome and Zebel). In all these versions Salome is the name of the doubting midwife. But owing to a widespread confusion with St. Mary Salome it was generally transferred to the believing one.

4. Cf. the collection of instances in M. Davies, *National Gallery Catalogues, Early Netherlandish School*, London, 1945, p. 38. All of these, however, do not really tell the story of the withered hand as does the Dijon "Nativity" and the miniatures referred to in note 123 ¹, but show the midwives approaching the scene or quietly standing by, Salome often carrying, in further amplification of the motif introduced by St. Bridget, a lantern. There should be added, however, a few instances in which Salome alone is shown in adoration of the Infant Jesus: the "Nativity" of 1448 in the Vieille Boucherie at Ghent, ascribed to Nabur Martins (L. Maeterlinck, "Le 'Maître de Flémalle' et l'école gantoise primitive," *Gazette des Beaux-Arts*, ser. 4, X, 1913, p. 53 ff.; ———, *Une Ecole méconnue; Nabur Martins ou le Maître de Flémalle*, Brussels and Paris, 1913); Petrus Christus' two "Nativities," one in the Kaiser Friedrich Museum at Berlin, the other formerly in the Henry Goldman Collection and now in the possession of Mr. Georges Wildenstein at New York (our figs. 409, 411); a Rhenish picture in the Metropolitan Museum apparently derived from Petrus Christus but reinterpreting the gesture of adoration into one of wonderment (H. B. Wehle and M. Salinger, *The Metropolitan Museum of Art, A Catalogue of Early Flemish, Dutch and German Paintings*, New York, 1947, p. 166); a Swiss picture at Basel (*Meisterwerke der Oeffentlichen Kunstsammlung in Basel*, P. Ganz, pref., Munich, 1924, p. 31); and a miniature in a Rouen Horae of *ca.* 1450, preserved in the Newberry Library at Chicago (ms. 23845, de Ricci-Wilson, *Census*, I, p. 527, not foliated), where Salome is shown kneeling in the center between the Virgin Mary and St. Joseph.

5. An unusual French miniature (which I have been unable to identify) showing Salome in adoration of the Christ Child is, however, illustrated in H. Ghéon, *Noël, Noël*, Paris, 1935, p. 18). It should be added that the rule (Mâle, *L'Art religieux de la fin du moyen âge en France*, 2nd ed., 1922, p. 34) according to which the midwives do not appear in Northern art until the end of the fourteenth century, while generally true, is not without exceptions. A midwife, assisting St. Joseph in bathing the Infant, already occurs in the Hohenfurth altarpiece of *ca.* 1350 (Stange, *op. cit.*, I, fig. 179; Glaser, *op. cit.*, fig. 7); and a midwife preparing the bath is found, at an even more surpris-

ingly early date, in the "Psalter of Yolande de Soissons" in the Morgan Library, ms. 729, fol. 246 v., of 1270–1280, the same manuscript that also anticipates the motif of the eldest King kissing the Christ Child's foot in the Adoration of the Magi (see note 23 [2]). A midwife testing the bath water — as later in Paris, Bibliothèque Nationale, ms. lat., 1156 A, fol. 48 (Leroquais, *Les Livres d'Heures*, pl. XLIV) — is seen, we remember, in Giovanni Pisano's Pisa pulpit and in the Hague Bible of 1371 by Jean Bondol (see p. 38).

6. Berlin, Staatsbibliothek, cod. germ. oct. 109 of *ca.* 1200. Cf. H. Degering, *Des Priesters Wernher drei Lieder von der Magd*, Berlin, 1925, p. 168–172.

7. Munich, Staatsbibliothek, clm. 14045. Cf. Stange, *op. cit.*, II, p. 175, fig. 232. The illuminator's name was Paul Crüger, also called Polener de Silesia.

8. Sanpere i Miquel, *op. cit.*, I, p. 273, fig. 99.

Page 128

1. Cf. again note 23 [2].

2. That the Crucifixion with the Virgin and St. John seated on the ground beneath the Cross instead of standing beside it is also an innovation of the Italian Trecento has been demonstrated by D. C. Shorr, "The Mourning Virgin and St. John," *Art Bulletin*, XXII, 1940, p. 61 ff., especially p. 68 f.

3. See Meiss, "The Madonna of Humility," p. 449 ff., fig. 18 (from Morgan Library, ms. 88, a Book of Hours for the use of Metz).

4. Cf., e.g., London, British Museum ms. Add. 16998 (by Herman Scheerre), fol. 65, our fig. 172.

5. Cf., e.g., the dedication page of the "Rouen Hours," fol. 12 v., our fig. 154.

6. For a Trecento Madonna of Humility in a domestic setting, however rudimentary, see the Sienese panel in the Pennsylvania Museum of Art illustrated in Meiss, "The Madonna of Humility," fig. 21.

7. Schreiber 1160; frequently illustrated, e.g., Michel, *Histoire de l'art*, III, 1, p. 337, fig. 180; Delen, *op. cit.*, I, pl. V.

8. Frequently illustrated, e.g., Glaser, *op. cit.*, fig. 59 (with erroneous caption); Winkler, *Altdeutsche Tafelmalerei*, pp. 50–53; Hartlaub, *op. cit.* The type of Our Lady amidst Virgin Saints, all seated on the ground, persisted in Netherlandish and German art throughout the fifteenth and early sixteenth centuries.

9. Suffice it to mention Conrad Witz's well-known picture of SS. Catherine and Magdalen at Strasbourg (frequently illustrated, e.g., Glaser, *op. cit.*, fig. 68).

10. See, e.g., Paris, Bibliothèque de l'Arsenal, ms. 660, fol. 395 (Leroquais, *Les Bréviaires*, pl. LII).

11. London, British Museum, ms. Egerton 859, fol. 5.

12. Baltimore, Walters Art Gallery, ms. 170, fol. 172 v. It is interesting to note that at the very end of the fifteenth century, when Jan van Eyck's "St. Barbara" was well known to Bruges illuminators (cf. the Horae owned by Mrs. William Emerson at Cambridge, Mass., *Walters Catalogue*, 1949, no. 204, pl. LXXVII), the type of Walters, ms. 170, fol. 172 v., with the tower directly attached to the bench of the Saint, survived in such manuscripts as the "Hours of Isabella of Spain," British Museum, ms. Add. 18851, fol. 297 (good color print in the series *British Museum Process Reproductions in Colour*, no. 42).

13. Robb, *op. cit.*, fig. 7.

Page 129

1. Van Marle, *op. cit.*, II, p. 234, fig. 158.

2. *Ibidem*, p. 519, fig. 333.

3. The nearest approach to an exception is in the Troyes Horae, Paris, Bibliothèque Nationale, ms. lat. 924, fol. 115 where, however, the posture of the Annunciate is halfway between the "humility pose" and normal sitting and her dignity is stressed by an enormous canopy.

4. Robb, *op. cit.*, fig. 27; Geisberg, *Meister Konrad von Soest*, pls. 2 and 46; Steinbart, *Konrad von Soest*, pls. 8 and 53.

5. Paris, Bibliothèque Nationale, ms. 1364, fol. 25.

6. Robb, *op. cit.*, fig. 9.

7. *Ibidem*, fig. 10.

8. *Ibidem*, p. 490, note 41.

9. For the Brenken altarpiece and its relation to a composition transmitted by Bicci di Lorenzo's panel in the Boston Museum of Fine Arts, see W. G. Constable, "A Florentine Annunciation," *Bulletin of the Museum of Fine Arts, Boston*, XLIII, 1945, p. 72 ff.; in view of the general trend in fourteenth-century art I incline to think that the German work depends on an Italian model rather than vice versa. For the picture in the Reinhart Collection (also transmitted through an engraving by the Master of the Nuremberg Passion, illustrated in M. Geisberg, *Die Anfänge des deutschen Kupferstichs und der Meister E. S.* [Meister der Graphik, II], 2nd ed. Leipzig, 1923, pl. 33), see Robb, *op. cit.*, fig. 36; and, more particularly, I. Futterer, "Zur Malerei des frühen XV. Jahrhunderts im Elsass," *Jahrbuch der Preussischen Kunstsammlungen*, XLIX, 1928, p. 187 ff., fig. 8. Since Miss Futterer — who rightly refuses to ascribe the Winterthur "Annunciation" to the same hand as the famous "Garden of Paradise" at Frankfort — has succeeded in finding an Italian prototype for a closely related "Birth of the Virgin" at Strasbourg (*op. cit.*, figs. 3 and 4), Italian derivation may also be assumed for the "Annunciation."

10. Haarlem, Teyler Stichting, ms. 76, fol. 9 v. (Byvanck and Hoogewerff, *La Miniature hollandaise*, pl. 204); also in the little Utrecht Horae, The Hague, Bibliothèque Royale, ms. 74 G 34, fol. 14 v. (Byvanck and Hoogewerff, pl. 6, fig. 20), datable *ca.* 1425.

11. "Arenberg Hours," quoted in Beissel, *op. cit.*, p. 442; New York, Morgan Library, ms. 87, fol. 345 v. (Byvanck, *Min. Sept.*, pl. XLVIII, fig. 135).

12. This is the "Annunciation" in the Arthur Sachs Collection at Santa Barbara (see p. 82; note 82 ⁹).

13. A thorough discussion of the Annunciation with the *parvulus puer formatus* (with a useful collection of instances) is found in Robb, *op. cit.*, p. 523 ff.

Page 131

1. *Protevangelium Jacobi* VIII–XI; Pseudo-Matthew VIII, IX; *Evangelium de Nativitate Mariae* VII–X. According to the *Protevangelium Jacobi* and the *Evangelium de Nativitate Mariae*, the Virgin Mary returned to the house of her parents after her marriage; according to Pseudo-Matthew, she worked with her companions (five in number) in the house of St. Joseph. This collective effort (though with only three companions present) is charmingly depicted in a Cologne picture of *ca.* 1460 (*Schaeffer Galleries Bulletin*, No. 5, May 1948, fig. 1). In the *Protevangelium Jacobi* the number of the other virgins is given as six, in the *Evangelium de Nativitate Mariae* as seven.

2. Cf. Robb, *op. cit.*, p. 481; figs. 1, 5.

3. For an exception to this general rule — an otherwise regular "Annunciation" exhibiting several features suggested by the *Protevangelium Jacobi* — see a provincial ivory plaque of *ca.* 1460 in the Museum at Orléans (Koechlin, *op. cit.*, II, p. 337, pl. CLXII, no. 911).

4. Paris, Bibliothèque Nationale, ms. lat. 10538, fol. 31. Several other instances (which could be multiplied *ad infinitum*) are listed in Robb, *op. cit.*, p. 487, note 35. Where the Virgin at the Loom occurs as a full-page miniature (e.g., Paris, Bibliothèque Mazarine, ms. 491, fol. 234 v.) this miniature does not replace the orthodox Annunciation at the beginning of Matins but serves to illustrate a special prayer. In one of the famous tapestries presented to Reims Cathedral by Archbishop Robert de Lenoncourt in 1530 (*The Art Institute of Chicago, Masterpieces of French Tapestry, March 17 to May 5, 1948*, no. 60, fig. 29), the representation of the Virgin at the Loom precedes the Infancy scenes but is developed into a comprehensive allegory in that the central figure, depicted within the Garden Inclosed, is surrounded by a complete array of Marian symbols as in the well-known panel in Schleissheim (J. von Schlosser, "Zur Kenntnis der künstlerischen Ueberlieferung im späten Mittelalter," *Jahrbuch der Kunsthistorischen Sammlungen des Allerhöchsten Kaiserhauses*, XXIII, 1902, p. 279 ff., especially p. 287 ff., pl. XVII) or in Simon Vostre's "Hours for Lyons Use," fol. i 3: the Tree of Jesse, the Well of Living Waters, the Tall Cedar, the Gate of Heaven, the Star of the Sea, the Sun, the City of God, the Moon, the Tower of David, the Fountain of Gardens, the Olive Tree and the Spotless Mirror. For Marian symbolism in general, see A. Salzer, *Die Sinnbilder und Beiworte Mariens in der deutschen Literatur und lateinischen Hymnenpoesie des Mittelalters*, Linz, 1893, supplemented by E. Lommatzsch, "Anatole France und Gautier de Coincy," *Zeitschrift für Romanische Philologie*, LVIII, 1938, p. 670 ff.; and E. Auerbach, "Dante's Prayer to the Virgin (Paradiso, XXXIII) and Earlier Eulogies," *Romance Philology*, III, 1949, p. 1 ff.

Page 132

1. The symbolical significance of these windows (though not with reference to their number and the important contrast between the fenestrated Gothic gable and the Orientalizing tower) has been stressed by Meiss, "Light as Form and Symbol," p. 178. For the specific symbolism of *three* windows, see Panofsky, "The Friedsam Annunciation," p. 450, note 30; also C. de Tolnay, "Flemish Paintings in the National Gallery of Art," *Magazine of Art*, XXXIV, 1941, p. 174 ff., especially p. 178, and p. 200, note 20. Cf. also above, p. 138.

2. Cf. de Tolnay, *ibidem*, p. 176 and p. 200, note 18. The simple phrase *Templum Trinitatis* is used in a hymn ascribed to Theophilus:

> "Venustate vernans rosa . . .
> Fons dulcoris,
> Vas decoris,
> Templum Trinitatis."

3. See E. Panofsky, "Der gefesselte Eros; zur Genealogie von Rembrandt's Danaë," *Oud Holland*, L, 1933, p. 193 ff., especially p. 203 ff.

4. For the Princeton panel, see F. J. Mather, Jr., "The Museum of Historic Art; Painting," *Art and Archaeology*, XX, 1925, p. 145 f.; a free variation is illustrated in van Marle, *op. cit.*, I, pl. facing p. 378. What looks like a towerlike structure in the "Annunciation" in Jean Pucelle's "Belleville Breviary," Paris, Bibliothèque Nationale, ms. lat. 10483, fol. 163 v. (Robb, *op. cit.*, fig. 16) may be due to the awkwardness of the illuminator who attempted to transform the scheme of the famous "Annunciation" in the "Hours of Jeanne d'Evreux" (our fig. 5) into a kind of outdoor setting. But a very emphatic tower, with an iron-braced door and a barred window, is found in the

NOTES

Bible Moralisée, Paris, Bibliothèque Nationale, ms. fr. 9561, fol. 129.

5. Paris, Bibliothèque Nationale, ms. lat. 10538, fol. 31.

6. Paris, Bibliothèque Nationale, ms. lat. 1161, fol. 31.

Page 133

1. See note 175 [13]. For another survival of the Orientalizing tower, see the "Annunciation" in the "De Buz Hours," fol. 20 (Panofsky, "The De Buz Book of Hours," pl. III).

2. Cf. H. Wendland, *Konrad Witz*, Basel, 1924, pl. 5: W. Ueberwasser, *Konrad Witz, Basel*, n.d. [1938], pl. 3.

3. See Panofsky, "The *Friedsam Annunciation*"; Robb, *op. cit.*, p. 505 f., fig. 30. For the special significance of the monkey console, see H. W. Janson, *Apes and Ape Lore in the Middle Ages and the Renaissance* (Studies of the Warburg Institute, XX) London, 1952, pp. 53, 116. Professor Janson kindly informs me that the console in the "Friedsam Annunciation" is an exact rendition of a Romanesque type that occurs in Northern Spain from the end of the eleventh century, and in France shortly after.

4. Engraving B. 42, frequently illustrated. For the significance of the monkey, see Panofsky, *Albrecht Dürer*, I, p. 67 and fig. 102; Janson, *op. cit.*, p. 151.

Page 134

1. Cf. Janson, *op. cit.*, pp. 117 f., 141. For the picture itself, see above, p. 307.

2. See Panofsky, "The Friedsam Annunciation," fig. 20; also A. K. Coomaraswamy, "Eckstein," *Speculum*, XIV, 1939, p. 66 ff.

3. Panofsky, "The Friedsam Annunciation," fig. 21.

4. *Ibidem*, fig. 25, and J. J. Rorimer, *The Metropolitan Museum of Art; Medieval Tapestries*, fig. 2. The weaver appears to have interpreted the keystone as a kind of pillow embroidered with a *bend cotised* (here made to appear as a *bend cotised sinister*) and a *cross crosslet*. While the general derivation of the compositon from Broederlam is obvious it is noteworthy that the motif of the skein of wool is omitted, while that of the *parvulus puer formatus* (see p. 129) has been interpolated.

Page 135

1. K. J. Conant, "Mediaeval Academy Excavations at Cluny, VII," *Speculum*, XVII, 1942, p. 563 ff., particularly p. 565.

2. The view that the Early Flemish masters, especially Jan van Eyck, were perfectly conscious of the stylistic contrast that exists between Romanesque and Gothic forms and deliberately used it to express the antithesis between Judaism and Christianity (see Panofsky, "The Friedsam Annunciation," p. 449, note; de Tolnay, *Le Maître de Flémalle*, p. 49, note 55; ———, "Flemish Paintings in the National Gallery of Art," pp. 176, 200, note 11) has recently been questioned by E. S. de Beer, "Gothic: Origin and Diffusion of the Term; the Idea of Style in Archtiecture," *Journal of the Warburg and Courtauld Institutes*, XI, 1948, p. 143 ff., notably on the grounds that "up to about 1600 . . . men were more aware of continuity than of change," and that "it was only the purification of the classical style in their own lands that enabled them to see Gothic as something different" (p. 157). De Beer overlooks, however, the fact that the penetration of the Italian Trecento style in the fourteenth century into the Northern countries had created a situation somewhat analogous to that produced by the invasion of the full-fledged Renaissance, and he underestimates the awareness of stylistic differences even with regard to the period when Gothic asserted itself against Romanesque. He holds that Suger's emphasis on the character of his *opus modernum* as opposed to the *opus antiquum* of the Carolingian St.-Denis only contrasts the old and the new without "any trace of the idea of style," and dismisses the well-known document relating to the church at Wimpfen ("Praepositus Ricardus . . . accito peritissimo in architectoria arte latomo, qui tunc noviter de villa Parisiensi e partibus venerat Franciae, opere francigeno basilicam . . . construi jubet") as a case "without parallel" (p. 158). He fails, however, to adduce the all-important passage wherein Gervase of Canterbury deliberately sets out to analyze the contrast between the old structure and the new chevet begun by William of Sens in 1174 ("operis utriusque differentiam"), and not only brilliantly describes such differences as that between groin vaults and rib vaults, or that between the old details "sculptured as though with an axe and not with a chisel" and the *sculptura idonea* of the new chevet, but virtually anticipates Paul Frankl's antithesis between an "additive" and a "divisive" interpretation of space when he writes: "There [in the old structure] a wall set upon the piers divided the transepts from the choir; here the transepts, not separated from the choir by any partition, seem to convene in one keystone placed in the center of the big vault which rests upon the four principal piers" (J. von Schlosser, *Quellenbuch zur Kunstgeschichte des abendländischen Mittelalters*, Vienna, 1896, p. 252 ff.; now easily accessible, in a somewhat free translation, in E. G. Holt, *Literary Sources of Art History*, Princeton, 1947, p. 56).

3. Cambridge, Mass., Philip Hofer Collection, fol.

1 v. Cf. E. G. Millar, *The Library of A. Chester Beatty*, II, no. 68, pl. CL; Sotheby & Co., *Catalogue of the Renowned Collection of Western Manuscripts, the Property of A. Chester Beatty, Esq., the Second Portion, Sold on May 9, 1933*, lot 51, pl. 24.

4. Frequently illustrated, e.g., Michel, *Histoire de l'art*, III, 2, p. 617, fig. 356; van Marle, *op. cit.*, VIII, p. 30, fig. 21.

Page 136

1. For the Master of the Darmstadt Passion, see p. 306 f. The idea of staging the Infancy scenes amidst ruins may have received an additional stimulus by the apparently original assertion of Johannes Hildesheimensis (cf. note 64⁴) that the Nativity had taken place in the cellar of the ruined house of David at Bethlehem.

2. See p. 160 f. De Tolnay's interpretation of the scene as the Rejection of Joachim's Offering (*Le Maître de Flémalle*, p. 25) is difficult to understand.

3. De Beer, "Gothic: Origin and Diffusion of the Term," p. 159.

4. Thomas Aquinas, *Summa Theologiae*, I, 2, qu. CII, art. 4, reply 4. A subtle difference can also be observed between the decoration of the circular sanctuary and that of the narthex. While the iconography as a whole keeps within the limits of the Old Testament, the decoration of the circular sanctuary is confined to the two earliest of the five periods which St. Augustine (*De Civitate Dei*, XXII, 30) distinguishes within the pre-Christian era, viz., the periods from Adam to the Flood and from the Flood to Abraham (the windows showing the events from the Creation of Eve to the Slaying of Abel, presumably followed by the story of Noah; the capitals and the reliefs on the attica, the stories of Lot, Abraham and Isaac). The narthex, however, its tympanum adorned with a statue of the Lord between Moses and, presumably, another Prophet, shows in its archevaults Samson Rending the Lion, the story of David and Goliath, the story of Absalom, Solomon and the Queen of Sheba, and the Temple of Jerusalem.

5. R. Maere, "Over het Afbeelden van bestaande Gebouwen in het Schilderwerk van Vlaamsche Primitieven," *Kunst der Nederlanden*, I, 1930–31, p. 201 ff., identifies the narthex with the south transept of Notre-Dame-du-Sablon at Brussels but rightly stresses the fact that the architectural data were used with considerable freedom. For the statuary — which is, of course, entirely of the painter's own invention — see the preceding note.

6. De Tolnay, *Le Maître de Flémalle*, p. 24 f. See above pp. 165, 222.

Page 137

1. For the style of the Romanesque murals in his Washington "Annunciation," cf. the frescoes in the transepts of Tournai Cathedral (Rolland, *La Peinture murale à Tournai*, pls. XIV–XXXI). The Samson niello in the pavement may be compared with the early thirteenth-century mural at Limburg-on-the-Lahn (P. Clemen, *Die romanische Monumentalmalerei in den Rheinlanden*, Düsseldorf, 1916, p. 514, fig. 365). For the fact that the "Romanesque revival" inaugurated by the van Eyck brothers exerted a basic influence upon the iconography of the Ghent altarpiece, see p. 215 f.

2. Apart from the fairly accurate rendering of Old St. Paul's at London in the "Rothschild Madonna," which was, however, executed by Petrus Christus (see p. 187 f.), the only "architectural portrait" in Jan's work is the tower of Utrecht Cathedral in the "Rolin Madonna" (see note 193¹) which is, however, treated considerably more freely than that in the Ghent altarpiece. For this, see note 225³.

3. The identification of the city prospect in the "Rolin Madonna" with Maastricht was vigorously championed by E. van Nispen tot Sevenaer ("Heeft Jan van Eyck te Maastricht gewoond?," *Oudheidkundig Jaarboek*, ser. 4, I, 1932, p. 91 ff.; ———, "De topografische Bijzonderheden van de Stad in den Achtergrond van de 'Madonna Rolin,'" *Wetenschap in Vlaanderen*, I, 1935–1936, p. 111 ff.); A. van Kessen, "De Madonna van Rollin en Maastricht," *De Maasgouw*, LXIII, 1943, p. 2 ff. The Liège hypothesis was formed by K. Voll, *Die Werke des Jan van Eyck*, Strasbourg, 1900, p. 36, and partially endorsed — with the correct reservation that the town is, on the whole, imaginary — by J. J. M. Timmers, "De Achtergrond van de Madonna van Rolin door Jan van Eyck," *Oud Holland*, LXI, 1946, p. 5 ff. The Lyons theory was proposed by Lieutenant Colonel Andrieu, "Le Paysage de la Vierge au Donateur, de van Eyck," *Revue Archéologique*, ser. 5, XXX, 1929, p. 1 ff. For the Prague hypothesis, see note 193¹. Quite recently, as M. Frédéric Lyna was kind enough to inform me, it has been suggested that the city is Brussels prior to the canalization of the Senne!

4. Cf., e.g., the interior of Amiens Cathedral in the "Priesthood of the Virgin" (text ill. 61), now in the Louvre (Sterling, *Les Primitifs*, fig. 174; Dupont, *Les Primitifs français*, p. 34; Evans, *Art in Mediaeval France*, fig. 231; Ring, *A Century*, Cat. no. 158, pl. 97); or that of Basel Cathedral in the Naples "Holy Family" often ascribed to Conrad Witz (illustrated, e.g., in Glaser *op. cit.*, fig. 67).

5. Frequently illustrated. See, e.g., H. Beenken, *Bildwerke des Bamberger Domes aus dem 13. Jahr-*

hundert, Bonn, 1925, figs. 35–42; H. Jantzen, *Deutsche Bildhauer des dreizehnten Jahrhunderts*, Leipzig, 1925, figs. 52–58, 76. See also E. Panofsky, "Renaissance and Renascences," *Kenyon Review*, VI, 1944, p. 201 ff., especially p. 226, fig. 22.

6. It is noteworthy that the washstand and towel in connection with the Annunciation scene already occur in the "De Buz Hours," fol. 20 (Panofsky, "The De Buz Book of Hours," pl. III). That the basin-and-towel combination was generally accepted as a symbol of Marian purity is evident from the fact that it occurs, in conjunction with some books, as an independent still life on the back of a Madonna of *ca.* 1480, copied from Roger van der Weyden's "Froimont Madonna" at Caen (p. 296; fig. 372), where it cannot possibly be explained as part of a naturalistically rendered interior; see *Catalogue of the D. G. van Beuningen Collection*, no. 35, pls. 26, 27; *Orangerie des Tuileries, La Nature morte de l'antiquité à nos jours, avril-juin 1952*, A. Maiuri, pref., C. Sterling ed., no. 7, pl. II.

Page 139

1. This may be illustrated by the following diagram.

Arrangement of the Zodiacal Signs in the Pavement of Jan van Eyck's Washington "Annunciation"; Signs Represented by Empty Circles Not Visible but Inferable from the Position of the Others

Essentially my interpretation of Jan van Eyck's Washington "Annunciation" (cf. also H. Kauffmann, "Jan van Eycks 'Arnolfinihochzeit,'" *Geistige Welt, Vierteljahresschrift für Kultur- und Geisteswissenschaften*, IV, 1950, p. 45 ff.) agrees with de Tolnay's ("Flemish Paintings in the National Gallery of Art," p. 175 ff.), except for the identification of the figure in the window as the Lord of the Old Testament rather than Christ (as I myself had erroneously assumed in "The Friedsam Annunciation," p. 450, note 32). It should,

however, be noted that the inscriptions on the Samson nielli are not quite accurately rendered in de Tolnay's note 12. The letter before the abbreviated CONVIVIO is not a "T" but an "I" with an abbreviation mark, standing for IN; and the inscription of the Samson and Delilah niello reads: . . . R A DALIDA VXORE S . . . , probably to be completed into "[Samson traditu]r a Dalida uxore s[ua]." For the interpretation of this scene as a *typus* of the Entombment, see, e.g., B. Rackham, *The Ancient Glass of Canterbury Cathedral*, London, 1949, p. 76: "Ecclesie causa Christi caro marmore clausa, Ut Samson tipice causa dormivit amice." For the idea of writing the "Ecce ancilla" upside down, cf., e.g., Fra Angelico's "Annunciation" in the Chiesa del Gesù at Cortona (Prampolini, *op. cit.*, pls. 44, 48).

2. This interpretation of the scene (a figure, apparently female, kneels before a military commander followed by soldiers) seems to be preferable to the assumption that it represents Esther before Ahasuerus (de Tolnay, *Le Maître de Flémalle*, p. 50, note 67); Ahasuerus receiving the complaint of Esther is normally represented enthroned rather than standing and clad in regal robes rather than in armor. It should also be noted that the big boat crosses the river, not from left to right (de Tolnay, p. 29) but from right to left. It is interesting that the text from which the inscription on the hem of the Virgin's robe ("Quasi cedrus exaltata sum in Libano . . .") is taken (Ecclesiastes XXIV, 17, frequently occurring in Dutch and Flemish service books) contains two direct references to Zion and Jerusalem. It continues with the phrase: "Et quasi cupressus in monte Sion" (v. 18) and is preceded by: "Et sic in Sion formata sum, et in civitate sanctificata similiter requievi, et in Jerusalem potestas mea" (v. 15).

Page 140

1. For the combination of Romanesque and Gothic forms in the "Rothschild Madonna" (fig. 257) and the altarpiece of Nicholas van Maelbeke (fig. 259), see pp. 187, 191.

2. New York, Morgan Library, ms. 729, fol. 345 v., *Morgan Catalogue*, 1934, no. 57, pl. 52.

Page 141

1. St. Bonaventure, *Liber Sententiarum*, III, dist. 9, art. 1, qu. 2: religious imagery is acceptable "propter simplicium ruditatem, propter affectuum tarditatem, propter memoriae labilitatem."

2. The Pelican group in the Dresden altarpiece has its counterpart in a Phoenix, and the back of the throne is adorned with statuettes representing the Sacrifice of Isaac (corresponding to the Pelican group)

and David's Victory over Goliath (corresponding to the Phoenix).

3. Dürer's "Madonna with the Iris," formerly in the Cook Collection at Richmond, is now in the National Gallery at London. See Panofsky, *Albrecht Dürer*, 3rd ed., 1948, I, p. 94 f.; II, p. 169, with further references.

4. Frequently illustrated, e.g., van Marle, *op. cit.*, III, p. 141, fig. 84; *Giotto, des Meisters Gemälde*, C. H. Weigelt, ed. (Klassiker der Kunst, XXIX, Stuttgart, Berlin and Leipzig, 1925), p. 126.

5. Frequently illustrated, e.g., van Marle, *op. cit.*, II, p. 32, fig. 18; C. H. Weigelt, *Duccio di Buoninsegna*, Leipzig, 1911, pl. 16. A near-identification of Jewish and pagan infidelity (so that both could be symbolized by classical "idols") is not at all unusual. Professor W. S. Heckscher calls my attention to an eleventh century "Presentation of the Virgin" (Prague, Piaristenkloster) where the two columns, Jachin and Boaz, are surmounted by clearly recognizable replicas of the famous "Spinario."

6. For illustrations showing the details in question — unfortunately cut off both in van Marle, *op. cit.*, p. 387, fig. 254, and A. Venturi, *Storia dell'arte italiana*, Milan, 1901–1939, V, p. 698, fig. 566 — see Rowley, *op. cit.*

Page 142

1. De Tolnay, *Le Maître de Flémalle*, p. 15.

Page 143

1. Cf. W. Molsdorf, *Christliche Symbolik der mittelalterlichen Kunst*, 2nd ed., Leipzig, 1926, p. 138 ff.; H. Swarzenski, *Die lateinischen illuminierten Handschriften*, p. 127, note 3.

2. *Speculum Humanae Salvationis*, ch. 10 (J. Lutz and P. Perdrizet, *Speculum Humanae Salvationis*, Mülhausen, 1907–1909, I, p. 23; II, pl. 20). For references to further passages in which the epithet "candelabrum" is applied to the Virgin Mary, see the Index of the *Patrologia Latina*, vol. CCXIX, col. 504. See also below, note 146[4].

3. See p. 126.

4. De Tolnay, *Le Maître de Flémalle*, p. 16, fig. 24; *The Worcester-Philadelphia Exhibition of Flemish Painting, February 23–March 12, and March 25–April 26, 1939*, no. 5.

Page 144

1. See de Tolnay, *Le Maître de Flémalle*, p. 33 and p. 5, note 79. For the symbolism of fruit, cf. also H. Friedmann, "The Symbolism of Crivelli's Madonna and Child Enthroned with Donor in the National Gallery," *Gazette des Beaux-Arts*, ser. 6, XXXII, 1947, p. 65 ff., especially p. 70.

2. Cf. Meiss, "Light as Form and Symbol," p. 179 f.

Page 145

1. Cf. e.g., de Tolnay, *Le Maître de Flémalle*, p. 24. For the unfounded hypothesis that the "Madonna in a Church" was based upon a lost composition by the Master of Flémalle, see below, note 194[2].

2. *Patrologia Latina*, CLXXII, col. 494: "Omnia, quae de Ecclesia dicta sunt, possunt etiam de ipsa Virgine, sponsa et matre sponsi, intelligi." For the conceptual and morphological connection between the Coronation of the Virgin and the *Sponsus* and *Sponsa* group, see P. Wilhelm, *Die Marienkrönung am Westportal der Kathedrale von Senlis* (Hamburg, doctoral dissertation, 1937), Hamburg, 1941, p. 31 ff. For the medieval mind this connection was all the more natural as the Vulgate translates the verse Song of Songs IV, 8 as follows: "Veni de Libano sponsa mea, veni de Libano, veni: *coronaberis* de capite amana." It should also be noted that one of the earliest instances showing Christ and the crowned Virgin Mary enthroned together, the well known mosaic in Santa Maria in Trastevere, shows inscriptions derived from Song of Songs II, 13, V, 1 and VII, 11. The interesting article by G. Zarnecki, "The Coronation of the Virgin on a Capital from Reading Abbey," *Journal of the Warburg and Courtauld Institutes*, XIII, 1950, p. 1 ff., publishing the earliest known instance of the Coronation proper, fails, curiously enough, to point out the connection with the Song of Songs, and even quotes the verse "Veni de Libano . . ." from the *Golden Legend* rather than from its source.

3. For this particularly effective antiphrasis, cf. A. L. Mayer, "*Mater et filia*; Ein Versuch zur stilgeschichtlichen Entwicklung eines Gebetsausdrucks," *Jahrbuch für Liturgiewissenschaft*, VII, 1927, p. 60 ff.

4. Herrad of Landsberg, *Hortus deliciarum*, A. Straub and G. Keller, eds., Strasbourg, 1901, pl. LIX, p. 45 f.

Page 146

1. Berlin, Staatsbibliothek, cod. theol. lat. fol. 323, fol. 2 v. Cf. V. Rose, *Verzeichniss der lateinischen Handschriften der Königlichen Bibliothek zu Berlin* (Handschriften-Verzeichnisse des Königlichen Bibliothek zu Berlin, XXX), Berlin, II, 2, 1903, p. 323; W. Diekamp, "Die Miniaturen einer um das Jahr 1100 im Kloster Werden geschriebenen Bilderhandschrift zur *Vita Sancti Ludgeri*," *Zeitschrift für vaterländische Geschichte und Alterthumskunde* (Verein für Geschichte und Alterthumskunde Westfalens), XXXVIII, 1880, p. 155 ff. This miniature is of great

interest in that its unusual composition is obviously inspired by the well-known Consular Diptych of Probianus, probably executed in 402 A.D. (R. Delbrück, *Die Consulardiptychen und verwandte Denkmäler*, Berlin and Leipzig, 1929, no. 65, p. 250 ff.). The two plaques of this diptych still adorn the box in which the manuscript is kept, and the latter's extraordinarily tall format (24 by 9 cm.) can be accounted for only by the assumption that its dimensions were deliberately adapted to those of the diptych (30 by 12.9 cm. and 31.6 by 12.9 cm., respectively). The diptych, then, must have been in the possession of the Abbey before the *Vita* of its titular saint was written, and it is not improbable that an ivory plaque of the early eleventh century, whose place of origin is not precisely known but which also seems to reflect the scheme of the Probianus diptych (A. Goldschmidt, *Die Elfenbeinskulpturen aus der Zeit der karolingischen und sächsischen Kaiser*, II, p. 34, no. 73, pl. XXIV), was likewise produced at St. Ludger's in Werden.

2. Escorial, ms. Vitr. 17, fol. 3. Cf. A. Boeckler, *Das goldene Evangelienbuch Heinrichs III*, Berlin, 1933, pl. 7; also E. Schramm, *Die deutschen Kaiser und Könige in Bildern ihrer Zeit*, Leipzig, 1928, p. 205, fig. 100 a. To what lengths the Middle Ages went in stressing the spiritual identity of an ecclesiastical community with the Virgin Mary (and the *Sponsa* of the Song of Songs) is nicely illustrated by an instance brought to my attention by Professor Adolf Katzenellenbogen. When, in 1176, the Chapter of Chartres Cathedral wrote to its Bishop Elect, John of Salisbury, it had no hesitation in equating its church with the Virgin and the future bishop with Christ: "Acclamantibus itaque omnium votis desideratum sibi postulat, et ad dilectum et ad electum sibi incunctanter aspirat Carnotensis Ecclesia, sponsique desideria iam languescens: *Osculetur me*, inquit, *osculo oris sui*."

3. P. Vitry, *La Cathédrale de Reims*, Paris, 1919, II, pls. XIII, XIV. The derivation of the aedicula of the Reims Madonna from Chartres Cathedral was observed by H. Kunze, *Das Fassadenproblem der französischen Früh- und Hochgotik*, Strasbourg, 1912, p. 52 ff.

4. For a late thirteenth-century instance, see, e.g., the shrine of Nivelles (H. Lüer and M. Creutz, *Geschichte der Metallkunst*, Stuttgart, 1904–1909, II, fig. 204); for a late fourteenth-century one, a reliquary at Aix-la-Chapelle (Lüer and Creutz, fig. 212). Of special interest in our context are those cases, brought to my attention by Mr. John B. Hills, in which a statuette of the Virgin Mary, enframed by an aedicula, is placed in the center of a chandelier as in the chandeliers in the Marienkirche at Kolberg and the Town Hall at Goslar (Lüer and Creutz, I, figs. 271, 273).

5. It is interesting to note that the anonymous copyist who placed Jan van Eyck's "Madonna at the Fountain" in an elaborate aedicula (Metropolitan Museum, Wehle and Salinger, *op. cit.*, p. 20 ff.) not only decorated this aedicula with symbolical statuary — Moses and the victorious Church on the Virgin's right, a Prophet and the vanquished Synagogue on her left — but also provided inscriptions which can be related, with equal right, to Our Lady as well as the Church. On the canopy we read: "DOMVS DEI EST ET PORTA CELI" (from Genesis XXVIII, 17, here referring to the place where Jacob had the vision of the Ladder), and on the front of the footpace: "IPSA EST QVAM PREPARAVIT DO[MI]N[V]S (not "DOM[U]S" as in Wehle and Salinger) FILIO D[OMI]NI MEI" (from Genesis XXIV, 44, here referring to Rebekah).

6. For the identification of the columbine (*aquilegia*, hence the French *ancolie* and the German *Aglei* or *Akelei*) with grief and sorrow, see, e.g., La Curne de Sainte-Palaye, *Dictionnaire historique de l'ancien langage françois*, I, 1875, p. 434 f.; in fifteenth-century poetry (as in Alain Chartier's "Au cueur avoit très-amère ancollye") the name of the plant could actually be used as a synonym for the psychological state. The recent article by R. Fritz, "Die symbolische Bedeutung der Akelei," *Wallraf-Richartz-Jahrbuch*, XIV, 1952, p. 99 ff., suffers from the fact that the author is not acquainted with this generally accepted significance of the columbine and even believes, without any evidence, that its German name, *Aglei*, was associated with the cabalistic name of God, AGLA; it contains, however, a useful collection of instances from fourteenth- and fifteenth-century paintings and tapestries. For the recurrence of the columbine in the Ghent altarpiece, the Portinari triptych by Hugo van der Goes and the Berlin Madonna by Geertgen tot Sint Jans, see figs. 280, 447, 462; pp. 326, 333; note 220 [2].

Page 147

1. The lines on the frame, fortunately transcribed before it was abstracted, read:

"Mater hec est filia,
Pater hic est natus.
Quis audivit talia?
Deus homo natus."

For the identification of the hymn, see Meiss, "Light as Form and Symbol," p. 179 f.

2. For the unfavorable implications of the north, see J. Sauer, *Symbolik des Kirchengebäudes*, 2nd ed.,

Freiburg, 1924, pp. 88, 90–92; also *Abbot Suger on the Abbey Church of St.-Denis and its Art Treasures*, pp. 210 ff., 244. It may be added that even today suicides and criminals are buried on the north side of the church in many places, especially in England, and that evil spirits are commonly believed to use the north door. This disapprobation of the north conflicted with the universally accepted symbolism of "right" and "left" in the case of the Crucifixion. The dying Christ, as the setting "Sun of Righteousness," was naturally supposed to face the west (see e.g., Johannes Molanus' *De picturis et imaginibus sacris*, Louvain, 1570, IV, 4; col. 311 in J. P. Migne's *Theologiae cursus completus*, vol. XXVII) so that just those "on His right hand" (Matthew XXV, 33) are to the north of Him. Needless to say, in this case the symbolism of "right" and "left" had to take precedence. The Good Thief and the Church are invariably on the right of the Cross, and the Bad Thief and the Synagogue on its left, as explicitly stated by Thomas Aquinas in *De sacramento altaris*, XXXI, and St. Augustine in *In septimum caput Johannis*, XXXI (Molanus, *op. cit.*, col. 335). How seriously these questions were taken by theologians is evidenced by the fact that Petrus Damianus devotes a long discussion to explaining why St. Peter was often represented on the left of the Lord "cum juxta vulgarem sensum hoc rerum ordo deposcat, ut Petrus, qui senatus apostolici princeps est, dextrum Domini latus, Paulus vero, qui junior erat, sinistrum jure possideat" (*Patrologia latina*, CXLV, col. 589 ff., adduced in Molanus, *op. cit.*, col. 236). The situation is further complicated by the fact that most symbols, including the typological examples from the Old Testament, are ambivalent or even multivalent. The Slaying of Abel, for instance, could be interpreted in a negative as well as positive sense, as a manifestation of Original Sin as well as a prefiguration of Christ's Sacrifice. In the Ghent altarpiece, a group representing this scene could thus be coupled with the figure of Eve and appear on the left of the Lord; in the "Madonna of the Canon van der Paele," it could be coupled with the figure of Adam and appear on the right of Our Lady.

Page 148

1. Here the whole text is inscribed on the moldings of the throne of the Virgin.

2. These are — assuming that the throne of Our Lady is placed in the eastern part, or sanctuary, of the respective structures — the Dresden altarpiece and the "Paele Madonna" where the whole text is inscribed on the frames. In both cases the light comes from the left, and it has been observed that, in the right-hand wing of the Dresden altarpiece, "it falls on Saint Katherine's face, although she is standing with her back to the window" (W. H. J. Weale with the co-operation of M. W. Brockwell, *The Van Eycks and Their Art* [hereafter quoted as "Weale-Brockwell"], London, New York and Toronto, 1912, p. 224). In the Ghent altarpiece, the light comes, exceptionally, from the right so as to conform to the actual illumination of the chapel — the first southern chapel of the lower ambulatory — for which it was destined (see p. 207). Here, then, the light may be presumed to come from the south also within the pictures; but in the "Annunciation" (fig. 276) the sun, painting two pools of light upon the right-hand wall of the Virgin's chamber, shines from the left, viz., given the special circumstances, from the north. And here again I am inclined to believe that the painter — universally admitted to be Jan van Eyck — acted with a symbolic intention rather than by inadvertence.

3. See note 178³.

Page 150

1. For Guillaume Dufay and Gilles Binchois, see especially C. van den Borren, *Guillaume Dufay, son importance dans l'évolution de la musique au XVᵉ siècle*. (*Académie Royale de Belgique, Classe des Beaux-Arts, Mémoires*, II, 2, 1926), p. 315 ff. The pertinent passages from Johannes Tinctoris' *Proportionale musices* and Martin le Franc's *Champion des Dames* are here reprinted for easy reference: "Quo fit ut hac tempestate facultas nostrae musices tam mirabile susceperit incrementum quod ars nova esse videatur, cuius, ut ita dicam, novae artis fons et origo apud Anglicos, quorum caput Dunstaple exstitit, fuisse perhibetur, et huic contemporanei fuerunt in Gallia Dufay et Binchois." And:

> "Tapissier, Carmen, Cesaris
> N'a pas long temps sy bien chantèrent
> Qu'ilz esbahirent tout Paris
> Et tous ceulx qui les fréquentèrent.
> Mais onques jour ne deschantèrent
> En mélodie de tel chois —
> Ce m'ont dit ceulx qui les hantèrent —
> Que G. du Fay et Binchois.
> Car ilz ont nouvelle pratique
> De faire frisque concordance
> En haulte et en basse musique,
> En feinte, en pause et en muance;
> Et ont pris de la contenance
> Angloise et ensuy Dunstable,
> Pour quoy merveilleuse plaisance
> Rend leur chant joyeux et notable."

2. W. Apel, *The Notation of Polyphonic Music, 900–1600*, Cambridge, Mass., 1942, p. 403 ff. Cf. his *French Secular Music of the Late Fourteenth Century*, Cambridge, Mass., 1950, *passim*, especially p. 17 ff.

NOTES

Page 151

1. C. Sachs, *The Commonwealth of Art*, New York, 1946, p. 348.

2. Having little or no experience in technical matters, I must refer the reader to the copious literature upon the subject. In addition to the titles quoted in note 152[4] (see also Weale-Brockwell, pp. 300–302), the following contributions may be mentioned: E. Berger, *Quellen und Technik der Fresko-, Oel-, und Temperamalerei des Mittelalters*, 2nd ed., Munich, 1912; A. Laurie, *The Pigments and Mediums of the Old Masters*, London, 1914 (see his "The van Eyck Medium," *Burlington Magazine*, XXIII, 1913, p. 72 ff.); A. Eibner, *Entwicklung und Werkstoffe der Tafelmalerei*, Munich, 1928 (see his "Zur Frage der van Eyck-Technik," *Repertorium für Kunstwissenschaft*, XXIX, 1906, p. 425 ff.); M. Doerner, *Malmaterial und seine Verwendung im Bilde*, 8th ed., Stuttgart, 1944 (English translation, entitled *The Materials of the Artist*, New York, 1934 and 1949); G. L. Stout, "A Study of the Method in a Flemish Painting," *Harvard Technical Studies*, I, 1933, p. 181 ff.; ———, "One aspect of the So-Called Mixed Technique," *Harvard Technical Studies*, VII, 1938, p. 59 ff.; D. V. Thompson, Jr., *The Materials of Medieval Painting*, New Haven, 1936; R. G. Gettens and G. L. Stout, *Painting Materials*, New York, 1943; A. Ziloty, *La Découverte de Jean van Eyck*, Paris, 1947; J. Maroger, *The Secret Formulas and Techniques of the Old Masters*, New York, 1948; J.-G. Lemoine, "Deux Secrets orientaux transmis à l'occident; La préparation du bleu d'outremer; Le vernis des Van Eyck," *Revue Belge d'Archéologie et d'Histoire de l'Art*, XIX, 1950, p. 175 ff.; P. Coremans, "Technische Inleiding tot de Studie van de Vlaamse Primitieven," *Gentse Bijdragen tot de Kunstgeschiedenis*, XII, 1950, p. 111 ff. The important article by P. Coremans, R. J. Gettens and J. Thissen, "La Technique des 'Primitifs Flamands'; I, Introduction; II, T. Bouts, 'Le Retable du Saint Sacrement,'" *Studies in (Etudes de) Conservation*, I, 1952, p. 1 ff., became available to me only after this book had been set in type. I am delighted to see that the researches summarized therein have established the fact that, while the binding medium of the underpainting (*préparation*) was animal glue, that of the visible layers of pigments (*couches picturales*) had as a base a drying oil (*huile siccative*), supplemented by an unknown substance (*x*) in glazes; and that it definitely was "not tempera as has so often been claimed."

3. *Cennino d'Andrea Cennini da Colle di Val d'Elsa, Il Libro dell'Arte*, vol. II, *The Craftsman's Handbook*, D. V. Thompson, Jr., trans., New Haven, 1933, Ch. LXXXIX, p. 57. In his *Vite de' pittori, scul-*
tori ed architetti napoletani (Naples, 1742, III, p. 63 f.) Bernardo de' Dominici, quoting some notes by the painter Marco Stanzioni (1585–1656), alleges that the oil technique was practised at Naples as early as 1300 (witness an "Annunciation" of that time), and that two local painters were able to restore Jan van Eyck's "Adoration of the Magi" in oils when it had been shipped to Alphonso of Aragon and damaged in transit. But de' Dominici is noted for his unreliability, and that he can be trusted in this case is all the less probable as Alphonso, so far as we know, did not own an "Adoration of the Magi" by Jan van Eyck. He did own, however, an Eyckian "Annunciation" (see note 2[7]), and it would be a nice irony if this were the very picture mistakenly referred to by de' Dominici.

4. Cf. Berger, *op. cit.*, p. 223.

5. *Ibidem*, p. 44.

6. *Ibidem*, p. 223.

7. *Ibidem*, p. 56.

8. See above, p. 86.

Page 152

1. Cf. Berger, *op. cit.*, pp. 15 f., 49, 57.

2. Cf., e.g., Cennino Cennini, Thompson, trans., ch. CXLIV, p. 89. The suggestion of velvet by means of oil glazes applied to metal foil is beautifully exemplified by the hats of St. Barbara's wicked father in Master Francke's Barbara altarpiece of *ca.* 1415 (Martens, *op. cit.*, pls. X, XII, XIII, XV, XVII).

3. *Reductorii moralis Petri Berchorii Pictavensis . . . Libri quattuordecim*, Venice, 1585, XIII, 6, p. 586: "Generaliter igitur pictura & imago primo quibusdam lineis protrahitur, tandem coloribus depingitur, colores vero, ut firmius adhaereant & maneant, oleo temperantur, & sic talibus imaginibus res vere absentes & praeteritae repraesentantur, & de ipsis rem [should read *templum*, as in other recensions] sanctorum superficialiter adornatur. Sic vere vir iustus imago proprie potest dici, quia scil. primo solet per pictores, id est, per praelatos et praedicatores, bonis documentis protrahi, & sic virtutibus colorari, necnon in compositione ipsius solet oleum misericordiae apponi, ut in statu virtutum possit melius & tenacius confirmari. Prover. 21 [v. 20]: *Oleum in habitaculo iusti.*" This important passage, apparently unnoticed in the literature of art, was kindly pointed out to me by Professor William S. Heckscher.

4. This now discredited view had been defended by several Belgian scholars, notably J. van der Veken ("Experimenten met Betrekking tot de van Eyck-Techniek," *Gentsche Bijdragen tot de Kunstgeschiedenis*, V, 1938, p. 5 ff.) and L. van Puyvelde: *L'Agneau Mystique* (hereafter quoted as "van Puyvelde,

418

Agneau"), Paris and Brussels, 1946 (English translation, *The Holy Lamb*, New York, 1948), p. 78 ff.; ———, "Jan van Eyck's Last Work," *Burlington Magazine*, LVI, 1930, p. 1 ff.; ———, "Die restaurierte Madonna van der Paele des Jan van Eyck," *Pantheon*, XIII, 1934, p. 175 ff.

5. K. Lange and F. Fuhse, *Dürers schriftlicher Nachlass*, Halle, 1893, pp. 117, 11; 148, 26; 149, 2; 152, 24; 161, 15, 16, 19, 21; 167, 5. For an inventory entry mentioning a picture "sans huelle," see Weale-Brockwell, p. 199. For the twelve copies after the "*Notre-Dame de Grâces*" ordered from Hayne de Bruxelles in 1454 with the specification that they should be executed in oils, see note 297[4].

6. Lange and Fuhse, *Dürers schriftlicher Nachlass*, p. 390, note 1. For the cost of ultramarine, see *ibidem*, pp. 50, 150.

7. With regard to the three following paragraphs, I wish to acknowledge my indebtedness to oral information generously supplied by Mr. H. Lester Cooke, Jr., and, quite particularly, Professor Arthur Pope.

8. Certain pigments, e.g., azurite, will be less translucent when mixed with oil than with other media, in this case egg yolk. The distinction between "oil" and "tempera" painting is therefore not always relevant, and on no account can general conclusions as to the technique used in a certain picture, let alone by a certain master or a whole school, be drawn from a few random samples.

Page 153

1. This analysis is largely based upon A. Pope, *An Introduction to the Language of Drawing and Painting, II* (*The Painter's Modes of Expression*), Cambridge, Mass., 1931, p. 73 ff. (3rd edition, 1949, p. 80 ff.).

2. Giovanni Santi in his *Chronicle* of ca. 1485 which I quote after H. Holtzinger's edition (*Giovanni Santi, Federico da Urbino*, Stuttgart, 1893, XXII, 16, 120, p. 189). In Weale-Brockwell, p. 282, and elsewhere the triplet is reprinted in a slightly different version and with an obviously erroneous *lodato* instead of *lodati*.

Page 154

1. De Tolnay, *Le Maître de Flémalle*, p. 12; cf. his "Zur Herkunft des Stiles der van Eyck," *Münchner Jahrbuch der Bildenden Kunst*, new ser., IX, 1932, p. 320 ff. For the apparent preponderance of the Master of Flémalle's general influence over that of Jan van Eyck, see p. 303 ff.

2. By "unknown quantities" I mean the early works of Hubert and Jan van Eyck the existence of which cannot be denied even if none of them should have come down to us (see p. 232 ff.). By "known quantities transferred to the wrong side of the equation" I mean, specifically, the portraits by Jan van Eyck which, according to de Tolnay, "unquestionably" derive from those by the Master of Flémalle (*Le Maître de Flémalle*, p. 36) although they differ from them in every respect; Jan's "Albergati" which "may be traced back to an earlier portrait by Campin which has not been preserved" (de Tolnay, p. 27); the donor's portraits in the Ghent altarpiece supposedly anticipated by a portrait which passed from Colnaghi's and the Harkness Collection into the Metropolitan Museum and is, in my opinion and that of other scholars, a work of Roger van der Weyden (de Tolnay, pp. 58, no. 11, and 49, note 58, fig. 25; see above, p. 292, and our fig. 361); and, most important, the "Madonna in a Church" at Berlin the architectural conception of which, according to de Tolnay, is based upon an archetype by the Master of Flémalle. For a more circumstantial critique of this last assertion (already doubted by Meiss, "Light as Form and Symbol," p. 181, note 47), see note 194[2].

3. H. von Tschudi, "Der Meister von Flémalle," *Jahrbuch der Königlich Preussischen Kunstsammlungen*, XIX, 1898, pp. 8 ff., 89 ff. For further bibliography, see de Tolnay, *Le Maître de Flémalle*, p. 81 f., to be supplemented by the *Art Index*, the Bibliographical Appendices of the *Zeitschrift für Kunstgeschichte* (from I, 1932); the Summaries in *Oud Holland*, LV, 1938, p. 276 f.; LVI, 1939, p. 287; LVII, 1940, p. 90; LXIII, 1948, pp. 128 ff., 213 ff.; LXIV, 1949, p. 156 ff.; and H. van Hall, *Repertorium voor de Geschiedenis der Nederlandsche Schilder- en Graveerkunst*, The Hague, 1936–1949; and the Bibliography published, from 1943, by the Rijksbureau voor Kunsthistorische Documentatie ("Netherlandish Institute for Art History") at The Hague.

4. This identification was first proposed in Hulin de Loo's brilliant article "An Authentic Work by Jaques Daret, Painted in 1434," *Burlington Magazine*, XV, 1909, p. 202 ff.

5. The attribution of the *oeuvre* of the Master of Flémalle to the early phase of Roger van der Weyden, tentatively proposed by several earlier writers (cf. de Tolnay, *Le Maître de Flémalle*, p. 41), was systematically developed by E. Renders, especially in his two-volume publication *La Solution du problème van der Weyden-Flémalle-Campin* (hereafter quoted as "Renders"), Bruges, 1931. It was accepted by J. Lavalleye, "Le Problème Maître de Flémalle – Rogier van der Weyden," *Revue Belge de Philologie et d'Histoire*, XII, 1933, p. 791 ff., and in: S. Leurs, ed., *Geschiedenis van de Vlaamsche Kunst*, Antwerp and The Hague, n.d. [1936–1939], I, p. 186 ff.; by M. J. Fried-

länder, *Die altniederländische Malerei* (hereafter quoted as "Friedländer"), Berlin (vols. X–XIV, Leiden), 1924–1937, XIV, p. 81 ff. (also, though with greater reservation, in his *Essays über die Landschafts-malerei und andere Bildgattungen*, The Hague, 1947, p. 32 ff.); and, on the more than questionable assumption that the repetition of motifs ("Wiederkehr des Gleichen") implies the identity of authors, by T. Musper, *Untersuchungen zu Rogier van der Weyden und Jan van Eyck*, Stuttgart, 1948 (hereafter quoted as "Musper"), p. 13 ff. For the opposite view, see especially Rolland, "La Double Ecole de Tournai," p. 296 ff.; A. Burroughs, "Campin and van der Weyden Again," *Metropolitan Museum Studies*, IV, 1933, p. 131 ff. (disproving the identity of Roger and the Master of Flémalle on the basis of X-ray analysis); ——, *Art Criticism from a Laboratory*, Boston, 1938, p. 204 ff. ("The Reality of Robert Campin"); L. Scheewe, "Die neueste Literatur über Roger van der Weyden," *Zeitschrift für Kunst-geschichte*, III, 1934, p. 208 ff.; M. Davies, "National Gallery Notes, III; Netherlandish Primitives: "Rogier van der Weyden and Robert Campin," *Burlington Magazine*, LXXI, 1937, p. 140 ff. (see also his *National Gallery Catalogues, Early Flemish School*, pp. 15 ff., 110 ff.); Hulin de Loo, in: *Biographie Nationale de Belgique*, Brussels, XXVII, 1938, col. 222 ff.; W. Schöne, *Dieric Bouts und seine Schule*, Berlin, 1938, p. 58 ff.; ——, *Die grossen Meister der niederländischen Malerei des 15. Jahrhunderts* (hereafter quoted as "Schöne"), Leipzig, 1939, p. 25 f.; de Tolnay, "Zur Herkunft des Stiles der van Eyck," p. 335 ff.; ——, *Le Maître de Flémalle*, particularly p. 41 ff.; W. Vogelsang, "Rogier van der Weyden," in: *Niederländische Malerei im XV. und XVI. Jahrhundert*, Amsterdam and Leipzig, 1941, p. 65 ff., especially p. 73 ff.; F. Winkler in: Thieme-Becker, XXXV, 1942, p. 468 ff., and *ibidem*, XXXVII, 1950, p. 98 ff.; L. van Puyvelde, *The Flemish Primitives* (hereafter quoted as "van Puyvelde, *Primitives*"), Brussels, 1948, p. 25 f.; Paul Rolland, "Les Impératifs historiques de la biographie de Roger," *Revue Belge d'Archéologie et de l'Histoire de l'Art*, XVIII, 1949, p. 145 ff.; and, most recently, H. Beenken, *Rogier van der Weyden*, Munich, 1951. This very interesting book (hereafter quoted as "Beenken, *Rogier*") appeared too late for critical consideration; I must limit myself to brief references in the notes.

Page 155

1. Not of her mother, Margaret of Burgundy, as stated in de Tolnay, *Le Maître de Flémalle*, p. 13. The point is not without importance because the very fact that Robert Campin was in the good graces of the not overly virtuous Jacqueline has been adduced, together with his own *vie d'ordure*, as an argument against his identification with the Master of Flémalle (Renders, I, p. 103). Needless to say, neither Campin's nor Jacqueline's morals disprove his talent; and certain it is that the intervention of the reigning princess in Campin's behalf bears witness to his reputation as an artist.

2. These well-known documents are reprinted in Renders, I, p. 136; for facsimiles of those referring to Roger, see *ibidem*, p. 56 f.

3. This is explicitly stated in the guild records of 1427 as well as 1432: "Rogelet de le Pasture, natif de Tournay" and "Maistre Rogier de le Pasture, natif de Tournay."

4. Cf. Renders, I, p. 116; Hulin de Loo, *Biographie Nationale*, XXVII, col. 228.

5. Cf. Hulin de Loo, *ibidem*, col. 226.

6. Renders, I, pp. 64, 171. Musper, p. 37, places so much confidence in this entirely conjectural identification (cf. the following note) that he declares the Rogelet de le Pasture of 1427 as *nachweisbar* ("demonstrably present") at Tournai in 1436–1437.

7. According to Renders, I, pp. 64, 121 f., 133 ff., the "Maistre Rogier le paintre" of 1436–1437 must be identical with the Rogelet de la Pasture of 1427, and cannot be identical with Rogier de Wanebac, because the latter, though admitted to the guild as "*franc maistre*" on May 15, 1427 (Renders, I, p. 134, under the heading of the "francs maistres paintres et voiriers lesquelz ont esté receus en ceste dicte ville de Tournay") did not bear, in addition, the "honorary" title of "Maistre" as did only Campin, Rogelet de le Pasture, Daret, and three others. There is, however, no reason why a painter, once having attained the status of *free* master, should not be occasionally referred to as "maistre" in later life, no matter whether he possessed the "titre honorifique" of "Maistre" in addition to the "simple titre patronal" of "*franc* maistre." In fact two other painters demonstrably not possessed of the "titre honorifique" are occasionally mentioned as "maistre" in the documents published by Renders himself: Nicaise Barat is called "maistre" in the guild roll on February 4, 1429 (Renders, I, p. 137) but never afterwards; and Phelippe Voisin is invariably called "maistre" in records of payment from 1479 to 1481 but neither from 1474 to 1478 nor from 1484 to 1504 (Renders, I, pp. 164–167). Renders, p. 119 ff., dismisses these two cases as "clerical errors," that of Barat because the master's title occurs in the guild roll but only once; that of Voisin because it occurs quite frequently but only in records of payment instead of the guild roll. However, granting that clerical errors occur (though hardly five times in succession

as in the Voisin case): the "Maistre Rogier le paintre" of 1436–1437, too, bears his allegedly "honorary" title only in records of payment, and nothing militates against the assumption that it was bestowed upon him in the same casual way as in the case of Phelippe Voisin. It is, therefore, by no means "impossible" to identify him with the Rogier de Wanebac admitted as "franc maistre" on May 15, 1427.

8. See p. 83.

9. See p. 86.

10. See pp. 178, 248.

Page 156

1. Renders, I, p. 123; Hulin de Loo, *Biographie Nationale*, XXVII, col. 223.

2. Since Roger's son Corneille was eight years old on October 20, 1435 (Hulin de Loo, *Biographie Nationale*, col. 224), the painter must have married in 1426 at the latest. His birth date — 1399 or 1400 — can be inferred from the fact that he gives his age as thirty-five on October 20, 1435, and as forty-three some time in 1442 (Hulin de Loo, *ibidem*).

3. M. Houtart, "Jacques Daret, peintre tournaisien du XVe siècle," *Revue Tournaisienne*, III, 1907, p. 34 f. In Renders, I, p. 66, the date of Daret's entrance in Campin's workshop (1418) is misprinted into 1415.

4. Renders, I, p. 123. See also below, note 165 [1].

Page 157

1. This is the opinion of Rolland, "La Double Ecole de Tournai," p. 299, and Hulin de Loo, *Biographie Nationale*, XXVII, col. 224.

2. It is true that Martin Schongauer and a painter named Nikolaus Eisenberg were enrolled at the University of Leipzig in 1465. But since Schongauer was about thirty-five years old at that time, and Eisenberg even older (about forty-five), it has justly been assumed that these two painters were enrolled, not in order to study but to do some work for the University without being members of the local guild; cf. Thieme-Becker, X, 1914, p. 430, and XXX, 1936, p. 250.

3. See Thieme-Becker, XXXV, 1942, p. 468.

Page 158

1. Hulin de Loo, "An Authentic Work by Jaques Daret," *passim*.

2. Davies, "National Gallery Notes, III," p. 143.

3. Friedländer, II, p. 118, no. 78, pl. LXV; de Tolnay, *Le Maître de Flémalle*, fig. 163; van Puyvelde, *Primitives*, pl. 31. For Roger van der Weyden's "Visitation," see p. 252.

4. Friedländer, II, p. 118, no. 80, pl. LXVII; de Tolnay, *Le Maître de Flémalle*, fig. 166.

5. Friedländer, II, p. 118, no. 81; de Tolnay, *Le*

Maître de Flémalle, fig. 165. For the Berlin "Adoration of the Magi" after the Master of Flémalle, see Friedländer, II, p. 117, no. 76, pl. LXIV; de Tolnay, *Le Maître de Flémalle*, p. 59, no. 3; Musper, fig. 13; O. Kerber, "Frühe Werke des Meisters von Flémalle im Berliner Museum," *Jahrbuch der Preussischen Kunstsammlungen*, LIX, 1938, p. 59 ff.

6. Friedländer, II, p. 118, no. 79, pl. LXVI and XIV, p. 87 f.; de Tolnay, *Le Maître de Flémalle*, fig. 164; van Puyvelde, *Primitives*, pl. 32 (erroneously captioned as "Adoration of the Kings" and therefore, p. 26, listed as a picture distinct from the four that constituted the Arras altarpiece). Daret's "Nativity" never belonged to the Metropolitan Museum, as often stated, but passed from the Morgan Collection into the Thyssen Collection at Lugano.

7. Friedländer, II, p. 108, no. 53; Renders, II, pls. 1–4, 12, 21, 40; de Tolnay, *Le Maître de Flémalle*, p. 55, no. 1, figs. 1–3; Schöne, p. 53; van Puyvelde, *Primitives*, pl. 24; Beenken, *Rogier*, figs. 3, 4. For the iconography of the picture, see de Tolnay, p. 14 f.; cf. also above, p. 126 f. A specific connection between the Nativity and the concept of *Sol iustitiae* is stressed in a beautiful sequence ascribed to Herimannus Contractus:

> "ipsum solem iustitiae
> indutum carne
> ducis in orbem."

(Auerbach, *op. cit.*, p. 14). According to G. van Camp, "Le Paysage de la Nativité du Maître de Flémalle à Dijon," *Revue Belge d'Archéologie et d'Histoire de l'Art*, XX, 1951, p. 295 ff., the landscape is based on reminiscences of the city of Huy.

Page 159

1. For the influence of this miniature upon the Dijon "Nativity," see de Tolnay, *Le Maître de Flémalle*, p. 13, fig. 153; for the inclusion of the shepherds, see above, p. 63; for the influence of the Limbourg brothers in general, Winkler, *Der Meister von Flémalle und Rogier van der Weyden* (hereafter quoted as Winkler), p. 141 ff.

2. De Tolnay, *Le Maître de Flémalle*, p. 13, figs. 157, 158; ——— "Zur Herkunft des Stiles der van Eyck," *passim*.

3. Winkler, p. 141 ff.

4. Rolland, *La Peinture murale à Tournai*, p. 42 ff., pls. XXXV–XXXVIII.

Page 160

1. The "Seilern Triptych" was published, as a work of Adriaen Isenbrant (!), in *The Illustrated London News*, CCI, 1942, August 22, p. 222. The obvious

attribution to the Master of Flémalle was first made public by K. Bauch, "Ein Werk Robert Campins?," *Pantheon*, XXXII, 1944, p. 30 ff., and justly endorsed by Beenken, *Rogier*, p. 20 f., fig. 1. Following Winkler, Bauch emphasizes the painting's connection with the tradition of Malouel and Bellechose; and, following de Tolnay, with the "Brussels Hours" which he, however, describes and captions as the "Très Belles Heures de Jeanne de France" or "Stundenbuch der Königin Johanna von Frankreich" (presumably because the Duc de Berry is designated as "Jean de France" in Fierens-Gevaert's publication).

2. Friedländer, II, p. 108, no. 50, pl. XLII; Musper, fig. 1; Kerber, "Frühe Werke des Meisters von Flémalle."

3. See p. 158.

4. See also p. 136. For the picture itself, see Friedländer, II, p. 108, no. 51, pl. XLIV; Renders, II, pls. 2, 3, 58; de Tolnay, *Le Maître de Flémalle*, p. 55, no. 2, figs. 4, 5; Musper, figs. 23–25.

Page 161

1. De Tolnay, *Le Maître de Flémalle*, p. 17.

2. See also p. 106 ff.; our figs. 135–141.

3. Fierens-Gevaert, *Histoire de la peinture flamande*, II, pl. IX (cf., however, Friedländer, II, p. 118, no. 82). Maeterlinck, *op. cit.*, ascribes this picture to the school of Nabur Martins.

4. The monstrance is the attribute of two saints, St. Clare of Assisi and St. Juliana of Liége, the proponent of the Feast of Corpus Christi. The latter, however, must be excluded because she was an Augustinian nun; she would, therefore, wear a leathern belt, and not a cord as does the figure in the Prado panel. Musper's designation of the figure as "Santa Fè" (p. 58, fig. 25) is without foundation in hagiology.

5. Lange and Fuhse, *op. cit.*, p. 48, 5.

6. De Tolnay, *Le Maître de Flémalle*, p. 26.

7. Frequently illustrated, e.g., Glaser, *op. cit.*, pp. 95, 135, figs. 66, 90; Winkler, *Altdeutsche Tafelmalerei*, pp. 72, 73.

8. See p. 78.

Page 162

1. Cf. G. Ring, "Beiträge zur Plastik von Tournai," p. 287 f.; P. Rolland, "Une Sculpture encore existante polychromée par Robert Campin," *Revue Belge d'Archéologie et de l'Histoire de l'Art*, II, 1932, p. 335 ff.; M. Weinberger, "A Bronze Bust by Hans Multscher," *Art Bulletin*, XXII, 1940, p. 185 ff., especially p. 188. For the connection between the "Annunciation" in Ste.-Marie Madeleine and Roger van der Weyden's "Annunciations" — a connection already observed by Miss Ring and, incidentally, further corroborating his

identity with Rogelet de le Pasture, the pupil of Robert Campin — cf. p. 254

2. The interrelation between "Sluterian" sculpture and Early Flemish painting was first stressed by R. Josephson, "Die Froschperspektive des Genter Altars," *Monatshefte für Kunstwissenschaft*, VIII, 1915, p. 198 ff.

Page 163

1. Friedländer, II, p. 110, no. 58, pl. L; Renders, II, pls. 9, 14; de Tolnay, *Le Maître de Flémalle*, p. 56, no. 5, figs. 9, 10; Schöne, pp. 54, 56; Musper, fig. 14.

2. Cf. p. 129. A tiny piece of the footrest is visible beneath the left-hand principal of the Virgin's bench, and its edge is marked by a short, horizontal break in her drapery. Davies (*National Gallery Catalogues, Early Netherlandish School*, p. 17) is thus technically correct in stating that Our Lady "does not appear to be sitting on the *ground*"; but this does not disprove the fact that she is a Madonna of Humility as maintained by Meiss ("The Madonna of Humility," p. 450 f., fig. 22; ———, *Painting in Florence and Siena*, pp. 143, 156, fig. 144).

3. Cf. de Tolnay, *Le Maître de Flémalle*, p. 16; Davies, *National Gallery Catalogues, Early Netherlandish School*, p. 17.

4. Cf. the Madonna in S. Zeno (F. Knapp, *Andrea Mantegna* [Klassiker der Kunst, XVI], Stuttgart and Leipzig, 1910, p. 79) and the "Madonna della Vittoria" in the Louvre (*ibidem*, p. 108).

Page 164

1. The genuine portion of the "Salting Madonna," with a strip of 3¾ inches along the right-hand side and a strip of 1¼ inches along the top removed, is illustrated in Davies, "National Gallery Notes, III," pl. facing p. 143. The copy of the whole picture, then owned by Mme. Reboux at Roubaix, was published by J. Destrée, "Altered in the Nineteenth Century? A Problem in the National Gallery, London," *Connoisseur*, LXXIV, 1926, p. 209 ff.

2. The Roubaix copy omits, for example, the tiles of the pavement, the stool, and the studs on the window shutters. The border of the Virgin's robe and the appearance of her prayer book are ruthlessly simplified, and the city prospect visible through the window is replaced by stained glass.

3. Friedländer, II, p. 109, no. 54, pls. XLVI, XLVII; Renders, II, pl. 5; de Tolnay, *Le Maître de Flémalle*, p. 56, no. 4, figs. 6–8; Schöne, p. 52; Musper, figs. 31–33; van Puyvelde, *Primitives*, pl. 27; Beenken, *Rogier*, p. 22 ff., fig. 5. For the furniture, especially the laver, see G. Schönberger, "The Medieval Laver of

the Wetzlar Synagogue," *Historia Judaica*, IX, 1947, p. 95 ff., and J. J. Rorimer, "A Treasury at the Cloisters," *The Metropolitan Museum of Art, Bulletin*, new ser., VI, 1947–48, p. 237 ff., especially p. 254 ff. Renders' contention that the fairly literal copy of the central panel in the Brussels Museum is based upon a different, allegedly Brabantine model (Renders, II, p. 34) is without foundation. For the iconography of the central panel, see de Tolnay, p. 15 f., and above, p. 143; for that of the St. Joseph's wing, M. Schapiro, "'Muscipula Diaboli,' The Symbolism of the Mérode Altarpiece," *Art Bulletin*, XXVII, 1945, p. 182 ff. Professor Held entertains the interesting hypothesis that the bearded man conspicuously yet modestly appearing behind the donors may be a self-portrait of the Master of Flémalle.

Page 165

1. Cf. de Tolnay, *Le Maître de Flémalle*, pp. 27 and 49, note 59; also above, p. 156. The record referring to Jan's second stay at Tournai, apparently again connected with a present of wine, was discovered by M. Houtart, *Quel est l'état de nos connaissances relativement à Campin, Jacques Daret et Roger van der Weyden?* (Communication faite au XXIIIe Congrès de la Fédération Archéologique et Historique), Ghent, 1914, p. 6. Houtart, unfortunately, does not give any details except that the record is found, like that of October 18, 1427, in the municipal records and — therefore — unceremoniously refers to Jan van Eyck as "Johannes pointre."

2. For this distinction, see the important article by O. Pächt, "Gestaltungsprinzipien der westlichen Malerei des 15. Jahrhunderts," *Kunstwissenschaftliche Forschungen*, II, 1933, p. 75 ff.

Page 166

1. For the problem of "oblique" or "two point" *vs.* "normal" or "one point" perspective, see Panofsky, "Once More 'The Friedsam Annunciation,'" p. 419 ff., especially p. 421 ff.; further, O. Pächt, "Jean Fouquet: A Study of His Style," *Journal of the Warburg and Courtauld Institutes*, IV, 1940–41, p. 85 ff.; and, most recently, J. White, *op. cit.*, especially *Journal of the Warburg and Courtauld Institutes*, XII, 1949, p. 65.

2. De Tolnay, *Le Maître de Flémalle*, p. 31, confuses obliquity with eccentricity when he says that, after the "Madonna in a Church" and the Washington "Annunciation," the perspective of Jan van Eyck's interiors, "qui était jusqu'ici oblique, devient maintenant frontale." The interiors of the "Madonna in a Church" and the Washington "Annunciation" (cf. p. 193 f.) are just as frontal as in all the later pictures by Jan van Eyck; they differ from these only in that the point of vision is shifted far to the right.

3. See p. 278.

Page 167

1. Friedländer, II, p. 110, no. 59, pl. LI; Renders, II, pls. 37–39, 42, 43, 45, 52; de Tolnay, *Le Maître de Flémalle*, p. 56, no. 3, figs. 11, 12; Schöne, p. 55; Musper, figs. 7, 8; van Puyvelde, *Primitives*, pl. 26; Beenken, *Rogier*, fig. 7. From the fact that the Liverpool copy (which also transmits the grisailles on the exterior, showing St. John the Baptist and St. Julian) bears the coat-of-arms of Bruges and that a later variation was also produced in this city, it has been inferred that the original was at Bruges during the fifteenth and early sixteenth centuries. A literal copy of the central panel is in the "*Très-Belles Heures de Notre Dame*" (Durrieu, *Heures de Turin*, pl. XXI); for another, found in the "Arenberg Hours," see p. 176 f. A free variation of ca. 1515–1520, testifying to the archaistic movement that may be considered as a prelude to the Renaissance in the Southern Netherlands (see p. 350 ff.) and brought to my attention by Professor Jakob Rosenberg, is in the Sjöstrand Collection at Stockholm. For a drawing of the Good Thief recently acquired by the Fogg Museum, see J. Rosenberg, "A Silverpoint Drawing by the Master of Flémalle acquired by the Fogg Art Museum," *Art Quarterly*, XIII, 1950, p. 251. In my opinion the differences between this drawing and the Liverpool copy are not sufficient to prove that it is an original study for the picture rather than a very good copy, especially since its fine quality is marred by certain weaknesses. The rough-hewn stem of the cross overlapping the left leg, for example, is not shaded whereas the foot and calf are almost overmodeled. As a result the calf seems to be in a plane before rather than behind the stem of the cross, and the three visible parts of the leg — foot, calf and knee — are difficult to connect into an organic unit. This would not seem to agree with the character of an original study in which the concept of the whole would precede that of the parts.

2. Perhaps the most significant example of the use of gold ground as an "iconographic" device is Enguerrand Quarton's famous "Coronation of the Virgin" in Villeneuve-lès-Avignon (C. Sterling, *Le Couronnement de la Vierge par Enguerrand Quarton*, Paris, 1939). Here the main scene is set out against a panorama, inspired by St. Augustine's *City of God*, which, according to the very circumstantial contract of 1453, comprises four zones: Hell and Purgatory, the earth, the sky (*chiel*), and Paradise. The "sky" is indicated by a light blue expanse overhung with dark blue clouds;

the "Paradise," surmounting this naturalistic sky, is indicated by gold.

Page 168

1. In fact, Musper, p. 26, emphatically declares the Frankfort Thief to be the Good Thief, and I should be most ready to agree were it not for the fact that the "Bad Thief" cannot possibly appear on the right of Christ and in conjunction with the donor. The tortured pose of the Good Thief, his head upraised and his eye lifted to Heaven (cf. Luke XXII, 43), may be explained as an exaggeration of the attitude exemplified, e.g., by the Crucifixion miniature in the "Boucicaut Hours," fol. 105 v. (Martens, op. cit., fig. 38).

2. Winkler, p. 141 ff.

3. See note 167 [1].

4. Vogelsang, "Rogier van der Weyden," p. 75.

Page 169

1. Friedländer, II, p. 111, no. 60, pls. LII–LIV; Renders, II, pls. 3, 12–14, 44, 50, 53; de Tolnay, Le Maître de Flémalle, p. 57, no. 10, figs. 13–15; Schöne, p. 60; Musper, figs. 9–12; van Puyvelde, Primitives, pl. 25; Beenken, Rogier, fig. 6 (detail of the Madonna). Though Flémalle, situated between Liége and Huy, did not possess an abbey as stated in the earlier literature, it did possess a priory of the Order of the Knight Templars which, after the dissolution of this Order in 1314, was turned over to the Order of St. John (van Camp, op. cit). It should be noted, however, that the provenance of the three Frankfort panels from Flémalle is not supported by documentary evidence.

2. See p. 266.

3. Friedländer, II, p. 112, no. 66, pl. LX; Renders, II, pls. 8, 10–13, 15, 28; de Tolnay, Le Maître de Flémalle, p. 57, no. 8, fig. 18. Although the proportions of the panel are evidently ca. 5:3 rather than ca. 5:2, its dimensions are invariably given as 48 cm. by 21 cm., even in the catalogues of the Museum itself. I am much indebted to M. Louis Malbos, Director of the Musée Granet, for kindly informing me that its real dimensions are 48 cm. by 31.6 cm.

Page 170

1. For the development of portraiture in Early Flemish painting, see G. Ring, Beiträge zur Geschichte niederländischer Bildnismalerei im 15. und 16. Jahrhundert, Leipzig, 1913; cf. also H. Keller, "Die Entstehung des Bildnisses am Ende des Hochmittelalters," Römisches Jahrbuch für Kunstgeschichte, III, 1939, p. 227 ff.; J. Lavalleye, Le Portrait au XVme siècle, Brussels, 1945; A. H. Cornette, De Portretten van Jan van Eyck, Antwerp and Utrecht, 1947.

2. F. Dworschak et al., Führer durch das Erz-

bischöfliche Dom- und Diözesanmuseum in Wien, Vienna, 1939, fig. 1; Stange, op. cit., II, fig. 28.

Page 171

1. Cf. J. H. Lipman, "The Florentine Profile Portrait in the Quattrocento," Art Bulletin, XVIII, 1936, p. 54 ff.

2. Paris, Bibliothèque Nationale, ms. fr. 12420, fol. 101 v.; Martin, La Miniature française, pl. 86, fig. CXIII. This miniature is of particular interest in that it shows that the idea of a self-portrait painted — not merely drawn — with the aid of a mirror was not unheard-of at the very beginning of the fifteenth century.

3. Sterling, Les Primitifs, fig. 39; ———, Les Peintres, pl. 18; Lemoisne, op. cit., pl. 42; Evans, Art in Mediaeval France, fig. 180; Ring, A Century, Cat. no. 63, pl. 26. A copy after this portrait was painted into the Horae, Paris, ms. lat. 1156 A, fol. 61 (illustrated, e.g., in Martin, Les Joyaux, fig. LXXXIX) when this manuscript was reworked some time after 1434 (cf. Heimann, op. cit., p. 13 f.).

4. See p. 82. An interesting problem is posed by two profile portraits of Wenceslas of Brabant (1337–1383), transmitted only through copies; cf. F. Lyna, "Uit en over Handschriften, II, Portretten van Wenceslaus van Brabant," Kunst der Nederlanden, I, 1930–31, p. 321 ff. One of them shows the prince as a very young man, and its original can thus be dated in 1354–1355; the other, at the age of about forty, which would date the original close to the year of his death. In both cases, however, the costume conforms to the fashion of ca. 1400–1410 rather than to that of the fourteenth century, and the later of the two portraits not only includes the right hand (which in itself would be unusual in a portrait of ca. 1380) but also shows this hand holding a pink, a motif which, according to Lyna himself, can not be shown to occur until the fifteenth century. We must, therefore, consider the possibility that the copies which have come down to us were made, not from the actual originals but from modernized replicas of ca. 1400–1410 — replicas which may have been made for one of those portrait collections which, as we happen to know, were formed by princes of this time (cf. note 291 [4]).

5. See Panofsky, Albrecht Dürer, I, p. 236 f.

6. See note 82 [3].

7. Renders, II, p. 86, pl. 56; Cornette, op. cit., fig. 2; P. Wescher, "Das höfische Bildnis von Philipp dem Guten bis zu Karl V, I," Pantheon, XXVIII, 1941, p. 195 ff.; ———, "Fashion and Elegance at the Court of Burgundy," CIBA Review, LI, July 1946, p. 1841 ff. (see also p. 291). H. Beenken, "Bildnisschöpfungen Hubert van Eycks," Pantheon, XIX, 1937, p. 116 ff.,

and *Hubert und Jan van Eyck* (hereafter quoted as "*Hubert und Jan*"), Munich, 1941, p. 16, fig. 23, has ascribed the Antwerp portrait of John the Fearless to Hubert van Eyck. So far as I know this attribution has not been accepted by any other scholar (see below, note 232 ²).

8. Indubitably original are the portraits of a Gentleman and His Wife in the National Gallery at London: Friedländer, II, p. 109, no. 55; Renders, II, pl. 51; de Tolnay, *Le Maître de Flémalle*, p. 58, no. 13, figs. 26, 27; Schöne, pp. 58, 59; Musper, figs. 35, 36; van Puyvelde, *Primitives*, pls. 28, 29; Davies, *National Gallery Catalogues, Early Netherlandish School*, p. 18 f. (our figs. 217, 218). The Portrait of a Musician, formerly in the Chillingworth Collection and now owned by Mrs. Magnin at New York (Friedländer, II, p. 111, no. 63, pl. LVI, and XIV, p. 87 f.; Musper, p. 23; J.-A. Goris, *Portraits by Flemish Masters in American Collections*, New York, 1949, fig. 5; our fig. 219) also gives the impression of authenticity. For the contested portraits and copies, see notes 175 ⁸⁻¹¹.

9. See p. 92.

Page 172

1. Friedländer, II, p. 112, no. 65; de Tolnay, *Le Maître de Flémalle*, p. 57, no. 7, fig. 17. See also the following note.

2. Friedländer, II, p. 111, no. 64, pl. LVII; Renders, II, pls. 16, 28; de Tolnay, *Le Maître de Flémalle*, p. 57, no. 6, fig. 16; Musper, fig. 29. While Friedländer gives identical measurements for the two Leningrad pictures (36 cm. by 25 cm.), the Catalogues of the Hermitage state the dimensions of the "Trinity" as 36 cm. by 25 cm. and those of the Madonna as 34 cm. (misprinted into "44 cm." in de Tolnay) by 24 cm. The panels may therefore have been independent compositions rather than parts of a diptych or polyptych. At some later date, however, they were enlarged by strips adorned with an identical pattern of fairly rustic (Russian?) workmanship which have been included in our figs. 210 and 211. For reminiscences of the Virgin's peculiar gesture, cf., for instance, such disparate examples as Patinir's "Rest on the Flight into Egypt" at Berlin (illustrated, e.g., in Winkler, *Die altniederländische Malerei*, p. 215, fig. 131); a "Holy Family" by Garofalo adduced in Friedländer, II, p. 137, no. 123, as possibly reflecting a composition by Roger van der Weyden; and the "Birth of Jupiter" (revealing the additional influence of the "Birth of St. John" in the "Turin-Milan Hours") in a *Recueil des histoires de Troie* illuminated by Pierre Gousset in 1495 (Paris, Bibliothèque Nationale, ms. fr. 22552, fol. 10).

Page 173

1. This idea may have been developed from the familiar motif of testing the temperature of the bath water (see note 127 ⁵), which had occasionally been transferred to the Virgin Mary herself as in the Books of Hours, Paris, Bibliothèque Nationale, ms. lat. 10538, fol. 63, and Walters Art Gallery, ms. 260, fol. 63 v. (our figs. 72 and 73).

2. Friedländer, II, p. 112, no. 67, pls. LXVIII, LXIX; Renders, II, pls. 17–23, 26–28, 45, 55, 56; de Tolnay, *Le Maître de Flémalle*, p. 59, no. 16, figs. 22, 23; Schöne, p. 61; Musper, figs. 42, 43; Beenken, *Rogier*, figs. 8, 9.

3. Friedländer, II, p. 114, no. 72; Renders, II, pl. 19 (middle section inserted between the two wings of the "Werl altarpiece"); de Tolnay, *Le Maître de Flémalle*, p. 60, no. 7, fig. 28; Musper, fig. 22.

4. See p. 255 f.

5. Gerda Boethius, *Bröderna van Eyck*, Stockholm, 1946, fig. 47.

6. See above, p. 144.

Page 174

1. See p. 3; see also the "Bathing Scene" referred to below, note 203 ⁵.

2. See p. 262 ff.

3. Friedländer, II, p. 109, no. 56, pl. XLVIII; Renders, II, pl. 48; de Tolnay, *Le Maître de Flémalle*, p. 58, no. 12, fig. 20. An intercessional diptych of the same type is presented to Pope Clement VI by Eudes IV, Duke of Burgundy, in a commemorative picture of *ca.* 1350 (Michel, *Histoire de l'art*, III, 1, p. 109, fig. 59). Since this painting is transmitted only through a miniature of the seventeenth century, it is difficult to decide whether the diptych was of Avignonese workmanship as conjectured by L. Dimier, *Les Primitifs français*, Paris, n.d., p. 28, or rather a product of the Franco-Flemish school as suggested by Sterling, *Les Primitifs*, p. 26 ff., fig. 12. For Roger van der Weyden's transformations of the Flémallesque diptych scheme, see p. 294; note 294 ¹⁵.

4. Apart from the Berlin "Calvary" (fig. 398) which will be discussed later (p. 298 f.) and the Portrait of a Gentleman mentioned in note 154 ², I am unable to accept the little "St. George on Horseback" (fig. 273) owned by the heirs of Lady Evelyn Mason of London (Friedländer, XIV, Nachtrag, p. 88, pl. VI; Renders, II, pls. 6–8; de Tolnay, *Le Maître de Flémalle*, p. 57, no. 9, fig. 19; Musper, fig. 27; Beenken, *Rogier*, pp. 29 f., 33 f., fig. 12). The very disproportion of the horse, as compared to the diminutive but perfectly proportioned animals in the Dijon "Nativity," the "Salting Madonna" and the "St. Barbara" (cf. Renders, II, pls. 4, 9, 26), makes the now fashionable attri-

bution of the picture to the Master of Flémalle — or, for that matter, to Roger van der Weyden, as assumed by Friedländer, Beenken, and Hulin de Loo, *Biographie Nationale*, XXVII, col. 233 — as hard to swallow as its former ascription to one of the van Eycks (Weale-Brockwell, p. 161). M. Devigne, "Notes sur l'exposition d'art flamande et belge à Londres," I, *Oud Holland*, XLIV, 1927, p. 65 ff., quite rightly felt that the picture belongs to the "entourage" of the Master of Flémalle rather than to the Master himself. An impressive Madonna with St. John the Baptist, St. Anthony, St. Catherine and St. Barbara, recently acquired by the Kress Foundation, is fairly close to the Master of Flémalle but evidently not executed by himself; it is justly ascribed to his studio in: *Paintings and Sculpture from the Kress Collection, Acquired by the Samuel M. Kress Foundation, 1945-1951*, Washington, 1951, no. 74. The "Dream of Pope Sergius and Consecration of St. Hubert," formerly in the Mortimer L. Schiff (not Friedsam) Collection at New York and now in the von Pannwitz Collection at Haartekamp near Haarlem, is by a follower of Roger van der Weyden; cf. note 298 [1].

Page 175

1. De Tolnay, *Le Maître de Flémalle*, p. 59, no. 17, fig. 24; *The Worcester-Philadelphia Exhibition of Flemish Painting*, no. 5. I have been informed that Dr. de Tolnay himself no longer considers the picture as an original. The curious idea of placing the moon on the grass is anticipated, for example, in a Dutch Horae variously dated about 1425 and about 1435: The Hague, Royal Library, ms. 131.G.3, fol. 14 (Byvanck and Hoogewerff, *La Miniature hollandaise*, pl. 6; cf. Byvanck, *Min. Sept.*, p. 139).

2. Friedländer, II, p. 115, no. 74 C (with illustration of an equally good replica, then in trade, on pl. LXIII); de Tolnay, *Le Maître de Flémalle*, p. 59, no. 1. The New York copy is illustrated in Winkler, pl. III, and Wehle and Salinger, *op. cit.*, p. 27 f. (with further references); it should be noted, however, that the Lyons Madonna here referred to in this connection as a work of Quentin Massys is only a good copy after an original now in the Collection of Count Seilern at London; see L. (von) Baldass, "Gotik und Renaissance im Werke des Quinten Metsys," *Jahrbuch der Kunsthistorischen Sammlungen in Wien*, new ser., VII, 1933, p. 137 ff., pl. XI. For other copies of and variations on the "Madonna in an Apse," see p. 352 f.

3. Friedländer, II, p. 113, no. 71, pl. LXI; de Tolnay, *Le Maître de Flémalle*, p. 60, no. 6; Musper, fig. 15.

4. Friedländer, II, p. 114, no. 73 a, pl. LXII; de Tolnay, *Le Maître de Flémalle*, p. 60, no. 5; Musper,

fig. 19. This picture, formerly in the Weber Collection at Hamburg, passed through the Kling Collection at Stockholm (Friedländer, XIV, p. 87 f.) into the Dr. E. Schwarz Collection at New York. After a recent cleaning, W. R. Valentiner, "Rogier van der Weyden; the 'Mass of Saint Gregory,'" *Art Quarterly*, VIII, 1945, p. 240 ff., declared it to be an original and, since he accepts the Master of Flémalle's identity with Roger van der Weyden, ascribed it to the latter, dating it about 1430.

5. Friedländer, II, p. 116, no. 75; de Tolnay, *Le Maître de Flémalle*, p. 60, no. 8; Musper, fig. 2.

6. De Tolnay, *Le Maître de Flémalle*, p. 60, no. 9; Musper, fig. 4.

7. J. Maquet-Tombu, *Colyn de Coter, peintre bruxellois*, Brussels, 1937, p. 18 ff., pl. I; cf. D. Klein, *St. Lukas als Maler der Maria*, Berlin, 1933, p. 40 ff.

8. Friedländer, II, p. 111, no. 61, pl. LV; Renders, II, pl. 49; Beenken, *Rogier*, fig. ii. The technique of this excellent picture, revealed by X-ray photographs, is so different from that of other works by the Master of Flémalle that I tend to agree with de Tolnay, *Le Maître de Flémalle*, p. 60, no. 10, in considering it as a copy. It is, however, accepted as an original work of the Master of Flémalle, not only by Friedländer and Renders but also by Schöne, p. 57; Musper, fig. 3; Cornette, *op. cit.*, fig. 25; and van Puyvelde, *Primitives*, pl. 30. Burroughs, *Art Criticism from a Laboratory*, p. 226, fig. 99 ascribes it to Roger van der Weyden. Presupposing the Master of Flémalle's identity with Roger, W. R. Valentiner, "Mino da Fiesole," *Art Quarterly*, VII, 1944, p. 150 ff., also attributes the picture to the latter. But since he accepts the long-discarded identity of the sitter with the equally fat but considerably younger Niccolo Strozzi (died 1469) as portrayed in Mino da Fiesole's bust of 1454, he is compelled to date it in 1450 when Roger was in Italy. This, of course, would be impossible even if the attribution to Roger were tenable.

9. Friedländer, II, p. 111, no. 62; de Tolnay, *Le Maître de Flémalle*, p. 60, no. 11; Musper, fig. 20 (here accepted as an original). It seems, however, to be a school picture reflecting the style of the Master of Flémalle and was, in fact, ascribed to Jacques Daret by Burroughs, *Art Criticism from a Laboratory*, p. 215, fig. 93.

10. Friedländer, II, p. 113, no. 69; Renders, II, pl. 57.

11. Friedländer, II, p. 109, no. 57, pl. XLIX (here accepted as an original); de Tolnay, *Le Maître de Flémalle*, p. 60, no. 12; *The Worcester-Philadelphia Exhibition of Flemish Painting*, no. 3 (here accepted as an original), and *Masterpieces of Art (Catalogue of European Paintings and Sculpture from 1300-*

1800), *New York World's Fair, May to October, 1939*, no. 243, pl. 48 (here accepted as an original). There is no evidence for the assumption (see, e.g., Vöge, *op. cit.*, p. 134) that the picture is meant to represent a Sibyl. For the portrait of a gentleman now identified as Guillaume Fillastre, which was at times ascribed to the Master of Flémalle, see p. 292; note 292[5].

12. See p. 175.

13. Friedländer, II, p. 108, no. 52, pl. XLV; de Tolnay, *Le Maître de Flémalle*, p. 59, no. 4 (as a copy after a lost original). For the pastiche character of the composition, see Panofsky, "The Friedsam Annunciation," p. 446, note 25; Robb, *op. cit.*, p. 517, note 123.

Page 176

1. Friedländer, II, p. 117, no. 77; de Tolnay, *Le Maître de Flémalle*, p. 59, no. 2 (as a copy after a lost original). For the pastiche character of the composition, see Davies, *National Gallery Catalogues, Early Netherlandish School*, p. 19 ff.

2. Schöne, "Ueber einige niederländische Bilder, vor allem in Spanien," *Jahrbuch der Preussischen Kunstsammlungen*, LVII, 1937, p. 153 ff., fig. 10. This picture is, I believe, no closer to the Master of Flémalle than many other German compositions of about the same period, for example — as pointed out to me by Dr. Guido Schönberger — a "Rest on the Flight into Egypt" by the Master B.M., illustrated in Lehrs, *op. cit.*, VI, pl. 153, and M. Weinberger, "Zu Dürers Lehr- und Wanderjahren," *Münchner Jahrbuch der Bildenden Kunst*, new ser., VI, 1929, p. 124 ff., especially p. 133, fig. 9.

3. See p. 298 ff.

4. See p. 103 f.

5. Byvanck, *Min. Sept.*, pl. XLVI, fig. 131; Hoogewerff, I, fig. 236; de Wit, *loc. cit.*, fig. 5.

6. De Wit, *loc. cit.*, fig. 6; Hoogewerff, I, fig. 233. In inserting the Thieves from the Master of Flémalle's "Descent from the Cross" into an altogether different composition, this miniature parallels an engraving by the Master of the Banderoles where the same figures serve to supplement a composition derived from the great "Descent" by Roger van der Weyden (see note 266[3]). For the motif of the iron bar to which the arms of one of the Thieves are fastened, see note 118[4].

7. Friedländer, VI, p. 86 (deriving the composition from Jan van Eyck), pls. LXXXIII–LXXXV. F. Winkler, "Neues von Hubert und Jan van Eyck," *Festschrift für Max J. Friedländer zum 60. Geburtstage*, Leipzig, 1927, p. 91 ff., conjectures a derivation from "either Hubert van Eyck or the Master of Flémalle" (p. 100) but does not arrive at a decision. Hoogewerff, I, p. 450, on the other hand, correctly

derives the miniature in the "Arenberg Hours" from a Flémallesque model but fails to connect it with the David picture.

Page 177

1. In this respect Friedländer's view, referred to in the preceding note, is perfectly justifiable.

2. L. (von) Baldass, "Ein Frühwerk des Geertgen tot Sint Jans und die holländische Malerei des XV. Jahrhunderts," *Jahrbuch der Kunsthistorischen Sammlungen in Wien*, XXXV, 1920/21, p. 1 ff.

Page 178

1. As to literature, I must refer the reader to the bibliographies in Weale-Brockwell, p. 281 ff. (up to 1912) and de Tolnay, *Le Maître de Flémalle*, p. 82 ff. (up to 1937–1938), supplemented by L. Scheewe (not "Scheeve"), *Hubert und Jan van Eyck, ihre literarische Würdigung bis ins 18. Jahrhundert*, The Hague, 1933; ———, "Die Eyck-Literatur (1932–1934)," *Zeitschrift für Kunstgeschichte*, III, 1934, p. 139 ff.; and the Bibliographical Appendices and Summaries referred to in note 154[3]. The most recent monograph, L. Baldass' extremely conscientious and scholarly *Jan van Eyck*, London and Toronto, 1952 (hereafter quoted as "Baldass, *Eyck*"), appeared when my own manuscript was in the hands of the publishers. I must limit myself to some brief references, particularly to the illustrations the captions of which will guide the reader to Mr. Baldass' Catalogue and hence to the relevant passages of his text. For literature concerning the Ghent altarpiece and works variously ascribed to Jan and Hubert, see the notes of the following chapter (pp. 205–243).

2. This assumption would be in harmony with the date, 1414, allegedly inscribed on the "Moorish King or Prince" which was owned in 1682 by Diego Duarte of Antwerp (see Weale-Brockwell, p. 199 f. and, more recently, J. Duverger, "Jan van Eyck voor 1422; Nieuwe Gegevens en Hypothesen," *Handelingen van het 3e Congres voor Allgemeene Kunstgeschiedenis*, Ghent, 1936, p. 13 ff., especially p. 16 f.). However, since this picture has not come down to us, we are unable to decide whether it was in fact a work of Jan van Eyck and, if so, bore a date as stated. In a document of 1436–1437, quoted by Duverger, p. 16, mention is made of "Jan en Margriete van Eycke, Kinderen Willems van Eycke." If this record could be presumed to refer to the great painter — which, however, would be "precocious to assert" — it would bear witness both to the actual existence of his and Hubert's elusive sister Margaret (Weale-Brockwell, pp. 22, 286 f.) and to the Christian name of their father.

3. As Joseph (not Frédéric) Lyna, "Les Peintres van Eyck et l'Ecole de Maestricht," *Paginae Biblio-*

graphicae, I, 1926, p. 114 ff. (cf. de Tolnay, *Le Maître de Flémalle*, pp. 18 and 47, note 34), has shown, the name "van Eyck" occurs about thirty times in Maastricht documents prior to 1400. It should be noted, however, that the Little Chapter *Haec est speciosior* (see above, p. 148), which has been adduced as peculiar to the use of Maastricht, was read in the same context (Feast of the Assumption, Lauds) in at least seven other localities: Bruges (Breviary of St. Donatian, see Weale-Brockwell, p. 123, note 1), Treves, Louvain (Breviary of St. Peter's), Brussels, St.-Omer, Liége, and Mons (Breviary of Ste.-Waudru). I am deeply grateful to Father Paul Grosjean, S.J., for his great kindness in verifying the statement in Weale-Brockwell and, in addition, informing me of the six other occurrences. Thus the hypothesis that the van Eyck brothers were natives of Maastricht rather than Maaseyck rests mainly on the fact that in the Brussels accounts of Philip the Good, year 1435–1436, mention is made of a *"Johannes van Tricht*, schilder mijns genedigen heren"* (Duverger, *op. cit.*, p. 15 f.; de Tolnay, *Le Maître de Flémalle*, p. 18). It seems, however, not very probable that a world-renowned painter, constantly referred to by the ducal clerks as Johannes, or Jehan, "van Eyck" (albeit in various spellings) since 1425, should suddenly, and only once, appear under a different name; it is as if the Chancery of Maximilian I would suddenly, and only once, refer to Albrecht Dürer as "Albrecht von Nüremberg." We may well ask whether the painter Jan van Tricht might not be an entirely different personality. As to the color notes on Jan's drawing of Nicholas Cardinal Albergati (see p. 200), their dialect agrees, according to all experts, with that of the Meuse region; but there is, of course, no possibility of distinguishing between two places only about eighteen miles apart. On the other hand, a special connection between Jan's family and Maaseyck may be inferred from the fact that his daughter, Livina, entered the Convent of St. Agnes in this town in 1450 (Weale-Brockwell, Document 36, p. xxxix ff.) and that he himself had donated a chasuble to this convent (*ibidem*, Document 37, p. xl).

4. This is unequivocally stated in the obituary of St. Donatian at Bruges (Weale-Brockwell, Document 35, p. xxxix); the burial took place — or, at least, was paid for — on the very same day (Weale-Brockwell, Document 30, p. xxxviii). On what grounds Schöne, p. 23, dates Jan's death at the end of June, I have been unable to discover.

Page 179

1. For Jan's voyage to Portugal, see L. van Puyvelde, "De Reis van Jan van Eyck naar Portugal,"

Koninklijke Vlaamsche Akademie voor Taal- en Letterkunde, Verslagen en Mededeelingen, 1940, p. 17 ff. Van Puyvelde believes, not without reason, that the secret missions of 1426, too, were undertaken for matrimonial purposes.

2. For the contention that this mission brought Jan van Eyck to Prague, see note 193 [1].

3. Letter of March 12, 1435 (Weale-Brockwell, Document 24, p. xxxvi). The original text is reproduced in W. H. J. Weale, *Hubert and John van Eyck, Their Life and Work*, London and New York, 1908, p. xlii f., a book still indispensable for documentary evidence and historical details.

4. See note 2 [f].

Page 180

1. Vasari, *Le opere di Giorgio Vasari*, G. Milanesi, ed., vol. II, p. 565 f.: ". . . he began to try out various kinds of colors and, being fond of alchemy, to play around with many oils in order to make varnishes and other things according to the fancy of such inquiring minds as his was. Now, on one occasion, when he had gone to very great trouble to paint a panel and completed it with the utmost diligence, he varnished it and put it in the sun as is the custom. But, whether the heat was too violent, or perhaps because the wood was badly joined or not sufficiently seasoned, said panel came badly apart at the joints. Therefore, seeing what harm the heat of the sun had done to him, Jan decided to fix it so that the sun would never again wreak such havoc with his works. And so, since he was no less disgusted with the varnish than with working in tempera, he began to think how he might find a kind of medium that would dry in the shade without his placing his pictures in the sun. Finally he discovered that, among all the oils which he had tried, linseed and nut oil dried better than all others. These, then, boiled together with other mixtures of his, gave him the varnish which he — and, for that matter, all the painters in the world — had long wished for. After having experimented with many other things, he saw that the mixing of the pigments with these kinds of oil gave them a very strong cohesion; and that, when dry, [this binding medium] was not only absolutely unafraid of water but also set the color afire to such an extent that it imparted to it a radiance by itself, without any varnish. And what appeared to him the most wonderful thing was that it blended (*si univa*) infinitely better than tempera." It is amusing that Pliny, allegedly a source of inspiration to Jan van Eyck (see again note 2 [7]) heaps his most lavish praise upon an analogous invention of Apelles: a varnish so subtle that it "cum repercussum claritatis colorum omnium excitaret custodi-

retque a pulvere et sordibus, ad manum intuenti demum appareret, sed et luminum ratione magna, ne claritas colorum aciem offenderet veluti per lapidem specularem intuentibus et e longinquo eadem res nimis floridis coloribus austeritatem occulte daret" (*Natural History*, XXXV, 97).

2. Cf. C. Wolters, *Die Bedeutung der Gemälde-durchleuchtung mit Röntgenstrahlen*, Frankfort, 1938, p. 25 f., fig. 9–12. It is, however, difficult to see why Wolters speaks of the Eyckian method in somewhat disparaging terms. That Jan van Eyck, in contrast to Roger van der Weyden, systematized the previously rather arbitrary use of lead white with an eye on luminosity rather than "design" does not imply a lack of understanding for the latter.

Page 181

1. See note 62 ².

Page 182

1. See Pope, *op. cit.*, p. 100 ff., caption of pl. LIII (3rd edition, p. 97, caption of pl. LXIII).

2. For the contested early works, some of which can hardly be surpassed in dramatic expressiveness, see pp. 235, 238, 245 f.

3. De Tolnay, *Le Maître de Flémalle*, p. 31 f.

Page 183

1. Weale-Brockwell, p. 109 ff.; Friedländer, I, p. 53, pl. XX; de Tolnay, *Le Maître de Flémalle*, p. 66, no. 4, fig. 84; Beenken, *Hubert und Jan*, p. 58 f., fig. 83; Musper, fig. 154; Baldass, *Eyck*, pl. 104, fig. 52. See also *Masterpieces of Art . . . New York World's Fair, 1939*, no. 113, pl. 46. The unusual placement and somewhat faulty spelling of the inscription has been plausibly explained by the conjecture that it was transferred from its normal place, the frame, into the picture itself. For the iconography of the picture, see above, p. 144.

2. Whether or not this substitution of red for blue was prompted by symbolic in addition to "esthetic" reasons it is difficult to decide. In the works of Roger van der Weyden (as also in the beautiful *"Pietàs"* in the Frick Collection and the Fogg Museum) the red robe of the Virgin Mary has certainly a Passional significance; cf. p. 261.

3. Weale-Brockwell, p. 120 ff.; Friedländer, I, p. 58, pls. XXIII, XXIV; de Tolnay, *Le Maître de Flémalle*, p. 67, no. 7, figs. 94–100 (it should be noted, however, that the coats-of-arms of the Carlyns family, seen in the upper right-hand and lower left-hand corners of the frame, refer, not to a "Canon Carlyns" but to George van der Paele's mother); Schöne, pp. 46–48; Beenken, *Hubert und Jan*, p. 66 ff., figs. 91–94;

Musper, figs. 160, 161; van Puyvelde, *Primitives*, pls. 12, 13 (in color); Baldass, *Eyck*, pls. 120–125, fig. 57. For full documentation see A. Janssens de Bisthoven and R. A. Parmentier, *Le Musée Communal de Bruges* (*Les Primitifs flamands, Corpus de la Peinture des Anciens Pays-Bas Méridionaux au Quinzième Siècle*, I), Antwerp, 1951, p. 36 ff.; it must be added, however, that three American scholars, Messrs. David G. Carter, Howard Davis and John McAndrew, have recently made the independent and most interesting observation that the figure of the painter, clad in red hose, a long, dark coat and a red turban, is mirrored in the buckler of St. George. A dermatologist, Dr. J. Deneux, *Rigueur de Jean van Eyck*, Brussels, 1951 (see also E. Michel, *Revue des Arts*, I, 1951, p. 147 ff.) claims that the face of the Canon has lost certain details, indicative of senile degeneration, on the occasion of the recent cleaning. For the iconography of the picture, see p. 140.

4. See note 147 ².

Page 184

1. Weale-Brockwell, p. 82 ff.; Friedländer, I, p. 100, pls. XLI, XLII; de Tolnay, *Le Maître de Flémalle*, p. 65, no. 3, figs. 74–83; Beenken, *Hubert und Jan*, p. 20 ff., figs. 28–30, 32, 33; Musper, figs. 125–127; van Puyvelde, *Primitives*, pl. 17; Baldass, *Eyck*, pls. 105–107. For the iconography of the picture, see p. 140.

2. Paris, Bibliothèque Nationale, ms. fr. 259, fol. 253; according to a kind communication of M. Jean Porcher, the miniature, illustrating the First Book of the Second Decade, represents the Coronation of Hannibal as "Emperor of Carthage" as described in the Fifth Chapter of that Book.

3. Weale-Brockwell, p. 145 ff.; Friedländer, I, p. 97, pl. XLIII; de Tolnay, *Le Maître de Flémalle*, p. 68, no. 9, fig. 105; Beenken, *Hubert und Jan*, p. 72 ff., figs. 95, 98; Musper, fig. 158; Baldass, *Eyck*, pl. 126. The picture, which bears its name from the fact that it belonged to the Duke of Lucca prior to being acquired by King William II of Holland and hence the Städelsches Kunstinstitut, may well have been commissioned by a member of the Lucchese colony at Bruges of which Giovanni Arnolfini, the faithful client of Jan van Eyck, was the most prominent member.

Page 185

1. Weale-Brockwell, p. 129 ff.; Friedländer, I, p. 62; de Tolnay, *Le Maître de Flémalle*, p. 67, no. 8, figs. 102–104; Beenken, *Hubert und Jan*, p. 71 f., fig. 97; Musper, fig. 167; Baldass, *Eyck*, pl. 127, fig. 59. Cf. S. Sulzberger, "La Sainte Barbe de Jan van Eyck;

Détails concernant l'histoire du tableau," *Gazette des Beaux-Arts*, ser. 6, XXXIV, 1948, p. 289 ff.

2. Cf. also the judicious remarks of van Puyvelde, *Agneau*, p. 80.

Page 186

1. See p. 128.

2. For the legend of St. Barbara, see especially Martens, *op. cit.*, p. 44 ff.

3. Weale-Brockwell, p. 131 ff.; Friedländer, I, p. 63; de Tolnay, *Le Maître de Flémalle*, p. 68 f., no. 12, fig. 108; Beenken, *Hubert und Jan*, p. 74 ff., fig. 96; Musper, fig. 168; van Puyvelde, *Primitives*, pl. 9; Baldass, *Eyck*, pl. 128.

4. In other instances Jan van Eyck wrote either *fecit* ("St. Barbara" and "Man in a Red Turban"), or *complevit* ("Ince Hall Madonna" and portrait of Margaret van Eyck), or *actum* ("Timotheos"). The seemingly redundant phrase employed in the "Madonna at the Fountain" recurs, in garbled form, only in the Berlin replica of Jan's "Holy Face" (see note 187¹) where it was obviously copied from the "Madonna at the Fountain."

5. O. Kerber, *Hubert van Eyck*, Frankfort, 1937, p. 317 f.

6. Cf. p. 251.

Page 187

1. Four replicas of Jan van Eyck's "Holy Face" — one at Berlin (Musper, fig. 166), one at Munich, one at Bruges, and one formerly in the E. von Oppolzer Collection at Innsbruck — are listed in Weale-Brockwell, p. 179 ff. and Friedländer, I, p. 116. The fifth picture, then in English trade, was published by Sir Martin Conway, "A Head of Christ by John van Eyck," *Burlington Magazine*, XXXIX, 1921, p. 253 f., and is reproduced in *Illustrated London News*, CLXVII, 1925, October 24, p. 805, as well as in Friedländer, pl. XLVII; Musper, fig. 171; Baldass, *Eyck*, pl. 131. De Tolnay, *Le Maître de Flémalle*, p. 73, no. 2, though referring to Sir Martin Conway's article, names only the Berlin replica (Baldass, pl. 130) and pronounces it to be the best. It cannot be questioned, however, that the picture published by Sir Martin — formerly in the J. C. Swinburne Collection at Durham, exhibited at the International Exhibition at Antwerp (*Exposition Internationale Coloniale, Maritime et d'Art Flamand, Antwerp, Juin-Septembre, 1930, Section d'Art Flamand Ancien*, p. 51, no. 133) and last heard of in 1951 when it was shown at the Hatton Gallery, King's College, Newcastle-upon-Tyne — is vastly superior to the four other replicas and may well be a somewhat damaged original. The problem is further complicated by the fact that the garbled inscription of the Berlin copy ("Johēs de Eyck me fecit et cpleuit . . . AME IXH XAN") states the date as "1438. 31 Ianuarij" whereas the text of the Bruges copy reads: "Johēs de eyck Inuentor. anno. 1440. 30. Januarij," and a materially identical inscription on the frame of the Swinburne picture (a note pasted on its back reads: "This head of our Saviour was pain[ted] by John van Eyc[k] 30 January 1440 his name and date of the year was written by himself on the frame which was [originally: 'my father'] sawed off. T. T. West 1784"). From this it has been concluded that there existed two archetypes, one of 1438, and one of 1440, and that the five pictures which have come down to us constitute in fact two families. The Bruges copy and the Swinburne picture agree with each other, not only in the inscription but also in every other respect, particularly in that the light comes from the left. The three other replicas (of which the one at Berlin is the best and the earliest) show slight variations in ornamental detail, especially the decoration of the neckband of Christ's robe, and are illuminated from the right. Yet the assumption of two separate archetypes does not seem absolutely convincing. The author of the Bruges copy, exactly repeating the inscription of the Swinburne picture and ascribing to Jan van Eyck only the "invention" but not the execution of his own product, is obviously an honest copyist. The intention of the Berlin copy, however, can be described only as fraudulent. A painter who claims that his work was "made and completed" by Jan van Eyck himself, may well have changed the date, and the direction of the light, for the express purpose of creating what, he hoped, would be accepted as a second original; and the authors of the Munich and von Oppolzer copies may have fallen prey to this deception. For the Bruges copy as well as the whole problem, see Janssens de Bisthoven and Parmentier, *op. cit.*, p. 27 ff.

2. Weale-Brockwell, p. 76 ff.; Friedländer, I, p. 98; de Tolnay, *Le Maître de Flémalle*, p. 69, no. 13, fig. 109; Beenken, *Hubert und Jan*, p. 76, note 2, fig. 99; Musper, fig. 170; Baldass, *Eyck*, pl. 132. The documents concerning the picture were discovered and excellently interpreted by H. J. J. Scholtens, "Jan van Eyck's 'H. Maagd met den Kartuizer' en de Exeter-Madonna te Berlijn," *Oud Holland*, LV, 1938, p. 49 ff. The document of 1443 (Scholtens, p. 51) alone, explicitly identifying the saint on the Virgin's left as "Elyzabeth," suffices to disprove the contention that she is St. Ludmilla of Bohemia (E. Notebaert, "Contribution à l'identification du paysage architectural dans les oeuvres des primitifs flamands," *Revue de Saint Luc*, 1939, p. 2 ff.). In addition the attribute of St. Ludmilla is the scarf with which she was

strangled, and not the three crowns which are peculiar to St. Elizabeth of Thuringia; cf., for example, the interesting woodcut pinned up on the wall in Petrus Christus' Portrait of a Donatrix in the Kress Collection at New York (M. J. Friedländer, "The Death of the Virgin by Petrus Christus," *Burlington Magazine*, LXXXVIII, 1946, p. 158 ff.; illustration on p. 161 B). The cityscape, including the portrait of Old St. Paul's which may be based upon an early sketch by Jan van Eyck, is repeated in the title page of the *Cité de Dieu* in the Bibliothèque Royale at Brussels, ms. 9015, which was executed for Jean Chevrot, Bishop of Tournai, in 1445 or 1446 (de Laborde, *Les Manuscrits à peintures de la Cité de Dieu*, pl. XXXII; Winkler, *Die flämische Buchmalerei*, pl. 4; Musper, fig. 106).

3. See p. 192 f.

Page 188

1. See also Panofsky, "The Friedsam Annunciation," p. 434, note 4.

2. For Petrus Christus in general, see p. 308 ff.

Page 189

1. Friedländer, XIV, p. 79, Nachtrag, pl. IV. The picture, listed as a copy after Jan van Eyck in de Tolnay, *Le Maître de Flémalle*, p. 76, no. 5, and so reproduced in Musper, fig. 107, was discovered in 1925. For the literature up to 1930, see *Paintings in the Permanent Collection of the Detroit Institute of Arts of the City of Detroit*, Detroit, 1930, no. 33; for the literature up to 1939, *Masterpieces of Art . . . New York World's Fair*, 1939, no. 114, pl. 47. For some addenda and an attempt to prove the picture's late date and partial authenticity, see E. Panofsky, "A Letter to St. Jerome; A Note on the Relationship between Petrus Christus and Jan van Eyck," *Studies in Art and Literature for Belle da Costa Greene*, Princeton, 1954, p. 102 ff.

2. Durrieu, *Heures de Turin*, pl. XL. See F. Winkler, "Neues von Hubert und Jan van Eyck," p. 91 ff., fig. 4; another Flemish miniature derived from the "Medici St. Jerome" is illustrated *ibidem*, fig. 5. The most adequate rendering of the composition in Flemish art, however, was recently discovered by Miss Dorothy Miner in a Book of Hours of *ca.* 1455 (Baltimore, Walters Art Gallery, ms. 721, fol. 277 v.) which, in spite of the customary adaptations and simplifications, retains all the significant features of the original composition, including the delicate motif of the fingers separating the pages of the big Bible. It even surpasses it in the treatment of the drapery which in the Detroit picture has greatly suffered from the shortcomings of Petrus Christus and subsequent overpainting; and I agree with Miss Miner in assuming that the miniature must have been executed on the basis of a faithful drawing retained in Jan van Eyck's workshop after delivery of the painting rather than on the basis of the painting itself. For an illustration, see Panofsky, "A Letter to St. Jerome," fig. 4.

3. See p. 1 f.

4. Even before the date, "1442," was discovered, the possibility of identifying the Detroit picture with the "Medici St. Jerome" was envisaged in *Paintings in the Permanent Collection . . . of the City of Detroit*. Afterwards, the hypothesis was finally formulated, by Valentiner, in *Masterpieces of Art*, no. 114, benevolently but noncommittally mentioned by Friedländer, XIV, p. 79, and repeated in *The Worcester-Philadelphia Exhibition of Flemish Painting*, no. 2, as well as in *Flemish Primitives, An Exhibition Organized by the Belgian Government, April 13–May 9, 1942*, New York (M. Knoedler & Co.), p. 16. Baldass, *Eyck*, pl. 9, is inclined to accept the Detroit picture as authentic but dates it early on account of its compositional relationship with such products of the International Style as the well-known "St. Jerome" in the Limbourgesque *Bible Moralisée*, Paris, Bibliothèque Nationale, ms. fr. 166, fol. 1 (illustrated, e.g., in Sterling, *Les Primitifs*, fig. 68, Lemoisne, *op. cit.*, pl. 31, and Baldass, *Eyck*, fig. 24). While this relationship is undeniable — an even closer similarity exists between the Detroit picture and the "St. Jerome" in the "Boucicaut Hours," fol. 171 v., our fig. 61 — it should be borne in mind that precisely such late works of Jan van Eyck as the "Holy Face" and the "Madonna at the Fountain" evince a markedly archaistic tendency.

Page 190

1. See p. 200 f.

2. See p. 3; note 305².

3. Weale-Brockwell, p. 135 ff.; Friedländer, I, p. 105; de Tolnay, *Le Maître de Flémalle*, p. 75, no. 3, fig. 145; Beenken, *Hubert und Jan*, p. 76, note 2; Musper, figs. 172, 173; Baldass, *Eyck*, pl. 129. Cf. Hulin de Loo, "Le Sujet du retable des Frères van Eyck à Gand: La glorification du Sauveur," *Annuaire des Musées Royaux des Beaux-Arts de Belgique*, III, 1940–42, p. 1 ff. Owing to legal difficulties the "Ypres altarpiece" is at present in the custody of the U. S. Government and kept incommunicado in the Museum of Fine Arts at Boston. For the copy of the central panel in the Albertina, see *Beschreibender Katalog der Handzeichnungen in der Graphischen Sammlung der Albertina*, II, *Die Zeichnungen der niederländischen Schulen* (by O. Benesch), Vienna, 1928, no. 13.

Page 192

1. Weale-Brockwell, p. 93 ff.; Friedländer, I, p. 101, pls. XLV, XLVI; de Tolnay, *Le Maître de Flémalle*, p. 68, no. 11, fig. 106; Beenken, *Hubert und Jan*, p. 23 ff., fig. 27; Musper, fig. 124; van Puyvelde, *Primitives*, pls. 14, 15; Baldass, *Eyck*, pl. 13. For the much-debated relationship between this panel and its nearly identical but very much larger replica in the Galleria Sabauda at Turin (Weale-Brockwell, p. 165 ff.; de Tolnay, fig. 107; Baldass, fig. 30; our fig. 269), which measures 29.5 cm. by 33.7 cm. as against 12.7 cm. by 14.6 cm., see C. Arù and E. de Geradon, *La Galerie Sabauda de Turin (Les Primitifs Flamands, Corpus de la Peinture des Anciens Pays-Bas Méridionaux au Quinzième Siècle*, II), Antwerp, 1952, p. 5 ff., pls. IX–XX, with excellent reproductions and complete bibliography. The recent cleaning of the Turin panel has shown that it is not later than, and not appreciably inferior to, the Philadelphia version; specifically, that the alleged misunderstanding in the figure of Brother Leo (apparently possessed of two right feet) is due to repainting. We have, therefore, no other choice than either to accept or to reject both pictures — in other words, either to accept or to reject the document on which their attribution tσ Jan van Eyck is based. This document is the will of Sir Anselm Adornes (1424–1483, Mayor of Bruges from 1475) of February 10, 1470, transmitted through a copy of the sixteenth century (transcription and photograph in Arù and de Geradon, p. 13, pl. XX): he leaves to each of his daughters, Margaret and Louise, both nuns, "a panel wherein there is a St. Francis depicted by the hand of Jan van Eyck" and orders his and his wife's portraits to be painted on the shutters protecting these two "little panels" (*tavereelkins*). Even assuming that the two panels preserved at Philadelphia and Turin are identical with those referred to by Sir Anselm, we have to ask ourselves whether or not his will has been correctly transmitted; and it would seem that the impossible position of the artist's name in the decisive passage ("van meester Jans handt van Heyck" instead of either "van meester Jan van Heycks handt" or "van handt van meester Jan van Heyck") strongly suggests an interpolation. And even assuming that this interpolation was made in good faith, it seems impossible to me to accept it for internal reasons. In execution, both pictures are dry and pedestrian yet strangely imprecise and partly fuzzy. The landscape is a conglomeration of Eyckian motifs rather than an integrated whole. There is no psychological relationship between the praying St. Francis and the apparition of the crucified Christ. The huddled figure of the faithful Brother Leo is a shapeless mass of drapery concealing an almost malformed body. And the figure of the saint himself is so badly constructed — a fact especially stressed by Professor Wilhelm Koehler in a conversation that went a long way to confirm this writer's misgivings — that it is unacceptable even as an invention of Jan van Eyck: given the arrangement of the drapery, on the one hand, and the position of the feet, on the other, it is impossible to determine the location of the knee with any amount of probability. If, in spite of these objections, the Philadelphia "St. Francis" should be accepted as genuine it would have to be dated relatively late (Friedländer, *loc. cit.*, and *Essays über die Landschaftsmalerei*, p. 29 ff.; de Tolnay, p. 34) rather than early (Beenken, *loc. cit.*; Musper, p. 107; Baldass, p. 277).

2. Friedländer, XIV, p. 78, Nachtrag, pls. I, II; ———, "A New Painting by van Eyck," *Burlington Magazine*, LXV, 1934, p. 3 f.; de Tolnay, *Le Maître de Flémalle*, p. 68, no. 10, fig. 101; Beenken, *Hubert und Jan*, p. 46, figs. 86, 87; Musper, figs. 162, 163; Baldass, *Eyck*, pl. 112. A recent article by S. Sulzberger, "L'Annonciation de Jean van Eyck dans la collection Thyssen à Lugano," *Revue Belge d'Archéologie et d'Histoire de l'Art*, XIX, 1950, p. 67 ff., does not contribute anything new or remarkable.

3. Weale-Brockwell, p. 87 ff.; Friedländer, I, p. 95, pl. XL; de Tolnay, *Le Maître de Flémalle*, p. 66, no. 6, figs. 91–93; Beenken, *Hubert und Jan*, p. 62 ff., figs. 88, 89; E. Michel, *L'Ecole Flamande . . . au Musée du Louvre*, p. 39 f., pls. III, IV; Musper, fig. 128; van Puyvelde, *Primitives*, figs. 20–23; Baldass, *Eyck*, pls. 116, 117, Frontispiece (color). For the iconography of the picture, see de Tolnay, p. 29 f., and above, p. 139. For the various attempts at identifying the city prospect, cf. notes 187 [2] and 193 [1].

4. Paris, Bibliothèque Nationale, ms. lat. 1161, fol. 290.

Page 193

1. Notebaert, *op. cit.* His arguments are three in number. He claims, first, that the general site of the city as well as its most prominent buildings, especially the bridge with its tower and the cathedral, corresponds to Prague; second, that the motif of the Infant Jesus carrying an orb derives from a famous cult image which has been worshipped in the Carmelites' Church from the seventeenth century and possibly repeats an earlier archetype; third, that the "Rothschild Madonna," connected with the "Rolin Madonna" by the recurrence of the orbed Christ Child and the river landscape with its arched bridge and big rowboat, testifies to Jan's stay in Bohemia by the inclusion of St. Ludmilla. The last of these arguments has already been dealt with (note 187 [2]). As for the second, it must be said that the orbed Christ Child

occurs, not only in numerous pre-Eyckian renderings of St. Christopher — e.g., in the Baerze-Broederlam altarpiece at Dijon, the "York Hours" (Kuhn, *op. cit.*, fig. 5) and the "Beaufort Hours" (*Ibidem*, fig. 7) — but also in several pre-Eyckian Madonnas, for instance in a Gradual in the Dyson Perrins Collection at Malvern (G. Warner, *Descriptive Catalogue of Illuminated Manuscripts in the Library of C. W. Dyson-Perrins*, Oxford, 1920, pl. CXIV) and in the St. Remaclus Reliquary at Stavelot (O. von Falke and H. Frauberger, *Deutsche Schmelzarbeiten des Mittelalters*, Frankfort, 1904, fig. 38). The third argument, finally, is invalidated by the fact that the Prague "Brückenturm" with its double gallery bears no specific resemblance to the simple structure in the "Rolin Madonna" and that Jan's cathedral bears a closer resemblance to those of Tournai and Utrecht than to that of Prague. The Netherlandish nature of the city prospect in the "Rolin Madonna" is further demonstrated by the presence of the Utrecht "Domtoren" which, emerging from behind the brow of the Infant Jesus (good illustration in van Puyvelde, *Primitives*, pl. 21), was identified by Weale as early as 1908 (cf. Weale-Brockwell, p. 92). This identification is all the more probable as the Utrecht tower (F. A. J. Vermeulen, *Handboek tot de Geschiedenis der Nederlandsche Bouwkunst*, I, The Hague, 1928, pl. 250) was completed in 1382 while none of its replicas at Maastricht, Rhenen and Amersfoort (Vermeulen, pp. 398, 412; pls. 215, 218, 219) appears to antedate the middle of the fifteenth century. It should not be overlooked, however, that the tower in the "Rolin Madonna" differs from the original in that each of its faces shows two tall windows separated by a mullion instead of two wall strips adorned with blind tracery.

2. Weale-Brockwell, p. 98 ff.; Friedländer, I, p. 104, pl. XLIV; de Tolnay, *Le Maître de Flémalle* (erroneously locating the picture in Boston), p. 66, no. 5, figs. 71–73; Beenken, *Hubert und Jan* (erroneously locating the picture in Boston), p. 69 ff., fig. 90; Musper, fig. 165; van Puyvelde, *Primitives*, pl. 23; Baldass, *Eyck*, pls. 113–115. For the iconography of the picture, see de Tolnay, "Flemish Paintings in the National Gallery of Art," p. 175 ff., and above, p. 137 ff. The early date proposed by this writer has recently been accepted by Held, Review of Wehle and Salinger's Metropolitan Museum Catalogue, *Art Bulletin*, XXXI, 1949, p. 142, but was rejected by Kauffmann, "Jan van Eycks 'Arnolfinihochzeit,'" p. 48, note 9.

3. Weale-Brockwell, p. 167 ff.; Friedländer, I, p. 78, pl. XXXIII; de Tolnay, *Le Maître de Flémalle*, p. 61, no. 1, figs. 33, 34; Schöne, p. 44; Beenken, *Hubert und Jan*, p. 17 ff., fig. 26; Musper, fig. 117, Baldass, *Eyck*,

pl. 10, fig. 28. For the iconography of the picture, see Meiss, "Light as Form and Symbol," p. 179 f., and above, p. 144 ff.

4. Cf. de Tolnay, "Flemish Paintings in the National Gallery of Art," pp. 176 and 199, note 10. While it is true that, prior to the Washington "Annunciation," the Angel Gabriel did not wear a brocaded pluvial and much less a crown, it is going too far to say that he was "always clothed in a simple blue or white robe." Beginning with the "Brussels Hours" (fig. 42), he often wears a dalmatic embellished with gold-embroidered and bejeweled borders as in the *"Très Riches Heures"* (fig. 80) and "Liége Hours" (fig. 131, here completed by stole and cross-enhanced diadem) or even brocaded throughout (Paris, Bibliothèque Mazarine, ms. 469, fol. 13, illustrated in Martin, *La Miniature française*, pl. 99, fig. CXXIX). A gold-bordered though not brocaded pluvial is seen in the Boucicaut Master's "Corsini Hours" (Panofsky, "The Friedsam Annunciation," fig. 17).

Page 194

1. See p. 183.

2. See p. 59. In order to prove that the architectural conception of Jan van Eyck's "Madonna in a Church" derives from the Master of Flémalle, de Tolnay (*Le Maître de Flémalle*, pp. 24; 48, note 52) adduces two compositions which, according to him, reflect a Flémallesque archetype supposedly antedating the "Madonna in a Church": a Burgundian "Presentation of Christ" of *ca.* 1450–60 (text ill. 64) which passed from the Pelletier Collection at Paris to the Louvre (S. Reinach, "Three Panels from the Ducal Residence at Dijon," *Burlington Magazine*, L, 1927, p. 234 ff.; E. Michel, "Une Présentation au Temple d'Ecole Franco-Flamande," *Bulletin des Musées de France*, III, 1931, p. 2 ff.); and a "St. Andrew Baptizing the Wife of the Proconsul of Greece" by the Hanseatic Master of Heiligenthal (text ill. 63), dated 1438, in the Nicolai-Kirche at Lüneburg (C. G. Heise, *Norddeutsche Malerei*, Leipzig, 1918, fig. 90; Panofsky, "Die Perspektive als symbolische Form," fig. 30). What these two pictures share with the "Madonna in a Church" is, of course, the ecclesiastical interior rendered in "eccentric perspective" — an arrangement which, we remember, can be traced back to the Boucicaut Master (see fig. 70). If the Pelletier "Presentation" and the Lüneburg "St. Andrew Baptizing" were derived from a Flémallesque archetype exploited also in Jan van Eyck's "Madonna in a Church" the influence of this archetype would manifest itself in specific features common to all the three interiors; and since Jan van Eyck was a more self-dependent artist than the two others, we should expect the Pelletier "Presen-

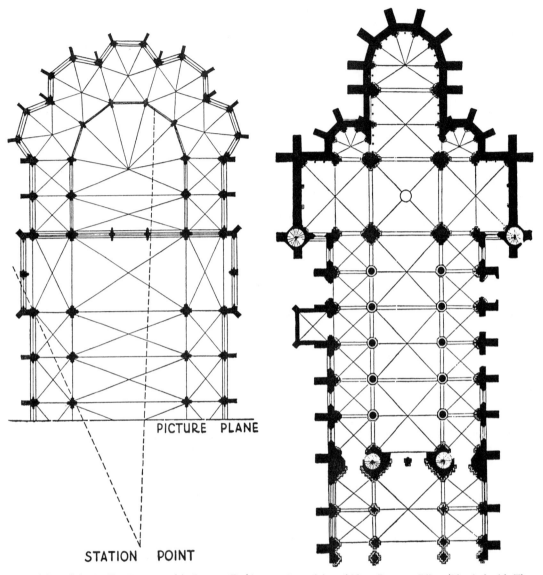

PICTURE PLANE

STATION POINT

Groundplan of the Basilica Represented in Jan van Eyck's "Madonna in a Church" (fig. 236).

Groundplan of Notre-Dame at Dijon (Identical with That of the Basilica Represented in the "Presentation of Christ," Text Ill. 64).

tation" to be more similar, from an architectural point of view, to the Lüneburg "St. Andrew Baptizing" than either of these is to the "Madonna in a Church." Such, however, is not the case. On the contrary, the Lüneburg "St. Andrew Baptizing," clumsily executed though it is, agrees in all significant particulars with the "Madonna in a Church" whereas the Pelletier "Presentation" no less significantly disagrees with both. In the "St. Andrew" as well as in the "Madonna in a

Church" the scene is laid in a High Gothic basilica terminating in a chevet with ambulatory and five radiating chapels which bears an obvious resemblance to those of Tournai and Utrecht Cathedrals and, therefore, to that of the. cathedral seen in the "Rolin Madonna" (cf. note 193 [1]); and an attempt to reconstruct the groundplan of the two edifices leads to perfectly identical results (see diagram). In both cases

the triforium and clerestory of the choir are on a higher level than those of the nave, a most characteristic peculiarity well motivated within the Eyckian composition but hardly found in any extant edifice. And in both cases the light comes from the north (cf. p. 147 f.). The architecture in the Pelletier "Presentation" is of an altogether different character. Its style is "transitional" rather than High Gothic. The light comes from the south. The triforium of the nave is flush with that of the choir. And a reconstruction of the ground plan discloses, instead of a "cathedral chevet" with ambulatory and radiating chapels, a solid apse and a square forechoir covered by a sixpartite vault (see diagram). In short, the architecture of the Pelletier "Presentation" fairly faithfully portrays the interior of Notre-Dame-de-Dijon as was already observed by Chabeuf in 1907 (cf. Michel and the Catalogue of the Antwerp *Exposition Internationale* of 1930, p. 124, no. 327). The inference is that the Lüneburg "St. Andrew" and the Pelletier "Presentation," far from reflecting a Flémallesque "prototype" of the "Madonna in a Church," represent two opposite possibilities of coping with the latter. The architecture of the Lüneburg panel with its "cathedral chevet," its raised choir triforium and its northern light, stems as unequivocally and exclusively from the "Madonna in a Church" as do the architectures in its literal copies (cf. Weale-Brockwell, p. 169) and its freer derivatives such as the Madrid triptych, formerly misnamed the "Cambrai altarpiece," by a follower of Roger van der Weyden (see note 283 ³) or the "History of St. Joseph" in Antwerp Cathedral (Fierens-Gevaert, *La Peinture en Belgique; Les Primitifs flamands*, Brussels, 1908–12, I, pl. XXXVIII; Destrée, *Roger de la Pasture-van der Weyden*, Paris and Brussels, 1930, pl. 119). The Burgundian Master of the Pelletier "Presentation," however, though probably no less familiar with the "Madonna in a Church" than was Roger's workshop, replaced Jan van Eyck's ideal architecture with a naturalistic portrayal of the most important local edifice — much as Roger himself had done when staging the Seven Sacraments in Ste.-Gudule at Brussels (our fig. 347; see also p. 283).

Page 196

1. F. O. Matthiessen, *The James Family*, New York, 1947, p. 318.

2. Weale-Brockwell, p. 108 ff.; Friedländer, I, p. 51, pl. XVIII; de Tolnay, *Le Maître de Flémalle*, p. 70, no. 15, fig. 112; Schöne, p. 51; Beenken, *Hubert und Jan*, p. 52 f., fig. 78; Musper, fig. 152; Cornette, *op. cit.*, fig. 8; Baldass, *Eyck*, pl. 135. Cf. Davies, *National Gallery Catalogues, Early Netherlandish School*, p. 35 f.; G. Münzel, "Zu dem Bilde des sogenannten

Tymotheos von Jan van Eyck," *Zeitschrift für Kunstgeschichte*, X, 1941–42, p. 188 ff.; E. Panofsky, "Who is Jan van Eyck's 'Tymotheos'?" *Journal of the Warburg and Courtauld Institutes*, XII, 1949, p. 80 ff. Only after this essay had been published did I realize, with the customary mixture of disappointment and gratification, that an identification of Jan's "Tymotheos" with the "reformer of Greek music" had already been envisaged by Fierens-Gevaert, *Histoire de la peinture flamande*, I, p. 90: "Quel est ce personnage? Un humaniste des Flandres, quelque savant 'docteur en décrets,' comme on l'a supposé? Ne pourrait-on voir en lui l'un des brillants musiciens de la cour de Bourgogne — le nom de Tymothée etant celui d'un grand réformateur de la musique grecque?" This passage is even referred to in Münzel's article; but the latter was accessible to me only in an abstract when I prepared my own essay.

Page 197

1. Paris, Bibliothèque Nationale, ms. fr. 12476, fol. 90 (reproduced in van den Borren, *op. cit.*, p. 34, and Panofsky, "Who is Jan van Eyck's 'Tymotheos'?," pl. 29 d).

2. The fact that fifteenth-, sixteenth- and even seventeenth-century authors, when speaking of "Timotheus," tended to fuse the perfectly historical Timotheos of Miletus, the great revolutionary of *ca.* 400 B.C., with the more legendary and, of course, considerably younger αὐλητής of Alexander the Great was kindly brought to my attention by Professor E. E. Lowinsky who also provided me with many of the references cited in this note. According to Dio Chrysostom (*De regno*, I, 1) and Basil the Great (*Sermo de legendis libris gentilium*, VIII, *Patrologia Graeca*, XXXI, col. 380), this second Timotheos — mentioned by Athenaeus, *Deipnosophistae*, XII, 54, 538 f.) among the five flute-players who performed at Alexander's wedding in 327 — was "such a master of his art that he was able, as he pleased, to excite the soul to wrath by a violent and impassioned melody and then again to mollify and appease it by a relaxed one": "On one occasion, it is said, he aroused Alexander to rush to his arms in the midst of a meal by playing to him a Phrygian tune and brought him back to his companions by softening the melody" (see *Saint Basile, Aux jeunes gens sur la manière de tirer profit des lettres helléniques*, F. Boulenger, ed. and tr., Paris, 1935, pp. 53, 67; the same anecdote is told by Plutarch, *Fort. Alex.* II, 2, 335 a, but here the name of the musician is Antigenidas). While the memory of the older Timotheos remained alive throughout the Middle Ages, Timotheos the younger seems to have been forgotten until the beginning of the fifteenth century when

Basil's Sermon, translated by Leonardo Bruni, became one of the basic documents of humanism. From then on, however, his name was constantly adduced wherever the emotional power of music was stressed: in Giannozzo Manetti's report on the music performed at the dedication of Florence Cathedral in 1436 (F. X. Haberl, "Die 'schola cantorum' und die päpstliche Kapelle in Avignon," *Vierteljahrsschrift für Musikwissenschaft*, III, 1887, p. 222); in Johannes Tinctoris' *Complexus effectuum musices* of *ca.* 1380 (E. de Coussemaker, *Scriptorum de musica medii aevi . . . nova series*, IV, Paris, 1876, p. 198); in Philippus Beroaldus' *Oratio in quaestiones Thusculanas et in Horatium*; in Giuseppe Zarlino's *Istitutioni harmoniche*, Venice, 1558, I, 2, etc. In all these sources no difference is made between the two Timotheoi. Their identity is taken for granted even in Dryden's *Alexander's Feast; Or, The Power of Music* (set to music by Handel, Benedetto Marcello and Mozart) where Alexander's favorite, originally only a flute-player, is pictured as a musician who, like Timotheos of Miletus, composes and sings his own verses and "with flying fingers" touches the lyre; and it is explicitly affirmed by Vincenzo Galilei, the well-known father of a famous son, who in his *Fronimo* (Venice, 1568) speaks of the lute as the instrument whereon "quel lirico *Thimoteo Milesio*, tanto famoso Musico, accompagnasse la voce, quanto incitava *il Magno Allessandro* al combattere, & da esso lo revocava." It was not until thirteen years later that the same Galilei, having familiarized himself with Suidas' *Lexicon*, discovered the difference between the two personages (*Dialogo della Musica Antica e Moderna*, Florence, 1581, p. 102 f.) and, incidentally, opposed the traditional view that Timotheos of Miletus had invented rather than merely revived the chromatic gender. Before 1581, then, no one seems to have doubted that Timotheos of Miletus was the very artist who ruled, as it were, over the emotions of Alexander the Great. The error is all the more pardonable as the music of the older Timotheos, too, was famed for its affective quality ("softness" and "wildness"). And to compare this composite character to Gilles Binchois would have seemed all the more natural as the latter, like the Milesian, was not only an innovator in the field of music but also a poet (*rhétoricien*), which may account for the fact that the scroll in the London portrait shows script rather than music; and as he, like the other Timotheos, excelled in playing upon the emotions. As has transpired very recently, one of his major compositions, rewarded with the considerable sum of twenty-four pounds, was entitled "*Passions en Nouvelles Manières*" (J. Marix, *Histoire de la musique et des musiciens de la Cour de Bourgogne sous le règne de Philippe le Bon*, Strasbourg,

1939, p. 180). There may even be a special point to this comparison. Philip the Good was constantly likened to, and even represented in the guise of, Alexander the Great (for a series of tapestries so portraying him, see Warburg, *op. cit.*, I, pp. 241 ff., 386 ff., with further references). To glorify Philip's court musician as "the new Timotheos" thus meant to glorify Philip himself as "the new Alexander" — and, incidentally, Jan van Eyck as "the new Apelles."

3. Weale-Brockwell, p. 148 ff.; Friedländer, I, p. 91, pl. XXVII; de Tolnay, *Le Maître de Flémalle*, p. 71, no. 19, fig. 115; Beenken, *Hubert und Jan*, p. 52 f., fig. 31; Musper, fig. 129; Cornette, *op. cit.*, fig. 20; Baldass, *Eyck*, pl. 143. The late date proposed by most recent writers (see also S. Pierron, "Le Portrait de Baudoin de Lannoy," *Revue de l'Art Ancien et Moderne*, XXXVI, 1914–1919, p. 263 ff.) does not appear convincing to me. While it is true that the Lannoy portrait is more detailed and "analytical" than the "Tymotheos" a similar contrast exists between the portrait of the Canon van der Paele and that of Jan de Leeuw, both dated 1436, and the age of the Chamberlain, born in 1386 or 1387, may be *ca.* forty-five as well as *ca.* fifty.

4. Not counting the breast-molding, the proportions of the field are *ca.* 26.8 cm. by 19 cm. in the "Tymotheos" as compared to 26 cm. by 20 cm. in the Lannoy portrait.

Page 198

1. Weale-Brockwell, p. 112 ff.; Friedländer, I, p. 52, pl. XIX; de Tolnay, *Le Maître de Flémalle*, p. 70, no. 16, fig. 113; Beenken, *Hubert und Jan*, p. 54 f., fig. 80; Musper, fig. 153; van Puyvelde, *Primitives*, pl. 10; Cornette, *op. cit.*, fig. 9; Baldass, *Eyck*, pl. 136 (color), fig. 70. Cf. Davies, *National Gallery Catalogues, Early Netherlandish School*, p. 34 f.

2. Cf. Panofsky, *Albrecht Dürer*, I, p. 16 (with reference to the self-portraits of Dürer and his father, reproduced *ibidem*, II, figs. 1, 2). In Italy, where the "look out of the picture" occurs in narratives as early as the fourteenth century and was explicitly recommended by Leone Battista Alberti (cf. p. 16), it does not seem to appear in portraits until comparatively late. The earliest instance known to me is furnished by the portraits of Giotto and Donatello in the still enigmatic and badly preserved "Five Fathers of Perspective" in the Louvre, now mostly ascribed to Paolo Uccello and dated *ca.* 1440–1450 (cf. W. Boeck, *Paolo Uccello*, Berlin, 1939, pp. 32, 111; pl. 16).

3. This earliest identification has recently been defended by van Puyvelde, "De Reis van Jan van Eyck naar Portugal." See also E. Schenk [zu Schweinsberg], "Selbstbildnisse von Hubert und Jan van Eyck," *Zeit-

schrift für Kunst (Leipzig), III, 1949, p. 4 ff.; and, most particularly, M. Meiss, "Nicholas Albergati and the Chronology of Jan van Eyck's Portraits," *Burlington Magazine*, XCIV, 1952, p. 137 ff. This excellent article appeared too late to be considered in the text (except for its main thesis, the relatively late dating of the Vienna Albergati portrait, which Professor Meiss was kind enough to communicate to me *avant la lettre* and with which I wholeheartedly agree). I am delighted to find myself in agreement with Professor Meiss also in most other respects. The interpretation of the London "Man in a Red Turban" as a self-portrait finds some support in the fact that the little "mirror image" on the buckler of the St. George in the "Madonna van der Paele" (cf. note 183 ³) shows the painter in the same costume. No special relation, however, seems to exist between the London portrait and the Portrait of Margaret van Eyck at Bruges (fig. 267) which faces in the same direction and measures 32.6 cm. by 25.8 cm. without the frame whereas the "Man in a Red Turban," while measuring 33.3 cm. by 25.8 cm. with the frame, measures only 25.7 cm. by 19 cm. without it (cf. Professor Meiss' Letter to the Editor in *Burlington Magazine*, XCV, 1953, p. 27). The rather ridiculous figure near the left margin of an "Adoration of the Magi" ascribed to Vrancke van der Stockt, which has been identified with Jan van Eyck because of a garbled inscription on its garter (A. Minghetti, "Un nuovo documento per l'iconografia dei van Eyck," *Arte*, XLIII, 1940, p. 36 ff.), is a clumsy inversion of the courtier near the right margin of the "Vision of Augustus" in Roger's Middelburg altarpiece (our fig. 338 *a*) and "has nothing to do with the case."

4. This alternative identification, proposed by Weale in 1910 (see Weale-Brockwell, p. 113) was announced as a new hypothesis by C. Aulanier, "Marguerite van Eyck et l'Homme au Turban Rouge," *Gazette des Beaux-Arts*, ser. 6., XVI, 1936, p. 57 ff.

5. Weale-Brockwell, p. 127 ff.; Friedländer, I, p. 58; de Tolnay, *Le Maître de Flémalle*, p. 71 f., no. 21, fig. 117; Beenken, *Hubert und Jan*, p. 55, fig. 79; Musper, fig. 159; Cornette, *op. cit.*, fig. 18; Baldass, *Eyck*, pl. 142, fig. 74.

Page 199

1. Weale-Brockwell, p. 75 ff.; Friedländer, I, p. 91, pl. XXXVI; de Tolnay, *Le Maître de Flémalle*, p. 71, no. 20, fig. 116; Beenken, *Hubert und Jan*, p. 52, fig. 76; Musper, fig. 151; Cornette, *op. cit.*, fig. 14; Baldass, *Eyck*, pl. 141. So far as I know, the Sibiu portrait has thus far been doubted only by K. Voll, *Die altniederländische Malerei von Jan van Eyck bis Memling*, Leipzig, 1906, p. 45. It lacks, in fact, both the con-

tentual profundity and the formal integration of other portraits by Jan van Eyck. The personality of the sitter does not project itself with the quiet authority characteristic of Jan's other subjects. The hands and ears give the impression of detachable units rather than parts of an integral whole. And the very fact that both hands are shown in their entirety is hard to reconcile with Jan's fine feeling for balance. It should also be noted that the dimensions of the panel do not conform to his usual practice. Jan van Eyck's other portraits are fairly standardized in size; the largest measures 35 cm. by 29 cm., the smallest 26 cm. by 19.5 cm., the average amounting to 30 cm. by 21 cm. The Sibiu portrait, measuring 17.4 cm. by 10.5 cm., is only about half that size. In style, it has a certain similarity with the equally small "Portrait of a Young Man" in the National Gallery at London, no. 2602 (M. Davies, *Early Netherlandish School*, p. 94 f.) but may well be a product of that "Archaism of about 1500" which, it seems, also gave birth to the Berlin "Man with a Pink."

2. Weale-Brockwell, p. 133 ff.; Friedländer, I, p. 64, pl. XXII; de Tolnay, *Le Maître de Flémalle*, p. 72, no. 22, fig. 118; Schöne, p. 50; Beenken, *Hubert und Jan*, p. 56 f., fig. 81; Musper, fig. 169; van Puyvelde, *Primitives*, pls. 18, 19 (color); Cornette, *op. cit.*, fig. 21; Baldass, *Eyck*, pls. 145, 146. For full documentation and many excellent illustrations, see Janssens de Bisthoven and Parmentier, *op. cit.*, p. 32 ff.

3. A. Burroughs, "Jan van Eyck's Portrait of His Wife," *Mélanges Hulin de Loo*, Brussels and Paris, 1931, p. 66 ff. Mr. C. T. Eisler has made the very good suggestion that the awkward hand and forearm may have been added, not by Jan himself but by Petrus Christus who may have finished Margaret's portrait as he demonstrably did the Medici "St. Jerome" and the "Rothschild Madonna."

Page 200

1. Weale-Brockwell, p. 103 ff.; Friedländer, I, p. 89, pl. XXXIV; de Tolnay, *Le Maître de Flémalle*, p. 69 f., no. 14, fig. 111; Beenken, *Hubert und Jan*, p. 51 f., fig. 75; Musper, fig. 150; van Puyvelde, *Primitives*, pls. 16; Cornette, *op. cit.*, fig. 5; Baldass, *Eyck*, pl. 134, fig. 69; Meiss, " 'Nicholas Albergati' and the Chronology of Jan van Eyck's Portraits." The change in the contour of the forehead is also noticeable in the X-ray photograph (Wolters, *op. cit.*, fig. 11). For the history of Albergati's veneration as a "Beatus," see Panofsky, "A Letter to St. Jerome."

2. Weale-Brockwell, p. 106 ff. (for a complete transliteration of the color notes, see Weale, *Hubert and John van Eyck*, p. 61); Friedländer, I, p. 90; de Tolnay, *Le Maître de Flémalle*, p. 73, no. 5, fig. 110;

Beenken, *Hubert und Jan*, p. 51 f., fig. 74; Cornette, *op. cit.*, fig. 4; Baldass, *Eyck*, pl. 133; Meiss, " 'Nicholas Albergati'."

3. I agree with de Tolnay, *Le Maître de Flémalle*, p. 73 f., in rejecting the drawings enumerated and in part illustrated under nos. 1–9; see also Baldass, *Eyck*, pls. 108–111, 151, 152 (corresponding to de Tolnay's nos. 7, 3, 1, respectively). For de Tolnay's nos. 1 and 2 ("Portrait of a Falconer" and "Portrait of a Lady," both preserved in the Städelsches Kunstinstitut at Frankfort), cf. recently Schenk, *op. cit.*, incomprehensively ascribing them to Hubert van Eyck. In my opinion the "Falconer" (ill. in Friedländer, I, pl. XLVIII; de Tolnay, fig. 144; Baldass, fig. 151; our fig. 424) reflects a work by Petrus Christus, and the same may be true of no. 6 ("Two Female Heads," Galleria Sabauda at Turin) while no. 5 ("Portrait of a Lady," Boymans Museum at Rotterdam, Baldass, p. 291, no. 85) may be an original by this master; for these three drawings, see note 310 [7]. For no. 9 (the "Annunciation" at Wolfenbüttel, Baldass, p. 291, no. 83, our text ill. 62) see note 344 [4]; and for the much-discussed Berlin "Adoration of the Magi" (Baldass, pl. 168, our fig. 302), p. 237 f. Whether or not the "Portrait of a Youngish Man" in the Boymans Museum at Rotterdam belongs in the circle of Jan van Eyck, as tentatively suggested by L. Baldass "Die Zeichnung im Schaffen des Hieronymus Bosch und der Frühholländer," *Die Graphischen Künste*, new ser., II, 1937, p. 18 ff., fig. 1), is difficult to decide in view of its unsatisfactory condition. I am, however, convinced that the four full-length portraits of Burgundian princes (Friedländer, XIV, p. 78; de Tolnay, p. 72 f., nos. 1–4, figs. 119–122; Baldass, pls. 147–150; our figs. 380–383) were produced in the entourage of Roger van der Weyden about 1455 rather than by Jan van Eyck in his youth, and that they suggest an earlier date only because most of them were copied from originals of the beginning of the fifteenth century; for a fuller discussion of this problem, see note 291 [4].

4. Dürer, engraving B. 107. See Panofsky, *Albrecht Dürer*, I, p. 239 f.; II, pp. 30 (no. 214), 106 (no. 1020), and fig. 305.

5. Cf. de Tolnay, *Le Maître de Flémalle*, p. 34.

Page 201

1. Weale-Brockwell, p. 146 f.; Friedländer, I, p. 92, pl XXXVIII; de Tolnay, *Le Maître de Flémalle*, p. 71, no. 18, fig. 114; Beenken, *Hubert und Jan*, p. 53 f., fig. 77; Musper, fig. 157; Cornette, *op. cit.*, fig. 10; Baldass, *Eyck*, pl. 144. Those who believe the London double portrait (our fig. 247) to represent the painter and his wife (see note 203 [3]) must, of course, proclaim

the Berlin panel, from which all characteristics of an *autoritratto* are conspicuously absent, as a self-portrait.

2. Weale-Brockwell, p. 80 ff.; Friedländer, I, p. 93, pl. XXXIX; de Tolnay, *Le Maître de Flémalle*, p. 77, no. 3 (rejected); Beenken, *Hubert und Jan*, p. 57, note, fig. 100 (rejected); Musper, fig. 131; Cornette, *op. cit.*, fig. 3; Baldass, *Eyck*, pl. 156 (rejected). Though a number of scholars (including Schöne, p. 23, and Ring, *A Century*, Cat. no. 144, fig. 34) still accept the picture as an early work by Jan van Eyck (Schenk, *op. cit.*, even ascribes it to Hubert as a late self-portrait), Karl Voll's emphatic objections (*Die Werke des Jan van Eyck*, p. 113 ff.; *Die altniederländische Malerei*, p. 44 f.) appear incontrovertible. It should be added that the very technique of the picture, with lead white used so lavishly that the X-ray looks almost like a normal photograph, essentially differs from that of the van Eycks, and most particularly from Jan's (see Burroughs, *Art Criticism from a Laboratory*, p. 246 f., fig. 114); and the "broken-color pink" (viz., a plant the blossoms of which are not all pink but partly white and partly scarlet) was, according to the excellent expert, the late Mrs. Eleanor C. Marquand, not known in the first half of the fifteenth century.

3. Weale-Brockwell, p. 114 ff.; Friedländer, I, p. 55, pl. XXI; de Tolnay, *Le Maître de Flémalle*, p. 70, no. 17, figs. 85–100; Schöne, p. 49; Beenken, *Hubert und Jan*, p. 60 ff., figs. 82, 84, 85; Musper, fig. 155; van Puyvelde, *Primitives*, pl. 11; Cornette, *op. cit.*, figs. 11–13; Baldass, *Eyck*, pls. 137–140 (one in color), figs. 72, 73. Cf. Davies, *National Gallery Catalogues, Early Netherlandish School*, p. 33 f.; and, for the chandelier, Rorimer, "A Treasury at the Cloisters," p. 250 f. For an appreciation of the picture in more general terms, see Kauffmann, "Jan van Eycks 'Arnolfinihochzeit.'" Davies' tentative suggestion that the position of Jeanne Cenami's hand may be another marriage symbol can be corroborated by the wedding scene in Roger van der Weyden's altarpiece of the Seven Sacraments (our fig. 349*b*) where the same gesture occurs.

Page 202

1. Munich, Staatsbibliothek, cod. gall. 16, fol. 35, reproduced (but erroneously captioned "French" instead of "English") in E. Panofsky, "Jan van Eyck's Arnolfini Portrait," *Burlington Magazine*, LXIV, 1934, p. 117 ff., p. 125. Cf. D. D. Egbert, "A Sister to the Tickhill Psalter; the Psalter of Queen Isabella of England," *Bulletin of the New York Public Library*, XXXIX, 1935, p. 759 ff.

2. See the tapestry in Cleveland, published in *The Bulletin of the Cleveland Museum of Art*, XIV, 1927, p. 34 ff.

3. Cf. H. Rosenau, "Some English Influences on Jan van Eyck, with Special Reference to the Arnolfini Portrait," *Apollo*, XXXVI, 1942, p. 125 ff., fig. IV. The author shows that the somewhat unorthodox motif of the bridegroom's grasping the bride's right hand with his left is not infrequent in English matrimonial tomb slabs.

Page 203

1. For the correctness of this translation, see the little discussion in *Burlington Magazine*, LXV, 1934, pp. 135, 189, 296 f.

2. See the delightful miniature in the *Traités divers* of Jean Mansel (Paris, Bibliothèque de l'Arsenal, ms. 5206, fol. 174, reproduced in Martin and Lauer, *op. cit.*, pl. LXXVI). It shows a married couple in bed, slippers on the floor and a candle burning before a statue of Moses holding the tablets, while a child is sent down to them by the Trinity Which appears in a cloud, surrounded by a scroll inscribed: "Faciamus hominem ad ymaginem et similitudinem nostram."

3. Recently, M. W. Brockwell, *The Pseudo-Arnolfini Portrait; A Case of Mistaken Identity*, London, 1952, has attempted to revive the old hypothesis according to which the London picture is not identical with the well-documented portrait of Giovanni Arnolfini and Jeanne Cenami in the act of contracting matrimony, traceable in Hapsburg ownership from 1516 to 1789, but is an ordinary double portrait of the painter and his wife, produced in the ninth or tenth year of their marriage (see also the rejection of this attempt in *The [London] Times Literary Supplement*, LII, 1953, January 9, and Mr. Brockwell's extraordinary answer, *ibidem*, February 13, 1953). There is, however, no evidence to show that Jan van Eyck ever painted a portrait of himself and his wife that might have been mistaken for the recorded marriage portrait of the Arnolfini couple. There is no evidence to show that the Arnolfini portrait was destroyed by fire in Madrid; it simply vanishes from the Spanish scene after 1789. There is no evidence to show that the panel now preserved in the National Gallery, the whereabouts of which is entirely unknown up to the time when it appeared in Belgium about 1815 and in the following year was offered to the Regent of Great Britain for approval (see O. Millar, "Jan van Eyck's Arnolfini Group: An Addition to its History," *Burlington Magazine*, XCV, 1953, p. 97 f.), had "never left the Netherlands" and, therefore, cannot be identical with the Hapsburg picture, last heard of at Madrid in 1789. In short, Mr. Brockwell provides the extant and recorded picture, A, with an imaginary *Doppelgänger*, X, and then proceeds to accuse all those who refer to A as "A" of "confusing" it with X — a neat variation

on the old Megarian paralogism known as ὁ κερατίνης: "Have you lost your eyes?," asks the logician. "No." "So you have your eyes." "Yes." "Have you lost your ears?" "No." "So you have your ears." "Yes." "Have you lost your horns?" "No." "So you have your horns." Moreover, Mr. Brockwell is unable to explain either the famous inscription "Johannes de Eyck fuit hic" or the *fides levata* and *fides manualis* gestures which caused the sixteenth-century observers to designate the Hapsburg picture as a "Betrothal" (see also notes 202 ¹,²). The only arguments against the London panel's identity with the Arnolfini portrait, and against its matrimonial significance, which may impress the uninitiated are easily refuted. Mr. Brockwell has failed to prove that any of Giovanni Arnolfini's and Jeanne Cenami's relatives — deduced from "genealogical *alberi*" in *The Pseudo-Arnolfini Portrait*, p. 79, and multiplying like rabbits in *The Times Literary Supplement* of February 13 — were alive and on hand at Bruges in 1434 (as a matter of fact, Jeanne Cenami's well-known great-uncles, the Rapondi brothers, were all dead and buried before December 16, 1432). That the London panel shows no traces of the shutters, allegedly emblazoned with the Guevara arms, which protected the Arnolfini portrait while it was owned by the Hapsburgs is due to the simple fact that the original frame to which these shutters were attached is lost. That the bridegroom grasps the right hand of the bride with his left is an anomaly often found in English art with which Jan van Eyck was demonstrably familiar (see note 202 ³). And if Giovanni Arnolfini's Flemish costume were a valid argument against his Italian origin we should be forced to rechristen all the Portinaris, Baroncellis, Tanis and Tanaglis who, when portrayed in Flanders and by Flemings, may also strike Mr. Brockwell as aborigines.

4. For the contested early works, see p. 232 ff. For erroneous attributions not as yet discussed, see the lists in de Tolnay, *Le Maître de Flémalle*, p. 77, nos. 1–7, and Baldass, *Eyck*, p. 288 ff., pls. 77, 153–155. Of these apocryphal works, Musper accepts as authentic the Leipzig Portrait of a Donor (de Tolnay, p. 77, no. 5; Musper, fig. 118; Baldass, pl. 155; Beenken, *Hubert und Jan*, p. 49, fig. 25), and the little Portrait of a Gentleman, who recurs as a donor in the "Fountain of Life" in the Prado, at Berlin (de Tolnay, p. 77, no. 4; Musper, p. 102, fig. 109; Baldass, p. 288, no. 65). The "Fountain of Life" itself poses a difficult problem. In the earlier literature it used to be ascribed to Hubert van Eyck, a view still held by P. Post ("Hubertus d Eyck Major Quo Nemo Repertus" and "Der Stifter des Lebensbrunnens der van Eyck," *Jahrbuch der Preussischen Kunstsammlungen*, XXXIII, 1922, p. 120 ff.). Musper and F. Winkler ("Die Stifter des Lebens-

brunnens und andere Van-Eyck-Fragen," *Pantheon*, VII, 1931, pp. 188 ff., 255 ff.) believe it to be a copy after an original produced by Jan van Eyck about 1436, and Baldass calls it a copy after an original produced by a follower of Jan. In view of the Lützschena drawing mentioned in note 108 [1] I am inclined to think that the author of the Prado picture, though unquestionably acquainted with the Ghent altarpiece, worked from a Flemish (though not necessarily Hubertian) archetype established not later than *ca.* 1420; so that, while the Prado picture in many ways depends upon the Ghent altarpiece, its archetype, as inferable from the Lützschena drawing, antedates the Ghent altarpiece and may be regarded as one of its possible sources. The Berlin portrait traditionally held to represent Bonne d'Artois (de Tolnay, p. 77, no. 6; Musper, p. 102, fig. 108; Baldass, *Eyck*, p. 281, no. 22a) is considered by Musper as a copy of an original of *ca.* 1425 whereas Winkler (in the article just quoted) and Baldass believe it to be a partial copy after the Jeanne Cenami in the London Arnolfini portrait. For a circumstantial discussion of the problem (from which it appears that the sitter can neither be Bonne d'Artois nor, as has been quite unreasonably supposed by some writers, Isabella of Portugal), see the recent Catalogue of the Museum at Cadiz where a replica of the Berlin portrait is preserved: C. Peman y Pemartin, *Museo Provincial de Bellas Artes de Cadiz, Catalago de las Pinturas*, Cadiz, 1952, p. 3 ff. The truly startling attribution of the "Portrait of a Fool" in the Gemäldegalerie at Vienna (M. W. Brockwell, "A New van Eyck," *Connoisseur*, CXXIV, 1949, p. 79 f.; Baldass, p. 288, no. 66) is in my and others' opinion unacceptable and has not gained in probability through an essay by R. J. M. Begeer," Le Bouffon Gonella peint par Jan van Eyck," *Oud Holland*, LXVII, 1952, p. 125 ff. Through an Italian miniature Mme. Begeer has corroborated what was known from the inventory of Archduke Leopold Wilhelm of Austria, anyway, namely, that in the seventeenth century the person portrayed in the Vienna picture was believed to be identical with one of the three Gonellas who served the Estes at Ferrara as court jesters, possibly with the one who lived under Niccolo III d'Este (1391 and 1441) and was thus a contemporary of Jan van Eyck. She has not proved, however, that this belief was correct (and when we remember that, conversely, the *bona fide* portrait of another court jester, Daniel Hopfer's well-known etching of Kunz von der Rosen, was held in the seventeenth century to represent a fourteenth-century pirate, we may well be skeptical of such posthumous identifications). She can account for a meeting between Gonella and Jan van Eyck only by the alternative hypotheses that Jan van

Eyck made a trip to Italy or that the Ferrarese court jester accompanied Cardinal Albergati on one of his journeys to the Netherlands. And she will hardly convince the reader that the style of the Vienna "Fool" is compatible with that of the London "Man in a Red Turban" or, for that matter, any other portrait by Jan van Eyck.

5. For works transmitted by copies other than the "Turin-Milan Hours" (for which see p. 232 ff.), see Friedländer, I, p. 109 ff., and the list in de Tolnay, *ibidem*, p. 75 f., nos. 1–11; cf. also Baldass, *Eyck*, p. 283 f. For de Tolnay's no. 1 (the "Ypres altarpiece"), see, however, above, p. 190 f.; for no. 2 (the "Holy Face"), above, p. 187, and note 187 [1]; for no. 5 (the Detroit "St. Jerome"), above, p. 188 ff. Willem van Haecht's "Gallery of Cornelis van der Geest" of 1628 (formerly owned by Lord Huntingfield, now, as I learn from Professor Julius Held, by Mrs. Mary van Berg at New York) transmits an Eyckian "Bathing Scene" (de Tolnay, p. 76, no. 10; Weale, *Hubert and John van Eyck*, p. 176; Weale-Brockwell, p. 197; Musper, fig. 156; Baldass, *Eyck*, figs. 79, 80) entirely unlike the superficially analogous composition described by Fazio; Professor Held will show that it represents a quasi-religious ritual rather than a mere genre scene.

In a number of cases not only the faithfulness of the copy but the very existence of an Eyckian original is open to doubt. This, I should say, is true of the "Hunting Party" at Versailles (de Tolnay, p. 76, no. 9; Baldass, fig. 77); the two portraits at Montauban and Philadelphia (de Tolnay, p. 76, nos. 6 and 7; Baldass, *Eyck*, pls. 153, 154) although the latter is accepted as authentic by Musper, fig. 110; of the Weimar drawing of a "Cavalcade of the Three Magi" (de Tolnay, p. 76, no. 8; Baldass, p. 290, no. 82) which may reflect a free variation on the Riders in the Ghent altarpiece rather than an independent original; and of the engraving known as "The Great Garden of Love" (de Tolnay, p. 76, no. 11; Baldass, *Eyck*, fig. 78) whose connection with Jan's early murals in John of Bavaria's castle at The Hague is admittedly conjectural.

Whether a Spanish Madonna in the Museum at Covarrubias, unaccountably quoted as a "work of Petrus Christus signed and dated 1452" in Arù and de Geradon, *op. cit.*, p. 4 (S. Reinach, "A Copy from a Lost van Eyck," *Burlington Magazine*, XLIII, 1923, p. 15 ff.; C. R. Post, *A History of Spanish Painting*, Cambridge, 1930–1950, IV, p. 18 ff., fig. 1), in fact reflects a lost composition by Jan van Eyck or, like the so-called Petrus Christus in the Galleria Sabauda at Turin (Arù and de Geradon, p. 1 ff., pls. I–VIII), represents a free variation on the "Ince Hall Madonna" embellished by other Eyckian — and, in the case of

the Turin panel, Flémallian — motifs is hard to decide.

6. For works known to us only through literary sources, see the lists in Weale-Brockwell, pp. 195–207, Friedländer, I, p. 109 ff., and de Tolnay, *Le Maître de Flémalle*, p. 78 f., nos. 1–14; Baldass, *Eyck*, p. 285. An approximate idea of the "circular map of the world where not only the places and location of regions but also the measurable distances between the places could be recognized" may be conveyed by the famous "Mappamondo Estense" (*Mappamondo Catalano della Estense, edito col concorso di S. E. il Ministro della Pubblica Istruzione pel Comitato ordinatore del Sesto Congresso Geografico Italiano in Venezia, annotato da Mario Longhena e Francesco L. Pullè*, Modena, 1907). In many cases the correctness of the attribution is, of course, open to question; in that of a "picture with half-length figures representing a patron making up his accounts with an agent" (Weale-Brockwell, p. 200; de Tolnay, no. 13), the ancient witness himself vacillates between Jan van Eyck and Memlinc, although the former attribution may possibly be correct (see p. 354). One composition, finally, deserves to be transferred from the class of works transmitted through mere descriptions to that of works transmitted through copies: as C. R. Post has shown, the "St. George on Horseback" acquired by Alphonso of Aragon in 1445 (Weale-Brockwell, p. 198; de Tolnay, no. 4) served as a model for the "St. George" by Pedro Nisart in the Museo Arqueologico at Palma de Mallorca (Post, *A History of Spanish Painting*, VII, 2, p. 615 ff., fig. 237, our fig. 272).

Page 204

1. See p. 127 f.

2. The peculiar charm of these prospects into the open consists of the fact that they combine two adaptations of the eye (long focus and short focus) as well as two kinds of light (perfect "interior light" and perfect "outdoors light") into a "total vision" which could never be obtained in practice yet is, in a sense, more "real" than reality: "This combination of one kind of light in the foreground with another kind in the landscape background . . . is an example of the general rationalization of all this painting. After all, if one sits in a room where one can by one adaptation of the eye see objects in the room and by another adaptation can look out of a window and see a distant mountainous landscape, one's concept is not confined to what one sees at either moment by itself but is a combination of the two. A painting in the manner of van Eyck would be a truer record of one's memory — of one's concept — than a painting in the manner of a nineteenth-century impressionist. The other day a

friend of mine showed me some photographs of his country house in New Hampshire. Some of these were of rooms in the house with views of the mountains seen through large windows. Each photograph was made by taking first of all a long exposure of the room with the outside shutters of the facing window closed; then without moving the camera the shutters of the window were opened and a short exposure was made to take in the landscape. The result suggested more of the actual experience of being in the room and looking out at the landscape than would have been possible with an ordinary photograph. The combination of two light effects to satisfy one's idea suggested the nonliteral rendering of concept by Van Eyck" (Pope, *op. cit.*, p. 102, note 1 [3rd ed., p. 97, note 14]).

Page 205

1. See E. Renders, *Hubert van Eyck, personnage de légende*, Paris and Brussels, 1933; ———, *Jean van Eyck, son oeuvre, son style, son évolution et la légende d'un frère peintre*, Bruges, 1935. Renders' revolutionary theory was more or less wholeheartedly accepted by M. J. Friedländer (see Friedländer, XIV, p. 73 ff.), M. W. Brockwell ("The Ghent Altarpiece: The Inscription Obliterated," *Connoisseur*, CXXI, 1948, p. 99 ff., and "'Hubert van Eyck'; The 'Hubertist' Bubble Finally Deflated," *ibidem*, CXXX, 1952, p. 111 ff.); and Tovell, *op. cit.*, pp. 89 ff., 117 ff. The traditional view, upheld by most other scholars, was defended by J. Duverger, *Het Grafschrift van Hubrecht van Eyck en het Quatrain van hets Gentsche Lam Gods Retabel* (*Verhandelingen van de Koninklijke Vlaamsche Academie voor Wetenschapen, Letteren en Schoone Kunsten*, VII, 4), Antwerp and Utrecht, 1945; see also ———, "Jan van Eyck voor 1422," and "Is Hubrecht van Eyck een legendarisch Personage?," *Kunst, Maandblad voor Oude en Jonge Kunst*, IV, 1933, p. 161 ff. See further H. Beenken, Review of Renders' earlier book, in *Kritische Berichte zur Kunstgeschichtlichen Literatur*, III/IV, 1930–32, p. 225 ff.; the articles referred to in Panofsky, "The Friedsam Annunciation," p. 454, note 36; de Tolnay, *Le Maître de Flémalle*, p. 18; van Puyvelde, *Agneau*, p. 86 ff.; and many of the books and articles referred to in the following notes.

2. Cf. Weale-Brockwell, p. xxxi ff.; the reference to the Visch-Van der Capelle bequest, *ibidem*, p. 200.

3. Weale-Brockwell, p. 5 ff. Cf. F. Lyna, "Uit en over Handschriften, II," (publication of an unnoticed sixteenth-century transcription); ———, "Over de Echtheid van de Grafschrift van Hubrecht van Eyck en het Quatrain van de Gentsche Altartafel," *Verzamelde Opstellen* (published by the Belgian State

Archives at Hasselt), IX, 1933, p. 99 ff.; Duverger, *Het Grafschrift van Hubrecht van Eyck*.

Page 206

1. Good but somewhat divergent reproductions of the inscription are found in van Puyvelde, *Agneau*, p. 87, and in the monumental though preliminary publication about the Ghent altarpiece by P. Coremans and A. Janssens de Bisthoven, *Van Eyck; The Adoration of the Mystic Lamb*, Amsterdam, 1948, fig. 209; see also Baldass, *Eyck*, fig. 87. The authenticity of the quatrain was first doubted by Lyna, "Uit en over Handschriften, II," (a fact not evident from Renders' publications) and subsequently defended — mostly with the reservation that it was put on at Ghent and not by Jan van Eyck himself — by the authors mentioned in note 205[1], especially Duverger. In my transliteration of the hexameters I follow Hulin de Loo, "La Fameuse Inscription du retable de l'Agneau," *Revue Archéologique*, ser. 6, III, 1934, p. 62 ff., and P. Debouxhtay, "A propos de l'Agneau Mystique," *Revue Belge d'Archéologie et d'Histoire de l'Art*, XIII, 1943, p. 149 ff., and XIV, 1944, p. 169 ff., rather than P. Faider, "Pictor Hubertus . . .; A propos d'un ouvrage récent," *Revue Belge de Philologie et d'Histoire*, XII, 1933, p. 1273 ff., and V. Tourneur, "Un Second Quatrain sur l'Agneau Mystique," *Académie Royale de Belgique, Bulletin de la Classe des Lettres et des Sciences Morales et Politiques*, ser. 5, XXIX, 1943, p. 57 ff. That the abbreviated word after *pondus* must be read as *que* and not as *quod* is evident from both paleographical and metrical considerations and the only objection, the period after *pondus*, can be met by pointing out that the punctuation in epigraphs of the time is often ornamental rather than grammatical (cf., e.g., the period between TYM and ΩTHEOS in Jan van Eyck's London portrait); the sentence must therefore be broken after *Incepit*. *Perfunctus* is preferable to either *perfecit* or *perpessus* because it could most easily be misread into *perfectus* (as in Christopher van Huerne's transliteration of the then undamaged inscription); because it rhymes with *fretus* no better but no worse than *mai* does with *tueri*; and because the phrase "pondus perfunctus" has a good classical parallel in Fronto's "onera [quaestoris] perfunctus est." I deviate (for epigraphical reasons) from Hulin de Loo's reading only in retaining *e eyck* instead of *deyck*. That *deyck* would scan better is not an absolutely cogent argument because *sexta mai* does not scan very well either, even if the *sexta* were to be interpreted as a nominative (as implied by van Puyvelde when he translates: "le sixième jour de mai vous invite . . ."); for, *mai* should count as two long syllables (cf. Ovid, *Fasti*, V, 185). For the signifi-

cance of the phrase "Judoci Vijd prece," cf., e.g., the famous colophon of the *Nuremberg Chronicle* of 1493, fol. 300 v.: "Ad intuitum *et preces* providorum civium Sebaldi Schreyer et Sebastiani kamermaister hunc librum dominus Anthonius koberger Nuremberge impressit"; Maximilian de Vriendt's quatrain discovered by Tourneur contains the unequivocal statement: "Eyckius hos Vytii reddidit [not *reddit*] aere patres," which means: "Van Eyck depicted these Parents for Vyd's money." The suggestion to interpret the unambiguous *incepit* as "approximately synonymous with *inauguravit*," so that Hubert would not have actually begun but only in some mysterious fashion "initiated" the Ghent altarpiece (Musper, p. 75 f.), is unacceptable even from a purely linguistic point of view.

2. This is the opinion of Renders, *Hubert van Eyck*.

3. See Panofsky, "The Friedsam Annunciation," p. 454, note 36.

Page 207

1. Weale-Brockwell, p. 202 f.

2. Cf. J. Duverger, "Huibrecht en Jan van Eyck; Eenige nieuwe Gegevens betreffende hun Leven en hun Werk," *Oud Holland*, XLIX, 1932, p. 161 ff.; van Puyvelde, *Agneau*, p. 90 f. E. P. Goldschmidt, *Hieronymus Münzer und seine Bibliothek* (Studies of the Warburg Institute, IV), London, 1938, p. 72 f., believes that the Ghent canons had meant to point out to Münzer the tomb of Jan — although their civic pride could have been interested only in Hubert, and although they must have known that Jan had died and was buried at Bruges.

3. *De Beatis, die Reise des Kardinals Luigi d'Aragona; Erläuterungen zu Janssens Geschichte des deutschen Volkes*, L. Pastor, ed., IV, 4, Freiburg, 1905, p. 117. It has been thought that the *Magna Alta* refers to "het keizerrijk tot onmiddellijk tot Westen van Keulen," viz., the "Holy Roman Empire." It should be noted, however, that the words *dietsch* and even *duitsch* very often denoted the eastern — "Dutch" — as opposed to the western — "Flemish" — districts of the Lowlands themselves and could thus easily be applied to a native of Maaseyck or Maastricht active at Ghent; a Dutch Book of Hours, written at Leiden, is designated as being written *in duytsche* (New York, Morgan Library, ms. 71, fol. 59, illustrated in Byvanck, *Boekillustratie*, fig. 66), and Verwijs and Verdam, *op. cit.*, s.v. "Dietsch," list such phrases as: "Duuts, dietsch, brabants, vlaamsch" or: "*Plumbum* heet men in Dietsche *bli*, ende in Vlaemsce *loet*." Thus the canons of Ghent, when speaking French and trying to convey the idea that the master of the Ghent altarpiece was not a Fleming but a native of the east-

442

ern sections of the Netherlands, were likely to translate the words *Dietschland* or *Duitschland* as *Allemagne*, which in turn was rendered as *Magna Alta* by de Beatis.

4. A. P. de Schryver and R. H. Marijnissen, *De Oorspronkelijke Plaats van het Lam Gods-Retable* (*Les Primitifs Flamands, Contributions à l'Etude des Primitifs flamands, I*), Antwerp, 1952. The authors, basing their conclusions on newly discovered original documents, correctly point out that the same conclusions should have been reached long ago by a more careful interpretation of de Beatis' description which, when read in context, clearly places the Ghent altarpiece in the *succorpo* (crypt) beneath the *choro relevato*.

5. F. J. Mather, Jr., "The Problem of the Adoration of the Lamb," *Gazette des Beaux-Arts*, ser. 6, XXIX, 1946, p. 269 ff.; XXX, p. 75 ff. It does not seem admissible to estimate the amount of time consumed by the old masters by modern standards, especially since we know very little about the division of labor in their workshops; and it should be noted that Dürer completed a portrait in oils — certainly a careful piece of work since the sitter was King Christian II of Denmark — within about a week (Lange and Fuhse, *op. cit.*, p. 177, 10 ff.): Dürer arrived at Brussels on July 3, 1521, and left on July 12, after having "lain idle" for two days (for want of transportation) and led an active social life all the time. In addition, Mather deducts from Jan van Eyck's "working potential" a number of paintings not contemporaneous with the Ghent altarpiece, even the London Arnolfini portrait of 1434.

6. Musper, p. 69.

7. The special literature about the Ghent altarpiece is perfectly enormous; even the bibliographical appendix of the monograph by Coremans and Janssens de Bisthoven (p. 39 ff., enumerating ninety items) is far from being complete. There are, in addition to this publication and van Puyvelde's *Agneau*, three earlier monographs: F. Winkler, *Der Genter Altar*, Munich, 1921; M. J. Friedländer, *Der Genter Altar von Hubert und Jan van Eyck*, Leipzig, 1921; C. de Tolnay, *Le Retable de l'Agneau Mystique des Frères van Eyck*, Brussels, 1938; and a great number of good illustrations (excepting such curious lapses as on pls. 60, 62, 63 and, most particularly, 85) can now be found in Baldass, *Eyck*, pls. 14–103 (three in color) and figs. 35, 49. In view of this plethora of illustrations, I have limited myself to a bare minimum in this volume. My own views, submitted in a discussion with H. Beenken (Panofsky, "The Friedsam Annunciation" and "Once More the 'Friedsam Annunciation'"); Beenken, "Zur Entstehungsgeschichte des

Genter Altars," and "The Annunciation of Petrus Cristus in the Metropolitan Museum and the Problem of Hubert van Eyck," *Art Bulletin*, XIX, 1937, p. 220 ff.), have naturally changed in many respects but not in principle; I am gratified to see that, in spite of all differences, there is a fairly wide area of agreement between myself and Baldass, "The Ghent Altarpiece of Hubert and Jan van Eyck," *Art Quarterly*, XIII, 1950, pp. 140 ff., 183 ff., and *Eyck*, p. 34 ff. I have not taken into account a new publication by Emil Renders, *Jean van Eyck et le Polyptique*; *Deux Problèmes Résolus*, Brussels, 1950, because its basic premises have been invalidated by even the preliminary reports on the thorough investigation to which the Ghent altarpiece was subjected in the Laboratoire Central des Musées de Belgique: P. Coremans, A. Philippot and R. Sneyers, *Van Eyck — L'Adoration de l'Agneau*; *éléments nouveaux interessant l'histoire de l'art*, Brussels, 1951, and *Palais des Beaux-Arts, Bruxelles, Traitement de l'Agneau Mystique, Guide du Visiteur*, P. Coremans, intr., Brussels, 1951 (a report by Cesare Brandi in *Bollettino dell'Istituto Centrale del Ristauro*, Rome, 1951, was not accessible to me). When the final report of the Laboratoire Central appears, and when the second volume of the Coremans and Janssens de Bisthoven monograph has come out, all previous writers, including myself, will have to revise their positions on more than one point; but I am afraid that nothing short of a personal communication from either Hubert or Jan van Eyck will convince me that the Ghent altarpiece was planned as it is now. Two recent attempts to prove the contrary (H. Peters, "Die Anbetung des Lammes; Ein Beitrag zum Problem des Genter Altars," *Das Münster*, III, 1950, p. 65 ff., and G. Bandmann, "Ein Fassadenprogramm des 12. Jahrhunderts und seine Stellung in der christlichen Ikonographie," *ibidem*, V, 1952, p. 1 ff.) fail, in my opinion, to solve the formal as well as the iconographical difficulties, especially that of the Adam and Eve panels.

Page 208

1. See Hulin de Loo, "La Fameuse Inscription du retable de l'Agneau."

2. See p. 147 f.

3. So far as I know this hypothesis was first proposed by M. E. Coosemans, reported and criticized by Hulin de Loo, *Académie Royale de Belgique, Bulletins de la Classe des Beaux-Arts*, IV, 1922, p. 7 ff. Its later champions are, apart from this writer, E. de Bruyn, "La Collaboration des Frères van Eyck dans le retable de 'l'Adoration de l'Agneau,' I," *Mélanges Hulin de Loo*, Brussels and Paris, 1931, p. 89 ff.; Beenken; "Zur Entstehungsgeschichte des Genter Al-

tars"; ———, "The Ghent Van Eyck Re-Examined," *Burlington Magazine*, LXIII, 1933, p. 64 ff.; ———, *Hubert und Jan*, p. 25 ff.; Schenk, *op. cit.*; and Renders in his three books (ascribing the whole altarpiece to Jan but believing it to be a kind of medley).

Page 209

1. See de Schrijver and Marijnissen, *op. cit.*

2. A pageant based upon the Ghent altarpiece, performed on April 23, 1458 and minutely described in the *Kronyk van Vlaenderen* (Weale, *Hubert and Jan van Eyck*, pp. lxxv, 206), was entitled, "Chorus beatorum in sacrificium agni pascalis." For an analysis of this pageant and its interpretation of the visual data, see van Puyvelde, *Agneau*, p. 60 ff. It may be added that the equation of the *chori beatorum* with the Beatitudes according to the Sermon on the Mount (Matthew V, 1–12) was obviously suggested by the fact that this passage figures as a Sequence in the Mass of All Saints.

3. In identifying the white-clad figure with the laurel wreath as Virgil I agree with Weale-Brockwell, p. 45. This identification is all the more probable since — as pointed out in Vöge's brilliant analysis of the two Sibyls on the exterior of the Ghent altarpiece, *op. cit.*, p. 93 f. — Jan van Eyck's Erythrea is the only Sibyl to be inscribed with a direct though slightly altered quotation from Virgil (*Aeneid*, VI, 50) rather than with a passage from her supposed prophecy. The interpretation of Virgil's neighbor as Isaiah rather than Jeremiah (tentatively suggested by Coremans and Janssens de Bisthoven, p. 28) is based, not only on the traditional parallelism between Isaiah and Virgil but also on Isaiah LV, 13: "Pro saliunca ascendet abies, *et pro urtica crescet myrtus*" (cf. also XLI, 19: "Dabo in solitudinem cedrum, et spinam, *et myrtum, et lignum olivae*").

Page 210

1. Beenken, "Zur Entstehungsgeschichte des Genter Altars," p. 210, note 34. To make assurance doubly sure, the Laboratoire Central conducted an examination of the wood which showed that the annual rings of the Pilgrims panel exactly coincide with those in the panel showing St. John the Evangelist. An iconographic reason for the preferred position of the "Anachoritae" is that they, but not the Pilgrims, form one of the accepted *chori beatorum* enumerated in the liturgy of the Feast of All Saints.

2. A list of identifications is found in Coremans and Janssens de Bisthoven, *op. cit.*, p. 26 ff. The traditional identification of the first and fourth Judge with Hubert and Jan van Eyck, proposed by Lucas de Heere in 1559, has recently been defended by Schenk,

op. cit., as well as by van Puyvelde, *Agneau*, p. 52, and "De Reis van Jan van Eyck naar Portugal," p. 19. It is, however, difficult to see how this view can be reconciled with the acceptance of the London "Man in a Red Turban" as another self-portrait of Jan van Eyck (cf. p. 198); one person could hardly have changed so much within a space of six or seven years at the utmost. For the identification of the four Judges with the four Counts of Flanders, see especially P. Post, "Wen stellen die vier ersten Reiter auf dem Flügel der gerechten Richter am Genter Altar dar?", *Jahrbuch der Preussischen Kunstsammlungen*, XLII, 1921, p. 67 ff., and, more recently, "Hubertus d Eyck Major Quo Nemo Repertus."

Page 211

1. According to Coremans and Janssens de Bisthoven, *op. cit.*, p. 43 ff., the three upper panels are 2.2 cm. – 2.3 cm. thick, the panels of Adam and Eve *ca.* 1.2 cm., and that of the Adoration of the Lamb *ca.* 3.4 cm. The remaining panels, sawed apart in 1893 so that the back and the front might be viewed simultaneously, are now about 0.5 cm. thick; their original thickness must thus have been about the same as that of the Adam and Eve panels is now.

2. Hulin de Loo, "Le Sujet du retable des Frères van Eyck à Gand," *passim.*

3. See note 167 [2].

Page 212

1. This point, it seems to me, is missed in most iconographic analyses of the Ghent altarpiece, even in the otherwise commendable article by E. Neurdenburg, "Eenige Opmerkingen naar Aanleiding van de nieuwste Verklaringen van de algemeene Beteekenis van het Gentsche Altaar," *Handelingen van het 3e Congres voor Algemeene Kunstgeschiedenis*, Ghent, 1936, p. 25 ff.

2. Cf., in addition to Weale-Brockwell, p. 38 ff., and the literature referred to in Coremans and Janssens de Bisthoven, *op. cit.*, p. 23, Panofsky, *Albrecht Dürer*, I, p. 126 ff.

3. Göttingen, University Library, cod. theol. 231, fol. 111; Udine, Biblioteca Capitolare, ms. 75, fol. 67 v.; cf. G. Richter and A. Schönfelder, *Sacramentarium Fuldense saeculi X* (Quellen und Abhandlungen zur Geschichte der Abtei und Diözese Fulda, IX), Fulda, 1912, pls. 33, 34. For a slightly later, more sophisticated but simplified and somewhat frozen version, see the *Collectarium* in the Treasury of Hildesheim Cathedral, ms. 688, fol. 83 v. (F. C. Heimann, "Bilderhandschrift des XI. Jahrhunderts in der Dombibliothek zu Hildesheim," *Zeitschrift für Christliche Kunst*, III, 1890, col. 137 ff., fig. VII). The latest pre-Eyckian

"Adoration of the Lamb" (apart from illustrations of the Apocalypse and Commentaries thereon) is found, so far as I know, in the Upper Church at Schwarzrheindorf, dating from the second half of the twelfth century (Clemen, *Die romanische Monumentalmalerei in den Rheinlanden*, Düsseldorf, 1916, p. 348 ff.).

4. Musical angels occur, e.g., in the instances adduced in notes 213 [5, 7–10] and in nearly all the *Cité de Dieu* manuscripts of the fifteenth century.

Page 213

1. *Golden Legend*, Feast of All Saints (Nov. 1): "One day, when the sacristan of St. Peter's at Rome had accomplished a pious visit to the altars in the church and invoked the intercession of All Saints, he finally went once more to the altar of St. Peter. There he stopped for an instant and had a vision. He saw the King of kings seated on an elevated throne and all the angels around Him. And the Holy Virgin of virgins came, crowned with a resplendent crown, and a great multitude of virgins which no man could number followed her. Then the King rose and bade her sit down on a seat at His side. And after that came a man clad in the hide of a camel, and a great number of Elders and venerable fathers followed him. Then came a man in bishop's vestments and he was followed by a great multitude in like robes, and then came a numberless multitude of knights followed by a great company of people of all kinds" (quoted, e.g., in Weale-Brockwell, p. 39).

2. This injunction, included in the Canons of the Synod "Quinisexta" of 692 (C. J. von Hefele, *Conciliengeschichte*, III, 2nd ed., Freiburg, 1877, p. 340 f.), was endorsed by Pope Hadrian II in his letter to the Patriarch Tarasius (*Patrologia Latina*, XCVI, col. 1235) and finally incorporated in Gregory's *Decreta*, Pars III, Dist. III, Canon 29. It was, however, exclusively aimed at representations of the Christ Incarnate (particularly in the Crucifixion) "ad memoriam in carne conversationis" (πρὸς μνήμην τῆς ἐν σαρκὶ πολιτείας).

3. Cf. A. de Laborde, *Les Manuscrits à peintures de la Cité de Dieu*. In one of the earliest instances, the manuscript in the Library of the Metropolitan Chapter at Prague, ms. lat. A 7, fol. 1 v. (de Laborde, pl. IV), God is represented in the guise of the Father holding two roundels in which appear the Lamb and the Dove. A special corner of the City of God is, amusingly, reserved to the Bohemians: "Spes, amor atque fides justos locat hic Boemenses."

4. Cf., e.g., the Breviary of Ercole I of Ferrara at Agram (H. J. Hermann, "Zur Geschichte der Miniaturmalerei am Hofe der Este in Ferrara," *Jahrbuch der kunsthistorischen Sammlungen des Allerhöchsten Kaiserhauses*, XXI, 1900, p. 117 ff., especially p. 217 ff., fig. 83).

5. Cf., e.g., the "Hours of John the Fearless," Paris, Bibliothèque Nationale, ms. lat. Nouv. Acqu. 3055, fol. 195 v. (Leroquais, *Un Livre d'Heures de Jean sans Peur*, pl. XIV).

6. Cf., e.g., Pigouchet's *Heures à l'Usaige de Rome* of 1498 (illustrated in Panofsky, *Albrecht Dürer*, II, fig. 173).

7. Cf., eg., the Bible in the Public Library at Leningrad, ms. V. 3. 19, fol. 1 (de Laborde, *Etude sur la Bible Moralisée*, IV, pl. 794).

8. Cf., e.g., Brussels, Bibliothèque Royale, ms. 10176, fols. 210 v., 211.

9. Brussels, Bibliothèque Royale, ms. 11129 (dated 1455 and attributed to Jean le Tavernier), fol. 125 v.; the miniature was kindly brought to my attention by Dr. Carl Nordenfalk.

10. M. Salinger, "A Valencian Retable," *The Bulletin of the Metropolitan Museum*, XXXIV, 1939, p. 250 ff. For the distinction of Old Testament personages by polygonal rather than circular haloes, cf., e.g., the "Transfiguration" in a manuscript of Johannes de Turrecremata's *Meditationes*, Biblioteca Vaticana, cod. Vat. lat. 973 (L. Donati, "Prolegomeni allo studio del libro illustrato Italiano," *Maso Finiguerra*, IV, 1939, p. 3 ff., fig. 24).

11. Paris, Bibliothèque Nationale, ms. fr. 22913, fol. 408 v. (illustrated in Panofsky, "Once More the 'Friedsam Annunciation,'" fig. 15).

Page 214

1. The existence of this *Voet-stuk*, allegedly executed in size color (which in itself makes its attribution to one of the van Eycks rather improbable) and, therefore, destroyed in an inept attempt at cleaning the altarpiece, is attested only by Mark van Vaernewyck's *Spieghel der Nederlandsche Audtheyt* of 1568 (Weale-Brockwell, pp. 38, 286). If he were right, it could only have been an antependium because the chapel which housed the altarpiece up to 1566 is much too low to permit the interposition of a regular predella between the altar and the retable.

2. Cf. the passage from the *Golden Legend*, quoted in note 213 [1]. The vacant space on the left of the Lord is standard in the *Cité de Dieu* manuscripts of the fifteenth century (cf. our text ill. 66 and numerous illustrations in Laborde, *Les Manuscrits à peintures de la Cité de Dieu*) and also occurs in the Spanish retable of *ca.* 1420 in the Metropolitan Museum (see note 213 [10]). In the Brussels miniature referred to in note 213 [9] the Virgin Mary presides over a little court of female saints directly beneath the throne of the Trinity while St. John the Baptist leads

the procession of the Elect on foot; for the "Hours of John the Fearless," where the Virgin Mary has even been awarded a place in the center of the Trinity Itself, see p. 120.

3. Thus, for example, in the Pigouchet Hours, referred to in note 213 [6], and in Dürer's "Landauer-Altar."

4. All representations of the Community of the Saints which include the figures of Adam and Eve postdate, so far as I know, the Ghent altarpiece so that the possibility of its retroactive influence cannot be excluded. In this case the subsequent demotion of the First Parents would be all the more significant.

5. See Panofsky, "Once More the 'Friedsam Annunciation,'" p. 433 ff., particularly p. 437, notes 87–89. An extraordinarily striking visual illustration of St. Augustine's phrase "where mention is made of God, the Christian understands the Trinity Itself whereby not only the Father is meant but also the Son and the Holy Ghost" is found in a beautiful leaf in the Morgan Library, ms. 742 (Italian, fourteenth century). In four medallions at the corners it shows four different ways of depicting what we may call the "explicit Trinity": Abraham visited by the three angels, the Throne of Mercy, the Three Persons in the guise of three perfectly identical figures enthroned behind an altar, and even the unorthodox type of one figure with three heads. The central picture, however, shows "Christ," youthful and cross-nimbed, enthroned on the rainbow, flanked by the rose and the lily, surrounded by the symbols of the four quarters of the universe, and worshiped by two cherubs and two music-making angels; and it is this central picture which surmounts the invocation "Alta Trinità Beata."

Page 215

1. St. Augustine, *De Trinitate*, I, 6, 9 (*Patrologia Latina*, XLII, col. 826). Owing to a misreading of the Greek Δ for a Roman "A" the words ΔNC ΔNANXIN have always been transliterated, by myself as well as others, as ANANX ANANXIN, which makes no sense. The reading in I Timothy VI, 15 ("Rex regum et Dominus dominantium," is a free quotation from "Dominus dominorum et Rex regum" in Revelation XVII, 14, where the *Dominus* was often, even by St. Augustine, changed to *Dominans*. The abbreviation signs above the "N's" are clearly discernible and the "C" at the end of ΔNC is clearly intended to be a Sigma. The Greek X seems to have taken the place of the ligature "TI" or "CI" while the "N" at the end of ΔNANXIN seems to have been used as a contraction for "UM." The idea that the supposed ANANX ANANXIN might be a garbled form of ἄναξ ἀνάκτων (which also would mean "Lord of

lords") is disproved by the fact that the Greek text, both in Timothy and Revelation, has κύριος τῶν κυριώντων.

2. This rare possibility is exemplified by a French Book of Hours of *ca.* 1460–1470 in the Royal Library at Copenhagen (ms. Thott 540, 4°; *Stockholm Catalogue*, no. 175) where the Coronation of the Virgin, normally performed at this period by the whole Trinity, is depicted in such a way that the Virgin receives her crown from the Dove while kneeling before a papal figure; here, then, this figure must be interpreted as representing both the First and Second Persons.

3. Weale, *Hubert and John van Eyck*, pp. lxxv, 206: "God den Vadre." Cf. also Lucas de Heere, reprinted *ibidem*, p. lxxvii.

4. Lange and Fuhse, *op. cit.*, p. 157, 27: "Gott Vater." Quite recently, L.-I. Ringbom, *Gralstempel und Paradies; Beziehungen zwischen Iran und Europa im Mittelalter* (*Kungl. Vitterhets Historie och Antikvitets Akademiens Handlingar*, Part 73), Stockholm, 1951, p. 427 ff., has proposed to identify the dominant figure of the Ghent altarpiece as well as that of the "Fountain of Life" in the Prado as an image of the famous "Prester John," then generally believed to have been a great Christian ruler in the heart of Asia. Ringbom promises to develop this theory, which strikes me as utterly fantastic, on some later occasion; but even now the reader's confidence is shaken by the fact that he summons Dürer — the same Dürer who explicitly speaks of the papal figure as "Gott Vater" — as a witness on the grounds that he had called the Ghent altarpiece "*eine* Johannes-Tafel," apparently taken by Ringbom to mean "*a* retable concerned *with* John (*scil.*, Prester John)." In reality, Dürer speaks (Lange and Fuhse, p. 157, 25) of "*des* Johannes Tafel," which, needless to say, means nothing but "*the* retable *by* John (van Eyck)."

Page 216

1. "Hic est fons aque vite procedens de sede Dei et agni." In the pageant of 1458 (Weale, *Hubert and John van Eyck*, p. 208), this quotation is significantly supplemented and explained by Genesis II, 10: "Fluvius egrediebatur de loco voluptatis ad irrigandum *Paradisum*."

2. Setting aside the well-known Early Christian and Carolingian instances and the countless representations of the Fountain of Paradise in the specific context of Genesis, we may refer to a twelfth-century miniature in the Bibliothèque de la Ville at Verdun, ms. 119, showing the fountain between Church and Synagogue (Panofsky, *Studies in Iconology*, p. 154, fig. 79); a miniature in the Lectionary of Cuno von

Falkenstein, datable about 1375, in the Cathedral Treasury at Treves, showing all mankind drinking from the fountain (M. Remy, *Die Buchmalerwerkstatt des Trierer Erzbischofs Cuno von Falkenstein*, Treves, 1929, pl. VI); and, last but not least, the famous Constantine medal of the Duc de Berry showing the fountain between what seem to be personifications of Nature and Grace (von Schlosser, "Die ältesten Medaillen and die Antike," pl. XXII; see also Panofsky, *Studies in Iconology*, p. 154, fig. 110).

3. See note 203⁴. For Ringbom's interpretation of the fountain in the Prado picture as the "sacred well in the legendary kingdom of Prester John," see note 215⁴.

4. See, apart from Roger van der Weyden's "Last Judgment" at Beaune, the "Life of St. Godelieve" in the Metropolitan Museum, Wehle and Salinger, *op. cit.*, p. 84.

Page 217

1. For the constant coupling of *judices* and *exercitus* in liturgical acclamations, see E. H. Kantorowicz, *Laudes Regiae: A Study in Liturgical Acclamation and Ruler Worship*, Berkeley and Los Angeles, 1946, pp. 15, 40, 43, 86, 88. For Masses *contra injustos judices*, see Leroquais, *Sacrementaires et Missels*, II, p. 353; III, p. 116. I am much indebted to Professor Kantorowicz for having enlightened me on the significance of the term *judex* in medieval usage.

2. Weale, *Hubert and John van Eyck*, p. xxviii.

3. See pp. 264 f., 318, 351.

Page 218

1. See Coremans, Philippot and Sneyers, *op. cit.*, p. 5. The decisive argument against the existence of a top piece is the absence of the dowels which would have been necessary to fasten it to the panel proper; since the dowels used in the central panel of the Ghent altarpiece are very long (*ca.* 11 cm.), traces of the dowels joining the top piece to the topmost board would be discoverable in the latter had the former been removed.

2. Two of these subjacent rays, observed by Jenö Lanyi, were introduced into the discussion by Beenken, "Zur Entstehungsgeschichte des Genter Altars," p. 180. In the course of the recent operations in the Laboratoire Central many more were traced with great accuracy and partly uncovered, whereby it was ascertained that they were raised and gilded (see Coremans, Philippot and Sneyers, *op. cit.*, p. 5, fig. 4). For the fact that raised and gilded ornaments of this kind were normally produced before the painting process started, see, e.g., Cennini's *Libro dell'arte*, especially chapters 124, 139, 140. For the importance of the subjacent

rays in connection with the "Hubert or Jan?" question, see p. 225.

3. After this chapter had been written, Dr. Coremans kindly informed me that he has good, and naturally quite different, reasons to believe that the Dove, though Eyckian, was originally absent from the "Adoration of the Lamb."

4. Semicircular glories encircling the divine image are found in the "Boucicaut Hours" on fols. 19 v. and 20 v.; glories without any figural design, on fols. 11 v., 15 v., 42 v., 43 v. In the "Antwerp-Baltimore Quadriptych" (figs. 108, 109) the pendent hemicycle is segmented and, since the pictures are painted on gold ground, painted blue.

5. As Coremans, Philippot and Sneyers have shown, the painted surface of all the panels in the Ghent altarpiece is limited by its original edge (*barbe*) and surrounded by a strip of unpainted wood which, in the case of the "Adoration of the Lamb," is beveled. However, while this observation invalidates all theories to the effect that the panels were trimmed after the pictures had been carried out in color up to the margins, it does not preclude the possibility of a curtailment at a time when the painting process had not as yet progressed beyond those areas of maximum interest on which most painters used to concentrate their efforts at the beginning (see, e.g., the unfinished "Madonna with St. John the Baptist and Four Angels," formerly ascribed to Michelangelo, in the National Gallery at London). In fact, another aspect of the examination conducted at the Laboratoire Central rather tends to support the idea that the "Adoration of the Lamb" may have been shortened at the top and bottom (I withdraw as unnecessary my previous suggestion, accepted by Beenken in "The Annunciation of Petrus Cristus in the Metropolitan Museum" and *Hubert und Jan*, p. 34, that it may have been cut down on all sides). It has been ascertained that the panel is composed of four horizontal elements of which Messrs. Coremans and Sneyers were kind enough to give me the exact measurements (see the diagram on p. 219): the height of the bottom board (*d*) is 33.8 cm.–34.3 cm.; that of the next (*c*), 34.7 cm.–35.4 cm.; that of the third (*b*), 36.3 cm.–36.7 cm.; that of the top board (*a*) 32.5 cm. The top and bottom boards are thus perceptibly narrower than those in the middle, the top board, *a*, differing form the adjacent board, *b*, by no less than 4 cm. If, in order to reduce the total height of the central panel by those 11 cm. by which it now differs from the lateral panels, *a* had been shortened by *ca.* 6 cm., and *d* by *ca.* 5 cm., both *a* and *d* would originally have been *ca.* 38.5 cm. high, which is not excessive in view of the fact that boards as wide as 43 cm.–45 cm. are known to have been used in

Early Flemish paintings (see, e.g., the left wing of Gerard David's St. John the Baptist triptych in the Musée Communal at Bruges, Janssens de Bisthoven and Parmentier, *op. cit.*, p. 20). A further argument in favor of the shortening hypothesis, kindly suggested to me by Dr. Paul Coremans himself, is the fact that the unpainted edge of the central panel is perceptibly narrower at the top and the bottom than at the sides — as though the painter had been anxious to make up for a loss in height by exploiting the remaining space to the utmost limit of technical possibilities.

6. A similar though less conspicuous disparity exists, for example, in the triptychs by the Master of Delft in the National Gallery at London (Davies, *National Gallery Catalogues, Early Netherlandish School*, p. 69 f.), by Jacob Cornelisz. van Oostsanen in the Kaiser Friedrich Museum at Berlin (Winkler, *Die Altniederländische Malerei*, fig. 140), by Adriaen Isenbrant in the Metropolitan Museum (Wehle and Salinger, *op. cit.*, p. 99 f.), and by Patinir, in the Metropolitan Museum (Wehle and Salinger, p. 115 ff.); also in the pentaptych by the Master of St. Godelieve, quoted in note 216[4]. However, all these instances are from fifty to a hundred years later than the Ghent altarpiece; whereas in all known triptychs by Jan van Eyck, the Master of Flémalle and Roger van der Weyden the heights of the panels and the widths of the frames are equal throughout.

Page 219

1. The four panels now constituting the shutters, each from 54 cm. to 55 cm. wide, are composed of vertical elements. Had they resulted from the bisection of two panels, each from 108 cm. to 110 cm. wide, they would either consist of two elements *ca.* 22 cm. wide, with dowels showing in the left-hand edges of the "Knights" and "Pilgrims" as well as in the right-hand edges of the "Justices" and "Hermits"; or of two or three elements distributed in such a way that the left-hand elements of the "Knights" and "Pilgrims" (and the right-hand elements of the "Justices" and "Pilgrims"), being the halves of one board sawed in two, would be considerably narrower than the others. Instead, each of the four panels is composed of three elements either approximately equal in width or distributed in such a way that the narrowest board is in the center: in the "Knights," the widths of the three elements are, from left to right, 15.6 (16.5) cm., 16.6 (16.5) cm., 21.7 (20.8) cm.; in the "Hermits," 26.8 (28.2) cm., 7.2 (6.4) cm., 20.5 (19.3) cm.; in the "Pilgrims," 20.8 (21.5) cm., 11.6 (11.7) cm., 22.6 (21.6) cm., the dimensions in parentheses being taken at the bottom, the others at the top. Again, I am deeply

grateful to Dr. Coremans for his great kindness in communicating these measurements to me.

Page 220

1. St. Augustine, *De Trinitate*, I, 13, 28 (*Patrologia Latina*, LXII, col. 841). Peters, *op. cit.*, p. 73, is in error when he refers to the Judge in the "Last Judgment" in the Wolfenbüttel Gospels of 1194 (cod. Helmst. 65, illustrated in K. Künstle, *Ikonographie der christlichen Kunst*, I, Freiburg, 1928, p. 537, fig. 300) as a Christ in Majesty; the Lord conspicuously displays the wounds in His palms.

2. The crown itself consists of a diadem adorned with naturalistically enameled flowers, all traditionally associated with the Virgin Mary: roses, lilies of the valley, columbines, and "Annunciation lilies." Of these three are visible in their entirety and one in part, so that their total number may be assumed to be seven. Professor William S. Heckscher therefore believes, and I incline to agree, that the unusual image was suggested by a passage in St. Bridget's *Revelationes*, I, 31 (Roman edition, I, p. 65): "Videbat Reginam coeli matrem Dei habentem coronam inaestimabilem in capite suo, & *capillos extensos super spatulas* admirabilis pulchritudinis. Tunicam auream splendore indicibili coruscantem . . . *In corona autem ejus posuit filius ejus septem lilia,* & inter haec lilia posuit septem lapides." The passage is all the more relevant as the visionary also sees St. John the Baptist who explains to her the symbolical significance of the above-mentioned details.

3. Petrus Chrysologus, *Sermones*, CXXVII (*Patrologia Latina*, LII, col. 549); cf. Panofsky, "Once More the 'Friedsam Annunciation,'" p. 441 ff.

4. Petrus Damianus, *Sermones*, XXII (*Patrologia Latina*, XCLIV, col. 634); cf. Panofsky, "Once More the 'Friedsam Annunciation,'" p. 442. It is significant that Jan Gossart, when transforming the "upper triptych" in the Ghent altarpiece into a real Deësis (Prado, our fig. 488; cf. Friedländer, VIII, pl. XXII, and Panofsky, "The Friedsam Annunciation," fig. 32) emphatically changed its iconography: the Virgin prays instead of reading; Christ is divested of His papal tiara; the Baptist, simply dressed and deprived of his book, emphatically points at Christ with his right hand and raises his left to his heart. Conversely, in Jean Bellegambe's Douai polyptych, the three central panels of which show not a Deësis but an overelaborate paraphrase of the "upper triptych" of the Ghent altarpiece, the image of God is replaced by an explicit Trinity and to the figure of the Virgin Mary are added two angels placing a crown upon her head (illustrated, e.g., in Sterling, *Les Primitifs*, fig. 181).

Page 221

1. See, in addition to Stephan Lochner's well-known "Presentation" of 1447 in the Darmstadt Museum, the instances illustrated in Panofsky, "The Friedsam Annunciation," figs. 30, 31, and "Once More the 'Friedsam Annunciation,'" figs. 11, 13.

2. For the organ tribune of Grand Andely, see G. Servières, *La Decoration artistique des buffets d'orgue*, Paris and Brussels, 1928, pl. XXVII; for the organ panels of Nonancourt, A. G. Hill, *Organ Cases of the Middle Ages and Renaissance*, London, 1883, pp. 20, 101; for the Augsburg organ shutters (by Jörg Breu), Glaser, *op. cit.*, p. 377, fig. 255. Winged music-making angels are, of course, also frequent on organs and organ tribunes (suffice it to mention the organs at Gonesse, Servières, pl. III, or Memlinc's well-known panels from Nájera, now in the Museum at Antwerp), and it is for this reason that the two panels at Kansas City mentioned in note 67[1] were referred to as organ shutters.

Page 222

1. See Josephson, *op. cit.* In a lecture delivered at Princeton on April 12, 1953, Dr. Coremans disclosed that the idea of sharpening the *di sotto in sù* effect by making Adam's left foot project beyond the picture plane and thus exposing its sole to view was what may be called an afterthought: originally the position of his legs corresponded, more or less, to that of Eve's.

2. This important discovery, showing that the whole exterior of the Ghent altarpiece was originally planned as a kind of two-storey façade, was announced by Dr. Coremans in the lecture referred to in the preceding note. That the "Annunciation" owes its present appearance to another last-minute decision lends further support to de Tolnay's assumption that Jan van Eyck was influenced by the Flémalle Master's Mérode altarpiece.

3. Even Dürer, who "did not like to begin too many things at the same time" (Lange and Fuhse, *op. cit.*, p. 47, 1), would have left in an unfinished state at least four paintings had he died in the early spring of 1508.

4. I see too late that Baldass, *Eyck*, p. 37, assigns the design of the "Annunciation" and part of its execution to Hubert. His most plausible argument — the similarity which unquestionably exists between the Angel Gabriel and the angel in the "Three Marys at the Tomb" in the van Beuningen Collection (cf. p. 230 f.) — is easily refuted by the fact that this angel, emphatically differing from the Three Marys themselves, is obviously repainted and, in my opinion, attributable to Jan.

Page 223

1. D. Roggen, "Van Eyck en François Villon," *Gentse Bijdragen tot de Kunstgeschiedenis*, XIII, 1951, p. 259 ff., calls attention to the analogy which exists between the ideal of beauty incorporated in Jan's Eve and that described in Villon's "Les Regrets de la Belle Heaulmière." Villon was born almost exactly one year before the dedication of the Ghent altarpiece.

2. For the restorations of the Ghent altarpiece, see Coremans and Janssens de Bisthoven, *op. cit.*, p. 18 ff., and *Palais des Beaux-Arts, Bruxelles*, p. 7 ff. As to the period before 1550, we have only Vaernewyck's unsupported report of that ill-starred attempt which allegedly destroyed the "predella" (cf. note 214[1]). It should be noted that the restorations of the nineteenth century (1825–1829 and 1859) did not affect the shutters which were sold in 1816 and passed to the Berlin Museums in 1821.

3. M. Dvořák, *Das Rätsel der Kunst der Brüder van Eyck* (originally published in *Jahrbuch der Kunsthistorischen Sammlungen des Allerhöchsten Kaiserhauses*, XXIV, 1904, p. 159 ff.).

Page 224

1. E. Cianetti, *Il Campo di Siena e il Palazzo Pubblico*, Florence, 1921, fig. 27.

Page 225

1. See note 218[2].

2. This was convincingly suggested by Dr. P. Coremans in a paper delivered at the Seventeenth International Congress of the History of Art, Amsterdam, 1952.

3. See Coremans, Philippot and Sneyers, *op. cit.*, p. 4, fig. 5. The very accuracy of this architectural portrait distinguishes it from that in the "Rolin Madonna" (see note 193[1]), and the assumption that it was added by Scorel as a reference to his own city is well in harmony with that rise of "Dutch" *vs.* "Belgian" patriotism which can be observed in the sixteenth century (see p. 356). For reminiscences in the authentic architectural features of the Ghent altarpiece — all of them, characteristically, very general — see the literature referred to in Coremans and Janssens de Bisthoven, *op. cit.*, p. 29; and, as far as the influence of English monuments (Ely, Ilminster) is concerned, Rosenau, *op. cit.*

4. See Coremans, Philippot and Sneyers, *op. cit.*, p. 5, fig. 3; *Palais des Beaux-Arts, Bruxelles*, fig. 8.

5. *Palais des Beaux-Arts, Bruxelles*, fig. 5. The difference between the spurious and the authentic buildings is clearly visible in Coremans and Janssens de Bisthoven, *op. cit.*, pl. 146 as compared to pls. 147 and

148, and Baldass, *Eyck*, pl. 40 as compared to pls. 38 and 41.

Page 226

1. This radical solution was proposed by de Tolnay, *Le Maître de Flémalle*, p. 20 ff., p. 47, notes 37, 41 and 42. The ivories "à deux étages" adduced as parallels to the two-storeyed, wingless retable which de Tolnay considers as the nucleus of the Ghent altarpiece are, however, hardly comparable with it from either a structural or iconographical point of view. In the first place, they do have shutters; in the second place, their lower tiers show, instead of many small-sized figures, a monumental image of the Madonna, flanked by two angels, which corresponds in scale to the triad above; in the third place, this upper triad represents an orthodox Deësis or, rather, an abbreviated version of the Last Judgment (including, in one case, the angels with the instruments of the Passion and, in the other, the Resurrected). That the chapel in which the Ghent altarpiece is placed today — and the same applies, *a fortiori*, to its original home in the crypt — is so small that its shutters cannot be opened completely (de Tolnay, p. 21, and p. 48, note 41) proves, if anything, the opposite of what is intended to show: had the wings been added *ex post facto*, the inconvenience would have been intentionally created at a time when everybody concerned was fully aware of the retable's place of destination. And de Tolnay's contention that the Mediterranean trees and plants, admittedly added in the "Adoration of the Lamb," had been present in the lateral panels from the outset is not borne out by the facts: the palms, umbrella pines, cypresses and orange trees seen in the right-hand shutters are "ajoutés après coup" precisely as are those in the central panel (see above, p. 225, and, for good illustrations, Baldass, *Eyck*, pls. 57–59) whereas the left-hand wing shows no southern flora at all.

2. Excellent shadowgraphs showing the continuation of the grassy slopes of the central panel into the original scenery of the Knights of Christ panel, the presence of a northern tree beneath the orange grove in the Pilgrims wing, and the superimposition of the rocky scenery as well as the figures of St. Mary of Egypt and the Magdalen upon the original background of the Hermits wing were presented and interpreted by Dr. Coremans in the paper referred to in note 225.[2] This writer, forced to revise his previous opinions in several other respects, may be forgiven for quoting with some satisfaction what he wrote many years ago: "Hubert . . . seems to have done some of the actual work in the group of Hermits which shows, in types and composition, some of the archaic qualities characteristic of the kneeling figures before the Foun-

tain of Life (particularly noticeable in their contrast with the two Maries)"; and: "The panel with the Pilgrims, which according to my conjecture would have to show traces of Hubert's actual painting, should be X-rayed in order to find out, if possible, whether these traces exist beneath the present coat of paint" ("The Friedsam Annunciation," p. 462, and "Once More the 'Friedsam Annunciation,'" p. 427).

Page 227

1. It is, for example, conceivable that the Just Judges were originally designed as much more obvious donors' portraits and had to be raised to a symbolic level when Jodocus Vyd appropriated the altarpiece for his own use and caused his and his wife's portraits to be displayed on the exterior.

2. For this relationship, see de Tolnay, *Le Maître de Flémalle*, p. 29 and p. 48, note 45.

3. Cf. Beenken, "Zur Entstehungsgeschichte des Genter Altars," p. 229.

Page 228

1. Coremans, Philippot and Sneyers, *op. cit.*, p. 4, figs. 1 and 2; *Palais des Beaux-Arts, Bruxelles*, pp. 14, 18. The contours incised into the gesso ground are not as yet mentioned in print. I owe my knowledge of them to the rare generosity of Messrs. Coremans and Sneyers, who not only called my attention to their existence but also gave me access to the X-ray photographs as well as to a tracing of the original inscription, which makes it possible to ascertain both its paleographical difference from and its textual identity with that now visible. It should be mentioned in passing that the incised vanishing lines of the pavement are carried through to the point of convergence so as to intersect the contours of the crown as well as the inscription; this, however, was common practice in laying out a foreshortened standing plane and does not necessarily imply that, at a still earlier stage, neither the crown nor the inscription were contemplated. The crude gold lines marking the joints of the present pavement (now, fortunately, greatly reduced in width), have been shown to be post-Eyckian and to date from two different periods. Those in the central panel must have been added before 1557–1559, when Michiel Cocxie copied the Ghent altarpiece for Philip II (Berlin, Kaiser Friedrich Museum, no. 525), those in the two lateral panels after that date (Munich, Alte Pinakothek, nos. 97, 98).

Page 229

1. That the *fattura* of the crown, while different from that of the morse, the node of the scepter, etc., is identical with that of the tiara and the scepter's top was

emphasized by my Belgian colleagues themselves in personal conversation and is evident, not only from the original but also from the photographs taken after the cleaning of 1950. For fairly good reproductions, see Baldass, *Eyck*, pl. 71 (crown), 69 (top of the scepter), 61 (tiara); the node of the scepter does not seem to have been reproduced as a detail.

2. Weale, *Hubert and John van Eyck*, p. 206: "God den Vadre . . . me eender keyserlyker (!) croenen up't hooft, eenen sceptre in de handt, *onder voer sijn voeten eene gulden croene . . .*" Indirectly, the presence of a crown in the fifteenth century is attested, I think, by Carlo Crivelli's Madonna in the National Gallery at Washington (Friedmann, *op. cit.*) which seems to presuppose the influence of the Ghent altarpiece, not only in that the inscription ("Memento mei, Mater Dei; Regina coeli laetare," somewhat garbled in Friedmann's article) appears on the molding of a niche but also in that a crown is placed at the feet of the enthroned figure.

Page 230

1. Weale-Brockwell, p. 69 ff.; Friedländer, I, pl. XXXI; de Tolnay, *Le Maître de Flémalle*, p. 74, fig. 29; Beenken, *Hubert und Jan*, figs. 21, 22; Musper, fig. 116; van Puyvelde, *Primitives*, pls. 6, 7; *Catalogue of the D. G. van Beuningen Collection*, no. 11, pls. 10–15; Baldass, "The Ghent Altarpiece," p. 183 ff., and *Eyck*, pls. 1–6, fig. 22 (endorsing the attribution to Hubert). For a free variation, now in trade, see Weale-Brockwell, p. 74.

2. For the "Life of the Virgin" in the Brussels Museum, see p. 96 and fig. 112. If the van Beuningen picture, measuring 71.5 cm. by 89 cm., had been part of a folding triptych it could have formed only the lower half of the left-hand shutter. But then the central panel would have been even more markedly oblong (*ca.* 145 cm. by *ca.* 200 cm.) than that tentatively postulated for the Prado "Betrothal" by the Master of Flémalle (see p. 161), which measures 79 cm. by 90 cm. Since a format of *ca.* 145 cm. by *ca.* 200 cm. would not have been very suitable for an Ascension, and since there is no evidence that the "Three Marys" showed figures on the back — as the "Betrothal" does — I incline to prefer the hypothesis of a friezelike composition to that of a folding retable.

Page 231

1. From the surprisingly faithful rendering of the city of Jerusalem it has even been concluded that the painter must have been acquainted with Breydenbach's *Pilgrimage to the Holy Land* of 1486. It should be borne in mind, however, that the city is seen from the opposite direction and that views of Jerusalem quite comparable to Breydenbach's in topographical accuracy must have been available at a much earlier date. The excellent views in Bertrandon de la Broquière's *Voyage d'Outremer* and Jean le Tavernier's *Chroniques et Conquêtes de Charlemaigne* (see Maere, *op. cit.*) presupposes, as pointed out to me by Miss Nicole Verhaegen, a common prototype which fairly well agrees with the view in the "Three Marys" while differing from the woodcut in Breydenbach's *Pilgrimage*.

2. The extensive bibliography concerning the "Friedsam Annunciation" is collected in Wehle and Salinger, *op. cit.*, p. 15 ff. To be added: Burroughs, *Art Criticism from a Laboratory*, p. 251 ff. (supporting the old attribution to Petrus Christus); Baldass, "The Ghent Altarpiece," pp. 188, 194; ———, *Eyck*, pls. 7, 8 (accepting the attribution to Hubert van Eyck with the reservation that he had no opportunity to see the original); Schild Bunim, *op. cit.*, p. 202 ff. (demonstrating the archaic character of the perspective); Held, Review of Wehle and Salinger. Even those who ascribe or ascribed the picture to Petrus Christus concede that it "derives from" or "repeats" a composition by either Hubert or young Jan van Eyck: Beenken, "The Annunciation of Petrus Cristus in the Metropolitan Museum and the Problem of Hubert van Eyck," pp. 234, 237; Schöne, "Ueber einige altniederländische Bilder, vor allem in Spanien," p. 157, note 7; ———, *Dieric Bouts und seine Schule*, p. 57, no. 22; Musper, pp. 102, 107, fig. 115. It cannot be emphasized too strongly that the very idea of placing the Annunciate in or before a building approached by the Angel from without is incompatible with a later date. The writer's statement according to which "after around 1430 there is not a single Annunciation of this type in Flemish panel painting except for those altarpiece shutters in which the Angel Gabriel and the Virgin Mary are shown as isolated figures in grisaille" still stands. J. S. Held, justly skeptical of the Metropolitan Museum's attribution to "Jan van Eyck and Helpers," suggests the possibility of "a master active in the Eyckian circle" who may be found among "Hubert's pupils and assistants" but does not seem to doubt that the picture was produced as early as "about 1420–1430." Held was, so far as I know, the first to realize that it was cut down on the top and probably at the bottom and the left margin. This was confirmed on the occasion of a recent treatment which, as was called to my attention by Mr. Jerome Rothlein, also brought out a further link between the Friedsam picture and Hubert van Eyck: the grass is dotted with the same stemless white blossoms which, to the despair of all botanists, appear in the foreground and "transitional plane" of the "Adoration of the Lamb."

Page 232

1. Some time ago, the rather mediocre "Portrait of a Young Man Holding a Rose" in the Kaiser Friedrich Museum at Berlin (no. 523 D, Friedländer, I, p. 165) was ascribed to Hubert van Eyck by Beenken, "Bildnisschöpfungen Hubert van Eycks," p. 116, fig. 24. No one, so far as I know, has taken this attribution very seriously (cf. Baldass, *Eyck*, p. 289, no. 73), and the same is true of the Antwerp portrait of John the Fearless (Baldass, p. 288, no. 68), also assigned to Hubert by Beenken (for this portrait, see p. 291).

2. See p. 45.

Page 233

1. For the "Descent from the Cross," see note 167 [1]; for the "St. Thomas Aquinas," p. 189; for the "Bearing of the Cross," p. 237.

2. Durrieu, *Heures de Turin*, pl. XIII; de Tolnay, *Le Maître de Flémalle*, p. 23, fig. 30.

3. Hulin de Loo, *Heures de Milan*, pl. XXIII; de Tolnay, *Le Maître de Flémalle*, p. 23, fig. 31; Beenken, *Hubert und Jan*, fig. 13; Musper, fig. 105.

4. Durrieu, *Heures de Turin*, pl. XXIX; de Tolnay, *Le Maître de Flémalle*, p. 23, fig. 32; Baldass, *Eyck*, pl. 12, fig. 33. For the interpretation of the *bas-de-page*, cf. A. Chastel, "La Rencontre de Salomon et de la Reine de Saba dans l'iconographie médiévale," *Gazette des Beaux-Arts*, ser. 6, XXXV, 1949, p. 99 ff., especially p. 105 f.

5. Hulin de Loo, *Heures de Milan*, pl. XXIV; de Tolnay, *Le Maître de Flémalle*, p. 24, fig. 141; Beenken, *Hubert und Jan*, fig. 14; Musper, fig. 111.

6. Durrieu, *Heures de Turin*, pl. XV; de Tolnay, *Le Maître de Flémalle*, p. 35 ff., figs. 133, 135; Beenken, *Hubert und Jan*, figs. 5, 11; Musper, fig. 103, Baldass, *Eyck*, fig. 85. A silver point drawing representing the Betrayal (London, British Museum) has been ascribed to Hubert van Eyck by Beenken ("Remarks on Two Silver Point Drawings of Eyckian Style," *Old Master Drawings*, VII, 1932/33, p. 18 ff., and *Hubert und Jan*, fig. 1), and to the Dutch master (allegedly Ouwater) supposed to be responsible for the whole *oeuvre* of "Hand G" (de Tolnay, *Le Maître de Flémalle*, p. 37, fig. 128). Baldass, *Eyck*, pl. 169, assigns it tentatively to "Hand G" which he refuses to identify with Jan or Hubert van Eyck but judiciously refrains from claiming as Dutch. I cannot see any intimate connection between this drawing and the miniature in the "Turin-Milan Hours" and agree with A. E. Popham, *Drawings of the Early Flemish School*, London, 1926, pl. 2, and, recently, Ring, *A Century*, Cat. no. 69, pl. 35, in attributing it to an anonymous Franco-Flemish master of the Limbourg circle.

Page 234

1. Durrieu, *Heures de Turin*, pl. XXX; Friedländer, I, pl. XXV; de Tolnay, *Le Maître de Flémalle*, p. 35, fig. 129; Beenken, *Hubert und Jan*, fig. 10; Musper, fig. 102; Baldass, *Eyck*, fig. 83. For the minature in the "*Heures de Savoie*," fol. 4 (Christ dressed as a pilgrim but identified by His cruciform halo), see Thompson and Dom Blanchard, *op. cit.*, pl. 7; for that in the Paris Horae (Bibliothèque Nationale, ms. lat. 1159, fol. 155 v.), Leroquais, *Les Livres d'Heures*, pl. LIII. Cf. also a stained glass window in Rouen Cathedral where St. Julian's wife expects her husband's boat on the shore, helpfully raising a lantern as does the hermit in so many representations of St. Christopher (G. Ritter, *Les Vitraux de la Cathédrale de Rouen, XIIIe, XIVe, XVe et XVIe siècles*, Paris, 1926, pl. XI).

2. Durrieu, *Heures de Turin*, pl. XXXVI; de Tolnay, *Le Maître de Flémalle*, p. 35, fig. 139; Beenken, *Hubert und Jan*, fig. 121; Musper, fig. 101; Baldass, *Eyck*, fig. 84 (*bas-de-page* only). Hulin de Loo, "Traces de Hubert van Eyck," suggests an influence of the Madonna upon the well-known Upper Rhenish "Madonna with the Strawberries," datable *ca.* 1425–1430, in the Museum at Solothurn, Switzerland. The assumption, borne out by the treatment of the border, that this page is the earliest member of the "Hand G" series, accounts for the fact that it strikes us as somewhat less progressive than the other examples, except for the page showing the Finding of the True Cross (see note 234 [5]) which would seem to be the next in point of time. The slight "weakness" of these two pages (cf. also de Tolnay, p. 52, note 82) has caused some scholars to ascribe them, or at least the "Finding of the Cross," to an assistant (Hoogewerff, II, p. 8 ff., ascribing them to Petrus Christus; Musper, p. 91). In my opinion the differences are not significant enough to warrant this hypothesis.

3. Durrieu, *Heures de Turin*, pl. XXXVII; Friedländer, I, pl. XXVI; de Tolnay, *Le Maître de Flémalle*, p. 35 ff., figs. 130, 136; Beenken, *Hubert und Jan*, figs. 2, 4; Musper, fig. 99; Baldass, *Eyck*, fig. 82.

4. Hulin de Loo, *Heures de Milan*, pl. XX; Friedländer, I, pls. XXVII, XXVIII; de Tolnay, *Le Maître de Flémalle*, p. 35 ff., figs. 132, 137; Beenken, *Hubert und Jan*, figs. 7, 9; Musper, fig. 104; Baldass, *Eyck*, pls. 157, 159.

5. Hulin de Loo, *Heures de Milan*, pl. XXI; Friedländer, I, pl. XXIX; de Tolnay, *Le Maître de Flémalle*, p. 35 ff., figs. 131, 138; Beenken, *Hubert und Jan*, figs. 6, 8; Musper, fig. 100; Baldass, *Eyck*, pls. 158, 160.

6. Hulin de Loo, *Heures de Milan*, pl. XXII; de Tolnay, *Le Maître de Flémalle*, p. 35, pl. 134; Beenken, *Hubert und Jan*, fig. 3; Baldass, *Eyck*, pl. 161. A simplified copy of the main miniature, formerly owned

by L. Rosenthal at Munich, is illustrated in de Wit, *op. cit.*, fig. 7. In a recent article A. Pigler, "Das Problem der Budapester Kreuztragung," *Phoebus*, III, 1950/51, p. 12 ff., attempts to prove that Emperor Sigismund and John of Holland are portrayed among the witnesses to the event (which causes him to ascribe the "Hand G" miniatures to Jan van Eyck). His argument is, however, vitiated by the fact that, according to him, the same personages also appear in the Budapest "Bearing of the Cross" (our fig. 305) where they would be cast in the unflattering roles of Roman officers in charge of the execution of Christ.

Page 235

1. The identification of "Hand H" with Petrus Christus was proposed by Hoogewerff, II, p. 8. For Petrus Christus' New York "Lamentation," see p. 309; for the dubious *"Pietà"* in the Louvre, note 311 [8].

2. For these three replicas, see Panofsky, "The Friedsam Annunciation," p. 471, note 75 and figs. 35, 36. For the picture in the Cà d'Oro, cf. Musper, p. 94 f., fig. 112; Renders, *Jean van Eyck*, pl. XIV; Baldass, *Eyck*, pl. 11. For that in the Accademia, see R. Longhi, "Calepino Veneziano, II," *Arte Veneta*, I, 1947, p. 185 ff., fig. 143. It should be added that the Crucifixion in the Roermond altarpiece (see p. 104) depends on the same Eyckian prototype.

3. See G. Vitzthum von Eckstädt, "Ein Stadtbild im Baptisterium von Castiglione d'Olona," *Festschrift zum sechszigsten Geburtstag von Paul Clemen*, Düsseldorf, 1926, p. 401 ff.

Page 236

1. See p. 65.

2. See de Tolnay, *Le Maître de Flémalle*, p. 37.

Page 237

1. Friedländer, I, pl. XXXII; de Tolnay, *Le Maître de Flémalle*, fig. 125; Schöne, p. 45; Beenken, *Hubert und Jan*, figs. 19, 20; Musper, fig. 130; van Puyvelde, *Primitives*, pl. 8; Baldass, *Eyck*, pl. 162. See also Panofsky, "The Friedsam Annunciation," p. 471, note 76, fig. 37.

2. For the miniature, see Durrieu, *Heures de Turin*, pl. XVIII. For the best of the painted replicas, a panel preserved in the Museum at Budapest (our fig. 305), see de Tolnay, *Le Maître de Flémalle*, p. 37, fig. 126; Musper, fig. 114; Baldass, *Eyck*, pl. 116; Pigler, "Das Problem der Budapester Kreuztragung" (cf. note 234 [6]). For a related picture in the Metropolitan Museum, see Wehle and Salinger, *op. cit.*, p. 23 ff. with further references; for one in the Suermondt Museum at Aachen, G. J. Kern, *Die verschollene Kreuztragung des Hubert oder Jan van Eyck*, Berlin, 1927, and the

review thereof by E. Panofsky, *Kritische Berichte zur kunstgeschichtlichen Literatur*, 1927/28, p. 74 ff. For the important drawing in the Albertina (our fig. 304), see Panofsky, *ibidem*, and *Beschreibender Katalog der Handzeichnungen in der . . . Albertina* (by O. Benesch), no. 22.

3. Cf. F. Saxl, "Studien über Hans Holbein d. J., I; Die Karlsruher Kreuztragung," *Belvedere*, IX/X, 1926, p. 139 ff.

4. See Panofsky, *Albrecht Dürer*, I, p. 60 f.

5. *Staatliche Museen zu Berlin, Die Zeichnungen alter Meister im Kupferstichkabinett; Die niederländischen Meister* (by E. Bock and J. Rosenberg), Frankfort, 1931, p. 2, pl. 4; de Tolnay, *Le Maître de Flémalle*, p. 37, fig. 127; Musper, fig. 98; Baldass, *Eyck*, pl. 168. Cf. also Winkler, "Neues von Hubert und Jan van Eyck," p. 98 ff.; Martens, *op. cit.*, p. 201 ff.; Hoogewerff, I, p. 461 ff.; Panofsky, Review of G. J. Kern. As a matter of curiosity it may be mentioned that Kerber, *Hubert van Eyck*, pp. 80, 148, dates the Berlin drawing about 1400 and the "Hand G" miniatures before 1412–13. I must confess that I am unable to understand Kerber's book except for the dates which are printed in Arabic numerals; these are certainly wrong.

6. See Winkler, "Neues von Hubert und Jan van Eyck." The earliest copy, in the "Bum Hours" by the Master of Zweder van Culemborg (see p. 103), is illustrated in Martens, *op. cit.*, fig. 56. The second, in the Museum Meermanno-Westreenianum manuscript 10 E 1 of 1438 by the Arenberg Master, in Winkler, fig. 6; Martens, fig. 57; Hoogewerff, I, fig. 244; our fig. 128 (for the manuscript, see note 104 [1]). The third, a stray miniature of Flemish rather than either Dutch or, as Martens has it, French origin, in Martens, fig. 55. The fourth, in a Dutch Bible (Vienna, Nationalbibliothek, ms. 2772) of *ca.* 1465, in Winkler, fig. 7. A drawing representing the Adoration of the Magi in the Rijksmuseum at Amsterdam (Popham, *Drawings of the Early Flemish School*, pl. 3; Baldass, *Eyck*, pl. 167) would seem to be the work of a minor master who tried to embellish a Flémallesque model such as the Epiphany reflected in the picture at Berlin (our fig. 223) by details inspired by the Eyckian composition here under discussion.

7. London, British Museum, ms. Add. 35311, fol. 199 (the "Breviary of John the Fearless"), illustrated in Martens, *op. cit.*, fig. 54.

8. New York, Morgan Library, ms. 515, fol. 64 v.

9. Friedländer, I, pl. XXX; de Tolnay, *Le Maître de Flémalle*, p. 37, figs. 123, 124; Schöne, pp. 42, 43; Beenken, *Hubert und Jan*, figs. 15–18; Musper, fig. 113; van Puyvelde, *Primitives*, pl. 5; Baldass, *Eyck*, pls. 163–165; Wehle and Salinger, *op. cit.*, p. 2 ff., with an enormous mass of earlier literature.

10. See the facetious reconstruction in Panofsky, Review of G. J. Kern, fig. 6.

Page 238

1. Guiffrey, *op. cit.*, II, p. 285, no. 1266. For an anticipation of this antithesis in a fourteenth-century ivory diptych, see Koechlin, *op. cit.*, pl. LXI, no. 234, where the Crucifixion, the Descent from the Cross, the Entombment and the Last Judgment are arranged in such a way that in the lower zone the Descent is juxtaposed with the Entombment, and in the upper the Crucifixion with the Last Judgment.

2. Held, Review of Wehle and Salinger, p. 141, agrees with me in doubting that the Metropolitan Museum panels originally formed part of a triptych with an "Adoration of the Magi" in the center but does not accept the diptych hypothesis either. Rather he prefers "to think of the 'Crucifixion' as the right wing of an altarpiece and the 'Last Judgment' as one of its outside panels." His reasons for this assumption are partly esthetic (he feels that the movement in the "Calvary" comes to so abrupt a halt at the right edge that it would be hard to conceive of this edge as a boundary between two adjoining pictures) and partly iconographic; in his opinion the woman "in a fashionable, if somewhat exotic, dress who stands at the right edge, calmly and unemotionally watching the heart-rendering scene before her" must be a donor. The first contention might be convincing were it not for the fact that the two pictures are set in perfectly identical frames, both gilded and covered with inscriptions; according to custom the frame of an "outside panel" would require a different, less sumptuous treatment. The second contention is unacceptable in view of the ironclad rule that donors are depicted kneeling and praying, not standing and calmly observant; in fact the unemotional lady is the Erythrean Sibyl (see p. 240). That the rider in the ermine-trimmed coat is Philip the Good (Musper, p. 86) is very improbable, not only because his alleged similarity to the authentic portraits of this prince is less than slight but also because he appears in the midst of the enemies of Christ, in fact directly beneath the Bad Thief. It is, therefore — unfortunately, from my point of view — not possible to adduce this figure as proof of Jan's authorship.

Page 239

1. For the first interpretation, see Durrieu, *Heures de Turin*, p. 25; for the second (suggested by Professor Andreas Jolles), Beenken, "Zur Entstehungsgeschichte des Genter Altars," p. 201, note 19, and *Hubert und Jan*, p. 5. The identification of "Hand G" with Hubert and of "Hand H" with Jan was proposed by Hulin de Loo, *Heures de Milan*, p. 23 ff. It has been vigorously championed by Beenken (in addition to the contributions already quoted, see also "Jan van Eyck und die Landschaft," *Pantheon*, XXVIII, 1941, p. 173 ff.) and is accepted, for example, by Winkler, *Die altniederländische Malerei*, p. 35 ff.; Schöne, p. 10; Mather, "The Problem of the Adoration of the Lamb"; van Puyvelde, *Primitives*, p. 24; and the Metropolitan Museum (Wehle and Salinger, *op. cit.*, p. 2 ff.). It should be noted, however, that the adherents of this view are not unanimous as to the attribution of other works to either Jan or Hubert. Quite apart from the moot question of the Ghent altarpiece, the Berlin "Madonna in a Church" is ascribed to Hubert by Hulin de Loo, Winkler, van Puyvelde, and Wehle and Salinger but to Jan by Beenken and to "Hubert or Jan" by Schöne; the Berlin "Crucifixion," to Hubert by Beenken, van Puyvelde, and Wehle and Salinger but to Jan by Winkler, Hulin de Loo (who reversed himself on this point as triumphantly noted by Renders, *Hubert van Eyck*, pp. 127 f., 164), and Schöne; the New York diptych, to "Hubert or Jan" by Schöne; and the Philadelphia "St. Francis," to Hubert by Wehle and Salinger.

2. The identification of "Hand G" with Jan and of "Hand H" with a disciple or imitator was proposed by Friedländer, I, p. 68 ff. (cf. also his *Von Eyck bis Bruegel*, 2nd edition, Berlin, 1921, p. 16 f., and *Essays über die Landschaftsmalerei*, p. 31). It is accepted, for example, by Martens, *op. cit.*, p. 174 f.; Renders, *Hubert van Eyck* and *Jean van Eyck*, *passim*; Hoogewerff, II, p. 5 ff.; Musper, p. 83 f.; Tovell, *op. cit.*, p. 76 ff.; Pigler, "Das Problem der Budapester Kreuztragung"; and this writer ("The Friedsam Annunciation," p. 468 ff.).

3. The attribution of the "Hand G" miniatures to a Dutch artist, presumably Albert Ouwater, originated from Karl Voll's discussion of the New York diptych (*Die altniederländische Malerei*, p. 269 ff.). This suggestion, endorsed by H. Zimmermann ("Ueber eine frühholländische Kreuztragung," *Amtliche Berichte aus den Königlichen Kunstsammlungen*, XXXIX, 1917/18, col. 15 ff.), developed into an article of faith in the Vienna school of art history thanks to the brilliant article by M. Dvořák, "Die Anfänge der holländischen Malerei," *Jahrbuch der Königlich Preussischen Kunstsammlungen*, XXXIX, 1918, p. 51 ff. Among its champions may be mentioned: (von) Baldass, "Ein Frühwerk Geertgen tot Sint Jans" (see, however, his recent retraction in *Eyck*, p. 97); O. Benesch, "Ueber einige Handzeichnungen des XV. Jahrhunderts," *Jahrbuch der Preussischen Kunstsammlungen*, XLVI, 1925, p. 181 ff.; and, above all, de Tolnay, "Zur Herkunft des Stiles

der van Eyck," p. 325 ff., and *Le Maître de Flémalle*, p. 35 ff. He differs, however, from the other adherents of the Dutch theory in ascribing the "Hand H" miniatures — except for the "Calvary" from the Turin section — to a pupil of Hubert van Eyck (*Le Maître de Flémalle*, p. 23). That the "Hand G" miniatures cannot have been ordered by Jacqueline's mother, Margaret of Burgundy (died March 8, 1441), can be inferred from the absence of the Burgundian arms from both the "Prayer on the Shore" and the "Mass of the Dead"; but Jacqueline herself would probably — though not quite as certainly — also have insisted on their inclusion. Frédéric Lyna in Leurs, *op. cit.*, I, p. 223 f., dates the "Hand G" miniatures about 1435 without, however, ascribing them to a definite school or locality.

4. For an analysis of the two horses, cf. Martens, *op. cit.*, p. 174 ff.

5. In addition, a small but hardly accidental detail connects the interior of the "Birth of St. John" with that of the "Annunciation" in the Ghent altarpiece. As observed by Mr. F. H. Hazlehurst, the stepped-up ledge in the right-hand corner of the window recess, on which a vase is set, almost literally recurs on the extreme left of the panel showing the Annunciate (good illustration in Coremans and Janssens de Bisthoven, pl. 86; Baldass, *Eyck*, pl. 93).

Page 240

1. This similarity was observed and illustrated by Renders, *Jean van Eyck*, p. 59, pl. II, figs. 4 and 5; cf. also Musper, p. 94.

2. For the exceptional role of the Erythrean Sibyl who "specialized in eschatology even in pagan Antiquity," see E. Mâle, *Quomodo Sibyllas recentiores artifices repraesentaverint*, Paris, 1899; C. Justi, *Michelangelo; Beiträge zur Erklärung der Werke und des Menschen*, Leipzig, 1900, pp. 79 ff., 126; E. Steinmann, *Die Sixtinische Kapelle*, II, Munich, 1905, p. 382; and (for a text written in fifteenth-century Flanders) M. Hélin, "Un Texte inédit sur l'iconographie des Sibylles," *Revue Belge de Philologie et d'Histoire*, XV, 1936, p. 349 ff. Recently, the subject of the Sibyls in general and the Erythrean Sibyl in particular has been conclusively discussed by Vöge, *op. cit.*, *passim*, especially pp. 15, 23 f., 115 ff. Particularly interesting in our context is a woodcut in the German translation of Boccaccio's *De claris mulieribus* (*Von etlichen Frouwen. . .*, Ulm, probably 1473, fol. 26 v., illustrated in Vöge, p. 49, fig. 12) where the Erythrean Sibyl is shown predicting both the end of the world and the Passion of Christ, the former expressed by crumbling buildings, the latter by the Man of Sorrows.

3. Dvořák, "Die Anfänge der holländischen Malerei," p. 54; de Tolnay, *Le Maître de Flémalle*, p. 52, note 83.

Page 241

1. Dvořák, "Die Anfänge der holländischen Malerei," p. 57; de Tolnay, *Le Maître de Flémalle*, p. 40, note 5, and, more circumstantially, "Zur Herkunft des Stiles der van Eyck," p. 326.

2. The reins are dropped, for instance, in the St. Martin miniature of the Boucicaut Hours, fol. 34 v., and in the St. George miniature of the Horae in the Czartoryski Museum at Krakow, ms. 2943 (see note 122 [1]), fol. 96 v. In both cases the horse is perfectly collected. The St. Martin panel in the Treviglio altarpiece (frequently illustrated, e.g., Venturi, *Storia dell'arte italiana*, VII, 4, p. 873, fig. 572, or R. Hamann, *Die Frührenaissance der italienischen Malerei*, Jena, 1909, fig. 173) is now generally ascribed to Bernardo Zenale rather than Bernardino Butinone; cf. a recent exhibition report by A. Scharff, *Phoebus*, II, 1949, p. 184, fig. 4.

3. Dvořák, "Die Anfänge der holländischen Malerei," p. 57; de Tolnay, *Le Maître de Flémalle*, p. 52 f., note 83, and "Zur Herkunft des Stiles der van Eyck," p. 326.

4. See the examples adduced in note 212[3]. The miniature in the Brussels Bible (Bibliothèque Royale, ms. 9019, fol. 136 v., Byvanck, *Min. Sept.*, pl. XXV, fig. 64), adduced by de Tolnay, *Le Maître de Flémalle*, p. 53, as a representation of "le même sujet," illustrates, incidentally, Revelation VII, 9–11, showing the Elders making music before the Lamb.

5. De Tolnay, *Le Maître de Flémalle*, p. 52, admits the possibility of "des sources communes"; this admission tends to invalidate the argument as far as the supposed priority of the Ghent altarpiece is concerned.

6. *The Pearl; An Anonymous English Poem of the Fourteenth Century*, Charles G. Osgood, tr., Princeton, 1907, p. 56 f.; for the original text, see his *The Pearl; A Middle English Poem*, Boston and London, 1906, p. 47, v. 1096–1116 (with a reference to the Ghent altarpiece in the excellent introduction, p. lviii, note 1). The passage quoted was brought to my attention by Professor William S. Heckscher.

Page 242

1. De Tolnay, *Le Maître de Flémalle*, p. 53, with reference to the articles by Zimmermann, Baldass and Benesch quoted in note 239[3]. The influence of the "Hand G" miniatures in the Turin-Milan Hours on the "Hours of Gysbrecht van Brederode" (Liége, University Library, ms. W. 13, executed at Utrecht about

1450) was observed by Winkler, "Studien zur Geschichte der niederländischen Miniaturmalerei," p. 327 ff., and even closer and more numerous relations with the works of "Hand G" have been shown to exist in the "Hours of Mary van Vronensteyn," produced at Utrecht in 1460 (now Brussels, Bibliothèque Royale, ms. II, 7619); see the excellent article by L. M. J. Delaissé, "Le Livre d'Heures de Mary van Vronensteyn, chef-d'oeuvre inconnu d'un atelier d'Utrecht, achevé en 1460," *Scriptorium*, III, 1949, p. 230 ff. It should be noted, however, that precisely this manuscript reveals, according to Delaissé himself, a "renouveau de l'influence *flamande*" which may or may not be connected with the arrival of David de Bourgogne at the episcopal court of Utrecht in 1457.

2. See. p. 103 f.

3. See p. 104.

4. See p. 280.

5. See p. 309.

6. Cf. C. R. Post, "The Master of the Encarnación (Louis Alimbrot??)," *Gazette des Beaux-Arts*, ser. 6, XXIII, 1943, p. 153 ff.

7. For Albert van Ouwater, see p. 319 ff.

8. Cf. Hoogewerff, II, p. 56 f., referring to documents of 1419, 1432, 1436 and 1439. In claiming the "Last Judgment" from Diest (Fierens-Gevaert, *Histoire de la peinture flamande*, I, pls. XXXI, XXXII) and the "Last Judgment" in the Musée des Arts Décoratifs (see note 61³) as "Dutch" because they show small, delicate figures, softly modeled draperies and in a general way are reminiscent of the Metropolitan Museum diptych, de Tolnay ("Zur Herkunft des Stiles der van Eyck," p. 330, note 10, figs. 2 and 3) appears to be begging the question. Nothing entitles us to assume that at a time when Haarlem had to rely on Brussels for even the simplest kind of painting jobs, an altarpiece destined for a church at Diest in Brabant and manifestly deriving from the Flemish "réalisme pré-Eyckien" as represented, e.g., by the Brussels "*Somme-le-Roy*" of 1415 (see p. 108; figs. 140, 141) was executed by a painter from Holland. And the panel in the Musée des Arts Décoratifs, even if not attributable to the Bedford Master with absolute certainty, is assuredly not Dutch and may easily be slightly earlier than the diptych in the Metropolitan Museum.

Page 243

1. Carel van Mander, *Het Schilder-Boeck*, Haarlem and Alkmaar, 1604, fol. 205 v. In order to illustrate the spirit of special pleading in which the passage is written, I translate it in context: "When I endeavored to ascertain who were the most outstanding men in our art, so that I might arrange them in order one after the other and be careful to call the earliest one first upon my stage, I was surprised to learn of Albert van Ouwater, painter of Haarlem, that he had become so skillful a painter in oils at so early a time. One must conclude, I believe, from certain established circumstances that he must have lived as far back as the time of Jan van Eyck. For, an old, honest man, the painter Albert Simonsz of Haarlem, testifies to know for certain that in this year, 1604, it is sixty years ago that he, Albert [Simonsz], was a pupil of Jan Mostart of Haarlem who was then seventy years of age. Therefore some hundred and thirty years [the text has "1030," which is an obvious typographical error] have passed from the birth of said Mostart to the present date. Further, Albert Simonsz, whose memory is very good, avers that said Mostart had not known Albert van Ouwater nor Geertgen van [*sic*] S. Jans, and that Albert van Ouwater preceded the renowned painter, Geertgen tot S. Jans, who was Ouwater's pupil. Thus I leave it to the reader to consider and judge how early the art of painting in oils was practiced at Haarlem." It should be noted that this calculation, even if it were as correct as it is wrong (see the following note), would not prove Ouwater to have been a contemporary of Jan van Eyck. According to van Mander himself (fol. 206), Geertgen tot Sint Jans died at the age of twenty-eight; assuming, for the sake of argument, that he really died as early as 1474, he would have been born in 1446 and could not have begun his apprenticeship until *ca.* 1460.

2. For Geertgen tot Sint Jans, see p. 324 ff. According to the latest estimate (Davies, "National Gallery Notes, I, Netherlandish Primitives: Geertgen tot Sint Jans," *Burlington Magazine*, LXX, 1937, p. 88 ff.; ———, *National Gallery Catalogues, Early Netherlandish School*, p. 36 f.) he died about 1495 and, according to the earliest, about 1485 (K. Oettinger, "Das Rätsel der Kunst des Hugo van der Goes," *Jahrbuch der Kunsthistorischen Sammlungen in Wien*, new ser., XII, 1938, p. 43 ff.). Jan Mostart, born about 1475, was thus between ten and twenty years old when Geertgen died.

3. Friedländer, III, p. 57; Hoogewerff, II, p. 57.

4. Cf. de Tolnay, *Le Maître de Flémalle*, p. 36.

5. For Ouwater's "Raising of Lazarus," see p. 320 ff.

Page 244

1. Martens, *op. cit.*, p. 173 ff. That the horse in the Ghent altarpiece has much in common with the heavier chargers in the May picture in the "*Très Riches Heures*" (de Tolnay, "Zur Herkunft des Stiles der van Eyck," p. 326, note 10) does not, of course,

militate against the authenticity of the miniature in the "Turin-Milan Hours" and its priority in relation to the Ghent altarpiece; it shows only that Jan van Eyck, as has never been questioned, was acquainted with the work of the Limbourg brothers as well as with that of the Boucicaut Master.

2. See pp. 59 and 114.

3. See p. 59. Why the "Birth of St. John" should presuppose the illuminator's familiarity with the Master of Flémalle's "Salting Madonna" (de Tolnay, *Le Maître de Flémalle*, p. 35), with which it has no more in common than that in both cases the scene is laid in a Flemish interior, it is difficult to see.

4. Durrieu, *Les Très Riches Heures*, pl. VII.

5. Cf., e.g., Ring, "Primitifs français," figs. 1 and 4, or British Museum, ms. Add. 29433, fol. 89 (*British Museum, Reproductions from Illuminated Manuscripts*, I, London, 1910, pl. XXVI).

Page 245

1. Cf. the "Construction of the Temple of David" (Durrieu, *Les Très Riches Heures*, pl. XXVI), and the "Raising of Lazarus," (*ibidem*, pl. LXI).

2. Pigler, "Das Problem der Budapester Kreuztragung," proposes a date around 1420 while Musper, p. 92, suggests the years from 1422 and 1424.

Page 246

1. For the Endymion type, see, e.g., Reinach, *Répertoire de reliefs*, III, pp. 184, 365; for the Jonah type, e.g., O. Wulff, *Altchristliche und byzantinische Kunst* (Handbuch der Kunstwissenschaft), Berlin-Neubabelsberg, 1914–16, I, pl. V, fig. 83.

Page 247

1. A satisfactory monograph on Roger van der Weyden has still to be written; the most voluminous and most profusely illustrated book, J. Destrée's *Roger de la Pasture-van der Weyden* (hereafter quoted as "Destrée"), is not very critical. In addition to the indispensable second volume of Friedländer's *Die altniederländische Malerei* ("Friedländer") and Winkler's equally indispensable *Der Meister von Flémalle und Rogier van der Weyden* ("Winkler"), the reader will do well to consult the literature quoted in note 154⁵, particularly the important articles in *Biographie Nationale de Belgique*, XXVII, 1938, col. 222 ff. (by Hulin de Loo), Thieme-Becker, XXXV, 1942, p. 468 ff. (by Winkler), and *Niederländische Malerei im XV. und XVI. Jahrhundert* (by Vogelsang), supplemented by the Bibliographical Appendices and Summaries referred to in note 154³. P. Lafond, *Roger van der Weyden*, Brussels, 1912, and W. Burger, *Roger van der Weyden*, Leipzig, 1923, are pretty

much out of date; as to the book by O. Kerber, *Rogier van der Weyden und die Anfänge der neuzeitlichen Tafelmalerei*, Kallmünz, 1936 (Review by L. Scheewe, *Zeitschrift für Kunstgeschichte*, V, 1936, p. 353 f.), I can only repeat what I have said of his *Hubert van Eyck* in note 237⁵. For H. Beenken's *Rogier van der Weyden*, Munich, 1951, see note 154⁵.

2. Cf. the documents published by A. Pinchart, "Roger de le Pasture, dit van der Weyden," *Bulletin des Commissions Royales d'Art et d'Archéologie*, VI, 1867, p. 408 ff., especially pp. 446, 452. As a matter of fact, the city fathers were to change their minds. After Roger's death his position was transferred to Vrancke van der Stockt (or Vranck van der Stock) who, though established at Brussels as successor to his father in 1444, was nothing but a feeble imitator of Roger van der Weyden throughout his long life (he died on June 14, 1495) and appears to be the author of a number of works formerly ascribed to Roger's own workshop if not to himself. For him, see Hulin de Loo in *Biographie Nationale de Belgique*, XXIV, 1926–27, col. 66 ff., and J. Duverger in Thieme-Becker, XXXII, 1938, p. 69.

3. "Der stadt tavereel" (number of sections not specified) was inspected by certain noblemen in 1441 (see Winkler, p. 177). For the probable difference in date between the two pairs of panels and the date, 1439, of the earlier pair, see p. 264.

4. See H. Kauffmann, "Ein Selbstporträt Rogers van der Weyden auf den Berner Trajansteppichen," *Repertorium für Kunstwissenschaft*, XXXIX, 1916, p. 15 ff., note 29.

Page 248

1. See the data collected in Winkler, p. 195 f., and Hulin de Loo in *Biographie Nationale*, XXVII, col. 225 ff. For further and extremely generous gifts and bequests to the Charterhouse of Hérinnes, see P. Landelin-Hoffmans, O.M.L., *Un Rogier van der Weyden inconnu*, Enghien, 1948, p. 23.

2. See the document reprinted in Winkler, p. 181.

3. See note 291⁴.

4. See Hulin de Loo, *Biographie Nationale*, XXVII, col. 227 f.

5. See the letter reprinted in Winkler, p. 190.

6. See the document partially reprinted in Winkler, p. 170 f., and Hulin de Loo, *Biographie Nationale*, XXVII, col. 227; the complete text is found in J. Destrée, "Le Retable de Cambrai de Roger de la Pasture," *Mélanges Hulin de Loo*, Brussels and Paris, 1931, p. 136 ff. For an important emendation of the text, and for the problem of connecting it with one of the works that have come down to us, see note 285³ (cf. also note 283³).

7. The Arras drawing is illustrated in Lafond, *op. cit.*, frontispiece, and Destrée, text vol., pl. 12. The self-portrait in the Berne tapestries was identified by Kauffmann, "Ein Selbstporträt Rogers van der Weyden." For the authenticity of both likenesses, see E. Panofsky, "Facies illa Rogeri maximi pictoris," *Late Classical and Mediaeval Studies in Honor of Albert Mathias Friend, Jr.*, Princeton, 1954, p. 392 ff. The objections raised by K. Rathe, *Die Ausdrucksfunktion extrem verkürzter Figuren* (Studies of the Warburg Institute, VIII), London, 1938, p. 48 ff., can be refuted on theological as well as philological grounds.

8. Friedländer, *Von Eyck bis Bruegel*, p. 8: "Jan van Eyck ist ein Entdecker (während Rogier ein Erfinder ist)." Cf. also the passage quoted on p. 348.

Page 249

1. For the Facius passage, see note 2 [7]. Whether or not van Mander's phrase (*op. cit.*, fol. 206 v.) is derived from Facius it is difficult to say. Certain it is, however, that the latter patterned his praise upon the model of Pliny's characterization of Aristides of Thebes in contradistinction to Apelles (*Naturalis historia*, XXXV, 98); "Aequalis eius [Apellis] fuit Aristides Thebanus; is omnium primus *animum* pinxit et *sensus* homnium expressit, quae vocant Graeci ἦϑη." It should be noted that in Pliny the passage on Aristides follows that on Apelles (quoted in note 180 [1]) just as in Facius' work the biography of Roger follows that of Jan van Eyck.

2. Alberti, *op. cit.*, p. 153.

3. G. Ring, "St. Jerome Extracting the Thorn from the Lion's Foot," *Art Bulletin*, XXVII, 1945, p. 188 ff. The picture is now in the Institute of Arts at Detroit (see E. P. Richardson, "St. Jerome in the Desert," *Bulletin of the Detroit Institute of Arts*, XXVI, 1947, p. 53 ff.). As to the iconography, it should be borne in mind that St. Jerome's excursion into the domain of veterinary surgery was not entirely unknown in pre-Rogerian art: see, e.g., "Heures d'Ailly" (*ca.* 1410, see note 62 [3]), fol. 186 v.; Morgan Library, ms. 866 (*ca.* 1415, see note 104 [6]), fol. 144 v.; Morgan Library, ms. 46 (*ca.* 1430–35, see note 121 [6]), fol. 156 v.; a relief published by W. Bode, "Tonabdrücke von Reliefarbeiten niederländischer Goldschmiede aus dem Kreise der Künstler des Herzogs von Berry," *Amtliche Berichte aus den Königlichen Kunstsammlungen*, XXXVIII, 1916/17, col. 315 ff., fig. 105. An Austrian fresco hardly later than *ca.* 1415 has recently been published by G. Tripp, "Restaurierung gotischer Fresken in Schloss Clam," *Oesterreichische Zeitschrift für Kunst und Denkmalspflege*, VI, 1952, p. 88 ff. In the "Boucicaut Hours," fol. 171

v. (our fig. 61), we have a touching prelude to the operation proper: the lion lifts his right paw in plaintive fashion and tries to call the busy saint's attention to the enormous thorn lodged therein; the lion in the Limbourgesque grisaille in the *Bible Moralisée*, Paris, Bibliothèque Nationale, ms. fr. 166 (see note 189 [4]) also lifts his paw and seems to be complaining in audible manner but the thorn is not visible. As for the picture published by Miss Ring (see also *Art News*, XXXVI, 1938, Sept. 17; *ibidem*, XXVIII, 1940, July 13; *The Worcester-Philadelphia Exhibition of Flemish Painting*, no. 9; Friedländer, XIV, p. 88; Beenken, *Rogier*, p. 99, fig. 126), I doubt that it was even partially executed by Roger. But that it is of his invention is confirmed by its enormous influence, especially on a painting by Memlinc (Ring, fig. 3) and the so-called "Sforza triptych," a work produced in Roger's school with the participation of young Memlinc (Friedländer, II, p. 121, no. 93; Destrée, pl. 28; detail showing the St. Jerome in Ring, fig. 2).

4. See p. 286 ff.

Page 250

1. See, e.g., Hulin de Loo, *Biographie Nationale*, XXVII, col. 242.

Page 251

1. See H. Beenken, "Rogier van der Weyden und Jan van Eyck," *Pantheon*, XXV, 1940, p. 129 ff. I agree with Beenken on several important points, especially the non-identity of Roger with the Master of Flémalle, the priority of the "Granada-Miraflores" altarpiece in relation to the Werl altarpiece, and the pronouncedly Eyckian character of the Louvre "Annunciation" (see p. 252 ff.). But I cannot follow him in his assumption (apparently no longer maintained in his book of 1951) that the Master of Flémalle was a person distinct from Robert Campin and that his influence on Roger superseded rather than interpenetrated with the Eyckian one; this interpretation fails to do justice to the complex character of even Roger's earliest works.

2. See pp. 169 and 186. For the picture itself, see Winkler, p. 126; Friedländer, II, p. 93, no. 7; Destrée, pl. 52; Renders, II, pl. 16; Schöne, p. 62; Musper, fig. 17; Beenken, *Rogier*, p. 44 f., fig. 38. The picture is often connected with a "nostra Donna sola cun el puttino in brazzo, in piedi, in un tempio Ponentino [viz., a sacred edifice built in the Gothic style], cun la corona in testa" seen by Marcantonio Michiel in the Palazzo Vendramin and ascribed by him to "Rugerio da Brugiis." However, contrary to Winkler, p. 186, the expression *tempio*, occurring hundreds of times in Renaissance sources, can only

mean "a church" and not "a niche" or "an aedicula." The little panel (*quadretto*) seen by Michiel was, therefore, a Madonna in a Gothic Church, quite possibly one of those replicas of Jan van Eyck's much-copied picture at Berlin one of which is still in an Italian collection (Rome, Galleria Doria, our fig. 487); a confusion of names would not be surprising in an author who, for example, lists Dirc Bouts' Portrait of Gentleman of 1462 (our fig. 422) as a self-portrait of Roger van der Weyden.

3. See p. 146. For the picture itself, see Winkler, p. 126 f.; Friedländer, II, p. 94, no. 8; Destrée, pl. 52; Renders, II, pls. 15, 16; Musper, fig. 18; Beenken, *Rogier*, p. 28 f., fig. 13.

4. Destrée, pl. 53; Renders, II, pls. 25, 26; Musper, p. 46; Beenken, *Rogier*, p. 44 ff., fig. 39. As far as can be judged from the reproduction, the "St. John the Evangelist" in the Kaiser Friedrich Museum at Berlin — published by F. Winkler, "Ein unbeachtetes Frühwerk Rogiers van der Weyden," *Jahrbuch der Preussischen Kunstsammlungen*, LXIII, 1942, p. 105 ff. and illustrated in Beenken, *Rogier*, fig. 14 — is closely related to the Vienna "St. Catherine" and may be by the same hand.

5. Long before Beenken, the Eyckian elements in the Vienna Madonna were strongly emphasized by Friedländer, II, p. 26 f., who also pointed out the similarity which exists between this picture and Jan's "Madonna at the Fountain." This similarity, however, should not tempt us to date the Vienna panel after 1439. Should it be more than coincidental it might even be accounted for by the assumption that Jan's distinctly archaic composition (cf. p. 186) was touched by the retroactive influence of the already famous Roger van der Weyden.

Page 252

1. Winkler, p. 65 ff., figs. 32–34; Friedländer, II, p. 135 f., no. 121; Musper, fig. 48. The composition may be said to synthesize a Flémallesque living room (cf. the nail-studded shutters, etc.) with the Eyckian scenery adopted for the "St. Luke Painting the Virgin" (view through a colonnade, walled garden, etc.). The pattern of the tiled floor is identical with that in the St. Luke picture and recurs in the left wing of the Bladelin altarpiece as well as in the left wing of the Columba altarpiece. With the latter and the St. Luke picture the "Madonna on a Porch" also shares the motif of a barrel-vaulted wooden ceiling; but nothing could be more different than the treatment of this motif in Roger's compositions and those of the Master of Flémalle (Werl altarpiece and Louvre drawing, our figs. 212 and 230). Whether or not another Madonna of Humility composition, known

as the "Madonna with the Flower" (Winkler, p. 63 f.; Friedländer, II, p. 135, no. 120), must be credited to Roger van der Weyden I dare not decide. Best transmitted through an engraving by the Master of the Banderoles (Friedländer, "Bernaert van Orley," *Jahrbuch der Königlich Preussischen Kunstsammlungen*, XXX, 1909, p. 9 ff., especially p. 18 ff.) and a painting in the Louvre (Musper, fig. 37), it was developed from the Master of Flémalle's "Madonna of Humility" at Berlin (our fig. 198) and, if authentic, would have held an intermediary position between the Vienna and Thyssen Madonnas, on the one hand, and the "Madonna on a Porch," on the other. The "Madonna with the Pear," transmitted through a panel of unknown location (Winkler, fig. 9) and a drawing formerly in the Königs Collection at Haarlem (Musper, fig. 38), appears to me Flémallesque rather than Rogerian.

2. Winkler, p. 126 ff., fig. 58; Friedländer, II, p. 94, no. 9; Destrée, pl. 115; Renders, II, pls. 54–56; E. Michel, *L'Ecole Flamande . . . au Musée du Louvre*, p. 42 f., pl. VI; Musper, figs. 46, 47; Beenken, *Rogier*, p. 31 ff., figs. 20–22. For the Eyckian character of the composition, see, apart from Beenken, "Rogier van der Weyden und Jan van Eyck," Robb, *op. cit.*, p. 508 ff., note 85 (summing up the results of a seminar conducted by this writer). For the history and date of the wings (preserved in the Galleria Sabauda at Turin), see p. 300 f.

3. For the Boston "St. Luke Painting the Virgin," see Friedländer, XIV, p. 88, Nachtrag, pl. IX; Beenken, *Rogier*, p. 34 f., figs. 24–26; P. Hendy and M. J. Friedländer, "A Roger van der Weyden Altarpiece," *Burlington Magazine*, LXIII, 1933, p. 53 ff.; A. Niederstein, "Die Lukas-Madonna des Rogier van der Weyden," *Pantheon*, XII, 1933, p. 361 ff. Its authenticity was contested, e.g., by M. Devigne, "La Peinture ancienne à l'Exposition Internationale de Bruxelles," *Oud Holland*, LII, 1935, p. 266 ff.; Burroughs, *Art Criticism from a Laboratory*, p. 262 ff.; Musper, p. 46. For the other versions, see Winkler, p. 60 ff., especially p. 62 f.; Friedländer, II, p. 126 f., no. 106, pl. LXXIII; Destrée, pls. 33, 34, and text vol., frontispiece; Musper, figs. 39–41. For the question as to whether the St. Luke can be called a "self-portrait" of Roger van der Weyden, see Panofsky, "Facies illa Rogeri maximi pictoris."

4. See p. 158. For the picture itself, see Winkler, pp. 78 ff., 130 f.; Friedländer, II, p. 93, no. 5, pl. VIII; Destrée, pl. 116; Renders, II, pls. 24, 26–28; Beenken, *Rogier*, p. 37 ff., figs. 28–30. For the relation between the Lützschena and Turin versions, cf. p. 301.

5. See note 2⁷.

Page 253

1. Hulin de Loo, *Biographie Nationale*, XXVII, col. 235.

2. Lange and Fuhse, *op. cit.*, pp. 124, 9; 122, 10.

3. *Ibidem*, p. 156, 10, 14.

4. Klein, *op. cit.*, *passim*.

Page 254

1. *Ibidem*, p. 69 ff. Miss Klein was, however, not acquainted with the Horae, Baltimore, Walters Art Gallery, ms. 281, fol. 17 (see note 61 ³) where the motif of the vision occurs as early as *ca.* 1430–1435.

2. See above, p. 175, and Klein, *op. cit.*, p. 40 ff. For the survival of this more naturalistic type, see Klein, p. 49 ff.

3. See p. 162.

4. See p. 203. For passages in which the Virgin Mary herself is called "thalamus pietatis," "thalamus humilitatis," "thalamus dei," etc., see *Patrologia Latina*, Indices, vol. CCIX, col. 519.

5. For Masolino's "Annunciation" (formerly Henry Goldman Collection, now National Gallery at Washington), see van Marle, *op. cit.*, IX, p. 292, fig. 187 and Prampolini, *op. cit.*, pl. 45. For that from the school of Fra Angelico (Mensola, S. Martino), see F. Schottmüller, *Fra Angelico da Fiesole* (Klassiker der Kunst, XVIII), Stuttgart and Leipzig, 1911, p. 221. For those by Bicci di Lorenzo (Boston, Museum of Fine Arts; Baltimore, Walters Art Gallery; Florence, Sant' Arcangelo a Legnaio; Porciano, Parish Church) and their connection with the Brenken altarpiece, see note 129 ⁹; Prampolini, figs. 45, 46; Constable, *op. cit.*

Page 255

1. De Tolnay, "Zur Herkunft des Stiles der van Eyck," p. 338.

2. Renders, II, pls. 55, 56; Friedländer, XIV, p. 83 f.

3. See p. 96.

Page 256

1. Renders, II, pl. 52.

2. Winkler, p. 162 ff.; Friedländer, II, p. 92, no. 3, pls. II–VI; Destrée, pls. 55–59; Renders, II, pls. 41, 43–45, 49, 50, 52, 53; Schöne, pp. 65, 67; Musper, figs. 55, 57; van Puyvelde, *Primitives*, pl. 33; Beenken, *Rogier*, p. 45 ff., figs. 40–44. The lost wings are said to have shown the Resurrection and the Four Evangelists. Two monographs with identical color plates but different texts have been published in English (W. Ueberwasser, *Rogier van der Weyden, Paintings from the Escorial and the Prado Museum*, London, 1945) and French (E. Michel, *Rogier van der Weyden; Sept reproductions en couleurs d'après les tableaux de l'Escurial et du Musée du Prado*, London, 1945). For the interpretation of the content, see a recent article by O. G. von Simson, "*Compassio* and *Co-redemptio* in Roger van der Weyden's Descent from the Cross," *Art Bulletin*, XXXV, 1935, p. 9 ff., which appeared too late to be considered but suffers somewhat from the fact that no mention is made of the "Descent from the Cross" by the Master of Flémalle, unquestionably a pre-Rogerian "attempt at an explicit juxtaposition of swoon and death." Roger's "Descent" may be called, without exaggeration, *the* most influential painting of Northern fifteenth-century art, and a study of this influence would fill a sizable monograph. For some fine observations, made in connection with a special case of this kind, see R. A. Koch, "Two Sculpture Groups after Roger's 'Descent from the Cross' in the Escorial," *Journal of the Walters Art Gallery*, XI, 1947, p. 39 ff.

Page 257

1. Illustrated, e.g., Destrée, pl. 64.

2. Cf., e.g., Renders, II, pl. 50.

3. Cf., e.g., Renders, II, pl. 49; M. J. Friedländer, "Flémalle-Meister-Dämmerung," *Pantheon*, VIII, 1931, p. 353 ff.

4. Hulin de Loo, *Biographie Nationale*, XXVII, col. 242.

Page 258

1. Viz., the Vienna and Thyssen Madonnas, on the one hand, the "Virgin in Red" in the Prado and the "Granada-Miraflores" altarpiece, on the other.

Page 259

1. Winkler, p. 169; Friedländer, II, p. 95, no. 12, pl. XI; Destrée, pl. 125; Renders, II, pls. 20, 58; van Puyvelde, *Primitives*, pl. 46; Beenken, *Rogier*, p. 31, fig. 15. Cf. Davies, *National Gallery Catalogues, Early Netherlandish School*, p. 112 f. The reputation and comparatively early date of the composition is attested by the fact that the Magdalen, in the guise of a donatrix, recurs in the "Hours of Isabelle of Brittany," executed between 1433 and 1442 (Pächt, "Jean Fouquet: A Study of His Style," p. 88).

2. Friedländer, XIV, p. 88, Nachtrag, pl. XI; Schöne, p. 63; Musper, fig. 56; Beenken, *Rogier*, p. 40 ff., figs. 34, 37.

3. Winkler, p. 166 f., Friedländer, II, p. 91, no. 1, pl. I; Destrée, pls. 13–17; Renders, II, pls. 2, 23, 45–47, 58; Musper, figs. 74, 75; Beenken, *Rogier*, p. 41 ff., figs. 31–33. Cf. Wehle and Salinger, *op. cit.*, p. 30 ff. A drawing of the head of St. Joseph, probably a workshop pattern of excellent quality rather than

an original, is in the Ashmolean Museum at Oxford (see K. T. Parker, *Catalogue of the Collection of Drawings in the Ashmolean Museum, Oxford,* 1938, no. 93, pl. XIX; F. Winkler, "An Attribution to Roger van der Weyden," *Old Master Drawings,* X, 1935, p. 1 ff.; Beenken, *Rogier,* p. 98). The "Granada" altarpiece, presented to Granada Cathedral by Isabella the Catholic after the conquest of 1492, was barbarically dismembered in 1632. The panels showing the Adoration of the Infant Jesus and the Lamentation were cut down at the top to serve as shutters of a reliquary still preserved in the Capilla Real; the "Appearance of Christ to His Mother," fortunately unmutilated and in better condition also in other respects, has found its way into the Metropolitan Museum. The "Miraflores" altarpiece, very slightly larger (each panel 71 by 43 cm. as against 63.5 by 38.1 cm.), is well preserved, and we possess more detailed information about it. In his *Viaje de España* (1783) the excellent Don Antonio Ponz, carefully distinguishing between firsthand evidence and hearsay, reprints a Latin document according to which the triptych was given to the Convent of Miraflores (near Burgos) by King Juan II in 1445 and adds that it was "believed" to have been received by the latter as a gift from Pope Martin V Colonna (Ponz's text is reprinted in Winkler, p. 166, note 3). Since Martin V died as early as 1431, this second piece of information — apparently suspected by Ponz himself — must be dismissed. The date 1445, however, stands and furnishes a *terminus ante quem,* the only question being whether this *terminus* applies to the altarpiece now divided between the Capilla Real and the Metropolitan Museum, to the altarpiece now at Berlin, or to both; for, we are faced with three possibilities. Either, the Granada-New York altarpiece and the Berlin altarpiece are genuine duplicates, both produced in Roger's workshop and not separated by an appreciable interval of time. Or, the Granada-New York altarpiece is a copy, made by order of Isabella, after the Berlin altarpiece. Or, the Berlin altarpiece is a copy, also presumably commissioned by Isabella, after the Granada-New York altarpiece, in which case the Queen would have transferred the original from Miraflores to Granada and left the copy as a substitute. The second of these alternatives has never been considered by the experts and is indeed most improbable from a stylistic point of view. But the third, preferred by Winkler, is no less difficult to substantiate; when the New York "Appearance," recently cleaned, could be compared with the Berlin triptych on the occasion of the latter's visit to the United States, no stylistic and technical differences indicative of an interval of *ca.* fifty years could be discovered. I am, therefore, inclined to accept the first alternative (with the proviso that the Berlin triptych is the second rather than the first "edition"); we may remember the two altarpieces ordered by Philip the Bold from Jacques de Baerze with the explicit understanding that they should exactly duplicate those furnished for Termonde and Byloke (see p. 78 f.).

Page 260

1. The inscriptions — that on the New York "Appearance" considerably garbled in Wehle and Salinger — were phrased on the basis of Scriptural texts mentioning the bestowal of crowns but having no specific reference to the Virgin Mary, and in one case the tense was changed so as to fit into a continuous progression of tenses from future to present and from present to preterit. With abbreviations expanded and the punctuation modernized, the three inscriptions are here juxtaposed with their sources.

Adoration of the Infant Jesus:

"Mulier hec fuit *probatissima,* munda ab omni labe; ideo *accipiet coronam vitae.* Ex Jac. I°."

"Beatus vir qui suffert tentationem; quoniam cum *probatus* fuerit, *accipiet coronam vitae*" (Epistle of James, I, 12).

Lamentation of Christ:

"Mulier hec fuit *fidelissima* in Christi dolore; ideo *datur ei corona vitae.* Ex Apoc. II° capitulo."

"Esto *fidelis* usque ad mortem, et *dabo tibi coronam vitae*" (Revelation II, 10).

Christ's Appearance to His Mother:

"Mulier hec perseuerauit *vincens* omnia; ideo *data est ei corona.* Ex Apoc. VI° capitulo."

"Et *data est ei* [*scil.,* to the rider on the white horse] *corona,* et exivit *vincens* ut vinceret" (Revelation VI, 2).

For the analogously derived inscriptions in the Chevrot triptych, see note 283².

2. For a detailed description of the scenes in the archevaults of the "Appearance," see Wehle and Salinger, *op. cit.,* p. 32; for the two other panels, see *Königliche Museen zu Berlin; Beschreibendes Verzeichnis der Gemälde im Kaiser-Friedrich-Museum,* 7th ed., Berlin, 1911, p. 478 f. It should be noted, however, that the second scene in the left-hand archevault of the "Lamentation" — here described only as "Mary with Two Apostles" — can be identified with an event depicted by Roger in the Naples canvases described by Fazio (see note 2⁷), viz., the Virgin Receiving the News of Christ's Arrest.

Page 261

1. In the Nativity relief (first panel, first archevault group on the left) this gesture is varied in that the thumbs are crossed as in the Bladelin and Columba altarpieces and, later on, in Dürer's Dresden altarpiece.

2. Cf., e.g., *Speculum humanae salvationis*, XXV (Lutz and Perdrizet, *op. cit.*, pls. 49, 50).

3. See Panofsky, "Reintegration of a Book of Hours," p. 479 ff., especially p. 491.

4. According to the experts, the best of these variations — none of which can possibly antedate the "Granada-Miraflores" altarpiece — is the "*Pietà* with St. Jerome, St. Dominic and a Donor" in the Collection of the Earl of Powis at London which is, however, not known to this writer (Winkler, p. 170; Friedländer, II, p. 98, no. 20, pl. XVII; Destrée, pl. 85). The others are: the very fine "*Pietà* with St. John the Evangelist and the Magdalen" in the Musée Royal at Brussels (Winkler, p. 161 f.; Friedländer, II, no. 20 a; Destrée, pl. 84; Musper, fig. 52; our fig. 390); the "*Pietà* with St. John the Evangelist and a Donor" (who can be identified among the retinue of Philip the Good in the dedication miniature of the *Chroniques du Hainaut*, fig. 330) in the Kaiser Friedrich Museum at Berlin (Winkler, p. 88; Friedländer, II, no. 20 b; Destrée, pl. 87; Musper, fig. 61); finally, a "*Pietà*" in the Prado perfectly identical with the Berlin picture but cut round at the top after the fashion of the early sixteenth century (Friedländer, II, no. 20 d; Destrée, pl. 86; Ueberwasser, *Rogier van der Weyden*, pl. 2; E. Michel, *Rogier van der Weyden*, pl. 2). A copy after the Berlin or Prado replica, preserved in a private collection at Naples (?) is listed by Friedländer, II, no. 20 c. A number of later variations on the Brussels version (with the Magdalen) may be grouped around the "Lamentation" by Gerard David in the Pennsylvania Museum of Art (Friedländer, VI, pl. LXX), e.g., a picture in the van Ittersum collection at Amsterdam (Musper, p. 51, fig. 60) and the central panel of a triptych, ascribed to the itinerant Austrian master known as the Master of the Krainburg Altarpiece, in the possession of Mr. and Mrs. Clarence Y. Palitz at New York (G. Ring, "An Austrian Triptych," *Art Bulletin*, XXVI, 1944, p. 51 f.; *Holbein and His Contemporaries*; *A Loan Exhibition . . .*, October 22–December 24, 1950, The John Herron Art Museum, Indianapolis, Ind., no. 53). In all these replicas and variations the posture of the dead Christ is somewhat softened in that the legs are slightly bent at the hip and both arms freed from the torso; and it is all the more noteworthy that both Dirc Bouts (Paris, Louvre, cf. p. 317) and Quentin Massys (Paris, Louvre, illustrated, e.g., in E. Michel, *L'Ecole Fla-*

mande . . . *au Musée du Louvre*, p. 64 f., pl. XXXIV), while abandoning the dramatic kiss motif, restored the Body to Its original rigidity. The picture formerly at Bottenwieser's in Berlin (Destrée, pl. 88) is a pastiche partly based on Hugo van der Goes' "Lamentation" at Vienna (fig. 457). The influence of Roger's composition in Spain is exemplified by Fernando Gallego (Post, *A History of Spanish Painting*, IV, p. 99, fig. 18).

5. We may compare Willem Key's well-known "*Pietà*" at Munich (Winkler, *Die altniederländische Malerei*, p. 320, fig. 190; cf., however, Friedländer, XIII, p. 96) with the "Granada-Miraflores" type, on the one hand, and with Sebastiano del Piombo's Paris drawing of the dead Christ (K. Frey, *Die Handzeichnungen Michelagniolos Buonarroti*, Berlin 1909–1911, no. 21; A. E. Brinckmann, *Michelangelo Zeichnungen*, Munich, 1925, pl. 23; E. Panofsky, "Die Pietà von Ubeda," *Festschrift für Julius Schlosser zum 60. Geburtstage*, Vienna, 1927, p. 150 ff.).

Page 262

1. For the genesis of this Italian pseudo-*Vesperbild*, and its probable origin in the Siena of Simone Martini and Ambrogio Lorenzetti, cf. the excellent paragraphs in M. Meiss, "Italian Primitives at Konopiště," *Art Bulletin*, XXVIII, 1946, p. 1 ff., particularly p. 8 ff.; Cecco di Pietro's panel is illustrated in fig. 18 and, in a somewhat larger reproduction, in *Bollettino d'Arte*, ser. 3, XXVII, 1933, p. 372, fig. 3.

2. Cf., e.g., Pinder, *Die deutsche Plastik des vierzehnten Jahrhunderts*, pl. 29.

3. Cf., e.g., Panofsky, "Reintegration of a Book of Hours," figs. 9, 11; ———, "The de Buz Book of Hours," pl. VI a.

4. Durrieu, *Les Très-Belles Heures*, pl. XXIV. For the "Lamentations" in the "*Petites Heures*" and "*Grandes Heures*," see pp. 44, 50.

5. See, e.g., the retables in the Musée des Arts Décoratifs at Paris (Post, *A History of Spanish Painting*, II, p. 281, fig. 172), in the Abella de la Conca (Sanpere i Miquel, *op. cit.*, II, fig. 15), and in Our Lady's Church at Manresa (G. Richert, *Mittelalterliche Malerei in Spanien*, Berlin, 1925, fig. 39, wrongly connected with St. Bridget by G. G. King, "Iconographical Notes on the Passion," *Art Bulletin*, XVI, 1934, p. 290 ff.). For the passage from St. Ambrose (*De virginitate*, III, 14), see *Patrologia Latina*, XVI, col. 283. It is a well-known fact that Christ's Appearance to His Mother is not authenticated in the Bible; it was, however, accepted as a matter of "reasonable belief" throughout the Middle Ages; an instructive though by no means complete list of authorities accepting it is found in the Roman edition of St.

Bridget's *Revelationes* (Rome, 1628, II, p. 164, note to VI, 94).

6. Cambridge, Fitzwilliam Museum, ms. 62 (workshop of the Rohan Master), no. 58 according to M. R. James, *A Descriptive Catalogue of the Manuscripts in the Fitzwilliam Museum*, p. 159.

Page 263

1. Pseudo-Bonaventure, *The Mirrour of the Blessed Lyf of Jesu Christ*, p. 263 f.; Ludolf of Saxony, *Vita Jesu Christi*, II, 70 (in the Lyons edition of 1519, fol. CCXXXVI).

2. The earliest and best known instance of this kind is the beautiful miniature in the *Passionale Cunigundae* of ca. 1320 (illustrated, e.g., in F. Burger, *op. cit.*, I, p. 160, fig. 180); for the early fifteenth century, see the woodcut, Schreiber, *Manuel de la gravure sur bois*, no. 700. A French example of the sixteenth century is found in the Hours of Henry II, Parma, Biblioteca Palatina, ms. pal. 169, fol. 86 v. (D. Fava, *Tesori delle Biblioteche d'Italia, Emilia e Romagna*, Milan, 1932, p. 211, fig. 93).

3. Best published illustration in G. Chierici, *Il Restauro della chiesa di S. Maria di Donnaregina a Napoli*, Naples, 1934, pl. XXXIV.

4. For the few instances of this type in Spanish and Italian Trecento painting, cf. Meiss, "Italian Style in Catalonia," fig. 2 A and p. 66, note 44; to be added: a miniature from an Italian *Chorale* in the Fitzwilliam Museum at Cambridge, ms. 194 (M. R. James, *A Descriptive Catalogue of the Manuscripts in the Fitzwilliam Museum*, pl. XIX). For the German tradition, culminating in Dürer's woodcut B. 46, cf. the woodcuts, Schreiber, *Manuel*, nos. 701–706 (no. 703 illustrated in P. Heitz, *Einblattdrucke des fünfzehnten Jahrhunderts*, LIX, Strasbourg, 1925, no. 6; no. 704, obviously reflecting a miniature of ca. 1430, *ibidem*, XXXV, 1913, no. 27). By the end of the fifteenth century this type could be used to illustrate the appearance of Christ to a private gentleman as in an unpublished Horae in the Huntington Library, ms. 1149 (de Ricci-Wilson, *Census*, I, p. 98, no. 1149) to which Professor Samuel C. Chew calls my attention; and in a *Dialogue de Jésus Christ et de la Duchesse* (London, British Museum, ms. Add. 7970, illustrated by the Master of Mary of Burgundy) the figure of Margaret of York is substituted for that of the Virgin Mary (Pächt, *The Master of Mary of Burgundy*, pl. 1). For copies and variations of Roger's composition, see, apart from a tapestry in the Fogg Museum at Harvard, a picture now ascribed to Vrancke van der Stockt in the National Gallery at Washington (Friedländer, II, p. 105, no. 41; Destrée, pl. 18; de Tolnay, "Flemish Paintings in the National

Gallery of Art," p. 184, fig. 14); a triptych shutter by the Master of the St. Ursula Legend in the Metropolitan Museum (Friedländer, VI, p. 137, no. 117, pl. LII; Wehle and Salinger, *op. cit.*, p. 76 f.); and an anonymous painting in the National Gallery at London, no. 1086 (Davies, *National Gallery Catalogues, Early Netherlandish School*, p. 115 f.). Of special interest is a composition, originating from the workshop of Dirc Bouts but known to us only through a copy by the Ulm Master of the Ehningen altarpiece (Schöne, *Dieric Bouts und Seine Schule*, pl. 74 a), which is generally based upon the Granada-Miraflores type but shows the right hand of Christ, bearing the print of the nail, directly extended toward the Virgin Mary. Here the idea of *ostentatio vulnerum* is all the more obvious as the picture forms the counterpart of a "Conviction of St. Thomas."

5. Brussels, Bibliothèque Royale, ms. II, 7831 (formerly Colbert de Beaulieu Collection), fol. 44; for the manuscript, see p. 108 f.

6. See, e.g., M. R. James, *The Apocryphal New Testament*, Oxford, 1924 and 1926, p. 183. The iconography of Christ's Appearance to His Mother in Early Christian art will be studied in a forthcoming article by J. D. Breckinridge.

7. See *Speculum humanae salvationis*, XIII (Lutz and Perdrizet, pls. 25, 26).

8. Not "Daniel" as erroneously stated in Wehle and Salinger, *op. cit.*, p. 32; see *Speculum humanae salvationis*, XXIX (Lutz and Perdrizet, pls. 57, 58).

9. See *Speculum humanae salvationis*, XXXII (Lutz and Perdrizet, pls. 63, 64).

10. See Luke XXIV, 38–40; John XX, 25.

11. De Tolnay's contention that the mantle of the resurrected Christ "would necessarily slide down" ("Zur Herkunft des Stiles der van Eyck," p. 337) is at variance with the fact that it is held in place by His wrist; and why the double function of His right arm should prove that Roger adapted the Master of Flémalle's St. John to his composition instead of the other way (Wehle and Salinger, *op. cit.*, p. 32) is difficult to see. It should be noted that a weak follower of Roger who in a huge altarpiece now preserved at The Cloisters at New York combined five or six different Rogerian compositions with a St. John patterned after that in the Werl altarpiece was careful to change the position of the Baptist's hand to the customary pointing gesture; See T. Rousseau, Jr., "A Flemish Altarpiece from Spain," *The Metropolitan Museum of Art, Bulletin*, new ser., IX, 1951, p. 270 ff.

Page 264

1. Friedländer, *Von Eyck bis Bruegel*, p. 24 (see also Friedländer, II, p. 66; Winkler, p. 36; Vogelsang,

"Rogier van der Weyden," p. 90). Friedländer's recantation is found in Friedländer, XIV, p. 84.

2. The subject of Giotto's murals, recurring in the Great Hall of the *Arte della Lana*, has been identified as "Brutus, Prototype of the Just Judge, Attacked by the Vices and Defended by the Cardinal Virtues"; see S. Morpurgo, "Brutus, 'il buon giudice,' nell' Udienza dell'arte della Lana," *Miscellanea di Storia dell'Arte in Onore di Igino Benvenuto Supino*, Florence, 1933, p. 141 ff.

3. Winkler, p. 103 f., pl. XIX; Destrée, pls. 73, 74; Musper, fig. 28. For the hypothesis (unconvincingly contested by Musper, p. 43 f.) that the Herkinbald pictures were added as late as after October 30, 1454, see Hulin de Loo, "Les Tableaux de justice de Rogier van der Weyden et les tapisseries de Berne," *XIVᵉ Congrès International d'Histoire de l'Art, Suisse, 1936, Actes du Congrès*, Basel, 1938, II, p. 141 ff.; for the date of the Trajan pictures (1439) and the liberties taken by the cartoonist of the tapestry, J. Maquet-Tombu, "Les Tableaux de justice de Roger van der Weyden à l'Hôtel de Ville de Bruxelles," *Phoebus*, II, 1949, p. 178 ff. For the general historical implication of the series, see H. van de Waal, *Drie Eeuwen vaderlandsche Geschied-Uitbeelding (1500–1800); Een iconologische studie*, The Hague, 1952, I, p. 261 ff., figs. 100 ff. Cf. also U. Lederle-Grieger, *Gerichtsdarstellungen in deutschen und niederländischen Rathäusern* (Heidelberg doctoral dissertation), Philippsburg, 1937; here Roger's panels are discussed on pp. 54 and 57 f., and on p. 10 is found an interesting reference to the lost representations from Valerius Maximus, Plutarch and Aulus Gellius which in 1378 could be seen in the Town Hall at Nuremberg and seem to be the earliest "Gerechtigkeitsbilder" on record.

Page 265

1. See Maquet-Tombu, "Les Tableaux de justice de Roger van der Weyden"; cf., however, Panofsky, "Facies illa Rogeri maximi pictoris."

2. As pointed out by Panofsky, *ibidem*, an important passage in Dubuisson-Aubenay's *Itinerarium Belgicum* (Paris, Bibliothèque Mazarine, ms. 4407) has been mispunctuated and, in one point, misread in the otherwise excellent article by Madame Maquet-Tombu who, in reading *se* instead of *servo*, has substituted a penitent Herkinbald for the lamenting servant actually present in the tapestry. The correct text is as follows: "Tertia tabula in prima sectione continet Archambaldum ducem Brabantiae nudum in lecto aegrotum, qui ascersitum ad se juvenem cultro jugulat insurgens acriter; servo factum deplorante et muliere admirante in secunda sectione, cum pictore ipso im-

berbo ibi assistente. Subscriptio talis est . . ." Which is in English: "The third picture contains in the first section Herkinbald, Duke of Brabant, lying nude and sick in bed, who, rising violently, cuts the throat of a young man summoned before him; while in the second section a servant deplores the deed and a woman looks on, the beardless painter himself being present. The title reads . . ."

3. See Kauffmann, "Ein Selbstporträt Rogers van der Weyden," and Panofsky, "Facies illa Rogeri maximi pictoris."

4. See Renders, II, pl. 21, C, D. The juxtaposition of these two heads with that of the Virgin Mary in the Dijon "Nativity" (pl. 21 A) and that of the St. Barbara in the Werl altarpiece (pl. 21 B) makes it most evident that a Roger of 1437–38 is infinitely closer to a Roger of ca. 1452 than to a contemporary Master of Flémalle.

Page 266

1. See note 2 [4].

2. For the document, see Winkler, p. 188. The drawing, preserved in the Boymans Museum at Rotterdam (our fig. 384), was published by M. J. Friedländer, "A Drawing by Roger van de Weyden," *Old Master Drawings*, I, 1926, p. 29 ff., pl. 38. Cf. also C. de Tolnay, *History and Technique of Old Master Drawings*, New York, 1943, pp. 58, 131, pl. 154; *De van Eyck à Rubens, Les Maîtres Flamands du Dessin* (Exhibition at the Bibliothèque Nationale, Paris, 1949), no. 9, pl. II; L. van Puyvelde, *Musée de l'Orangerie, Paris: Les Primitifs flamands, 5 juin–7 juillet*, Brussels, 1947, no. 101, pl. LXXII. The numerous paintings derived from Roger's composition were assembled by Winkler, p. 76 f., figs. 41–43, and Friedländer, *loc. cit.*; to be added: a much-repeated Madonna (the posture of the Christ Child changed in various ways) by the Master of the Embroidered Foliage (Friedländer, IV, p. 144 f., no. 84, pl. LXIII). My reasons for connecting the Rotterdam drawing with Roger's lost Carmelite Madonna are, apart from the fact that its style agrees with the middle of the 'forties: first, that the pose of the Virgin, reminiscent of such compositions as the Louvre "Sacra Conversazione" after the Master of Flémalle (fig. 231) or the Rothschild Madonna by Jan van Eyck and Petrus Christus (fig. 257), implies a fairly formal "Andachtsbild" with donors; second, that the earliest variation on the original, a picture of ca. 1480 in the Municipal Museum at Leipzig (Winkler, fig. 42; Friedländer, *loc. cit.*, fig. 2), retains the characteristic motif — absent from the later replicas — of two angels crowning the Virgin with a "star-encircled crown" (*corona stellis insignita*).

3. For the two "Descents from the Cross" in half-length (one with, one without St. John the Evangelist), see Friedländer, II, p. 123 f., nos. 97, 98, pls. LXX, LXXI; Destrée, pl. 65; Musper, figs. 50, 51; S. Reinach, "A Lost Picture by Roger van der Weyden," *Burlington Magazine*, XLIII, 1923, p. 214 ff.; E. Salin, "Copies ou variations anciennes d'une oeuvre perdue de Rogier van der Weyden," *Gazette des Beaux-Arts*, ser. 6, XIII, 1935, p. 15 ff. To be added: a triptych by the Master of the Holy Blood in the Metropolitan Museum, Wehle and Salinger, *op. cit.*, p. 81 f.

For a many-figured but somewhat stiff "Descent from the Cross" in full length, best transmitted by a picture at Munich now ascribed to Vrancke van der Stockt, see Winkler, p. 89 ff., figs. 49–51 (also Friedländer, II, p. 123, no. 95, and XIV, p. 86; Destrée, pl. 63; Musper, fig. 58; our fig. 393); and for another, simpler one, M. J. Friedländer, "Der Meister der Katharinen-Legende und Rogier van der Weijden," *Oud Holland*, LXIV, 1949, p. 156 ff. Both these compositions may, however, have been devised by a follower rather than Roger himself. The model of the engraving by the Master of the Banderoles referred to in note 176⁶ (Renders, II, pl. 42; Musper, p. 28, fig. 45), a picture at Douai published by J. Maquet-Tombu ("Autour de la Descente de Croix de Roger," *Bulletin de la Société Royale d'Archéologie de Bruxelles*, 1949, July, p. 1 ff., fig. 3), is even less likely to repeat an original composition by Roger van der Weyden. And to make him responsible for the design of a "Descent from the Cross" in the village Church of Niederwaroldern not far from Cassel in Central Germany (W. Medding, "Der Kreuzabnahmealtar zu Niederwaroldern und seine Beziehungen zu Rogier van der Weyden," *Zeitschrift für Kunstgeschichte*, VII, 1938, p. 119 ff.; Musper, p. 26 f., fig. 30) seems almost sacrilegious to this writer.

For the "Bearing of the Body to the Sepulchre" (our fig. 392), finally (apparently the central panel of a triptych the left-hand wing of which showed a Bearing of the Cross transmitted through a drawing formerly in the F. Becker Collection at Leipzig, our fig. 391), see Winkler, p. 81 ff., figs. 44–46; Friedländer, II, p. 122 f., no. 94; Destrée, pl. 61; Musper, figs. 49, 53; E. Michel, "Le Maître de Francfort," *Gazette des Beaux-Arts*, ser. 6, XII, 1934, p. 236 ff. The credit for having recognized the connection between the Louvre and Leipzig drawings belongs to F. Winkler, "Some Early Netherland Drawings," *Burlington Magazine*, XXIV, 1914, p. 224 ff., pl. III. The frames, faithfully copied in both drawings, suggest the possibility that this composition — manifestly presupposing and not preceding the great "Descent" from the Escorial, as is assumed by Musper, p. 29 — was sketched by Roger for the benefit of a sculptor rather than executed as a painting (one of the replicas, illustrated in Michel, fig. 8, is, in fact, a wood-carved altarpiece). W. Houben, "Raphael and Rogier van der Weyden," *Burlington Magazine*, XCI, 1949, p. 312 ff., is, however, inclined to identify the archetype with a painting originally stationed in Italy because he believes it to have exerted some influence on Raphael's famous "Bearing of the Body" in the Galleria Borghese; if this were true (which seems rather doubtful) it may be identical with the "e supplicio humanati Jovis pientissimum agalma" which was admired by Cyriacus of Ancona and Facius at Ferrara (see notes 2⁴,⁷) and, contrary to Houben's view, cannot be identical with the "Farewell at the Tomb" now preserved in the Uffizi (see p. 273 f.; fig. 331).

4. One of these fragmentary works (possibly executed by an assistant) is the Berlin panel showing SS. Apollonia and Margaret, apparently the right-hand shutter of a triptych the left wing of which showed St. John the Baptist and St. John the Evangelist; it may be dated between 1445 and 1450 (Winkler, p. 160; Friedländer, II, p. 96 f., no. 17, pl. XV; Destrée, pl. 121; Musper, fig. 72; Beenken, *Rogier*, p. 99). The other (not personally known to this writer who is therefore reluctant to pronounce about its date and authenticity) consists of two heads — that of St. Joseph and that of a female saint rather than the Virgin Mary — last heard of in the Gulbenkian Collection at New York (Winkler, p. 175; Friedländer, II, p. 103, no. 36, pls. XXXII, XXXIII; Destrée, pl. 120).

5. Winkler, p. 176, fig. 54; Friedländer, II, p. 95, no. 11, pl. X; Destrée, pl. 21 and text vol., pl. 9; Renders, II, pls. 22, 30, 32, 37–39, 43, 44, 48; Schöne, pp. 54, 66; Musper, figs. 62, 63; Beenken, *Rogier*, p. 51 ff., figs. 45–50.

Page 267

1. Cf., e.g., the compositions by and copied after Jan van Eyck (p. 235; figs. 290–293, 301) and the "Calvary" by the Master of Flémalle reconstructible from the miniature in the "Arenberg Hours" and the picture by Gerard David in the Thyssen Collection (p. 176 f., figs. 129, 229).

2. See Durrieu, *Les Très Riches Heures*, pl. LV; Martens, *op. cit.*, figs. 38, 87.

3. Cf. a sermon by George of Nicomedia quoted in F. E. Hyslop, Jr., "A Byzantine Reliquary of the True Cross from the Sancta Sanctorum," *Art Bulletin*, XVI, 1934, p. 333 ff. (p. 339), or the *Liber de Passione Christi et doloribus et planctibus Mariae* wrongly

ascribed to St. Bernard (*Patrologia Latina*, CLXXXII, col. 1134 ff.). This text seems to be the source of the inscription on the Berlin "Calvary" (see p. 298 f., fig. 398) which reads (with abbreviations expanded): "O Fili, dignare me attrahere et crucis in pedem manus figere. Bernhardus." In the *Liber de Passione* the Virgin addresses the crucified Christ with a versicle from the Song of Songs I, 3, significantly changing the words "Trahe me *post* te" to "Trahe me *ad* te" (col. 1135), and in the "Meditations" on John XIX, 25 ("Iuxta crucem stabat Maria") her actions are described as follows: "Considerans vultu benigno Christum pendentem in crucis ligno, stipite saevo, pedibusque flexis iunctisque [this very phrase tends to show that the text postdates the twelfth century] manibus [sese] levabat in altum, amplectens crucem . . ." In Western art I do not know of any such representation prior to Roger's; even in the East the reliquary discussed by Hyslop (better illustration in W. F. Volbach, *Biblioteca Apostolica Vaticana, Guida, I, L'arte bizantina nel Medioevo*, Rome, 1935, pl. II), showing the Virgin standing instead of kneeling, seems to be a *hapax legomenon*. For the Magdalen embracing the Cross, see note 26².

4. For a copy in the Gemäldegalerie at Dresden, see Friedländer, II, p. 121, no. 90; Destrée, pl. 26; for another, preserved in the Prado, Destrée, pl. 24.

5. Cf. p. 298 f.; fig. 398.

Page 268

1. Winkler, p. 157 f.; Friedländer, p. 95, no. 14; Destrée, pls. 92–101; Renders, II, pls. 3, 11, 13, 22, 48; Schöne, fig. 71; Musper, figs. 67–69; van Puyvelde, *Primitives*, pl. 36; Beenken, *Rogier*, p. 62 ff., figs. 60–72, 74, 76, 77. A photograph of the Paradise wing prior to restoration is reproduced in Vogelsang, "Rogier van der Weyden," p. 89. For the history of the altarpiece, see M. le Baron Verhaegen, "Le Polyptyque de Beaune," *Congrès Archéologique de France*, XCI, 1928, p. 327 ff. The Uffizi drawing illustrated in Destrée, pl. 149, is only remotely connected with Roger. Since the dimensions of the Beaune altarpiece are given only in general terms or even faultily in the literature (especially confusing the caption in van Puyvelde, *Flemish Primitives*, pl. 36), it may be useful to indicate them here after a kind communication from Mr. Robert A. Koch.

Height of central panel: *ca.* 225 cm.
Height of lateral panels: *ca.* 135 cm.
Height of top shutters: *ca.* 80 cm.
Interior overall width (including inner frames): 546 cm.
Width of central triptych (including inner frames): 273 cm.

Width of central panel: 108 cm.
Width of St. Peter and St. Paul wings: 82.5 cm.
Width of "Paradise," "Hell," and top shutters: 54 cm.

2. For Rolin, see *Biographie Nationale de Belgique*, XIX, 1907, col. 828 ff.; the phrase of Jacques du Clercq ("un des plus sages hommes du royaume, a parler temporellement, car au regard de l'espirituel, je m'en tais") is quoted in col. 838. The monograph by A. Perrin, *Nicolas Rolin*, Paris, 1904, was not accessible to me.

3. Brussels, Bibliothèque Royale, ms. 9242, fol. 1 (some of the heads repainted at an early date). Cf. Destrée, pl. 144; Musper, fig. 76; Beenken, *Rogier*, p. 54 f., fig. 51. Durrieu, *La Miniature flamande*, pl. XXXVI; Lyna, *De Vlaamsche Miniatuur*, fig. 25; P. Post, "Die Darbringungsminiatur der Hennegauchronik in der Bibliothek zu Brüssel," *Jahrbuch für Kunstwissenschaft*, I, 1923, p. 171 ff. That Roger himself is responsible for the design of this beautiful page is highly probable, not only because the composition was frequently imitated (see Winkler, "Studien zur Geschichte der niederländischen Miniaturmalerei," p. 307 f., fig. 22) but also because the heads closely resemble Roger's authentic portrayals of the same personages in style and interpretation. The manual execution of the page may, however, have been left to a professional illuminator.

4. Jacques du Clercq (quoted in *Biographie Nationale de Bilgique*, XIX, col. 834): "Nul si eust voulu souffrir régner en son lieu pour luy retraire en la paix, mais contendoit à monter tousjours et à multiplier jusqu'à son darrenier et de mourir l'espée au poing, triomphant sur fortune."

Page 269

1. See p. 101; also illustrated in Destrée, pl. 91.
2. See p. 237 ff.; fig. 301.
3. See note 61³.
4. See note 242⁸; also illustrated in Destrée, pl. 90.
5. Durrieu, *Les Très Riches Heures*, pl. XLVII.
6. See note 167².

Page 270

1. See M. P. Perry, "On the Psychostasis in Christian Art," *Burlington Magazine*, XXII, 1912–13, pp. 94 ff., 208 ff.

Page 271

1. This he does, e.g., in a Spanish altar frontal in the Museo Arqueológico at Vich (J. Gudiol i Cunill, *Els Primitius* (La Pintura Mig-Eval Catalana), Barcelona, II, 1929, p. 215, fig. 98) while a smaller devil attaches himself to the wrong scale from underneath.

2. The outcome of the weighing process therefore varies more or less at random, frequently according to the exigencies of the composition (Cf. Perry, *op. cit.*), and often remains, quite literally, "in the balance" as in the altar frontal just quoted or, to mention another example distinguished by the fact that St. Michael weighs the two souls in his bare hands instead of in a pair of scales, in the well-known mural (school of Bartolo di Fredi) in San Michele at Paganico (van Marle, *op. cit.*, II, p. 507, fig. 328).

3. This transitional form is also found, e.g., in another Spanish altar frontal at Vich (Gudiol i Cunill, *Els Primitius*, II, p. 199, fig. 90) where the little human figure emphatically "outweighs" the *diavolino*.

4. The earliest occurrence of the Chalice (triumphantly outweighing the symbols of sin) known to me is in the Wolfenbüttel Gospels of 1194 referred to in note 220 ¹. The figure in Chartres is too much mutilated to permit the identification of the symbol of good (evil is here expressed by frogs). How complex the situation may become in certain cases is demonstrated by representations of the legend of Emperor Henry II (see the recent article by J. Roosval, "Die Seelenwägung Kaiser Heinrichs II. in der Gotländischen Malerei," *Zeitschrift für Kunstwissenschaft*, IV, 1950, p. 125 ff.). According to this legend, the Emperor's sins, especially his unfounded suspicions of his saintly wife, threatened to outweigh his virtues when St. Lawrence placed a Chalice (referring to Henry's gift to the Church of Einstetten) in the opposite scale and thereby turned the balance in his favor. On the Emperor's tomb by Tilmann Riemenschneider (see Perry, *op. cit.*, p. 209, pl. I D) his sins are very properly expressed by an ugly little demon. In Orcagna's famous altarpiece of 1357, however, the chalice is balanced against the crowned figure of the Emperor himself (O. Siren, *Giotto and Some of His Followers*, Cambridge, Mass., 1917, pl. 185) so that the helpful action of the saint results, strictly speaking, in his protégé's perdition.

Page 272

1. As it does in all the more "logical" representations of the Psychostasia, e.g., in the Niederrotweil altarpiece by the German sculptor, Master H. L., or, to quote two "out-of-the-way" instances, a Swedish painting of *ca.* 1275 in the Museum ("Gotlands Fornsal") at Visby, no. 108, or another, of *ca.* 1520, in the Statens Historisk Museum at Stockholm. For Memlinc's "Last Judgment" and its connection with the Tani and Portinari families, see Warburg, *op. cit.*, I, p. 190 ff. It should also be noted that in a picture now ascribed to Vrancke van der Stockt and

almost literally repeating the upper section of the "Last Judgment" at Beaune, the Psychostasia is omitted while a great number of devils has been added (Friedländer, II, p. 125, no. 102, and XIV, p. 86; illustrated in *Königliche Museen zu Berlin; Die Gemäldegalerie des Kaiser Friedrich Museums* [by H. Posse], Berlin, 1911, p. 111).

2. The Latin text is reprinted in Winkler, p. 189.

3. E. H. Kantorowicz, "The Este Portrait by Roger van der Weyden," *Journal of the Warburg and Courtauld Institutes*, III, 1939–1940, p. 165 ff.

Page 273

1. *Ibidem*, p. 180.

2. Kantorowicz (p. 179 f.) calls attention to an entry in the accounts of the Ferrarese Court, dated August 15th, 1450, according to which twenty ducats were paid to Roger through Paolo Pozio, merchant of Bruges, a payment later referred to in the *Registro dei Memoriali dell anno 1450* of December 31st. Assuming that it took four weeks for the ducal order to reach Pozio and another four weeks for Pozio's report to reach Ferrara, Kantorowicz correctly concludes that Roger must have been in the Netherlands around June 15. There is, however, no reason to suppose that he was not in Italy in August and that he could have spent there "only a few weeks, at most a few months" in the spring. He may have left very soon after the receipt of his twenty ducats and stayed abroad up to the end of the year; in fact, he may have requested this payment for the very purpose of financing his journey. Even if we were to assume, against all probability, that the entry of December 31, 1450, instead of merely repeating the earlier record in the final account for the calendar year, refers to another twenty ducats, Roger would have had two-and-a-half clear months (from the middle of July to the end of September) in Italy. I agree, however, with Kantorowicz in feeling that a stay at Ferrara is neither demonstrable nor probable.

3. Kantorowicz, p. 180.

4. Winkler, p. 165; Friedländer, II, p. 99, no. 22, pl. XIX; Destrée, pl. 89; Musper, fig. 83; Beenken, *Rogier*, p. 60 ff., figs. 55, 56. The fact that the Uffizi panel is not identical with the lost "Deposition" at Ferrara (see note 266 ³) but with the *tavola* showing "el sepolcro del nostro Signore schonfitto di crocie e cinque altre figure" listed in the inventory of Villa Careggi, was demonstrated by Warburg, *op. cit.*, I, pp. 215 ff., 381 ff.; cf. also Hulin de Loo, *Biographie Nationale*, XXVII, col. 237.

5. See K. W. Jähnig, "Die Beweinung Christi vor dem Grabe von Rogier van der Weyden," *Zeitschrift für Bildende Kunst*, LIII, 1918, p. 171 ff.

6. Cf., e.g., Schottmüller, *op. cit.*, pp. 22, 44, 69, 112. This detail was pointed out to me by Messrs. Albert Bush-Brown and Robert A. Koch.

7. Illustrated in W. L. Hildburgh, "A Mediaeval Pectoral Cross," *Art Bulletin*, XIV, 1932, p. 79 ff., fig. 19. The miniature in Turin, University Library, ms. E IV 14, fol. 1 v., has not been published and was pointed out to me by Dr. Hanns Swarzenski.

Page 274

1. Cf., e.g., G. de Francovich, *Scultura medioevale in legno*, Rome, 1943, pl. 37.

2. The group in S. Antonio at Pescia was published in *Burlington Magazine*, LXXXIX, 1947, p. 54; for that in S. Miniato al Tedesco, see de Francovich, *op. cit.*, pl. 40.

3. See F. Antal, *Florentine Painting and Its Social Background*, London, 1947, pl. 27 A. The gradual dissociation of the Body from the Cross is further illustrated by a picture in the Museum of Historic Art at Princeton (here tentatively ascribed to Lorenzo Monaco) and Masaccio's famous "*Pietà*" at Empoli (van Marle, *op. cit.*, IX, p. 267, fig. 170).

4. A certain influence of Roger's composition, manifesting itself in the conformation of the Body and in the presence of two supporting figures instead of one, can be observed, I think, in a vaguely Castagnesque picture in the Museo Andrea Castagno (van Marle, *op. cit.*, X, p. 377, fig. 236) and in a panel from the circle of Jacopo del Sellaio in the Accademia (van Marle, XII, p. 410; U. Procacci, *La Regia Galleria dell' Accademia di Firenze*, Rome, 1936, p. 44, no. 5069). The "Entombment" formerly ascribed to Michelangelo in the National Gallery at London is reminiscent of Roger's in a more general way (cf. Warburg, *op. cit.*, I, p. 215), and the motif of the cloth supporting the Body from underneath seems to derive from a Predella by Bartolommeo di Giovanni preserved in the Accademia (van Marle, XIII, p. 256; Procacci, p. 44, no. 8627). According to V. C. Habicht, "Giovanni Bellini und Rogier v. d. Weyden," *Belvedere*, X, 1931, p. 54 ff., the Magdalen in Bellini's "Crucifixion" at Pesaro is patterned after that in Roger's Uffizi "Entombment." This theory, based upon the erroneous assumption that Roger's picture was in Ferrara, is not convincing; rather it would seem that both figures derive from a common Italian source. But their resemblance cannot be questioned and contributes to the Italianate character of Roger's composition.

5. Winkler, p. 165 f.; Friedländer, II, p. 98, no. 21, pl. XVIII; Destrée, pl. 31; Renders, II, pls. 14, 53; Musper, fig. 82; Beenken, *Rogier*, p. 59 ff., figs 52–54.

6. A. J. Wauters, "Roger van der Weyden, II," *Burlington Magazine*, XXII, 1913, p. 230 ff. Wauters believes the Frankfort picture to have been executed about 1426–1427 (!) for the newly founded University of Louvain; that Roger was then a citizen of Louvain (of which St. Peter is indeed the patron); that the St. John refers to one Jan van Rode who had placed a house at the disposal of the University; and that the coat-of-arms belongs to the Gheylensone family of which, however, no such academic connection is known. By juxtaposing the *fleur de lys* seen in the Frankfort Madonna with an arbitrarily modernized form of the Florentine Lily, Wauters creates the erroneous impression that the former is less similar to the latter than to the Gheylensone arms; the *fleur de lys* in Roger's picture is, however, perfectly identical with the authentic Florentine Lily as illustrated, e.g., in the famous *Biadaiolo* of 1330 (P. d'Ancona, *La Miniature italienne du Xe au XVIe siècle*, Paris and Brussels, 1925, pl. XXXIII, fig. 47). It should also be noted that not only the "Medici Madonna" itself but also a free replica of it, formerly in the Cook Collection at Richmond (Friedländer, II, p. 136, no. 122; Destrée, pl. 32), was acquired in Italy.

7. See Wauters, *op. cit.*, and Destrée, p. 110 ff.

Page 275

1. See Kantorowicz, *op. cit.*, p. 179, and W. Stein, "Die Bildnisse von Roger van der Weyden," *Jahrbuch der Preussischen Kunstsammlungen*, XLVII, 1926, p. 1 ff., especially p. 19. The features of Jean le Fèvre de St. Remy are transmitted by his portrait (after Roger) in the Antwerp Museum (Winkler, p. 179 f.; Friedländer, II, p. 105, no. 44; Destrée, pl. 129; Stein, fig. 5 b). Those of Pierre de Beffremont are known to us from a drawing in the "Recueil d'Arras" (Winkler, fig. 27; Stein, fig. 5).

2. For the personality of Jean le Fèvre de St. Remy, see *Biographie Nationale de Belgique*, XI, 1890/91, col. 666 ff. (his missions to Italy mentioned in col. 669).

3. For the principle of triangulation *vs.* isocephaly, see D. Roggen, "Roger van der Weyden en Italie," *Revue Archéologique*, ser. 5, XIX, 1924, p. 88 ff. It is significant that in the replica of the "Medici Madonna" referred to in note 274 [6] the head of the Virgin is perceptibly lowered and, more important, that the bare polygonal base has been replaced by the conventional Flemish dais covered with an oriental rug. For Domenico Veneziano's "*Sacra Conversazione*," very frequently reproduced, see van Marle, *op. cit.*, X, p. 311, fig. 192.

4. Winkler, pp. 49 f., 168; figs. 19–21; Friedländer, II, p. 100 f., no. 26, pls. XXI–XXIII; Destrée, pls. 102–104; E. Michel, *L'Ecole Flamande . . . au Musée du Louvre*, p. 43 f., pls. VII–IX (with illustration of the

backs); Musper, fig. 85; van Puyvelde, *Primitives*, pls. 34, 35; Beenken, *Rogier*, p. 67 ff., figs. 78, 80, 81. Three drawings of the Magdalen, all in the British Museum, are illustrated in Destrée, pl. 105 B–D. For the best of these (Destrée, pl. 105 D, often and perhaps correctly considered as an original, our fig. 384), see Popham, *Drawings of the Early Flemish School*, pl. 12, and ———, *Catalogue of Drawings by Dutch and Flemish Artists . . . in the British Museum*, V, London, 1932, p. 55; Beenken, *Rogier*, p. 69, fig. 79.

Page 276

1. Hulin de Loo, *Biographie Nationale*, XXVII, col. 236.

2. St. John the Baptist: "Ecce agnus Dei qui tollit peccata mun[di]" (John I, 29). The Virgin Mary: "Magnificat anima mea dominum et exultavit spiritus meus in Deo sal[utari meo]" (Luke I, 46, 47). Christ: "Ego sum panis vivus qui de coelo descendit" (John VI, 51). John the Evangelist: "Et verbum caro factum est" (John I, 14). The Magdalen: "Maria ergo accepit libram unguenti nardi pistici pretiose [should read *pretiosi*] et unxit pedes Ihesu" (John XII, 3). For a description of the back and a transliteration of its inscription, see Winkler, p. 168. For the pseudo-Kufic inscription on the headdress of the Magdalen (visible only in a raking light and allegedly containing the signature "Wijden"), see F. de Mély, "Signatures de primitifs; Le retable de Roger van der Weyden au Louvre et l'inscription du turban de la Madeleine," *Revue Archéologique*, ser. 5, VII, 1918, p. 50 ff.

3. Friedländer, *Von Eyck bis Bruegel*, p. 31.

4. Hulin de Loo, *Biographie Nationale*, XXVII, col. 236.

5. Winkler, p. 159 f., Friedländer, II, p. 103, no. 38; Destrée, pls. 111, 112; Renders, II, pls. 2, 8, 21, 31, 33, 38; Schöne, fig. 74; Musper, figs. 90, 91; van Puyvelde, *Primitives*, pl. 40; Beenken, *Rogier*, p. 78 ff., figs. 85–87. A drawing after the left wing is illustrated in Destrée, pl. 149.

6. For Peter Bladelin, see *Biographie Nationale de Belgique*, II, 1868, col. 445 ff.; for the history of Middelburg, H. Brugmans and C. H. Peters, *Oud Nederlandsche Steden*, Leiden, I, 1909, p. 198 ff., and J. J. de Smet, "Notice sur Middelbourg en Flandre," *Messager des Sciences et des Arts de la Belgique*, IV, 1836, p. 333 ff. (with a line engraving after the Bladelin altarpiece). An illustrated monograph on Middelburg by Karel Verschelde, 1867, was not accessible to me.

Page 277

1. This "Annunciation" — so far as I know, not reproduced before — contains a number of still-life features which recall the exterior of the Ghent altarpiece and, even more emphatically, the wings of the "Annunciation" in Ste.-Madeleine at Aix-en-Provence (see p. 307). But even more remarkable is the fact that the drapery style and the facial types do not agree at all with those of Roger and his entourage. The draperies are arranged in deeply scooped-out, angular masses again reminiscent of the Aix altarpiece, and the faces are equally un-Rogerian, especially that of the Angel Gabriel with its bulbous forehead, large, liquid eyes, wide, somewhat prognathous mouth, and thin, button-tipped nose. The closest contemporary parallel I know is the Angel Gabriel in the famous window of Jacques Coeur in Bourges Cathedral, begun in 1447 (see L. Grodecki, "The Jacques Coeur Window at Bourges," *Magazine of Art*, XLII, 1949, p. 64 ff.); and the inference is that the assistant responsible for the exterior of the Bladelin altarpiece had received his preliminary training in France and may even have been a Frenchman by extraction (cf. also note 344[4]).

2. *Jacobi a Voragine Legenda Aurea vulgo Historia Lombardica dicta*, T. Graesse, ed., Breslau, 1890, VI, p. 43 f. The suggestion that the program of the Bladelin altarpiece is based upon the *Speculum humanae salvationis*, originally made by Emile Mâle, was accepted by Winkler, p. 159 f. However, while the *Speculum* does recount both the Vision of Augustus and the Vision of the Three Wise Men in much the same way as does the *Golden Legend* (Chapters IX and X, Lutz and Perdrizet, *op. cit.*, pls. 15, 16 and pls. 17, 18), it connects only the first of these events with the Nativity whereas the second is linked to the Adoration of the Magi. Moreover, in the description of the Vision of Augustus no mention is made of either the fact that Augustus offers incense or of the altar which so prominently figures in Roger's painting and, so far as I know, does not appear in other representations of the incident (cf. Lutz and Perdrizet, p. 194 ff.; Cornell, *The Iconography of the Nativity of Christ*, p. 83 ff.), except for such direct copies as that in the altarpiece at The Cloisters referred to in note 263[11].

3. The Virgin Mary supporting herself on a column prior to giving birth is described in a passage of the *Meditationes* by Pseudo-Bonaventure, already adduced by Mâle, *L'Art religieux de la fin du moyen âge en France*, 2nd ed., 1922, p. 47 f., which I quote from *Sancti Bonaventurae . . . opera*, XII, p. 390: "Cumque venisset hora partus, sc. in media nocte Dominicae diei, surgens virgo appodiavit ad quandam columnam, quae ibi erat, Joseph vero sedebat moestus . . ." The column of the Flagellation is mentioned, in direct connection with the Nativity, in the speech of the Virgin addressed to St. Bridget and describing how she foresaw the Passion as soon as she had given birth to the

Lord: "Ductus ad columnam personaliter se vestibus exuit" and "personaliter ad columnam manus applicuit" (*Revelationes*, I, 10; Roman edition of 1628, vol. 2, p. 23). Since the Gospels say only that Christ was scourged but do not mention the column, this passage once more corroborates the fact that St. Bridget's visions, like those of many other visionaries, were strongly influenced by pictorial representations; they combine, as Bertrand Russell would say, "imagination-images" with "memory-images." See also the following note.

Page 278

1. On the strength of Isaiah I, 3 ("The ox knoweth his owner and the ass his master's crib") and Habakkuk III, 2 (where, according to the Itala, the work of the Lord will be made known "inter *duo animalia*" rather than "in *medio annorum*" as the Vulgate has it) the two animals attending the Nativity were always presumed to have been aware of Christ's divinity. But since a subtle difference is made between the ox, who knows his master, and the more materialistic ass, who knows only his master's crib, the two animals were not always thought of as being equally worshipful. Originally, the ass, always representing the inferior principle, was distinguished from the ox as symbolic of the Gentiles as opposed to the Jews (as in the majority of patristic sources). But after this distinction had lost much of its interest, the ass came to be identified with the Old Testament as opposed to the New (as already in St. Jerome and, later on, in such medieval authors as Walafrid Strabo or Rupert of Deutz). Accordingly, we find, in addition to the many representations in which both animals show their affection for the Christ Child, a number of others in which the behavior of the ass differs unfavorably from that of the ox: the ox may kneel down while the ass remains standing (as in Daret's "Nativity" in the Thyssen Collection, our fig. 233, or Schongauer's engraving B. 4) or concentrates his attention on the fodder in "his master's crib" instead of on the Infant Jesus. The ass may register contempt and dismay by loudly braying or even attempt to devour or tear off the Infant's swaddling clothes with his teeth while St. Joseph tries to ward him off with a stick (see, for example, the amazing Psalter of Yolande de Soissons, Morgan Library, ms. 729, fol. 246 v., and the material collected by M. Harrsen, "A Book of Hours for Paris Use," *Die Graphischen Künste*, new ser., III, 1938, p. 91 ff.). Occasionally, the ox and the ass engage in an actual tug-of-war about the swaddling clothes as in a wood-carved roof boss at Nantwich (England) published but insufficiently interpreted by R. Berliner, "A Relief of the *Nativity* and a Group from an *Adoration*

of the Magi," *Art Bulletin*, xxxv, 1953, p. 145 f., fig. 3. The Infant Jesus in turn may give the ox a friendly tap on the nose whereas the ass is not equally favored (Paris, Bib. Nat., ms. lat. 10538, fol. 63, and Baltimore, Walters Art Gallery, ms. 260, fol. 63 v., our figs. 72 and 73).

In other contexts, too, the "stubborn," "benighted" Jews were likened to the headstrong and stupid ass, and the Synagogue herself is seen riding a donkey in Herrad of Landsberg's *Hortus deliciarum* (*op. cit.*, pl. XXXVIII) as well as in several mystery plays (see P. Weber, *Geistliches Schauspiel und kirchliche Kunst in ihrem Verhältnis erläutert an einer Ikonographie der Kirche und Synagoge*, Stuttgart, 1894, p. 90 f.). The symbolical equation "Ass = Ignorance = Synagoge" even survived into the Renaissance; see Tommaso Garzoni, *La Sinagoga degl' Ignoranti*, Pavia, 1589, briefly discussed in E. Mandowsky, *Untersuchungen zur Iconologie des Cesare Ripa* (Hamburg dissertation, 1934), pp. 21, 89. In the *Golden Legend*, on the other hand, both animals are described as adoring the new-born Saviour on their knees (in Pseudo-Bonaventure's *Meditationes* they even warm Him with their breath), and this idea, too, was perpetuated in such representations as Geertgen tot Sint Jans' "Nativity" in the National Gallery at London (fig. 448) or Gerard David's "Nativity" in the Metropolitan Museum (Wehle and Salinger, *op. cit.*, p. 95 f.). The whole subject — reflecting, in a small way, the ambivalent attitude of the Christian Middle Ages toward Judaism — will be treated, it is to be hoped, in an essay by Mr. Thomas J. McCormick, Jr.

The motifs discussed in this and the preceding note are dramatized, as it were, in the somewhat crude but interesting "Nativity" by the south German "Master of the *Vita Frederici*" in the Art Institute of Chicago (F. A. Sweet, "The Nativity Attributed to Albrecht Altdorfer," *Bulletin of the Art Institute of Chicago*, XXXIV, 1940, p. 2 f.). Here the significance of the enormous column is explained, so to speak, by the group seen in the background, the Virgin Mary bending with fatigue and pain and St. Joseph pointing in the direction from which he hopes to summon help (for a similar motif in Hugo van der Goes' Portinari altarpiece, cf. p. 333). The ox, munching nutritious hay, turns toward the Infant Jesus whereas the ass, turning away from Him, attempts to devour his own tail, thereby expressing the self-destructive sterility of Judaism. A sword lily, prophetic of the Passion, completes the complicated symbolism of the picture.

2. Winkler, p. 174; Friedländer, II, p. 99 f., no. 24; Destrée, pl. 109; Beenken, *Rogier*, p. 100. Whether the picture was executed by Roger himself or an assistant I dare not decide for want of personal acquaint-

ance with it but am inclined in favor of the first alternative. For the interpretation of the subject, see Hulin de Loo, *Biographie Nationale*, XXVII, col. 239; for identifiable portraits of Jean le Fèvre de St. Remy and Pierre de Beffremont, note 275 ¹.

3. For an illustration of Castagno's "Farinata," see, e.g., van Marle, *op. cit.*, X, p. 354, fig. 216; for the St. Mammas in Pesellino's London altarpiece, e.g., P. Hendy, "Pesellino," *Burlington Magazine*, LIII, 1928, pl. facing p. 67 (a drawing for, or after, the figure is reproduced in van Marle, *op. cit.*, p. 502, fig. 302).

4. Winkler, p. 158; Friedländer, II, p. 91 f., no. 2; Destrée, pl. 19; Renders, II, pls. 7, 8, 23; Schöne, p. 70; Musper, figs. 78–81; van Puyvelde, *Primitives*, pl. 41. The Berlin triptych doubtless precedes that at Frankfort (see the convincing juxtaposition in Musper, figs. 80 and 81, text, p. 54); but here, as in the case of the "Granada-Miraflores" altarpiece, the Frankfort "replica" — each panel measuring 45 cm. by 28 cm. as against 77 cm. by 46 cm. — would seem to have been produced in Roger's own workshop. Either the one or the other of the two triptychs would seem to be identical with the "retable représentant la Vie de Saint Jean-Baptiste, peint par Roger van der Weyden, et donné à l'église [St.-James at Bruges], en 1476, par Baptiste del Agnelli [not "Aquelli" as stated in van Puyvelde, *Primitives*, p. 26] négociant de Pise" (Winkler, p. 183, after Weale who, however, does not give any source). For a detailed description of the scenes in the archevaults, see *Königl. Museen zu Berlin*; *Beschreibendes Verzeichnis der Gemälde im Kaiser-Friedrich Museum*, p. 480 f. A drawing for — or after? — the "Baptism," showing the head, shoulders and right arm of the Baptist as well as two legs, is in the Robert Lehman Collection at New York (Sotheby & Co., *Catalogue of Important Old Master Drawings, Fine Paintings, . . . Sold on June 30, 1948*, no. 153, frontispiece; also *The Illustrated London News*, CCXIII, 1948, July 10, p. 48).

Page 279

1. Hulin de Loo, *Biographie Nationale*, XXVII, col. 236.

2. Friedländer, XIV, p. 85; Wehle and Salinger, *op. cit.*, p. 32; Musper, p. 52 f.

Page 280

1. Hulin de Loo, *Biographie Nationale*, XXVII, col. 236.

Page 281

1. Matthew XIV, 10, 11; Mark VI, 27, 28. For earlier representations of these two scenes, see, e.g., the second window in the Chapelle de Ste. Jeanne d'Arc

in Bourges Cathedral (A. Martin and C. Cahier, *Monographie de la Cathédrale de Bourges*, I, *Vitraux du XIIIᵉ siècle*, Paris, 1841–1844, pl. XVI) or Andrea Pisano's south door of the Baptistry at Florence (I. Falk, *Studien zu Andrea Pisano*, Hamburg, 1940, figs. 26, 28). N. B. Rodney, "Salome," *The Metropolitan Museum of Art, Bulletin*, new ser., XI, 1953, p. 190 ff., curiously omits Roger's "Martyrdom of St. John" in favor of its weak imitation by Memlinc (Bruges, Hôpital Saint-Jean) and erroneously states that it was Heinrich Heine who in his *Atta Troll* "conceived the idea of Salome's fatal passion for John the Baptist." The lady whom Heine credits with this passion is Herodias; to substitute the daughter for the mother was left to the *fin de siècle* (Oscar Wilde, Aubrey Beardsley and Richard Strauss).

2. Van Marle, *op. cit.*, X, p. 489, fig. 293; cf. also Fra Angelico's representation of the same subject in the Louvre (Schottmüller, *op cit.*, p. 134).

3. See the woman with the bundle in the sixth relief (Joseph story) of Ghiberti's "Gates of Paradise" (J. von Schlosser, *Leben und Meinungen des Florentinischen Bildners Lorenzo Ghiberti*, Basel, 1941, pl. 55) or the groom feeding a horse in Giovanni del Ponte's Brussels "Adoration of the Magi" (van Marle, *op cit.*, IX, p. 69, fig. 40). Cf. also one of the Nine Heroines in a mural in the Castello della Manta in Piedmont, now tentatively ascribed to the Italo-French painter Jacques Iverny of Avignon (van Marle, VII, p. 191, fig. 123; Lemoisne, *op. cit.*, pl. 44; Ring, *A Century*, Cat. no. 84, pls. 33, 34).

4. For the iconography of the Birth and Naming of St. John the Baptist, see Falk, *op. cit.*, p. 98 ff.; —— and J. Lányi, "The Genesis of Andrea Pisano's Bronze Doors," *Art Bulletin*, XXV, 1943, p. 132 ff.; U. Middeldorf, "A Note on Two Pictures by Tintoretto," *Gazette des Beaux-Arts*, ser. 6, XXVI, 1944, p. 247 ff. I do not know of any other representations of the Birth of St. John in which the Virgin Mary, even if present, carries the infant to Zacharias so that he may name him. In pre-Rogerian renderings she either stands or sits near the bed of St. Elizabeth, holding the child in her arms (an early instance is the Italo-Byzantine retable in the Accademia at Siena illustrated in van Marle, *op. cit.*, I, p. 386, fig. 215), while Zacharias, if participating in the action at all, receives him from or converses with a handmaiden (cf., e.g., the well-known Urbino murals by the Salimbeni brothers, illustrated in van Marle, VIII, p. 219, fig. 127, and *Bollettino d'Arte*, IV, 1910, p. 414; a Lorenzettesque picture in the Louvre mentioned by van Marle, II, p. 370, note; a Ravennate panel reproduced in *Jahrbuch der Königlich Preussischen Kunstsammlungen*, XXXVII, 1916, pl. facing p. 88; two panels of a polyptych, dated 1369, in the

Pinacoteca at Fermo; a Spanish painting in the Rusiñol Collection at Sitges, published by Post, *A History of Spanish Painting*, II, p. 305, fig. 185). Or, less frequently, she calmly looks on as in a mural in the Chapel of Innocent VI at Villeneuve-lès-Avignon (J. Guiffrey and P. Marcel, *La Peinture française; Les primitifs*, Paris, n.d., I, pl. 8) or talks to St. Elizabeth as in the "Pericope of Henry II" in the Munich Staatsbibliothek, olm. 4452, Cim. 57 (G. Leidinger, *Miniaturen aus Handschriften der Kgl. Hof- und Staatsbibliothek in München*, Munich, V, n.d., pl. 29). All these examples are either Italian or Italianate except for the miniature in the "Pericope of Henry II," and this represents, as correctly pointed out by Leidinger, p. 41, a fusion between the Birth of St. John and the Visitation; the illuminator — reversing, as it were, the roles of the principal characters — has simply combined the Virgin and Child of an ordinary Nativity with the Elizabeth of the Visitation so that in his miniature Our Lady looks much older than her cousin. In Jean Fouquet's "Hours of Etienne Chevalier," nearly contemporary with Roger's St. John altarpiece, the idea of showing the Virgin Mary sitting on the ground and holding the infant St. John on her lap is evidently one of the Italianisms in which this manuscript abounds (cf. Pächt, "Jean Fouquet: A Study of His Style," pl. 22 b).

Page 282

1. Winkler, pp. 54 f., 113 ff.; Friedländer, II, p. 96, no. 16; Destrée, pls. 75, 76, and text vol., pl. 11; Renders, II, pls. 35, 36, 40; Musper, pp. 52, 59, figs. 64, 65; van Puyvelde, *Primitives*, pls. 38, 39; Beenken, *Rogier*, pp. 92 f., 99, figs. 119–121. Cf. P. Rolland, "Het drieluik der Zeven Sacramenten van Rogier van der Weyden," *Annuaire du Musée Royal des Beaux-Arts d'Anvers*, 1942–47, p. 99 ff.

2. Central panel: 200 cm. by 97 cm. as against *ca.* 225 cm. by 108 cm.; lateral panels: 120 cm. by 79 cm. as against *ca.* 135 cm. by 82.5 cm. The repaintings already noticed by Winkler and Friedländer are, specifically: the heads of the Priest, the Father and the Male Witness in the Baptism; the heads of the men behind the Canon on the right of Jean Chevrot; the heads of the Bridegroom and the Witness in the Wedding Scene; the head of the Priest in the Extreme Unction. That the figure emerging from behind the second pier in the central panel has been painted in was first observed by Mr. Koch.

3. See note 268 [3]. Here Jean Chevrot, clad in an episcopal cassock of pink-violet color, is seen on the right of Chancellor Nicholas Rolin. His identity is established by the fact that the Bishop of Tournai and close adviser of Philip the Good was the logical person

to assist at the dedication of a chronicle of the Hainaut, and that he is paired off with Nicholas Rolin in the same way as in the Memoirs of Jacques du Clercq: "Lequel evesque estoit l'ung des principaux, avecq le chancellier de Bourgogne, counseiller et gouverneur de Philippe, Duc de Bourgogne" (*Mémoires de Jacques du Clercq*, IV, 13, year 1460 [J.-A. Buchon, *Collections des Chroniques Nationales Françaises*, XV. siècle, vol. XIV, Paris, 1826, p. 52]).

4. For earlier renderings, cf. E. P. Baker, "The Sacraments and the Passion in Mediaeval Art," *Burlington Magazine*, LXXXIX, 1947, p. 81 ff. The drawing in the Musée Condé at Chantilly, illustrated as a sketch by Roger in Destrée, text vol., pl. 10, belongs, like its companion pieces in the same collection (Destrée, pl. 146) and in the Kunsthalle at Hamburg (G. Pauli, *Zeichnungen alter Meister in der Kunsthalle zu Hamburg, Niederländer*, new ser., Frankfort, 1926, nos. 1, 2), to a "Symbolum Apostolicum" series probably produced by a North-Netherlandish artist about 1470–1480.

Page 283

1. The angel of the Eucharist is clad in green, that of Baptism in white, that of Confirmation in yellow, that of Penance in red, that of Holy Orders in violet, that of Matrimony in blue, and that of Extreme Unction in dark purple.

2. See note 260 [1]. With abbreviations expanded and punctuation modernized, the seven inscriptions, juxtaposed with their sources, read as follows.

Eucharist:

"Hic *panis*, manu *sancti spiritus* formatus in *virgine*,
Igne passionis est decoctus in cruce.
Ambrosius in Sacramentis."

"Quomodo potest qui *panis* est, corpus esse Christi? . . . Accipe ergo quemadmodum sermo Christi creaturam omnem mutare consueverit, et mutet, cum vult, instituta naturae . . . quia voluit Dominus, de *Spiritu sancto et Virgine* natus est Christus" (St. Ambrose, *De sacramentis*, IV, 4, 14–17).

Baptism:

"Omnes in aqua et pneumate *baptizati*
In *morte Christi* vere sunt renati.
Ad Romanos VI capitulo."

"An ignoratis, quia quicumque *baptizati* sumus *in Christo Jesu*, in *morte ipsius baptizati* sumus"? (Romans VI, 3).

Confirmation:

"Per crisma, quo a praesule inunguntur,
Vi passionis Christi in bono confirmantur.
In quarto Sententiarum."

Cf. the discussion of the Sacrament of Confirmation in Peter Lombard's *Liber sententiarum*, IV, dist. VII.

Penance:

"*Sanguis* [*Christi*] nostras *consciencias emundabit*,
Dum penitentiale debitum *seipso* mitigauit.
Ad Hebraeos IX capitulo."

"*Quanto magis sanguis Christi*, qui per Spiritum sanctum *semetipsum* obtulit immaculatum Deo, *emundabit conscientiam* nostram. . . "? (Hebrews IX, 14).

Ordination:

"*Dum summus pontifex* Jesus *in sancta intrauit*,
Tunc sacramentum ordinis vere instaurauit [?].
Ad Hebraeos IX capitulo."

"Neque ut saepe offerat semetipsum, quemadmodum *Pontifex intrat in Sancta* per singulos annos in sanguine alieno" (Hebrews IX, 25).

Matrimony:

"Matrimonium a Christo commendatur,
Dum *sponsa sanguinum* in carne [con]copulatur.
Exodi IIII capitulo."

"Tulit illico Sephora acutissimam petram, et circumcidit praeputium filii sui, tetigitque pedes eius, et ait: *Sponsus sanguinum tu mihi* es" (Exodus IV, 25).

Extreme Unction:

"*Oleo* sancto in anima et corpore *infirmati*
Sanantur merito passionis Christi.
Jacobi ultimo."

"*Infirmatur* quis in vobis? inducat presbyteros Ecclesiae, et orent super eum, ungentes eum *oleo* in nomine Domini" (James V, 14).

3. The individual Sacraments were unimaginatively imitated in the simulated sculptures on the buttresses enframing the central panel of the much-debated triptych in the Prado formerly identified with that Cambrai altarpiece the dimensions of which Roger increased "pour l'amour de l'oeure" (see p. 248 and note 285³). Accepted, against Karl Voll's well-founded objections, by Winkler, pp. 46, 170, figs. 17, 18, it is now unanimously considered as the work of a mediocre imitator (Friedländer, II, p. 106, no. 47, pl. XL, and XIV, p. 86; Destrée, pls. 77–80; ———, "Le Retable de Cambrai de Roger de la Pasture"; Duverger in Thieme-Becker, XXXII, p. 69; Winkler in Thieme-Becker, XXXVII, p. 93). This imitator, according to Hulin de Loo identical with Vrancke van der Stockt (while Hoogewerff, II, p. 230 ff., ascribes it to the workshop of Dirc Bouts), may also be considered responsible for a series of drawings of the Seven Sacraments in the Ashmolean Museum at Oxford (Destrée,

pl. 83; K. T. Parker, *op. cit.*, p. 40 f., nos. 94–97) which were employed for the embroideries on a chasuble in the Historisches Museum at Berne (Winkler, p. 48 ff., figs. 15, 16; Destrée, pls. 81, 82; cf., however, P. Wescher, "The Drawings of Vrancke van der Stoct," *Old Master Drawings*, XIII, 1938–39, p. 1 ff.).

4. That Jan van Eyck's "Madonna in a Church" was well known in Roger's circle is demonstrated by the fact that its architecture, with the characteristic feature of the raised choir triforium, was imitated in the central panel of the pseudo-Cambrai altarpiece in the Prado (cf. preceding note) as well as in the "History of St. Joseph" (see note 194²). Both these works presuppose, however, the Chevrot triptych as well.

5. Cf. Maere, *loc. cit.*

Page 284

1. Illustrated, e.g., in van Marle, *op. cit.*, VIII, p. 41, fig. 30.

2. E. Panofsky, "Two Roger Problems: The Donor of the Hague Lamentation and the Date of the Altarpiece of the Seven Sacraments," *Art Bulletin*, XXXIII, 1951, p. 33 ff. The bishop administering Holy Orders is here tentatively identified with Jean Avantage, Bishop of Amiens.

3. *Musée Royal de Tableaux, Mauritshuis à la Haye, Catalogue Raisonné des Tableaux et Sculptures*, The Hague, 3rd ed., 1935, p. 397 ff.; Winkler, p. 131 f.; Friedländer, II, p. 106, no. 46, pl. XXXIX; Destrée, pl. 60; Musper, p. 51 f., fig. 59; Beenken, *Rogier*, p. 99, fig. 128. Cf. also Voll, *Die altniederländische Malerei*, p. 77; Hulin de Loo, *Biographie Nationale*, XXVII, col. 238; Beenken, "Rogier van der Weyden und Jan van Eyck," note 4; Winkler, Thieme-Becker, XXXV, pp. 471, 474. The picture has been published in seven color reproductions by W. Vogelsang, *Rogier van der Weyden, Pietà*; *Form and Color*, New York, n.d. (1949). The identity of the donor with the Canon in the Chevrot triptych was also observed by Professor Julius S. Held; for his conjectural identification with Pierre de Ranchicourt, see Panofsky, "Two Roger Problems." A "Lamentation" recently discovered in the Hôpital St.-Nicolas at Enghien and vaguely related to that in The Hague (Landelin-Hoffmans, *op. cit.*) is supposed to come from the Charterhouse of Hérinnes (see note 248¹) but dates from the last quarter of the fifteenth century.

4. M. W. Brockwell, "A Document Concerning Memling," *The Connoisseur*, CIV, 1939, p. 186 f.

Page 285

1. Hulin de Loo, *Biographie Nationale*, XXVII, col. 235.

2. Winkler, p. 175, figs. 22, 23; Friedländer, II,

p. 96, no. 15, pls. XII, XIII; Destrée, pl. 29; van Puyvelde, *Primitives*, pl. 42; *The Worcester-Philadelphia Exhibition of Early Flemish Painting*, no 6; Beenken, *Rogier*, p. 100, figs. 124, 125 ("designed but hardly executed by Roger"). All illustrations save those in Beenken show the diptych before the cleaning which disclosed the original gold ground. Winkler, p. 120, dates it "shortly before 1450"; Friedländer, "about 1445"; Destrée, text vol., p. 108, "close to the Vienna triptych," viz., about 1440; Hulin de Loo, *Biographie Nationale*, XXVII, col. 238, "not far from 1435." That the two panels cannot have formed the exterior shutters of a folding retable is proved by their admirably careful execution, the sophisticated coloring and the presence of gold ground; in all other instances, the exterior wings of Roger's altarpieces are treated as second-class work and were normally entrusted to assistants. The original presence of a left-hand panel (presumably showing the donor), on the other hand, is precluded by the perfect balance of the composition. As pointed out to me by Mr. Henri Marceau, the cloths of honor are placed in such a way that the wall strips on the extreme right and left are wider than those in the center, which makes the layout of the present diptych perfectly symmetrical.

3. E. P. Richardson, "Rogier van der Weyden's Cambrai Altar," *Art Quarterly*, II, 1939, p. 57 ff. According to the document referred to in note 248 [6] (Lille, Archives du Département du Nord, no. 36 H 431, fol. 221), the dimensions of the Cambrai altarpiece, originally stipulated as "V piez en quarrure," were voluntarily increased by Roger to "VI piez et demi de hault" and "V piez de large"; it was thus pronouncedly vertical in format (proportion of width to height exactly 1:1.3) whereas the Philadelphia panels, each measuring 5 feet 11 inches by 3 feet 5/16 inch, very nearly constitute a square. Moreover, Richardson himself has rightly pointed out that the Philadelphia panels cannot possibly have formed the exterior wings of a folding triptych (see preceding note). The Cambrai altarpiece, however, was a triptych with movable shutters. As discovered by the late Paul Rolland ("Madone Italo-Byzantine de Frasnes-lez-Buissenal," *Revue Belge d'Archéologie et d'Histoire de l'Art*, XVII, 1948, p. 97 ff.), the Lille document does not speak of a "tabliau a II *huystoires*" ("a retable showing two subjects") but of a "tabliau a II *huysseries*" ("a retable with two shutters"); the photograph kindly placed at my disposal by M. Paul de St.-Aubin, Archiviste en Chef du Département du Nord, leaves not the slightest doubt as to the correctness of Rolland's reading. The fact that the Cambrai altarpiece was a folding triptych, and not a diptych, may seem to lend support to the old hypothesis according to which it is identical with the altarpiece in the Prado referred to in note 283 [3]. But here again the measurements do not agree with the document, the Prado triptych measuring 1.95 m. by 1.72 m. whereas — equating 1.95 m. with six feet and one half — its width should only amount to 1.50 m. Apart from this, the Prado altarpiece has long been eliminated from Roger's work.

4. Haarlem, Teyler Stichting, Ms. 77 (a Pontifical for Térouanne use produced between 1451 and 1456), fol. LVI, illustrated in A. W. Byvanck, "Les Principaux Manuscrits à peintures conservés dans les collections publiques du Royaume des Pays-Bas," *Bulletin de la Société Française de Reproductions de Manuscrits à Peintures*, XV, 1915, p. 25 ff., pl. VIII. This miniature and its importance for the explanation of Roger's Philadelphia "Calvary" (as well as of his later "Crucifixion" in the Escorial, our fig. 357) was called to my attention by Professor Wilhelm Koehler who generously permitted me to make use of his ingenious observation.

Page 286

1. Winkler, p. 172 ff.; Friedländer, II, p. 107, no. 49, pl. XLII; Destrée, pls. 106–108; Schöne, pp. 75–77; Musper, figs. 94–97; Beenken, *Rogier*, p. 82 ff., figs. 100–102 and color plates facing pp. 32, 64, 80.

2. Kantorowicz, "The Este Portrait by Roger van der Weyden," p. 178, seems to refer to this figure when he speaks of the youngest King in an "Adoration of the Magi now in Frankfort" whom he tentatively identifies with Francesco d'Este as represented in the New York portrait. This similarity I am unable to see.

3. See Hulin de Loo, *Biographie Nationale*, XXVII, col. 230; Winkler, p. 184.

4. Winkler, p. 160 f.; Friedländer, II, p. 105, no. 42, pl. XXXVII; Destrée, pl. 127; Renders, II, pl. 57; Musper, fig. 77; Beenken, *Rogier*, p. 72, fig. 111; Wescher, "Das höfische Bildnis." Winkler's and Friedländer's tentative identification of the Berlin portrait with the "chief du duc Charles" listed in Margaret of Austria's inventory of 1516, as opposed to the "tableau de la portraiture de M. S. le duc Charles de Bourgogne" listed in her inventory of 1524, is not convincing. As can be inferred from the identity of the other items, both inventories (reprinted in Winkler, p. 184) describe one and the same picture, and that of 1524 explicitly states that the Duke had "un rolet en sa main dextre." Apart from this difference in attributes, the similarity between the Berlin portrait and that once owned by Margaret of Austria extends even to the fact that the Golden Fleece is not worn on the

formal collar composed of "Flint and Steel" but on a simple *chayne*.

5. While Friedländer's dating ("after rather than before 1460") appears too late the date proposed by Musper, p. 59 (between 1446 and 1450), is evidently too early since Charles the Bold was born in 1433. In 1446 he was a small boy of thirteen and is portrayed as such in the dedication miniature of the *Chroniques du Hainaut*.

Page 287

1. For the "Offering of the Water from the Well of Bethlehem," see p. 278; for the interpretation of the scene as a *typus* of the Adoration of the Magi, see, e.g., *Speculum humanae salvationis*, IX (Lutz and Perdrizet, *op. cit.*, pl. 17). Concerning the Jewish connotation of the yellow color, see, apart from the proverbial "yellow badge," the stage directions of two mystery plays which prescribe this color for the costume of the Synagogue (Weber, *op. cit.*, pp. 86 ff., 92). The blue object in the yellow-clad man's right hand is his hat; Professor L. H. Heydenreich kindly informs me that the figure was originally bare-headed and that the turban was added as an afterthought, perhaps in order to stress its "oriental" character.

2. That a tapestry in the Historisches Museum at Berne, illustrated in H. Göbel, *Wandteppiche*, Leipzig, 1923–1934, I, 2, pl. 211, reflects a design of Roger van der Weyden as conjectured by Voll, *Die altniederländische Malerei*, p. 58, and endorsed by Winkler, p. 178, seems rather doubtful to this writer (cf. also Friedländer, II, p. 84: "Eine Tapisserie, deren Karton von dem Meister herzurühren schiene, ist mir nie zu Gesicht gekommen").

3. This poignant condensation of the old antithesis between the Adoration of the Magi and the Crucifixion (cf., e.g., the Bargello Diptych discussed above, p. 82 f., or the ivories, Koechlin, *op. cit.*, nos. 295, 320, 470, 478, 481, 488 bis, 824) is prefigured in a miniature in the "de Buz Hours," fol. 57, where the scene is staged, in the interior of a church, before an altar surmounted by a retable that shows the Crucifixion (Panofsky, "The de Buz Book or Hours," pl. V a).

Page 288

1. See D. Shorr, "The Iconographic Development of the Presentation in the Temple," *Art Bulletin*, XXVIII, 1946, p. 17 ff., especially p. 30 f.

2. Cf., e.g., the fresco illustrated in Labande, *Le Palais des Papes*, II, p. 55.

3. Good illustrations in M. Pittaluga, *Filippo Lippi*, Florence, 1949, figs. 18 and 22.

4. Winkler, p. 164; Friedländer, II, p. 100, no. 25; Destrée, pl. 27; Musper, fig. 84; Beenken, *Rogier*, p.

89 ff., figs. 104, 105, 107. Cf. A. Alvarez Cabanas, "La Crucifixión, tabla de Roger van der Weyden," *Religión y Cultura*, XXIV, 1933, p. 56 ff.; F. J. Sanchez Canton, "Un gran cuadro de Van der Weyden resucitado," *Miscellanea Leo van Puyvelde*, Brussels, 1949, p. 59 ff. So far as I know, Schöne, p. 26, is the only scholar to date the Escorial "Crucifixion" as late as I am inclined to do; according to Winkler, p. 195 (unfortunately without indication of the source) Roger advanced some money to the Charterhouse of Scheut in 1462. I am indebted to Dr. J. M. Pita Andrade for the photograph showing the picture in its present condition.

Page 289

1. Frey, *op. cit.*, no. 130; Brinckmann, *op. cit.*, pl. 73.

2. The medievalistic tendencies of Michelangelo's last phase have often been commented upon. For a brief summary, see Panofsky, *Studies in Iconology*, p. 229, note 190.

3. Destrée, text vol., p. 175.

4. Vogelsang, "Rogier van der Weyden," p. 114.

Page 290

1. Cf. E. Kris and E. Gombrich, "The Principles of Caricature," *Journal of Medical Psychology*, XVII, 1938, p. 319 ff., especially p. 324 ff.

Page 291

1. Winkler, p. 169 f.; Friedländer, II, p. 99, no. 23, pl. XX; Destrée, pl. 132; Schöne, p. 69; van Puyvelde, *Primitives*, pl. 43 (still as "Lionello d'Este"); Beenken, *Rogier*, p. 72 ff., fig. 113 (inclining to ascribe the execution to an Italian pupil, possibly Zanetto Bugatto); Wehle and Salinger, *op. cit.*, p. 35 ff. For the identification of the sitter, see Kantorowicz, "The Este Portrait by Roger van der Weyden."

2. Winkler, p. 162; Friedländer, II, p. 103, no. 37; Destrée, pl. 141; Musper, fig. 87; Wescher, "Das höfische Bildnis." Since the "Grand Bâtard" (Anthony of Burgundy, son of Philip the Good and Jeanne de Prelles) was born in 1421 and does not look older than *ca.* thirty-five, the portrait — identifiable by a drawing in the "Recueil d'Arras" — may be dated about 1455.

3. See p. 171.

4. For this drawing, see *Catalogue of the D. G. van Beuningen Collection*, no. 164, pl. 200; Friedländer, XIV, p. 78; de Tolnay, *Le Maître de Flémalle*, p. 72 f., fig. 120; *De van Eyck à Rubens*, no. 1; van Puyvelde, *Musée de l'Orangerie*, no. 40, pl. XXXII. One of the three others, representing John IV, Duke of Brabant (1403–1426) is also in the van Beuningen Collection (illustrated in the *Catalogue*, no. 165, pl. 201; de

Tolnay, fig. 119; *De van Eyck à Rubens*, no. 2, pl. I; van Puyvelde, *Musée de l'Orangerie*, no. 41, pl. XXXIII). The two remaining ones, representing Philip, Duke of Brabant (died 1430) and Philip, Count of Nevers (killed at Agincourt in 1415), were in the Mannheimer Collection at Amsterdam and were destroyed during the war (illustrated in de Tolnay, figs. 121 and 122, respectively). These four drawings — all illustrated again in Baldass, *Eyck*, pls. 147–150 — are almost generally supposed to be early works by Jan van Eyck, presumably executed in preparation for four of the brass statuettes — "plorants" — on the lost tomb of Louis de Mâle (died 1384) in St. Peter's at Lille. This tomb, erected by Philip the Good in 1455, is known to us only from old engravings and drawings from which we learn that it was repeated, with the effigies changed but most of the "plorants" substantially unaltered, first, in the tomb of Joan of Brabant formerly in the Carmelites' Church at Brussels (completed in 1458–1459 and also known to us only through later reproductions); and, second, in the tomb of Isabella of Bourbon formerly in the Abbey of St. Michael at Antwerp (completed 1476, the effigy of Isabella preserved in Antwerp Cathedral and ten of the "plorants" in the Rijksmuseum at Amsterdam). Cf. C.M.M.A. Lindeman, "De Dateering, Herkomst en Identificatie der 'Gravenbeeldjes' van Jacques de Gérines," *Oud Holland*, LVIII, 1941, pp. 49 ff., 97 ff., 161 ff., 193 ff., and H. Gerson's summary of previous discussions in *Oud Holland*, LXIII, 1948, p. 135 ff. It cannot be denied that the drawings are related to the "plorants" appearing on these three tombs, though none of the figures recurs quite literally. But their attribution to Jan van Eyck is open to several objections. First of all, we have no evidence for the assumption that the tomb of Louis de Mâle was planned and prepared more than a quarter-century before its erection. Second, the drawing of Philip of Brabant (de Tolnay, fig. 121) shows him with a falcon on his left hand, a motif hardly compatible with the idea of a "plorant." Third, Louis I of Savoy — first cousin of Philip the Good, 1402–1465 — looks like a man of at least forty in the van Beuningen drawing and wears, accordingly, an unmistakably mid-fifteenth-century costume (compare, e.g., his headgear with that of Herkinbald's nephew in the Berne tapestries); this, needless to say, establishes a *terminus post quem* for the whole series. Fourth, the style of the drawings has nothing in common with that of Jan's portrait of Cardinal Albergati (fig. 264) although the interval of time, were they by Jan, would not amount to more than five or six years, the *terminus ante quem non* for Jan's supposed participation in the tomb of Louis de Mâle being, of course, his appointment to the Burgundian court in 1425. In

spite of the fact that three of the four princes are clad in early fifteenth-century garb, the drawings look Rogerian rather than Eyckian, and it has been shown that a mutilated drawing in the Berlin Kupferstichkabinett, always ascribed to Roger's school and even thought to be a portrait of him (Destrée, pl. 147; Stein, *op. cit.*, fig. 6), belongs to the same series (P. Wescher, "Beiträge zu einigen Werken des Kupferstichkabinetts," *Berliner Museum*, LIX, 1938, p. 51).

In fact, Roger's name is explicitly mentioned in connection with the second of the three tombs, viz., that of Joan of Brabant, and there is every reason to suppose that he also took part in the preparation of its model, the tomb of Louis de Mâle. Of the latter, we know that it was ordered by Philip the Good and produced "*en sa ville de Bruxelles* (where Roger was *facile princeps* in all artistic activities) par Jacques de Gerines bourgeois dicelle" (M. Devigne, "Een nieuw Document voor de Geschiedenis der Beeldjes van Gérines," *Onze Kunst*, XXXIX, 1922, p. 49 ff., especially p. 55 f.). As to the former, we have an elaborate record of payments which shows that the statues, again supplied by the aforementioned "coppersmith" (*cooperslagere*) Jacques de Gérines, had been "cut" (*gesneden*) and were "done over" (*gerepareert*), by the "sculptor" (*beeldesnyder*) Jean Delemer — apparently the same who in 1428 had carved the beautiful "Annunciation" in Ste.-Marie Madeleine at Tournai (see pp. 162, 254). Since the statuary is so nearly identical in both monuments, and since Jacques de Gérines seems to have been responsible only for the casting, we are entitled to assume that Delemer had played the same role in the execution of the tomb of Louis de Mâle as he did in that of Joan of Brabant, and that the same is true of Roger van der Weyden who, in 1459, received 100 crowns (equivalent of 2400 shillings or 120 pounds Flemish) "voir zynen loon van te hebben die voirscreve beelde by den voirscreven Jacoppe ende Janne de la Mer gelevert, gestoffert *van schilderien bevoirwaert ende gecomentschapt als voere*," that is to say, "as his remuneration for having polychromed the aforesaid statues, supplied by the aforesaid Jacques [de Gérines] and Jean Delemer, *from paintings bespoken and agreed upon as before*" (Devigne, p. 61; also Winkler, p. 183). This can only mean that the polychroming was done *on the basis of paintings* already commissioned for this purpose on an earlier occasion ("als voere"). For the phrase "*van schilderien*," cf. the document quoted in note 39 [2]; and that it was not unusual to order paintings or colored drawings preparatory to the polychroming of sculptures is demonstrated by the fact that, in 1442, the painter Dieric Aelbrechts — possibly identical with Dirc Bouts — was paid for a design (*patroen*) on the basis of which a new Madonna statue was to be polychromed: "Dieric

Aelbrechts, schildere, die een patroen gemaect hadde, om daer op d'nieuwe beelt van Onser Vrouwe te *stofferen*" (E. van Even, "Monographie de l'ancienne Ecole de peinture de Louvain," *Messager des Sciences Historiques*, XXXIV, 1866, p. 1 ff., p. 30; referred to in H. Huth, *Künstler und Werkstatt der Spätgotik*, Augsburg, 1923, p. 95).

In connection with the Burgundian tombs, then, Roger's workshop must have been commissioned with fairly numerous paintings portraying all the members of the family who were to figure as "plorants" — paintings, of course, the great majority of which had to be copied from originals thirty or forty years old; it should be remembered that the Duc de Berry already owned a regular portrait gallery housed in his Castle of Bicêtre (Michel, *Histoire de l'art*, III, 1, pp. 138, 145). This hypothesis accounts for the fact that Roger received the very substantial sum of one hundred crowns while Jacques de Gérines, having supplied the entire statuary, received only sixty, and Jean Delemer, remunerated for work but not for materials, only fifteen. And it also explains, I think, the deceptively archaic appearance of the pseudo-Eyckian drawings as well as the existence of the Antwerp portrait of John the Fearless.

The foregoing account was written before the publication of J. Leeuwenberg, "De tien bronzen 'Plorannen' in het Rijksmuseum te Amsterdam; Hun Herkomst en de Voorbeelden waaraan zij zijn ontleend," *Gentse Bijdragen tot de Kunstgeschiedenis*, XIII, 1951, p. 13 ff. While I am not convinced of Leeuwenberg's conclusion that the four or five "Eyckian" drawings were copied after the little statues formerly on the Lille tomb rather than executed in preparation thereof (the little pieces of terrain on which the figures stand are very different, I feel, from the abstract, polygonal plinths that served to support the actual statuettes) I am delighted to see that he dates them, as I do, in the sixth decade of the fifteenth century and vigorously denies their attribution to Jan van Eyck.

5. Cf., in addition to the portraits of Charles the Bold, the "Grand Bâtard" and Francesco d'Este, the portrait of Philip the Good in the *Chroniques du Hainaut* as well as the panels showing him "en ung chapperon bourellé" and the portrait of Jean le Fèvre de St. Remy (see note 275 ¹). For the significance of the hammer as an attribute of high office or as a symbol of victory in a tournament, see Kantorowicz, *op. cit.*, p. 176 f.

Page 292

1. Winkler, p. 160; Friedländer, II, p. 93, no. 4, pl. VII; Renders, II, pls. 51, 57; Destrée, pl. 140; Schöne, p. 68; Musper, fig. 6; Beenken, *Rogier*, pp. 36, f., 73 f., frontispiece in color. For a drawing in the

British Museum, reflecting a somewhat similar portrait, see Winkler, p. 54, fig. 25; ——, "Rogier van der Weyden's Early Portraits," *Art Quarterly*, XIII, 1950, p. 211 ff.; Destrée, pl. 148; Popham, *Drawings of the Early Flemish School*, pl. 11; ——, *Catalogue of Drawings . . . in the British Museum*, v, p. 54; Beenken, *Rogier*, p. 37, fig. 27.

2. Winkler, p. 176, fig. 24; Friedländer, II, p. 101, no. 29 A, pl. XXVIII; Destrée, pl. 137; Musper, fig. 66; van Puyvelde, *Primitives*, pl. 45.

3. Winkler, p. 161; Friedländer, II, p. 102, no. 32, pl. XXX; Destrée, pl. 133; Beenken, *Rogier*, p. 71 f., fig. 109.

4. Friedländer, XIV, p. 88, Nachtrag, pl. X; de Tolnay, *Le Maître de Flémalle*, p. 58, no. 11, fig. 25; Destrée, pl. 128; Renders, II, pl. 51; Beenken, *Rogier*, p. 70, fig. 35 (under "London, Colnaghi"); see also notes 154 ², 294 ¹⁴.

5. Friedländer, XIV, p. 88, Nachtrag, pl. XII; Hulin de Loo, *Biographie Nationale*, XXVII, col. 239; Musper, fig. 34; F. Winkler, "Rogier van der Weyden's Early Portraits"; A. Scharf, *A Catalogue of Paintings and Drawings from the Collection of Sir Thomas Merton, F.R.S., at Stubbingshouse, Maidenhead*, London, 1950, p. 74 f., no. XXXI; Beenken, *Rogier*, p. 35 f., figs. 16, 17. Scharf's identification of the sitter as Guillaume Fillastre appears to be well founded and can be corroborated, I think, by his appearance about 25 years later in Simon Marmion's altarpiece from St.-Omer in the Kaiser Friedrich Museum (Ring, *A Century*, Cat. no. 170, pl. 104). The only objection seems to be that Fillastre, born about 1400, entered the Benedictine order at an early age and was already an abbot in his early thirties. We know, however, that he concurrently pursued his studies at the University of Louvain and received his doctoral degree there in 1436 (*Biographie Nationale de Belgique*, VII, col. 61 ff.). He may, therefore, have had dispensation to wear secular dress in those years, and it may have been precisely in 1436 that he sat to Roger in his new doctor's habit. The curious headgear which he wears is a doctor's hood identical with that worn by the two doctors attending a sermon of Jean Gerson in the *Miroir d'Humilité*, Valenciennes, Bibliothèque Municipale, ms. 240 (231), fol. 117 (319), illustrated in V. Leroquais, *Le Bréviaire de Philippe le Bon, Bréviaire parisien du XVᵉ siècle*, Brussels, 1929, pl. 40 (kindly brought to my attention by Canon A. L. Gabriel). The back of the picture shows a beautifully designed holly plant with the difficult motto: "Je he ce que mord" which has been variously rendered as "I hate that which stings" (Winkler) and "J'ai ce qui mord," "I have that which stings" (Scharf). Both translations are, how-

ever, unconvincing: the first, because an emblem represents a thing with which the bearer symbolically identifies himself, and not a thing which he dislikes (nobody would assume the device of a snail or turtle accompanied by the motto "I hate sloth"); the second, because *Je he* can only be the first person present of *hair*, and not of *avoir* which never has an aspirate "h" and, consequently, requires the elision of the preceding "e" in *Je*. The correct translation, for which I am indebted to Professors Leo Spitzer and Ernst Robert Curtius, would seem to be: "I hate that which I sting," meaning that the bearer will use his weapons only against those of whom he morally disapproves.

A Portrait of a Young Man which, if authentic, would be approximately contemporaneous with that of Guillaume Fillastre was recently sold at Christie's (*The Illustrated London News*, CCXVII, 1950, November 18th, p. 826; Beenken, *Rogier*, p. 106, fig. 114); but to judge from the reproduction it is not equally convincing.

6. E. Renders and F. Lyna, "Deux Découvertes relatives à Van der Weyden," *Gazette des Beaux-Arts*, ser. 6, IX, 1933, p. 129 ff.; van Puyvelde, "Die Flämische Kunst auf der Ausstellung zu Brüssel," *Pantheon*, XVI, 1935, p. 321 ff.

7. Stein, *op. cit.*, figs. 1 and 1 a. For the supposed "Demoiselle de Villa," allegedly dating from 1430–1435, see p. 300 f.

Page 293

1. Cf. Winkler, p. 52 ff.

2. Winkler, p. 174; Friedländer, II, p. 95, no. 13, pl. XIV; Destrée, pl. 139; Renders, II, pl. 57; Musper, fig. 89; Beenken, *Rogier*, p. 74 f., fig. 93. See also *Masterpieces of Art . . . New York World's Fair*, 1939, no. 410, pl. 48; *Flemish Primitives, An Exhibition Organized by the Belgian Government*, p. 26; Wescher, "Das höfische Bildnis."

3. Most scholars, including Beenken, date the picture in the 'fifties (cf., e.g., Friedländer, II, p. 42; Musper, pp. 25, 59). I accept the dating of Hulin de Loo, *Biographie Nationale*, XXVII, col. 240 f., which agrees with the apparent age of the sitter as well as her costume (cf. especially the Bride in Petrus Christus' famous "St. Eloy" of 1449 in the Robert Lehman Collection at New York [fig. 407] and the donor's portrait of Isabella herself in the "Nativity" of 1448 ascribed to Nabur Martins [see note 127 [4]]).

4. For the identification of the sitter, see Stein, *op. cit.*, figs. 4 and 4 a; Devigne, "Notes sur l'exposition d'art flamand et belge," p. 72; van Puyvelde, "De Reis van Jan van Eyck naar Portugal." It may be mentioned that the "Portrait of a Lady" by a Portuguese master which has recently passed from the Harkness Collection to the Metropolitan Museum (no. 50.115.15) is a free copy of the Rockefeller panel minus the inscription.

5. For the tradition of the Sibyls, see the literature referred to in note 240 [2]. For the Memlinc portrait of 1480, preserved in the St. John's Hospital at Bruges, see, e.g., van Puyvelde, *Primitives*, pl. 91.

6. The inscription has always puzzled observers (cf., e.g., Friedländer, II, p. 95); when Stein, *op. cit.*, p. 10, attempts to explain it by the contention that it was natural for the "Nordmensch" to identify a princess of "semi-African origin" (!) with an oriental Sibyl it must be objected that this explanation does not account for the numeral and that the "semi-African" origin of Isabella of Portugal would have suggested, if anything, the *Lybica*, and not the *Persica*.

Page 294

1. For a lost cycle of Flemish panels of *ca.* 1450–1455, representing the Sibyls and pagan Philosophers in half-length, which are transmitted through nearly contemporary woodcuts and engravings and were revived from these prints by Ludger and Herman tom Ring, see Vöge, *op. cit.*, p. 132 ff., figs. 59, 61, 63–65, 67, 70, 71, 73–76.

2. Cf. Winkler, p. 178; Friedländer, II, p. 137 f., nos. 125 f and g. No. 125 g, preserved in the Musée Communal at Bruges, is illustrated in Destrée, pl. 130 (see Janssens de Bisthoven and Parmentier, *op. cit.*, p. 63 ff.).

3. See above, p. 275.

4. These doubtful or unacceptable pictures are:

(a) Portrait of a Young Man, formerly in the Cardon Collection at Brussels (Winkler, p. 162; Friedländer, II, p. 102, no. 33; Destrée, pl. 134; Renders, II, pl. 57). Very doubtful.

(b) Portrait of a Man in a Turban, in the Metropolitan Museum (Friedländer, XIV, p. 89; Destrée, pl. 142; Musper, fig. 88; Beenken, *Rogier*, p. 99, fig. 122; Wehle and Salinger, *op. cit.*, p. 35). In my — and, as I see now, Beenken's — opinion not acceptable in view of the indifferent design and the un-Rogerian vacancy of the glance; Hulin de Loo, *Biographie Nationale*, XXVII, does not mention the picture.

(c) Portrait supposedly of M. Broers in the possession of Mesdemoiselles Le Maire-Broers, Brussels (Dr. C. Le Maire, "Vers l'identification d'un portrait exécuté par Roger van der Weyden," *Bulletin de la Société Royale d'Archéologie de Bruxelles*, VIII, 1935, p. 107 ff.; *The Worcester-Philadelphia Exhibition of Flemish Painting*, no. 8). The unusually small picture (only 11.2 cm. by 10.2 cm.) is unacceptable and seems

to be a forgery after the portrait of the donor in the Berlin *"Pietà"* (see note 261 [4]).

(d) Portrait supposedly of a "Demoiselle de Villa" in the de Rothschild Collection at Paris (fig. 401); see below, p. 300 f.

For the assumption that the portrait of Robert de Masmines (allegedly of Niccolo Strozzi) was executed on Roger's journey to Italy in 1450, see note 175 [8]. For two alleged copies after early Rogerian portraits — the drawing of a Falconer in the Städelsches Kunstinstitut at Frankfort (our fig. 424) and a portrait held to represent Roger, Count Blitterswyk-Geldern, in the Fogg Museum at Cambridge, see notes 310 [7] and 354 [4].

5. See p. 292. Stein's identification of the sitter with Pierre de Beffremont (*op. cit.*, plate) does not appear convincing to this writer.

6. See p. 286.

7. See p. 291.

8. *Ibidem.*

9. See p. 292.

10. Winkler, p. 169; Friedländer, II, p. 102, no. 34, pl. XXIX; Renders, II, pl. 57; Destrée, pl. 138; Beenken, *Rogier*, pp. 74, 99. Cf. Davies, *National Gallery Catalogues, Early Netherlandish School*, p. 111 ff. The undeniable similarity that exists between this portrait and the two charming, even more Javanese-looking little girls in a "Presentation" in the Czernin Collection at Vienna, originally the right-hand wing of a triptych now mostly ascribed to Memlinc (Friedländer, II, p. 119, no. 85; *idem*, VI, p. 18 ff., and XIV, p. 102; Destrée, pl. 110), has caused Hulin de Loo to conjecture that these two heads may have been painted in by Roger himself ("Hans Memlinc in Rogier van der Weyden's Studio," *Burlington Magazine*, LII, 1928, p. 160 ff.). The inclusion of the Czernin "Presentation" and its companion pieces in the *oeuvre* now assigned to Vrancke van der Stockt (de Tolnay, "Flemish Paintings in the National Gallery of Art," p. 200, note 39) is difficult to understand.

11. Winkler, p. 171 f.; Friedländer, II, p. 137, nos. 125 a-c. No. 125 c, preserved at Antwerp, is illustrated in Destrée, pl. 131.

12. Hulin de Loo, "Diptychs by Rogier van der Weyden," *Burlington Magazine*, XLIII, 1923, p. 53 ff., and XLIV, 1924, p. 179 ff., with all available data concerning the sitters.

13. Friedländer, II, p. 138, no. 126; Destrée, pl. 126.

14. Friedländer, II, p. 106, no. 45, pl. XXXVIII; Destrée, pl. 135; Beenken, *Rogier*, p. 71, fig. 36 (see also *Burlington Magazine*, LXVIII, 1936, p. 94). The picture is, however, so small (19 cm. by 14 cm., only about half the usual size) that it may be worth while to investigate whether it is a donor's portrait cut out from a larger composition rather than the wing of a devotional diptych. The same would seem to be true of the Metropolitan Museum's "Man in Prayer" (see p. 292; fig. 361) which has the right size but gives an uncomfortably crowded, fragmentary impression. The "Man in Prayer" owned by Abbé de Lescluse at Berchem near Antwerp (Beenken, *Rogier*, p. 71, fig. 111), on the other hand, unquestionably belonged to a devotional diptych but is known to me only from Beenken's reproduction. It strikes me as a heavily damaged but possibly authentic picture.

15. These "intercessional diptychs," ushered in by the Master of Flémalle's Philadelphia picture (see p. 174; fig. 216), became so popular that the studio and school of Dirc Bouts produced them *en masse* and partly for export (see Friedländer, III, p. 68): at least nine specimens are known (Friedländer, III, p. 118 ff.; Schöne, *Dieric Bouts und seine Schule*, p. 129 ff.). Whether or not they all derive from an original by Roger (Destrée, p. 173 f., pl. 123) is a matter of surmise.

16. In contrast to altarpieces and book illuminations, where greater freedom prevailed, Early Netherlandish portraiture is governed by the laws of heraldry. In ordinary double portraits of man and wife the husband occupies the dexter panel, facing to the right, while the wife occupies the sinister panel, facing to the left. Conversely, in devotional diptychs where a gentleman is represented praying to the Madonna, his portrait is relegated to the sinister side so that he prays to the left. Wherever a Netherlandish portrait of a gentleman shows the sitter praying in the opposite direction, viz., to the right, we are confronted either with the wing of a triptych showing the Madonna between the two spouses, in which case the husband naturally reasserts his right of precedence; or, with a fragment of a larger composition. The former possibility is represented, e.g., by Memlinc's portraits of Tommaso and Maria Portinari in the Metropolitan Museum (Wehle and Salinger, *op. cit.*, p. 65 ff.), the same master's Moreel portraits in the Brussels Museum (see p. 349) and the Frankfort triptych constructed around an early Madonna by Hugo van der Goes (see p. 338; fig. 455). The latter possibility is exemplified, not only by the Metropolitan Museum's "Portrait of a Young Man" by Hugo van der Goes (see note 332 [1]) but also by the same museum's beautiful "Portrait of a Man" by Dirc Bouts (see note 318 [3]). Memlinc's "Portrait of a Young Man at Prayer" in the National Gallery at London may also be a fragment rather than the wing of a triptych since it appears to have been cut down at the

margin (Davies, *National Gallery Catalogues, Early Netherlandish School*, p. 82). I am inclined to believe that these rules also apply to French fifteenth-century painting although two portraits by Fouquet show gentlemen praying to the right: the portrait of Guillaume Jouvenel des Ursins in the Louvre (see, e.g., Ring, *A Century*, Cat. no. 126, pl. 72) and the portrait of Etienne Chevalier, protected by St. Stephen, in the Kaiser Friedrich Museum (see, e.g., Ring, Cat. no. 122, pl. 73). Nothing is known of the original context of the "Jouvenel des Ursins" which may have belonged to a triptych or have been painted so as to face a sculptured image. And the documented fact that the "Etienne Chevalier" formed a diptych with the Antwerp Madonna, said to immortalize the features of Agnès Sorel (see, e.g., Ring, Cat. no. 123, pl. 74), for at least three centuries does not entirely dispose of Bouchot's old theory — based upon artistic rather than heraldic considerations and still upheld by Wescher — according to which this diptych was originally a triptych, its right wing showing Chevalier's wife, Cathérine Budé, with St. Catherine. The right-hand wing may easily have been removed before the two extant panels found their way into Notre-Dame at Melun where Denys Godefroy (*Remarques sur l'histoire de Charles VII*, p. 886) saw them some time before 1661.

Page 295

1. This is even true of the double portrait of Hugues de Rabutin and Jeanne de Montaigu in the Rockefeller Collection at New York by the Master of St.-Jean-de-Luz (cf., e.g., Ring, *A Century*, Cat. no. 235, pls. 131, 132), where the objects of veneration are included in the portraits themselves. The husband — here, of course, occupying the dexter panel — is shown praying to a statuette of the Madonna; the wife, to a statuette of St. John the Evangelist.

2. Winkler, p. 174; Friedländer, II, p. 101, no. 28, pl. XXV; Destrée, pl. 38; Beenken, *Rogier*, p. 71, fig. 97. The date, not before 1460, can be inferred from the fact that Jean Gros, first mentioned in 1469 and not married until 1472, was hardly born before *ca.* 1430.

3. Musper, p. 24.

4. Friedländer, II, p. 101, no. 29, pl. XXIV; Destrée, pl. 37; Beenken, *Rogier*, p. 76 f., fig. 96.

5. Winkler, p. 156 f.; Friedländer, II, p. 103 f., no. 39; Destrée, pl. 40; Schöne, p. 73; Musper, fig. 93; Beenken, *Rogier*, p. 70 f., fig. 99. The picture is datable about 1460 because (contrary to Musper, p. 24) Philippe de Croy did not assume the title "Seigneur de Sempy," as implied by the inscriptions and coat-of-arms on the back of the panel, until 1459 and

employed it only until 1461 when he inherited the Seigneurie de Quiévrain.

6. Winkler, p. 174; Friedländer, II, p. 104, no. 40, pl. XXXIV; Destrée, pl. 39; Schöne, p. 72; Musper, fig. 92; Beenken, *Rogier*, p. 89, fig. 98.

7. Winkler, p. 175; Friedländer, II, p. 102, no. 30, pl. XXVII; Destrée, pl. 36; Musper, fig. 71; van Puyvelde, *Primitives*, pl. 44 (hands only); Beenken, *Rogier*, p. 71 ff., figs. 89–91. The date (about 1460, in contrast to Musper's dating in the 'forties, p. 59) follows from the similarity which exists between the Caen Madonna and the Virgin Mary in the central panel of the Columba altarpiece.

8. Friedländer, II, p. 102, no. 31, pl. XXVI; Destrée, pl. 35; Musper, fig. 70; Beenken, *Rogier*, p. 75 ff., fig. 88. Cf. E. Lambert, "La Vierge à l'Enfant de la Collection Mancel à Caen," *Bulletin des Musées Français*, VIII, 1946, p. 27 ff.

Page 296

1. Friedländer, II, p. 101, no. 27; Destrée, pl. 45.

2. Winkler, p. 161; Friedländer, II, p. 105, no. 43, pl. XXXVI; Destrée, pl. 44; Musper, fig. 44. The type represented by the Renders Madonna, the Madonna in the Art Institute at Chicago and the Berlin "Madonna with the Iris" is very closely followed in the Metropolitan Museum Madonna erroneously ascribed to Dirc Bouts (Wehle and Salinger, *op. cit.*, p. 45 ff.) and also underlies one of Dirc Bouts' finest original works, the Madonna in the National Gallery at London (p. 317; fig. 426). For further replicas and variations, see Friedländer, II, p. 128 ff., nos. 107 a–n, pls. LXXIV, LXXV (no. 107 g is now in the Metropolitan Museum, Wehle and Salinger, *op. cit.*, p. 75); Destrée, pls. 46, 51. The Madonnas with the Infant holding an apple (Friedländer, II, p. 131 ff., nos. 109 a–g, pl. LXXVI; Destrée, pl. 48) constitute only a subgroup of this type.

3. Cf. Winkler, p. 71 ff., figs. 37–39; Friedländer, II, pl. 130 f., nos. 108 a–n, pls. LXXIV, LXXV (no. 108 l is now in the Metropolitan Museum, Wehle and Salinger, *op. cit.*, p. 42 f.); Destrée, pl. 47. This type is the basis of the Madonna in the Pennsylvania Museum of Art (Winkler, fig. 40) now frequently ascribed to Hugo van der Goes (Friedländer, IV, pl. I); the Madonna in the Herzog-Czete Collection at Budapest, also belonging in Hugo's circle (Friedländer, IV, pl. XXXVII); and, with more substantial changes, his well-known Frankfort Madonna (Friedländer, IV, pl. VII, our fig. 455). It was also fairly literally repeated in two pictures from the workshop of Dirc Bouts, one preserved in the Städelsches Kunstinstitut at Frankfort (Friedländer, III, p. 108, no. 15, pl. 22), the other formerly in the Stroganoff Collec-

tion at Rome and now belonging to Mrs. Jesse Straus at New York (Friedländer, III, p. 107, no. 11, pl. XVIII).

4. Cf., e.g., Winkler, fig. 39; Friedländer, II, pl. LXXV; Destrée, pl. 48.

5. Winkler, p. 57, fig. 31; Friedländer, II, p. 133, no. 110 a, pl. LXXVII; XIV, p. 88, Nachtrag, pl. X (after cleaning); Destrée, pl. 49; Beenken, *Rogier*, p. 77, fig. 95. The copy mentioned by Winkler, p. 57, note 1, and listed by Friedländer, II, p. 133, no. 110 b, is now in the Wyckhuise Collection at Roulers and illustrated in Destrée, pl. 50. For the charming silverpoint drawing of the Virgin's head in the Louvre, possibly an original, see Winkler, p. 174, fig. 30; Popham, *Drawings of the Early Flemish School*, pl. 13.

6. Friedländer, II, p. 102, no. 35, pl. XXXI; Destrée, pl. 43; Schöne, p. 79. Cf. *Masterpieces of Art . . . New York World's Fair*, 1939, no. 411, pl. 50, and *Museum of Fine Arts, Houston, Texas, Catalogue of the Edith A. and Percy S. Straus Collection*, 1945, no. 27. Though the Houston picture has been unanimously accepted by the authorities (except, as I see now, by Beenken, *Rogier*, p. 99, under "Amerikanischer Privatbesitz") and doubtless reflects a genuine composition, such weaknesses as the design of the left eye, the unconvincing foreshortening of the averted half of the face and, above all, the loose and casual treatment of the embroidered pattern of the Virgin's cloak (all pointed out to me by Professor Wilhelm Koehler) make its manual authenticity extremely doubtful. The composition was to form the basis of Dirc Bouts' Madonna in the Metropolitan Museum (Wehle and Salinger, *op. cit.*, p. 44 ff., our fig. 425) as well as of a Madonna by Memlinc (London, Lady Ludlow, Friedländer, VI, pp. 27 f., 125, no. 48, pl. XXIX) which, for this very reason, occupies an isolated place within his *oeuvre*.

7. This is the opinion of Musper, p. 21.

Page 297

1. Petrus Christus' Madonna of 1449, now in the Thyssen Collection at Lugano (cf. p. 313), is about the earliest instance of this revival.

2. See notes 296 [2, 3, 5]. For several Madonnas in half-length of more or less Rogerian character yet not derivable from originals attributable to Roger with certainty, see Friedländer, II, p. 133 ff., nos. 111–119 (no. 119 illustrated on pl. LXXVI and, according to Friedländer, XIV, p. 88, now in the Faust Collection in New York). The Madonna no. 117, now in the del Monte Collection in The Hague and generally resembling the Brussels version (Winkler, fig. 36; Friedländer, II, pl. LXXIV, no. 108 a; Destrée, pl. 47), ex-

cept for the fact that the Infant plays with the toes of His right foot as in the Madonna now in the Museum at Houston, Texas (see preceding note), has been declared as an original, which does not seem convincing to this writer (G. Glück, *La Collection del Monte*, Vienna, 1928, p. 6, pl. I; van Puyvelde, *Musée de l'Orangerie*, no. 97). How a picture in private possession, recently published by P. Wescher, "Eine unbekannte Madonnna von Rogier van der Weyden," *Phoebus*, II, 1949, p. 104 ff., could be considered as a Madonna in half-length and acclaimed as an original is hard to understand. It is evidently a fragment of a Madonna Enthroned vaguely related to the "Madonna in Red" in the Prado (our fig. 317), and has nothing to do with Roger in style and execution.

3. Winkler, p. 79, with reference to an earlier remark of Hugo von Tschudi.

4. *The William Rockhill Nelson Collection*, p. 42 (new edition, p. 57). The picture's connection with the *"Notre-Dame de Grâces"* was discovered, and its authorship correctly established, by J. Dupont, "Hayne de Bruxelles et la copie de Notre-Dame de Grâces de Cambrai," *L'Amour de l'Art*, XVI, 1935, p. 363 ff. The issue was, however, obscured by Rolland, "La Madone Italo-Byzantine de Frasne-lez-Buissenal," who —basing his conjecture upon the fact that the commission given to Hayne de Bruxelles specifically states that the twelve copies should be painted "in oils" while no such stipulation was deemed necessary in the case of the three copies ordered from Petrus Christus — proposes to ascribe the Kansas City panel to the latter while making Hayne de Bruxelles responsible for a copy preserved in the Church of Frasne-lez-Buissenal. It is true that the medium of the Kansas City picture has occasionally been described as "tempera"; but it is in fact painted in the usual Flemish technique which, though probably involving a certain amount of lean pigments, was and is normally referred to as "oils." (I am indebted to Mr. Harold W. Parsons, Adviser to the William Rockhill Nelson Gallery, for having explicitly reassured me on this point.) Its style has no connection with that of Petrus Christus, and nothing militates against its attribution to Hayne de Bruxelles who may or may not be identical with that "Hayne, jone peintre," who in 1459 painted the frame of Roger's Cambrai altarpiece and part of the surrounding wall (cf. the document reprinted in Winkler, p. 170 f.; the identification is not too probable in view of the fact that this Hayne is explicitly referred to as "young" as late as 1459). The panel in the church of Frasne-lez-Buissenal, on the other hand, is a truly "archeological" copy, practically indistinguishable from the original, completely beyond the compass of a Flemish painter of the fifteenth century

and possible only at the time of Peiresc. It belongs to a group of early seventeenth-century "duplicates" of the "*Notre-Dame de Grâces*" enumerated and in part reproduced by Dupont, pp. 365 (Demandolx-Dedons Collection at Marseilles) and 366 (Douai, Museum, inscribed: "A la dame Marguerite de Haynin et à Madame Novreul, 1627").

Page 298

1. In addition to the works already mentioned in the preceding notes, I am unable to accept the following paintings:

(a) The "Annunciation" in the Museum at Antwerp (Winkler, pp. 126, 128; Friedländer, II, p. 94, no. 10; Destrée, pl. 114; Musper, fig. 86). With its diminutive format, rather soft forms and sharp contrasts between blue and red, the picture gives the impression of having been executed by an artist normally engaged in book illumination.

(b) The "Clugny Annunciation" in the Metropolitan Museum (Winkler, p. 135; Friedländer, II, p. 106, no. 48, pl. XLI; Destrée, pl. 113; Musper, fig. 73; van Puyvelde, *Primitives*, pl. 37; Beenken, *Rogier*, p. 82 ff., figs. 83, 84; Wehle and Salinger, *op. cit.*, p. 38 ff. with further references). In my opinion this picture was not produced until *ca.* 1470 — quite possibly by Memlinc — and shows the more static quality characteristic of this phase; even the substitution of a stiff chasuble for a flowing pluvial or alb in the Angel's vestments, frequent in Boutsian compositions but not to be found in Roger's, is symptomatic of this fundamentally un-Rogerian spirit.

(c) The "Madonna with St. Paul and a Donor" in the same Museum, now officially ascribed to a follower (Winkler, p. 74; Friedländer, II, p. 104, no. 40 A, pl. XXXV; Musper, p. 54; Beenken, *Rogier*, p. 99, fig. 127; Wehle and Salinger, *op. cit.*, p. 41 f., with further references).

(d) The "Exhumation of St. Hubert" in the British Museum (fig. 397) and its counterpart, the "Dream of Pope Sergius and Consecration of St. Hubert" (fig. 396) which has passed from the Schiff Collection in New York to the von Pannwitz Collection at Haartekamp near Haarlem and is now, not quite convincingly, ascribed to a different hand (Beenken, *Rogier*, p. 99, under "New York, Schiff Collection"). For the "Exhumation," see Winkler, p. 124 ff., fig. 55, and Thieme-Becker, XXXVII, p. 97; Friedländer, II, p. 97, nos. 18, 19, pl. XVI; Destrée, pl. 118; Davies, *National Gallery Catalogues, Early Netherlandish School*, p. 113 ff., with further references. For the drawing of a procession, ascribed to the same hand, see Winkler, figs. 56, 57; Popham, *Drawings of the Early Flemish School*, pls. 16, 17; ———, *Catalogue*

of Drawings . . . in the British Museum, V, p. 56 f. The two panels have been ascribed to Roger himself as well as to various followers known from other pictures (de Tolnay, *Le Maître de Flémalle*, p. 58, no. 14, even ascribes the "Dream of Pope Sergius" to the Master of Flémalle without mentioning the "Exhumation of St. Hubert"; cf. note 174[4]); but they seem to have beeen produced by a fairly independent and somewhat old-fashioned member of Roger's workshop — perhaps a former pupil of the Master of Flémalle — to whom no other painting can be ascribed with any amount of certainty. Their date is, in my opinion, about 1445 rather than about 1440 whether or not they were commissioned in connection with the foundation of the Order of St. Hubert in 1444 (see V. Servais, "Notice historique sur l'Ordre de Saint Hubert," *Revue Nobiliaire Historique et Biographique*, IV, 1868, p. 145 ff.). According to Dubuisson-Aubenay they were preserved in Ste.-Gudule at Brussels in the first half of the seventeenth century and were, even then, ascribed to Roger only with some reservation ("*estimé* de la main de Rogier"; see L. Halkin, "L'Itinerarium Belgicum de Dubuisson-Aubenay," *Revue Belge d'Archéologie et d'Histoire de l'Art*, XVI, 1946, p. 47 ff., especially p. 60).

(e) A picture at Petworth (Lord Leconfield Collection), composed of a donor with St. James the Great and a Virgin Mary originally forming part of an "Annunciation" from which the Angel has been cut off with the exception of a fragment of his scroll (reproduced as "Burgundian School related to the School of Petrus Christus" in C. H. Collins Baker, *Catalogue of the Petworth Collection of Pictures in the Possession of Lord Leconfield*, London, 1920, no. 122, pl. facing p. 12, but ascribed to Roger by Friedländer, XIV, p. 88, Hulin de Loo, *Biographie Nationale*, XXVII, col. 239, and Beenken, *Rogier*, p. 81 f., fig. 82). While the type of the Annunciate is obviously derived from Roger, the characterization of the donor and the treatment of space (a tiled floor almost as rapidly receding towards a brocaded background as in the Basel and Geneva altarpieces by Conrad Witz) are not compatible with Roger's style.

For the "St. George" formely owned by Lady Evelyn Mason (fig. 273) and the "Mass of St. Gregory" in the Schwarz Collection (fig. 227), both occasionally ascribed to Roger van der Weyden, see notes 174[4], 175[4]. Of the "Virgin on a Grassy Bench" mentioned by Hulin de Loo, *Biographie Nationale*, col. 234, as being in Swiss trade, and probably referred to by Beenken, *Rogier*, p. 99, under "München, Collecting Point," I have not even seen a reproduction. According to Beenken it is certainly not by Roger.

As for supposedly authentic drawings not as yet referred to, I am more than skeptical of a "Crucifixion" in the Louvre reproduced in J. Dupont, "Que dirons-nous?," *De van Eyck à Breughel* (special issue of *Les Beaux-Arts*, November 9, 1935), p. 10. The attribution of a drawing showing two figures apparently copied from an "Ascension of Christ" (the Virgin Mary and St. Peter), also in the Louvre and reproduced in *De van Eyck à Rubens*, no. 10, pl. III, is not even debatable.

2. Winkler, p. 38 f.; Renders, II, pls. 14, 29, 32–37, 39, 40, 44, 45; Friedländer, II, p. 112, no. 68; de Tolnay, *Le Maître de Flémalle*, p. 58, no. 15, fig. 21; Musper, fig. 16; Beenken, *Rogier*, p. 51 ff., fig. 10 (as "Master of Flémalle").

3. M. J. Friedländer, "Der Rogier-Altar aus Turin," *Pantheon*, XI, 1933, p. 7 ff.; Friedländer, XIV, p. 88, Nachtrag, pls. VII, VIII; Musper, fig. 54; Beenken, *Rogier*, pp. 34, 53, figs. 115–118 (justly denying Roger's authorship, but maintaining the early date). That the jewel worn by the donor around his neck is the Order of the Porcupine was claimed by Renders, II, "Appendice" (p. 93); to me it looks like an ordinary filigree pendant. It should also be borne in mind that the Order of the Porcupine (cf. G. Giucci, *Iconografia storica degli Ordini Religiosi e Cavallereschi*, III, Rome, 1840, p. 20 ff.) was the family Order of the Orléans with whom Oberto de Villa had no known connections. It was founded by Louis of Orléans in 1393 and was in abeyance, as it were, during his son's captivity from 1415 to 1440.

4. Friedländer, II, p. 74; cf. Winkler, p. 38 ff.

5. Renders, II, "Appendice" (p. 93).

6. Friedländer, XIV, p. 85: "[Dieses Gesamtwerk] wird am festesten verklammert durch den . . . Altar, der vor wenigen Jahren in die Sammlung Abegg gelangt ist."

7. This was ascertained beyond any doubt when the picture could be examined at Washington. Winkler, p. 38, rightly compares the undisfigured angels to those in the title page of the Brussels *Cité de Dieu* of 1445 or 1446 (see note 213[9]).

8. See note 267[3].

9. This was already observed by von Tschudi, *op. cit.*, p. 94, who therefore — and, from his point of view, without any misgivings — considered the Berlin "Calvary" as dependent upon the Vienna triptych.

Page 299

1. Compare the juxtaposition of the two heads in Renders, II, pl. 36. The head of the Magdalen, on the other hand, is reminiscent of a drawing in the British Museum, Destrée, pl. 150, top (cf. Popham, *Catalogue of Drawings . . . in the British Museum*,

V, p. 60) which would also seem to represent the Magdalen rather than the Virgin Mary; in contrast to two somewhat later panels, quoted by Popham, in which the same type is in fact employed for a Mater Dolorosa, the drawing shows the figure with very long hair and clad in wordly garments.

2. An instructive list of such self-repetitions — including, however, a number of shopworks — is found in Hulin de Loo, *Biographie Nationale*, XXVII, col. 231.

3. See pp. 116, 122.

Page 300

1. Hulin de Loo, *Biographie Nationale*, XXVII, col. 235; Winkler in Thieme-Becker, XXXV, p. 472. Since death has prevented Hulin de Loo from stating his arguments, I must refer my readers to other sources for information about the de Villa family: J. Destrée, "Ein Altarschrein der Brüsseler Schule," *Zeitschrift für Christliche Kunst*, VI, 1893, col. 173 ff.; ———, *Tapisseries et sculptures bruxelloises*, Brussels, 1906, p. 57 ff.; ———, "Etudes sur la sculpture brabançonne au Moyen Age, IV," *Annales de la Société d'Archéologie de Bruxelles*, XIII, 1899, p. 273 ff., especially p. 287 ff.; V. Angius, *Sulle Famiglie nobili della Monarchia di Savoia*, Turin, 1841, II, p. 1162 ff. (kindly brought to my attention by Signora Anna Maria Brizio); N. Gabrielli, "Opere di maestri fiamminghi a Chieri nel Quattrocento," *Bollettino Storico-Bibliografico Subalpino*, XXXVIII, 1936, p. 427 ff. What argues in favor of Hulin de Loo's identification is the fact that the donor of the Abegg altarpiece is represented in Italian costume and would thus seem to have sat for his portrait as a visitor to Flanders rather than as a permanent resident, and this is true of Oberto de Villa (a younger son of Franceschino, Lord of Villastellone and Counsellor to the last Count of Piedmont) who was a country squire and courtier (Equerry to Louis of Savoy) rather than a merchant and visited the Netherlands only on the occasion of a mission to Philip the Good (date unfortunately not specified). But this, of course, does not exclude the possibility that other Piedmont de Villas, too, paid visits to the Netherlands. Concerning Oberto, the available evidence as to his dates is somewhat contradictory. We know that his father was still alive in 1425 (Angius, *loc. cit.*); and that he himself signed a power of attorney as late as November 22, 1494 (Gabrielli, p. 429, note), which would place his birth in ca. 1420–1425. On the other hand, he is said to be mentioned, as early as 1416, as the recipient of a bequest in a will in which he figures together with four sisters, three of them married and the fourth of marriageable age (Been-

ken, *Rogier*, p. 102, notes 26 and 27, referring to the "unpublished *exposé*" of a famous lecture delivered by Hulin de Loo in 1936). I was unable to ascertain the source of this statement which is not included in the brief printed summary of Hulin de Loo's lecture (F. Salet, "Overzicht betreffende nederlandsche Kunst," *Oud Holland*, LV, 1938, p. 276) and even in Arù and de Geradon, *op. cit.*, p. 24, is repeated only on Beenken's authority. In view of the document of 1494 — the date of which agrees with the fact that a first cousin of Oberto's father, Claudio de Villa, was still alive about 1480 (see note 301 [5]) — I am inclined to doubt the accuracy of Beenken's quotation; and in this case the identity of the youthful donor in the Abegg altarpiece, which for stylistic reasons cannot be dated before *ca.* 1455, with Oberto de Villa could be maintained.

2. Friedländer, XIV, p. 85 ("about 1438"); Hulin de Loo, *Biographie Nationale*, XXVII, col. 235 ("prior to the 'Descent from the Cross' of the Escorial"); Musper, p. 59 ("prior to the 'Descent of the Cross' of the Escorial"); Winkler in Thieme-Becker, XXXV, p. 472 ("still in the 'thirties'"); Beenken, *Rogier*, caption of fig. 115 ("about 1435–40").

3. For the Turin "Visitation," see Friedländer, II, p. 93, no. 5, pl. IX; Destrée, pl. 116. For its and its counterpart's original connection with the Louvre "Annunciation," see Hulin de Loo, *Biographie Nationale*, XXVII, col. 233 f.; Salet, *op. cit.*; Musper, pp. 45 f., 58, fig. 46; Winkler in Thieme-Becker, XXXV, p. 475, and *ibidem*, XXXVIII, p. 97 (under "Meister der Exhumation des Heiligen Hubertus"); E. Michel, *L'Ecole Flamande . . . au Musée du Louvre*, p. 43 f., pl. VI; Beenken, *Rogier*, pp. 31 f., 33 ff., 37 f., 102, figs. 18–23; and, most recently, Arù and de Geradon, *op. cit.*, p. 21 ff., pls. XLI–LVII (with excellent reproductions and extensive but incomplete bibliography). Owing, again, to Hulin de Loo's lamented death, this ingenious hypothesis has never, to my knowledge, been fully expounded in print. So far as I could ascertain with the kind help of M. Louis Grodecki and M. Jacques Dupont (who played a major role in the development of the hypothesis), the sequence of events was approximately as follows. On the occasion of the Brussels Exhibition in 1935, Hulin de Loo observed that the original portrait had been cut out from the Turin donor's wing and suggested that the Turin shutters, each measuring 86 cm. by 36 cm., belonged to the Louvre "Annunciation" which measures 86 cm. by 92 cm. This was stated in *Cinq Siècles d'Art à Bruxelles, Mémorial de l'Exposition*, I (*Recueil de Planches*), Brussels, 1935, pl. II (illustration of the complete triptych) but not as yet in *Exposition Universelle et*

Internationale de Bruxelles, Cinq Siècles d'Art, I (*Guide illustré par M. Paul Lambotte*), Brussels, 1935, pp. 3, 5. The statements made in the *Mémorial* were substantially repeated in *Musée de l'Orangerie; De van Eyck à Brueghel* (P. Lambotte, pref., P. Jamot, introd.), Paris, 1935, p. 62 ff., nos. 87–89 (only the "Annunciation" illustrated) and summarized by J. Dupont, "Que dirons-Nous?," p. 8 (with illustration of the complete triptych). While the Turin panels were in Paris, M. Dupont discovered by means of X-rays that the donor's wing bore the de Villa coat-of-arms, obliterated by overpainting (see illustration in Arù and de Geradon, *op. cit.*, pl. LIV, right), and proposed to identify the original portrait cut out from it with the Heseltine-Rothschild "Portrait of a Lady" which thus became the "Portrait of a Demoiselle de Villa" (see note 301 [1]). In this improved form the whole hypothesis was formulated by Hulin de Loo in the historic lecture of 1936 which was never published *in extenso* but became the basis of a dogma perpetuated in all subsequent literature.

4. For the Frankfort Madonna by Hugo van der Goes and the "Martyrdom of St. Hippolytus," see notes 338 [3], 336 [2]; for the St. Francis panels attributed to Jan van Eyck, note 192 [1].

Page 301

1. The Heseltine-Rothschild portrait supposedly cut out from the Turin don's wing is surrounded by a veil of mystery and confusion which, the generous assistance of Messrs. Martin Davies, Jacques Dupont and Charles L. Kuhn notwithstanding, could be lifted only in part. Inscribed on the back with a spurious "Johannes van Eyck Miiij[c] XXV," it was exhibited as a work from the school of Jan van Eyck at the famous Bruges Exhibition of 1902 (*Exposition des Primitifs Flamands et d'Art Ancien, Première Section, Tableaux*, p. 40, no. 96) but immediately recognized as belonging in the orbit of Roger van der Weyden. It was assigned to the Master of the Edelheer Altarpiece, then held to be identical with the Master of the Exhumation of St. Hubert (see note 298 [1]) and/or the Master of the History of St. Joseph (see note 194 [2]), and dated 1450–1460 (M. J. Friedländer, "Die Brügger Leihausstellung von 1902," *Repertorium für Kunstwissenschaft*, XXVI, 1903, p. 66 ff., especially p. 72; Hulin de Loo, *Bruges, 1902, Exposition de Tableaux Flamands des XIVe, XVe et XVIe siècles, Catalogue Critique*, Ghent, 1902, p. 21, no. 96). Later on, it was shown as "School of Roger van der Weyden," at the "Exposition Internationale" of 1930 at Antwerp (*Trésor de l'Art Flamand du Moyen Age au XVIIIe siècle, Mémorial de l'Exposition d'Art Flamand Ancien à Anvers, 1930, I, Peintures*, Paris, 1932, p. 113, no. 132

bis). As for illustrations — the painting reproduced in Destrée, pl. 143, over the caption "Rogier(?), Portrait de Femme, Collection Edmond de Rothschild" is in reality the London Portrait of a Lady by the Master of Flémalle, our fig. 218 — I know those in F. Laban, "Ein neuer Roger," *Zeitschrift für Bildende Kunst*, new ser., XIX, 1908, p. 49 ff., fig. p. 62; *Ten More Little Pictures* (one of a series of catalogues of pictures and drawings belonging to J. P. Heseltine), London, 1909, no. 5; Arù and de Geradon, *op. cit.*, pl. LIV, left; and Beenken, *Rogier*, fig. 23 (here inserted into its alleged context). These reproductions make it abundantly clear that Hulin de Loo's and Friedländer's original verdict ("follower of Roger van der Weyden, *ca.* 1450–1460") was basically correct; even Beenken, p. 34, agrees that the picture can be considered only as a workshop product, dating it, however, *ca.* 1435. On no account can the Heseltine-Rothschild picture be ascribed to Roger himself, and if it were in fact the portrait cut out of the Turin donor's wing it would constitute the strongest possible argument against the latter's (and its counterpart's) authenticity. However, this hitherto unchallenged hypothesis is fraught with considerable difficulties. To begin with, there is a curious lack of precision, even unanimity, in the rather vital matter of measurements. The rectangular hole in the Turin donor's wing, from which the Heseltine-Rothschild panel is supposed to have been cut out, measures 17.4 cm. by 11.5 cm. (Arù and de Geradon, p. 22). Concerning the panel itself, however, the statements as to its dimensions vary between 16 cm. by 12 cm. (*Ten More Little Pictures* and Beenken), which would be a little too short and too wide, and 12.5 cm. by 9 cm. (both the Bruges Catalogue and the Antwerp *Trésor*), which would be much too small (the statement in Friedländer, II, p. 138, no. 127, where the dimensions are given as 31 cm. by 22.5 cm., is an obvious clerical or typographical error). Even if this difficulty could be resolved, and even if we were prepared to overlook the fact that the angle at which the body and face of the Rothschild lady are turned more closely approaches frontality than is customary in a donor's portrait (the Bruges Catalogue describes her as "vue de face"), even then we should be forced to make two further assumptions: we should have to postulate not only that the black background of the Heseltine-Rothschild portrait conceals a section of landscape (Arù and de Geradon, p. 23) but also, which appears rather improbable from the photographs, that the eyes are entirely repainted. As it is, the lady's glance is fixed on the beholder instead of being turned toward the sacred event in the central panel, and in a donor's portrait this would be so unparalleled a violation of custom and decorum that neither the vanity of the sitter nor the

painter's infatuation with the Eyckian "look out of the picture" would suffice to excuse it; Beenken himself is honest enough to admit that his reconstruction is hard to swallow (p. 34: "so schwer es auch unserer Vorstellung fällt"). Since the Heseltine-Rothschild portrait has been inaccessible for the last fifteen years and has never been X-rayed, I hesitate to pronounce "final judgment"; but on the basis of the available evidence it seems rather improbable that the panel ever formed part of the Turin donor's wing and, therefore, represents a Demoiselle de Villa.

2. Friedländer, II, p. 24. Musper as well as Arù and de Geradon consider the Turin version as somewhat later (*plus evoluée*) than the Lützschena picture while Beenken considers it as an imperfect prelude to the latter; but no one seems to doubt that it was executed as early as 1435–1438.

3. A *terminus ante quem* for the Turin version is established by the fact that the castle in the background was copied, about 1460, in the "Legend of St. Ulric" in St. Ulrich's at Augsburg (Glaser, *op. cit.*, p. 190, fig. 125).

4. The Visitation in the altarpiece at The Cloisters (see 263¹¹) is, however, derived from the Lützschena version.

5. For this quadriptych, now in the Wallraf-Richartz Museum at Cologne, see Friedländer, IV, p. 107 ff., no. 69, pl. LIV (the "Visitation"); W. Schnütgen, "Ein niederländisches Flügelbild aus dem Ende des XV. Jahrhunderts," *Zeitschrift für Christliche Kunst*, II, 1889, p. 49 ff. (with complete series of illustrations); Gabrielli, *op. cit.*, p. 433 ff., figs. 4–6. Claudio de Villa, banker at Brussels, was a son of Odonnino, the brother of Oberto's father, Franceschino. According to Gabrielli, p. 429, note, he was no longer alive in 1483; but the style of the Cologne quadriptych precludes a date before *ca.* 1480 (it is, in fact, placed in the very end of the century by most authorities). Claudio, therefore, must have acquired it shortly before his death, and this agrees with his very advanced age in the portrait which he caused to be painted into it.

Page 302

1. This miniature, showing a St. Martin on Horseback, is found in a North Italian manuscript in the Biblioteca Communale at Reggio Emilia, ms. 17 A 144, fol. 225 (Fava, *op. cit.*, p. 321, fig. 170; as to the date of the manuscript, cf. V. Ferrari, "Le Miniature dei Corali della Ghiara e di altre Chiese di Reggio Emilia," *La Bibliofilia*, XXV, 1923, p. 57 ff., fig. 7).

2. This date would be in harmony with a recent hypothesis according to which two grisailles showing the *Ecce Homo* (Friedländer, II, p. 120, no. 87 a, now owned by the E. and A. Silberman Galleries at New

York) originally formed the exterior wings of the Abegg altarpiece (*Bosch to Beckmann, A Loan Exhibition . . . April 15th to May 14th, 1950, the Buffalo Fine Arts Academy, Albright Art Gallery*, Buffalo and New York, no. 1, with illustration). Their style has always been correctly associated with that of the exterior wings of the pseudo-Cambrai altarpiece (Friedländer, *loc. cit.*, and XIV, p. 86) which is now frequently ascribed to Vrancke van der Stockt (see note 283³) and they are never dated earlier than towards 1460 (Hoogewerff, II, p. 231, fig. 205, even ascribes them, somewhat unaccountably, to a Haarlem master of the 'sixties). The Catalogue of the *Bosch to Beckmann* show itself assigns the Silberman panels to Roger van der Weyden only with the reservation that he received "some assistance from his close collaborator and pupil, Vrancke van der Stockt." However, here as in the case of the Heseltine-Rothschild portrait, this writer hesitates to accept a theory so favorable to his own views; while the wings of the Abegg altarpiece measure 103 cm. by 32 cm. each (the central panel measuring 103 cm. by 70 cm.), the dimensions of the Silberman wings are only 94 cm. by 28 cm. each, and they do not give the impression of having been cut down at the edges.

3. Cf. Friedländer, "Der Rogier-Altar aus Turin," p. 12.

Page 303

1. De Tolnay, *Le Maître de Flémalle*, p. 12

2. For Lucas Moser, see, e.g., Glaser, *op. cit.*, p. 85 ff.; Winkler, *Altdeutsche Tafelmalerei*, p. 64 ff.; J. Graf Waldburg-Wolfegg, *Lukas Moser*, Berlin, 1939. For further literature, see the very informative Catalogue of the exhibition held at Paris in 1950: *Musée de l'Orangerie, Paris; Des Maîtres de Cologne à Albert Dürer*, G. Bazin, pref., K. Martin, introd., Paris, 1950, p. 66 f., with further references. The Tiefenbronn altarpiece is now available in a popular-priced little monograph: W. Boeck, *Der Tiefenbronner Altar von Lucas Moser*, Munich, 1951. For the windows in the Besserer Chapel in Ulm Cathedral recently ascribed to Moser, see H. Wentzel, *Meisterwerke der Glasmalerei*, Berlin, 1951, p. 60 ff., figs. 199, 200, 203–205, color plate 3.

Page 304

1. Cf., e.g., Durrieu, *Les Très Riches Heures*, pls. VI, XXXIX, LXIV.

2. See p. 78. For Hans Multscher, see, e.g., Glaser, *op. cit.*, p. 102 ff.; Winkler, *Altdeutsche Tafelmalerei*, p. 74 ff.; Gerstenberg, *Hans Multscher*; G. Otto, *Hans Multscher*, Burg bei Magdeburg, 1939. Cf. *Des Maîtres de Cologne à Albert Dürer*, p. 68 f., with further references.

3. Glaser, *op. cit.*, p. 111 ff. Cf. Thieme-Becker, XXXVII, p. 330 f.

4. A. Elsen, "Gabriel Angler, der Meister der Pollinger Tafeln," *Pantheon*, XXVII–XXVIII, 1941, p. 219 ff. In my opinion, the Netherlandish, especially Flémallesque, influence upon this interesting master decidedly predominates over that of Pisanello as stressed by Elsen.

5. Pächt, *Oesterreichische Tafelmalerei*, figs. 11–14. The altarpiece after which the master is named was ordered by Albrecht II, King of Germany in 1438 but never crowned because he died on October 27, 1439. See Thieme-Becker, XXXVII, p. 9.

6. For Conrad Laib, see, e.g., Glaser, *op. cit.*, p. 124 ff.; Winkler, *Altdeutsche Tafelmalerei*, p. 80; Pächt, *Oesterreichische Tafelmalerei*, figs. 33–36 (under "D. Pfenning"); L. Baldass, *Conrad Laib und die beiden Rueland Frueauf*.

7. The inscription on the Vienna Calvary (Glaser, *op. cit.*, p. 124, fig. 82; Pächt, *Oesterreichische Tafelmalerei*, fig. 34) reads as follows: "d. PFENNING 1449 ALS ICH CHUN." The first part, no longer accepted as a signature, may refer to the fact that the picture was presented in lieu of a *Pfennig*, viz., a fee or tax (cf. Grimm, *Deutsches Wörterbuch*, VII, col. 1668), the "d" standing either for *denarius* or for *dedit*. Baldass, *Conrad Laib*, p. 65, doubts the identity of Conrad Laib's "Als ich chun" with Jan van Eyck's "Als ich chan" on the ground that the *chun* could not be interpreted as a form of the verb *können*; he believes it to be the first syllable of the painter's name Conrad (archaically spelled *Chunrat*) so that "Als ich, Chun[rat] . . ." would be the fragmentary beginning of a long sentence the meaning of which remains obscure. However, *chun* (*kun, kunne, künn*) is a perfectly legitimate dubitative subjunctive (cf. Grimm, *op. cit.*, V, col. 1720, with quotation of Luther's "darumb *künnestu* nicht so gewis sein," "therefore thou mayest not be able to know for sure"). "Als ich chun," then, expresses, in even more modest fashion, precisely what Jan van Eyck expressed in his famous motto: "As best I can."

Page 305

1. Pächt, *Oesterreichische Tafelmalerei*, fig. 12. In another "Annunciation" by the Master of the Albrecht Altarpiece (Klosterneuburg, Stiftsgalerie, Pächt, fig. 13) the Angel is clad in an alb as in the Mérode altarpiece but equipped with peacock's wings as in the Friedsam "Annunciation."

2. Glaser, *op. cit.*, p. 113, fig. 76. The motif of a round object protruding from a shelf seen from below — a motif which can be traced back to the "Pythagoras," (or, perhaps more probably, Boetius) in the

Portail Royal of Chartres Cathedral — does not occur in any extant work by either the Master of Flémalle or Jan van Eyck; but there is reason to ascribe its vogue in fifteenth-century painting to the latter rather than the former. In the first place, it is found in the Madonna at Covarrubias in Spain (see note 203⁵) which, whether the reflection of a lost original or a mere variation on the "Ince Hall Madonna," is purely Eyckian in character. In the second place, it is prominently featured, not only in the wings of the Aix "Annunciation" (see p. 307) but also in the Naples "St. Jerome" by Colantonio whence it found its way into the famous London "St. Jerome" by Antonello da Messina. And since Colantonio, active at Naples, may be presumed to have known Jan van Eyck's "St. Jerome" in the collection of Alphonso V (see J. Lauts, "Antonello da Messina," *Jahrbuch der Kunsthistorischen Sammlungen in Wien*, new ser., VII, 1933, p. 15 ff.; ——, *Antonello da Messina*, 2nd ed., Vienna, 1940, pp. 11 f., 33), the deal box would seem to have figured among the foreshortened objects so much admired by Fazio in this lost composition (see note 2⁷). In Italy, it does not seem to occur before the fourth decade of the fifteenth century, and then in works with Northern connotations: in an Avicenna manuscript in the Biblioteca Universitaria at Bologna, ms. 2197 (Toesca, *La Pittura e la miniatura nella Lombardia*, p. 490, fig. 392); in a fresco, dated 1435, in S. Caterina at Galatina in Apulia (van Marle, *op. cit.*, IX, p. 576, fig. 360); in the "Annunciation" by Justus of Ravensburg in the Convent of S. Maria di Castello at Genoa, dated 1451 (A. Schmarsow, *Die oberrheinische Malerei und ihre Nachbarn*, Kgl. Sächsische Gesellschaft der Wissenschaften, *Abhandlungen der Philologisch-Historischen Klasse*, Leipzig, XXII, 1904, no. 2, p. 94, pl. I); and in the "St. Gregory" in the Eremitani Chapel at Padua by Niccolò Pizzolo, datable between 1448 and 1453 (G. Fiocco, *L'Arte di Andrea Mantegna*, Bologna, 1927, p. 146). The deal box in worm's-eye perspective also appears in a most interesting South German or Austrian *trompe l'oeuil* picture (Mr. Mortimer S. Brandt at New York) which may be called the earliest independent still life although it probably served a definite practical purpose (*Orangerie des Tuileries, La Nature Morte*, no. 5, pl. III).

3. For Conrad Witz, see, e.g., Glaser, *op. cit.*, pp. 95 ff., 127 ff.; Winkler, *Altdeutsche Tafelmalerei*, p. 69 ff.; Wendland, *op. cit.*; Ueberwasser, *Konrad Witz*. Cf. *Des Maîtres de Cologne à Albert Dürer*, p. 74 ff., with further references.

4. Mrs. Jane Langton calls my attention to the fact that Conrad Witz was the first to observe, in his "St. Christopher" (Basel, Oeffentliche Kunstsammlung, Glaser, *op. cit.*, p. 134, fig. 89) and "Miraculous Draft

of Fishes" (Geneva, Museum, Glaser, p. 135, fig. 90), the optical law according to which objects immersed in water are visible only as long as the angle of incidence does not exceed the critical limit (*ca.* 48.5 degrees) beyond which total reflection takes the place of partial refraction.

5. This rather self-evident connection has recently been stressed by Hulin de Loo, "Traces de Hubrecht van Eyck."

6. Cf. O. Fischer, "Die künstlerische Herkunft des Konrad Witz," *Pantheon*, XXIX, 1942, p. 99 ff.

Page 306

1. For this picture, see note 194².

2. For Stephen Lochner, see, e.g., Glaser, *op. cit.*, p. 146 ff.; Winkler, *Altdeutsche Tafelmalerei*, p. 61 ff.; O. H. Förster, *Stephan Lochner*, Cologne, 1938; H. Linfert, *Alt-Kölner Meister*, Munich, 1941, *passim*. Cf. *Des Maîtres de Cologne à Albert Dürer*, p. 39 f., with further references.

3. For the Master of the Darmstadt Passion, see, e.g., Glaser, *op. cit.*, p. 138 ff. Cf. *Des Maîtres de Cologne à Albert Dürer*, p. 43, and Thieme-Becker, XXXVII, p. 75 f., with further references.

Page 307

1. For the intrusion of Flémallesque and Rogerian influences upon the later work of the Bedford Master, see notes 74³, 259¹; for his use of the landscape in Jan van Eyck's "Rolin Madonna" in the "Hours of Jean Dunois (see note 55⁵)," Weale-Brockwell, p. 92, and Pächt, "Jean Fouquet: A Study of His Style," p. 88.

2. For the Master of Aix, see, e.g., Lemoisne, *op. cit.*, pl. 47; Sterling, *Les Primitifs*, p. 96 f., and note 100; ——, *Les Peintres*, pls. 78–82; Ring, *A Century*, Cat. no. 91, pls. 43–52, color plate facing p. 28; *Catalogue of the D. G. van Beuningen Collection*, no. 19, pls. 17–21; Thieme-Becker, XXXVII, p. 342 ff. The similarity between his style and that of Colantonio (cf. note 305²) is so strong that it has been proposed to identify the two masters (L. Demonts, "Le Maître de l'Annonciation d'Aix; des van Eyck à Antonello de Messine," *Revue de l'Art Ancien et Moderne*, LIII, 1928, p. 257 ff.; ——, "Le Maître de l'Annonciation d'Aix et Colantonio," *ibidem*, LXVI, 1934, p. 131 ff.; ——, "Le Maître de l'Annonciation d'Aix et Colantonio," *Mélanges Hulin de Loo*, Brussels and Paris, 1931, p. 123 ff.; C. Arù, "Colantonio ovvero il 'Maestro della Annunciazione di Aix,'" *Dedalo*, XI, 1931, p. 1121 ff.). Like most scholars, I cannot accept this identification of the two artists but agree with Demonts in insisting on the importance of the Eyckian component in their style.

3. Sterling, *Les Primitifs*, p. 96.

4. See Robb, *op cit.*, p. 517 f., with illustration of the "Annunciation" in the "Hours of Louis of Savoy" in the Bibliothèque Nationale, ms. lat. 9473, fol. 17 (fig. 37). For the Prado "Annunciation" erroneously ascribed to the Master of Flémalle, see note 175 [13].

5. Meiss in *Burlington Magazine*, LXXXIX, 1947, p. 286. For Eyckian parallels, see the Musical Angels in the Ghent altarpiece, the donor's portrait in the Ypres altarpiece and, quite particularly, the St. Donatian in the "Madonna van der Paele."

Page 308

1. For the Master of 1456, see, e.g., Lemoisne, *op. cit.*, pls. 62, 63; Sterling, *Les Primitifs*, p. 86 f.; Ring, *A Century*, Cat. no. 143, pl. 91; Thieme-Becker, XXXVII, p. 366 f. As in the case of Colantonio and the Master of Aix, the similarity between the Master of 1456 and the Portugese painter, Nuño Gonçalvez, would seem to be based on common Flemish sources and does not justify their identification with one another.

2. L. Grodecki, *op. cit.*

3. Pächt, "Jean Fouquet: A Study of His Style" p. 100.

4. Rogerian influence in France is first exemplified by an altarpiece in the Metropolitan Museum, dated 1451 (Sterling, *Les Peintres*, pl. 131; Ring, *A Century*, Cat. no. 155, with further references).

5. Cf. Glaser, *op. cit.*, pp. 157 ff., 186 ff. For one of the earliest and most enthusiastic Rogerians, Friedrich Herlin, see now *Des Maîtres de Cologne à Dürer*, p. 34.

6. See Post, *A History of Spanish Painting*, especially vols. IV–VII.

7. For Petrus Christus, see, apart from the literature referred to in the following notes, Friedländer, I, p. 142 ff., 169 ff., pls. XLIX–LXX; Schöne, pp. 26 f., 80–84; ———, *Dieric Bouts und seine Schule*, p. 55 ff. (complete chronology according to the *via moderna*); van Puyvelde, *Primitives*, p. 27, pls. 48–55.

Page 309

1. Friedländer, I, p. 148, pls. LIII–LV; van Puyvelde, *Primitives*, pl. 50 (only the "Nativity"). As evidenced by its perspective, the panel showing the Annunciation and the Nativity was the left wing of a triptych the right wing of which was formed by the "Last Judgment." The central panel may be presumed to have shown the Calvary or, possibly, a Deposition or Lamentation.

2. A. C. Bough, ed., *A Literary History of England*, New York and London, 1948, p. 102.

3. Friedländer, I, p. 156 ff., pl. LXIX; Schöne, pp. 82, 84; van Puyvelde, *Primitives*, pl. 54 (landscape detail).

4. Friedländer, I, p. 151, pl. LX; Schöne, p. 83; Wehle and Salinger, *op. cit.*, p. 19 f.

5. Schöne, p. 14, says that the figures are "arrayed one beside the other in frieze-like fashion." This is correct in comparison with works of Dirc Bouts, Hugo van der Goes or Geertgen tot Sint Jans; but in comparison with its chief prototype, the great "Descent from the Cross" by Roger van der Weyden, the Brussels "Lamentation" is definitely "spatial."

Page 310

1. De Tolnay, "Flemish Paintings in the National Gallery," p. 181.

2. *Fra Luca Pacioli, Divina Proportione*, C. Winterberg, ed. (Quellenschriften für Kunstgeschichte, new ser., II), Vienna, 1889, p. 160.

3. See G. J. Kern, *Die Grundzüge der linear-perspektivischen Darstellung in der Kunst der Gebrüder van Eyck und ihrer Schule*, Leipzig, 1904, p. 18 ff.; ———, "Perspektive und Bildarchitektur bei Jan van Eyck," *Repertorium für Kunstwissenschaft*, XXXV, 1912, p. 27 ff.; Panofsky, "Die Perspektive als symbolische Form," p. 318 f., note 53. The principle was accurately applied from as early as *ca.* 1450.

4. See p. 289 f.

5. Friedländer, I, p. 145 f., pl. L, and XIV, p. 79; Wehle and Salinger, *op. cit.*, p. 17 ff. The halo, suspected by Friedländer, is old enough to have withstood the recent cleanings — which, however, does not prove that it dates back to 1446. Should it be authentic (which seems improbable to me for stylistic reasons) the sitter may have been cast in the role of St. Bruno, the founder of the Order, who was venerated as a saint long before he received his place in the liturgy in 1514 and was formally canonized in 1623 (see *Acta Sanctorum*, October, vol. III, p. 694 ff.). If not, it may have been added on either of these two occasions in order to transform a *bona fide* portrait into an image of the Founder (the two other Carthusian saints, St. Hugh of Lincoln and St. Hugo of Grenoble, would hardly have been of sufficient interest in Flanders). Traditionally, the sitter is identified with the famous Carthusian theologian, Dionysius of Louvain (died 1471), and Professor Meyer Schapiro was good enough to inform me that this hypothesis would be in keeping with the eye-deceiving fly which has settled on the parapet: in his *De venustate mundi* Dionysius of Louvain describes the beauty of the natural universe as a hierarchy which starts with the very insects. On the other hand, a fly is often seen feasting on a death's head (as in Joos van Cleve's "St. Jerome" in the Princeton Art Museum, a Crucifixion ascribed to Vecchietta owned by Mrs. Dan Fellows Platt and now on loan in the Princeton Art Museum, or Guercino's

famous "*Et in Arcadia Ego*" in the Galleria Corsini at Rome) so that it may play the role of an inconspicuous *memento mori*. The illusionistic use of such an insect — recurring in Carlo Crivelli and Dürer and even attributed to Giotto by Vasari — can be traced back to classical antiquity: in his Narcissus chapter (*Imagines*, I, 22 [23]) Philostratus delightfully describes how the painter, "enamored of verisimilitude," had depicted a bee sitting on a flower in such a manner that it was impossible to decide whether "an actual bee had been deceived by the picture or a painted bee deceived the beholder."

6. Friedländer, I, p. 145, pl. XLIX.

7. The same is true of the much-debated silverpoint "Portrait of a Falconer" in the Städelsches Kunstinstitut at Frankfort which would seem to reflect another portrait by Petrus Christus (Friedländer, I, p. 124, pl. XLVIII). This attribution of the drawing — or, rather, its original (Panofsky, "Die Perspektive als symbolische Form," p. 318 f., note 53; "The Friedsam Annunciation," p. 438, note 14) — was accepted (without quotation) by Beenken, *Hubert and Jan*, p. 52, note. Winkler's recent hypothesis according to which the drawing reflects a lost original by Roger van der Weyden ("Rogier van der Weyden's Early Portraits") is hardly acceptable; so far as we know, Roger never showed the sitter within a perspective interior. An apparently original drawing by Petrus Christus ("Portrait of a Lady," then in the W. Gay Collection at Paris) was published by Popham, *Drawings of the Early Flemish School*, pl. 10), and I am also inclined to ascribe to him the "Portrait of a Lady" in the Boymans Museum at Rotterdam, formerly attributed to Jan van Eyck, which shows a remarkable similarity with the Grymestone portrait (Friedländer, I, p. 127; de Tolnay, *Le Maître de Flémalle*, p. 74, no. 5, fig. 147). Mr. C. T. Eisler calls my attention to the fact that another apocryphal van Eyck drawing, the "Two Female Heads" preserved in the Galleria Sabauda at Turin (see note 200[3]), may well be a copy after Petrus Christus, the heads resembling those in the "Nativity" formerly in the Goldman Collection (Friedländer, p. 128; de Tolnay, *Le Maître de Flémalle*, p. 74, no. 6; phot. Anderson, no. 9803).

Page 311

1. O. Pächt, "Die Datierung der Brüsseler Beweinung des Petrus Christus," *Belvedere*, IX/X, 1926, p. 155 ff.; Schöne, pp. 14, 26; ———, *Dieric Bouts und seine Schule*, p. 56; de Tolnay, "Flemish Paintings in the National Gallery of Art," p. 179. Some doubt of this reinterpretation of the facts, however, has been expressed by M. Davies, "National Gallery Notes, II; Netherlandish Primitives: Petrus Christus," *Burling-ton Magazine*, LXX, 1937, p. 138 ff. See also Panofsky, "A Letter to St. Jerome."

2. De Tolnay, *Le Maître de Flémalle*.

3. Frankfort, Städelsches Kunstinstitut. Friedländer, I, p. 148 f., pl. LVI.

4. Formerly in the Fritz Thyssen Collection, Mülheim a. d. Ruhr. Friedländer, I, p. 154, pl. LXV, and XIV, p. 79. As to the date, I agree with Miss Ring, who first published the picture, in feeling that it was painted about the time when Petrus Christus joined the Confraternity of the Dry Tree, which happened shortly before 1462. The apparently paradoxical connection of the Virgin Mary with a dry tree is founded on Ezekiel XVII, 24: "And all the trees of the field shall know that I the Lord have brought down the high tree, have exalted the low tree, have dried up the green tree and *have made the dry tree flourish*." This He did, as graphically explained by Guillaume de Deguileville, by grafting a branch of the Tree of Life onto the dry Tree of Knowledge, that is to say, by causing the Virgin Mary to be conceived by St. Anne (see Ludwig, *op. cit.*, and Hartt, *op. cit.*).

5. Friedländer, I, p. 152, pls. LXII–LXIV; van Puyvelde, *Primitives*, pl. 48. For the late dating of the picture, see Schöne, *Dieric Bouts und seine Schule*, p. 56; for its real date, Scholtens, *op. cit.*, and above, p. 188. It received its conventional name from the fact that it was acquired, in 1888, from the collection of the Marquis of Exeter.

6. Both the "Annunciation" and the "Nativity" bear a curious and hardly accidental resemblance to the two Rhenish panels in the Metropolitan Museum referred to in note 127[4], the "Nativity" even in that the shed is combined with a rock formation which must be interpreted as a residue of the cave seen in the provincial Nativities according to St. Bridget (see p. 125 f.).

7. Friedländer, I, p. 150 f., pl. LIX.

8. Friedländer, XIV, p. 70, Nachtrag, pl. II; van Puyvelde, *Primitives*, pl. 51; de Tolnay, "Flemish Paintings in the National Gallery," p. 179 ff. Mr. Eisler, already mentioned, has expressed doubts as to the authenticity of the Washington "Nativity" which have not entirely convinced me. I am, however, certain that the following pictures should be eliminated from Petrus Christus' work: (1) a "Portrait of a Lady," now in the Robert Lehman Collection at New York (Friedländer, I, p. 158, pl. LXX) which has no appreciable relation to Petrus Christus' style and must be dated, by reason of the costume, *ca.* 1470–1480 rather than *ca.* 1450; (2) the "Portrait of a Young Man" in the County Museum at Los Angeles (*Art News*, XLIII, 1944, December 15, cover); (3) two altar wings, showing St. John the Baptist and St.

Catherine, in the Kaiser Friedrich Museum at Berlin (Friedländer, I, p. 150); (4) the "Lamentation" formerly in the Schloss Collection at Paris (Friedländer, I, p. 152, pl. LXI) and now in the Louvre (E. Michel, *L'Ecole Flamande . . . au Musée du Louvre*, p. 41, pl. V), which, even after a thorough cleaning, remains unconvincing and may well have been produced by a Flemish-trained Italian rather than a Netherlander (see particularly the pure profile view of the figure on the extreme right); (5) the "Death of the Virgin" recently acquired from Knoedler's by the Putnam Foundation in San Diego, Cal. (Friedländer, "The Death of the Virgin by Petrus Christus"; *Flemish Primitives, An Exhibition Organized by the Belgian Government*, p. 22, color plate). The enormous picture (67⅞ by 54½ inches, a somewhat suspicious fact in itself) is not in very good condition; for a reproduction before restoration, see Venturi, *Storia dell'Arte Italiana*, VII, p. 172, fig. 100. But even so it is, in my opinion, unacceptable as a work of Petrus Christus; discovered in Sicily, it may well have been produced by one of those South Italian or Hispano-Italian masters who painted in the Flemish manner on too large a scale.

9. De Tolnay, "Flemish Paintings in the National Gallery." That the St. Joseph should be inspired by the Prophets in the Ghent altarpiece seems less convincing.

Page 312

1. According to de Tolnay, *ibidem*, p. 180, the last archevault relief represents "Cain Founding His Race in the Land of Nod" (Genesis IV, 16). However, the elderly couple with spade and distaff, respectively, are manifestly identical with the First Parents seen in the second relief. Since Adam, supporting himself on the spade as on a crutch, is characterized as very old and weak, the young man kneeling before him must be his third son, Seth, about to set out in quest of the health-giving branch of the Tree of Life. And since this branch was to grow into the tree from which the Cross of Christ was made, the scene forms both an appropriate ending of the Genesis cycle and an appropriate prelude to the main subject of the picture.

2. Cf. M. Schapiro, "Cain's Jaw-Bone That Did the First Murder," *Art Bulletin*, XXIV, 1942, p. 205 ff., especially p. 208.

3. See p. 188 ff. De Tolnay, while insisting that Petrus Christus did not arrive at Bruges until 1444, "three years after van Eyck's death" ("Flemish Paintings in the National Gallery," p. 179), yet admits the possibility that he completed the "Rothschild Madonna" (*Le Maître de Flémalle*, p. 33) which was completed at Bruges some time before September 3, 1443.

4. Friedländer, I, p. 155, pl. LXVI; Weale-Brockwell, p. 67 ff., pl. IX (as Hubert van Eyck).

5. Cf. note 192 [1].

Page 313

1. Friedländer, I, p. 147 f., pl. LII, and XIV, p. 79; A. L. Mayer, "Die Ausstellung der Sammlung 'Schloss Rohoncz' in der Neuen Pinakothek, München," *Pantheon*, VI, 1930, p. 297 ff. In van Puyvelde, *Primitives*, p. 27, this rather unattractive picture — closely dependent upon the Frankfort Madonna by the Master of Flémalle — is listed twice, once under its correct address, and once as being in the collection of Count Matuschka-Greiffenklau whence it was sold to Mr. Thyssen.

2. Friedländer, I, p. 146 f., pl. LI; Schöne, p. 81; van Puyvelde, *Primitives*, pl. 49. I agree with Friedländer in rejecting Weale's hypothesis (revived in *Art News*, XLIII, 1944, June, p. 12) according to which the picture represents the legend of St. Eloy and St. Godeberta of Noyon whom he affianced to Christ in the presence of King Clothaire II. The event described in the *Life of St. Eloy* (*Acta Sanctorum*, April, II, p. 32 f.) took place in the Royal Palace and consisted of St. Eloy's solemnly placing his own episcopal ring upon the finger of the maiden whose matrimonial prospects were being discussed by her parents and their liege lord, the King. Petrus Christus, however, stages the scene in a shop and shows us, instead of a Bishop *in pontificalibus*, an honest goldsmith weighing two rings for a young couple, the young man tenderly embracing the shoulder of the girl (which in itself precludes his identification with King Clothaire). The idea of a perfectly normal marriage is further emphasized by the bridal girdle conspicuously placed upon the counter and significantly contrasted with the image in the mirror which reflects two elegant young bachelors idling along with their falcon, time-honored symbol of the leisure class. St. Eloy, then, is here depicted, not as a champion of virginity but, on the contrary, as a protector of holy matrimony, and much can be said for the assumption that the picture was ordered by a goldsmiths' guild which had more reason to advertise its social usefulness than to propagandize asceticism.

3. Friedländer, I, p. 156, pl. LXVIII; and XIV, p. 80.

4. The attribution of this painting, which I had no occasion to see, is somewhat doubtful; see Baldass, *Eyck*, p. 288, no. 64.

5. Friedländer, I, .p. 155 f., pl. LXVII; van Puyvelde, *Primitives*, pl. 55; Davies, *National Gallery Catalogues, Early Netherlandish School*, p. 21 ff. Since the margins are covered with a "band of new

gold which may slightly encroach upon the original painted surface," it is difficult to decide to what extent the picture, which seems to be a fragment of either a triptych (not diptych) wing or a *Sacra Conversazione*, has been cut down.

6. *Paintings and Sculpture from the Kress Collection*, no. 75; Friedländer, "The Death of the Virgin by Petrus Christus"; van Puyvelde, *Primitives*, pl. 53 (the male donor only). See note 187[2].

7. Friedländer, I, p. 150, pl. LVIII; Schöne, p. 80; van Puyvelde, *Primitives*, pl. 52. That the date assigned to the panel by Schöne, p. 27 ("about 1446") is more than twenty years too early is evidenced by the dress which has its closest parallel in portraits such as Memlinc's "Maria Baroncelli-Portinari" in the Metropolitan Museum (Friedländer, VI, pl. XXXVIII; Wehle and Salinger, *op. cit.*, p. 67 f.), datable 1470–1471, and by the curious cap which recurs in almost identical form in the Paris "Froissart," Bibliothèque Nationale, ms. fr. 2645, fol. 321 v. (Durrieu, *La Miniature flamande*, pl. XLIX). The identification of the sitter with Lady Talbot, first wife of Sir Edward Grymestone, is without foundation. If we wish to indulge in speculation, we may rather identify the Berlin panel — originally owned by Eduard Solly who acquired most of his treasures in Italy — with the portrait of a "French lady by Pietro Cresti da Bruggia" listed in the inventory of Lorenzo de' Medici of 1492 (Friedländer, I, p. 144). According to Waagen, the lost frame bore the painter's signature, which would explain the fact that the inventory quotes him by name.

8. See, e.g., Schöne, p. 26; de Tolnay, "Flemish Paintings in the National Gallery," p. 179.

9. Hoogewerff, II, p. 14.

10. See p. 103 f.

Page 314

1. See p. 242 f.

2. For Dirc Bouts, see, apart from Friedländer, III, pp. 11 ff., 105 ff., pls. I–XLV, the elaborate monograph by Schöne, *Dieric Bouts und seine Schule*, with full bibliography up to 1937. Cf. also L. Baldass, "Dirk Bouts, seine Werkstatt und Schule," *Pantheon*, XXV, 1940, p. 93 ff.

3. Van Mander, *op. cit.*, fol. 206 v.

4. See note 291[4]. Though the identity of this "Dieric Aelbrechts" with Dirc Bouts is admittedly conjectural it recommends itself also by the fact that the latter, after having called his first son after himself, called his second son "Aelbrecht."

5. Friedländer, III, 105, no. 1, pls. I–IV; Schöne, p. 87 ("Annunciation"); ———, *Dieric Bouts und seine Schule*, p. 75 ff., pls. 1–5. For a comparison between the "Nativity" and the Washington "Nativity"

by Petrus Christus, see de Tolnay, "Flemish Paintings in the National Gallery," p. 179.

Page 315

1. De Tolnay, "Flemish Paintings in the National Gallery."

2. As pointed out by Davies, *National Gallery Catalogues, Early Netherlandish School*, p. 11, another archevault relief in the "Granadà-Miraflores" altarpiece was employed by Dirc Bouts for his "Lamentation" in the National Gallery at London (fig. 420, note 316[1]).

3. Friedländer, XIV, p. 90; Schöne, pp. 88, 89; ———, *Dieric Bouts und seine Schule*, p. 79 ff., pls. 8–14. Friedländer, III, p. 105, no. 2, pls. V, VI, reproduces only the replica in the Colegio del Patriarca at Valencia.

4. Cf. also the "Resurrection," now generally attributed to one of Dirc Bouts' *Doppelgängers*, in the Pinakothek at Munich (Friedländer, III, p. 109, no. 20, pl. XXIX; Schöne, *Dieric Bouts und seine Schule*, p. 163, pl. 56).

Page 316

1. Friedländer, III, p. 105, no. 3, pl. VII; Schöne, *Dieric Bouts und seine Schule*, p. 82 ff., pl. 15. The picture's derivation from the sixth archevault relief in the central panel of the "Granada-Miraflores" altarpiece was observed by Davies, *National Gallery Catalogues, Early Netherlandish School*, p. 11.

2. Friedländer, III, p. 105, no. 4, pl. VIII; Schöne, *Dieric Bouts und seine Schule*, p. 121 f., pl. 44 a (as by Dirc Bouts the Younger); Michel, *L'Ecole Flamande . . . au Musée du Louvre*, p. 46 f., pls. XI, XII. The fame of the composition is attested, not only by the numerous replicas (Schöne, pls. 43, 44 b) but also by the fact that an Italo-Flemish picture in the Naples Museum (phot. Anderson, no. 5598) shows it fused with the Rogerian *Pietà* type exemplified by our figs. 320 and 390.

3. See notes 296[2, 3, 6].

4. The framing system of the Granada triptych is transmitted only through the replica at Valencia.

5. Friedländer, III, p. 108, no. 12, pl. XIX; Schöne, p. 91; ———, *Dieric Bouts und seine Schule*, p. 87 f., pl. 18; van Puyvelde, *Primitives*, pl. 56; Davies, *National Gallery Catalogues, Early Netherlandish School*, p. 12. When Davies objects to the acceptance of Dirc Bouts' London panel as the "earliest example of a portrait in a room with a view out of the window" on the grounds that Petrus Christus' donor's portrait, also preserved in the National Gallery (see p. 313), "is at least very nearly the same thing," it should be borne in mind that the latter picture is in all proba-

bility a fragment and that the original spatial context cannot be ascertained with sufficient accuracy. The London portrait of 1462 has been associated in style and period with the "Portrait of a Young Man" in silver point which has passed from the Oppenheimer and Rosenthal Collections to the Tryon Art Gallery of Smith College at Northampton, Mass. (Popham, *Drawings of the Early Flemish School*, pl. 17; Schöne, *Dieric Bouts und seine Schule*, p. 88, pl. 19; A. P. A. Vorenkamp, "A Famous Drawing by Bouts; Northampton," *Art News*, XXXVII, 1939, June 3, p. 9; A. Mongan [ed.], *One Hundred Master Drawings*, Cambridge, Mass., 1949, p. 14). This fine drawing (our fig. 423) has been unanimously accepted as an authentic work of Dirc Bouts. But while it is surely an original, and not a copy, it must be ascribed, I think, to one of Bouts' followers. In the first place, the hairdress and the excessively high cap conform to the fashion of the 'seventies and not of the 'sixties. In the second place, the style (see particularly the contours of the shoulders, the folds of the sleeve and the dent in the cap) show a sharp, discontinuous angularity utterly foreign to Dirc Bouts. In the third place, the drawing is manifestly a self-portrait, marked by that curiously fishy stare which results from the fact that the irises and pupils were drawn in *ex post facto* as is the case in the well-known self-portraits in silver point of Albrecht Dürer and his father (referred to in note 198 [2]). From these it differs only in that the figure is turned to the left, with the result that the artist's right arm and hand (appearing, of course, as his left in the drawing) could be included in the picture while the other forearm is concealed; the very fingers give the impression of holding a pencil. Since Dirc Bouts was already an elderly man in 1462, the Northampton drawing could, therefore, not be attributed to him even if its style were compatible with that of the London portrait.

6. See p. 290.

Page 317

1. Friedländer, III, p. 108, no. 14, pl. XXI; Schöne, p. 96; ———, *Dieric Bouts und seine Schule*, p. 96 f., pl. 28; Davies, *National Gallery Catalogues, Early Netherlandish School*, p. 12. See note 296 [2].

2. Friedländer, III, p. 107, no. 9 a (with illustration of a replica in the Bargello on pl. XVI); Schöne, p. 90; ———, *Dieric Bouts und seine Schule*, p. 77 f., pl. 7; Wehle and Salinger, *op. cit.*, p. 44 f. Cf. note 296 [6]. Schöne, while rightly sensing the picture's derivation from Roger van der Weyden, dates it as early as *ca.* 1447. This is hardly acceptable since Roger himself did not produce Madonnas in half-length before 1450 and since the Rogerian model employed by Dirc

Bouts, the Houston Madonna, presupposes the *"Notre-Dame de Grâces"* of Cambrai which did not become popular in the Netherlands until 1454 and probably did not come to Roger's attention until between 1455 and 1459 (see note 297 [4]; Schöne himself, p. 26, correctly considers the Houston Madonna as one of Roger's last works). In my opinion the New York Madonna antedates the London Madonna, which may be dated about 1465, by only a few years.

3. This is also true of several Madonnas, not attributable to Dirc Bouts himself, which have been mentioned in notes 296 [2, 3] (one in the Metropolitan Museum, the second now in the collection of Mrs. Jesse Straus at New York, the third in the Städelsches Kunstinstitut at Frankfort), as well as of a rather fine Madonna owned by Baron van der Elst (Friedländer, XIV, p. 90, Nachtrag, pl. XIV) which Schöne, *Dieric Bouts und seine Schule*, p. 185, pl. 84 b, ascribes to the Master of the Pearl of Brabant (according to him identical with Dirc Bouts the Younger). This picture is erroneously reproduced as being the Madonna owned by Mrs. Jesse Straus (see note 296 [3]) in *Flemish Primitives, An Exhibition Organized by the Belgian Government*, p. 34.

4. Friedländer, III, p. 109, no. 22, pl. XXXII; Schöne, p. 97; ———, *Dieric Bouts und seine Schule*, p. 106 f., pl. 32. The composition is based on John I, 28 f. and was, later on, remodeled into a more literal illustration of this passage by the transformation of the Baptist into a preacher and the addition of a group of disciples (Berlin, Kaiser Friedrich Museum, Friedländer, III, p. 123 f., no. 82, pl. LXVIII). The fact that the disciples differ in style from the two principal figures would seem to eliminate the possibility that this picture, a school piece, reflects an original of which the Wittelsbach picture would be an abridged variation.

5. See p. 322.

Page 318

1. Louvain, St. Peter's. Friedländer, III, p. 107, no. 8, pls. XIII, XIV; Schöne, *Dieric Bouts und seine Schule*, p. 84 ff., pls. 16, 17; van Puyvelde, *Primitives*, pls. 58, 59.

2. Friedländer, III, p. 108 f., no. 18, pls. XXIV–XXVIII; Schöne, pp. 92–95; ———, *Dieric Bouts und seine Schule*, p. 88 ff., pls. 20–27; van Puyvelde, *Primitives*, pls. 60, 61. According to documents this work was executed between 1464 and 1467. Our fig. 427 shows the arrangement decided upon by the Louvain authorities when the triptych was reassembled in St. Peter's after the first World War and approved by Schöne, *Dieric Bouts und seine Schule*, p. 91. It should be noted, however, that the original distribution of the

lateral panels is not documented and that other scholars, notably Friedländer, III, p. 22, have proposed a different one (left wing: Abraham and Melchizedek above the Passover; right wing: the Gathering of Manna above Elijah in the Desert). Neither do we know whether the two scenes stipulated for the exterior (one being the "Shewbreads" according to Leviticus XXIV, 5–9, the other unspecified) were ever executed. For the identity of the four characters in contemporary costume — probably the Masters of the Brotherhood of the Sacrament, for which the altarpiece was executed, rather than Dirc Bouts and his sons — see J. G. van Gelder, "Het zoogenaamde Portret van Dirc Bouts op 'Het Werc van den Heilichen Sacrament,'" *Oud Holland*, LXVI, 1951, p. 51 ff. For the technique and condition of the work, see Coremans, Gettens and Thissen, "La Technique des 'Primitifs Flamands,'" II.

3. For these two panels, now in the Musée Royal at Brussels, see Friedländer, III, p. 111, no. 33, pls. XLII–XLV; Schöne, pp. 98–100; ———, *Dieric Bouts und seine Schule*, p. 108 ff., pls. 34–39; van Puyvelde, *Primitives*, pl. 53. Cf. also van de Waal, *op. cit.*, II, p. 126, note 263, and Lederle-Grieger, *op. cit.*, pp. 25, 58. The commission, given in 1468, called for four pictures representing two subjects (precisely as in Roger's famous series in the Town Hall of Brussels). However, when Dirc Bouts died in 1475 only the first pair, illustrating the Justice of Emperor Otto III, was approximately completed, and only one of these two panels was entirely finished. The "Execution of the Innocent Count" (Friedländer, pl. XLII) was evidently finished by a rather clumsy follower who supplied the whole foreground, including the beheaded body of the Count and the two wooden bystanders on the extreme right and left. According to van Gelder (quoted in the preceding note) the Augustinian Canon in the "Ordeal of the Countess" bears the features of Dr. Janne van Haeght, charged with the supervision of the program. Dirc Bouts' latest style is further represented by his "Portrait of a Man" in the Metropolitan Museum (Friedländer, III, p. 111, no. 32, pl. XLI; Schöne, *Dieric Bouts und seine Schule*, p. 107 f., pl. 33; Wehle and Salinger, *op. cit.*, p. 47 f.). As already indicated in note 294[16], this beautiful work should not be listed as "half of a diptych" but as a fragment from a larger composition. This assumption, based on iconographical considerations, was confirmed by a technical investigation kindly undertaken, at my suggestion, by Mr. Murray Pease. Mr. Pease was kind enough to inform me that the wood on all four edges is not original but consists of skilfully attached pieces; that the X-ray shows a "wide, contraction-type crackle in the background area which is not characteristic of

paintings of this type and is not found elsewhere in this painting"; and that there is visible in the X-ray "a thin, straight line, running slightly off the vertical, somewhat to the right of the face, which may be part of the original background."

4. The "Paradise" is in the Musée des Beaux-Arts at Lille: Friedländer, III, p. 111, no. 30, pl. XXXIX; Schöne, p. 101; ———, *Dieric Bouts und seine Schule*, p. 98 ff., pl. 29. The "Hell" is in the Louvre: Friedländer, III, p. 111, no. 31, pl. XL; Schöne, *Dieric Bouts und seine Schule*, p. 98 ff., pl. 30; van Puyvelde, *Primitives*, pl. 57 (color); Michel, *L'Ecole Flamande . . . au Musée du Louvre*, p. 46 f., pl. XIV. A rough copy of the whole "Last Judgment" is illustrated in Schöne, *Dieric Bouts und seine Schule*, pl. 45 b.

5. Cf. P. du Colombier, "Essai sur les personnages de Claude Lorrain," *Bulletin de la Société Poussin*, *Troisième Cahier* (Chefs-d'Oeuvre perdus et retrouvés), Paris, 1950, p. 41 ff.

Page 319

1. Quoted in Friedländer, III, p. 15. Molanus (*recte* Vermeulen) is the author of the well-known *De picturis et imaginibus sacris* referred to in note 147[2].

2. Transmitted only through workshop copies and replicas: Friedländer, III, p. 126, nos. 92, 93, pls. LXXVI, LXXVII.

3. Friedländer, III, pl. XXVIII; Schöne, p. 94. Friedländer's masterly description (p. 26) is inaccurate only in describing the illumination as *abendlich* ("vespertinal"). According to Exodus XVI, 19–21, the Manna was gathered in the early morning; for, "when the sun waxed hot it melted."

4. Friedländer, III, p. 109 f., no. 24, pls. XXXIII, XXXIV; Schöne, *Dieric Bouts und seine Schule*, pp. 43 ff., 180 f., pls. 79–81, 88 a (as by Dirc Bouts the Younger). Cf. Baldass, "Dirk Bouts, seine Werkstatt und Schule" (as by the Master of the Pearl of Brabant whom Baldass does not consider as identical with Dirc Bouts the Younger). See also Thieme-Becker, XXXVII, p. 269.

Page 320

1. For Ouwater, see, e.g., Friedländer, III, pp. 56 ff., 112 f., pls. XLVI–XLVIII; Hoogewerff, II, p. 58 ff.; W. R. Valentiner, "Aelbert van Ouwater," *Art Quarterly*, VI, 1943, p. 74 ff. W. Schöne, "Albert van Ouwater; Ein Beitrag zur Geschichte der holländischen Malerei des XV. Jahrhunderts," *Jahrbuch der Preussischen Kunstsammlungen*, LXIII, 1942, p. 1 ff., was unfortunately inaccessible to me, while an article by K. G. Boon, "De Erfenis van Aelbert van Ouwater," *Nederlandsch Kunsthistorisch Jaarboek*, I, 1947, p. 33 ff., became available too late to be considered. For

Ouwater's dates and his alleged responsibility for the "Hand G" miniatures and their relatives, see p. 242 f.

2. K. Gerstenberg, "Ueber ein verschollenes Gemälde von Ouwater"; cf. A. Katzenellenbogen, "The Separation of the Apostles," *Gazette des Beaux-Arts*, ser. 6, XXXV, 1949, p. 81 ff., especially p. 96 f.

3. Van Mander, *op. cit.*, fol. 205 v.

4. Friedländer, III, p. 112, no. 34, pl. XLVI; Schöne, pp. 85, 86.

5. The only approximate parallel known to me is a drawing in the Kupferstichkabinett at Berlin (Friedländer, III, p. 60, pl. XLVIII) which is so close to Ouwater in design and interpretation that it has been described as a copy after a lost composition attributable to Ouwater himself. But even here the resurrected Lazarus turns to Christ rather than the beholder, and the scene is laid in an open porch rather than in a closed "temple."

Page 321

1. Friedländer, III, p. 57.

2. Wehle and Salinger, *op. cit.*, p. 50.

3. Friedländer, III, p. 112, no. 35, pl. XLVII; Wehle and Salinger, *loc. cit.* A Madonna in half length, also preserved in the Metropolitan Museum (Friedländer, no. 36, pl. XLIX; Wehle and Salinger, p. 52 ff.), seems to be the work of a follower drawing from both Ouwater and Bouts. It is, however, possible that an authentic "Crucifixion" by Ouwater, now lost, is reflected in a drawing formerly in the Kupferstichkabinett at Dresden (Friedländer, III, p. 60; illustrated in Hoogewerff, II, p. 70, fig. 32).

4. See note 298 [1], item (d). It is hard to see how the dependence of Ouwater's "Raising of Lazarus" on the "Exhumation of St. Hubert" can be denied (Schöne as quoted by Davies, *National Gallery Catalogues, Early Netherlandish School*, p. 115) without either reversing the relationship between the two compositions, which would be unwarranted both for stylistic and historical reasons, or postulating a common source almost exactly identical with the "Exhumation," which would unnecessarily complicate but not alter the situation as far as Ouwater is concerned.

5. Friedländer, III, p. 51.

Page 322

1. *Ibidem*, p. 55.

Page 323

1. P. Geyl, *Eenheid en Tweeheid in de Nederlanden*, Lochem, 1946, p. 195 (translation mine); —— *From Ranke to Toynbee; Five Lectures on Historians and Historiographical Problems* (Smith College Studies in History, XXXIX), Northampton,

Mass., 1952, p. 37 ff. Cf. also Hoogewerff, I, p. 1 ff.

2. Friedländer, III, p. 112 f., no. 38; Hoogewerff, I, p. 564 ff., figs. 321, 322; *Centraal Museum, Utrecht, Catalogus der Schilderijen*, 1952, no. 285.

3. See, e.g., the frescoes in the Buurkerk at Utrecht, mentioned by Hoogewerff, *loc. cit.*; the "Bearing of the Cross" in the Musée Royal at Brussels (Winkler, *Die altniederländische Malerei*, p. 155, fig. 95); the "Gathering of Manna" in the Museum at Douai (Friedländer, III, p. 112, no. 37; Hoogewerff, I, p. 552, fig. 312); a "Calvary" in the Museum at Budapest (Hoogewerff, I, p. 560, fig. 315); the "Healing of the Blind of Jericho" owned by Prof. J. P. Kleinweg de Zwaan at Amsterdam (Hoogewerff, I, p. 556, fig. 313).

4. Friedländer, V, pp. 65 ff., 139 ff., pls. XXXI–XLII; Schöne, p. 142; Hoogewerff, II, p. 240 ff.; Thieme-Becker, XXXVII, p. 346.

Page 324

1. Friedländer, III, p. 39.

2. The attribution of several woodcuts to Ouwater by Valentiner, "Aelbert van Ouwater," is, to say the least, unconvincing.

3. E. Graf zu Solms-Laubach, "Der Hausbuchmeister," *Städel-Jahrbuch*, IX, 1935/36, p. 13 ff. I wholeheartedly agree with this author's thesis that the Housebook Master was a native of Holland and that his style developed from (and remained allied to) the Dutch tradition; but I am skeptical of his contention that the Housebook Master is identical with Erhard Reuwich of Utrecht, the famous illustrator of Breydenbach's *Peregrinationes in terram sanctam* of 1486 and regret to say that Count Solms-Laubach's recent contribution ("Nachtrag zur Hausbuchmeisterfrage," *Essays in Honor of Georg Swarzenski*, Chicago and Berlin, 1951, p. 111 ff.) has failed to convert me.

4. For Geertgen tot Sint Jans, see, in addition to the literature referred to in note 243 [2]: Friedländer, V, pp. 11 ff., 131 ff., pls. I–XV; Schöne, pp. 29 f., 121–129; Hoogewerff, II, p. 138 ff.; L. Balet, *Der Frühholländer Geertgen tot Sint Jans*, The Hague, 1910; L. Baldass, *Geertgen van Haarlem* (Kunst in Holland, V–VI), Vienna, n. d. [1921]; J. H. H. Kessler, *Geertgen tot Sint Jans; zijn Herkomst en Invloed in Holland*, Utrecht, 1930. That Geertgen was a native of Leyden is suggested by an engraving by Theodore Matham where he is called *Gerardus Leydanus Pictor*; that he served his early apprenticeship at Bruges is attested by a document published by R. A. Koch, "Geertgen tot Sint Jans in Bruges," *Art Bulletin*, XXXII, 1951, p. 259 ff. The date of this apprenticeship (1475) agrees with the estimated dates of his birth and death (see note 243 [2]). The number of works attributable to Geertgen has recently been aug-

mented by two delightful early pictures. One, now in the van Beuningen Collection at Vierhouten, shows the Madonna in half-length surrounded by a magnificent glory evoking the idea of a real spectrum in that its colors imperceptibly change from red to orange, yellow, green, and blue, and by a cloud of angels carrying musical instruments, the instruments of the Passion, scrolls inscribed "Sanctus," and the Rosary (M. J. Friedländer, "Zu Geertgen tot Sint Jans," *Maandblad voor Beeldende Kunsten*, XXV, 1949, p. 187 ff.; D. M. Hoffman, "A Little-Known Masterpiece; Our Lady of the Sanctus," *Liturgical Arts*, XVIII, 1950, p. 43 ff.). The other, now in the Museum at Cleveland, is a tiny "Adoration of the Magi"; see M. J. Friedländer, "Eine bisher unbekannte Epiphanie von Geertgen," *Maandblad voor Beeldende Kunsten*, XXVI, 1950, p. 10 ff.; H. S. Francis, "Two Dutch Fifteenth-Century Panels" (the other being a "St. John the Baptist" by Dirc Bouts, Friedländer, III, p. 109, no. 20, pl. XXX, formerly in the Thyssen Collection), *Bulletin of the Cleveland Museum of Art*, XXXIX, 1952, p. 326 ff. Cf. also *Art Quarterly*, XV, 1952, p. 188 ff. A lost painting by Geertgen tot Sint Jans, illustrating the legend of the Rosary, has been tentatively reconstructed by G. Ring, "Attempt to Reconstruct a Lost Geertgen Composition," *Burlington Magazine*, XCIV, 1952, p. 147.

Page 325

1. Friedländer, V, p. 131, no. 1, pl. I; Schöne, p. 121; Hoogewerff, II, p. 175 ff., fig. 79. Davies, *National Gallery Catalogues, Early Netherlandish School*, p. 37, and "National Gallery Notes, I," is the only scholar to express some doubt as to the authenticity of the picture.

2. Both the "Dream of King René" in the *Cuer d'Amours Espris* and the "Dream of Constantine" by Piero della Francesca are frequently illustrated; the former, e.g., in Sterling, *Les Primitifs*, p. 90, fig. 100, and Ring, *A Century*, pl. 54, the latter in van Marle, *op. cit.*, XI, p. 37, fig. 20.

Page 326

1. Friedländer, V, p. 132, no. 7, pl. XI; Schöne, p. 129; Hoogewerff, II, p. 179 ff., fig. 81. The authenticity of the picture was unjustly doubted by Balet, *op. cit.*, p. 157, and Kessler, *op. cit.*, pp. 7 f., 51 f. For its iconography, see Panofsky, "Imago Pietatis," p. 290 ff.

2. Schöne, p. 19, would seem to think of half-length compositions such as the Malouel *tondo* in the Louvre (fig. 101) or the frequent renderings of the Man of Sorrows, the *Piété Nostre Seigneur*, etc., rather than of what I have called pseudo-fragments, when he says

that the *Ausschnitt als geschlossene Bildform* had been frequent in Europe around 1400. In the work of Hugo van der Goes the pseudo-fragment occurs, so far as I can see, only once, viz., in a "Descent from the Cross" reflected in the replicas referred to in note 338². And since the original has not come down to us, it is not impossible that it had been mutilated before it became accessible to the copyists.

3. Friedländer, V, p. 132, no. 9; Hoogewerff, II, p. 164. Illustrations are found in Winkler, *Die altniederländische Malerei*, p. 178 (whence my quotation), fig. 111; Baldass, *Geertgen van Haarlem*, pl. 3; F. Dülberg, *Frühholländer*, Haarlem, n.d., III, p. 8, pl. IV. It is significant that Geertgen's first master (see note 324⁴) was not a panel painter but a member of the illuminators' and bookbinders' guild.

4. Friedländer, V, p. 132, no. 8, pl. XII; Schöne, p. 128; Hoogewerff, II, p. 162 ff., figs. 74, 75. The picture is unanimously accepted as a fairly late work.

5. See p. 146; note 146⁶.

Page 327

1. Friedländer, V, p. 132, no. 10, pl. XIII; Hoogewerff, II, p. 165 ff., fig. 76. The authenticity of the picture was doubted by Davies, "National Gallery Notes, I," and Oettinger, "Das Rätsel der Kunst des Hugo van der Goes," p. 66 ff. I find it, however, impossible to separate it from the unquestioned "Raising of Lazarus" in the Louvre, and its iconography would seem to link it with the community of which Geertgen tot Sint Jans was a member. In the High and Late Middle Ages, the Holy Kinship, as venerated by those who believed in the *trinubium Annae*, consisted primarily of the husbands and direct descendants of St. Anne, viz., first, the Virgin Mary, daughter of St. Anne and Joachim and wife of St. Joseph, and her son, Jesus Christ; second, Mary, the daughter of St. Anne and Cleophas and wife of Alphaeus, and her four sons, St. James the Less, St. Simon, St. Jude and Joseph the Just (who failed to become an Apostle because the lot decided for Barnabas); third, Mary, daughter of St. Anne and Salomas ("Mary Salome") and wife of Zebedee, and her two sons, James the Great and John the Evangelist. It is this "Holy Kinship in the narrower sense" which is listed in numerous mnemonic verses (the best-known in the *Golden Legend* in the chapter on the Birth of the Virgin, September 8), figures in most pictorial and graphic representations of the subject (two early instances in the "Queen Mary's Psalter," fol. 68, G. Warner, ed., London, 1912, pl. 120, and in Gautier de Coincy's "Miracles de Notre Dame," Paris, Bibliothèque de l'Arsenal, ms. 3517, fol. 7, illustrated in Martin, *La Miniature française*, pl. 15, fig. XIX), and was personally intro-

duced to Saint Collette of Corbie, who had been blaming St. Anne for having married three times but was set right by means of a vision in which "Madame Saincte Anne s'apparut à elle moult glorieusement, menant avec elle sa noble progénie" (E. Sainte-Marie Perrin, *La Belle Vie de Sainte Collette de Corbie*, Paris, 1921, p. 64). The cadet branch of the family, centered around St. Elizabeth of whom nothing is said in the Bible except that she was the wife of Zacharias and the Virgin Mary's cousin (Luke, I, 36), had to be built up without the benefit of Biblical sources. While an early medieval mural in Santa Maria Antiqua, ultimate source of all representations of the Holy Kinship, is limited to the three "Holy Mothers," St. Anne with the infant Virgin Mary, the Virgin Mary with the Infant Jesus and St. Elizabeth with the infant John the Baptist (W. de Grüneisen, *Sainte-Marie-Antique*, Rome, 1911, p. 110, fig. 84), later medieval imagination, first crystallized in the *Golden Legend*, provided St. Elizabeth with a mother (Esmeria, Ismeria, Hismeria), a father (Ephraim, Effra) and a younger brother (Eliud). And this younger brother, having married an alleged Emerentia, was supposed to have been the father of one Emin, Enim or Emynen who with his wife, Memelia or Emilion, produced St. Servatius, Bishop of Tongres (strangely presumed by others to have been a brother rather than a nephew of St. Elizabeth); for all of this, cf. B. Kleinschmidt, *Die heilige Anna*, Düsseldorf, 1930, p. 252 ff. In artistic renderings (Kleinschmidt, p. 263 ff.) this cadet branch, if represented at all, is therefore either reduced to St. John the Baptist and his parents, as in a Book of Hours for Mâcon use in which St. Anne and her three husbands, the Holy Family, Mary Cleophas with husband and sons, Mary Salome with husband and sons, and St. Elizabeth with husband and son are represented in five separate miniatures, the last-named treated as a kind of *bas-de-page* and showing St. Elizabeth and Zacharias squatting on cushions instead of enthroned (V. Leroquais, *Un Livre d'Heures manuscrit à l'usage de Mâcon*, Mâcon, 1935, p. 18 f., pls. XI, XII). Or it is limited to the ancestry of St. John, significantly opposed to that of Christ alone so as to express the opinion of those who, like Jacob Faber Stapulensis, Sylvius Egranus and Agrippa of Nettesheim, protested against the belief in the *trinubium Annae* (thus in a picture by Bernhard Strigel in the Vienna Gemäldegalerie, illustrated in Glaser, *op. cit.*, p. 289, fig. 197, and Kleinschmidt, p. 158, fig. 95, in which St. Anne is defiantly called UNICUM VIDUITATIS SPECIMEN, and Joachim UNICUS MARITUS ANNAE). Or it appears complete and unabridged so as to do honor to St. Servatius of Tongres whose cult grew to enormous proportions from the

beginning of the fifteenth century (cf. Kleinschmidt, p. 269 f.). Instances of this kind were therefore especially popular in Mosan and Rhenish art, one of the earliest being the well-known eponymous picture by the Elder Master of the Holy Kinship in the Wallraf-Richartz Museum at Cologne (H. Reiners, *Die Kölner Malerschule*, München-Gladbach, 1925, pl. XIV; Linfert, *op. cit.*, fig. 17). The painting normally ascribed to Geertgen tot Sint Jans is unique in that St. John the Baptist and his mother, but neither his father nor any other member of the cadet branch, are conspicuously included in a "Holy Kinship in the narrower sense." It glorifies the little Baptist much as the "complete and unabridged" renderings of the subject do St. Servatius, and this creates a strong presumption in favor of its attribution to a painter who was a member of the Order of St. John and always showed his special veneration for this Order's patron saint; in fact the picture may well have been executed for the very community in which he lived. Concerning the individual little Apostles (Joseph the Just was apparently omitted because he failed to become one), I believe that the boy on the extreme left should be identified with St. James the Less, whose attribute is the club, while the boy engaged in lighting the candles on the choir screen would seem to be St. Jude, his Γ-shaped lighter being a substitute for St. Jude's traditional, L-shaped carpenter's rule. Ss. James the Great, John the Evangelist and Simon are uniquely determined.

2. Friedländer, V, p. 131, no. 4, pls. IV–VI; Schöne, p. 122; Hoogewerff, II, p. 173 f., fig. 78. The picture (though not its wings) is accepted by all scholars excepting Balet, *op. cit.*, p. 138 ff., and should be dated early rather than late.

3. Friedländer, V, p. 132, no. 5, pls. VII, VIII; Hoogewerff, II, p. 156, fig. 72.

4. Friedländer, V, p. 133, no. 12, pl. XIV; Schöne, p. 123; Hoogewerff, II, p. 158 ff., fig. 73.

5. Friedländer, V, p. 132, no. 6. pls. IX, X; Schöne, pp. 124–126; Hoogewerff, II, p. 141 ff., figs. 65–70. The huge altarpiece of which the Vienna panels formed part is described by van Mander (the other painting assigned by him to Geertgen, an architectural portrait of St. Bavo's, still *in situ* and illustrated in Balet, *op. cit.*, pl. facing p. 35, and Hoogewerff, II, p. 153, fig. 71, is difficult to judge because of its purely scientific character). Van Mander states that the central panel of the altarpiece represented the Calvary but does not specify the subject of the left wing. The general assumption that it was a Bearing of the Cross is, however, very probable for iconographic reasons. Except for the fact that the central panel showed the Calvary instead of the Bearing of the Body to the Sepulchre, Geertgen's altarpiece was thus somewhat

similar to the lost triptych from the Roger workshop which can be reconstructed from several paintings and drawings (note 266³; figs. 391, 392); and this applies, I think, not only to its program but also to its form. As they are, the Vienna panels, attached to a rectangle almost twice as wide as it is high, would make a very awkward ensemble, and the fact that the Cross in the "Lamentation" as well as the buildings in the "History of the Baptist's Remains" are now cut off by the upper margin led me to the conclusion that the Vienna panels were mutilated when they were sawed apart so as to make them look like normal, rectangular pictures. Their original form must have resembled that of the Leipzig drawing after Roger's "Bearing of the Cross" (Musper, fig. 49; our fig. 391), that is to say, the "Lamentation" must have had a top piece on the left, and the "History of the Remains" one on the right. The "Calvary" must thus have had two top pieces on either side like the Paris drawing after Roger's "Bearing of the Body" (Destrée, pl. 61; Winkler, fig. 45; Musper, fig. 53; our fig. 392). This hypothesis (see diagram) was confirmed by a tech-

nical investigation undertaken at my request in the Vienna Gemäldegalerie. According to a kind communication from Dr. Friederike Klanner the upper margin of the two panels is not a true edge but came about by a cut so crudely performed that particles of the pigment splintered off and the damage had to be patched up with putty subsequently colored.

6. The fact that these "group portraits" include only five actual knights, whereas most of the other persons are not even members of the Order, fits in with the fact that the Grand Prior's visit in 1495 — not very long after the presumable date of Geertgen's altarpiece — mentions precisely this number; see E. A. van Beresteyn, *Geschiedenis der Johanniter Orde in Nederland tot 1795* (van Gorcums Historische Biblioteek, deel 8), Assen, 1935, p. 56 ff. Recently, this shrinkage of the Haarlem Commandery in the last years of the fifteenth century has given rise to ·the hypothesis that the altarpiece was executed at a much earlier date. A declining community, it has been

argued, would not have been able to afford so expensive an ornament, and from the fact that in the group behind the sarcophagus nearly equal prominence is given to two knights rather than one, it has been concluded that the altarpiece was ordered in 1460, when the then Commander, Gerrit van Schooten (died 1461), had made his son, Pieter, "Coadjutor," and that it was executed during the latter's Commandership from 1461 to 1471; see A. Châtelet, "A propos des Johannites de Haarlem et du retable peint par Geertgen tot Sint Jans," *L'Architecture Monastique, Actes et Travaux de la Rencontre Franco-Allemande des Historiens d'Art (1951)*, Numéro Spécial du *Bulletin des Relations Artistiques France-Allemagne*, Mayence, 1951. These reasons, however, do not seem strong enough to support a date incompatible with all the other evidence, including the crucial fact that the "Lamentation" evinces the influence of the Monforte altarpiece by Hugo van der Goes. The presence of only five knights would be hard to explain had their number been greater. A *famulus* of the Order would have been willing, if not obliged, to work without pay — apart from the fact that the laymen figuring in the main group of knights as well as the old Canon in the "Lamentation" (see note 329²) may well owe their inclusion to the fact that they had contributed to the material expense of the altarpiece. There is nothing to show that the two ranking dignitaries must be Commander and Coadjutor rather than Commander and Prior, and even if this assumption were true it should be noted that, according to van Beresteyn, p. 55, the appointment of a Coadjutor (implying his designation as successor to the Commander) was by no means characteristic only of the year 1460 but was a tradition of the Haarlem Commandery from as early as 1391. In conclusion, it should be noted that Châtelet himself reproduces an interesting seventeenth-century drawing (preserved in the Municipal Archives of Haarlem) which by its inscription claims to portray Geertgen tot Sint Jans and, if indeed reflecting a lost self-portrait, would seem to constitute a further argument in favor of the commonly accepted dates: it shows a young man of about twenty-five, clad in the costume of the middle 'eighties.

Page 328

1. See Panofsky, *Albrecht Dürer*, I, p. 24; II, p. 40, no. 337, figs. 69, 70.

2. *Ibidem*, I, p. 23, II, p. 79, no. 725, fig. 24.

3. Most frequently illustrated, the first state in Panofsky, *Albrecht Dürer*, II, fig. 209. Owing to the printing process, the motif is reversed.

4. This was suggested by W. Krönig, "Geertgens Bild Johannes des Täufers," *Das Münster*, III, 1950, p. 193 ff.

Page 329

1. Durrieu, *Les Très Riches Heures*, pl. XVIII. The motif, ultimately derived from classical sources, would seem to have been transmitted through Italian channels, perhaps a Resurrected in a "Last Judgment" (cf. Durrieu, pl. XXV); in Geertgen's painting, it appears reversed, which is not unusual in copies based upon tracings on *carta lucida*. As Durrieu, p. 9, has shown, the famous manuscript was in the possession of the House of Savoy through Jean de Berry's daughter, Jeanne, the wife of Amédée VII, and was completed under Charles I who reigned from 1482 to 1489. Between 1472 and 1482 it probably belonged to the latter's older brother, Philibert, who was, however, a minor even at the time of his death. Its whereabouts at the time of Geertgen's apprenticeship (1475–1476) are, therefore, difficult to determine, and it is not impossible that it had been sent to Bruges for repairs or in an abortive attempt to have it finished.

2. The presence of this old Canon is as yet unexplained. Were it not for the fact that the Order of St. John was absolutely independent of all spiritual and temporal authority save that of Rome (*Catholic Encyclopedia*, VII, p. 478, col. 2), it might be thought that he is the archdeacon in charge of the monastery, for the bishops of major dioceses used to delegate the annual visitations of religious houses to archdeacons, each of whom was in permanent charge of a certain district, which often resulted in a strong feeling of loyalty and affection on both sides. As it is, the Canon must be a special well-wisher of the Haarlem Commandery and more likely than not contributed to the expense of the work (see note 327 [6]).

3. Compare the landscape in Geertgen's "St. John in the Wilderness" with that in Hugo's Vienna "Fall of Man" (our fig. 456). It is conceivable that Hugo himself produced a "St. John in the Wilderness" which may be dimly reflected in Hans Memlinc's little picture at Munich (Friedländer, VI, p. 124, no. 44; illustrated, e.g., in K. Voll, *Memling, Des Meisters Gemälde* [Klassiker der Kunst, XIV], Stuttgart and Leipzig, 1909, p. 17; Krönig, "Geertgens Bild Johannes' des Täufers," fig. 5; L. von Baldass, *Hans Memling*, Vienna, 1942, fig. 56). This little picture displays a landscape so much more advanced in perspective than do its counterpart (a "St. Veronica" in the Thyssen Collection, illustrated in Baldass, fig. 57) and its somewhat later parallel, the left exterior wing of the Floreins altarpiece in the Hôpital Saint-Jean at Bruges of 1479 (Friedländer, VI, p. 114, no. 2; Voll,

p. 43; Baldass, fig. 68), that Goesian influence must be considered.

4. The paramount importance of Hugo's influence on Geertgen was first stressed and admirably analyzed by A. Goldschmidt, "Der Monforte-Altar des Hugo van der Goes," *Zeitschrift für Bildende Kunst*, XXVI, 1915, p. 221 ff.

5. Friedländer, V, p. 131, no. 2, pl. II; Hoogewerff, II, p. 169, fig. 77. Now universally considered as a school piece.

Page 330

1. For this motif, see, e.g., the second archevault relief on the right-hand side of the first panel in Roger's "Granada-Miraflores" altarpiece; Dirc Bouts' "Adoration" in the Prado (p. 314 f.); two "Adorations" supposed to reflect compositions by Hugo van der Goes (Friedländer, IV, pl. XXXII, and J. Destrée, *Hugo van der Goes*, Paris and Brussels, 1914, plates facing p. 122); Jerome Bosch's "Adoration" in the Philadelphia Museum of Art (Friedländer, V, pl. XLIV).

2. For Hugo van der Goes, see, e.g., Friedländer, IV, pp. 9 ff., 123 ff., pls. I–XL; Schöne, pp. 17 ff., 28 f., 108–120; van Puyvelde, *Primitives*, pls. 66–75; J. B. Knipping, "Hugo van der Goes," in: *Niederländische Malerei im XV. und XVI. Jahrhundert*, Amsterdam and Leipzig, 1941, p. 121 ff. For the assemblage of the material and, above all, the biographical data, J. Destrée, *Hugo van der Goes* (referred to in the preceding note) is still the standard work while R. Rey, *Hugo van der Goes*, Brussels, 1945, is very unreliable. For stylistic criticism, see especially Oettinger, "Das Rätsel der Kunst des Hugo van der Goes."

3. See E. Panofsky and F. Saxl, *Dürers Kupferstich "Melencolia I"* (Studien der Bibliothek Warburg, II), Leipzig and Berlin, 1923, p. 32 ff.

4. Traces of Hugo's work in honor of Charles the Bold and Margaret of York have been thought to survive in a series of tapestries one of which is believed to contain the portraits of the ducal couple; see F. H. Taylor, "'A Piece of Arras of the Judgment'; The Connection of Maître Philippe de Mol and Hugo van der Goes with the Mediaeval Religious Theatre," *Worcester Art Museum Bulletin*, I, 1935–1936, p. 1 ff. This article suffers, however, from several inaccuracies and a constant confusion between the marriage festivities at Bruges (July 3–12, 1468) and the subsequent *joyeuses entrées* into Ghent.

Page 331

1. H. G. Sander, "Beiträge zur Biographie Hugos van der Goes und zur Chronologie seiner Werke,"

Repertorium für Kunstwissenschaft, XXXV, 1912, p. 519 ff. (cf. Destrée, *Hugo van der Goes*, p. 214 ff.). Knipping, *op. cit.*, p. 129, erroneously refers to the author as "Gerard" Ofhuys.

2. Hieronymus Münzer in his traveling record of 1495: "Quidem alius magnus pictor supervenit volens imitari in suo opere hanc picturam et factus melancholicus et insipiens" (Weale, *Hubert and John van Eyck*, p. lxxiv f.; Destrée, *Hugo van der Goes*, p. 17, note 1).

3. The "Meeting of David and Abigail," described by van Mander as the center of a legendary love story, has come down to us only in copies; cf. Friedländer, IV, p. 129, no. 19, pl. XXX; Destrée, *Hugo van der Goes*, p. 66 ff., pls. facing pp. 66 and 70.

4. Friedländer, IV, p. 125 f., no. 10, pls. XI–XVIII; Schöne, pp. 109–115; van Puyvelde, *Primitives*, pls. 68, 69, 71; Destrée, *Hugo van der Goes*, p. 96 ff., pls. facing 98, 100, 102, 104, 106, 108, 110, 112, 114. The triptych has been published in a little monograph by G. Marchig, *L'Adorazione di Hugo van der Goes*, Florence, 1947. For the cleaning and restoration of the "Annunciation" on the exterior, cf. R. Oertel, "Die Verkündigung des Hugo van der Goes," *Pantheon*, XX, 1937, p. 377 ff.; for the date of the triptych, see note 333 ¹.

5. Warburg, *op. cit.*, I, p. 190.

Page 332

1. I know only two authentic portraits by Hugo van der Goes and both of them are donor's portraits cut out from larger compositions. One is the "Portrait of a Young Man" in the Metropolitan Museum (Friedländer, XIV, p. 93, Nachtrag pl. XVI; Wehle and Salinger, *op. cit.*, p. 57 f. with further references); the other is the "Portrait of a Donor and St. John the Baptist" in the Walters Art Gallery at Baltimore (Friedländer, IV, p. 128, no. 18, pl. XXIX; Destrée, *Hugo van der Goes*, pl. facing p. 128; van Puyvelde, *Primitives*, pl. 74; *The Worcester-Philadelphia Exhibition of Flemish Painting*, no. 14, recording the discovery of the donor's orant hands which were revealed by a cleaning in 1939; our fig. 370). The "Portrait of a Monk" in the Metropolitan Museum (Friedländer, IV, p. 126 f., no. 13, pl. XX; van Puyvelde, *Primitives*, pl. 75; Wehle and Salinger, *op. cit.*, p. 58 f. with further references), though accepted by Oettinger, "Das Rätsel der Kunst des Hugo van der Goes," p. 56 f., must, in my opinion, be assigned to a follower of Roger van der Weyden. And the "Portrait of a Young Man" in the Rhode Island School of Design at Providence, R. I. (C. de Tolnay, "Hugo van der Goes as Portrait Painter," *Art Quar-*terly, VII, 1944, p. 181 ff.) should never have been published as an original.

2. For this date, see the following note.

Page 333

1. In 1901–1902 A. Warburg (*op. cit.*, I, pp. 198, 209 ff.) established the names and birth dates of the first Portinari children as follows: (1) Maria, born 1471; (2) Antonio, born 1472; (3) Pigello, born 1474; (4) Margherita, presumably born 1475; (5) Guido, born 1476. Since only three children, the youngest of them Pigello, are represented in the Portinari triptych, and since the fourth, the conjectural Margherita, was supposed to be on her way in 1475, Warburg concluded that it was commissioned in this year and was finished in 1476, accounting for the presence of St. Margaret by the assumption that she was included both as the patroness of childbirth and as the future Margherita's name saint. Warburg's identification of the children has been unanimously accepted by the specialists, including those who tend to shift the date of the altarpiece to 1474–1475 (Oettinger, "Das Rätsel der Kunst des Hugo van der Goes," p. 44) or even to 1472–1475 (Schöne, p. 29, regardless of the fact that Pigello did not exist until 1474). In reality, however, Warburg's *terminus ante quem non* is a little too early rather than too late. It seems to have escaped notice that he himself has corrected his original list in one important point: the first-born child was not named Maria but Margherita, born on September 15, 1471, while the birth date of Maria is unknown (Warburg, p. 378). The presence of St. Margaret is, therefore, as self-evident as that of St. Anthony: she is the patron saint of the first-born daughter precisely as St. Anthony is the patron saint of the first-born son. And since there was no child in 1475 at all while the comparatively mature appearance of all the children suggests a date as late as is compatible with the historical data, we have every reason to assume that the triptych was not commissioned until 1475–1476 (when Guido was expected) and was executed shortly after. In 1476–1477, Margherita was between five and six, Antonio between four and five, and Pigello between two and three. It is true that they look older than even that; but their mother, born in 1456 and married at the age of fourteen (not seventeen, as stated in Knipping, *op. cit.*, p. 142), also looks older than twenty. Yet it is a gross exaggeration to say that the apparent age of Hugo's children may be entirely discounted in an attempt to date one of his works (Oettinger, p. 56). He makes them older but there is a fairly constant ratio between their real and apparent age; we have only to subtract about three years from the latter in order to arrive at the former (see also note 335 ¹).

Knipping, p. 143, on the other hand, goes too far in the other direction when he proposes to date the Portinari triptych as late as *ca.* 1480, assuming that Guido (born, we remember, in 1476) and his younger sister or sisters (a Dianora was born in 1479) were not included because they were too small to be comfortably transported to the Roode Kloster for a sitting. The omission even of babes in arms from a donation of this kind would have amounted to a *diminutio capitis* which no self-respecting family would have inflicted upon their offspring.

2. Cf. Panofsky, *Albrecht Dürer*, II, p. 10 f., no. 28. The iris also occurs in the Monforte altarpiece and, most significantly, in the Vienna "Fall of Man" where one of its blossoms takes the place of the traditional fig leaf. For the symbolism of the columbine, see p. 146; note 146 [6].

3. Not counting, of course, the angel announcing the birth of the Lord to the shepherds in the distance.

4. The Eucharistic significance of the grain is even more explicit in Botticelli's well-known Madonna in the Isabella Stewart Gardner Museum at Boston (L. Venturi, *Botticelli*, New York and Vienna, 1937, pl. 4) where it is supplemented by grapes and blessed by the Christ Child. For the connection between the Eucharist and the word "Bethlehem," see, e.g., the Eighth Homily of St. Gregory (kindly brought to my attention by Professor Adolf Katzenellenbogen), *Patrologia Latina*, LXXVI, col. 1104.

Page 334

1. This was already emphasized by Destrée, *Hugo van der Goes*, p. 98.

2. Isaiah IX, 6. The Vulgate has *Parvulus* instead of *Puer*.

3. Jean Lemaire de Belges, *La Couronne Margaritique* (frequently quoted, e.g., in Weale-Brockwell, p. 283, and Destrée, *Hugo van der Goes*, p. 1):

> "Hugues de Gand, qui tant eut les tretz netz,
> y fut aussi, et Dieric de Louvain,
> avec le roy des peintres Iohannes."

It is regrettable that none of the drawings ascribed to Hugo van der Goes is of unquestionable authenticity. The, relatively speaking, most convincing attributions are the magnificent "Meeting of Jacob and Rachel" in Christ Church, Oxford (Friedländer, IV, pl. LXXVI; Destrée, *Hugo van der Goes*, pls. facing pp. 72, 74; best reproduction in S. Colvin, *Selected Drawings from Old Masters in the University Galleries and in the Library of Christ Church, Oxford*, Oxford, 1903 ff., III, 17), and the "Young Female Saint Sitting on the Ground" in the Ludwig Rosenthal Collection at Berne (now Lewis V. Randall Collection

at Montreal) first published by M. J. Friedländer, "Eine Zeichnung von Hugo van der Goes," *Pantheon*, XV, 1935, p. 99 ff., and recently reproduced in Mongan (ed.), *One Hundred Master Drawings*, p. 16. A "St. Luke Painting the Virgin" formerly in the Königs Collection at Haarlem (I. Adler, "Hugo van der Goes," *Old Master Drawings*, V, 1930–1931, p. 54, pl. 34) is, in my opinion, not only too weak but also too late to be assigned to Hugo. Neither am I able to accept a "Crucified Christ" at Windsor Castle, much less a Madonna at Dumbarton Oaks, recently proposed by K. G. Boon, "Naar Aanleiding van Tekeningen van Hugo van der Goes en zijn School," *Nederlandsch Kunsthistorisch Jaarboek*, III, 1950–51, p. 83 ff. The fine but certainly non-authentic drawing showing St. George and St. Margaret (formerly in the Lanna Collection, Friedländer, IV, p. 62, pl. LXXVII) is now in the Lessing Rosenwald Collection; cf. *Rosenwald Collection; An Exhibition of Recent Acquisitions, National Gallery of Art*, E. Mongan, ed., L. J. Rosenwald, pref., Washington, 1950, no. 25.

4. Friedländer, IV, p. 127 f., no. 17, pl. XXVII; Schöne, pp. 108, 110; van Puyvelde, *Primitives*, pl. 72; Destrée, *Hugo van der Goes*, p. 77 ff., pls. facing pp. 76, 78, 80, 82. For the date and reconstruction of the Monforte altarpiece, see Goldschmidt, "Der Monforte-Altar des Hugo van der Goes."

Page 335

1. Friedländer, IV, p. 126, no. 12, pl. XIX; Schöne, pl. 118; Destrée, *Hugo van der Goes*, p. 91 ff., pls. facing pp. 92, 94, 96. The date (1478–1479) is confirmed by the fact that the Crown Prince, born in 1473, looks about the same age as Margherita Portinari, born in 1471. Destrée's hypothesis according to which the pictures antedate the birth of the future James IV and the young prince is the King's younger brother, Alexander, Duke of Albany, must be discarded, not only for stylistic reasons but also because it is most improbable that the royal couple should have been portrayed in the company of the heir presumptive as long as an heir apparent was a distinct possibility.

2. St. George, the patron saint of England, would be the very last saint to be included in a portrayal of the King and Queen of Scotland; the only logical counterpart of St. Andrew, patron of Scotland, is St. Canute, patron of Denmark. As such, however, he should carry the Dannebrog, *a cross argent on a field gules*, and not *a cross gules on a field argent*, which is the *velabrum* of St. George. Since Mr. Ellis Waterhouse kindly informs me that the banner has not been repainted, the only explanation is that the painter, knowing no more of the Dannebrog than that it

showed a cross device in *gules* and *argent*, confused it with the *velabrum* by sheer ignorance — a confusion all the more understandable as the whole figure is patterned after the St. George in Jan van Eyck's "Madonna van der Paele." I have been unable to ascertain whether the inscription of the banner, "Ihesus Maria," bears Danish or Scottish implications.

3. This was observed by Destrée, *Hugo van der Goes*, p. 91.

4. Concerning the text of this hymn there is considerable confusion which was dispelled with the kind help of Professor Erich Auerbach. According to Destrée, *Hugo van der Goes*, p. 92, Hugo's text is a variation on the hymn still sung at Trinity Vespers and on the following Saturday Vespers:

> "Iam sol recedit igneus:
> Tu, lux perennis, Unitas,
> Nostris, beata Trinitas,
> Infunde lumen [or *amorem*] cordibus."

According to Knipping, *op. cit.*, p. 161, it was composed by the well-known philosopher and theorist of optics, John Peckham, Archbishop of Canterbury (died 1292). In reality Hugo's text is much older than both the official version and the Peckham hymn. It was ascribed to St. Ambrose as early as in the ninth century and may well be authentic (cf. G. M. Dreves and C. Blume, *Analecta hymnica medii aevi*, Leipzig, II, 1886, p. 34, no. 17; H. A. Daniels, *Thesaurus hymnologicus*, Leipzig, 1855, I, p. 36 ff., no. XXVI, and IV, p. 47 f.). The hymn actually composed by Peckham (Dreves and Blume, L, 1907, p. 595, no. 392), a typical product of the thirteenth century, reads as follows:

> "O lux beata Trinitas,
> Tres unum, trium unio,
> Imperialis unitas
> In trium contubernio."

Page 336

1. Hugo's anxiety about unfinished work is mentioned by Gaspar Ofhuys. The non-authenticity of the panel showing the Queen and St. Canute was emphasized by Destrée, *Hugo van der Goes*, p. 94, but announced as an important discovery by Oettinger, "Das Rätsel der Kunst des Hugo van der Goes," p. 56.

2. A similar temper can be discerned in the St. John in the Baltimore fragment referred to in note 332¹ (our fig. 370). The wing with a portrait of Hippolyte de Berthoz and his wife, Elizabeth de Keverwyck, added by Hugo van der Goes to the Boutsian St. Hippolytus altarpiece in St.-Sauveur at Bruges (Friedländer, IV, p. 126, no. 11; Destrée, *Hugo van der Goes*, p. 120 f., pl. facing p. 128; cf.

Friedländer, III, p. 111, no. 29), is, on the other hand, very close to the Portinari altarpiece and should be dated in 1477–1478. Oettinger, "Das Rätsel der Kunst des Hugo van der Goes," p. 57, believes it to postdate the Bonkil panels (which he, convinced that the apparent age of James IV may be disregarded, dates only slightly later than the Portinari triptych) while Schöne, *Dieric Bouts und seine Schule*, p. 168, unaccountably declares it an early work, "on no account postdating the Monforte altarpiece."

Page 337

1. Friedländer, IV, p. 127, no. 15, pls. XXIV–XXVI; Destrée, *Hugo van der Goes*, p. 110 ff., pls. facing pp. 116, 118. From the measurements of the Berlin "Nativity" (97 cm. by 245 cm.) it has been concluded that it may have served as a predella for the Monforte altarpiece (150 cm. by 247 cm.). If so, an interval of almost ten years would have to be assumed between the execution of the altarpiece and its "predella," and it seems much more probable that the near-identity of the widths is purely fortuitous. This is all the more plausible as one of the lost wings of the Monforte altarpiece itself exhibited the Nativity (cf. Goldschmidt, "Der Monforte-Altar des Hugo van der Goes") so that a representation of this subject in the predella would have amounted to a duplication.

2. Friedländer, IV, p. 127, no. 14, pls. XXI–XXIII; Schöne, p. 119; van Puyvelde, *Primitives*, pl. 73 (color); Destrée, *Hugo van der Goes*, p. 123 ff., pl. facing p. 130. For full documentation and many excellent illustrations, see Janssens de Bisthoven and Parmentier, *op. cit.*, p. 50 ff. The "Nativity" in the collection of Lord Pembroke at Wilton House (Friedländer, IV, p. 127, no. 16, pl. XXVII; Schöne, p. 120; van Puyvelde, *Primitives*, pl. 70; Destrée, *Hugo van der Goes*, p. 118 ff., pl. facing p. 124; our fig. 475), though extravagantly praised in latter-day criticism, is, in my opinion, more than questionable. Destrée, p. 119 f., supported by Hulin de Loo, considers it as a copy; but it may easily be the work of an imitator.

3. For the iconography of the Dormition, see now H. Swarzenski, "A Masterpiece of Bohemian Art." Even where Christ appears, not very frequently, in a glory instead of standing on the ground (as in the Bohemian diptych in the Morgan Library, Swarzenski, fig. 2, and an Austrian miniature in the National Gallery at Washington, Lessing J. Rosenwald Collection, Swarzenski, fig. 8), He is represented as a quiet figure, holding the soul of the Virgin on His left arm and extending His right hand in blessing.

4. See the excellent analysis in Friedländer, IV, p. 49 f.

5. This position of the bed occurs, e.g., in Schon-

gauer's engraving B. 33. If, as has been assumed, this print, copied as early as 1481, were dependent on Hugo's painting the latter's *terminus ante quem* would be toward 1480. The relation between the two works is, however, extremely doubtful, and Schongauer's familiarity with Hugo's picture is flatly rejected by Friedländer, IV, p. 51.

Page 338

1. De Busscher's essay is quoted by Destrée, *Hugo van der Goes*, p. 19. In recent times, and without reference to de Busscher, the hypothesis of Hugo's trip to Italy was put forward with great *éclat* by Oettinger, "Das Rätsel der Kunst des Hugo van der Goes," p. 50 ff., and accepted by Schöne, pp. 17, 28. Rey, *op. cit.*, p. 26, misdating Hugo's admission to the painters' guild by two years, goes so far as to say: *"Nous savons qu'il était installé à Gand en 1465, au retour d'un voyage qu'il venait de faire en Italie."*

2. Friedländer, IV, p. 123 f., no. 4, pls. IV–VI; Schöne, pp. 116, 117; van Puyvelde, *Primitives*, pl. 66 ("Fall of Man" only); Destrée, *Hugo van der Goes*, p. 38 ff., pls. facing pp. 32, 36, 40. The similarity between Adam and Christ was justly emphasized by Knipping, *op. cit.*, p. 152. Oettinger's late dating of the Vienna diptych and its relatives was accepted by Schöne, p. 29, but — as I saw with gratification when the publication became accessible to me — rejected by Baldass, *Hans Memling*, p. 36. So far as I know, Rey, *op. cit.*, is the only scholar to assign different dates to the two parts of the diptych, proposing an early date for the "Fall of Man" and a late one for the "Lamentation." The date of the Vienna diptych would also seem to apply to the suppositive original of a "Descent from the Cross" on two panels which is reflected in a canvas in the Kaiser Friedrich Museum (Friedländer, IV, p. 124 f., no. 7, pl. VIII; Destrée, *Hugo van der Goes*, p. 43 f., pl. facing p. 44) and in a diptych by Memlinc in the Capilla Real at Granada (Friedländer, VI, p. 118, no. 13, pls. XV, XVI; Destrée, p. 53 f., pl. facing p. 54).

3. Friedländer, IV, p. 124, no. 5, pl. VII; Destrée, *Hugo van der Goes*, p. 31 ff., pl. facing p. 4 (Madonna only). The Madonna forms the central panel of a diptych donated by William van Overbeke and Johanna de Keysere who were married on February 5, 1478. The donors, the husband protected by St. William, the wife by St. John the Baptist, are represented in the wings. These were, however, subsequently added to a much smaller central panel originally designed as an independent devotional image, and the three pictures were then set into a sumptuous framework. The lateral panels were executed by an inferior artist who tried to adapt his style to Hugo's even to the

extent of imitating the stippled gold ground of the Madonna; but just in this detail the difference between precise yet animated order and sloppy yet pedantic accumulation is so evident that it is hard to understand how Oettinger, "Das Rätsel der Kunst des Hugo van der Goes," p. 44, could adduce this gold ground as proof of contemporaneity. In reality the date of the donors' marriage, while constituting a *terminus post quem* for the wings and the framework, constitutes only a *terminus ante quem* for the Madonna which may have been acquired by the Overbekes any number of years after its completion (see also Baldass, *Hans Memling*, p. 36). The related Madonnas in the Philadelphia Museum of Art and the Herzog-Czete Collection at Budapest (see note 296[3]) would seem to be shopwork.

Page 339

1. Oettinger, "Das Rätsel der Kunst des Hugo van der Goes," p. 47.

2. *Ibidem*, p. 49.

Page 340

1. For the "Nativity" in the Vieille Boucherie, see note 127[4]. Maeterlinck's attempt to construe a flourishing "school of Ghent" by annexing the *oeuvre* of the Flémalle Master and a great number of other important items for his home town cannot be taken more seriously than, for example, Max Lautner's nearly forgotten proposal to assign the whole work of Rembrandt to Ferdinand Bol.

2. For Joos van Ghent, see, e.g., Friedländer, III, pp. 74 ff., 129 ff., pls. LXXXII–XCIII; Schöne, pp. 106, 107; van Puyvelde, *Primitives*, pls. 76–78; J. Lavalleye, *Juste de Gand, Peintre de Frédéric de Montefeltre*, Louvain, 1936. For further references, see the following notes.

Page 341

1. For Joos van Ghent's activities at the court of Urbino, especially the much-debated extent of his collaboration with the mediocre Spanish painter, Pedro Berruguete, see, in particular, Lavalleye, *Juste de Gand*, p. 95 ff.; Hulin de Loo, *Pedro Berruguete et les Portraits d'Urbin*, Brussels, 1942; Post, *A History of Spanish Painting*, IX, p. 17 ff.; *Città di Forlì, Mostra di Melozzo e del Quattrocento Romagnolo*, Forlì, 1938, p. 25 ff.; Davies, *National Gallery Catalogues, Early Netherlandish School*, p. 45 ff. Quite recently, the problem has been further complicated by the injection of Bramante; see P. Rotondi, *Il Palazzo Ducale di Urbino*, Urbino, 1951, p. 353 ff.; ———, "Contributi Urbinati al Bramante pittore," *Emporium*, CXIII, 1951, p.

109 ff. (kindly brought to my attention by Mr. David G. Carter).

2. Friedländer, III, p. 129, no. 101, pl. LXXXIII; van Puyvelde, *Primitives*, pl. 76; Wehle and Salinger, *op. cit.*, p. 54 ff., with further references. O. Pächt (*Kritische Berichte zur kunstgeschichtlichen Literatur*, 1927/28, p. 37 ff.) is the only scholar to date the New York "Epiphany" in Joos van Ghent's Italian period. I agree with Lavalleye, *Juste de Gand*, p. 79 ff., pl. VI, in considering it as the painter's earliest known work.

3. Friedländer, III, p. 129, no. 100; van Puyvelde, *Primitives*, pl. 77 (central panel only); Lavelleye, *Juste de Gand*, p. 85 ff., pls. VIII–X. A reproduction showing the triptych in its entirety is found in Winkler, *Die altniederländische Malerei*, p. 113, fig. 66. A restoration after the conflagration of 1822 not only disfigured the work by crude overpainting (especially noticeable in the sky and landscape background) but also mutilated the panels as such: in the central panel the unpainted area surmounting the trefoil arch was cut and patched; in the wings the corresponding arches were reduced to triangles and later restored to arches by the addition of new segments (see the diagram in Lavalleye, p. 88 which is, however, conjectural in accepting the slanting cuts in the central panel as authentic and thus postulating a triangular top piece). As evident from the "barbe," the central panel and the wings were always cut round on top so that the upper contour of the triptych offered an aspect somewhat similar to that of its great local predecessor, the Ghent altarpiece by the van Eycks. For the choice of prefigurations, see Lutz and Perdrizet, *op. cit.*, pp. 274, 326; and, more particularly, Cornell, *Biblia Pauperum*, p. 277 ff., pls. 39, 53, 57.

4. See figs. 393–395; 353, 386.

5. See p. 314.

6. Friedländer, III, p. 83.

7. Winkler, *Die altniederländische Malerei*, p. 114.

Page 342

1. Jean Lavalleye (*Juste de Gand*, p. 94, and in Leurs, *op. cit.*, I, p. 212) writes that the early works of Joos van Ghent "exerted a very strong influence on Hugo van der Goes, his young fellow artist" but does not go very far in substantiating this very just statement.

2. A similar gesture occurs in Memlinc's free copy after Hugo van der Goes in the Capilla Real at Granada (referred to in note 338[2]).

3. An even more similar Magdalen is found in a "Calvary" in the Descamps Collection at Brussels ascribed to Joos van Ghent (though probably the work

of a follower) by Lavalleye, *Juste de Gand*, p. 82 ff., pl. VII.

4. The influence of the Ghent altarpiece on Hugo van der Goes' Vienna diptych is not limited to the First Parents but extends to such details as, e.g., the treatment of the fruit tree, the vegetation on the ground and the Cain and Abel reliefs in the spandrels of the St. Geneviève panel.

5. Cf. J. Wilde, "Eine Studie Michelangelos nach der Antike," *Mitteilungen des Kunsthistorischen Institutes in Florenz*, IV, 1932, p. 41 ff.

6. Friedländer, III, p. 129, no. 99, pl. LXXXII; Schöne, p. 106; Lavalleye, *Juste de Gand*, p. 49 ff., pl. I.

7. Another pre-Italian reminiscence in the Urbino panel is the figure believed to represent Caterino Zeno, Venetian Ambassador to the Shah of Persia, which literally repeats the wicked ruler in Dirc Bouts' "Martyrdom of St. Erasmus" (cf. Lavalleye, *Juste de Gand*, p. 68 f., pl. IV). The assumption that the Vienna diptych antedates the Portinari triptych is further confirmed by the fact that it — or at least a work or works in the same style — must have been known to Geertgen tot Sint Jans (see p. 329 and note 329[3]) who was in Bruges in 1475–1476 and to whom the Portinari triptych was apparently unknown.

Page 343

1. This is also the opinion of Destrée, *Hugo van der Goes*, p. 18 f., and Knipping, *op. cit.*, p. 162.

2. For the Virgin Mary in particular, cf., e.g., Dirc Bouts' London Madonna and Roger's "Madonna of Laurent Froimont" at Caen.

Page 344

1. For the document concerning the decoration of St. Pharahildis, see Destrée, *Hugo van der Goes*, p. 247 f. A detailed contemporary description of the "merveilleux et devost triumphe" is reprinted in Monget, *op. cit.*, II, p. 162 ff., and H. Chabeuf, "Charles le Téméraire à Dijon en janvier 1474; L'Entrée et les Funérailles," *Mémoires de la Société Bourguignonne de Géographie et d'Histoire*, XVIII, 1902, pp. 83 ff., 257 ff.: "Lesdiz tres nobles corps, lesquelz mondit seigneur le duc Charles a fait amener en merveilleux et devost triumphe des pays de Flandres et autres de par de la ou ilz ont payé le tribu de nature humaine. Pour approucher ladicte ville de Dijon et y estre receuz en telle réverence et honneur qu'il appartenoit ont esté amenez jusques en ung villaige nommé Saint-Appollonnet assiz environ demie lieue de distance d'icelle ville de Dijon et en l'église d'illec descenduz et posez le dimanche sixiesme jour de fevrier MCCC soixante treze. Accompaigniez de tres hault et puissant prince monseigneur Adolf de Cleves seigneur de Ravestein et

de grant nombre de grans et puissans seigneurs tant barons que autres chevaliers, escuiers et aussi de gens d'église et de gens laiz avec deux cens hommes de pied tous vestuz et habillez de noir qui ont portées les torches durant tout le voiaige." (Chabeuf, p. 292 f.).

2. For the Master of Moulins, see, e.g., Sterling, *Les Primitifs*, p. 118 ff.; ———, *Les Peintres*, pls. 64–71 (three in color); Ring, *A Century*, Cat. nos. 292–313, pls. 156–170, figs. 44, 45, color plate facing p. 236; F. Winkler, "Der Meister von Moulins und Hugo van der Goes," *Pantheon*, X, 1932, p. 241 ff.; Thieme-Becker, XXXVII, p. 235 ff. For his non-identity with Jean Perréal, see M. Huillet d'Istria, "Jean Perréal," *Gazette des Beaux-Arts*, ser. 6, XXXV, 1949, pp. 313 ff., 377 ff.; G. Ring, "An Attempt to Reconstruct Perréal," *Burlington Magazine*, XCII, 1950, p. 225 ff. An authoritative re-examination of the whole question is expected from M. Jacques Dupont. As far as the Master of Moulins' relationship with Hugo van der Goes is concerned, the easiest explanation would be that he made friends with him on the occasion of the famous Fleming's visit to Dijon and was allowed to see him in the Roode Kloster in later years. It should also be noted that Hugo van der Goes is the only Flemish artist included in the well-known list of famous painters appended to the third edition (Toul, 1521) of Jean Pèlerin's treatise on perspective which otherwise contains only the names of masters "decorans France, Almaigne et Italie"; see A. de Montaiglon, *Notice historique et bibliographique sur Jean Pèlerin dit Le Viateur Chanoine de Toul et sur son livre De Artificiali Prospectiva*, Paris, 1861, p. 59 ff.

3. For Fouquet's Madonna, see, e.g., Lemoisne, *op. cit.*, pl. 54; Sterling, *Les Primitifs*, fig. 75 (color); ———, *Les Peintres*, pl. LII; Ring, *A Century*, Cat. no. 123, pl. 74. For the Angel in the Jacques Coeur window, see L. Grodecki, *op. cit.*

4. For the gesture of the Angel, see p. 43; note 43 [1]. Angels approaching the Annunciate from the right are so frequent in France that it is impossible to enumerate them (for the Boucicaut Master, cf., e.g., Bibl. Nat., ms. lat. 10538, fol. 31) and were especially in favor with Fouquet and his followers, not only in the Annunciation proper but also in the Annunciation of the Virgin's Death; cf., apart from the Horae in the Royal Library at Copenhagen, ms. Gl. kgl. Saml. 1610,4° (*Stockholm Catalogue*, no. 176) the famous "Hours of Etienne Chevalier" (P. Wescher, *Jean Fouquet und seine Zeit*, Basel, 1945, pls. 2, 5; K. G. Perls, *Jean Fouquet*, Paris, 1940, pls. 3, 7). For a later example, see, e.g., an anonymous French "Annunciation" in the Musée Calvet at Avignon (Sterling, *Les Primitifs*, p. 116, fig. 140). The "Annunciation" on the exterior of the Moulins altarpiece from which the Master of Mou-

lins received his name presupposes, of course, the influence of the Portinari triptych. As far as Netherlandish panel painting of the fifteenth century is concerned, the rarity of this arrangement, commented upon by Hulin de Loo, is such that I know only three instances outside Hugo's own workshop: first, the "Annunciation" on the exterior of Roger's Middelburg altarpiece referred to in note 277 [1], which shows French connotations also in other respects. Second, the Berlin "Annunciation," close in style to Aelbert Bouts, which appears to be a reversed version of an original by his father (Friedländer, III, p. 114 f., no. 44 b, pl. LII; cf. Schöne, *Dieric Bouts und seine Schule*, pp. 148, 191, pl. 54 b). Third, a much-repeated composition, copied by the Swabian Master of the Ehningen altarpiece some time before 1482 (the alleged date, 1476, is arbitrary), which also seems to be based on an invention of Dirc Bouts and the best replica of which, formerly in the Taymans Collection at Brussels, now seems to be in trade (Friedländer, III, p. 122 f., no. 78; Destrée, *Hugo van der Goes*, p. 166 f., pl. facing p. 196; Schöne, *Dieric Bouts und seine Schule*, p. 116 f., pls. 41, 42 [cf. also pl. 71 a]; *Flemish Primitives, An Exhibition Organized by the Belgian Government*, p. 58). In the two latter cases, however, the reversion of the customary arrangement may well have been caused by the supervening influence of Hugo van der Goes himself who, we remember, visited the heirs of Dirc Bouts in 1479/80; the Taymans "Annunciation" is, in fact, said to come from the Roode Kloster. The silver point drawing of an "Annunciation" at Wolfenbüttel (H. Zimmermann, "Eine Silberstiftzeichnung Jan van Eycks aus dem Besitze Philipp Hainhofers," *Jahrbuch der Königlich Preussischen Kunstsammlungen*, XXXVI, 1915, p. 215 ff.; Friedländer, I, p. 126; de Tolnay, *Le Maître de Flémalle*, p. 74, no. 9; our text ill. 62) I hold to be the work of a French artist active between 1440 and 1450. Only by this assumption can we account for the gesture of the angel and the provincial reconversion of an Eyckian interior into a semi-exterior view.

5. Illustrated, e.g., Lemoisne, *op. cit.*, pl. 52 a; Sterling, *Les Primitifs*, p. 74, fig. 72; ———, *Les Peintres*, pl. XLVII; Ring, *A Century*, Cat. no. 120, pl. 69.

Page 345

1. Glaser, *op. cit.*, p. 207, introduces the chapters dealing with German painting from *ca.* 1480 with a little preface entitled "Der spätgotische Barock."

2. Glaser, *op. cit.*, p. 384 ff., figs. 261, 262.

3. Friedländer, V, pp. 56 f., 135 f., nos. 26–27, pl. XXII; Thieme-Becker, XXXVII, p. 98 f. (as "Meister der Figdorschen Kreuzabnahme").

4. See above, p. 323 f.

5. For Jacob Cornelisz., see Friedländer, XII, pp. 96 ff., 193 ff., pls. XLV–LVII; Hoogewerff, III, p. 72 ff.; K. Steinbart, *Die Tafelgemälde des Jakob Cornelisz. von Amsterdam*, Strasbourg, 1922; ———, *Das Holzschnittwerk des Jakob Cornelisz. von Amsterdam*, Burg bei Magdeburg, 1937.

6. For Cornelis Engelbrechtsz., see Friedländer, X, pp. 53 ff., 129 ff., pls. XXXIX–LVII; Hoogewerff, III, p. 144 ff.; E. Gavelle, *Cornelis Engelbrechtsz.*, Lyons, 1929. The style of the "Antwerp Mannerists of *ca.* 1520," first studied in M. J. Friedländer's admirable essay, "*Die Antwerpener Manieristen von 1520*," *Jahrbuch der Königlich Preussischen Kunstsammlungen*, XXXVI, 1915, p. 65 ff., has so much in common with that of their Dutch contemporaries that it can be accounted for only by a strong North Netherlandish influence; in fact the problem of disentangling "Dutchmen" from "Flemings" in this group has proved to be one of the thorniest in the history of art (cf. the famous problem of "Jan de Cock" and "Jan van Leyden," Master at Antwerp from 1503, discussed at length in Hoogewerff, III, p. 355 ff.). For the work of the "Antwerp Mannerists," see Friedländer, XI, pp. 9 ff., 116 ff., pls. I–LII.

7. See p. 100 ff.

Page 346

1. Wehle and Salinger, *op. cit.*, p. 72 f.

2. For Aelbert Bouts, see Friedländer, III, pp. 64 ff., 114 ff., pls. L–LXIII; Schöne, *Dieric Bouts und seine Schule*, p. 190 ff.

3. Cf. Friedländer, III, pp. 70 ff., 122 f., nos. 74–77, pls. LXIV–LXVII; Thieme-Becker, XXXVII, p. 324 f.

4. Friedländer, V, p. 105.

5. See note 247².

6. Friedländer, IV, p. 108 f.

7. Friedländer, IV, pp. 101 ff., 137 ff., pls. XLVI–L; ———, "Der Meister der Katharinen-Legende und Rogier van der Weijden"; Thieme-Becker, XXXVII, p. 177 f.

8. Friedländer, IV, pp. 109 ff., 139 ff., pls. LI–LIV; Thieme-Becker, XXXVII, p. 33 ff.

9. Friedländer, XII, pp. 15 ff., 165 ff., pls. I–IX; Thieme-Becker, XXXVII, p. 211. Cf. Davies, *National Gallery Catalogues, Early Netherlandish School*, p. 78 f.

10. Friedländer, IV, pp. 112 ff., 141 f., pls. LV–LIX; Thieme-Becker, XXXVII, p. 130. Cf. Davies, p. 75 ff.

11. Friedländer, IV, pp. 118 f., 144 ff., pls. LXIII–LXVII; Thieme-Becker, XXXVII, p. 117 f.

12. Friedländer, IV, pp. 115 ff., 143 f., pls. LX–LXII; Thieme-Becker, XXXVII, p. 167.

13. Friedländer, VI, pp. 60 ff., 136 ff., pls. LI–LVI; Thieme-Becker, XXXVII, p. 335. A nice detail from the eponymous diptych in the Convent of the Black Sisters at Bruges is illustrated in van Puyvelde, *Primitives*, pl. 104.

14. Friedländer, VI, pp. 65 f., 139, pls. LVII–LIX; Thieme-Becker, XXXVII, p. 34.

15. Friedländer, XIV, p. 105, Nachtrag, pl. XXII; Thieme-Becker, XXXVII, p. 28. Cf., however, Janssens de Bisthoven and Parmentier, *op. cit.*, p. 71 ff.

16. Friedländer, VI, pp. 66 ff., 140 ff., pls. LX–LXVI; Thieme-Becker, XXXVII, p. 203 f.

17. See Wehle and Salinger, *op. cit.*, p. 84 ff.

18. For the Master of St. Giles, whom some scholars believe to be a Frenchman, see, e.g., Sterling, *Les Primitifs*, p. 135, figs. 168–172; ———, *Les Peintres*, pls. 140, 141 (color); Ring, *A Century*, Cat. nos. 239–249, pls. 135–138, color plate facing p. 24; M. J. Friedländer, "Le Maître de St.-Gilles," *Gazette des Beaux-Arts*, ser. 6, XVII, 1937, p. 221 ff.; Thieme-Becker, XXXVII, p. 6 f. Cf. Davies, *National Gallery Catalogues, Early Netherlandish School*, p. 70 f. Two pictures of the St. Giles series, the "Conversion of an Arian by St. Gregory" and the "Baptism of Clovis," have recently been acquired by the Kress Foundation (*Paintings and Sculpture from the Kress Collection*, nos. 82, 83). While the Master of the Legend of St. Giles was active at Paris three Flemish painters active at Genoa have been discussed by M. J. Friedländer, "Drei niederländische Maler in Genua," *Zeitschrift für Bildende Kunst*, LXI, 1927–1928, p. 273 ff.

Page 347

1. Cf. M. Conway, "The Abbey of Saint-Denis and its Ancient Treasures," *Archaeologia or Miscellaneous Tracts Relating to Antiquity*, LXVI (ser. 2, XVI), 1915, p. 103 ff.; ———, "Some Treasures of the Time of Charles the Bald," *Burlington Magazine*, XXVI, 1914–1915, p. 236 ff.; A. M. Friend, "Carolingian Art in the Abbey of St.-Denis," *Art Studies*, I, 1923, p. 67 ff.; *Abbot Suger on the Abbey Church of St. Denis and Its Art Treasures*, p. 179, figs. 9, 10.

2. Friedländer, IV, p. 125, no. 9, pls. IX, X; Destrée, *Hugo van der Goes*, p. 33 ff., pls. facing pp. 8, 12, 16. I agree with Oettinger, "Das Rätsel der Kunst des Hugo van der Goes," in believing that this altarpiece, the "Annunciation" on the exterior showing the Angel approaching from the right, is not an early work of Hugo van der Goes but was produced by a meek follower already acquainted with the Portinari triptych, and that the same is true of the "Madonna with St. Anne" in the Musée Royal at Brussels (Friedländer, IV, p. 123, no. 2, pl. II; van Puyvelde, *Primitives*, pl. 67 [color]; Destrée, *Hugo van der Goes*, p. 129 f., pl. facing p. 134; a better color reproduction in *Flemish Primitives, An Exhibition Organized by the Belgian Government*, p. 36).

3. London, W. H. Samuel (now Viscount Bearsted of Maidstone) Collection; Friedländer, IV, p. 133, no. 31, pl. XXXVII.

4. Friedländer, IV, p. 134, no. 36, pl. XL.

5. Memlinc is, significantly, the only Early Flemish master represented in the "Klassiker der Kunst" series (Voll, *Memling*). See also, e.g., Friedländer, VI, pp. 9 ff., 114 ff., pls. I–XLVIII; Baldass, *Hans Memling*; M. J. Friedländer, *Memling*, Amsterdam, n.d. [1950]. There are also little monographs on individual works and groups of works, e.g., M. Guillaume-Linephty, *Hans Memling in the Hospital of St. John at Bruges*, Paris, 1939; ———, *Hans Memling: The Shrine of St. Ursula*, Paris, 1939; P. Lambotte, *Hans Memling, Le Maître de la Châsse de Ste. Ursule*, Antwerp, 1939; W. Drost, *Das Jüngste Gericht des Hans Memling in der Marienkirche zu Danzig*, Vienna, 1941; C. G. Heise, *Der Lübecker Passionsaltar von Hans Memling*, Hamburg, 1950.

6. For Memlinc's birthplace, see Brockwell, "A Document Concerning Memling." Since Seligenstadt is a comparatively small place, it is easy to conceive that he was locally known only as a "native of Mainz" (see the following note).

7. Rombouts de Doppere, Notary at St. Donatian's in Bruges (reprinted in Friedländer, VI, p. 10 f.): "Die XI Augusti, Brugis obiit magister Johannes Memmelinc, quem praedicabant peritissimum fuisse et excellentissimum pictorem totius tunc orbis christiani. Oriundus erat Magunciaco, sepultus Brugis ad Aegidii . . ."

8. Friedländer, VI, p. 56.

9. For Eyckian vistas seen through colonnettes, see, e.g., Friedländer, VI, pls. XI, XXXII; for brocaded cloths of honor and oriental rugs, *ibidem*, pls. XI, XVII, XXX, XXXII, XXXIV–XXXVI; for historiated capitals, the Madonna in the Liechtenstein Collection at Vienna (*ibidem*, p. 126, no. 54, illustrated, e.g., in Voll, *Memling*, p. 131; Baldass, *Hans Memling*, fig. 62 [color]); for convex mirrors, Friedländer, pls. XVII, XXXI.

Page 348

1. Friedländer, VI, pls. XV, XVI (see note 338²).

2. Henry James, *A Little Tour in France*, M. Swan, intr., New York, 1950, p. 75.

3. Friedländer, VI, p. 54 f.

4. Stuttgart, Museum. Friedländer, VI, p. 121, no. 25, pl. XXIII.

5. Cf. Friedländer, VI, p. 50: "Memling ist stückweise der Natur nahe."

6. Bruges, Hôpital Saint-Jean. Friedländer, VI, p. 121, no. 24, pl. XXI, XXII; van Puyvelde, *Primitives*, pl. 85. For a complete series of illustrations, black-and-white or colored, see Voll, *Memling*, pp. 78–91; Baldass, *Hans Memling*, figs. 104–117; and the monographs listed in note 347⁴.

Page 349

1. Bruges, Hôpital St.-Jean, dated 1487. Friedländer, VI, p. 118, no. 14, pls. XVII, XVIII; Schöne, pp. 104, 105; van Puyvelde, *Primitives*, pls. 86, 87 (color).

2. Friedländer, VI, p. 130, no. 74, pl. XLII.

3. Friedländer, VI, p. 128 f., nos. 67, 68; illustrated, e.g., in Voll, *Memling*, figs. 58, 59; Baldass, *Hans Memling*, figs. 58, 59.

4. Friedländer, VI, p. 130, nos. 75, 76 (hardly as early as *ca.* 1470), illustrated, e.g., in van Puyvelde, *Primitives*, pl. 93 (the lady only); Voll, *Memling*, pp. 74, 75.

5. Friedländer, VI, p. 120, no. 23 B (dated 1487 and originally forming a triptych with the Berlin Madonna, no. 23 A, and the St. Benedict in the Uffizi, no. 23 C), illustrated, e.g., in Voll, *Memling*, pp. 70–72; Baldass, *Hans Memling*, figs. 99–101.

6. Friedländer, VI, pp. 44 f., 130, no. 73, pl. XLI.

7. Friedländer, VI, p. 119, no. 16 B, pl. XIX; Wehle and Salinger, *op. cit.*, p. 64. For the pink as a symbol of betrothal see F. Mercier, "La Valeur symbolique de l'œillet dans la peinture du moyen-âge," *Revue de l'Art Ancien et Moderne*, LXXI, 1937, p. 233 ff. The relationship between the Metropolitan Museum portrait and its companion piece in the van Beuningen Collection (Friedländer, no. 16 A, pl. XIX; *Catalogue of the D. G. van Beuningen Collection*, p. 39, no. 24, pl. 25) has baffled the experts because the van Beuningen picture "instead of the expected portrait of the lady's betrothed, shows a pair of untrammeled horses standing with their feet in a brook." That the two pictures constituted a regular diptych, and neither belonged to an altarpiece (as tentatively assumed by Friedländer and in the van Beuningen *Catalogue*) nor formed the front and back of one and the same panel (as conjectured by Wehle and Salinger) is evident from the fact that the landscape as well as the parapet are continuous and that the vanishing lines of the "diaphragm arches" converge in such a manner that the interval between the two pictures cannot have amounted to more than the width of two frames. The horses, therefore, cannot belong to a missing narrative (to associate them with an Adoration of the Magi is *ipso facto* improbable because they are only two in number and have neither saddles nor reins) but must be read in direct connection with the portrait. This is by no means so absurd as it may seem. Continuing a tradition which can be traced back as far as Ibycus, an amorous significance was attached to the horse ("Sont autant que leurs chevaulx, Jennes amoureux nou-

veaulx," sings Charles d'Orléans), and in medieval poetry the steed was an accepted symbol of the *inamorato*, the "man in love." As such he is described, for example, by Guittone d'Arezzo and Francesco Barberino and pictured in fourteenth-century painting (cf. F. Egidi, "Un Trattato d'Amore inedito di Fra Guittone d'Arezzo," *Giornale storico della letteratura italiana*, XCVII, 1931, p. 49; ———, "Le miniature dei Codici Barberiniani dei 'Documenti d'Amore,'" *L'Arte*, V, 1902, pp. 1 ff., 78 ff.; Panofsky, *Studies in Iconology*, p. 116 ff., figs. 90, 91). And here Cupid himself, conceived as a malignant force by Guittone and as *Amore honesto* by Francesco Barberino, is made to stand on the animal's back. In a charming drawing in Jacopo Bellini's Louvre Sketchbook (V. Goloubew, *Die Skizzenbücher Jacopo Bellinis*, Brussels, 1908–1912, II, pl. XXXVIII) a little Faun and a clear-sighted Cupid, his bandage encircling his brow instead of covering his eyes, are seen competing for the control of a horse which an adult Satyr attempts to hold back by its tail. The horses in the picture by Memlinc (who may have received his commission and instructions from one of the numerous Italians residing at Bruges) are obviously a variation on this popular theme. The white horse (and it should be borne in mind that in Christian symbolism the white horse often bears unfavorable implications because the "equus pallidus" in Revelation VI, 8, ridden by Death and followed by Hell, used to be represented as white rather than "pale" as can be seen, for example, in an impressive miniature in the "Hours of Alfonso of Castile," Morgan Library, ms. 854, illustrated in F. B. Adams, Jr., *Second Report to the Fellows of the Pierpont Morgan Library*, New York, 1951, pl. facing p. 28) is controlled by a monkey, symbol of everything self-seeking and base in human nature. He is bent only on quenching his thirst and pays no attention whatever to the lovely young lady. The noble isabel, however, free from low appetites and not subjected to undesirable pressures, looks at the girl with an expression of unending devotion. The former personifies the bad lover, the latter the good one. Strange though it may appear to the modern beholder, he *is*, in a sense, the "portrait of the lady's betrothed" so sorely missed by the Metropolitan Museum: the image of a lover "true as the truest horse that yet would never tire," as Shakespeare's Thisbe still says of her Pyramus. And that in this case the lady occupies the dexter side of the diptych is only natural in view of the fact that she was not as yet the donor's wife; in the guise of a stallion, he looks up to his beloved as he would look, in human form, to the Madonna.

8. Friedländer, VI, p. 129, no. 71, pl. XXXIX; van Puyvelde, *Primitives*, pl. 92. Since the young man proffers a coin of Nero rather than a medal of his own manufacture, I agree with Friedländer, p. 42, in doubting his identity with either Forzore Spinelli or, as proposed by Hulin de Loo ("Le Portrait du Médailleur par Hans Memlinc: Jean de Candida et non Niccolo Spinelli," *Festschrift für Max J. Friedländer zum 60. Geburtstage*, Leipzig, 1927, p. 103 ff.), Giovanni de Candida. In fact the portrait seems to be even later than 1477–1479 when the latter was in the service of Charles the Bold.

9. Friedländer, VI, p. 130, no. 79, pl. XLIV; Schöne, p. 102.

10. This can be inferred from the physiognomical type and, in part, even the place of preservation. In addition to the two instances already adduced, there may be mentioned the portraits in the Musée Royal at Brussels, Friedländer, VI, p. 131, no. 84 (Voll, *Memling*, p. 20, Baldass, *Hans Memling*, fig. 50); in the Cà d'Oro at Venice, Friedländer, VI, p. 130, no. 77 (Voll, p. 23, Baldass, fig. 51); in the Galleria Corsini at Florence, Friedländer, VI, p. 131, no. 86 (Voll, p. 22, Baldass, fig. 52); in the Uffizi (Friedländer, VI, p. 132, no. 89, illustrated in Winkler, *Die altniederländische Malerei*, p. 126, fig. 75); and in the collection of Baron van der Elst at Vienna (Friedländer, XIV, p. 103, Nachtrag, pl. XXI, Baldass, fig. 53). I am not acquainted with the portrait at Copenhagen, Friedländer, VI, p. 131, no. 82.

11. Friedländer, VI, p. 115, no. 7 (central panel of a triptych the wings of which show the Martyrdom of St. Sebastian and the Ascension), illustrated in Voll, *Memling*, pp. 113–115; Baldass, *Hans Memling*, fig. 118.

12. The Washington Madonna: Friedländer, VI, p. 127, no. 60, pl. XXXIV, and XIV, p. 106. The Vienna Madonna (central panel of a triptych the wings of which show the two Saint Johns on the interior and the First Parents on the exterior): Friedländer, VI, p. 116, no. 9, illustrated, e.g., in Voll, *Memling*, pp. 117–119; Baldass, *Hans Memling*, figs. 119, 120. The Uffizi Madonna: Friedländer, VI, p. 128, no. 61, pl. XXXV; van Puyvelde, *Primitives*, pl. 88.

13. Chatsworth, Duke of Devonshire Collection. Friedländer, VI, p. 117, no. 10, pls. XI–XIII.

Page 350

1. Friedländer, VI, p. 122, no. 33, illustrated, e.g., in Voll, *Memling*, pp. 32–39. Since the composition includes such scenes as the Circumcision and the Massacre of the Innocents, Baldass, *Hans Memling*, p. 44, figs. 75–83, is correct in calling it "The Life of Christ and Mary" rather than "The Seven Joys of the Virgin."

2. Friedländer, VI, p. 123, no. 34, pl. XXVI (full series of illustrations in Voll, *Memling*, pp. 92–98;

Baldass, *Hans Memling*, figs. 13-17). For a complete series of photographs and extensive bibliography, see Arù and de Geradon, *op. cit.*, p. 14 ff., pls. XXII–XL.

3. Friedländer, VI, p. 114, no. 1, pl. I.

4. Friedländer, VI, p. 114, no. 2, pls. II–IV.

5. Friedländer, VI, p. 50: "Er schmückte die Bildfläche symmetrisch und harmonisch wie ein kölnischer Maler."

6. Wehle and Salinger, *op. cit.*, p. 20 ff. See note 146[5].

7. The "Archaism of around 1500" is often referred to in writings in art history and was well commented upon by Baldass, "Gotik und Renaissance im Werke des Quinten Massys" but still awaits a comprehensive treatment which it will receive, it is to be hoped, by Mademoiselle Nicole Verhaegen. Instructive juxtapositions of several early sixteenth-century works with their early fifteenth-century prototypes are found in G. Brom, "Vernieuwing van onze Schilderkunst in de vroege Renaissance," *Gentsche Bijdragen tot de Kunstgeschiedenis*, VII, 1941, p. 7 ff.; but this author's interest is focused on the transformation of these prototypes rather than on the problem of why they were resorted to.

Page 351

1. See note 334[3].

2. Cf. G. Doutrepont, "Jean Lemaire de Belges et la Renaissance," *Académie Royale de Belgique, Classe des Lettres et des Sciences Morales et Politiques, Mémoires*, ser. 2, XXXII, 1934, especially p. XXVIII.

3. For Gerard David, see, e.g., Friedländer, VI, pp. 71 ff., 143 ff., pls. LXVII–CI; Schöne, pp. 30 f., 143-145; van Puyvelde, *Primitives*, pls. 94-103. E. Freiherr von Bodenhausen, *Gerard David und seine Schule*, Munich, 1905, still remains one of the finest monographs in the field of Early Netherlandish Painting. Cf. also F. Winkler, "Gerard David und die Brügger Miniaturmalerei seiner Zeit," *Monatshefte für Kunstwissenschaft*, VI, 1913, p. 271 ff.; ———, "Das Skizzenbuch Gerard Davids," *Pantheon*, III, 1929, p. 271 ff.

4. Munich, Alte Pinakothek; Friedländer, VI, pp. 105, 148, no. 181, pl. LXXXI.

5. Friedländer, VI, p. 156, no. 222, pls. C, CI; van Puyvelde, *Primitives*, pls. 94, 95 (pl. 95 in color). For full documentation and many excellent illustrations, see Janssens de Bisthoven and Parmentier, *op. cit.*, p. 12 ff. For the unusual subject, cf. van de Waal, *op. cit.*, II, p. 124, note 261; Lederle-Grieger, *op. cit.*, pp. 25, 42 ff.; E. Gans and G. Kisch, "The Cambyses Justice Medal," *Art Bulletin*, XXIX, 1947, p. 121 ff. The "Judgment of Cambyses" is dated 1498.

6. Friedländer, VI, p. 145, no. 165, pls. LXXIV, LXXV.

7. See p. 176 f.

Page 352

1. Friedländer, VI, p. 152, no. 202, illustrated, e.g., in Bodenhausen, *op. cit.*, p. 157.

2. Friedländer, VI, p. 82: "kerzensteif und kerzenrund."

3. Friedländer, VI, p. 155, no. 217, pl. XCVIII.

4. A list of such borrowings is found in Friedländer, VI, p. 103.

5. Friedländer, VI, p. 147, no. 173, XIV, p. 106; Schöne, pp. 144, 145. As evidenced by the perspective of the pavement, the panels are cut out from a larger picture in which the Virgin Mary was placed on a higher level than the Angel. Cf. the recent article by M. Salinger, "An Annunciation by Gerard David," *The Metropolitan Museum of Art, Bulletin*, new ser., IX, 1951, p. 225 ff.

6. Friedländer, VI, p. 155, no. 216, pl. XCVII. See Davies, *National Gallery Catalogues, Early Netherlandish School*, p. 29 f.

7. Friedländer, VI, p. 155, no. 215, pl. XCVI; Schöne, pp. 148, 152; van Puyvelde, *Primitives*, pl. 98. Why Schöne, p. 31, should have revived Bodenhausen's hypothesis according to which the woman facing Gerard David's self-portrait is not his wife, Cornelia Cnoop, but a lady who had paid for the wood panel on which the picture was painted (while Cornelia is supposed to appear under the guise of St. Catherine) I have been unable to determine.

8. Friedländer, VI, p. 149, no. 189, pl. LXXXVIII.

9. See p. 267. Gerard David's resumption of the older type was rightly stressed by Friedländer, VI, p. 86.

10. See the "Crucifixion" in the Barnes Collection at Merion near Philadelphia, Friedländer, VI, p. 149, no. 187, pl. LXXXVI.

11. Friedländer, IV, pp. 119 ff., 146 ff., pls. LXVIII–LXXIII; Maquet-Tombu, *Colyn de Coter*.

12. Madrid, Prado. Friedländer, VIII, p. 173, no. 125 a, pl. LXXXVIII. Cf. Brom, *op. cit.*, pp. 26, 27.

Page 353

1. Tournai, Municipal Museum. Friedländer, VIII, p. 151, no. 5, pl. XII; van Puyvelde, *Primitives*, p. 130 (detail). Cf. Brom, *op. cit.*, pp. 12, 13.

2. Madrid, Prado. Friedländer, VIII, p. 154, no. 19, pl. XXII. See note 220[4] and Brom, *op. cit.*, pp. 20, 21.

3. Friedländer, VIII, p. 151, no. 3, pl. VII. Cf. Brom, *op. cit.*, pp. 28, 29.

4. See Panofsky, *Albrecht Dürer*, I, p. 104; ———, "Dürers Stellung zur Antike," *Jahrbuch für Kunstgeschichte*, I, 1921/22, p. 43 ff., particularly p. 86 ff.

5. For Massys, see, e.g., Friedländer, VII, pp. 15 ff., 113 ff., pls. I–LV; W. Cohen, *Studien zu Quinten Metsys*, Bonn, 1904; J. de Bosschere, *Quinten Metsys*, Brussels, 1907; H. Brising, *Quinten Matsys, Essai sur l'origine de l'Italianisme dans l'art des Pays-Bas*, Uppsala, 1909; Baldass, "Gotik und Renaissance im Werke des Quinten Metsys."

6. Dürer in his Diary (Lange and Fuhse, *op. cit.*, p. 111, 16; p. 112, 5); cf. also, p. 117, 1 ff.: "They spare no expense in such matters [viz., architecture and decoration], for there is money enough."

7. Friedländer, VII, p. 117, no. 17, pl. XIX; Schöne, p. 146.

8. Friedländer, XIV, p. 108, no. 27, best illustrated in Baldass, "Gotik und Renaissance im Werke des Quinten Metsys," pl. XI (see note 175²). For the Lyons Madonna, see Friedländer, VII, p. 119, no. 27.

9. Friedländer, XIV, p. 108, no. 27; Schöne, p. 157.

Page 354

1. Friedländer, VII, p. 122, no. 53, pl. L; van Puyvelde, *Primitives*, pl. 123 (color); Michel, *L'Ecole Flamande . . . au Musée du Louvre*, p. 63 f., pls. XXXII, XXXIII. For a juxtaposition with Petrus Christus' "St. Eloy," see Baldass, "Gotik und Renaissance im Werke des Quentin Metsys," and Brom, *op. cit.*, pp. 14, 15.

2. See note 203⁶.

3. For the identification of the Master of the Death of the Virgin, named after two altarpieces in the Pinakothek at Munich and the Wallraf-Richartz Museum at Cologne, with Joos van Cleve (*recte* Joos van der Beeke), see Friedländer, IX, pp. 20 ff., 127 ff., pls. XVI–LVII, and L. Baldass, *Joos van Cleve, der Meister des Todes Mariä*, Vienna, 1925. Cf., however, the critical remarks in Davies, *National Gallery Catalogues, Early Netherlandish School*, p. 45.

4. Friedländer, IX, pp. 53, 140, no. 74; *Art News*, XXVIII, 1930, April 26 (colored reproduction on cover); J. Rosenberg, "Early Flemish Painting," *The Bulletin of the Fogg Museum of Art*, X, 1943, p. 47 f. Friedländer and Rosenberg rightly ascribe the picture — supposedly representing Roger Count Blitterswijk-Geldern — to Joos van Cleve and account for its archaic character by the assumption that the painter, like Roger van der Weyden and others before him, was asked to recreate an ancestor portrait. Winkler, "Rogier van der Weyden's Early Portraits," unconvincingly attributes it to Jan Mostaert and considers it as a copy after an early work of Roger van der Weyden.

5. New York, Metropolitan Museum. Friedländer, IX, pp. 41 f., 137 f., no. 65, pl. XXXVIII; Wehle and Salinger, *op. cit.*, p. 133; Brom, *op. cit.*, pp. 24, 25.

6. For the numerous versions of this composition,

see Friedländer, IX, p. 138, no. 66, pl. XXXIX; Baldass, *Joos van Cleve*, p. 18, pls. 34, 35; Davies, *National Gallery Catalogues, Early Netherlandish School*, p. 66 ff.

7. See the "Holy Families" best exemplified by nearly identical paintings in the Thyssen Collection at Lugano (formerly Holford Collection at London) and the Vienna Gemäldegalerie: Friedländer, IX, p. 137, no 64, pls. XXXVII, and XIV, p. 115; Baldass, *Joos van Cleve*, pl. 54.

8. Friedländer, VII, pp. 43 f., 122, no. 51, pl. XLVIII. For the comparison with the "Robert de Masmines," see Baldass, "Gotik und Renaissance im Werke des Quinten Metsys."

Page 355

1. See p. 171.

2. Cf. M. J. Friedländer, "Neues zu Quentin Massys," *Cicerone*, XIX, 1927, p. 1 ff.

3. For the cap affected by Cosimo de' Medici, see the medals reproduced in J. Friedländer, *Die italienischen Schaumünzen des fünfzehnten Jahrhunderts*, Berlin, 1882, p. 144 ff., pl. XXVII, 3, 4; and — even more strikingly — the famous Uffizi portrait by Jacopo Pontormo (F. M. Clapp, *Jacopo Carucci da Pontormo; His Life and Work*, New Haven, London and Oxford, 1916, p. 147 ff., fig. 42).

4. Panofsky, *Albrecht Dürer*, I, p. 238; II, no. 210, figs. 299, 300.

5. Friedländer, VII, pp. 64, 122, no. 52, pl. IL (XLIX); ———, "Neues zu Quentin Massys."

Page 356

1. *The Praise of Folly* by Desiderius Erasmus of Rotterdam, H. H. Hudson, tr., Princeton, 1941, p. 42.

2. See Friedländer, "Neues zu Quentin Massys," and, for the Leonardo drawing (in fact, a very good copy after a Leonardo original). K. Clark, *A Catalogue of the Drawings of Leonardo da Vinci in the Collection of His Majesty the King at Windsor Castle*, 1935, p. 70 f., no. 12492. Apart from further lowering the lady's dress and adding the no less "disgusting" hands, Massys did little to change his model. But he would not have thought of using it for a large, independent painting at all had not Erasmus' *Praise of Folly* — first published in 1512, immediately before the presumable date of the "Ugly Duchess" — supplied him with an iconographic "theme." In his commentary on the Windsor drawing, Sir Kenneth Clark correctly considers Wenzel Hollar's engraving as the source of the lady's identification with the *Regina di Tunis* but, curiously enough, refers to Tenniel's figure as the "Red Queen" rather than the "Duchess." He also narrows down the possibilities too much in stating that Tenniel must have worked from either the Windsor drawing or the Hollar print. He may just as well have worked from Massys'

painting which was in England from at least 1836–1837 when G. F. Waagen saw it in the collection of H. D. Seymour.

3. T. Wright, *A History of Caricature and Grotesque in Literature and Art*, London, n.d. [1864], p. 101 f., fig. 67; F. Bond, *Wood Carvings in English Churches*, I, *Misericords*, London, New York, etc., 1910, pp. 180, 225.

4. For Lucas van Leyden, see, e.g., Friedländer, X, pp. 78 ff., 134 ff., pls. LVIII–LXXXVII; ———, *Lucas van Leyden* (Meister der Graphik, XIII), Leipzig, 1924; Hoogewerff, III, p. 207 ff.; R. Kahn, *Die Graphik des Lucas van Leyden*, Strasbourg, 1918; L. Baldass, *Die Gemälde des Lucas van Leyden*, Vienna, 1923; N. Beets, "Lucas van Leyden," in: *Niederländische Malerei im XV. und XVI. Jahrhundert*, Amsterdam and Leipzig, 1941, p. 245 ff. For Scorel, see, e.g., Friedländer, XII, pp. 118 ff., 199 ff., pls. LVIII–LXXVIII; Hoogewerff, IV, p. 23 ff.; ———, *Jan van Scorel, Peintre de la renaissance hollandaise*, The Hague, 1923; C. H. de Jonge, "Jan van Scorel," in: *Niederländische Malerei im XV. und XVI. Jahrhundert*, p. 209 ff.

5. Dürer's fundamental importance for Lucas van Leyden is too well-known and ubiquitous to require exemplification. As to his influence on Scorel, the numerous instances referred to in the earlier literature have recently been augmented by a "Fall of Man" in private ownership which is an almost literal copy of Dürer's engraving B. 1 (Hoogewerff, V, figs. 84, 85), and I should like to add that a work as mature as the "Lamentation" in the Centraal Museum at Utrecht, executed about 1535–1540 (Friedländer, XII, p. 201, no. 323, pl. LXVII; Hoogewerff, IV, p. 137, fig. 60; de Jonge, *op. cit.*, p. 359, fig. 311; *Utrecht, Centraal Museum, Catalogus der Schilderijen, no. 261*), still harks back to a "Lamentation" produced in Dürer's workshop about 1500–1501 (Nuremberg, Germanisches Nationalmuseum, illustrated, e.g., in F. Winkler, *Dürer, Des Meisters Gemälde, Kupferstiche und Holzschnitte* [Klassiker der Kunst, IV, 4th ed.], Stuttgart and Leipzig, 1928, p. 23). Dürer's initial influence on Gossart was especially emphasized by F. Winkler, "Die Anfänge Jan Gossarts," *Jahrbuch der Preussischen Kunstsammlungen*, XLII, 1921, p. 5 ff.; see also W. Krönig, "Die Frühzeit des Jan Gossart," *Zeitschrift für Kunstgeschichte*, III, 1934, p. 163 ff. For Dürer's influence on Netherlandish painting in general, see J. Held, *Dürers Wirkung auf die niederländische Kunst seiner Zeit*, The Hague, 1931.

Page 357

1. Of the enormous literature on Jerome Bosch a few publications postdating C. de Tolnay's fundamental *Hieronymus Bosch*, Basel, 1937, may be mentioned: M. J. Friedländer, *Hieronymus Bosch*, The Hague, 1941; L. von Baldass, *Hieronymus Bosch*, Vienna, 1943; L. van den Bossche, *Jeroen Bosch*, Diest, 1944; J. Combe, *Jérôme Bosch*, Paris, 1946; V. W. D. Schenk, *Tussen Duivelgeloof en Beeldenstorm, een Studie over Jeroen Bosch en Erasmus van Rotterdam*, Amsterdam, 1946; J. de Bosschère, *Jérôme Bosch*, Brussels, 1947; J. Mosmans, *Iheronimus Anthonis-zoon van Aken, alias Hieronymus Bosch, zijn Leven und zijn Werk* (important for documentary evidence), 'sHertogenbosch, 1947; W. Fraenger, *Hieronymus Bosch, Das tausendjährige Reich*, Coburg, 1947 (English translation: *"The Millennium" of Hieronymus Bosch*, Chicago, 1951). D. Bax, *Ontcijfering van Jeroen Bosch*, The Hague, 1948; W. Fraenger, *Die Hochzeit zu Kana, Ein Dokument semitischer Gnosis bei Hieronymus Bosch*, Berlin, 1950.

2. An excellent survey of such influences is found in Bax, *op. cit.*, p. 246 ff.

3. Bosch's connection with pre-Eyckian art, especially book illumination, was especially stressed by de Tolnay, *Hieronymus Bosch*, and Bax who also gives a useful survey of "what Bosch read" (*op. cit.*, p. 275 ff.).

4. A particularly surrealistic interpretation of this scene, kindly brought to my attention by Professor Millard Meiss, is found in Bibliothèque Nationale, ms. fr. 823, fol. 78. Divine Grace leads the Pilgrim, to quote from John Lydgate's charming translation:

"To a roche of hardë ston
And, at an eyë, there ran oute
Dropys of water al aboute:
The dropys wer (to my semyng)
Lych saltë terys of wepyng;
And in- ta cisterne ther besyde,
The dropys gonnë for to glyde."

(*The Pilgrimage of the Life of Man*, Early English Text Society, extra series, LXXVII, LXXXIII, XCII, London, 1899–1904, p. 582, v. 21806 ff.). The rock is made of the hard human hearts which, softened by God, shed tears of contrition. Collected in a "cistern" (the French text has *cuvier*), these tears make a "nice, lukewarm" bath, viz., the Second Baptism of Repentance which the Pilgrim must take before embarking on the Ship of Religion.

5. Brussels, Bibliothèque Royale, ms. 10176–78 (see p. 108), fol. 68; Gaspar and Lyna, *op. cit.*, I, pl. LXXXVII a, our fig. 138. The scene represents Envy carrying her two daughters, Treason and Detraction, the latter serving her

"With ffarsyd Erys, fful off poysoun,
Put on A spytë by traysoun."

(*The Pilgrimage of the Life of Man*, p. 413, v. 15363 f.).

An image like this would seem to explain the famous pair of skewered ears in the right wing of Bosch's "Garden of Lusts" in the Prado at least as adequately as do the Biblical passages adduced by Fraenger, *Hieronymus Bosch, Das tausendjährige Reich*, p. 67, which either refer to ears but not to arrows, or to arrows but not to ears.

6. An astrological explanation of several Bosch compositions, notably the so-called "Prodigal Son" now in the Boymans Museum at Rotterdam, has been attempted by A. Pigler, "Astrology and Jerome Bosch," *Burlington Magazine*, XCII, 1950, p. 132 ff.

7. See Fraenger, *op. cit.* Recently this author has identified the imaginary "Hochmeister" of the heretical Adamite sect, whom he considers as Bosch's chief patron and mentor and whom he originally seemed to consider as an Italian reared in all the arts of Florentine Neoplatonism, with a tangible personality with whom Bosch was probably in contact: Jacob van Almangien, a converted Jew who in 1496 entered the Confraternity of Our Lady under the name of Philippe van Sint Jans but reconverted himself, some ten years later, to the Jewish faith (Fraenger, *Der Tisch der Weisheit, bisher "Die Sieben Todsünden" genannt*, Stuttgart, 1951; ———, "Hieronymus Bosch in seiner Auseinander-setzung mit dem Unbewussten," *Du, Schweizerische Monatsschrift*, XI, 1951, October, p. 7 ff.). There is, it seems, no shred of evidence to show that this personage had anything to do with the Adamites or possessed that wealth of occult knowledge ascribed to Bosch by Fraenger; but he may well have been partly responsible for Bosch's unquestionable familiarity with Jewish legends and customs which will be discussed by Dr. Lotte B. Philip, "The Prado Epiphany by Jerome Bosch," *Art Bulletin*, XXXV, 4 (in print). For some factual objections to Fraenger's theory, which could be multiplied *ad infinitum*, see Bax, *op. cit.*, p. 207 ff.

8. Frequently illustrated, e.g., in P. Lafond, *Hieronymus Bosch*, Paris and Brussels, 1914, pl. facing p. 1, and Bax, *op. cit.*, fig. 2.

9. For an interesting discussion of Bosch's effect on Spanish literature see X. de Salas y Bosch, *El Bosco en la literatura española*, Barcelona, 1943.

Page 358

1. *Medicinarius, Liber de arte distillandi simplicia et composita; Das nüv buch der rechten kunst zu distillieren*, Strasbourg, 1505, fol. CXXXXI ff. (the couplet here quoted, fol. CLXXIV v.).

CONDENSED BIBLIOGRAPHY

This bibliography does not include titles referred to only once, except for books and articles of special interest directly related to the subject of this book.

I. AUTHORS

Adler, I., "Hugo van der Goes," *Old Master Drawings*, V, 1930–1931, p. 54, pl. 34.

Alberti, Leone Battista, *Kleinere kunsttheoretische Schriften*, H. Janitschek, ed. (Wiener Quellenschriften für Kunstgeschichte, XI), Vienna, 1877.

Alvarez Cabanas, A., "La Crucifixión, tabla de Roger van der Weyden," *Religión y Cultura*, XXIV, 1933, p. 56 ff.

Andrieu, Lieutenant Colonel, "Le Paysage de la Vierge au Donateur, de van Eyck," *Revue Archéologique*, ser. 5, XXX, 1929, p. 1 ff.

Apel, W., *French Secular Music of the Late Fourteenth Century*, Cambridge, Mass., 1950.

—— *The Notation of Polyphonic Music, 900–1600*, Cambridge, Mass., 1942.

Arù, C., "Colantonio ovvero il 'Maestro della Annunciazione di Aix,' " *Dedalo*, XI, 1931, p. 1121 ff.

—— and Geradon, E. de, *La Galerie Sabauda de Turin* (Les Primitifs Flamands, Corpus de la Peinture des Anciens Pays-Bas Méridionaux au Quinzième Siècle, Vol. II), Antwerp, 1952.

Aubert, M., *La Bourgogne; La Sculpture*, Paris, 1930.

—— *La Sculpture française du moyen âge et de la renaissance*, Paris, 1926.

Aubert de la Rue, H., "Les Principaux manuscrits à peintures de la Bibliothèque Publique et Universitaire de Genève," *Bulletin de la Société Française de Reproductions de Manuscrits à Peintures*, II, 1912.

Auerbach, E., "Dante's Prayer to the Virgin (Paradiso, XXXIII) and Earlier Eulogies," *Romance Philology*, III, 1949, p. 1 ff.

Aulanier, C., "Marguerite van Eyck et l'Homme au Turban Rouge," *Gazette des Beaux-Arts*, ser. 6, XVI, 1936, p. 57 ff.

Baker, C. H. Collins, see *Catalogues and Exhibitions*, Petworth, *Collection of Lord Leconfield*.

Baker, E. P., "The Sacraments and the Passion in Mediaeval Art," *Burlington Magazine*, LXXXIX, 1947, p. 81 ff.

Baldass, L. (von), *Conrad Laib und die beiden Rueland Frueauf*, Vienna, 1946.

—— *Geertgen van Haarlem* (Kunst in Holland, V–VI), Vienna, n.d. [1921].

—— *Die Gemälde des Lucas van Leyden*, Vienna, 1923.

—— *Hans Memling*, Vienna, 1942.

—— *Hieronymus Bosch*, Vienna, 1943.

—— *Jan van Eyck*, London and New York, 1952. REFERRED TO IN THE NOTES AS "Baldass, *Eyck*."

—— *Joos van Cleve, der Meister des Todes Mariä*, Vienna, 1925.

—— "Dirk Bouts, seine Werkstatt und Schule," *Pantheon*, XXV, 1940, p. 93 ff.

—— "Ein Frühwerk des Geertgen tot Sint Jans und die holländische Malerei des XV. Jahrhunderts," *Jahrbuch der Kunsthistorischen Sammlungen in Wien*, XXXV, 1920/21, p. 1 ff.

—— "The Ghent Altarpiece of Hubert and Jan van Eyck," *Art Quarterly*, XIII, 1950, pp. 140 ff., 183 ff.

—— "Gotik und Renaissance im Werke des Quinten Metsys," *Jahrbuch der Kunsthistorischen Sammlungen in Wien*, new ser., VII, 1933, p. 137 ff.

—— "Die Zeichnung im Schaffen des Hieronymus Bosch und der Frühholländer," *Die Graphischen Künste*, new ser., II, 1937, p. 18 ff.

Balet, L., *Der Frühholländer Geertgen tot Sint Jans*, The Hague, 1910.

Bandmann, G., "Ein Fassadenprogramm des 12. Jahrhunderts und seine Stellung in der christlichen Ikonographie," *Das Münster*, V, 1952, p. 1 ff.

Bauch, K., "Ein Werk Robert Campins?" *Pantheon*, XXXII, 1944, p. 30 ff.

Bax, D., *Ontcijfering van Jeroen Bosch*, The Hague, 1948.

Bazin, G., *L'Ecole Franco-Flamande, XIV et XV siècles* (Les Trésors de la peinture française, II, 2), Geneva, 1941.

—— *L'Ecole Parisienne* (Les Trésors de la peinture française, I, 5), Geneva, 1942.

—— *L'Ecole Provençale, XIV et XV siècles* (Les Trésors de la peinture française, I, 3), Geneva, 1944.

—— See also *Collections and Exhibitions*, Paris, *Musée de l'Orangerie, Des Maîtres de Cologne* ...

Beenken, H., *Hubert und Jan van Eyck*, Munich, 1941. REFERRED TO IN THE NOTES AS "Beenken, *Hubert und Jan*."

—— *Rogier van der Weyden*, Munich, 1951. REFERRED TO IN THE NOTES AS "Beenken, *Rogier*."

—— "The Annunciation of Petrus Cristus in the Metropolitan Museum and the Problem of Hubert van Eyck," *Art Bulletin*, XIX, 1937, p. 220 ff.

—— "Bildnisschöpfungen Hubert van Eycks," *Pantheon*, XIX, 1937, p. 116 ff.

—— "Zur Entstehungsgeschichte des Genter Altars: Hubert und Jan van Eyck," *Wallraf-Richartz Jahrbuch*, new ser., II/III, 1933/34, p. 176 ff.

—— "The Ghent Van Eyck Re-Examined," *Burlington Magazine*, LXIII, 1933, p. 64 ff.

—— "Jan van Eyck und die Landschaft," *Pantheon*, XXVIII, 1941, p. 173 ff.

—— "Remarks on Two Silver Point Drawings of Eyckian Style," *Old Master Drawings*, VII, 1932/33, p. 18 ff.

—— Review of Renders, *Hubert van Eyck*, *Kritische Berichte zur Kunstgeschichtlichen Literatur*, III/IV, 1930–1932, p. 225 ff.

———— "Rogier van der Weyden und Jan van Eyck," *Pantheon*, XXV, 1940, p. 129 ff.

Beer, E. S. de, "Gothic: Origin and Diffusion of the Term; the Idea of Style in Architecture," *Journal of the Warburg and Courtauld Institutes*, XI, 1948, p. 143 ff.

Beets, N., "Lucas van Leyden," in: *Niederländische Malerei im XV. und XVI. Jahrhundert*, Amsterdam and Leipzig, 1941, p. 245 ff.

Begeer, R. J. M., "Le Bouffon Gonella peint par Jan van Eyck," *Oud Holland*, LXVII, 1952, p. 125 ff.

Beissel, E. (S.), "Un Livre d'Heures appartenant à S. A. le duc d'Arenberg à Bruxelles; Etude iconographique," *Revue de l'Art Chrétien*, XV, 1904, p. 436 ff.

Benesch, O., "Ueber einige Handzeichnungen des XV. Jahrhunderts," *Jahrbuch der Preussischen Kunstsammlungen*, XLVI, 1925, p. 181 ff.

———— See also *Collections and Exhibitions*, Vienna, *Beschreibender Katalog . . . der Albertina*.

Berger, E., *Quellen und Technik der Fresko-, Oel-, und Temperamalerei des Mittelalters*, 2nd ed., Munich, 1912.

Berkovits, E., "La miniatura ungherese nel periodo degli Angioini," *Janus Pannonius*, I, 1947, p. 67 ff.

Bisthoven, A. Janssens de, see Janssens de Bisthoven, A.

Blanchard, Dom P., *Les Heures de Savoie, Facsimiles of Fifty-Two Pages from the Hours Executed for Blanche of Burgundy, being all that is known to survive of a famous Fourteenth-Century Ms., which was burnt at Turin in 1904* (printed for H. Yates Thompson), London, 1910.

Blum, R., "Jean Pucelle et la miniature parisienne du XIVᵉ siècle," *Scriptorium*, III, 1949, p. 211 ff.

———— "Maître Honoré und das Brevier Philipps des Schönen," *Zentralblatt für Bibliothekswesen*, LXVIII, 1948, p. 225 ff.

Bober, H., "The Apocalypse manuscript of the Bibliothèque Royale de Belgique," *Revue Belge d'Archéologie et d'Histoire de l'Art*, X, 1940, p. 11 ff.

———— "The Zodiacal Miniature of the 'Très Riches Heures' of the Duke of Berry; Its Sources and Meaning," *Journal of the Warburg and Courtauld Institutes*, XI, 1948, p. 1 ff.

Bock, E., see *Collections and Exhibitions*, Berlin, *Staatliche Museen; Die Zeichnungen alter Meister*.

Bode, W., "Tonabdrücke von Reliefarbeiten niederländischer Goldschmiede aus dem Kreise der Künstler des Herzogs von Berry," *Amtliche Berichte aus den königlichen Kunstsammlungen*, XXXVIII, 1916/17, col. 315 ff.

Bodenhausen, E. Freiherr von, *Gerard David und seine Schule*, Munich, 1905.

Bodkin, T., *The Wilton Diptych in the National Gallery* (The Gallery Books, no. 16), London, n.d.

Boethius, Gerda, *Bröderna van Eyck*, Stockholm, 1946.

Boinet, A., "Les Manuscrits à peintures de la Bibliothèque Sainte-Geneviève de Paris," *Bulletin de la Société Française de Reproductions de Manuscrits à Peintures*, V, 1921, p. 122.

———— See also *Collections and Exhibitions*, Paris, *Edouard Kann Collection*.

Boll, F., *Sternglaube und Sterndeutung*, 3rd ed., W. Gundel, ed., Leipzig, 1926.

Bonaventure, St., *Sancti Bonaventurae . . . opera*, Venice, 1751–1756.

Bonaventure (Pseudo-), *The Mirrour of the Blessed Lyf of Jesu Christ*, L. F. Powell, ed., London, Edinburgh, New York and Toronto, 1908.

Boon, K. G., "De Erfenis van Aelbert van Ouwater," *Nederlandsch Kunsthistorisch Jaarboek*, I, 1947, p. 33 ff.

———— "Naar Aanleiding van Tekeningen van Hugo van der Goes en zijn School," *Nederlandsch Kunsthistorisch Jaarboek*, III, 1950–1951, p. 83 ff.

Borenius, T., "Das Wilton Diptychon," *Pantheon*, XVIII, 1936, p. 209 ff.

Borren, C. van den, *Guillaume Dufay, son importance dans l'évolution de la musique au XVᵉ siècle (Académie Royale de Belgique, Classe des Beaux-Arts, Mémoires*, II, 2, 1926).

Bossche, L. van den, *Jeroen Bosch*, Diest, 1944.

Bosschère, J. de, *Jérôme Bosch*, Brussels, 1947.

———— *Quinten Metsys*, Brussels, 1907.

Bossert, H. Th., *Geschichte des Kunstgewerbes aller Zeiten und Völker*, Berlin, V, 1932.

Boström, K., "Un Livre d'Heures d'Utrecht au Musée National à Stockholm," *Nordisk Tidskrift för Bok- och Bibliotekväsen*, XXXVIII, 1951, p. 156 ff.

Bouchot, H., see *Collections and Exhibitions*, Paris, *L'Exposition des Primitifs Français*.

Brinckmann, A. E., *Michelangelo Zeichnungen*, Munich, 1925.

Brising, H., *Quinten Matsys, Essai sur l'origine de l'italianisme dans l'art des Pays-Bas*, Uppsala, 1909.

Brockwell, M. W., *The Pseudo-Arnolfini Portrait: A Case of Mistaken Identity*, London, 1952.

———— "A Document Concerning Memling," *Connoisseur*, CIV, 1939, p. 186 f.

———— "The Ghent Altarpiece: The Inscription Obliterated," *Connoisseur*, CXXI, 1948, p. 99 ff.

———— " 'Hubert van Eyck'; The 'Hubertist' Bubble Finally Deflated," *Connoisseur*, CXXX, 1952, p. 111 ff.

———— "A New van Eyck," *Connoisseur*, CXXIV, 1949, p. 79 f.

———— See also Weale, W. H. J.

Brom, G., "Vernieuwing van onze Schilderkunst in de vroege Renaissance," *Gentsche Bijdragen tot de Kunstgeschiedenis*, VII, 1941, p. 7 ff.

Brugmans, H., and Peters, C. H., *Oud Nederlandsche Steden*, Leiden, 1909–1911.

Bruyn, E. de, "La Collaboration des Frères van Eyck dans le retable de 'l'Adoration de l'Agneau,' I," *Mélanges Hulin de Loo*, Brussels and Paris, 1931, p. 89 ff.

Bunim, M. Schild, *Space in Medieval Painting and the Forerunners of Perspective*, New York, 1940.

Burger, F., *Die deutsche Malerei vom ausgehenden Mittelalter bis zum Ende der Renaissance* (Handbuch der Kunstwissenschaft), Berlin-Neubabelsberg, 1913.

Burger, W., *Abendländische Schmelzarbeiten*, Berlin, 1930.

—— *Die Malerei in den Niederlanden*, Munich, 1925.

—— *Roger van der Weyden*, Leipzig, 1923.

Burroughs, A., *Art Criticism from a Laboratory*, Boston, 1938.

—— "Campin and van der Weyden Again," *Metropolitan Museum Studies*, IV, 1933, p. 131 ff.

—— "Jan van Eyck's Portrait of His Wife," *Mélanges Hulin de Loo*, Brussels and Paris, 1931, p. 66 ff.

Bye, A. E., "Illuminations from the Atelier of Jean Pucelle," *Art in America*, IV, 1916, p. 98 ff.

Byvanck, A. W., *De middeleeuwsche Boekillustratie in de noordelijke Nederlanden*, Antwerp, 1943.
REFERRED TO IN THE NOTES AS "Byvanck, *Boekillustratie*."

—— *La Miniature dans les Pays-Bas septentrionaux*, Paris, 1937.
REFERRED TO IN THE NOTES AS "Byvanck, *Min. Sept.*"

—— *Les Principaux Manuscrits à peintures de la Bibliothèque Royale des Pays-Bas et du Musée Meermanno-Westreenianum à la Haye*, Paris, 1924.

—— "Aanteekeningen over Handschriften met Miniaturen," *Oudheidkundig Jaarboek*, particularly IV (ser. 3, V, 1925, p. 208 ff.) and IX (ser. 3, X, 1930, p. 93 ff.).

—— "Kroniek der noord-nederlandsche Miniaturen," *Oudheidkundig Jaarboek*, particularly II (ser. 4, IV, 1935, p. 10 ff.) and III (ser. 4, IX, 1940, p. 29 ff.).

—— "Les Principaux Manuscrits à peintures conservés dans les collections publiques du Royaume des Pays-Bas," *Bulletin de la Société Française de Reproductions de Manuscrits à Peintures*, XV, 1931.

—— and Hoogewerff, G. J., *La Miniature hollandaise*, The Hague, 1922–1926.

Camp, G. van, "Le Paysage de la Nativité du Maître de Flémalle à Dijon," *Revue Belge d'Archéologie et d'Histoire de l'Art*, XX, 1951, p. 295 ff.

Cartellieri, O., *Am Hofe der Herzöge von Burgund*, Basel, 1926. (American edition: *The Court of Burgundy*, New York, 1929).

Cennini, Cennino d'Andrea, *Cennino d'Andrea Cennini da Colle di Val d'Elsa, Il Libro dell'Arte*, vol. II, *The Craftsman's Handbook*, D. V. Thompson, Jr., trans., New Haven, 1933.

Chabeuf, H., "Charles le Téméraire à Dijon en janvier 1474; L'Entrée et les funerailles," *Mémoires de la Société Bourguignonne de Géographie et d'Histoire*, XVIII, 1902, pp. 83 ff., 257 ff.

Champeaux, A. de, and Gauchery, P., *Les Travaux d'art exécutés pour Jean de France, Duc de Berry*, Paris, 1894.

Champion, P., *Histoire poétique du quinzième siècle*, Paris, 1923.

—— *Vie de Charles d'Orléans*, Paris, 1911.

—— See also Orléans, Charles d'.

Chastel, A., "La Rencontre de Salomon et de la Reine de Saba dans l'iconographie médiévale," *Gazette des Beaux-Arts*, ser. 6, XXXV, 1949, p. 99 ff.

Châtelet, A., "A propos des Johannites de Haarlem et du retable peint par Geertgen tot Sint Jans," *L'Architecture Monastique, Actes et Travaux de la Rencontre Franco-Allemande des Historiens d'Art* (1951), Numéro Spécial du *Bulletin des Relations Artistiques France-Allemagne*, Mayence, 1951.

Clarke, M. V., "The Wilton Diptych," *Burlington Magazine*, LVIII, 1931, p. 283 ff.

Clemen, P., "Von den Wandmalereien auf den Chorschranken des Kölner Domes," *Wallraf-Richartz Jahrbuch*, I, 1924, p. 29 ff.

Cockerell, S. C., *The Book of Hours of Yolande of Flanders*, London, 1905.

Cohen, W., *Studien zu Quinten Metsys*, Bonn, 1904.

Colvin, S., *Selected Drawings from Old Masters in the University Galleries and in the Library of Christ Church, Oxford*, Oxford, 1903–1904.

Combe, J., *Jérôme Bosch*, Paris, 1946.

Constable, W. G., "A Florentine Annunciation," *Bulletin of the Museum of Fine Arts, Boston*, XLIII, 1945, p. 72 ff.

Conway, W. M., *The Van Eycks and Their Followers*, New York, 1921.

—— "A Head of Christ by John van Eyck," *Burlington Magazine*, XXXIX, 1921, p. 253 f.

—— "Some Treasures of the Time of Charles the Bald," *Burlington Magazine*, XXVI, 1914–1915, p. 236 ff.

Coosemans, M. E., see Hulin de Loo, G., "Rapport."

Coremans, P., "Technische Inleiding tot de Studie van de Vlaamse Primitieven," *Gentse Bijdragen tot de Kunstgeschiedenis*, XII, 1950, p. 111 ff.

——, Gettens, R. J., and Thissen, J., "La Technique des 'Primitifs Flamands'; I, Introduction; II, Th. Bouts, Le retable du Saint Sacrement," *Studies in (Etudes de) Conservation*, I, 1952, p. 1 ff.

—— and Janssens de Bisthoven, A., *Van Eyck; The Adoration of the Mystic Lamb*, Amsterdam, 1948.

——, Philippot, A., and Sneyers, R., *Van Eyck — L'Adoration de l'Agneau; Eléments nouveaux intéressant l'histoire de l'art*, Brussels, 1951.

—— See also *Collections and Exhibitions*, Brussels, *Palais des Beaux-Arts*, and *Addendum* at the end of this Bibliography.

Cornell, H., *Biblia Pauperum*, Stockholm, 1925.

—— *The Iconography of the Nativity of Christ*, Uppsala, 1924.

Cornette, A. H., *De Portretten van Jan van Eyck*, Antwerp and Utrecht, 1947.

Couderc, C., *Les Enluminures des manuscrits du moyen âge*, Paris, 1927.

Creutz, M., see Lüer, H.

Daniels, L. M., *Meester Dirc van Delft, O. P., Tafel van den Kersten Ghelove*, Antwerp and Utrecht, I, 1939.

David, H., *Claus Sluter*, Paris, 1951.

—— "Au pays de Claus Sluter," *Annales de Bourgogne*, XI, 1939, p. 187 ff.

Davies, M., *National Gallery Catalogues, Early Netherlandish School*, London, 1945.

—— "National Gallery Notes, I; Netherlandish Primitives: Geertgen tot Sint Jans," *Burlington Magazine*, LXX, 1937, p. 88 ff.

—— "National Gallery Notes, II; Netherlandish Primitives: Petrus Christus," *Burlington Magazine*, LXX, 1937, p. 138 ff.

—— "National Gallery Notes, III; Netherlandish Primitives: Rogier van der Weyden and Robert Campin," *Burlington Magazine*, LXXI, 1937, p. 140 ff.

Debouxthay, P., "A propos de l'Agneau Mystique," *Revue Belge d'Archéologie et d'Histoire de l'Art*, XIII, 1943, p. 149 ff. and XIV, 1944, p. 169 ff.

Degenhart, B., *Antonio Pisanello*, Vienna, 1940.

Delachenal, R., *Histoire de Charles V*, Paris, 1909–1931.

Delaissé, L. M. J., "Le Livre d'Heures d'Isabeau de Bavière," *Scriptorium*, IV, 1950, p. 252 ff.

—— "Le Livre d'Heures de Mary van Vronensteyn, chef-d'oeuvre inconnu d'un atelier d'Utrecht, achevé en 1460," *Scriptorium*, III, 1949, p. 230 ff.

—— "Une Production d'un atelier parisien et le caractère composite de certains Livres d'Heures," *Scriptorium*, II, 1948, p. 78 ff.

Delen, A. J. J., *Histoire de la gravure dans les anciens Pays-Bas*, Paris, 1924–1935.

Delisle, L., *Les Heures dites de Jean Pucelle, manuscrit de la collection de M. le Baron Maurice de Rothschild*, Paris, 1910.

—— "La Bible de Robert Billyng," *Revue de l'Art Chrétien*, LX, 1910, p. 297 ff.

Demonts, L., "Une Collection française de primitifs," *Revue de l'Art Ancien et Moderne*, LXX, 1937, p. 247 ff.

—— "Le Maître de l'Annonciation d'Aix et Colantonio," *Mélanges Hulin de Loo*, Brussels and Paris, 1931, p. 123 ff.

—— "Le Maître de l'Annonciation d'Aix et Colantonio," *Revue de l'Art Ancien et Moderne*, LXVI, 1934, p. 131 ff.

—— "Le Maître de l'Annonciation d'Aix; des van Eyck à Antonello de Messine," *Revue de l'Art Ancien et Moderne*, LIII, 1928, p. 257 ff.

Deschamps, Eustache, *Oeuvres complètes*, De Queux de Saint Hilaire and G. Raynaud, eds., Paris, 1878–1903.

Desneux, J., *Rigueur de Jean van Eyck*, Brussels, 1951.

Destrée, Joseph, *Hugo van der Goes*, Paris and Brussels, 1914.

—— *Tapisseries et sculptures bruxelloises*, Brussels, 1906.

—— "Ein Altarschrein der Brüsseler Schule," *Zeitschrift für Christliche Kunst*, VI, 1893, col. 173 ff.

—— "Etudes sur la sculpture brabançonne au moyen âge, IV," *Annales de la Société d'Archéologie de Bruxelles*, XIII, 1899, p. 273 ff.

Destrée, Jules, *Roger de la Pasture-van der Weyden*, Paris and Brussels, 1930.
REFERRED TO IN THE NOTES AS "Destrée."

—— "Altered in the Nineteenth Century? A Problem in the National Gallery, London," *The Connoisseur*, LXXIV, 1926, p. 209 ff.

—— "Le Retable de Cambrai de Roger da la Pasture," *Mélanges Hulin de Loo*, Brussels and Paris, 1931, p. 136 ff.

Devigne, M., *La Sculpture mosane du XIIᵉ au XVIᵉ siècle*, Paris and Brussels, 1932.

—— "Een nieuw Document voor de Geschiedenis der Beeldjes van Gérines," *Onze Kunst*, XXXIX, 1922, p. 49 ff.

—— "Notes sur l'exposition d'art flamand et belge à Londres," I, *Oud Holland*, XLIV, 1927, p. 65 ff.

—— "La Peinture ancienne à l'Exposition Internationale de Bruxelles," *Oud Holland*, LII, 1935, p. 266 ff.

Dimier, L., *Les Primitifs français*, Paris, n.d.

—— "Les Primitifs français," *Gazette des Beaux-Arts*, ser. 6, XVI, 1936, pp. 35 ff., 205 ff.

Doerner, M., *Malmaterial und seine Verwendung im Bilde*, 8th ed., Stuttgart, 1944 (English translation, entitled *The Materials of the Artist*, New York, 1934 and 1949).

Dolfen, C., *Codex Gisle*, Berlin, 1926.

Doutrepont, G., *La Littérature française à la cour des Ducs de Bourgogne* (Bibliothèque du XVᵉ siècle, VIII), Paris, 1909.

—— "Jean Lemaire de Belges et la Renaissance," *Académie Royale de Belgique, Classe des Lettres et des Sciences Morales et Politiques, Mémoires*, ser. 2, XXXII, 1934.

Drost, W., *Das Jüngste Gericht des Hans Memling in der Marienkirche zu Danzig*, Vienna, 1941.

Dülberg, F., *Frühholländer*, Haarlem, n.d.

Dupont, J., *Les Primitifs français*, Paris, 1937.

—— "Hayne de Bruxelles et la copie de Notre-Dame de Grâces de Cambrai," *L'Amour de l'Art*, XVI, 1935, p. 363 ff.

—— "Que dirons-nous?" *De van Eyck à Breughel* (special issue of *Les Beaux-Arts*, November 9, 1935).

Durrieu, P., *Heures de Turin*, Paris, 1902.

—— *La Miniature flamande aux temps de la cour de Bourgogne*, Brussels, 1921.

—— *Les Très-Belles Heures de Notre-Dame du Duc Jean de Berry*, Paris, 1922.

—— *Les Très Riches Heures de Jean de France, Duc de Berry*, Paris, 1904.

—— "Les 'Belles Heures' de Jean de France Duc de Berry," *Gazette des Beaux-Arts*, ser. 3, XXXV, 1906, p. 265 ff.

—— "Les Heures du Maréchal de Boucicaut du Musée Jacquemart-André," *Revue de l'Art Chrétien*, LXIII, 1913, pp. 73 ff., 145 ff., 300 ff.; LXIV, 1914, p. 28 ff.

—— "Jacques Coene, peintre de Bruges établi à Paris sous le règne de Charles VI," *Les Arts Anciens de Flandre*, II, 1905, p. 5 ff.

—— "Le Maître des Heures du Maréchal de Boucicaut," *Revue de l'Art Ancien et Moderne*, XIX, 1906, p. 401 ff.; XX, 1906, p. 21 ff.

—— "Manuscrits de luxe exécutés pour des princes et grands seigneurs français," *Le Manuscrit*, II, 1895, pp. 82 ff., 97 ff., 130 ff., 145 ff., 162 ff., 178 ff.

Duverger, J., *De Brusselsche Steenbickeleren . . . met een Aanhangsel over Klaas Sluter*, Ghent, 1933.

—— *Het Grafschrift van Hubrecht van Eyck en het Quatrain van hets Gentsche Lam Gods Retabel (Verhandelingen van de Koninklijke Vlaamsche Academie voor Wetenschapen, Letteren en Schoone Kunsten, VII, 4)*, Antwerp and Utrecht, 1945.

—— "Is Hubrecht van Eyck een legendarisch Personage?," *Kunst, Maandblad voor Oude en Jonge Kunst*, IV, 1933, p. 161 ff.

—— "Huibrecht en Jan van Eyck; Eenige nieuwe Gegevens betreffende hun Leven en hun Werk," *Oud Holland*, XLIX, 1932, p. 161 ff.

—— "Jan van Eyck voor 1422; Nieuwe Gegevens en Hypothesen," *Handelingen van het 3e Congres voor Allgemeene Kunstgeschiedenis*, Ghent, 1936, p. 13 ff.

Dvořák, M., *Das Rätsel der Kunst der Brüder van Eyck*, Munich, 1925.

—— "Die Anfänge der holländischen Malerei," *Jahrbuch der Königlich Preussischen Kunstsammlungen*, XXXIX, 1918, p. 51 ff.

—— "Die Illuminatoren des Johann von Neumarkt," *Jahrbuch der Kunsthistorischen Sammlungen des Allerhöchsten Kaiserhauses*, XXII, 1901, p. 35 ff.

Egbert, D. D., *The Tickhill Psalter and Related Manuscripts*, Princeton, 1940.

—— "A Sister to the Tickhill Psalter; the Psalter of Queen Isabella of England," *Bulletin of the New York Public Library*, XXXIX, 1935, p. 759 ff.

—— "The Western European Manuscripts," *The Princeton University Library Chronicle*, III, 1942, p. 123 ff.

Eibner, A., *Entwicklung und Werkstoffe der Tafelmalerei*, Munich, 1928.

—— "Zur Frage der van Eyck-Technik," *Repertorium für Kunstwissenschaft*, XXIX, 1906, p. 425 ff.

Ernst, R., *Beiträge zur Kenntnis der Tafelmalerei Böhmens im 14. und am Anfang des 15. Jahrhunderts*, Prague, 1912.

Evans, Joan, *Art in Mediaeval France, 987–1498*, London, New York and Toronto, 1948.

—— "The Duke of Orleans' Reliquary of the Holy Thorn," *Burlington Magazine*, LXXVIII, 1941, p. 196 ff.

—— "The Wilton Diptych Reconsidered," *Archaeological Journal*, CV, 1948 (published 1950), p. 1 ff.

Even, E. Van, "Monographie de l'ancienne Ecole de peinture de Louvain," *Messager des Sciences Historiques*, XXXIV, 1866, p. 1 ff.

Faider, P., "Pictor Hubertus; A propos d'un ouvrage récent," *Revue Belge de Philologie et d'Histoire*, XII, 1933, p. 1273 ff.

Falk, I., *Studien zu Andrea Pisano*, Hamburg, 1940.

Fava, D., *Tesori delle biblioteche d'Italia, Emilia e Romagna*, Milan, 1932.

Fazio, Bartolommeo, *Bartholomaei Facii De Viris Illustribus* (L. Mehus, ed.), Florence, 1745.

Fierens-Gevaert, *La Peinture en Belgique; les primitifs flamands*, Brussels, 1908–1912.

—— *Les Très-Belles Heures de Jean de France*, Brussels, Leyden and Paris, 1924.

—— and Fierens, P., *Histoire de la peinture flamande des origines à la fin du XVe siècle*, Paris and Brussels, 1927–1929.

Filarete, Averlino, *Antonio Averlino Filaretes Tractat über die Baukunst*, W. von Oettingen, ed., Vienna, 1890.

Fischel, L., "Ueber die künstlerische Herkunft der Frankfurter 'Paradiesesgärtleins,'" *Essays in Honor of Georg Swarzenski*, Chicago, 1951, p. 85 ff.

Fischer, O., "Die künstlerische Herkunft des Konrad Witz," *Pantheon*, XXIX, 1942, p. 99 ff.

Focillon, H., *Le Peintre des Miracles Notre Dame*, Paris, 1950.

Förster, O. H., *Stephan Lochner*, Cologne, 1938.

Fourez, L., "Le Roman de la Rose de la Bibliothèque de la Ville de Tournai," *Scriptorium*, I, 1946/47, p. 213 ff.

Francis, H. S., "Two Dutch Fifteenth-Century Panels," *Bulletin of the Cleveland Museum of Art*, XXXIX, 1952, p. 326 ff.

Fraenger, W., *Hieronymus Bosch, Das tausendjährige Reich*, Coburg, 1947 (English translation: *"The Millennium" of Hieronymus Bosch*, Chicago, 1951).

—— *Die Hochzeit zu Kana, Ein Dokument semitischer Gnosis bei Hieronymus Bosch*, Berlin, 1950.

—— *Der Tisch der Weisheit, bisher "Die Sieben Todsünden" genannt*, Stuttgart, 1951.

——— "Hieronymus Bosch in seiner Auseindersetzung mit dem Unbewussten," *Du, Schweizerische Monatsschrift*, XI, 1951, October, p. 7 ff.

Frankenburger, M., "Zur Geschichte des Ingolstädter und Landshuter Herzogsschatzes und des Stiftes Altötting," *Repertorium für Kunstwissenschaft*, XLIV, 1924, p. 23 ff.

Freeman, M. B., see Rorimer, J. J.

Frey, K., *Die Handzeichnungen Michelagniolos Buonarroti*, Berlin, 1909–1911.

Friedländer, M. J., *Die altniederländische Malerei*, Berlin (vols. X–XIV, Leiden), 1924–1937.
Referred to in the Notes as "Friedländer."

——— *Essays über die Landschaftsmalerei und andere Bildgattungen*, The Hague, 1947.

——— *Van Eyck bis Bruegel*, 2nd edition, Berlin, 1921.

——— *Der Genter Altar der Brüder van Eyck*, Munich, 1921.

——— *Hieronymus Bosch*, The Hague, 1941.

——— *Lucas van Leyden* (Meister der Graphik, XIII), Leipzig, 1924.

——— *Memling*, Amsterdam, n.d. [1950].

——— "Die Antwerpener Manieristen von 1520," *Jahrbuch der Königlich Preussischen Kunstsammlungen*, XXXVI, 1915, p. 65 ff.

——— "Bernaert van Orley," *Jahrbuch der Königlich Preussischen Kunstsammlungen*, XXX, 1909, p. 9 ff.

——— "Eine bisher unbekannte Epiphanie von Geertgen," *Maandblad voor beeldende Kunsten*, XXVI, 1950, p. 10 ff.

——— "Die Brügger Leihausstellung von 1902," *Repertorium für Kunstwissenschaft*, XXVI, 1903, p. 66 ff.

——— "The Death of the Virgin by Petrus Christus," *Burlington Magazine*, LXXXVIII, 1946, p. 158 ff.

——— "A Drawing by Roger van der Weyden," *Old Master Drawings*, I, 1926, p. 29 ff., pl. 38.

———"Drei niederländische Maler in Genua," *Zeitschrift für bildende Kunst*, LXI, 1927–1928, p. 273 ff.

——— "Flémalle-Meister-Dämmerung," *Pantheon*, VIII, 1931, p. 353 ff.

——— "Zu Geertgen tot Sint Jans," *Maandblad voor beeldende Kunsten*, XXV, 1949, p. 187 f.

——— "Le Maître de St.-Gilles," *Gazette des Beaux-Arts*, 6 ser., XVII, 1937, p. 221 ff.

——— "Der Meister der Katharinen-Legende und Rogier van der Weijden," *Oud Holland*, LXIV, 1949, p. 156 ff.

——— "Neues zu Quentin Massys," *Cicerone*, XIX, 1927, p. 1 ff.

——— "A new Painting by van Eyck," *Burlington Magazine*, LXV, 1934, p. 3 f.

——— "Der Rogier-Altar aus Turin," *Pantheon*, XI, 1933, p. 7 ff.

——— "Eine Zeichnung von Hugo van der Goes," *Pantheon*, XV, 1935, p. 99 ff.

——— See also Hendy, P.; and *Collections and Exhibitions*, Vierhouten, D. G. van Beuningen Collection.

Friedmann, H., "The Symbolism of Crivelli's Madonna and Child Enthroned with Donor in the National Gallery," *Gazette des Beaux-Arts*, ser. 6, XXXIII, 1947, p. 65 ff.

Fuhse, F., see Lange, K.

Futterer, I., "Zur Malerei des frühen XV. Jahrhunderts im Elsass," *Jahrbuch der Preussischen Kunstsammlungen*, XLIX, 1928, p. 187 ff.

Gabriel, A., *Les Rapports dynastiques franco-hongrois au moyen-âge*, Budapest, 1944.

Gabrielli, N., "Opere di maestri fiamminghi a Chieri nel quattrocento," *Bollettino Storico-Bibliografico Subalpino*, XXXVIII, 1936, p. 427 ff.

Galbraith, V. H., "A New Life of Richard II," *History*, XXVI, 1942, p. 223 ff.

Gans, E., and Kisch, G., "The Cambyses Justice Medal," *Art Bulletin*, XXIX, 1947, p. 121 ff.

Gaspar, C., and Lyna, F., *Les Principaux Manuscrits à peintures de la Bibliothèque Royale de Belgique*, Paris, 1937–1945.

Gauchery, P., see Champeaux, A. de.

Gavelle, E., *Cornelis Engelbrechtsz.*, Lyons, 1929.

Geisberg, M., *Die Anfänge des deutschen Kupferstichs und der Meister E. S.* (Meister der Graphik, II), 2nd ed., Leipzig, 1923.

——— *Die Kupferstiche des Meisters E. S.*, Berlin, 1924.

——— *Meister Konrad von Soest* (Westfälische Kunsthefte, II), Dortmund, 1934.

Gelder, J. G. van, "Het zoogenaamde Portret van Dieric Bouts op 'Het Werc van den Heilichen Sacrament,'" *Oud Holland*, LXVI, 1951, p. 51 f.

Geradon, E. de, see Arù, C.

Gerson, H., *Van Geertgen tot Frans Hals; De Nederlandsche Schilderkunst*, Amsterdam, 1950.

Gerstenberg, K., *Hans Multscher*, Leipzig, 1928.

——— "Ueber ein verschollenes Gemälde von Ouwater," *Zeitschrift für Kungstgeschichte*, V, 1936, p. 133 ff.

Gettens, R. J., and Stout, G. L., *Painting Materials*, New York, 1943.

——— See also Coremans, P.

Geyl, P., *Eenheid en Tweeheid in de Nederlanden*, Lochem, 1946.

——— *From Ranke to Toynbee; Five Lectures on Historians and Historiographical Problems* (Smith College Studies in History, XXXIX), Northampton, Mass., 1952.

Gillet, L., *La Peinture française, moyen âge et renaissance*, Paris and Brussels, 1928.

Glaser, C., *Die altdeutsche Malerei*, Munich, 1924.

Glück, G., see *Collections and Exhibitions*, The Hague, Del Monte Collection.

Göbel, H., *Wandteppiche*, Leipzig, 1923–1934.

Goetz, O., "Der Gekreuzigte des Jacques de Baerze," *Festschrift für Carl Georg Heise zum 28. Juni, 1950*, Berlin, 1950, p. 158 ff.

Goldschmidt, A., *Die Elfenbeinskulpturen aus der Zeit der Karolingischen und Sächsischen Kaiser*, II, Berlin, 1918.

—— "Holländische Miniaturen aus der ersten Hälfte des 15ten Jahrhunderts," *Oudheidkundig Jaarboek*, III, 1923, p. 22 ff.

—— "Der Monforte-Altar des Hugo van der Goes," *Zeitschrift für Bildende Kunst*, XXVI, 1915, p. 221 ff.

Goris, J.-A., *Portraits by Flemish Masters in American Collections*, New York, 1949.

Graesse, T., see Jacobus de Voragine.

Graham, R., "The Apocalypse Tapestries from Angers," *Burlington Magazine*, LXXXIX, 1947, p. 227.

Grodecki, L., "The Jacques Coeur Window at Bourges," *Magazine of Art*, XLII, 1949, p. 64 ff.

Gudiol i Cunill, J., *Els Primitius* (La Pintura Mig-Eval Catalana), Barcelona, 1927–1929.

Guiffrey, J. M. J., *Inventaires de Jean, Duc de Berry*, Paris, 1894–96.

Guiffrey, J., and Marcel, P., *La Peinture française; Les primitifs*, Paris, n.d.

Guillaume-Linephty, M., *Hans Memling in the Hospital of St. John at Bruges*, Paris, 1939.

—— *Hans Memling: The Shrine of St. Ursula*, Paris, 1939.

Guyot de Villeneuve, F. G. A. de, *Notice sur un manuscrit français du XIVᵉ siècle; les Heures du Maréchal de Boucicaut* (pour la Société des Bibliophiles Français), Paris, 1889.

Habicht, V. D., "Giovanni Bellini und Rogier v. d. Weyden," *Belvedere*, X, 1931, p. 54 ff.

Hahnloser, H. R., see Villard de Honnecourt.

Halkin, L., "L'Itinerarium Belgicum de Dubuisson-Aubenay," *Revue Belge d'Archéologie et d'Histoire de l'Art*, XVI, 1946, p. 47 ff.

Hall, H. van, *Repertorium voor de Geschiedenis der Nederlandsche Schilder- en Graveerkunst*, The Hague, 1936–1949.

Hannema, D., see *Collections and Exhibitions*, Vierhouten, D. G. van Beuningen Collection.

Harrsen, M., *The Nekcei-Lipocz Bible, A Fourteenth-Century Manuscript from Hungary in the Library of Congress*, Washington, 1949.

—— "A Book of Hours for Paris Use," *Die Graphischen Künste*, new ser., III, 1938, p. 91 ff.

Hartlaub, G. F., *Das Paradiesesgärtlein von einem oberrheinischen Maler* (Der Kunstbrief, 1947).

Hartt, F., "Lignum Vitae in Medio Paradisi: The Stanza d'Eliodoro and the Sistine Ceiling," *Art Bulletin*, XXXII, 1950, p. 115 ff.

Hatzfeld, H. A., "Literary Criticism through Art and Art Criticism through Literature," *Journal of Aesthetics and Art Criticism*, VI, 1947, p. 1 ff.

Heidrich, E., *Alt-Niederländische Malerei*, Jena, 1910 (reprinted 1924).

Heimann, A., "Der Meister der 'Grandes Heures de Rohan' und seine Werkstatt," *Städel-Jahrbuch*, VII–VIII, 1932, p. 1 ff.

Heise, C. G., *Der Lübecker Passionsaltar von Hans Memling*, Hamburg, 1950.

—— *Norddeutsche Malerei*, Leipzig, 1918.

Heitz, P., *Einblattdrucke des fünfzehnten Jahrhunderts*, LIX, Strasbourg, 1908 ff.

Held, J., *Dürers Wirkung auf die niederländische Kunst seiner Zeit*, The Hague, 1931.

—— Review of Wehle and Salinger's Metropolitan Museum Catalogue, *Art Bulletin*, XXXI, 1949, p. 139 ff.

Hélin, M., "Un Texte inédit sur l'iconographie des Sibylles," *Revue Belge de Philologie et d'Histoire*, XV, 1936, p. 349 ff.

Hendy, P., and Friedländer, M. J., "A Roger van der Weyden Altarpiece," *Burlington Magazine*, LXIII, 1933, p. 53 ff.

Herbert, J. A., *The Sherborne Missal*, Oxford, 1920.

Hermann, H. J., *Beschreibendes Verzeichnis der illuminierten Handschriften in Oesterreich*, VIII, VII, 3, Leipzig, 1938.

Herrad of Landsberg, *Hortus deliciarum*, A. Straub and G. Keller, eds., Strasbourg, 1901.

Heubach, D., *Aus einer niederländischen Bilderhandschrift vom Jahre 1410; Grisaillen und Federzeichnungen der altflämischen Schule*, Strasbourg, 1925.

Hill, A. G., *Organ Cases of the Middle Ages and Renaissance*, London, 1883.

Hölker, C., *Meister Conrad von Soest* (Beiträge zur Westfälischen Kunstgeschichte, VII), Münster, 1921.

Hoffman, D. M., "A Little-Known Masterpiece; Our Lady of the Sanctus," *Liturgical Arts*, XVIII, 1950, p. 43 ff.

Hoffmann, E., "Die Bücher Ludwigs des Grossen und die Ungarische Bilderchronik," *Zentralblatt für Bibliothekswesen*, LIII, 1936, p. 653 ff.

Holter, K., "Eine Wiener Handschrift aus der Werkstatt des Meisters des Zweder van Culenborg," *Oudheidkundig Jaarboek*, ser. 4, VII, 1938, p. 55 ff.

Holtzinger, H., see Santi, Giovanni.

Hontoy, M., "Les Miniatures de l'Apocalypse flamande de Paris," *Scriptorium*, I, 1946–1947, p. 289 ff.

Hoogewerff, G. J., *Jan van Scorel, peintre de la renaissance hollandaise*, The Hague, 1923.

—— *De Noord-nederlandsche Schilderkunst*, The Hague, 1936–1947.

REFERRED TO IN THE NOTES AS "Hoogewerff."

—— See also Byvanck, A. W.

Horstmann, C., *The Three Kings of Cologne* (Early English Text Society, vol. LXXXV), London, 1886.

Houben, W., "Raphael and Rogier van der Weyden," *Burlington Magazine*, XCI, 1949, p. 312 ff.

Houtart, M., *Quel est l'état de nos connaissances relativement à Campin, Jacques Daret et Roger van der Weyden?* (Communication faite au XXIIIᵉ Congrès de la Fédération Archéologique et Historique), Ghent, 1914.

—— "Jacques Daret, peintre tournaisien du XVe siècle," *Revue Tournaisienne*, III, 1907, p. 34 f.

Hugelshofer, W., "Eine Malerschule in Wien zu Anfang des 15. Jahrhunderts," *Beiträge zur Geschichte der Deutschen Kunst*, E. Buchner and K. Feuchtmayr, eds., Augsburg, 1924, I, p. 21 ff.

Huillet d'Istria, M., "Jean Perréal," *Gazette des Beaux-Arts*, ser. 6, XXXV, 1949, pp. 313 ff., 377 ff.

Huizinga, J., *The Waning of the Middle Ages*, London, 1924.

—— *Herbst des Mittelalters*, 2nd ed., Munich, 1928; 3rd ed., Munich, 1931.

Hulin de Loo, G., *Heures de Milan*, Brussels and Paris, 1911.

—— *Pedro Berruguete et les Portraits d'Urbin*, Brussels, 1942.

—— "An Authentic Work by Jaques Daret, Painted in 1434," *Burlington Magazine*, XV, 1909, p. 202 ff.

—— "La Bible de Philippe le Hardi historiée par les frères de Limbourc: Manuscrit français no. 166 de la Bibliothèque Nationale à Paris," *Bulletin de la Société d'Histoire et d'Archéologie de Gand*, XVI, 1908, p. 183 ff.

—— "Diptychs by Rogier van der Weyden," *Burlington Magazine*, XLIII, 1923, p. 53 ff., and XLIV, 1924, p. 179 ff.

—— "La Fameuse Inscription du retable de l'Agneau," *Revue Archéologique*, ser. 6., III, 1934, p. 62 ff.

—— "Hans Memlinc in Rogier van der Weyden's Studio," *Burlington Magazine*, LII, 1928, p. 160 ff.

—— "Le Portrait du Médailleur par Hans Memlinc: Jean de Candida et non Niccolo Spinelli," *Festschrift für Max J. Friedländer zum 60. Geburtstage*, Leipzig, 1927, p. 103 ff.

—— "Rapport," Académie Royale de Belgique, *Bulletins de la Classe des Beaux-Arts*, VII, 1925, p. 123.

—— "Roger van der Weyden," *Biographie Nationale de Belgique*, Brussels, XXVII, 1938, col. 222 ff.

—— "Le Sujet du retable des Frères van Eyck à Gand: La glorification du Sauveur," *Annuaire des Musées Royaux des Beaux-Arts de Belgique*, III, 1940–42, p. 1 ff.

—— "Les Tableaux de justice de Rogier van der Weyden et les tapisseries de Berne," *XIVe Congrès International d'Histoire de l'Art, Suisse, 1936, Actes du Congrès*, Basel, 1938, II, p. 141 ff.

—— "Traces de Hubrecht van Eyck; Empreintes contemporaines en Suisse et Allemagne," *Annuaire des Musées Royaux de Belgique*, IV, 1943–1944, p. 3 ff.

—— "Les Très Riches Heures de Jean de France, Duc de Berry, par Pol de Limbourc et ses frères," *Bulletin de la Société d'Histoire et d'Archéologie de Gand*, XI, 1903, p. 178 ff.

—— See also *Collections and Exhibitions*, Bruges, 1902, *Exposition*, and Bruges, *Renders Collection*.

Huth, H., *Künstler und Werkstatt der Spätgotik*, Augsburg, 1923.

—— "A Mediaeval Painting," *The Art Institute of Chicago, Bulletin*, XLII, 1948, p. 18 ff.

Ivins, W. M., Jr., *Art and Geometry*, Cambridge, Mass., 1946.

Jacobus de Voragine, *Jacobi a Voragine Legenda Aurea vulgo Historia Lombardica dicta*, T. Graesse, ed., Breslau, 1890.

Jähnig, K. W., "Die Beweinung Christi vor dem Grabe von Rogier van der Weyden," *Zeitschrift für Bildende Kunst*, LIII, 1918, p. 171 ff.

James, M. R., *The Apocryphal New Testament*, Oxford, 1924 and 1926.

—— See also Collections and Exhibitions, Cambridge, England, *Fitzwilliam Museum*; London, *H.Y. Thompson Collection*; and Manchester, *John Rylands Library*.

Jamot, P., see *Collections and Exhibitions*, Paris, *Musée de l'Orangerie*.

Janitschek, H., see Alberti, Leone Battista.

Janson, H. W., *Apes and Ape Lore in the Middle Ages and the Renaissance* (Studies of the Warburg Institute, XX), London, 1952.

Janssens de Bisthoven, A., and Parmentier, R. A., *Le Musée Communal de Bruges* (*Les Primitifs Flamands, Corpus de la Peinture des Anciens Pays-Bas Méridionaux au Quinzième Siècle*, Vol. I), Antwerp, 1951.

—— See also Coremans, P.

Jerchel, H., "Die Niederrheinische Buchmalerei der Spätgotik," *Wallraf-Richartz Jahrbuch*, X, 1938, p. 65 ff.

Jonge, C. H. de, "Jan van Scorel," in: *Niederländische Malerei im XV. und XVI. Jahrhundert*, Amsterdam and Leipzig, 1941, p. 209 ff.

Josephson, R., "Die Froschperspektive des Genter Altars," *Monatshefte für Kunstwissenschaft*, VIII, 1915, p. 198 ff.

Kahn, R., *Die Graphik des Lucas van Leyden*, Strasbourg, 1918.

Kantorowicz, E. H., "The Este Portrait by Roger van der Weyden," *Journal of the Warburg and Courtauld Institutes*, III, 1939–1940, p. 165 ff.

—— "The Quinity of Winchester," *Art Bulletin*, XXIX, 1947, p. 73 ff.

Katzenellenbogen, A., "The Separation of the Apostles," *Gazette des Beaux-Arts*, ser. 6., XXXV, 1949, p. 81 ff.

Kauffmann, H., "Jan van Eycks 'Arnolfinihochzeit,'" *Geistige Welt, Vierteljahrsschrift für Kultur- und Geisteswissenschaften*, IV, 1950, p. 45 ff.

—— "Ein Selbstporträt Rogers van der Weyden auf den Berner Trajansteppichen," *Repertorium für Kunstwissenschaft*, XXXIX, 1916, p. 15 ff.

Kehrer, H. C., *Die heiligen drei Könige in Literatur und Kunst*, Leipzig, 1908–09.

Keller, G., see Herrad of Landsberg.

Keller, H., "Die Entstehung des Bildnisses am Ende des Hochmittelalters," *Römisches Jahrbuch für Kunstgeschichte*, III, 1939, p. 227 ff.

Kerber, O., *Hubert van Eyck*, Frankfort, 1937.

——— *Rogier van der Weyden und die Anfänge der neuzeitlichen Tafelmalerei*, Kallmünz, 1936.

——— "Frühe Werke des Meisters von Flémalle im Berliner Museum," *Jahrbuch der Preussischen Kunstsammlungen*, LIX, 1938, p. 59 ff.

Kern, G. J., *Die Grundzüge der linear-perspektivischen Darstellung in der Kunst der Gebrüder van Eyck und ihrer Schule*, Leipzig, 1904.

——— *Die verschollene Kreuztragung des Hubert oder Jan van Eyck*, Berlin, 1927.

——— "Perspektive und Bildarchitektur bei Jan van Eyck," *Repertorium für Kunstwissenschaft*, XXXV, 1912, p. 27 ff.

Kessen, A. van, "De Madonna van Rollin en Maastricht," *De Maasgouw*, LXIII, 1943, p. 2 ff.

Kessler, J. H. H., *Geertgen tot Sint Jans; zijn Herkomst en Invloed in Holland*, Utrecht, 1930.

Kisch, G. see Gans, E.

Klein, D., *St. Lukas als Maler der Maria*, Berlin, 1933.

Kleinclauz, A., "Les Peintres des Ducs de Bourgogne," *Revue de l'Art Ancien et Moderne*, XX, 1906, p. 161 ff.

Kleinschmidt, B., *Die heilige Anna*, Düsseldorf, 1930.

Kletzl, O., "Studien zur böhmischen Buchmalerei," *Marburger Jahrbuch für Kunstwissenschaft*, VII, 1933, p. 1 ff.

Knipping, J. B., "Hugo van der Goes," in: *Niederländische Malerei im XV. und XVI. Jahrhundert*, Amsterdam and Leipzig, 1941, p. 121 ff.

Koch, R. A., "Geertgen tot Sint Jans in Bruges," *Art Bulletin*, XXXII, 1951, p. 259 ff.

——— "Two Sculptures after Rogier's 'Descent from the Cross' in the Escorial," *Journal of the Walters Art Gallery*, XI, 1947, p. 39 ff.

Koechlin, R., *Les Ivoires gothiques français*, Paris, 1924.

Kozáky, I., *Geschichte der Totentänze*, Budapest, 1936.

Krautheimer, R., "Ghiberti and Master Gusmin," *Art Bulletin*, XXIX, 1947, p. 25 ff.

Krönig, W., "Die Frühzeit des Jan Gossart," *Zeitschrift für Kunstgeschichte*, III, 1934, p. 163 ff.

——— "Geertgens Bild Johannes' des Täufers," *Das Münster*, III, 1950, p. 193 ff.

Kuhn, A., "Die Illustration des Rosenromans," *Jahrbuch der Kunsthistorischen Sammlungen des Allerhöchsten Kaiserhauses*, XXXI, 1913/14, p. 1 ff.

Kuhn, C., "Hermann Scheerre and English Illumination of the Early Fifteenth Century," *Art Bulletin*, XXII, 1940, p. 138 ff.

Kurth, B., "Ein Freskenzyklus im Adlerturm zu Trient," *Jahrbuch des Kunsthistorischen Institutes der K. K. Zentralkommission für Denkmalpflege*, V, 1911, p. 9 ff.

——— "Die Wiener Tafelmalerei in der ersten Hälfte des 14. Jahrhunderts," *Jahrbuch der Kunsthistorischen Sammlungen in Wien*, new ser., III, 1929, p. 25 ff.

Laban, F., "Ein Neuer Roger," *Zeitschrift für Bildende Kunst*, new ser., XIX, 1908, p. 49 ff.

Labande, L.-H., *Les Primitifs français*, Marseille, 1932.

——— "Les Miniaturistes Avignonais et leurs oeuvres," *Gazette des Beaux-Arts*, ser. 3., XXXVII, 1907, pp. 213 ff., 289 ff.

——— *Le Palais des Papes et les monuments d'Avignon au XIVe siècle*, Marseille, 1925.

Laborde, A. de, *Etude sur la Bible Moralisée illustrée*, Paris, 1911–1927.

——— *Les Manuscrits à peintures de la Cité de Dieu de St. Augustin*, Paris, 1909.

Lafond, P., *Hieronymus Bosch*, Paris and Brussels, 1914.

——— *Roger van der Weyden*, Brussels, 1912.

Lambert, E., "La Vierge à l'Enfant de la Collection Mancel à Caen," *Bulletin des Musées Français*, VIII, 1936, p. 27 ff.

Lambotte, P., *Hans Memling, Le Maître de la Châsse de Ste. Ursule*, Antwerp, 1939.

——— See also *Collections and Exhibitions*, Brussels, *Exposition Universelle*, and Paris, *Musée de l'Orangerie*.

Landelin-Hoffmans, P., O. M. L., *Un Rogier van der Weyden inconnu*, Enghien, 1948.

Lange, K., and Fuhse, F., *Dürers schriftlicher Nachlass*, Halle, 1893.

Lauer, P., see Martin, H.

Laurie, A., *The Pigments and Mediums of the Old Masters*, London, 1914.

——— "The van Eyck Medium," *Burlington Magazine*, XXIII, 1913, p. 72 ff.

Lauts, J., *Antonello da Messina*, 2nd ed., Vienna, 1940.

——— "Antonello da Messina," *Jahrbuch der Kunsthistorischen Sammlungen in Wien*, new ser., VII, 1933, p. 15 ff.

Lavalleye, J., *Juste de Gand, Peintre de Frédéric de Montefeltre*, Louvain, 1936.

——— *Le Portrait au XVme siècle*, Brussels, 1945.

——— "Le Problème Maître de Flémalle-Rogier van der Weyden," *Revue Belge de Philologie et d'Histoire*, XII, 1933, p. 791 ff.

——— See also Leurs, S.

Lederle-Grieger, U., *Gerechtigkeitsdarstellungen in deutschen und niederländischen Rathäusern* (Heidelberg doctoral dissertation), Philippsburg, 1937.

Leeuwenberg, J., "De tien bronzen 'Plorannen' in het Rijksmuseum te Amsterdam, hun Herkomst en de Voorbeelden waaran zij zijn ontleend," *Gentse Bijdragen tot de Kunstgeschiedenis*, XIII, 1951, p. 13 ff.

Lehnert, G., *Illustrierte Geschichte des Kunstgewerbes*, Berlin, II, n.d.

Lehrs, M., *Geschichte und Kritischer Katalog des deutschen, niederländischen und französischen Kupferstichs im XV. Jahrhundert*, Vienna, 1908–1930.

Lejard, A., *Les Tapisseries de l'Apocalypse de la Cathédrale d'Angers*, Paris, 1942.

Le Maire, Dr. C., "Vers l'identification d'un portrait exécuté par Roger van der Weyden," *Bulletin de la Société Royale d'Archéologie de Bruxelles*, VIII, 1935, p. 107 ff.

Lemoine, J. G., "Deux Secrets orientaux transmis à l'occident; La préparation du bleu d'outremer; Le vernis des Van Eyck," *Revue Belge d'Archéologie et d'Histoire de l'Art*, XIX, 1950, p. 175 ff.

Lemoisne, P. A., *Gothic Painting in France*, Florence, 1931.

Leroquais, V., *Les Bréviaires manuscrits des bibliothèques publiques de France*, Paris, 1934.

—— *Les Livres d'Heures manuscrits de la Bibliothèque Nationale*, Paris, 1927.

—— *Un Livre d'Heures de Jean Sans Peur, Duc de Bourgogne*, Paris, 1939.

—— *Un Livre d'Heures manuscrit à l'usage de Mâcon*, Mâcon, 1935.

—— *Les Pontificaux manuscrits des bibliothèques publiques de France*, Paris, 1937.

—— *Les Psautiers manuscrits latins des bibliothèques publiques de France*, Mâcon, 1940–41.

—— *Les Sacramentaires et les Missels manuscrits des bibliothèques publiques de France*, Paris, 1924.

—— *Supplément aux Livres d'Heures manuscrits de la Bibliothèque Nationale*, Mâcon, 1943.

Leurs, S., *Geschiedenis van de Vlaamsche Kunst*, Antwerp and The Hague, n.d. [1936–1939].

Liebreich, A., *Claus Sluter*, Brussels, 1936.

Lindeman, C. M. M. A., "De Dateering, Herkomst en Identificatie der 'Gravenbeeldjes' van Jacques de Gérines," *Oud Holland*, LVIII, 1941, pp. 49 ff., 97 ff., 161 ff., 193 ff.

Linfert, H., *Alt-Kölner Meister*, Munich, 1941.

Lipman, J. H., "The Florentine Profile Portrait in the Quattrocento," *Art Bulletin*, XVIII, 1936, p. 54 ff.

Ludwig, G., "Giovanni Bellinis sogennante Madonna am See," *Jahrbuch der Königlich Preussischen Kunstsammlungen*, XXIII, 1902, p. 163 ff.

Lüer, H., and Creutz, M., *Geschichte der Metallkunst*, Stuttgart, 1904–1909.

Lutz, J., and Perdrizet, P., *Speculum Humanae Salvationis*, Mülhausen, 1907–1909.

Lyna, F., *De Vlaamsche Miniatuur van 1200 tot 1530*, Brussels, n.d. [1933].

—— "Over de Echtheid van de Grafschrift van Hubrecht van Eyck en het Quatrain van de Gentsche Altartafel," *Verzamelde Opstellen* (published by the Belgian State Archives at Hasselt), IX, 1933, p. 99 ff.

—— "Uit en over Handschriften, II, Portretten van Wenceslaus van Brabant," *Kunst der Nederlanden*, I, 1930–31, p. 321 ff.

—— "Les Miniatures d'un ms. du 'Ci Nous Dit' et le réalisme Préeyckien," *Scriptorium*, I, 1946–1947, p. 106 ff.

Referred to in the Notes as "Lyna, 'Le Réalisme.'"

—— "Une Oeuvre inconnue du Maître de Marie de Bourgogne," *Scriptorium*, I, 1946/47, p. 310 ff.

—— See also Gaspar, C.; Leurs, S.; and Renders, E.

Lyna, J., "Les Peintres van Eyck et l'École de Maestricht," *Paginae Bibliographicae*, I, 1926, p. 114 ff.

Maere, R., "Over het Afbeelden van bestaande Gebouwen in het Schilderwerk van Vlaamsche Primitieven," *Kunst der Nederlanden*, I, 1930–31, p. 201 ff.

Maeterlinck, L., "Le 'Maître de Flémalle' et l'École Gantoise primitive," *Gazette des Beaux-Arts*, ser. 4, X, 1913, p. 53 ff.

Mâle, E., *L'Art religieux de la fin du moyen âge en France*, first ed., Paris, 1908.

—— *Quomodo Sibyllas recentiores artifices repraesentaverint*, Paris, 1899.

Malo, M., "*Les Très Riches Heures du Duc de Berry*," Paris, 1933.

Manasse, E. M., "The Dance Motive of the Latin Dance of Death," *Medievalia and Humanistica*, IV, 1946, p. 83 ff.

Mander, Carel van, *Het Schilder-Boeck*, Haarlem (and Alkmaar), 1604.

Maquet-Tombu, J., *Colyn de Coter, peintre bruxellois*, Brussels, 1937, p. 18 ff.

—— "Autour de la Descente de Croix de Roger," *Bulletin de la Société Royale d'Archéologie de Bruxelles*, 1949, July, p. 1 ff.

—— "Inspiration et originalité des tapisseries de l'Apocalypse d'Angers," *Mélanges Hulin de Loo*, Brussels and Paris, 1931, p. 260 ff.

—— "Les Tableaux de justice de Roger van der Weyden à l'Hôtel de Ville de Bruxelles," *Phoebus*, II, 1949, p. 178 ff.

Marceau, H., see *Catalogues and Exhibitions*, Philadelphia, *The John G. Johnson Collection*.

Marcel, P., see Guiffrey, J.

Marchig, G., *L'Adorazione di Hugo van der Goes*, Florence, 1947.

Marijnissen, R. H., see Schryver, A. P. de.

Marle, R. van, *The Development of the Italian Schools of Painting*, The Hague, 1923–1938.

Maroger, J., *The Secret Formulas and Techniques of the Old Masters*, New York, 1948.

Martens, B., *Meister Francke*, Hamburg, 1929.

Martin, H., *Le Boccace de Jean sans Peur*, Brussels and Paris, 1911.

—— *Les Joyaux de l'enluminure à la Bibliothèque Nationale*, Paris and Brussels, 1928.

—— *La Miniature française du XIIIe au XVe siècle*, Paris and Brussels, 1923.

—— *Le Térence des Ducs*, Paris, 1907.

Martin, H., and Lauer, Ph., *Les Principaux Manuscrits à peintures de la Bibliothèque de l'Arsenal à Paris*, Paris, 1929.

Martin, K., see *Collections and Exhibitions*, Paris, *Musée de l'Orangerie, Des Maîtres de Cologne*.

Matějček, A., *Gotische Malerei in Böhmen*, Prague, 1939.

Matějček, A., and Pesina, J., *Czech Gothic Painting 1350–1450*, Prague, 1950.

Mather, F. J., Jr., "The Problem of the Adoration of the Lamb," *Gazette des Beaux-Arts*, ser. 6, XXIX, 1946, p. 269 ff.; XXX, p. 75 ff.

Mayer, A. L., "Die Ausstellung der Sammlung 'Schloss Rohoncz' in der Neuen Pinakothek, München," *Pantheon*, VI, 1930, p. 297 ff.

Medding, W., "Der Kreuzabnahmealtar zu Niederwaroldern und seine Beziehungen zu Rogier van der Weyden," *Zeitschrift für Kunstgeschichte*, VII, 1938, p. 119 ff.

Meiss, M., *Painting in Florence and Siena after the Black Death*, Princeton, 1951.

—— "A Documented Altarpiece by Piero della Francesca," *Art Bulletin*, XXIII, 1941, p. 53 ff.

—— "Fresques italiennes, cavallinesques et autres, à Béziers," *Gazette des Beaux-Arts*, ser. 6, XVIII, 1937, p. 275 ff.

—— "Italian Primitives at Konopiště," *Art Bulletin*, XXVIII, 1946, p. 1 ff.

—— "Italian Style in Catalonia and a Fourteenth-Century Italian Workshop," *The Journal of the Walters Art Gallery*, IV, 1941, p. 45 ff.

—— "Light as Form and Symbol in Some Fifteenth-Century Paintings," *Art Bulletin*, XXVII, 1945, p. 175 ff.

—— "The Madonna of Humility," *Art Bulletin*, XVIII, 1936, p. 434 ff.

—— " 'Nicholas Albergati' and the Chronology of Jan van Eyck's Portraits," *Burlington Magazine*, XCIV, 1952, p. 137 ff.

Mély, F. de, "Le Bréviaire Grimani et les inscriptions de ses miniatures," *Revue de l'Art Ancien et Moderne*, XXV, 1909, p. 81 ff.

—— "Signatures de primitifs; Le retable de Roger van der Weyden au Louvre et l'inscription du turban de la Madeleine," *Revue Archéologique*, ser. 5, VII, 1918, p. 50 ff.

Mercier, F., "La Valeur symbolique de l'oeillet dans la peinture du moyen-âge," *Revue de l'Art Ancien et Moderne*, LXXI, 1937, p. 233 ff.

Meurgey, J., *Les Principaux Manuscrits à peintures du Musée Condé*, Paris, 1930.

Michel, A., *Avignon, les fresques du Palais des Papes*, 2nd edition, Paris, 1926.

—— *Histoire de l'art*, Paris, 1905–1929.

Michel, E., *L'Ecole Flamande du XVᵉ siècle au Musée du Louvre*, Brussels, 1944.

—— "Le Maître de Francfort," *Gazette des Beaux-Arts*, ser. 6, XII, 1934, p. 236 ff.

—— "Une Presentation au Temple d'École Franco-Flamande," *Bulletin des Musées de France*, III, 1931, p. 2 ff.

—— "A propos de l'Exposition d'Art Flamand à Londres," *Gazette des Beaux-Arts*, ser. 5, XIV, 1926, p. 345 ff.

—— *Rogier van der Weyden; Sept reproductions en couleurs d'après les tableaux de l'Escurial et du Musée du Prado*, London, 1945.

—— See also *Collections and Exhibitions*, Bruges, *Renders Collection*.

Milanesi, G., see Vasari.

Millar, E. G., *English Illuminated Manuscripts of the XIVth and XVth Centuries*, Paris and Brussels, 1928.

—— See also *Collections and Exhibitions*, London, *The Library of A. Chester Beatty*.

Millet, G., "Recherches sur l'iconographie de l'Evangile," *Bibliothèque des Ecoles Françaises d'Athènes et de Rome*, vol. CIX, 2, 1916.

Molanus, Johannes, *De picturis et imaginibus sacris*, Louvain, 1570, reprinted in J. P. Migne's *Theologiae Cursus Completus*, vol. XXVII.

Mongan, A. (ed.), *One Hundred Master Drawings*, Cambridge, Mass., 1949.

Mongan, E., see *Collections and Exhibitions*, Washington, *Rosenwald Collection*.

Monget, C., *La Chartreuse de Dijon d'après les documents des Archives de Bourgogne*, Montreuil-sur-Mer, 1898–1905.

Morey, C. R., *Mediaeval Art*, New York, 1942.

—— "A Group of Gothic Ivories in the Walters Art Gallery," *Art Bulletin*, XVIII, 1936, p. 199 ff.

Morin, L., "Le Manuscrit Colbert de Beaulieu du 'Ci nous dit,' " *Scriptorium*, I, 1946/47, p. 75 ff.

Morpurgo, S., see Vries, Scato de.

Mosmans, J., *Iheronimus Anthonis-zoon van Aken, alias Hieronymus Bosch, zijn Leven und zijn Werk*, 'sHertogenbosch, 1947.

Münzel, G., "Zu dem Bilde des sogennanten Tymotheos von Jan van Eyck," *Zeitschrift für Kunstgeschichte*, X, 1941–42, p. 188 ff.

Musper, T., *Untersuchungen zu Rogier van der Weyden und Jan van Eyck*, Stuttgart, 1948. REFERRED TO IN THE NOTES AS "Musper."

Neurdenburg, E., "Eenige Opmerkingen naar Aanleiding van de nieuwste Verklaringen van de algemeene Beteekenis van het Gentsche Altaar," *Handeligen van het 3ᵉ Congres voor Algemeene Kunstgeschidenis*, Ghent, 1936, p. 25 ff.

Niederstein, A., "Die Lukas-Madonna des Rogier van der Weyden," *Pantheon*, XII, 1933, p. 361 ff.

Nispen tot Sevenaer, E. van, "Heeft Jan van Eyck te Maastricht gewoond?" *Oudheidkundig Jaarboek*, ser. 4, I, 1932, p. 91 ff.

—— "De topografische Bijzonderheden van de Stad in den Achtergrond van de 'Madonna Rolin,'" *Wetenschap in Vlaanderen*, I, 1935–1936, p. 111 ff.

Norberg, R., "Den heliga Birgitta Codex i Osnabrück," *Forvännen*, XXXIV, 1939, p. 226 ff.

Nordenfalk, C., see *Collections and Exhibitions*, Stockholm, *Nationalmuseum*.

Notebaert, E., "Contribution à l'identification du paysage architectural dans les oeuvres des primitifs flamands," *Revue de Saint Luc*, 1939, p. 2 ff.

Oertel, R., "Die Verkündigung des Hugo van der Goes," *Pantheon*, XX, 1937, p. 377 ff.

Oettingen, W. von, ed., see Filarete, Averlino.

Oettinger, K., "Der Meister von Wittingau und die böhmische Malerei des späteren XIV. Jahrhunderts," *Zeitschrift des deutschen Vereins für Kunstwissenschaft*, I, 1934, p. 293 ff.

—— "Neue Beiträge zur Kenntnis der böhmischen Malerei und Skulptur um die Wende des 14. Jahrhunderts," *Wiener Jahrbuch für Kunstgeschichte*, X, 1935, p. 5 ff.

—— "Das Rätsel der Kunst des Hugo van der Goes," *Jahrbuch der Kunsthistorischen Sammlungen in Wien*, new ser., XII, 1938, p. 43 ff.

Oliger, P. L., "Le 'Meditationes Vitae Christi' del Pseudo-Bonaventura," *Studi Francescani*, new ser., VII, 1921, p. 143 ff.; new ser., VIII, 1922, p. 18 ff.

Olsen, K., see *Collections and Exhibitions*, Stockholm, *Nationalmuseum*.

Orléans, Charles d', *Charles d'Orléans, Poésies*, P. Champion, ed., Paris, 1923–1927.

—— *The English Poems of Charles of Orleans* (Early English Text Society, Original Series, 215), London, 1941.

Osten, G. von der, *Der Schmerzensmann; Typengeschichte eines deutschen Andachtsbildes von 1300 bis 1600*, Berlin, 1935.

Otto, G., *Hans Multscher*, Burg bei Magdeburg, 1939.

Owen, L. V. D., *The Connection between England and Burgundy during the First Half of the Fifteenth Century*, London, 1909.

Pächt, O., *The Master of Mary of Burgundy*, London, n.d. [1948].

—— *Oesterreichische Tafelmalerei der Gotik*, Augsburg, 1929.

—— "Die Datierung der Brüsseler Beweinung des Petrus Christus," *Belvedere*, IX/X, 1926, p. 155 ff.

—— "Early Italian Nature Studies and the Early Calendar Landscape," *Journal of the Warburg and Courtauld Institutes*, XIII, 1950, p. 13 ff.

—— "Gestaltungsprinzipien der westlichen Malerei des 15. Jahrhunderts," *Kunstwissenschaftliche Forschungen*, II, 1933, p. 75 ff.

—— "A Giottesque Episode in English Mediaeval Art," *Journal of the Warburg and Courtauld Institutes*, VI, 1943, p. 51 ff.

—— "Jean Fouquet; A Study of his Style," *Journal of the Warburg and Courtauld Institutes*, IV, 1940–1941, p. 85 ff.

—— Review of Friedländer, *Die altniederländische Malerei*, III, in: *Kritische Berichte zur Kunstgeschichtlichen Literatur*, 1927/28, p. 37 ff.

Panofsky, E., *Albrecht Dürer*, Princeton, 1943 (2nd ed., 1945; 3rd ed., 1948).

—— *Studies in Iconology*, New York, 1939.

—— "The de Buz Book of Hours; A New Manuscript from the Workshop of the Grandes Heures de Rohan," *Harvard Library Bulletin*, III, 1949, p. 163 ff.

—— "Facies illa Rogeri maximi pictoris," *Late Classical and Mediaeval Studies in Honor of Albert Mathias Friend, Jr.*, Princeton, 1954, p. 392 ff.

—— "The Friedsam Annunciation and the Problem of the Ghent Altarpiece," *Art Bulletin*, XVII, 1935, p. 433 ff.

—— "Guelders and Utrecht; A Footnote on a Recent Acquisition of the Nationalmuseum at Stockholm," *Konsthistorisk Tidskrift*, XXII, 1953, no. 2–3, p. 90 ff.

—— "Imago Pietatis," *Festschrift für Max J. Friedländer zum 60. Geburtstage*, Leipzig, 1927, p. 261 ff.

—— "Jan van Eyck's Arnolfini Portrait," *Burlington Magazine*, LXIV, 1934, p. 117 ff.

—— "A Letter to St. Jerome; A Note on the Relationship between Petrus Christus and Jan van Eyck," *Studies in Art and Literature for Belle da Costa Greene*, Princeton, 1954, p. 102 ff.

—— "Once more the 'Friedsam Annunciation and the Problem of the Ghent Altarpiece,'" *Art Bulletin*, XX, 1938, p. 429 ff.

—— "Die Perspektive als symbolische Form," *Vorträge der Bibliothek Warburg*, 1924–1925, p. 258 ff.

—— "Reintegration of a Book of Hours Executed in the Workshop of the 'Maître des Grandes Heures de Rohan,'" *Medieval Studies in Memory of A. Kingsley Porter*, Cambridge, Mass., 1939, II, p. 479 ff.

—— Review of G. J. Kern, *Die verschollene Kreuztragung des Hubert oder Jan van Eyck*, Berlin, 1927, in: *Kritische Berichte zur Kunstgeschichtlichen Literatur*, 1927/28, p. 74 ff.

—— "Who is Jan van Eyck's 'Timotheos'?" *Journal of the Warburg and Courtauld Institutes*, XII, 1949, p. 80 ff.

—— "Two Roger Problems: The Donor of the Hague Lamentation and the Date of the Altarpiece of the Seven Sacraments," *Art Bulletin*, XXXIII, 1951, p. 33 ff.

Pansier, P., *Les Boucicaut à Avignon*, Avignon, 1933.

—— *Les Peintres d'Avignon aux XIVe-XVe siècles*, Avignon, 1934.

Parker, K. T., see *Collections and Exhibitions*, Oxford, *Ashmolean Museum*.

Parkhurst, C. P., Jr., "The Madonna of the Writing Christ Child," *Art Bulletin*, XXIII, 1941, p. 292 ff.

526

Pauli, G., *Zeichnungen altar Meister in der Kunsthalle zu Hamburg, Niederländer*, new ser., Frankfort, 1926.

Perdrizet, P., see Lutz, J.

Perls, K. G., *Jean Fouquet*, Paris, 1940.

—— "Le Tableau de la famille des Juvenal des Ursins; le 'Maître du Duc de Bedford' et Haincelin de Hagenau," *Revue de l'Art Ancien et Moderne*, LXVIII, 1935, p. 173 ff.

Perrin, A., *Nicolas Rolin*, Paris, 1904.

Perry, M. P., "On the Psychostasis in Christian Art," *Burlington Magazine*, XXII, 1912–13, pp. 94 ff., 208 ff.

Peters, H., "Die Anbetung des Lammes; Ein Beitrag zum Problem des Genter Altars," *Das Münster*, III, 1950, p. 65 ff.

Pesina, J., see Matějček, A.

Peters, C. H., see Brugmans, H.

Pierron, S., "Le Portrait de Baudouin de Lannoy," *Revue de l'Art Ancien et Moderne*, XXXVI, 1914–1919, p. 263 ff.

Pigler, A., "Astrology and Jerome Bosch," *Burlington Magazine*, XCII, 1950, p. 132 ff.

—— "Das Problem der Budapester Kreuztragung," *Phoebus*, III, 1950/51, p. 12 ff.

Pinchart, A., "Roger de la Pasture, dit van der Weyden," *Bulletin des Commissions Royales d'Art et d'Archéologie*, VI, 1867, p. 408 ff.

Pinder, W., *Die deutsche Plastik des vierzehnten Jahrhunderts*, Munich, 1925.

Pope, A., *An Introduction to the Language of Drawing and Painting*, II (*The Painter's Modes of Expression*), Cambridge, Mass., 1931; 3rd edition, 1949.

Popham, A. E., *Drawings of the Early Flemish School*, London, 1926.

—— See also *Collections and Exhibitions*, London, *Drawings . . . in the British Museum*.

Porcher, J., *Les Grandes Heures de Rohan* (Les Trésors de la peinture française, I, 7, XVI), Geneva, 1943.

—— "Two Models for the 'Heures de Rohan,'" *Journal of the Warburg and Courtauld Institutes*, VII, 1945, p. 1 ff.

Posse, H., see *Collections and Exhibitions*, Berlin, *Königliche Museen . . . Die Gemäldegalerie*

Post, C. R., *A History of Spanish Painting*, Cambridge, Mass., 1930–50.

—— "The Master of the Encarnación (Louis Alimbrot?)," *Gazette des Beaux-Arts*, ser. 6, XXIII, 1943, p. 153 ff.

Post, P., "Die Darbringungsminiatur der Hennegauchronik in der Bibliothek zu Brüssel," *Jahrbuch für Kunstwissenschaft*, I, 1923, p. 171 ff.

—— "Pictor Hubertus d Eyck, Major Quo Nemo Repertus," *Zeitschrift für Kunstgeschichte*, XV, 1952, p. 46 ff.

—— "Der Stifter des Lebensbrunnens der van Eyck," *Jahrbuch der Preussischen Kunstsammlungen*, XXXI, 1922, p. 120 ff.

—— "Wen stellen die vier ersten Reiter auf dem Flügel der gerechten Richter am Genter Altar dar?" *Jahrbuch der Preussischen Kunstsammlungen*, XLII, 1921, p. 67 ff.

Powell, L. F., see Bonaventure (Pseudo-).

Prampolini, G., *L'Annunciazione nei pittori primitivi italiani*, Milan, 1939.

Procacci, U., see *Collections and Exhibitions*, Florence, *Reale Galleria*.

Puyvelde, L. van, *L'Agneau Mystique*, Paris and Brussels, 1946 (English translation, *The Holy Lamb*, New York, 1948). REFERRED TO IN THE NOTES AS "van Puyvelde, *Agneau*."

—— *The Flemish Primitives*, Brussels, 1948. REFERRED TO IN THE NOTES AS "van Puyvelde, *Primitives*."

—— "Die Flämische Kunst auf der Ausstellung zu Brüssel," *Pantheon*, XVI, 1935, p. 321 ff.

—— "Jan van Eyck's Last Work," *Burlington Magazine*, LVI, 1930, p. 1 ff.

—— "De Reis van Jan van Eyck naar Portugal," *Koninklijke Vlaamsche Akademie voor Taal- en Letterkunde, Verslagen en Mededeelingen*, January, 1940.

—— "Die Restaurierte Madonna van der Paele des Jan van Eyck," *Pantheon*, XIII, 1934, p. 175 ff.

—— See also *Collections and Exhibitions*, Paris, *Musée de l'Orangerie, Les Primitifs Flamands*.

Queen Mary's Psalter, see Warner, G.

Rathe, K., "Ein unbeschriebener Einblattdruck und das Thema der 'Aehrenmadonna,'" *Mitteilungen der Gesellschaft für Vervielfältigende Kunst* (supplement of *Die Graphischen Künste*), XLV, 1922, p. 1 ff.

Réau, L., *French Painting in the XIVth, XVth and XVIth Centuries*, London, Paris and New York, 1939.

Reinach, S., *Répertoire de reliefs grecs et romains*, Paris, 1909–1912.

—— "A Copy from a Lost van Eyck," *Burlington Magazine*, XLIII, 1923, p. 15 ff.

—— "A Lost Picture by Roger van der Weyden," *Burlington Magazine*, XLIII, 1923, p. 214 ff.

—— "Three Panels from the Ducal Residence at Dijon," *Burlington Magazine*, L, 1927, p. 234 ff.

Reiners, H., *Die Kölner Malerschule*, München-Gladbach, 1925.

Remy, M., *Die Buchmalerwerkstatt des Trierer Erzbischofs Cuno von Falkenstein*, Trèves, 1929.

Renders, E., *Hubert van Eyck, personnage de légende*, Paris and Brussels, 1933.

—— *Jean van Eyck, son oeuvre, son style, son évolution et la légende d'un frère peintre*, Bruges, 1935.

—— *Jean van Eyck et le Polyptique; Deux Problèmes Résolus*, Brussels, 1950.

—— *La Solution du problème van der Weyden-Flémalle-Campin*, Bruges, 1931.
Referred to in the Notes as "Renders."

—— and Lyna, F., "Deux Découvertes relatives à Van der Weyden," *Gazette des Beaux-Arts*, ser. 6, IX, 1933, p. 129 ff.

Rey, R., *Hugo van der Goes*, Brussels, 1945.

Ricci, Seymour de, and Wilson, W. J., *Census of Mediaeval and Renaissance Manuscripts in the United States and Canada*, New York, 1935–37.
Referred to in the Notes as "de Ricci-Wilson, *Census*."

Richardson, E. P., "Rogier van der Weyden's Cambrai Altar," *Art Quarterly*, II, 1939, p. 57 ff.

Richter, G. M., "Pisanello Studies," *Burlington Magazine*, LV, 1929, pp. 58 ff., 128 ff.

Rickert, M., *The Reconstructed English Carmelite Missal in the British Museum*, Chicago, 1951.

—— "Herman the Illuminator," *Burlington Magazine*, LXVI, 1935, p. 39 f.

—— "The Illuminated Manuscripts of Meester Dirc van Delf's Tafel van den Kersten Ghelove," *Journal of the Walters Art Gallery*, XII, 1949, p. 79 ff.

—— "The Reconstruction of an English Carmelite Missal," *Burlington Magazine*, LXVII, 1935, p. 99 ff.

Ring, G., *Beiträge zur Geschichte niederländischer Bildnismalerei im 15. und 16. Jahrhundert*, Leipzig, 1913.

—— *A Century of French Painting, 1400–1500*, London, 1949.
Referred to in the Notes as "Ring, *A Century*."

—— "Attempt to Reconstruct a Lost Geertgen Composition," *Burlington Magazine*, XCIV, 1952, p. 147.

—— "An Attempt to Reconstruct Perréal," *Burlington Magazine*, XCII, 1950, p. 255 ff.

—— "An Austrian Triptych," *Art Bulletin*, XXVI, 1944, p. 51 f.

—— "Beiträge zur Plastik von Tournai im 15. Jahrhundert," *Belgische Kunstdenkmäler*, P. Clemen, ed., Munich, 1923, I, p. 269 ff.

—— "Primitifs français," *Gazette des Beaux-Arts*, ser. 6, XIX, 1938, p. 149 ff.

—— "St. Jerome Extracting the Thorn from the Lion's Foot," *Art Bulletin*, XXVII, 1945, p. 188 ff.

Ritz, J. M., see Schnürer, G.

Robb, D. M., "The Iconography of the Annunciation in the Fourteenth and Fifteenth Centuries," *Art Bulletin*, XVIII, 1936, p. 480 ff.

Robert, C., *Die antiken Sarkophag-Reliefs*, Berlin, 1890–1919.

Roggen, D., "André Beauneveu en de 'Visite' van Klaas Sluter te Mehun-sur-Yèvre," *Gentsche Bijdragen tot de Kunstgeschiedenis*, II, 1935, p. 114 ff.

—— "Het Beeldhouwwerk van het Mechelsche Schepenhuys," *Gentsche Bijdragen tot de Kunstgeschiedenis*, III, 1936, p. 86 ff.

—— "Hennequin de Marville en zijn Atelier te Dijon," *Gentsche Bijdragen tot de Kunstgeschiedenis*, I, 1934, p. 173 ff.

—— "Is Klaas Sluter van Duitsche Afkomst?" *Gentsche Bijdragen tot de Kunstgeschiedenis*, II, 1935, p. 103 ff.

—— "De Kalvarieberg van Champmol," *Gentsche Bijdragen tot de Kunstgeschiedenis*, III, 1936, p. 31 ff.

—— "Klaas Sluter, Nouvelles notes sur ses origines et son charactère," *Annales de Bourgogne*, V, 1933, p. 263 ff., 385 ff.

—— "Klaas Sluter voor zijn vertrek naar Dijon in 1385," *Gentsche Bijdragen tot de Kunstgeschiedenis*, XI, 1945–1948, p. 7 ff.

—— "Les Origines de Klaas Sluter," *Annales de Bourgogne*, IV, 1932, p. 293 ff.

—— "De 'Plorants' van Klaas Sluter te Dijon," *Gentsche Bijdragen tot de Kunstgeschiedenis*, II, 1935, p. 127 ff.

—— "De Portaalsculpturen van het Brusselsche Stadhuis," *Gentsche Bijdragen tot de Kunstgeschiedenis*, I, 1934, p. 123 ff.

—— "De Portaalsculpturen van Champmol," *Gentsche Bijdragen tot de Kunstgeschiedenis*, IV, 1937, p. 107 ff.

—— "De Rekeningen Betreffende het Atelier van Klaas Sluter," *Gentsche Bijdragen tot de Kunstgeschiedenis*, IV, 1937, p. 151 ff.

—— "Roger van der Weyden en Italie," *Revue Archéologique*, ser. 5, XIX, 1924, p. 88 ff.

Rolland, P., *La Peinture murale à Tournai*, Brussels, 1946.

—— *Les Primitifs tournaisiens, peintres, et sculpteurs*, Brussels, 1932.

—— "La Double Ecole de Tournai, peinture et sculpture," *Mélanges Hulin de Loo*, Brussels and Paris, 1931, p. 296 ff.

—— "Het Drieluik der Zeven Sacramenten van Rogier van der Weyden," *Annuaire du Musée Royal des Beaux-Arts d'Anvers*, 1942–1947, p. 99 ff.

—— "La Madone italo-byzantine de Frasnes-lez-Buissenal," *Revue Belge d'Archéologie et d'Histoire de l'Art*, XVII, 1948, p. 97 ff.

—— "Stèles funeraires tournaisiennes gothiques," *Revue Belge d'Archéologie et d'Histoire de l'Art*, XX, 1951, p. 189 ff.

Rooses, M., *Art in Flanders*, New York, 1914.

Rorimer, J. J., *The Metropolitan Museum of Art; Mediaeval Tapestries, A Picture Book*, New York, 1947.

—— "The Museum's Collection of Mediaeval Tapestries," *The Metropolitan Museum of Art, Bulletin*, new ser., VI, 1947/48, p. 91 ff.

—— "A Treasury at the Cloisters," *The Metropolitan Museum of Art, Bulletin*, new ser., VI, 1947/48, p. 237 ff.

—— and Freeman, M. B., "The Nine Heroes Tapestries at the Cloisters," *The Metropolitan Museum of Art, Bulletin*, new ser., VIII, 1949, p. 243 ff.

Rosenau, H., "Some English Influences on Jan van Eyck, with Special Reference to the Arnolfini Portrait," *Apollo*, XXXVI, 1942. p. 125 ff.

Rosenberg, J., "Early Flemish Painting," *The Bulletin of the Fogg Museum of Art*, X, 1943, p. 47 f.

—— "A Silverpoint Drawing by the Master of Flémalle Acquired by the Fogg Art Museum," *Art Quarterly*, XIII, 1950, p. 251.

—— See also *Collections and Exhibitions*, Berlin, Staatliche Museen.

Rosenwald, L. J. (pref.), see *Collections and Exhibitions*, Washington, *Rosenwald Collection*.

Rousseau, Th., Jr., "A Flemish Altarpiece from Spain," *The Metropolitan Museum of Art, Bulletin*, new ser., IX, 1951, p. 270 ff.

Rowley, G., "Ambrogio Lorenzetti il pensatore," *La Balzana*, I, 1928, no. 5.

Rue, H. Aubert de la, see Aubert de la Rue, H.

Salas y Bosch, X. de, *El Bosco en la literatura española*, Barcelona, 1943.

Salet, F., "Overzicht der Literatur betreffende nederlandsche Kunst," *Oud Holland*, LV, 1938, p. 276.

Salin, E., "Copies ou variations anciennes d'une oeuvre perdue de Rogier van der Weyden," *Gazette des Beaux-Arts*, ser. 6, XII, 1935, p. 15 ff.

Salinger, M., "An Annunciation by Gerard David," *The Metropolitan Museum of Art, Bulletin*, new ser., IX, 1951, p. 225.

—— "A Valencian Retable," *The Bulletin of the Metropolitan Museum*, XXXIV, 1939, p. 250 ff.

—— See also Wehle, H. B.

Salomon, R., *Opicinus de Canistris* (Studies of the Warburg Institute, I), London, 1936.

Salzer, A., *Die Sinnbilder und Beiworte Mariens in der deutschen Literatur und lateinischen Hymnenpoesie des Mittelalters*, Linz, 1893.

Sanchez Canton, F. J., "Un gran cuadro de Van der Weyden resucitado," *Miscellanea Leo van Puyvelde*, Brussels, 1949, p. 59 ff.

Sander, H. G., "Beiträge zur Biographie Hugos van der Goes und zur Chronologie seiner Werke," *Repertorium für Kunstwissenschaft*, XXXV, 1912, p. 519 ff.

Sanpere i Miquel, S., *Els Trescentistes* (La Pintura Mig-Eval Catalana), Barcelona, n.d. [1924].

Santi, Giovanni, *Federico da Urbino*, H. Holtzinger, ed., Stuttgart, 1893.

Sauer, J., *Symbolik des Kirchengebäudes*, 2nd ed., Freiburg, 1924.

Saunders, O. E., *English Illumination*, Florence and Paris, 1928.

Saxl, F., "A Spiritual Encyclopaedia of the Later Middle Ages," *Journal of the Warburg and Courtauld Institutes*, V, 1942, p. 82 ff.

—— "Studien über Hans Holbein d.J., I; Die Karlsruher Kreuztragung," *Belvedere*, IX/X, 1926, p. 139 ff.

—— and Wittkower, R., *British Art and the Mediterranean*, Oxford, 1948.

Schaefer, J., *Les Primitifs français du XIVe et du XVe siècle*, Paris, 1949.

Schapiro, M., "Cain's Jaw-Bone That Did the First Murder," *Art Bulletin*, XXIV, 1942, p. 205 ff.

—— "'Muscipula Diaboli,' The Symbolism of the Mérode Altarpiece," *Art Bulletin*, XXVII, 1945, p. 182 ff.

Scharf, A., *A Catalogue of Pictures and Drawings from the Collection of Sir Thomas Merton, F.R.S., at Stubbings House, Maidenhead*, London, 1950.

Scheewe, L., *Hubert und Jan van Eyck, ihre literarische Würdigung bis ins 18. Jahrhundert*, The Hague, 1933.

—— "Die Eyck-Literatur (1932–1934)," *Zeitschrift für Kunstgeschichte*, III, 1934, p. 139 ff.

—— "Die neueste Literatur über Roger van der Weyden," *Zeitschrift für Kunstgeschichte*, III, 1934, p. 208 ff.

—— Review of O. Kerber, *Roger van der Weyden und die Anfänge der neuzeitlichen Tafelmalerei* in: *Zeitschrift für Kunstgeschichte*, V, 1936, p. 353 f.

Schenk [zu Schweinsberg], E., "Selbstbildnisse von Hubert und Jan van Eyck," *Zeitschrift für Kunst* (Leipzig), III, 1949, p. 4 ff.

Schenk, V. W. D., *Tussen Duivelgeloof en Beeldenstorm, een Studie over Jeroen Bosch en Erasmus van Rotterdam*, Amsterdam, 1946.

Schild Bunim, M., See Bunim, M. Schild.

Schilling, R., "A Book of Hours from the Limbourg Atelier," *Burlington Magazine*, LXXXI, 1942, p. 194 ff.

—— See also Swarzenski, G.

Schlosser, J. (von), "Die ältesten Medaillen und die Antike," *Jahrbuch der Kunsthistorischen Sammlungen des Allerhöchsten Kaiserhauses*, XVIII, 1897, p. 64 ff.

—— "Armeleutekunst alter Zeit," reprinted in *Präludien*, Berlin, 1927, p. 324 ff.

—— "Zur Kenntnis der künstlerischen Ueberlieferung im späten Mittelalter," *Jahrbuch der Kunsthistorischen Sammlungen des Allerhöchsten Kaiserhauses*, XXIII, 1902, p. 279 ff.

—— "Ein Veroneser Bilderbuch und die höfische Kunst des XIV. Jahrhunderts," *Jahrbuch der Kunsthistorischen Sammlungen des Allerhöchsten Kaiserhauses*, XVI, 1895, p. 144 ff.

Schmarsow, A., *Die oberrheinische Malerei und ihre Nachbarn*, Kgl. Sächsische Gesellschaft der Wissenschaften, Abhandlungen der Philologisch-Historischen Klasse, Leipzig, XXII, 1904, no. 2.

Schnürer, G., and Ritz, J. M., *Sankt Kümmernis und Volto Santo* (Forschungen zur Volkskunde, 13-15), Düsseldorf, 1934.

Schnütgen, W., "Ein niederländisches Flügelbild aus dem Ende des XV. Jahrhunderts," *Zeitschrift für Christliche Kunst*, II, 1889, col. 49 ff.

Schöne, W., *Dieric Bouts und seine Schule*, Berlin, 1938.

—— *Die grossen Meister der niederländischen Malerei des 15. Jahrhunderts*, Leipzig, 1939.
REFERRED TO IN THE NOTES AS "Schöne."

—— "Albert van Ouwater; Ein Beitrag zur Geschichte der holländischen Malerei des XV. Jahrhunderts," *Jahrbuch der Preussischen Kunstsammlungen*, LXIII, 1942, p. 1 ff.

—— "Ueber einige altniederländische Bilder, vor allem in Spanien," *Jahrbuch der Preussischen Kunstsammlungen*, LVIII, 1937, p. 153 ff.

Scholtens, H. J. J., "Jan van Eyck's 'H. Maagd met den Kartuizer' en de Exeter-Madonna te Berlijn," *Oud Holland*, LV, 1938, p. 49 ff.

Schottmüller, F., *Fra Angelico da Fiesole* (Klassiker der Kunst, XVIII), Stuttgart and Leipzig, 1911.

Schryver, A. P. de, and Marijnissen, R. H., *De Oorspronkelijke Plaats van het Lam Gods-Retabel* (*Les Primitifs Flamands, Contributions à l'Etude des Primitifs Flamands*, Vol. I), Antwerp, 1952.

Servières, G., *La Décoration artistique des buffets d'orgue*, Paris and Brussels, 1928.

Shaw, W. A., "The Early English School of Portraiture," *Burlington Magazine*, LXV, 1934, p. 171 ff.

Sherborne Missal, see Herbert, J. A.

Shorr, D., "The Iconographic Development of the Presentation in the Temple," *Art Bulletin*, XXVIII, 1946, p. 17 ff.

—— "The Mourning Virgin and St. John," *Art Bulletin*, XXII, 1940, p. 61 ff.

Simson, O. G. von, "*Compassio* and *Co-redemptio* in Roger van der Weyden's *Descent from the Cross*," *Art Bulletin*, XXXV, 1953, p. 9 ff.

Smet, J. J. de, "Notice sur Middelbourg en Flandre," *Messager des Sciences et des Arts de la Belgique*, IV, 1836, p. 333 ff.

Smital, O., and Winkler, E., *Livre du Cuer d'Amours Espris* (Vienna, Nationalbibliothek, ms. 2597), O. Smital and E. Winkler, eds., Vienna, 1926.

Smits, K., *Iconographie van de Nederlandsche Primitieven*, Amsterdam, 1933.

Solms-Laubach, E. Graf zu, "Der Hausbuchmeister," *Städel-Jahrbuch*, IX, 1935/36, p. 13 ff.

Soulier, G., *Les Influences orientales dans la peinture toscane*, Paris, 1924.

Speculum humanae salvationis, see Lutz, J., and Perdrizet, P.

Spencer, E. P., "The International Style and Fifteenth-Century Illuminations," *Parnassus*, XII, 1940, March, p. 30 f.

Squilbeck, J., "La Vierge à l'Encrier ou à l'Enfant Ecrivant," *Revue Belge d'Archéologie et d'Histoire de l'Art*, XIX, 1950, p. 127 ff.

Stammler, W., *Der Totentanz, Enstehung und Deutung*, Munich, 1948.

Stange, A., *Deutsche Malerei der Gotik*, Berlin, 1934-1938.

Steele, R., see Orléans, Charles d'.

Stein, W., "Die Bildnisse von Roger van der Weyden," *Jahrbuch der Preussischen Kunstsammlungen*, XLVII, 1926, p. 1 ff.

Steinbart, K., *Das Holzschnittwerk des Jakob Cornelisz. von Amsterdam*, Burg bei Magdeburg, 1937.

—— *Konrad von Soest*, Vienna, 1946.

—— *Die Tafelgemälde des Jakob Cornelisz. von Amsterdam*, Strasbourg, 1922.

Sterling, C., *Le Couronnement de la Vierge par Enguerrand Quarton*, Paris, 1939.

—— *La Peinture française; les peintres du moyen âge*, Paris, 1941.
REFERRED TO IN THE NOTES AS "Sterling, *Les Peintres*."

—— *La Peinture française; les primitifs*, Paris, 1938.
REFERRED TO IN THE NOTES AS "Sterling, *Les Primitifs*."

—— See also *Collections and Exhibitions*, Paris, *Musée de l'Orangerie*.

Stout, G. L., "One Aspect of the So-Called Mixed Technique," *Harvard Technical Studies*, VII, 1938, p. 59 ff.

—— "A Study of the Method in a Flemish Painting," *Harvard Technical Studies*, I, 1933, p. 181 ff.

—— See also Gettens, R. J.

Straub, A., see Herrad of Landsberg.

Strümpel, A., "Hieronymus im Gehäuse," *Marburger Jahrbuch für Kunstwissenschaft*, II, 1925/26, p. 173 ff.

Suger, Abbot, *Abbot Suger on the Abbey Church of St.-Denis and its Art Treasures*, E. Panofsky, ed. and trans., Princeton, 1946.

Sulzberger, S., "La Sainte Barbe de Jan van Eyck; Détails concernant l'histoire du tableau," *Gazette des Beaux-Arts*, ser. 6, XXXIV, 1948, p. 289 ff.

Swarzenski, G., "Miniatures from a Lost Manuscript," *Bulletin of the Museum of Fine Arts, Boston*, XLII, 1944, p. 28 ff.

—— and Schilling, R., *Die illuminierten Handschriften und Einzelminiaturen des Mittelalters und der Renaissance in Frankfurter Besitz*, Frankfort-on-the-Main, 1929.

Swarzenski, H., *The Berthold Missal*, New York, 1943.

—— *Die lateinischen illuminierten Handschriften des XIII. Jahrhunderts in den Ländern an Rhein, Main und Donau*, Berlin, 1936.

—— "A Masterpiece of Bohemian Art," *Bulletin of the Museum of Fine Arts, Boston*, L, 1952, p. 64 ff.

Taylor, F. H., " 'A Piece of Arras of the Judgment'; The Connection of Maître Philippe de Mol and Hugo van der Goes with the Mediaeval Religious Theatre," *Worcester Art Museum Bulletin*, I, 1935-1936, p. 1 ff.

Thieme, U., and Becker, F., *Allgemeines Lexikon der bildenden Künstler*, Leipzig, 1910-1950.
REFERRED TO IN THE NOTES AS "Thieme-Becker."

Thissen, J., see Coremans, P.

Thompson, D. V., Jr., *The Materials of Medieval Painting*, New Haven, 1936.

———— See also Cennini, Cennino d'Andrea.

Thompson, Henry Yates, see Yates Thompson, H.

Tieschowitz, B. von, *Das Chorgestühl des Kölner Domes*, Berlin, 1930.

Timmers, J. J. M., "De Achtergrond van de Madonna van Rolin door Jan van Eyck," *Oud Holland*, LXI, 1946, p. 5 ff.

Toesca, P., *La Pittura e la miniatura nella Lombardia*, Milan, 1912.

Tolnay, C. de, *Hieronymus Bosch*, Basel, 1937.

———— *History and Technique of Old Master Drawings*, New York, 1943.

———— *Le Maître de Flémalle et les Frères van Eyck*, Brussels, 1938.

———— *Pierre Bruegel l'Ancien*, Brussels, 1935.

———— *Le Retable de l'Agneau Mystique des Frères van Eyck*, Brussels, 1938.

———— "An Early Dutch Panel: A Contribution to the Panel Painting before Bosch," *Miscellanea Leo van Puyvelde*, Brussels, 1949, p. 49 ff.

———— "Flemish Paintings in the National Gallery of Art," *Magazine of Art*, XXXIV, 1941, p. 174 ff.

———— "Zur Herkunft des Stiles der van Eyck," *Münchner Jahrbuch der Bildenden Kunst*, new ser., IX, 1932, p. 320 ff.

———— "Hugo van der Goes as Portrait Painter," *Art Quarterly*, VII, p. 181 ff.

Tourneur, V., "Un Second Quatrain sur l'Agneau Mystique," *Académie Royale de Belgique, Bulletin de la Classe des Lettres et des Sciences Morales et Politiques*, ser. 5, XXIX, 1943, p. 57 ff.

Tovell, R. M., *Flemish Artists of the Valois Courts*, Toronto, 1950.

Trenkler, E., *Das Evangeliar des Johannes von Troppau, Handschrift 1182 der Oesterreichischen Nationalbibliothek*, Klagenfurt and Vienna, 1948.

———— *Das Livre du Cuer d'Amours espris des Herzogs René von Anjou*, Vienna, 1946.

———— *Livre d'Heures, Handschrift 1855 der Osterreichischen Nationalbibliothek*, Vienna, 1948.

Tristram, E. W., "The Wilton Diptych," *The Month*, new ser., I, 1949, p. 379 ff.; II, 1949, p. 18 ff.

Troche, E. G., *Niederländische Malerei des fünfzehnten und sechzehnten Jahrhunderts*, Berlin, 1935.

Tröscher, G., *Die Burgundische Plastik des ausgehenden Mittelalters und ihre Wirkungen auf die Europäische Kunst*, Frankfort, 1940.

———— *Claus Sluter und die Burgundische Plastik um die Wende des XIV. Jahrhunderts*, Freiburg, 1932.

Tschudi, H. von, "Der Meister von Flémalle," *Jahrbuch der Königlich Preussischen Kunstsammlungen*, XIX, 1898, pp. 8 ff., 89 ff.

Ueberwasser, W., *Konrad Witz*, Basel, n.d. [1938].

———— *Rogier van der Weyden, Paintings from the Escorial and the Prado Museum*, London, 1945.

Valentiner, W. R., "Aelbert van Ouwater," *Art Quarterly*, VI, 1943, p. 74 ff.

———— "Rogier van der Weyden; The 'Mass of Saint Gregory,'" *Art Quarterly*, VIII, 1945, p. 240 ff.

Vasari, *Le opere di Giorgio Vasari*, G. Milanesi, ed., Florence, 1878-1906.

Veken, J. van der, "Experimenten met Betrekking tot de van Eyck-Techniek," *Gentsche Bijdragen tot de Kunstgeschiedenis*, V, 1938, p. 5 ff.

Venturi, A., *Storia dell' arte italiana*, Milan, 1901-1939.

Verdam, J., see Verwijs, E.

Verhaegen, M. le Baron, "Le Polyptyque de Beaune," *Congrès Archéologique de France*, XCI, 1928, p. 327 ff.

Verheyden, P., *La Reliure en Brabant*, Antwerp, 1935.

Vermeulen, F. A. J., *Handboek tot de Geschiedenis der Nederlandsche Bouwkunst*, I, The Hague, 1928.

Verwijs, E., and Verdam, J., *Middelnederlandsch Woordenboek*, VII, 1912.

Villard de Honnecourt, Kritische Gesamtausgabe des Bauhüttenbuches ms fr. 19093 der Pariser Nationalbibliothek, H. R. Hahnloser, ed., Vienna, 1935.

Villeneuve, F. G. A. de, see Guyot de Villeneuve.

Vitzthum von Eckstädt, G., *Die Pariser Miniaturmalerei von der Zeit des hl. Ludwig bis zu Philipp von Valois und ihr Verhältnis zur Malerei in Nordwesteuropa*, Leipzig, 1907.

———— "Ein Stadtbild im Baptisterium von Castiglione d'Olona," *Festschrift zum sechszigsten Geburtstag von Paul Clemen*, Düsseldorf, 1926, p. 401 ff.

Vöge, W., *Jörg Syrlin der Aeltere und seine Bildwerke*, II (*Stoffkreis und Gestaltung*), Berlin, 1950.

Vogelsang, W., *Holländische Miniaturen des späteren Mittelalters*, Strasbourg, 1899.

———— *Rogier van der Weyden, Pietà; Form and Color*, New York, n.d. [1949].

———— "Rogier van der Weyden," in: *Niederländische Malerei im XV. und XVI. Jahrhundert*, Amsterdam and Leipzig, 1941, p. 65 ff.

———— "Veertiend' eeuwsche beeldhouwers in Utrecht en Keulen," *Kunst der Nederlanden*, I, 1930-31, p. 456 ff.

———— See also *Collections and Exhibitions*, Twenthe-Enschede.

Voll, K., *Die altniederländische Malerei von Jan van Eyck bis Memling*, Leipzig, 1906.

———— *Memling, Des Meisters Gemälde* (Klassiker der Kunst, XIV), Stuttgart and Leipzig, 1909.

———— *Die Werke des Jan van Eyck*, Strasbourg, 1900.

Vorenkamp, A. P. A., "A Famous Drawing by Bouts; Northampton," *Art News*, XXXVII, 1939, June 3, p. 9.

Vries, Scato de, and Morpurgo, S., *Das Breviar Grimani*, Leipzig, n.d.

Waal, H. van de, *Drie Eeuwen vaderlandsche Geschied-Uitbeelding* (*1500–1800*); *een iconologische Studie*, The Hague, 1952.

Waldburg-Wolfegg, J. Graf, *Lukas Moser*, Berlin, 1939.

Warburg, A., *Gesammelte Schriften*, Leipzig and Berlin, 1932.

Warner, G., *Queen Mary's Psalter*, London, 1912.

—— See also *Catalogues and Exhibitions*, Malvern, *Library of C. W. Dyson-Perrins.*

Wauters, A. J., "Roger van der Weyden, II," *Burlington Magazine*, XXII, 1913, p. 230 ff.

Weale, W. H. J., *Hubert and John van Eyck, Their Life and Work*, London and New York, 1908.

—— and Brockwell, M. W., *The Van Eycks and Their Art*, London, New York and Toronto, 1912.
Referred to in the Notes as "Weale-Brockwell."

Weber, P., *Geistliches Schauspiel und kirchliche Kunst in ihrem Verhältnis erläutert an einer Ikonographie der Kirche und Synagoge*, Stuttgart, 1894.

Webster, J. C., *The Labors of the Months in Antique and Mediaeval Art*, Princeton, 1938.

Wehle, H. B., and Salinger, M., *The Metropolitan Museum of Art, A Catalogue of Early Flemish, Dutch and German Paintings*, New York, 1947.

Weinberger, M., *Die Formschnitte des Katharinenklosters zu Nürnberg*, Munich, 1925.

—— "A Bronze Bust by Hans Multscher," *Art Bulletin*, XXII, 1940, p. 185 ff.

—— "An Early Woodcut of the Man of Sorrows at the Art Institute, Chicago," *Gazette des Beaux-Arts*, ser. 6, XXIX, 1946, p. 347 ff.

—— "A French Model of the Fifteenth Century," *The Journal of the Walters Art Gallery*, IX, 1946, p. 9 ff.

Wendland, H., *Konrad Witz*, Basel, 1924.

Wescher, P., *Jean Fouquet und seine Zeit*, Basel, 1945.

—— "Beiträge zu einigen Werken des Kupferstichkabinetts," *Berliner Museen*, LIX, 1938, p. 51.

—— "The Drawings of Vrancke van der Stoct," *Old Master Drawings*, XIII, 1938–39, p. 1 ff.

—— "Fashion and Elegance at the Court of Burgundy," CIBA *Review*, LI, July, 1946, p. 1841 ff.

—— "Das höfische Bildnis von Philipp dem Guten bis zu Karl V, I," *Pantheon*, XXVIII, 1941, p. 195 ff.

—— "Eine unbekannte Madonna von Rogier van der Weyden," *Phoebus*, II, 1949, p. 104 ff.

—— See also *Collections and Exhibitions*, Berlin, *Beschreibendes Verzeichnis . . . des Kupferstichkabinetts.*

White, John, "Developments in Renaissance Perspective, I," *Journal of the Warburg and Courtauld Institutes*, XII, 1949, p. 58 ff.; XIV, 1951, p. 42 ff.

Wilhelm, P., *Die Marienkrönung am Westportal der Kathedrale von Senlis* (Hamburg doctoral dissertation, 1937), Hamburg, 1941.

Wilson, W. J., see Ricci, Seymour de.

Winkler, E., see Smital, O.

Winkler, F., *Altdeutsche Tafelmalerei*, 2nd ed., Munich, 1944.

—— *Die altniederländische Malerei*, Berlin, 1924.

—— *Die flämische Buchmalerei des XV. und XVI. Jahrhunderts*, Leipzig, 1925.

—— *Der Genter Altar von Hubert und Jan van Eyck*, Leipzig, 1921.

—— *Der Meister von Flémalle und Rogier van der Weyden*, Strasbourg, 1913.
Referred to in the Notes as "Winkler."

—— "Die Anfänge Jan Gossarts," *Jahrbuch der Preussischen Kunstsammlungen*, XLII, 1921, p. 5 ff.

—— "An Attribution to Roger van der Weyden," *Old Master Drawings*, X, 1935, p. 1 ff.

—— "Gerard David und die Brügger Miniaturmalerei seiner Zeit," *Monatshefte für Kunstwissenschaft*, VI, 1913, p. 271 ff.

—— "Der Meister von Moulins und Hugo van der Goes," *Pantheon*, X, 1932, p. 241 ff.

—— "Neues von Hubert und Jan van Eyck," *Festschrift für Max J. Friedländer zum 60. Geburtstage*, Leipzig, 1927, p. 91 ff.

—— "Ein neues Werk aus der Werkstatt Pauls von Limburg," *Repertorium für Kunstwissenschaft*, XXXIV, 1911, p. 536 ff.

—— "Paul de Limbourg in Florence," *Burlington Magazine*, LVI, 1930, p. 94 ff.

—— "Rogier van der Weyden's Early Portraits," *Art Quarterly*, XIII, 1950, p. 211 ff.

—— "Simon Marmion als Miniaturmaler," *Jahrbuch der Königlich Preussischen Kunstsammlungen*, XXXIV, 1913, p. 251 ff.

—— "Das Skizzenbuch Gerard Davids," *Pantheon*, III, 1929, p. 271 ff.

—— "Some Early Netherland Drawings," *Burlington Magazine*, XXIV, 1914, p. 224 ff.

—— "Die Stifter des Lebensbrunnens und andere Van-Eyck-Fragen," *Pantheon*, VII, 1931, p. 188 ff., 255 ff.

—— "Studien zur Geschichte der niederländischen Miniaturmalerei des XV. und XVI. Jahrhunderts," *Jahrbuch der Kunsthistorischen Sammlungen des Allerhöchsten Kaiserhauses*, XXXII, 1915, p. 281 ff.

—— "Ein unbeachtetes Frühwerk Rogiers van der Weyden," *Jahrbuch der Preussischen Kunstsammlungen*, LXIII, 1942, p. 105 ff.

Wit, K. de, "Das Horarium der Katharina von Kleve als Quelle für die Geschichte der südniederländischen Tafelmalerei und der nordniederländischen Miniaturen," *Jahrbuch der Preussischen Kunstsammlungen*, LVIII, 1937, p. 114 ff.

Wittkower, R., see Saxl, F.

Wolters, C., *Die Bedeutung der Gemäldedurchleuchtung mit Röntgenstrahlen*, Frankfort-on-the-Main, 1938.

Worringer, W., *Die Anfänge der Tafelmalerei*, Leipzig, 1924.

Wurzbach, A. von, *Niederländisches Künstlerlexicon*, Vienna and Leipzig, 1906–1911.

Yates, Thompson, H., *A Lecture on Some English Illuminated Manuscripts*, London, 1902.

—— *Thirty-Two Miniatures from the Book of Hours of Joan II, Queen of Navarre*, London, 1899.

Ziloty, A., *La Découverte de Jean van Eyck*, Paris, 1947.

Zimmermann, Heinrich, "Ueber eine frühholländische Kreuztragung," *Amtliche Berichte aus den Königlichen Kunstsammlungen*, XXXIX, 1917/18, col. 15 ff.

Zimmermann, Hildegard, "Eine Silberstiftzeichnung Jan van Eycks aus dem Besitze Philipp Hainhofers," *Jahrbuch der Königlich Preussischen Kunstsammlungen*, XXXVI, 1915, p. 215 ff.

II. COLLECTIONS AND EXHIBITIONS

Antwerp

Collections du Chevalier Mayer van den Bergh, Catalogue des tableaux exposés dans les galeries de la Maison des Rois Mages, Antwerp, 1904.

Exposition Internationale Coloniale, Maritime et d'Art Flamand, Antwerp, Juin-Septembre, 1930, Section d'Art Flamand Ancien.

Trésor de l'Art Flamand du Moyen Age au XVIIIᵉ Siècle, Memorial de l'Exposition d'Art Flamand Ancien à Anvers, 1930, I, Peintures, Paris, 1932.

Baltimore

Early Christian and Byzantine Art, The Walters Art Gallery, An Exhibition held at the Baltimore Museum of Art April 25–June 22, Baltimore, 1947.

The Walters Art Gallery, Illuminated Books of the Middle Ages and Renaissance, an Exhibition held at the Baltimore Museum of Art, January 27–March 13, 1949. Referred to in the Notes as "Walters Catalogue, 1949."

Berlin

Königliche Museen zu Berlin; Beschreibendes Verzeichnis der Gemälde im Kaiser-Friedrich-Museum, 7th ed., Berlin, 1911.

Königliche Museen zu Berlin; Die Gemäldegalerie des Kaiser Friedrich Museums (H. Posse), Berlin, 1911.

Beschreibendes Verzeichnis der Miniaturen, Handschriften und Einzelblätter des Kupferstichkabinetts der Staatlichen Museen Berlin (P. Wescher), Leipzig, 1931.

Staatliche Museen zu Berlin; Die Zeichnungen alter Meister im Kupferstichkabinett; Die niederländischen Meister (E. Bock and J. Rosenberg), Frankfort, 1931.

Bourges

Musée de Bourges, Chefs-d'Oeuvre des Peintres-Enlumineurs de Jean de Berry et de l'Ecole de Bourges, Hotel Cujas, 23 Juin–4 Septembre, 1951.

Bruges

Bruges, 1902, Exposition de Tableaux Flamands des XIVᵉ, XVᵉ et XVIᵉ siècles, Catalogue Critique (G. Hulin de Loo), Ghent, 1902.

Exposition des Primitifs Flamands et d'Art Ancien, Première Section, Tableaux, Bruges, 1902.

Les Peintures Primitives des XIVᵉ, XVᵉ, et XVIᵉ Siècles de la Collection Renders à Bruges (G. Hulin de Loo and E. Michel) London and Bruges, 1927.

Le Musée Communal de Bruges, see Janssens de Bisthoven, A., and Parmentier, R. A.

Brussels

Cinq Siècles d'Art à Bruxelles, Mémorial de l'Exposition, I (*Recueil de Planches*), Brussels, 1935.

See also Paris, Musée de l'Orangerie, *De van Eyck à Brueghel.*

Exposition Universelle et Internationale de Bruxelles, Cinq Siècles d'Art, I (*Guide illustré par M. Paul Lambotte*), Brussels, 1935.

Palais des Beaux-Arts, Bruxelles, Traitement de l'Agneau Mystique, Guide du Visiteur, P. Coremans, intr., Brussels, 1951.

Buffalo

Bosch to Beckmann, A Loan Exhibition . . ., April 15th to May 14th, 1950, the Buffalo Fine Arts Academy, Albright Art Gallery, Buffalo and New York.

Cambridge, England

A Descriptive Catalogue of the Manuscripts in the Fitzwilliam Museum (M. R. James), Cambridge, 1895.

Cambridge, Massachusetts

One Hundred Master Drawings (exhibited in the Fogg Art Museum in honor of the seventieth birthday of Paul J. Sachs), see Mongan, A.

Chantilly, Musee Condé, see Meurgey, J.

Chicago

Art Institute of Chicago, Masterpieces of French Tapestry, March 17 to May 5, 1948.

Detroit

Paintings in the Permanent Collection of the Detroit Institute of Arts of the City of Detroit, Detroit, 1930.

Florence

La Regia Galleria dell' Accademia di Firenze (U. Procacci), Rome, 1936.

Forlí

Città di Forlí, Mostra di Melozzo e del Quattrocento Romagnolo, Forlí, 1938.

The Hague

La Collection del Monte, The Hague (G. Glück), Vienna, 1928.

Musée Royal de Tableaux, Mauritshuis à la Haye, Catalogue Raisonné des Tableaux et Sculptures, The Hague, 3rd edition, 1935.

Royal Library and Museum Meermanno-Westreenianum, see Byvanck, A. W., *Les Principaux Manuscrits.*

Hamburg, see Pauli, G., *Zeichnungen . . . in der Kunsthalle.*

Houston

Museum of Fine Arts, Houston, Texas, Catalogue of the Edith A. and Percy S. Straus Collection, 1945.

Indianapolis

Holbein and His Contemporaries; A Loan Exhibition . . ., October 22–December 24, 1950, The John Herron Art Museum, Indianapolis, Ind., 1950.

Kansas City

William Rockhill Nelson Collection, Kansas City [two editions, both n. d.].

London

A Descriptive Catalogue of the Second Series of Fifty Manuscripts in the Collection of Henry Yates Thompson (M. R. James), Cambridge, 1902.

Burlington Fine Arts Club, Exhibition of Illuminated Manuscripts, London, 1908.

Illustrations from One Hundred Manuscripts in the Library of Henry Yates Thompson, London, 1914.

One Hundred Manuscripts in the Library of Henry Yates Thompson, London, V, 1915.

The Library of A. Chester Beatty; II, A Descriptive Catalogue of the Western Manuscripts (E. G. Millar), Oxford, 1930.

Catalogue of Drawings by Dutch and Flemish Artists . . . in the British Museum (A. E. Popham), V, London, 1932.

Sotheby & Co., *Catalogue of the Renowned Collection of Western Manuscripts, the Property of A. Chester Beatty, Esq., the First Portion, Sold on June 7, 1932.*

Sotheby & Co., *Catalogue of the Renowned Collection of Western Manuscripts, the Property of A. Chester Beatty, Esq., the Second Portion, Sold on May 9, 1933.*

Sotheby & Co., *Catalogue of the Manuscripts, Printed Books and Autograph Letters Presented to the Duke of Gloucester's Red Cross and St. John Fund, Sold October 13–15, 1942.*

Sotheby & Co., *Catalogue of Important Old Master Drawings, Fine Paintings, etc., Sold on June 30, 1948.*

Sotheby & Co., *Catalogue of . . . Illuminated Manuscripts and Printed Books Selected from the Renowned Library Formed by Baron Horace de Landau, Sold July 12–13, 1948.*

National Gallery, see Davies, M.

Maidenhead, see Scharf, A.

Malvern

Descriptive Catalogue of Illuminated Manuscripts in the Library of C. W. Dyson-Perrins (G. Warner), Oxford, 1920.

Manchester

A Descriptive Catalogue of the Latin Manuscripts in the John Rylands Library at Manchester (M. R. James) Manchester, London, etc., 1921.

New York

The Pierpont Morgan Library, Exhibition of Illuminated Manuscripts Held at the New York Public Library, November 1933 to April 1934. REFERRED TO IN THE NOTES AS "Morgan Catalogue, 1934."

Masterpieces of Art (Catalogue of European Paintings and Sculpture from 1300–1800), New York World's Fair, May to October, 1939.

Flemish Primitives, An Exhibition Organized by the Belgian Government, April 13–May 9, 1942, New York (M. Knoedler & Co.).

Illuminated Manuscripts from the Bibliothèque of Their Highnesses the Dukes d'Arenberg, Jacques Seligmann & Co., New York, 1952.

Metropolitan Museum, see Wehle and Salinger.

Nordkirchen

Duke of Arenberg Collection, see New York.

Oxford

Catalogue of the Collection of Drawings in the Ashmolean Museum (K. T. Parker), Oxford, 1938.

Paris

L'Exposition des Primitifs Français; La Peinture en France sous les Valois (H. Bouchot), Paris, 1905.

La Collection de Miniatures de M. Edouard Kann (A. Boinet), Paris, 1926.

Musée de l'Orangerie; De van Eyck à Brueghel (P. Lambotte, pref., P. Jamot, intr.), Paris, 1935.

See also Brussels, *Cinq Siècles d'Art.*

Musée de l'Orangerie, Paris; Les Primitifs Flamands, 5 juin–7 juillet (L. van Puyvelde), Brussels, 1947.

De van Eyck à Rubens, Les Maîtres Flamands du Dessin (Exhibition at the Bibliothèque Nationale, Paris, 1949).

Musée de l'Orangerie, Paris; Des Maîtres de Cologne à Albert Dürer (G. Bazin, pref., K. Martin, intr.), Paris, 1950.

Orangerie des Tuileries; La Nature Morte de l'Antiquité à nos Jours, avril–juin, 1952 (A. Maiuri, pref., C. Sterling, ed).

Bibliothèque de l'Arsenal, see Martin, H., and Lauer, P.

Bibliothèque Ste.-Geneviève, see Boinet, A.

Petworth

Catalogue of the Petworth Collection of Pictures in the Possession of Lord Leconfield (C. H. Collins Baker), London, 1920.

Philadelphia

The John G. Johnson Collection, Catalogue of Paintings (H. Marceau), Philadelphia, 1941.

Stockholm

Nationalmuseum; Gyllene Böcker, Illuminerade medeltida handskrifter i dansk och svensk ägo, Maj–September 1952 (K. Olsen and C. Nordenfalk). Referred to in the Notes as *"Stockholm Catalogue."*

Turin

La Galerie Sabauda de Turin, see Arù, C., and Geradon, E. de.

Twenthe-Enschede

Noord-Nederlandsche Handschriften, 1300–1500, Catalogus van de Tentoonstelling in het Rijksmuseum Twenthe-Enschede, December 1952, W. Vogelsang, ed.

Vienna

Beschreibender Katalog der Handzeichnungen in der Graphischen Sammlung der Albertina, II, Die Zeichnungen der niederländischen Schulen (O. Benesch), Vienna, 1928.

Vierhouten near Amersfoort, Holland

Catalogue of the D. G. van Beuningen Collection (D. Hannema, preface by M. J. Friedländer), Rotterdam, 1949.

Washington

National Gallery of Art, Book of Illustrations, 2nd ed., Washington, D. C., 1941.

National Gallery of Art, Preliminary Catalogue of Paintings and Sculpture, Washington, D. C., 1941.

Rosenwald Collection; An Exhibition of Recent Acquisitions, National Gallery of Art (E. Mongan, preface by L. J. Rosenwald), Washington, 1950.

Paintings and Sculpture from the Kress Collection, Acquired by the Samuel M. Kress Foundation, 1945–1951, Washington, 1951.

Worcester

The Worcester-Philadelphia Exhibition of Flemish Painting, February 23–March 12, and March 25–April 26, 1939.

ADDENDUM

The final report on the technical examination of the Ghent altarpiece, referred to on several occasions (see, e.g., p. 223 and note 207[7]), appeared after this book had gone to press: P. Coremans, ed., *L'Agneau Mystique au Laboratoire, Examen et Traitement* (*Les Primitifs Flamands, Contributions à l'Etude des Primitifs Flamands*, Vol. II), Antwerp, 1953. The pleasure of comparing the results of this publication, equally important for the special problem of the Ghent altarpiece and for the understanding of Early Netherlandish painting in general, with the opinions set forth in the present volume must be left to the reader.

Some marriage rituals, e.g., that of Avignon, actually required the groom to hold the right hand of the bride in his left; *see* R. Girard, "Marriage in Avignon in the Second Half of the Fifteenth Century," *Speculum*, XXVIII, 1953, p. 491.

Page 203; Note 203[5]

To be added to the works of Jan van Eyck transmitted through more or less trustworthy copies: the Portrait of the Infanta Isabella of Portugal, commenced on January 13, 1429 (1428 old style) and sent to Philip the Good on February 12 of that year. A seventeenth-century drawing purporting to be a copy thereof was published by L. Dimier, "Un Portrait perdu de Jean van Eyck," *La Renaissance de l'art français et des industries de luxe*, V, 1922, p. 541 f. (cf. his "Dessin du Portrait d'Isabelle de Portugal par van Eyck," *Bulletin de la Société Nationale des Antiquaires de France*, 1921, p. 116; S. Reinach, "Un Portrait d'Isabelle de Portugal (1429)," *Revue Archéologique*, ser. 5, 1922, p. 174), but does not seem to be mentioned in the more recent literature.

Page 203; Note 203[6]

To be added to the works of Jan van Eyck known to us through literary sources: "The Drowning of Pharaoh and His Hosts in the Red Sea," apparently not referred to in any book or article on Jan van Eyck although it was owned by no less illustrious a patroness of the arts than Isabella d'Este. Originally the property of a Venetian collector, Michele Vianello, this work had been bought, after Vianello's death in the spring of 1506, by a local nobleman named Andrea Loredan who could, however, be persuaded to cede it to Isabella for one hundred ducats and a *mancia* of twenty-five. This transaction was negotiated with the help of a Venetian banker, Taddeo Albano, and it is from one of his letters, dated June 18, 1506 (A. Luzio, *La Galleria dei Gonzaga venduta all' Inghilterra nel 1627–28*, Milan, 1913, p. 105 f.), that we learn the following facts: first, that the *Summersione di Farahone* — previously referred to only by subject so that A. Venturi, "Gian Cristoforo Romano," *Archivio Storico dell'Arte*, I, 1888, p. 150 f., was inclined to believe that it was a relief — was a painting; second, that this painting was sold and bought as an authentic work of Jan van Eyck; third, that it changed hands (as it would today accompanied by an expertise) together with a likeness "di quel Janes de Brugia che fece

la prefatta sumersione fatta de propria mano." Conceivably this lost composition, the authenticity of which is of course a matter of surmise, is dimly reflected in a "Drowning of Pharaoh" by Ludovico Mazzolino of Ferrara (Dublin, National Gallery of Ireland, no. 606).

Page 284; Notes 284[2,3]; fig. 359

The identification of the Episcopal donor of The Hague "Lamentation," also figuring as a visiting Canon in the Antwerp "Seven Sacraments" (fig. 349, left), with Pierre de Ranchicourt, Bishop of Arras, finds welcome support in a neglected footnote in the catalogue of the Bruges *Exposition des Primitifs Flamands* of 1902, no. 120*, according to which the picture, then ascribed to an unknown master of *ca.* 1500, came from the chapel of the *Collège d'Arras* at Louvain. This college was founded by Pierre de Ranchicourt's successor, Nicolas de Ruistre (erroneously referred to as Bishop of Utrecht instead of Atrecht in the earlier literature), who reigned from 1501 to 1509.

Page 315; Note 316[1]; fig. 420

Dirc Bouts' "Entombment" in the London National Gallery, though painted on canvas, must have belonged, presumably as the lower portion of the right-hand wing, to a large triptych the central panel of which, a "Calvary," is preserved in an unidentified collection at Florence: *Città di Firenze, Mostra d'Arte Fiamminga e Olandese dei Secoli XV e XVI, Palazzo Strozzi, Maggio-Ottobre 1947*, Catalogue, Florence, 1948, p. 34, fig. 29.

Note 327[5]

The architectural portrait of St. Bavo's at Haarlem, traditionally assigned to Geertgen tot Sint Jans, has been correctly attributed to one Pieter Gheryts (whose patronymic was apparently confused with Geertgen's Christian name) and dated in 1518. The facts emerged from a long discussion in *Oud Holland*, L, 1933, the most notable contribution being E. H. ter Kuile, "Nog eens: de Maquette van de St. Bavokerk te Haarlem," p. 152 ff. (see, more recently, R. Meischke, "Het architectonische Ontwerp in de Nederlanden gedurende de late Middeleeuwen en de zestiende Eeuw," *Bulletin von de Kon. Ned. Oudheidkundige Bond*, ser. 6, V, 1952, p. 179).

Except for the case of Isabella d'Este's "Drowning of Pharaoh," and that of the Avignonese marriage ritual, I owe the information condensed in the foregoing *Addenda* to the erudition and generosity of Professor J. G. van Gelder.

INDEX

As a rule, notes belonging to text passages referred to by page numbers are not indexed separately; exceptions have, however, been made on various occasions (for instance, where the note, but not the text passage, contains the library signature of a manuscript). For the method of reference, see p. 359.

INDEX

INDEX

Rembrandt van Rijn, pp. 158, 322, 324, note 340[1]. WORKS: Amsterdam, Rijksmuseum, Syndics, p. 189; New York, Metropolitan Mus., Old Woman Paring Nails, p. 194

Renaud IV, Duke of Guelders, pp. 91, 100, 102 f. *See* New York, Morgan Library, ms. 87

Rennes. Bib. Municipale: ms. 22 (Salisbury Psalter), note 116[9]

Reuwich, Erhard, note 324[3]

Reynolds, Sir Joshua, David Garrick between Tragedy and Comedy, London, Baron Rothschild Coll., p. 194

Richard II, King of England, p. 118; note 118[5]. *See* London, Nat. Gall., Anon. (English), Wilton Diptych

Richier, Ligier, p. 74

Richmond. Cook Coll. (formerly): free copy after Roger van der Weyden's "Medici Madonna" (Frankfort-on-the-Main, Städelsches Kunstinstitut), notes 274[6], 275[3]

Riemenschneider, Tilmann, Tomb of Emperor Henry II, Bamberg, Cathedral, note 271[4]

Rigaud, Hyacinthe, Portrait of President Gueidan as Shepherd, Aix-en-Provence, Mus. Granet, p. 194

Rijn, Hendrik van, Canon of Utrecht Cathedral, pp. 36, 92. *See* Antwerp, Mus. Royal des Beaux-Arts, Anon. (Utrecht)

Ring, Hermann and Ludger, portraits of Sybils, note 294[1]

Ripaille, Château de, Engel-Gros Coll. (formerly): Boucicaut Master (attr. to workshop of), Dives and Lazarus, note 54[1]

Robbia, Luca della, *Cantoria*, Florence Cathedral, p. 221

Robiert le pointre, mestre (identical with Robert Campin?), p. 159

Robinet d'Etampes, pp. 45, 232

Rode, Jan van, benefactor of Louvain University, note 274[6]

"Roermond altarpiece." *See* Amsterdam, Rijksmuseum, Anon.

Rogelet de le Pasture. *See* Pasture

Roger van der Weyden. *See* Weyden

Rogier de le Pasture, Maistre. *See* Pasture

Rogier le peintre, Maistre, p. 155; note 155[7]

Rogier de Wanebac. *See* Wanebac

"Rohan Hours." *See* Paris, Bib. Nat., ms. lat. 9471

Rolin, Nicholas, Chancellor of Burgundy, pp. 193, 268, 292; note 282[3]. *See* Eyck, Jan van, Madonna, Paris, Louvre; Weyden, Roger van der, Last Judgment, Beaune; Brussels, Bib. Royale, ms. 9241

Romanesque, p. 13 f. (general); pp. 134–140, note 135[2] (symbolical significance in juxtaposition with Gothic); pp. 134–140, 215 f., 227 f. (revival in Eyckian art)

Rombouts de Doppere, notary of St. Donatian at Bruges, note 347[7]

Rome. Galleria Doria: Gossart, Jan van, Madonna in a Church (after Jan van Eyck), p. 353; note 251[2]

— Lateran Museum: Early Christian sarcophagi showing Woman with the Issue of Blood, note 22[5]

— S. Maria Antiqua: The Three Holy Mothers (mural), note 327[1]

— S. Maria in Trastevere: Coronation of the Virgin (mosaic), note 145[2]

— Vatican Library: Odyssey landscapes, pp. 9, 12 f., 19; text ill. 3. ILL. MANUSCRIPTS: cod. Urb. 603 (Breviary of Blanche de France), note 32[1]; cod. Vat. lat. 973 (Johannes de Turrecremata), note 213[10]; cod. Vat. lat. 1993 (Opicinus de Canistris), note 26[7]

— Vatican, Museo Cristiano: Crucifixion (reliquary), note 267[3]

Rosen, Kunz von der, note 203[4]

Rostock. Nicolaikirche: Anon. (German), Nativity, p. 125

Rotterdam. Boymans Mus.: Bosch, Jerome, Prodigal Son, note 357[6]. DRAWINGS: Christus, Petrus (attr.), Portrait of a Lady, notes 200[8], 310[7]; Eyck, Jan van (attr.), Portrait of a Lady, identical with the foregoing; Eyck, Jan van (attr.), Portrait of a Young Man, note 200[3]; Weyden, Roger van der, Madonna, p. 266, fig. 385

Roubaix. Mme. Reboux Coll. (formerly): copy after Master of Flémalle's "Salting Madonna" (London, Nat. Gall.), p. 163 f.; notes 164[1,2]

Rouen. Bib. de la Ville: ms. 3024 (Book of Hours): pp. 112–115, 117, 120; notes 104[7], 112[4,5]; 114[2], 122[4], 128[5]; figs. 154–158

— Cathedral: St. Julian and Wife (window), note 234[1]

— Mus. de la Ville: David, Gerard, Virgin among Virgins, p. 352; fig. 484

Roulers. Wyckhouse Coll.: Weyden,

Roger van der (after), Madonna in Half-Length, note 296[5]

Rubens, Peter Paul, pp. 180, 322, 335

Rudolf IV, Archduke of Austria, p. 170 f.

Rummen and Quaebeke, Arnold Lord of. *See* Arnold

Runkelstein Castle, murals, p. 68

Rupert of Deutz, note 278[1] (on Nativity)

Ruusbroeck, Johannes, pp. 108, 331. *See* Brussels, Bib. Royale, ms. 19295–19297

Ryckel, Denis de ("Dionysius the Carthusian"), *Traité des quatre dernières choses. See* Brussels, Bib. Royale, ms. 11129

Rym, Daniel, pp. 119–121. *See* Baltimore, Walters Art Gall., ms. 166

Saint-Pathus, Guillaume de. *See* Paris, Bib. Nat., ms. fr. 5716

Salimbeni brothers, Infancy of the Baptist, Urbino, S. Giovanni, note 281[4]

Salmon, Pierre. *See* Geneva, Bib. Publique et Universitaire, ms. fr. 165; Paris, Bib. Nat., ms. fr. 23279

San Diego (Calif.). Putnam Foundation, Petrus Christus (attr.), Death of the Virgin, note 311[8]

San Marino (Calif.). Huntington Art Gallery: Weyden, Roger van der, Madonna in Half-Length, p. 295 f.; fig. 370

— Huntington Library: ms. 1149 (Book of Hours), note 263[4]

San Miniato al Tedesco. Church: Descent from the Cross (wood sculpture), p. 274

Sankt Florian. Stiftsmuseum: Anon. (Austrian), altarpiece, note 25[2]

Sant' Angelo in Formis: Entombment (mural), note 23[3]

Santa Barbara (Calif.). Arthur Sachs Coll.: Anon. (French, attr.), Annunciation, pp. 82, 129; note 129[12]

Santi, Giovanni, p. 153; notes 2[3], 153[2]

Sappho, pp. 53, 58

Sarpedon, p. 23

Scheerre, Herman, pp. 115–118, 122, 260, 299; notes 116[8], 118[3–5], 122[3]. *See* London, Chester Beatty Coll. (formerly), "Neville Hours"; —, Brit. Mus., mss. Add. 16998, Add. 42131, Royal 1 E IX, Royal 2 A XVIII; —, Lambeth Palace, ms. 69; —, E. G. Millar Coll., Book of Hours; Oxford, Bodleian Library, ms. Lat. Liturg. f.2

Schickhardt, Wilhelm, p. 11

INDEX

PLATES

2. Piero della Francesca, *Sacra Conversazione*; Milan, Brera.

1. Masolino, Death of St. Ambrose; Rome, S. Clemente.

Plate I.

3. Odysseus in the Land of the Cannibals; Rome, Vatican Library.

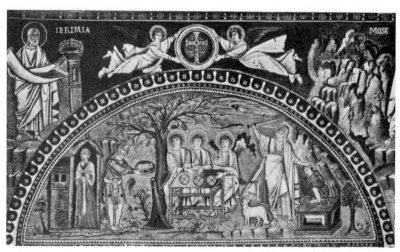

4. Abraham and the Angels; Ravenna, S. Vitale.

Plate 2.

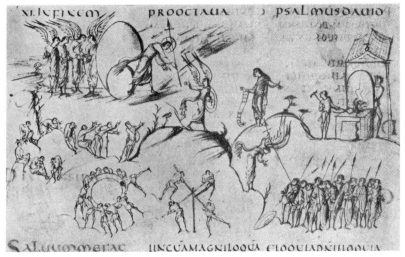

5. Psalm XI (XII); Utrecht, University Library, Utrecht Psalter.

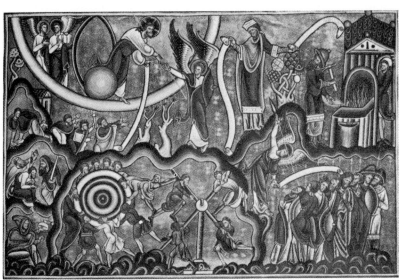

6. Psalm XI (XII); Paris, Bibliothèque Nationale, ms. lat. 8846.

Plate 3.

8. Apostle Statues; Amiens, Cathedral.

7. Romanesque Madonna; Dresden, Altertümermuseum.

Plate 4.

10. I Kings X, 3–5; Paris, Bibliothèque Nationale, ms. lat. 10525.

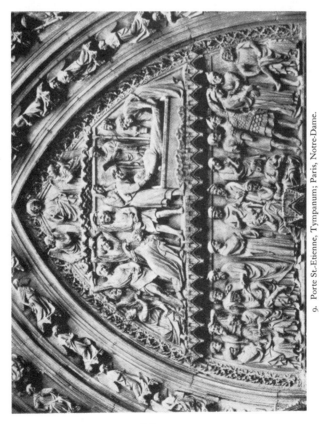

9. Porte St.-Etienne, Tympanum; Paris, Notre-Dame.

Plate 5.

11. Dream of Pharaoh; Florence, Baptistry.

12. Last Supper; Monreale, Cathedral.

13. Christ Healing the Palsied Man; Monreale, Cathedral.

14. Last Supper; Naumburg, Cathedral.

Plate 6.

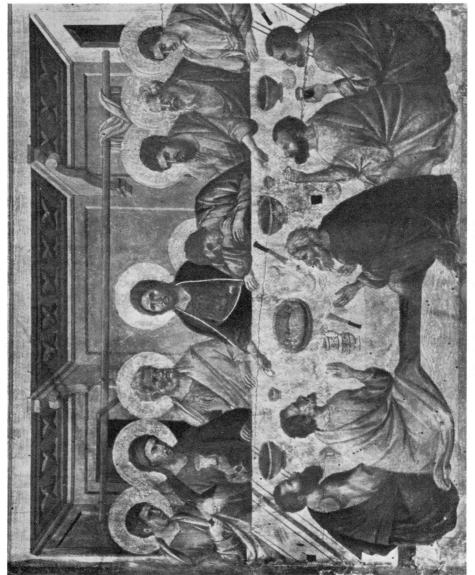

15. Duccio, Last Supper; Siena, Opera del Duomo.

Plate 7.

16. Ambrogio Lorenzetti, *Presentation of Christ*; Florence, Uffizi.

Plate 8.

17. Pietro Lorenzetti, Birth of the Virgin; Siena, Opera del Duomo.

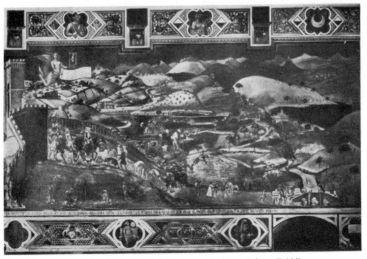

18. Ambrogio Lorenzetti, "Ager Senensis"; Siena, Palazzo Pubblico.

Plate 9.

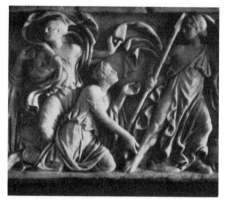

19. Achilles Leaving the Daughters of Lycomedes;
Cambridge, Fitzwilliam Museum.

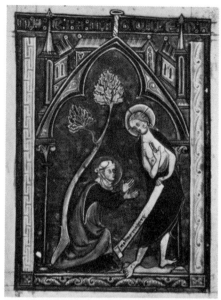

20. *Noli Me Tangere*; New York, Morgan Library, ms. 72.

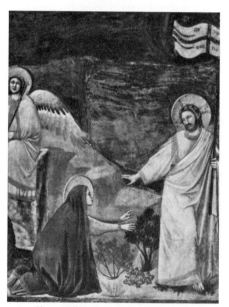

22. Giotto, *Noli Me Tangere*; Padua, Arena Chapel.

21. Austrian Master, Three Marys at the Tomb and
Noli Me Tangere; Klosterneuburg, Monastery.

Plate 10.

23. Entombment; New
York, Metropolitan
Museum.

25. Lamentation; Berlin, Staatsbibliothek.

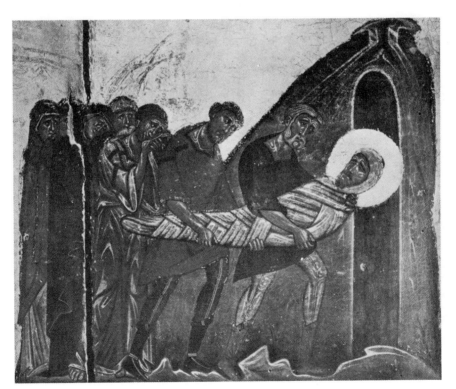

24. Entombment; Florence, Accademia.

Plate 11.

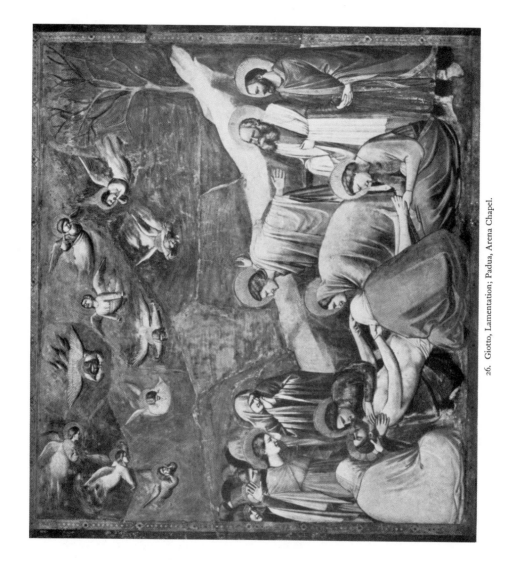

26. Giotto, Lamentation; Padua, Arena Chapel.

Plate 12.

28. The "Goldenes Rössel," Rear View; Altötting, Church.

27. The "Goldenes Rössel," Front View; Altötting, Church.

Plate 13.

30. Middle-Rhenish Master, Adoration of the Magi; Darmstadt, Landesmuseum.

29. Master Francke, Adoration of the Magi; Hamburg, Kunsthalle.

Plate 14.

32. Follower of Master Bertram, Angels Announcing the Passion; Hamburg, Kunsthalle.

31. Master Francke, Pursuit of St. Barbara; Helsingfors, Museum.

Plate 15.

33. Conrad of Soest, Calvary; Niederwildungen, Church.

Plate 16.

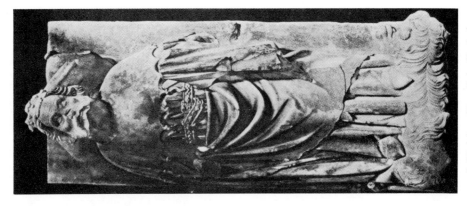

36. Workshop of Peter Parler, Tomb of Ottokar I; Prague, Cathedral.

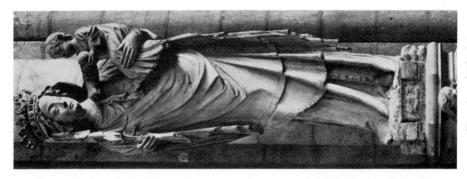

35. "Notre-Dame la Blanche"; Paris, Notre-Dame.

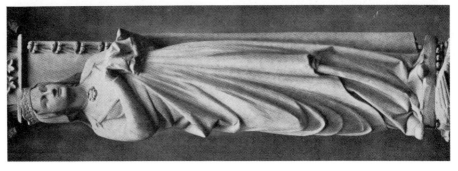

34. Madonna of the North Transept: Paris, Notre-Dame.

Plate 17.

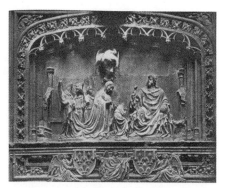

37. Coronation of the Virgin; La Ferté-Milon, Church.

38. Charles IV Receiving Homage; Mühlhausen, Church.

40. St. Catherine; Strasbourg, Cathedral.

39. Hans Multscher, "Karg-Altar"; Ulm, Cathedral.

Plate 18.

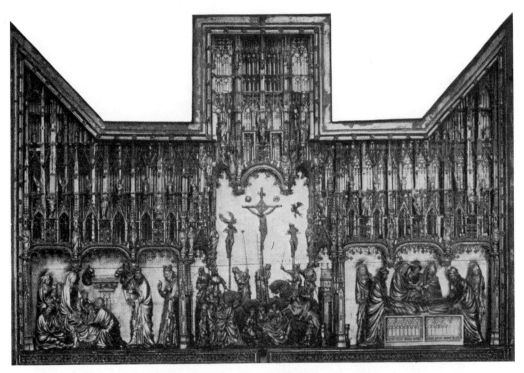

41. Jacques de Baerze, Central Relief of an Altarpiece; Dijon,
Musée de la Ville.

Plate 19.

42. Claus Sluter *et al.*, Portal; Chartreuse de Champmol.

Plate 20.

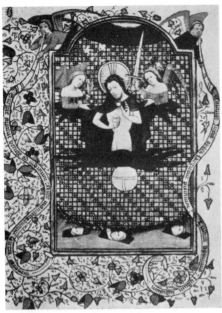

43. Man of Sorrows; New York, Morgan Library, ms. 46.

44. Man of Sorrows (Woodcut); London, Brit. Mus.

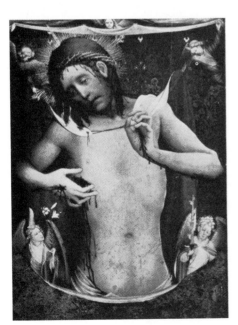

45. Master Francke, Man of Sorrows; Hamburg,
Kunsthalle.

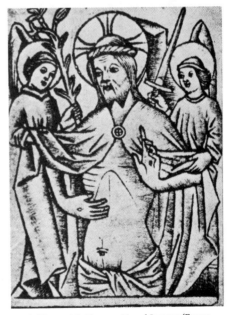

46. Master of St. Erasmus, Man of Sorrows (Engraving); Dresden, Kupferstichkabinett.

Plate 21.

50. Upper Rhenish Master, Annunciation; Winterthur, O. Reinhart Coll.

49. Lower Rhenish Master, Annunciation; Berlin, Deutsches Museum.

47. Master Francke, Nativity; Hamburg, Kunsthalle.

48. Nativity; Baltimore, Walters Art Gallery, ms. 211.

Plate 22.

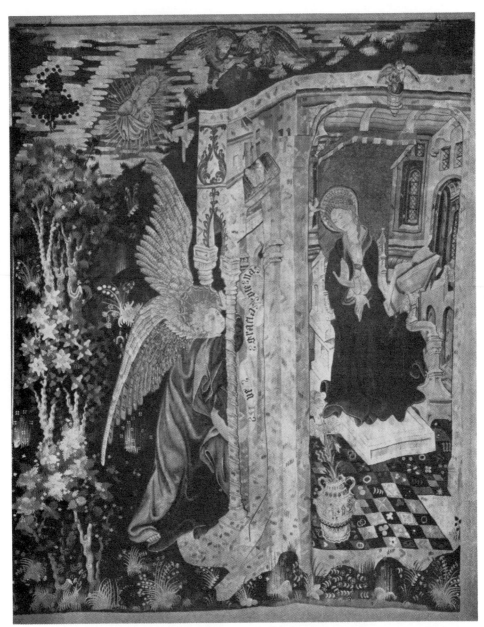

51. Annunciation (Tapestry); New York, Metropolitan Museum.

Plate 23.

55. St. Augustine; Cambridge, Philip Hofer Coll., *Cité de Dieu* ms.

56. Jan van Eyck, Pelican in Her Piety; Detail of fig. 241.

54. Werthina; Berlin, Staatsbibliothek, cod. theol. lat. fol. 323.

52. Madonna; Reims, Cathedral, Portal of North Transept.

53. Hubert van Eyck (?), Monkey; Detail of fig. 284.

Plate 24.

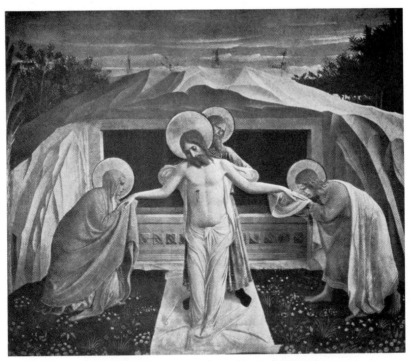

57. School of Fra Angelico, Entombment; Munich, Alte Pinakothek.

58. Consecration of a Bishop; Haarlem, Teyler Stichting, ms. 77.

Plate 25.

60. Hayne de Bruxelles, Madonna; Kansas City, W. R. Nelson Coll.

59. Notre-Dame de Grâces; Cambrai, Cathedral.

Plate 26.

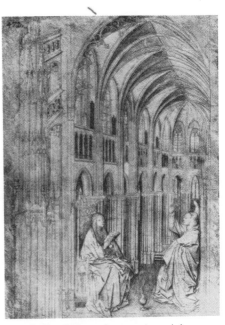

61. Amiens Master of 1437, Our Lady as
Priest; Paris, Louvre.

62. French Master of *ca.* 1450, Annunciation;
Wolfenbüttel, Landesmuseum.

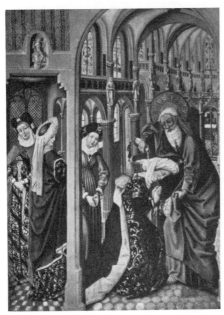

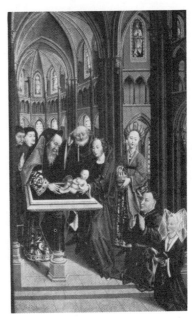

63. Master of Heiligenthal, St. Andrew Baptizing;
Lüneburg, Nikolaikirche.

64. Burgundian Master of *ca.* 1450–60, Presen-
tation of Christ; Paris, Louvre.

Plate 27.

65. "Old Style" All Saints Picture. Göttingen, University Library,
cod. theol. 231.

66. "New Style" All Saints Picture. Paris, Bibliothèque Ste.-Geneviève, ms. 246.

Plate 28.

Icon Editions